International Dictionary of Art and Artists

ART

International Dictionary of Art and Artists

ART
ARTISTS

International Dictionary of Art and Artists

ART

With a foreword by
Cecil Gould

Editor
James Vinson

ST. JAMES PRESS

AN IMPRINT OF GALE

Detroit · New York · Toronto · London

ST. JAMES PRESS
645 Griswold, Suite 835
Detroit, MI 48226

British Library Cataloguing in Publication Data
International dictionary of Art and Artists.
1. Visual Arts
I. Vinson, James
700

ISBN 1–55862–001–X

10 9 8 7 6 5 4 3 2

CONTENTS

FOREWORD

I have been asked to write a short foreword to this new *International Dictionary of Art and Artists*, to explain its novelties in its arrangement and presentation.

It is arranged in two volumes. The first, *Artists*, lists in alphabetical order the most important artists from the 13th to the 20th centuries (from Cimabue to Hockney). But in place of a "life and works" article in the style of other art encyclopedias, the *International Dictionary of Art and Artists* presents the work in four parts.

The first records the essential facts in the artist's career. The second lists the most important public and private collections of his work. Third is a bibliography, titles and dates of publication of books and articles – sometimes amounting to more than 50 items – on the subject of the artist; as well, where applicable, his own writings are listed. Lastly, there is a critical essay of up to 2,000 words which discusses historical and critical aspects of his art.

The other volume, *Art*, discusses some 500 individual works of art, arranged in roughly chronological order. In some cases the work is the artist's acknowledged masterpiece, in others a representative production. In some ways, this volume functions as an extended catalogue of the ideal art gallery.

Since the writer of each critical essay is given a free hand to express his views, there are variations in the approach and style of the results.

It is hoped that the arrangements of the material and the freedom given the essayists will make for an avoidance of monotony and will help to throw new light on the artists and their work.

<div align="right">CECIL GOULD</div>

EDITOR'S NOTE

The selection of artists and art works in the two volumes of the *International Dictionary of Art and Artists* is based on comments by the contributors, listed on page xi. In addition, valuable advice has been given by a number of other critics and scholars, including Brian Allen, Alexandra Comini, Creighton Gilbert, Ronald Lightbown, Linda Murray, Colin Naylor, and Peter Selz. Special thanks are due to Henry Adams, Reidar Dittmann, Laurinda Dixon, Cecil Gould, Annie-Paule Quinsac, Guilhem Scherf, Ruth Wilkins Sullivan, and Christopher Wright.

The entry for each artist consists of a short biography, a list of collections/locations where works can be seen, a list of books and articles on the artist (as well as books and articles *by* the artist, where applicable), and a signed critical essay.

Collections are listed alphabetically by city (though the Royal Collection is generally listed last). Abbreviations are avoided, but one exception is the abbreviation "cat", indicating an exhibition catalogue. Revised or expanded editions of books are indicated by the addition of a second date at the end of the entry.

We would like to thank the contributors for their cooperation and patience in helping us compile the *Dictionary*.

CONTRIBUTORS

Ackerman, Gerald M.
Acres, Alfred J.
Adams, Henry
Ahl, Diane Cole
Azuela, Alicia
Balakier, Ann Stewart
Barrett, Elizabeth
Bazarov, Konstantin
Benge, Glenn F.
Bergstein, Mary
Bird, Alan
Bisanz, Rudolf M.
Bock, Catherine C.
Boström, Antonia
Bourdon, David
Bradley, Simon
Bremser, Sarah H.
Brown, M.R.
Burnham, Patricia M.
Campbell, Malcolm
Caplow, Harriet McNeal
Cavaliere, Barbara
Caygill, Caroline
Chappell, Miles L.
Cheney, Liana
Chevalier, Tracy
Clegg, Elizabeth
Cohen, David
Collins, Howard
Cossa, Frank
Crellin, David
Crelly, William R.
Croydon, Abigail
Davidson, Abraham A.
Davidson, Jane P.
Dittmann, Reidar
Dixon, Annette
Dixon, Laurinda S.
Dodge, Barbara
Downs, Linda
Edmond, Mary
Eustace, Katharine
Evans, Magdalen
Evelyn, Peta
Faxon, Alicia
Florence, Penny
Foskett, Daphne
Gale, Matthew
Galis, Diana
Garlick, Kenneth
Gash, John
Gauk-Roger, Nigel
Gibson, Jennifer
Glenn, Constance W.
Goldfarb, Hilliard T.
Gould, Cecil
Green, Caroline V.
Greene, David B.
Griffin, Randall C.

Grunenberg, Christoph
Gully, Anthony Lacy
Habel, Dorothy Metzner
Hancock, Simon
Harper, Paula
Heath, Samuel K.
Heffner, David
Hirsh, Sharon
Holloway, John H.
Howard, Seymour
Hulsker, Jan
Hults, Linda C.
Hutchison, Jane Campbell
Jachec, Nancy
Jacobs, Fredrika H.
Jeffett, William
Jenkins, Susan
Kahr, Madlyn Millner
Kaplan, Julius D.
Kapos, Martha
Kaufman, Susan Harrison
Kenworthy-Browne, John
Kidson, Alex
Kind, Joshua
Kowal, David Martin
Lago, Mary
Landers, L.A.
Larsson, Lars Olof
Lawrence, Cynthia
Lesko, Diane
Levin, Gail
Levy, Mark
Liedtke, Walter A.
Lister, Raymond
Lothrop, Patricia Dooley
Mack, Charles R.
Mackie, David
Mainzer, Claudette R.
Maller, Jane Nash
Manca, Joseph
Massi, Norberto
Matteson, Lynn R.
Mattison, Robert Saltonstall
McCullagh, Janice
McGreevy, Linda F.
McKenzie, A. Dean
Milkovich, Michael
Miller, Lillian B.
Miller, Naomi
Mills, Roger
Milner, Frank
Minor, Vernon Hyde
Minott, Charles I.
Mitchell, Timothy F.
Moffitt, John F.
Morris, Susan
Moskowitz, Anita F.
Murdoch, Tessa
Nelson, Kristi

North, Percy
Nuttall, Paula
Olson, Roberta J.M.
Oppler, Ellen C.
Overy, Paul
Palmer, Deborah
Parker, Stephen Jan
Parry, Ellwood C. III
Parshall, Peter W.
Partridge, Loren
Pelzel, Thomas
Peters, Carol T.
Piperger, Justin
Pomeroy, Ralph
Powell, Cecilia
Powell, Kirsten H.
Pressly, William L.
Quinsac, Annie-Paule
Radke, Gary M.
Rajnai, Miklos
Rand, Olan A., Jr
Reynolds, Lauretta
Riede, David G.
Robinson, Susan Barnes
Roworth, Wendy Wassyng
Ruda, Jeffrey
Russo, Kathleen
Scherf, Guilhem
Schneider, Laurie
Scott, David
Scribner, Charles III
Shaw, Lindsey Bridget

Shesgreen, Sean
Shikes, Ralph E.
Slayman, James H.
Smith, David R.
Sobré, Judith Berg
Spike, John T.
Stallabrass, Julian
Standring, Timothy J.
Stevenson, Lesley
Stratton, Suzanne L.
Sullivan, Ruth Wilkins
Sullivan, Scott A.
Surtees, Virginia
Teviotdale, E.C.
Thompson, Elspeth
Tomlinson, Janis A.
Tufts, Eleanor
Verdon, Timothy
Walder, Rupert
Walsh, George
Wanklyn, George A.
Wechsler, Judith
Weil, John A.
Weiland, Jeanne E.
Wells, William
West, Shearer
Whittet, G.S.
Wolk-Simon, Linda
Woods-Marsden, Joanna
Wright, Christopher
Zilczer, Judith

International Dictionary of Art and Artists

ART

Antonella da Messina
 St. Jerome in His Study
Cima da Conegliano
 Virgin and Child with Saints
Cosmè Tura
 The Roverella Altarpiece
Francesco del Cossa
 Hall of the Months
Ercole de' Roberti
 The Pala Portuense
Carlo Crivelli
 The Annunciation
Rogier van der Weyden
 Descent from the Cross
Robert Campin
 Mérode Triptych
Dirk Bouts
 The Last Supper
Jan van Eyck
 The Ghent Altarpiece
 The Madonna with Chancellor Nicolas
 Rolin
Hans Memling
 Altarpiece of the Two St. Johns
Petrus Christus
 Portrait of a Carthusian
Hugo van der Goes
 Portinari Altarpiece
Hieronymus Bosch
 Ship of Fools
 Garden of Earthly Delights
Joos van Ghent
 The Institution of the Eucharist
Gerard David
 Baptism of Christ Augustine
Jaume Huguet
 Consecration of Saint Augustine
Bartolomé Bermejo
 The Pietà of Canon Lluis Desplà
Pedro Berruguete
 Auto da Fé
Limbourg Brothers
 October, from Très Riches Heures du Duc de Berry
Jean Perréal
 The Moulins Triptych
Jean Fouquet
 St. Stephen and Etienne Chevalier
Master of the Housebook
 Aristotle and Phyllis
Hans Multscher
 Virgin and Child
Master Bertram of Minden
 Grabow Altar
Master Francke
 St. Thomas à Becket Altar
Konrad Witz
 The Miraculous Draft of Fishes
Lucas Moser
 Tiefenbronner Altar
Stefan Lochner
 Madonna in the Rose Bower
Martin Schongauer
 Madonna of the Rosehedge
Michael Pacher
 St. Wolfgang Alarpiece
Michael Wolgemut
 God in Majesty

Albrecht Dürer
 Self-Portrait
 Knight, Death, and the Devil
Leonardo da Vinci
 Mona Lisa
 The Last Supper
 The Virgin and Child with Saint Anne
 The Virgin of the Rocks
Michelangelo
 Pietà
 David
 Moses
 Medici Chapel
 Sistine Chapel Ceiling
Raphael
 The School of Athens
 Triumph of Galatea
 Pope Leo X with Cardinals
Giulio Romano
 Fall of the Giants
Andrea del Sarto
 Madonna of the Harpies
Fra Bartolommeo
 Mystical Marriage of St. Catherine
 of Siena
Rosso Fiorentino
 The Deposition of Christ
Perino del Vaga
 The Fall of the Giants
Beccafumi
 The Birth of the Virgin
Jacopo Pontormo
 Deposition
Agnolo Bronzio
 Venus, Cupid, Folly, and Time
Francesco Salviati
 The Deposition
Giorgio Vasari
 Allegory of the Immaculate Conception
Niccolò dell' Abbate
 Landscape with the Death of Eurydice
Benvenuto Cellini
 Perseus with the Head of Medusa
Bartolommeo Ammanati
 Fountain of Neptune
Giambologna
 Rape of the Sabine Women
Sodoma
 St. Sebastian
Correggio
 Assunta Cupola
Parmigianino
 Madonna of the Long Neck
Vittore Carpaccio
 St. Ursula Cycle
Giorgione
 Tempestà
Palma Vecchio
 St. Barbara Altarpiece
Sebastiano del Piombo
 The Raising of Lazarus
Titian
 Sacred and Profane Love
 The Pesaro Madonna
 The Venus of Urbino
Jacopo Bassano
 Rest on the Flight into Egypt

Tintoretto
 St. Mark Freeing a Slave
 Susanna
 The Crucifixion
Veronese
 Mars and Venus
 The Feast in the House of Levi
Jacopo Sansovino
 The Loggetta
Alessandro Vittoria
 St. Jerome
Lorenzo Lotto
 Sacra Conversazione
Pordenone
 Dome Frescoes
Dosso Dossi
 Circe
Andrea Sansovino
 The Virgin and Child with St. Anne
Taddeo Zuccaro
 Papal Legate Cardinal Farnese Entering
 Paris
Annibale Carracci
 The Farnese Gallery
Marthis Grünewald
 Isenheim Altarpiece
Lucas Cranach
 Crucifixion
Hans Burgkmair
 St. John Altar
Albrecht Altdorfer
 The Battle of Alexander
Hans Baldung
 Eve, the Serpent, and Death
Wolf Huber
 Lamentation
Hans Holbein
 Portrait of Georg Gisze
 The Ambassadors
Viet Stoss
 St. Mary Altarpiece
Tilman Riemanschneider
 Altarpiece of the Holy Blood
Quentin Massys
 The Money Changer and His Wife
Jan Gossaert
 Danaë
Joachim Patinir
 Charon Crossing the Styx
Maerten van Heemskerck
 Family Portrait
Lucas van Leyden
 Last Judgement
Pieter Aertsen
 Christ in the House of Martha and Mary
Anthonis Mor
 Portrait of Queen Mary Tudor
Frans Floris
 The Fall of the Rebel Angels
Adriaen de Vries
 Hercules Fountain
Pieter Bruegel
 Hunters in the Snow
 Peasant Wedding
Jan Bruegel
 Hearing

Hendrick Goltzius
 Portrait of a Young Man with Skull and
 Tulip
Jean Cousin
 Eva Prima Pandora
Jean Clouet
 Marie d'Assigney, Madame de Canaples
François Clouet
 Pierre Quthe
Germain Pilon
 Tomb of Valentine Balbiani
Jean Goujon
 The Fountain of Innocents
Alonso Berruguete
 The Transfiguration of Christ
El Greco
 Burial of the Count of Orgaz
 View of Toledo
Francisco Ribalta
 St. Francis Embracing the Crucified Christ
Nicholas Hilliard
 Young Man among Roses
Isaac Oliver
 Unknown Melancholy Man
Caravaggio
 Bacchus
 The Calling of St. Matthew
 The Conversion of St. Paul
Orazio Gentileschi
 Allegory of Peace and the Arts
Artemisia Gentileschi
 Judith Slaying Holofernes
Guido Reni
 Aurora
Domenichino
 The Last Communion of St. Jerome
Giovanni Lanfranco
 The Ecstasy of St. Margaret of Cortona
Guercino
 Aurora
Pietro da Cortona
 Salone of the Barberini Palace
Andrea Sacchi
 An Allegory of Divine Wisdom
Salvator Rosa
 Democritus in Meditation
Allessandro Algardi
 Bust of Cardinal Laudivio Zacchia
Gian Lorenzo Bernini
 Apollo and Daphne
 The Ecstasy of St. Teresa
 Fountain of the Four Rivers
Domenico Fetti
 The Parable of the Wheat and the Tares
Bernardo Strozzi
 The Calling of St. Matthew
Giovanni Benedetto Castiglione
 Allegory of Vanity
Giovanni Battista Gaulli
 Triumph of the Name of Jesus
Andrea Pozzo
 Allegory of the Jesuit Missions
Evaristo Baschenis
 Still Life with Musical Instruments
Mattia Preti
 St. John the Baptist Preaching

John Trumbull
 The Death of General Warren at the
 Battle of Bunker's Hill
J. A. D. Ingres
 Madame Moitessier
Eugène Delacroix
 Liberty Guiding the People
J. B. C. Corot
 Chartres Cathedral
Théodore Géricault
 The Raft of the Medusa
Honoré Daumier
 A Third Class Carriage
Antoine-Louis Barye
 Tiger Devouring a Gavial Crocodile
Jean-François Millet
 The Gleaners
Eugène Boudin
 On the Beach of Deauville
Johan Barthold Jongkind
 River with Mill and Sailing Ships
Gustave Courbet
 The Burial at Ornans
Gustave Doré
 Newgate—Exercise Yard
Jean-Léon Gérôme
 Arabs Crossing the Desert
Edgar Degas
 The Absinthe Glass
 The Rehearsal
Edouard Manet
 Le Déjeuner sur l'herbe
 Olympia
 A Bar at the Folies-Bergère
Camille Pissarro
 Boulevard des Italiens, Morning, Sunlight
Rosa Bonheur
 The Horse Fair
Alfred Sisley
 Snow at Louveciennes
Claude Monet
 Gare St Lazare
 Le Portail et la Tour d'Albane
 Le Bassin aux nymphéas
Pierre-Auguste Renoir
 Monet Working in His Garden at Argenteuil
 The Bathers
Berthe Morisot
 In the Dining Room
Gustave Moreau
 Jupiter and Semele
Odilon Redon
 Il y eût peut-être une vision
Henri Rousseau
 Sleeping Gypsy
Auguste Rodin
 The Burghers of Calais
 Balzac
Paul Cézanne
 Madame Cézanne in a Red Armchair
 The Card Players
 Mont Sainte-Victoire Seen from Les Lauves
Paul Gauguin
 Day of the God
Georges Seurat
 Sunday Afternoon on La Grande Jatte

Henri Toulouse-Lautrec
 At the Moulin Rouge
Pierre Bonnard
 The Dining Room in the Country
Edouard Vuillard
 Woman Sweeping
Giovanni Fattori
 The Palmieri Rotunda
Medardo Rosso
 The Conversation in the Garden
Giovanni Segantini
 The Evil Mothers
J. M. W. Turner
 The White Library, Petworth
 Snow Storm—Steam-Boat Off a Harbor's Mouth
John Constable
 The Haywain
 The Leaping Horse
John Crome
 Poringland Oak
John Sell Cotman
 Greta Bridge
David Wilkie
 The Blind Fiddler
Richard Parkes Bonington
 La Siesta
Samuel Palmer
 A Hilly Scene
William Powell Frith
 Derby Day
Ford Madox Brown
 The Last of England
William Holman Hunt
 The Light of the World
Dante Gabriel Rossetti
 The Wedding of St. George and the Princess Sabra
John Everett Millais
 Christ in the House of His Parents
Edward Burne-Jones
 King Cophetua and the Beggar Maid
Frederic Leighton
 Flaming June
James McNeill Whistler
 Arrangement in Grey and Black No 1: The
 Artist's Mother
John Singer Sargent
 The Daughters of Edward D. Boit
Walter Sickert
 The Gallery of the Old Bedford
Wilson Steer
 Girls Running, Walberswick Pier
Thomas Cole
 Scene from "The Last of the Mohicans"
Albert Bierstadt
 The Rocky Mountains, Lander's Peak
George Caleb Bingham
 Fur Traders Descending the Missouri
Winslow Homer
 The Gulf Stream
Thomas Eakins
 The Gross Clinic
Mary Cassatt
 The Bath
Albert Pinkham Ryder
 The Dead Bird
Maurice Prendergast
 On the Beach, No. 3

Casper David Friedrich
 Monk by the Sea
Philipp Otto Runge
 Rest on the Flight
Johann Friedrich Overbeck
 Italia and Germania
Ferdinand Georg Waldmüller
 Christmas Morning
Adolph von Menzel
 The Iron Rolling Mill
Hans von Marées
 The Hesperides
Wilhelm Leibl
 Three Women in Church
Lovis Corinth
 The Three Graces
Arnold Böcklin
 Island of the Dead
Ferdinand Hodler
 Night
Max Klinger
 Attunement
Gustav Klimt
 The Kiss
Egon Schiele
 The Family
Vincent van Gogh
 The Potato-Eaters
 The Night Cafe
 The Starry Night
James Ensor
 The Entry of Christ into Brussels
Edvard Munch
 The Scream
Ilya Repin
 The Cossacks
Johan Christian Dahl
 Hjelle in Valdres
Raoul Dufy
 The Paddock at Deauville
Aristide Maillol
 La Méditerranée
Henri Matisse
 The Green Stripe
 Harmony in Red
 Backs I-IV
Raymond Duchamp-Villon
 The Horse
Constantin Brancusi
 Bird in Space
Georges Rouault
 The Old King
Julio Gonzalez
 Woman Combing Her Hair
Andre Derain
 The Pool of London
Francis Picabia
 I See Again in Memory My Dear Udnie
Robert Delaunay
 Windows Open Simultaneously
Maurice Vlaminck
 La Restaurant de la Machine à Bougival
Pablo Picasso
 Les Demoiselles d'Avignon
 Guernica
Fernand Léger
 The City

Georges Braque
 Le Portugais
Marc Chagall
 Dedicated to My Fiancée
Marcel Duchamp
 The Bride Stripped Bare
Jean Arp
 Femme Amphore
Chaim Soutine
 Carcass of Beef
Andre Masson
 Niobé
Paul Delvaux
 Sleeping Venus
Yves Tanguy
 Indefinite Divisibility
Alberto Giacometti
 Man Pointing
Jean Dubuffet
 Archetypes
Victor Vasarely
 Orion MC
Emil Nolde
 Doubting Thomas
Ernst Barlach
 The Ascetic
Käthe Kollwitz
 Outbreak
Paula Modersohn-Becker
 Self-Portrait
Wassily Kandinsky
 Improvisation 30
Paul Klee
 Death and Fire
Ernst Ludwig Kirchner
 The Street
Franz Marc
 Fighting Forms
Max Beckmann
 The Night
August Macke
 Zoological Garden I
Kurt Schwitters
 Merz 19
Otto Dix
 Portrait of Sylvia von Harden
George Grosz
 The End
Max Ernst
 The Elephant Celebes
Oskar Kokoschka
 The Tempest
Piet Mondrian
 Composition with Red, Yellow, and Blue
René Magritte
 Time Transfixed
Asger Jorn
 In the Beginning Was the Image
Karel Appel
 Questioning Children
Kasimir Malevich
 White Square on White
Vladimir Tatlin
 Monument to the Third International
Antoine Pevsner
 Portrait of Marcel Duchamp

Naum Gabo
 Linear Construction: Variation
Ossip Zadkine
 Destroyed City
Jacques Lipchitz
 Figure
Giacomo Bella
 Dynamism of a Dog on a Leash
Umberto Boccioni
 Unique Forms of Continuity in Space
Gino Severini
 Dynamic Hieroglyphic of the Bal Tabarin
Amadeo Modigliani
 Italian Woman
Giorgio de Chirico
 Mystery and Melancholy of a Street
Marino Marini
 Pomona
Salvador Dalí
 The Persistence of Memory
Joan Miró
 Head of a Woman
José Clemente Orozco
 Hospicio Cabañas Murals
Diego Rivera
 Detroit Industry
David Alfaro Siqueiros
 Portrait of the Bourgeoisie
Rufino Tamayo
 The Singer
Augustus John
 Madame Suggia
Jacob Epstein
 Rock Drill
Stanley Spencer
 The Resurrection: Cookham
Ben Nicholson
 White Relief
Henry Moore
 Madonna and Child
 Reclining Figure
Barbara Hepworth
 Forms in Echelon
Graham Sutherland
 Crucixifion
Victor Pasmore
 Abstract in White, Black, and Crimson
Francis Bacon
 Three Studies for a Crucifixion
David Hockney
 A Bigger Splash
John Sloan
 The Coffee Line

Joseph Stella
 Brooklyn Bridge
George Bellows
 Stag at Sharkey's
Charles Demuth
 I Saw the Figure 5 in Gold
Lyonel Feininger
 Bird Cloud
Edward Hopper
 Nighthawks
Thomas Hart Benton
 Persephone
Hans Hofmann
 Effervescence
Georgia O'Keeffe
 Music—Pink and Blue II
Alexander Archipenko
 Walking Woman
Alexander Calder
 Lobster Trap and Fish Tail
Man Ray
 The Gift
Stuart Davis
 Lucky Strike
Ben Shahn
 The Red Stairway
Jackson Pollock
 Autumn Rhythm
Barnett Newman
 Vir Heroicus Sublimis
Willem de Kooning
 Woman I
Franz Kline
 Chief
David Smith
 Cubi XIX
Mark Rothko
 Green and Maroon
Morris Louis
 Theta 1960
Robert Motherwell
 Elegy to the Spanish Republic
Larry Rivers
 Washington Crossing the Delaware
Robert Rauschenberg
 Bed
Roy Lichtenstein
 Whaaam!
Edward Kienholz
 The State Hospital
Jasper Johns
 Three Flags
Andy Warhol
 Gold Marilyn Monroe

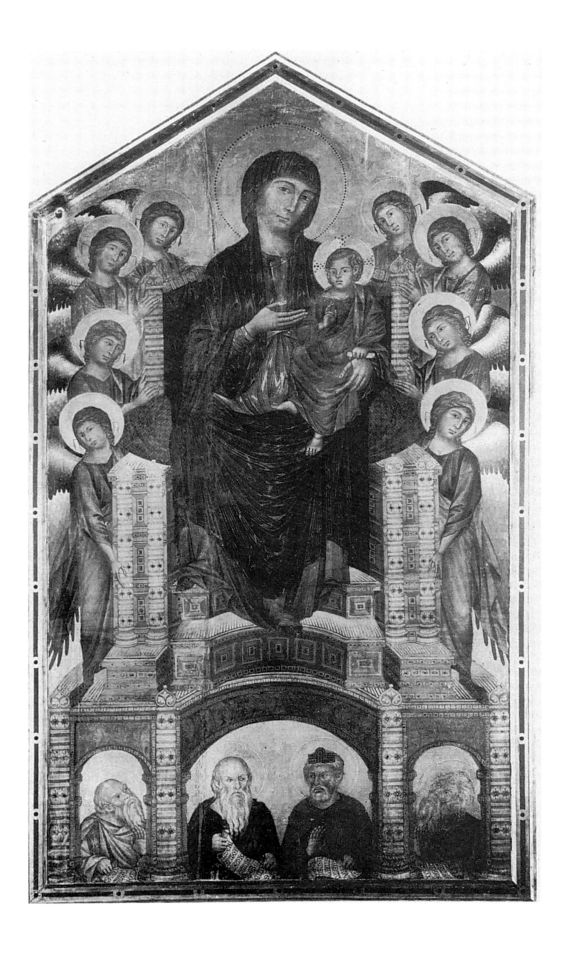

Cimabue (c. 1240 or c. 1250–1302)
Santa Trinita Madonna
Panel, 12 ft. 7⁵/₈ in. x 7 ft. 3³/₄ in. (385 x 222.6 cm.)
Florence, Uffizi

Cimabue's Santa Trinita *Madonna*, the artist's most important surviving altarpiece, depicts one of the dominant themes in thirteenth century Tuscan painting, the enthroned Virgin and Child adored by angels. Not included in the first edition of Vasari's *Lives of the Most Eminent Painters, Sculptors, and Architects* (1550), it is mentioned in the revised second printing of 1568:

> He [Cimabue] afterwards undertook a large picture for the monks of Vallombrosa in their abbey of Santa Trinita at Florence. This was a Madonna with the Child in her arms, surrounded by many adoring angels, on a gold ground. To justify the high opinion in which he was already held, he worked at it with great industry, showing improved powers of invention and exhibiting Our Lady in a pleasing attitude. The painting when finished was placed by the monks over the high altar of the church, whence it was afterwards removed to make way for the picture of Alessio Baldovinetti, which is there today. It was afterwards placed in a minor chapel on the left aisle in that church.

The only earlier mention of the panel had occurred in a brief notice in the *Libro di Antonio Billi* (c. 1516–30), that Cimabue "fece in Santa Trinita una tavola." Like most of Cimabue's oeuvre, with the exception of the mosaic *Saint John* of 1302 from the end of the artist's life, the date of the Santa Trinita *Madonna* is unknown. Due to a series of seeming inconsistencies within the work itself, its date has been so widely disputed that critics have assigned it to every phase of the artist's career.

The theme of the enthroned Madonna first appeared in early 13th-century Tuscan painting in a hieratic, symmetrical format, as seen in the *Madonna degli occhi grossi* (Cathedral Museum, Siena). Here, seated frontally on a low cushioned bench, the Virgin holds the Child, both confronting the viewer straight ahead. As this motif evolved, the Virgin's frontality gave way to a more natural contrapposto position, and the throne rotated to a three-quarter view, providing improved spatial definition. Cimabue's increasingly advanced treatment of enthroned figures in space can be traced through his Assisi frescoes, starting with his *Four Evangelists* in the vaults of the crossing of the Upper Church, followed by his *Virgin in Glory* (also Upper Church); and his *Enthroned Madonna and Child with Angels and Saint Francis,* in the Lower Church. The advances in the latter fresco include a massive chair throne set in three-quarter view, with a projecting double stepped, arched footstool; the Virgin seated with her left knee raised to support the Child in a logical fashion; and four angels brought into a new proximity to the Virgin.

Cimabue's Santa Trinita *Madonna,* however, does not fit neatly into this developmental scheme. Although it incorporates some of the advanced features of the Lower Church *Enthroned Madonna and Child,* its overall format returns to the earlier archaic type of hieratic, frontal, symmetrical presentation. Moreover, the Virgin's position on the throne defies logic: the upper part of her body appears to incline toward the viewer's right, while her legs turn toward the viewer's left. Nor does the position of her left foot on the lower step provide the needed anatomical support for the Child. A comparison with Duccio's famous Rucellai *Madonna* (Uffizi), commissioned in 1285, is instructive, since both panels show exceptionally large, monumental depictions of the same subject, using similar secondary elements and devices. They differ in certain important aspects, however. In keeping with the new Gothic sensibility, Duccio's Virgin wears a deep blue mantle, embellished only by the fluid, calligraphic line of its thin, golden border. Cimabue's version, in contrast, retains the old fashioned Byzantine gold-striated drapery. Although the perspectival treatment of the thrones in both is still empirical, the Rucellai *Madonna* is spatially far more coherent, anatomically more convincing, and stylistically more advanced. While this would seem to suggest that Cimabue's Santa Trinita panel predated the Rucellai *Madonna,* there is no scholarly consensus on this issue. Although there was interaction between Cimabue and Duccio throughout their careers, their precise relationship during the critical period of the 1280's remains to be defined.

Balancing the Santa Trinita *Madonna's* archaisms cited above are the panel's notable innovations, some building on motifs introduced more tentatively by Cimabue at Assisi. The arches, formerly used at Assisi to create depth, are here deepened and brilliantly developed into an arcade forming a kind of proto-predella, or base for the altarpiece. This was an advanced new feature evolving at this time. The device of the proto-predella here serves the important function of raising the throne and elevating the image of the Virgin Mother, thus further exalting her.

Another innovative aspect of this altarpiece is Cimabue's use of the four half-length figures of Old Testament Prophets in the arcade beneath the throne. In fact, the lower third of the panel is not only more innovative, but is actually animated by an entirely different spirit. In contrast to the monumental serenity of the Madonna above, the Prophets below express a psychological intensity that recalls the impassioned drama of Cimabue's Assisi *Crucifixion.* The twisted postures and probing glances of the two outside figures, Jeremiah and Isaiah, are particularly akin to the monumental sculptured forms of Giovanni Pisano for the facade of Siena Cathedral (1284–96), most notably his *Mary sister of Moses,* now in the Siena Cathedral Museum.

Cimabue's Prophets bear texts that read as follows: Jeremiah, "Creavit Dominus novum super terram femina circumdabit virum (For the Lord has created a new thing on the earth: a woman protects a man," Jeremiah 31:22); Abraham, "In semine tuo benedicentur omnes gentes (And by your descendants shall all the nations of the earth bless themselves," Genesis 22:18 or 26:4); David, "De fructu ventris tui ponam super sedem tuam (One of the sons of your body I will set on your throne," Psalms 132:11); and Isaiah, "Ecce virgo concipiet et pariet, (Behold, a Virgin shall conceive and bear a son," Isaiah 7:14) Taken together these prophetic texts prefigure the Incarnation.

—Ruth Wilkins Sullivan

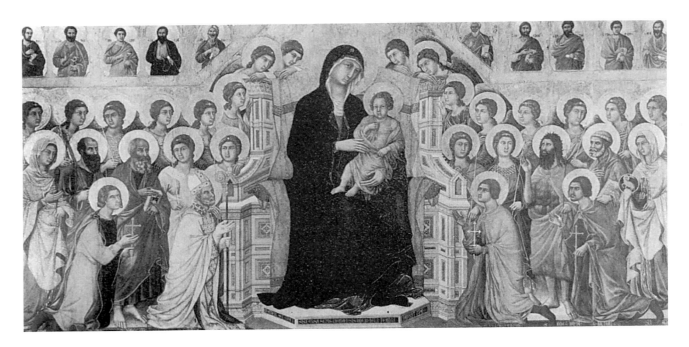

Duccio di Buoninsegna (c. 1255 or c. 1260—c. 1318–19)
The Maestà, 1311
Panel; 6 ft. 10¹/₂ in. (206 cm.) (height)
Siena, Pinacoteca Nazionale

Bibliography—

Brandi, Cesare, *Duccio: La Maestà,* Rome, 1954.
Brandi, Cesare, *Il restauro della Maestà di Duccio,* Rome, 1959.
Carli, Enzo, *La Maestà di Duccio,* Florence, 1981.

Commissioned for the high altar of the Cathedral of Siena, Duccio's *Maestà* had been called the richest, most complex, and most influential altarpiece ever painted in Italy. With its bright, glowing colors, and its sumptuous use of gold, it has also been called the most beautiful. Indeed, in celebration of its completion 9 June 1311, it was carried from the artist's studio to the Cathedral in a solemn yet joyous procession through the streets of Siena, a remarkable testimony to the devotion of the entire populace.

Originally freestanding, the *Maestà* was painted front and back, its two main panels on both sides surmounted by a series of truncated gables, which were crowned with angel pinnacles. It also included a predella (base), which was still a rare feature at that time. Dismantled in 1771, a number of its subsidiary panels were dispersed, and some were subsequently lost. By the late 1870's, several predella panels were already in private hands, making their way out of Italy by the 1880's. Out of a possible total of approximately sixty narrative scenes, fifty-three survive, the majority of which are preserved in the Museum of the Cathedral, Siena. Since the lost scenes raise vital issues, the problem of reconstructing the *Maestà* has engaged art historians over the past century.

The *Maestà* (Majesty) takes its name from the front face of the altarpiece which depicts the Enthroned Virgin holding her Child, flanked by her heavenly court of saints and angels. This throng includes Saints Catherine of Alexandria, Paul, John the Evangelist, John the Baptist, Peter, and Agnes; the four Patron Saints of Siena kneeling in the foreground—Ansanus, Savinus, Crescentius, and Victor; and above, an arcade of half-length figures of the ten additional Apostles who appear outside Mary's immediate entourage. Originally facing the congregation and intended to be viewed from afar, Mary's larger-than-life image dominated the front of the altarpiece. This was appropriate, since the *Maestà* was commissioned as a replacement for an earlier, much venerated icon, the *Madonna degli occhi grossi* (Cathedral Museum, Siena), to whom the Sienese owed their miraculous victory over the Florentines at Montaperti in 1260. In Siena, therefore, the Virgin was venerated not only as the Queen of Heaven, but also as the protectress of the city as well. It was to her, in this capacity, that Duccio dedicated his altarpiece. The inscription, notable for containing the only record of Duccio's name on any of his surviving works, reads: MATER SANCTA DEI/ SIS CAUSA SENIS REQUIEI SIS DUCIO VITA TE QUIA/ PINXIT ITA, "Holy Mother of God, be the cause of peace to Siena, and life to Duccio because he has painted thee thus."

Above, the front gables recounted the Last Days of the Virgin, which probably culminated in the large central gable (now missing) illustrating the Coronation of the Virgin. Below, on the front predella, the small narrative scenes depicted the Infancy of Christ. The story of Christ's life continued on the back predella of the *Maestà* with illustrations of Christ's Ministry. The main back face consisted of twenty-six narrative scenes that recounted the Passion cycle. These small scenes

facing the back of the Cathedral would have been viewed at close range by the clergy from their choir stalls. Above, in the gables, Christ's post-Resurrection appearances were shown. The missing back central gable probably illustrated either Christ's Resurrection of Ascension; or the former surmounted by the Ascension. The altarpiece was intended to be read from the predella upward (left to right), in a rising path that led from Christ's human life on earth to his glorification in heaven.

In the development of the Sienese altarpiece from a simple rectangular panel to a multi-tiered, pinnacled architectonic complex frequently likened to a Gothic church facade, the *Maestà* marked a watershed. It incorporated all of the previous advances in altarpiece design, as well as Duccio's own extensive formal and iconographic innovations. Some of these were seminal. The image of the Virgin flanked by her celestial court became the model for numerous other versions of this subject by Duccio's followers and successors. It was in the predellas, however, working on a smaller scale in these less crucial areas, that Duccio, like many other artists, was more inclined toward innovation. In the Infancy of Christ cycle on the front predella, Duccio showed great invention in linking each of the first six narrative scenes with the appropriate Old Testament Prophet that followed on its right, demonstrating that the New Testament events of Jesus' early life were prefigured in the prophecies of the Old. Likewise, Duccio arranged the back predella to affirm in increasingly dramatic images Christ's divinity and power over death, starting with his Baptism (missing) and Temptations and culminating in his most powerful miracle, the *Raising of Lazarus* (Kimbell Art Museum).

Throughout the *Maestà*, Duccio maintains an impressive visual logic and consistency. The portraits of the twelve Apostles on the main front panel establish the physiognomy and color of the vestments of these same figures in the small narrative scenes throughout the Life of Christ cycle. Thus, the major actors are always recognizable by their facial type and the consistent coloration of their mantles and robes. There is a similar consistency of settings, both interior and landscape, to indicate that certain episodes occurred in the same location, such as the *Agony in the Garden* and the *Betrayal*. Some of the box-like interiors (the *Last Supper*) have been likened to stagesettings, suggesting the influence of sacred drama on Duccio's imagery.

Although the gracious, courtly forms and flowing lines on the main front face of the *Maestà* reflect the new Gothic sensibility, Duccio's small narrative scenes on the back are most frequently based on Byzantine prototypes, such as those found in illuminated manuscripts. While retaining the overall basic Byzantine schemes with their abstract gold backgrounds, Duccio inserted borrowed elements, as well as his own inventions. His sources were many. He borrowed from his Sienese predecessors, Guido da Siena and the Saint Peter Master; also from the Siena Cathedral pulpit (finished in 1268) of Nicola Pisano. But he was also aware of the most advanced art of his day, at Assisi and at Rome, and was especially influenced by the powerfully expressive Gothic sculptural forms of his younger friend, Giovanni Pisano.

Duccio's figures, while lacking the weight and gravity of Giotto's at Padua, have a refinement and ethereal beauty, capable of expressing an extensive range of emotional and psychological responses. A master storyteller, Duccio is able to evoke the excitement and carnival atmosphere of the *Entry into Jerusalem;* or the tragedy and desolation of the *Crucifixion* and *Entombment.* He frequently achieves a convincing integration of figural groupings into landscape or architectural settings, as in *Christ and the Woman of Samaria* (Thyssen-Bornemisza Collection), where the disciples actually emerge from the gate of the city. His landscapes and townscapes (*Temptation on the Mountain,* Frick Collection) are more than mere backdrops. Sometimes, where a figure appears simultaneously both inside and outside a building (*Pilate Washing his Hands*), the viewer is unable to decide if the artist was incapable of achieving a realistic solution, or whether he intentionally distorted reality for the sake of emphasizing a dramatic gesture (the hand-washing).

Frequently the issue of workshop participation is raised in relation to the *Maestà.* Even though the 9 October 1308 contract specifically stated that Duccio was to paint the altarpiece *suis manibus,* "with his own hands," the participation of assistants was the standard workshop procedure of the time and would have been necessitated by such an extensive undertaking. Nonetheless, the overall altarpiece shows a unity and consistency that come form a single Master. Duccio's guiding intellect is the unifying element that holds the *Maestà* together allowing it, with all its diversity, to speak in a single language.

—Ruth Wilkins Sullivan

Giotto (c. 1266–1337)
Ognissanti Madonna, 1303–11
Panel; 10 ft. 8 in. x 6 ft. 8 in. (325 x 204 cm.)
Florence, Uffizi

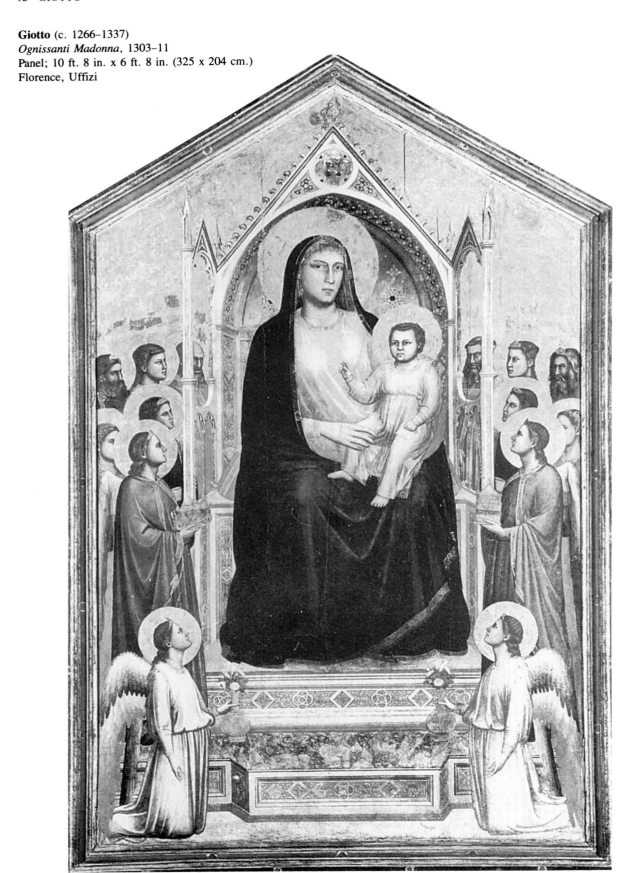

Bibliography—

Behles, Joseph *Giottos Ognissanti-Madonna in Florenz*, Frankfurt, 1978.

The *Ognissanti Madonna* takes its title from the Florentine church of the same name where it occupied the high altar until about 1360. Although unaccompanied by documentation, the authorship of this large panel (3.25 x 2.04 m) has rarely been questioned. Since at least 1417-18, it has been ascribed to the Florentine painter Giotto di Bondone, with most recent critics preferring to place it, on stylistic grounds, either directly before or after the artist's work in the Scrovegni chapel, Padua, that is, between 1303 and 1311. The painting's original location within the church is problematic: the iconography contains no overt reference to the Umiliati, the guardian order of Ognissanti in the early Trecento. The church's dedication to "all the saints," however, may be subtly suggested by the diverse holy figures that flank the Virgin and Child. The panel's subject (a Virgin and Child enthroned, with angels), its simple gabled shape, and its monumental size class it among a type of altarpiece that enjoyed a great vogue in late 13th-century Italy, when devotion to the Virgin was reaching a fervent pitch. Both of Giotto's great peers, his Florentine predecessor Cimabue and his older Sienese contemporary Duccio, had painted *Madonnas* of the genre for other churches in Florence: Cimabue for the high altar of S. Trinità, and Duccio (in 1285) for the chapel of a lay confraternity in S. Maria Novella. Giotto's Ognissanti patrons had, no doubt, wished to follow this now established fashion of honoring the Virgin, and the artist has, in several respects, retained traditional features belonging to the dugento type. Nonetheless, he has managed to surpass the very premise upon which this type is based and with which the older masters were in unquestioning conformity.

Giotto's new vision revolves around the related problems of the relation of man to his Diety and of the observer to the work of art. His is a revolutionary statement made even more impressive because it is anchored by the moorings of pictorial devices familiar to a visually conservative society. Within the modestly adorned frame, Giotto has asserted the traditional importance of two-dimensional altarpiece design by rendering his Madonna and Child as the nexus of a great, symmetrical pattern bounded by the repetitive rectangular gabled enclosures of throne and outer cornice. He has kept the restrained pose of the seated Madonna holding the blessing Child on her left (the Byzantine *Hodegetria:* "she who points the way") found in earlier examples of this type. Like Duccio and Cimabue, he has also allowed her to fix the attention of the observer with a direct gaze while paradoxically remaining elevated and formally set apart from both her real and painted worshippers by reason of her greater size and by means of various compositional devices. Yet, even while the sacred realm in which the Virgin and her son exercise their eternal, divine power remains intact, the viewer's relationship to it and to them has been transformed: the reasoned response of the human intellect has been substituted for the older, Byzantine-derived mystical and emotional ardor. For the first time in Italian devotional art there is an overt link with divinity in material and logical terms; the observer is led by the artist onto the forbidden threshold of the painted world to gaze into the court of the Queen of Heaven.

The open, horizontal step of the throne and the heraldic, kneeling angels that flank it form the base line and outer limits, respectively, of the observer's special position in space in the lower center of the composition. With the Virgin and Child as the focus and apex of a great compositional triangle into which he is included, the viewer becomes part of that unified movement towards the center. Moreover, from his low vantage point he is also able to note a composition that, in spite of a scaffolding of two-dimensional design, opens up not only into the foreground but in depth and laterally as well, where the bodies of saints, almost casually hidden by solid gold discs of haloes or cut off by the frame, hint at the endless continuation of the entourage.

This suggestion of pictorial incompleteness was effectively utilized by Giotto in the *Betrayal* scene of the Scrovegni chapel frescoes. In the *Ognissanti Madonna* it is a brilliant application of a tool that the artist found useful for dramatic narrative. There are, however, closer ties between the *Madonna and Child* and the Padua frescoes, for in the panel the personages also act according to the premise of an individual dramatic moment and are positioned to reveal the meaning of this moment with crystalline clarity. Unlike Giotto's late frescoes at S. Croce, Florence, where the pictures are complicated by a greater sense of inter-narrative fluidity or a foray into more complex spatial effects, these earlier works have the power of concentrated equilibrium and self-imposed limitation. Such characteristics are most strikingly apparent in Giotto's grave, blocky figures, made palpable and active through naturalistic modelling techniques. Yet, even with their acquired corporeal plasticity, his personages are carefully composed to emanate an immobile, superhuman aura.

The *Ognissanti Madonna* is, above all, a purveyor of this aura. Ostensibly contained by the rich, ivory-colored throne inlaid with green and red stone, her presence, in fact, expands up to and beyond the limits of the frame. In the density of a body visible beneath a sheer, white tunic and the controlled activity of a slightly turned torso, she has often been compared with ancient Roman sculpture. Surely, it would not be a mistake to recognize the spirit of the antique in her, nor should her plastic compatibility with the cubic masses of Giotto's contemporary, the sculptor Arnolfo di Cambio, be ignored, as there is a similar striving for a pure and powerful clarity of mass and contour, a stripping away of the superfluous in the *ioeuvres* of both artists. Indeed, this desire for clarity is imbued in every element of the Ognissanti altarpiece, even to the ideation of the marble throne, which unlike the elaborately carved and turned wood seats of a dugento Virgin and Child, is conceived according to the simplified linearity of such contemporary Italian gothic furniture as Arnolfo's sculpted ciboria in Rome.

The *Ognissanti Madonna* unquestionably takes its place as one of the seminal works created at the dawn of the Renaissance in Italy. In it Giotto has not only introduced the formal devices needed to attain his unprecedented naturalism, but has fundamentally changed the relationship of the viewer to the work of devotional art he contemplates. The impact of this change was immediate and irreversible and its consequences decisive for the subsequent history of Renaissance painting.

—Carol Talbert Peters

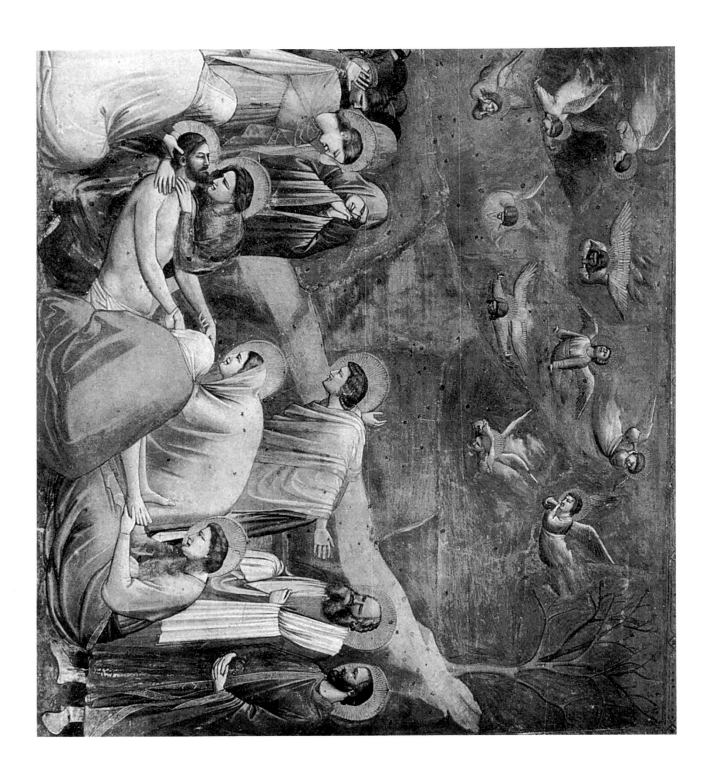

Giotto (c. 1266–1337)
Arena Chapel Frescoes, c. 1304–12
Frescoes
Padua, Arena Chapel

Bibliography—

Schlegel, Ursula, "On the Picture Program of the Arena Chapel," in *Zeitschrift für Kunstgeschichte* (Munich), 20, 1957.
Stubblebine, James H., *Giotto: The Arena Chapel Frescoes*, New York, 1969.
Ladis, Andrew, "The Legend of Giotto's Wit and the Arena Chapel," in *Art Bulletin* (New York), December 1986.

The Arena Chapel stands on the site of an old Roman arena in Padua. The land was acquired in 1300 by Enrico Scrovegni, who commissioned a small, barrel-vaulted chapel and its interior decoration partly to atone for his family's sins (Dante had consigned one of his relatives to Hell for the sin of usury). By 1305, the building was consecrated and Giotto decorated the interior with frescoes, probably between 1304 and 1312.

Inside the Arena Chapel, the observer is in a world that is at once natural and symbolic. Windows are kept to a minimum, thereby leaving as much space as possible for the frescoes themselves. The vaulted ceiling, symbolizing the heavens, is painted a rich blue adorned with small gold stars. Tondos, or round paintings of Mary and Christ, prophets with scrolls, Christ and the evangelists, are the only human figures on the ceiling.

The narrative scenes, arranged on three horizontal levels, illustrate the lives of Mary and her parents, Anna and Joachim, and the life of Christ. A dado on the lowest level is of imitation marble with grisaille figures representing the seven deadly sins on the left and the seven virtues on the right. This opposition of left, associated with evil, and right, with virtue, is traditional in Christian art.

Each narrative panel is set in a rectangular frame containing figures that are about half life-size. The frames themselves contain small prophets, the Old Testament men who foretold the future, or scenes from the Old Testament that were interpreted as prefigurations of the New Testament scenes to their right. In this way, the observer is constantly reminded of the Christian view of history in which fulfillment and prophecy played a prominent role.

Upon entering the chapel, one is first confronted by the chancel arch and the scene at the top introducing Christ's earthly life; God summons Gabriel and the angels to announce His mission. Immediately below, separated into two sections by the opening of the arch, is the *Annunciation*. On the next level down are two scenes from the narrative of Christ's life, the *Visitation* and the *Betrayal of Judas*. In this way, we see the beginning of Christ's life and are also forewarned of events to come. It is not until we have made a complete turn and viewed the narrative scenes that we encounter the entrance wall as we prepare to leave the chapel. At this point we are facing the monumental fresco of the *Last Judgment*, reminding us of our own future and of Christ's ultimate triumph as king and judge of the universe. As a result of Giotto's organization of the frescoes therefore, they correspond to the observer's time sequence—entering, contemplating, and leaving the chapel.

The Arena Chapel frescoes are a landmark in the history of western art because they are the earliest narrative cycle painted primarily in the Renaissance style. Apart from a few remnants of the middle ages, such as the slanted and outlined byzantine eyes, the non-classical proportions of the nude figures, and the essentially medieval Hell of the *Last Judgment*, Giotto introduced most of the innovations that would characterize the new Renaissance developments in painting.

His solid, organic, and monumental figures are set in a narrow, but convincingly three-dimensional space in which they turn freely. Giotto was the first Christian painter to represent figures in back view, which requires a 180 degree turn in space. His dramatic use of such figures is evident, for example, in *The Kiss of Judas*, where the hooded man in grey on the far left turns away from the observer, maintaining his anonymity and arousing a sense of foreboding. Giotto's naturalistic forms are rendered in terms of light and dark rather than line and, set on a horizontal ground, they obey the laws of gravity. Through their gesture language and significant glances, the characters enact one of the most dramatic renditions of Christ's life. It is no coincidence that Padua was a center of humanist learning in the late 12th and early 13th centuries and had witnessed a revival of classical theatre. Indeed, the sense of psychological drama with which the Arena Chapel figures are imbued has resulted in many comparisons with developments in contemporary theatre and the resurgence of interest in antiquity.

—Laurie Schneider

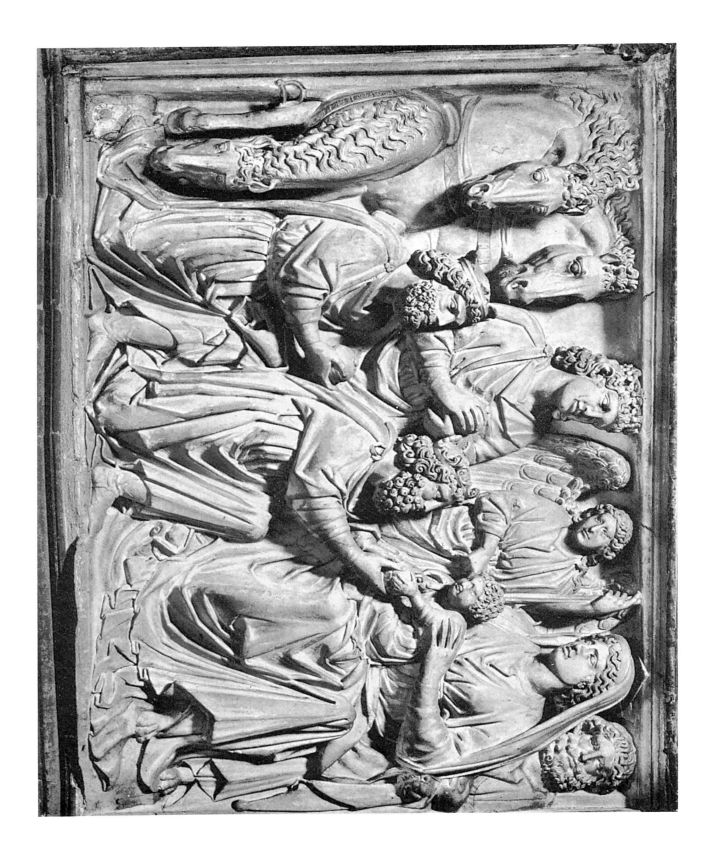

Nicola Pisano (active 1258–78)
Baptistery Pulpit, 1260
Marble
Pisa, Baptistery

Bibliography—

Kosegarten, Antje, "Die Skulpturen der Pisani am Baptisterium von Pisa: Zum Werk von Nicola and Giovanni Pisano," in *Jahrbuch der Berliner Museen,* 10, 1968.

The hexagonal pulpit in the Baptistry of Pisa bears an inscription beneath the relief of the Last Judgment that identifies the artist "of this noble work" as Nicola Pisano, and the date of its execution as 1260. It is the sculptor's earliest dated work. The polygonal form of the pulpit, while not an invention of Nicola's, was rare in Tuscany but was happily suited to the centralized plan of the Baptistry with its octagonal baptismal font. The pulpit is supported by seven columns: one in the center whose base is surrounded by crouching figures and animals, and a ring of 6 outer columns alternately resting on lions and on the ground. The columns support an archivolt with trilobed arches between which are placed representations of Virtues and John the Baptist. Above this section rises the casket with its historiated relief fields separated by triple colonettes. Five of the six sides (the sixth is the entrance to the pulpit platform) contain reliefs from the life of Christ: 1) the Annunciation, Nativity, and Annunciation to the Shepherds, 2) the Adoration of the Magi, 3) the Presentation in the Temple, 4) the Crucifixion, and 5) the Last Judgment. The narratives are dominated by vertical and horizontal movements that lend stability to the compositions and at the same time serve to relate the reliefs to the architectural forms surrounding and supporting them. The pulpit is composed of red, green, and white marbles; the background of reliefs originally were filled with colored glazed tesserae (some of which remain), and parts of the figures were originally painted, all of which contributed to a rich coloristic effect, an effect not entirely absent even today when most of the polychromy is lost.

It is, however, Nicola's achievements as a narrative sculptor employing powerfully plastic and expressive forms that has impressed viewers throughout the intervening centuries. Rejecting the highly stylized and stilted figures in the Romanesque style created by his predecessors and even his contemporaries, Nicola turned to ancient sculpture and to northern gothic art as sources of inspiration for a new style, one that combined majesty and human feeling. On the pulpit the figures have bulk and a sense of weight; they act with dignity yet their gestures have a convincing naturalism.

The 13th century was a period that witnessed a diffusion of apocryphal literature, in which the sparse accounts of the lives of the sacred persons as told in the Gospels were enriched with homely incident. The popularity of these embellishments was to have a profound effect on the art of the following century but Nicola, already, was not content merely to present symbolic narratives of transcendental events. His goal was, rather, to tell a human story in a convincing manner. Not only are events included on the pulpit that are not mentioned in the Bible (such as the Washing of the Christ Child in the first relief), but the figures are rendered with a convincing naturalism of gesture and movement. In the Annunciation to Mary we witness the Virgin's strong reaction to Gabriel's message, conveyed by her gesture and the impulsive retreat of her body. Similarly, in the second relief, the Adoration of the Magi, the Christ Child is not a stiff icon but a pudgy infant leaning forward eagerly to touch the gifts. The Crucifixion, with the swooning Virgin and gesticulating figures surrounding Christ, is an especially poignant scene. Compared to earlier representations, the figure of Christ has a wholly new sense of physical presence; at the same time, there is a restrained yet eloquent emotional power that suggests Nicola's awareness of developments north of the Alps. The close study of antique forms is clearly demonstrated in the articulation of the torso and limbs, and in the modeling of the flesh conceived as a soft covering over a skeletal frame.

During an age when the concept and techniques of copying forms directly from life were virtually unknown, antique Roman sculpture offered Nicola models of plastic form that appeared to imitate the physical forms of nature. Several extant Roman monuments have been identified as the sources for motifs on the Pisa pulpit. The stately Virgin in the Adoration of the Magi, for example, is a direct quotation from the 2nd-century sarcophagus of Hyppolytus and Phaedra which stood outside the cathedral during Nicola's lifetime and is now in the Camposanto. Even where specific prototypes have not been found, Nicola's adaptation of the antique is apparent, as in his rendering of the powerfully muscular nude figure of Fortitude (the nudity itself an astonishing innovation), which stands in a *contrapposto* pose (with weight apparently on one leg) above one of the capitals. Instead of suggesting the spiritual attributes of Fortitude by means of symbolic accoutrements, as was traditional, here Nicola chose to convey those attributes by means of the figure's physical characteristics, selecting an antique Hercules for his model. The rich, dense relief patterns, the tendency to use the full height of the relief field for the figures, and the extensive use of the drill also recall characteristics of Roman sculpture, particularly of sarcophagi.

So impressed were the Sienese by this pulpit that in 1265 they commissioned Nicola to create the pulpit for their cathedral. Although larger and more complex than the first, the Siena pulpit is also a polygonal structure (this time octagonal) with historiated reliefs. Nicola's son Giovanni produced two further pulpits based on the Pisan prototype, the small pulpit in San Andrea, Pistoia (1301) and that in the cathedral of Pisa (1302–10). Nicola's Pisa Baptistry pulpit of 1260, indeed, marks the beginning of that remarkable development of Italian sculpture that combined naturalism and idealism, and that culminated in the art of Michelangelo.

—Anita F. Moskowitz

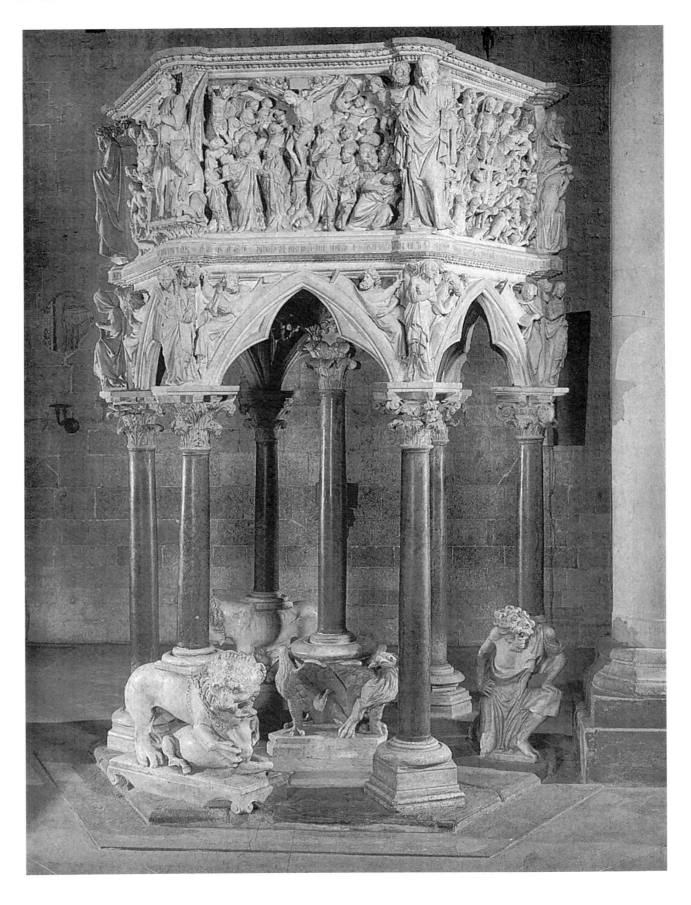

Giovanni Pisano (c. 1248—after 1314)
Pulpit, 1297–1301
Marble
Pistoia, S. Andrea

Bibliography—

Seidel, Max, *Pisano: Il pulpito di Pistoia*, Florence, 1965.
Mellini, Gian Lorenzo, *Il pulpito di Pisano à Pistoia*, Milan, 1969.

The pulpit is hexagonal with narrative scenes contained in panels on five sides: (i) the Annunciation, Nativity, Annunciation to the Shepherds and the Washing of the Christ-child, (ii) the Adoration of the Magi, (iii) the Massacre of the Innocents, (iv) the Crucifixion, (v) the Last Judgement. Angle figures divide the narrative scenes: (i) a Deacon, (ii) the Apocalyptic Christ, (iii) the Prophet Jeremiah (or S. Andrea?), (iv) the symbols of three of the Evangelists (Matthew, Mark and Luke), (v) the writers of the Canonical Epistles, (vi) four angels. Below at the angles of the archivolts are figures of sibyls flanked by prophets. The whole is supported on seven columns, four of which have sculpted supporters: a figure of Adam, a lion, and a lioness support alternate outer columns and, at the centre, a griffin, eagle, and winged lion. The trefoiled pointed arches which link the columns emphasize the vertical stress of the design.

An inscription around the fascia reads (translated from Latin): "In praise of the triune God I link the beginning with the end of this task in thirteen hundred and one. The originator and donor of the work is the canon Arnoldus, may he be ever blessed. Andrea, (son?) of Vitello, and Tino, son of Vitale, well known under such a name, are the best of treasurers. Giovanni carved it, who performed no empty work. The son of Nicola and blessed with higher skill, Pisa gave him birth, endowed with mastery greater than any seen before."

The background of the reliefs was originally covered with glass, with gold, red and green ornament. It would appear likely that in addition to the inscriptions painted on the scrolls, the colouring on the figures was confined to gold rimming on the drapery edges and gilding of the crowns, etc., together with the painting of any exposed linings, only traces of which survive. The pulpit was originally placed on the right-hand side of the nave, adjacent to the choir, but appears to have been moved in the 17th century (after 1619) to its present position on the left. The order of the angle figures was also slightly altered, and the two lecterns removed.

In this pulpit, Giovanni Pisano reached the heights of his artistic achievement, of which he was himself well aware, as evidenced by the self-laudatory inscription. It is from this inscription that we gain our knowledge of the commission for the pulpit which, according to Vasari, took four years to execute. The presence of a major sculptural pulpit in a small provincial church may be explained by established tradition in Pistoia; three others already existed there at that time (one has

since been dismantled). At S. Andrea, however, Giovanni drew heavily on the earlier pulpits of his father at Pisa Baptistery and at Siena Duomo (where he worked as an assistant in his youth) for the basic design and much of the iconography. The Gothic elements already evident at Siena were developed, fuelled by Giovanni's experience and knowledge of imported small-scale northern Gothic sculpture, and were combined with his father's classicism. This, together with his expressive technique and dramatic approach to narrative produced Giovanni's individual style.

The narrative in the relief panels is expressed in a highly charged, emotional manner, created by movement and linear rhythms, and an unrestrained use of expression and gesture. This is particularly effective in the handling of the *Massacre of the Innocents*, especially when compared to Nicola's version at Siena. Nicola's still shows a heavy reliance on classical sarcophagi for its layout, whereas his son's swirling, agitated treatment creates a series of curvilinear forms and gestures which inter-relate the figures across the relief. Giovanni's use of facial expression to relay the grief and terror of the mothers encourages a more emotional response than Nicola's almost cerebral feeling of despair.

The angle figures and sibyls display the marriage of Gothic delicacy of handling and drapery style with a classical awareness of human form. The jutting heads and twisted poses of many of the figures are reminiscent of Giovanni's prophets and sibyls on the Siena Duomo facade (c. 1285–96). In the *Crucifixion*, the sinuous and stretched body of Christ reflects a new-found Gothic realism. The Virgin falls back in a dramatic faint at the sight of her son on the cross.

In addition to the expression of movement and emotion, the sculptor's use of chisels, rasps, and (to some extent) drills creates surface textures which accentuate the dramatic content of the narrative, whereas the supporting and angle figures are more highly polished. The cavities created by deep undercutting in the reliefs produce *chiaroscuro* effects which would have been exaggerated by the glazed background. In candle-light the background would have appeared black, but in the brief periods of strong light the effect on the panels facing the nave would have been to flatten the relief and the coloured pattern of the glazing would have been visible. The other gilding and painting would also have increased the play of light and colour, and the linear rhythms linking the figures.

The Pistoia pulpit is Giovanni's only major autograph work to survive. It is undoubtedly a masterpiece of Italian Gothic, providing a great insight into the skill and dramatic achievement of one of the most immediately influential artists of the period.

—Peta Evelyn

Pietro Cavallini (1240's–1330's)
The Last Judgment, c. 1293
Fresco
Rome, S. Cecilia in Trastevere

The attribution of the fresco to Pietro Cavallini is based on Lorenzo Ghiberti, who wrote that Cavallini "painted with his hand the whole of Santa Cecilia in Trastevere." Probably the decoration originally covered the central nave and the interior of the entrance wall where the *Last Judgment* (or what remains of it) is today. The fresco, which once covered the entire wall, has in large part disappeared; only the central band has survived.

Like Cimabue and Duccio, Cavallini belongs to the generation born before Giotto, when Byzantine influences permeated Italian art. Cavallini's great accomplishment is to have completely mastered and synthesized the technical means and the poetic values of the past, to reach, through a more realistic, sober use of color and form, the visible expression of an individualized moral and physical beauty. Far from the stereotyped characters seen in the 11th or 12th century mosaic *Last Judgment* of Torcello, clearly tied to the Byzantine scheme, Cavallini's figures all express the reflection of particular psychological states; they are beings in which humanity and holiness merge, the witnesses of the instant in which the chasm separating contingency from eternity is dissolved. The personages, far from being inaccessible or metaphysical, all share the mark of earthly individuality; this is what, above all, makes them, and the scene in general, real and convincing.

In the center of the field Christ the Judge, serene, perfect, and compassionate, sits on an imposing throne, enclosed within a mandorla, flanked by hierarchies of angels. The praying Virgin and the Baptist stand next to Christ, while to their right a row of Apostles seated on simpler thrones, each one carrying the instrument of his martyrdom, cover the remaining surface of the upper register. Below Christ, an altar, upon which are displayed the instruments of the Passion, is flanked by erect angels playing trumpets to awake the dead, while other angels (extant only in part, as are all the other figures) guide the resurrected toward eternal bliss or damnation.

With the exception of the altar, usually not represented in similar scenes, the iconographical scheme follows the traditional one developed through the centuries in the Byzantine East: the innovative quality of the fresco does not reside in the originality with which the theme has been represented, but rather in the use of color, a color that models with heavy folds the solid, convincing mass of the actors, and imparts at the same time a serene monumentality to the whole composition.

Never before have thrones seemed so heavy, or had the inner quality of mass been rendered with more plasticity. Thanks to the adroit use of internal illumination light sculpts the bodies, caresses the faces, and, by means of soft graduation, enhances their individuality. The most striking quality of the fresco is given by the majesty of the images and their classical serenity which possibly derives, more than from an evolution of traditional medieval iconography or coeval neo-Hellenistic works, from a keen observation of Roman classical statuary and antique coloristic schemes. Fundamentally deriving from Roman painting is the dark, nearly black background, against which the plasticity of forms stands out with force, and the pairing of colors, reds and greens set against blacks, grays and pinks gently graded in large brushstrokes thick with pigment, or, in the heads, infinite tonal passages that give form to the changing softness of hair, the hirsute consistency of beards.

Perhaps the most splendid coloristic passage of the whole fresco resides in the large wings of the angels which, hierarchically arranged, provide the link between the inner core of the scene (the isolated Christ) and the rest of the figures seen in the upper zone. Contrasting vividly with the darker hues of the background, or of the tunics, each wing becomes a chromatic passage that rises in intensity to reach an unparalleled coloristic force: black gradually becomes a dazzling white, light pink is transmuted into a dark purple that burns like a flame: the angels seem to glow of their own essence.

Stern, grave, severe, the composition emerges from a bottomless atmosphere, a negation of space in which the thrones and the figures become blocks of tangible matter drawn in a rudimentary three-dimensional way. It is difficult to gauge the influence of the once complete fresco upon the later development of Italian painting: suffice it to say that before Giotto Cavallini had already succeeded in giving to his figures the weight, the proportions, the mass of a convincing human form through which sentiments and personality are vividly represented.

—Norberto Massi

Simone Martini (c. 1284–1344)
Annunciation, 1333
Panel; 6 ft ³/₈ in. × 6 ft 10⁵/₈ in. (184 × 210 cm.) (central
 panel)
Florence, Uffizi

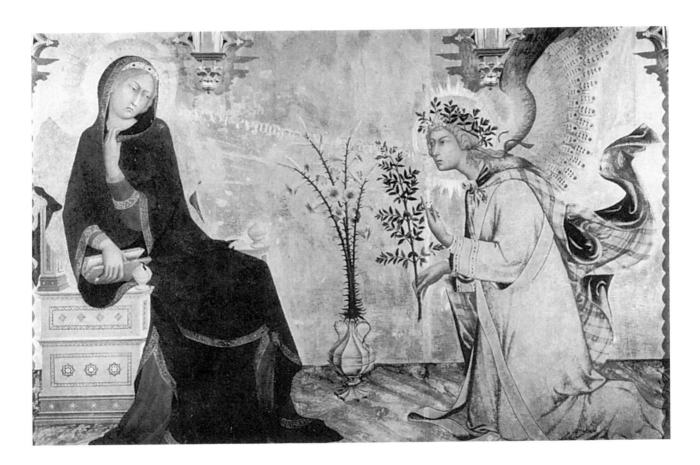

Bibliography—

Frederick, Kavin M., "A Program of Altarpieces for the Siena Cathedral," in *Rutgers Art Review* (New Brunswick, New Jersey), 4, 1983.

Os, Henk van, *Sienese Altarpieces 1215-1460*, vol. 1, Groningen, 1984.

Originally painted for the chapel of St. Ansanus in the cathedral of Siena, Simone Martini's large triptych depicts the *Annunciation* in its central panel and a saint in each lateral panel. Above are four small roundels, each with an identifying inscription, depicting Jeremiah, Ezekiel, Isaiah, and Daniel. The lost central roundel was quite probably filled with an image of God the Father. The youthful male figure in the left side panel, holding a martyr's palm frond and a black-and-white banner in the Sienese colors, is St. Ansanus, a patron saint of Siena. In the right panel is a female saint, holding a cross and palm, identified variously as St. Giulitta (in the 19th-century inscription in the renewed frame), St. Giustina, and St. Maxima, the godmother of St. Ansanus. More probably, she is St. Margaret, as she was identified in a 15th-century cathedral inventory.

By the 17th century, the altarpiece had been removed from the cathedral and was in the church of S. Ansano, Castelvecchio, where it remained until the end of the 18th century. By that time, the side panels had been separated from the central panel. When the *Annunciation* entered the collection of the Uffizi Gallery in the 19th century, the present, gabled gothic frame was added. While there seem to be no losses to the lateral edges of the side panels, the central panel was probably cut down slightly on the sides and has been heightened by the addition of a narrow strip of wood along its lower edge. At present, there exists an awkward disjunction in ground levels between the two lateral saints and the central image. How the original medieval frame may have compensated for the abrupt change in ground level is unknown.

While painted for the altar of St. Ansanus, the saint was relegated to the side panel, and the main panel was dedicated to the *Annunciation*. This innovative choice, almost certainly made by the cathedral authorities, marks the first appearance of the *Annunciation* as the main subject of an altarpiece and one of the earliest appearances of a narrative theme in that position. Shortly after, two other narrative altarpieces were executed for the Sienese cathedral, Pietro Lorenzetti's *Birth of the Virgin* and his brother Ambrogio's *Purification of the Virgin*, both dated 1342 and also originally flanked by lateral saints. Henk van Os has examined the iconography of the altarpieces created in the late Middle Ages and Renaissance for the Sienese cathedral and concluded that the *Annunciation* was one of seven altarpieces commissioned between 1329 and 1430 as part of a deliberate plan for the Sienese cathedral in honor of the Virgin, to whom the city of Siena was dedicated. More recently, Kavin Frederick had posited that there were originally only four altarpieces planned, dedicated to the four patron saints of the Tuscan city.

In order to accomodate the main narrative subject of the *Annunciation*, the large unified space of the central panel was created by eliminating the two inner columns of a polyptych frame. Within this field, Gabriel and Mary act out the drama of the *Annunciation*. Gabriel, plaid cloak billowing behind him and wings still extended, has just landed and gestures gracefully to Mary. Startled by Gabriel's appearance, she draws back in a posture of timidity and surprise, twisting her body back and clasping her cloak to her neck. Gabriel's message is laid out in raised, gilded gesso, AVE MARIA GRATIA PLENA DOMINVS TECVM ("Hail Mary, full of grace, the Lord is with thee"; Luke 1:28). Further inscriptions are found on the border of Gabriel's stole: NE (TI) MEAS (MARIA) ("Do not be afraid . . ."; Luke 1:30); ECCE C[ON]CIPIES IN (VTERO) ("behold, thou shalt conceive . . ."; Luke 1:31); SPIRITVS S[AN]C[TV]S SVP[ER]VENIET I[N] TE ET VIRTVS ALTIS (SIMI OBVMBRABIT TIBI) ("the Holy Spirit will come upon thee, and the power of the most High will overshadow thee"; Luke 1:35), and on his sleeves: GABRIEL on the right and . . . IR . . . on the left.

Simone's presentation of the theme is notable for its particular combination of dramatic intensity and elegant lyricism. The twisted pose of Mary's slender, elongated body conveys both her surprise and timidity and is also graceful, particularly in the sinuous curves of her outline and the gold edging of her cloak. The central panel is remarkable for its decorative richness, with its elaborate variety of gold tooling, marble floor, and intarsia work on Mary's throne.

While Simone Martini has always been accepted as the prime author, the contribution of his brother-in-law Lippo Memmi has been much debated. When the frame was renewed, part of the old frame was retained and inserted below the *Annunciation*. This contains an inscription: SIMON MARTINI ET LIPPVS MEMMI DE SENIS ME PINXERVNT ANNO DOMINI MCCCXXXIII ("I was painted by Simone Martini and Lippo Memmi of Siena in the year of Our Lord 1333"). The surviving account book in the archives of the cathedral works, the Opera del Duomo, reveals that Lippo was paid for ornamentation. While Lippo's participation is clear from both the documents of payment and inscription, the nature and extent of the collaboration between Simone and Lippo are unclear. There is general consensus that the design of the *Annunciation* is Simone's and that Lippo's later style was dependent on Simone's example. Numerous attempts have been made to apportion the execution between the two artists, ranging between assigning Lippo the two lateral saints on the grounds of their darker tonality and stiffer character compared to the central figures, to giving him responsibility only for ornamentation. Despite the numerous attempts to divide up the work, more recent understanding of the workings of late medieval artists' workshops results in the realization that artists often worked so closely together that it is often impossible to ascertain a particular artist's contribution to large projects where one hand often worked alongside or even on top of another. While the altarpiece continues to resist attempts to subdivide itself between the two artists, there is no doubt that Simone remained the more innovative master, and the *Annunciation* demonstrates again the dominant position of his style in 14th-century Siena.

—Barbara Dodge

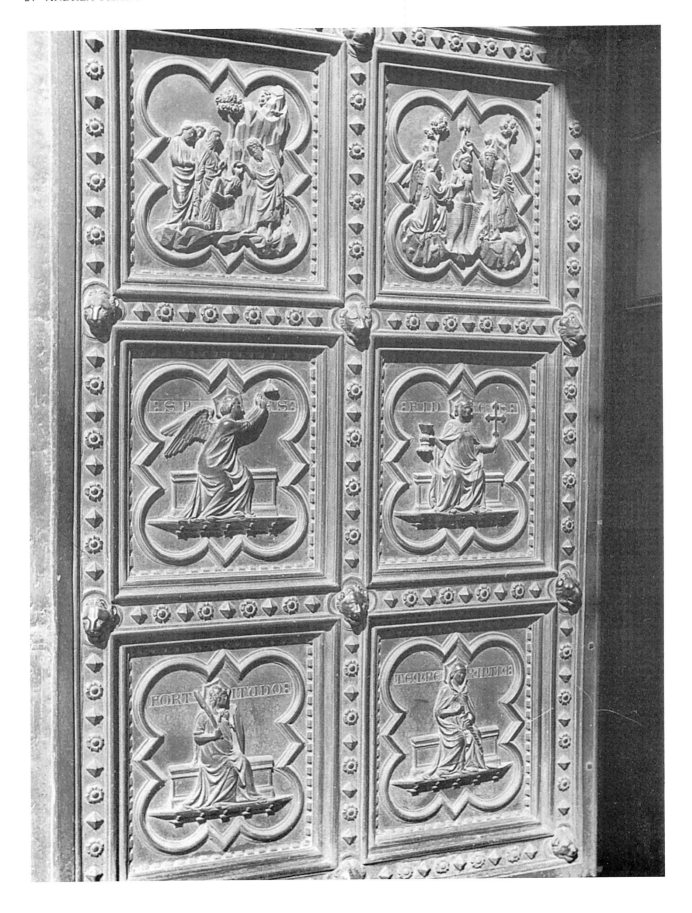

Andrea Pisano (c. 1290-95—1348-49)
Baptistery Doors, 1330
Bronze; 18 ft. 6 in. (564 cm.) (height of south door)
Florence

Bibliography—

Falk, I., and J. Lányi, "The Genesis of Pisano's Bronze Doors," in *Art Bulletin* (New York), 25, 1943.

In 1329 the Arte di Calimala (Merchant's Guild in charge of the Baptistry), abandoning an earlier plan to cover the Baptistry's wooden doors with metal plates, decided to install new doors cast in bronze. Documents identify the designer of the new doors as Andrea of Pontedera, Pisan goldsmith. The doors, signed and dated 1330, and installed in 1336, were cast by means of the ancient *cire perdu* (lost wax) method, with the figures and details of setting and decorative motifs fire-gilt. The 28 rectangular fields, each enclosing a quatrefoil frame, contain reliefs illustrating the life of John the Baptist and, on the lowest two rows, seated Virtues.

Andrea's doors impress the viewer as a work belonging to both monumental and "minor" art, the creation of an architect, a sculptor, and a goldsmith. Brilliantly calculated to achieve maximum overall decorative unity, the design presents a series of varied geometric shapes that encourage the transition from monumental door to small narratives Thus, the eye is led from the rectilinear pattern of the lattice framework about the reliefs, to the highly decorative yet more varied quatrefoils, to focus finally on the narratives in which geometrically conceived compositions, decorative rhythms, and naturalistic, organic forms are coordinated. Within this overall unity, the large single figures of Virtues on the two lowest rows provide a subtly differentiated base for the twenty narrative scenes above.

Within the quatrefoil frames episodes from the life of John the Baptist are related with utmost concentration and focus by means of few figures and the sparing use of props. The austerity of the images, in which strongly projecting figures are set against the flat background, is mitigated by the flowing drapery rhythms that enliven the surface of each quatrefoil. Poignant and expressive gestures are often isolated against the background plane so that the stance of a body, the movement of arms and hands, or the tilt of a head is saturated with significance—as in a pantomime production on a stage. Within these concentrated worlds the figures achieve an unexpected monumentality more characteristic of large-scale sculpture.

The compositions tend to adhere closely to the demands, not of the quatrefoil frame, but of an inner, "invisible" rectangle determined by the intruding points of the angles and lobes. In the *Visitation,* for example, the companion of Mary provides the left-hand limit of the implied rectangle while the tower delineates its border on the right. The horizontal cornice draws attention to the upper boundary and the lower edge is defined by the platform on which the figures stand. Internally, too, verticals and horizontals predominate as the main compositional vectors although diagonal and circular movements in the architecture, figures, and drapery tend to echo the curves and diagonals of the pierced quatrefoil.

Despite the overall unity achieved in the design, close observation reveals changes in composition, figure style, the degree of freedom of the handling of landscape elements, and the conception of the architecture. When examined in relation to earlier Tuscan reliefs and Andrea's own subsequent relief style on the Campanile (bell tower) of Florence, it becomes apparent that not only are the earlier reliefs more closely tied to iconographic precedents in Tuscan sculpture and goldsmithwork but also that the quatrefoils evolved from the more linear and decorative mode of the left-hand valve to the more plastic and monumental relief conception on the right-hand valve.

St. John the Baptist is both the patron saint of the building whose bronze doors depict his life and the patron saint of the city of Florence itself—which may explain the prominence given to his life both in the mosaics of the cupola within the Baptistry and on the doors. The events depicted on the doors derive from several sources: from the Gospel accounts, particularly the book of St. Luke, which is the only Gospel to include the first five episodes that appear on the doors; and from the apocryphal literature that had achieved tremendous popularity during the 13th and 14th centuries. In this body of writings the sparse accounts in the Bible were embellished with homely incident that tended to humanize the sacred persons, including particular episodes from the childhoods of Mary, Christ, and John the Baptist. For instance, the Young John in the Wilderness is a scene that has no biblical source. The naturalism and dominance of the landscape elements in the relief are astonishing for the early 14th century. A *Vita* of John the Baptist by an anonymous 14th-century writer informs us that already as a young child John entered the woods to begin his mission in the wilderness. Andrea has caught the joyful mood of the child as well as the freshness of the surroundings described in the *Vita.* As is true of the paintings of Andrea's great older contemporary Giotto, on the doors sacred events are interpreted in the most human and down-to-earth terms, achieved without sacrificing that sense of exalted drama which lifts the narratives into the realm of the spiritual. This classic balance between spiritual idealism and narrative realism informs Andrea's art throughout his career.

Andrea Pisano's Baptistry doors became the model for Lorenzo Ghiberti's first set of doors executed after the latter won the competition of 1401 against his rival Brunelleschi. Ghiberti's north doors containing New Testament scenes closely follow the decorative scheme of the earlier pair with its 20 narratives and 8 seated figures, all within pierced quatrefoils and rectangular frames.

—Anita F. Moskowitz

Orcagna (c. 1308–after 1368)
Strozzi Altarpiece, 1357
Panel, 9 ft. 8 in. (294.6 cm.) (width)
Florence, S. Maria Novella

Andrea di Cione's polyptych for the Strozzi chapel in the Dominican church of S. Maria Novella, Florence, is arguably the best-known Italian painting of the mid-14th century. The altarpiece was commissioned by Tommaso di Rossello Strozzi in 1354, for the family funerary chapel in the left (west) transept arm of the church, and finished by the artist—as the original inscription below the central panel indicates—in 1357. The work has survived in very good condition, its appearance altered primarily by some questionable details in the 19th-century frame. Although the Strozzi altarpiece has received much attention, there has been no more influential criticism of it than that offered by Meiss (1951), who employed Andrea's work as the lynchpin in a theory that sought to connect an overwhelming natural disaster (the Black Plague of 1348) with a contemporary change in artistic style. Cognizance of the early, general agreement with, and most recently, attempts at a refutation of Meiss's daring hypothesis will necessarily color any discussion of this work.

As recent scholarship has made increasingly clear, the physical and circumstantial contexts in which the Strozzi altarpiece was created have a great bearing on how it must be understood. The chapel, itself, was constructed in the early 1340's by merchants and bankers of the wealthy Stozzi clan. Its mortuary function was accentuated by construction over a family tomb chamber, and by the close physical relationship to another funerary chapel located in the adjacent Cloister of the Dead, to the west of the church. The altarpiece and the accompanying fresco decorations (executed by Andrea's brother Nardo) that enclose it above and on three walls were created with this funereal context in mind. They explicate the need of the patrons to atone for the usurious practices of Tommaso's father, Rosso di Ubertino, and possibly of other family members, as well. As in Giotto's Arena chapel, the gatherers of interest might find restitution by filling the coffers of the church.

Repentence and desire for mercy are, thus, central to the meaning of the altarpiece and to Nardo's frescoes. Together, they work to develop these messages on a general as well as an individual level. Andrea's polyptych, set on the altar in the chapel's center, is the fulcrum of the visual complex. In it the overall theme is concentrated and personalized. In contrast to the universal history of salvation depicted on the walls, the function of the altarpiece is largely symbolic—and this may have encouraged the harsh, otherworldly impression it creates on the viewer.

The Strozzi polyptych is divided into five arched compartments on its main level and three predella panels below: one corresponding to the large, central panel and one for each of the two lateral sections, above. In the main, central section, a full length Christ, frontal and enveloped in golden light appears in the midst of a taut mandorla composed of cocoonlike angels. As the architypal head of the Church, he dispenses the keys to Peter, the symbol of her temporal head, who kneels in pure profile on the right. On the left, St. Thomas Aquinas, the chapel's patron, kneels to receive a book from Christ's right hand which contains biblical passages concerning the desire

for wisdom and the apocalyptic Book of Judgment (I Kings 3:12; Revelation 5:9). The Saviour here assumes a pose that reflects his role as judge in *The Last Judgment* frescoed directly behind the altarpiece, on the window wall, where the saved and damned loom up to His right and left, respectively.

The particular way to salvation is graphically indicated by Peter, as the Church's authority, and by Thomas, who represents the Dominicans. Further stress on the Dominican's role in the process is given in the largest predella scene, directly below Christ, which depicts *The Navicella* (or *The Calling of Peter*): an event used by the Friars Preachers to underline the necessity of repentence.

Mary and John the Baptist accompany Thomas and Peter in the presence of Christ. The precursor's frontal stance and physical isolation from Peter contrasts with the Virgin's gentle, protective gesture, as she presents the saint to her Son. Both of these personages, however different their attitudes toward the saints they support, fulfill important roles as mediators before the Judge; thus, mercy, especially on the part of Mary, may temper the penalty imposed on the sinner as he seeks remission with the aid of the Dominican order.

The saints in the lateral fields (Michael and Catherine of Alexandria on the left, Laurence and Paul on the right) also relate iconographically to the themes set forth on the altarpiece and in the chapel frescoes. Farther away from Christ, they do not exhibit the hieratic intensity of those nearest the Source. In fact, the immediate relationship of two of these flanking figures to the larger environment of the chapel is quite clear. As the weigher of souls in the Last Judgment, Michael, with the dragon at his feet, points the way to Nardo's *Paradise,* on his right, while Laurence is connected with the *Inferno* fresco, on his left, through the predella scene below him. Here, in *The Saving of the Soul of Henry II of Germany,* Laurence places a gold chalice on the Scales of Judgment, and thus rights the balance in the king's favor—an appropriate comment in favor of the wealthy patrons of the work.

The hieratic and didactic style that Andrea exhibits on the main level of the altarpiece can, thus, partly be understood in terms of the nature of the subject, where symbolism dominates over narrative. Further, stylistic, factors include the likely influence of one of Andrea's most notable predecessors, Maso di Banco, whose works shows a crystallization of Giottesque mass and volume. This, and the purity of his figural arrangements may well be reflected in Andrea's powerful, plastic figures who clearly attain a dynamic balance of frontal, profile, and three-quarter views to either side of the central Christ. Andrea's continuation of the trend toward opulence, begun in the 1330's, is elaborated here in the rich tapestries and the tooled and punched decoration that emphasize surface over depth. And, in spite of the imbalance caused by a flattened space and warring, acidic colors, there is a desire for an overriding physical and psychological unity among the participants: only the twisted colonettes, tooled on the panel itself, remain as sectional divisions—although here they lie behind, not between the figures.

Andrea di Cione's altarpiece is, in sum, a complex synthe-

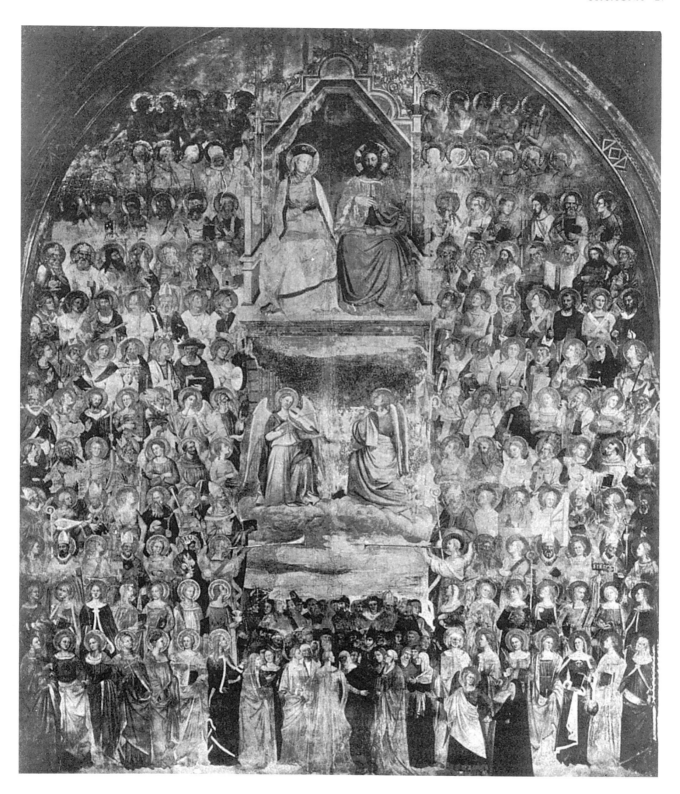

sis, and becomes, ultimately, more than the sum of its parts. The energy, power, and sense of intellect apparent in his few known works made him a fitting choice for the Strozzi commission. Here, there can be no doubt that he shows a decided shift away from the stylistic perceptions of the first part of the trecento. However, the multiple factors that were involved in this shift are not always easy to ascertain. Perhaps the least explored of these is the stylistic range and versatility of the artist who created the Strozzi altarpiece—and about whom we still know so little.

—Carol T. Peters

Lorenzo Maitani (c. 1270–1330)
Creation of Adam and Eve
Stone
Orvieto, Cathedral facade

The first specific scenes in the far left pilaster of the Orvieto Cathedral facade, these two have as their base a gracefully carved ribbon showing God moving across the primal rock calling to life the animals of the sea, the land, and the sky. Appearing again in the divided panel above, God, observed by two angels, is first seen on the left breathing life into a dormant Adam, who then rises in naked splendour. The framing vines, winding their way to the top, have their roots in the newly created earth but emerge from it slightly behind the frontal scene to allow a free flow of space between the Creation of Adam and that of Eve happening on the opposite side of the vine. Eve, rising from the breast of the sleeping Adam, thus countering his dormant pose, moves toward the Creator, drawn by his life-giving hands. The two angels from the first scene participate in the second as well, having descended from their lofty, detached observation of the first event to a more intimate, earth-bound involvement in the second. The imaginatively placed figures, divine and earthly, moving within a sparse, as yet unfinished landscape, express the omnipotent divine power versus the trance-like wonderment of humanity at the beginning of time.

—Reidar Dittmann

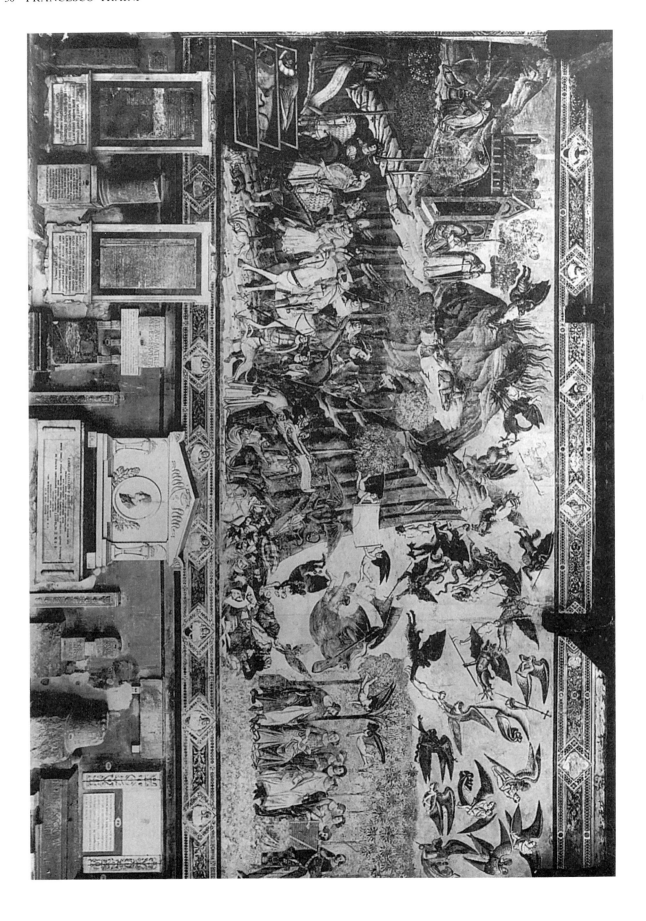

Francesco Traini (active c. 1321–63)
The Triumph of Death
Frescoes
Pisa, Camposanto

Bibliography—

Oertel, Robert, *Traini: Der Triumph des Todes im Camposanto zu Pisa,* Berlin, 1948.
Sanpaolesi, P., Mario Bucci, and Licia Bertolini, *Camposanto monumentale di Pisa: Affreschi e sinopie,* Pisa, 1960.

The *Triumph of Death* is a vast fresco that originally occupied the east end of the south wall of the Camposanto, the burial ground of the Cathedral of Pisa. As such, the *Triumph* opened the narrative sequence on the south wall, followed by the *Last Judgment,* the *Inferno,* and the *Thebaid.* Due to extensive damage in World War II and their subsequent restoration, these frescoes were detached from the wall, revealing remarkable *sinopia* drawings beneath the coat of smooth plaster (*intonaco*), on which they were painted.

Although now known to predate the Black Death, these frescoes were formerly believed to have alluded to the devastating plague of 1348. Various aspects seemed to support this proposal, such as their gruesome preoccupation with death and decay, the emphasis on Christ's condemnation in the *Last Judgment,* the allocation of an entire scene to the horrors of Hell, and the insistence on the evanescence of life and threat of eternal punishment awaiting sinners. One of the inscriptions that accompanies the *Triumph* records this grim message: "Since prosperity has left us, Death, the medicine for all pains, come now to give us our last supper."

The *Triumph of Death,* which might have been painted as early as the 1330's, has been likened by many critics to the large-scale, panoramic *Allegories of Good and Bad Government* (Siena, Palazzo Pubblico), painted 1338–40, by the Sienese master Ambrogio Lorenzetti. While Ambrogio's message is essentially optimistic, and focused on the rewards of ethical conduct in this world (as symbolized by majestic figures of Justice, Concord, and Peace); the *Triumph of Death* projects an image of evil and sin in this life, and everlasting punishment and torment in the next. In the lower left corner of the *Triumph* is depicted a familiar late medieval theme, the traditional Meeting of the Three Living and the Three Dead. In the course of a hawking expedition, three richly dressed horsemen, accompanied by their ladies and attendants, unexpectedly come upon three open coffins. Each contains a corpse shown in progressive stages of decay. One of the elegant hunts-men turns his head from the sight, while his companion holds his nose. The dogs and horses, here used as attributes of power and wealth, catch the stench of death, lower their heads, and shy away. On the far right, balancing this vignette, is an idyllic scene where young lovers, revelers, and musicians entertain themselves in a secluded grove, unaware that Death, a fearsome, white-haired hag with a scythe, is swooping toward them. Above a heap of corpses, demons carry off souls, while occasionally an angel intervenes. A vignette on the upper left, showing hermits in the wilderness, at work and in contemplation of divine truths, presents the ascetic Christian life as an alternative to worldly pleasures, with their inevitable consequences.

The *Triumph of Death* and related Camposanto frescoes have been the subject of scholarly debate from their first mention in the critical literature (the Book of Antonio Billi, about 1530), until the present day. In the second edition of *The Lives* (1568), Vasari erroneously attributed the Camposanto *Triumph* and *Last Judgment* to the Florentine artist Orcagna (active about 1343–68). Vasari further claimed that having completed these works in the Camposanto, Orcagna returned to Florence, where he painted the same subjects in the Church of Santa Croce, leaving his brother Bernardo in Pisa to paint the *Inferno.* According to Vasari, Orcagna displayed better design and showed more diligence in the Florentine than the Pisan version. In fact, Orcagna's authorship of the Pisan frescoes was a myth of Vasari, but this error was perpetuated for centuries.

It was in 1894 that I. B. Supino first attributed the Pisan *Triumph of Death* and *Last Judgment* to the native Pisan artist Francesco Traini (active about 1321–63). By the 1920's, many scholars had accepted the attribution to Traini, although in 1928 Roberto Longhi contended the frescoes were probably Bolognese, later claiming them for Vitale da Bologna and his circle. In 1933 Millard Meiss clarified some of the issues connected with the oeuvre of Francesco Traini, reasserting Supino's claim for Traini's authorship, basing his arguments on redefined stylistic grounds. In 1974 L. Bellosi attributed the *Triumph of Death* to Buonamico Buffalmacco, a Florentine artist praised by Vasari. Presently, critical opinion appears to remain divided between Traini and Buffalmacco.

—Ruth Wilkins Sullivan

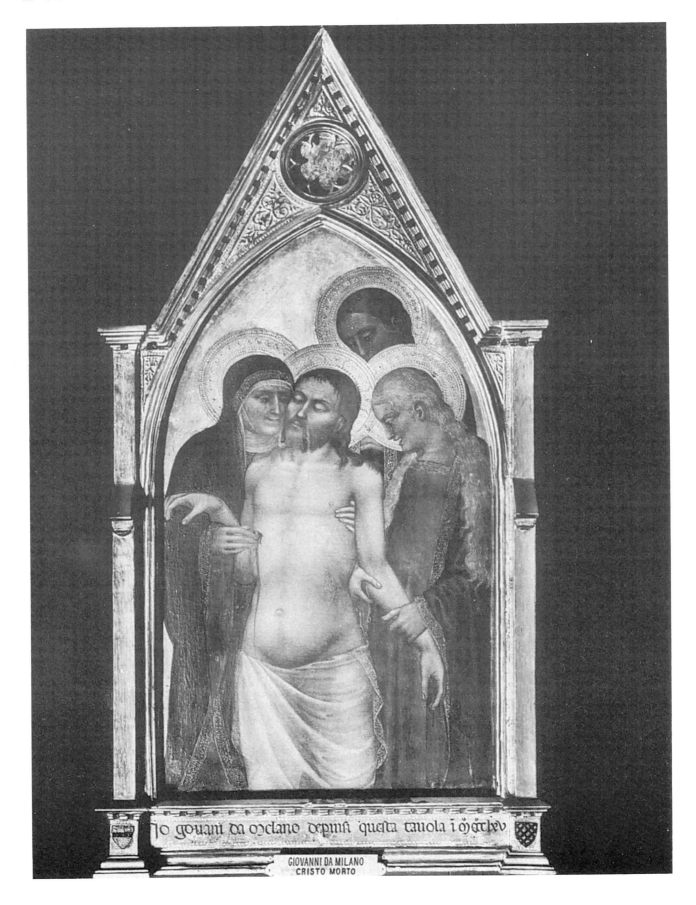

GIOVANNI DA MILANO
CRISTO MORTO

Giovanni da Milano (active c. 1350–69)
Pietà
48 x 22 in. (122 x 56 cm.)
Florence, Accademia

Giovanni da Milano's *Pietà* shows the dead Christ lamented by the Virgin, Magdalen, and St. John. This painting is one of the earliest Florentine examples of this theme. Giovanni makes significant innovations in the traditional trecento type of the dead Christ surrounded by mourning figures to create a devotional image, or *Andachtsbild*, of great spiritual intensity. Here he weds the monumentality of his mature Florentine style to a Lombard-derived attention to minutely rendered details that stress Christ's suffering and the grief of the other figures. The increased display of emotion distinguishes this work from his other devotional images.

This image is a variant of the traditional trecento half-length icon of the Man of Sorrows supported by the Virgin and St. John. Giovanni deviates from the usual symmetrical three-figure scheme by adding the Magdalen, taken from images of the *Descent from the Cross*. Giovanni's amplification of the theme established a tradition for the multi-figural half-length *Pietà* that combines a devotional character with dramatic possibilities for the Venetian *Lamentation* in works by Jacopo and Giovanni Bellini.

In Giovanni's *Pietà* the Virgin's gesture toward the wound in Christ's side invests the display of Christ's body with increased pathos. The intimacy between the Virgin and the Son is made evident by the proximity of their faces; this juxtaposition derives from Dugento images of Christ supported by his mother. However, by making their heads the same size, Giovanni makes her a figure of equal, instead of lesser, importance. St. John stands behind and above the group to the right. His position apart from the figures in the foreground and his lack of contact with Christ's body make him seem a secondary figure in the composition. However, the close spiritual communion of all the figures is suggested by their overlapping haloes, the converging of their glances toward Christ, and the interplay of their hand gestures.

Giovanni brings the monumental figures up close to the picture surface and crowds them together for a direct emotional impact on the viewer. He omits the traditional sarcophagus and makes the figures three-quarter length. The placement of the figures in depth is made poignant, as the body of Christ is pushed forward toward the viewer. The architectonic filling of the available space with figures recalls the massing of figures in other works by Giovanni: the celestial choirs of the predella of the Ognissanti altarpiece; crowds of onlookers in the Rinuccini Chapel fescoes (*Raising of Lazarus, Christ at the House of Mary and Martha*). In the Accademia *Pietà* the verticality of the ogival arch of the frame opening accentuates the sense of crowding and emotional urgency.

Giovanni focuses on Christ's suffering in various ways. The delicate brushwork and sensitive chiaroscuro modeling give Christ's body anatomical verisimilitude with extremely smooth surfaces and attention to textural differences of hair, skin, and the diaphanous loincloth. Realistic details suggest Christ's suffering: His face has an exhausted expression, his half-open mouth reveals teeth, his eyes are closed, and his hands have turned rigid in agonized positions. Blood flows from the gaping wound in his side. The bright red of the blood counterbalances that of the patch of John's tunic. It is the most intense color note and contrasts with the greenish tint of Christ's dead flesh as well as with the subdued colors of the women's garments—the blues of the mantles, the brown of the Virgin's tunic, and the dusky rose of the Magdalen's tunic. The garment edges form decorative lines echoing the contours of Christ's body.

The mourners' grief is conveyed by tears running down their cheeks and grimacing mouths that seem to cry out in anguish. This emotional content marks a departure in Giovanni's devotional works. In his earlier works with the dead Christ and mourners, the figures show very little facial expression and commune silently. The increase in emotional intensity in the Accademia *Pietà* parallels that of the Rinuccini Chapel frescoes (seen in such details as the intense stares of the priest and Joachim in the *Expulsion of Joachim*, the disapproving faces of the onlookers in the *Raising of Lazarus*). However, the figures in the *Pietà* do not yield themselves up to a full outpouring of sorrow. In this painting Giovanni maintains a balance between Giottesque dignity of the human form and north Italian expressive details.

—Annette Dixon

Bernardo Daddi (c. 1290–c. 1349–51)
Bigallo Triptych, early 1330's
Panel; 35³/₈ × 32¹/₄ in. (90 × 82 cm.)
Florence, Museo di Bigallo

The elaborate portable triptych residing in the museum of S. Maria del Bigallo, Florence, is one of the touchstones of Bernardo Daddi's career. Although painted in an environment charged with the monumental probities of Giotto and his immediate followers, Taddeo Gaddi and Maso di Banco, the intimate mood and jewel-like palette of Daddi's small altarpiece reveal a Florence in which personal, quotidian devotion was also permitted, not only to blossom, but to reach a level of serene purity.

There is no document or other early text to connect the triptych with Daddi. Even information citing its placement in the residence of the Bigallo confraternity goes no farther back than 1843. And the inscribed date, located on the socle area of the central panel, was restored long ago. Nonetheless, with the exception of one early modern critic, the attribution of this small altarpiece to Daddi (by C. Gamba in 1904) has not been seriously contested. A date in the early 1330's reinforces the line of Daddi's stylistic development so well that only the fine points concerning the exact year have proved to be problematic.

That the triptych was originally connected to the Bigallo seems a distinct possibility. This confraternity, traditionally thought to have been founded in 1244, included St. Nicholas—who is represented in full-length on the left outer wing and in the two small scenes on the top inside levels of both wings—as a patron. The Virgin, to whom the confraternity is dedicated, is prominently displayed, as well—enthroned with the Child in the central section; in the *Nativity* (left inside wing); and in the *Crucifixion* (right inside wing). The particular emphasis on Nicholas (the patron saint of children), as well as the presence of St. Christopher carrying the Child on the right outer wing opposite Nicholas indicate that a child or children may have been linked with the commission. Moreover, the appearance of a male and female kneeling donor below and to the right and left of the enthroned Virgin and Child (entreating parents or a childless couple?) points to an even more specific role for the altarpiece.

There is, in addition, a distinctly Franciscan tone to this work with St. Francis appearing at the foot of the *Crucifixion.* This saint's presence may have been at the request of the donor, but he also serves as a reminder of the more general character of the portable triptych. Byzantine in derivation, the form was popularized by the Friars Minor in the 13th century, its small size a perfect vehicle for the close rapport between the worshipper and the Gospel accounts that was fostered by the Order. This devotional intimacy converged with the developing wealth of individuals and made such objects perfect instruments of private rather than public worship.

The creation of the Bigallo triptych coincided with the introduction into Florence of the modernized portable triptych form in the 1320's and 1330's—about a decade later than its appearance in nearby Siena. And whether the form of the Bigallo work was the invention of Daddi, himself, of Giotto, or of Maso di Banco, a Giotto follower (as has been conjectured), it is through Daddi that this type attained a standard form for much of the 14th century. The iconography of subsequent examples of the portable triptych varied little; true development lay in the creation of mood and situation—a challenge for which Daddi's talents were admirably suited.

To compare Daddi's *Virgin and Child Enthroned* with the center panel of a smaller, but otherwise almost identical triptych by Taddeo Gaddi dated only a year later (Berlin, Gemäldegalerie), is to understand the suitability of Bernardo's temperament to this format. Both his and Taddeo's Madonnas are placed within generous tabernacle-like thrones on seats that describe a dramatic perspectival space. Yet, while Taddeo's weighty figures are emphasized, and their interpersonal involvement held in check by the restrained and sober contours of monumental Giottesque painting. Bernardo (although certainly indebted to Giottesque mass and volume), encloses his personages with generous, curving contours and situates them in an architectural space that acts as an environment which they, with their softened plasticity, do not overwhelm. Within this created world, his Madonna leans toward her active child with a finger raised in warning, and although the postures of his figures had already been displayed in earlier works, Daddi's interpretation uniquely stresses the episodic and subjective nature of a private event captured and frozen in time. Other moods are explored in the small narrative scenes on the inner wings. To the left of the main panel, Bernardo's Madonna and Child of the *Nativity* are wrapped within the inward spiraling contours of the still, maternal bond, while in the *Crucifixion,* opposite, Mary's dark and hooded head snaps down and away from the sight of her dead son with the sharp curve of a broken flower. Yet, even in this tragic and emotional episode Daddi's sensibility remains Florentine. However much he is indebted to the Sienese in points of style, iconography, or technique, his forms evince a Florentine intellectual control, and his palette, while broader in scope than in his earlier works, adheres to a formal, descriptive function.

The place of the Bigallo triptych within Daddi's development makes clear an artist attuned to the researches into late Giottesque problems of figures occupying extended space, of more complex color, and of an interest in richer surface decoration. Aside from the punched designs on the gold background of this work (which Bernardo may have introduced into Florence), his unique contribution was the poetic temperament with which he interpreted his subjects. His achievement in this endeavor may be measured by the many portable triptychs assigned to him, his shop, and his followers that were successors to this one. With the Bigallo triptych, Daddi captured the universal sentiments and the deep and personal religious longings of his contemporaries. In it he reveals an intimate genius that his more monumentally inclined peers could not match.

—Carol T. Peters

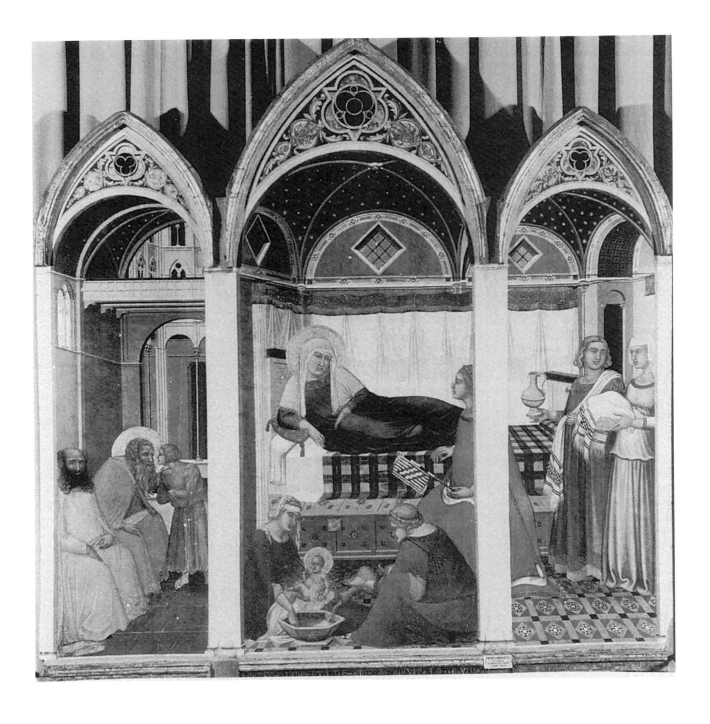

Pietro Lorenzetti (active c. 1280–1348)
Birth of the Virgin, 1342
Panel, 6 ft. 2 in. x 6 ft. (188 x 182.9 cm.)
Siena, Cathedral Museum

Pietro Lorenzetti's *Birth of the Virgin,* has been called the most astonishing interior painted on panel in the first half of the 14th century. It is signed and dated: PETRUS LAUREN-TII DE SENIS ME PINXIT A MCCCXLII (Pietro Lorenzetti of Siena painted me in the year 1342). From 15th-century inventory descriptions (1429 and 1446), this work is known to have originally been the central panel of the Saint Savinus altarpiece in the Cathedral of Siena. Recent research has revealed that the *Birth of the Virgin* was part of a distinct program of altarpieces for that cathedral, commissioned for the altars of the four patron saints of Ssiena, but depicting episodes from the life of the Virgin, who was the protectress of the city of Siena. In addition to Pietro's *Birth,* this series also included the 1333 *Annunciation,* by Simone Martini and Lippo Memmi (Florence), for the altar of Saint Ansanus; Ambrogio Lorenzetti's 1342 *Purification of the Virgin* (Florence), for the Altar of Saint Crescentius; and Bartolommeo Bulgarini's *Nativity* (Cambridge, Massachusetts), for that of Saint Victor. This series, using large narrative scenes for the central panel, provided a new prototype for altarpieces in Siena.

Although finished in 1342, the *Birth of the Virgin* is known from documentary sources to have been commissioned as early as 1335. One document records payment of thirty gold florins to the artist, "maestro Petro Lorenzi dipegnatore," for painting "la tavola di sancto Savino." The second document records an additional payment to a "maestro Ciecho," for translating the legend of Saint Savinus from the Latin so that it could be recorded on panel. Inventory descriptions also reveal that the *Birth* was originally flanked by side panels (now lost) depicting Saints Savinus and Bartholomew. As titular saint of the chapel, Savinus would have occupied the traditional position of honor, at the viewer's left. This altarpiece also had a predella, probably consisting of small scenes recounting the life of Savinus, whose legend had been translated into the vernacular, presumably for the benefit of the artist.

The *Birth of the Virgin* is remarkable for its innovative treatment of pictorial space and its astonishing illusionism. Al-though the laws of representing rational, one-point perspective had not yet been formulated, Pietro succeeded in marshaling every space-creating device at his command. First, the fictive architecture of his painting recedes back from the four wooden uprights of the frame in such a way that the frame and pictorial space are continuous. So convincing is this illusion, that the wooden uprights actually appear to support the painted vaulting above. This merging of the frame with pictorial space marks a break with the past, since the frame had traditionally served as the demarcation between the sacred space of the painting and the real space of the worshiper.

The large bedchamber fills the central arcade and spills over into the right arcade. This imposing room has a high vaulted ceiling, dark blue with red ribs, and studded with golden stars, an allusion to the heavens. The right arcade repeats this ceiling pattern, reduced appropriately in scale. The bedchamber is dominated by the monumental reclining figure of Saint Anne, whose volumetric presence is frequently associated with the work of the Florentine sculpture Arnolfo di Cambio. The tipped-up tile floor, mostly blocked-out in the central arcade by the seated figures of the midwives, works at the right to provide the necessary perspectival lines to create depth. The lines of the plaid bedcover ingeniously reinforce this effect by continuing the orthogonals of the floor tiles; the patterns of both diminish in size as they recede.

The arcade at the left represents an adjoining chamber, with very different spatial qualities, including a floor that appears to tip up more steeply, and a vista that recedes further back into space, revealing a brightly lit courtyard beyond. In the foreground, a child informs Saint Joseph of the birth of the holy infant. But only the presence of halos signals to the viewer that this everyday bourgeois scene actually depicts a sacred event. Although this panel, with its sparkling colors and wonderful narrative detail, relates this episode with great human warmth, the real achievement remains the artist's manipulation of pictorial space through his use of shifting viewpoints.

—Ruth Wilkins Sullivan

Ambrogio Lorenzetti (c. 1290's—1348)
Good and Bad Government, 1338-39
Frescoes
Siena, Town Hall

Bibliography—

Rubinstein, Nicolai, "Political Ideals in Sienese Art: The Frescoes by Ambrogio Lorenzetti and Taddeo di Bartolo in the Palazzo Pubblico," in *Journal of the Warburg and Courtauld Institutes* (London), 21, 1959.

Feldges-Henning, Uta, "The Pictorial Programme of the Sala della Pace: A New Interpretation," in *Journal of the Warburg and Courtauld Institutes* (London), 35, 1972.

Starn, Randolph, "The Republican Regime of the 'Room of Peace' in Siena 1338-40," in *Representations* (Berkeley), 18, 1987.

Greenstein, Jack M., "The Vision of Peace: Meaning and Representation in Lorenzetti's *Sala della Pace* Cityscapes," in *Art History* (Oxford), December 1988.

Ambrogio Lorenzetti's frescoes painted for the Sala dei Nove of Siena's town hall occupy a special place in the history of civic decoration. Conceived in the shape of large, rectangular, figurative panels with historiated borders and inscriptions, the work is divided among the three windowless walls of the former chamber of Siena's highest magistrats who ruled from 1287 to 1355. The title of *Good and Bad Government* by which the frescoes are popularly known dates back only to the 18th-century. Earlier sources, such as Vasari (1550) and the sculptor Ghiberti (c. 1455), referred to them as *Peace* and *War*, a description which is more appropriate to their original purpose.

This masterpiece of 14th-century painting, documented to Ambrogio in ten payments between 1338 and 1339, has unfortunately undergone vicissitudes of time and fortune which have altered its original appearance. Because of physical adjustments to the room itself—extensive repainting, the details of Ambrogio's style must be approached with reference to other works of his later period—which also contain broad, compact figures enclosed in deceptively simple and integrated contours. Present in the frescoes as well is Ambrogio's omnipresent sense of measure between solid and void, decoration and unadorned area. His ability boldly to capture the essence of a subject in the daubs and sweeps of his brush has been noted in the panoramic landscape, and reaffirms what has been learned of his drawing technique in the sure, summary *sinopia* sketches that underlie other remaining frescoed scenes. (No *sinopie* for the Sala dei Nove have been found.)

Although the theme of the frescoes—that a government based on the common good is superior to one founded on private interests—was, in all probability, conceived by those close to or part of the Sienese government, the complexity of the subject matter must certainly have excited Ambrogio's intellectual abilities in novel ways. The ideas underlying the work are based on the political theology descended from Thomas Aquinas with reference to Aristotle and to other classical authors popular in the later Middle Ages. The exaltation of a well-ordered and unified society (here, the commune of Siena) is made possible by the concept of justice, descended from God and implemented through the works of society's

members. Without justice, society (i.e., Siena) will fall into the evil of tyranny and vices. With justice, it can transform itself into a reflection of the New Jerusalem to which it aspires as the eternal and perfect reconciliation between God and his creation. In light of the civil turbulence plaguing the Italian communes in this age, the message set forth here was one fundamental for safeguarding a stable and productive society against internecine warfare and the lawlessness of the nobility.

Ambrogio has dedicated two of the three walls to this vision of the ideal city-state. On the short (north) wall the theoretical structure of the just society is set out in allegorical terms on three horizontal levels. Frontal and enthroned, *Ben Comun* (the Commune), personified as an old man (perhaps a *senus,* a play on the word Siena), sits on a long bench that occupies the central and right hand portions of the middle level of the fresco. Larger than the six virtures who flank him, he is the center of attention. In his right hand *Ben Comun* holds the mace, symbol of temporal power, and in his left a shield depicting the Virgin, patroness of Siena, and her Child. Above flutter the three theological virtures, while below a she-wolf suckles the two sons of Remus, Ascanius, and Senius, legendary founders of Siena.

The figure of a frontal and enthroned Justice on the left central section forms a visual and iconographic link to *Ben Comun.* Justice lifts her eyes heavenward to a small, winged figure of Divine Wisdom, while steadying to either side the pans of the scales that Wisdom holds. Here, acts of commutative and distributive justice are carried out by two angels. Directly from these pans two cords, white and red, are caught on the lower level by the figure of Concord (con-cordia; again, a play on words) who, joining them, offers the twisted, double strand to twenty-four citizens (perhaps the original members of the 13th-century government). These file, in turn, toward *Ben Comun,* in whose hand the opposite end of the cord rests. Above the citizens, in the center of the wall, reclines the figure of Peace, dressed in the garments of antiquity. On the sinister side of *Ben Comun* sit the protective guard of a second, armed Justice, carrying a sword and severed head, Temperance, and Magnanimity, while below them appear soldiers who accompany prisoners dressed as villeins, and two men in armor who offer the Commune a fortress.

The long, east wall to the left of this theoretical exposition shows the effects of the communal rule of the just. On the left, the walled city, identified as Siena by the black and white cathedral appearing in the upper left fans out harmoniously from a central piazza where nine maidens dance while a tenth beats time with her cymbal. These graceful dancers appear to function on an allegorical level, unlike the smaller figures with whom they share this scene. Perhaps they represent Concord, stemming from Justice, as implied in the inscription below. From the commune, busy with daily activity, a main throughfare leads out into the country. Here, commerce to and fro is made safe by Security, depicted above as a young, winged personage holding a banderole and a gallows with a hanged criminal. In the countryside, activities of spring and summer, personified in the border quatrefoils, above, are shown. Thus,

Ambrogio Lorenzetti, Gli effetti del Buon Governo
in campagna - Siena. Palazzo Comunale

in town and country a state ruled by Justice provides productivity through the arts both mechanical and liberal, the latter of which are figured in the lower borders of both Good Government frescoes.

Tyranny and lawlessness prove the absence of a just society, and Ambrogio has condensed the content of the allegory of Tyranny and its effects on the wall opposite the entrance to the council room. In imitation of *Ben Comun,* Tyranny and his nine vices occupy the right side of the wall. At his feet Justice lies in chains; to his right Cruelty strangles a child, while at his left Discord, dressed in the black and white of the Sienese coat of arms, and inscribed with *Si* and *No,* holds a saw, in direct contrast to the plane that smooths away all differences held by her opposite, Concord.

The city and countryside show the effects of misrule: as the inscriptions state rapine, robbery, and murder are endemic. Here, there are no arts, and no productive work is done. In the border, above, the malevolent planets of Mars and Saturn appear, while below the figure of Nero remains as a reminder of the other tyrants formerly depicted on this very damaged wall.

In the Sala dei Nove, Ambrogio succeeded not simply in translating, but embodying late medieval republican ideals. Here, the conflicts of virtue and vice, concord and strife, put on garments of flesh and blood, of mass and space; and for this he well deserves Ghiberti's praise of "a most perfect master . . . learned like none of the others. . . . "

—Carol T. Peters

Taddeo Gaddi (c. 1300–66)
Baroncelli Chapel, c. 1330's
Frescoes
Florence, S. Croce

Bibliography—

Gardner, J. "The Decoration of the Baroncelli Chapel in Santa
Croce," in *Zeitschrift für Kunstgeschichte* (Munich), 34,
1971.

One of the most precious works of the Florentine trecento is
the fresco cycle commissioned by two separate branches of the
Baroncelli clan for their double-bayed chapel at the end of the
south transept arm of S. Croce, Florence. The complex of
frescoes, altar, altarpiece, entry gate, sepulchral monument,
and sculpture is the only chapel from the early trecento to have
survived virtually intact. No documents exist to link this work
with Taddeo Gaddi, yet his name has rightly been associated
with it since the 16th century. The inception of the programme
can be dated to c. 1328 through an inscription on the tomb
monument in the chapel. Taddeo, probably not quite thirty
years old, was thus engaged on an important commission for a
major Franciscan convent.

Taddeo's exercises in the Baroncelli chapel are indebted to
the painting of his teacher, Giotto, especially the latter's
slightly earlier cycle in the nearby Peruzzi chapel. Unlike
Giotto, however, Taddeo's approach to narrative composition
is less controlled by dignified restraint and gravity. His person-
ages more often inhabit the realm of the emotions than of the
intellect, and he embraces the personal and the particular at
the expense of his master's universal classicism. His paintings
here reveal a young artist filled with optimism, humor, and an
appetite for formal experimentation.

The Baroncelli cycle is first encountered as a richly imag-
ined environment. The simply articulated east and south walls
of the first bay of the chapel, and the arches and vaults of both
bays, are clothed with a range of delicate or rare tones of deep
red, saffron, aqua, ivory, and violet set against a midnight
blue background. Within this movement of color, Taddeo has
organized his surfaces through a complex scaffolding of illu-
sionistic architecture The perspectival logic of this painted
world is not consistently directed toward observers standing
just outside the chapel, as has recently been maintained.
Rather, the structure introduces levels of reality that continue
to unfold within the work. A concern of Taddeo's is where the
boundaries among these levels lie.

The painted dado of the chapel's first bay is envisioned as
marble panels pierced, on the east, by fictive aumbries con-
taining materials for the Mass. This dado upholds an east wall
divided into a lunette with two rows of two scenes below that
depict events from the early life of Mary. Elaborate painted
colonettes appear to support the horizontal ledges separating
the three narrative levels. On the south (altar) wall, the three
Advent and Nativity scenes to either side of the lancet window
are placed on fictive consoles that seem to project into the
viewers' space. As did Giotto before him, Taddeo gives his
cycle a unified light source to accord with the natural illumi-
nation of the chapel, which comes from the south (altar) win-
dow. All the painted elements thus exist in the actual world,
even, paradoxically, the personifications of the *Four Cardinal*

Virtues in the vault of the first bay. These weighty personages,
seated behind octofoil frames, are illuminated so realistically
against their gold ground that they push beyond the boundary
of intellect into that of flesh and blood.

Light is also the conveyer of the heavenly level. And prop-
erly so, for in the Annunciate Virgin, the cycle's focus, the
realm of the Divine is miraculously fused with the human. In
three scenes on the altar wall, heavenly messengers appear to
the Virgin, the Shepherds, and the Magi from the direction of
the natural light of the window, their orange-yellow aureoles
glowing against the blue-black sky. The natural order is here
transformed through the agency of the supernatural, just as the
actual light is, itself, transformed as it passes through the col-
ored glass into the sacred area of the church. The *Coronation
of the Virgin* altarpiece on the altar, below, bears further evi-
dence of the ultimate source of this illumination. Designed by
Giotto and his shop in close connection with Taddeo's project,
the now detached pinnacle (San Diego, Fine Arts Museum) of
the original frame depicts God the Father flanked by angels
who hold mirrorlike objects to shield themselves from (or to
reflect?) His brilliance.

Taddeo's interest in light effects and astrological phenomena
has been a much discussed topic. The integral role it plays
here may be a happy conjunction of personal interest by the
artist with the deep interest in light metaphysics of the Friars
Minor.

Other reminders of a Franciscan presence in the chapel are
the humble postures of Joseph, Mary, and Joachim (whose
placement on the ground in *The Annunciations to Joachim and
Mary* and *The Nativity* recall the Franciscan virtue of humil-
ity), and the several small, half-length figures displaying mo-
nastic virtues in the window splays.

The general seriousness of Taddeo's theme did not preclude
him from interpreting part of his story on a popular level.
Perhaps the Franciscans, with their emphasis on the personal
re-experiencing of the Gospel narratives, extended an encour-
aging hand here, as well. For example, in *The Betrothal of the
Virgin* to the aged Joseph on the lower right of the east wall,
the actions of the gay company who whisper, gesture, and play
music have recently been linked to contemporary Tuscan prac-
tices of good-naturedly hounding such mismatched couples.

The overall inquiring spirit which succeeds in embracing all
levels of experience in the Baroncelli chapel must be credited
to Taddeo alone. This spirit can be found in the marvelously
varied postures of the figures and the rhythmical interconnec-
tions of certain motifs, such as the triad of men in *The Expul-
sion of Joachim from the Temple* in the east lunette and their
gossiping female counterparts in *The Meeting at the Golden
Gate*, directly below. Taddeo's incisive observation of the natu-
ral world is a further manifestation of this spirit, as the por-
trayal of the hunched dog who warily regards the angelic
apparition in the *Annunciation to the Shepherds* makes abun-
dantly clear.

In their broadest context, Taddeo Gaddi's frescoes in the
Baroncelli chapel help to define the expansionist and optimis-
tic tenor of the early trecento. His compositions inspired the
works of many of his successors, although the boldness with
which he explored the range of reality would not be met with
again until the following century.

—Carol T. Peters

Agnolo Gaddi (active 1369–96)
The Legend of the True Cross, c. 1390
Fresco
Florence, S. Croce

The fresco cycle depicting *The Legend of the True Cross* in the choir of the Franciscan church of S. Croce, Florence, is neither dated nor documented, yet even the earliest sources attribute this grand ensemble to Agnolo Gaddi. Executed around 1390, the work occupies an important place in both Agnolo's *oeuvre* and the history of Florentine art at the dawn of the Renaissance.

The fresco was probably commissioned by the powerful degli Alberti family of Florence, the choir's patrons. The chronicle of the journey of the Cross through history was attractive to the Friars Minor: meditation on the Cross was a central theme in the life of the founder, St. Francis, and continued to be important in Franciscan spirituality. A depiction of the Legend in the choir of a church dedicated to the Holy Cross would, thus have been viewed as highly appropriate.

The story from which Agnolo's *Legend* was composed can be divided into two main parts, each with a feast day marked by the Western church. The Invention of the Cross (3 May) chronicles the history of the holy branch taken from the Tree of Life in Paradise and planted on Adam's grave by his son, Seth. In the time of Solomon, the wood's sacred character was recognized by the Queen of Sheba, who foretold of its use in the Crucifixion. Fashioned into a cross and buried after the Passion, it was recovered by Helena, the mother of Constantine, who brought it back to Jerusalem. The second, and separate part of the legend, The Exaltation of the Cross, (14 September) concerns the theft of the cross from Jerusalem by the Moslem King Chosroes in the 7th century, and its subsequent restitution by the Christian Emperor Heraclius. Medieval love of type and antitype (Adam the Old Man versus Christ the New; infidel king versus Christian emperor) revolves around the Cross, the symbol of the Redemption. In S. Croce, Agnolo combined the two narratives for the first time to give the viewer a complete exposition of the history of the Cross.

Agnolo's depiction of the Legend follows closely the version given by the 13th-century Dominican, Jacopo da Voragine, in his *Golden Legend.* The artist has divided each side wall of the choir into three large rectangular panels below a lunette. The scenes are arranged in chronological order beginning in the upper right and ending at lower left. Agnolo's narrative is part of a total environment created through design and color. The monumental entrance pilasters present tabernacled standing saints, and the deep blue vault displays the Evangelists, John the Baptist, and St. Francis. Through stained glass lancet windows on the east, colored light complicates the variegated reds, blues, straw yellows, greens, and whites of Agnolo's palette.

The treatment of the eight historical scenes reveals in detail Agnolo's talents as a fresco painter and narrative composer. These compositions are peopled by forms of mass and weight who move now slowly, now energetically across the foreground. Behind them the middle and distant planes of space open into a panoramic landscape of the imagination illuminated by a shifting light that moves across the mountains and valleys. Agnolo's romantic vision of the wilderness is indebted to his father Taddeo's sensitive, emotional approach to narrative environment as well as to the greater emphasis placed on this portion of the picture in mid-century Florentine painting. Yet, no one before appears to have created settings with such breadth and consistence of mood.

As the observer progresses through the narrative in a chronological fashion, Agnolo's artistic maturity and growing experience with the fresco medium become evident. The composition of the first scene, *The Death of Adam,* is awkwardly divided into two superimposed sections with the large, kneeling Seth, who receives a branch of the Tree of Life from the angel, dwarfing the lower episode in which he reappears to plant the branch over his father's corpse. The panel that closes the cycle, on the lower left wall, however, shows the artist's great skill in combining three successive incidents: *The Beheading of Chosroes, The Angel Appearing to Heraclius,* and *Heraclius's Entry into Jerusalem.* The scenes are not sharply divided, but flow into one another, weaving in and out from left to right through the device of a moving cortege that transforms itself into the actors appropriate to each episode.

Agnolo's development can be noted in two other areas. Beginning with the final panel on the right wall, the figures attain more naturalistic proportions, are clothed in softer drapery, and are smaller in relation to their environment. These changes, which suggest that the artist painted his scenes in chronological order from right to left, is strengthened by a shift in color scheme. The tonalities of the left wall are slightly deeper, and the individual areas of color are more expansive, which allows the figures to be more easily read from the floor. Still, throughout the cycle there is a great love of detail—in the landscape settings, the rich clothing of the royal entourages, and the individualistically rendered heads of certain male figures—which continually prevents too facile a reading.

Agnolo's ability to balance minute descriptive accents with the broader strokes of large-scale narrative exemplifies the vigor of Florentine art at the end of the trecento. More particularly, Agnolo's compositions, created for the leading Franciscan church in Tuscany, are the base upon which the later cycles of Cenni di Francesco (Prato), Masolino (Empoli), and Piero della Francesca (Arezzo) would be built.

—Carol T. Peters

Maso di Banco (active c. 1325–50)
Saint Sylvester Raising Two Magicians in the Forum, c. 1336–
41
Fresco
Florence, S. Croce

Saint Sylvester Raising Two Magicians in the Forum, Maso di Banco's acknowledged masterpiece, is the dominant scene of the Saint Sylvester cycle in the Bardi di Vernio Chapel, in the Franciscan church of Santa Croce in Florence. Although unsigned and undocumented, these Saint Sylvester frescoes were specifically attributed to a painter named Maso by Lorenzo Ghiberti in his *Commentarii* around 1447. Ghiberti further identified Maso as a pupil of Giotto, asserting that "few things by him are not perfect."

Maso's frescoes in the Bardi di Vernio Chapel might reasonably be dated between c. 1336 and 1341. These dates have been approximated more on the basis of patronal family history than on art historical grounds. The patrons were probably the family of Gualterotto di Jacopo Bardi (d. before 1336), whose will provided for a chapel in Santa Croce for himself and his descendants. The presence of the Bardi di Vernio arms in the chapel suggests the participation of Gualterotto's son Piero, who founded the Bardi di Vernio branch of the family by purchasing the feudal properties of Vernio in 1332, and occupying the castle of Vernio in 1335. Because these frescoes represent Maso's mature work, and he is believed to have died of the plague in 1348, it seems likely that they would have been executed during the late 1330's. Moreover, since the Bardi suffered a series of financial catastrophes from 1339 until 1345 (when they were declared bankrupt), the date probably should not be extended too far into the 1340's.

Saint Sylvester Raising Two Magicians in the Forum takes its subject from the legend of the Saint, as told in Jacobus de Voragine's *Legenda aurea* (1263–73). Maso shows Sylvester, accompanied by two priests, sealing the mouth of a deadly dragon that had been devastating Rome. Upon his emergence from the dragon's pit, Sylvester revives two pagan magicians, who had tried to follow him but had been overcome by poisonous fumes. According to the legend, Sylvester then converted them to Christianity. Maso's scene would have been understood as a symbolic representation of the triumph of Christianity over Paganism, with the dragon used as a metaphor for idolatry and the rubble in the left foreground signaling the collapse of the pagan world. The jagged edges of the ruins intensify this aspect of the painting.

Maso depicts both episodes in a single composition, which he divides into three sections. Sealing the dragon's mouth occupies the left third of the composition; Sylvester reviving the two pagan magicians is shown in the wider central area; while the Emperor Constantine and his entourage fill the right third, as witnesses to the two miracles. The first two episodes are divided by a dramatically lit, single white marble column. A second strong vertical accent, marking the center of the composition, is provided by the weighty figure of Sylvester himself, wearing his papal tiara and ample crimson robe. Although the foreground is divided into these three separate vignettes, the architectural setting in which all of this is enacted is a single, coherent space, organized in broad, flat planes, with architectural elements painted in high-keyed colors. Each of these parallel planes establishes a successive level of depth. Maso's remarkable achievement here is his creation of a vast, uncluttered, continuous space, which recedes coherently from foreground to background. Maso's success with architectural settings suggests the influence of Ambrogio Lorenzetti, who painted the *Effects of Good and Bad Government* frescoes in the Palazzo Pubblico, Siena, (doc. 1338–39). Although a native Sienese painter, Lorenzetti is known to have worked earlier in Florence, having matriculated into the Florentine Guild of the Medici and Speziale in 1327.

Rivaling Maso's astonishing spatial achievements is the pure beauty of his color and forms. His human figures, like Giotto's, have a weight, dignity, and sense of conviction and moral value. Draped in ample robes, they appear permanent and unperturbable. Although his female figures are often serenely idealized, his male figures are strongly individualized, with carefully differentiated temperaments and psychological responses. This is reflected in their facial features, postures, and gestures. Maso uses a sure, confident outline to delineate facial features and to intensify their expressive content. This is especially effective in his profile portraits, such as those of the magicians, who are shown kneeling at the feet of Sylvester following their revival. Maso's brushstrokes always reveal a sure sense of anatomical structure. Just as Maso's differentiation of individual personality goes beyond that of his master Giotto, so too does his use of color. Maso uses some of the same pastel hues as Giotto, but to the pale pinks, mauves, and yellows he adds deep plum, crimson, and russet. These color effects are heightened by his use of flickering white. Maso's color always carries its own luminosity.

Filippo Villani, writing around 1400, stated that Maso "painted most delicately of all, with marvelous loveliness." When applied to this work, these laudatory words become appropriate praise. If this monumental fresco were Maso's single surviving work, it would, on its own merit, earn the artist an esteemed place in the history of art.

—Ruth Wilkins Sullivan

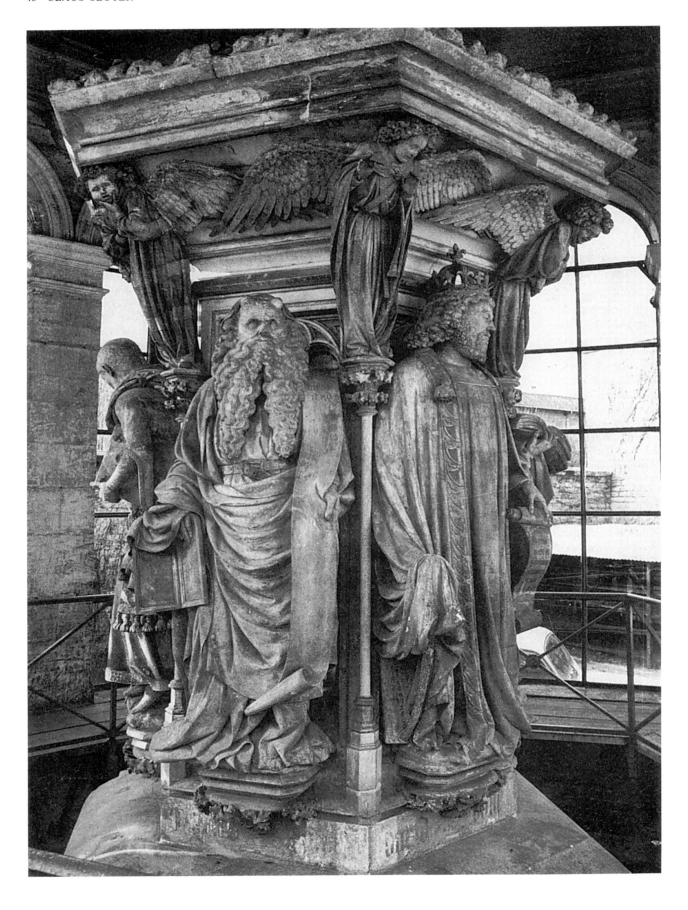

Claus Sluter (1340—1405–06)
The Well of Moses, 1395–1406
Marble; figures are 6 ft. (180 cm.) high
Champmol, Chartreuse

Bibliography—

Kreytenberg, Gert, "Zu Komposition des Skulpturenzyklus am sogenannten Mosesbrunnen von Sluter," in *Pantheon* (Munich), 43, 1985

The *Well of Moses* is the most famous monument sculpted by Claus Sluter. It stands at a well-head in the cloister of the Chartreuse de Champmol near Dijon in Burgundian France. Dutch by birth, Sluter spent most of his active life as "varlet de chambre" in service to duke Philip the Bold, the first of the Valois dukes of Burgundy, who had founded the monastery. It was Philip's plan to establish the place as a pantheon for the ducal line. The monument was one of several great works of art commissioned by the duke for the site. Sluter worked on it from 1395 to 1406.

While the work is known today as the *Well of Moses,* it is actually only a fragment of the original plan. It consists of a hexagonal pedestal with lifesize marble figures of prophets standing before each of the six faces, flanked by slender columns at each corner. Atop each column is a sorrowing or weeping angel. Their sorrow is directed upwards because the pedestal was designed to support a Crucifixion group with Christ on the cross flanked by the Virgin Mary, John the Evangelist, and Mary Magdalene. The cross was to have risen some 25 feet above the pedestal.

Each of the prophets bears a scroll with his own prophecy of the Passion. They include Zechariah, Jeremiah, David, Daniel, Isaiah, and Moses. Moses is the most dramatic and powerful of the figures. Thus he has lent his name to the entire work as it stands.

Sluter's figures combine elements of the Late Gothic, so-called International Style. The figures represent an active, rhythmic naturalism while the costumes are heavy, rather bulky swaths. The costumes retain vestiges of colorful polychromy. The pedestal rises from the pool of the well-head. It is capped by a heavily molded cornice which served as the base for the Crucifixion group above. Stylized rocks rim the borders of the cornice above a base for the original Passion group above.

It has been suggested that the combination of elements, prophets, weeping angels, and Crucifixion group, was inspired by Gothic mystery plays. This is made convincing by the expressive attention to lifelike details and emotion. The plays and the art of the period together depend on the strong popularity of typological analogies and comparisons in contemporary literature. The texts of religious dramas of the period frequently invoke the testimony of the prophets as reassuring evidence for the miracles of deed and faith in the Christian past and present.

Claus Sluter is considered the foremost among the sculptors of his time in the western part of Europe. He is credited with establishing the Burgundian-Netherlandish style of sculpture. The style continued into the 15th century in Burgundy and Flanders, particularly. It influenced the important schools of German sculpture as well. Sluter's work is chronologically parallelled by the Peter Parler school of Bohemia in eastern Europe, a style which also influenced succeeding generations of sculptors in that region and Germany.

—Charles I. Minott

Melchior Broederlam (14th century-after 1409)
Champmol Altarpiece, 1394–99
Tempera on panels, 65³/₄ x 49¹/₄ in. (167.4 x 125 cm) (each
 panel)
Dijon, Musée des Beaux-Arts

In 1363 the French King John the Good conferred the duchy of Burgundy on his youngest son Philip the Bold. By 1384 Flanders had been added to the expanding territory under Philip's control. Dijon became the cultural center of the region and it was there that Philip commissioned numerous works of art. He brought renowned Flemish artists to his court, and among them was the sculptor Claus Sluter from Haarlem who arrived in 1385 at Dijon. He and the Flemish sculptor Jean de Marville were responsible for the portal sculptures of the Chartreuse de Champmol, a Carthusian monastery built by Philip the Bold near Dijon. Sluter was also responsible for the justly famous *Well of Moses* (1395–1403) in the cloister of the Chartreuse de Champmol. The degree of naturalism in Sluter's monumental figures was revolutionary. His work influenced not only the history of northern sculpture, but it had a profound effect on subsequent painting in the north.

Another Flemish artist that caught the attention of Duke Philip was Melchior Broederlam, a contemporary painter. He was commissioned to paint the exterior wings of an elaborate carved and giled altarpiece for the Chartreuse de Champmol. The paintings on these two odd-shaped panels represent a remarkable achievement for this period (1394–99). They reflect an accomplished integration of progressive and courtly elements from France, Flanders, and Italy. The influence of Sluter is clearly evident in the voluminous draperies that envelops the holy figures. Another progressive element that foreshadows the great masterpieces in oil by 15th-century Flemish painters, is the extensive use of disguised symbolism.

The panel of the *Annunciation to the Virgin and the Visitation of the Virgin and Elisabeth* clearly illustrates Broederlam's interest in receding space, not only in the architecture, but in the rocky landscape as well. In the upper corner appears a bust of God the Father from whose mouth issues a beam down which descends the dove of the Holy Spirit through a Gothic window towards Mary who sits reading Old Testament prophecies. The surprised Virgin turns with raised hand at the appearance of the Archangel Gabriel who crouches outside the chapel, unrolling a scroll on which is printed the Biblical salutation ("Ave Gratia Plena Dominus tecum," "Hail, O Favored One the Lord is with You," Luke 1:28). The lilies in the foreground vase symbolize Mary's chastity. Small sculpted figures on the Gothic chapel represent Moses (Old Law) and Isaiah (prophecy that a Virgin would conceive, Isaiah 7:14). The walled garden and the adjacent tower both symbolize the chastity of the Virgin. The Romanesque domed building in the background represents the Temple, symbolic once again of the Old Law while the Gothic chapel would symbolize the New Law. The rocky landscape that recedes into the right background is reminiscent of settings in Byzantine art as adapted in the paintings of the Italian artist Duccio and his Sienese followers. An angel hovers above a distant

castle as a falcon swoops down from a rocky perch. In the foreground the aged and concerned Elisabeth reaches out to feel the swelling abdomen of the regal Virgin. These figures reflect the progressive sculptural approach of Claus Sluter and the naturalism of 14th-century Sienese painters. The emphasis on minute detail and courtly gestures continues the manuscript painting tradition as seen in the work of Jean Pucelle or Jacquemart de Hesdin.

The right panel also has a spacious architectural interior contrasted with a rapidly receding landscape. The *Presentation of the Christ Child in the Temple* combines four solemn and sculptural figures with a squirming and apprehensive blond Christ Child who looks back at his Mother while clinging to the beard of St. Simeon. The latter is dressed as a priest and looks with concern towards Mary. Behind the deep blue maphorion of the Virgin can be seen the aged Joseph and a young lady holding a taper and a basket with two turtle doves as offering. The extraordinary Gothic chapel within which this ceremony is performed has gilded, ribbed vaulting, lancet windows, and a tilted-up tile floor. The setting is very reminiscent of paintings by the Sienese artists Pietro Lorenzetti and Bartolo di Fredi. Outside the chapel one sees the Holy Family on their way to Egypt to escape the wrath of King Herod. The naturalism of the rustic Joseph, whose floppy boots and walking stick clearly mark him as a peasant, reflects a trend in northern painting at this time. He drinks from a small canteen while guiding the charming donkey up the rocky path. Seated on the donkey is the aristocratic Virgin who holds her swaddled Child next to her cheek, a pose strongly reminiscent of a popular Byzantine icon type known as the *Virgin of Tenderness*. The foregound landscape has much realistic vegetation and short leafy trees while the barren rocky mountain in the background is surmounted by a castle. Halfway up the path a statue falls from its pedestal. This is a reference to the apocryphal Gospel of Pseudo-Matthew which referred to pagan idols falling from their pedestals in the presence of the True God (Christ). The atmosphere and chiaroscuro used in this painting are indeed progressive. Color harmony was used to give depth to the scenes.

Disguised symbolism is used throughout, most prominent being the contrasted Romanesque and Gothic buildings in both panels. This type of symbolism continued with more extensive application in the works of the famous Flemish artists that followed, as, for example, in Robert Campin's *Merode Altarpiece.*

In these two splendid panel paintings, Broederlam has clearly shown that he was a master of composition and used a realism that was "more forceful than that of any previous artist" (Panofsky).

—A. Dean McKenzie

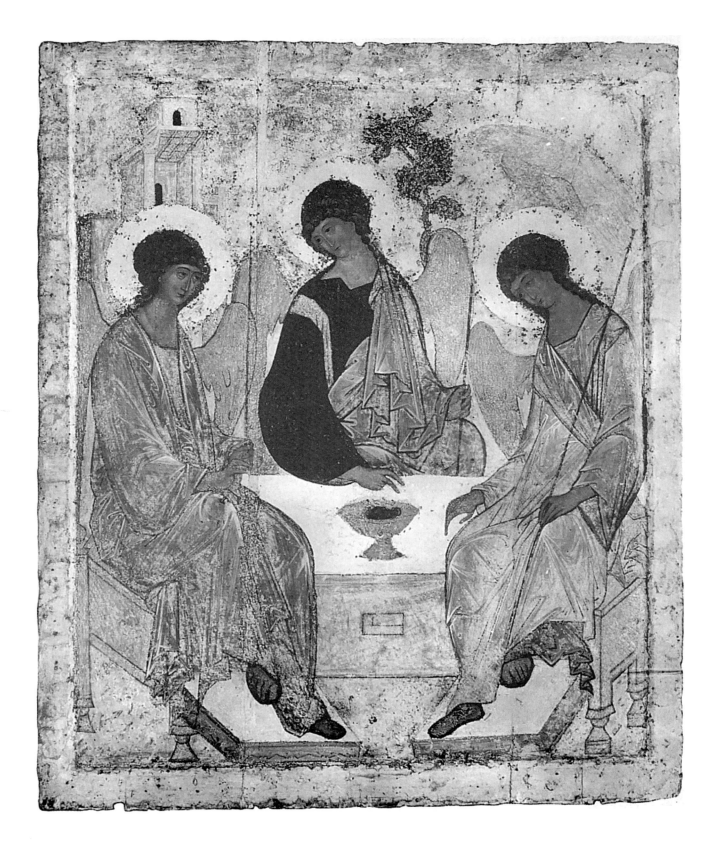

Andrei Rublev (1360 or 1370–c. 1430)
Old Testament Trinity, c. 1411
Tempera on panel; 55⁷/₈ x 44³/₈ in. (141.8 x 112.7 cm.)
Moscow, Tretyakov

Following Grand Prince Vladimir's embracing Greek Orthodox Christianity as his own religion in A.D. 988 and insisting his subjects do the same, Greek clerics, architects, and icon painters were imported by the prince and his successors. Magnificent churches were built, monasteries were established, and since icons were essential elements in Orthodox worship, icon workshops were set up in the major monasteries. Gradually the Russian monastic painters developed their own styles based on the Byzantine imports. Of the Russian "Schools" of painting that developed, the most prominent in the 12th–14th centuries was the Novgorod School. However, it was gradually eclipsed by the emergence of the Moscow School of painting whose founder was the eminent monk of the Trinity-Sergius Monastery, Andrei Rublev. Rublev was responsible for frescoes and major icons for numerous churches in Moscow and its surroundings. Of the icons that are indisputably from his hand, the most famous is *Old Testament Trinity* commissioned by Nikon, Abbot of the Trinity-Sergius Monastery and successor to the beloved founder of the monastery, St. Sergius. The icon, in fact, was painted "in honor of Father Sergius" and was consequently displayed in the Trinity Cathedral at the grave of the saint. Only in the 17th century was it moved to be part of the iconostasis in the cathedral. After this icon was rediscovered in 1904, later over-paintings (17th and 18th centuries) and riza covers were removed.

Although much has been lost from the original painting, enough survives to justify the place this icon occupies as the most venerated and aesthetically integrated icon painted by a Russian artist.

The theme, also known as the *Hospitality of Abraham,* derives from the event described in Genesis 18 where the Lord appears to Abraham and Sarah in the form of three men. St. Cyril of Alexandria (died A.D. 444) first interpreted this event as the original revelation of the Holy Trinity to man. In art the theme appears as early as the 4th century in the catacomb paintings under the Via Latina in Rome. Later it is used as major church decoration (Santa Maria Maggiore, Rome; S. Vitale, Ravenna, etc.) as a symbolic reference to the Eucharistic sacrifice. Rublev's version is dependent upon earlier Byzantine examples, although in his interpretation the three "men" are transformed into angels. Abraham and Sarah who appear in earlier versions are here ommitted. The three figures would fit very neatly into a circle, a symbol of eternity, and a favorite compositional device used by Rublev. The building in the left background could refer both to Abraham's tent and the Christian Church. On the right is a barren mountain (Mt. Sinai?) and in the center is seen an oak tree echoing the posture of the central angel (Christ). This tree not only is a reference to the plains of Mamre, but, more importantly, a symbol of the Cross on which Christ would be sacrificed for mankind. This Cross often is referred to as the Tree of Life. The three figures are grouped around an altar-like table. On the table the golden chalice containing a calf's head is clearly a symbol of Christ's sacrifice, the calf being a sacrificial animal and the chalice referring to the Eucharistic cup. It is the Chalice of Death. The rectangular niche cut out of the front of the altar has been interpreted as a reference to the empty tomb of Christ.

Aesthetically the composition is truly a masterpiece of curves and counter-curves. Rhythmical lines tie the three figures together like contrapuntal motifs in music. Practically no depth is suggested nor are there shadows indicated. This is a spiritual theme, a heavenly scene that transcends the physical boundaries of time and space.

The subtle colors used by Rublev help bind the group together in a hormonious unity. The central figure stands out in the deep purple chiton with a gold stripe. Over his shoulder is draped a deep blue himation. This blue is used for the chiton of the other two figures. God Father's chiton is mostly obscured by the pink himation, although it is faintly seen through the outer garment. The Holy Spirit, on the other hand, wears a light green mantle. The golden wings and golden thrones frame and enjoin the figures.

The entire effect of the icon even in its partially preserved state is one of serenity and deep spirituality that engenders a meditative response. Rublev's version of the *Old Testament Trinity* became the model for hundreds of later Russian icons. In 1554 the Moscow Council of bishops (Stoglav Council) adopted the following canon as proclaimed by Archbishop Macarius: "Icons should be painted by the artist in the ancient tradition . . . in the manner that Rublev's Holy Trinity was painted."

Alpatov summed up the significance of this icon in the following way: "In the history of the arts there is no other one work that to the same extent as *The Trinity,* embodies the best spiritual forces of an entire nation. . . . The best sons of the Russian land brought together their precious gifts and handed them to Rublev, and he embodied them in his finest creation" (*Art Treasures of Russia,* p. 132).

—A. Dean McKenzie

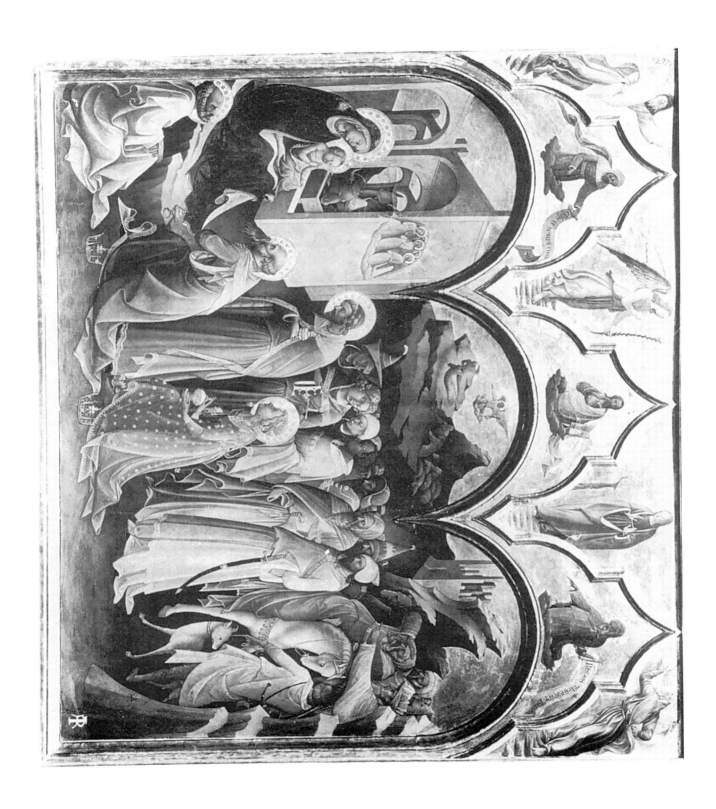

Lorenzo Monaco (c. 1370–72—c. 1422–25)
The Adoration of the Magi, 1422
Panel; 4 ft. 8³/₄ in. × 5 ft. 9⁵/₈ in. (144.1 × 176.8 cm.)
Florence, Uffizi

The Adoration of the Magi by Don Lorenzo Monaco hangs in the Uffizi Museum of Florence, on the wall adjacent to the better known *Adoration* of Gentile da Fabriano. Like Gentile's work, Lorenzo's altarpiece was painted in Florence, probably at the beginning of the 1420's, and reveals yet another facet of the so-called International Style that began to sweep across Europe around the beginning of the quattrocento. Of the two works, Lorenzo's is less well preserved; the frame is fragmentary and a predella is missing. It also lacks clear documentation, although modern sources have connected it with a payment of 144 florins to the artist for an altarpiece in S. Egidio, the hospital church of the convent of S. Maria Nuova, Florence. The date of the payment, 1422, accords with what is known of Lorenzo's style at this time, and thus, the tenuous link of the painting with S. Egidio remains undisputed. To set Lorenzo's altarpiece against the background of Gentile's more famous one is to begin to understand not only the elusive art of this Sienese-born Camaldolite monk, but, in a broader sense, to realize the complexities and divisions of stylistic currents in early 15th-century Italy; for Lorenzo's vision, unlike Gentile's, is Florentine as well as being uniquely his own.

Although known to nearby Siena, neither the Adoration of the Magi, nor the related theme of the Nativity were subjects for the main panels of Florentine altarpieces prior to the appearance of Lorenzo's and Gentile's works. Executed almost simultaneously, they share some notable affinities in the round, tripartite arches of the frames, which give the altarpieces the division of a triptych without obstructing the narrative with dividing colonettes, and in the disposition of the narrative from right to left. Both artists also utilize features that appear in Sienese versions of this subject: the elaborate company of retainers and animals that accompany the Magi, and the deep landscape background.

Nonetheless, aside from these striking (and surely not coincidental) similarities, there emerges, in the work of the Florentine monk, a vision of the underlying theme of *The Adoration*—God's revelation to the Gentiles—that is totally at odds with the interpretation of his peer. Where Gentile offers a magical description viewed through the complex richness and variety of precious materials and colors, Lorenzo simplifies in order to lay bare the spiritual nature of the event. He sets his composition on two parallel planes of foreground and background, much as the earlier Florentine artist Agnolo Gaddi did in his frescoes in the choir of S. Croce, Florence, leaving the

far distance physically disconnected form the main narrative. His conception of solids is remarkable. The heads of the figures contain volumetric palpability in their carefully graded modelling, and betray an overriding will to stark abstraction—to the pure idea that underlies any given object. This clarity, Florentine in nature, is carried to an extreme of refinement in the manner in which the angles of the cut-out cubes composing the Holy Family's shed and the distant castle contrast with the cones and cylinders of the exotic hats and turbans of the Eastern visitors. Such geometric play, so suggestive of the later painter Paolo Uccello, is woven into a network of rhythmic lines that pulls the observer, imperceptively, across the panel to the focal area—the humble Madonna and Child—at once the end and the inception of the Wise Men's journey.

In contrast to Gentile's work, gold is used sparingly. The richness of Lorenzo's visionary scene is displayed in the vagaries of color and mood. In the central background, the *Annunciation to the Shepherds,* executed in brown monochrome, takes place on a lonely and rocky ledge devoid of other natural life, yet suffused with the reflected golden yellow of the sky and of divine revelation. The ascetic aura shaped by the desert landscape continues into the main scene, where the palette, composed of coral, saffron, apple green, lavender, blue, and cream, in all its delicate variety adds, enigmatically, a further touch of otherworldly displacement to an already mystical event in which an epiphany through contemplation is striven for.

Although both come under the heading of the International Style, Lorenzo's *Adoration* is at the opposite extreme from Gentile's loving explication of the tangible, multifaceted nature of experience. Here is an exegesis of an inner vision, a product of the artist's later career, and, ironically, the end of a highly mystical phase that saw the execution of such ethereal works as the cut-out *Crucifixion with Mary and St. John* in S. Giovannino dei Cavalieri, Florence. In the *Adoration,* Lorenzo's style takes on greater plasticity: the graceful elegance of his draperies weighs down at the hems, and the introduction of spatial depth distinguishes the *Adoration's* abstracted shed. Such changes enacted on a structure of spiritualized form indicate the nascent effects of the measured and more practical world of the early Renaissance, a world which would have to struggle to reintegrate the non-material so faultlessly embodied in Lorenzo's visionary art.

—Carol T. Peters

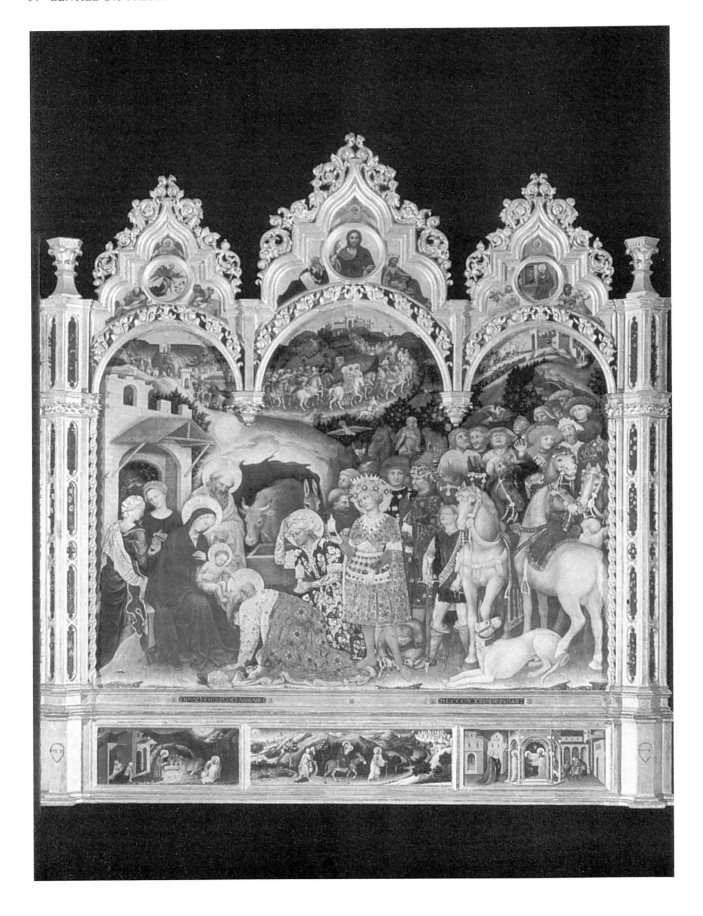

Gentile da Fabriano (c.1355-1427)
The Adoration of the Magi, 1422–23
Panel; 5 ft. 8^1/$_8$ in. × 7 ft. 2^5/$_8$ in. (173 × 220 cm.)
Florence, Uffizi

Gentile's masterpiece, *The Adoration of the Magi,* was commissioned by Palla di Noferi Strozzi for his family chapel in the church of S. Trinità in Florence. The dedication of the chapel was to SS. Onophrius and Nicholas, and it was famous during the 15th century. It is likely that Donatello collaborated with Pietro Lamberti on the tomb of Noferi Strozzi, the father of Palla. The frescoes depicting flowers which decorate the arch above this tomb may also have been executed by Gentile. Lorenzo Ghiberti was also probably involved in the design of the exterior of the chapel. The altarpiece was moved several times before its final deposit in the Uffizi in 1919. However, one of the predella panels, (the *Presentation in the Temple*) was removed and transported to France (perhaps by Marshal Dupont) where it now remains (Louvre). The present predella panel is a copy. The work is signed and dated "OPUS GENTILIS DE FABRIANO MCCCCXXII MENSIS MAJ," although Gentile received payment in 1423.

This works distills the range of artistic styles that Gentile had assimilated through his contacts in Milan, Siena, and Florence. The composition is arranged in a continuous landscape divided by three cusped arches. Within these arches the scenes preceding the arrival of the three Magi are depicted: under the left arch the Magi stand on a rock (the mount of Golgotha) at the sea shore blinded by the appearance of the star shining over the grey and stormy sea. From here, accompanied by a retinue of knights and attendants dressed in elaborate headdresses and brocade cloaks, with leopards and birds of prey, they wend their way through a landscape described with meticulous attention. In ploughed fields of green maize and new vines are stags and oxen, and a hunter with his dog watches as the cavalcade passes on the road to Bethlehem. At the gates to the city waits an excited crowd. Finally, in the right arch the Magi reach the gates of the city.

The *Adoration* occupies the entire foreground space, separated from the background by rocks and holly and pomegranate bushes. The brilliance and sumptuousness of this scene at first blind the spectator from understanding the complexity of Gentile's composition. To the right the crowd of courtly attendants and their horses and beasts jostle in their confined space. Here Gentile displays all his powers of characterisation in contrasting the elegantly attired and featured knights with the coarse and stocky attendants. His beautiful depiction of exotic animals such as the monkeys and tigers, of peacock feathers which make up the hat of the youthful knight on the right, and the horses and guard dogs anticipates the drawings of Pisanello and reinforces the debt he owes to Lombard illuminations and the courtly style of northern Europe.

The centre of the composition is marked by the young Magi (perhaps a portrait of Palla's son, Lorenzo) whose gold stirrups are removed by an attendant. In a curve the eye moves to the left where the kneeling Magi (a portrait of Palla Strozzi) supports himself as he kisses the outstretched foot of Christ. He is watched by the second Magi and the gracefully inclining Virgin and the benign figure of Joseph. Behind the Virgin are two elegant attendants curiously studying the gold ointment jar brought as a gift. The kufic inscription of the embroidered cloak and headress of the left figure is picked out in gold. Only the Virgin's veil is decorated—her blue mantle is otherwise unadorned and spreads out in broad folds around her. The ground these figures occupy seems to break at the lower picture edge as if they were arranged on a ledge that falls away before them.

Beneath are arranged three predella panels depicting the *Nativity,* the *Flight into Egypt* and the *Presentation in the Temple.* Here Gentile depicts the same landscape, at night (the *Nativity*) and at dawn (the *Flight*); the *Presentation* is enacted in a hexagonal arcaded chapel placed in a geometrically arranged townscape.

Perhaps the most important contribution to Florentine painting at this date is not the illusionistic conceits that are achieved here, but Gentile's success in conveying rational space and light. Here light is employed as a unifying and descriptive accessory. Whether from a natural source or from the brilliant rays of the star and Holy Dove, light is seen to fall coherently, casting shadows in the shed behind the Holy Family or illuminating the rock behind this group. In the cavalcade colours are modulated and the range of dullish reds, greys, browns, and blues are deliberately contrasted with the dazzling gold, blue, and scarlet of the central figures. In the scenes arranged under each arch the suffused light cast by the gold ground sky falls softly on the landscape creating a chiaroscuro effect of great subtlety. To an even greater degree, Gentile experiments with light effects in the predella panels. The *Nativity* is one of the first night scenes in Florentine painting and shows an awareness of northern illuminations (perhaps miniatures by the Boucicaut Master), and the *Flight* leads the way for the dawn landscapes that Giovanni Bellini was to paint later in the century. Christiansen has observed that the rigid spatial arrangement of the *Presentation* suggests that Gentile was aware of Brunelleschi's perspective studies.

The naturalism that is evoked in this painting is one of its most important features, but its more lyrical qualities must not be ignored. As Jakob Burckhardt wrote: "There are few pictures in the creation of which it was so much a matter of course for the artist to represent an ideal world; few which radiate such an overpowering air of poetry."

—Antonia Boström

Antonio Pisanello (c. 1395–1455)
Triumphator et Pacificus, 1449
Medal

In 1444 Pisanello's patron, Leonello d'Este, became the son-in-law of King Alfonso V of Aragon, who had conquered the Kingdom of Naples in 1442. King Alfonso probably sought Pisanello's services as soon as the artist's work was brought to his attention during the marriage negotiations in April 1443, but the artist did not arrive in Naples until the end of 1448.

From Pisanello Alfonso commissioned many medals, of which three—among the largest to be created in the 15th century—survive. On the obverse of our medal, dated 1449, the artist presented the King as if he were depicting an actual portrait bust seen in profile, a type of bust, however, that was not to be created in monumental sculpture until the next decade. Both Mino da Fiesole's 1453 marble bust of Piero de'

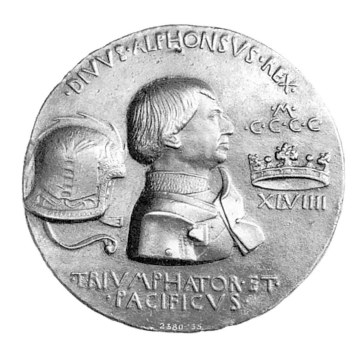

Medici and Pisanello's 1449 bronze depiction of a bust display what has been shown to be a new creation of the 15th century, in that the busts were fully modeled in the round, were cut horizontally at a point between shoulder and elbow, and were presented without a base.

To date the artist's obverses had included only a portrait and an inscription, but the new scale permitted the significant additions of crown and helmet on either side of Alfonso's likeness. The Alphonsine device on the helmet, a sun shining on an open book seen from the cover, probably signifies Alfonso's love of learning. Hence the wisdom symbolized by the book and the skill in arms represented by the helmet—the contemplative life contained within, and therefore encouraging, the active life, as it were—can be seen as having earned the King his crown.

Alfonso followed his son-in-law's lead by going beyond the titles of territorial lordship and military rank on medals, here using the inscription: DIVVS ALPHONSVS REX TRIVMPHATOR ET PACIFICVS. The King was probably the first Renaissance ruler to associate himself with the term *divus,* which was occasionally used in the second half of the 15th century to mean "saint" or "holy." In the Roman world, however, the word signified "god who was previously a mortal," and only the Emperor or a member of the Imperial family could be so deified. Furthermore, apotheosis as a *divus* could only take place after death and then only by decree of the Roman Senate. Alfonso's self-deification thus implies that he claimed the same homage—indeed, worship—from his subjects while still alive as that rendered after death to *Divus Iulius Caesar* or to the deified hispanic Emperors Trajan and Hadrian whom the Spanish Alfonso claimed as spiritual ancestors. This interpretation is reinforced by the Duke of Milan's bitter characterization of Alfonso after his old enemy's death: "his arrogance and his pride were such that he believed himself worthy not only of being honoured among men but also adored among the gods." By using the words TRIVMPHATOR ET PACIFICVS, the king who spent most of his life at war in pursuit of his territorial ambitions and who had just returned from an unsuccessful campaign to add Lombardy to his conquests—with, as a result, a somewhat damaged reputation—presents his deified self as peace-loving as well as victorious, perhaps because, as his ally Borso d'Este of Ferrara reminded him, "peace will cause you to be loved by your subjects."

The reverse of these double-sided portable objects normally allowed the commissioner, whose likeness was portrayed on the obverse, consciously to project an image of his circumstances, achievements, and enthusiasms, and, unconsciously, his fantasies and illusions. On his reverse Alfonso did not, like Sigismondo Malatesta or Lodovico Gonzaga, present himself as a *condottiere* actively engaging in war but followed his son-in-law's venture into allegory. Placed in the same central position as the portrait on the obverse, the eagle, attribute of

Jupiter and symbol of supreme Imperial power, conveys his Imperial largesse or LIBERALITAS AVGVSTA in a medieval *exemplum*—the eagle supposedly always left part of his prey to other, lesser birds who waited at his feet until he finished his meal—although the visual source for the eagle was undoubtedly an Augustan coin.

In the Quattrocento "liberality" was regarded as a means of consolidating a given ruler's position, since it was believed that, in antiquity, "giving much and giving often" connoted regal behavior. Alfonso, as we might have guessed from this medal, cultivated a style of generosity, one which the bookseller Vespasiano da Bisticci defined admiringly as "infinitely liberal." Hence, the King's handouts to his humanists—20,000 ducats, if Vespasiano is to be believed—and to artists—a handsome annual stipend of 400 ducats, for instance, to Pisanello—rendered him "famous and aimable," as the humanist Pontano put it, in contemporary eyes, and earned him the title of "Magnanimous" that has stuck with him ever since.

Alfonso would certainly have considered the demeanour of the lesser birds on the reverse, clustered humbly at the eagle's feet, to be entirely appropriate for the Neapolitan barons over whom he now ruled. The King's self-apotheosis on works of art has to be seen against a background that was far from peaceful, a recently conquered Naples that was still divided between Aragonese partisans and Angevin sympathisers. Suspicious of the Kingdom's well-entrenched feudal aristocracy, Alfonso seized every opportunity to weaken their challenge to his authority. Thus, far from being "adored among the gods" by his barons as he must have hoped, Alfonso was instead told by a well-informed Borso d'Este, that "in this kingdom your Majesty is not at all loved, on the contrary you are rather hated." Pisanello's medal, suggesting that all the Neapolitan barons needed was a vehicle through which to express their homage to their new king, and hence adherence to his regime, accordingly allowed—even encouraged—Alfonso to ignore opposition to his rule.

A skilled court artist such as Pisanello will not only reflect the ideology of the regime he is serving but will also articulate it in ways that must—surely—have clarified it for the patron. We can imagine the pleasure with which Alfonso—who wrote that art was a source of "contentment and delight not only to the physical senses but also to the spirit"—would have received Pisanello's medal. Holding it in his hand, he would have watched the light waver over the gentle modeling and incisive profiles of the richly modulated surfaces, while admiring the artist's mastery of organization of motifs within the circular format. Given Alfonso's amply documented determination to be regarded as heir to the Roman Emperors, his pleasure can only have been increased by Pisanello's innovative presentation of him as a modern Neapolitan Caesar transformed into a god in this recreation of an *all'antica* art form.

—Joanna Woods-Marsden

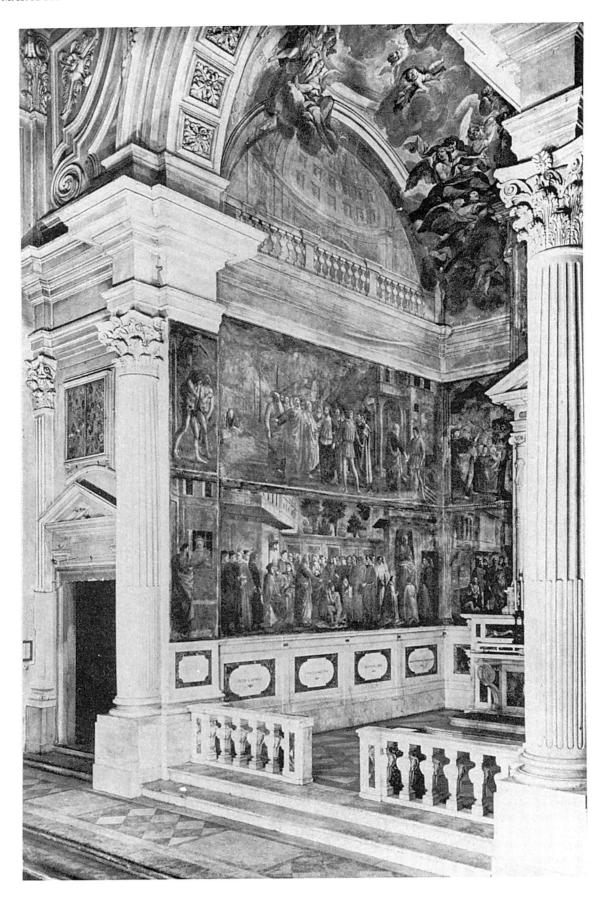

Masaccio (1401–c.1428)
The Tribute Money
Fresco
Florence, S. Maria del Carmine (Brancacci Chapel)

Bibliography—

Salmi, Mario, *Masaccio, Masolini, Filippino Lippi: La Cappella Brancacci a Firenze,* Milan, 2 vols., 1948.
Meller, P., "La Cappella Brancacci," in *Acropolis,* 2, 1961.
Watkins, L. B., "Technical Observations on the Frescoes of the Brancacci Chapel," in *Mitteilungen des Kunsthistorischen Institutes in Florenz,* 17, 1973.
Molho, A., "The Brancacci Chapel: Studies in Its Iconography and History," in *Journal of the Warburg and Courtauld Institutes* (London), 40, 1977.

This fresco is the best known of those done by Masaccio in the Brancacci Chapel in Florence, which he began working on c. 1425 or 1426. It is a large painting in three parts, a triptych without the usual separations provided by an architectural frame. The fresco illustrates the story (in *Matthew* 17:24–27) of Christ's entry into Capurnaum where the Roman tax collector asks for tribute.

In the large central scene, we see the back of the tax collector and Christ explaining to Saint Peter that he will find a coin in the mouth of a fish in an inlet at the edge of the Sea of Galilee. Peter, the oldest of the apostles, at once protests as he seems to push away the suggestion with his foreshortened left hand and also complies by repeating Christ's gesture with his outstretched right hand. The figure of Saint Peter is one of the great portrayals of ambivalence and confusion in western art and it reveals Masaccio's phychological insight as well as his genius for powerful monumental form.

Christ is surrounded by a semi-circle of apostles who lend an air of imposing dignity to the event. This configuration, a circle or semi-circle around a central point or figure, is a traditional Christian reference to Christ's role as the center of the Church. The circle was considered by Renaissance humanists to be the most suitable shape to represent the Church because of its continuous, never-ending character. In a composition such as this one, therefore, the observer is referred forward in time to the establishment of the Church and Saint Peter's role as its foundation—Peter means "rock" in Greek. Among the semi-circle of apostles, the young blond Saint John is clearly derived from Roman portrait busts, reminding us of Masaccio's study of antiquity.

Following the gestures of Christ and Saint Peter, the observer's attention is directed to the second event depicted on the far left. Here, a compact and foreshortened kneeling figure of Saint Peter draws the coin from the fish's mouth. The narrative concludes on the far right as Saint Peter pays the tax collector. In this scene, the figures are accented more by architecture than landscape as the archway frames Peter and echoes the upward curves of his massive yellow drapery. Nevertheless, the simple, imposing mountainous background landscape reinforces the quiet grandeur of the events unfolding in the fresco.

The psychological character of this painting, together with its monumental humanist style, places Masaccio directly in the tradition of Giotto. Masaccio shares Giotto's genius for portraying convincing three-dimensional reality, representing figures that turn freely in the mathematically constructed space, and capturing the dramatic aspects of the biblical events so that the observer identifies with the conflicts and triumphs of the scene. By taking up Giotto's innovations of the previous century, Masaccio became the leading painter of his generation.

—Laurie Schneider

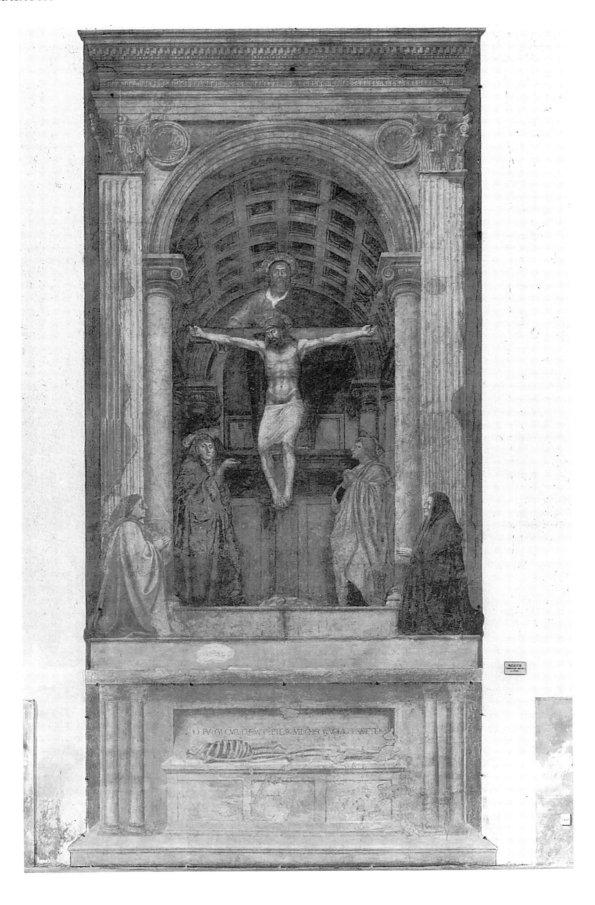

Paolo Uccello (c. 1397–1475)
Battle of San Romano, c. 1434
Panel; 6 ft. × 10 ft. 6 in. (182.9 × 320 cm.)
Florence, Uffizi

Bibliography—

Pope-Hennessy, John, *Uccello: The Rout of San Romano,* London, 1944.

The *Battle of San Romano* (Uffizi) was one of three panels probably commissioned about 1434 by Cosimo il Vecchio de'Medici for the old Palazzo Medici. After Michelozzo's new palace was built, the panels were transferred to the ground floor bedroom of Lorenzo de'Medici where they were documented in 1492.

The battle was one episode in Florence's unpopular war with Lucca (1430–33) which provoked a power struggle between the Albizzi and the Medici families. In 1433 the Albizzi got the upper hand and exiled the Medici. But the next year the Medici faction recalled Cosimo and exiled the Albizzi marking the end of the Florentine republic in all but name and the beginning of one-family (Medici) rule. It was probably also at this time that Cosimo commissioned Uccello's *Battle of San Romano* to celebrate his return and to put a victorious face on a war that had been a disaster for Florence.

According to official dispatches and histories of Florence, on the morning of 2 June 1432, the Florentine commander, Niccolò da Tolentino, who was encamped above San Romano in the lower Arno valley, sent an avant-garde down stream. Stumbling onto Sienese troops besieging the Florentine town of Montopoli and forced to engaged them in the valley between Montopoli and San Romano, the avant-garde was being routed when Tolentino appeared with the main body of his troops. Tolentino leading his forces to the rescue is the subject of the left panel of the triptych (London, National Gallery). Meanwhile Tolentino sent for Micheletto Attendolo, another Florentine commander, who by chance was encamped lower down the valley above Pisa. Micheletto's attack on the Sienese from the rear is represented on the right panel of the triptych (Paris, Louvre). The central Uffizi panel shows the climax of the battle with the unhorsing of the Sienese commander, Bernardino della Carda, and the retreat of the Sienese troops. According to Florentine sources Tolentino scored a decisive victory capturing up to ten thousand prisoners. But since the Sienese dispatches claimed a *Sienese* victory with the capture of many hundreds of Florentines, the battle was more likely a draw.

Most elements of Uccello's representation derive from a medieval tradition of monumental wall painting, preserved mostly in manuscript illuminations, showing battles in terms of chivalric conventions, rituals, and patterns which had little to do with the chaos and absurdity of real warfare. These include brightly colored caparisons, banners, shields, and headgear; the panoramic sweep of the battlefield with real-seeming topographical details; soldiers with contemporary arms and armor organized as a flat densely packed frieze featuring individual duels between pairs of knights; trumpet fanfares, rearing horses, rhythmically dropping and thrusting lances, and a clutter of fallen horses, dying men, and broken weapons.

But the three panels also presents something new to the representation of war: decisive moments in time, rational space ordered by one-point perspective (defined by the fallen lances), and highly geometricized forms. They also read in a right, left, center sequence, which not only corresponds to the actual order of events, but builds to the dramatic climax of unhorsing. In contrast to the unfocused and naively reportorial mode of earlier battle representations, here the disarray of battle seems to have been brought under rational control.

Uccello's blend of tradition and innovation precisely reflects the cultural situation of Florence in the mid-1430's. The chronicle tradition of history writing (e.g., Giovanni Villani), where wars were simply recorded without any particular order, purpose, or point of view, was giving way to a classical rhetorical tradition (e.g., Matteo Palmieri), where battles were marshalled with an eye to time and place, seemingly controlled by human agency for predetermined goals, and, therefore, having beginnings, middles, and ends. Uccello's Uffizi panel with the clash of mostly anonymous and faceless knights has much in common with the chronicle tradition, while the flanking panels showing Tolentino and Micheletto controlling the action relate more to the rhetorical tradition.

The year 1435 was also precisely the moment at which the rules of one-point perspective were codified by Alberti in his treatise *On Painting.* The clash between the tapestry-like landscape with its high horizon above the tops of the paintings and the perspectival ordering of the foreground with its horizon at the level of the heads of the soldiers accurately embodies this conflict between the spatial sensibilities of the International Gothic and the early Renaissance.

Alberti also laid down new rules for *istoria* (narrative) which he saw as a compromise between Gothic variety, abundance, and ornament and Renaissance moderation, dignity, and modesty. The former elements are amply represented in Uccello's Uffizi panel by use of the chivalric conventions of battle representation, the latter by the reduction of the foreground to an even distribution of seven mounted knights, two fallen, who are geometrically described and perspectively ordered.

The 1420's and 1430's were also decades of bitter debate in Florence on the relative merits of a civic militia as opposed to mercenary bands like those of Tolentino and Micheletto. On one side writers like Leonardo Bruni (*De Militia,* 1421) advocated the establishment of a civic militia which would consist of loyal and patriotic citizens as skilled in the art of war as in the art of government. On the other side it was argued that only the mercenaries were properly equipped with the necessary heavy armor, as well as professionally specialized and continuously practiced in the constantly evolving tactics of warfare to be an effective fighting force, even if they had often proved to be expensive, unreliable, and subject to manipulation by the wealthy citizens. Uccello's panels were not only important documents in this unresolvable military debate, but contained similar tensions and ambiguities: the unresolved

combination of Gothic chivalric formulas and the classically inspired rhetorical conventions of Alberti's *istoria;* the illusion of rational control and tactical efficiency of the part of Tolentino and Micheletto when in fact the battle seems to have happened by accident and was "won" with ad hoc tactics; the glorification of the individual mercenaries by the presence of their personal banners and insignias, yet the absence of any unambiguous emblems of Florence in whose name they were presumably fighting; or the commemoration by a non-combatant merchant in his private palace of a communal battle of extremely problematic outcome and significance.

Since Alberti had made the case in *On Painting* that artists belonged to the liberal rather than the mechanical arts, the 1430's also marks a period when artists began to seek higher social status. In the Uffizi panel Uccello shows by his signature on a shield that this narrative is not anonymous as most previous battle representations, but authored—authored by a painter who even makes claims to armorial privilege. At the same time, as if in recognition of the impossibility of freezing and ordering what by definition is violent and confused, Uccello has placed his signature on a shield that has fallen.

The frequent characterization of the *Battle of San Romano* as a delightful but insignificant decorative frieze of carousel horses clearly misses the mark. Nor are the panels, except in the móst general sense, a record of the battle of 2 June 1432. Rather the conflicts which they represent are those of the cultural moment of their making.

—Loren Partridge

Luca della Robbia (1400–82)
Madonna and Child (Stemma of the Arte dei Medici e degli Speziali), c. mid–1460's
Enameled terracotta; 5 ft. 11 in. (180 cm.) diameter
Florence, Orsanmichele

As is well known, Luca della Robbia invented and explored the artistic capabilities of tin-glazed terracotta. Although a similar technique had been used by ceramicists for the production of apothecary jars and practical objects, Luca was the first to create masterpieces of sculpture in this medium which had the advantage of being clearly and colorfully visible from a distance. One of the most interesting of his many works in terracotta is a *Madonna and Child* relief, set into the south wall of Or San Michele in Florence above the niche of the Guild of Doctors and Apothecaries. The *stemma,* or armorial device, of this Guild was the Virgin and Child in a tabernacle with Annunciation lilies, and, like all the Guild commissions at Or San Michele, it was to be placed above the allocated niche, although this roundel is unique in being made of terracotta rather than marble. The niche itself had been filled with a marble statue of the seated Virgin and Child by Niccolo di Pietro Lamberti in 1399, and for the roundel above it Luca produced a clearly pictorial relief (Florentine painters were members of The Doctors and Apothecaries Guild). By stylistic comparisons with Luca's other works, it is usually dated in the mid–1460's, but the exact date is not documented.

Across the bottom of the stone roundel is a platform on which rests a white arched structure supported by columns. Outside the tabernacle green and white lilies sprout against a blue ground. A curtain, patterned with yellow quatrefoils and interspersed green leaves and blue and yellow flowers, hangs behind the Madonna. She is seated on a green bench and wears a blue cloak lined with green over a burgundy dress decorated with a yellow neck-band and green cuffs. Both she and the nude Child have blonde hair, and Luca has attempted to impart flesh tones and naturalistic color to the skin. The whole roundel thus produces a remarkably vivid polychromatic effect. It has been said that the technique for this colorful glazing was a "secret formula" of the della Robbia shop, passed down to Luca's heirs as part of the "capital" of the enterprise.

In the composition, Luca adapted two elements from paintings by Domenico Veneziano: the contrapposto stance of the nude Child is like that of the Child in the *St. Lucy Altarpiece* but He stands on the right instead of left side; and the pose and type of the Virgin is related to the Veneziano *Madonna* in the Berenson collection. Both Luca's figures gaze downward and to the right, the Madonna protectively clasping His pudgy little body. Although somewhat hieractic in pose, they exude a feeling of tenderness and compassion, of a truly human relationship between a loving mother and her child, which is fundamental to the enjoyment of all the creations of the master.

—Harriet McNeal Caplow

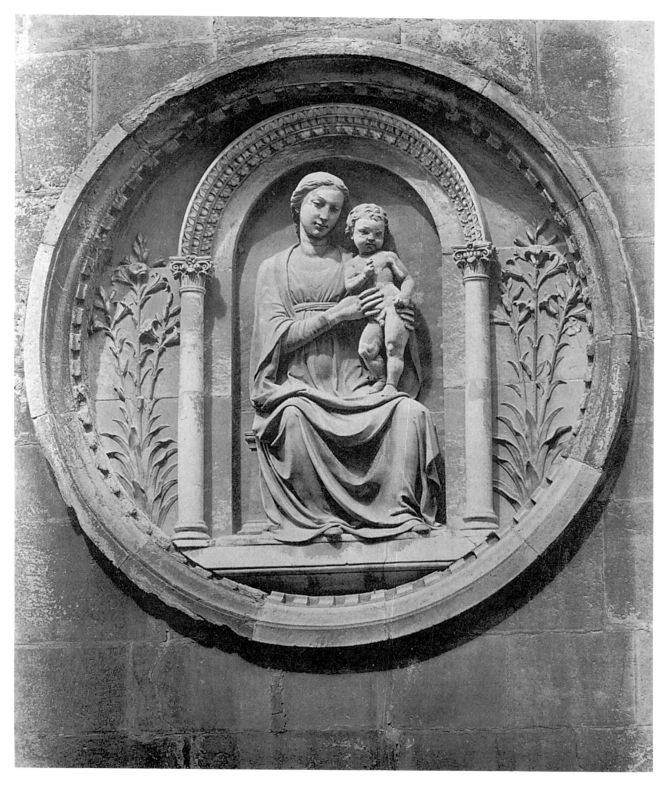

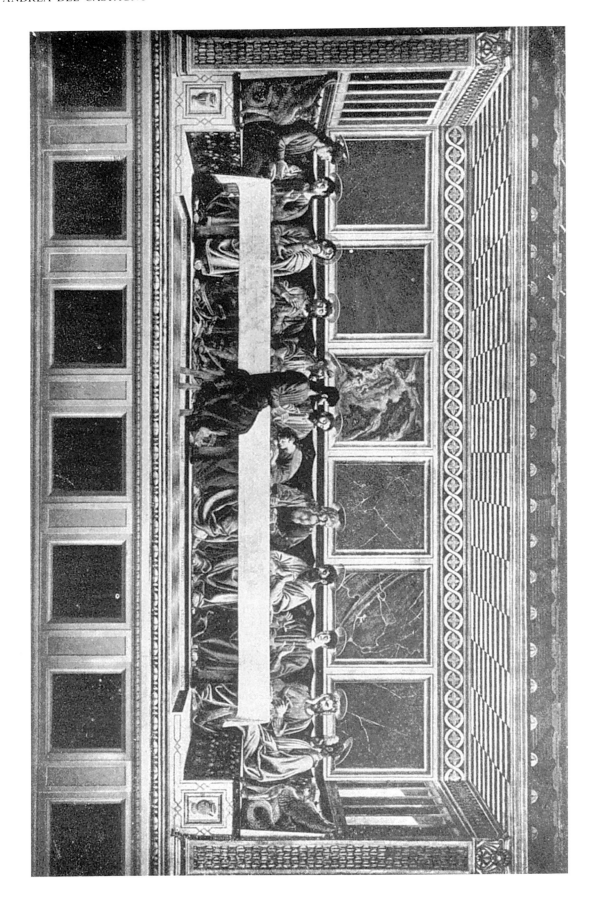

Andrea del Castagno (c. 1419–57)
The Last Supper
Fresco 14 ft. 9 in. × 31 ft. 11 in. (453 × 975 cm.)
Milan, S. Apollonia

The Last Supper, with our present understanding of Andrea del Castagno, is taken as his masterpiece, completed in the autumn of 1447. Ironically enough, as if emblematic of our only recently altered presumption of his intense, repressed, and irascible nature—from stories surviving about his life which have included a murder charge—the fresco was in a convent closed to the public, and thus unknown until the opening of the religious orders by government expropriation late in the 19th century. Castagno's general format appears most closely related to the oldest surviving large scale fresco of the theme, by the Florentine Taddeo Gaddi, in the refectory of Santa Croce, c. 1365. Like that work, but here in the 15th century for reasons of narrative interpretation, there is hardly any outward and extended depiction of movement. And this is to be Castagno's idiom as seen as well in his other known surviving works: large and simplified figures, in deeply enfolded drapery, clearly sculptural-homage; points of almost dissonant and very personal color; a thoughtful and calculated use of spatial effects—and a hovering sense of tension.

The stony, panelled room, with its antique and *au courant* ornamental aura, gives an effect of stage-like space—three walls with the forward wall removed; as if to further emphasize the particularity of the volume, a continuation through drawing and perspective delineation of the actual refectory, meticulously painted brick walls on either side and the crisp overhang of the clay tile roof, further separate the space of Christ's sacrificial self-perpetuation from the remainder of the painted wall. A possible number symbolism has been detected in the ostensibly self-conscious use of 17 and 33½ guilloches (the curvilinear motif of interlaced lines) as the upper border frieze of the side and rear wall of this space: 17 is still unlucky in Italy, while Christ was just past the age of 33 at the time of this event. Just so, the Harpy statuettes at either end of the Apostles' bench appear more than a simple increase of antique effects, but may have been added specifically for the female audience of the work. Not only were these the mythic female birds who carried the soul to hell, but the Harpy became the ancestor of the medieval witch.

A further iconographic survey suggests the intentional repetition in the rear-wall, square marble and porphyry panels, of the similar pattern on the sarcophagus shown in *The Ressurection* and *The Entombment* on the upper left and right hand corners of the same refectory wall (there badly damaged by leakage). Hartt feels that this insistence upon the sepulchral motif, and several other vivid iconographic details, are surely dependent upon a knowledge, by Castagno's theological advisor, of a well-known *The Life of Christ* by a 14th-century Carthusian monk, Ludolph of Saxony. There, the life of the cloistered religious monastic is likened to the entombment of Christ. Other parallels to this text in symbolic details include having Judas—who, following an old tradition, is apart from the other Apostles at the table-front—not dip his hand into the dish with Christ, but rather take the sop in wine to signify his betrayal; as well, to Christ's left, St. Andrew holds up a knife, with which he would be martyred, to a praying St. Bartholomew. The Apostles evince their grief and comprehension not by overt bodily movement or facial expression—the exception is St. John the Evangelist who lays his head on his arm—but rather, as if a vow of silence had been taken, by hands upraised or brief side-wise glance. Perhaps as a pedagogical device for the nuns, the names of the Apostles have been imprinted on the edge of the narrow foot rest above the lower edge of the painting. Their awesome, unhandsome immediacy is typical of Castagno's handling of religious figures, a reflection of his life-long closeness to Florentine painting and sculpture of the "monumental" tradition, most especially the moral and emotional power of Masaccio and Donatello. But there are powerful "pictorial" moments here as well: for instance, just behind Judas's back, St. Peter has crossed his left hand over his right wrist, making it appear as if it grows there—an ancient emblem of fraud (a motif widely known in our time by its appearance in Bronzino's *Exposure of Luxury*). Furthermore, Castagno has arranged the 12 figures behind the white oblong of the table cloth so that their relation to the square panels behind is neither repetitive nor regular. And most extraordinary of all is the convergence of the four heads of Peter, Judas, Christ, and John before the third panel from the left. There, the cornelian explodes into salmon, white, and pink, with flamingo-red borders: one of the great pre-20th century and non-narrative visualizations of abstract music which attempts to convey the polyphony of feeling of the moment.

As reference to the artist's understanding of perspective, the figure of St. Thomas, third from the left, moves his head into an extreme foreshortened position as he looks upward; and the figure of Judas appears somewhat larger than Christ immediately behind him, since he is closer to the picture plane. Although likewise seemingly "correct," the linear perspective scheme, so insistent here, is not consistently based upon the Albertian scheme of a single vanishing point. There is such a single point, just below the hands of the reclining St. John, for the ceiling, and yet the individual rows of tiles there show no diminution from front to back and similarly parallel are the panel rows and border frieze of the side walls. Castagno did not want to distill the emotional effect—his prime concern—and thus limit the viewer to a central position which would have occurred if he had produced the traditional, unified, one-point perspective space. Thus the perspective is at the service of the content; the spatial formulas are not permitted to overwhelm the content, but only to enhance it. The table top is out of sight, and the foreshortened floor tiles are so obliquely seen that they are indecipherable. The mystery of the scene is intensified by its seeming presence above the viewer before it.

—Joshua Kind

Domenico Veneziano (1405?–61)
Virgin and Child with SS. Francis, John the Baptist, Zenobius, and Lucy, c. 1445–47
6 ft. 10¹/₄ in. × 6 ft. 11⁷/₈ in. (208.9 × 213 cm.)
Florence, Uffizi

Domenico Veneziano's *Virgin and Child with SS. Francis, John the Baptist, Zenobius, and Lucy,* painted for the high altar of the Florentine church of S. Lucia de'Magnoli in about 1445–47, is a profound meditation on the meaning of a *sacra conversazione* and on the distinction between natural and spiritual vision.

Although the painting with its loggia recalls a traditional Gothic triptych format, it is perfectly square with a one-point perspective construction, the rules for which Alberti had codified in *On Painting* a decade before. Following Alberti Domenico first decided on the height of a foreground figure, "divided the height of this man into three parts," and then used the resulting module to divide "the bottom line of the rectangular painting into as many parts as it will hold." Here there are six modular units, the division between them occurring exactly at the center of each of the star-like patterns in the foreground of the pavement. If vertical lines are extended upward from these points of division, they precisely define the axis of the Virgin, the centers of the four forward columns, and the leading edge of the two piers between each pair of saints. This division provides equal surface areas for the saints and a double area for the Virgin and Child, an appropriate hierarchical arrangement expressive of relative importance. If the diagonals of the pavement pattern are extended outward beyond either side of the painting they come together two modular units up from the bottom line of the painting and five out from either side. This locates the horizon line two modular units up from the bottom of the painting. If the diagonal recession lines of the architecture are extended across the surface of the painting they focus between the Virgin's knees precisely at the center of the horizon line. These calculations establish that the ideal viewer was five modular units away from the painting with eyes directly opposite the focal point between the Virgin's legs, i.e., corresponding to the original position of the officiating priest.

A perspective scheme like this, one of the most advanced of the period, was extremely paradoxical, because it not only created a measured, mathematically proportioned, and geometrically lucid space, but also a powerful illusion of spatial continuity with the world of the viewer. This paradox of easy-seeming accessibility to a sacred world of such mathematical and geometrical perfection that it was in fact a world apart captured both the essence of the Christian divinity, who was flesh of the world, and spirit outside of it, and the essence of the *sacra conversazione* type of altarpiece, which represented saints who had earned a place in the court of heaven by their faith and martyrdom, but who were still active exemplars and intercessors for the living.

Domenico has visualized this paradox more vividly than ever before. If the viewer focuses on the lower part of the composition, he is encouraged by the glance and gesture of St. John the Baptist and by the benediction of St. Zenobius, to approach the Virgin and Child who seem to sit far back in space in front of the loggia. Yet if the viewer focuses at the top of the painting, he looks up steeply at the vaults of the loggia, the arches of which seen to lie right on the surface of the painting thus compromising the spatial recession and drawing the sacred figures toward the foreground and under the loggia. Similarly, the Virgin is a monumental and physically immediate figure—larger than the saints, elevated by a three-stepped dais, magnified by three arches over her head—yet she is also frontal, hieratic, dematerialized by bright light, iconically removed. On the steps at her feet are the words "Hail Mary" and "Oh Mother of God." One phrase was spoken by an immaterial angel while announcing that the Word would be made flesh (and in this regard the focal point at the womb of the Virgin is surely no accident). The other proclaimed her to be both a mother and a divinity. The outdoor loggia and exedra with trees above can be read as a lovely garden court or as a heavenly church with its rood screen in the nave through which the apse is seen. Domenico, in short, has created a space that is both secular and sacred; made to the measure of man, yet perfected beyond human experience; addressed to all the faithful, yet properly viewed only by the priest. He has populated this space by holy figures who are both far and near, both spirit and flesh.

The light and color of the painting are equally paradoxical. Streaming in from the upper right and casting a diagonal shadows the outdoor background light is bright, sparkling, and warm, like the sun of a spring day. But there is also a strong foreground light flooding across St. Lucy from the right as if coming mystically from inside the church. In either case this light, absolutely unprecedented for its optical sensitivity, not only defines the forms three-dimensionally, but also illuminates their colored surfaces in ways that correspond both to the colors of natural materials, yet have a stunning almost etherial delicacy and supernatural harmony. This play between natural and spiritual light was heightened by the fact that the figures receiving the strongest painted light are the Virgin and Child, the embodiments of divine illumination, and SS. Lucy and Francis. St. Lucy, to whom the church of S. Lucia de'Magnoli was dedicated and whose name means light, was the patron saint of sight. She not only holds her physical eyes in front of here on a gold salver, but with her palm of martyrdom, also seems to write a word signifying the Word of spiritual light. With her spiritual eyes she looks across at St. Francis who reads the Word and seems to touch the wound of the stigmata on his chest received when he was illuminated by a seraphim with divine understanding. Furthermore, words on the bottom step of the dais—"Have mercy on me"—are the words of a blind man asking Christ for his sight to which Christ responded, "Receive they sight: thy faith hath made thee whole" (Luke 18:35–43). Another part of the inscription—"To you it is given"—is from Mark 4:11 where Christ explains the function of parables to the twelve apostles: "*To you it is given* to know the mystery of the kingdom of God: but to them that are without, all things are done in parables: That seeing they may see, and not perceive . . ." The distinction Christ draws between natural sight and divine understanding is parallel to the contrast that Domenico has created in the painting between natural and spiritual light and color.

—Loren Partridge

Sassetta (c. 1392–1450)
St. Francis Altarpiece, 1437–44
Panels; central panels about 6 ft. × 3¹/₂ ft.; sizes vary
Paris, Louvre, Florence, Berenson Collection, London, National Gallery, and Chantilly, Musée Condé

Bibliography—

Carli, Enzo, "Sasetta's San Sepolcro Altarpiece," in *Burlington Magazine* (London), 93, 1951.
Wyld, Martin, and Joyce Plesters, "Some Panels from Sassetta's Sansepolcro Altarpiece," in *National Gallery Technical Bulletin* (London), 1, 1977.
Scapecchi, Piero, "La rimozione e lo smembramento della pala del Sassetta di Borgo San Sepolcro," in *Prospettiva* (Florence), 20, 1978.
Braham, Allan, "Reconstructing Sassetta's Sansepolcro Altarpiece," in *Burlington Magazine* (London), June 1978.

Stefano di Giovanni, called Sassetta for unknown reasons, was commissioned to paint the high altarpiece of the church of S. Francesco in Sansepolcro, Tuscany, on 5 September 1437. Seven years later, on 5 June 1444, it was delivered to the church. The work is well documented: the extant contract lays out the height, breadth, and form of the altarpiece, and the cost (510 florins) and number of payments. The contract also specifies that Sassetta was to paint both sides, that he was to do his best possible work, and that the friars were to decide the scenes and figures. The work was to be delivered in Siena within four years, and Sassetta was then to set it up in Sansepolcro. The date and names of the *operarii* cited in the contract were confirmed by an inscription, now lost, which was recorded on the base of the frame of the *St. Francis in Ecstasy* panel. When the altarpiece was consigned to the church in 1444, another document testifies that the work was complete and full payment made.

Apparently removed from the high altar to the friary of S. Francesco in the 16th century, the altarpiece was dismembered and sold in the early 19th century. The five main panels were sawn apart to separate the front and back images, and the various panels changed hands a number of times until they arrived in the collections of the National Gallery of London, the Berenson Collection in Florence, and the Musée Condé in Chantilly.

An elaborate and impressive work before it was dismembered, the large pentaptych was painted on both front and back, buttressed, and equipped with pinnacles and a double-sided predella. It is generally agreed that the front consisted of a central panel of the *Virgin and Child with Angels* (Paris), flanked by the four tall, narrow panels containing full-length figures of the *Blessed Ranieri Rasini* (Florence), *St. John the Baptist* (Florence), *St. Anthony of Padua* (Paris), and *St. John the Evangelist* (Paris). The *St. Francis in Ecstasy* formed the central image of the back of the altarpiece and was flanked by the eight scenes of the Life of St. Francis now in London and Chantilly arranged on two levels (*The Whim of the Young St. Francis to Become a Soldier, St. Francis Renounces His Earthly Father, The Pope Accords Recognition to the Franciscan Order, The Stigmatization of St. Francis, St. Francis Bears Witness to the Christian Faith Before the Sultan, The Legend of the Wolf of Gubbio,* and *The Funeral of St. Francis*—all in London—and *The Mystic Marriage of St. Francis with Poverty,*

Chastity, and Humility—in Chantilly). While all the major panels of the altarpiece have been identified, a number of panels have been suggested as possible predella and pinnacle panels, including a *Story of the Blessed Ranieri Rasini* (Berlin) as a probably part of the predella, and a *St. Francis Before the Crucifix* (Cleveland) which was probably over the *St. Francis in Ecstasy.*

There is general agreement on the main elements of the altarpiece, but the sequence of the narrative scenes of the Life of St. Francis is still debated. The panels supply only limited physical evidence of their original order. The seven paintings in London were drastically restored in the 1920's while in the possession of Lord Duveen: they were sawn out of their frames, reduced in thickness, heavily cradled, and returned to their frames without reuniting them with their original spandrels. The only technical evidence remaining indicates that four London panels were originally in the upper row. The Chantilly panel has not been cut from its frame and must have been in the bottom row, along with the three remaining London panels.

Neither is iconographic evidence conclusive on the arrangement of the narrative scenes. Despite a long and popular iconographic tradition of the saint's life, there was no established visual or literary sequence in the 15th century. Pope-Hennessy and Carli proposed placing the four panels with blue skies in the lower register, and the four with gold backgrounds in the upper register. Allan Braham has pointed out a number of weaknesses in these proposals, and suggested that the panels should be grouped in pairs with alternating blue and gold backgrounds.

The St. Francis altarpiece is the major work of the most important Sienese painter in the Renaissance. The *St. Francis in Ecstasy* in particular shows his ability to combine large-scale naturalistic effects and a poetic vision. The transfigured saint appears, arms outstretched in the attitude of the cross, enraptured face looking heavenward, amidst a mandorla of cherubim and seraphim. A crowned figure of Wrath, wearing armor and accompanied by a lion, lies prostrate under St. Francis's feet. To the left of Wrath reclines Lust, accompanied by a boar and looking into her mirror, and to the right is Avarice, dressed as a nun with a money bag firmly held in a press. Above float the three Franciscan Virtues: Chastity proffering a lily, a yoked Obedience, and Poverty dressed in rags. The panel is notable iconographically for its presentation of St. Francis as a second Christ.

Sassetta was aware of the achievements of Masolino and Masaccio in Florence as evidenced by his command of *chiaroscuro* and the competent recession of the sea behind St. Francis in the scene of his ecstatic triumph. Equally, his Sienese heritage is evident in the emphasis on pattern, line, and colour, and in the slender, graceful figures found in the narrative scenes. The visionary scene of the *Mystic Marriage of St. Francis* presents a touching dramatization of the saint gracefully proffering a ring to a delicate, reticent figure of Poverty against a panoramic landscape background. When seen in its original location and with its now scattered panels still united, these narrative scenes and the triumphant figure of St. Francis they surrounded, offered their viewers, close by in the monk's choir, a remarkable series of mystical, dignified, and lyrical images.

—Barbara Dodge

Giovanni di Paolo (c. 1395-99—c. 1482-83)
Expulsion from Paradise
17³/₄ × 20¹/₂ in. (45 × 52 cm.)
New York, Metropolitan

Giovanni di Paolo's *Expulsion from Paradise* is one of several predella scenes from a larger altarpiece, the *Guelfi Polyptych,* which has been dismembered and dispersed. Despite its small size, the radiant little *Expulsion* is a noteworthy example of 15th-century Sienese painting, and is among Giovanni di Paolo's best-known works. Stylistically, it displays none of the fascination with visual theory that characterized much of 15th-century Italian painting. Instead, its decorative charm and vivid color recall the accomplishments of French manuscript illuminators and earlier Sienese masters such as Duccio and Simone Martini. Giovanni di Paolo's archaic treatment of space and geometrically layered background forms belong more to the courtly International Style of the 14th century than to mainstream 15th-century painting, centered in Florence.

Though visually conservative, the *Expulsion from Paradise* reveals much about religious devotion and scientific developments in the 15th century. At first glance, Giovanni di Paolo seems to have depicted two distinct subjects. The left segment of the panel shows the universe as a nest of vividly colored concentric rings surmounted by God and his attendant angels, while to the right, an angel drives Adam and Eve naked from Paradise. Their carnal sin is symbolized by the oranges, carnations, strawberries, and rabbits, all erotic symbols, that surround them. Because the two scenes do not share the same rational space, scholars have assumed that they were meant to be perceived as chronological events, and have called the panel the "Creation of the World and the Expulsion from Paradise." Medieval thought, however, was not so linear as our own way of thinking, and associations between concepts unrelated by time or location were commonly drawn as memory aids in religious devotion. In this panel, the two scenes are joined conceptually by the stern glance and pointing finger of God. The link is one of cause and effect as God sentences Adam and Eve to the prison of the earth for their sin.

Traditional art historical interpretations of the *Expulsion,* derived in large part from writings published before 1950, limit the search for the iconographical meaning of Giovanni's panel to visual models. They posit a link between the panel's multi-layered universe and images inspired by Dante's *Divine Comedy,* which Giovanni illustrated early in his career. Certainly the relationship exists, for Dante based his writings upon the time-honored Biblical-Aristotelian paradigm that had been part of common wisdom for a thousand years. Today Giovanni's predella panel enjoys a privileged position in a major museum; however, it is important to remember that it was once related visually and iconographically to an altarpiece dedicated to the Virgin Mary, and was not commissioned as an independent illustration of Dante.

Giovanni's painting shows the universe in traditional form—as a nest of concentric spheres beginning with the four elements—earth, water, air, and fire—which comprise the terrestrial world. Beyond these were the spheres of the seven known planets, followed by the circle of the zodiac and finally the "primum mobile," which controlled the motion of the planets beneath it. In Giovanni's picture, the dark-brown ele-

ment earth appears on the surface of the innermost stationary sphere. Water, the second element, is colored green, as was customary, and begins the first of a series of stratified rings. Beyond lies a circle whose delicate blue identifies it as air, and it, in turn, is bounded by a bright-red ring, the realm of fire. Between the four elements and the ring of stars containing the almost illegible symbols of the zodiac are the spheres of the planets—the moon, Mercury, Venus, the sun, Mars, Jupiter, and Saturn. Giovanni's painted universe derives from illustrated cosmological books of the time, such as Johannes Sacrabosco's *Sphera Mundi,* which were readily available in both manuscript and printed forms in the 15th century.

Giovanni's universe may be a depiction drawn from ancient sources; however, the image of the planet's surface departs from medieval tradition and bears the unmistakable imprint of Renaissance thought. Earth itself is not presented as a diagram, but as a realistic world map that shows the influence of geographical observations made by 15th-century explorers and navigators. Indeed, it is strikingly like a famous Portuguese map prepared for the Venetian doge (the so called *Map of Fra Mauro,* Venice, Biblioteca Marciana). Keeping in mind that early cartographers sometimes placed south at the top of their maps. It is possible to discern the shapes of the European, Asian, and African continents—the compass of the known world in Giovanni's time. Placed at the top of the map is the so-called "Mountain of the Moon," where Christian cartographers reasoned that Eden—now lost to mortals—must be located. The snows that covered its inaccessible summit were believed to melt seasonally, to feed the rivers of the earth, here portrayed a sinuous streams spreading calligraphically across the land. Giovanni's map is therefore a very modern depiction of the physical lay-out of the earth expanded and revised by Renaissance explorers.

Science was not separate from Christian thought in the 15th century, a fact demonstrated by God's gesture as he points to a place on the Zodiac sphere midway between the signs of Aries and Taurus. In general, these signs designate the season of spring; however, most important to the meaning of the panel, they also indicate the time of the Feast of the Annunciation (March 25), which happens within a few days of the vernal equinox. The significance of God's gesture is explained by a passage from Jacobus de Voragine's *Golden Legend,* a popular book devoted to the legends of the saints, which stated that the incarnation "took place to repair . . . the Fall of Man." The time of year implied by God's gesture therefore reminds viewers of the Annunciation, which leads to meditations upon the purpose of the coming of Christ—to "repair the Fall" enacted by Adam and Eve in the adjoining sector of the panel, and to redeem the sins of man, which their Expulsion represents. Thus, Giovanni's Biblical-Aristotelian scene reflects the unity of science and liturgy basic to medieval thought while, at the same time, looking forward to the modern age of empirical observation in its reflection of Renaissance cartography.

—Laurinda S. Dixon

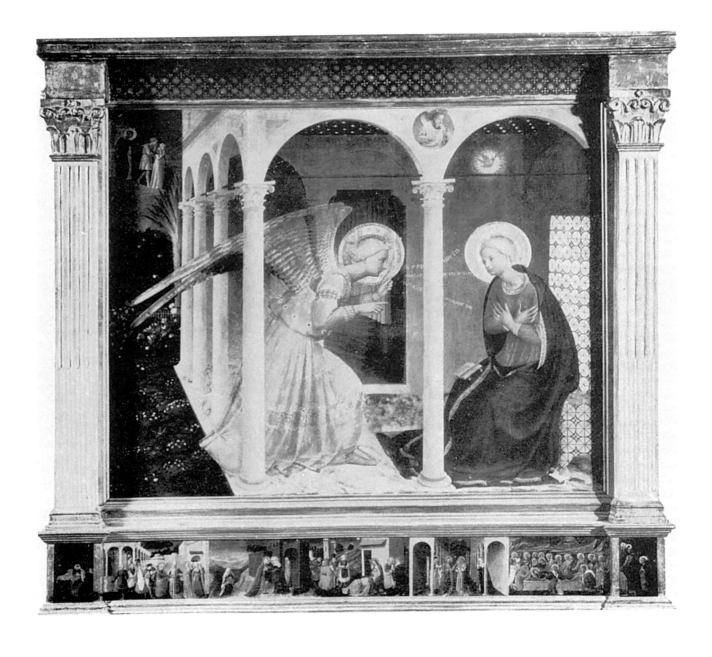

Fra Angelico (c. 1400–55)
Annunciation
Tempera on panel; 5 ft. 8 in. × 5 ft. 10 in. (175 × 180 cm.)
Cortona, Museo Diocesano

The Cortona *Annunciation* is among Fra Angelico's best-known works. It seems to have been executed during the decorative campaign for the church and monastery of San Domenico di Cortona, which Pope Eugenius IV himself encouraged by means of a papal Bull in 1438. Probably by 1440, five new works, three by Angelico, adorned the church. They express a uniquely Dominican spirituality, as is especially evident in the *Annunciation.*

Along with the Coronation of the Virgin and the Madonna and Child with Saints, the Annunciation was a theme favored by the Dominican Order: indeed, Angelico himself earlier had represented these three subjects in his own monastery church of San Domenico di Fiesole. The Annunciation signifies Mary's unique privilege and role as Handmaiden and Mother of God, Redemptress of Original Sin. In the Cortona *Annunciation,* the literal moment of the Incarnation, when the "Word was made flesh," is represented. The Archangel Gabriel, whose long, golden wings quiver with arrested flight, alights to approach the Virgin. Mary leans forward, a small book, open to Isaiah's prophecies, on her lap. Hands crossed over her breast in perfect submission, she gives herself to the will of the Lord. The sacred colloquy of messenger and maiden is inscribed in the space between them. The imminence of this suspended moment of Incarnation is suggested by Dove of the Holy Spirit, radiating light, whose wings are poised in midflight. He has been sent by the Lord, Who is depicted in a sculpted relief in the spandrel of the loggia's central arch. With flowing beard and unfurled scroll, the Creator witnesses the fulfillment of His will. Behind the loggia is Mary's bedchamber, the *thalamus virginis,* enclosed by a curtain and symbolic of her chastity.

Mary's divinely ordained role in redeeming mankind is shown outside the the loggia, too. Here we see the *hortus conclusus,* the closed garden of her virginity, to which the *Song of Songs* alludes. Within the fenced, luxuriantly blooming garden are the "palm of Cades" and "rose of Sharon" from Solomon's *Song.* Beyond this is Eden, where Adam and Eve are expelled for the transgression that only Christ's birth could redeem. The spiritual darkness of humanity is suggested by a deep blue, almost nocturnal sky. This contrasts with the radiance of salvation promised by the Archangel, with his exquisite, shimmering wings, halo, and gown; the Holy Spirit, suspended in a aureole of light; and the Virgin, seated on a glittering golden throne of wisdom and grace.

The Marian theme of the predella magnifies the Virgin's role as conceived by the Dominican Order. Recounting Mary's life from her marriage to her death, it illustrates her importance as chaste vessel and servant of the Lord's will. In the famed *Visitation,* Old and New Testaments are miraculously conjoined in the solemn meeting of Mary and her cousin Elizabeth. Dawn radiates the valley horizon, promising mankind's redemption through the Virgin's Son. We are reminded of Mary's unique privilege, her freedom from mortal decay, in the *Death of the Virgin.* Mary's protection of the Dominican Order itself is signified in the scenes at either end beneath the pilasters of the frame. In one, we witness the birth of Saint Dominic; in the other, Dominic receives the habit from the Virgin herself.

In terms of its style, the *Annunciation* reveals Angelico's understanding of the most progressive currents of the day. The remarkable, foreshortened loggia, with its slender arcade and Corinthian columns, suggests his fascination with perspective—not as an end by itself, as in the works of his contemporary Paolo Uccello, but as a means of constructing a convincing space. The receding progression of arches and interiors seems inspired by the *Story of Isaac,* from Ghiberti's *Gates of Paradise,* by that time complete save for chasing. In a similar manner, the architecture, landscapes, and delicately proportioned figures suggest Ghiberti's influence. Figures are slender, with necks and fingers gracefully elongated and expressive, tautly delineated. Drapery flows rhythmically, expressing movement and emotion. The painter's response to Ghiberti's refined surfaces is evident in the exquisite working of each feather of the Archangel's wings and the decorative tooling of the golden hem, shoulders, and cuffs of his gown that would scintillate by the candles illuminating the image. Similarly, Angelico's configuration of the predella, in which angled walls create a discrete yet contiguous space for each scene, seems a rethinking of the traditional predella, with its individually framed episodes, that may have been prompted by Ghiberti's innovations. In 1433, Angelico signed the contract for the *Linaiuoli Tabernacle* (Florence, Museo di San Marco), the frame and drawing for which had been provided by Ghiberti a year earlier. As a result of this collaboration, Angelico's style bears the indelible stamp of the sculptor's influence. Among the most exquisite of the painter's works from the 1430's, the *Annunciation* was done at the climax of this period.

In terms of both iconography and style, the *Annunciation* epitomizes the art of Fra Angelico. Doctrinally, it reveals the Dominican conception of the Virgin's role in human salvation and her obedient submission to God's will. Through the Incarnation, original sin—here shown by the forced departure of our progenitors from a now-darkened Paradise—is redeemed at the very moment the Word is made flesh. Its style suggests Angelico's receptivity to the progressive influence of Ghiberti and his understanding of perspective and light. Appropriately, the *Annunciation* is identified with Angelico, for it shows the artist at his most brilliant.

—Diane Cole Ahl

Fra Filippo Lippi (c. 1406–69)
The Annunciation, 1430's
Florence, S. Lorenzo

The undocumented San Lorenzo *Annunciation* shares the artistic concerns of Fra Filippo's *Tarquinia Madonna*, dated 1437 (Rome, Palazzo Barberini), and his Barbadori altarpiece, documented in progress in March 1437 (Paris; Florence). They integrate the most important themes pursued by early Renaissance artists: intelligibly constructed figures and setting; animated, emotionally wide-ranging behavior; and intellectually rich content.

The do stand out in several ways from Italian art of the late 1430's. The palette emphasizes distinctive mixed colors rather than pure hues, and strikingly dark yet translucent shading. The faces are more individual, less idealized, than any traditional mode. The settings, though based on old formulas, are notably complicated and fantastic as architecture. Finally, the symbolic contents are elaborate if not abstruse. The *Annunciation* differs slightly from the *Tarquinia Madonna* and the Barbadori altarpiece; its figure drawing is a little more articulate, its shading is subtler, and its color scheme is more integrated with spatial illusion. It probably dates about 1439–40.

As an Annunciation, the San Lorenzo painting raises special problems. The two extra angels are peculiar, though not unique. The epitomize the rich symbolism and its relationship to Fra Filippo's naturalism. They also point up what a strange object this painting is, with the nominal subject confined to half the picture field and an obvious split down the central column (most apparent in the mouldings near the top).

The painting might seem to be an altarpiece for its present location, where it is first recorded (1510). It has a predella by Fra Filippo (and workshop), designed with a central division that lines up with the column in the *Annunciation*, illustrating stories of St. Nicholas in a chapel long patronized by the descendents of Niccolò Martelli. As a square painting from early in the construction of Filippo Brunelleschi's first church, it has been called the first altarpiece with a "modern" Renaissance format, and it is certainly one of the first with centralized perspective.

The Martelli Chapel, however, was originally patronized by them jointly with two other families as the *operai* (board of works) of the church. More troublesome, around 1440 the building construction in this area was about shoulder high and at a dead standstill that lasted nearly a decade. Finally, the division of the two halves is carpentered into the *Annunciation*, which must have been built for framing in two panels (like a slightly later painting, Fra Angelico's *Annunciation* at Montefalco).

What of the "extra" angels? Many angels flock to the Annunciation of the early Christian triumphal arch mosaics of Santa Maria Maggiore in Rome; more discreet companions follow Gabriel in a 14th-century Florentine version, Bernardo

Daddi's in the Louvre. They probably reflect early Christian texts about the Incarnation of Christ: "When Christ Descended to assume human nature, he was attended by a heavenly company: when the good news was announced to Mary, when the shepherds saw the heavenly assembly . . ." (St. Hilary); "when the angels saw the prince of the heavenly host dwell in earthly places, they entered by the way He had opened, . . . distributed . . . as guardians to those who believed in Him" (Origen).

Theologically, the Annunciation is the moment of Christ's Incarnation, when human redemption is finally possible. Fra Filippo's painting is exceptionally lavish with more common emblems of Christ and Mary, the bringer and the bearer of redemption. The stage-like foreground may be "the porch at the eastern gate of the sanctuary" (Ezekiel 44:1–2); the courtyard, the Enclosed Garden; and the distant tower, the Tower of David: all Marian emblems. The courtyard encloses a grape arbor perhaps after Jesus's saying "I am the vine" (John 15:1), and its fountain is probably the Well of Living Waters. The glass carafe illustrates Mary's role as the vessel of the Incarnation, transparent like her purity and low like her humility. Its water is the ritual pair to eucharistic wine; Jesus, dually human and divine, shed both at his Crucifixion. Some scholars have taken the similarly naturalized symbolism of Flemish art, along with Fra Filippo's shadowy color, to suggest that he was the first Italian to adapt ideas from Jan van Eyck or Robert Campin. In fact, the symbols are all rooted in 14th-century Italian art, and Fra Filippo's lighting and coloring in the work of Masaccio, Gentile de Fabriano, and the sculptor Donatello.

The poses of Mary and Gabriel imitate Donatello's Cavalcanti *Annunciation* (Florence, S. Croce), though Fra Filippo's Mary is more mundane than Donatello's courtly Virgin, more the Handmaid of the Lord than the Queen of Heaven. She has nearly lost her balance; she bares her teeth with a little gasp, showing physical surprise rather than prophetic sorrow. All this belongs to a four-part dance with the angels. She and they are arranged by pose and color in complementary pairs, bright and grayed, forward and back, active and receptive, to bracket the perspective vanishing point whose orthogonals are studded with sacred emblems.

We simply do not know the original use or sponsorship of this painting. Clearly, though, as a rare blend of dynamic naturalism, powerful imagination, and impressive learning, it was a special achievement even for an artist with more such works to his credit, and evidence for a highly sophisticated audience as well.

—Jeffrey Ruda

Piero della Francesca (c. 1410-20—1492)
Arezzo Frescoes, 1452-66
Arezzo, S. Francesco

Bibliography—

Salmi, Mario, *Piero della Francesca: Gli affreschi di San Francesco in Arezzo,* Bergamo, 1944.

Schneider, Laurie, "The Iconography of Piero della Francesca's Frescoes Illustrating the Legend of the True Cross in the Church of San Francesco in Arezzo," in *Art Quarterly* (New York), 32, 1969.

D'Ancona, Paolo, *Piero della Francesca: Il ciclo affrescato della Santa Croce nella chiesa di S. Francesco in Arezzo,* Milan, 1980.

Piero's frescoes in the church of San Francesco in Arezzo illustrate the popular medieval legend of the True Cross; the legend was compiled in the 12th century by Jacobus da Voragine in *The Golden Legend.* This is the only extant narrative fresco cycle we have by Piero, the others being either altarpieces or individual paintings. The Arezzo frescoes adorn the Bacci Chapel and were commissioned by the Bacci, a family of apothecaries. The original commission was awarded to a lesser artist than Piero, Bicci di Lorenzo, in 1447, but was assumed by Piero upon Bicci's death in 1452. The work was finished on 20 December 1466.

The legend of the True Cross begins with the death of Adam, who sent his son, Seth, to meet the archangel Michael at the entrance to the Garden of Eden for the holy oil promised him by God. Instead, Michael gave Seth a sprig to plant over Adam's grave. The sprig grew into a tree which was later used by King Solomon to construct a bridge. When the Queen of Sheba made her historic visit to Solomon, she recognized the holy nature of the wood of the bridge and knelt to adore it. She predicted that the bridge would bring about the downfall of the Jews, whereupon Solomon had the wood buried and so it remained for many centuries. Piero represents the *Annunciation* among the scenes of the legend proper as another kind of bridge, namely between the Old Dispensation and the New.

The next event chronologically, which Piero includes, is the Dream and Victory of Constantine, resulting in his conversion to Christianity, which he made the official religion of Rome in the 4th Century A.D. Constantine then decided to send his mother, Saint Helena, to Jerusalem to find the True Cross. Upon her arrival, she learns that a certain Judas knows its whereabouts but refuses to reveal the secret. She has him thrown into a well for three days until he finally relents. In the scene of the *Discovery and Proof of the Cross,* Saint Helena is outside Jerusalem, whose walls and architecture resemble those of Arezzo itself, where her workmen dig up three crosses. In order to identify the True Cross, Helena holds each one in turn over the body of a corpse in a passing funeral procession. The True Cross brings the corpse back to life. The church facade in this scene is reminiscent of Albertian architecture and, like the temple of Solomon and the building of the *Annunciation,* exemplifies Pierto's attention to the new humanist forms and his study of classical antiquity.

Some three hundred years after Saint Helena's pilgrimage, Chosroes, a heretic, steals the Cross and sets up a false Trinity with himself as God the Father, a rooster as the Holy Ghost, and the stolen Cross as the Son. Below the false Trinity, we see Chosroes about to be beheaded by Heraclius, who defeats him in the battle on the left. Among the figures surrounding Chosroes are portraits of the Bacci family, who commissioned the frescoes. In the scene of the *Battle of Heraclius Against Chosroes,* which is formally and iconographically opposite the *Battle of Constantine* across the chapel, Heraclius defeats the usurper. In the final scene, *The Exaltation of the Cross,* in which Heraclius restores the cross to Jerusalem, the legend comes to an end, opposite the first scene of the cycle, *The Death of Adam.*

The unique aspect of Piero's arrangement is that it does not follow the chronological progression of events in the legend. Rather, the scenes are organized according to a system of typological, liturgical, and visual parallels, thereby enriching their meaning and increasing the impact on the observer. Themes of prophecy and fulfillment are prominent in this legend as well as in Piero's depiction of it. For example, just as Christ is the New Adam, so Mary is the New Eve; Solomon and Constantine were also typed with Christ as Saint Helena was with Mary and Eve. Liturgically, these figures are related most directly by the date of March 25th, the date of the Creation, Fall, and Death of Adam, the Annunciation to Mary, and Christ's Crucifixion. Visually, Piero opposes the two grand battles for Christian victory on the lower level of the chapel and next to these, on either side of the window, are the *Annunciation* and *The Dream of Constantine.* These two small scenes juxtapose night with day, dark with light, and the time before and after enlightenment. Above, the two large scenes in which heroic women, Sheba and Helena, discover and recognize the wood of the cross face each other. Next to these are the two small scenes in which wood is buried on the right and Judas emerges from the well on the left. At the top of the chapel, beginning and end oppose each other; the Cross begins life as a sprig on the right and is exalted outside the walls of Jerusalem on the left. In this way, at the very beginning of the narrative, we also know the end.

—Laurie Schneider

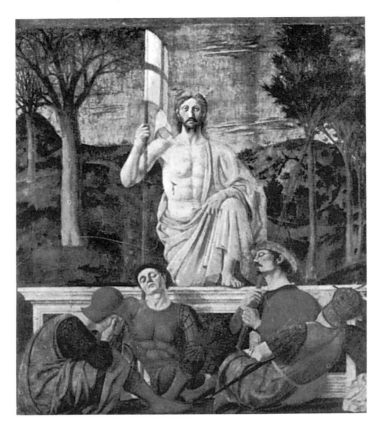

Piero della Francesca (c. 1410–20—1492)
The Resurrection
Fresco; 78³/₄ in. (200 cm.) (height)
Borgo San Sepolcro, Galleria Comunale

This impressive fresco is now in the Galleria Comunale in Piero's home town, the small village of Borgo San Sepolcro, which means village of the Holy Sepulchre. It depicts the resurrected Christ wearing a pale pink cloak, which has been drawn to one side to reveal the stigma. Christ climbs assertively from His sarcophagus and carries the traditional banner—white with a red cross—of victory over death. The massive, organic, monumental aspect of Christ and the sleeping soldiers at the foot of the tomb place Piero squarely in the tradition of the great humanist painters of 15th-century Italy. Also reflecting humanist concerns are the Corinthian columns flanking and framing the picture so that we look upon the biblical event through the architecture of classical antiquity.

The clear symmetry of the composition is accented by the centrality of Christ as well as by the symmetrical forms of His body. Light comes from the left in this painting so that Christ's form is consistently illuminated from that direction. He Himself is so architecturally conceived, particularly His geometric head and columnar neck whose vertical plane continues to the horizontal of the sarcophagus, that He seems to echo the Corinthian columns framing Him. Equally pronounced are the verticals of the trees on either side of Christ. These trees contain the traditional green and dry tree symbolism, which not only refer to life and death but also reinforce the formal right-left symmetry with iconographic opposites. On our right, the trees are green, resonating with rebirth, resurrection, and the coming of spring. On our left, they are dry, symbolizing both Christ's death and the earth's vegetation which dies every year before being reborn in the spring.

The circular arrangement of sleeping Roman soldiers at the foot of the tomb is symbolic of the church and therefore of Christ's future role as its center. In this composition, too, Christ rises as if from the center of the spatial circle of figures. Sleep, in Christian art, may symbolize death—in Greek mythology, sleep and death are twins—and in the context of the *Resurrection* scene, the soldiers' sleep also refers to ignorance and sin in not recognizing the miraculous event taking place.

The one soldier whose face is clearly visible and illuminated from the front is thought by some scholars and local tradition to be a self-portrait of the artist. This possibility is supported by the individualized features, the singling out of the figure by light so that he casts a shadow on the sarcophagus, his relatively frontal pose, and the accent provided by Christ's banner pole which is directly behind the soldiers' head. In comparison to the other soldiers, this figure has a more direct relationship with the observer and is more highlighted. Such emphasis on light in Christian art is nearly always significant and perhaps implies Piero's identification with the mortal and sinful soldiers at the same time as he strives for salvation and en*light*ment. Further reinforcing the self-portrait hypothesis is the resemblance of this figure to another purported self-portrait in the group of kneeling figures around the *Madonna della Misericordia* in the Pinacoteca Civica of Borgo San Sepolcro.

—Laurie Schneider

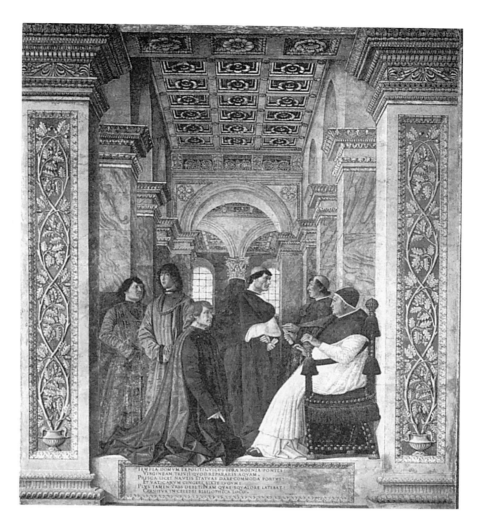

Melozzo da Forli (1438–94)
Portrait of Sixtus IV and His Nephews, 1477
Fresco
Vatican, Pinacoteca

This is Melozzo's first documented work; it commemorates Sixtus IV's nomination of Platina as prefect of the Vatican library in 1477. Originally a fresco, the picture was transferred to canvas and is now in the Vatican Museum in Rome. The architectural setting of this painting, with the insistence on strict symmetry and the marble piers supporting the horizontal ceiling, suggest the influence of Alberti. The architectural symmetry is repeated in the arrangement of the figures, who are clearly portraits. The grouping of the portraits attending the nomination recalls Mantegna's group portraits of the *Camera degli Sposi* in the Ducal Palace in Mantua. Both sets of figures occupy an illusionistic, three-dimensional space that seems to recede behind a wall separating the observer from the painted figures. Melozzo's attention to illusionism is further evident in the folds that overlap the wall below the main scene.

Platina kneels and points downwards to indicate his own Latin composition in praise of the pope. His robe falls into angular folds on the floor. Such folds are typical of 15th-century Flemish painting, and they recur in the Pope's drapery. These folds, along with the lined faces of the two central figures, suggest the influence of Justus von Ghent, whom Melozzo may have known at the humanist court of Urbino. The two glass windows in the background, accented by the Corinthian column supporting round arches, is an arrangement found in the Flemish paintings of Jan van Eyck. While there is no evidence of contact between van Eyck and Melozzo, it is nevertheless clear that contacts existed between Italy and Flanders in the 15th century and that Melozzo was aware of them. Also consistent with Flemish taste are the intricate detailed patterns on the Pope's chair and the architectural surfaces.

Placing Melozzo in the progressive Florentine tradition of Masaccio and Piero della Francesca, on the other hand, are the organic, monumental figures set in three-dimensional space constructed according to the laws of one-point perspective. The symmetrical organization of the painted architecture results in a vanishing point about midway down the central standing figure, which is also the eye level of the average observer. In contrast to Masaccio, however, Melozzo uses virtually no sfumato and his figures are more crisply drawn. In this respect, Melozzo is more reminiscent of Piero, as he is in the white light that pervades the picture.

—Laurie Schneider

Benozzo Gozzoli (1420 or 1421–97)
Adoration of the Magi, 1459
Fresco
Florence, Palazzo Medici

Bibliography—

Amaducci, Alberto, *La Cappella di Palazzo Medici,* Florence, 1977.

Benozzo Gozzoli's *Adoration of the Magi* (begun 1459) is a paradigm of Medici patronage and Florentine painting of the mid-15th century. Like an opulent, brilliant tapestry whose style it emulates, the *Adoration* adorns the walls of the private chapel begun under the aged Cosimo de' Medici in the grand palazzo he had commissioned only a decade earlier. Its iconography proclaims the *magnificenza* of its patron, who was member and Maecenas of the Confraternity of the Magi. In addition to this fresco, four other paintings and a tapestry in the Palazzo Medici as well as the decoration of Cosimo's private cell in San Marco attest the personal devotion of Florence's rulers to this theme. Indeed, a series of letters between Cosimo's son Piero and the artist reveals the patron's involvement in the decoration of the chapel down to the appearance of its angels.

The imagery of the chapel is inexhaustibly rich. As a theme, the *Adoration* celebrates the liturgical role of the Saviour as well as the three wise men who came to adore Him. Theologically, it signifies the first presentation of the Infant Jesus to the Gentiles. The associations it would have conjured in mid-15th-century Florence may be surmised from two devotional *laudi* by Lucrezia Tornabuoni, wife of Piero de' Medici. Her "Deh venitene pastori" and "Ben vegna osanna" express intense veneration of the Infant Saviour by the humble, by cherubim and seraphim, and by the potentates of the world.

In the context of Medici patronage, the associations of this iconography are amplified further. From Giovanni di Bicci through Lorenzo the Magnificent, the Medici belonged to the lay Company of the Magi. With their ascent to power, the Medici assumed munificent sponsorship of this religious confraternity, whose power and ultimate decline seems to have been contingent on the family's political fortunes. The brotherhood met in San Marco, the monastery whose reconstruction the Medici had subsidized, and when it outgrew these quarters, the Medici financed construction of its new meeting place. The Company of the Magi thus became identified with and dependent on the family's patronage. In their processions, the richly garbed Magi, the Medici among them, and their entourage would move from the Palazzo Vecchio to San Marco by way of the Via Cavour so that they passed before the family's grand palazzo. Under Lorenzo the Magnificent, Florence was even referred to as the "republic of the three Magi," ruled by the family that claimed in all respects to be their heirs.

Identifiable portraits within the train of the Magi allude to the role of the Medici and their city in great sacred and political events of the day. Cosimo the Elder, Piero, Giuliano, the youthful Lorenzo, and Cosimo's illegitimate son Carlo all seem to be depicted, as are several Medici partisans and the artist himself. Pride of place is accorded to Joseph, Patriarch of Constantinople, and the Byzantine Emperor, John Paleologus, shown as the first and second magi. In 1439, they came to the Medici-ruled city for the momentous Council of Florence-Ferrara in which the unity of Eastern and Western Christendom was pledged. Chronicles of the day marvelled at the exoticism and splendor of the Byzantine clergy and ruler, and at the festivities in their honor. This was not the only time in recent memory, however, that the Medici had hosted such distinguished visitors. In 1459—the very year the chapel's decoration was begun by Benozzo—Galeozzo Maria Sforza and Sigismondo Malatesta came to Florence to meet Pope Pius II, who was to launch a crusade to Jerusalem to recover the Holy Sepulchre from the infidels. During a sojourn of two weeks, splendid pageants, banquets, a hunt, and a tournament dazzled the visitors, who stayed at the Palazzo Medici. Benozzo included the portraits of Galeozzo and Sigismondo in the entourage of the magi in homage to them.

While few private chapels from Renaissance palaces survive, the decoration of the Medici chapel seems to have been unusually sumptuous. The ceiling, with its gilt soffits, is faced by a pavement of rich, polychrome intarsia of geometric design and Medici *impresa*. Below the frescoes, exquisitely inlaid, intarsia choir stalls designed by Giuliano da Sangallo line the walls. Filippo Lippi's altarpiece of the *Nativity* stood on the altar. A *bambino Gesù,* listed in Medici inventories as early as the 1420's, was placed in the chapel as well. The most splendid adornment of the altar was a magnificent gold and ivory French reliquary, once in Sainte-Chapelle, that enclosed the relics of the Passion of Christ. The life of Christ from Nativity to Passion is thus symbolically recapitulated through these sacred objects. In their brilliant, variegated surface that scintillated with gold, Benozzo's frescoes complemented the splendor of the chapel decorations and the fine chalices, candlesticks, and corporals of the altar.

The style of the frescoes is quite different from that of the artist's earlier works. A master of mural painting, Benozzo had executed several cycles of saints' lives in his previous commissions. In accordance with the norms of this hagiographic genre, episodes were arranged in registers, individually framed, and focussed on a single protagonist. Here, one event alone is represented and it flows in a continuum across the walls. As in Uccello's contemporary *Battle of San Romano* cycle, another commission for the Palazzo Medici, space is uptilted, decorative, without rational recession. Both of these works seem to emulate the conceit of tapestry, and it is important to remember in this regard that numerous tapestries are recorded in Medici inventories. The chapel evinces an elegant wit and preciosity in the depiction of the procession. Across the richly foliated landscape or mountainous terrain, splendidly garbed men traverse the chapel walls. Their garments are of the finest and most varied brocades and silks. Splendidly caparisoned mounts prance in tandem, enhancing the stately character of the procession. Birds soar through the skies; stag pursued by hounds leap gracefully; angels sing on an adjacent wall. Camels, caravans, and leopards seem inspired by pattern books rather than nature, and several of the figures may have been modelled after the antique. Landscape

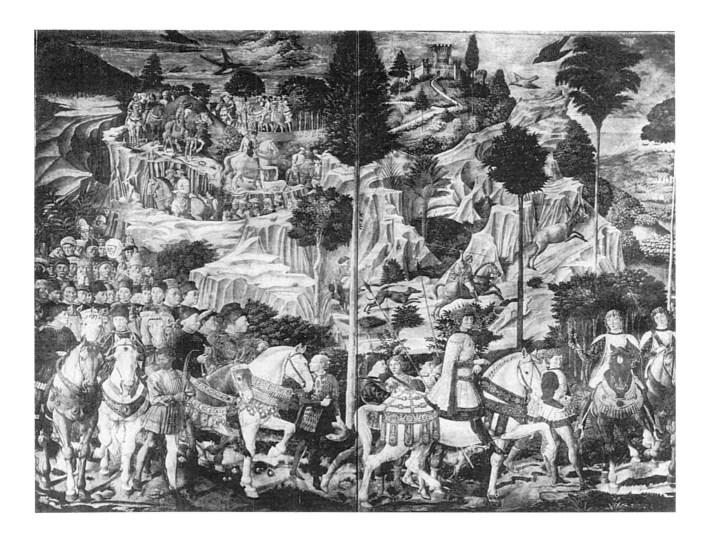

as a genre was receiving new attention in contemporary works by Piero della Francesca and Baldovinetti: here, it is splendorously interpreted by Benozzo. Tall cypresses and umbrella pines prolong a broad space traversed by craggy mountains, verdant meadows, and dense, dark forests. Surfaces are richly patterned and brocades shimmer with gold. Serving as a transition to the solemn space of the choir are solitary bucolic scenes with contemplative shepherds tending their flocks. Behind and around the altar, choirs of angels are seen in veneration, providing a model of devotion to be emulated by the faithful.

The frescoes of Palazzo Medici have always been viewed as a symbol of the wealth and political potence of their patrons. At the same time, they reveal Benozzo Gozzoli as a supreme artist whose sensibility could be adapted to the unique character of each commission. In the chapel, he has painted a portrait of court life that evokes the grandeur and political pretensions of the Medici even 500 years later.

—Diane Cole Ahl

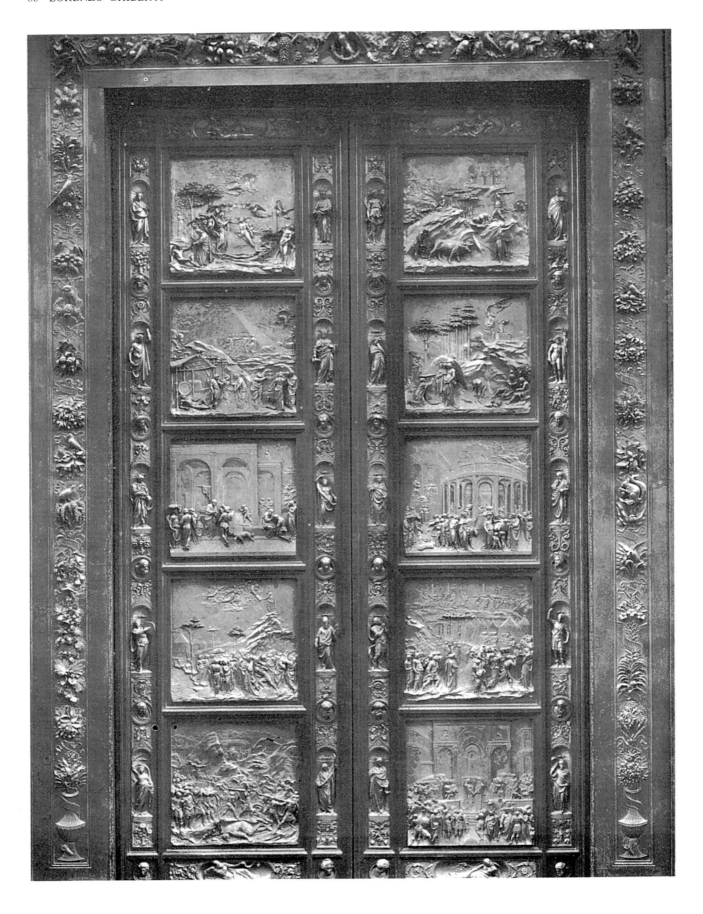

Lorenzo Ghiberti (c. 1378–1455)
The Gates of Paradise, 1425–55
Bronze
Florence, Baptistery

Bibliography—

Poggi, G., *La porta del paradiso di Ghiberti,* Florence, 1949.
Krautheimer, Richard, *Ghiberti's Bronze Door,* Princeton, 1971.

Who but Michelangelo could have named these doors so perfectly? As a sculptor he perceived their incredible beauty and their technical perfection just as surely as he recognized their symbolic value.

By 1425 when the guild in charge of the Florentine baptistry, the Arte di Calimala, gave Ghiberti the commission for his second pair of bronze doors for that building, he was at the height of his creative powers. Not only is his mastery of composition and relief evident here; we see another dimension of reality added to the new Albertian perspective by the complete gilding of each panel to highlight the atmospheric impression of light and air. In all this he far surpassed the accomplishments of his 20 years spent on the previous doors.

Documents suggest that prior to 1424 the Calimala requested the theologian Leonardo Bruni to devise a suitable scheme. His proposal called for 20 panels of Old Testament scenes above eight panels of prophets, placed within quatrefoils, the same format as the earlier doors. Although Ghiberti speaks with pride and love of his work on the Gates in the autobiographical section of his *Commentari,* he does not say who devised the program or why the old format was abandoned. We must presume the new Renaissance form was his, for he says he was allowed "to execute it in whatever way I thought would produce the greatest perfection, the most ornament and the greatest richness." Here the goldsmith in Ghiberti is speaking; perhaps an echo of this is heard further on when he speaks of the figures, but one also hears another voice. When he mentions his imitation of nature, the number of figures, and the way they are modeled from very high to very low relief so that they are seen in planes from near to far as in reality, it is Ghiberti the Renaissance sculptor speaking. He tells of the ten panels, each with four scenes, and of the small figures in the frames surrounding the panels—were these his solution to a need to include prophets?—and he says with justice that they were all his work. In one sense they are, but an occasional figure or passage suggests other hands, sometimes worthy of the master, sometimes not.

The wax models for the panels were executed in the 1430's; this fact coupled with unusual handling of subject matter in the last panel, Solomon and Sheba, gives a clue to the intended meaning or contemporary significance of the doors. In his book on Ghiberti, Krautheimer perceived the wedding-like quality of that panel and brilliantly associated it with the intention of the Councils of Ferrara and Florence (1438–39) to effect the union of the Eastern and Western Churches. Sheba, the East, joins hands with Solomon, the West, before an ecclesiastical architectural setting.

Various theologians have been suggested as the source for the program. Among these are the Archbishop of Florence, St. Antoninus, and Ambrogio Traversari, concerned for some time with church unity. Whoever it was, the interest of the council in the Church Fathers and its influence on Ghiberti's was shown by Krautheimer in Noah's pyramidal ark, an extraordinary shape stemming from Origen, the 3rd-century Alexandrian theologian. For an Egyptian Christian, what could be a more telling illustration of the permanence of the church as symbolized by the Ark than a pyramid?

These few observations strongly suggest we are to see the Gates of Paradise as a typos for the church. The name itself in singular form recalls a medieval trope for the Virgin, still in common use. Moreover, as the Gate of Paradise, Mary personifies the church as attested by the equation, Maria-Ecclesia, again of medieval derivation. At the top of the frame recline Adam and Eve, the first parents, and at the bottom, Noah and Puraphera, the second. Eve, however, is distinguished by the number of symbols accorded her. She holds a branch, the Tree of Life, representing both Christ and his cross. Sacrifice is further indicated by a wheat sheaf and a sheepskin, both reminiscent of Cain and Abel's sacrifice as well as Christ's. That Eve is of singular importance is borne out in the Creation panel. She, not Adam, is the central subject. Angels hover in adoration as putti raise her classic, radiant body from Adam's side to present her to God. Contrary to custom, she stands between us and a barely visible Adam at the Expulsion as she turns her body, derived from both antiquity and nature, to gaze upwards towards the angel who sends her forth.

If the Solomon and Sheba panel represents the unification of the church, the Creation of Eve represents its inception; through her came not only humanity but from her *felix culpa* the Redemption was necessitated. Eve, therefore, according to tradition, was as Mary, the Second Eve, the Church.

The intervening panels, rather than being simple narrative, must be read as further explication. The Cain and Abel panel establishes two themes carried out by the others: the relationship of brother to brother and man to God. Sometimes one or the other is more obvious, but the thread is continuous. From Noah to Abraham, to Isaac and Jacob we see both; in the Joseph panel fraternity is paramount. The covenant between God and man dominates the Moses and Joshua panels as the Law is given and the Promised Land reached. The David panel is exceptional in that its primary function is to present David as the hero and patron of Florence. As Mary and Eve are the Church, so David is Florence. It is here that man and man came together with God to reunite his ultimate covenant, the church, celebrated by the next and last panel.

Michelangelo was right. Whether he was playing on the word *paradisium,* the area in front of the cathedral facing the doors, matters little; the name he bestowed acknowledges both the meaning and the beauty of Ghiberti's work.

—Olan A. Rand, Jr.

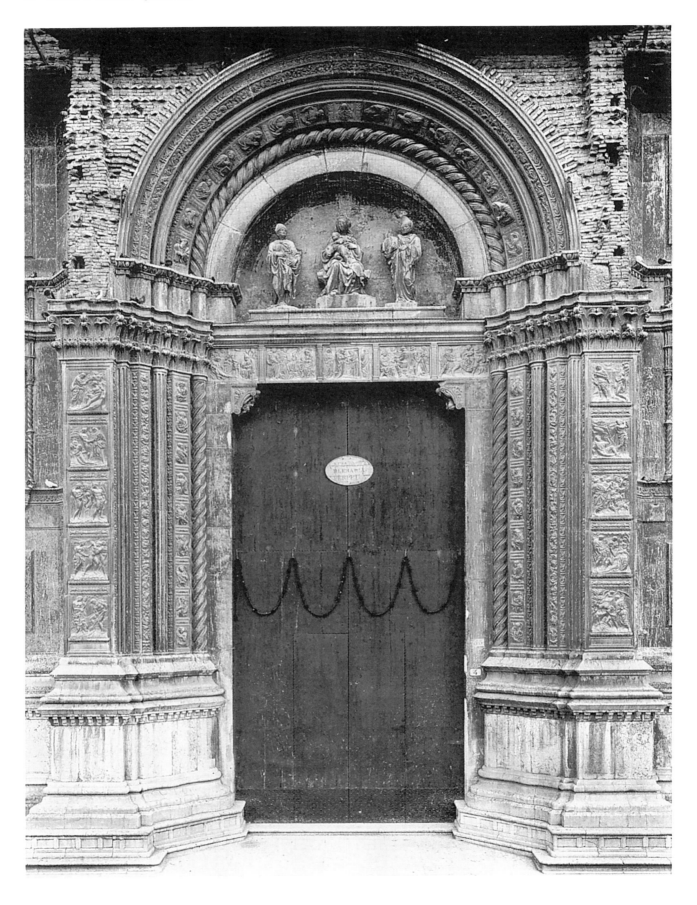

Jacopo della Quercia (c.1374-1438)
S. Petronio Doorway, 1425–38
Stone
Bologna, S. Petronio

Bibliography—

Supino, Igino, *Le sculture delle porte di S. Petronio in Bologna,* Florence, 1914.

Beck, James H., *Quercia e il portale di San Petronio a Bologna,* Bologna, 1970.

Emiliani, A., editor, *Quercia e la facciata di San Petronio a Bologna,* Bologna, 1982.

Bellosi, L., "La 'porta magna' di Quercia," in *La Basilica di San Petronio in Bologna,* Bologna, 2 vols., 1983.

This is Quercia's last work and usually considered his masterpiece. The contract was signed 28 March 1425 (the original text was copied in the 16th century). The original plans, based on a pre-existing drawing by Quercia, called for 14 narrative scenes on the lateral pilasters (seven on each side) and three Nativity scenes on the architrave above the doorway, 28 smaller busts of Prophets, a statue of the *Virgin and Child* with Saints in the lunette above the door. In the event, changes were made in most of these requirements, so that there were eventually five narrative reliefs on each lateral pilaster instead of seven, though occupying roughly the same area, and five New Testament scenes above the doorway instead of three; the Prophets number 18 (nine on each side) rather than the original 28 (the 15 Prophets above the lunette are by a later sculptor), and the Saints accompanying the *Virgin and Child* in the lunette are also different (possibly because of the changed political situation in Bologna from 1428). Few documents pinpoint the actual completion of each part of the doorway, though we do know that the statue of St. Petronius was installed in the lunette on 21 November 1434, and Quercia is recorded on visits to Verona and Venice to procure stone in the late 1420's and early 1430's.

The completed lunette consists of the *Virgin and Child* and *St. Petronius* by Quercia, and *St. Ambrose* by Domenico Aimo da Varignana (c. 1510). The *Virgin and Child,* of saccaroid marble, is a remarkable work: she is posed at an angle, with her right knee advanced, and the child is held forward in her right arm so that the left side of the group falls away. Both figures are animated, vigorous, and intensely human.

The Old Testament reliefs on the sides of the doorway have as their subjects the *Creation of Adam,* the *Creation of Eve,* the *Fall,* the *Expulsion from Paradise,* and the *Labors of Adam and Eve* (on the left), and the *Sacrifices of Cain and Abel,* the *Murder of Abel,* the *Release from the Ark,* the *Drunkenness of Noah,* and the *Sacrifice of Isaac* (on the right). The New Testament reliefs in the architrave above the doorway are representations of the *Nativity,* the *Adoration of the Magi,* the *Presentation in the Temple,* the *Massacre of the Innocents,* and the *Flight into Egypt.* The selection of relief subjects are somewhat unusual, and probably reflect a tradition in Emilia: they are similar to those at Modena Cathedral; the overall arrangement of the upper part of the doorway is also seemingly based on the Modena model.

The reliefs are flat, adhering closely to the relief plane, so that the overall composition of each relief can be thought of in terms of line, characteristic of the Sienese style. Yet though flat and relatively small, the reliefs have a "monumental" scale about them, and Michelangelo, who saw them in 1494, was impressed. The figure of Jehovah, in the *Creation* reliefs, has great power (even terribilità) in his posture, heavy brow, flame-like hair, enormous hands, and bunched drapery. Adam is athletic, eager, full of life, while Eve seems to float out of Adam's sides, but they are both individualized and immediate. The *Expulsion* echoes Masaccio's fresco version in the Church of the Carmine in Florence.

—George Walsh

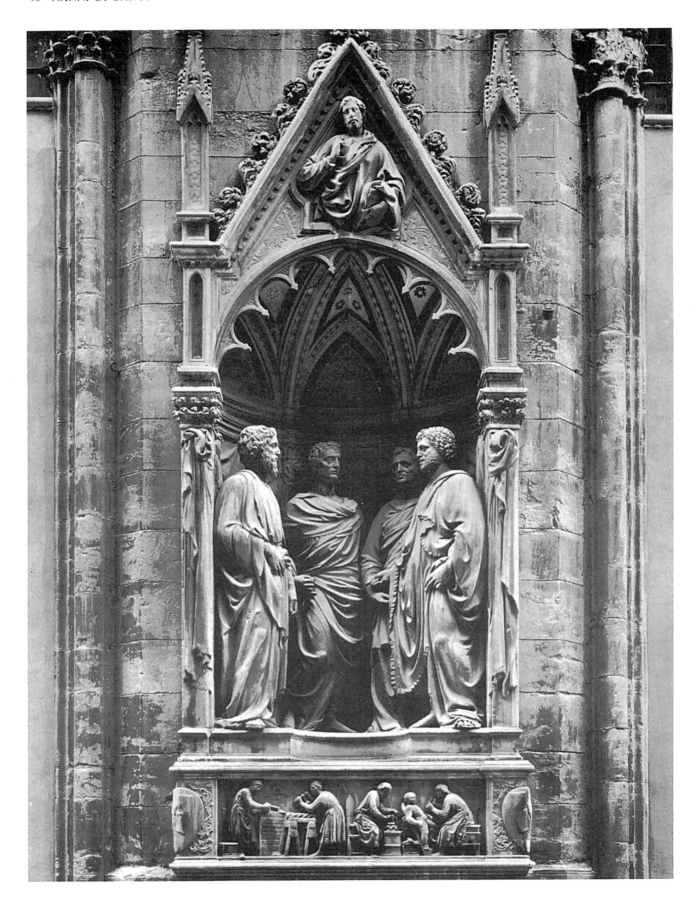

Nanni di Banco (mid-1370's-1421)
Four Saints, c. 1415
Marble; 6 ft. (183 cm.) (height of statues)
Florence, Orsanmichele

Bibliography—

Horster, Marita, "Nanni di Banco: *Quattro Coronati,*" in *Mitteilungen des Kunsthistorischen Institutes in Florenz,* 31, 1987.
Bergstein, Mary, "The Date of Nanni di Banco's *Quattro Santi Coronati,*" in *Burlington Magazine* (London), December 1988.

The outdoor ensemble dedicated to the Quattro Santi Coronati, patron saints of the Stonemasons guild, is built into the third pilaster of the north wall of Orsanmichele. The work is divided into three zones: 1) the pediment where a half-length figure of Christ Blessing projects in high relief; 2) the niche itself which is divided into bays by corinthian colonette capitals draped with a fictive curtain, and where inside a group of four statues of men—the two at the right intersect and are in fact carved from the same block—stand on a concave semicircular platform, which forms the floor of the niche; and 3) the socle (bracketed by the guild's coat of arms on either end) with a relief of four contemporary masons, stone-carvers, and sculptors at work. Although primary documentation of the commission no longer exists, tradition from Francesco Albertini (1510) forward has universally ascribed the *Four Saints* to Nanni di Banco. A sale of marble from the cathedral Opera to the Stonemasons guild on 9 October 1415 indicates that the work was in progress at that time.

In response to the practical challenge set before him—that of assembling a group of four standing figures in a traditional niche—Nanni di Banco created a view into a framed aperture, composing a stage-like "picture" with actual, finite, dioramic space and solid volumes. The semicircular plan of the floor platform—its central void parallels the middle bay of the niche wall—draws the viewer back into spatial depth. Engaged in conversation with one another, none of the statues looks straight out at the beholder, and this seemingly casual, unposed grouping of figures enhances the sensation that one is observing a scene enacted through the proverbial Albertian window. Such an effective use of space in a figural composition must have had an incalculable impact on the painters who were to follow: the eliptical assembly of Apostles in Masaccio's *Tribute Money* (Brancacci Chapel, S. Maria del Carmine) is the example most readily called forth. In the world of sculpture, the *Four Saints* paved the way for Donatello's Cavalcanti *Annunciation* at S. Croce and Verrocchio's *Christ and St. Thomas* (in Donatello's Parte Guelfa niche) at Orsanmichele.

The *Four Saints* appears to be a concrete affirmation of the corporate republican ideals maintained by merchant class and artisan class guild members in Florence; and as such it is a profoundly self-referential work of art. Nanni di Banco's conception of the protector saints of his own guild avoids direct reference to the complicated legend of the four Roman martyrs who chose death rather than to carve a cult image of the god Aesculapius. (He fully rejects the static, iconographically orthodox precedent painted in 1403 on the interior north wall of Orsanmichele by Ambrogio di Baldese and Smeraldo di Giovanni.) In Nanni's version, the standing figures are presented *all'antica* and with great attention to empirical realism: dressed in toga-like garments, their heads are free interpretations of Roman portrait busts, and the rhetorical gesture of the figure on the outer right, whose mouth is open in speech, is derived from a Roman orator type. In this ostensibly Christian subject, the saints display neither haloes, nor crowns, nor attributes, nor palms of martyrdom. Critics have time and again characterized the group of statues as evoking the image of four Roman senators or their contemporary Florentine counterparts—members of the elected group of citizens that steered the Florentine republic—rather than the zealous martyrs of early Christian times.

The theme is developed with an "upstairs-downstairs" logic in the socle zone, where the corporate patron, religious subject, and artist's image of his own role merge in a single image. Four stonemasons are shown at work 15th-century style, in contemporary dress, with the sculptor at the right completing the image of a wingless, nude boy—an (ironically) pagan style *putto.* Like the merchant class humanists who compared themselves with the ancients, and quoted *exempla* from classical literature to voice the ideals of the republican state, Nanni based his group of four standing men on classical Roman sculpture, introducing a new naturalism, and setting the classicizing group above a relief description of the everyday work of the Florentine artisan. In physically juxtaposing the Greco-Roman ideal of the four statues with the descriptive Florentine "vernacular" of the workshop scene below Nanni effectively compares his own corporate group not only with the Christian martyrs but with the republicans of ancient Rome. The statues of the four saints have been interpreted as an open reference to the perfect entente and dignity of the four elected consuls of the Stonemasons guild. This observation becomes all the more understandable when we reflect upon the fact that Nanni di Banco himself chose a life of civic engagement, and that he entered the public sphere through the prominent position established by his family and himself in the Stonemasons guild.

—Mary Bergstein

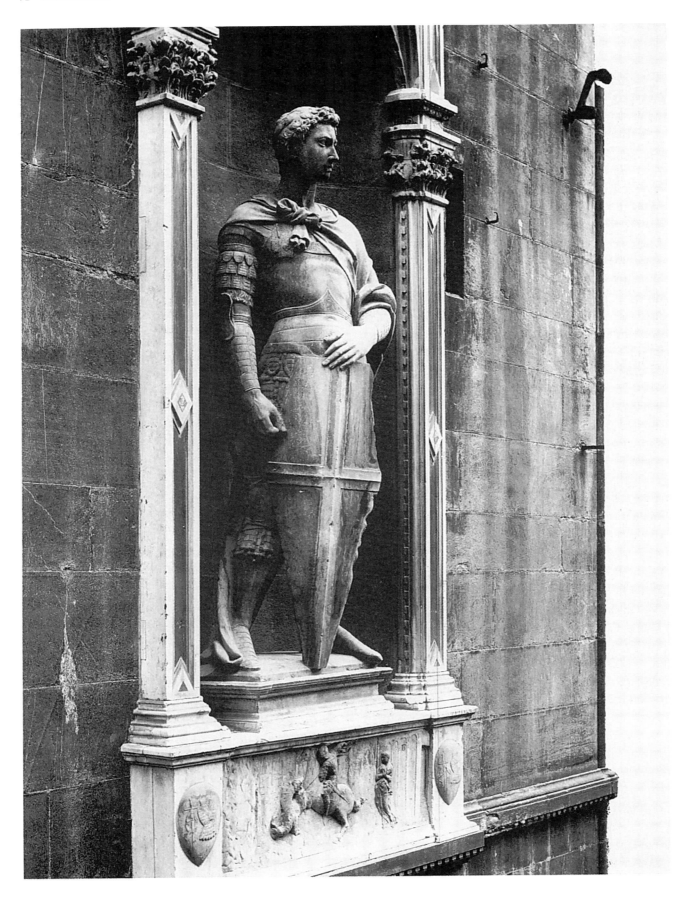

Donatello (1383 or 1386–1466)
St. George, c. 1416
Marble; 6 ft. 10¼ in. (209 cm.)
Florence, Bargello

The triumph of Donatello's early works is the famous *St. George,* commissioned by the Guild of Armorers and Sword-makers for a niche in the southwest pier of Or San Michele in Florence about 1416, although a slighty earlier date also has been suggested. In addition to the figure, Donatello executed the marble relief below and a half-length God the Father above, although the tabernacle itself may have been designed earlier by an unknown stone-carver. The original marble statue was removed from its niche at the end of the 19th century; now in the Bargello, it was replaced by a bronze copy. A hole in the right hand and drill holes at the waist and the back of the head indicate that he once had a sword, sheath, and helmet, implements connected with the Guild that commissioned the statue.

The figure, standing forthrightly within an unusually shallow niche, projects forward into the space of the observer who sees him only a little above eye level. The tips of the missing sword and the huge shield draw the eye to the armored upper body and the steady resolute gaze. A cloak over the shoulder, like that of Donatello's marble *David* for the Cathedral (1408; now in the Bargello), is knotted, and repeats the taut, tense lines of the rest of the figure even more clearly than on the earlier statue. Nervous tension is also seen in the face, but resolved by an expression of confidence and control. The open stance and opposing contrapposto (weight on the left leg, body turned to the right) reinforces the concept of strength within tension, as in the earlier (1411–13) *St. Mark,* also for Or San Michele. *George,* the essence of youthful courage and action, is a very human, not an ideal, hero.

Although the statue has connections with Donatello's earlier works for the Cathedral, the relief below it is revolutionary. St. George, dressed in armor similar to that which he wears above, sits on his rearing horse and plunges a lance into the dragon which has emerged from his cave on the left to threaten the lovely Princess Margaret on the right. These narrative foreground figures are carved in high relief, and, except for the horse, have a residual Gothic flavor. It is in the background that an entirely new method of relief carving is employed, suggesting deep space: *rilievo schiacciato,* flattened relief. Instead of forms carved out of the background, they are partially engraved into it, creating an illusion almost like painting. Here Donatello's concern is not with the plastic volume of the foreground figures but with the variations of light and shade in the gradations of relief surface. Foreshortening of the horse and arcade and a single vanishing point of the orthogonals enhance the illusion of space, but it is in the new technique of *schiacciato* that the innovative genius of Donatello first appears, recurring in most of his later works.

Passages of *schiacciato* are found in the relief of God, high above in the architectural framework of the tabernacle. The half-length figure peers through a triangular form which functions like a window, his hand and book resting on the sill. When seen from the street, the foreshortened figure appears in correct proportion.

Because of the innovative techniques, new concept of the human figure, and humanistic spirit, conceived at the dawn of the Renaissance, Donatello and his *St. George* are harbingers of the modern world.

—Harriet McNeal Caplow

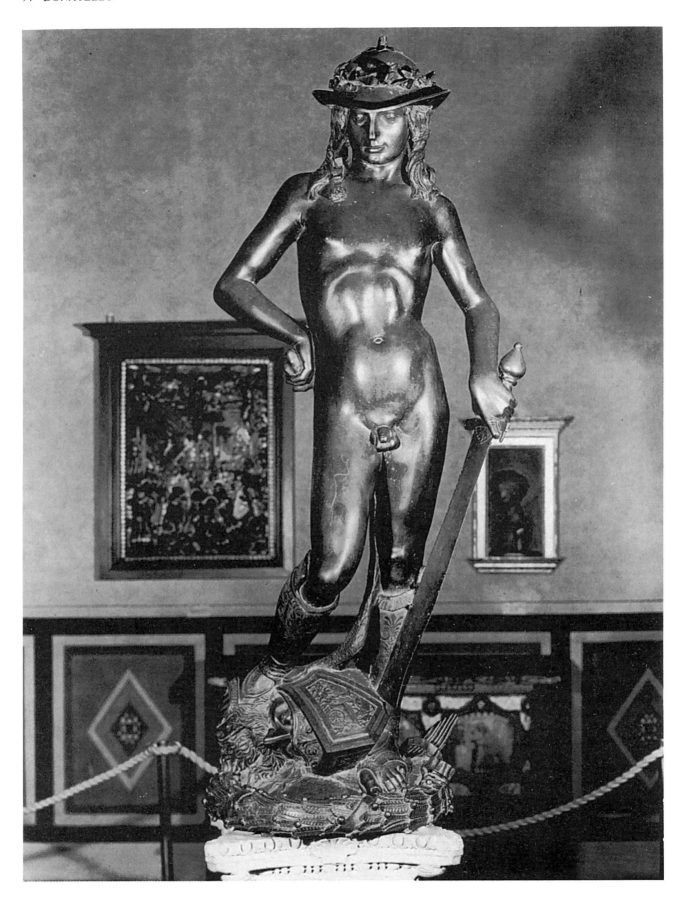

Donatello (1383 or 1386–1466)
David, c. 1460
Bronze, 62¼ in. (156 cm.)
Florence, Bargello

The bronze *David* by Donatello, now in the Bargello, Florence, has long been one of the most admired, and most discussed, figures in the sculptor's *oeuvre*. No documents relating to the commission or original location of the statue survive, but an eyewitness account of the wedding of Lorenzo de' Medici in 1469 mentions a "bronze David" in the courtyard of the Medici Palace, and two documents of 1495 describe its removal to the Palazzo Vecchio. With one exception scholars agree that it is by Donatello, probably made for the Medici family. But questions of date, iconography, symbolic significance, and the unusual pose and form of the figure continue to be debated.

The statue represents a pre-adolescent life-size male nude—perhaps the first since antiquity—who holds in his left hand the stone with which he killed Goliath and, in his right, the Giant's huge sword. Disdainfully David gazes down at the severed head of the oppressor, his feet precariously unbalanced on the head and on a laurel wreath. The nudity is accentuated by a floppy shepherd's hat, encircled by another laurel wreath, and by elaborately decorated boots. His left hand rests on his hip and the pelvis is thrown forward to sustain balance in a pose without classical precedence or Renaissance ideals. Anatomical forms are feminine: soft belly and buttocks, small chest, graceful curves. In fact, the extremely sensuous quality of the body, the pose, and the strong highlights that caress the smoothly polished surface of the bronze, have led some scholars (Janson, Schneider) and even casual observers to assume that Donatello has depicted his *David* as a youthful homosexual. Although this idea may derive from 20th-century stereotypes, some ambiguities must have been present even for the 15th-century viewer. In any case, the sensuality, softness, and tactile qualities of the modelling are unique in the work of Donatello and the Renaissance, and raise unanswered questions about the purpose of the commission and why the sculptor chose this type of representation, so unlike his earlier marble *David* or Verrocchio's later bronze *David*.

Was this unheroic, arrogant youth intended to be framed by the massive arches and columns of the palace courtyard of the powerful Medici family? The downcast gaze and multi-sided points of view suggest that it was placed high on a column or pedestal with enough space for the observer to walk around it. If it were made for the palace, a date after Donatello's return to Florence from Padua in 1454 would be necessary. Stylistically it is not related to any of Donatello's other works of any period except in the generic qualities found in all his work: a unique vision of human experience, an emphasis on the psychology and meaning of the individual subject, freedom from the constraints of traditional or classical precedents, a passion for innovative forms and concepts, and the virtuosity in the handling of materials. Thus, stylistically the bronze *David* could be placed at any time in his career, but probably about 1460.

Despite the remarkable surface polish and the smooth undulating planes which play with light and shadow, there were problems with the casting: David's right index finger below the knuckle is missing, there is no second wing of Goliath's helmet to match the one which caresses David's thigh, and there are numerous holes and patches in the metal. Other passages, like the relief on the helmet (adapted from an antique cameo in the Medici collection), the wing feather and the design on David's boots, are remarkable in the detail of their modelling and casting.

The expression on the face of the youth is not typical of the proud, conquering hero of the Bible. This David is calm, relaxed, self-assured, meditative, musing on his deed. It has been suggested that the expression indicates that the statue may symbolize the virtue of Humility, or that the sculptor was also representing other aspects of David's life as poet and musician as narrated in the Bible. Self-absorbed and sensuously nude, the bronze *David* is revolutionary in the history of sculpture.

—Harriet McNeal Caplow

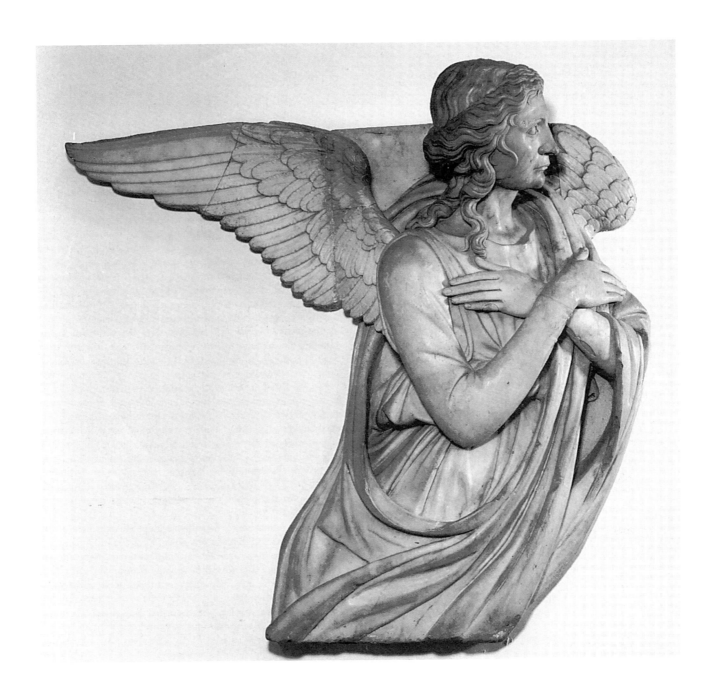

Michelozzi Michelozzo (1396–1472)
Aragazzi Monument, 1429–38
Marble
Montepulciano, S. Maria

In his report to the tax officials in 1427, Michelozzo declared that he and his partner Donatello were working on three unfinished tombs, one of which was for Bartolomeo Aragazzi of Montepulciano, a humanist, poet, and papal secretary. Documentary and stylistic evidence proves that the design and execution of this monument was by Michelozzo alone; it is undeniably his masterpiece. This history of the tomb is, however, a mystery with clues and circumstantial evidence but no uncontested solutions.

Aragazzi had commissioned his tomb before his death, which occurred in Rome in June 1429. Approximately a year later, Leonardo Bruni, humanist and Florentine statesman, wrote a letter describing an encounter with a mule driver who was transporting marble statues, two effigies, and other pieces of sculpture and architecture to Montepulciano for Bartolomeo's tomb. Bruni launched a vicious attack, unusual in humanist correspondence, condemning his "friend" professionally and impugning his character and morals, as well as those of his family. But the letter does indicate what some of the sculpture represented and that it had at least been roughed out by 1430. Michelozzo worked on the tomb sporadically through the 1430's, and it was finally put in place in a chapel of the Pieve of Santa Maria, Montepulciano in 1438. About 175 years later when a new cathedral was built and the old church destroyed, the monument was dismantled and lost. Not until 1815 were some of the pieces of sculpture found "behind the choir stalls"; later they were placed in various locations in the cathedral where they can now be seen. These pieces include the recumbent effigy, two relief panels, two life-size free-standing figures, a long base with garland-carrying putti, a large male figure emerging from an arched background, and part of a bronze plate with an inscription; two winged, half-length angels, now in London, were identified as part of the ensemble; none of the architectural framework has survived.

Two questions necessarily arise: What does each of the surviving sculptures represent? What was the original appearance of the monument? Without documentary evidence or descriptions, answers must be hypothetical. Although scholars have attempted reconstructions, based on comparisons, with similar monuments completed before and after this one, none is entirely convincing.

The two life-size statues are the most arresting of the surviving pieces and are considered the best of Michelozzo's work. They have been variously identified as the Virtues of Faith and Fortitude (highly unlikely), as personifications of Rhetoric and Cicero, or as candle-bearing mourning angels. Their sexuality is ambiguous; both statues have male and female characteristics. The figure now standing on the left side of the altar clutches a candleholder and although dressed in a *peplos* (Greek female attire), has no breasts; the muscular arms and large hands appear to be male. A Roman toga and military boots are worn by the figure on the right, but the facial features are feminine; it holds a twisted broken column. These characteristics and attributes have no precedents in monumental sculpture. The unusual pose of the left figure, with it swaying stance and sharply turned head is rare in antique sculpture but has echoes of Ghiberti's style in its contrapposto pose. Expressive, dramatic features display an inner conflict and aggressive presence, unique in the work of Michelozzo or other early Renaissance sculptors.

The two reliefs represent idealized aspects of Aragazzi's life: in one he is welcomed into Heaven by his mother and siblings; in the other he is presented to the Madonna and Child in the presence of the same members of the family. The shallow space, high relief, and squat proportions of the figures are reminiscent of late antique reliefs and show the classicizing qualities of Michelozzo's style, so different from contemporary works by Donatello and Ghiberti.

Among the remaining sculpture, the male relief-statue is the most problematical. He has been identified as the Resurrected Christ, God the Father, or Saint Bartholomew, but there are inconsistencies in all these. Obviously he was placed high on the tomb, as he gazes down on the effigy, blessing it with his left hand. His calm demeanor, complex drapery, masterful carving, and expressive features produce Michelozzo's most monumental figure.

The remaining pieces, though less monumental and expressive, show Michelozzo's typical style which includes derivations from classical sources, trecento influences, and his own individual approach to realism. The effigy of Aragazzi, for instance, is carved with simple, flowing drapery and finely detailed facial features, probably modelled from life. The base, with a frieze of putti, garlands, and ribbons, is the most charming of the Aragazzi sculpture; in contrast to the nude infants in the relief panels, these winged putti are like little gentlemen, their bodies slender, their movements graceful, the modelling softer and more fluid. How the angels came to London from Montepulciano remains a mystery, but their connection with the tomb is undeniable. Inspired by similar angels by Ghiberti, their air of solemnity and detachment place them clearly in the style of Michelozzo.

One of the sins of history is the inexplicable destruction of important pages on which our heritage is inscribed. So it is with the Aragazzi monument, the first humanist tomb and the masterpiece of Michelozzo. Its importance can be demonstrated by its influence of later humanist tombs. That of Leonardo Bruni by Bernardo Rossellino and of Carlo Marsuppini by Desiderio da Settignano can only provide indications and clues to the original appearance of the innovative Aragazzi monument which, unfortunately, survives only in fragments.

—Harriet McNeal Caplow

Antonio del Pollaiuolo (c. 1430–98)
The Martyrdom of St. Sebastian, c. 1475
Panel; 9 ft. 6³/₄ in. × 6 ft. 7³/₄ in. (291.4 × 202.5 cm.)
London, National Gallery

Bibliography—

Chiarini, M., "The Martyrdom of St. Sebastian," in *Enjoying Paintings,* edited by David Piper, London, 1964.

The *Martyrdom of St. Sebastian,* now in the National Gallery in London, was painted by Antonio and Piero Pollaiuolo about 1475 for the Pucci Chapel in SS. Anunziata in Florence. The two heads of moors within wreaths on the ruined triumphal arch in the background, in fact, are emblems of the Pucci family. The Roman battle relief within the triumphal arch, on the other hand, alludes to the fact that Sebastian had been an officer in the praetorian guard under the emperor Diocletian in the 3rd century A.D. When he converted to Christianity, he was tried for treason and condemned to death. The large round relief at the top of the arch underneath the broken pediment depicts his trial before the emperor with a group of mounted and foot soldiers bearing down upon him with lances and other weapons as if eager to carry out his execution. In the foreground the sentence is actually carried out (unsuccessfully as it turned out; he was later beaten to death) as six archers load their weapons and discharge their arrows into the almost nude body of the saint tied to a tall tree stump. Since St. Sebastian was thought to offer protection against the plague, this painting may have been commissioned as a votive painting during one of the repeated outbreaks of the disease in Renaissance Florence.

The painting is remarkable, both for its naturalism and its idealism. A strong natural light seems to enter the painting from the upper right modeling and sculpting the foreground figures. The figures themselves are captured in movement—taking aim, drawing their bows, or loading their crossbows. The muscles of the two central foreground archers seem to ripple under their skin as they strain to steady the crossbow with right foot and left hand and simultaneously cock the bowstring by lifting up on a cord attached to a belt around the waist. Similarly the bowmen take a wide, firm stance, lower their right shoulders, and arch their bodies sidewards in response to the pulling, bent right arm and the straight, extended left arm. So carefully have the figures and weapons been delineated that the painting is a lucid document for how bows were made and arrows were loaded and shot in the Renaissance. More than likely an assistant in the workshop was posed with actual weapons, but in only three positions, since five of the six archers are alternate views of only two poses. Although bound to a tree, even the saint—his taut, angular body sharply bent at the joints and his eyes straining toward heaven—expresses movement and anatomical torsion spiraling upward around the vertical axis of his body. The dynamism of the figures is reinforced by the naturalistic background setting with the tree-lined Tiber meandering through the Tiber valley. To heighten the realism the painters have employed aerial perspective so that as the eye moves back in space forms gradually becomes less distinct and more blue in color.

In contrast to all these naturalistic elements the composition has been controlled by a rigorous formal structure. The foreground figures who stand on a circular hill (in turn echoed by a ring of horsemen and foot soldiers in the middle ground) form a triangle or, better, pyramid. The composition is further abstracted and idealized by the high "god's eye" viewpoint, as well as by the exceptionally broad and deep landscape, unprecedented for its time, which fades into a vast expanse of sky silhouetting and monumentalizing the saint and creating a kind of cosmic halo around his head. In other words, in contrast to the anatomical dynamism and violent action of the lower portion of the painting, the underlying geometrical structure moves the eye upward to a realm of increasing breadth, depth, immateriality, and light. What better way to express the ultimate transcendence of the saint for his steadfast faith? In this context the triumphal arch takes on added meaning. On one level it signifies the triumph of the Roman empire. But since it is in ruins, it also suggests the triumph of Christianity over the paganism and the personal triumph of St. Sebastian over his persecutors. The Pucci emblems on the arch, then, would express the hoped-for triumph and salvation of the family through the intercession of the saint.

But in the final analysis the style of the painting is disjunctive. The elements of naturalism do not quite blend with those of abstraction. It will only be with the work of Leonardo that the realism and idealism of this painting will be fused into the seamless, harmonious whole of a High Renaissance style. But the synthesis of Leonardo would be unthinkable without the precedent of this brilliant painting.

—Loren Partridge

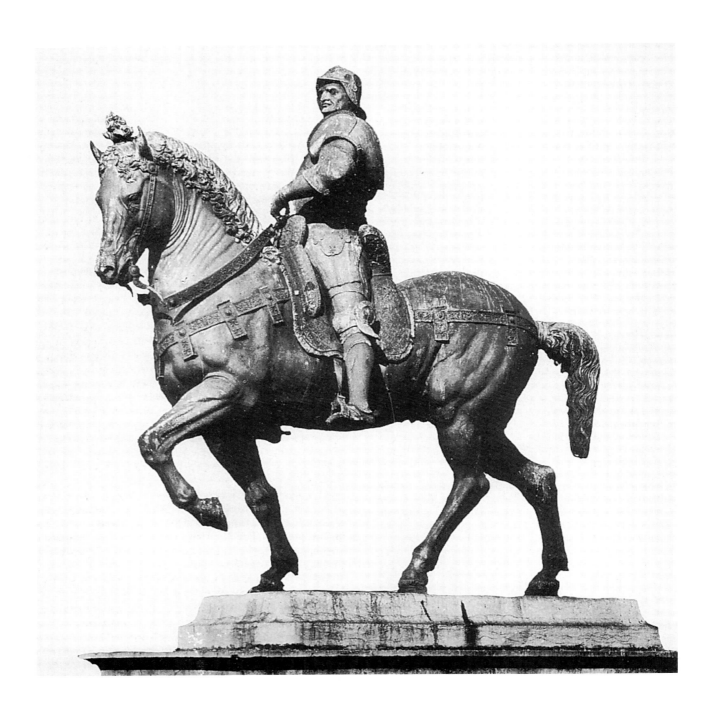

Andrea del Verrocchio (1435–88)
Equestrian Monument of Bartolomeo Colleoni, 1481–88
13 ft. (400 cm.)
Venice, Campo SS. Giovanni e Paolo

The *Equestrian Monument of Bartholomeo Colleoni* in Venice is one of the truly outstanding achievements of one of the greatest sculptors of the early Renaissance. Designed when Andrea Verrocchio was at the height of his powers, he unfortunately "caught a chill and died within a few days" in 1488 in the process of casting the work, according to Vasari. The casting was then carried out by Alessandro Leopardi who also designed the base and completed the monument in 1496.

Bartolomeo Colleoni (1400–76) was one of the most famous *condottieri* or mercenary captains of the Renaissance. He served Venice off and on from the 1430's onward, and his expertise and bravery contributed significantly to what success Venice had in its repeated wars with Milan as it attempted to expanded and consolidated its control over the Po Valley, a process that had begun in the early 15th century. After the Peace of Lodi (1454) which settled its war with Milan, Colleoni was made commander-in-chief of the Venetian forces. He was kept a faithful servant of the republic by periodic gifts of money and land which made him a wealthy man and allowed him to establish an extravagant court at Malpaga outside of Bergamo. When he died, he left 1000 ducats for an equestrian monument with a request that it be placed in the Piazza San Marco. He sweetened his request by leaving the huge sum of 100,000 ducats to Venice for its struggle against the Turks. The senate voted to comply with his wishes in 1479 and held a competition which was won by Verrocchio who entered a life-size wooden model covered with black leather in 1481.

There was certainly little chance that Colleoni's monument would have been erected in Piazza San Marco where it would have detracted from the attention due St. Mark, the doge, and the Venetian government. Nevertheless, it was given an impressive and politically significant location in front of the Scuola S. Marco and along side of the church of SS. Giovanni e Paolo. Since it was dedicated to the patron saint of Venice and guardian of one of his relics, the Scuola S. Marco was one of the foremost confraternities of the city, and SS. Giovanni e Paolo, as the burial pantheon of the majority of the city's doges, was one of its premier churches. The Venetians were no doubt led to choose this important location from a sense of competition with the Milanese, who at that time had a famous ancient Roman equestrian monument, the *Regisole,* on a column outside the cathedral of Pavia, as well as with the papacy, who had the equestrian statue of Marcus Arelius (still believed by many to be emperor Constantine) on a pedestal outside of S. Giovanni in Laterano, the cathedral of Rome. It was a traditional cliché of Venetian propaganda in justification of the city's imperialist policies on sea and land that Venice was a New Rome. By honoring a commander who played a major role in controlling the terraferma and by placing his monument, which emulated those of the classical antiquity, in a major civic space closely associated with the government, Venice declared itself once again to be a New Rome with the Campo SS. Giovanni e Paolo one of its fora.

Already at the beginning of the century the Venetian government had honored with a state funeral and an equestrian tomb in the church of the Frari Paolo Savelli (d. 1405), the hero of the conquest of Padua which marked the beginning of Venetian expansion onto the mainland. As a symbol of continued success in its campaigns against the Visconti of Milan and its further consolidation of control of the Veneto, the Venetian state commissioned Donatello to erect from 1445 to 1450 in the square in front of the church of S. Anthony in Padua his splendid bronze equestrian monument of Erasmo da Narni, called Gattamelata (1370–1443). The statue recalled by its scale, material, style, and placement the *Regisole* and *Marcus Aurelius* in Pavia and Rome. The *Colleoni* was a further extension of this artistic policy of celebrating the power of the Venetian empire and the peace and security it was claimed to provide, but now more boldly in a square in Venice itself.

Just as Colleoni was no doubt competitively stimulated to request an equestrian monument by the fame of Gattamelata, along side whom he had occasionally served, and by the honors accorded him by the Venetian state, Verrocchio on a stylistic level must have been challenged by Donatello's monument to Gattamelata. Verrocchio and Leopardi met this challenge by eliminating all funerary references which characterized the Gattamelata, such as the doors at the base of the monument (symbolic since classical antiquity of death and regeneration), thereby making the Colleoni more simply a monument of military power and victory. The raised front leg in both the Gattamelata and Colleoni monuments derived from the motif of an ancient Roman *adventus,* or victorious imperial entry. But whereas Donatello stabilized this raised leg by placing a cannon ball under it, Verrocchio raised it much higher creating a sharper angle and freeing it from the pedestal. His group thus was supported at only three instead of four points which was not only a much more difficult technical feat but also made a much more dynamic silhouette. Not only does Verrocchio's horse seem to step forward with far greater force, but its muscles are much more sharply defined, quivering with explosive power as its head is more tightly reined in and turned with an almost audible snort. In addition, Verrocchio's rider stands more erect in the stirrups, rotates his upper body and head into a far more dramatic *contrapposto* of seemingly indomitable energy as he screws his features into a scowl of leonine intensity and ferocity. Verrocchio's artistic triumph over such a sublime work as Donatello's Gattamelata is perhaps far more glorious than the victories claimed by Venice and its commander.

—Loren Partridge

Francesco di Giorgio (1439–1501)
The Deposition, c. 1474–77
Bronze; 33¹/₂ × 22¹/₂ in. (85 × 57 cm.)
Venice, S. Maria del Carmine

This bronze relief is the earliest work that can be securely related to Francesco di Giorgio's sojourn at Urbino in the service of Duke Federigo da Montefeltro from 1475 to 1485. Although the relief has lost the frame which identified Federigo as the donor, an early 19th-century guidebook to the churches of Urbino (Lazzari, 1801) records that the relief was donated by the Duke to the Oratorio di Santa Croce in Urbino, a confraternity devoted to the veneration of the Cross, to which he belonged. The relief was probably removed to Milan by the French forces in 1810 or 1813, from where it passed to the collection of Barone Malgrani who donated it to the Church of the Carmine in Venice in 1852. It was then considered to be by Jacopo Sansovino. Internal evidence suggests that the relief was executed between 1472 and 1477, two years after Francesco's move to Urbino from Siena: the little child depicted in the group at the right of the relief is probably Guidobaldo, Federigo's son, born in 1472.

The bronze relief is one of Francesco's most powerful works in this medium, and the subtlety of handling and composition exploits the full range of relief techniques. The relief seems to depict two planes: in the upper, heavenly plane, the Cross appears to hover against a limitless space in which anguished angels, modelled in the lowest *schiacciato* relief, flutter among thin bands of cloud. The lower, earthly plane is occupied by the mourners and attendants at Christ's deposition from the cross. In a wide curve along the front of the relief is stretched the lifeless figure of Christ, his head supported by one of the Marys, with the Virgin tenderly bending over him to the right. His muscular chest and the angles of his outstretched chin and knees, vigorously sculpted in high relief, catch the light from the right (also the source of natural light in the church). The eye follows the curve of his legs up to the seated contemplative figure of St. John, a youthful figure whose restrained pose contrasts strongly with the distraught and hysterical movements of the two women at the foot of the cross. The right female figure, probably the Magdalene, seems to mirror in reverse the movements of the angel diagonally above her, while the forward rushing female figure in the centre echoes the angel hovering above to the right of the cross. A bearded man looks back towards the frantic women, as his bearded companion proffers a pot of ointment towards the figures attending Christ. Behind him is the shadowy figure of a youth. Behind St. John, as if silent attendants to the drama of this scene, are the three figures of the young Guidobaldo, Federigo da Montefeltro (distinguished by his hook nose), and a man who has convincingly been identified as a self-portrait of Francesco di Giorgio. The inclusion of Guidobaldo in this relief helps to date the work to between 1472, the year of his birth, and 1477, since the child depicted can be no older than five years. Although Francesco is not recorded in the Duke's permanent service until 1477, he may have had earlier contacts with Urbino, and the dissolvement of his partnership with Nerroccio in 1475 may have been prompted by his increasing activities at Montefeltro's court.

The attribution of the relief has been problematic, early scholars favouring Verrocchio and Leonardo as possible candidates for the authorship. Schubring (1907) was the first to suggest Francesco di Giorgio as the sculptor, and Hill (1908) supported this by comparison of Montefeltro's portrait in the relief with a medal of the Duke by Francesco in the British Museum. Comparison with other reliefs by him, such as the *Discord* (terracotta, London, Victoria and Albert) and the *Flagellation* (terracotta, Perugia), reinforces the stylistic connection, especially in his handling of drapery which is broken and feverish, and in the exaggerated muscularity of the male figures, evoking Pollaiuolo's engraving of *Battle of Men.* However, rather than searching for stylistic parallels with his own contemporaries (though he must have known Verrocchio's work, and certainly knew Leonardo later in the 1490's), we should note the overwhelming impact of Donatello's sculpture. Francesco left the bronze unchased and rough in some areas, particularly in the areas of low relief, such as the angels, clouds, and two central female figures, but he worked up some of the figures, for instance St. John, into highly polished and smooth figures of almost three-dimensional relief. The combination of rough and smooth surfaces comes close to Donatello's technique, particularly in the high altar reliefs for the Santo in Padua and in the S. Lorenzo pulpit reliefs in Florence. The bearded man looking back over his shoulder might have been inspired by the male heads seen in the background of *Feast of Herod* relief for the Siena Baptistery font (1423–27), and a close source for the distraught central figure can be found in Donatello's relief of the *Deposition* (c. 1455–60, bronze, London, Victoria and Albert) where the Magdalene pulls at her hair in a similarly desperate expression of grief. The Virgin's curious headdress with the veil drawn tightly beneath her chin, is also seen on Donatello's celebrated public figure of *Judith and Holofernes,* a statue that Francesco must have known from visits to Florence. The unfinished appearance of Donatello's *Deposition* panel (the background was probably chiselled away after a casting fault) is also echoed by Francesco: in the Venice relief the unchased metal faithfully translates every subtlety of the preparatory wax, especially in the complicated draperies of the angels and figures. This uneven surface also contributes to the effects of light and shade, and the absence of any architectural setting (as in his two other reliefs) places the action in an imaginary, and boundless space.

The device of including donors in the religious drama had been employed by Masaccio in the *Trinity* fresco (1421, Florence, S. Maria Novella), and in the full-scale sculptural *tableaux vivants* of Guido Mazzoni and Niccolo dell'Arca the religious figures might bear the facial characteristics of the donors, or the donors would be depicted as praying figures attendant at the scene, as here.

Despite the myriad influences that might have affected Francesco, including that of his supposed teacher Vecchietta, the power of the Carmine relief depends entirely on his complete mastery of the medium and his ability to suggest a tangible space occupied by the mourning figures and onlookers, and a space defined by neither time or place.

—Antonia Boström

Bernardo Rossellino (1409–64)
The Tomb Monument of Leonardo Bruni, c. 1446–48
Marble
Florence, S. Croce

The *Libro di Antonio Billi* of c. 1520, written as a guide to the art and artists of Florence, recorded that "it was Bernardo, the architect . . . who constructed in S. Croce the sepulcher of Mess. Leonardo Bruni of Arezzo. . . ." Another book of about the same date, the so-called *Codice Magliabecchiano*, stated that "this Antonio [Rossellino] had a brother named Bernardo, who was an architect and sculptor, who made the sepulcher of Leonardo Bruni of Arezzo in the church of the friars of S. Croce in Florence." The testimony of these two 16th-century sources has served to connect Bernardo Rossellino with what probably is the most important funerary monument of the 15th century. Although no documentation for the erection of the tomb and no contemporary mention of who its sculptor was has been found, the attribution to Bernardo Rossellino has seldom been challenged. Debate, instead, has centered upon the date of execution and upon what portions of the tomb are autograph and what portions were done by other members of the Rossellino shop or by associates (e.g., Antonio Rossellino, Desiderio da Settignano, Buggiano, Verrocchio).

Leonardo Bruni died in Florence on 9 March 1444. His fame as a statesman, historian, humanist scholar, and the State Chancellor of Florence was so great that, three days later, he was given an elaborate public funeral and his body interred in the Church of Santa Croce. Despite Bruni's request for a modest memorial, both the Florentine Republic and the citizens of his native Arezzo determined on a grander monument. That Bernardo Rossellino received the important commission may be due, in part, to his earlier Arezzo connections but, with the departure of Donatello for Padua in 1443 and Michelozzo's increasing absorption with architectural projects, the Rossellino shop had emerged as Florence's principal sculptural firm and the choice was logical. In the absence of documentation, it cannot be determined with absolute certainty exactly when the Bruni Monument was begun. Traditionally, the execution has been assigned to the years immediately following Bruni's death. Some scholars, however, have felt that Bernardo could not have conceived its classical design prior to his stay in Rome in the early 1450's. A careful examination of the sculptural and architectural features and their sources does not reveal anything which would preclude the usual dating. Stylistically, the tomb seems a logical continuation of the classicizing manner which Bernardo had recently displayed in his design for the portal to the Sala del Concistoro in the Palazzo Pubblico of Siena. The fact that he left that doorway unfinished also suggests that had returned to Florence to undertake the important Bruni assignment. The probable dates for the Bruni Tomb Monument are 1446–48, with some finishing touches, perhaps, being completed by members of his shop into the early 1450's.

Bernardo Rossellino's design for the Bruni Monument utilized a shallow wall niche framed by pilasters topped by a semicircular arch, suggesting the triumphal arch of both immortal fame and Christian deliverance. Within this niche is placed Bruni's sarcophagus which, in turn, supports a brocade-draped bier upon which rests the effigy of the humanist statesman. A tondo containing the Madonna and Child and flanked by half-length angels appears within the arch above the bier, while two large angelic putti, bearing the Bruni *stemma*, climb the crest of the archivolt. In arriving at his design, Bernardo drew upon a variety of possible precedents. The idea of a wall sepulcher and, indeed, of one with a raised bier and recumbent effigy may be traced back to several 14th-century tombs in Rome done by members of the Cosmati School as well as to the recently executed Baldassarre Coscia and Brancacci Tombs of Donatello and Michelozzo. Any relationship to Michelozzo's Aragazzi Tomb in Montepulciano must remain hypothetical due to the dismembered state of that monument. What made the Bruni Tomb so unique and what established it as the "standard" upon which so many later Renaissance tombs (including that for Carlo Marsuppini, executed a few years later by Desiderio and also in Santa Croce) were to be patterned was its sense of unity.

The spatial qualities of the Bruni Tomb also were novel. It did much the same for architectural sculpture as Masaccio (and Brunelleschi?) had done for painting in the fresco of the Trinity in Santa Maria Novella. The impression given in the Bruni monument was not that of the old attached and projecting wall tomb but rather of a spatial area opening off the nave of the church. The Bruni Monument is a visual side chapel but it is a chapel dedicated to the spirit of Renaissance Humanism. Instead of an altar, this "chapel" contains the bier of a civic leader and scholar. Yet the spirit of religious redemption remains in the image of the Madonna and Child above. Although it is true that Bruni does not hold a Bible in his hands but one of his own works, he has closed it and has given his own last thoughts over to heavenly contemplation. The design of the Bruni Tomb is closely tied to the humanist's own emphasis upon the concept of enduring earthly fame as a complement to the Christian belief in spiritual immortality and, as such, offers a superb demonstration of the new ideals of the Italian Renaissance.

The Bruni tomb was a tour de force in classical devices and the Florentine Renaissance interpretation of ancient architectural decoration. Significantly, it displayed Bernardo Rossellino's interest, as yet only at second hand, in the *maniera all'antica* and showed his uncompromising efforts to master classical sculptural and architectural vocabulary. Even prior to his extended stay in Rome from 1451 to 1455 and his close contact with Alberti and the monuments of antiquity, Bernardo Rossellino had demonstrated a thorough appreciation for the classical revival. This sympathy for the meaning of classicism extended beyond the details of decoration to an understanding for the harmonious relationships, balance, order, stability, and grandeur found in the best products of antiquity, qualities also evident in the finest architectural accomplishment of the artist's early years in the nearby Spinelli Cloister of Santa Croce (1448–51) and predicting his work for Pope Pius II at Pienza (1459–64).

—Charles R. Mack

Antonio Rossellino (1427–before 1481)
The Tomb of the Cardinal of Portugal, 1461–66
Marble
Florence, S. Miniato al Monte

Bibliography—

Hartt, Frederick, G. Corti, and C. Kennedy, *The Chapel of the Cardinal of Portugal 1434–1459 at San Miniato al Monte in Florence,* Philadelphia, 1964.

The masterpiece of the Renaissance sculptor Antonio Rossellino was the tomb of the Cardinal of Portugal in the church of San Miniato in Florence. It honors James, a prince of the Portuguese royal family, who was made a Cardinal when he was only 22 years old, partially because of his extraordinary piety, sincerity, and simplicity. Serving brilliantly as a statesman and ambassador of the Pope, he became seriously ill with tuberculosis when visiting Florence in 1459, and died there on August 27 at the age of 25. In his Testament he expressed the wish to be buried in San Miniato, a church of the Olivetan Order with which he had special connections. Bishop Alvaro Alfonso, the young Cardinal's mentor and friend, was appointed his executor and supervisor of the chapel and tomb built in his honor. Although most of James's personal wealth was left to the poor, his royal relatives had invested a considerable about of money in the Florentine Monte del Comune and these funds were dedicated to constructing his magnificent memorial. Documents detailing the daily progress of the construction of the tomb and chapel which contains it were discovered by Corti (published in Hartt, Corti, and Kennedy) and Apfelstadt.

Work on the chapel, attached to the north flank of San Miniato, started almost immediately after the Cardinal's death in 1459. Designed by Antonio Manetti, the actual carving of the architectural details was undertaken and supervised by Giovanni Rossellino, an elder brother of Antonio Rossellino. In no other monument of the Renaissance is the work of so many artists so brilliantly united: the chapel contains paintings by Baldovinetti and the Pollaiuolo brothers, terracotta ceiling decorations by Luca della Robbia, stained glass and other furnishings by major artisans, and the magnificent tomb by Antonio Rossellino. They all provided a colorful jewel-like setting for the remains of the young Cardinal.

When he signed the contract for the tomb in 1461, Antonio had several precedents in Florence from which to draw ideas—principally the tombs of Pope John XXIII, Leonardo Bruni, and Carlo Marsuppini—but his design shows important differences and new ideas. Set into a niche in the wall, there is no projecting architectural structure like that gracing the other tombs; and light and shade play gracefully around the figures. The marble curtains from the John XXIII monument are reintroduced, but are drawn aside and less prominent. Angels are soaring rather than static, and winsome putti play on the sarcophagus rather than stand beside it. The usual tripartite division on the wall behind the figures is replaced by a deep red porphyry slab. Antonio imitated—at the Cardinal's request—an ancient Roman sarcophagus which stood in the portico of the Pantheon in Rome. Although Rossellino was helped in the actual carving by his older more famous brother, Bernardo, and several other assistants, documentary and stylistic evidence leaves little doubt that Antonio was the designer and leading master.

The effigy of the young Cardinal, dressed as a deacon and wearing a bishop's mitre, is one of Antonio's most touching figures. Soft gradations of light seem to caress his body and face whose features were subtly modelled from a death mask supplied by Desiderio da Settignano; the face is both a realistic portrait and a superbly organized work of art. The same harmonious control and organization is seen above in the flying angels who hold a wreath enclosing the Madonna and Child who bless the recumbent Cardinal lying below. Two more angels reverently kneel on pilasters framing the sarcophagus. One holds the crown of eternal life and is clearly by the more conservative Bernardo, while the ecstatic angel on the right who once carried the palm of victory (now lost) displays in its delicately crumpled drapery, shimmer of light, and dynamic movement the brilliance of Antonio's personal style. Deriving from classical models, the charming little boys on the lid of the sarcophagus fondle the drapery on which the Cardinal rests and are among Antonio's most delightful creations. Both brothers seem to have carved the base, but the classical motifs were designed by Antonio.

The saintly Cardinal who was beloved by the people of Florence, the wise and faithful Bishop Alvaro who efficiently supervised all the details, and the generosity of the royal relatives provided the purpose and practical possibilities of the construction of the monument. But it was Antonio Rossellino who created it. Here is the clearest evidence of his ideals and style: refined volumes, gentle movement, technical mastery, harmonious proportions, subtle shading, and most of all the serene expression of spiritual beauty in this masterpiece of Renaissance sculpture.

—Harriet McNeal Caplow

Desiderio da Settignano (1428–31—1464)
Tabernacle of the Sacrament, c. 1461
Marble
Florence, S. Lorenzo

Bibliography—

Kennedy, C., *The Tabernacle of the Sacrament,* Northampton, Massachusetts, 1929.
Cardellini, I., "Desiderio e il tabernacolo di San Lorenzo," in *Critica d' Arte* (Modena), 3, 1956.
Parronchi, A., "Sulla collacazione originaria del Tabernocolo di Desiderio," in *Cronache di Archeologia e di Storia dell' Arte* (Catania), 4, 1965.

Unquestionably one of the most decoratively delightful sculptural productions of the early Renaissance, this marble tabernacle for the host consists of a pilaster framed aedicula within which is a spatially receding barrel vault leading to the *sportello* doorway of the sacramental receptacle. Above, within a lunette arch, two angels flank a free-standing image of the Christ Child surmounting the sacred chalice. To either side of the aedicula stand statues of angelic youths clasping tall candelabra. An antependium relief depicts the Lamentation.

The history of this tabernacle is difficult to reconstruct. That Desiderio was at work on it in 1461 is documented. It may have been intended for Brunelleschi's Old Sacristy of San Lorenzo but was installed, instead, in the Sacramental Chapel dedicated to the Medici saints, Cosmas and Damien, located in the left transept of the church proper. Another, and perhaps more acceptable, view based upon a different interpretation of the sketchy documentary record, holds that the tabernacle originally was installed in the main choir chapel. In any case, in 1677 it was removed from its original location, dismembered, and reinstalled in the Neroni family chapel in the right transept. In this installation, the components of the tabernacle were rearranged, with the flanking youths placed in reversed positions, facing outward. Console blocks were used to support the tabernacle and the whole was set against a background of colored marble panels of typically Florentine Baroque design. After World War II, the tabernacle was again transferred, this time to the right side of the nave and set against the wall of the Corsi family chapel across from Donatello's Epistle Pulpit. At this time an attempt was made to clarify the original compositional arrangement, but it is apparent that a number of the architectural elements have disappeared.

Desiderio's tabernacle represents a decorative elaboration of the example executed in 1449–50 by Bernardo Rossellino for the chapel of the Women's Hospital of Santa Maria Nuova (now in San Egidio). From Rossellino's simpler and far smaller version, Desiderio picked up the concept of the spatially receding chamber and the idea of adoring angels who enter from the sides. Rossellino's angels walk with a calm serenity; Desiderio's rush forward with draperies fluttering with the pictorial excitement of Fra Filippo Lippi. In Rossellino's design the little archway above the *sportello* was occupied by angels worshipping the Host; Desiderio uses his space to display a small relief of God holding an open Bible. The chalice of the host is elevated by Desiderio to the lunette above and is used as a pedestal for a blessing figure of the Infant Jesus. Vasari notes that this statue "was taken away and is placed today on the altar at Christmas time as being a marvelous thing." Vasari adds that a replacement for the tabernacle was carved by Baccio da Montelupo (1469–1535). Although most authorities regard the present tabernacle figure to be Desiderio's original, others believe that it remains the copy of Baccio and that Desiderio's figure is really the one in the Cleveland Museum. Two enraptured angels crouch in adoration below the image of the Christ Child. In all these figures, the open-mouthed expressions are typical of Desiderio's display of emotional immediacy. The two youthful torchbearers on either side of the niche are reminiscent of those used earlier for Desiderio's tomb monument for Carlo Marsuppini in Santa Croce. They stand in a relaxed weightshift pose, one hand on hip and the other embracing delicately carved candelabra. The drapery passages of these figures reveal Desiderio's sensitivity for surface modulations and love for decorative detailing.

In the present reconstruction, the antependium relief of the Lamentation seems rather out of place but its association with the tabernacle has not been doubted. Actually, it must be seen as forming an essential part in Desiderio's iconographic program. The dead body of Christ forms a base upon which his spiritual body is contained and above which the Infant Saviour stands in Benediction. The Lamentation provides a fine example of Desiderio's talent for low relief carving but does not display the *rilievo schiaccato* which he often used in his sculptural panels of the Madonna and in the Saint Jerome in Washington. Although the possibility of the intervention of an assistant can not be excluded, the facial expressions of the Madonna and Saint John (perhaps just a bit cloying in intensity) demonstrates the appreciation of Desiderio by Raphael's father, Giovanni Santi, who spoke of "the dreamy Desiderio so gentle and beautiful."

—Charles R. Mack

Benedetto da Maiano (1442–97)
S. Croce Pulpit, 1472–75
Marble
Florence, S. Croce

The S. Croce pulpit marks the high point of Benedetto da Maiano's career in Florence. Commissioned by the wealthy Florentine banker Pietro Mellini, the pulpit marked the patron's intended burial place in S. Croce. Completed by 19 May 1485, when Pietro mentioned it in his last will and testament, the pulpit is the last of his documented commissions to Benedetto, which included a meticulously detailed portrait bust in 1475 and a tabernacle for the Badia delle SS. Flora e Lucilla at Arezzo in 1478. At S. Croce, where Mellini had served as an Operaio in 1472 and had secured patronage rights to a chapel in the cloister, Benedetto provided a cunning design for pulpit and tomb. Mellini's burial place was suitably marked on the floor by an inlaid marble plan of the pulpit above it. His coats of arms were emblazoned in bronze on the floor and in marble on the basket weave corbel at the base of the pulpit itself. The identification between patron and pulpit was unmistakable. But since the major focus of the pulpit lay higher up in its five carved reliefs and the messages preached from behind them, Benedetto seems to have been accomodating Mellini's modesty in refraining from any further inclusion of his arms—this in bold contrast to much of Quattrocento practice, which even allowed patrons' coats of arms to be displayed on priests' liturgical vestments. Here, instead, the pulpit was pre-eminent.

Handsomely carved and partially gilded colonettes, corbels, friezes, red marble niches with five statuettes of Virtures (Faith, Hope, Charity, Justice, Fortitude), and reliefs of significant moments in Franciscan history (The Approval of the Rule, St. Francis before the Sultan, The Stigmatization, The Verification of the Stigmata, and The Beheading of Franciscan Martyrs) made the work particularly splendid. In the mid-16th century Vasari still marveled at its daring structure as well. Unlike the earlier pulpit by Brunelleschi and Buggiano at Santa Maria Novella or the Maiano shop's own wooden pulpit at the Collegiata in San Gimignano, the S. Croce work has no exterior stairs. Instead, Benedetto excavated a staircase through the center of the nave pier to which the pulpit is attached. Cleverly reinforcing the lower part of the pier with an inconspicuous layer of stone and supporting the major weight of the pulpit on cantilevered brackets and a corbel, Benedetto obviated any need for his patron to acquire rights to preexisting tombs at the east and west of the pier. At the same time, the full integration of the pulpit into the very structure of the church must have struck the resident friars as a particularly felicitous emblem of the centrality of preaching and teaching in the Franciscan order.

The present form of the pulpit seems to have evolved over the period of the commission. The inventory taken of Benedetto's shop at the time of his death lists six terracotta models for the S. Croce narratives, and the sixth, unused relief can be identified with a terracotta in East Berlin showing the Dream of Innocent III. It is similar in style and scale to three fullsized models, preserved in London, which were used for the pulpit. Even then, however, the terracotta reliefs are each 20 percent smaller than the finished marbles, indicating that a reduction in the number of projected reliefs from six to five led to a enlargement of the finished works. Detailed examination of the reliefs has shown that certain background details were carved in the exact same dimensions as the models but that foreground figures and the architectural settings were enlarged. Thus, Benedetto enhanced the sense of spatial illusionism in his finished work, producing images that clearly inspired Ghirlandaio in the mid-1480's at the Sassetti Chapel in Santa Trinità.

The choice of subjects for Benedetto's reliefs largely follows the precedent of Giotto's Bardi Chapel in S. Croce. The central position of the Stigmatization on the pulpit parallels Giotto's placement of this scene over the entrance to the Bardi chapel. Giving witness to Francis's total identification with the crucified Christ, the Stigmatization visually reinforced the dedication of the church to the Holy Cross. Along with the Verification of the Stigmata inside the chapel and to the right of the central relief on the pulpit it stressed the veracity of Franciscan belief in Francis as a kind of second Christ.

In both chapel and pulpit the Approval of the Rule showed that the Franciscan order had the full institutional sanction of the papacy, and the scene of Francis Before the Sultan demonstrated the saint's great faith and the Franciscan commitment to preaching and conversion.

The only scene unique to the pulpit, The Beheading of Franciscan Martyrs, reinforced this last message. The number of Franciscans in the relief does not correspond exactly to accounts of either the famous martyrdoms at Ceuta or Marakesh in the 1220's, but the canonization of the Marakesh group by the Franciscan pope Sixtus IV in 1481 does add a timely significance to the portrayal. It was the sight of the bodies of the Marakesh martyrs that led the most famous of Franciscan preachers, Anthony of Padua, to join the order, so the scene was particularly appropriate to a pulpit, whose preachers most certainly emulated Anthony. In addition, Sixtus IV's repeated, though unsuccessful, calls for a crusade against the Turks would have found important historical precendent in the martyrs' missionary activities with the infidel in Morocco.

Splendid in its style, daring in its structure, timely in its iconography, the S. Croce pulpit was unsurpassed by any other marble pulpit in Renaissance Italy.

—Gary M. Radke

Guido Mazzoni (c. 1450–1518)
Lamentation, c. 1486–92
Terracotta
Naples, S. Anna dei Lombardi

On 26 February 1489, Alfonso of Aragon, Duke of Calabria and heir apparent to the throne of Naples, reimbursed his Florentine bankers for 25 ducats advanced to Guido Mazzoni in Modena to enable the artist to move to Naples. In December of the same year, Mazzoni received 50 ducats "in partial payment of a greater sum owed him for certain figural works [*certi lavorj de inmagini*] for my Lord the Duke." And three years later, in December of 1492, Guido was paid another 50 ducats in partial settlement of "the price of a sepulcher that he has made for the said Lord, which still has to be given the last, finishing touches."

These, and other, more routine records of his monthly salary of 16 ducats and payment of rent for a house near the ducal residence in Naples, mark the chronological and financial "terms" of our knowledge of Mazzoni's masterpiece, the *Lamentation over the Dead Christ,* modelled in terracotta for the future Alfonso II at the monastery that the Aragonese rulers of Naples were then transforming into a dynastic mausoleum, Monteoliveto, better known as S. Anna dei Lombardi. Alfonso had probably summoned Guido to Naples expressly to create this ensemble; as military alley of Ercole I d'Este in the 1480's, the Duke of Calabria had been often in Emilia, and must have see Mazzoni's Lamentation group in Ferrara (Church of the Gesù), which incorporates portraits of Ercole and his duchess, Eleonora d'Aragona, Alfonso's sister. He could also have seen the *Bewailings* by Mazzoni in Modena (S. Giovanni Battista), Busseto (S. Maria degli Angeli), and Cremona (S. Lorenzo, now lost). Replication of impressive, modern works seen elsewhere was in fact a feature of Alfonso's plan for the artistic renewal of Naples: in the same church of S. Anna dei Lombardi, Giuliano and Benedetto da Maiano had recreated Florentine funerary monuments for other members of the Neapolitan court.

By the time of his transferral to Naples, Guido Mazzoni was a mature master, uniquely skilled in his chosen *genre.* In at least five earlier *Bewailing* groups, Guido had perfected the format he would use: a monumental tableau of eight lifesize, naturalistically pigmented figures in terracotta, modelled and fired in horizontal sections and assembled *in situ,* articulated in the full round and probably meant to be seen in a wide, deep niche from multiple viewing angles. The dramatic moment Mazzoni depicted was distinct from that standard in French and German ensembles: neither the *Deposition* nor the *Entombment,* but an imagined, highly lyrical interlude be-

tween these two historical episodes when seven mourners pause to vent their grief, employing a conventionalized sign-language of sorrow such as must have been used by professional *pleureurs* from antiquity down to the Renaissance. Closely related to religious theater, Guido's treatment of this theme had particular effectiveness as a dramatic "excerpt" because of the detailed realism of his style: his focus on gesture and facial expression sharpened the lifelike rendering of hands and faces to give a 15th-century equivalent of the cinematic close-up.

All the early sources confirm that Mazzoni included a portrait of Alfonso II in this group, one of several "breathing images of the faith of Aragon" (as an inscription in the chapel, now lost but recorded by a 17th-century chronicler, stated). By means of this portrait, certainly to be identified with the fat, kneeling man with shriven pate and a purse at his belt, Alfonso "commended himself in clay, as a witness to this faith of adamant" (as the lost inscription went on) to the prayers of the Benedictine monks who would pray there for the repose of his soul. The disturbing realism of this likeness is based on life casts, but Mazzoni has alterred the data furnished by the mechanical process, balancing mimetic fidelity with powerful emotional interpretation. Before figures like this, one is reminded that effigies in 15th-century *ex votos* had quasi-legal importance: they were testimonial instruments whose validity depended upon the "signature" provided by factual depiction of the donor.

This dimension of the Naples *Bewailing* must have been still more striking when the figures had their original coloring. The recent cleaning of a bust of a child attributed to Mazzoni (Windsor Castle) revealed the astounding skill with which he painted flesh tones, eyes, and fabric; the aesthetic distance that the modern removal of polychromy from the Naples figures creates—and the confusion felt before other of his groups, clumsily repainted—would originally have given way to a response of utter conviction that the richly robed, lifesize and lifelike, "breathing" figures seen across banks of votive candles, in their niche as if on stage, were not statues but living men and women. For a moment the viewer was meant to lose his sense of where "reality" ended and "art" began, and enter a world of ideally profound grief at the archetypal suffering of the Savior. Such a total illusion of trans-historical presence was indeed Mazzoni's great gift.

—Timothy Verdon

Niccolò dell'Arca (c. 1435-40—1494)
Lamentation, 1463
Terracotta
Bologna, S. Maria della Vita

A 17th-century digest of documents states that the "Ospedale della Vita" in Bologna paid "Niccolò di Puglia" for a consignment of a "sepolcro" on 8 April 1463. Payment was made by Antonio Zanolino, a cloth merchant who was also a member of the lay confraternity that ran the hospital, the "Battuti della Vita," and Rector of the hospital itself. Other documents record rent payments for a workshop for Niccolò, who is described as a terracotta master; these extend from 1462 through 1463. Finally, a Papal Bull issued by Paul II in 1464 offered an Indulgence to all who would contribute to the upkeep of the "sepulcher" and visit it in a spirit of penitence, after confessing their sins, at Christmas, Easter, Pentecost, and on the feast of St. Ranieri. Recent research has established that is 1463 Easter fell on April 10: the day the sepulcher was delivered to the hospital, April 8, was therefore Good Friday.

These facts suggest the date, circumstances, and specific function of Niccolò dell'Arca's *Lamentation,* which is still to be seen in the (much altered) church of S. Maria della Vita. There can be little doubt that at least the nucleus of the seven-figure ensemble was completed by 1463, by an artist whose previous activity was related to the culture of southern Italy. These lifesize figures—of the dead Christ, Mary his mother, three other Holy Women (Mary of Magdala, Mary Cleopha, Mary Salome), John the Beloved Disciple, and Nicodemus—were made for pious layfolk who, moved by Christian compassion, ran a small "hospital," probably more a hospice for the aged than a medical institution. The sculptural group, which depicts grief with unparalleled violence, was intended to be seen in a state of heightened spirtual sensitivity, at privileged moments in the believer's religious life—Christmas, Easter, etc. Significant traces of the original pigmentation are still visible on several of the figures, especially the St. John, and so the aesthetic distance confered today by loss of color would not have been possible; we can only imagine the impact of this frenzied, lifelike chorus upon the members of the flagellant confraternity, the "Battuti," when it was "unveiled" on Good Friday, 1463!

Some scholars have found it hard to accept that such virtually expressionistic interpretation of the subject, and a number of specific stylistic elements in this group, can have been articulated as early as 1463. Since the same features are central to the style of local Emilian artists in the 1470's and 1480's—Francesco del Cossa and Ercole de'Roberti in painting, and Guido Mazzoni in sculpture—these art historians theorize that Niccolò's group in S. Maria della Vita is a foreigner's response, vehement and mannered, to the pre-existent "national" style; for them the documents cited above refer to a lost group, replaced in the mid-1480's with the present figures. Another possibility exists, which would reconcile the two positions in some measure: a few of the figures we see today may have been consigned in 1463, others added later, either as replacements or to amplify the group. In their movement, gestures, drapery, and mood, two of the Holy Women do appear to belong to a more elementary phase of Niccolò's art; the other two Maries, though, represented as running toward Christ's corpse with draperies flying, are among the supreme masterpieces of terracotta sculpture in any period, brilliant in their manipulation of material and dramatic power.

The careful cleaning of these figures in the mid-1980's revealed these hitherto unsuspected qualities. The two "later" Maries are quite simply the most voluptuous female figures that 15th-century European art produced; the ample proportions of their bodies, and the skill with which "wet" drapery has been used to model breasts, hips, thighs—together with the figures' violent expressiveness—suggest that Niccolò's understanding of Hellenistic sculpture (dating presumably from his years in southern Italy) surpassed that of any other early Renaissance master except Donatello, with whose comparable expressive bronze pulpit reliefs in Florence (S. Lorenzo) the "early" *Lamentation* figures are in fact contemporary. In those terms it is quite likely that this group significantly influenced the following generation of Emilian artists, including Guido Mazzoni.

It is important to distinguish Niccolò's single *Lamentation* from the several versions of the theme made by Mazzoni. In his dramatic tableaux as in portraiture, Guido Mazzoni maintained a careful balance between poetic recreation and "unedited" reportage. By contrast, Niccolò wilfully shattered that balance, capitalizing on inherent sensationalism of subject to generate abstract stylistic energy. In Mazzoni's groups, "style" is used covertly, to intensify experience, the artist taking pains never to compromise the illusion of a world coextensive with our own, peopled by real men and women. In Niccolò's group, however, not belief but sensation is the desired effect: his "maenads" are technical *tours de force,* but outside the pale of visual or emotional experience—dream creatures, whose berserker frenzy exalts and disturbs us. Where Mazzoni sought to be self-effacing, Niccolò dell'Arca invades, overwhelms the viewer's sensibilities; the one figure in the group that clearly aims at literalness, the kneeling Nicodemus, often thought to be a portrait of the artist, is prosaic alongside the fantasy creatures of the scene. If, as has been thought, this figure was originally balanced by another "donor" portrait, representing Joseph of Arimathea, the overall effect would have been of two real people present at, but not participating directly in, a visionary instant of ideal sorrow.

—Timothy Verdon

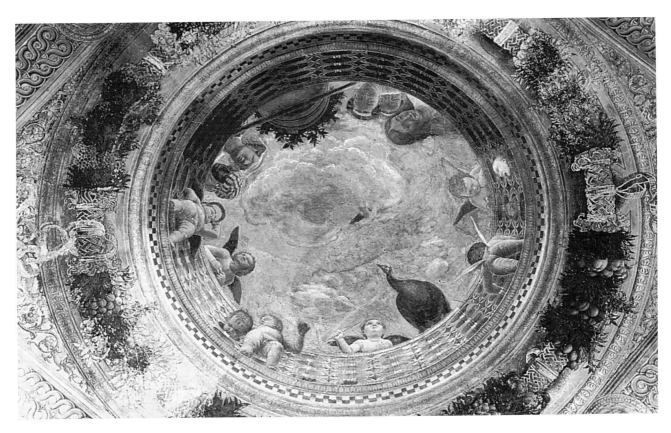

Andrea Mantegna (1430–31—1506)
Camera degli Sposi, completed 1474
Frescoes
Mantua, Ducal Palace

Bibliography—

Milesi, R., *Mantegna und die Reliefs der Brauttruhen Paolo Gonzagas,* Klagenfurt, 1975.

Mantegna worked for the Gonzaga family in Mantua from the late 1450's. His most famous extant commission in that city was the series of frescoes on the wall and ceiling of the bedroom of the Duke and Duchess. Finished in 1474, these pictures represent Mantegna's mature style and also provide us with excellent examples of the monumental developments in Renaissance painting of the 15th century.

The Camera degli Sposi is a square room with three lunettes on each side and a vaulted ceiling resting on corbeled brackets. There are two corner windows, architraves over the two doors and a classical frieze on the mantel. Mantegna's painted decoration blends real space with pictorial space so convincingly that at certain points it is difficult to distinguish between them. The main wall scenes depict members of the Gonzaga family and the return of Cardinal Francesco as if they take place on a narrow balcony projecting from the wall. The many portraits among these figures suggest the influence of Flemish art, especially in the linear facial patterns. Other scenes depict the family servants, pages, horses, dogs, and putti. The landscapes are typical of Mantegna's radical diminishing of size to create the impression of great distance without losing the clarity of the forms. The effect of these frescoes is to expand the illusion of space beyond the confines of the room's architectural reality and also to make the family perpetually present through their portraits.

Even more convincing than the illusion of space behind the walls is the occulus in the ceiling. The vault itself has a gold background with painted architectural and sculptural decoration. In the center of the vault, painted to simulate a round opening in the roof, is one of the most original 15th-century images. As we look up, we are confronted by figures looking down; women seem to converse, a pot of flowers balances precariously between the ledge and a cross-bar, an irate putto has caught his head in a hole in the wall and cries in outrage at his predicament. The putto, who seems about to drop an apple on the heads of those beneath him, is seen in the most radically foreshortened view which is characteristic of the artist's condensation of space and monumentalization of figures.

The illusionism which Mantegna has achieved in the Camera degli Sposi is an elaboration of the Renaissance interest in replicating natural reality on a two-dimensional surface. The illusionistic integration of painted and real architecture occurs in many of Mantegna's altarpieces as well as in the Gonzaga bedroom, although here it is on a grander scale. These frescoes, in any case, are an impressive expression of the Renaissance conception of a painting as a projection through a window into a natural space.

—Laurie Schneider

This large painting may be the single most complex expression of 15th-century Italian Renaissance humanism. Because of its charm and synthetic nature, it is also one of the most popular but baffling iconographic puzzles from the period. The explanations posited on its meaning are legion. It can be dated on the basis of style to a relatively early stage in Botticelli's career. It is very close stylistically to the three Sistine Chapel frescoes and the *Adoration of the Magi* (Washington) that he painted in Rome. Together with his slightly later *Birth of Venus* (Florence) the *Primavera* was seen at the Medici Villa of Castello in the mid-16th century.

The *Primavera* is one of the few large secular paintings to have survived from 15th-century Florence. Because Botticelli did not have a specific prototype available for his subject, he and his unknown patron, together with an unknown advisor(s) invented the sophisticated program, based on an intriguing pastiche of literary and visual sources.

Botticelli painted nine figures, the exact number Alberti recommended for an *istoria* in his treatise *On Painting*. For the general layout, he used three basic models combined in a unique fashion. First of all, he modified a common religious formula, the *sacra conversazione* with its Madonna and court of saints, just as in the *Birth of Venus* he adapted the standard composition of the Baptism of Christ. To this format he added ideas gleaned from tapestries and classical sarcophagi or reliefs. In addition, each of the figures had a number of ancient and Renaissance visual and literary sources. While there is a general concensus about the identity of the figures in Botticelli's painting, the meaning of the *Primavera* has been the cause of much debate. There is agreement, however, on two points: that the painting is set in spring and that it is ruled over by the goddess of love and beauty, Venus.

The setting is the Garden of Venus or the Garden of the Hesperides, where spring, burgeoning with flowers reigns eternal. The recent restoration of the panel has revealed the setting to be on a high, wooded plateau. The figures stand in a shallow space before a row of orange trees. In one poetic tradition the fruit of this garden was the orange, which had been a symbol of the Medici since the early 15th-century.

At the center of the tripartite work is Venus, whose gesture of welcome greets the viewer. She is dressed very decorously, rather like a Madonna, and is surrounded by a mandorla of myrtle, symbolic of Venus. Her clothing allies her to the ancient Greek/Roman goddess of gardens, Aphrodite/Venus Genetrix. This identification also stresses her nutritive nature, demonstrated graphically in her swollen abdomen. Her garments are neither classical nor contemporary, but rather fanciful creations of the artist; they contain symbolic elements, like the golden flames of love that decorate her bodice. Above flies her son Cupid, god of love, who shoots a burning arrow toward the central member of the three Graces at the left. His posture and proportions derive from ancient reliefs, while his blindfold indicates in Neoplatonic terms that he is the highest form of love.

The lefthand group consists of the three Graces, considered handmaidens of Venus and companions of Mercury, and Mercury, god of eloquence, sometimes considered the father of Cupid. The rhythmically connected Graces depend on Seneca's description (echoed by Alberti) as clothed. They seem to reflect the ideas of Marsilio Ficino—the Medicean Neoplatonic philosopher and translator of Plato—about the Graces,

written in a letter to Lorenzo di Pierfrancesco. These elongated, frankly sensuous but refined figures are dressed in revealing diaphanous garments. Their intricately arranged locks may reflect Alberti's comments on the seven movements of hair, while their graceful dance is one of Botticelli's most beguiling images. Accompanying the Graces is Mercury, dressed in winged boots, a helmet, and a cloak with a pattern of gilt flames (again, the flames of love, perhaps from Ficino's *De Amore*). Mercury was also important in Neoplatonic thought as being the conductor to the divine realm. His sword has a hilt of laurel leaves, alluding to Lorenzo, as well as handles of lilies, emblematic of Florence. Mercury turns away from the rest of the composition, looking up and moving his caduceus in the cluster of clouds at the upper left.

On the right side of Venus are three figures arranged in succession. The first is winged Zephyr, the West Wind, who flies down through laurel trees. His cheeks are inflated with warm air as he lasciviously embraces the voluptuous nymph Chloris. His gentle but violent intentions are resisted by the fleeing nymph who looks back at her pursuer in horror. Botticelli derived his Chloris from a reversed image of Dejaniera in Pollaiuolo's *Rape of Dejaniera,* underscoring the early dating of the panel. Under the influence of Zephyr's erotic onslaught, flowers issue from Chloris's now fecund mouth. In literature, after her rape, Zephyr marries Chloris who is then transformed into the Goddess Flora; Botticelli has depicted this metamorphosis by connecting the three figures. He has clothed Flora, associated with the Garden of the Hesperides, in a garment embroidered with flowers (nearly identical quattrocento materials still exist.) Wreathed in flowers, Flora scatters blossoms in a generative act as she strides forward, smiling shyly and looking out at the viewer. The literary source for the right half of Botticelli's painting is assuredly Ovid's *Fasti,* a poetical calendar of the Roman year which also describes the Floralia, a licentious festival of flowers in May. The overtly joyful yet restrained mood of the painting, together with its carnal nature, find their contemporary literary equivalent in Poliziano's poem *Stanze per la Giostra,* which may also have suggested a number of images for the work. The Florentine lily is painted prominently at the lower right in the carpet of flowers, as if to underscore emblematically the importance of the painting to Florence.

Scholarly exegeses on the painting seem to cluster into two groups: (1) those which view the panel with its pagan and classical content as an allegory of spring and/or marriage, and (2) those which interpret it in light of Neoplatonic thought or astrological theory. However, while the painting is pervaded with eroticism, it also contains abstract qualities endemic to Botticelli's art and well-established intellectual ideas that seem to deny a monodimensional approach.

Botticelli's composition unusually reads from right to left in a W form, with Venus and Cupid at its apex. The W descends on the right with a blatantly baser form of love, lust, and ascends toward the unseen heights pointed out by Mercury's cadeceus on the left. This motion corresponds to that proposed in one theory that claims the painting is a depiction of the season of spring organized in accordance with the Roman rustic calendar, from the beginning of spring in March to its departure in May. This theory depends on the original rural location of the painting at the Villa of Castello. Certainly the right to left progression does read like the motion of the zo-

diac, so that it is not surprising that an astrological interpretation has also been suggested. An alchemical interpretation of the work, dependent on an allegory of marriage and physical and spiritual love, has also been advanced. Several individuals base their varied interpretations on the fact that the painting may have been a marriage picture made for Lorenzo di Pierfrancesco. The marriage theory would explain much of the love imagery of the *Primavera,* its frankly sensuous content in harmony with the contemporary attitudes toward marriage, as well as the languidly suggestive but sublimated sexuality of Botticelli's figures. Another recent interpretation focuses on the plant and flower symbolism, which supports the interconnected Neoplatonic themes of the search for truth and love, whose growth from the baser to the higher forms reads from right to left.

Certainly one key to the understanding of the painting is Florentine humanist thought, which ran through the aristocratic fabric of the society during the early 1480's. The influence of Ficino and the Neoplatonists was very marked in the circles of both Lorenzo do Pierfrancesco and Lorenzo the Magnificent. The Neoplatonists organized reality on several planes; the earthly, being the lowest, was but a pale reflection of the divine. The result of this stratified universe was a method of layering meanings and their consequent interpretations. Art communicated a message pertinent to the natural world, and through it, the observer was led to perceive some higher spiritual truth.

Meant to be discussed and read on levels. Botticelli's painting contains a network of overlapping associations drawn from knowledge of classical and contemporary literature. It also contains concepts that were more clearly attached to the figures in the Renaissance but for us are difficult to reconstruct precisely. In creating a programme, the advisor(s) would not necessarily be bound by one source, but could draw liberally on several. Paintings like the *Primavera* were meant to challenge the imaginative and intellectual faculties of the patron and his associates. Therefore, a search for a single text which fully explicates the painting would be fruitless. In addition, an important tenet of Neoplatonic philosophy was that when truth appeared on earth it was obscured by the mystery of revelation. Each figure would be veiled in multiple meanings so that truth would remain an eternal revelation. Love was central to Neoplatonic philosophy of the 15th century, and the lover through a contemplation of Venus—there were two according to Ficino—could rise to the contemplation of divine love, beauty, and truth.

In this manner, the *Primavera* does depict in classical guise an allegory of spring and fecundity, with the appropriate allusion to the marriage for which it may have been commissioned. Botticelli used this cycle of the season to give expression to the divine cycle of love under the direction of Venus, about whom Ficino wrote in a letter to Lorenzo di Pierfrancesco. Botticelli was probably chosen as the artist because of his ability to create complex, lyrically poetic paintings that could be read in layers and were, in fact, the visual equivalent to contemporary humanist poetry.

—Roberta J. M. Olson

Pintoricchio (c. 1454–1513)
Enea Silvio's Mission to King James of Scotland, 1505–07
Fresco
Siena, Piccolomini Library

The second fresco in a sequence of ten, the *Mission to King James* contains all the elements that give the Piccolomini Library not only its indisputable splendour but also its pictorial abundance with its threat of repetition and superficiality.

The room itself, designed as a rectangle composed of two squares, appears confined. The frescoes were therefore composed on the basis of a scheme intended to alleviate such confinement with painted pilasters framing each staged image which, through a receding perspective of architectural details and background landscapes, tends to give the illusion of great depth.

This is certainly so in the second fresco where the foreground, beyond a deep, richly painted portal, consists of a loggia opening onto a valley shaped by a river widening out toward the distant, open sea. To the left in the landscape, high on a cliff, is a multi-turreted castle unlike any found in Italy and no doubt inspired by the artist's conception of what such structure might look like in faraway Scotland. In the middle ground, below the castle, a ship rides at anchor and closer yet, visible above the balustrade, are the mast and sprit of another vessel, these no doubt part of the ambassodorial fleet. In the right background, softly rounded hills similar to those surrounding Siena recede into the bluish distance.

King James, here a venerable patriarch—who in reality died at age 37—garbed in generous robes of blue, green, and brown, sits high on a throne placed in the symmetrical center of the prominently painted receding perspective. With his right hand raised and head turned toward his distinguished visitor he salutes Enea Silvio, whose features are as demonstratively young as the ruler's are old: the king's hair and beard flow in silvery dignity while Enea's tresses cascade in golden waves over his shoulder. His clothes, classically purple and scarlet, stand out against the king's more subdued tones, and a similar contrast is apparent in the groups of bystanders, those to the right, the king's side, while certainly festively attired, much less conspicuously so than the members of Enea's entourage, among whom we note a brightly turbaned Turk, a golden-helmeted warrior, and, as if to stress the exotic aspect of this Mediterranean group, a dark-faced Moor.

Ingenious is the thematic interplay of colours. The blue and green of the king's robes appear separately in the flanking foreground figures, while the purple and scarlet of Enea's attire are recapitulated in the two most prominent figures immediately to the king's left.

The many fine features of the fresco are somewhat threatened by less successful aspects. Its emphasis on symmetry totally eliminates any possibility of pleasant surprise, and in the painting of the groups the participation of assistants is far too obvious. The characters placed within a triangle having its beginning in the flanking figures and reaching its apex in the king's crown are far more skillfully painted than the more peripheral participants in the event, no doubt from the hands of assistants. All in all, however, the Piccolomini frescoes are the work of an artist inspired by his subject and confident of his skill.

—Reidar Dittmann

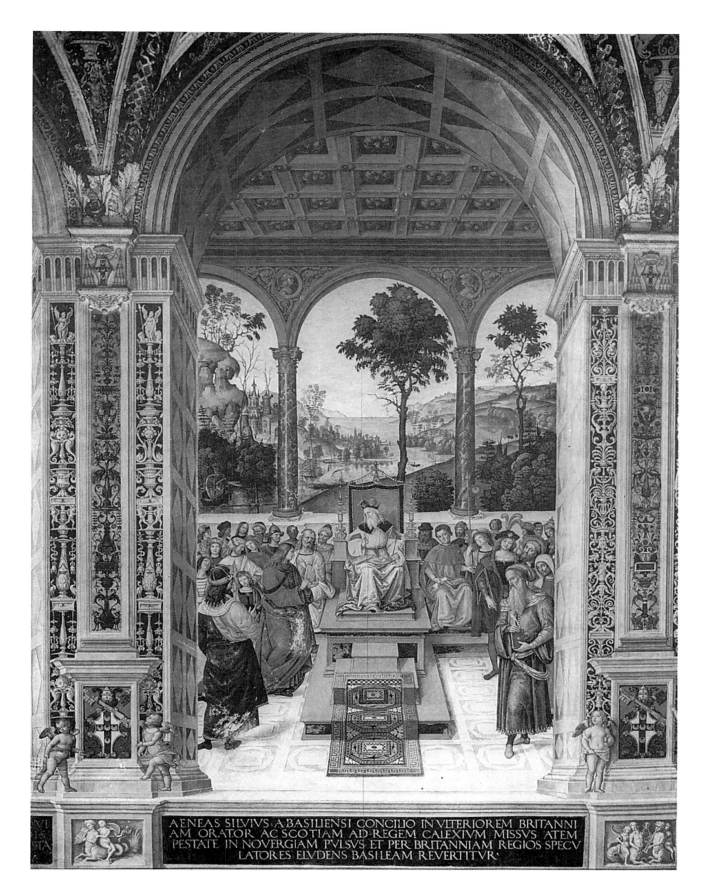

AENEAS SILVIVS A BASILIENSI CONCILIO IN VLTERIOREM BRITANNI
AM ORATOR AC SCOTIAM AD REGEM CALEXIVM MISSVS ATEM
PESTATE IN NOVERGIAM PVLSVS ET PER BRITANNIAM REGIOS SPECV
LATORES ELVDENS BASILEAM REVERTITVR

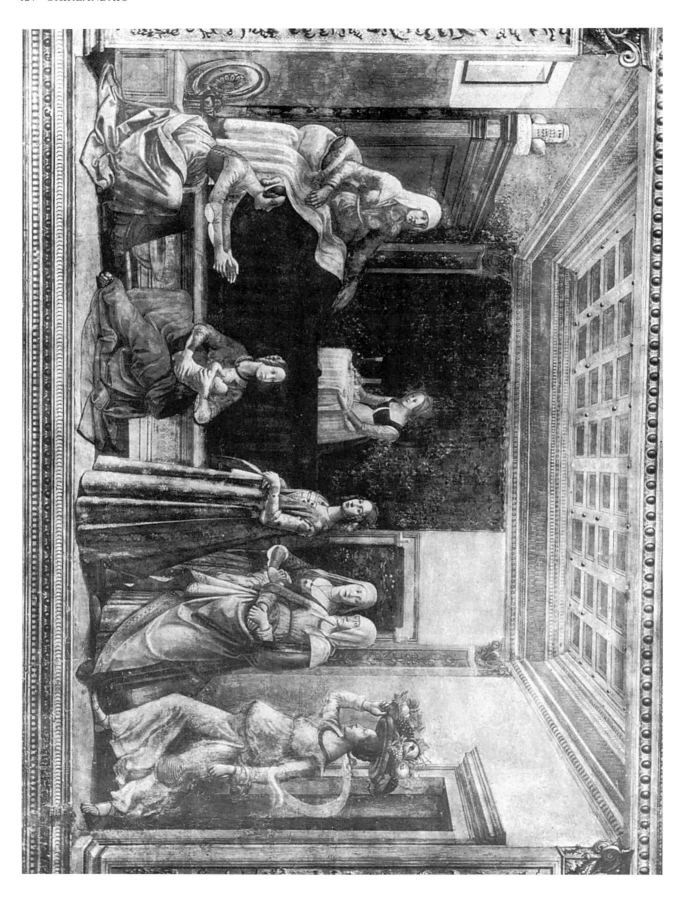

Ghirlandaio (1449–94)
Birth of the Virgin, 1486–90
Fresco
Florence, S. Maria Novella

Bibliography—

Marchini, G., "The Frescoes in the Choir of S. Maria No-
vella," in *Burlington Magazine* (London), 95, 1953.

The scene is part of a huge cycle, covering the whole choir
of the church, depicting the lives of the Virgin Mary and of St.
John the Baptist, patron saint of the commissioner, Giovanni
Tornabuoni. The contract for the cycle was signed on 1 Sep-
tember 1485, but the actual work was begun in May 1486 and
completed in May 1490, at the apogee of the Laurentian age.

The birth of the Virgin Mary to St. Anne is represented as
taking place in a sumptuous Florentine chamber. Although the
religious content of the scene has been kept, the sacred birth
has become for Ghirlandaio a pretext to represent a contempo-
rary social gathering: the after-birth visit by women friends to
the new mother, which was frequently depicted on traditional
Florentine *deschi da parto.*

The discursive, facile, charming style adopted by the painter
should not distract the viewer from the real value of the work,
which resides in its exact, precise perspective, and in the to-
tally convincing reality of the figures and of the space they
inhabit, a space in which richly carved pillars, wall panels
inlaid with Roman motifs, and a frieze of *putti* remind us that
indeed the Renaissance was about the rebirth of classical art.

The scene is clearly divided by the two pillars into two sec-
tions: to the right the main event, to the left, on the landing of
a staircase, framed by a door, Anna embraces Joachim (an
allusion to their meeting at the Golden Door.) Although two
different episodes from the life of St. Anne are being told, it
seems obvious that Ghirlandaio wants us to concentrate on the
second. The group of women seen in the foreground serves as
a link between the separate stories, yet, by their turning their
backs to the staircase and slowly walking toward Anna, they
force our attention on the chamber's interior, where two ser-
vants are taking care of the baby and a third one, with casual
elegance, pours water into a basin, while the mother, propped
up on a well-furnished bed, fixes her eyes not on her own
daughter, but on the young figure of the patron's daughter,
Lucrezia Tornabuoni, who, unlike her older attendants, is por-
trayed in full profile.

Splendidly dressed in a rich, heavy, embroidered damask,
her hands gently folded on her belly (as Florentine manners
required of a woman of distinction), strongly contrasting with
the simple dress and less than stately step of her attendants,
she nobly advances, fully conscious of her superior social sta-
tus. She is not only the focal point of the composition but of
the story itself. Anna and one of the maids look at her intently,
while she fixedly looks ahead, aloof and isolated, unaware of
what is taking place around her. Portraits are by no means rare
in religious works of the time: rarely, however, does a portrait
become, as in this fresco, the focus of the composition and of
the viewer's attention. The pre-eminence given by Ghirlandaio
to Lucrezia must have pleased her father, one of the wealthiest
men in Florence, whose sister was the grandmother of the
unproclaimed ruler of the city, Lorenzo il Magnifico. Indeed
the whole fresco testifies to the wealth, culture, refinement,
and elegance shared by the ruling elite.

If on one hand the fresco is an adulatory homage to the
Tornabuoni, on the other, for us, it is a precious document on
the private Florentine life of the period, in which the intermin-
gling of different social strata is visualized with keen observa-
tion and delight. Thus, the three young girls tending Mary
have the vivacity, spontaneity, and easy charm proper to their
age, if not always to their social status; they are indeed a
smiling contrast to the controlled pose of Lucrezia Torna-
buoni, the only real portrait among all the personages.

The prevailing happy atmosphere of the scene is certainly
underlined and increased by the row of dancing, playing and
singing *putti,* a reminder not only of classical sculpture but
also of coeval marble reliefs, a note of boisterous joy balanced
by the sober Latin inscription seen beneath them "NATIVI-
TAS TUA DEI GENITRIX VIRGO GAUDIUM ANNUN-
TIAVIT UNIVERSO MUNDO" (your birth, virgin mother of
God, was joyously proclaimed to the whole world.) Sacred and
secular at the same time this fresco is surely one of the most
appealing ever painted by Ghirlandaio, whose popular, easy
style is in this case perfectly suited to the story. Far from the
doubts that by this time already questioned the validity of the
Renaissance itself (Botticelli and Savonarola are classic cases)
the painter seems perfectly conciliated with his world, un-
aware of its fragility or of the forces and conflicts that within a
few years would destroy it.

—Norberto Massi

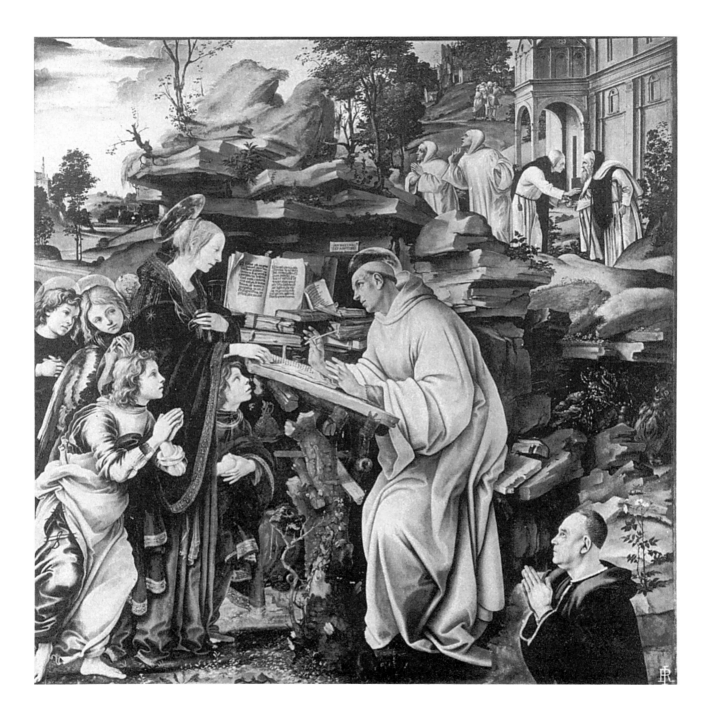

Filippino Lippi (c.1457/58-1504)
The Vision of St. Bernard, c. 1481–86
6 ft. 10¾ × 6 ft. 4¾ in. (210 × 195 cm.)
Florence, Badia

The Vision of St. Bernard is the masterpiece of Filippino Lippi's early career and one of the most outstanding Florentine panel paintings of the late 15th century. It holds its own with contemporary works by slightly older painters such as Botticelli, Perugino, and Domenico Ghirlandaio, with whom Filippino was favorably compared in his lifetime.

The panel, now in the Florentine church of the Badia, was originally in the convent of the Campora at Marignolle, near Florence, commissioned for his chapel there by Francesco del Pugliese, whose portrait appears in the bottom right-hand corner. The Pugliese were a distinguished mercantile family; Francesco held office in the Florentine government and was an ardent follower of Savonarola. He was also a connoisseur whose private picture collection was unusually large for the date and included works by Piero de Cosimo and Fra Bartolommeo as well as Filippino Lippi.

The commission for the *Vision of St. Bernard* is comparatively well documented and it is known that Filippino received 150 ducats for the work. The exact date of its completion is not, however, recorded, and is controversial. The construction of Pugliese's chapel was finished by 1481, but there was often a lapse of some years before new chapels were furnished with altarpieces. Immediately following the payment to Filippino in the Campora account-book relating to the chapel is an entry dated 1486, recording the donation of a chalice. Filippino must therefore have completed the altarpiece before this. Stylistically, it seems closest to his *Annunciation* (San Gimignano) of 1483–84 and his Signoria altarpiece of the *Virgin and Child with Sts. John the Baptist, Victor, Zenobius, and Bernard* (Florence, Uffizi) of 1485–86. While the figure-types in the *Vision* are often likened to the latter, particularly the St. Bernard, which is almost identical in both works, the colour is closer to that of the *Annunciation*. A date of c. 1485, between the *Annunciation* and the Signoria altarpiece, seems most likely.

The *Golden Legend* tells how St. Bernard of Clairvaux, while engaged on his writings, experienced a vision of the Virgin Mary, who was frequently the subject of his texts. The theme was popular in Florence; it had been treated by Filippino's father Fra Filippo Lippi (London) and was later the subject of an altarpiece by Perugino (Munich). Like them, Filippino uses a naturalistic approach, which is characteristic of the 15th century and contrasts with earlier depictions of the scene stressing its visionary aspect. Notwithstanding her train of angels, Filippino's Virgin is a being of flesh and blood who confronts the saint across his writing-table, touching the book from which he has lifted his gaze.

The subtle counterpoise of the composition typifies Filippino's unconventional, imaginative approach to design and his concern with emotional expression. The scene is set out of doors, with the protagonists framed by a central rocky outcrop into which St. Bernard's books and desk are incorporated. The inclined figure of the saint, isolated on one side of the desk, is balanced by the upright form of the Virgin and the angels clustering around her, while his austere white robes contrast with the vivid colours of the visionary group. At its centre the composition is dramatically empty, apart from St. Bernard's expressively raised hands. Attention focuses on the interlocked gaze of the two principal figures, whose solemn immobility is emphasized by the agitated movement of the angels and, in the middle distance, the group of monks excitedly witnesses the miraculous event. The directional thrust of the two foremost angels leads the eye to the saint on a diagonal axis which is counterbalanced by the diagonal leading from the saint down to the donor portrait.

The treatment of the portrait, cut by the picture-frame and not incorporated into the actual scene, is somewhat old-fashioned and was presumably dictated by Pugliese. By contrast, the technique and meticulous verisimilitude of the work testify to Filippino's assimilation of the latest artistic trends. The influence of Netherlandish painting, notably Hugo van der Goes's Portinari triptych (Florence, Uffizi) which reached Florence in 1483, is evident in the still-life detail of the books, the atmospheric landscape, and cloudy sky. The glowing colours and lustrous finish suggest that Filippino used oil glazes in response to new technical developments. The work constitutes a *tour de force* of naturalism not only within Filippino's oeuvre but also in the wider context of late 15th-century Florentine painting.

—Paula Nuttall

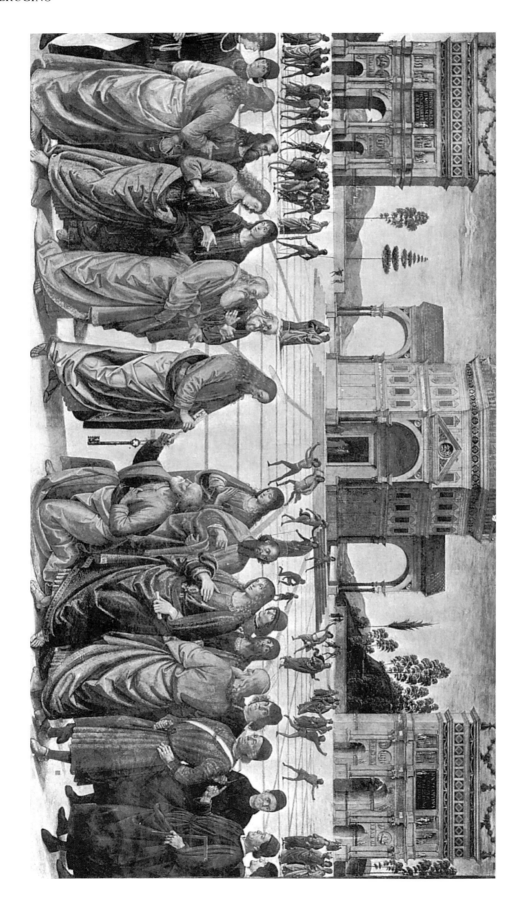

Jacopo Bellini (c.1400–1470 or 1471)
The Procession to Calvary
Drawing; 11³/₈ × 16³/₄ in. (29 × 42.7 cm.)
Paris, Louvre

Jacopo Bellini's drawing *The Procession to Calvary* is from one of the two copious sketchbooks that form his principal artistic legacy. The books are unique for the time in that they were apparently intended as exercises or works of art in their own right and not primarily as source material for paintings as in the case of medieval pattern books. One of the volumes, now in the British Museum, was drawn in lead point on prepared paper. The other, in the Louvre, contains *The Procession to Calvary* and is largely in ink or parchment. Together they comprise almost three hundred pages and are considered a remarkable testament to Jacopo's role in promoting the new Florentine style into the still gothic city of Venice. Although the drawings reflect a wide variety of sources and interests, they are particularly characterized by a profusion of quasifictive architecture that invariably dwarfs whatever events occur within or about it.

The Procession to Calvary (29 × 42.7 cm.) embodies, in both style and content, the spirit of Jacopo's critical role in the stylistic transformation of Venetian art. The Holy Procession is virtually dwarfed by a background of fanciful architecture—an amalgam of Renaissance and Venetian Gothic punctuated by heroic figures atop commemorative columns from antiquity. The perspectival elaborations of the mythical city seem to grow out of the process itself as the monuments push their way into the deep space of the scene. Indeed it has been said that perspective is the principal subject of many of the drawings in the books. In addition to the architectural monuments and the Roman soldiers escorting the condemned to Calvary, evidence of Jacopo's interest in and knowledge of the antique are scattered throughout the work. The standards of the mounted soldiers bear the inscription S.P.Q.R. (The Senate and the People of Rome)—a motto often used to mark the presence of Roman soldiers in the passion scene. It appears in reverse on the standard, in normal fashion on the trappings of the mount, and finally, in the lower right foreground, on the shield of a centurion who has been thrown from his mount. The image of a thrown or fallen rider appears often in monuments from antiquity such as Roman narrative relief columns and can be a symbol of broken pride. On the furled standard to the extreme right of the procession the image of a scorpion is partly discernible. Because of its treacherous and often deadly bite, the scorpion is often used as a symbol of Judas. To the far left there is a group of masonry workers on a scaffold repairing the crumbled stucco facing of the great wall of the city possibly suggesting the transient nature of man's earthly efforts. In the center foreground, in surprising prominence, a sculptor busily carves a pagan image (the cornucopia suggests a follower of Bacchus) which, as the column and its base lying nearby would indicate, will, after the crucifixion, rise in place.

It may be apparent, even to the unsophisticated observer, that the fluid, expressive style of the pen work (c.1470's) is not contemporary with the severe perspectival sweep of the architecture. Actually the initial drawing was probably completed in the early 1440's when Jacopo was under the influence of the writings of the theorist Leon Battista Alberti, whose treatise on painting (*De Pictura*) had been published in 1435. Evidence of many of Alberti's preachments can be detected in both volumes of Jacopo's books. However, the most apparent characteristic is the exactitude of the perspective which gives the appearance of an accelerated foreshortening. Early Renaissance perspective was, in essence, a mathematical system based on the notion that the rays of vision as they pass from the observed object to the eye of the viewer are intersected by a plane of vision (picture plane). They are then arrested at this point to form the pictorial image. The rays as they fan out to pass through the imaginary plane, which is parallel to the viewer, are necessarily distended toward the periphery, thus, for example, columns that are away from the central area of the drawing are flattened, domed buildings that stray from the center of the composition have oval drums, the domes are ovoids, and square towers appear rectangular. The penwork, on the other hand, is presumed to be restorative and done sometime before 1479 when it is believed that the eldest son Gentile took the Paris volume to Constantinople as a gift to the Sultan Mehmet II. The restoration was undoubtedly the result of a concerted shop effort to ready the volume for its exalted mission. The technique displayed in the drawing is probably the work of the youngest son, Giovanni—as distinguished from the more conservative style of either Jacopo or his oldest son, Gentile. The remarkable pathos evoked by his deft hand is particularly evident in the figure of Christ who, momentarily stopped in his journey, looks back at the sorrowful figures of his Mother Mary and the holy women—the "Daughters of Jerusalem"—as they leave the gates of the holy city.

The amalgam of these diverse elements is responsible in great part for the compelling power of the drawing. The eye of the viewer is, in a sense, rescued from the magnetic pull of the perspective by the emotional power of the baleful procession as it passes beyond a foreground of irreverent banalities.

—Howard Collins

Gentile Bellini (1429–1507)
Procession of the Cross in St. Mark's Square, 1496
12 ft. ¹/₂ in. × 24 ft. 5¹/₄ in. (367 × 745 cm.)
Venice, Accademia

The huge canvas was one of three commissioned by the Scuola Grande di San Giovanni Evangelista, one of Venice's most prestigious lay confraternities. The scene describes the solemn procession which took place every year on St. Mark's day (April 25) to honor the patron saint of the city and, more specifically, that of the year 1444, during which Jacopo de Salis, a merchant from Brescia (seen kneeling behind the baldachin), prayed to the relic of the True Cross and obtained the recovery of his gravely ill son.

In the center foreground, under a rich baldachin of red brocade emblazoned with the coats-of-arms of the major Venetian *scuole,* carried and surrounded by members of the confraternity who commissioned the work, we see the precious reliquary which forms the focal point, together with the main door of St. Mark's basilica in the background, of the composition. The stately procession emerges from the Porta della Carta, turns at the middle of the square to pass in front of the viewer, and then moves slowly along the left portion of the painting to reach the side entrance of the basilica.

The composition combines religious devotion with the innate love for his city felt by every Venetian, and as such it is a precious social and historical document, showing on one hand the important role that religious events played in the civic life of the community and, on the other, providing us with a unique documentary view of the square, seen as it was before the great architectural changes of the following century.

Gentile delineates figures and buildings in a precise, sharp line, meticulously rendering with the utmost care every figure and every architectural detail: the peculiar attraction of this work resides precisely in the accurate, at times pedantic, description of the Venetian reality of the times. The Doge is seen on the right, covered by the traditional baldacchino, preceded by the insignia of his authority and followed by the compact mass of the political elite of the Republic. Each individual proclaims his status through the color of his garment, and the solemn rows of the confraternity members slowly walking in front of us are the "real" personages of the composition, while the colorful throng of curious spectators, of indifferent Turks or of people casually standing on the original pink pave-ment of bricks, is just the necessary complement that articulates and marks the spatial depth. The variety in costumes is matched by the variety of expressions and postures. The solemn row of figures in front of us is portrayed with the utmost spontaneity: heads turn, candelabra stay at rest on one's arm, singers attract listeners, some smile, others are enrapt by the melody; women at windows eagerly watch or comment on the advancing procession.

In the background St. Mark's basilica frontally faces the viewer with its Byzantine splendor. Painted with photographic accuracy, the old church still shows its original mosaic decoration, pinnacles are still gilded, whereas the sites of the Torre dell'Orologio, to the left, or, on the opposite side, that of the Procuratie Nuove, not yet built, are occupied by anonymous buildings. Although the focus of the painting ought to be the miracle-working relic, the gaze is pulled inward toward the basilica, which constitutes the real fulcrum of the composition. As if on a stage, of which St. Mark and the Ducal Palace are the backdrop, the countless personages act their roles with dignified stolidity. For once the Doge and his retinue are not the main personages; clearly recognizible yet pushed to the right, the political leaders have to give place of pre-eminence to the rich canopy and the portable altar upon which stands the reliquary. But even here, at the most important section of the story, Bellini concentrates his attention not on the relic itself (we see only the profile of its gold encasing) but on the preciousness of both material and workmanship. The venerated relic, reduced to the bare minimum, seems, more than the central subject, a pretext to represent one of the many Venetian events in which religion and civic pride, conspicuous display of wealth, and the splendor of the city are intermingled. To this end even the physical space of the square is subtly altered: the campanile is pushed to the right to allow a better view of the Ducal Palace and of the Porta della Carta, resplendent with gilded reliefs, while at the same time the perspective is flattened, so that the facade of the basilica seems nearer (and its decoration more visible) than reality would permit.

—Norberto Massi

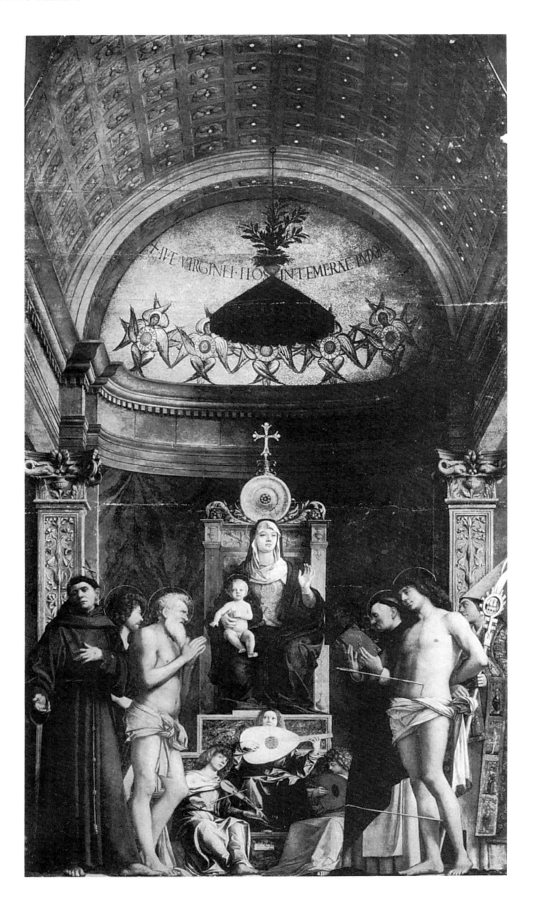

Giovanni Bellini (c.1430–1516)
S. Giobbe Altarpiece, c. 1489
Panel; 15 ft. 4^1/$_4$ in. × 8 ft. 4^3/$_8$ in. (468 × 255 cm.)
Venice, Accademia

Bibliography—

Hubala, Erich, *Bellini: Madonna mit Kind: Die Pala di San Giobbe,* Stuttgart, 1969.

Although the date of its commission has been lost, we know that the panel was *in situ* in the Venetian church of San Giobbe by the year 1489. The painting is a fundamental work in Bellini's development of the *sacra conversazione* theme, standing in time between the lost *pala* for the church of SS. Giovanni e Paolo (c. 1470) and the later San Zaccaria altarpiece (1505).

In the center of the composition, seated on a high marble throne covered with reliefs and surmounted by a cross, Mary, aloof yet serene and benign, faces the viewer while holding her Child on one side and raising her left hand in a welcoming gesture. Above her hangs a baldacchino identical to the one which covered the Doge of Venice during official ceremonies. Under her, on marble steps sit three musical angels, while to her side in two loose groups the saints Francis, John the Baptist, and Job, and Dominic, Sebastian, and Louis of Toulouse are assembled. All the figures are seen within a Renaissance architecture: two decorated pillars with dolphin-capitals mark the boundary of the inner cubic space covered by a coffered vault, closed by a marble apse surmounted by a half-dome encrusted with simulated gold mosaic (the only concession to traditional Venetian church decoration). It shows the inscription "Ave Virginei Flos Intemerate Pudoris" (Hail undefiled flower of virginal modesty), a reference, together with the words "Ave gratia plena" imprinted on the stylized forms of cherubim, to the Annunciation.

Unfortunately the modern location, and the reduction of its size, do not allow a full understanding of the magnificent spatial arrangement conceived by Bellini. As in the other two altarpieces mentioned above, the fictive architecture of the scene echoes and imitates the marble architecture of the original setting, so that the pilasters and the arch framing the panel, in the church of San Giobbe, were perspectively repeated in the work itself: real and pictorial space being then conflated into a single entity in which the illusionistic scheme created by the painter became a continuation of the physical world in which the beholder faced the sacred group. This feeling of utter reality was further increased by the rhetorical gesture of St. Francis, who, turning toward the outer space of the painting, shows his stigmata (like the cross above the throne, a reminder of Christ's Passion), and, through his outstretched hand and gaze, seems to intercede and at the same time to invite us to join the *sacra conversazione.* The extremely low vanishing point (in its original location this corresponded to the spectator's eye-level), with the consequent elimination of the floor, undoubtedly reinforced the illusionistic effect of the perspectival grid: the figures stand out imposingly and magnificently, close to us, tangible and near.

The prototype for Bellini's composition was quite certainly Antonello da Messina's *San Cassiano Altarpiece* (1475–76), in which for the first time figures inhabited a closed architecture. But at the same time the artist must have had some knowledge of Piero della Francesca's *Montefeltro Altarpiece* (c. 1472) and of Masaccio's *Trinity* (1428): the fundamental similarities between the coffered vaults of the latter works and that of Bellini seem too close to be purely a product of chance.

The most fascinating aspect of the altarpiece, however, is not provided by the precise illusionism, nor by its classicizing architecture, but by the extraordinary softness of its internal illumination which anticipates Giorgione and Titian. The crisp, crystalline, pure light of Antonello, which defines contours with the utmost precision, becomes here a tender radiance, permeating the whole composition with an ethereal light, gently rounding the magnificent, youthful nudity of St. Sebastian, and the older flesh of St. Job, with a golden hue, permeating the vault with an inpalpable radiance, unifying through its tender atmosphere the whole tonality of the painting, in which colors are never shrill or bright, but brought into total harmony by the mysterious rays that, entering from the right, bathe the entire composition in paradisiacal peace.

—Norberto Massi

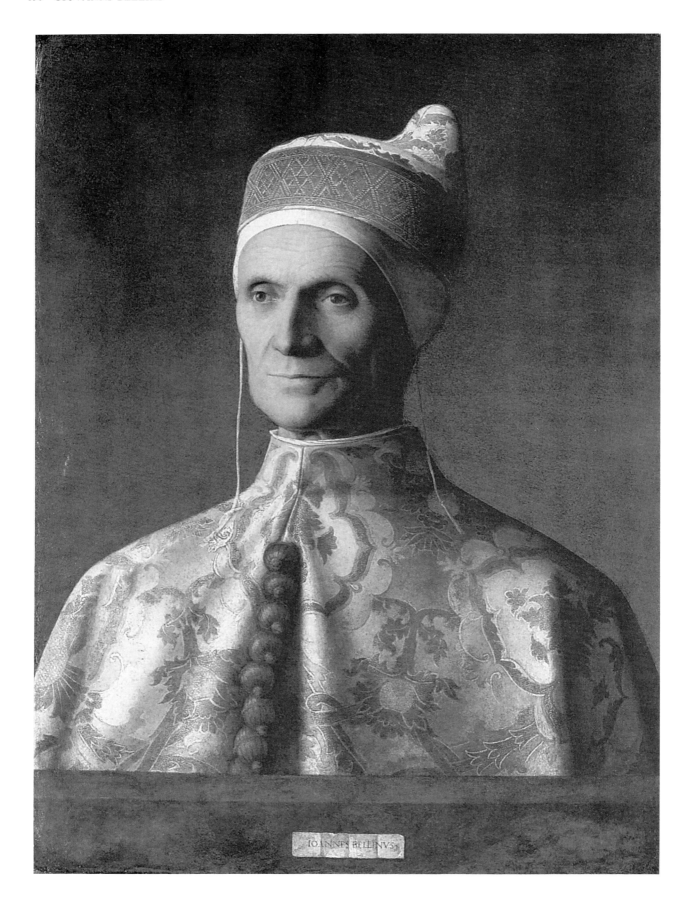

Giovanni Bellini (c.1430–1516)
The Doge Leonardo Loredan, early 1500's
Panel; 24 × 17 in. (61.5 × 45 cm.)
London, National Gallery

Leonardo Loredan was elected Doge of Venice at the age of 65 on 2 October 1501. He was to rule for the next 20 years. Bellini, who was appointed State Painter of the Republic in 1483, must have completed this portrait, if not soon after the election, in the years immediately after.

Seen behind a parapet of Veronese red marble, upon which the *cartellino* is pasted, against a terse, pure blue sky, Loredan is portrayed half-bust, his head slightly turned, wearing the insigna of his office: the white bonnet, the ducal *corno,* and a rich cape of ivory-white damask patterned with an intricate design. In this official portrait the precise rendition of the somatic features is coupled to the meticulous description of the ceremonial robes. The perfectly cloudless sky seen behind the Doge is a neutral backdrop that should not distract our attention from the figure; thus we are forced to concentrate our gaze on the personage standing before us, the living symbol of Venetian power.

The cold, strange luminosity of the sky perfectly matches the mood of the painting, in which Loredan's face has the abstract fixity of an icon. The compact mass of the figure, a pyramid of granitic solidity, is bathed and sculpted by an even, quiet light that obliquely strikes the figure, a figure of calm, composed dignity in which the folds of the aged skin, the minute lines around the eyes, the deeper creases of the high front are just as precisely and realistically depicted as the thin bloodless lips, the strong nose, the bright and mellow eyes. Loredan's physiognomy seems to reflect the wisdom of old age, the sharp intelligence, the calm self-assurance of a man who would weigh, judge, and shape the political life of Venice.

Even more striking than the idealized realism of the head, is the prowess shown by the old master (Bellini was then about 70 years old) in the mimetic rendition of the stiff, heavy cape which covers the shoulders of the sitter with ample folds, of the large, round buttons, or the embroidered *corno.* The beautiful, meticuously painted, golden arabesque, standing out against the lustrous texture of the cloth, adds a touch of vivacity to the otherwise too solemn portrait, while the massed sequence of the golden buttons emphasize the richness of the precious costly garmet, which becomes an allusion to, even a symbol of, the Republic's wealth and of its conspicuous display on official occasions.

Leonardo Loredan was Doge during one of the most perilous and troubled periods in the long history of Venice, when the city had to face, in 1509, the coalition of practically the whole of Europe, when enemy armies camped across the lagoon, systematically burning villages or pillaging and holding cities to ransom. The crisis, mostly thanks to Venetian diplomatic skills and wealth, but also to the implacable, unwavering will of Doge Loredan, was overcome. According to Francesco Sansovino, the Doge "during these times of trial showed a more than human courage, always rising to the need, mindful of the Republic's safety, helping the cause with hard work, advice, intelligence, his own wealth and that of his family." All this took place years after the portrait was done, yet, looking at it, masked beneath sovereign benignity, we already sense the iron will, the energy, the cold appraisal of the experienced leader of later times.

Totally devoid of the rhetorical pompousness of too many official portraits, Bellini's work strikes us for its utter adherence to reality, its simplicity and sincerity. The painter has depicted the quality of a man and his high social rank without fanfare but quietly, silently, placing him in a timeless, ideal, humanistic sphere in which harmony seems to rule.

—Norberto Massi

Antonello da Messina (c. 1430–79)
St. Jerome in His Study
Panel; 18 × 14 in. (45.7 × 35.9 cm.)
London, National Gallery

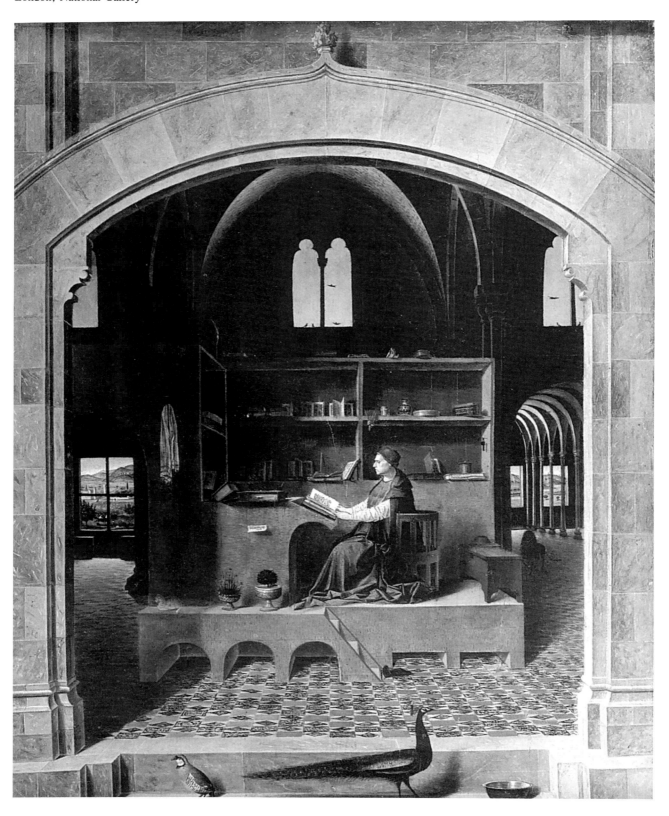

Bibliography—

Jolly, P. H., "Antonello da Messina's *St. Jerome in His Study: A Disguised Portrait?*," in *Burlington Magazine* (London), 124, 1982.

Jolly, P. H., "Antonello da Messina's *Saint Jerome in His Study:* An Iconographic Analysis," in *Art Bulletin* (New York), June 1983.

Only recently has this most Flemish-appearing of Italian paintings been given a thorough iconographic survey in an effort to uncover its potential for disguised symbolism among its many precisely detailed objects, plants, and animals. Although a search for such material has long been undertaken in the study of Flemish art, Italian art seemed to resist the establishments of such a tradition. If a work from the outset of Antonello's career, c. 1450–60 as has recently been asserted, then the painting must have been produced under the influence of the Flemish-inspired Neapolitan artist Colantonio; as well, it appears that this work may directly reflect the lost Jan van Eyck Lomellini Triptych in which a panel adjacent to the Annunciation showed St. Jerome in his study. In a well-known text, the 1456 *De Viris Illustribus* by Bartolomeo Fazio, the van Eyck work is noted in the collection of Alfonso V of Aragon, King of Naples.

A recent study (Jolly, 1982) attempts to demonstrate that the facial features of Antonello's St. Jerome clearly resemble, in their deep-set eyes and aquiline nose, those of King Alfonso: his profile portrait appears on medal plaques made by Pisanello (e.g., one of c. 1448 is in the Metropolitan). With this assumption, one of the outstanding features of the work—the stony *repoussoir* arched door opening—can become a firm aspect of the work's iconography. Through the use of this portal arch, an ancient emblem of access, and the translation of the human soul to the Paradise of the other world, this painting would become a posthumous tribute to Alphonso who died in 1458. A further confirmation of the use of such a "disguised portrait" here is the long-accepted feeling that the Detroit *St. Jerome in his Study,* now accepted as a copy of a lost Jan van Eyck, is likewise a pious humanist in the guise of the Saint—Cardinal Niccolò Albergati. And incidentally, this latter work was probably in Italy by the late 1430's. Alphonso also had a reputation as being devout and dedicated to the advancement of learning.

In Antonello's miniature and quite Eyckian painting, St. Jerome is presented seated at his dest on a raised platform in the middle of a large stone-vaulted building. In a recent analysis (Jolly, 1983), it was suggested that the scene, with all its naturalism, suggests an underlying tripartite, grid-like division, both vertically and horizontally: three windows at the upper level, two landscape views and Jerome himself at the middle level, and, on the lower level, the step of the stone-arched portal with a partridge, peacock, and water basin. Among the numerous objects, many have more than a single meaning as the 15th century received these age-old exegetical traditions, including some from the writings of Jerome himself; in fact, the basis for the present interpretation lies in a then well-known letter of Jerome to a young woman, Eustochium, *Epistle 22.* And at this time in the 15th century, Jerome was especially extolled as the epitome of Christian power and wisdom.

Since this Epistle both advocates and celebrates a life of celibacy, many of the objects usually found together in scenes of the Annunication, where they refer to the purity of Mary, here surround Jerome. For instance, the round, flat wooden box, called a pyx, refers to Mary's womb and its virginal state is indicated by the stoppered clear-glass carafe; the apothecary jars symbolize the healing of mankind's ills through Christ's Incarnation. While the potted tree is an indoor version of the enclosed garden of Mary's virginity, the carnations in the adjacent pot may emblemize bethrothal, Mary to Christ, or fleshliness, Christ's Incarnation and Passion. By way of contrast, above on the wall, the dirtied towel, the unlit lamp, and the cat below, all on the shadowy left side, are emblems of impurity and sexual promiscuity. The distant landscape view on the left side includes a city, with people and animals visible, while on the right side only countryside is seen. The lion on the right represents both an attribute of Jerome—the widely known story of his friendship with the beast from the moment he extracted a thorn from its paw—and the cleansing power of wilderness. So that the water-filled basin below can be interpreted vertically as an aspect of such cleansing power; a Paradise garden may be intended: the water as the Fountain of Life and the Resurrection adjacent to the Peacock whose flesh was held not to putrify. While the partridge at the left can also be found in such celestial settings, tradition labels him sexually perverted, a bird constantly filled with desire. Yet astonishingly enough, his positive aspect, through the female's ability—according to the medieval bestiary—to become pregnant by hearing a voice, made the partridge an emblem of the Annunciation.

In Jerome's use of comparison and contrast is found the source of Antonello's use of symbols with both positive and negative aura, and every aspect of the image is assigned a reference in Jerome's text. For instance, the other birds visible occur only in the center and in the uppermost right-hand side of the uppermost windows, over Jerome and the uninhabited landscape. Long an emblem of the Christian soul flying up to heaven, they are not seen on the shadowy left side in the city of man, here seen as filled with the potential of evil, seduction, and treachery. This portion of Antonello's painting may be seen as a visual concretization of that portion of Jerome's letter where Eustochium is counselled to become a recluse and leave behind the sinful, worldly life, and is, of course, in contrast to the cleansing emblems of the right-hand landscape, lion, and water-filled basin.

Beyond references in his Epistle, Jerome had come through time to have powerful association with Mary. Like the Virgin at the Annunciation and the Conception of Christ, he, through his creation of the New Latin Bible, the Vulgate, was a means to the knowledge necessary for the salvation of mankind. His establishment of the authenticity of the four canonical gospels record the life of Christ. Thus like Mary at the Annunciation, Jerome is shown by Antonello in a divine light and visited by a divine presence, the inspiration for his work; his shoes, removed, affirm that he is on holy ground.

Through contact with northern European art, the Italian Antonello had absorbed both a technique and an attitude towards the spiritual forces inherent in mute material objects, which has allowed him to produce an extraordinary image in honor of both humanist and theological traditions.

—Joshua Kind

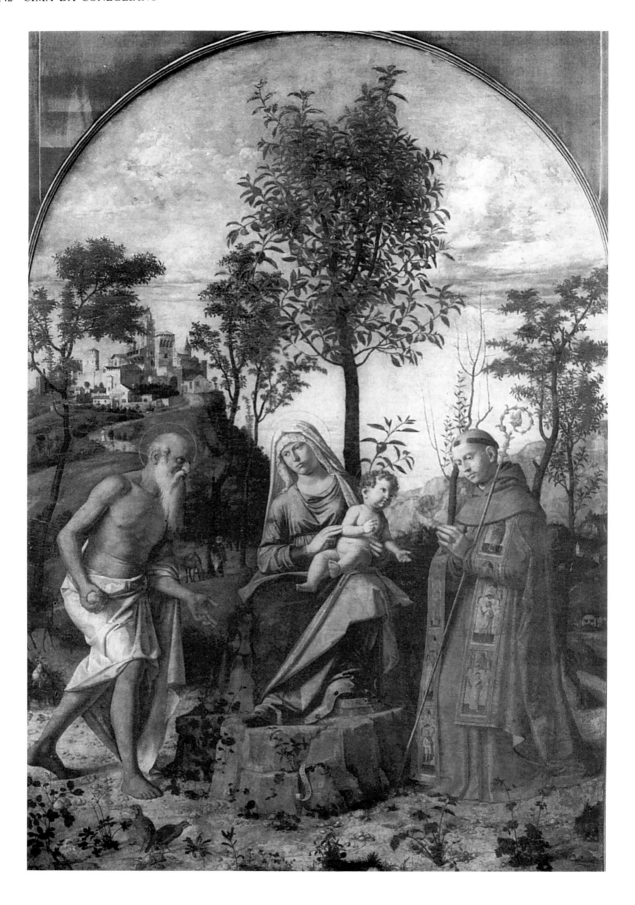

Cima da Conegliano (c. 1450–60—1517–18)
Virgin and Child with SS. Jerome and Louis of Toulouse in a
Landscape with an Orange Tree, c. 1496–98
Panel; 6 ft. 11^1/$_2$ in. × 4 ft. 7^1/$_8$ in. (212 × 139 cm.)
Venice, Accademia

The *Virgin and Child with SS. Jerome and Louis of Toulouse in a Landscape with an Orange Tree* for the Church of S. Chiara in Murano (Venice, Accademia, c. 1496–98) is a characteristic work of Cima at the height of his powers. Cima's clients were largely clergy, especially Franciscans, and characteristically this work was commissioned by the Franciscan Observant nuns of Murano. It is also a large altarpiece of the *sacra conversazione* type (i.e., the Virgin and Child in the company of saints), a specialty of Cima's prolific Venetian workshop. Significantly, it is one of the earliest *sacra conversazione* to set the saints both in a landscape and in a dramatic relationship to each other, inventions that became a major characteristics of Venetian altarpiece design in the 16th century.

The youthful Virgin sits with her Child on a rustic and stony throne (symbolic of the Church founded by Christ, the cornerstone) in the center of the composition. She is dressed in beautiful robes of rose, gold, blue, green, and white, which make a virtuoso display of Cima's skill as a colorist. Cima's compositional talents are evident in his use of the orange tree, the converging hills, and the golden glow at the horizon to emphasize the divine figures. The Virgin leans toward St. Jerome who strides forward about to beat his breast with a rock as he fervently addresses the Christ Child with outstretched hand, as if asking for recognition and acceptance of his ascetic and penitential way of life. The Christ Child, raised and displayed on the knee of his mother who tenderly holds him, turns to receive and bless the tonsured St. Louis whose hands are folded in prayer and who is dressed in a sumptuous bishop's cape over his Franciscan habit. Just as Jerome's passionate expression and forceful action are reinforced by the widely spaced trees, the broken silhouette of the fortified town, and the serpentine course of the road running down the steep hill behind him, so too are the inward calm and columnar dignity of St. Louis magnified by the narrow spaced trees, the rugged

majesty of the mountains, and the expansive sky behind him. To the faithful contemplating this painting, the gentle reception and benediction of the two intercessor saints by the divine Mother and Child must have offered visual assurance of the effectiveness of penance and prayer, a particularly apt message for an observant convent.

Prayer and penance were efficacious, of course, because of the coming of Christ into the world, his redemptive sacrifice, and his resurrection. Everywhere in the painting are symbols which allude to these events. The pair of partridges in the lower left foreground recall the Incarnation because the female was thought to conceive by hearing the call of the male, just as the Virgin conceived when hearing the annunciation of the archangel Gabriel. Between Jerome and the Virgin in the middle ground is a figure looking like St. Joseph with a mule. He brings to mind the Flight into Egypt occasioned by the Massacre of the Innocents, a traditional prefiguration of Christ's sacrifice. The setting sun, the wintery season (orange trees fruit in winter), the rocky and barren foreground, the wild animals in the landscape (a lion and a fox behind and to the right of SS. Jerome and Louis respectively), all suggest sacrifice and death. On the other hand, the rabbit and the deer (behind St. Jerome), the green middle ground with leafy trees, a sun which could be rising as well as setting, the oranges (the fruit of paradise), and the warm golden tone of the entire painting, all suggest fecundity, renewed life, and salvation.

Here, in short, can be seen the very best qualities of Cima, which were also some of the best qualities of Bellini from whom he derived his style: superb handling of a rich, deep color and a warm, naturalistic light; acutely observant rendering of nature with subtle religious allusions; and restrained, quiet staging of figures to create psychologically nuanced, emotionally poignant, and deeply felt spiritual dramas.

—Loren Partridge

Cosmè Tura (c. 1430–95)
The Roverella Altarpiece, 1474
Panel; 7 ft. 10¹/₂ in. × 3 ft. 4 in. (240 × 101.6 cm.) (central
 panel)
Parts in London, National Gallery, Paris, Louvre, Rome, Col-
 onna Collection, and San Diego, Museum of Art

In 1474, Cosmè Tura painted a large polyptych in the Fer-
rarese church of San Giorgio; the work was apparently com-
missioned to commorate the death of Bishop Lorenzo
Roverella. The 18th-century biographer Girolamo Baruffaldi
noted that Lorenzo was portrayed on the left side, in a now-
lost section; a latin inscription noted that Lorenzo was knock-
ing at the gates to heaven. Our knowledge of the altarpiece's
original appearance is incomplete; some parts are lost, others
are scattered. The *Madonna Enthroned* in London (National
Gallery) formed the central panel. Other parts included a
Pietà, originally overhead (now in the Louvre), a panel with
Sts. Maurelius, Paul, and a donor (Colonna Collection,
Rome), and a small fragment in San Diego of the head of St.
George; these latter two belonged to panels that flanked the
central one. Two now-lost parts with images of St. Benedict
and St. Bernard occupied the sides at the level between the
Madonna Enthroned and the *Pietà.* Some writers believe that
three *tondi* by Tura with scenes from the life of Christ (Metro-
politan Museum, New York, Fogg Art Museum, Cambridge,
and the Gardner Museum, Boston) belonged to the complex,
but this is doubtful, for it contradicts Baruffaldi's statement
that the predella was composed of paintings that illustrated the
lives of the saints in the panels above.

Although separated by frames, the side panels with saints
and donors were in the same implied space as the central *Ma-
donna and Child;* thus, the *Roverella Altarpiece* was in the
tradition of the *sacra conversazione* as represented by Antonio
Vivarini and Giovanni d'Alemagna (Accademia, Venice),
Donatello (Santo, Padua), and, especially, Mantegna (San
Zeno, Verona). But what a difference in style the form re-
ceives in the hands of an artist working in the mannered, Fer-
rarese tradition. Tura's colors are startling, dominated by
bright pinks and greens. The space is flattened out. The com-
position in the central panel is narrow and vertical, and the
figures are in the traditional shape of a mandorla, lacking the
solidity and simplicity of other 15th-century *sacre conversa-
zioni* in north Italy. The garments are bent like foliated metal,
and the physiognomies are characteristic of the artist in their
bizarre distortions; the Madonna, as well as some of the an-
gels, is a conscious contradiction to the usual sweet form that
the Virgin and angels take in 15th-century art. The upper sec-
tion of the Virgin's throne is copiously detailed, reminding us
that Tura's duties as court artist for the Este included the de-

sign of fanciful sculpture. The flatness, the bright, varied col-
oring, and the minute details give the *Madonna Enthroned* the
appearance of a manuscript illumination, again in contrast to
the monumental *sacre conversazioni* as produced by the Flor-
entines, Venetians, and Mantegna. Such miniaturism is hardly
surprising, given the importance of the thriving school of illu-
minators then active in Ferrara. Tura's *Roverella Altarpiece* is
a translation into the Ferrarese dialect of the Italian "holy con-
versation" of Madonna and saints.

The iconography of the altarpiece is rich. The elevated
throne makes reference to Mary's title of *Regina caeli.* The
music-making angels connote the divine harmony of creation.
The victory of the New Testament over the Old Testament is
suggested by the crowning of the throne with symbols of the
Evangelists, placed in a higher position than the memento of
the ear *sub lege,* the tablets of Moses. The outcome of Christ's
coming is manifest in the important motif of the sleeping
Christ Child, which suggests Christ's future death and the
consequent salvation of mankind. Tura represented the sleep-
ing Child in a painting in Washington (National Gallery of
Art) and in Venice (Correr Museum); in the latter the connec-
tion between sleep and death is made explicit with an inscrip-
tion that equates Christ's awakening from sleep with his
resurrection after death. In the *Roverella Altarpiece,* the con-
notation of death is signified by the Child's pose, which forc-
ibly recalls a Pietà, and is echoed in the actual *Pietà* overhead.
Over the Child's head in the *Madonna Enthroned* are signs of
his coming death, including grapes, symbols of the sacrifice of
his blood, and gourds, which signify resurrection.

The *Pietà* in the Louvre is brought into unity with the *Ma-
donna Enthroned* by the repetition of the green and pink barrel
vault overhead. But in contrast to the London panel, where an
air of emotional languor reigns, the *Pietà* is endowed with
strong sentiment. Tura eliminates extraneous details and con-
centrates on the presentation of Christ. The image gains force
through the large scale of the figures (larger than those in the
panels below), and through the dead Christ's pathetic repeti-
tion of the pose of the sleeping child below. Few works from
Tura's hand reach such a high level of religious expression; the
Pietà forms a dramatic capstone to one what is probably
Tura's greatest surviving work.

—Joseph Manca

Francesco del Cossa (1435–36—1477)
Hall of the Months
Frescoes
Ferrara, Palazzo Schifanoia

Cossa's frescoes on the east wall of the Hall of the Months in the Palazzo Schifanoia form one of the most famous and important works of the Italian Renaissance; they offer, in a charming and attractive style, valuable glimpses into secular life of a flourishing Renaissance court. The importance of the project even extends to Cossa's attitude towards his work. He displayed typical Renaissance pride when he complained in 1470 in a letter to the Duke of Ferrara that he was too poorly paid for such fine painting. Cossa bragged that he used a better fresco technique than the other masters who worked in the hall. Indeed, good technique helped to preserve his work when it was freed from whitewash early in the 19th century. After their rediscovery, the frescoes were rightly celebrated as a major monument in the history of art.

Cossa painted three of the twelve months in the hall. Each month is divided into three main registers, separated vertically by classicizing pilasters. The top registers represent the triumph of a classical deity appropriate for the month: Minerva in March, Venus in April, and Apollo in May. The middle registers contain the sign of the zodiac, as well as three *decani,* who were derived from Middle Eastern astrology; each *decanus* presides over one-tenth of the 360 degree course of heavenly bodies. In the lowest register, Duke Borso d'Este appears among his courtiers and other subjects, who take part in activities associated with the particular month. Thus, there are varied sources for Cossa's frescoes: the upper registers are inspired by classical antiquity, the middle registers derive from eastern sources, and the lowest registers recall Gothic *Book of Hours* and their scenes of the lord among his subjects who carry out their seasonal duties.

The style of the frescoes is deeply rooted in Ferrarese artistic tradition. The patron, Borso d'Este, supported an active school of miniaturists in Ferrara, and it is often noted that the Schifanoia frescoes appear to be miniatures rendered in large scale. This resemblance is brought about by bright and varied coloring and by the abrupt contiguity of the strips of scenes. A miniaturistic quality is also conveyed by the small scale of the figures, who are well under life size, so different from the monumental mural tradition of Tuscany. The courtier in *April* who sits on the ledge has the stature of a leprechaun, a diminutive scale very obvious to the viewer in the hall who stands next to him.

The style matches the subject matter in its light-heartedness and wit. The space is consciously irrational, very different from the more scientific perspective characteristic of much of Renaissance painting. Note how in the center of the lowest register of *April* an arch is strangely broken to allow a view in the distance, and a section of the city of Ferrara seems to float above an arched wall. The landscapes are fantastic and multicolored; they must have been a pleasurable change for the Ferrarese courtiers, who were accustomed to looking at the flat Po Valley. Cossa achieves a decorative effect with the motley garments of the courtiers portrayed in the lowest register, whose clothes would appear even more colorful had they survived in better condition. In all, the stylization, fantasy, and wit were designed to cater to Ferrarese demands for an art of direct and pleasurable appeal.

The subject matter in *April* is the most playful of all of the months. In the lowest register, Borso gives a coin to a court fool; nearby, courtiers are riding and hawking, and in the distance Cossa shows us the Ferrarese *palio,* with courtiers and fancifully-dressed ladies in attendance. The Love Garden in the upper register is a pure delight. Venus rides in triumph, with Mars subdued before her. Venus's cart is pulled by two swans, who float and squawk on the bubbling lake. The cloth hangings on the goddess's car gracefully ripple and flap in the wind. The picture is full of symbols of fertility and love: pairs of birds, numerous rabbits, and the Three Graces. The sensuousness of Ferrarese court life comes out in the idealized group of courtiers. On the right, young people hold musical instruments, symbols of passion, and one young man has his hand under the dress of a girl, who does not protest. Others watch with approval. On the left side, young people gather in a garden, and two girls seem to argue over possession of a handsome youth. The figures are mostly fair-haired, fulfilling a courtly ideal of beauty. The realm of Venus reminds us that the name of the Palazzo Schifanoia means "Banish-Care" (*esquive ennui*), and, although serious events did occur there, it was a suburban place of retreat for the Este and other courtiers. Cossa's frescoes there remain our most valuable glimpse into the ideal world of a north Italian court, and they stand as part of a project that is a rare surviving example of what was once only one of many secular fresco decorations made for the Este family in the Renaissance.

—Joseph Manca

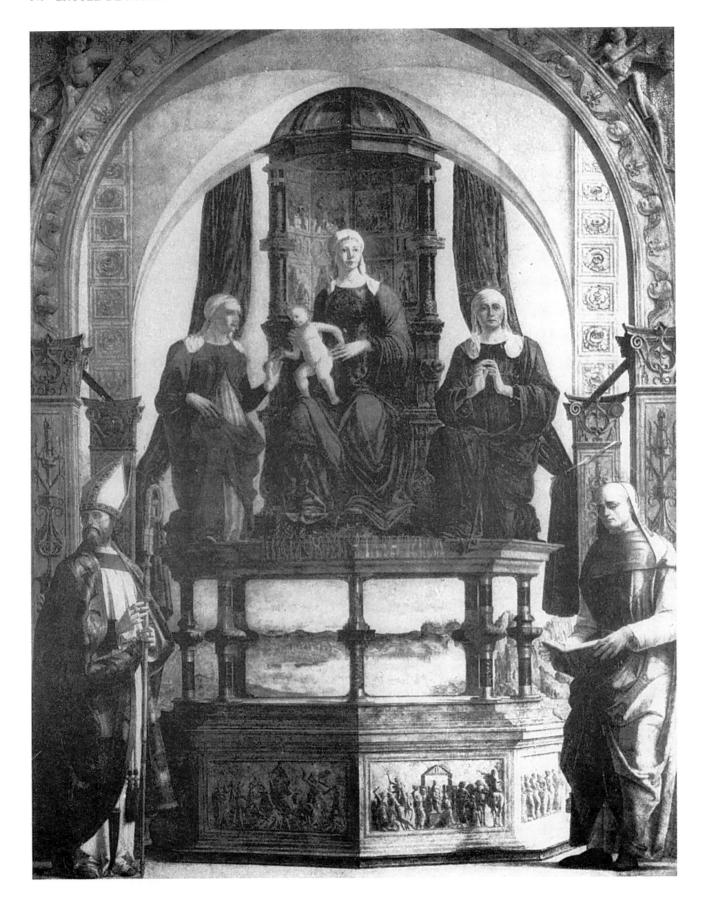

Rogier van der Weyden (1399 or 1400–64)
Descent from the Cross
Panel; 7 ft 2¹/₂ in. × 8 ft. 7 in. (219.7 × 261.6 cm.)
Madrid, Prado

Little is known about Rogier van der Weyden, a scholarly predicament exacerbated by the fact that he neither signed nor dated his works. Documents can supply a few facts about his life; however, most of Rogier's major paintings were destroyed by the end of the 17th century, and his once renowned name was all but forgotten until four hundred years after his death, when interest in the so-called "Flemish Primitives" was revived during the 19th century. Nonetheless, Rogier van der Weyden is recognized today as a forceful and influential figure who, along with Robert Campin (the "Master of Flemalle") and Jan van Eyck, formed the mighty "first generation" of northern Renaissance painters.

The reconstruction of the actual events of Rogier van der Weyden's life and the dating and attribution of his paintings still engender controversy among scholars. As more documents are discovered and interpreted, the facts begin to emerge, and it is now generally acknowledged that Rogier was born in Tournai, where he apprenticed with Robert Campin before going on to win fame and fortune as the official painter of the city of Brussels and intimate of the Burgundian Court. He visited italy in 1450, but the effect of this journey upon his own highly personal style was mainly relegated to motifs and compositions borrowed from Italian masters. Rogier van der Weyden remained always a quintessential "Northern" painter, his style gradually evolving from the sturdy, bourgeois influence of his teacher Robert Campin to an elegance and urbanity reflective of the wealthy, aristocratic Burgundian court.

Within the hypothetical evolution of Rogier's style, the Prado *Descent from the Cross* is generally accepted as a fairly early work. yet, the characteristics of Rogier's mature style are clearly evident, making this the most famous and often copied of his paintings, if not his most important commission. The *Descent* exists today as a single panel, but it was originally part of a triptych consisting of two additional painted wings. A second version (the *Edelheer Altarpiece*, Louvain, Church of St. Peter), dated 1443, was once believed to be the original and the Prado painting a copy. However, laboratory study has revealed that the Prado version is the older of the two, probably dating from the 1430's, and must therefore be accepted as the original. The fact that the *Edelheer Altarpiece*, a close copy, was executed so soon after the original attests to the great fame and notoriety of the *Descent*.

The ten human participants in Rogier's Passion drama can be identified according to medieval accounts of the crucifixion. At the left are two holy women who aid the apostle John in attending the prostrate Virgin. The third Mary, the Magdelen, clasps her hands in grief at the far right of the panel, her bent posture echoing like a parenthesis the pose of John the Evangelist at the opposite end. Supporting the bleeding body of Christ are Nicodemus and Joseph of Arimathea whose traditional tasks were to remove the nails from Christ's feet and hands. Two unnamed assistants also participate, one poised on the ladder gently grasping Jesus's left arm, the other standing between Nicodemus and the Magdelen holding an ointment

jar. These figures enact the sad drama within a shallow gilded niche barely large enough to contain them as they move in a sinuous calligraphic rhythm across the picture plane. Gone is the Eyckian obsession with minute detail and miniature forms. No perspective depth or landscape background is permitted to interfere visually with the human drama enacted within. It is as if a sculpted altarpiece has come to life.

The most extraordinary aspect of the Prado *Descent* is Rogier's treatment of the Virgin Mary, who collapses senseless to the ground, her body posed in a visual parallel to that of her crucified son. The motif of the swooning Virgin was not new in the 15th century; however, the unity of Mary's spiritual sorrow with her son's physical agony appears for the first time in Rogier's painting. This unique artistic development reflects the expanded role of Mary in the religious devotion of the 15th century, when the cult of the suffering Virgin culminated in the declaration of a feast dedicated to her sorrows. It was believed that Mary felt greater agony in her soul than was possible physically during the crucifixion because her mother's deep compassion allowed her to experience fully her son's agony. The Virgin's active participation in the passion therefore qualified her as co-redemtrix along with her son. In the words of Otto von Simson, Rogier's *Descent* ". . . portrays the extreme expression of Mary's share in the divine sacrifice."

The subject matter and meaning of the Prado *Descent* are closely related to the circumstances of its commissioning. Painted for the Church of Notre Dame hors-les-murs (Our Lady Outside the Walls) in Louvain, it was paid for by the guild of crossbowmen and presumably placed within their chapel. Rogier's emphasis on Mary's suffering corresponds to the dedication of the Church to the "Virgin of Sorrow." Likewise, the order of crossbowmen identified themselves with the suffering Virgin, whose heart was described by biblical commentators as pierced by an arrow or a sword at the crucifixion. Rogier indicated the participation of the guild by painting the delicate Gothic tracery in the corners of the *Descent* in the stylized shapes of small crossbows. Thus, style and content in Rogier's work cannot be separated, for both arose from the religious and artistic context of the time.

Rogier's style, as demonstrated in the Prado *Descent*, brought strength and drama to the painterly vocabulary of Northern art. Here, depth and intensity of human feeling are emphasized by eliminating the clutter of symbolic objects that sometimes overruns the paintings of Rogier's contemporaries. His works are, in the words of Erwin Panofsky, "physically barer and spiritually richer" than those of Campin and Van Eyck. As early as 1604, Carel van Mander recognized that ". . . by depicting the inner desires and emotions of his subjects," Rogier van der Weyden "improved our art of painting greatly." He was correct, for it is the powerful yet restrained emotionalism of the Prado *Descent* that speaks most eloquently to modern audiences.

—Laurinda S. Dixon

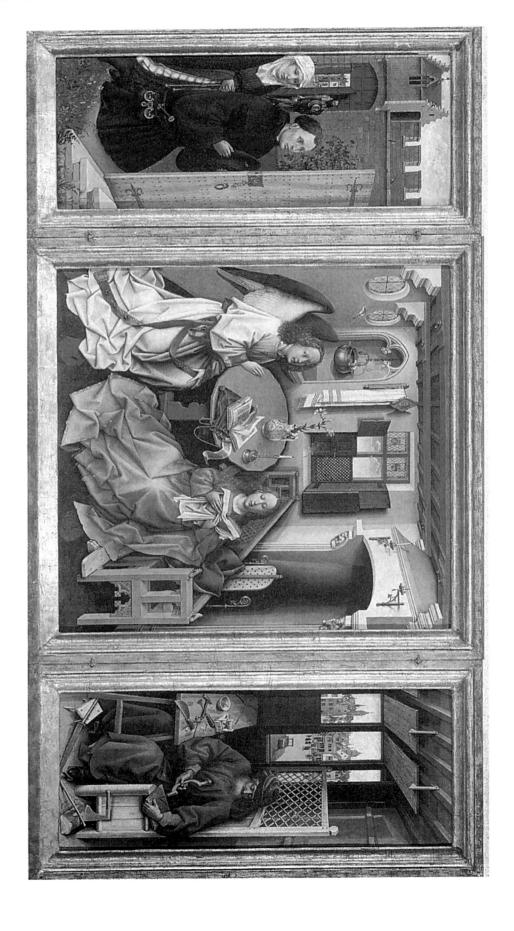

Robert Campin (c. 1378–1444)
Mérode Triptych, c. 1425
Panel, 25¹/₂ in. (63.8 cm.) height
New York, Cloisters

Bibliography—

Minott, Charles I., "The Theme of the Mérode Altarpiece," in
Art Bulletin (New York), 51, 1969.

The *Mérode Triptych* in the Cloisters Collection of the Metropolitan Museum of Art in New York City is named for the prominent Belgian family to whom it once belonged. The coats-of-arms in the window glass of the central panel further identify it as having early association with the Inghelbrechts family of Malines (Mechelin). The triptych is undated and unsigned but stylistic analysis has produced a consensus among scholars that it was painted by the Tournai artist Robert Campin, probably about 1425.

The style of the *Mérode Triptych* is an early example of the new and impressive "realism" of Flemish painting in the 15th century. Campin was one of the originators of this style, and his painting features prominently in almost all discussions of the art of the period. It was executed in the new medium of oil paint on oak panels. This gives it the characteristically bright color and freshness associated with the works of the great masters of early Flemish painting.

The central panel of the triptych shows the *Annunciation to the Virgin Mary,* a very deeply spiritual event in Christian worship. Its immediacy for the worshipper is indicated by the modern (15th century) setting and by the pair of donors in the left wing who are privileged to gaze upon the scene itself. Because it celebrates the Incarnation, some modern scholars have suggested that it represents a votive prayer by the donors for the blessing of children for their own marriage. There is no proof of this, of course, but the idea is very appealing.

In the *Annunciation* scene Mary is shown reading, seated on a cushion on the floor before a long bench and a fireplace. The archangel has just entered and a tiny image of the Christ-child glides along a light-beam towards the Virgin from an oculus window on the left. He bears His cross already, indicating His purpose in coming to earth.

Behind the donors in the left wing is a walled garden. In the portals leading to the street beyond stands a figure whom we take to represent the Prophet Isaiah. he appears in the guise of a town messenger, an appropriate role for Isaiah whom God appointed as messenger to Jerusalem (Isaiah 6). He is important here as the prophet who predicted the event we see (Isaiah 7:14). He stands as a distant witness, just inside the outer portal, echoing Gabriel's position inside the door to the Virgin Mary's room.

The right wing, opposite, shows the workshop and person of Mary's spouse, St. Joseph the carpenter. He rarely appears in portrayals of the *Annunciation* because of a traditional apprehension that his presence may confuse the issue surrounding the special circumstances of the Incarnation. It is clear that other criteria bring him to the fore, here. Among these is the particular veneration for St. Joseph that had been preached and promulgated at the Council of Constance (1418). St. Joseph was also seen as the model for the ideal spouse in marriage and so promoted by the church at this time.

At a more subtle and complex level, Robert Campin introduced meaning into this triptych by means of symbols. These provide a reassuring link to the spiritual lessons and teachings read daily by the faithful of the 15th century. They helped him in his meditations even in the presence of the sensual pleasures of beautiful colors and forms provided by this new style of realism in artistic expression. We certainly do not know how to interpret all such symbols today. Yet they hold a kind of fascination; a special energy of their own. Campin was an extraordinary master at the formulation of symbols as, in their individual ways, were his contemporaries Roger van der Weyden and Jan van Eyck.

Perhaps the most appealing and important of these symbols in the *Mérode Triptych* appears in St. Joseph's workshop. It is the little mousetrap on the saint's workbench, a tiny boxtrap of a design not very familiar in our day but common enough, we suppose, in the Tournai of 1425. In the context of St. Joseph's workshop this simple object might be seen as a carpenter's homely product. But as a symbol it serves well to justify the presence of the saint and to explain his enormous importance to the way of salvation. Campin based his mousetrap on a popular religious treatise written by St. Augustine. The learned saint likened the cross of the Crucifixion to a mousetrap in which the Devil was caught by Christ's self-sacrifice. Christ, metaphorically, was the bait and St. Joseph the trapper. Satan, confused by his own mistaken belief that St. Joseph was the natural father of Jesus, was destroyed by his error.

To reinforce this symbolism and to tie it to the emphasis on Christ's Incarnation, Campin added other symbolic details to his work, taking care that they were appropriate to the visual world of the events shown. They are mostly drawn from the prophecies of Isaiah whose importance in this context and presence in the triptych we have already noted. Most obvious is the smoldering candle, all but extinguished, on the table in front of Mary. The candle is a symbol of Christ. it is shown with a "dimly burning wick," the "smoking flax" of Isaiah 42, 3. The little spark represents the humble, human life-force of the tiny Christ-child as the Lord "brings forth judgment unto truth."

A second symbolic entity in the triptych is the little array of tools at the feet of St. Joseph. The saw, rod and ax represent the tools mentioned in Isaiah 10, 15. They, like St. Joseph himself, are the instruments used by the Lord for his own ends, the active extensions of God's hand.

Robert Campin and his contemporaries' extraordinary ability to employ visual symbolism in this way engendered the controversial concept of "disguised symbolism" expounded by Erwin Panofsky. It is largely a controversy of semantics and revolves about the extraordinary ability of these artists to reconcile objects and artifacts bearing direct symbolic meaning with the visual continuity of their paintings. Most would agree that the use of this form of symbolism in no way constitutes a disguise or concealment of the meaning from the patrons and contemporaries of the artists. Today's viewers, whose culture has evolved far from the 15th-century religious patterns of life and art, find access to the meaning more difficult. But the alternate search, for aesthetic and stylistic value in the works, need not obscure the vivid and insistent statements of faith that they contain.

—Charles I. Minott

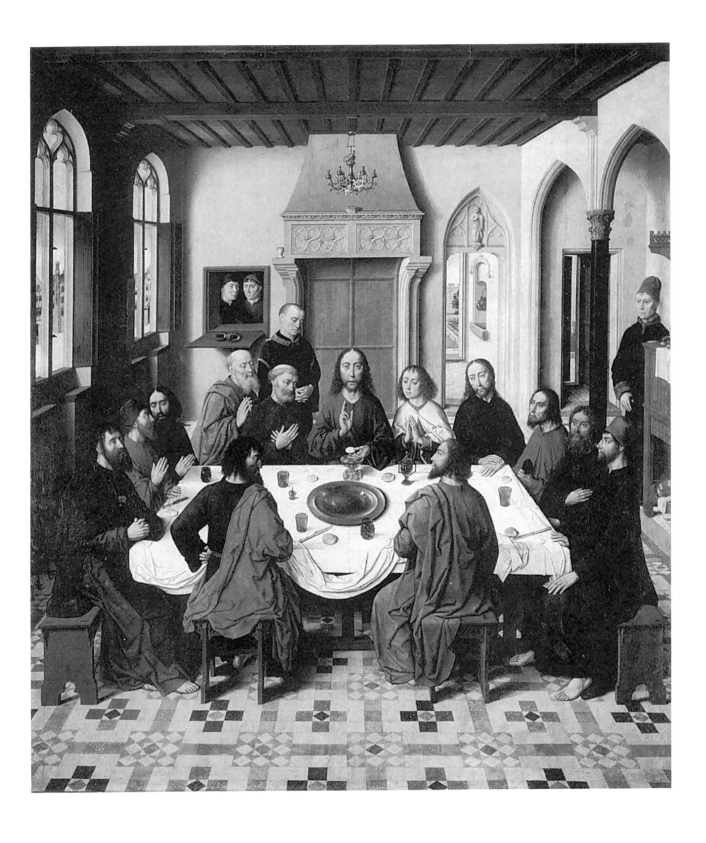

Dirk Bouts (c. 1415–75)
The Last Supper, 1464–68
Panel; 5 ft. 11 in. × 4 ft. 11 in. (180.3 × 149.9 cm) (central
 panel)
Louvain, St. Peter

Dirk Bouts's documented works are all from the later part of his life, between the years 1464 and 1475 (though the *Portrait of a Man* is dated 1462 on the work itself). In fact, no documents survive concerning Bouts's life before he came to Louvain as a mature painter, and there is consequently difficulty in tracing any development in his art. *The Last Supper*, for instance, is his first fully documented work (we have details of the commission by the Brotherhood of the Holy Sacrament, fees, etc., from the years 1464–68), but is certainly not a work by an inexperienced painter. In fact, it is characteristic of Bouts's work, and a masterpiece.

The work consists of a large central panel representing Christ and his disciples at the last supper (four other men are also in the representation), in a spacious well-lighted room with windows at the rear and the left side opening onto the city. Four panels, each roughly one-quarter the size of the central panel, function as wings on each side of the major panel.

The viewer's first response to the large central panel is one of seriousness: though there is implied movement in the position of the disciples, especially in their hands, the sense of formality and stasis is strong. The theological basis for this commissioned work had been set by two professors at the University of Louvain, Jan Varenacker and Aegidius Baelwael, and the seriousness with which Bouts approached the work is obvious.

Christ faces forward from the exact center of the panel, with his right hand raised in blessing as he holds the wafer of the Eucharist. Obviously, then, this is a panel which might be called the *Institution of the Eucharist*, and not the more familiar scene in which Christ prophesies that one of the disciples will betray him. (Judas is noticeable in the painting: he sits in a rather convoluted posture, with his hand—the one that will accept the 30 pieces of silver—held behind his back, almost as if he cannot share the meal. But this is a minor element in the overall work.) The disciples are seated in strict order around the rectangular table, four at the back with Christ, three at each side, and two with their backs to the viewer. Each one is reacting to what Christ has just said and done—and their faces are all visible. Equally emphasized are the expressive hands of the disciples—picked out by direct light in most cases.

The formal, almost hieratic, structure is heightened by a series of triangular shapes overlaying the picture. Christ and the two disciples sitting opposite him form the most obvious shape, but a larger triangle is formed by the disciples seated at the sides of the table and the chandelier over Christ's head.

There is a high eye-level, which adds to the formality—as if we were looking down on the scene. The figures are well back into the picture space: in fact, there is a rather large portion of tiled floor at the very bottom of the panel, and a side section of the room on the right balances the windows on the left, suggesting even more space. A window and a hatch at the back also open out the room.

The most obvious reason for this sense of spaciousness is to balance the figures in the main panel with those in the side panels. In the side panels, the figures are brought to the front of the picture space, and the result is that the figures in both side and central panels are roughly the same size.

The subject matter of the side panels obviously reflects the advise of the university professors, though some of the material was traditional. The four panels represent scenes from the Old Testament, and are of events that had come to be seen as pre-figuring the Eucharist.

The panel of the *Meeting of Abraham and Melchizedek* shows the gift of the meal of bread and wine after a famous victory. This panel, like several other works of Bouts, contains specific portraits of Louvain men, perhaps associated with the commissioning of the picture. (The four extraneous figures in the central panel—two attendants and two seen through the hatch at the back—are also thought to be portraits.) Diagonal movement in the back of the panel leads into the distance, with smaller figures to give perspective.

The *Gathering of Manna* panel suggests the gift of food (and life) from God. The gatherers are putting the manna into vessels, suggesting later church ritual. There is similar diagonal movement in this panel, with rugged hillocks perhaps meant to represent a desert landscape.

The *Elijah in the Wilderness* panel shows an angel bending over the sleeping figure of Elijah. His being fed by an angel so that he can journey for 40 days prefigures elements in Christ's life. Elijah is also seen on the road leading into a hillocky desert landscape on the right, and away from the more lush landscape on the left.

The *Sacrifice of the Paschal Lamb* panel shows a family group eating standing up before beginning the journey out of Egypt. This panel is the only one of the four to be set in a room, and the table and tiled floor heighten the link to the central panel.

The success of *The Last Supper* was evidently adequate for Bouts to be named the official painter of Louvain in 1468.

—George Walsh

Jan van Eyck (c. 1390–1400—1441)
The Ghent Altarpiece, 1432
Ghent, St. Bavo

Bibliography—

Puyvelde, Leo van, *Van Eyck: The Holy Lamb,* 1947.

Coremans, Paul N., and A. J. de Bisthoven, *Van Eyck: The Adoration of the Mystic Lamb,* Antwerp, 1948.

Coremans, Paul N., *L'Agneau Mystique au laboratoire: Examen et traitement,* Antwerp, 1953.

Denis, Valentin, *Van Eyck: The Adoration of the Mystic Lamb,* Milan, 1964.

Thelheimer, Siegfried, *Der Genter Altar,* Munich, 1967.

Philip, Lotte Brand, *The Ghent Altarpiece and the Art of van Eyck,* Princeton, 1971.

Dixon, Laurinda S., "The 'Musical Angels' of the *Ghent Altarpiece,*" in *Bulletin, University of Cincinnati,* 1971.

Dhanens, Elisabeth, *Van Eyck: The Ghent Altarpiece,* New York, 1973.

Radke, Gary M., "A Note on the Iconographical Significance of St. John the Baptist in the *Ghent Altarpiece,*" in *Marsyas,* 18, 1975–76.

Jolly, Penny Howell, "More on the Van Eyck Question: Philip the Good of Burgundy, Isabelle of Portugal, and the Ghent Altarpiece," in *Oud Holland* (The Hague), 101, 1987.

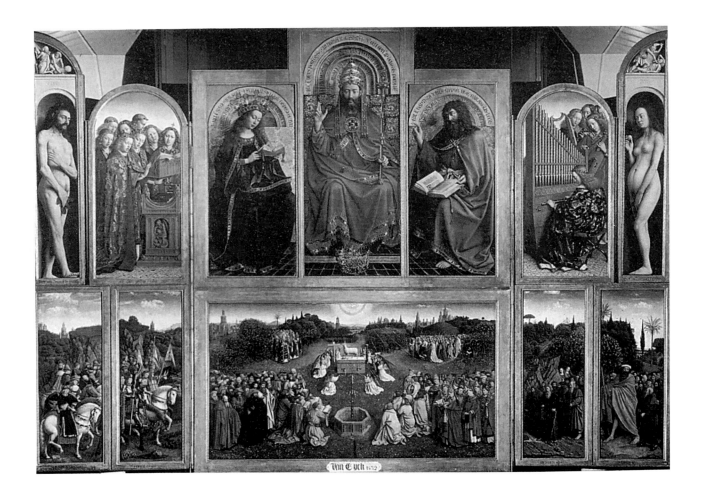

The *Ghent Altarpiece* was considered one of the wonders of the world in the sixteenth century. Today it is recognized as one of the wonders of northern Renaissance art. Four lines of inscription written on the outside of its lower frame ascribe the work to the brothers Hubert and Jan van Eyck and proclaim a date of 6 May 1432 for its dedication. This famous quatrain, discovered in 1550, has perhaps instigated more controversy among scholars than any other verbal inscription in the history of art. Written in Latin, its accepted translation is: "The painter Hubert van Eyck, greater than whom no one was found, began [this work]; and Jan, his brother, second in art, having carried through the task at the expense of Jodocus Vyd, invites you by this verse, on the sixth of May [1432], to look at what has been done." To some, the verse suggests the tantalizing possibility that the famous Jan van Eyck, universally considered to be the father of Netherlandish painting, was actually subordinate to a brother named Hubert. Despite many attempts to identify paintings by Hubert van Eyck, though, the fact remains that not a single one exists, compared to the many extant works by his "lesser" brother Jan. Scholars have suggested many solutions to the problem of division of hands in the polyptych, but in the end they have little to go on without further documentary information. It appears that the famous inscription on the frame asks more questions than it solves.

Despite the controversy that surrounds it, the *Ghent Altarpiece* is, after all, a marvel of painterly virtuosity and complex iconographical content. The 12 panels that comprise its exterior are arranged in three ascending tiers and depict the donors and patron saints on the lower level, the Annunciation in the middle register and four prophets and sibyls in the arched spaces above. The donors, Jodocus Vyd, Mayor of Ghent, and his wife, Isabel Borluut, appear with typical Eyckian naturalism as the elderly couple that they were in 1432, kneeling in narrow niches. Between them on the lowest level are *trompe l'oeil* statues of Saints John the Baptist and John the Evangelist, patrons of the city of Ghent. Above the donors and saints in the middle register is an Annunciation scene, which takes up four panels. Here, the traditional symbols of Mary's purity—lilies, wash basin, and towel—figure prominently. The figures in the upper arches represent the prophets Zechariah and Micah and the Cumaean and Erythrean sibyls.

When opened, the altarpiece erupts in a splendid display of brilliance and color. The 12 interior panels are arranged in two registers consisting of seven in the upper tier devoted to angels and large isolated holy figures, and five in the lower register filled with multiple figures and detailed landscape vistas. In the upper tier, the central grouping consists of the enthroned figures of God the Father, Mary, and John the Baptist. On either side are two groups of musical angels dressed in sumptuous robes; at the outer edges of the altarpiece, the nude figures of Adam and Eve stand in slender stone niches. Among the five panels that make up the lower register is a large central scene depicting the Adoration of the Lamb. Here, Eucharistic symbolism abounds as small angels swing censors and blood pours from the breast of the sacrificial lamb standing upon a spotless altar. Below is an octagonal baptismal font symbolizing the fountain of life which is filled with floating host wafers. On either side of the font are groups of apostles and martyrs on the right and Old Testament prophets and kings on the left. Behind them, in the distant landscape, Virgin

martyrs carrying palm branches and blue-robed confessors emerge from groves of trees and flowers. The procession of saints continues in the four panels at either side of the "Adoration." Identified by inscriptions on the frame, the Just Judges and Holy Warriors appear on horseback within a mountainous landscape in the two left panels, and Hermits and Pilgrims walk through the rocky sands of a desert landscape in the right panels. In fact, every category of sainthood is represented in the encyclopedic panels of the lower register.

The complex iconographic program of the interior panels is as much of a conundrum as the famous quatrain. The inspiration for the Adoration of the Lamb by All Saints comes from the Book of Revelations and is required reading for the vigil of All Saints' Day (November 1) in the church calendar. A specific text which would unify the whole altarpiece, however, has yet to be identified, though various sources have been suggested. The possibility exists that Jan van Eyck himself devised the multifarious iconographic program, as he was known during his day as an erudite student of theology.

Any attempt to interpret the meaning of the *Ghent Altarpiece* must take into consideration its checkered history and the fact that the altarpiece looks very different today than it did in 1432. The work has been cleaned and restored at least six times and dismantled even more often. It was removed from the Vyd chapel in the 1560's when it became a target for iconoclastic rioters in Ghent. In 1822 the altarpiece was threatened by a fire, and in 1934 one of its panels was stolen and replaced by a copy painted after a photograph of the original. During World War II, Hitler had designs on the *Ghent Altarpiece* as the centerpiece for his planned Museum of the Third Reich, and it was hidden in a cave for several years. Indeed, the condition of the altarpiece today betrays its past history. When closed, for example, the exterior panels do not cover the interior panels, and the blue sky above the gilded thrones of the Virgin and Baptist peeks out over the rounded arches of the prophets and sibyls. Perspective views and figural scales also differ from panel to panel. The sole of Adam's foot, for example, reveals a view from below, whereas the Angels and Holy Figures appear head-on. Furthermore, neither the treatment of the floors nor the backgrounds in the seven upper-register interior panels match. In 1950 comprehensive scientific examination of the altarpiece by X-ray and spectrography revealed evidence of contemporary overpaint, leading scholars to posit proof of the intervention of Jan van Eyck in the uncompleted work of Hubert. It appears, for example, that Jan might have painted over the trefoil arches that originally bracketed the two Annunciation panels on the exterior. Likewise, contemporary alterations were made to the interior, resulting in the addition of elaborate brocade robes and crowns and the modernization of several musical instruments in the musical angels panels. The attempt to reconstruct the original organization of the *Ghent Altarpiece* and to discern the work of Jan and Hubert van Eyck continues as new evidence is uncovered. For the moment, however, the great polyptych must be seen as the work of Hubert van Eyck filtered through the vision of his brother Jan. Though problems plague our appreciation of the work, it is still acknowledged as the major masterpiece of northern Renaissance art.

—Laurinda S. Dixon

Jan van Eyck (c. 1390–1400—1441)
The Madonna with Chancellor Nicolas Rolin, c. 1436
Oil and tempera on panel; 26¹/₂ × 24³/₄ in. (66 × 62 cm.)
Paris, Louvre

Bibliography—

Snyder, James, "Van Eyck and the Madonna of Chancellor Nicolas Rolin," in *Oud Holland* (The Hague), 82, 1967.

Brownlow, F. W., and M. Felheim, "Van Eyck's Chancellor Rolin and the Blessed Virgin," in *Art Journal* (New York), 27, 1968.

Adhémar, Hélène, "Sur la Vierge du Chancellor Rolin de van Eyck," in *Bulletin: Institut Royal du Patrimoine Artistique* (Paris), 15, 1975.

Van Buren, Anne Hagopian, "The Canonical Office in Renaissance Painting, Part II: More about the Rolin Madonna," in *Art Bulletin* (New York), 60, 1978.

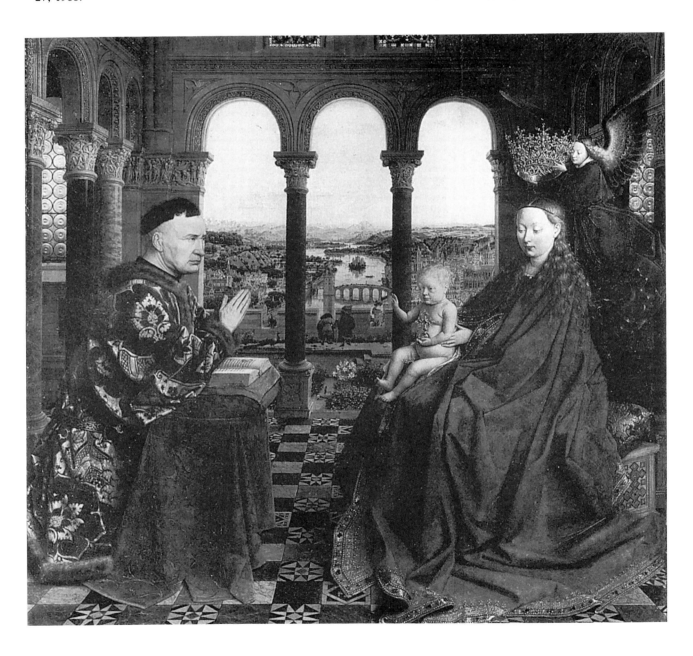

Petrus Christus (c. 1410–20—1473?)
Portrait of a Carthusian, 1446
Tempera and oil on panel; 11¹/₂ x 8 in. (29.2 x 20.3 cm.)
New York, Metropolitan

The *Portrait of a Carthusian* is one of six paintings signed and dated by Petrus Christus, who worked in Bruges from 1444 until his death in 1472 or 1473. Though the number of extant autographs works by this painter is nearly as large as the number remaining by Jan van Eyck, his was not a career filled with public acclaim. In fact, Petrus Christus was not included in Van Mander's 1604 *Book of Painters* and Vasari (1550) only mentioned him in passing as being the author of a painting in the collections of the Medici. His importance today lies in the fact that his works are the only remnant of painting in Bruges from the death of Jan Van Eyck in 1441 to the arrival of Hans Memling in 1465. As such, the art of Petrus Christus is worthy of examination and appreciation as a link between the Netherlandic tradition of the "founders" Van Eyck and van der Weyden, and a new emerging "Dutch" view with roots in the Haarlem style.

The *Portrait of a Carthusian* represents Petrus Christus's expanded commentary upon the venerable Eyckian tradition that infused every aspect of cultural life in Bruges. The painting, signed and dated "PETRUS ˙ XPI ˙ ME ˙ FECIT ˙ A° 1446," shows a three-quarter view of a cleric dressed in the white robe of the Carthusian order. Following the northern portrait tradition established by Jan van Eyck (see, for example, the *Man in a Red Turban,* 1433, London, and *Portrait of Margaretha van Eyck,* 1439, Bruges) the subject looks directly out of the picture, locking eyes with the viewer's. His closely observed, meticulously detailed features rival the microscopic vision of Van Eyck himself. The pleasant face is not handsome—the young man possesses an over-long nose and a prim, yet sensitive mouth. The forthright plainness of the visage suggests that this is not an idealized, sanctified image, but a portrait painted from life. The delicate halo surrounding the head was probably added later by some owner who preferred to have an image of a Carthusian saint—perhaps Saint Bruno or Denis the Carthusian—rather than an individualized portrait of an anonymous cleric.

A sense of mystery surrounds this portrait, and quite a bit of art-historical controversy. Certainly portraits of monks are rare, as they took vows of poverty and maintained personal anonymity within the confines of their orders. To preserve one's features for posterity in a portrait would seem to deny the monastic virtue of humility and contradict the tradition of self-deprecation practiced by the cloistered Carthusians. It has been suggested that the young clerick's shaved upper lip and full head of hair mark him as a lay brother, since shaving the face was denied to fully invested monks whereas shaving the top of the head into the form of a tonsure was required. Indeed, the very existence of this portrait is less baffling when explained in secular terms as the portrait of a lay brother attached to the Carthusian order.

Another controversial element in this portrait is the extraordinary presence of a painted fly positioned on the bottom of the frame, just above the last letter of the artist's first name, "PETRUS." This insect, rendered with exacting *trompe l'oeil* effect, gives the impression that the painted frame is actually a three-dimensional parapet, and that the fly has landed for a brief moment in time. This striking detail certainly demonstrates the artist's virtuosic skill. Indeed, Erwin Panofsky suggested that the fly was intended to remind the viewer of an ancient tradition found in the writings of Philostratus Lemnius, a Roman writer of the third century A.D. Lemnius referred to a famous antique painting in which the artist reproduced a bee on a flower so convincingly that one was not sure whether "an actual bee had been deceived by the picture or a painted bee deceived the beholder." Interpreted in the context of Christian thought, however, the fly would carry moralizing content. As a creature believed, in the 15th century, spontaneously to generate from decay and filth, the fly becomes a symbol of the corruption of the grave. Serving as a *memento mori,* the insect reminds the viewer of the final grim consequence of original sin, though the portrait, ever fresh and youthful, would seem to preserve life eternal. In this context, some have proposed that the portrait was posthumous.

Though the *Portrait of a Carthusian* closely follows the Eyckian tradition, employing a three-quarter pose, microscopic detail, and symbolic content, it does, in fact, depart from tradition dramatically. Whereas Jan van Eyck and Rogier van der Weyden placed their portrait subjects in stark relief against blank backgrounds, Petrus Christus enlivened his setting with the suggestion of logical three-dimensional space defined by both light and perspective. A light source coming from the left illumines the back wall of the shallow "space box" in which the monk sits, whereas the fly on the bottom of the frame defines the foreground—the viewer's space. This illusion of space, combined with Petrus Christus's simple, unpretentious manner, distinguishes the *Portrait of a Carthusian* as a major link between the refined, aristocratic Eyckian tradition and the emergence of the Dutch temperament in northern Renaissance art.

—Laurinda S. Dixon

Hugo van der Goes (c. 1440–82)
Portinari Altarpiece, c. 1475
Panel, 8 ft. 2 in. × 9 ft. 10¹/₈ in. (248.1 × 300 cm.)
Florence, Uffizi

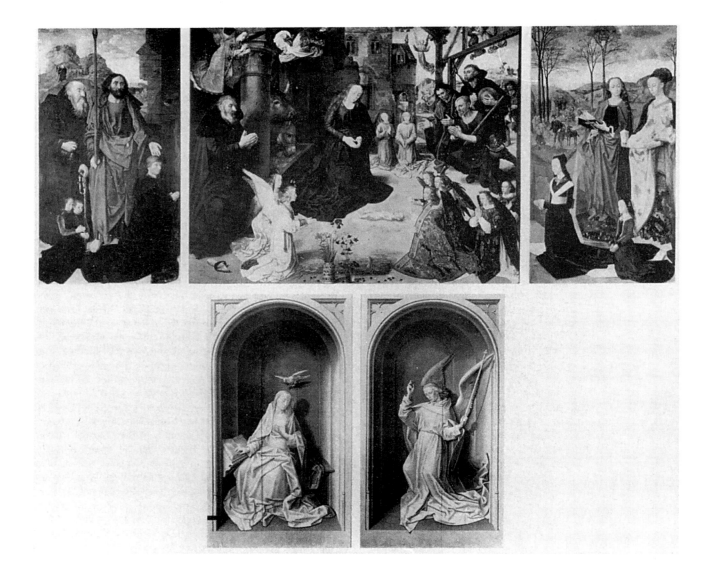

Bibliography—

Walker, Robert M., "The Demon of the *Portinari Altarpiece*," in *Art Bulletin* (New York), 42, 1960.

McNamee, M. B., "Further Symbolism in the *Portinari Altarpiece*," in *Art Bulletin* (New York), 45, 1963.

Koch, Robert A., "Flower Symbolism in the *Portinari Altarpiece*," in *Art Bulletin* (New York), 46, 1964.

Hugo van der Goes, the principal figure in Flemish painting of the second half of the 15th century, is among the most fascinating and enigmatic personalities in art history. He was blessed during his lifetime with widespread fame and enjoyed privileged status as a painter connected with the Burgundian court. Hugo was, however, a man keenly aware of his own shortcomings. He sought peace of mind in the last years of his life as a lay brother in the monastery of the Red Cloister (Roode Klooster) near Brussels. Solace eluded him, however, and, driven mad with self-doubt, he died a year after an attack of insanity cut short his brilliant career. According to a document written by a fellow monk, Hugo's "strange illness of mind" was caused by pride and aggravated by the painter's habit of drinking wine with the illustrious guests who often visited him at the cloister. Another tradition claims that Hugo, a native of Ghent, became so frustrated by his inability to match the quality of jan van Eyck's *Ghent Altarpiece* (Cathedral of St. Bavo, Ghent) that he lost his mind. No matter what the real story, the *Portinari Altarpiece* is a masterpiece. Its technical excellence and complex disguised symbolism were unrivaled in its day, and art historians are still challenged by its enigmas.

The *Portinari Altarpiece* bears the name of its patron, Tommaso Portinari, a wealthy Florentine businessman who represented the Medici family in Bruges. Sometime around 1475, Tommaso privately commissioned the altarpiece, and subsequently took it back with him to Florence, where it remains to this day. The subject of the painting was standard for the 15th century, consisting of a *grisaille* Annunciation on the two exterior wings which, when opened, reveal portraits of the Portinari family and their patron saints flanking a large central Nativity scene. The left panel depicts the male members of the family, Tommaso himself and his sons Antonio and Pigello with Saints Anthony and Thomas. Tommaso's wife, Maria Baroncelli, appears with her daughter Margherita in the right panel and their name saints Mary Magdalen and Margaret. Scholars have dated the altarpiece by the ages and number of the children represented on the interior wings. Since only three of the Portinari's six children are represented, and the fourth, a son Guido, was born in 1476, scholars assume a date of 1475 for the triptych.

The central Nativity of the *Portinari Altarpiece* reflects, in style and subject matter, two dominating forces in Hugo's life—humble devotion and the exalted example of Jan van Eyck. In his use of hidden symbolism and love of naturalistic detail, Hugo imitated the earlier master, imbuing common forms with spiritual meanings culled from the theological commentaries of his time. An example is found in the still-life of flowers and wheat casually placed in the lower foreground of the scene. Here, the sheaf of wheat alludes symbolically to the birthplace and genealogy of Christ, since the word "Bethlehem" means "house of bread." In another important sense, the wheat represents the sacrament of the Eucharist, during which bread is transubstantiated into the body of Christ. The second component of the Eucharist, Christ's blood, is signified by the grapes and vines decorating the Spanish albarello. This jar, in turn, contains a wonderfully realistic arrangement of flowers, each with its own symbolic meaning. Two red lilies symbolize the blood of Christ, and the blue and white irises represent the trinity. To the right, the transparent glass filled with columbines and carnations suggests the miracle of the Immaculate Conception, when, just as light passes through glass without breaking it, so did God enter Mary's body. The three carnations, known as "nail flowers" in the 15th century, represent the wounds of Christ, and the seven blue columbines symbolize the seven sorrows of the Virgin. Strewn on the ground are twenty violets, small flowers which grow close to the earth, symbolizing the humble devotion of each of the twenty souls gathered to adore the newly born Christ.

The concentrated symbolism of the foreground still-life is echoed throughout the center panel. The tympanum above the door of the stone castle is carved with a harp to signify the house of David, from whence Christ was descended. The letters "PNSC" and "MV" carved around it stand for "Puer Nasceture Salvator Christus" (a child is born Christ the redeemer) and "Maria Virgo" (Virgin Mary), words said at the Christmas mass. The Eucharistic flavor of Hugo's Nativity is reinforced by the angels, who wear the liturgical garments required of the celebrants of a young Priest's first Mass. Significantly, none wears the chasuble, the garment reserved for the priest himself. Clearly, it is the Christ child who is the priest, as it was he who first celebrated the Eucharist at the Last Supper. In the words of M. B. McNamee, "The chasuble that He wears is His human flesh which He assumed at the incarnation precisely that he might offer Himself as the victim for sin." Hugo combined these allusions to Christ's Passion with an emphasis on humility. Though an Adoration of the Magi would have been a grander subject to include in a Nativity scene, Hugo chose instead to paint an Adoration of the Shepherds. These unaffected, homely men, who kneel at the upper right of the scene, reflect the "modern devotion" of the 15th century, which championed a simpler, more personal faith.

Hugo van der Goes neither signed nor dated his paintings, and the *Portinari Altarpiece* is the only documented work of his that exists. It thus serves as a pivot point around which art historians argue the evolution of Hugo's style. Using the artist's insanity as justification, those paintings displaying agitated forms and dramatic emotion, such as the *Nativity* in West Berlin (Gemäldegalerie, Staatliche Museen), are generally placed later in his career. This assumption, however, is still a matter of debate, and the problem of the dating and attribution of Hugo's works continues to inspire controversy among scholars and connoisseurs. We may never know to what extent, or if at all, Hugo's style was influenced by his state of mind. His major work, the *Portinari Altarpiece* is, in the words of James Snyder, "Hugo's own personal comment on life . . . a noble, albeit sad, warm, and intensely human confession."

—Laurinda S. Dixon

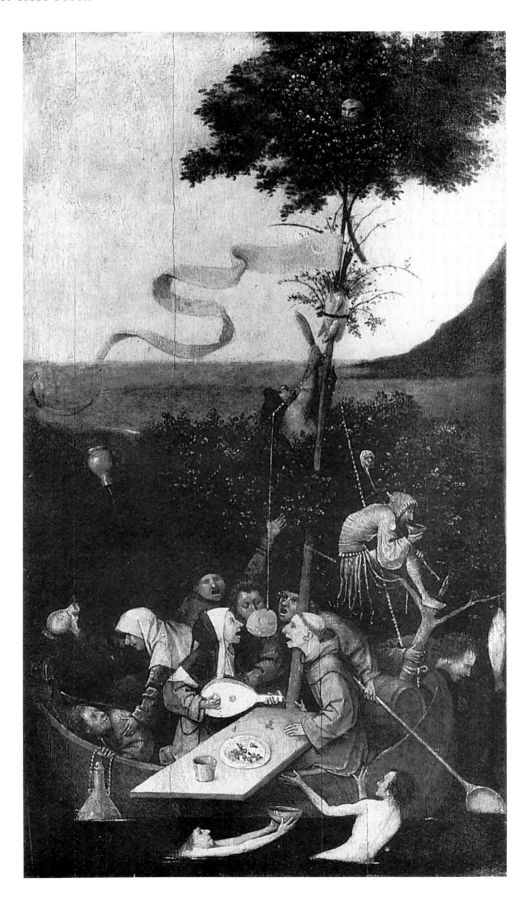

Hieronymus Bosch (c. 1450–1516)
Ship of Fools
Panel; 22 × 12⁵/₈ in. (56 × 32 cm.)
Paris, Louvre

Bibliography:

Cuttler, C. D., "Bosch and the *Narrenschiff*: A Problem in Relationships," in *Art Bulletin* (New York), 51, 1969.
Boczkowska, Anna, "The Lunar Symbolism of the *Ship of Fools* by Bosch," in *Oud Holland* (The Hague), 86, 1971.

Art historians know almost nothing of Bosch's life. As a result, they have freely suggested many highly idiosyncratic theories about his life and work. Bosch has been described variously as a bitter heretic and a devout Christian—a provincial humorist and a learned sage. Scholars have labeled him a lunatic, a religious fanatic, a drug addict, and a cultivated intellectual. Netherlandish folklore, witchcraft, astrology, alchemy, Biblical texts, and even Freudian psychology have all fueled the controversy surrounding this enigmatic painter. Art historians have found pictorial models for some of Bosch's images among 15th-century prints, manuscript illuminations, church furniture, and cathedral sculpture. Scientists have joined the fray, examining the paintings with X-rays and ultraviolet light in an effort to chart the development of Bosch's style. It would seem that the strange, amorphous forms and fierce monsters in Bosch's works present visual incongruities that cannot be rationalized within the context of 20th-century experience.

Bosch's paintings are not so mysterious, however, when understood in the context of his time. Like all artists, Bosch was molded by the concerns of his fellow human beings and those concerns, in turn, shaped his imagery. Working from this practical assumption, recent scholarship has found keys to much of Bosch's symbolism in literature and documents dating from the late 15th and early 16th centuries. These sources reveal that the conventional wisdom of Bosch's time was quite different from the post-atomic pragmatism of the late 20th century.

Bosch drew heavily upon the popular moralizing literature of his day to illustrate the folly of the human race, and his *Ship of Fools* is one of several works inspired by such sources (see also the *Haywain* triptych, Madrid, Prado). The painting is long and narrow in shape, and it probably once formed part of a triptych along with two other works, the *Death of the Miser* (Washington) and a fragment of a panel illustrating the sin of gluttony now at the Yale University Art Gallery (New Haven). Scholars have interpreted the *Ship of Fools* variously. However, they all agree that Bosch's motley crew is incapable of sailing their boat safely, for they have no pilot, no rudder, and no sail. The ship's only oar is nothing but a giant spoon, and its mast is formed out of a tree in full leaf. The passengers, unaware of their hazardous situation, are more interested in eating, drinking, vomiting, singing, and swimming naked than in navigating their craft. A fool, perched where the masthead should be, leads him in their folly.

Though the wayward ship has been a popular metaphor since medieval times, Bosch's painting was probably inspired by Sebastian Brant's *Narrenschiff* (*Ship of Fools*), which was published in at least six editions and several languages during the painter's lifetime. Scholars have suggested a source for both Brant and Bosch in the grim floating asylum boats of the time that occasionally docked for supplies at port cities, drawing crowds of curious onlookers. Art historians have also noticed the resemblance of Bosch's boat to popular May-day and Carnival parade floats. Indeed, the painting's satire is centered around a frolicking monk and nun who, surrounded by cherries, wine, and music, engage in a mock courtship. Their implied lust is augmented by intimations of gluttony as they gaze greedily at a large unleavened loaf, the food of Lent, which dangles from a string between them. Above the impious pair a gluttonous peasant scrambles toward a cooked goose tied to the tree-mast. Also tied to the mast and waving above the frivolous crowd is a yellow flag bearing the image of a crescent moon, which, in medieval astrological theory, dominated lunatics and inconstant persons. The yellow crescent was also the emblem of the infidel Turks, and perhaps Bosch meant to add heresy to his litany of foolish acts. Barely visible among the branches of the tree, is an owl, the bird which, because it sees only in darkness, represents perverted wisdom. Bosch's moralizing message is then clear. Painted on the eve of the Reformation, the *Ship of Fools*, like Brant's book of the same title, criticizes the Church for turning a blind eye to widespread moral abuse.

—Laurinda S. Dixon

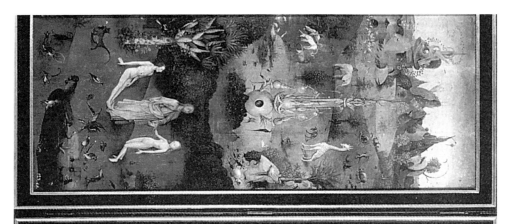

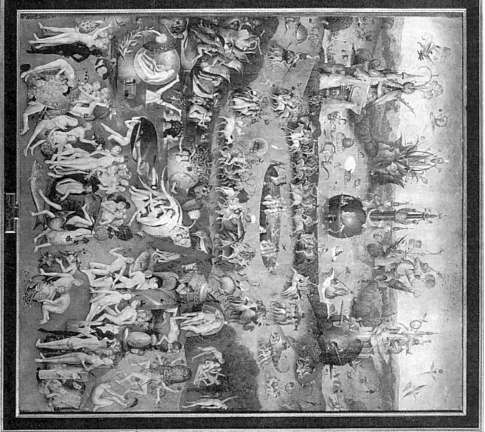

Hieronymus Bosch (c. 1450–1516)
Garden of Earthly Delights
Panel; 7 ft. 2⁵/₈ in. × 6 ft. 4³/₄ in. (220 × 195 cm.)
Madrid, Prado

Bibliography:

Lennenberg, H. H., "Bosch's *Garden of Earthly Delights:* Some Musicological Considerations and Criticisms," in *Gazette des Beaux-Arts* (Paris), 58, 1961.

Gombrich, Ernst, "Bosch's *Garden of Earthly Delights:* A Progress Report," in *Journal of the Warburg and Courtauld Institutes* (London), 32, 1969.

Glum, P., "Divine Judgment in Bosch's *Garden of Earthly Delights,*" in *Art Bulletin* (New York), 58, 1976.

Boczkowska, Anna, "The Crab, the Sun, the Moon, and Venus: Studies in the Iconology of *The Garden of Earthly Delights,*" in *Oud Holland* (The Hague), 91, 1977.

Jouffrey, Jean-Pierre, *Le Jardin des Délices de Bosch: Grandeur nature,* Paris, 1977; as *The Garden of Earthly Delights,* Oxford and New York, 1979.

The best known of Bosch's works, and perhaps his masterpiece, is the triptych entitled *The Garden of Earthly Delights.* Closed, the exterior panels illustrate the empty world encased within a transparent globe, an image unique in the history of art. When opened, the interior presents the Biblical history of the human race, beginning with Adam and Eve, continuing with their multiplication into the peoples of the earth, and ending with the violent destruction of the world. However, the surface conventionality of the subject is dispelled upon closer examination, for the painting is filled with outrageous vignettes that together form an impression of amazing complexity and incongruity. Filled with amorphous geological shapes and hybrid mutations, the large center panel is thronged with naked men and women who consort shamelessly with giant birds and partake exuberantly of huge succulent fruit. They meet their end in the grisly hell panel, where fire and ice coexist in one of the most diabolical images ever represented in art.

Several volumes could be written just summarizing the myriad interpretations of the *Garden of Earthly Delights* put forth by art historians. It has been suggested, for example, that Bosch's panels contain astrological symbols associated with the moon, and that the painting predicts a lunar eclipse. Another theory maintains that Bosch illustrated the renewal of the human race after the flood of Noah, and yet another claims that the painting depicts the future destruction of the earth by fire as foretold in *Revelations.* Many have noticed that the triptych contains many of the iconographical elements found in medieval "gardens of love," and they see the frolicking nudes as sinners whose lust will result in their punishment in hell. Others assert that the triptych is filled with illustrations of old Dutch proverbs having to do with sex, wherein the giant fruit and fish serve as erotic symbols. More than one author bids us look yet closer, to see that Bosch's playful nudes are not sinners at all, but are simply taking innocent pleasure in the bounty of Eden. It is true that Bosch well knew how to represent immorality in all its guises, and that none of the sprightly folk in his garden possess any of the trappings of sin so familiar to medieval audiences. Evidently, the symbolic vocabulary that once supplied a unified key to Bosch's patrons and public lies in another direction.

There is a symbolic framework for the *Garden of Earthly Delights* that fits comfortably within the conventional wisdom of Bosch's time, yet is part of a world view so alien to our own that no remnant remains. Such a philosophy was alchemy, the early science of chemistry practiced by doctors and pharmacists in the making of medicines. In Bosch's time, alchemy was a legitimate science, defined as the art of transmutation of base substances into pure matter via the common process of distillation. Its goal was not much different from that of modern science: to discover a way to prolong life by stopping the natural aging and weakening of an organism—or, as alchemical authors phrased it, to return the human race to the Garden of Eden. This quest had occupied learned men since the time of the ancient Greeks, and by the 15th century it had developed into a philosophical enterprise with its own obscure literary and pictorial symbolism. Taking God's creation of the world as their ultimate model, early chemists sought to make the "elixir of life," a perfect medicine capable of curing on contact. They attempted to achieve this by combining, or "transmuting" vegetable, mineral, and animal substances into a balanced material containing the properties of all three. The actual laboratory process varied considerably; however, the equation of the creation of the earth with the making of a perfect medicine was the major alchemical metaphor of the 15th century. Hundreds of alchemical manuscripts and printed books were available to anybody who could read in the 15th century. Furthermore, we know that Bosch married a wealthy woman from a family of pharmacists. In the context of his life and times, then, Bosch's knowledge of alchemy can be safely assumed.

Both the general organization and the multitudinous details of *The Garden of Delights* conform to popular alchemical allegory and practice. The Adam and Even panel, for example, echoes alchemical instructions to join substances in the same manner as God joined Adam and Even in the Garden of Eden. During this stage, known as "conjunction," ingredients of opposite natures were "married" into a unified mass. In the background of this panel, a flock of black birds flies upward through an odd-shaped mountain, eventually turning white and returning through a hole in the top of a rounded hillock. This vignette illustrates the circulation, condensation, and cleansing of impure gases, described symbolically as black birds (dirty gasses) who, flying to the tops of mountains (furnaces and flasks), become cleansed (white) and return to earth. The contradictory innocence and nudity of the folk in the center panel is explained alchemically by reference to the next stage in the operation, when the ingredients fermented, bubbled, and "multiplied" in the laboratory flask. Treatises called this stage "child's play," when substances came together in "exuberant love." It was often illustrated in alchemical texts as a sexual union. The strange hybrid flower-animal-human creatures who cavort throughout this panel would then indicate transmutation in progress. Bosch's Hell panel depicts the "putrefactio" stage of the process, when the ingredients were "punished" and

"killed" by burning and blackening in the hottest fire possible. Alchemists called this stage "hell," and warned of its monsters and explosive dangers. The resurrection and cleansing of the alchemical ingredients after their death, called the "flood of Noah," is depicted on the exterior of the altarpiece, where the earth-elixir appears within its glass flask, ready to begin the cyclic process of distillation once again with the opening of the shutters. All four scenes contain objects modeled after common laboratory apparatus, camouflaged as organic forms, and animals, fruit and stones possessing healing powers. Thus, the Biblical program of Creation, the allusion to Noah's flood, erotic symbols, sense of childish fun, and astrological imagery noticed by scholars come together within the symbolic structure of the healing art of alchemy.

Unfortunately, we do not know for whom Bosch painted his fascinating pictures,. However, Phillip II greatly admired Bosch's works, and took many of them back to Spain, where they remain today. It is unlikely that either the moralistic or the alchemical meaning of Bosch's paintings would have escaped this monarch's attention, for it was Phillip II whose conservative brand of Catholicism gave rise to the Inquisition, and it is also known that he spent vast sums of money building alchemical laboratories in the Escorial palace. It is highly unlikely, then, that Bosch's works illustrate any secret heretical or moral purposes beyond those recognized by any literate, devout Christian of his time. Now, as in the 16th century, the complexity of Bosch's iconography and the variety of his sources continue to inspire meditation and admiration.

—Laurinda S. Dixon

Joos van Ghent (before 1440–c. 1480)
The Institution of the Eucharist (*Communion of the Apostles*)
Panel; 10 ft. 2³/₈ in. × 11 ft. (311 × 335 cm.)
Urbino, Galleria Nazionale delle Marche

Duke Federigo da Montefeltro, high protector of the confraternity of *Corpus Domini,* had in the 1460's commissioned an altarpiece for its church in Urbino. Originally entrusted to Paolo Ucello who, by the time of his dismissal from the project, had finished a predella depicting in a stylized, rather primitive yet vivid fashion certain episodes from a current legend of a "Miracle of the Host," the commission was then in 1473 given to Joos.

The subject, central to members of a society dedicated to the honoring of the body of Christ, is of course depicted by a great many Renaissance artists in Italy as well as in the north, and Joos's rendition is both similar to and different from those of predecessors and contemporaries. In facial features and figure poses he is a northerner, revealing a kinship with the central panel in Dirk Bouts's *Holy Sacrament* altarpiece completed for St. Peter's in Louvain in 1467. However, the commanding geometry with its architecturally designed, symmetrically arranged receding perspective so prominent in the earlier work is absent in the Urbino altarpiece where symmetry, although present, is less emphatic and yields in importance to gestures and expressions.

The traditional Upper Room has been replaced by the apse of a church, the communion table with an altar around which the kneeling disciples eagerly await the priestly delivery of the host. Christ, instead of solemnly seated at the table, is shown in a dramatically striding pose in the center, graciously extending the wafer, while a youthful John the Evangelist stands at the altar ready to pour the wine into the chalice.

The unequal grouping of the disciples allows for a necessary inclusion of certain bystanders. A biography of the Duke published in 1604 states that a Persian delegation had appeared at the Urbino court and that the Duke, to commemorate the event, had himself and members of the delegation painted into the "main altar of the Confraternity of Corpus Domini in Urbino by Joos Tedesco, famous painter of those times and of whom it is said that he was the first to bring to Italy the modern use of painting in oil."

Clearly identifiable with his familiar profile is the Duke, and with him is an exotically attired stranger so deeply moved by the ritual that he is about to turn his eyes away from it when restrained by the calming touch of the Duke. A Madonna and Child image in a shaded background niche is thought to be the recently departed Duchess holding her son Guidobaldo.

Above the entire scene in graceful symmetry and serene brightness float two angels in a manner reminiscent of Fra Angelico, whose work in the Vatican Joos must have had occasion to study.

The Institution of the Eucharist does not display the colour richness and the elegance so characteristic of Fra Angelico and his Italian contemporaries. However, gestures and expressions indicative of a humanity hungry for spiritual food give the image a sense of urgent reality often missing in its Italian counterparts.

—Reidar Dittmann

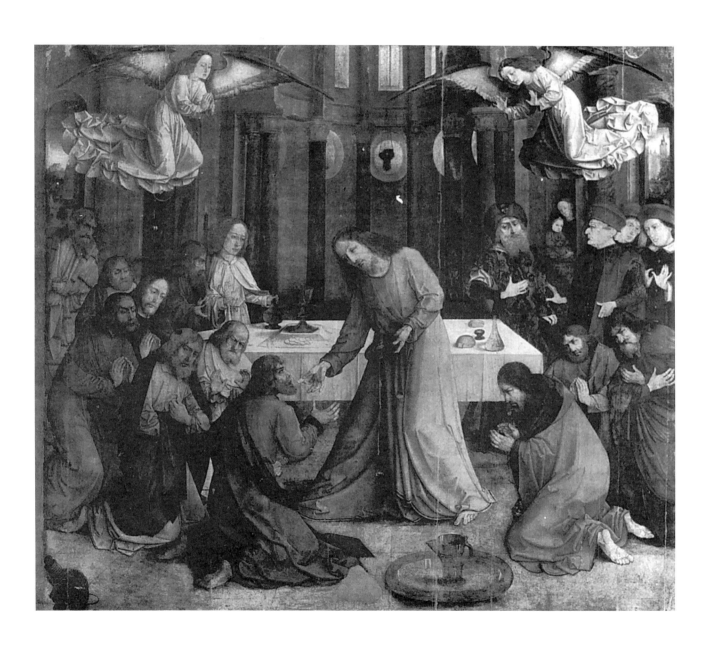

Gerard David (c. 1450–1523)
Baptism of Christ Altarpiece, 1502–07
52 × 38⁵/₈ in. (132 × 98 cm.) (central panel)
Bruges, Groenige Museum

From shortly before 1502 to 1507, the Bruges artist Gerard David painted the great triptych of the *Baptism of Christ* for Jan de Trompes of Ostende. De Trompes, who had been Magistrate of Ostende in 1498–99, lived in Bruges after 1500 where he held various official posts. The altarpiece, David's best-known work, was given to the Brotherhood of the Sworn Clerks of the Tribunal of Bruges for their chapel in the church of Saint Basile in 1520, after Jean de Trompes's death. It is now in the Groenige Museum in Bruges.

The main panel of the triptych shows a panoramic view of the baptism, its landscape continuous with that of the wings. Christ stands in the center, knee deep in the waters of the Jordan River. He is flanked by St. John the Baptist who kneels on a rock by the river, anointing Christ's head with its waters. A richly clad angel kneels on the riverbank in the lower left, holding Christ's robe. Centered over the baptism hovers the Dove of the Holy Spirit and above is God the Father at the upper edge of the panel, ringed by a circlet of puffy cloud. Within the glory surrounding the Lord are four tiny nude figures who probably represent the deceased children of Jan de Trompes.

Beyond the foreground figures in the baptism are additional groups of figures. The great feature of David's painting is the capacity of the artist to portray continuous space and to integrate the actions of these groups. On the ground in the left middle distance, St. John appears preaching to a gathering of followers. On the right John appears again, singling out the approaching figure of Christ to a few witnesses. His words *"Ecce agnus Dei"* (Behold, the Lamb of God), define a revered symbol of Christ. Beyond, near the horizon, is distant Jerusalem and above it a fortified mountaintop castle.

Jan de Trompes in company with his son appears on the left wing with St. John the Baptist. He kneels on a path bordered with flowers before a deep landscape with distant hills and groves of trees. His first wife, Elizabeth, who died in 1502,

appears on the right wing with her four daughters, accompanied by her patroness, St. Elizabeth. Hills and a closer forest appear in the background of this scene.

On the outer sides of the two wings, David painted Jan de Trompes's second wife, Madeleine Cordeier, with their first child, now four years old. They are kneeling before the Virgin, presented to her by St. Mary Magdalene. The dates of de Trompes's first wife's death, in March of 1502, his remarriage, and the age of his second wife's first child have established the time period wherein David produced the painting.

David's triptych displays a comfortable and colorful naturalism, learned in part during his early training in Haarlem from Geertgen tot Sint Jans. One can even sense a tribute to his early master in the dedication of this work to St. John the Baptist. But elements in it also display influence from Memling and other Flemish masters such as Hugo van der Goes and Jan van Eyck, whose angels on the wings of the *Ghent Altarpiece* are distinctly the ancestors of David's angel in the left foreground of the center panel.

The rational space and believable visual perspective in the *Baptism of Christ* triptych are David's own. They are achievements that carry his art beyond the 15th-century limitations of his predecessors. Misgivings about the role of Bruges in the 16th-century have tended to overshadow the true achievement of Gerard David as the city's leading painter. As did others among his contemporaries, David used motifs and references to the works of his great predecessors in a deliberate kind of "archaism," but this proved to be a vehicle for transition to new forms in the Northern Renaissance of the 16th-century. In any event, the exuberance of color and expressive but calm landscape in the triptych represent Gerard David at his best. His skills were to influence a wide range of his contemporaries and followers.

—Charles I. Minott

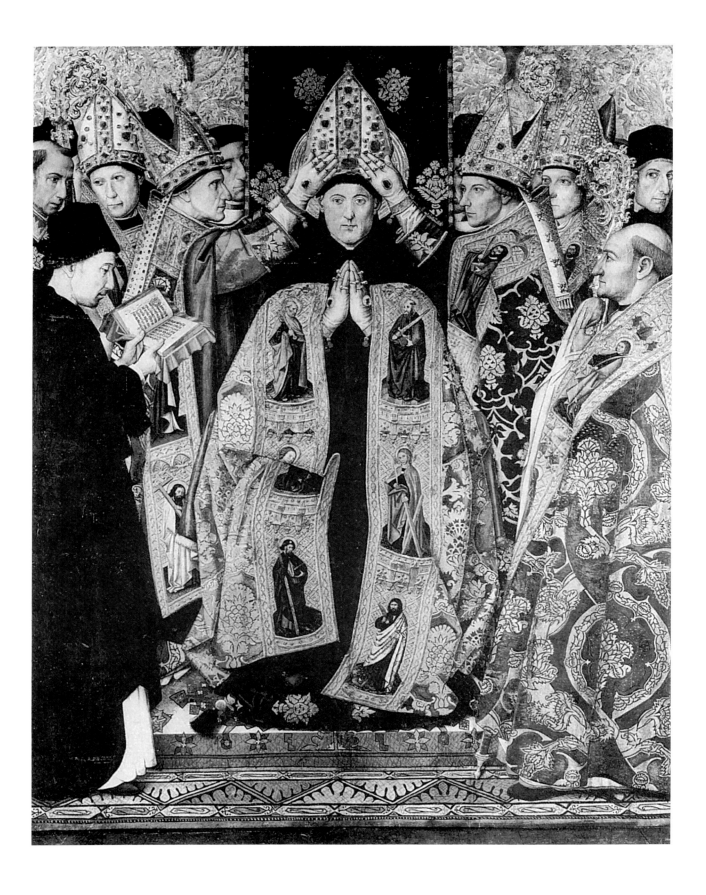

Jaume Huguet (1414–92)
Consecration of Saint Augustine, 1480
Panel
Barcelona, Catalan Museum

This large panel depicts Saint Augustine being consecrated bishop by a group of four bishops and six other churchmen (with the presence of several more implied by views of the tops of their heads in back). The saint, sumptuously attired in a golden cope adorned at its borders with six saints, which include Saints Peter, Paul, Eulalia, James, and Bartholomew, is seated, a dark brocaded cloth of honor behind him, a brocaded pillow under his feet, and an oriental rug beneath this. The churchmen, symmetrically grouped around him, are dressed with equal richness. The two bishops who place the mitre on his head wear rich copes, as do the two others behind them and the kneeling, unmitered figure at the left. The remaining figures wear the sober habits of Augustinian monks.

The number of colors used in the painting are limited: black, white, vermillion, a deep blue-green, and flesh tones are the dominant hues, though there were probably brighter blues as well which have since darkened. The rest of the surface is a web of gold-leafed patterns of brocades, gilded and jewelled accents, and gold ground. The patterned ground, cope accents, bishop's mitre, and Augustine's ringed halo are modelled in raised, gilded gesso in the process known as *embutido*. The number of different patterns superimposed over one another is large, but what makes this panel unique is that no one pattern dominates the composition.

Equal attention is given to the faces of the participants: each is an individual, each reacts differently (one, for example, peers at an angle with his nose around the cloth of honor to get a better view) and each animates this very formal, static scene. What results is truly a treatment of genius: Huguet manages to give the viewer a feeling of a tangible world—a beautiful pageant frozen in time, within the bounds of such flattening devices as gold-leaf patterns and the light-reflecting qualities of *embutido.*

The formal scene of an enthroned, robed prelate was a popular one for the center of Spanish retables during the 15th century, and can be found all over the peninsula. the *Consecration of Saint Augustine* is the most impressive of its genre, and is all the more remarkable because it was not the central effigy of the *Retable of Saint Augustine* at all, but merely one of the flanking subsidiary panels (the center was a carved image of the saint).

The story of this retable, commissioned by the Tanner's brotherhood of Barcelona, is a long one. Preparation of the altarpiece began in 1452, when the carpenter Macià Bonafé was given the contract for the woodwork supports and frame. Specifications in the contract are somewhat vague, and the exact layout of the retable is still in dispute, but it is thought that there were to be six panels of nine *palms* each in width to each side of the carved effigy (one of them, of course depicting the *Consecration*), a *banco* of four smaller paintings flanking a carved tabernacle, plus two doors to either side. Nine

palms would measure nearly two meters in width, which gives an idea of the gigantic size of the planned retable—a fact borne out by the large size of the *Consecration* and other surviving panels.

The original painting contract went not to Huguet, but to Lluis Dalmau, the celebrated painter of the *Virgin of the Councillors,* in 1456, but he had apparently abandoned the task by 1460 without doing anything. In 1463 a new contract was made with Huguet, with the stipulation that it be completed by 1468—a long time when one looks at contracts of the period, but not so long considering the extraordinary size of the altarpiece. Fate, however, was to intervene in the vicissitudes of the civil war of the Catalans against the Aragonese king Juan II, which was already raging at the time of the commission, and was not to end until 1472. The Catalan economy, not strong when the war began, collapsed when it was over. The brotherhood, committed to pay the substantion sum of 1100 *LLiures* for the altarpiece, could not come up with the final payment until 1480, and that was when the altarpiece was completed.

We will never know the original disposition of the panels of the altarpiece, or even precisely how many there were, for the church of Sant Augusti was destroyed in the 17th century. The *Consecration of Saint Augustine* is one of seven scenes to survive; all are now in the Museum of Catalan Art, Barcelona. The other scenes include Augustine listening to a sermon by Ambrose, one of his confrontations with a heretic, Augustine meeting Christ in the form of a child, Augustine washing the feet of Christ who is disguised as a pilgrim, Augustine's conversion, and one scene from the *banco,* smaller than the others, but still of significant size, depicting the Last Supper.

Besides the *Consecration,* only the *Last Supper* is wholly the work of Huguet. The others all show shop intervention: outlines are heavier, forms are more static, compositions are flattened. Though Huguet was in his late forties when the work was commissioned, he was in his mid-sixties when it was completed. By this time, he was working a great deal with assistants, and although he would survive into his late 70's (he died in 1492), he probably needed help with the sheer physical effort of decorating such large surfaces.

It is known that the completed retable was much admired: in 1489 the Augustinian Friars of Zaragoza sent their painter, Martin Bernat to Barcelona to look at the retable and incorporate the best scenes from Huguet's altarpiece into his own. Though Bernat's *Retable of Saints Augustine and Monica* does not survive, it is a pretty good bet that one of the compositions he chose to emulate was Huguet's superb *Consecration,* whose formal, static yet intensely human composition represents the best of indigenous Spanish traditions of the 15th century.

—Judith Berg Sobré

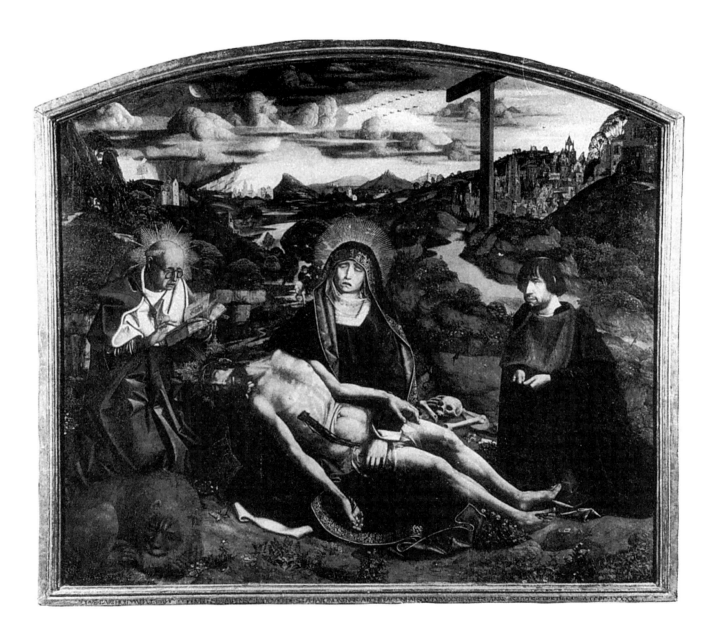

Bartolomé Bermejo (c. 1450–after 1498)
The Pietà of Canon Lluis Desplà, 1490
Panel; 5 ft. 8⁷/₈ in. × 6 ft. 2³/₈ in. (175 × 189 cm.)
Barcelona, Cathedral Museum

An inscription on the frame of the *Pietà,* now in the Barcelona Cathedral Museum, painted by Bartolomé de Cárdenas, called Bermejo, reads *OPUS BARTOLOMEI VERMEIO CORDUBENSIS IMPENSA LODOVICI DE SPLA BARCINONENSIS ARCHIDIACONI ABSOLUTUM XXIII APRILIS ANNO SALVATIS CHRISTIANA MCCCC LXXXX—THE WORK OF BARTOLOMEI VERMEIO CORDOBAN PAID FOR [BY] LODOVICI DE SPLA, BARCELONIAN ABSOLUTE ARCHDEACON XXIII APRIL [OF] THE YEAR OF THE CHRISTIAN SAVIOUR MCCCC LXXXX*

Though there is some dispute as to whether the inscription was put on the frame in 1490 or added later, the information it imparts has never been questioned: that Bartolomé Bermejo from Córdoba painted it, that Archdeacon Lluis Desplà from Barcelona commissioned it, and that it was completed on 23 April 1490. This is the only concrete evidence we have that Bermejo came from Córdoba (he spent his active career not there, but rather entirely within territories of the Crown of Aragon).

Other corroborating evidence tells us much about both patron and painter. Bermejo, after a checkered career that included at least one partially broken contract, had arrived in Barcelona around 1485, after having spent time in Valencia, Daroca, Zaragoza, and then Valencia again. He had been much in demand for his ability to paint in oil in the Flemish manner, but at the same time he appears to have had a reputation for abandoning works before completion, as the strictures put forth in his contract for the *Retable of Sainto Domingo de Silos* (1474) suggest.

Lluis Desplà i Oms was one of the great intellectuals in a city that was in a state of economic and political decline. Born in 1444, he was from a prominent Barcelona family, held the posts of Canon and Archdeacon of Barcelona Cathedral, and became virtual spokesman for the canons in municipal political matters by the mid-1480's. He was also a collector of antiquities and a patron of the arts. The *Pietà* that he commissioned from Bermejo for the chapel of his palace, located across the street from the Cathedral, called the *Casa del Ardiaca,* was the first of a substantial number of religious works that he had made in the late 15th and early years of the 16th century for the Cathedral, the church of Sts. Justus and Pastor in Barcelona, and the parish churches of Argentona and Alella.

Hinges at the sides of the *Pietà* discovered during a cleaning in 1971 suggest that there might have been wings for this altarpiece (like those of the *Triptych of the Virgin of Montserrat* in the Cathedral of Acqui Terme: see J. Garriga, *Thesaurus, l'art als Bisbats a Catalunya, 1000–1800,* Barcelona, 1986). However, there are no traces of any such wings, nor any mention of them from the time that the work was first published in 1839. The frame, if original, also seems to preclude the existence of a *banco,* the predella-like lower portion of images, often eucharistic, usually found in Spanish retables.

The theme of the painting, the dead Christ on his mother's lap, was a rather recent import into Spain, its origins being Northern Europe, though by the 1480's it is found in southern France and Italy as well. A sculpted image is found on the tympanum of one of the cloister entrances in Barcelona, executed by the German sculptor Michael Luchner in the 1480's. The theme is called the *Trasfixo* in Spain, the *Piedat* referring to the eucharistic image of the dead Christ in his tomb.

Desplà is depicted as if he were at a vigil, probably kneeling there contemplating since the Crucifixion, hat in hand, growth of beard on his face, in scale as large as the other figures. To the right of the Virgin and Christ is Saint Jerome, reading, presumably an account of Christ's death in his own translation of the gospels, with glasses on his nose. As is typical in 15th-century iconography, he wears cardinal's robes and his lion crouches at his feet, though in reality he was not a cardinal (merely a Papal secretary), and the lion had been appropriated in medieval times from the legend of another saint.

The four figures are placed in an extraordinary landscape teeming with wildlife, including snails, butterflies, and lizards, all of which probably have symbolic meaning (Garriga, p. 168). Behind the figures is the cross. To the right rear is Jerusalem, bathed in the setting sun. In a doorway in the city is a spinning woman—perhaps a reference to the *Annunciation?* To the left is a darker stormier scene, with a squall breaking over a cliff (the darkening of the sky at the time of Christ's death?), and a figure with a spear sitting in a cave—probably the contemplative Longinus. In the center a horseman rides towards the sunset, and above his head is the palest of rainbows.

In spite of all the detail, it is the light, reddish to the right, greenish and stormy to the left, that unifies the picture, and bathes the still figures in a moody glow. The general impression is one of contemplation and silent grief.

Bermejo certainly displayed his best talents in this work: the breadth of the atmospheric landscape, among the best produced at this date in Europe, the uncompromising portrait of the donor, the luminous surfaces painted in oil. Indeed, the only weak point is Christ's rather distorted anatomy. Part of the greatness of the work is probably due to the fact that the painter here was liberated from the compartmentalizing constraints of the traditional retable. But part of it is undoubtedly due to the personality of the work's donor. Though Bermejo sometimes used disguised symbolism in his work (for example, the Hebrew and Latin letters in his *Death of the Virgin* (Berlin, Staatliche Museum)—a very unusual occurrence in Spain—the complexity of the symbolism here suggests that the erudite Desplà had a hand in its content. It may well be that the work is, spiritually at least, a collaboration between a sympathetic donor and a talented but temperamental painter.

—Judith Berg Sobré

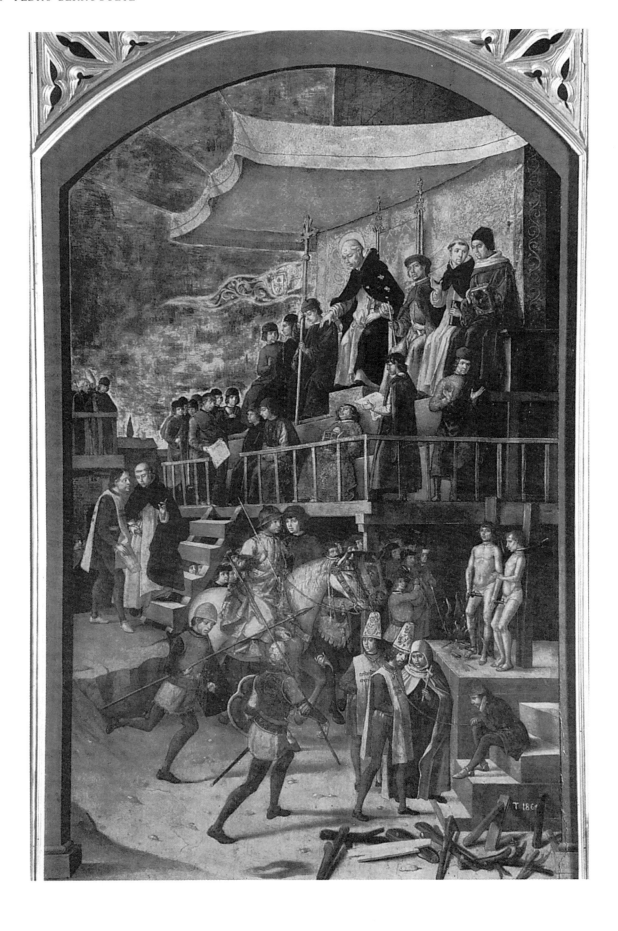

Pedro Berruguete (c. 1440 or c. 1450–1503)
Auto da Fé
Panel; c. 5 × 3 ft. (152.4 × 91.4 cm.)
Madrid: Prado

The subject matter of this panel has captured the imagination of many viewers, because of the infamous reputation of the Inquisition, which had been revived in Spain during Berruguete's lifetime by Fernando and Isabel (1469). The composition is divided into two zones. At the top, on a raised platform, are the two actual inquisitors—two Dominicans—plus the various secular officials of "the secular arm" who make up the Inquisitorial Tribunal, and who were actually the ones who carried out sentences of execution. Below, two small figures at the right are being burnt at the stake, while two others, clad in the penitental yellow cloak known as the *sambenito* with inscriptions reading *condenado erético* (condemned heretic), and heretic's conical hats, are receiving last rites from a hooded priest, all being supervised by soldiers. To the left, another penitent (without a hat) is being counseled by another Dominican.

Though it looks like a contemporary Inquisition scene, this panel is actually a narrative which refers to an incident in the life of Saint Dominic, as recounted by Jacopo da Voragine in the *Golden Legend,* in which Dominic was reputed to have saved a heretic by the name of Raymond, delivering him to a Dominican companion to be rehabilitated. Saint Dominic had died in 1221, and the first Inquisition, designed to root out recalcitrant Albigensians, was not established by Pope Gregory IX until 1231, but the Dominican order was to be intimately associated with both the 13th-century Inquisition and its 15th-century Spanish revival; in both cases the two officiating inquisitors were always two Dominican (or occasionally Franciscan) monks.

A narrative panel such as the *Auto da Fe* was never intended to be seen in isolation. This panel is known to have come from the Dominican church of Santo Tomás in Avila, for which Pedro Berruguete painted three retables. He executed the high altar retable, still in place, dedicated to Saint Thomas Aquinas. he also painted two lateral retables. One was dedicated to Saint Peter Martyr, a Dominican monk who served as an inquisitor, and was assassinated in this capacity on the road from Como to Milan in 1252. The other was dedicated to Saint Dominic himself. Both of these retables were dismantled and removed from their original positions in the church, and eventually came to the Prado Museum. The size of the *Auto da Fe* matches other narrative panels from the retable of Saint Dominic; however, the writer Cruzada Villaamil reported that in 1865 he saw the latter, along with another, now vanished Inquisition scene, flanking the image of the *Virgin of the Catholic Kings,* now also in the Prado. The *Virgin of the Catholic Kings,* painted by another artist, shows the Madonna and Child enthroned flanked by Saints Thomas Aquinas and Dominic, plus Queen Isabel and King Ferdinand, three of their children, and two Dominican priests, one of whom is popularly supposed to be Tomás de Torquemada, head of the Tribunal of the Inquisition, which was seated in the very church of Santo Tomás in the 1490's.

Though iconographically an inquisition scene might fit with the *Virgin of the Catholic Kings,* the *Auto da Fe* is taller in size, which would be unusual in such an arrangement. As a narrative, it could well blend with the other ones surviving from the *Retable of Saint Dominic,* which include the testing of orthodox versus heretical books by fire, the resuscitation by Saint Dominic of a boy who had fallen from a window and was thought dead, and the apparition of the Virgin to Dominic. In any case, the *Auto da Fe* has to be from either one altarpiece or the other.

Berruguete may have had a first-hand experience of these tribunals. His uncle, also named Pedro, was a Dominican monk, and it is thought that the latter might have been influential in securing him the commission for the works he painted for Santo Tomás. The church and its attached Dominican convent were founded in 1482 and completed in 1493, the Inquisitorial Tribunal being held on the site from 1490 to 1496. Though the Inquisition itself could investigate and prosecute only lapsed Catholics, other events paralleled their fanaticism. In 1491 a number of Jews had been burned at the stake before another church in Avila, San Pedro, for allegedly profaning a consecrated host and sacrificing a Christian child—traditional charges against them during the medieval period—however, it was this event that provided Ferdinand and Isabel with the pretext for expelling them from Spain.

For those Jews who remained, conversion was mandatory, though many *conversos* continued to practise their former faith in secret; it was these people whom the Inquisition targeted. The *Auto da Fe* thus presented worshippers with a timely message: you could be like the *condenados* and be executed by fire, or like Raymond you could confess, and after due penance (often extremely harsh) be rehabilitated.

Berruguete brings this message home with all the formal elements at his command. His experience in Italy taught him the rudiments of perspective, which he manages competently, particularly in the upper half of the painting, with its low eye level and foreshortened figures and architecture, though somewhat less happily in the lower right half of the painting, where the two men being burnt at the stake are inordinately small. The drama of the scene is enhanced by illusionistic use of textures in the Flemish tradition, which Berruguete probably learned during his apprenticeship in Castile, but may have polished under Josse van Gent at Urbino. In typical Castilian fashion the background is gold, but that does not intrude or flatten out the scene. In short, this painting represents the amalgam of Italian, Flemish, and Castilian elements that characterizes Berruguete's style.

—Judith Berg Sobré

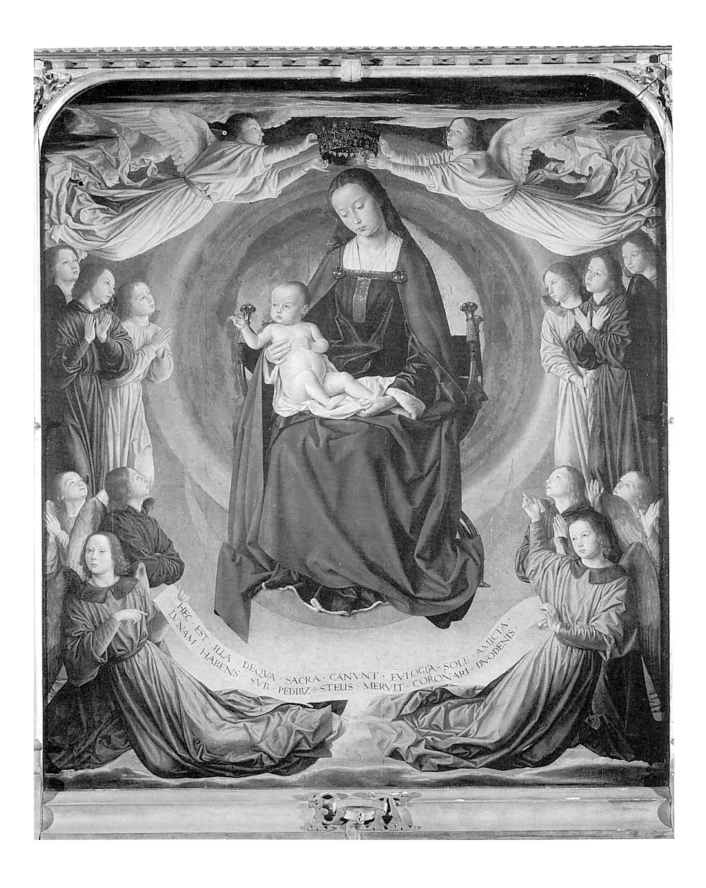

Jean Perréal (c. 1455–1530)
The Moulins Triptych
5 ft. 3 in. × 4 ft. 4³/₈ in. (159 × 133 cm.) (central panel)
Moulins, Cathedral

The script roll on the central panel with the verse from *Apocalpyse* 12:1 (Hec est illa dequa sacra canunt Eulogia sole amicta lunam habens sub pedibus stellis meruit coronati duodenis [And there appeared a great wonder in heaven: a woman clothed with the sun, and the moon under her feet, and upon her head a crown of twelve stars]) clearly relates the Triptych to a type of Marian representation in which the Madonna, usually standing with the child in her arms, has her feet resting on a crescent of the moon (lunam sub pedibus) as a sign of the mortal inconstancy she transcends.

She is clothed in the rays of the sun (sole amicta) meaning the Sun of righteousness (Malachi 4:2), and above her head is placed a crown with twelve stars (stellis meruit coronati duodenis).

Inherent is the idea of the immaculacy of the Virgin Mary even before her birth, reigning as queen of the heavens from time immemorial as in the words of Proverbs 8:23: "I was set up from everlasting, even from the beginning, or ever the earth was."

On the inside of the shutters are the kneeling figures of Pierre II, sire de Beaujeu who had succeeded to the Bourbon dukedom in 1488, facing his wife, Anne, daughter of the deceased king of France, Louis XI, with their daughter Suzanne (b. 1491) whose apparent age is the only indication of when the triptych was executed. In 1505 she married Charles de Montpensier, who became Duc de Bourbon on the death of her father in 1503.

Pierre II and Anne de France, Duke and Duchess of Bourbon, are shown in their ducal state robes with their patron saints: St. Peter wearing triple crown and a magnificent cloak embroidered with the starred heads of winged cherubim and the Bourbon motto Esperance, and St. Anne, a figure of great dignity who, as the mother of the Virgin Mary, is relevant both to the donor and to the theme of the central panel.

The immaculate conception was probably the theme of an earlier now incomplete altarpiece attributed to the same artist working for the same donors who appear on two of the surviving panels now in the Louvre, Paris. A third in the National Gallery, London, portrays the Meeting of Joachim and Anna at the Golden Gate, and a fourth in the Art Institute, Chicago, the Annunciation, the subject of the grisaille painting on the outside of the triptych's shutters where the scene takes place beneath ogival arches embellished with the Bourbon device of the Ceinture d'Esperance.

This refers to the Ordre du Chevalier de Notre-Dame d'Esperance founded in 1370 by Louis II duc de Bourbon whose badge, evidently inspired by the verse quoted on the script roll of the triptych, showed the Virgin of the Apocalypse, crowned with twelve stars and her feet resting on a crescent moon.

The Bourbon family's devotion to the Virgin Mary and her immaculate conception was continued by a succeeding duke, Jean II, and his duchess Jeanne de France (a sister of Louis XI) for whom Antoine de Levis, comte de Villars, translated from the Latin his *Deffenseur de l'originalle innocence de la Vierge Marie*. The superb manuscript, formerly in the Bourbon library, is now in the Bibliothèque Nationale, Paris, in which the author is depicted in the frontispiece miniature presenting his translation to the duchess. Jean II and Jeanne also initiated the building of the Chapitre Collègiale at Moulins which forms the nucleus of the cathedral (mostly 19th century) where the triptych stands.

In commissioning the triptych, therefore, Pierre II and Anne were continuing a family cult which found its supreme artistic expression in the work of an artist who had probably been employed by them and other members of the family for twenty years or so and who perhaps shared their faith.

Owing to the partial destruction by fire of the Bourbon archives in 1737 and 1793, it is unlikely that the documentary evidence necessary to establish his identity beyond doubt still exists. But with the possible exception of Jean Hey, author of a remarkable *Ecce Homo* now in a Brussels museum painted for Jean Cueillette, notary and secretary to king Charles VIII in 1494, the most probable candidate, despite much scepticism in recent years, remains Jean Perréal whose connection with Mme. de Beaujeu is established by at least one document of 1487.

Moreover, although the Moulins municipal records do not mention Perréal, they do contain evidence that several artists closely associated with him received commissions from Pierre II and Anne over a number of years. These include Michel Colombe, the most famous sculptor of his time in France, for whom Perréal designed the Nantes tomb, and two of Colombe's assistants, Jean de Rouen, who was installed at Moulins in 1496–97 making a fountain for Duchess Anne, and Jean de Chartres, who worked for her at Moulins in 1501 and is the probable author of three notable sculptures found on the site of the Bourbon residence at Chantelle representing Sainte Suzanne, Sainte Anne and the Virgin, and St. Peter, now in the Louvre, Paris. Jean de Rouen was probably the "bon ouvrier et excellent disciple" whom Perréal recommended to work with him at Brou in a letter of 15 November 1509; Jean de Chartres, described as currently working for Mme. de Beaujeu, was recommended for the same project by Michel Colombe.

Apart from this circumstantial evidence it is reasonable to assume that the outstanding masterpiece in painting of its time in France is likely to be the work of an artist described by a discerning contemporary as a modern Apelles, and most unlikely that two very influential and active patrons deeply involved in numerous projects requiring architects, sculptors, and painters would have failed to profit from his services. That Perréal shared the Bourbon's veneration of the Virgin Mary may be deduced from the invitation he received from a fellow poet about 1527 to contribute a "chant royal" of his own composition to a palinode at Rouen.

In the central panel of the triptych the Madonna is enthroned flanked by adoring angels in a composition which reveals the Moulins master's luminosity of colouring at its most lyrical, fraught as it were with the music of the spheres. According to the text she is clothed with the sun (sole amicta), but here there are no rays and she does not appear to be enthroned in front of the orb of the sun itself, for the serene image behind

her is not one of pulsating heat but rather one of concentric rings receding through an almost spectroscopic range of colours from greyish blue to a glowing centre, perhaps intended to represent the Aristotelian conception of the universe then current. It is significant that the Bourbon library included at this time two well-known manuscripts of Aristotle's treatise on the heavens and the earth translated with a commentary from the Latin into French by the churchman Nicole Oresme between 1370 and 1377 for king Charles V. They are listed in the Bourbon library inventory of 1523 (nos. 12 and 40) and they may well have been a source of inspiration to the painter of the triptych. This again points to Perréal, for he makes four references to the *De Celo et Mundo* in his poem called the "Complaint of Nature to the Alchemist", and the following lines from this poem paraphrasing a Latin prose passage then ascribed to Raymond Lull (also mentioned by Perréal) in which the deity is said to have created the universe from three substances of varying purity, angels from the purest, stars and planets from the less pure, and the earth from the least pure, tend to confirm the attribution:

> De la plus pure premierement
> Il crea cherubins archanges
> Les serephins et tous les anges:
> Et de la moins pure et seconde
> Il crea les cieulx a la ronde
> Et de la tierce part moins pure
> Les elements et leur nature.

—William Wells

Jean Fouquet (c. 1420–c. 1477–80)
St. Stephen and Etienne Chevalier (Melun Diptych), c. 1450
Tempera on wood; 36½ × 33½ in. (92.7 × 85.1 cm.)
Berlin-Dahlem, Staatliche Museen

Bibliography—

Chatelet, A., "La Reine Blanche de Fouquet: Remarques sur le diptyque de Melun," in *Etudes d'art français offertes à Charles Sterling,* Paris, 1975.
Schaefer, C. "Le Diptyque de Melun de Fouquet conservé à Anvers et à Berlin," in *Jaarboek van het Koninklijk Museum voor Schone Kunsten* (Antwerp), 1975.

As the outstanding French artist of the 15th century, Jean Fouquet was in much demand during his mature years. As a portrait artist he painted the Pope's portrait in Rome, and in France he worked for, among others, Charles VII, Louis XI, the Duke of Nemours, and Etienne Chevalier, the Finance Minister of the French king.

Perhaps the most representative work from his hand is a panel painting, the left half of the Melun Diptych which shows two figures, Etienne Chevalier, the commissioner, and his patron saint Stephen (Etienne in French). This type of donor portrait with ¾-view of the patron and his saint, as well as the clarity of detail, the realism of textures, and the deep, glowing colors, is in the mainstream of Flemish painting of the period.

Fouquet's stay in Rome (1445–47), however, exposed him to early Renaissance art and architecture which was well under way at the time. This new cultural direction obviously very much impressed Fouquet. This is seen in our panel by the setting Fouquet employs, as well as the perspective and the use of monumental forms. The oblique perspective view reminds us of the perspective system invented by Filippo Brunelleschi to aid artists in accurately depicting architecture on a flat surface. The inset veined-marble panels and the Classical pilasters with acanthus leaf carving are very much in the Italian Renaissance mode. Etienne's name appears to be carved into the base of the pilaster nearest him.

The two figures loom large within the composition with the standing St. Stephen dressed in a deacon's dalmatic and his hair trimmed in a monk's tonsure. His features have a rugged youthfulness. He holds in his left hand a gospel book which in turn supports a large, jagged rock, a symbol of his method of martyrdom (Acts 7:58–60). Barely noticeable is the blood dripping into his cowl from a wound at the top of his head. As a gesture of introduction to the Virgin and Child that appear on the opposite panel, St. Stephen rests his right hand on the back of the kneeling minister, his hands held in adoration. A very similar dedicatory image by Jean Fouquet with the same two participants in a similar though expanded Renaissance setting is found in the Book of Hours that our artist painted for Etienne Chevalier, now in the Musée Conddé, Chantilly.

The monumental forms, the remarkable realism in facial features and other elements, and the Classical setting illustrate the extraordinary talents of this foremost French artist of the period to blend the artistic advances in northern Europe with those of Renaissance Italy. Fouquet was the harbinger for the direction that northern art would take in the following century.

—A. Dean McKenzie

Master of the Housebook (c. 1445–after 1505)
Aristotle and Phyllis
Drypoint, 6¹/₄ in. (15.5 cm.) in diameter

The Master of the Housebook is so called in reference to the Wolfegg "Housebook" (privately owned), a munitions officer's album containing a few drawings of the children of the Planets by his hand, among drawings of tournaments, and of courtly life and military tactics and armaments by other artists. The same anonymous artist is also known as the Master of the Amsterdam Cabinet by virtue of the fact that the largest and most important collection of his rare drypoint engravings is in the Rijksprentenkabinet in Amsterdam. Recent research utilizing infrared reflectography proves conclusively that the artist, who could never had made his living solely from the works by which he is best known, was also the painter of the so-called *Speyer Altar* (five panels now dispersed between the Augustinermuseum in Freiburg/Breisgau, the Städelsches Kunstinstitut, Frankfurt am Main, and the state galleries of the two Berlins), and of four of the nine large panels of a Life of the Virgin series (Mainz, Gemäldegalerie).

His method of drawing and modeling, together with his disregard for the finer points of linear perspective and his use of miniaturists' motifs (e.g., acrobats, scratching dogs, playing infants, etc.) suggest that he was originally trained as a book illuminator, unlike most other graphic artists of the 15th century who began their careers as goldsmiths. A manuscript of the four Gospels (c. 1475–80 Cleveland Museum of Art), traceable to the Carthusian cloister at Coblenz, contains portraits of the four Evangelists by his hand.

By 1480 the master was active at the Palatine court in Heidelberg, where he drew the portrait of the Elector Philipp the Sincere with his court minstrel and poet, Johann von Soest (dated 1480; Heidelberg, Universitätsbibliothek), as the dedication page in the poet's translation of the medieval romance, *Die Kinder von Limburg.* It seems to have been at Philipp's court that he developed the delicate silverpoint-like style which characterizes his most elegant prints, including *Aristotle and Phyllis* and its companion piece, *Solomon's Idolatry,* as well as *Death and the Young Man, The Lovers,* and the silverpoint drawings of courtly young lovers (Berlin-Dahlem; Leipzig).

The Housebook Master was the first printmaker to make consistent use of the drypoint needle as a substitute for the engraver's burin, a technique too fragile to be profitable, which was only to be fully exploited centuries later by Rembrandt and Whistler. Working on small plates of soft metal—perhaps pewter—rather than on longer-lasting copper, his delicate plates could be printed only a few times before their characteristic soft burr began to break off. The *Aristotle and Phyllis* exists today in one of the artist's largest "editions"—a total of four impressions. (The majority of his plates are known from only single impressions, most of which are in Amsterdam.)

The story of Aristotle and Phyllis has nothing to do with the historical Aristotle, but was apparently invented by an early 13th-century cleric, Jacques de Vitry, in order to ridicule classical philosophy, while cathedral sculpture began to include the image of the philosopher *chevauché* among the symbols of Luxury. The theme was quickly taken up by the early 13th-century poet Henry d'Andely, however, and turned into a long poem glorifying the power of love. By c. 1485 when the Housebook Master's drypoint was made, the story had been popularized as a south German carnival play, *Ain spil von maister Aristotiles,* written in a dialect spoken in the area around Freiburg and Biberach. Like the play, his drypoint features four characters—Aristotle, a king and his queen, and a scribe. As the play opens, the King praises Aristotle for his complete indifference to beautiful women. The Queen, piqued, then declares that she herself will rob the great philosopher of his wits, and proceeds to tantalize the old gentlemen with her beauty. Aristotle, now thoroughly besotted, offers to teach her "grammar, logic, philosophy, rhetoric, and many other arts," but is rebuffed by the Queen, who tells him loftily that such things are of no interest to the fair sex. She then suggests that, as a more suitable pastime, he should carry her around the garden on his back. The famous piggy-back ride then ensues, with the Queen remarking sarcastically on the comforts of riding a horse stuffed so full of knowledge, and the denouement, of course, features the reactions of the King and Scribe, who have hidden themselves to witness the entire procedure.

Although by the early 16th century Aristotle's folly was to become one of a quartet of "power of women" subjects (together with Samson and Delilah, Solomon's idolatry, and Virgil in the basket), the Housebook Master appears to have been the first to pair two of the subjects. His choice of the two ancient intellectuals, Aristotle and Solomon, seems related both to the vogue at the Palatine court in Heidelberg for the love poetry of the Imperial poet laureate, Konrad Celtis, who visited Heidelberg in 1484, and for the so-called *Via Moderna* philosophy of the international Occamist movement, represented at the court of the Pfalzgraf Philipp by the great Frisian humanist, Rudolph Agricola, and by the court poet, Johann von Soest. In contrast to the neo-Thomist adherents to the philosophy of St. Thomas Aquinas, who called themselves the "via Antiquq," the Modernists—Agricola, in particular were scornful of the Thomists' uncritical acceptance of the traditional philosophical authority of Aristotle. The Housebook Master's two depictions of the follies of Aristotle and Solomon, two men particularly revered by the Ancients for their wisdom but both undone by women's wiles, was at once an exquisite joke at the expense of the *Via antiqua* faction of the University of Heidelberg, and a celebration of the power of love. In the hands of a younger generation of printmakers, such as Hans Baldung and Master MZ working in the "mass media" of copperplate and woodcut, however, these themes were to become anti-feminist caricatures, subsumed under the general heading of the "power of women."

—Jane Campbell Hutchison

Hans Multscher (c. 1400–67)
Virgin and Child, 1456–59
Painted wood
Vitipeno, Parish Church

Bibliography—

Müller, Thomas, "Ein Beitrag zum Sterzinger Altar," in *Festschrift für Hans Jantzen,* Berlin, 1951.
Rasmo, N., *Der Multscheraltar in Sterzing,* Bolzano, 1963.

Hans Multscher's *Virgin and Child* in Vipiteno (formerly Sterzing) was the heart of one of the most influential German altarpieces of the 15th century. She stands now within a 19th-century neo-gothic altarpiece in the Parish Church of Our Lady, having been orphaned from the monumental structure for which she was carved. Dismantled in 1779, that altarpiece's elements are now scattered among collections at Vipiteno, Innsbruck, Munich, and Basel. As the centerpiece of what was probably Multscher's last great project, the Vipiteno *Virgin and Child* offers an important look at his mature woodcarving style, influential on many artists active in Swabia, the Tyrol, and beyond.

Documents surviving from this commission allow us to date its production more precisely than is usual for works of the period. In January 1456 Multscher and a spokesman from Sterzing met at Innsbruck to negotiate a contract for the project. The choice of an artist from the relatively distant city of Ulm has been seen as evidence of Multscher's considerable renown by this date. Work proceeded on the carvings under Multscher's direction in his large Ulm workshop until early 1458. By the middle of that year, the components had been shipped, and Multscher and his crew were assembled at Sterzing to construct the altarpiece. Completed in January 1459, it must have been a glorious addition to the parish church's new gothic choir, which had been finished only a few years earlier.

Though different reconstructions of the Sterzing altarpiece have been suggested, most agree on the fundamental composition of its known parts. In the central body of the work, perhaps under gothic tracery, the *Virgin and Child* stood flanked on each side by two standing female saints (Apollonia, Barbara, Catherine, and Ursula). Two angels held a crown above the Virgin's head while four others held cloths of honor behind the figures. Painted wing panels were affixed to the sides of the work, showing four scenes from the Life of the Virgin when open, and four from the Passion of Christ when closed over the sculpture. On the outer edges of the altarpiece, visible only when the wing panels were closed, stood the figures of Saints George and Florian, the latter being particularly popular in the Tyrolian region around Sterzing. Other known elements, including figures of the Virgin, John the Evangelist, John the Baptist, and architectural fragments, were somehow deployed among the predella (bottom level), reverse side, and crowning structure of the altarpiece. Recent reconstructions suggest that the central sculptural shrine approached five meters in height, and that the pinnacle of the entire work may have stood as high as 17 meters above the church's pavement. It was a complex, towering spectacle composed around a lively

dialogue between colored sculpture, painted scenes, and gilded architectural elements. Its general format probably recalled the forms taken by two of Multscher's commissions from the 1430's, the Karg (Ulm) and Wurzacher (Berlin) altarpieces, and in turn it provided a significant formal source for major sculptors to follow, including Michael Pacher in Austria and Michel Erhart in Ulm.

The Vipiteno *Virgin and Child* was originally polychromed, as was typical for German carved figures before the late 15th century, but it now bears the paint of a heavy-handed 1913 restoration. With a crown suspended above her head and in the company of Virgin saints from different historical periods, Mary was presented not in a narrative moment from the gospels, but rather as the Mother of God and Virgin Queen of Heaven. The crescent moon beneath her feet is an ancient symbol of chastity, and belongs specifically to a medieval association of Mary with the Apocalyptic Woman described by St. John, "a woman clothed with the sun, and the moon under her feet" (Rev. 12:1). Judging from the opened palm of his now-damaged left hand, it is likely that Christ held a small orb, symbol of his universal dominion.

Multscher's treatment of the figures is sophisticated and appealing. The Christ Child is held high, his eyes nearly at the level of his Mother's. Rather than cradling him low on her hip or holding him closer across her middle, the Virgin offers the gentlest of support to an essentially upright, autonomous figure of the Child, a relationship similarly conceived in Multscher's Madonnas at churches in Ummendorf and Landsberg. His faces never offer a blank stare or empty smile, and the Vipiteno *Virgin and Child* register the kind of solemn, prophetic meditation he favors on most of his holy figures.

An initial glance at the Virgin's drapery might suggest complex pattern, but this impression quickly resolves into one of logical, sensitive observation of the behavior of heavy folds. Just as Multscher's faces suggest the reflection of inner thoughts, all surfaces here respond eloquently to a play between the implied movements of the body beneath and the quiet demands of gravity. The articulate turns and spills of cloth gathered in and below the Virgin's right hand justify Multscher's reputation for having cultivated a strong flavor of realism in his work, moving beyond the lovely but increasingly restrictive conventions of the late 14th-century *"Schöne Madonna"* type that had radiated from the prolific shops of the Parler family in Prague. But Multscher's special concern for the expression of real internal forces in the Vipiteno figures must not be mistaken for the liberation of the sculptural body as we might imagine in modern terms. Consciously conceived within firmly established symbolic and formal traditions, the *Virgin and Child* was designed, carved, and painted to participate in a very specific context, as the leading voice in a carefully conducted chorus of figures, pictures, and architecture.

—Alfred J. Acres

Master Bertram of Minden (c. 1340–c. 1415)
Grabow Altar
Panel; 9 ft. 1 in. (2.77 meters) (height)
Hamburg, Kunsthalle

The so-called Grabow Altar, the largest and most important 14th-century altarpiece in northern Europe, was originally made for the high altar of the parish church of Sts. Peter and Paul in Hamburg. It is popularly known as "the Grabow altar" today because, when it was replaced by a baroque altarpiece in 1731, it was donated to a church in the small village of Grabow, Mecklenburg, which had lost its own altarpiece in a recent fire. It was in Grabow that Alfred Lichtwark, an early Director of the Hamburg Kunsthalle, discovered and acquired this key monument of early German painting and sculpture, which is documented in the *Hamburg Chronicle* as having been made in 1383 by "mester Bartram van Mynden."

Like many later German altars of the 15th and 16th centuries, the Grabow is a transforming altar with two pairs of wings covering a sculptured shrine; since Master Bertram is mentioned in several contemporary documents as having received payment for pieces of polychromed sculpture, it is assumed that he was responsible for the original shrine as well as for the painted wings. As Max Hasse and Christian Beutler have recently shown, however, the central Crucifixion is not by Master Bertram, but is a pastiche made up of a 13th-century Crucifix set into a late 16th-century landscape with figures of Mary and John. It is highly probable that, as Beutler suggests, the Crucifixion scene was inserted as a suitable post-Reformation substitute for an original reliquary with relics of Sts. Peter and Paul, surmounted by a depiction of the popular medieval theme (from the Song of Songs) of the "marriage" of Christ and the Virgin, in which the Virgin Mary, enthroned on an altar beside her Son, personifies the Christian church. The remainder of the sculptured program, which was the festival day aspect of the altar, has survived intact: the shrine itself as the palace of heaven, inhabited by two rows of stout prophets, apostles, male and female saints, and biblical personages, including the three Magi and the Wise and Foolish Virgins (whose presence offers further evidence that the central event was a marriage of Christ rather than a Crucifixion.) On the socle, flanking a smaller carving of the Annunciation in which the Virgin, seated on an altar, blesses the viewer, are a selection of seated figures of early Christian scholars, many of whom wrote commentaries on the Song of Songs, including both Origen and his translator, St. Jerome, as well as Sts. Augustine, Dionysius, Gregory the Great, Ambrose, John Chrysostom, Bernard, and Benedict.

If the sculptured shrine has certain parallels with the iconography of high Gothic cathedral portals, the painted wings are without precedent in monumental works of art. Master Bertram's altar is the first to have a full cycle of painted panels representing the Creation, as well as major events from the lives of the Old Testament patriarchs from Abraham to Jacob, shown in their narrative order rather than as comparative material for subjects from the New Testament. Thus the painted wings of the second transformation, or "Sunday side" of the altar were designed to function as biblical history, rather than as devotional objects in and of themselves. It was perhaps this very feature that made the altarpiece a candidate for remodeling rather than removal during the Reformation.

The outer panels which would have constituted the workday view of the altarpiece have been lost, but may well have depicted scenes from the lives of Sts. Peter and Paul, the church's patrons. The Sunday view, which totally obscures the sculpture when fully opened, consists of two rows of twenty-four highly original paintings representing the first six days of creation, beginning with the fall of the rebel angels, and continuing through the fall of Adam and Eve, their expulsion from Eden, and their life together afterward, isolated from God, "when Adam delved and Eve span." On the lower register, the first six paintings deal with the stories of Cain and Abel, Noah, Abraham and Isaac, and Jacob's deception of both his father, Isaac, and his brother Esau. The final six initiate the process of salvation from the "sins of the fathers" by depicting the narrative of Christ's birth, from the Annunciation to the Flight into Egypt and Massacre of the Innocents. These twenty-four scenes reveal in the most dramatic way the presence of good and evil in the world from the moment when light was divided from darkness, with a benign and stubby-fingered God as the creator of both possibilities. In the most famous scene from the altar, that of God creating the animals, some of the creatures have begun to devour one another. God moves implacably forward with His grand design, however, creating Adam from the dust of the ground, while angels swing censers to perfume the air, and in the most remarkable feat of all, creating Eve from Adam's rib, while further angels play a musical anaesthesia on the lute and viol. After the sacrifice of Cain and Abel, God shows Himself no more, but directs the righteous Noah and Abraham by means of heavenly messengers, and hides Himself entirely from the sight of Abel's death and Jacob's trickery. He reappears again only to send the soul of the tiny, naked Christ child, already carrying a cross over His shoulder, sliding down a beam of light as Gabriel greets the Virgin Mary. It is not by accident that this series of six scenes lies directly beneath the sequence representing the Fall of Man, since Master Bertram and his iconographer, who is though to have been Canon Wilhelm Horborch, viewed the Virgin Mary in traditional medieval fashion as "the New Eve."

What is nearly as remarkable as the ambitious size and unusual programs of the altar is the fact that it was made, neither for royalty nor for a cathedral, but for the parish church in a blue-collar neighborhood of Hamburg, a city of only 8,000 people. Among the craftsmen in its parish, however, was Master Bertram himself. And Canon Wilhelm Horborch was the Mayor's brother.

—Jane Campbell Hutchison

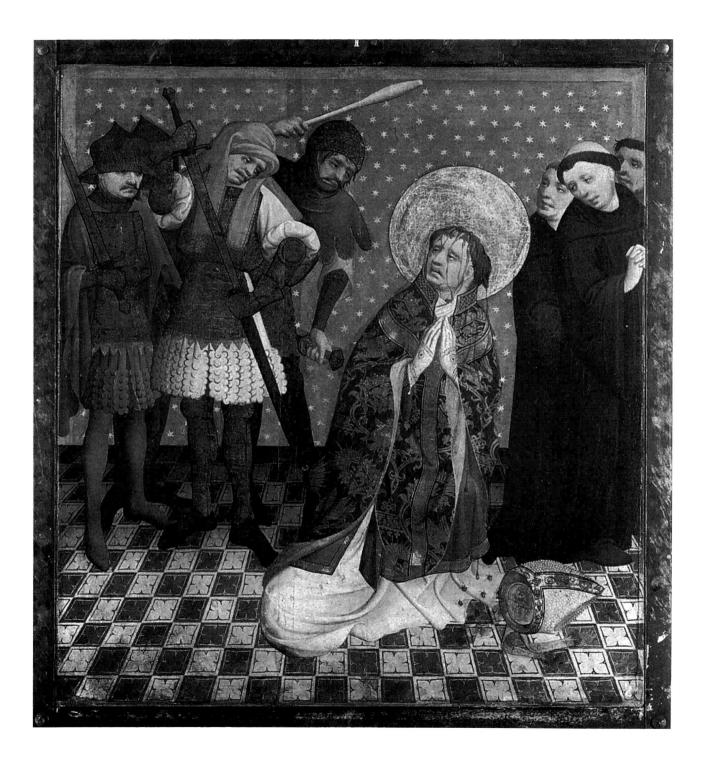

Master Francke (active c. 1405—after 1424)
St. Thomas à Becket Altar, 1424
Tempera on oak panels; 39³/₈ in. (89 cm.) (panel height)
Hamburg, Kunsthalle

A 16th-century copy of the artist's original contract with Borcherth Bennyn and Matthias Schiphower, elders of the Englandfahrer Gesellschaft, records the fact that on the Monday before St. Nicholas's Day in 1424 the English Trading Company of Hamburg dedicated in their chapel, on the south side of the Dominican church of St. John, an altarpiece painted by "mester Franckenn" which cost the "ungeheuerlich" (immense) sum of 100 Lübeck marks. Although both the predella and the two fixed wings are now lost, and the great Calvary which was its painted center survives in only a fragment, the movable wings of this altar show clearly that the Trading Company had obtained the services of one of northern Europe's most gifted painters in return for their investment.

This altarpiece, like Master Francke's slightly earlier *St. Barbara Altar* (c. 1415; Helsinki Museum) shows that the painter was not trained in Hamburg, where the prevailing style was that of Master Bertram. In contrast to Master Bertram's stocky figure style, pastel color schemes, and minimal interest in pictorial space, Master Francke's art is based on the slender proportions of the International style, and is characterized by a stronger balance of symbolic scarlet and blue—the colors of martyrdom and fidelity—as well as by a powerful compulsion to create and organize deep space through the use of repoussoirs. It is not known where he received his training, although his art shows similarities both with French miniature painting from the circle of the Boucicaut Master and with the style of the earlier Westphalian painter Conrad von Soest. Most modern scholars accepts Reincke's hypothesis that he was a Dominican friar, perhaps identical with "Frater Francone Zutphanico" (Brother Frank of Zutphen) born in the north Netherlands, who is also known to have worked in the Westphalian episcopal city of Münster. Frater Francone's mother was a native of the Hamburg area.

An engraved reproduction of the altar as it looked in the early 18th century is included in Nicolas Staphorst's *Kirchengeschichte* (1731), showing that the lost predella contained busts of Christ and the twelve Apostles. The exterior sides of the movable wings are divided into two registers: at the top, the Nativity and Adoration of the Magi, and at the bottom, two scenes from Herbert of Boseham's life of St. Thomas à Becket, patron saint of Hamburg's English Trading Company. On the left is depicted the escape of St. Thomas from assassins hired by Henry II, who have succeeded only in amputating the tail of the good saint's horse, and are left cursing in frustration as he and his companions ride off behind a lava-like protuberance in the foreground. The other represents the more famous scene, later recreated by T. S. Eliot and Jean Anouilh, of Becket's murder in the Cathedral of Canterbury. The implacable Archbishop kneels to forgive his assassins, although the top of his skull has already been sliced neatly off, and still nestles inside his mitre on the floor. The Becket scenes originally were flanked by the altar's fixed wings,

showing the popular English martyr's consecration as Archbishop, and finally the prayer of the French King Louis VII at his graveside.

The scenes from Christ's infancy share with the Becket scenes a background of scarlet, studded with twinkling golden stars. The Nativity, with its extraordinary rear view of a kneeling angel, is one of the earliest examples illustrating the influence of the *Revelationes* of St. Bridget of Sweden (canonized 1391), in which it is alleged that the holy birth took place instantaneously and painlessly while Mary knelt on the ground in a pure white gown. In keeping with St. Bridget's description, the scene is set in a neo-Byzantine cave, and is not witnessed by Joseph, who had tied the two animals to the manger before discreetly leaving the premises. St. Bridget, herself the mother of eight, was struck by the fact that, as soon as the birth had taken place, the Infant glowed with divine light, and the mother's body immediately contracted from its previously swollen state, and that "with great awe, she adored the Child and said to Him, 'Welcome, my God, my Lord and my Son!' "(see Johannes Jorgensen, *Saint Bridget of Sweden,* London, 1954). St. Bridget's words are inscribed on the Virgin's banderole: "Dominus meus, deus meus." The holy Child is surrounded by His own halo, and is touched by golden rays proceeding from the mouth of God, who blesses the entire operation and has sent an angel to waken the shepherds on the nearby hillside.

The Adoration, unlike the Nativity, takes place in a stable, with a back view of Joseph, who sits on a humble three-legged stool, extending his hand as if to receive the Infant's gifts, which he proposes to store in the family's trunk. Not yet canonized, he is treated as the old family retainer, while the Virgin and Child hold court, as King and Queen of Kings.

The interior, holy-day aspect of the altarpiece once centered on a tall, many figured Calvary, which must have looked rather similar to Conrad von Soest's at Niederwildungen. Only the lower left-hand corner of this composition has survived, with its expressive group of willowy Holy Women. The four scenes from the Passion which surround it all have gold grounds. The Scourging of Christ is as remarkable for its daring but inaccurate depiction of interior space as for its prize collection of sociologically ugly torturers, who reappear on the Road to Calvary to jostle and insult Christ and the Holy Women. The Entombment and Resurrection are no less remarkable: in the former, a valiant attempt is made by Christ's companions to lower his body into a tilting tomb too narrow to receive His enormous halo. The Resurrection, in defiance of the Germanic preference for the iconography of the closed tomb, shows Christ Himself turning His back to the viewer, arms akimbo, as He escapes from the open sarcophagus and the sleeping soldiers.

—Jane Campbell Hutchison

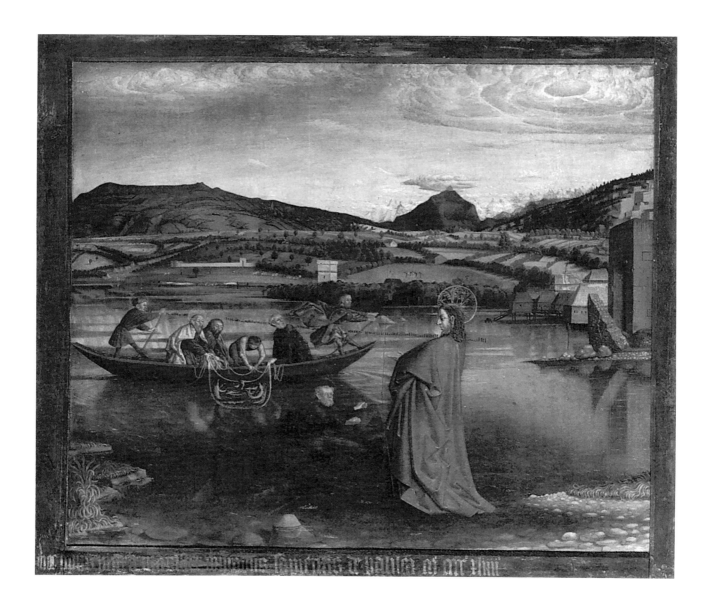

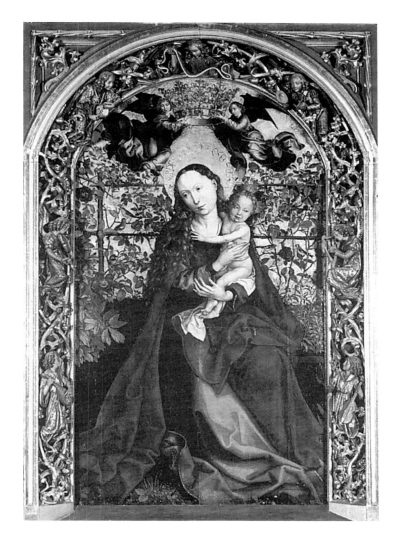

Martin Schongauer (c. 1440–45—1491)
Madonna of the Rosehedge, 1473
Panel; 6 ft. 6³/4 in. × 3 ft. 9¹/4 in. (200 × 115 cm.)
Colmar, St. Martin

Bibliography—

Martin, K., "Zur *Madonna im Rosenheg* im Isabella Stewart Gardner Museum in Boston," in *Studien zur Kunst des Oberrheins: Festschrift für Werner Noack,* Constance, 1959.

The artist's most famous work and the one most safely attributed to him is found in Colmar in the church dedicated to his namesake St. Martin. It represents the Holy Virgin and the infant Christ, and the surviving panel—its extremities appear reduced—measures 2.00 × 1.15 meters. It bears the date 1473, and although the inscription seems to be a slightly later addition, its authenticity is generally accepted. The work is therefore from Schongauer's youth, painted before his thirtieth year.

A much smaller copy, now in Boston and not by Schongauer's hand, as well as a number of his engravings, suggest what is presently missing in the Colmar panel: God the Father, the dove of the Holy Spirit, the edges of the Virgin's robes, and a more generous display of flowers and foliage.

The Madonna, larger than life-size and seated on a grassy bench in front of a garden trellis, supports the naked Christ-child whose arms are around her neck. A Latin inscription is part of her halo: "Pluck me also for thy son, O Holiest Virgin," a reference to the symbol of the rose in the Passion Story. Above the Virgin two angels floating in symmetry balance a golden crown, its delicate pattern derived from the foliate background and painted by one familiar with the design and shaping of precious metals.

The Virgin, regally placed against a richly gilded background, forms a towering triangle highlighted by cascading scarlet and soft flesh tones. Her deeply melancholy expression contrasts with the triumph of her impending coronation.

An abundance of irises, columbines, and roses peers forth from the trellis whose winding branches also accommodate joyfully chirping birds. It has been pointed out that such imagery is traditional, that the birds and the flowers are frequently used symbols in Gothic painting. However, anyone familiar with the summery orchards and vineyards and the rose-covered hedges of Alsace sees in this particular representation a Holy Virgin simultaneously regional and universal.

—Reidar Dittmann

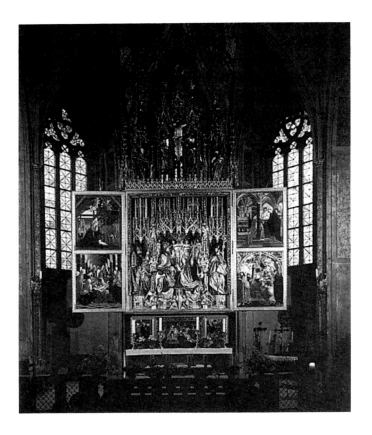

Michael Pacher (c. 1435–98)
St. Wolfgang Altarpiece, 1471–81
St. Wolfgang am Abersee, Austria, Parish Church

Bibliography—

Stiassny, Robert, *Pachers St. Wolfganger Altar,* Vienna, 1919.
Scheffler, Karl, *Pacher's Altar von St. Wolfgang,* Königstein im Taunas, n.d.
Strohmer, E., *Der Pacher-Altar in St. Wolfgang,* Vienna, 1940.

The Tyrolean sculptor and painter Michael Pacher's masterpiece is the large altarpiece for the high altar of the parish church of St. Wolfgang am Abersee in Austria. It is a huge complex of sculpture with panel paintings in the multiple wings. The work was contracted in 1471. It was not completed until 1481, evidently because the choir of the church was still under construction (consecrated in 1477) and Pacher was at work in 1471 on an altarpiece contracted just before, for the parish church at Gries, near Bolzano in the Tyrol. The *St. Wolfgang Altarpiece* is the only one of several known altarpieces by Pacher to survive intact.

The *St. Wolfgang Altarpiece* is about 40 feet high and more than 20 feet wide, overall. The central corpus, more than 12 by over ten feet, shows the *Coronation of the Virgin.* Here the mystic figure of Christ, enthroned and crowned, blesses the kneeling Virgin, herself wearing a crown. The Dove of the Holy Spirit hovers above the center of the composition. Statues of St. Wolfgang and St. Benedict flank this central group. At least 16 diminutive angels are distributed through the scene,

playing music, singing or simply supporting draperies. An elaborate architectural frieze occupies the upper third of the interior of the corpus. The frame bordering the corpus is a finely carved representation of the Tree of Jesse, with the ancestors of Christ in its branches beginning with Adam at the lower left corner. On the outer casing of the corpus, statues of St. George and St. Catherine on the left, St. Florian and St. Margaret on the right. Atop the corpus is a superstructure of seven pinnacles. On the highest, in the center, is an Annunciation group with God the Father. Below that is the Crucifixion with St. John and the Virgin. The outer pinnacles support saints' figures, on the left, St. George and a female saint, on the right, St. John the Baptist and St. Ottilie.

The altarpiece has two sets of wings that close over the corpus. Each wing has two paintings on its inner and outer sides. Each of these 16 paintings is approximately 5′ 8″ × 4′ 7″. When the work is wholly closed, four of the scenes are visible, covering the corpus. They are scenes of the life of St. Wolfgang. When the outer wings are opened they reveal scenes of Christ's life that combine with paintings on the outer sides of the inner wings, still closed over the corpus. When the inner wings are opened their four inner scenes of Mary's life enhance the central *Coronation.*

The predella, or *Sarg,* under the Corpus contains a carved scene of the *Adoration of the Magi.* It also has a pair of covering wings with the four Church Fathers, Sts. Jerome Augustine, Gregory, and Ambrose, on their outer sides. Open they display additional scenes of Mary's life. There are eight portraits of saints on the back of the corpus, Christopher, Erasmus, Elizabeth, Ottmar, Francis, Hubert, Egidius, and Ulrich.

—Charles I. Minott

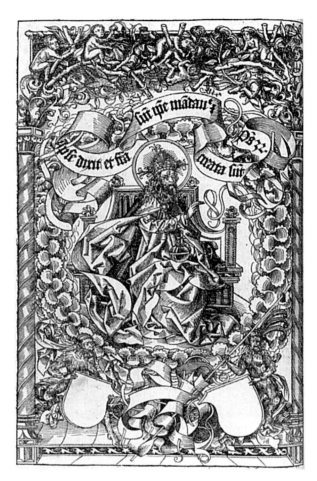

Michael Wolgemut (1434–1519)
God in Majesty, from *The Nuremberg Chronicle,* 1493
Woodcut; 13³/₈ × 10³/₈ in. (34.3 × 26.5 cm.)

Bibliography—

Ortmayer, Robert, "Woodcuts of the Nuremberg Chronicle," in *Journal of the Perkins School of Theology,* 16, 1963.
Wilson, Adrian, *The Making of the Nuremberg Chronicle,* Amsterdam, 1976.

Wolgemut was the first major German painter to contract directly with a publisher, and to employ his own block cutters to execute his own and his draftsmen's designs for book illustrations. The woodcuts which his workshop produced for printed books were technically among the best to be had in Europe during the 1480's and early 1490's, achieving unprecedented effects of modeling and landscape detail. Two of the best-known books illustrated in the Wolgemut shop were published by Dürer's godfather, Anton Koberger—Stephen Fridolin's *Schatzbehalter* (Treasure Chest; 1491) and Hartmann Schedel's *Weltchronik* (World Chronicle, better known as "The Nuremberg Chronicle"; 1493.)

Dr. Schedel's *Nuremberg Chronicle,* with its 1800 woodcut illustrations (many of which are reused), was financed by two wealthy and cultured Nuremberg humanists, Sebald Schreyer and Sebastian Kammermeister. A comprehensive history of the world, it begins, of course, with the Creation. Michael Wolgemut's richly ornamented frontispiece depicts the Ancient of Days crowned, haloed, and holding a crystal imperial orb. Seated on a substantial gothic throne, he is surrounded by a decorative motif resembling folded ribbon, which since late antiquity has symbolized heavenly visions. The folded banderole above His head reads, "Ipse dixit et facta sunt—ipse mandavit et creata sunt—Ps. 32" [For he spoke and it was done; he commanded and it stood fast. Psalm 33:9]. A dozen years later, Hieronymus Bosch, who certainly knew this book and its illustrations, would adopt this motif as the prelude to that most perplexing of all triptychs, the *Garden of Earthly Delights.*

Wolgemut's vision of the Creator is further surrounded by an ornamental framework featuring, at the top of the composition, a latticework of late gothic vines infested with gamboling infants. As Anzelewsky has noted, the preliminary drawing for the frontispiece (London), including its ornament, is a transposition of Erhard Reuwich's design for Bernhard von Breydenbach's *Peregrinationes in terram sanctam* (Mainz, 1486), and Reuwich's city views for the same travel book almost certainly influenced the decision to include an even greater selection of city panoramas in the *Nuremberg Chronicle.* The *Chronicle* continued to hold fascination for artists well into the 16th century although, as both history and travel literature, it was already superannuated on the day of publication, since the authors had failed to take note of Christopher Columbus's voyage of discovery in 1492.

—Jane Campbell Hutchison

Albrecht Dürer (1471–1528)
Self-Portrait, 1498
Panel; 20½ × 16⅛ in. (52 × 41 cm.)
Madrid, Prado

Bibliography—

Kehrer, Hugo, *Dürers Selbstbildnisse und die Dürer-Bildnisse,* Berlin, 1934.

Albrecht Dürer is the first northern European artist who is truly known to us as an individual, since he was the first in history to leave both an extensive series of self-portraits and a body of autobiographical writing and correspondence. As an adult he certainly became aware of the earlier 15th-century precedent of Leon Battista Alberti, famous as a pioneer of Italian Renaissance literary introspection and creator of two relief portraits of himself. Dürer's first self-portrait, however, was also his first attempt at portraiture of any kind: the famous drawing made at the age of thirteen (Vienna, Albertina), with its later inscription explaining that he had made it "with a mirror, when I was still a child." This is a precocious work indeed, for not only did he draw it before he had taken formal instruction in painting, and in an age when children's portraits were unknown in Germany, but he used the medieval medium of silverpoint, which cannot be erased. The work is a tour de force and a clear indication of the type of inborn talent for drawing which has rarely been seen in the history of art.

Two quick pen sketches (c. 1491, Erlangen, and 1493, New York) record the artist as an adolescent journeyman; the later one served as groundwork for the formal painting in Paris (1493). This half-length portrait, in which he holds a sprig of *Männertreu* (eryngium) in his working hand, was evidently done in connection with his long-distance engagement to Agnes Frey, the bride selected for him by his father. His air of slightly apprehensive nonchalance, the cut of his hair, and his clothing—a scarlet tasseled cap, a loose green coat trimmed in orange, worn over a wide-necked linen shirt which is bound into pleats by a lavender ribbon wound round and round his torso—suggest a rather studied attempt to live up to the example of the elegant young lovers of the 1480's from prints by the Housebook Master and Wenzel von Olmütz.

In 1498, Dürer painted a new and more prepossessing self-portrait (Madrid, Prado), similarly posed, but done in the permanent medium of oil on panel. This one shows a successful and ostentatiously tailored young businessman in a white suit and cap with black stripes, a cape draped rakishly over one shoulder, and wearing a pair of the finest grey doeskin gloves, a Nuremberg specialty. With great savoir faire, both hands are folded elegantly together as though someone else were doing the painting—a trick which may have been accomplished with the aid of a flat Venetian mirror. The inscription reveals that the artist was then 26 years old ("Das malt ich nach meiner gestalt/Ich war sex und zwenzig Jor alt/Albrecht Dürer") but he is already wearing a full beard and moustache. The beard, which had made its first appearance in the New York drawing of 1493 as two or three tentative blond hairs, came to be Dürer's trademark in an age when virtually every other young man in Europe—and the vast majority of older ones—were clean-shaven. (He would later use the beard to dramatically glossy effect in the dark and Christ-like self-portrait dated

1500 [Munich], but his friends teased him about it unmercifully.)

Unlike the Paris portrait with its dark and indefinite background, the Madrid one has the full-blown architectural setting popular in Netherlandish and south German "society" portraiture: a corner space with an open window giving a view of landscape outside. The formula had originated in the Netherlands, where it was first favored by Dirk Bouts and his circle, but was soon transplanted both to Italy, where Ghirlandaio was using it by 1480, and to Germany. Dürer's Nuremberg master, Michael Wolgemut, had used a very similar format in the early 1490's for his portrait of Levinus Memminger (Lugano-Castagnola), as had the Master WB (Frankfurt: *Portrait of an Unknown Man,* 1487), and the anonymous upper-Rhenish painter of an unknown young man (New York, 1491). Dürer himself had just used the same device in 1496 for the Haller Madonna (Washington), and in 1497 for the portrait of an 18-year-old young woman with bound hair (Berlin). Soon, in 1499 he would use it again in two portrait diptychs for Elspeth, Niclas, Hans and Felicitas Tucher of Nuremberg (panels; Weimar and Kassel).

The Prado painting has been called "the first self-portrait in the history of art not painted for a specific purpose" (Von der Osten and Vey) on the one hand, and an expression of "pharisaical self-adoration" on the other (Pope-Hennessy). The truth probably lies somewhere between. It is certainly demonstrable from the writings of such humanist friends of Dürer's as Lorenz Behaim and Joachim Camerarius that the artist was considered one of the handsomest men in Europe in his day. It is equally evident that he was not entirely unaware of that fact, to judge from his letters from Venice to his friend, Willibald Pirckheimer. It is also true that Dürer's formal portraits of himself ceased well before the onset of middle age, as was to be true of a later and even more inveterate self-portrayer, Anthony van Dyck.

It should be borne in mind, however, that Dürer was both a professional painter of portraits and a teacher of young men who wished to learn that useful and lucrative art, and that his self-portraits never left his house during his lifetime, but would always have been available to show to clients as modelli or to use as teaching pieces. Dürer, in making his painted self-portraits, was surely aware of their value as both advertisements of his talents and guarantees of quality, however much or little he may have enjoyed beholding his own features in the mirror as he painted. His self-portraits served, as well, as a history of his rising fortunes, since his clothing reflects his rise in income and social status, from slightly moon-struck journeyman in his first finery, to the sumptuous sable-collared and internationally renowned master who appears seven years later in the Munich self portrait "painted," as the inscription says, "with undying colors, at the age of 28 years." Nuremberg's city council kept careful watch over the city's dress code, permitting certain kinds of garment trim and various widths of fur collar only to citizens of considerable substance.

In 1498, when he painted the Madrid *Self-Portrait,* Dürer had become the successful young owner of an independent workshop, opened in 1495 after his return from a winter in Italy. One of his first clients had been the Saxon Elector, Frederick the Wise (Europe's only other young bearded male). Frederick was the most powerful and highly respected nobleman in the Empire, and it was an enormous honor when Dürer

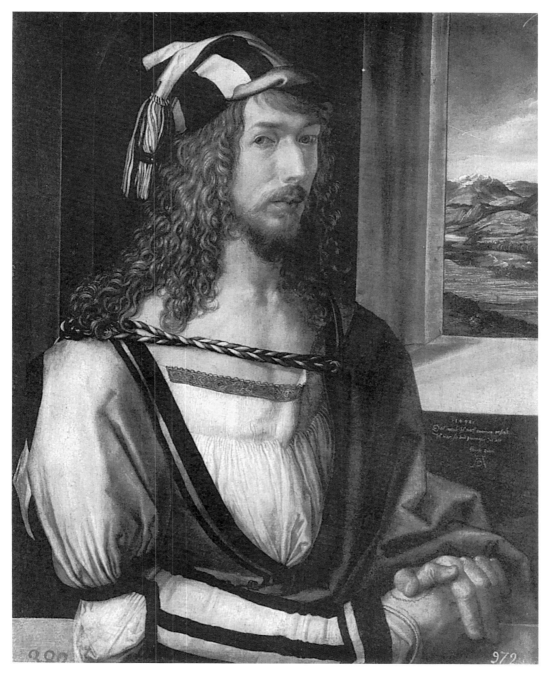

was asked to do his portrait (1496; watercolor, Berlin). The Elector was painted in the simple format with plain background that resembled Dürer's *Self-Portrait* of 1493, a format also used by Dürer for the last portrait of his father (1497, London). Frederick's patronage, predictably, set off a sudden vogue among the Nuremberg patricians for portraits by Dürer, which lasted for the next four years, and these portraits, like his own of 1498 have landscape backgrounds viewed through open windows or partially concealed by tapestries.

In addition to the honor accorded him by the patronage of Frederick the Wise, Dürer had other reasons to rejoice over his professional image in 1498, for he had just become the illustrator and—more importantly for his social standing, the publisher—of his own edition of the *Apocalypse*, using the type faces and heavy printing equipment belonging to his godfather, Anton Koberger. The enormous woodcuts of this brilliant picture book were the most virtuosic ever done, and they set new standards for both woodcut design and for the craft of cutting. By 1498 Dürer was becoming internationally famous—and widely forged—on both sides of the Alps. Thus the landscape viewed through the window in the Madrid *Self-Portrait*, with its view of snow-capped Alpine peaks, reminiscent of the watercolor landscape studies made on his journey, is not only a memento of his recent trip to Italy, but a reference to his ambition to conquer Italy with his art.

—Jane Campbell Hutchison

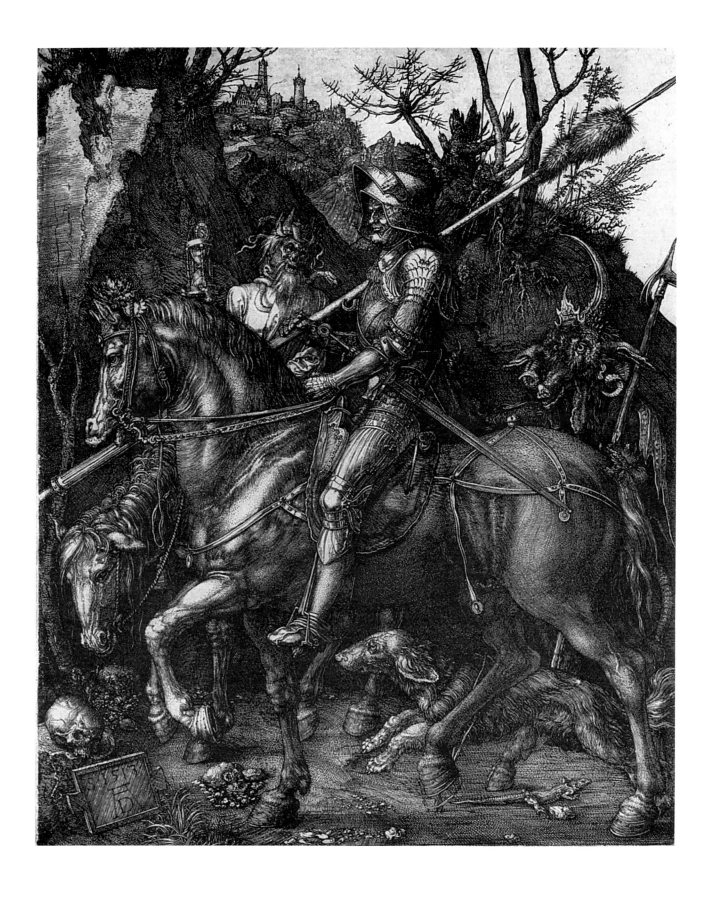

Albrecht Dürer (1471–1528)
Knight, Death, and the Devil, 1513
Engraving

Bibliography—

Wittber, Alfred, *Ritter trotz Tod und Teufel: Protestantisches zu Dürers Kupferstich,* Berlin, 1959.

Karling, Sten, *"Ritter, Tod, und Teufel:* Ein Beitrag zur Deutung von Dürers Stich," in *Actes 22e Congrès International de l'Histoire d'Art,* Budapest, 1969.

Thessing, Heinrich, *Dürers "Ritter, Tod und Teufel": Bildsinn und Sinnbild,* Berlin, 1978.

Meyer, Ursula, "Political Implications of Dürer's *Knight, Death, and the Devil,"* in *Print Collector's Newsletter* (New York), 9, 1978.

Knight, Death, and the Devil is the earliest of Dürer's so-called Master Engravings, three highly elaborate works which together represent the apogee of engraving technique in the early 16th century. Close in size to *Melencolia I* and *St. Jerome in his Study* (both dated 1514), Dürer's *Knight* has also been regarded as a part of an intellectual and spiritual trilogy. We know from Dürer's Netherlands Diary (1521), however, that he did not necessarily sell the prints together, and certainly each engraving stands on its own, formally and iconographically. There are also many relationships that can be construed between different *pairs* of these engravings.

Knight, Death, and the Devil is almost as difficult to penetrate as *Melencolia I;* both prints have inspired a huge body of growing scholarship. Dürer himself called *Knight, Death, and the Devil* simply "Reuter" (Rider). The most widely agreed upon interpretation of the *Knight,* taking it as a positive symbol of Christian virtue, was put forth by Erwin Panofsky in his monograph on Dürer, and has been expanded and elaborated more recently by Heinrich Theissing. Panofsky connected the engraving to Erasmus's essay *Enchiridon militis christiani* (Handbook of the Christian Soldier), published in 1503. Erasmus developed the concept of the Christian Knight who is armed with his faith against the enemies of sin and death. St. Paul's use of military metaphors (e.g., Ephesians 6:11) to describe Christian virtue, and Dürer's dubbing of Erasmus as a "Knight of Christ" in the famous Luther-passage of the Netherlands Diary, should also be noted. According to Panofsky, then, Dürer's Knight—looking much like an Italian *condottiere*—is a personification of the active Christian life. He rides through a rocky, forbidding landscape past the Devil and Death, in the form of a corpse seated on an emaciated horse and holding an hourglass as a symbol of the passage of time. Dauntless, the Knight seeks the fortress of Virtue in the distance. The details of the engraving may be interpreted in accordance with this general meaning: for example, the oak leaves adorning the horse stand for fortitude and the dog for fidelity; the lizard is an attribute of the devil; the foxtail on the Knight's lance is a symbol of deceit which the Knight has conquered. The "S" of the inscription probably refers to "Salus" ("In the year of Grace"), which Dürer used on three other prints.

This line of thinking about Dürer's *Knight* has had its de-tractors, many of whom have presented interesting arguments. Ernst Gombrich thought the print was a Dance of Death, and the Knight a reprehensible character who needs to mend his ways in the light of the transitory nature of life. Sten Karling and Ursula Meyer have based their analyses on the corrupt state of the knighthood in Dürer's time. The Knight thus becomes evil, and Death and the Devil are his attributes rather than his antagonists. Alexander Perrig has recently viewed the engraving as an anti-papal statement, in which the Knight personifies the Papacy, more specifically Julius II, whose oak-leaf emblems adorn the horse.

Negative interpretations of the print remain unconvincing, however. They fail to account for the overtly idealized form of the horse, for the possibility that Dürer, like the Emperor Maximilian, understood knighthood in terms of its chivalrous past rather than its debased present, for the apparent courage and staunchness of the Knight and his superiority over the skulking Death and Devil, whose stances and gestures indicate their intention to distract the Knight from his quest. Theissing has noted that the Devil's hooklike weapon is one which was used to pull a rider off a horse from behind—scarcely the action of an ally. Most importantly, negative analyses have not accounted for any relationship between *Knight, Death, and the Devil* and the other two Master Engravings. Although we cannot take the idea of a trilogy too rigidly, there is probably some cogent relationship among three contemporary engravings of comparable size and complexity.

An understanding of the Knight as a personification of active Christian virtue, however, makes sense with the other Master Engravings. While the Saint personifies the contemplative Christian life, and especially the life of the Christian scholar, the Knight is Christian virtue put to work, not in the study but the world. And, in contrast to the life of the troubled secular genius, whose intellect and creativity compete with God in *Melencolia I,* the Saint and the Knight use their abilities in the service of God. Their activities may be contrasted with the inertia of Melancholy, whose skills are not equal to the godlike vision with which she has been gifted.

Despite a noticeable *pentimento* beneath the horse's back right hoof, and the fact that it was succeeded by the virtuoso performances of *Melencolia I* and *St. Jerome in His Study, Knight, Death, and the Devil* is still one of Dürer's most brilliant technical creations. The horse is the culmination of his studies of idealized equine proportions—an important concern in the Renaissance. Throughout the print, the burin has been employed to produce a variety of marks conveying different textures: the Knight's armor, the lizard's scaly skin, the dog's fur, the skull's bony surface. The Devil, surely concocted with Martin Schongauer's *Temptation of St. Anthony* and Master LCz's *Temptation of Christ* engravings in mind, is one of Dürer's cleverest creations. His hybrid, meticulously rendered anatomy and equivocal posture convey his sinister intent as well as his ultimate failure to hamper the Knight.

—Linda C. Hults

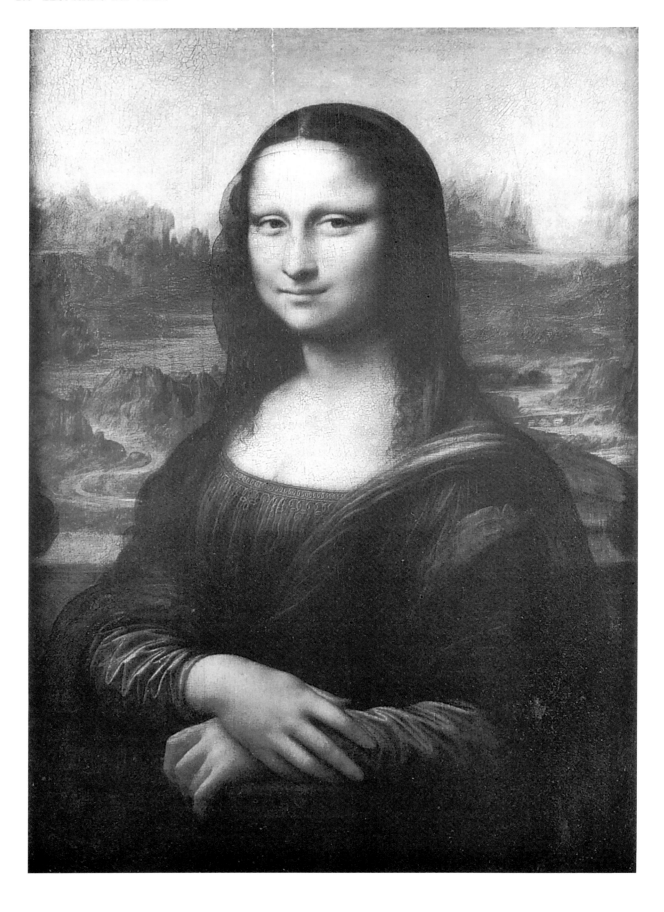

Leonardo da Vinci (1452–1519)
Mona Lisa
Panel, 30 × 20 in. (76.8 × 52.9 cm.)
Paris, Louvre

Bibliography—

McMullen, Roy, *Mona Lisa: The Picture and the Myth*, Boston, 1975.
Smith, Webster, "Observations on the *Mona Lisa* Landscape," in *Art Bulletin* (New York), June 1985.

This is probably the most famous painting in the world. Sung by poets and satirized by artists of all ages, the *Mona Lisa* has become a world icon. In 1911 the painting was stolen from the Louvre by an Italian house painter and hidden under his bed in Florence for two years. When it was recovered, it toured Europe by train like a living celebrity and was accorded a heroine's welcome upon its return to Paris. In the 1960's the *Mona Lisa* went to be exhibited at the Metropolitan Museum in New York and, during her first-class sea voyage, she was accompanied at all times by an armed security guard.

Despite the fanfare, however, the known facts of the picture are few. According to Vasari, the 16th-century biographer of the Italian Renaissance artists, Leonardo was commissioned in 1503 by a Florentine business man, Francesco del Giocondo, to paint a portrait of his wife, Lisa di Antonio Maria Gherardini. Leonardo worked on the picture for several years, but never delivered it to the patron. Instead, he took it with him to the French court of Francis I, where he died, and the painting remained in France.

The personality of the *Mona Lisa* has eluded identification for centuries. It may be her very elusiveness that makes her an object of such universal fascination. She sits on a balcony in a relaxed three-quarter pose, her gaze following the observer as he moves back and forth in front of her. More than any other painting, the *Mona Lisa* set the standard for subsequent female portraits in the 16th century and later.

In addition to the figure's personality, there are other puzzling aspects of the painting. For example, the woman herself is seen directly by the observer, whereas the landscape is rendered as a bird's eye view. A similar shift occurs in the light: the balcony and the figure are bathed in a soft yellow light while the landscape is imbued with a blue mist. Nor is the landscape any more identifiable than the character of the woman herself; its dream-like quality is as elusive as the personality of the Mona Lisa.

One of the most distinguishing characteristics of this painting is the close integration of woman and landscape, particularly woman and mountain. The traditional relationship between women, especially maternal women, and landscape (that is, Mother Earth) is given a new context by Leonardo. There are numerous formal parallels between the two in this painting. For example, the aqueduct on the right flows naturally into the fold over the woman's left shoulder and the small curved arches of the bridge are repeated in the curving gold embroidery just below her neck line. The spiral road on the left is repeated in the folds of the sleeves, which in turn recur in the lines of the fingers resting on the crossed arms in the foreground. The blue mist over the mountains filters light just like the light veil around the woman's head. Finally, the woman herself repeats the forms of the dolomites so that she herself becomes a symbolic woman-mountain.

Leonardo compared the human body to the earth. He said that the rocks were like the bones, the earth the flesh and the waterways the circulatory system. In the *Mona Lisa,* he seems to have expressed this metaphor with the monumental form of a woman, who corresponds to the imaginary landscape behind her. The very abstraction of the correspondence may account for the continuing fascination and inexplicability of this painting.

—Laurie Schneider

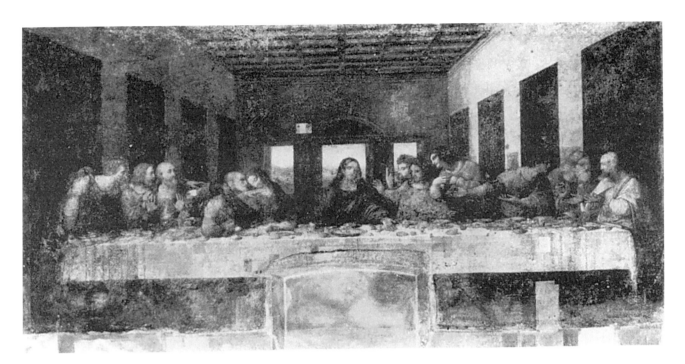

Leonardo da Vinci (1452–1519)
The Last Supper
Fresco, 13 ft. 9³/₈ in. × 29 ft. 10¹/₄ in. (420 × 910 cm.)
Milan, S. Maria delle Grazie

Bibliography—

Steinberg, L., "Leonardo's *Last Supper*," in *Art Quarterly* (New York), 36, 1973.
Brown, David Alan, *Leonardo's Last Supper: The Restoration,* Washington, 1983.
Armstrong, George, "Leonardo Revealed: The Restoration of *The Last Supper*," in *Art News* (New York), March 1988.

It is very difficult to take a just estimate of the originality of Leonardo's *Last Supper* for two different reasons. In the first place, it is hopelessly over-familiar. Most visitors have grown up with innumerable reproductions of it, whether in colour or black and white, not to mention small copies on metal or wood or even mother-of-pearl which litter the shops that sell holy pictures and knick-knacks all over the Christian world. Secondly, the story of its decay—how it started to perish even within Leonardo's lifetime owing to the failure of his attempt to find a technique of wall painting which should permit him to work at his leisure—how a door was most insensitively let into the middle of it, and how it has been restored so many times that it would be surprising if there were any original paint left on it. All this has become a legend in its own right which impedes consideration of the work of art for itself.

Despite all this most visitors agree that the sight of the famous wreck in its own setting—at the end of the long hall of the refectory of the monastery—is still very moving. Yet even this is surprising. It is clear that the side walls in the painting are intended to give the impression of continuing the actual side walls of the hall. But they do not do so. They appear to converge inwards at an angle from the real walls. This was evidently the result of a conflict between religious emphasis and dramatic effect. The vanishing point of the perspective of the painted walls is situated in Christ's head, and this concentrates attention on it. But for this reason the painted walls would only seem to continue the line of the real ones if the spectator were opposite Christ's head and on the same level, whereas in fact he will be standing several feet lower down.

When it was first shown, in the last years of the 15th century, Leonardo's *Last Supper* must have seemed revolutionary. For obvious reasons a representation of this subject had been usual in the refectory of a monastery. But previous to this they had been quite different. The picturesque detail in the backgrounds of most of them detract from the event and contrast with the austerity of Leonardo's setting. It had been the practice to emphasize the infamy of Judas Iscariot by isolating him on the near side of the table, thus impairing the unity of the composition. In one of Leonardo's early drawings of the subject he retains this arrangement, but he finally abandoned it for visual reasons. In the painting itself Judas is on the left of the group to the spectator's left of Christ. He knocks over the salt in his agitation at Christ's words: "One of you will betray me."

The arrangement of the twelve apostles into four groups of three gives coherence to the design and isolates Christ in the centre. More important still is the varied reaction of the apostles. In the painting's original state the expressions on their faces, now retouched and blurred, would have contributed to this. But their gestures, which are still legible, contribute more. One holds up his hands in disbelief, another stretches his arms wide in amazement, a third protests his innocence with both hands to his chest. And so on. This demonstration of dumb language foreshadows the Grand Manner in painting, soon to be developed by Raphael and to pass from him to the academic curriculum of art schools throughout western Europe for the next three centuries or more. And this is the most enduring legacy of Leonardo's Last Supper.

—Cecil Gould

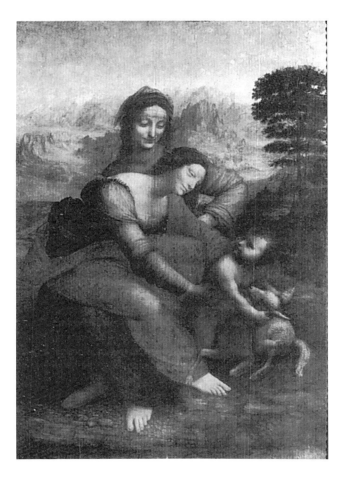

Leonardo da Vinci (1452–1519)
The Virgin and Child with Saint Anne
Panel, 5 ft. 6¹/₈ in. × 4 ft. 3¹/₄ in. (168 × 130.1 cm.)
Paris, Louvre

Bibliography—

Clark, Kenneth, "Leonardo: *The Virgin with St. Anne,*" in *Looking at Pictures,* London, 1960.

The circumstances of the commission of this panel painting, now in the Louvre, are not known. It is generally believed that Leonardo began working on it around 1500, and it is one of several works which he took with him to the French court, where he died.

One of the most interesting aspects of this picture is the existence of the cartoon (or drawing) for it, which is in the National Gallery in London. The cartoon allows us to see the changes made by Leonardo as he went from drawing to painting. Leonardo altered the poses of the two women in the final version and eliminated the eerie expression on Anne's face as her gesture, the pointing finger. Also different is the presence of Christ's childhood playmate and second cousin, John the Baptist, in the cartoon; in the painting, John has been replaced by a lamb, which Christ mounts. The iconography of this painting has been extensively disputed, particularly the suggestions of Freud. What is indisputable, however, is that the lamb is a combined symbol, referring both to Christ as the "lamb of God" and to John the Baptist, who often holds the lamb as an attribute and who identified Christ to the multitude.

Christ mounting the lamb is an unprecedented motif, as is the youth of Mary and her mother, Saint Anne. Since Saint Anne would have been much older than she is depicted by Leonardo, scholars have attempted to explain her nearness in age to Mary. Some have accepted Freud's view that the two young women in the painting represent Leonardo's own two mothers, his natural and his adoptive mother, both young and both known to him.

The style of the painting is characteristic of Leonardo's maturity. The pyramidal construction of the figures is found in *The Virgin of the Rocks* and the unfinished *Adoration of the Magi,* and corresponds to the background dolomite forms. A yellowish light infuses the foreground, which is set on a brown rocky surface. The tree to the right is probably a symbolic reference to the tree of the Garden of Eden as well as to the cross, thereby uniting man's past with his future, with Christ as the link between the Christian and the pre-Christian era. The yellow light and gradual shading typical of Leonardo soften the skin textures and enhance the tactile quality of the figures. The background is a landscape bathed in a blue mist, whose mountains correspond with the edges of Saint Anne's head and the folds in her right sleeve. The blue is carried into the pyramid of figures through Mary's outer drapery so that women and landscape merge through light, color, and form.

—Laurie Schneider

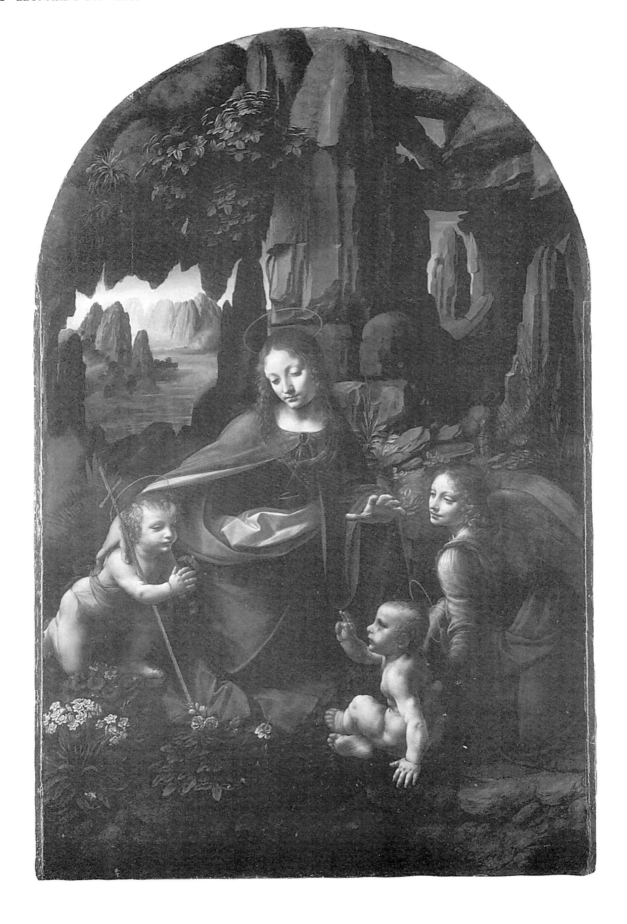

Leonardo da Vinci (1452–1519)
The Virgin of the Rocks
Louvre version, 78³/₈ × 48 in. (199 × 122 cm.); London
 version, 74³/₄ × 47¹/₄ in. (189.5 × 120 cm.)
Paris, Louvre; London, National Gallery

Bibliography—

Sironi, Grazioso, *Nuovi documenti riguardanti la "Vergine delle Rocce"* di Leonardo, Milan, 1981.
Cannell, William S., "Leonardo da Vinci—*The Virgin of the Rocks:* A Reconsideration of the Documents and a New Interpretation," in *Gazette des Beaux-Arts* (Paris), October 1984.

The two versions of Leonardo's Virgin of the Rocks, in the Louvre and the National Gallery, London, pose a similar problem to a detective story. Most critics would agree that the Louvre picture is the better, but nothing is known for certain of its history before the mid-17th century, that is, at least a century and a half after it was painted. The London version, on the other hand, has a pedigree which is documented right back to within Leonardo's lifetime. Yet it lacks the quality of the Louvre picture.

The relevant documentation is copious but does not fully account for the anomaly. On the 25 April 1483 Leonardo and the brothers Evangelista and Ambrogio Preda, or De Predis, were jointly commissioned to gild an existing carved altarpiece for the chapel of the Confraternity of the Immaculate Conception in the church of S. Francesco Grande at Milan, and to paint three pictures to go in it. Leonardo was to paint the central panel and Ambrogio Preda the wings. Evangelista was evidently responsible for the gilding.

The central painting was still unfinished when Leonardo left Milan at the end of 1499. An appeal, undated but probably of several years before this, complains that Leonardo and Ambrogio (Evangelista being by this time dead) had already spent more than the fee on the work. A second contract, of 1506, makes it clear that only Leonardo's share of the work remained unfinished (twenty-three years after he had been commissioned!) and allots more money provided that he returned to Milan from Florence and finished it. In the event he did return and the painting was delivered to the Confraternity. This picture was sold in the 18th century and is certainly the one now in London.

The problem is therefore to account for the Louvre picture. Though the solution is unlikely to be universally agreed, the most probable sequence of events is the following. In November 1493 Bianca Maria Sforza, the niece of Lodovico Il Moro, the dictator of Milan, married the Emperor Maximilian I. Lodovico, her uncle, who was Leonardo's employer, was determined to spare no expense to conduct the wedding (which was by proxy) with the most extreme splendour. We know that a picture by Leonardo was sent to the Emperor in Germany. Lodovico would certainly have known of Leonardo's dispute with the Confraternity. He would have instructed Leonardo to

finish the picture so that he could give it as a wedding present and to paint a replacement for the Confraternity. As they had not yet taken delivery of Leonardo's picture there would have been no need to inform them of the transaction and officially they would never have known. But as some money had already been paid for it Leonardo would have had, on leaving Milan in 1499, to surrender the replacement, even though it was not finished. When he did finish it, after 1506, he would have been assisted by his studio, which would account for the unevenness of the result. In this way we may regard the Louvre picture as an original (but now rather damaged) Leonardo dating mainly from the 1480's, and the London version as started by Leonardo in the 1490's and finished, mainly by his assistants, in 1506 or a little later.

The difference between the two pictures confirms this solution. The Louvre picture has a wealth of detail in the vegetation which still gives it a quattrocento appearance. The London version is nearer to the High Renaissance ideal in its greater simplicity. The greatest difference is in the angel on the right. In the Paris version he points to the infant Baptist with one hand but looks in the opposite direction. In the London picture the angel no longer points. Instead he faces the Baptist. The extreme beauty of the angel's face in the London picture, with the half smile characteristic of Leonardo, is the most striking feature of the painting, and here, if anywhere, we may recognize Leonardo's own hand. But the leaden colouring of the flesh is uncharacteristic of him but characteristic of Ambrogio Preda, to judge from the many authentic portraits by him which survive. It seems likely that most of the top paint in the London picture is his. Leonardo probably went over it at the end to some extent—the spiky leaves, half way up on the right hand side are of exquisite workmanship, when examined in detail, and typical of him. As if in compensation the preservation of the London picture is much better than that of the Louvre version. The fact that the Confraternity concerned itself with the Immaculate Conception has caused some critics to see this as the subject of the pictures. But though there may be a symbolic allusion, such is not strictly the subject.

The final element in the unsolved mystery is how did the Louvre picture get to France? Once again we can only theorize. Nevertheless, it is a fact that the granddaughter of Maximilian and Bianca Maria, Charles V's sister, Eleanora, married Françis I of France as his second wife, probably in 1530. As Françis was known to be a passionate devotee of Italian painting it may well have seemed appropriate to include among the bride's trousseau the picture which is likely to have been in that of her grandmother. The Louvre picture is first recorded at Fontainebleau in 1625.

—Cecil Gould

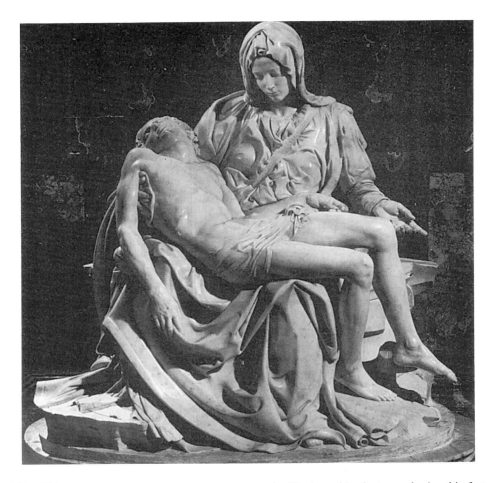

Michelangelo (1475–1564)
Pietà, 1496–1501
Marble; 5 ft. 8¹/₂ in. (174 cm.)
Vatican, St. Peter's

Bibliography—

Hupka, P., *Michelangelo: Pietà,* New York, 1975.

The figures in this famous group are life size, but because of the enormous proportions of the setting they appear smaller. The group was carved in Rome when Micelangelo was living here between 1496 and 1501. It is his most highly finished sculpture and the only one which he signed. The signature reads: MICHAELAGELVS.BONAROTVS.FLORENT.FA-CIEBAT. It is inscribed on the ribbon which descends from the Virgin's left shoulder. The patron was a French cardinal, Jean Bilhères de Lagraulas (Villiers de la Grolaie). The contract for the work is dated August 1498. The cardinal died in 1499, probably before the work was finished. It was an immediate success, the first great triumph of Michelangelo's life, but there was some criticism at the time that the Virgin Mary looked too young. Michelangelo replied that that was on account of her purity.

Following his usual practice Michelangelo carved the group from a single block of marble, and he was at pains to plan the group compactly, so that something of the block-like quality remained. The exception to this is the outstretched left hand of the Virgin, evidently to emphasize this feature—the speaking hand as contrasted with her impassive features. Nevertheless it must be borne in mind that the hand was broken at an early date and may not have been accurately restored.

The idea of the dead Christ lying in the lap of the Virgin came from northern European art. Though it enables the two figures to be welded together in a pictorial sense there is a built-in disadvantage from an artist's point of view, that a man's body is bigger than a woman's. In the present group Michelangelo has been willing to run this risk in the interests of the visual qualities. But if his two figures were to stand up the Virgin would be much taller than Christ.

Later in his life the subject of the Pietà, together with the Crucifixion, absorbed his increasingly religious turn of mind almost to the exclusion of all others. In a magnificent finished drawing in the British Museum, long misattributed to Sebastiano del Piombo and only recently restored to Michelangelo, the body of Christ is again lying in the Virgin's lap. It is now the proper size—that is, much bigger than the Virgin's—but the lower part of her body is concealed, and the group made up by the presence of no less than four other figures in the background. In the late sculpture group in Florence cathedral Christ's body is upright, but falling, while in what is probably the last of all (Milan, Castello Sforzesco) and in the so-called *Palestrina Pietà* (Florence, Accademia), whose authenticity is still sometimes doubted, both Christ and the Virgin are upright.

—Cecil Gould

Michelangelo (1475–1564)
David, 1501–04
Marble; 13 ft. 5³/₈ in. (410 cm.)
Florence, Accademia

Bibliography—

Seymour, Charles Jr., *Michelangelo's David: A Search for Identity,* Pittsburgh, 1967.
Hartt, Frederick, *David—By the Hand of Michelangelo: The Original Model Discovered?,* London, 1987.

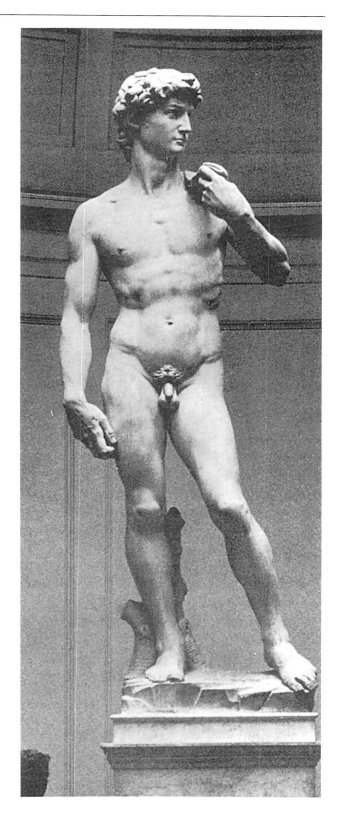

The *David,* which made Michelangelo the most celebrated artist alive at the time of its completion, was started by him in 1501 and finished three years later. He was then twenty-nine. The colossal block of marble from which he carved the figure had been quarried at Carrara some forty years previously, but to facilitate transport had been roughly blocked out on the spot and thereby spoiled. It was subsequently offered to various sculptors but without result. Having lain around in the precincts of Florence cathedral for many years it was finally offered to Michelangelo, since he alone undertook to carve a figure from it without adding another piece of marble. In view of his stated belief that it was possible to imagine any figure in any pose as already existing in any block of marble this claim becomes intelligible. Nevertheless he himself said that he found the previous mauling of the block posed great difficulties. In particular, the space between the legs had already been hollowed out, so that David's stance may not be entirely what he, Michelangelo, would have wished. And because of what he considered a defect in the shoulders he would have preferred the statue to be shown in a niche, rather than in the open air in front of the Palazzo Vecchio where, in the event, it was finally set up. Later criticism has focussed attention on the relatively enormous hands, though this feature was evidently intentional—to stress David's youthfulness. Nevertheless the resulting impression is heroic, in sharp contrast with Donatello's beautiful but somewhat effeminate bronze *David* in the Bargello and also with Verrocchio's hesitant adolescent in the same museum. It can hardly be denied that the impressiveness of Michelangelo's figure is at least partly due to its enormous size, but this is itself self-defeating in one sense. The essence of the Bible story is of the little man's defeating the big man. If David is to be depicted 13 feet high Goliath would have had to be at least 20 feet. Unlike Donatello and Verrocchio, both of whom had shown David in his moment of victory, with Goliath's decapitated head at his feet, Michelangelo's David is shown at an earlier stage. He is mentally measuring the distance between him and his enemy in order to calculate his throw. It was left to Bernini in the succeeding century to carve a David at the actual moment of slinging the stone.

The left arm of Michelangelo's David was broken in 1527 when a chair fell out of the window in the Palazzo Vecchio behind it. In 1873 the sculpture was moved to the Accademia to protect it from further erosion from the weather. It was replaced outside the Palazzo Vecchio by a copy in marble. There is also a bronze copy on the Piazzale Michelangelo overlooking the city. The original statue has always been completely nude. The fig leaf which appears in older photographs was painted on the negatives.

—Cecil Gould

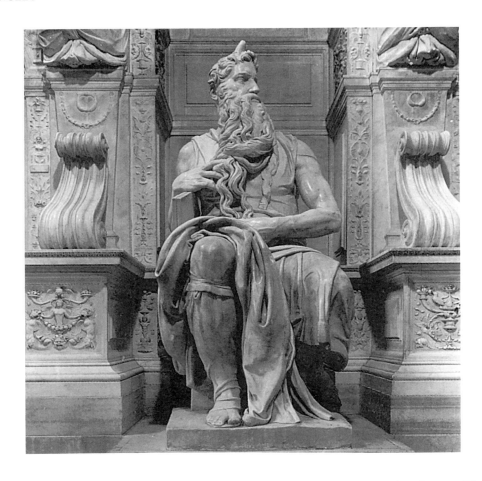

Michelangelo (1475–1564)
Moses
Marble, 7 ft. 8¹/₂ in. (235 cm.)
Rome, S. Pietro in Vincoli

Bibliography—

Guidoni, Enrico, *Il Mosè di Michelangelo,* Rome, 1982.

Michelangelo's Moses, one of the most famous and most frequently reproduced of his sculptures, is intimately bound up with the tangled and protracted history of the tomb of Pope Julius II, which it was intended to adorn, and which it still adorns. But the project was modified repeatedly owing to political and financial factors, to Michelangelo's increasing frustration. He himself declared that the episode was the greatest tragedy of his life.

In the early stage (1505) Julius is said to have planned the rebuilding of St. Peter's, Rome, in order to set off the tomb that Michelangelo should make for him; and Michelangelo's own ideas, which habitually started large and then became larger, responded enthusiastically to the megalomaniac project. He planned a vast, free-standing architectural monument, enclosing a funerary chapel and adorned with no less than forty marble statues.

For some unexplained reason the Pope soon turned against the idea and diverted Michelangelo on to modelling a vast statue of the Pope himself, to be cast in bronze, and then to painting the ceiling of the Sistine chapel. After Julius's death in 1513 the project was revived in a modified form as a wall tomb—a form which persisted through all the succeeding blueprints down to and including the final one as executed. But from now on the money could no longer come from Vatican funds but had to be found by the late Pope's family, the Della Rovere; and with the years both the funds and the enthusiasm dwindled. Project succeeded project, getting always smaller, and when, in 1545 the tomb was finally installed it had only three sculptures by Michelangelo himself (the Moses and the Rachel and Leah), the others being by assistants.

It is essential to realize that the Moses, most of which is likely to have been carved immediately after Pope Julius's death, was intended to be seen from a lower level. It was to be located on a platform above the ground storey of the tomb in its earlier states. When seen, as it is, from the level, the head appears too large and the upper half of the body too high. But the effect which it gives of power and majesty continues to impress. And the massive draperies falling majestically over the prophet's massive legs, are the most impressive of any in Michelangelo's sculptures.

A final irony concerning the tomb of Pope Julius is that by the time, in the 1540's, that it was ultimately ready to be installed, St. Peter's, the rebuilding of which was started in order to show it off, was still in no condition to receive a monument. The church of S. Pietro in Vincoli, where the truncated monument finally came to rest, had been the titular church of Pope Julius as Cardinal.

—Cecil Gould

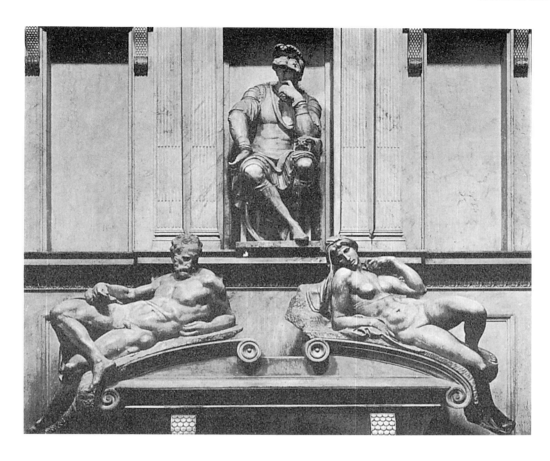

Michelangelo (1475–1564)
Medici Chapel, 1520–34
Florence, S. Lorenzo

Bibliography—

Brockhaus, H., *Michelangelo und die Medici-Kapelle,* Leipzig, 1909, 1911.
Papp, E. A., *Die Medici-Kapelle Michelangelos,* Munich, 1922.
Berti, L., *Michelangelo: Le Tombe Medicée,* Florence, 1966.

The funerary chapel for members of the Medici family, the largest assembly of Michelangelo's sculptures (no less than seven), was started in 1520 and abandoned by him, only half finished, when he forsook Florence finally for Rome in 1534.

The first Medici Pope, Leo X, had previously commissioned Michelangelo to design a facade for the Medici church in Florence, S. Lorenzo. In accordance with his normal practice of adapting his ideas for a previous work when faced with a new one, Michelangelo's designs for the facade, which envisaged an interplay of statues, reliefs, and pillars, was in effect an improved version of his current project for the tomb of Pope Julius. And when the facade project was abandoned unexecuted (the church of S. Lorenzo lacks a facade to this day) Michelangelo adapted his ideas for it when planning the funerary chapel. This explains the curious sham architecture, with blank niches, and pilasters which have no functional justification, which he inserted inside the main structural arches of the chapel in order to show off his sculpted figures.

The impetus for building the chapel had been the premature deaths of the Pope's younger brother, Giuliano de'Medici, Duke of Nemours, in 1516, and of his nephew, Lorenzo, Duke of Urbino, in 1519. Neither of these young men had been of the slightest distinction, but their tombs were the only ones which Michelangelo, in the event, executed, and even then did not entirely finish. The main feature of the chapel as planned, the double tomb of Lorenzo the Magnificent and of his brother, the older Giuliano, was never executed.

The tombs of the other Lorenzo and the other Giuliano, as executed, consist in both cases of statues seated above naked figures on the lids of the tomb chests underneath. These represent the times of day—morning and night (female) and evening and day (male)—to stress the transience of human existence. The seated figures, although representing Giuliano and Lorenzo, are not intended as portraits. The features of both are very similar, not only to each other but also to those of the female figures on the sarcophagus lids. It was always intended to include figures of river gods at the lowest level of each tomb, but these were never executed. And none of the other figures is quite finished either, the most unfinished being the figure of day. The sculpture of the Virgin and Child, intended for the double tomb and now placed facing the altar, flanked by figures of SS. Cosmas and Damian, designed but not executed by Michelangelo, is also unfinished, though it was the first that Michelangelo started. Michelangelo seems to have abandoned work on the chapel some time before he moved to Rome, and its final form, had he ever finished it, cannot be accurately reconstructed.

—Cecil Gould

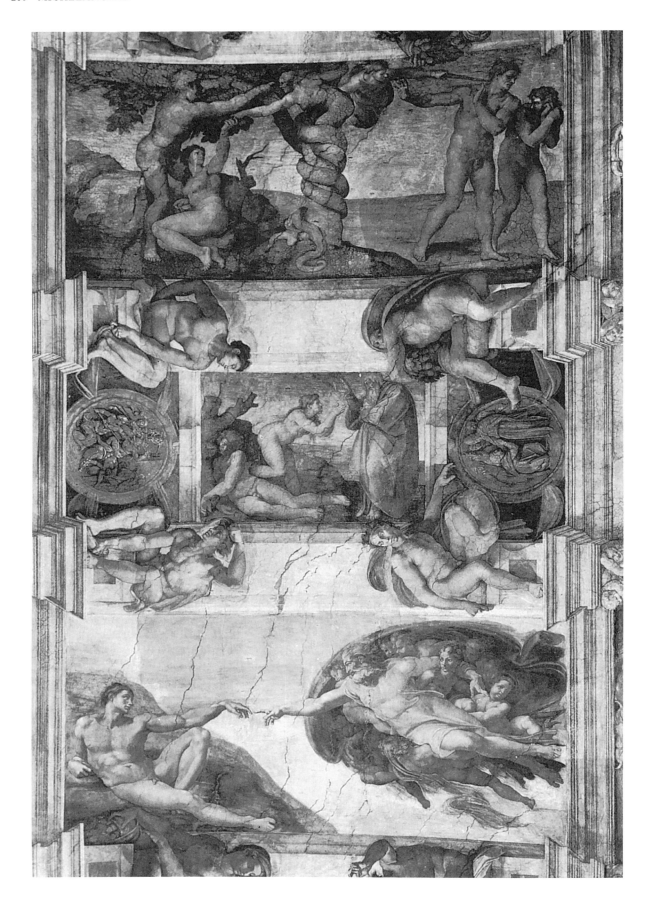

Michelangelo (1475–1564)
Sistine Chapel Ceiling, 1508–12
Fresco
Vatican

Bibliography—

de Tolnay, Charles, *The Sistine Chapel,* Princeton, 1945.
Seymour, Charles, Jr., *Michelangelo: The Sistine Chapel Ceiling,* New York, 1972.
Giacometti, Massimo, editor, *The Sistine Chapel: Michelangelo Rediscovered,* London, 1986.
Bull, Malcolm, "The Iconography of the Sistine Chapel Ceiling," in *Burlington Magazine* (London), August 1988.

The ceiling of the Sistine chapel, Michelangelo's most magnificent achievement as painter, occupied him from 1508 to 1512. It was all his own work apart from manual assistance. There was a preliminary showing of the unfinished work in 1511. The first project consisted merely of figures of the twelve apostles to be painted on the pendentives between the windows. The rest of the surface was to be covered with ornamental panels and other abstract decoration. As this scheme seemed too slight, and as Michelangelo's ideas invariably became larger and more grandiose in the course of work, he claimed that he had obtained the permission of Pope Julius II to substitute a more elaborate scheme of his own devising. This envisaged a semi-illusionist framework of painted architecture designed to show off a number of painted scenes and single figures. The first scheme was perhaps conceived as compensation for the sculptures of the twelve apostles which he had contracted to execute for the cathedral of Florence, but which he had only just started at the time when he was summoned to Rome by the Pope. And the final scheme may be considered basically as an attempt to adapt his ideas for the tomb of Pope Julius, on which, likewise, work had been suspended and which, like the Sistine ceiling as executed, had envisaged an interplay of sculpture and architecture.

The ceiling painting consists of nine major painted scenes, alternately wide and narrow, which occupy the crown of the vault and portray the story of the Creation down to the Flood.

In this way they connect iconographically with the scenes from the life of Moses which had been painted lower down, on the left wall of the chapel, by Botticelli and others before Michelangelo's time. On the pendentives are seven prophets and five sibyls, as foretelling the coming of Christ. Each of them is enthroned in a massive architectural surround. The figures in the lunettes and spandrels above the windows are the ancestors of Christ. The celebrated naked figures, the "ignudi," among the most sublime in art, surround the narrower of the scenes on the crown of the vault. At the four corners of the chapel are large, triangular scenes from the Old Testament and the Apocrypha.

Michelangelo started work at the end of the chapel farthest from the altar (as in St. Peter's, the so-called east end of the Sistine chapel actually faces west). As he progressed towards the altar wall the scale of the figures increases. This could be justified logically as offering visual compensation for distance to a viewer standing at the far end of the chapel; but the basic cause was probably Michelangelo's irresistible compulsion towards increased size as he progressed on any of his work. At the same time the technique becomes more fluid, the later paintings being apparently painted directly on to the plaster without the use of preliminary cartoons as guides to the outlines. Contrary to what is often said, Michelangelo did not paint the ceiling lying on his back. A drawing which he made of himself at work shows that he stood on the scaffolding and threw his head back.

The recent cleaning of the ceiling has revealed, in the lunettes, an astonishingly bold technique. But however much the 20th-century critic may like to see this as anticipation of Impressionism it is likely that it represents not so much a new mode of vision as a kind of painterly shorthand, with simplifications designed to compensate for the great height at which the frescoes are seen.

—Cecil Gould

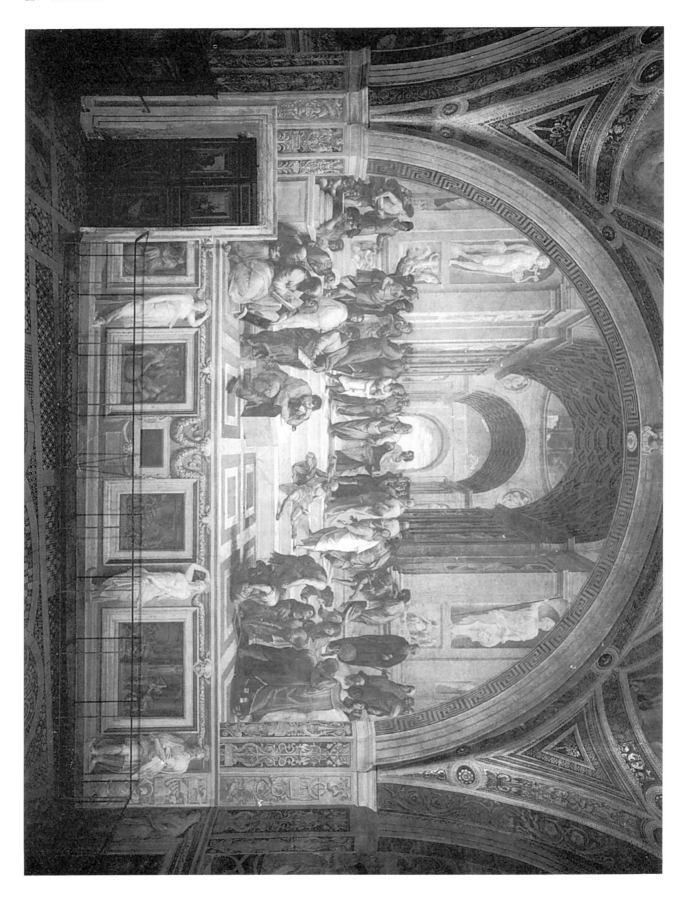

Raphael (1483–1520)
The School of Athens, 1508-09—1511
Fresco; 25 ft. 3 in. (770 cm.) (width at base)
Vatican

Bibliography—

O'Malley, John W., "The Vatican Library and the School of Athens," in *Journal of Medieval and Renaissance Studies,* 7, 1977.

Fichtner, Richard, *Die verborgene Geometrie in Raphaels "Schule von Athen,"* Munich, 1984.

The fresco called by this name is the most famous and the finest of the four murals painted by Raphael in the Stanza della Segnatura of the Vatican in the years between 1508–09 and about the end of 1511. The original function of the room is disputed. In recent times it has been suggested that it was intended as the Pope's private library. Against this theory is the fact that the private library of Pope Julius II amounted to little more than 200 volumes.

The theme of the frescoes in the room was stipulated by Pope Julius himself. Though the meaning of the frescoes has been endlessly discussed as regards the details it is unlikely, in the absence of contemporary documentation, that agreement will be reached. It is nevertheless clear that the general theme is a conspectus of contemporary knowledge, sacred and secular. *The School of Athens,* which represents many men (and no women) evidently illustrates part of the latter. In the lower left group a youth holds a slate with a demonstration of musical harmony. On the right, a bald-headed man, identified as a portrait of Bramante but probably intended for Euclid, expounds a geometrical proposition. On the upper level the old man in the centre who points upwards holds a book marked "Timeo" and is therefore Plato, while the younger one, to the spectator's right of him, holds one inscribed "Etica" and is therefore Aristotle. To the left of him the bald-headed man in green is easily recognizable as Socrates. It is therefore clear that the men on the lower level are discussing music and geometry and those above are engaged in philosophical discus-sion. Such an abstract subject might well have seemed to an artist impossible to illustrate, but in the event Raphael produced one of the noblest of all frescoes.

No preliminary composition sketches (apart from the cartoon) survive for the School of Athens, but there can be little doubt that the design evolved from that of Raphael's earlier fresco of the Disputa in the same room. In this the upper row of figures is shown on clouds. By bringing the two rows closer together in the *School of Athens* Raphael achieved greater unity and concentration but left the upper half of the lunette shape empty. The elaborate architectural perspective with which he filled this is based rather loosely on Bramante's design for the new St. Peter's.

The *School of Athens* has always been regarded as the unapproachable model for grouping draped figures, whose contrasted poses, standing, seated, leaning, crouching, or kneeling, seen from slightly above, slightly below, from the back, the front or from either side, are set off by the gray architecture of the background. The complex shapes of the spaces between them are as important to the composition as the shapes of the figures.

It is probable that many of the faces are portraits of Raphael's contemporaries. His own self-portrait, second from the right at the lower level, is vouched for by Vasari and is his only certain self-portrait. The portrait of Bramante has already been mentioned. In modern times the seated man, left centre in the foreground, who does not figure in the full-size cartoon, now in the Ambrosiana at Milan, and who was therefore an afterthought, has been claimed as a portrait of Michelangelo. But this seems due to a confusion. This figure shows strong influence of Michelangelo's figures of prophets on the Sistine ceiling, but does not represent him. He was a small man with a broken nose. This one is a giant with a long beaky nose.

—Cecil Gould

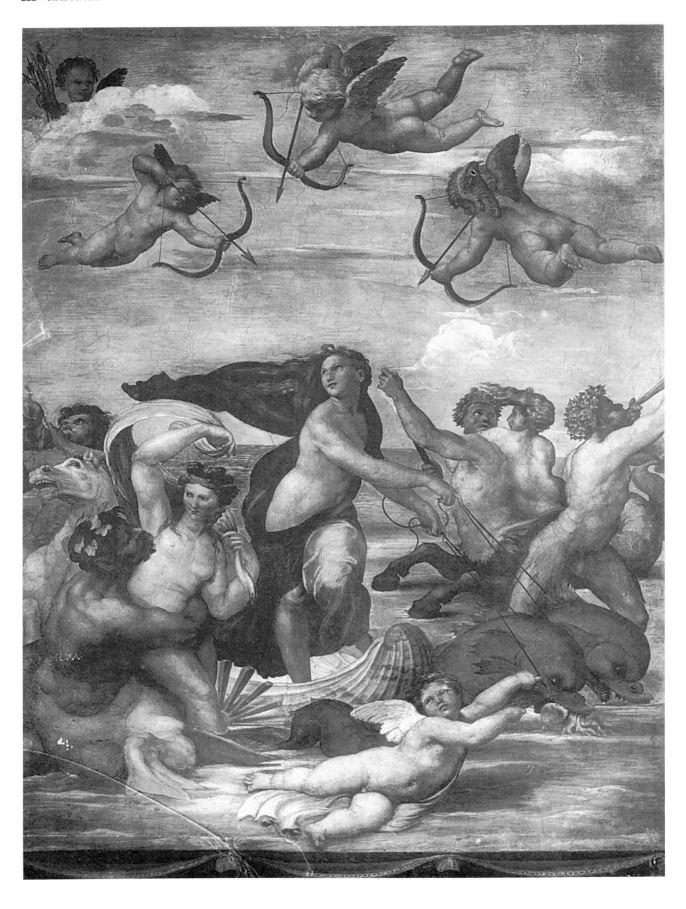

Raphael (1483–1520)
Triumph of Galatea, c. 1511–12
Fresco, 9 ft. 10 in. × 7 ft. 6 in. (295 × 225 cm.)
Rome, Villa Farnesina

Triumph of Galatea (c. 1511–12) frescoed on a wall of the ground floor garden room of Peruzzi's Villa Farnesina is one of the most beautiful and accessible of all Raphael's works. Based primarily on Poliziano's poem *Stanze per la giostra* (stanzas 115–118), the work must be read in conjunction with a slightly earlier fresco in the adjoining bay to the left by Sebastiano del Piombo. Sebastiano's work shows the huge cyclops Polyphemus seated on a stone under a tree with his dog between his feet, holding a panpipe and a shepherd's staff, and singing about his unrequited love for the sea nymph Galatea. Since, according to Ovid's account *(Metamorphoses,* 13:750–897), Polyphemus killed Acis, the lover of Galatea, when he discovered the couple together, Raphael's fresco could show Galatea fleeing this moment of violence. At the very least she is spurning his love, as told by Poliziano without reference to the murder of Acis: "Two shapely dolphins pull a chariot; on it sits Galatea and wields the reins; as they swim, they breath in unison; a more wanton flock [of dolphins] circles around them; one spews forth salt waves, others swim in circles, one seems to cavort and play for love; with her faithful sisters [the nymphs], the fair nymph [Galatea] charmingly laughs at such a crude singer [Polyphemus]."

The two frescoes, in either case, are about the dual nature of love, a common theme in Renaissance art and literature—Polyphemus the embodiment of sinful and lustful terrestrial love, Galatea of pure and chaste celestial love.

Their are several details in Raphael's work that reinforce this interpretation—all additions to his poetic sources. Three airborne cupids shoot arrows at Galatea as if she were Venus, the goddess of celestial love and beauty (and in contemporary descriptions of the fresco Galatea was mistaken for Venus). Galatea's breasts and genitals are discretely covered, and, while her head is turned in the direction of Polyphemus, her eyes look heavenward. Even more telling, one of the dolphins eats an octopus, a vignette which encapsulates the difference in significance between Polyphemus and Galatea. In medieval and Renaissance animal lore the dolphin was a tender, loving fish devoted to its mate and children. The octopus by contrast was believed to practice a savage love which exposed it to death by its prey from sheer exhaustion after love making. Furthermore, the dolphin was a common Christian symbol of salvation and the tritons and nereid who accompany Galatea were used in both antiquity and the Renaissance primarily in funerary art where their love making and vitality symbolized regen-

eration and renewed life after death. Therefore, the triumph of Galatea represents not only the triumph over the sin and lust of Polyphemus, but ultimately the triumph of pure spiritual love over death. This high-minded moralization is, of course, in tension with the undeniable erotic appeal of Raphael's nymphs, the poignant tragedy of Polyphemus, and the known prurient taste of the patron, Agostino Chigi.

Raphael's style is similarly a style of tension held in balance. A long diagonal runs from the cupid holding a bunch of arrows in the upper left to the dolphins in the lower right which accentuates the general left to right movement of Galatea's chariot and the hitch-hiking cupid in the central foreground. The sense of animation, even turmoil, is further heightened by the strong spiraling torsion of the bodies of virtually all the figures, the dramatic gestures of outflung arms, and the forceful actions of discharging arrows or blasting on a conch shell or trumpet. But the left to right movement is counterbalanced by the wind which blows the draperies and hair of the nymphs in the opposite direction. In addition, one of the pair of music makers, one of the two couples of embracing tritons and nereids, and one of the pair of cupid archers closest to Galatea move to the left while the opposite number of each pair makes a counter move to the right. The action, then, while moving to the right, is also rotational, turning back on itself. It further defines a circle whether considered in terms of the surface pattern of the fresco or the plan of the figures in depth. The harmonious blend of dynamic but counterbalanced action, and graceful but immutable geometrical structure is both contained within and generated by the graceful spiraling figure of Galatea who defines (with the cupids above and below her) the central axis and rotational armature of the design. This poised equilibrium has been enriched by Raphael's exclusive use of forms from classical Roman sculpture—nymphs, tritons, cupids, even the paddle wheel on Galatea's chariot—and by his simultaneous infusion of these ideal and distant types with spontaneity, energy, and warmth.

The myth of Galatea embodied many of the ambiguities of Renaissance attitudes toward love, but Raphael's High Renaissance style of *sprezzatura* (extreme calculation masked by casual grace) miraculously seems to hold these polarities in a harmonious equilibrium. The scene is at once lusty, earthy, and tragic, yet aspires to the perfection of divine order and beauty.

—Loren Partridge

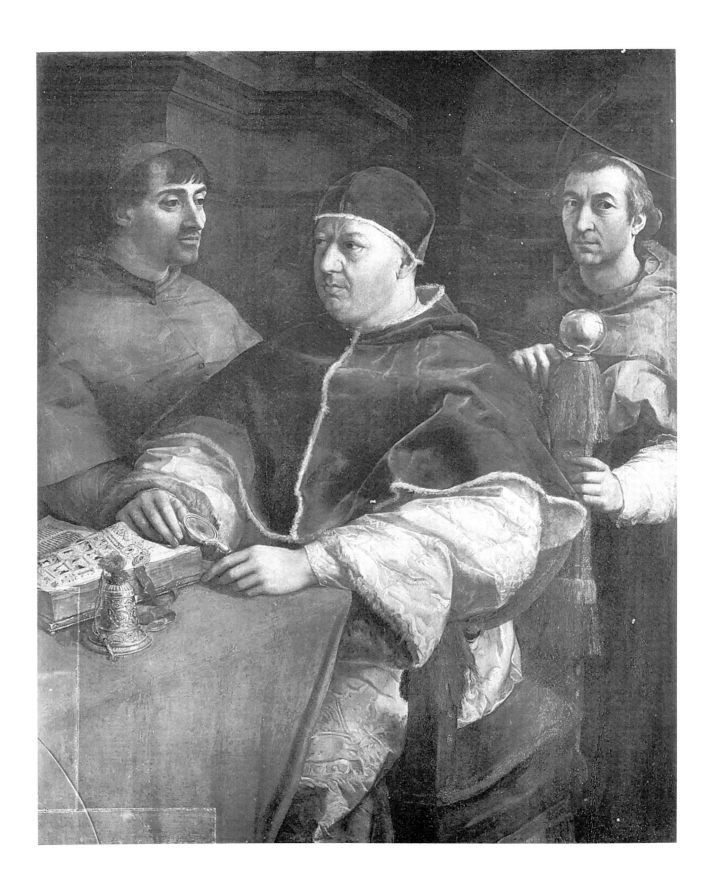

Raphael (1483–1520)
Pope Leo X with Cardinals Giulio de'Medici and Luigi de'
Rossi, 1517–19
Panel, 60⁵/₈ × 46⁷/₈ in. (153.9 × 118.9 cm.)
Florence, Uffizi

Leo, of the celebrated family of the Medici, son of Lorenzo, was of a noble stature. He had an ungainly and fat body, a very large head. His complexion was ruddy, his eyes were large and extraordinarily developed, but his sight was so weak that he was unable to recognize objects without the aid of a magnifying glass which, for this reason, he constantly carried with him. His shoulders were large, . . . his neck was almost covered by his double chin. His chest was large; his belly, enormous; his hips and thighs, so thin that they seemed lacking in harmony with his head and his bust. He was vain about the whiteness of his hands and enjoyed admiring them

There is little in this intimate verbal portrait by an anonymous contemporary that Raphael has not captured in his magnificent painting of *Pope Leo X with Cardinals Giulio de'Medici and Luigi de'Rossi* in the Uffizi. But the degree of informal familiarity is manyfold greater. The composition, for example, has a casual almost ad hoc feeling about it. The two diagonals (or perspective orthogonals) formed by the cornice lines of the background architecture and by the edge of the table and left arms of the pope and Luigi de'Rossi come together only far outside the painting to the right suggesting that the painting has captured only an isolated corner of a much large space. The canting of the table and chair obliquely to the picture plane creates a void in the right foreground that allows, even seems to demand, the presence of the viewer close to the pope in order to balance the composition. That viewer is initially, of course, Raphael himself who can be easily imagined before an easel, palette and brushes in hand, contemplating this trio of clerics with his back to the window reflected in the polished gold ball on the back of the chair.

The sense of vividness and proximity is further heightened by the Raphael's extraordinary rendering of color and texture. The hot reds all leap to the eye, but the contrast between the deep burgundy of the pope's costume and orange-reds of the table covering and the cardinals' capes also sets up a vibrant dissonance that is almost palpable. One can also "feel" the soft velvet plush of the pope's chair and ermine-lined *camauro* (cap) and *mozzetta* (cape), the sensuous finish and embossed pattern of his watered silk tunic, or the exquisite chasing of the silver relief on his gold bell. By two subtle actions within the painting—the hands of Luidi de'Rossi firmly griping the back of the velvet chair, and the fingers of the infinitely more refined and delicate hands of the pope lightly holding the magnifying glass and touching the illuminated parchment of the open Bible—Raphael dramatizes the feeling of textures which his paint so powerfully evokes.

The psychological drama which the sitters seem to enact also creates a world that is as intimate as it is allusive. Luigi de'Rossi looks out of the painting toward his left as if contemplating the painter/viewer. The pope glances out in the opposite direction as if about to address an unseen person while simultaneously about to turn a page of the Bible he has been examining. Giulio de'Medici, the future Pope Clement VII, seems to both look at the pope and inward, as if meditating on his fate.

Taken together the details of the painting add much to the image of the pope in the passage cited above: his passion for collecting books, his lavish patronage of the arts, especially small precious objects of the finest craftsmanship, his love of the company of family and friends, and his exploitation of the papacy for the advancement of Medici interests. But the painting is far more than a humane glimpse of a genial and extravagant pope. It is also a state portrait intended to express all of the grandeur and power appropriate for the head of the Church which claimed supreme universal temporal and spiritual authority over all of Christendom. The composition, for example, is more balanced and ordered than first appears. If the diagonals defined by the light entering from the upper right and by the inside edge of the table are extended they come together outside the painting to the left balancing those which focus on the right. Similarly, with the felt but unseen presence of the painter/viewer, the forms define in plan a stable X-shaped configuration at the center of which, dominating and controlling the composition, sits the massive bell-shaped bulk of the pope. The pope as well as his companions, as we have seen, suggest movement and drama, but all action is momentarily suspended.

The "chair" on which the pope sits is, of course, not simply a chair, but a regal throne. Furthermore, since the seated pope's head is almost on line with the those of the standing cardinals, the throne must be on a dais which further ennobles the pope. While the costume of the pope is informal and nonliturgical, it derives from the dress of French kings and signifies royalty, wealth, and power. The physiognomy of the pope, while strongly individualized, has also been subtly shaped to accentuate the square sagging jaw, the large firmly set lips, the fixed staring eyes, the thick eyebrows, and the knit forehead. These characteristics are all signs of the leonine personality, apt not only because of his papal name, but also because the leonine type was thought to be as courageous, fierce, powerful, and clement as a lion. The lion was also a symbol of Florence, his birthplace, and of Christ, whose vicar he was.

It is the blend of convincing naturalism and elevated grandeur that defines a High Renaissance style. Here at the height of his powers and only shortly before his death Raphael has created one of the supreme masterpieces of High Renaissance portraiture.

—Loren Partridge

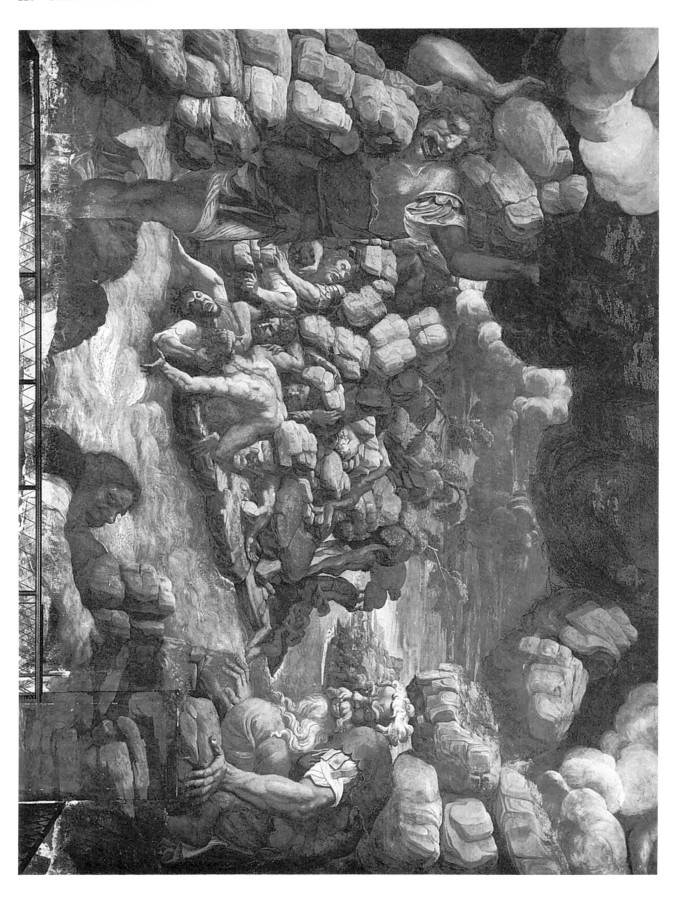

Giulio Romano (c. 1499-1546)
Falls of the Giants, 1532
Fresco
Mantua, Palazzo del Te

Bibliography—

Tibaldi, Umberto, *Il Palazzo del Te a Mantova*, Bologna, 1967.

Verheyen, Egon, *The Palazzo del Te in Manuta: Images of Love and Politics*, Baltimore, 1977.

The *Fall of the Giants* is the most famous component of the pictorial cycle of the Palazzo del Te, the pleasure villa and later permanent residence of Federigo Gonzaga, Duke of Manutua, who was Giulio Romano's patron. The frescoes, which cover the entire vault and four walls of the Sala Dei Giganti, were begun in 1532. Although their invention is entirely owing to the wit and genius of Giulio himself, the execution is largely the work of his followers, primarily Rinaldo Mantovano.

The decoration has as its subject an episode from Greek myth, narrated by Ovid among others, concerning a race of human giants who attempted to scale Mount Olympus and overthrow Jupiter, only to be mercilessly defeated by the god. At the apex of the vault appears a coffered cupola supported on a circular colonnade—the temple of Jupiter which is presided over by the god's eagle guarding his throne. Below the eagle, floating on a cloud, is seen the powerful figure of the god himself, poised to hurl his terrible thunderbolts down on the rebellious giants below. A contingent of straining, cowering Olympians, among them Bacchus, Ceres, Hercules, Mercury, Vulcan, Mars, Venus, Cupid, Apollo, Neptune, and Diana, reacting with horror to the vengeance wrought by his wrath, occupies the circular bank of clouds around Jupiter. This configuration echoes the shape of the colonnade above and lends a sense of order to this zone of the composition which contrasts dramatically with the utter chaos and catastrophic disorder below. Here, the brutish, grotesque giants suffer the full magnitude of Jupiter's ire, as massive rocks, marble columns, and brick walls crash down and crush them.

In the Sala dei Giganti, the walls are illusionistically contiguous with rather than clearly delineataed from the vault. This has the effect of eroding the rational, architectural order of the space—an effect which is reinforced by the all-encompassing pictorial decoration which covers every surface and has no clear beginning nor end. The viewer entering this chamber, who is immediately confronted by the vengeful Jupiter overhead, is thus completely surrounded by the horrific drama and has the sense of stepping directly into the middle this scene of apocolypse. This illusionism, which may have been inspired by the painted domes of Correggio in S. Giovanni Evangelista and the cathedral in nearby Parma, and has as a precursor Mantegna's oculus in the Camera degli Sposi in Mantua, was remarkable in its day and has never failed to astonish spectators throughout the centuries. Vasari's description of the *Fall of the Giants* aptly captures the dramatic effect of Giulio's invention: "it is not possible . . . to imagine a more beautiful fantasy then this painting, therefore let no one ever think to see a work of the brush more horrible and frightful, nor more natural than this; and who enters into that room, seeing the windows, the doors, and other such things twist and about to crumble, and the mountains and the edifices to collapse, cannot but fear that everything will fall in ruin on top of him."

The *Fall of the Giants* was conceived as an allegorical celebration of Charles V, with whom the Gonzaga was allied. During the period that this work was executed, the emperor was engaged in a campaign to unify Italy and subjugate its independent city states under his rule. The imagery alludes to this political effort: the triumphant figure of Jupiter in the heavens, whose eagle was also fortuitously the emblem of Charles V and the Hapsburg dynasty, metaphorically refers to the Emperor. Imperial authority is thus exalted and reigns triumphant, while the punishment for disloyalty and rebellion is clearly spelled out in the conflagration below, which consumes the prideful giants—challengers to the emperor's primacy. Charles V visited Mantua and resided at the Palazzo del Te while the decoration of the Sala dei Giganti was in progress, and contemporary documents reveal that the artists' scaffolding was actually taken down so that he could view the frescoes. This bit of imperial propaganda introduced by Federigo Gonzaga into the otherwise personal imagery of the Palazzo del Te thus did not go unappreciated.

Although it was designed to communicate this political theme, the *Fall of the Giants* is foremost a brilliant testimony to the engaging wit and prodigious artistic imagination of its creator, Giulio Romano.

—Linda Wolk-Simon

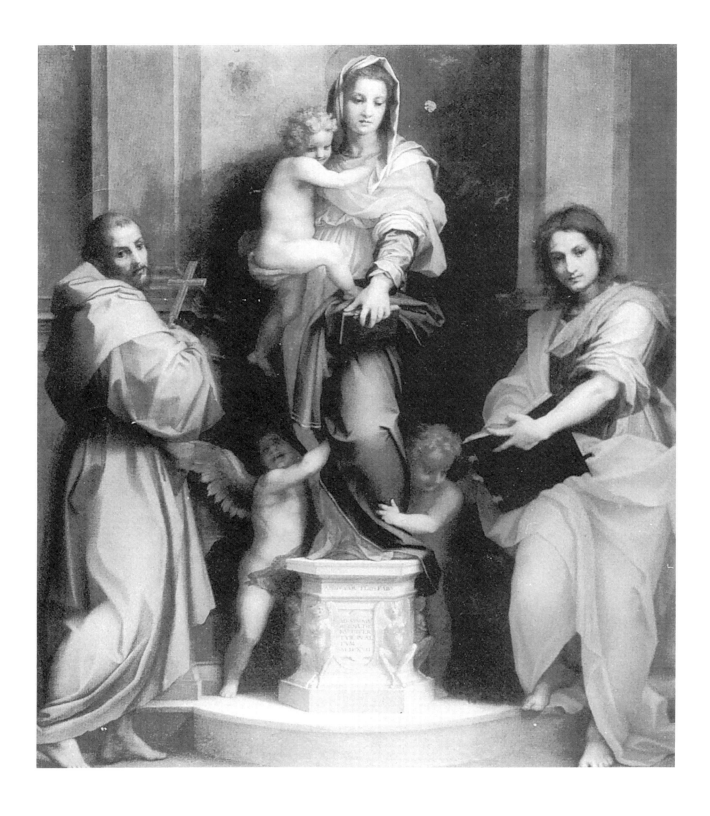

Andrea del Sarto (1486–1530)
Madonna of the Harpies, 1517
6 ft. 9 in. × 5 ft. 10 in. (205.7 × 177.8 cm.)
Florence, Uffizi

Universally regarded as one of the artist's greatest master-pieces, the *Madonna of the Harpies* was commissioned from Andrea del Sarto in 1515 by the abbess of a convent of Franciscan nuns to serve as the high altar of their church in Florence, S. Francesco de' Macci. As the inscription on the base of the pedestal on which the Virgin stands reveals, the painting was completed in 1517. It remained in its original location for less than 200 years, acquired by Prince Ferdinando de' Medici in 1683 and installed in the Palazzo Pitti. In 1795 the painting was transferred to the Uffizi, where it remains to the present day.

The altarpiece depicts the Madonna and Child standing on a plinth supported by two winged angel-putti and flanked by Saint Francis and Saint John the Evangelist. It owes its title to Vasari, who referred to the winged female creatures ringing the Virgin's pedestal as harpies. These enigmatic creatures are, in fact, a key to deciphering the meaning of the work. Following Vasari's description of them as harpies, they have been interpreted by some scholars as symbols of pagan antiquity over which Christianity, personified in the Virgin and Child, triumphed. Others have proposed that these fantastic beasts are not harpies, but sphynxes, symbols of wisdom, which allude to the epithet of Mary as *Sedes sapientiae*—the Throne of Wisdom. In the Renaissance, sphynxes were regarded as the guardians of the mysteries of religion; they may, then, assume a Christian context in Sarto's altarpiece, alluding to either the Incarnation of the Christ or the Immaculate Conception of the Virgin, central mysteries of the Catholic faith. More recently, these hybrids have been identified as the half-human, half-equine locusts, agents of misery and suffering, described in the ninth chapter of Saint John the Evangelist's vision of the Apocalypse. The clouds of smoke in the painting mentioned by Vasari, traces of which have re-emerged following a recent restoration, are also explicated by this text, in which Saint John describes the smoke emanating from the well of the abyss. Over these diabolical forces, and in the eternal struggle with the devil, the Virgin Mary in Andrea del Sarto's altarpiece is victorious.

This reading of the imagery is supported by the presence in the altarpiece of Saint John the Evangelist, his book opened, presumably, to the *Apocalypse*. The Franciscan patronage of the altarpiece accounts for the appearance of the other major figure, Saint Francis, and for the reference to the Assumption of the Virgin contained in the inscription on the pedestal on which Mary stands, which is taken from a 14th-century antiphon on this subject: the Assumption, and the closely related Marian theme of the Immaculate Conception to which Sarto's altarpiece may also allude, were particularly venerated by the Franciscans; the latter was vigorously promoted by the order in the Renaissance long before it was recognized as official dogma by the Church. Finally, the Immaculate Virgin was often identified by exegetes with Saint John's vision described in the 12th book of the Apocalypse of "the woman who appeared in the sky dressed in the sun, with the moon beneath her feet and on her head a crown of twelve stars." Thus the theme of the Assumption of the Virgin converges with the Apocolyptic imagery of the Book of Revelation in the *Madonna of the Harpies*, a devotional image carefully tailored to Franciscan theology.

With their delicately shadowed features and distracted, vaguely melancholic expressions, Sarto's figures occupy a realm visible but not accessible to the worshipper. The physical space of the real world is no longer continuous with the pictorial space of the painting as in such earlier works as Raphael's *Madonna del Baldacchino* (Pitti). The architectural background is glimpsed but not fully articulated, thus remaining an enigmatic space; the artist has cast this spiritual drama in a setting which is clearly not of this world. Infused with a pervasive sense of mystery to which its arcane subject matter and delicate *chiaroscuro* contribute, the painting reveals in these respects the influence of Leonardo da Vinci, whose unfinished *Adoration* (Uffizi) and *Madonna and Child with Saint Anne* cartoon (lost) cannot but have impressed the younger master.

In the *Madonna of the Harpies*, Andrea del Sarto adopts the compositional formula characteristic of the High Renaissance, his figures disposed in a pyramidal arrangement which imparts to the image a sense of immutable stability. Ultimately derived from Leonardo and employed to great effect by Raphael in his Florentine Madonnas, this compositional format was also adopted by Sarto's contemporary, Fra Bartolommeo, in such works as the *Salvator Mundi* of 1516 (Pitti). This is not a paradigmatic High Renaissance image, however, and the seeds of what will become full-fledged Mannerism in the hands of his followers Pontormo and Rosso Fiorentino are already apparent in Sarto's painting. Saint Francis twists in space in a graceful, balletic posture reminiscent of Mary Magdalene in Raphael's celebrated *Saint Cecilia* altarpiece of 1516 (Bologna), a work which John Shearman has called—with particular reference to this figure—"incipiently Mannerist." From Sarto's Saint Francis, it is only a small step to Pontormo's graceful Virgin Annunciate of 1526 in the Capponi Chapel in S. Felicità, a fully Mannerist invention. Sarto's rich and innovative palette seen in a characteristic manifestation in this painting—the pink and acqua *cangiante* drapery covering Saint John's left shoulder, the acidic, secondary, and tertiary colors of the Virgin's draperies and the hot, metalically smooth robe of the Evangelist—was also of fundamental importance for the Mannerist colors of Rosso and Pontormo. And the agitated, slightly crazed putti who support the Virgin on her pedestal are the forerunners of similar figures in the works of both artists, seen, for example, in Pontormo's *Pala Pucci* of 1518 (Florence, S. Michele Visdomini) and Rosso's S. Maria Nuova Altarpiece of the same year (Uffizi).

While he does not qualify as a Mannerist artist, Andrea del Sarto, Like Raphael in Rome, anticipated and provided the impetus for many of the artistic developments singled out as the hallmarks of this style. A brilliant formal invention and moving devotional image, the *Madonna of the Harpies* is a major monument of Florentine Renaissance art and a work which stands on the threshold of Mannerism.

Linda Wolk-Simon

Fra Bartolommeo (1475–1517)
Mystical Marriage of St. Catherine of Siena, 1511
Panel; 8 ft. 5¹/₄ in. × 7 ft. 1³/₄ in. (257 × 218 cm.)
Paris, Louvre

Bibliography—

Fisher, Chris, "Remarques sur Le Mariage mystique de Sainte Catherine de Sienne par Fra Bartolommeo," in *Revue du Louvre* (Paris), 32, 1982.

Dated 1511, the *Mystical Marriage of St. Catherine of Siena* by Fra Bartolommeo was painted for the church of San Marco, a Dominican monastic establishment in Florence with which the artist was associated from 1500 until his death in 1517. The painting was acquired by the Florentine government only a few months after its installation in the church and presented as a diplomatic gift to the French ambassador and bishop of Autun, Jacques Hurault. Through this act of largesse, the city's ruling party wished to express its gratitude for French support in its struggle to establish and maintain an independent, republican government. Such generosity proved to be precipitious, as the French were forced to retreat completely from Italy in 1512, thus abandoning their Florentine ally. Fra Bartolommeo's painting made its way to France nonetheless, where it was it was dispatched to the cathedral of Autun. It hung in the sacristy until the onset of the French Revolution, at which time the altarpiece was transferred to the Ecole de Dessin in Autun. In 1800, the work entered the Louvre.

Commissioned by the monks of S. Marco, who were also the benefactors of the chapel which housed it, the *Mystical Marriage of St. Catherine of Siena* was painted for an altar dedicated to this saint—a 14th-century mystic whose Dominican affiliation would have made her the object of particular veneration at S. Marco. The dedication of the altar accounts for the subject matter of the painting, the mystical union with Christ experienced by St. Catherine in one of her visions, while the rather unusual circumstances of its patronage explain why the altarpiece was so readily and easily sold by the church shortly after its execution: most private chapels were endowed by individual, secular patrons to whom their furnishings would have belonged, but in the case of Fra Bartolommeo's painting, the monks themselves controlled the chapel and its contents.

The painting depicts the Virgin and Child, ringed by nine saints, enthroned in a raised plinth beneath a curtained baldachin. In addition to St. Catherine of Siena, who kneels at the feet of the Christ Child to receive a ring sealing their symbolic union, the company on the left includes St. Peter holding his keys, St. Vincent, a martyr identified by the inscription on the book he holds, and St. Steven, recognizable by the stone on his head. On the right appear St. Catherine of Alexandria, a martyr saint (probably St. Lawrence), St. Bartholomew, and behind the Virgin's throne, Sts. Francis and Dominic engaged in an embrace. Like Catherine of Siena, St. Dominic was the object of particular devotion by the Dominican order which he founded. His posture alludes to a vision narrated in the popular *Golden Legend*, a 13th-century compendium of saints' lives, in which Dominic embraced Francis as a fellow defender of the Christian faith, "the two becoming of one heart and one soul," and proclaimed that their followers should live in eternal friendship.

The *Mystical Marriage of St. Catherine of Siena* is a "sacra conversazione"—an iconic rather than a narrative image which depicts the Madonna and Child flanked by a sundry congregation of saints who engage in a "spiritual discourse," responding to and meditating on the Incarnation. The artist produced a number of such altarpieces, among them the unfinished *St. Anne Altar* (Florence, S. Marco Museum), and the *Pala Pitti* (*The Mystical Marriage of St. Catherine*, Florence, Accademia), and many beautiful black chalk drawings by Fra Bartolommeo of "sacred conversations" reveal his deep engagement with the formal and dramatic challenges posed by this type of composition. Indeed, one of Fra Bartolommeo's major innovations was to endow this fundamentally iconic, hieratic type of devotional image with a new energy, animation, and formal unity.

In the Louvre *Mystical Marriage*, Fra Bartolommeo has conceived a balanced and strictly symmetrical composition, the Madonna and Child forming a pyramid in the center around which the attendant figures are arranged in a hemisphere. The massive aedicula behind the Virgin, like the canopy above her throne, echoes the disposition of the standing saints and provides a backdrop of classical purity and grandeur. Through their monumental forms, contemplative expressions, and shadowed, vaguely wistful features, the figures lend an air of somber restraint to the image. The harmony, equilibrium, and immutable stability that characterize the altarpiece are hallmarks of the High Renaissance classical style which reached it apogee in Florence in the first decades of the 16th century, notably in the works of Fra Bartolommeo.

—Linda Wolk-Simon

Rosso Fiorentino (1494–1540)
The Deposition of Christ, 1521
7 ft. 1 in. × 4 ft. 1 in. (215.9 × 124.5 cm.)
Volterra, Pinacoteca

An irony—which might have been sardonically appreciated by the hyper-conscious Rosso—was the relative unawareness of this exotic work by historians of art until the mid-20th century; then, its reproduction in survey texts of art history has led *The Deposition* to appear as *the* representative example of Mannerist style. Volterra, where the work still remains, was the arena for its commission seemingly because the artist was unable to find opportunity in his Florentine home to present such extreme style. Work in the previous years—*The Madonna with Saints,* 1518 (Florence)—presented, if not so radical a compositional pattern, a similar, close-up, spaceless, presentation of vacant and abstracted figures in extreme psychological states. And such work had led to criticism, especially from his teacher and the reigning artist in the city, Andrea del Sarto, that may have stifled any continuing opportunity for commissions.

Joseph of Arimathea is the heavily mustached, turbaned head above the top edge of the cross. The gospel source—the episode of Christ's removal from the Cross appears in all four Gospels—which has Joseph a wealthy member of the Sanhedrin, would account for his lavish cloth. His two arms appear as if they belonged to two distinct systems on either side of his head. At the left, from a long cylindrical sleeve, issues a hand-edge, while at the right a semi-circular puff with lower elongated linear creases yields to a cricket-like arm with a hand, perhaps both insectile and grotesque through being hidden on the top of cross-arm. Almost an apparitional caricature, Joseph's head is most like the shards of cloth from which issues a head, with hands, to mark St. John at the lower right. Similarly, the figure who holds the upper body of Christ disappears behind Him to be seen with only his squeezed head showing his nose, eye socket, and hair which may be meant to appear, since contiguous, as if from Christ's head. It is his fingers alone which appear, brightly lit and also insectile, grasping the Cross.

Equally caricatural is the head of Christ, with its "smile of detached and secret satisfaction" which led Hartt to sense here the "chronic jokester" and the "dilemma of a lost generation." His head type, also seen here in the heads of the two women who support the swooning Madonna at the lower left, is a kind of short-hand physiognomy with its bridgeless nose and characterless eyes—often used by Rosso for sacred figures, and like much else here that is exhilarating in its novelty, both psychic and visual, ultimately derived from the *Sistine Ceiling* of Michelangelo. Christ's loin cloth presents the dominating visual effect, with its concommitant jarring undertone, which carries throughout the entire upper part of this painting: it shifts color and rhythm at its center, and thereby appears a non-single, disjunctive form. The body of Nicodemus, at the upper left, is similarly treated: his left arm, like his left leg, is an almost indecipherable and flattened form. The "lost profile" of his cropped head—an unsettling motif to be found again in the lower right hand corner of the *Moses and the Daughters of Jethro,* c. 1523 (Florence)—is repeated in effect with the lost left arm. In the lower half of the image, the Virgin Mary is supported in her faint by two women at her sides, while Mary Magdalene, venerated as an emblem of Christian penitence, grasps her legs and John stands off alone at the other side. These figures appear as if abstracted according to a system of drawing different from that applied to the upper painting. None of the effects is dependent upon foreshortening, overlap, or anatomical virtuosity.

Several of the effects, or motifs, used here by Rosso, are seemingly found in the Sistine Chapel ceiling. Since the artist apparently did not go to Rome until 1524, he might have known it through engraved prints, or possibly through contact with Michelangelo himself, who was mostly resident in Florence from 1518 through 1534. Rosso is linked to the world of Roman printmaking through a drawing which he made in 1517 to be engraved in Rome by Agostino Veneziano—*The Allegory of Death and Fame,* one of the most bizarre images of the time. In it there are allusions to the graphic world of Dürer, and in its relief effect there is a Donatello-like quality like the archaic aura of *The Deposition* in its placement of the figures at the forward edge of the pictorial space. Michelangelo's influence in *The Deposition* might appear, in the hair-decor and the head of Mary Magdalene, to stem from the Judith figure in the Sistine spandrel holding the *Judith and Holofernes.* In the upper section, ambiguity through foreshortening might stem from the seated Jonah figure, or several of the ignudi; the treatment of Jonah's back, its confused division through the shadow at the left shoulder, and the facial fragment of the other figure who handles the body of Christ may be an echo of the famous ignudo at the upper left of the central panel showing *The Creation of the Sun, Moon, and Planets.* Finally, the head of Joseph of Arimathea appears to derive from Michelangelo's sculpture of *Moses* (Rome, S. Pietro in Vincolo), while the closed eyes and turn of the head of Rosso's dead Christ are like the Louvre *Dying Slave.* The obsessive interest of Rosso in form ambivalence is paralleled by the shadowy psychology of his figures. *The Deposition* is appreciated in our time as a reflection of the social and religious disorder of Rosso's time.

—Joshua Kind

Perino del Vaga (1501–47)
The Fall of the Giants, 1529–34
Fresco
Rome, Palazzo Doria

In 1528, following the expulsion of the French from the city, the celebrated admiral Andrea Doria was proclaimed prince and ruler of his native Genoa, a momentous event which prompted him to undertake the complete interior refurbishment of his palace to order to render it a fitting princely dwelling. This artistic transformation was entrusted to Perino del Vaga, one of Raphael's major disciples and an artist eminently capable of designing and carrying out the type of decorative ensemble envisioned by his new patron. Perino was lured to Genoa to undertake this campaign following the devasting sack of Rome in 1527. He became court artist to Andrea Doria and was occupied with the Palazzo Doria decorations from 1529 until 1534.

A typical aristocratic urban palace, the Palazzo Doria contained public rooms and private apartments. Perino and the corps of assistants carried out decorations in both these quarters. The private apartments contain painted vaults divided into geometric compartments embellished with diminutive narrative scenes and *all'antica* grotesque motifs, a format derived from ancient Roman prototypes. The major public rooms of the palace—the ground floor atrium, the Loggia degli Eroi, the Salone dei Giganti, and the Salone del Naufragio—combine a wealth of fresco and stucco decoration, and the imagery, drawn from a range of classical literary sources, celebrates Andrea Doria's new status as liberator, peacemaker, and founder and defender of the Genoese Republic. Doria's august and mythical ancestors, outfitted with assorted martial trappings that signal their role as defenders of liberty, populate the Loggia degli Eroi, while Doria was eulogized as Neptune, god of the sea, in the now lost *Neptune Calming the Waves* in the Salone del Naufragio.

The laudatory character of the Palazzo Doria decorations extends to the imagery of the west salone, where Perino painted the *Fall of the Giants*—a subject also represented by Giulio Romano at the Palazzo del Te in Mantua. This common subject matter, and the nearly contemporary dates of these works by two of Raphael's former pupils, was no coincidence: through this deft exercise in the art of political propoganda, both Federigo Gonzaga and Andrea Doria proclaimed their political allegiance to the Hapsburg Emperor, Charles V, who is allegorically celebrated and apotheosized as the powerful Jupiter in the frescoes by Perino and Giulio. The two princes owed their political livelihood to the emperor's support, and both dutifully paid homage to their imperial patron through these images of the triumph of divine authority, in which Jupiter vanquishes the earthly giants who vainly challenged him. Charles V visited Mantua and Genoa on more than one occasion, and was housed in the Palazzo del Te and the Palazzo Doria, respectively, during his second visit to each city; that both versions of the Fall of the Giants on one level referred to him is certain. Indeed, it has recently been demonstrated that the Salone dei Giganti served as the emperor's throne room during his sojourn in Genoa. Thus, the connection between the terrestrial person and authority of Charles V and the divine presence and power of Jupiter in the vault above would have been forcefully and unambiguously communicated in the Palazzo Doria.

Aside from the subject matter, Perino del Vaga's *Fall of the Giants* exhibits conspicuously few similarities with Giulio's fresco and is, in many respects, its antithesis. In the Sala dei Giganti in the Palazzo del Te, chaos and disorder prevail. The Olympian deities in the vault of the chamber cower and cringe in the presence of Jupiter, whose divine wrath they witness, while the brutish, grotesque giants in the lower zone of the room writhe and fumble as they are crushed by massive rocks, consumed by flames, and buried by the debris of their collapsing city. Horror, drama, and high-pitched energy characterize Giulio's treatment of the subject, which covers the entire vault and wall surface and completely surrounds and subsumes the viewer who enters the chamber.

In contrast, Perino's *Fall of the Giants* is a stylized, graceful ballet devoid of all traces of drama, tension, and struggle. Confined to the vault of the room, the fresco is enframed by a decorative band of stucco reliefs. The effect is that of a monumental easel painting attached to the ceiling rather than the startling illusionism of Giulio's frescoed room. Its figures compressed against the surface plane, the composition is conceived as two distinct tiers, the terrestrial and Olympian realms clearly demarcated by the cloud bank along which the gods and goddesses are disposed. This organization imparts a sense of order and stability to the whole which Giulio's *Fall* deliberately lacks. Although they point and gesture gracefully toward the floating figure of Jupiter with his thunderbolts, Perino's deities seem largely oblivious to, or at least unconcerned by, the war being waged against the rebellious giants below. Little threat is posed from this quarter, where the ground is littered with the fallen forms of the enormous giants, collapsed in a heap of gracefully turned wrists, crooked elbows, and spiralling torsos. The true action takes place not in the foreground, where the vanquished giants are eternally frozen in their artful torsions, but in the distant background, where comically tiny titans launch an assault and attempt to scale Olympus on the mountain they have fashioned. The conflagration represented in horrifying detail by Giulio is entirely eschewed by Perino, who has created instead a fluid, measured, and graceful dance.

The different temperaments of Raphael's two major disciples are highlighted in the respective treatments of the subject of the *Fall of the Giants*. Bizarre wit and boundless imagination characterize Giulio's invention, which plays with the viewer's expections and completely subverts Renaissance principles of order, balance, and the rational underpinnings of visual experience. His penchant for violent, straining figures and heightened dramatic content found an ideal outlet in this particular subject. For Perino, the *Fall of the Giants* offered instead an opportunity to couch high drama in a purely aesthetic, stylized language drained of all emotional intensity. Terror and conflagration have no place in his Olympian vision, in which the decorative pattern created by the elegant posturings of victor and vanquished alike is the primary concern. If Raphael's probing imagination had an heir in Giulio Romano, his beauty and grace find a legacy in Perino del Vaga. In these works by his two most important followers, two aspects of his singular artistic genius endured.

—Linda Wolk-Simon

Beccafumi (c. 1486–c. 1551)
The Birth of the Virgin, early 1540's
7 ft. 7³/₄ in. × 4 ft. 8¹/₈ in. (233 × 145 cm.)
Siena, Pinacoteca Nazionale

The *Birth of the Virgin* in the Pinacoteca Nazionale of Siena ranks among Beccafumi's greatest works. The painting, which is undocumented, was executed for the church of S. Paolo in Siena where it remained until the suppression of religious orders in the 19th century. From there it passed directly to its present location. A predella illustrating other scenes from the life of the Virgin—the Nativity, the Visitation, and the Presentation of the Virgin in the Temple—originally formed a part of the altarpiece. This was separated from the main panel when the altarpiece was removed from its original setting, and the three small narrative scenes are now in an English private collection. Vasari states that the *Birth of the Virgin* was painted immediately after Beccafumi's return from Pisa, where he is documented in the year 1541; this dating to the earliest years of the 1540's has largely been accepted by modern scholars on the basis of style.

The Virgin Mary was the object of particular devotion and veneration in Siena, which had officially proclaimed itself "City of the Virgin" following a stunning and unexpected military victory in 1260 when the Virgin's divine protection and intercession against the city's enemies had been invoked. This victory was attributed to the special favor that she had for Siena, and from this date on, images of the Virgin, both narrative and devotional, were enormously popular. The cathedral of Siena was dedicated to the Virgin, and in the early 14th century, with the projected rebuilding of the Duomo, a new pictorial and iconographic program was initiated which called for four altars illustrating scenes from the life of Mary. (The most well-known of these is Simone Martini's *Annunciation* in the Uffizi.) With this campaign, the tradition of narrative rather than iconic altarpieces depicting Marian subjects was inaugurated in Siena. Beccafumi's altarpiece is a 16th-century product of this tradition, which remained strong throughout the Renaissance.

The great Sienese prototype for all subsequent treatments of the theme is Pietro Lorenzetti's *Birth of the Virgin* (Siena, Museo del Opera del Duomo), which was one of the four Marian altarpieces executed for the cathedral in the campaign of the 14th century. Beccafumi's altarpiece, like earlier, 15th-century Sienese representations of the subject, conforms to the general compositional format established in this Trecento work. Among Pietro Lorenzetti's innovations was the depiction of this momentous event in a familiar, intimate domestic setting; this conception is retained by Beccafumi, whose Birth of the Virgin takes place in a bourgeois bedroom. Like Lorenzetti, Beccafumi depicts the Virgin's mother, St. Anne, visited by two female attendants standing on the right, another female participant who approaches the bed, and two nursemaids sitting on the floor. In both works, the latter figures are shown bathing the newborn infant in a basin with water provided from a ewer. Finally, Beccafumi further resorts to the Lorenzetti model in placing Saint Anne's husband, Joachim, in an ancillary chamber in the company of a male companion and a diminutive servant. (In Beccafumi's painting, the seated male figure beside Joachim is virtually impossible to see in reproductions.) Beccafumi adds the whimsical detail of the small terrier bursting into Saint Anne's quarters and the young child clutching a bird at the left of the composition, but his debt to the 14th-century precedent is pervasive and unambiguous.

Beccafumi's painting is not a literal imitation of this late medieval model, however; and the artist has "modernized" the setting of the narrative in notable respects. Pietro Lorenzetti's starry groin vault has been replaced with an elaborately carved Renaissance coffered ceiling, while the canopied bed with its bundled hanging recalls a contemporary source—Andrea del Sarto's fresco in the atrium of SS. Annunziata in Florence depicting the *Birth of the Virgin*, executed some 30 years earlier. Like Sarto, who depicted angels and putti in the upper zone of his composition, Beccafumi includes a detail to indicate that the subject represented is not an everyday scene despite its deceptively homey, domestic aspect: the figure of God the Father in benediction with the dove of the Holy Ghost appears in the lunette over the doorway leading from the Virgin's room.

One of the most innovative colorists of the 16th century, Beccafumi demonstrated a predilection for resonant, glowing, rich colors. This facility is amply revealed in such works as the *Nativity* (Siena, S. Martino), the *Fall of the Rebel Angels* (Siena, S. Nicolò al Carmine), and the *Birth of the Virgin*. Like other, contemporary Mannerist painters, the artist favors a rich spectrum of secondary and tertiary colors which are not deeply saturated and often blanched. With this glowing palette Beccafumi combines in the *Birth of the Virgin* a richly expressive, raking light which falls boldly on the foreground figures, leaving the rest of the space in murky shadow. This painting is, in fact, a nocturnal scene illuminated by no fewer than three sources of light: the warm glow of the unseen fire in the ancillary room before which the servant dries a swaddling cloth, the golden ray issuing from the open window high in the left wall, and the bright, intense light which falls on the attendants and nursemaids from an unseen source beyond the left edge of the picture. In this combination of different types and effects of light in a single work, Beccafumi achieves a tour-de-force demonstration of his painterly skill. But light also serves a symbolic and expressive function in the composition: to the natural light of the fire and window is contrasted with the supernatural light from an unknown source which envelopes the tiny figure of the Virgin Mary. Through this device, the divine nature of the infant is communicated, just as her future role in the course of human salvation is alluded to through the presence of God the Father and the dove of the Annunciation in the lunette. In the *Birth of the Virgin*, Beccafumi has cloaked a profoundly spiritual subject in the most intimate, human terms.

—Linda Wolk-Simon

Jacopo Pontormo (1494–1557)
Deposition, 1525–28
Panel; 10 ft. 3 in. × 6 ft. 3 in. (312.4 × 190.5 cm.)
Florence, S. Felicità

Jacopo Pontormo's *Deposition* in S. Felicità is the artist's best-known work and a hallmark of Florentine Mannerism. It was commissioned by the Florentine financier Ludovico Capponi shortly after he was ceded the patronage of the chapel for which the altarpiece was painted in 1525, and completed by 1528. Capponi intended this to be his mortuary chapel, and he and his heirs are entombed in this space. When the patron was granted the rights to the chapel, it was rededicated to the *Pietà*; this dedication is alluded to in Pontormo's altarpiece, which represents a scene of grieving over the body of the dead Christ. Often referred to as a *Deposition*, the painting actually depicts the moment when Christ is lifted from the lap of his grieving mother and transported by attendant mourners toward the tomb.

Pontormo's treatment of this theme is novel in numerous respects. The artist has deliberately abstracted the action from any recognizable physical or temporal setting: the drama takes place in an undefined, timeless "non-space" whose only natural feature is the wispy cloud floating at the upper left edge of the composition. Not even the base of the cross from which the dead Christ was lowered or the ladder that appears in Pontormo's preparatory study for the composition (Oxford, Christ Church) appears, and the spatial setting is created and defined only by the dense mass of figures that occupies it. These graceful, weightless forms clothed in undifferentiated, diaphanous garments, their individual identities unrecognizable, are tightly interwoven in a complicated, vaguely irrational arrangement, the precise position of each figure in space difficult if not impossible for the viewer to fully comprehend. They are not frozen or static, but in a state of flux and movement, Pontormo conveying a sense of continuous action through time and space by means of the figures transporting Christ: as he moves the body away from the Virgin, effecting a caesura in the center of the composition, the male bearer on the left seems poised to deposit the corpus outside the altarpiece and into the space of the chapel itself on the altar below the painting. It is this remarkable illusionism, and Pontormo's conception of pictorial action that takes place across space in the physical realm of the viewer, that has earned the Capponi Chapel the epithet "Proto-Baroque." One of the most carefully orchestrated artistic campaigns of the Renaissance, this work is in many respects analogous to Raphael's brilliant invention in the Chigi Chapel in S. Maria del Popolo in Rome.

The expressive, dramatic conceit of Pontormo's *Deposition* may only be fully appreciated if the work is considered in the setting for which it was painted. The altarpiece of the chapel, the *Deposition* is the focal point of a larger iconographic program which originally included a painted dome representing God the Father and four Patriarchs, a tondo in each of the pendentives depicting the Four Evangelists (two of these tondi are by Pontormo's pupil Bronzino), and a fresco on the right was dedicated to the subject of the Annunciation. (With the exception of the painted dome, which was destroyed upon construction of the corridor built to connect the Uffizi with the Palazzo Pitti on the other side of the Arno, this entire ensemble survives in situ.) The illusionism of the altarpiece, particularly the pivotal movement of the body of the dead Christ on an orthogonal toward the viewer-worshipper, links the painting in an expressive drama with these other elements of the chapel's decoration, and with the rite of the mass celebrated at the altar above which the painting is placed.

Through the different components of Pontormo's brilliantly conceived tableau, the promise of salvation is narrated. The divine orchestrator of this drama was the erstwhile figure of God the Father, who appeared in the dome, initiating with his outstretched hand the course of Christian history with the Annunciation—the Incarnation of the word of God—which is depicted on the chapel's right wall. Attentively witnessed by Virgin Annunciate who gazes toward the altar wall, the conclusion of Christ's life on earth is depicted in the altarpiece, where the dead Christ is lifted upward by the male figure at the left and presented to God the Father in the dome. With this action, the christological cycle is brought to its conclusion and Christ's imminent ascent into heaven is foreshadowed (Steinberg). But through this pivotal movement, Christ is also simultaneously lowered onto the altar, symbol of the tomb, and presented to the worshipper and the celebrant of the mass who stand in the chapel before the altarpiece, the corpus alluding to the host in which the body of Christ is present through transubstantiation. The imagery, then, also refers to the celebration of the mass in which the sacrifice of Christ is eternally reenacted, which took place in the chapel before this image (Shearman). The promise of human redemption through the sacrifice of Christ is, then, the sacramental theme of the altarpiece, and the dramatic content of Pontormo's painting thus reciprocally derived from its setting. This sacramental theme acquires a particular relevance in the context of a funerary chapel: the soul to whom the promise of redemption is extended is that of Pontormo's patron, Ludovico Capponi, who is entombed in the floor of the chapel before the altar.

Pontormo's *Deposition* is striking in its haunting pathos and drama. The weightless, ethereal, floating figures must have assumed the quality of an apparition in the flickering candlelight, the artist's bright, high-pitched colors glowing in the relative darkness of the chapel. (Indeed, it is this concern for the conditions in which the work would be seen—a sense of setting and context that informs the entire Capponi Chapel program—that largely accounts for Pontormo's unusual and innovative palette in this painting.) The profound sorrow of the figures is communicated not through overt, dramatic gestures, but in the melancholic expressions of the mourners, each of whom seems consumed by a private grief. In the red-rimmed eyes, and limpwristed, whispered farewell of the Virgin, Pontormo has created a universal image of loss and longing that speaks across space and across centuries with an undiminished poignancy.

—Linda Wolk-Simon

Agnolo Bronzino (1503–72)
Venus, Cupid, Folly, and Time
Panel; 57¹/₂ × 45³/₄ in. (146 × 116.1 cm.)
London, National Gallery

Vasari described this painting in the *Lives* as commissioned by Cosimo I, Duke of Tuscany, for Francis I of France: "Venere ignuda con Cupido, ched la baciava and il piacere da un lato, e il gioco con altri amorini, ed all'altro la Fraude, Gelosia, ed altre passioni d'amore." Scholars writing on this work express conflicting views on the meaning of this puzzling painting; the nature of their disagreement rests on the interpretation of Vasari's text and the reprint of his text by Milanesi and others, eliminating Vasari's punctuation. Recently, DuBrul has clearly explained this point. Several problems challenge the interpretation of this painting: (1) in Vasari's original text editions, the figure of Time is not included; (2) Vasari does not explain why Cosimo I would send a gift of a painting to his enemy, Francis I; (3) whether Time reveals or conceals what he sees is unclear; (4) identification of the allegorical figures of Fraud, Folly, and Pleasure is ambiguous.

Scholars agree on the identification of Venus and Cupid as well as Time. The ambiguity of the action of Time—revealer or concealer—attests to the Mannerist insistence that a painting must evoke an intellectual suspension. If Time acts as a revealer of the incestual passion of Venus and Cupid and the collaboration of Pleasure, Folly, and Jealously in this manifestation of love, then Fraud is exposed. But if Time is a concealer, hiding the lustful passion, then Fraud is an accomplice of Time and Pleasure, Folly and Jealousy.

The major disagreement among scholars is in the identification and interpretation of the figures below Time: Pleasure and Folly. Some art historians claim that the sphinx represents Fraud. Other translate Vasari's word *piacere* as *pleasure* (Lamia or Echidna, that is to say the figure is a personification of Pleasure). The Cupid with roses is for some scholars a symbol of Pleasure; for others, the Cupid personifies Pleasure or Innocence; but for Vasari, Cupid is Folly. Vasari's allusion to other lovers (*altri amorini*) has been interpreted as Insincerity, Fraud, or Vice, or even Deceit or Discarded Lovers. On the other side of Venus and Cupid is Jealousy (Vasari's Gelosia), for most art historians the depiction of female jealousy, but for other male jealousy. Vasari mentions other attributes to the passion of love that are depicted in the painting (caresses, doves, arrows, pillows, silky blue sheets, etc.).

In the London painting, Venus has taken one of Cupid's arrows to control his passion while holding a golden fruit. The fruit could imply the gift of Paris to Venus or Venus's gift to Hippomenes to lure Atlanta away from the path of virtue. In either instance, Venus's seductions are handsomely rewarded.

Bronzino's painting contains a hidden message concerning anti-brothel propaganda. Although from the time of Augustus to Aquinas, brothels were state regulated and taxed, during the 16th century the Christian Church in Europe had initiated a series of moral crusades against prostitution. In the Bronzino painting, Time is an allegorical figure symbolizing the Christian Church. The action of time's right shoulder, arm, and hand rotating forward to cover or end the foreground lust scene, may imply the church intervention on prostitution. Unlike Passion or Lust, Pleasure needs no concealment. Pleasure in the form of a sphinx is associated with Lamia or her mother Echidna, the beautiful she-viper, mother of half of the monsters in classical mythology. Folly leads her with his dances, holding roses stained with blood shed by Venus when she pricked herself. Folly's foot is thorn-pierced by hasty pleasure. This image echoes, among other allusions, Ovid's verse, "The spine stays as roses fade."

On the left side of the painting are two previously unnoted tiny golden masks, on Cupid's quiver sling. These masks, as well as those at the feet of Venus, allude to other lovers (Vasari's *altri amorini*). The cooing doves represent Vasari's images of other manifestations of passion (*altre passione*), recalling Ovid's verse, "White dove torn from her conjugal mate to burn on Venus' idelian altar," in mourning for Adonis's death. The symbolism of burning in this instance is also a subtle reminder of *infermitas nefanda*, burning infirmity or venereal disease.

The figure behind Cupid is Jealousy. Whether male or female, Jealousy is wracked by moral, mental, and physical pain. For some art historians her/his anguish is due to the burning infirmity or tertiary syphilis. Vasari noted that the representation of these two figures with Venus was of interest to Bronzino, since he painted another version on the same theme, *Venus, Cupid and Jealousy* (c. 1550), sighed "Il Bronzino Fior F" (Budapest). In this painting, Jealousy appears behind Cupid, as in the London work. Masks and cupids with roses (Folly) are seen playfully lusting on the left side of Venus. The composition is perhaps less complex but it is as seductive as the London painting.

In the London work, above the figure of Jealousy appears a masked female figure in despaire. This allegorical figure has been identified by most art historians as symbolizing Truth or Virtue, although some see her, as Vasari described her, as an image of Fraud. She acts horrified or shocked by the uncovering of Time. Does she comply with or prevent Time? Her features are similar to the expression of the mask located at the left of Venus.

Bronzino's *Venus, Cupid, Folly, and Time* as a present from Cosimo I to Francis I would have seemed peculiar at the time. Cosimo I probably commissioned the painting as an ironic diplomatic joke or rebuke to Francis I. It was shortly after receiving this beautiful gift in 1547 that Francis I died of *morbus gallicus*—syphilis. When the London painting was understood at the court of Fontainebleau, it was no doubt deemed insulting and sent away, to re-emerge only in the 19th century. Since 1881 any accurate reading of Bronzino's images has been hampered by art critics unwittingly relying on Milanesi's edited version of Vasari's *Lives*. Even though badly printed, the 1568 edition of Vasari's *Lives* clearly reveals the enigma of the painting.

—Liana Cheney

Francesco Salviati (c. 1510–63)
The Deposition, late 1540's
Florence, Museo di S. Croce

This magnificent altarpiece was one of the two major fruits of Salviati's second attempt to gain recognition and patronage at the court of Cosimo I de' Medici. The other was his brilliant decoration of the Sala dell'Udienza in the Palazzo Vecchio in 1543–45, in which his dazzling display of the sophisticated heights of virtuoso Mannerist ornamental painting, derived from Roman and north Italian sources, did not fail to impress, while it may also have surprised and even shocked, his Florentine audience.

The creation of a monumental religious image was quite a different kind of commission, which he was assigned by Giovanni and Pietro Dini to provide an altarpiece for the chapel of their father Agostino in S. Croce, Florence, c. 1547. The result was Salviati's grandest and most considered religious work, an important contribution to central Italian explorations of the theme. The subject had not been common in Italy, although it was popular in the Netherlands in the 15th century. The first major 16th-century Italian treatment was Rosso's (1521; Volterra), searingly emotional yet exaggeratedly stylised. An immediate response was Pontormo's *Lamentation* (c. 1527; Florence, S. Felicita), equally intense, with its surreal setting and brilliant metallic colours. This image of hallucinatory beauty became a dominant one in Florence; but it was Rosso's more naturalistic composition which was influential. The High Mannerist examples characteristically classicise these very personal interpretations, as in Daniele da Volterra's famous and powerful fresco of 1541–45 (Rome, SS. Trinità dei Monti, Cappella Orsini) and Vasari's altarpiece of 1540 (Camaldoli, Arcicenobio), both evidently dependent on Rosso.

Curiously it is the least distinguished of the precedents, his friend Vasari's typically lifeless and turgid painting, which is most clearly reflected in Salviati's work, although there are specific references to Daniele as well. However, to the force of the latter and the emptiness of the former Salviati opposes a display of the sheer beauty of his style. His composition is as static as Vasari's, but his is the deliberate stasis of a balletic tableau. To the barely controlled hysteria of Pontormo he presents a decorous contrast of naturalism and grace. He returned to the high-arched shape used by both Rosso and Pontormo; he even provided a comment on the heavy, elaborately carved frame of Pontormo's altarpiece by using a narrower one, more elegantly carved with antique grotesque scrolls, and with three panels, those on each side showing a serpent coiled around a cross (representing the Fall which Christ's death redeemed) and that below bearing an inscription: "Quemcumque momorderit / astutia Satanae / intulatur Christum / in Ligno pendentem" (Whosoever is trapped by the wiles of Satan may be considered like Christ on the cross).

These deliberate and moving references should make it clear that Salviati's painting is a serious religious work and not merely, as is sometimes claimed, a facile decorative exercise. Decorative it certainly is (Salviati was unable to create anything ugly), but its apparent superficiality is the result of Mannerism's intellectual insistence on the primacy of the work of art before its content, on *bella maniera* before direct expression. The passages of expressive feeling and gesture Salviati describes, as for instance in and around the figure of the Virgin, are meant to be admired as much—and first—for their inventive grace as for their emotional weight; the pathos of Christ's body is intended to lie in its classic beauty (derived in part from Raphael's *Entombment* in the Villa Borghese, Rome) as well as in its tragic circumstances.

The diagonal created by the light on Christ's body in the upper half of the picture is reflected below by that from St. John's head to the Virgin's outstretched foot. It is opposed by the curve formed by the heads and shoulders of the figures in the lower half, which is echoed in turn by that inside the figures bending above Christ; both curves are contained by the great semi-circular sweep, in two and three dimensions, which the main figures describe around the body. The two halves of the composition are linked by the graceful youth who receives the body in his arms while turning towards the Marys below. The vivid red of his cloak also forms a chromatic centrepoint from which the other hues, colder but not less brilliant, radiate.

The antique dignity of the Virgin, flanked by the mannered contortion of the Magdalen and the serpentine elegance of the other Mary, has its counterpart in the godlike torso of Christ which, marmoreally gleaming below the exaggerated circular gesture of St. Joseph of Arimathea displaying the nails, reflects the Roman perfection of Michelangelo's *Pietà*. More vigorous echoes of Michelangelo are evident in the contrastingly muscular man on the ladder to the right, and in St. John below. All these allusions are dominated by the controlling effect of Salviati's supremely elegant drawing, and by the superimposed pattern of light and colour which forcibly presents the picture's two-dimensional surface to the spectator's eye. It was precisely this effect of aesthetic distance which made the conscious artifice of Mannerism eventually unacceptable as religious art during the Counter-Reformation, and led gradually to the populist immediacy of the Baroque.

—Nigel Gauk-Roger

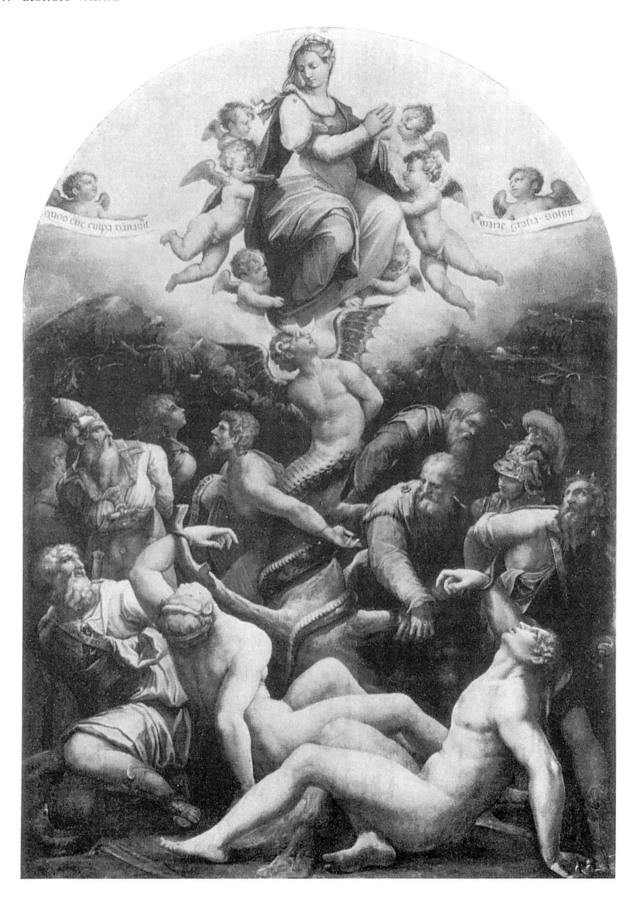

Giorgio Vasari (1511–74)
Allegory of the Immaculate Conception, 1540
Florence, SS. Apostoli

The assassination of Duke Alessandro in January 1537 brought Vasari's close and long-time association with the Medici to an abrupt end. Despite assurances from the Duke's cousin, Ottaviano, the young painter was uneasy about his future prospects in Florence and hastily left the city. Vasari's departure was not matched by an absence in spirit. Although he did not return to Florence to live until 1554, he made numerous visits to the city and maintained his relationship with Ottaviano. The most important of the sojourns occurred in 1540 when Bindo Altoviti commissioned him to paint a altarpiece for his family chapel in Santi Apostoli. The resultant *Allegory of the Immaculate Conception* remains one of Vasari's most notable paintings, possibly reflecting the artist's recognition of the importance of this work to his career. Because of its high visibility, the *Allegory* would be seen by the Florentine patriciate, including Alessandro's successor, Cosimo I.

As the painting suggests and Vasari confirms, the obviously complex program for *The Allegory of the Immaculate Conception* was devised by the painter's many learned friends ("molti.. amici, uomini letterati"). Bound and slumped at the base of a dead tree, around which a serpent is coiled, are Adam and Eve, "the first transgressors of God's commandments." Immediately behind them, but slightly reduced in scale, Abraham, Isaac, Jacob, Moses, Aaron, Joshua, David, Samuel, and John the Baptist are similarly bound. Above, in an aureol of light and supported by an angelic host, is the Virgin Mary, redeemer of the sins of Eve (as banderoles held by two angels proclaim) and the mother of Christ, who will redeem the sins of man.

With remarkable skill, Vasari matched the multifarious nature of the theme with a composition that is equally labyrinthine. The strong verticle axis of the composition, defined by the trunk of the tree, serpent, and Virgin, is countered by a horizontal thrust created at the base of the picture by the sprawling figures of Adam and Eve. This configuration is repeated two-thirds of the way up the painting by the lateral extension of the tree's branches and by a change from a dark (terrestrial) to light (celestial) background. Against this play of organization thrusts, the figures writhe and wrest against their restraints.

Cognizant of the ethereal and mellifluous compositional constructs of Pontormo and reflective of the manneristic predilection for *grazia*, Vasari relied on an intricate flow of curves and counter curves to determine the arrangement of the composition. Thus, the coiled tail and twisted torso of the serpent is countered by the mannerist contrapposto of the Virgin, while the lateral motion of the figures pulling away from the central axis in the lower half of the painting is inverted by the angels that move in to surround Mary who visually continues this axis in the upper portion of the painting. Although Vasari's *Allegory* is less of a spatial tour-de-force than Raphael's *Saint Michael*, 1517, the confluence of linear patterns created by the intertwining of forms in Vasari's work is a exposition of the principles of the *figura serpentinata*.

In accordance with the subtle intricacies of line, Vasari softened his palette with an atmospheric *sfumato* similar to that seen in many of Andrea del Sarto's works. Although in a typically Florentine manner coloristic effects *(colorito)* are less developed than those of line *(disegno)*, Vasari did rely on color as a unifying device. Throughout the work shades of red and blue have been carefully placed. This, as well as a reliance on onal variation, helps the many divergent thrusts cohere as may be seen when the painting is juxtaposed with the finished study (Paris, Louvre). Because this symbolic work is without any defining background and, therefore, necessarily rests on the picture surface, Vasari's manipulation of line and placement of color had to function in this manner. To have done otherwise would have left the painting without any central focus.

It is notable that many of the aesthetic qualities that Vasari was to tout in *Della pittura* and the *Vite*, and mandate with the establishment in 1563 of the Accademia del Disegno, are visible in the *Allegory of the Immaculate Conception*. The easy grace, or *grazia*, of the Virgin, Adam and Eve, the spiraling of the serpent, or *figura serpentinata*, and the many postures, or *varieta*, of the personages in the lower portion of the painting are obvious. Perhaps less immediately recognizable but no less important, was the manner in which Vasari presented a complex theme and, thereby, illustrated his ability to overcome compositional difficulties, or *difficulta*, with facility, or *facilita*. The applicability of these qualities to the *Allegory* distinguishes the work as a characteristic example of Mannerism.

—Fredrika H. Jacobs

Niccolò dell'Abbate (1509 or 1512–1571?)
Landscape with the Death of Eurydice (The Story of Aristaeus)
6 ft. 2¹/₂ in. × 7 ft. 9¹/₂ in. (188 × 236 cm.)
London, National Gallery

This is one of Niccolò's finest and most characteristic works. It dates almost certainly from his sojourn in France, where he went from Bologna in 1552. A painting identical in style and mood, and of similar dimensions and comparable subject, is his *Rape of Proserpina* (Louvre); it is tempting to connect them both with the four large landscapes paid for by the King of France, Henri II, in 1557.

The subject of the picture is identified by the National Gallery as the *Story of Aristaeus*. Aristaeus was the son of Apollo and the nymph Cyrene. He was brought up in Libya and instructed in the arts of agriculture and bee-keeping. He travelled to Greece, where he married the Theban princess Autonoë and fathered Actaeon; but on a journey into Thrace he saw and fell in love with Eurydice, the wife of the poet Orpheus. She fled from his advances, was bitten by a snake and died. (Orpheus subsequently tried to rescue her from Hades.) Aristaeus's bees were destroyed, and in despair he asked his mother what to do; she advised consulting Proteus, who told Aristaeus to sacrifice cattle to appease Eurydice's shade. When he did so, a swarm of bees appeared miraculously from the dead animals' entrails.

Niccolò's painting describes several stages in this story. On the left Eurydice's companions gather flowers in a meadow, apparently unaware of the adjacent Aristaeus attempting the fleeing Eurydice, who treads on the snake; in the middle distance the unconscious Orpheus charms wild animals with his lyre. To the right of the live Eurydice is her prone corpse, while further away Aristaeus consults Cyrene, and at the extreme right Proteus surveys the trageic events. No real sense of tragedy invades Niccolò's graceful and fantastic scene. A melancholy charm pervades it, chiefly because the spectator is distanced from these wispily elegant figures caught in their decorative posturing, while they are detached from the vast and dominating landscape behind them.

The stylistic sources of Niccolò's invention are diverse. There is no trace of his earliest dependence on Correggio, but the influence of Parmigianino remains in his stylised elegance. Among other Emilian influences there is, perhaps, an echo of the naive charm of Mantegna's *Parnassus* (Louvre); the most important for Niccolò, however, was undoubtedly Dosso Dossi, not for Dosso's Venetian colour and warmth but specifically for his fantastic landscapes bathed in unnatural light. Niccolò's *Eurydice* shows clearly, moreover, that he was even more aware than Dosso of the huge imaginary views of northern European painters such as Joachim Patinir. Niccolò's vast background lacks their sensational quality; its more decorative effect is due to its insubstantiality, and the delicate handling and colour-range. Silvery tones of blue and grey dominate the distance, soft green and pale brown the foreground, against which the pearly figures shimmer: the strongest colour in the whole composition is the silky blue of Eurydice's cloak, which provides a curving contrast to the dominant diagonals.

Also possibly derived from northern sources is Niccolò's revival of the medieval practice of combining different episodes of a narrative in one picture, which in major Italian centres had scarcely outlived the mid-15th century (though not, perhaps, in his provincial birthplace, Modena). His revival of this archaic method gives unexpected charm as well as unreality to his scene, in which the protagonists seem like delightful ghosts, re-enacting their myth before a wonderfully invented backdrop, as if in a hazy dream.

—Nigel Gauk-Roger

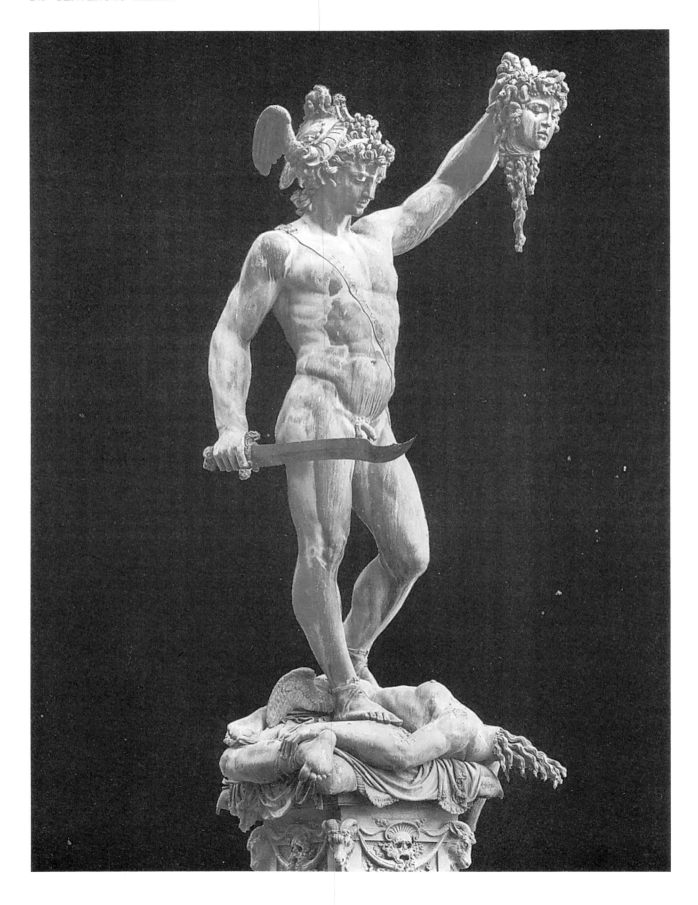

Benvenuto Cellini (1500–71)
Perseus with the Head of Medusa, 1564
Bronze
Florence, Loggia della Signoria

In his *Autobiography* (1558; published 1728), Cellini describes the commission in 1545 for *Perseus with the Head of Medusa*, and in *Trattato della scultura* he discusses the laborious execution of this magnificent piece of Mannerist art. After his return from France, leaving the court at Fontainebleau under the patronage of Francis I, Cellini sought patronage through the court of Medici. He visited Cosimo I at Poggio a la Cajano and offered his services as an artist. His first commission for the duke was to execute a *Perseus*. First, he explains, he did a wax model, a technique that he claimed had been lost. According to his *Autobiography*, Cellini first worked on a prepared full-scale gesso model from which it was intended that the bronze should be modeled and cast. This method apparently did not work efficiently and soon he began to work on a model in terracotta for the Medusa built upon an iron frame, as well as the body of *Perseus*. Eventually both were covered with wax and then cast in bronze. When the Duke saw the wax model, Cellini says, he was suspicious about its actual casting success. Cellini elaborates at length on the accounts of the success of the casting, especially casting the body in one single piece (except for damage to the right foot) which had not been accomplished earlier. The main figure is inscribed on the strap worn across the shoulder: "Benvenutus Cellinus Civis Flor./Faciebat MDLIII," recalling Michelangelo's *Pieta* (Vatican Museum) inscription. The wooden model for the base describes the figures in the niches: *Danae with the Child Perseus* (inscribed "Tuta Iove Ac/Tanto Pignore/Laeto Fugor"), *Jupitor* (inscribed "Te Fili Siquis/Laeserit/Vitor/Ero"), *Athena* (inscribed "Quo Vincas/Clypevm do Tibi/Casta Soror"), and *Mercury* (inscribed "Fris Vt Arma/Geras Nuvus ad Astra Volo").

Beneath is a relief of Perseus rescuing Andromeda (original in the Museo Nazionale, copy beneath the statue), for which a wax model is recorded in Cellini's studio. This was a popular theme of the Mannerist period (Vasari's *Perseus and Andromeda*, 1570, Florence, Palazzo Vecchio). In *Perseus with the Head of Medusa*, Cellini combines the ambiguity of style and content in Mannerist art. The first sketch for the composition shows the expression of pride and horror Perseus wears as he holds out the head of the Medusa with his extended arm, presenting it to the viewer.

The model for the Perseus statue is Donatello's *Judith*, similar in subject and stance, where the victim is placed upon a square cushion fez and decorative base. Perseus is an athletic, sensual nude, like the David of Donatello. As Perseus holds the severed head of the Medusa triumphantly—her expression of fear remaining in her downcast eyes, her lips parted in appeal—she appears to be pleading for mercy to the viewer.

The wax model is less solid and compact, expressing fear rather than triumph. The arm and knee of Perseus are less angular and bent. The bronze statue of Perseus elaborates on details such as hair, helmet, serpent, spouting blood. At the base, bronze statues of Danae, Athena, Jupiter, and Mercury are placed in delicate architectural niches. These tabernacles are decorated with masks, bucrania, garlands, and volutes. Their serpentine movement and extreme elegance of stance and motion rank them as outstanding creations of the Mannerist style.

Perseus's modeling expresses a careful study of anatomy and interplay of light and shadow in the tradition of Michelangelo's marble nudes. Like Donatello, Cellini is able to evoke drama and horror in a controlled manner. *Perseus with the Head of Medusa* is one of his most successful sculptural works.

—Liana Cheney

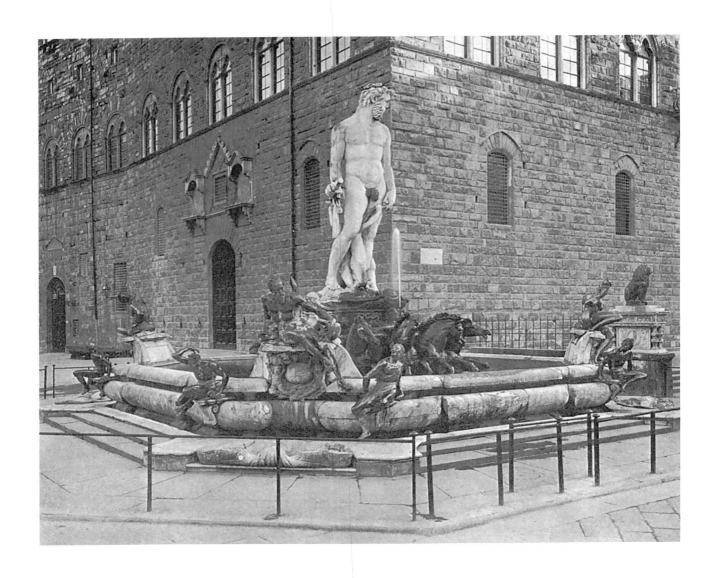

Bartolommeo Ammanati (1511-92)
Fountain of Neptune
Marble and bronze
Florence, Piazza della Signoria

Cosimo I de'Medici, second Duke of Florence and later first Grand Duke of Tuscany, commissioned this fountain to commemorate his naval achievements. When he conceived the project, and entrusted it to his favourite sculptor, the mediocre Baccio Bandinelli, these amounted only to the building of some new galleys launched at Livorno in 1550. Luckily for his public esteem—and typically of the foresight which characterised his political career—by the time the fountain was completed in 1575 they included the relief of the siege of Malta by the Turks in 1565, and a noticeable part in the resounding defeat of the Turkish fleet by Venetian, Papal, and Imperial ships at Lepanto in 1571.

When Bandinelli died in 1560 he had already begun work on an enormous block of white marble intended for the central group of the fountain. This was to prove a considerable problem for Ammanati when he took over the commission. His appointment was probably due to the influence of his friend Giorgio Vasari, court painter to Cosimo I, with whom Ammanati had previously worked in Rome. Ammanati began work on the marble block, set up in the Loggia dei Lanzi in the Piazza della Signoria, in October 1560; the carving of the figure of Neptune and his supporting tritons, the chariot-plinth below, and sea-horses in front had been completed, with the help of numerous assistants, by September 1565. The foundations of the fountain was begun in the piazza in 1563, and the whole group was erected above them in time for the wedding of Cosimo I's son Francesco to Joanna of Austria in the autumn of 1565.

Ammanati's huge Neptune was not considered a success: "Ammanato, Ammanato,/che bel marmo hai rovinato" (Ammanati, what a fine piece of marble you've ruined) chanted the Florentines, and referred to it as "il Biancone" (the great white thing). This was not entirely the fault of Bandinelli's clumsy start on the block. Ammanati had never before carved a figure on such a large scale or, more importantly, one intended to be seen in the round. Neptune's uncomfortable air of constriction may well be due to Bandinelli's original blocking out; certainly his nearby group of *Hercules and Cacus* suffers from a similar effect. But Ammanati contrived some impressive and indeed beautiful views within the inherited constraints, particularly from the sides of the figure, and it is tempting to ascribe its overall lack of either relaxed stasis or convincing movement to Ammanati's inexperience. The adjacent presence of Cellini's nervously vibrant *Perseus* and Michelangelo's tensely static *David* (a copy) serves merely to accentuate the deficiencies of Ammanati's inert giant.

It was probably the desire to outdo the *David* (which effortlessly dominates his neighbouring *Hercules*) which led Bandinelli to attempt such a large figure for the Neptune. It may even have been Bandinelli's original designs for the fountain which ordained the disproportionate relative sizes of central figure and surrounding basin, since Bandinelli's sense of scale was always shaky. But it was certainly Ammanati who controlled the design of the subsidiary bronze figures which decorate the outer rim of the basin, and these are decidedly too small and delicate in comparison with the central marble. Nevertheless, it is these bronzes which constitute the chief glory of the ensemble. Only one or two are considered to bear Ammanati's autograph, but his assistants, such as Vincenzo de'Rossi and Andrea Calamech, were sculptors of talent. Calamech is credited with the execution of the exquisite Naiad on the right, a serpentine figure of typically Mannerist elegance, while the more tensile Sea God opposite is ascribed to Ammanati, and the posturing nudes on the lower level divided between him and de'Rossi. These last figures, life-size and virtually at street-level, create a lively and effective link between the spectator and the larger bronzes above, while the latter, backed by the shimmering jets of water, make a playful circuit around the vast white shape in the centre: all together, a piece of urban scenography which, while hardly perfect, successfully contrasts with the looming rustication of the abutting Palazzo Vecchio.

Although its proportions and total effect are disappointing, in detailing and in position Ammanati's creation makes an interesting and influential link between the other two great Neptune fountains of the period, Montorsoli's harmonious example in Messina (c. 1551) and Giambologna's superbly confident version in Bologna (begun 1563). All of them were to have a great influence on the proliferating waterworks of Baroque Europe.

—Nigel Gauk-Roger

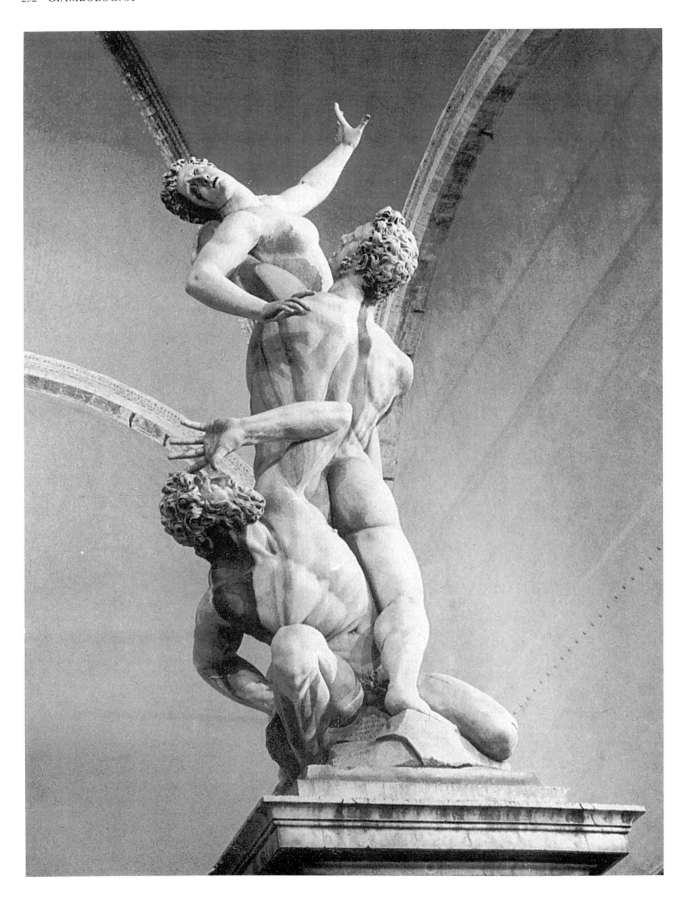

Giambologna (1529–1608)
Rape of the Sabine Women, 1581–82
Marble; 13 ft. 5³/₈ in. (410 cm.)
Florence; Loggia dei Lanzi

Giambologna's *Rape of the Sabine Woman*, an exquisitely balanced, slowly-moving spiral of three nude figures, rises with an incredible elegance against the dark space beneath the arches of the Loggia dei Lanzi in Florence. An operatic sort of plausibility marks the action. The lower male figure cowers in defeat, as he looks upward in anguish toward the woman taken from him. The central male figure stands manfully astride the defeated, older Sabine warrior, and boldly raises his trophy on high, viewing her with an expression not of lust but of a classical reverie touched with sadness. He holds her hip against his chest and supports her upper back with his right and left hands, respectively. The Sabine woman glances downward toward the crouching male, her mood a restrained mixture of alarm and shock, her arms reaching helplessly in the air.

This group is Giambologna's late mannerist *coda* to the series of famous colossal figures created for the Piazza della Signoria at the heart of Florence, a series elicited by the challenge of Michelangelo's marble *David*, a work quite singular in scale, Hellenistic beauty, and understated psychological characterization. The series comprises Bandinelli's *Hercules and Cacus* (marble, 1534), Cellini's *Perseus* (bronze, 1554), and Ammanati's colossal *Neptune* for the great fountain (c. 1565). Eschewing the antique frontality of these earlier works, *Rape of the Sabine Woman* presents instead a design with "a thousand views" as Cellini would put it, a virtuoso composition to be read from many sides. For John Shearman, the work is a *figura serpentinata* "in triplicate," well reflecting "the artist's god-like relation to his material." Formal mastery is everywhere apparent, from the antiquarian quotations—the face of a *Dying Niobe*, the torso of a *Dying Gaul*—to the controlled uniformity of balletic stance and gesture, the perfect integration of pace and intensity of movement, the extreme coolness of tone, the abstract sleekness of unreal surface. Seen in terms of the larger development of Italian sculpture, such extremes of *maniera* formalism would in turn engender the early baroque reaction of, say, Gianlorenzo Bernini's *Apollo and Daphne*, a style marked by realism, a lush sensuousness of surface, a psychological specificity, a focus upon a persuasively climactic moment in time and space—all emphases radically different from the closed emotional world, and the endlessly continuing balletic movement of Giambologna's *Sabine* group. The brilliance of the design elicited a number of poems written in admiration, poems collected in a single volume, *Le composizioni di diversi autori in lode del ratto della Sabine*, 1583.

In a letter written by Giambologna to Ottavio Farnese, the Duke of Parma, in 1579, the artist describes a related small bronze as one that could "be interpreted as the rape of Helen, or even that of Proserpine, or as the rape of one of the Sabine women." Giambologna says further, the "the subject was chosen to give scope to the knowledge and study of art." Thus the mannerist sculptor's concern was so overwhelming formal that he reversed the classical procedure whereby a literary notion (say, the situation of David facing Goliath), would dictate the formal concept (such as the troubled gaze of Michelangelo's *David*). Instead, Giambologna's interest in "the study of art" led him to progress from two-figure groups to a three-figure design, that is, to an ultimate display of compositional virtuosity.

This composition, in the view of Charles Avery, was inspired by a Hellenistic work, the *Punishment of Dirce* (also called the *Farnese Bull*), which Avery feels "pointed the way for a different approach to sculpture from that of Michelangelo." Still, unlike the *Farnese Bull*, Giambologna's *Sabine* is not so scattered in space, nor is it so much a compilation of isolated, discrete entities. On the contrary, it is very closely interwoven, with respect to stance, gesture, and line. For E. Tietze-Conrat, in fact, its compact design is "composed within a slender, prismatic column," and, "were it not for the unifying effect of the concise block-form, the design would fly apart in all directions." since not one of the three figures "embodies the vertical axis" of the group. She maintains, furthermore, that this manner of "composing within a block" is a distinctly "Northern European trait" with Giambologna's style.

Earlier works by Michelangelo predict this intricate, columnar, group-composition: the *Bacchus with a Young Satyr* (Bargello), the small sketch-models for *Hercules and Cacus* or *Samsom and the Philistine* (Florence, Galleria Buonarroti), and his marble group *Victory* (Pilazzo Vecchio), for which latter Giambologna's marble, *Florence Triumphant over Pisa*, c. 1564–70 (Bargells), was intended as a mate. Two further Florentine compositions stand in this tradition, the *Victory* group by Bartolommeo Ammanati and *Honor Triumphant over Falsehood* by Vincenzo Danti (both in the Bargello). These several designs, however, vary as to the completeness of their commitment to the idea that they may be viewed equally as well from all sides. The best view of *Sabine*, according to E. Tietze-Conrat, is that from the corner of the pedestal, rather than from the front or relief-bearing face.

Two small sketch-models in red wax survive, as documents of the development of the design, one with two figures and another with three (both in London, Victoria and Albert), as does a full-size presentation model, built not of gesso but of unfired clay and glue (so-called creta), and coated with whitewash (Florence, Accademia).

Some five extant small bronzes of this subject are discussed by Charles Avery (1987). The first is documented as in the collection of Ottavio Farnese, Duke of Parma, in 1579 Naples). Another is documented in the collection of Emperor Rudolph II, at Prague, c. 1607–11 (Vienna, Kaiserliche Schatzkammer). A third came from the shop of Antonia Susini (private collection). Two other versions in the same smaller scale are in the Bavarian Museum in Munich and Liechtenstein.

—Glenn F. Benge

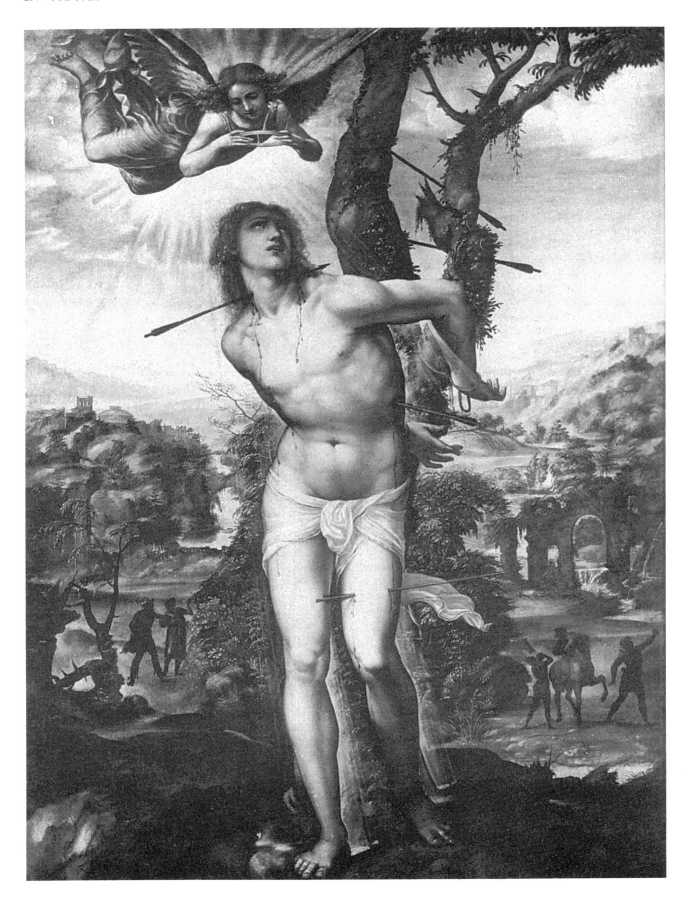

Sodoma (1477–1549)
St. Sebastian, c. 1525
Banner; 6 ft. 9¹/₈ in. × 5 ft. ⁵/₈ in. (206 × 154 cm.)
Florence, Pitti

Executed around the year 1525, the *St. Sebastian* by Sodoma is a *gonfalone* or processional banner. The work was commissioned by the Confraternity of St. Sebastian in Camollia, Siena. Its subject matter reflects the nature of the commission: the confraternity (a charitable lay organization) had the artist depict their patron saint. An early Christian martyr who miraculously survived the execution with arrows ordered by Emperor Diocletian, St. Sebastian is the most popular "plague saint"—a divine intercessor whose aid was invoked against pestilence. That the confraternity was dedicated to him suggests that its particular mission was the care of plague victims and the nursing of the sick. This is reinforced by the image on the reverse of the *gonfalone*, which shows the *Madonna and Child with Sts. Roch and Sigismond*. Like St. Sebastian, the protective intervention of St. Roch was implored during outbreaks of plague, and the two often appear together in votive images commissioned in times of pestilence. Although less commonly represented, St. Sigismond also has a saluatary connotation, being the protector against fever. This figure, too, thus refers to the mission of the confraternity, whose members appear in their hooded robes venerating the Virgin and Child in the company of Sts. Roch and Sigismond on the reverse of the *gonfalone*. It is probable that the banner was carried through the city in processions staged during the plague and on other ceremonial occasions.

Sodoma's *St. Sebastian* has been widely acclaimed from the time it was painted. An initial payment of 20 ducats that the artist received for this work was supplemented by an additional sum of 10 ducats some six years later. The explanation for this later payment recorded in the document states that it was dispersed because Sodoma "deserved it." Vasari records that the *gonfalone* was so admired by a group of Lucchese merchants that they desired to buy it for the sum of 300 gold *scudi*, but the confraternity refused to part with its treasure. A later aspiring owner, the Grand Duke of Tuscany, was more successful: he acquired the painting for the Medici collections around the year 1786, at which time it entered the Uffizi. In 1928 the *Saint Sebastian* was transferred to the Pitti where it remains today.

In addition to the popularity that his status as a plague state conferred upon him, St. Sebastian was a favorite subject in the Renaissance because it allowed artist to depict the heroic, male nude form. This was evidently the case with earlier treatments of the subject—the well-known painting by Pollaiuolo and Mantegna, for example—and with Sodoma's work as well, where the artist has represented the martyred saint as an idealized, Apollonian hero. The powerful nude torso, its muscles and sinews carefully modelled with a shadowy *chiaroscuro*, suggest the artist's study of antique sculpture, and were it not for the arrows and crown of martyrdom bestowed by a radiant angel at the upper left, the figure might be mistaken for a protagonist from classical myth or legend rather than a Christian saint.

The composition of the *gonfalone* is dominated by the monumental figure of the tortured saint bound to a craggy tree and gazing heavenward to acknowledge the divine source of his spiritual strength. A haunting, evocative landscape which recedes to a far-off, hazy mist serves as the backdrop to the scene. The delicate, aural light of this distant landscape contrasts with the crepuscular, deeply shadowed, and vaguely infernal light of the foreground, where diminutive figures—perhaps the saint's torturers—are silhouetted. A massive, crumbling archway at the right invests the scene with a poetic quality, while suggesting the historical era in which this episode took place— the late antique period when classical culture was gradually superseded by Christianity. Indeed, the demise of the antique world is perhaps symbolized by the ruinous nature of this clearly antique structure, while the triumph of Christianity is signalled by the figure of St. Sebastian himself, whose victory over the malevolent forces of the pagan emperor, and over death itself, is communicated by the divine radiance that envelopes him and the martyr's crown he is about to receive.

In Sodoma's *Saint Sebastian*, the Renaissance interest in the classically inspired, heroic nude form converges with traditional Christian faith and piety to form a powerful and expressive cult image.

—Linda Wolk-Simon

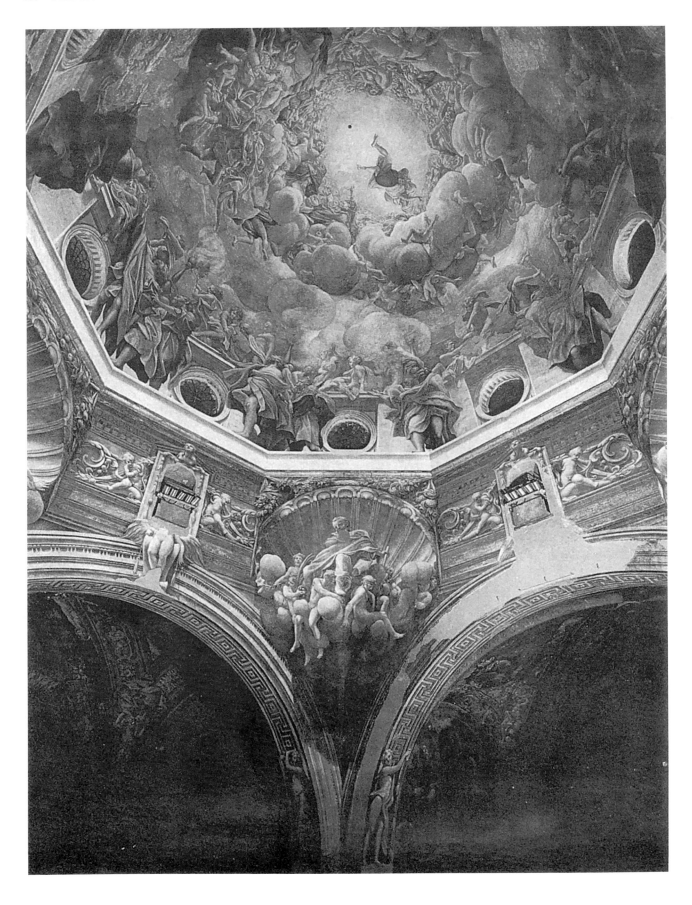

Correggio (c. 1489–1534)
Assunta Cupola
Fresco
Parma, Cathedral

Bibliography—

Tassi, Roberto, *La cupola del Correggio nel Duomo di Parma,* Milan, 1968.

Riccomini, E., et al., *Correggio: Gli affreschi nella cupola del Duomo di Parma,* Parma, 1980.

In the year 1522 the young Correggio finished the first half of an elaborate programme of fresco decoration in the recently rebuilt monastery church of S. Giovanni Evangelista at Parma. It evidently caused an immense sensation as contracts for other work rained in on him at this time. One consequence was that the authorities of Parma cathedral, a much older building than S. Giovanni and situated immediately adjoining it, were spurred to engage Correggio and the other painters who had been working with him at S. Giovanni. Correggio was immediately put under contract to do the same at the cathedral as he had been doing at S. Giovanni—that is, to paint the half dome of the apse, the choir vault, and the main dome. As he had still not finished at S. Giovanni he did not start work at the cathedral for another four years, and then did no more than part of what he had contracted to do, that is, the main dome. But this proved to be the most astonishing piece of virtuosity in the whole history of Italian painting.

As the spectator mounts the huge flight of marble steps leading up from the nave of the cathedral to the choir he looks up and sees emerging from under the last arch of the nave vault the Virgin Mary swept up to heaven. By the time he has reached the top step he can see that she is escorted by a squadron of angels and that Christ is descending to meet her. He is taking a flying leap and looks as though he would drop on the heads of the spectators. His pose is in fact so athletic that many critics, even some of those in our own day, have refused to believe that he is Christ and have pretended that he is an angel, regardless of the fact that he has no wings and that the angels who escort the Virgin Mary are equipped with them. In addition, it was traditional for Christ to receive his mother on this occasion. If the spectator can overcome his astonishment at the overwhelming spectacle he realizes that the Virgin Mary is supposed to have ascended from a tomb on the floor of the choir. The involvement of the spectator in the event is thus total.

By this time Correggio, having finished his work at S. Giovanni Evangelista, was able to profit by it and to improve on it. In the dome of the monastery church he had painted a ring of apostles. They are on a large scale and in consequence are foreshortened differently by the curvature of the cupola. Their heads, towards the top of the dome, are fairly fully revealed to anyone looking upwards. But the lower half of their bodies appear telescoped where the dome descends to the vertical. By reducing the scale of the figures in the cathedral cupola Correggio was able to avoid this effect. And he introduced another, more extreme, innovation. At S. Giovanni Evangelista the apostles are majestically enthroned on clouds. But at the cathedral the angels are actually flying, and, as we have to look up at them, all we see, in some cases, are their legs. It was evidently this, which greatly adds to the exciting and even disturbing realism of the whole, which gave offense to the more conservative members of the cathedral chapter who referred to the work as "a mess of frogs." And this in its turn may explain why Correggio never fulfilled the rest of his work at the cathedral and returned home to the town of Correggio where he had come from. Despite this the dome of Parma cathedral became the model for hundreds of Baroque cupolas painted all over the western world in the 17th and 18th centuries.

—Cecil Gould

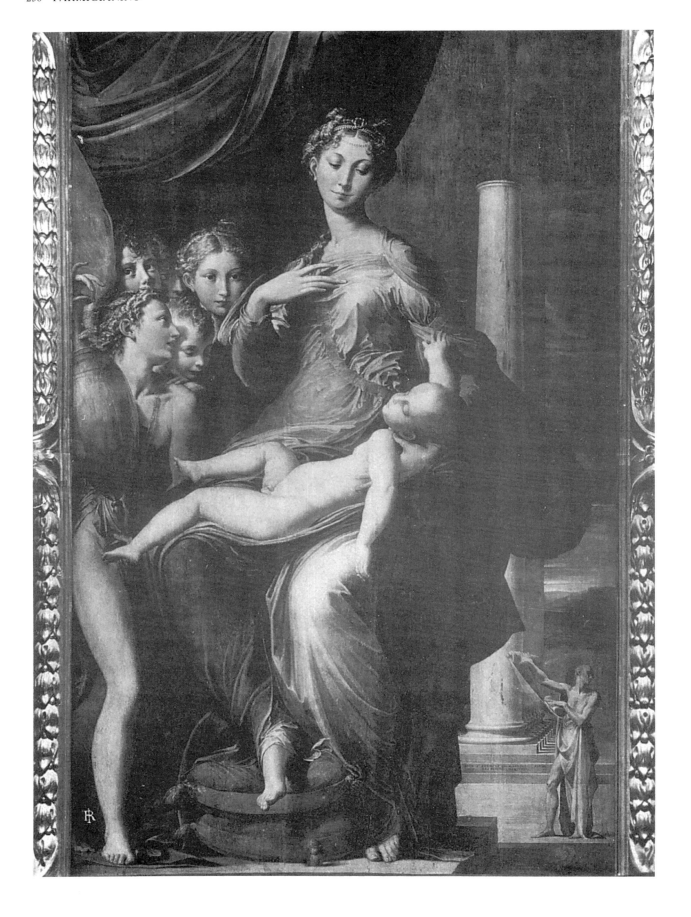

Parmigianino (1503-40)
Madonna of the Long Neck
Panel; 7 ft. 1 in. × 4 ft. 4³/₈ in. (218.4 × 133 cm.)
Florence, Uffizi

Bibliography—

Popham, A. E., "Two Drawings by Parmigianino," in *National Gallery of Canada Bulletin* (Ottawa), 4, 1964.

Davitt-Asmus, U., "Zur Deutung von Parmigianinos *Madonna dal collo lungo*," in *Zeitschrift für Kunstgeschichte* (Munich), 4, 1968.

Ekserdjian, David, "Parmigianino's First Idea for the *Madonna of the Long Neck*," in *Burlington Magazine* (London), July 1984.

Parmigianino's *Madonna of the Long Neck* is his most famous work, and in many ways epitomizes his mannerist sensibility. His early life in Parma led to his being strongly influenced by Correggio, but he also took on the influences on both Michelangelo and Raphael, and worked in Rome in the 1520's. Vasari's recognition of the new style of mannerism ("maniera") is appropriate for Parmigianino's work, and his definition of such a work as based on intellectual rather than visual conceptions is highly suggestive in terms of many of Parmigianino's works.

Several preparatory drawings for the *Madonna of the Long Neck* are extant, and they reveal that the original idea was for a *Virgin and Child with St. Jerome and St. Francis*. In its present form, St. Francis is almost completely off the canvas (one can detect a foot behind St. Jerome), and St. Jerome himself is reduced to a somewhat mysterious figure in the background unrolling a scroll. (The original commission for the work was for the Church of the Servi in Bologna, in 1534.)

The Virgin dominates the work, and her image is related to Virgins in several other of Parmigianino's works, notably that of the *Vision of St. Jerome* (1527; London), with elongated proportions, sloping shoulders, and a refined expression. The Virgin is seated in an elegant posture, with the exaggeratedly long fingers of her right hand lightly touching her breast. The top of her torso is turned decidedly to her right to give her head an elegant turn to the left, which emphasizes her unnaturally long neck. Her eyelids and brows are artificially defined, and her nose and lips are almost too regular; her hair is elegantly coiffed, decorated with jewels, including a large ruby. Her clinging gown is almost marmoreal, as if it were classical drapery, defining her nipples, stomach, and navel. She has elegant unshod feet. The overall impression of the Virgin is one of elegance, refinement, even a chilly eroticism. She is not a modest or motherly figure, but self-assured and confident.

This is ironically emphasized by the large size of the child lying in her lap. He lies as if dead, his left arm hanging limp (in this respect, as well as in the size, reminiscent of Michelangelo's St. Peter's *Pietà*), though his right arm touches his mother's upper left arm. His legs are akimbo, and his head is bald.

To the left are five figures crowded together regarding the couple. They are sexually ambiguous, and in various stages of dress. One holds a large urn, and another looks (almost) directly at the viewer (possibly a self-portrait). All five look in different directions.

Behind the figures on the right is smooth column without a capital—obviously "finished" by the painter, but part of what was to be a portico that was left unfinished. St. Jerome stands at the base of this column, but his small size relative to the figures at the front of the picture area is disconcerting.

In some other works by Parmigianino (for instance, the *Madonna of the Rose*), one feels he has less interest in the subject matter than in the way he presents it. In his own time, and in ours, Parmigianino has always been thought of as graceful, and the very work "parmiginare" came to mean to submerge the subject in elegance and delicacy.

—George Walsh

Palma Vecchio (1480-1528)
St. Barbara Altarpiece
Venice, S. Maria Formosa

This superb polyptych has been recognised as Palma's masterpiece since Vasari (1568). It was commissoned by the members of the Scuola dei Bombardieri, or artillerymen's guild, for the altar in the south transept of the church of S. Maria Formosa, Venice, over which they acquired the rights in 1509–10, and where it still stands. It used to be thought that 1510 was also the date of the altarpiece, but over recent decades it has been generally agreed that stylistically it belongs rather to the early 1520's. This is particularly evident in the central figure of St. Barbara, patron saint of artillery, whose ample beauty, Classical equilibrium, and bulky drapery are clearly dependent on Titian's *Sacred and Profane Love* (1515; Rome, Borghese) and *Assumption of the Virgin* (1518; Venice, Frari); and in general the polyptych, with its harmonious disposition of panels scarcely containing their carefully contrasted and proportioned figures, is a remarkable advance on those of the previous decade, such as the *St. James Altarpiece* (1515; Peghera, S. Giacomo Maggiore) and the *Presentation of the Virgin with Saints* (1514; Serina, SS. Annunziata). The chief differences are the increase in size of the central panel compared with the others, and the palpable physicality of the figures. They show Palma fully assimilating, on a grand scale, the warmth, immediacy, and sensuous conviction that were the achievements of the Venetian High Renaissance, as expressed by Giorgione and Titian.

The arrangement of the subsidiary panels, with single full-length saints on either side, half-length saints above them, and a half-length *Pietà* at the top, is reasonably conventional, deriving from Giovanni Bellini. What is unusual, and quite as modern as recent developments from Titian, is the individual treatment and presentation of each figure, combined with an attempt to unify the overall relationships of the altarpiece with visual consistency. The most obvious device used is that the light in each panel falls from the right (as it does, indeed, in the actual environment of the church). Beyond this is the balance set up between the partially clothed St. Sebastian and St. John the Baptist on the left, and the monkish habits of St. Anthony Abbot and St. Vincent Ferrer on the right; this is reflected in the positions of the semi-nude Christ and draped Virgin above. Horizontal harmony is created by the symmetrically opposed positions of the half-length John and Vincent, and the mirrored *contrapposti* of Sebastian and Anthony. These links are reinforced by the naturalism of the half-lengths, which gaze insistently outwards, and the more hieratic full-lengths, rapt in their own dramas; in further contrast, the *Pietà* appears as an icon displayed to the faithful. But unity is also maintained by the subtle realism of colour and chiaroscuro.

The Classicism of the St. Sebastian—evidently derived from an engraving by Raphael's follower Marcantonio Raimondi—attests to Venetian awareness of artistic developments elsewhere. St. Barbara, however, while showing in her even more marked *contrapposto* and noble profile the influence of Roman sculpture, is triumphantly a figure of Venice; indeed, she might even stand as an image of the regal republic, and certainly climaxes Palma's series of depictions of a certain type of blonde beauty perennially popular in the city. But, although magnificently physical, she has no overtly erotic appeal, and embodies equally convincingly the concept of victorious religion. As impressive as is her dominance of the polyptych, not simply through her much greater size, but also because her figure draws together all the contrasting curves, light and shade, glowing backgrounds, and subtle tonalities of the other panels. There is no vibrant colour in the central panel: the subtle red of the cloak and white of the veil curve around the warm brownish hue of the tunic, which is echoed by the grey-brown of the plinth and emblematic tower, and set off by the gentle blue and grey of the sky and distant hills. A soft light caresses the flesh of cheek and neck, and touches the delicate fingers holding the martyr's palm. The boldly sculptural folds create a sense of movement in the Classic stasis of the saint's stance, hinting at the drama of her story. The original giltwood frame of the polyptych was replaced by the current one of carved marble in 1719. This, though over-elaborate, scarcely detracts from the directness of Palma's timeless vision of Venetian beauty, radiance, and elegiac spirituality.

—Nigel Gauk-Roger

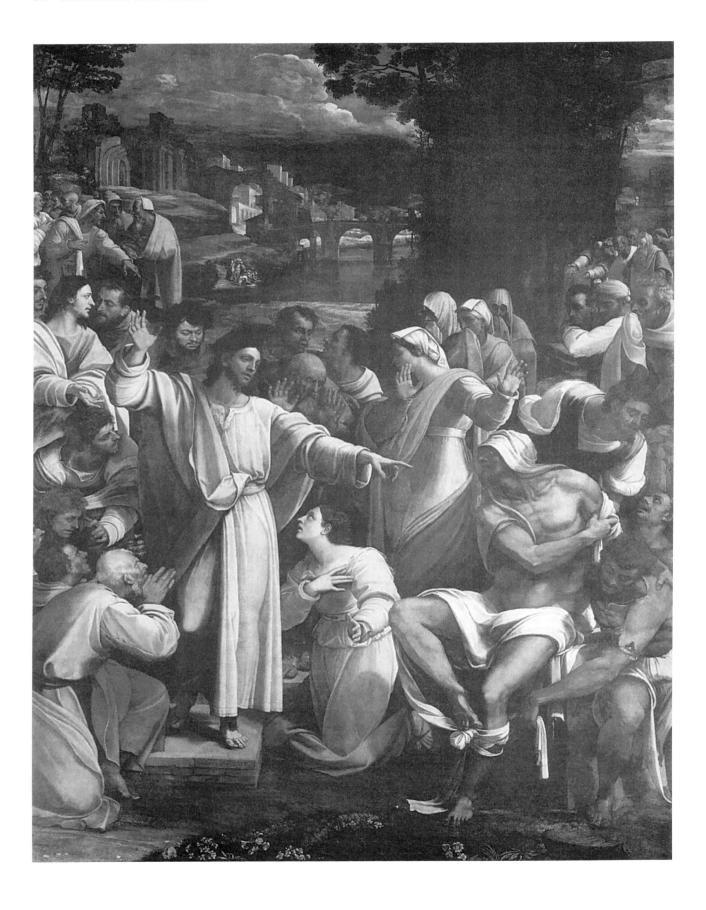

Sebastiano del Piombo (c. 1485–1547)
The Raising of Lazarus, 1517–18
12 ft. 6 in. × 9 ft. 6 in. (381 × 289.6 cm.)
London, National Gallery

The remarkable background to this commission testifies to both the exhilarating artistic milieu of early 16-century Rome and the importance of specific personalities within it. In 1516 Pope Leo X's cousin Cardinal Giulio de'Medici (the future Clement VII) decided to honour the cathedral of his French bishopric, Narbonne, with a major altarpiece; he also decided, perhaps in a spirit of nationalism, or of cultural imperialism, that it should represent the best of contemporary Italian painting. Consequently he commissioned both Raphael, then the leading painter in Rome, and Sebastiano del Piombo, the pictorial delegate of Raphael's only serious rival, Michelangelo, to produce a suitably grandiose work for the cathedral.

Michelangelo had decided, after completing his four years' work on the Sistine Chapel ceiling in 1512, not to undertake any more painting commissions. However, he had no desire to leave Raphael unchallenged in that field. He therefore chose as deputy Sebastiano, who deeply admired him, whose natural inclination towards monumental breadth of form had been accentuated by his influence, and whose Venetian training had emphasised an aspect of the art unknown to the central Italian background of Raphael or of Michelangelo himself—the expressive use of colour and light. It was this last quality that enabled Sebastiano to transform the suggestions that Michelangelo presumably made him and the drawings that Michelangelo certainly provided him with into truly personal creations.

Michelangelo's intervention in the *Raising of Lazarus* was almost certainly less dominant than in Sebastiano's earlier *Pietà* (c. 1515; Viterbo). The only figure studies—one in Bayonne, Musée Bonnat, and two in London, British Museum—which have been attributed to Michelangelo in connection with this work depict Lazarus and his two attendants. Although the previous existence of such drawings for other figures has been plausibly postulated, there is no indication that Michelangelo was specifically involved in the design of the composition. That, indeed, appropriately enough, shows the influence of recent Raphael masterpieces like the so-called *Spasimo di Sicilia* (c. 1516; Madrid) and the cartoons for the Sistine Chapel tapestries (1515; London, Victoria and Albert) with grandiosely static figures disposed in asymmetrical yet balanced groups and controlled by powerfully thrusting diagonals. The design also achieves a remarkably mature relationship between the foreground protagonists and the lesser groups behind, and between those and the landscape background, creating a harmonious development in depth which is a considerable progression beyond similar effects in the Vatican works of either Raphael or Michelangelo, and which refers back rather to the sensuous realisation of space in Giorgione and the early Titian, combined with an appreciation of the intellectual conquests of Leonardo.

The impressive dignity and powerful beauty of Sebastiano's work illustrate a central episode of Christian legend. Three distinct moments are depicted: Mary Magdalene beseeching Christ's help, Christ calling Lazarus from his tomb (with Martha's appreciation about the stench of the body fully justified), and the Jewish elders murmuring against the miracle afterwards. The particular religious significance of the event was a prefiguration of Christ's own resurrection. Sebastiano recreates the story not only with Roman gravitas and weighty Michelangelesque physicality, but with a dramatic use of light and an almost abstract pattern of colour, which play contrastingly across the forms of the composition before being united in the glowing landscape; there the lowering clouds and ruined arches (probably based on actual Roman remains) proclaim the future destruction of the pagan world.

Sebastiano began work on the painting during the first half of 1517. However, it is clear that he had discussed the project with Michelangelo before the latter's departure from Rome at the end of the previous year, because he used Michelangelo's design for Lazarus as the basis for a figure in the Borgherini chapel in S. Pietro in Montorio, Rome, which was executed in the autumn of 1516. The figure of Lazarus in the altarpiece, on the other hand, suggests that it was Michelangelo's only direct contribution, since its exaggerated muscularity and contorted stillness contrast strangely with the other figures. Sebastiano made a virtue of this potential problem by pivoting the whole design around Lazarus, and emphasising the distinction of his miraculous state, colouring the recently dead body a paradoxically vivid, warm brown which stands out from the grey tonalities, dark shadows, white draperies, and occasional patches of intense blue in the rest of the picture.

Michelangelo only saw the painting once, at the beginning of 1518, before its completion. Later that year Sebastiano interrupted his work on it, afraid that it might be seen and used to advantage by Raphael, who had not yet begun his own altarpiece and who was known to be unhappy at being exposed to such direct competition—he even, apparently, tried to arrange that Sebastiano's painting be framed in France and therefore, presumably, not displayed in Rome. However, by May 1519 the painting was finished, and by the following December framed, varnished and exhibited, with, according to Sebastiano himself, great acclaim. It was exhibited again, alongside Raphael's glorious *Transfiguration* (Vatican), in April 1520, a few days after Raphael's death. And, although Michelangelo's supporters claimed that both altarpieces were equally praised, it was the *Lazarus* which was despatched to Narbonne, while the *Transfiguration* was kept in Rome.

The Raising of Lazarus remained in Narbonne Cathedral, probably in the Chapel of St. Martin, until it was acquired by the Duc d'Orléans during his Regency (1715–23), being replaced in the cathedral with a copy by Carle Vanloo. The original stayed in the Orléans collection at the Palais-Royal, Paris, until the end of the century; at some time during this period it was transferred from its original wooden panel onto its current canvas. It was sold on the dispersal of the Orléans collection in 1798 to John Julius Angerstein (who was supposedly advised by Thomas Lawrence). Angerstein's own collection was purchased by the Government in 1825 to form the nucleus of a National Gallery. The altarpiece, proudly signed "Sebastianus Venetus faciebat," is still, perhaps, the Gallery's most important single, complete representative of the triumphant years of the Roman High Renaissance.

—Nigel Gauk-Roger

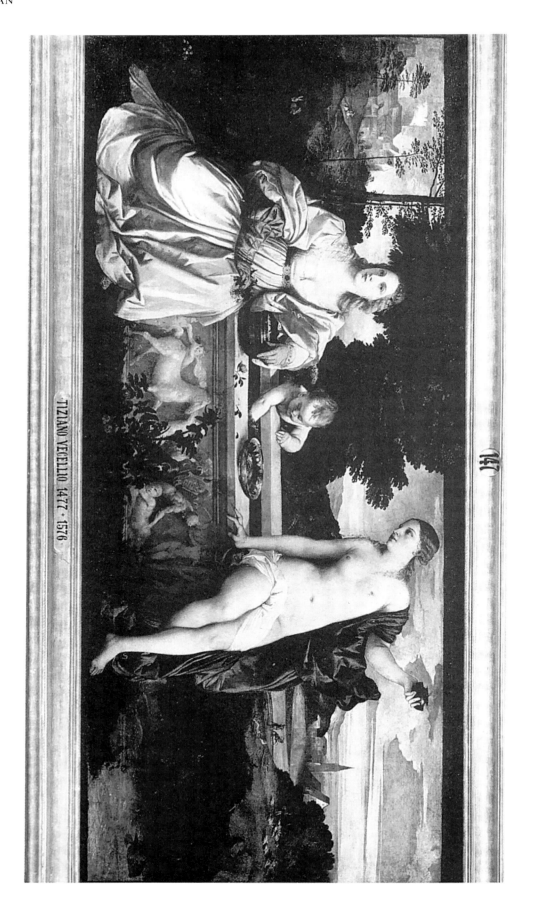

Titian (c. 1480–85—1576)
Sacred and Profane Love, 1515
3 ft. 10¹/₂ in. × 9 ft. 2 in. (118.1 × 279.4 cm.)
Rome, Borghese Gallery

Titian's *Sacred and Profane Love* (1515, Rome, Borghese Gallery) received its title only at the end of the 17th century. It may well, in fact, be a misleading name, as the exact subject of the work is still being argued. Consequently, since its creation this painting has intrigued its admirers as much for its mysterious iconography as for its stunning beauty.

The work is laid out in an unusually wide rectangular format which echoes the shape of the sarcophagus that dominates the center of the scene. Sitting on either end of the carved stone box are two women who are virtually identical except for their attire. One is nude except for a small white drapery across her hips and a rich rose cloth that hangs from her right arm; the other is dressed in a lavish white gown accented by a jewelled belt and one rose-colored sleeve. Between them a plump little cupid stirs the water that fills the sarcophagus. Behind them stretches a magnificent landscape of hills and lakes set against an aquamarine sky streaked by golden clouds. The harmony of the lines and colors and the beauty of the contrasts of flesh and drapery, object and landscape are so remarkable that one can become fascinated with the picture without even knowing what it signifies.

This is fortunate, for the meaning of the canvas remains obscure. It is known that the work was commissioned by Niccolo Aurelio, the Secretary of the Council of Ten in Venice, to commemorate his wedding in May 1514 to Laura Bagarotto, the daughter of a Paduan professor who had been executed for treason by the Venetian government five years before. Aurelio's escutcheon appears in the center of the relief on the fountain, while that of his wife's family is faintly visible on the inside of the silver dish which rests on the fountain's ledge (Wethey, *The Paintings of Titian,* London, 1975, vol. III, p. 177). The presence of these family shields as well as the cassone-like proportions of the canvas itself suggest that Titian had a nuptial theme in mind when he designed the work. Exactly what this was, however, has caused considerable debate.

All those who have studied the work agree that it treats a love theme, but their ideas of how this is done vary considerably. Friedlaender believed that the picture shows a scene from the *Hypnerotomachia Poliphili,* a popular romance published in Venice in 1499, in which the heroine, Polia, recounts her adventures to Venus. The reliefs on the sarcophagus, he argues, refer to the heroine's dreams and thus let us follow, at least in vague terms, the history she is recounting. The dressed woman, though, is in fact saying nothing, bringing this interpretation of the work into question.

Panofsky compared the figures in Titian's painting to emblematic descriptions in Ripa's *Iconologia,* and thus identified the nude as "*Felicita Eterna,*" whose nudity denotes her contempt for perishable earthly things and whose flame symbolizes the love of God. The dress of the clothed figure, or "*Felicita Breve,*" signifies satisfaction, and her wealthy possessions are symbols of vain and shortlived happiness. Together they present a sophisticated theme drawn from the Neoplatonizing writings of Marsilio Ficino. Felicita Eterna corresponds to the "Celestial Venus" discussed in Ficino's *De Amore* and symbolizes the principle of universal and eternal but purely intelligible beauty. The woman beside her is the philosopher's Terrestrial Venus, who stands for the generative forces of nature and the visible and tangible Beauty found on earth.

Panofsky's interpretation has proven quite popular, but it does present problems. In order to accept it, one must reject a strong medieval tradition in which the draped figure normally and quite logically stood for a saintly or lofty principle whereas the nude connoted carnal pleasure. The dressed woman, moreover, looks less like an allegorical figure than a well-dressed aristocratic woman of 16th-century Venice.

A different approach was suggested by De Tolnay, who, impressed by the nude's sensuality, chose to interpret her quite directly as Venus, the goddess of love. She is shown trying fruitlessly to recruit the woman seated beside her, identified by her white dress and tightly girded waist as chastity. Chastity turns away, rejecting Venus's offer, suggesting a theme of the victory of chastity over lust.

Citing the recently discovered escutcheons in the painting, Charles Hope has chosen to see the *Sacred and Profane Love* more simply as a marriage picture. The clothed woman wears the traditional wedding dress of 16th-century Venetian brides. Her myrtle wreath symbolizes the lasting and legitimate joys of marriage, while her roses evoke images of both the bride and the goddess. The woman is in the presence of Venus, who, as a deity, remains invisible to her companion, though we are able to see her as she turns to offer the bride her blessing. The picture, Hope concludes, portrays not *Sacred and Profane Love,* but "The Bride of Niccolo Aurelio at the Fountain of Venus."

The interpretation of the woman at the left as Aurelio's bride is convincing, although it is difficult to be certain whether this is an actual portrait of Laura Begarotto or an idealized image. Her resemblance to the goddess Venus beside her might be a kindly bit of flattery on the part of the artist, but it could also suggest that the bride, although hesitant as she approaches her new role as wife and lover, is starting to identify with the goddess by putting on her myrtle wreath and holding her flowers. Before long, as a new wife, she will also lift the defenses of her chastity and thus become the bridegroom's personal Venus.

Whatever the proper interpretation of the work (and many more have been suggested besides those mentioned here), the *Sacred and Profane Love* stands as a testament not only to Titian's intellectual achievement, but also to the stylistic richness of his early works. The glorious reds associated with his name enliven the canvas, the female form which he championed is resplendent, and the light creates a shimmering beauty that bathes the scene in golden hues. It is the very perfection of the artist's style, in fact, that has perhaps encouraged scholars to look for equally lofty themes.

—Jane Nash Maller

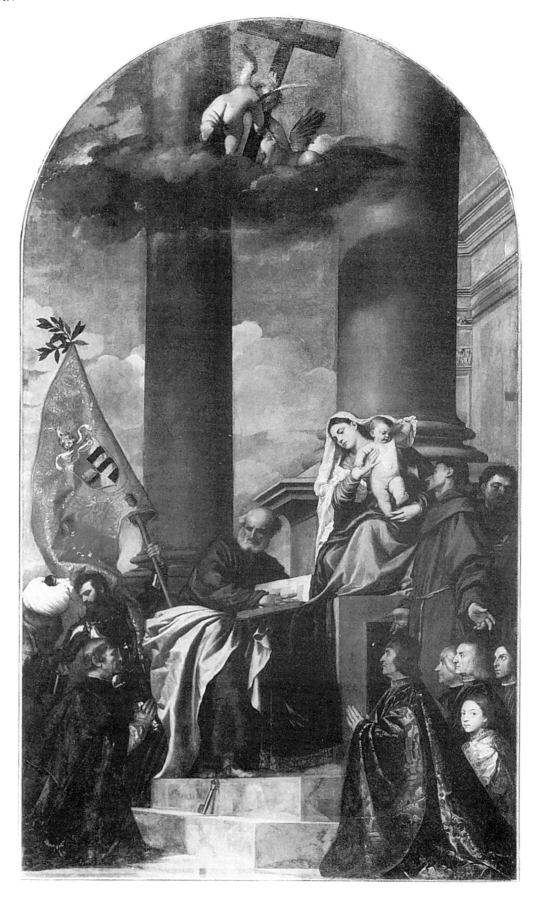

Titian (c. 1480–85—1576)
The Pesaro Madonna, 1526
15 ft. 8¹/₄ in. × 8 ft. 9¹/₂ in. (478.1 × 268 cm.)
Venice, S. Maria Gloriosa dei Frari

Bibliography—

Fehl, Phillip, "Saints, Donors, and Columns in Titian's *Pesaro Madonna*," in *Renaissance Papers,* Chapel Hill, North Carolina, 1974.
Ettlinger, Helen S., "The Iconography of the Columns in Titian's Pesaro Altarpiece," in *Art Bulletin* (New York), 61, 1979.

The *Pesaro Madonna* (1526, Venice, Sta. Maria Gloriosa dei Frari) appeared in 1526 as a bold break with Renaissance artistic norms. Rather than following the standard altarpiece format of the time, which would have called for an isosceles triangle reaching up from a base peopled by saints and donors to the image of the Virgin in the apex, Titian turned to a dramatic diagonal composition, and thus created a work which not only works in a unique cooperation with its environment, but also foreshadows the favorite compositional device of the 17th-century baroque style.

The altarpiece was commissioned in April 1519 by Jacopo Pesaro, Bishop of Paphos, as a votive picture for his family chapel in the north aisle of the Church of the Frari. The work was intended both to aid in Pesaro's quest for salvation and to commemorate his success against the Turks at the battle of Santa Maura in 1502. As a victory over the infidel, the event was seen both as a moment of Venetian glory and as Pesaro's missionary achievement; the bound Turk and black slave who are being led toward the Madonna by an armor-clad saint, then, are not only tokens of Venetian glory, but also Pesaro's offerings to the Madonna as well as examples of the fortunate souls to whom he has offered the opportunity for Christian salvation. The painting thus ambodies several functions, which Titian's inventively complex composition helps to express.

It apparently took the artist some time to resolve the demands of his subject and setting. He worked on the altarpiece intermittently for seven years, and it is known from X-rays that he modified it several times during that period. (C. Hope, *Titian,* Harper and Row, 1980, p. 46 and D. Rosand, *Art Bulletin* vol. 53, p. 205). Titian originally planned to set the holy figures in a church, but early on he decided to move them to the portico of the Virgin's heavenly palace which is indicated in the painting by two colossal columns. Interestingly, X-rays have shown that these dramatic architectural elements were also a late inspiration, which he added to give grandeur to the setting and visual support to the religious figures, while at the same time lending a stately cadence to the composition.

The columns and their accompanying architecture also help relate the picture to its actual setting. Their stately classicism echoes elements in the frame of the altarpiece as well as the architecture of Jacopo's tomb which is to the right. The huge columns are also modified versions of those which separate the nave from the side aisle in the church itself. Their repetition helps to create the illusion that one is looking out of the space of the church into an adjoining heavenly arena as the Pesaro family members act as transitional figures from one to the other.

This effect is perhaps most apparent when the visitor first sees the altarpiece shortly after entering the church. We look left through the columns of the nave to the steps which rise at approximately the same angle as our own sightlines. We thus feel invited to join Jacopo Pesaro at the foot of the steps and to follow his gaze up the steps to St. Peter and the Madonna. Our view of the picture changes, however, as we approach it from the chapel and see it straight on. Now it is the right hand side that first catches our eye, thanks largely to the youngest member of the Pesaro family, who looks out at us as we approach the altarpiece. Now we are much more aware of the action of the right hand side of the panel, for while Mary and St. Peter address Jacopo on the left, Jesus turns his attention to St. Francis, who intercedes for the cluster of family members on the right. In their devotion, this group forms a contemplative counterpart to the action implied by the armored saint and captives who accompany Jacopo Pesaro on the left.

These interactions are held together by complex plays of colors and geometric forms. The main triangle, which is formed by the diagonal leading to the Madonna and the lines connecting the donors, is offset by the equilateral triangle that finds its apex in St. Peter. A third triangle is marked by the bold rose tones of the banner, the Madonna's gown and the red brocade of the man in the right foreground. Smaller triangles echo throughout the painting in individual figures and drapery patterns and interact with other geometric forms. The banner, held at an angle, helps to balance the group on the right and counter the strong line of the diagonal leading up the stairs. The cylinders of the columns space the action of the painting, add depth to the image, and lead our eye upward to the cherubs who hold the cross in the sky above. Titian's light, as usual, filters through the scene, picking out details, such as the cherubs, the head and golden cloak of St. Peter, the Madonna and Child, and the little boy in the right foreground, and at the same time gives the altarpiece a golden glow that suggests the salvation awaiting the donors.

While the altarpiece heralds the baroque style of the following century, it is also a fully Renaissance work in its stately monumentality, measured rhythms and intellectual complexity. It is at the same time Venetian in its richness and Italian in its subtlety. But it is above all Titianesque in its invention and its ability to combine these various elements.

—Jane Nash Maller

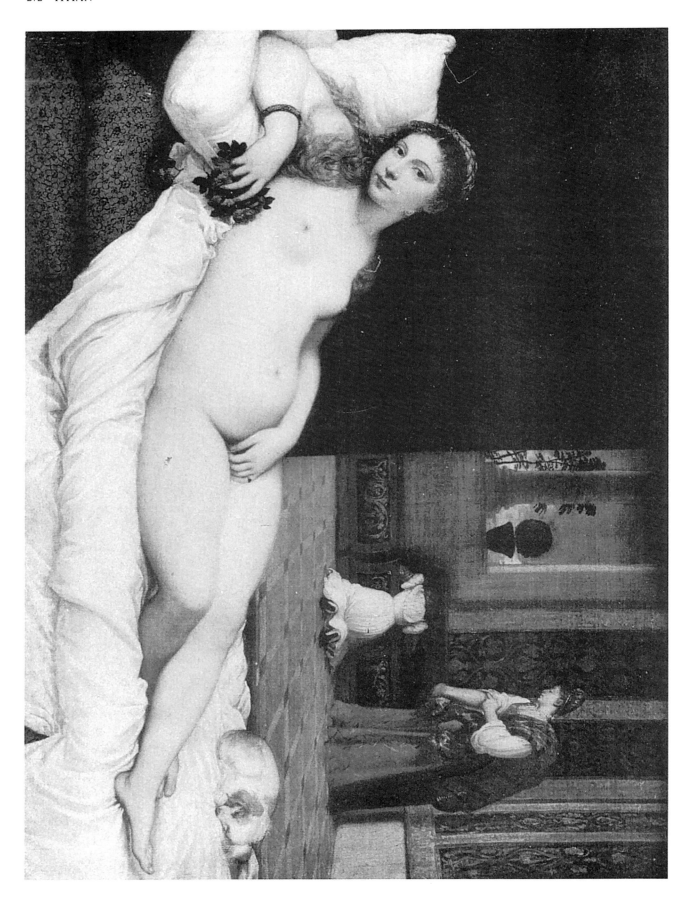

Titian (c. 1480-85—1576)
The Venus of Urbino, 1538
7 ft. 3 in. × 8 ft. 9 in. (216 × 263 cm.)
Florence, Uffizi

Bibliography—

Reff, Theodore, "The Meaning of Titian's *Venus of Urbino,*" in *Pantheon* (Munich), 21, 1963.

When Guidobaldo della Rovere wrote to Titian about purchasing the *Venus of Urbino* (1538, Florence, Galleria degli Uffizi), he referred to the painting simply as "la donna ignuda." There is no question that the woman in the painting is a specific though as yet unidentified person; we see the same model in a blue dress in the painting known as *La Bella* (1536, Florence, Palazzo Pitti) and again in the *Woman in Fur* (c. 1535, Vienna, Kunsthistorisches Museum). The *Venus of Urbino* received its current title only later, and the question of whether this is indeed a picture of Venus or simply a portrait of a nude woman is still disputed.

The painting is clearly derived from Giorgione's *Sleeping Venus* in Dresden, a work which Titian revised after the earlier master's death. Like Giorgione, Titian adopts the *Venus Pudica* pose common since antiquity and adjusts it into a reclining position. Titian also follows his predecessor in stressing the soft, feminine beauty of his subject. Nevertheless, the overall tone of the two paintings is strikingly different. Giorgione placed his nude in a landscape; her curves echo those of the hills behind her and she sleeps, suggesting her serene acceptance of her place as part of nature. She is a beautiful image to behold, and we do so safely from our position outside the picture space. Titian, on the other hand, has moved his figure into the bedroom of a rich palace, has given her attendants, and has woken her up. In so doing, he has entirely changed her disposition. She now looks at us coyly as if inviting us to join her. Consequently, she has lost the innocence that marked Giorgione's nude; indeed, the *Venus Pudica* pose of her left hand, originally developed as a gesture of modesty, is now one of titillation, and this woman has become not merely nude, but naked, not only sensual, but sexual.

Titian makes the most of this transformation, creating one of the most erotic figures ever painted. Her soft body, molded in creamy tones, undulates across the bed. Her hair caresses her shoulder as she luxuriates against a pair of pillows. The deep green of the drapery behind her helps make her body stand out, while the red of the bed below her echoes the rosy blush of her cheeks.

But who is this woman? She is certainly not the mother of Giuliano della Rovere as suggested in the past, nor his wife, for it is hard to imagine Giuliano referring to his wife simply as a "nude woman"; moreover, she was only thirteen when the picture was painted. This has not stopped some writers from suggesting that she might be some sort of idealized bridal figure, however. Theodore Reff in particular has pointed out that the picture does include a number of references to marriage, such as the sleeping dog, a traditional symbol of fidelity; the bouquet of roses from which one has just fallen to suggest her deflowering; the potted myrtle plant on the window ledge; and the busy activity at a marriage *cassone* in the background of the scene. On the other hand, as scholars from Tietze to Hope have argued, her coy look and gesture, her setting and attendants, and the presence of the dog, which could signify bestiality and luxury as much as fidelity, suggest that the picture might well be what it first appears: an erotic portrait, perhaps of one of the many courtesans who prospered in sixteenth-century Venice. (C. Hope, "A Neglected Document about Titian's 'Danae' in Naples," *Arte Veneta,* 31, 1977, 188-9 and *Titian,* New York, 1980, p. 82). Certainly Manet must have thought so when he chose the *Venus of Urbino* as the model for his *Olympia.* At the same time, however, one cannot so easily dismiss the idea that this may also be Venus. Myrtle and roses were both attributes of the goddess, and the nude's pose, of course, also brings this identification to mind. She was, moreover, associated with love in all its aspects, and she served as patroness of prostitutes as well as brides. Finally, rather than trying to limit oneself to a single interpretation of the work, it may be more useful to regard it as Titian's witty play in which he explored the multiple implications associated with a single image. In fact, the *Venus of Urbino* was the first of a series of similar figures to which he would return throughout the following decades, placing other "Venuses" with organ players and lute players, or transforming them into images of Danaë to appear in yet other canvases. In so doing, he has given art historians subjects for endless fascinating argument.

—Jane Nash Maller

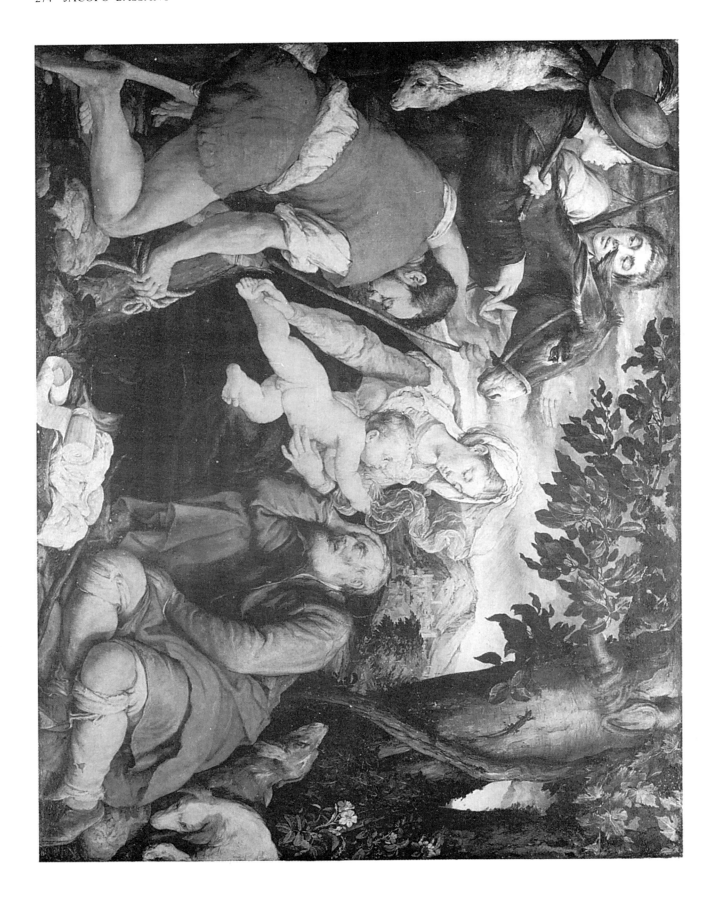

Jacopo Bassano (c. 1510–92)
Rest on the Flight into Egypt, late 1540's
46³/₈ × 61 in. (117.9 × 154.9 cm.)
Milan, Ambrosiana

The *Rest on the Flight into Egypt* at Milan is thought by most authorities to date from the late 1540's and shows what was to become Jacopo's characteristic blend of a rarefied and elegant figure style, which he learned from Parmigianino, and his own innate predilection for the vernacular and countrified. This unique combination of the courtly and the humble accounts for much of the charm of Jacopo's art; peasant mixes with courtier, and courtly elegance inspires the gesture of pose of some humble artisan. In this painting Joseph has only his rich cloak, added almost as an afterthought, to separate him from the subsidiary characters in the composition and to indicate his importance in the narrative, but other than this, he is dressed like a beggar with his leggings in tatters. Even the clothes of the other travellers, who look like some local lads from Bassano, are in better condition. The Virgin, however, in her pristine beauty, is depicted as an aristocrat's daughter, and dressed according to tradition, a blue mantle over a rose gown. She possesses grace and elegance, her costume disposed about her limbs with fastidious attention given to every minute fold. This highly artificial refinement is what many scholars mean when they describe the artist's style as Mannerist. The paint is applied with a buttery richness which is a sure sign of an artist who delighted in the physical act of painting. The work is painted in a high key, using colours generally earthy in tone and of limited range.

The densely structured composition with its tightly interlacing forms rests on a foundation of two diagonals, that of Joseph's languorous body and the more vigorous figure on the left, shown tying the donkey to the stump of a tree. Together, these constitute a pyramidal shape lying in the shallow space of the picture, with the child, as befits his importance, lying at its apex. The cutting of the figures at the sides of the painting does not necessarily indicate loss of some of the picture; it is a favourite device of the artist's which he used to suggest movement and to heighten the sense of activity by crowding the scene. In this and many other examples the narrative is pressed into a stage of limited depth with distant landscape views visible through the rare openings in the congested compositions. Often these are representations of the artist's native town and the nearby mountains in the hinterland of Venice.

The co-mingling of the rustic and courtly, a constant feature in Bassano's work, can take many forms. Here, the crouching traveller on the left, who has no place in the biblical narrative, has an exact counterpart in the Edinburgh *Adoration of the Magi* and he reappears as the Good Samaritan in the Royal Collection at Hampton Court. He is a timeless, everyday type in a humble role, with the weathered features of a countryman. He wears short breeches and has his sleeves rolled up as much to allow Bassano to display his skills in representing the muscles of his forearms and legs as for reasons of work. Although the figure in this complicated pose is crucial to the narrative in the Hampton Court painting, he is entirely extra-neous in the Milan and the Edinburgh works, yet he is awarded a prominent position in both these compositions. Such seemingly redundant figures are accounted for by the fact that they are quotations from one of the most important and influential works of the 16th century: Michelangelo's drawing usually referred to as the *Battle of Cascina Cartoon*, which was known throughout Italy from contemporary prints. Such figures are display pieces through which the artist shows his skill. In the paintings of the 1550's such as the Copenhagen *Beheading of St. John the Baptist* or the later *Adoration of the Magi* at Vienna, the artificiality is taken even further with Jacopo now imbuing all the figures in the composition with an unreal physical grace that is the antithesis of naturalism. In the *Beheading of St. John the Baptist* even the executioner is possessed of a balletic air which is entirely at variance with his robust, athletic form and gruesome task.

In the cramped, over-full composition of the Milan work, the Virgin and Joseph alone attend to the Child. They form a centre of calm veneration and familial warmth in the painting. The other figures concern themselves with the journey and show no awareness of its significance, which is to escape into Egypt and thereby save the child from Herod's attempts to murder him. The motif of the child moving with such spirit and energy across the Virgin's lap in pursuit of her veil is found in Raphael's *Bridgewater Madonna* at Edinburgh and Michelangelo's *Taddei Tondo* in the Royal Academy, London, but the baby that Bassano paints is all his own; the idea alone is borrowed. Joseph is transfixed by the child and gazes in adoration while Mary's hands are gently protective but do not restrict his movement. The atmosphere is serene and calm. This is truly a rest on a strenuous journey and both Mary and Joseph sit, as if tired and thankful for their escape, silently in communion with the baby. This area of the composition falls within the Venetian tradition in religious painting termed *Sacra Conversazione*, in which the Virgin and Child, possibly with attendant saints and other figures are shown as if embraced by the one mood of mediative calm and possessed of the same thoughts: a mute exchange of ideas. In this Jacopo shows his talent for investing his figures with the suggestion of a rich inner life. This area of repose is counterbalanced by the bustle of the other travellers and their animals, depicted in their humble rusticity in which the artist always delighted.

The painting can be enjoyed at any number of levels, for its intimacy in depicting the Holy Family without rhetoric or formality, for its suggestion of summer in the country, and for its realism in the landscape and still-life elements. However, the matter-of-fact depiction often conceals a deeper and more sinister meaning. The stump of the tree, the pieces of cloth in the foreground, and the lamb suspended from the shepherd's shoulder can also be read as references to the death of Christ.

—David Mackie

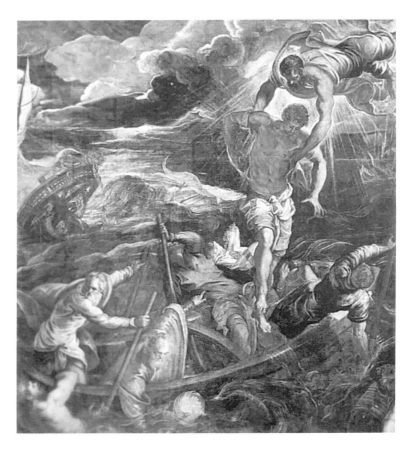

Tintoretto (1518-94)
St. Mark Freeing a Slave, 1548
13 ft. 7³/₈ in. × 17 ft. 9 in. (415 × 541 cm.)
Venice, Accademia

This vast picture, by causing a scandal at the time of its completion in 1548, first drew the kind of hostile publicity to Tintoretto which his explosive temperament apparently needed and which continued throughout his long life. The authorities of the Scuola di S. Marco, one of the prestigious charitable societies of 16th-century Venice, who had commissioned the picture, already had a large and famous picture by Paris Bordon—the *Doge and the Fisherman's Ring* (Venice, Accademia)—as well as illustrations of various miracles of St. Mark. Tintoretto's subject is drawn from *The Golden Legend*. A slave belonging to a wealthy nobleman of Provence was sentenced to be blinded and to have his legs broken because he had venerated the relics of St. Mark against his master's orders. But when the punishment was beginning St. Mark himself flew down and stopped it.

This subject had already been illustrated as one of a series of bronze reliefs by Jacopo Sansovino in St. Mark's basilica at Venice, and Sansovino's work exercised a strong influence on Tintoretto's picture. It is also likely that Tintoretto had some indirect knowledge of Michelangelo's fresco of the *Conversion of Saul*, which at that time had only recently been painted in the Cappella Paolina of the Vatican. But Tintoretto's picture is far more brutal than Sansovino's relief, or even Michelangelo's fresco, and it was probably its very violence and the unpolished vigour of its technique which aroused such hostility in some of the members of the Scuola that Tintoretto withdrew it in pique and had to be begged to return it. There had been a similar outcry on the part of the more conservative elements in Venice on the reception of Titian's dramatic altarpiece of the *Assumption* for the church of the Frari, thirty years previously. But that work, though the extent of its animation was revolutionary at the time, has a degree of humanity and nobility which is lacking in Tintoretto's picture.

The airborne St. Mark may be invisible to the other figures—at least none of them is looking at him. He is shown flying down and also inwards, violently foreshortened. Such an attitude could obviously never be studied from a living model, but we know that Tintoretto used clay or wax models for his more elaborate attitudes. The picture as a whole is not only violent, but also extraordinarily callous, even inhuman. None of the spectators express any sign of sympathy with the victim, or condemnation or relief at his rescue. And as usual with Tintoretto hardly any of the main figures show more than a little of their features. Most of them are looking down, thereby causing strong foreshortening of their faces. As to the technique, it is only necessary to think back, for a moment, to the delicate nuances of tone which Titian, at this moment (1548) was applying to figures of equal grandeur to consider Tintoretto's rapid way of painting—his abrupt transitions from light to shadow, or his naked brush strokes—raw and even slapdash. After finally wearing down opposition to this picture Tintoretto followed it with others illustrative of further miracles of St. Mark (now divided between the Accademia at Venice and the Brera at Milan).

—Cecil Gould

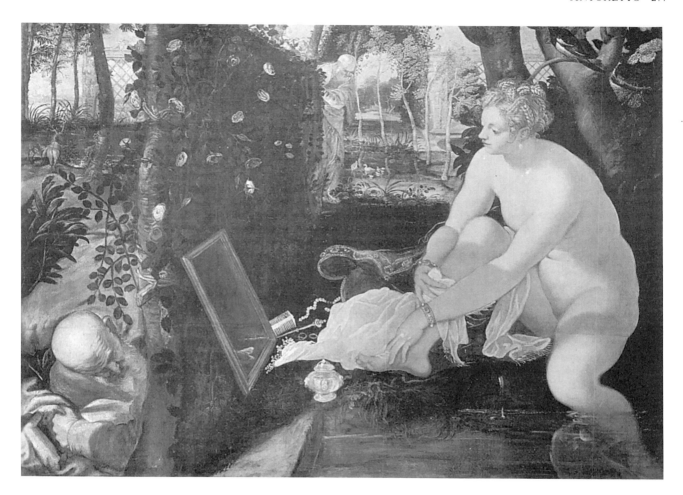

Tintoretto (1518–94)
Susanna
57$^1/_2$ × 76 in. (147 × 194 cm.)
Vienna, Kunsthistorisches Museum

The story of Susanna, in the Apocrypha, is similar in its duplicity to that of Joseph and Potiphar's wife in the Old Testament. When Joseph declined the invitation of Potiphar's wife to share her bed she accused him of trying to seduce her. In Susanna's case the elders said that if she did *not* sleep with them they would say they saw her sleeping with another man. Her refusal led them to carry out their threat, causing her to be sentenced to death. She was only rescued when Daniel, by means of brilliant trick questions, exposed the falsehood of the elders, who were then executed.

Tintoretto's magical picture of this subject fully encapsulates the essentials of the story—the innocence of Susanna and the menacing evil of the elders. We are to suppose that she has not yet seen them—not quite. The elder in the background has only just started to creep round the far end of the hedge, and the one on the left, crouching conspiratorially, has only just pushed his head round the nearer end of it. Susanna herself is still admiring her own beauty in the glass which is propped up against this very hedge.

From a visual point of view this picture is unique in Tintoretto's work, and indeed in western art. The naked Susanna, who echoes, fairly distantly, a famous antique marble status of the crouching Venus, is unusually large for Tintoretto in relation to the surround. And the strong, direct light on her body and on the white drapery at her feet, as well as on the silver vase, discarded pearls, comb, and pin, is both theatrical and unreal. The magical unreality is increased by the restriction of the colours in the main, to orange and green, and also by Tintoretto's strange device of painting a few large and very distinct leaves in order to symbolize a whole tree.

A more or less full-frontal nude, like this Susanna, would have been frowned on at a time—the mid-16th century—when the Inquisition was interfering with deadly effect into as many lives as possible. The picture must therefore have been intended for a private house, and for someone who was powerful enough to deter interference from the Church. Tintoretto's biographer, Ridolfi (1648), notes that in his time the picture was in the house of the painter, Nicolo Renieri, but the name of the original patron is not known.

—Cecil Gould

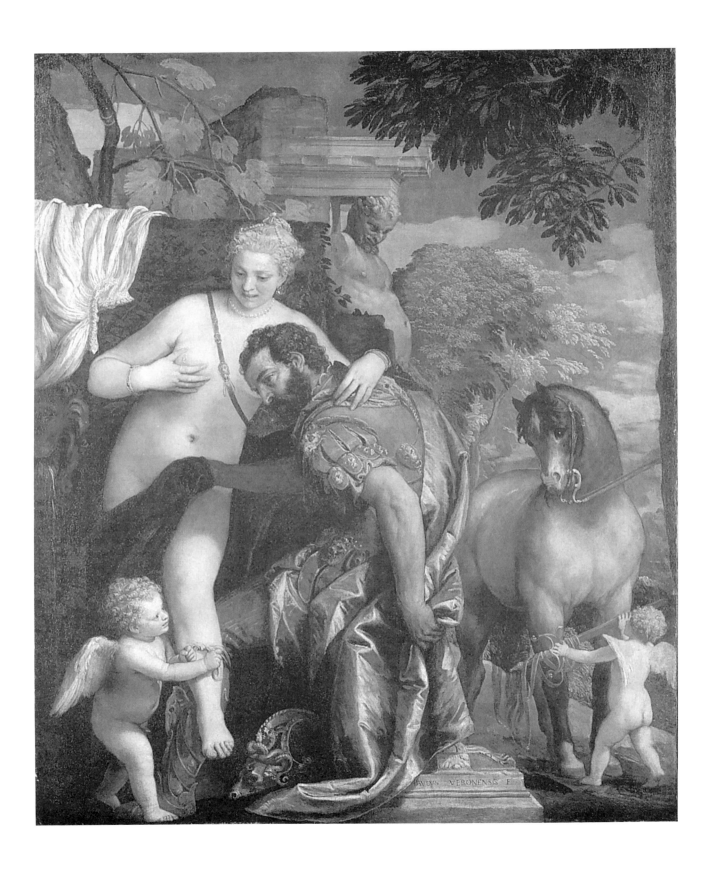

Veronese (1528–88)
Mars and Venus
6 ft. 7³/₄ in. × 5 ft. 3³/₈ in. (205 × 161 cm.)
New York, Metropolitan

If the demand in the Renaissance for pictures of the Madonna and Child was so great as to make it very difficult for a painter to impart real originality to the subject, in pictures of classical mythology it was often the reverse. By the mid-16th century, when Veronese was active, this genre was still a fairly recent development. There were few Greek or Roman originals available as prototypes—particularly in Venice—and painters who had long been accustomed to basing their religious compositions on the work of their predecessors and then trying to introduce variations of their own evidently felt the lack of such guidance when treating mythology. It is only necessary to remember that the design of one of the earliest of all Italian Renaissance mythological paintings—Botticelli's *Birth of Venus*—is based on that of a *Baptism of Christ* to understand the artist's dilemma and his solution of it.

Veronese's *Mars and Venus*, one of the most beautiful of his rare mythological subjects, illustrates this problem. The pose of Venus derives from an antique marble like the Venus de' Medici (though that particular one may not have been known until later). And the strange attitude of Mars, half lying down and half propped up, seems to derive both from an antique relief and from a famous Venetian painting which had itself drawn on the same antique source. The relief, which was well known in the Renaissance, is called the Meleager Sarcophagus and shows a dead body carried with its near arm hanging down. Renaissance artists had drawn on this in pictures of the entombment of Christ, and in Titian's version, now in the Lou-

vre but at Mantua in Veronese's day, the attitude of the dead Christ is very similar to that of Veronese's living Mars. The idea of using a dead body as model for a live one evidently did not deter Veronese, whose imagination, as is clear from the totality of his work, evidently functioned primarily in visual terms rather than intellectually.

It is perhaps not surprising that the dependence of both figures on such different visual prototypes should result in a picture in which the action is far from clear. Mar's lassitude may be merely a consequence of having just made love to Venus all night, but in that case why has he kept his armour on? There are three other possible clues, but none of them is explicit. One of the little Cupid holds back Mar's horse, presumably indicating a preference for love over war. Mars covers Venus's pudenda with part of her cloak, and she herself presses milk from her right breast towards no one in particular.

A final uncertainty concerns the origin of the picture. It belonged in the 17th century to Queen Christina of Sweden, most of whose collection was originally formed by the Emperor Rudolf II who reigned from Prague at the end of the 16th century and early in the 17th. He may indeed have commissioned Veronese's picture, whose abstruse but erotic subject would have been in line with his taste. But, as with many other things in the history of Renaissance art, this cannot be proved.

—Cecil Gould

Veronese (1528–88)
The Feast in the House of Levi, 1573
12 ft. 2½ in. × 42 ft. (555 × 1280 cm.)
Venice, Accademia

Bibliography—

Fehl, Phillips, "Veronese and the Inquisition: A Study of the Subject Matter of the So-Called *Feast in the House of Levi*," in *Gazette des Beaux-Arts* (Paris), 58, 1961.
Delogu, Giuseppe, *Veronese: La cena in casa di Levi*, Milan, n.d.

The *Feast in the House of Levi* is the largest of Veronese's famous pictures of feasts, and one of the biggest pictures in the world. It is also the finest of Veronese's pictures of this kind. It shows him doing what he most liked and what he did best—painting figures of extraordinary elegance, dressed in magnificent clothes of very varied colours and textures and set against overpoweringly splendid architecture. Until a little before the end of his life his art had dwelt on the surface of things—on visual splendour rather than on the deeper emotions or the more profound of Christian mysteries; and this is relevant to the history of this picture, whose legend is almost as famous as its inherent quality.

It was on account of this picture, which was painted for the refectory of the monastery of SS. Giovanni e Paolo at Venice, that Veronese was brought before the Inquisition in 1573. The fact that the picture replaced one of the Last Supper by Titian which had been destroyed in a fire has led to the popular assumption that this was the original subject of Veronese's picture. This theory seemed to receive some support from a remark by one of the Inquisitors at Veronese's examination (the minutes of which, by an unusual chance, are preserved) which uses the words "last supper of Our Lord." But the subsequent sense of the proceedings leave no doubt that this was a slip of the tongue on the part of the Inquisitor. Not even Veronese would have dared to introduce the decorative accessories—the parrots, monkeys, dwarfs, and soldiers—who appear in the canvas if the subject had been the Last Supper. And the minutes of the examination make it clear that the original subject was the *Feast in the House of Simon*. This was the occasion when Mary Magdalene washed the feet of Christ, and the Inquisitors' first complaint was that should have been included in the picture and was not. During his interrogation Veronese admitted what was evidently a major item in his personal creed—that when faced with a large canvas he liked to include certain figures for decorative effect even if there was no biblical justification for them.

In the end Veronese escaped punishment merely by changing the name of the picture from *Feast in the House of Simon* to *Feast in the House of Levi*—an occasion very briefly mentioned in a few words by St. Luke with no details and therefore with freedom for the artist to interpret as he wished. In order to take no chances the revised title was inscribed in bold letters on the left of the canvas, together with the biblical authority.

During the Napoleonic wars the picture was cut into three pieces vertically to facilitate transport to Paris. In the 1980's it was cleaned with sensational results. It was found on that occasion that the pale cream colour of the sky was a later overpainting and that Veronese's own sky, now revealed, was midnight blue.

—Cecil Gould

Jacopo Sansovino (1486–1570)
The Loggetta, 1538–45
Venice, Piazza San Marco

The *Loggetta* (commissioned 1537, constructed 1538–40, sculpture completed 1545 with assistance of Danese Cattaneo and Tiziano Minio, destroyed and rebuilt after the collapse of the companile in 1902) at the base of the campanile in the Piazza San Marco exemplifies the best of Sansovino's architectural and sculptural genius and expresses with classical grandeur and pomp the Venetian myth of the perfection of Venice. Its function, like the earlier wooden loggia it replaced, was to provide a sheltered, elevated, and privileged dais for the nobles of Venice to view processions and festivities in the Piazza San Marco as well as to give them a place to meet before and after attendance at the Sunday meetings of the Great Council.

As part of his plan of the early 1530's to regularize and enlarge the Piazza San Marco, Sansovino isolated the medieval companile from surrounding buildings and made it into a free standing lynch pin which helped to unite the spaces of Piazza and the Piazzetta more fully than before. In order to relate the now more visible and even more austere shaft of the bell tower with the much more festive and sculptural facades of the church of St. Mark's and the Library (which Sansovino had just begun to construct on line with the east flank of the campanile), it must have been clear from the beginning that the old wooden loggia would have to be replaced with something more grand, even before lightening gave him the chance in 1537 by collapsing part of the campanile and destroying the loggia below. The new loggia would also have the advantage of better defining the axis of the Piazzetta, marked at either end by the pair of granite columns near the water and by the clock tower at the entrance to the Mercerie, as well as more strongly articulating the transition to the major cross axis of the Piazza, marked by the churches of St. Mark's and San Geminiano (the latter now destroyed). Finally, it gave a new monumental and majestic focus to ducal processions as they came down the Scala dei Giganti, through the Porta della Carta, and out into the Piazza.

In response to its important role in the governmental and ritual life of the republic the Loggetta's sculptural program (perhaps invented by Procurator Antonio Capello) was especially grandiloquent. The four bronze classical deities symbolized the spirit of what the Venetian wanted to believe gave their government its stability and renown: wisdom and ingenuity (*Minerva*), dominion and harmony (*Apollo*), commerce and eloquence (*Mercury*), and tranquility and security (*Peace*). In the central relief in the attic was the embodiment of Venice as *Justice* seated on the throne of wisdom with two river gods at her feet signifying her mainland empire. The two flanking reliefs were *Jupiter* and *Venus*, embodiments respectively of Crete and Cyprus, and, therefore, signifying the Venetian empire at sea. Swags, trophies, and winged victories completed the program by suggesting that Venice was ever victorious.

Sansovino gave dramatic life to this program not only by the animated *contrapposto* of each of his exceptionally beautiful bronze sculptures in the deep inches flanking the arches, but also by the relationship of one figure to another according to a pattern of rhythmic syncopation. The *contrappostos*, gestures, and glances of *Minerva* and *Apollo* (who originally held a lyre) are nearly identical, yet one is female and clothed in armor while the other is male and nude. Similarly, *Mercury* and *Peace* have closely similar costumes and contrappostos, but the male deities who flank the central arch and the female deities who flank the outside arches have been related to each other in an equally carefully calculated formal response and counterpoint. Sansovino not only drew inspiration for the individual sculptures from Michelangelo (e.g., *Mercury* from *St. Matthew*, *Apollo* from *The Risen Christ*), but also the complex integration of the entire group was learned from Michelangelo's *Slaves* for the Julius Tomb. Yet in the final analysis Sansovino's works were much more classicistic than Michelangelo's, the *Apollo*, for example, being closer to the *Apollo Belvedere* than Michelangelo's *Risen Christ*.

Sansovino's design for the architecture was also classicistic, since he began with the motif of a Roman triumphal arch. He made it uniquely his own, however, by making it more elaborate sculpturally and by using a wider range of materials than any ancient prototype. The paired Corinthian pilasters which flank the sculpture niches and the paired marble Corinthian columns with the entablature breaking out over their capitals create a rich play of light and dark across the surface. The four pairs of strong verticals that cut across the horizontal entablatures of the design communicate a sense of support balancing the load. But, since the columns support nothing, and since the relatively thin and narrow pilasters terminate in an open balustrade, the verticals seem to soar like the pilasters of the campanile to which they were intended to relate. At the same time the attic and balustrade provide strong horizontal planes which relate to the horizontality and sculptural richness of the facades of the Library and St. Mark's. Integration was also achieved by the lavish and expensive materials (red Verona marble, white and grey Carrara marble, dark green *verde antico*, creamy Istrian stone, rare varicolored oriental marble columns, and bronze sculpture) which created a warm harmony of color and texture keyed to the facades and pavement in the rest of the square. In short, as a perfect complement to the myth of Venice expressed by the program of sculpture, Sansovino's design was an eloquent expression of harmony, unity, triumph, wealth, abundance, stability, and *romanitas* (Romanness), with all its implications of longevity, empire, and dominion.

—Loren Partridge

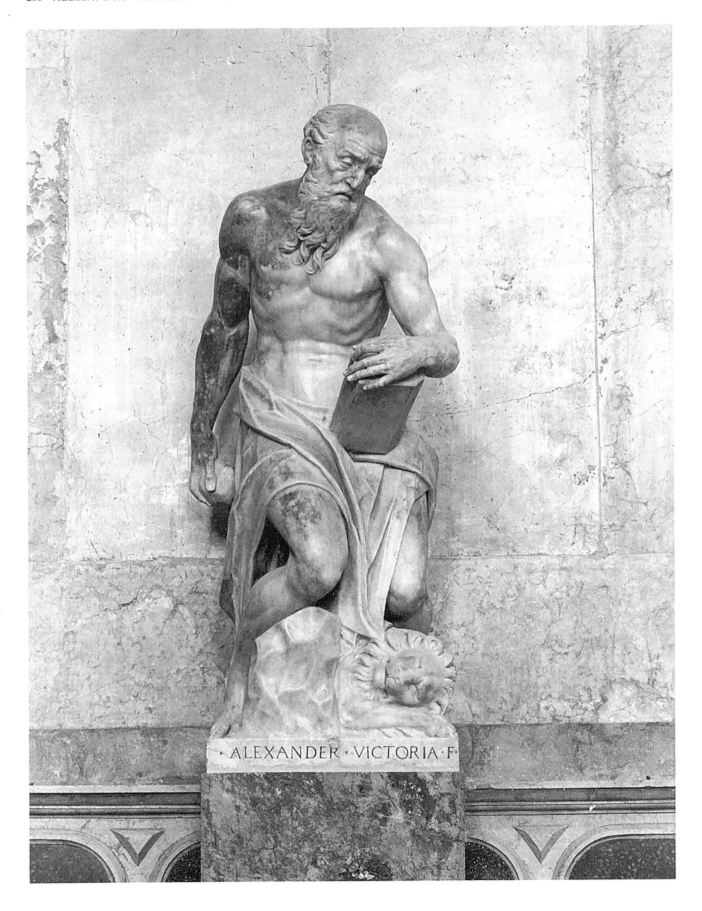

Alessandro Vittoria (1525–1608)
St. Jerome, c. 1576–84
Marble; 5 ft. 6¹/₂ in. (169 cm.)
Venice, SS. Giovanni e Paolo

Alessandro Vittoria's deeply sad *St. Jerome* kneels upon a faceted rock; his knee rests above the face of the small lion whose thorn-pricked paw he had healed, according to legend, while he was translating the Latin Vulgate at the monastery of St. Paula in Bethlehem. The *St. Jerome* is bearded and balding, his gaunt face lined with the weight of his penitence in the Syrian desert, where he would fight off sexual hallucinations (those "fires of concupiscence" as the *Golden Legend* puts it) by beating at his chest with the rock he clutches in his right hand. His left hand rests on a book, emblematic not only of the Vulgate, but also of his earlier study of pagan, classical texts, for which Christ had rebuked him in a vision. Rhythmical accents nicely echo in the spiraling tufts of the saint's beard, the arches of his ribs and pectorals, the curved fingers on the book the folds of drapery across the thighs, and the lion's halo of mane, all splendid focal passages set against the long S-curve of this *figura serpentinata* design.

Vittoria's over-life size figure of St. Jerome was carved for a niche in the Scuola di San Fantin, Venice, once the seat of the joint confraternities of St. Jerome and S. Maria della Giustizia, according to Pope-Hennessy. It is thought to date between c. 1576–84, and is signed at the front of the plinth, ALEXANDER.VICTORIA.F. Today it is on the first altar at the left in SS. Giovanni e Paolo, Venice.

So Leonardesque are the romantic moodiness and the accents of anatomical display in Vittoria's *St. Jerome* as to pose the question whether the sculptor had seen Leonardo's panel painting of St. Jerome (c. 1483; Vatican Gallery). In style this marble is quite unlike the generalized *maniera* of the earlier, standing figure of *St. Jerome* Vittoria had carved in the mid-1560's (Church of the Frari, Venice), especially in its un-

real condition of wholly tensed musculature, which recalls Bandinelli's famous *Hercules and Cacus* (1534; Florence, Piazza della Signoria), its decorative physique a mere "sack of nuts" in the view of Michelangelo. Vittoria's later marble *St. Jerome* pointedly reiterates both the figural stance and major motifs of Leonardo's panel. Of the latter, Kenneth Clark has said that "Leonardo's figure is a great invention. It stands midway between Signorelli and Michelangelo," which argues in favor of its probable impact upon Vittoria. The *maniera* quality of weightlessness so clear in Vittoria's earlier, balletic *St. Jerome* is replaced with a plausible settling movement, as though the saint were falling to his knees, his physical state an evident symbol of his spiritual burden, a concept in keeping with Leonardo's *Trattato della pittura*. Even the lion's face resting upon its cheek like a peaceful housecat, has a touch of romantic humanization that recalls Leonardo's leonine masks, though it is lyrical rather than ferocious in tone. Unlike Leonardo's stable, *quattrocento* pyramid, the design of Vittoria's *St. Jerome* resembles a long, cascading serpentine line. The gaze of Leonardo's saint is one of active projection, an intensely ecstatic yet anguished rapport with the divine directly encountered, whereas the face of the Vittoria is averted, restrained, inward-turning, profoundly sad. It thus marks a considerable personal departure from Leonardo, and from the earlier Florentine prototype in the art of Andrea del Castagno (*Vision of St. Jerome*, 1454, SS. Annunziata). The legacy of Vittoria's elegant *St. Jerome* is clear in Camillo Mariani's colossal stucco figure for a niche in San Bernardo alle Terme, Rome, dated about 1600.

—Glenn F. Benge

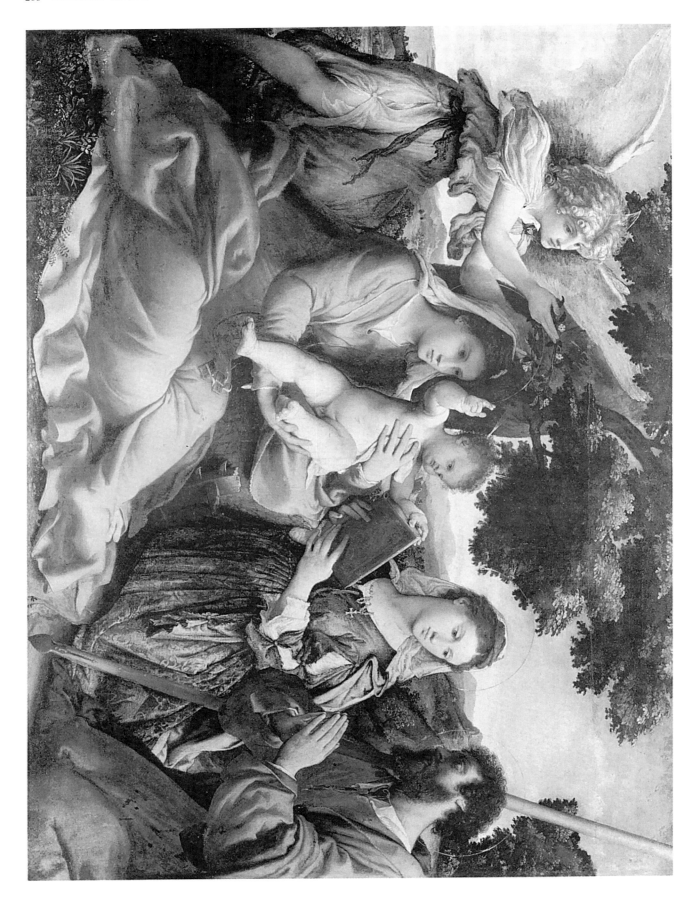

Andrea Sansovino (c. 1467–1529)
The Virgin and Child with St. Anne, 1510–12
Marble
Rome, S. Agostino

Andrea Sansovino's marble group of the *Virgin and Child with St. Anne* is one of the principal sculptural achievements of the Roman high Renaissance. Deemed by Vasari to be "among the best works of modern times," it was from the date of its completion the subject of numerous eulogistic verses composed by admiring humanists. It was commissioned in December 1510 by Johann Goritz of Luxembourg, Protonotary Apostolic and a celebrated humanist, who instituted an annual poetry contest to mark its unveiling on St. Anne's day, 26 July 1512.

The statue was originally located against the third pier on the left of the nave of S. Agostino, beneath Raphael's fresco of the prophet Isaiah, but during the 18th-century restoration of the church it was moved to its present location in the second chapel of the left aisle. It formed the central part of a funerary ensemble divided horizontally into three zones, with Raphael's *Isaiah* above and an altar (since destroyed) below. In the pavement beneath the pier was a tomb intended, but never used, for Goritz, who died in Verona, having fled Rome after the sack of 1527.

The base of the statue bears Sansovino's signature, while the plinth is carved with Goritz's dedicatory inscription in Latin. A similar dedication, this time in Greek, appears above Raphael's *Isaiah*; the painted scroll held by the prophet carries a third inscription, in Hebrew, from *Isaiah* 26:2: "Open ye the gates that the righteous nation which keepeth the truth may enter." This prophecy can be interpreted in the medieval sense of soliciting the entry of the deceased to heaven, which would be appropriate in a funerary context. A more complex Renaissance interpretation, however, suggests the incarnational significance of the phrase, prophecying the Age of the Messiah, an age of wisdom, piety, and salvation, which would have been equally appropriate in the humanist circle to which Goritz belonged.

No record exists of the original appearance of the ensemble, but this can be reconstructed from archaeological evidence. Sansovino's sculpture was placed in a shallow, round-headed niche, which would have framed it tightly, and from which it would have protruded dramatically, in a manner similar to that of his niche-figures in the tombs in S. Maria del Popolo. Per-

haps because of the limitations imposed on Sansovino by the dimensions of the niche, the *Virgin and Child with St. Anne* was not designed to be viewed frontally, but to be seen from the left, by the spectator approaching it up the nave from the church entrance. The same directional axis is found in Raphael's *Isaiah*.

Sansovino had a recent and important prototype on which to base his design, in the numerous versions of the *Virgin and Child with St. Anne* by Leonardo. Of these, Leonardo's celebrated cartoon in London, with its *contrapposto* poses and soft swathes of drapery, seems to have been the chief inspiration for the statue. The contrasting facial types of Sansovino's figures, however, relate to more traditional representations of the youthful Virgin and her elderly mother. The severely classical, idealised features of Sansovino's Virgin were considered to be of "divine beauty" by Vasari, who also praised the strong characterisation of St. Anne.

Technically, the statue is a *tour de force*, being carved from a single block of marble, a feat which undoubtedly represented a challenge to a sculptor of Sansovino's calibre. It was only a few years since Michelangelo had carved his colossal *David* from a single block, a block which Sansovino himself had been interested in working, but which he had lost to Michelangelo because the latter proposed to carve a figure from it without adding any pieces. This had not previously been attempted by a modern sculptor. As well as the challenge to Sansovino of his formidable contemporary, there was the challenge presented by classical precedent, since it was known from the writings of Pliny that the ancients had carved multi-figure monolithic groups. One of the most famous of these, the *Laocoön*, had been recently discovered and was therefore highly topical in 1510, although it turned out to have been carved in several pieces. Sansovino's *Virgin and Child with St. Anne* may in fact be the first life-size monolithic statue of three figures ever carved. It was consequently praised by its humanist admirers as evidence of the superior achievements of modern artists over those of the past, and as signifying the arrival of a new Golden Age.

—Paula Nuttall

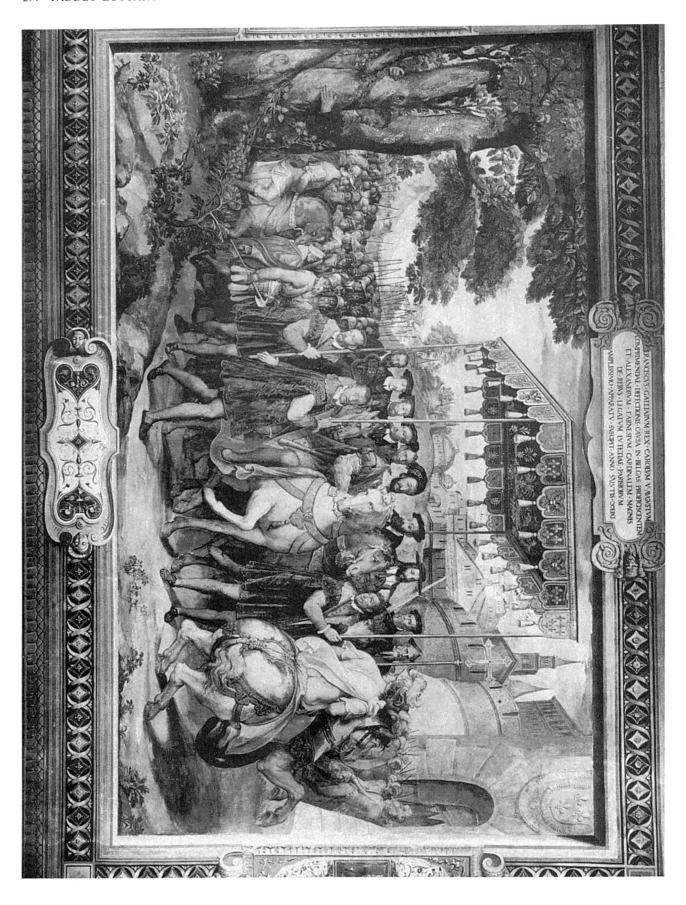

Taddeo Zuccaro (1529-66)
Papal Legate Cardinal Farnese Entering Paris in 1540 with
 Emperor Charles V and Francis I, King of France, 1562-63
Fresco
Caprarola, Villa Farnese

Bibliography—

Partridge, Loren, "Divinity and Dynasty at Caprarola: Perfect
 History in the Room of Farnese Deeds," in *Art Bulletin*
 (New York), September 1978.

It was in 1559 that Cardinal Alessandro Farnese (1520-89), one of the most distinguished and discriminating patrons in Rome, gave Taddeo Zuccaro the commission to decorate his new pentagonal villa which Giacomo Vignola (1507-73) was building for him at Caprarola, about 30 miles north of Rome. Eventually forty-three rooms and spaces in this palace and its *palazzina* in the upper gardens would be decorated, but Taddeo lived to fresco only ten rooms on the northeast side, the so-called summer apartments on the ground floor and the *piano nobile*. This was the largest and most important commission of Taddeo's entire career and, as Vasari pointed out, a major turning point. For the first time in his life he had prestige and economic security (two hundred *scudi* a year), as well as appreciation of his design talents, efficiency in managing a large workshop, and reliability in getting work done.

The most important room decorated by Taddeo at Caprarola is the *salone* on the *piano nobile,* the Room of Farnese Deeds (1562-63), illustrating the early history of the Farnese family (vault), significant events in the lives of the Cardinal's father and brothers (end walls), and four important episodes in the Cardinal's own career as the secretary of state under his grandfather, Pope Paul III (side walls). One of the latter scenes, illustrated here, shows *Papal Legate Cardinal Farnese Entering Paris in 1540 with Emperor Charles V (1500-58) and Francis I, King of France (1494-1547).*

The Cardinal's mission was to try to establish peace between the two arch-rival Habsburg and Valois rulers, who had been upsetting the peace and stability of Europe for over two decades, in order that they might join with Paul III in a military campaign against the Turks and against the rebellious English king, Henry VIII, as well as support the convocation of a general Church council to resolve differences with the Protestants. Cardinal Farnese accomplished nothing at Paris, but Taddeo has created a composition which for a number of reasons makes it appear as if all is well in Christendom. First, even though Francis I is front and center as required by protocol in his capital, in terms of the order of procession first comes the pope's legate, then the emperor, then the king of France—the proper hierarchy from a papal point of view. Second, the group under the canopy, a symbol of the universal spiritual and temporal sovereignty of Christendom, is flanked by Pietro Strozzi, commander of the French forces in Italy, and Anne de Montmorency, the Constable of France, with drawn sword, as if the temporal sword of France were protecting the Church and Christendom. (In fact, rarely, if ever, could this have been said to be the case in the Renaissance.) Third, rather than a scene of negotiation, Taddeo has depicted a triumphal entry into Paris. The warrior in ancient Roman

dress on a rearing horse to the extreme right, derived from Roman coins showing an *adventus regis,* or imperial entry, further transformed visually this specific triumph into a triumph of the Roman empire, a model for the Christian Commonwealth over which the papacy claimed supreme temporal power. Finally, rather than a horse Cardinal Farnese was shown riding a mule, in imitation of Christ's entry into Jerusalem, transforming symbolically the city and Christendom into a New Jerusalem of universal spiritual sovereignty claimed by the pope (or his legate). Although this is a subtle detail, there is no doubt about its significance. In the 16th century the horse/mule question was extremely polemical, since the Protestants delighted in contrasting in writing and woodcuts the proud pope on a horse with the humble Christ on a mule.

The two canopy-bearers in the foreground are portraits of Taddeo Zuccaro to the right and to the left his younger brother Federico, who assisted in painting this room. Dressed in the imperial livery of rich purple coats and bright yellow shirts and tights they not only make a strong visual impact but are shown as active supporters of the notion of a unified, peaceful, universal, and victorious Christian Commonwealth. This bold self-representation suggests prestige and status, but as was increasingly true for all artists of the period, at the price of subservience to the hierarchical and authoritarian social and political order they illustrate.

The scene is shown as if it were a tapestry hanging on the wall recalling one of the Mannerist devices of spatial ambiguity and textural tension used by Raphael and Giulio Romano in the Sala di Constantino in the Vatican, although here the "tapestries" are inflexible, abstract, and paper-thin, without seeming weight, substance, or visible means of support. The graceful curvilinear movement of the rearing horse and the rhythmic pattern of the legs of figures pressed rather close to the picture plane are common Mannerist conventions. But since the scene also appears to be viewed through a window with masonry-like sills behind which is a *tableau vivant* with life-size figures rendered with careful attention to costume and physiognomic likeness, it also approximates a High Renaissance style in its clarity, naturalism, and accessibility. This synthesis of a Raphaelesque High Renaissance style with a Mannerist style is historically important. Often called a Counter Mannerist style, it proved to be ideal for the Counter Reformation. Its stylish Mannerist *sprezzatura* (casual gracefulness masking extreme calculation) appealed to an audience that was visually and socially sophisticated. Its references back to the classics of antiquity and the High Renaissance provided a sense of security and continuity in an age of challenges and doubts. And its propagandistic content spelled out with diagrammatic clarity were suited to a period in which challenges to the established order were met with sharp counter attacks.

—Loren Partridge

Annibale Carracci (1560–1609)
The Farnese Gallery, 1597–1608
Frescoes
Rome, Palazzo Farnese

Bibliography—

Martin, John Rupert, *The Farnese Gallery,* Princeton, 1965.
Highes, Anthony, "What's the Trouble with the Farnese Gallery? An Experiment in Reading Pictures," in *Art History* (Oxford), September 1988.

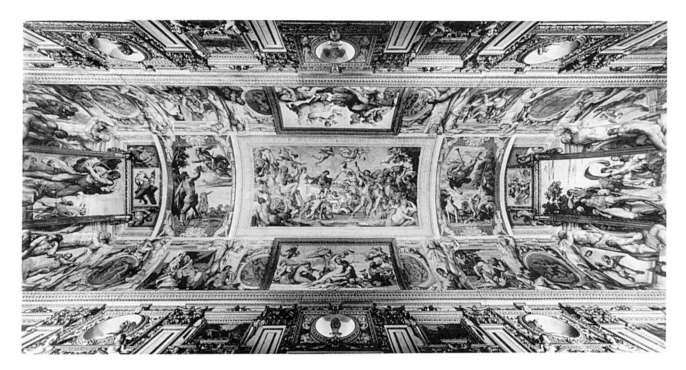

This large, complex, and harmonious ceiling decoration was perhaps the most influential achievement of the early Baroque. It was the final and perfect result of Carracci's synthesis of the idealised naturalism and classical harmony of the High Renaissance with the complexity and inventiveness of Mannerism, invigorated by a new hedonistic verve, formal richness, and physical realism. It contained the seeds both of the energetic immediacy and brilliance of the High Baroque and of the balanced clarity and directness of Baroque Classicism.

Carracci had been summoned to Rome in 1594 by Cardinal Odoardo Farnese specifically to decorate rooms in the family palace there. The achievements of the Carracci and their Academy in Bologna were evidently well known to the Farnese, rulers of the nearby Duchy of Parma and Piacenza, just as knowledge of Correggio's masterpieces in Parma had been one of the seminal influences on the development of the Carracci style. The first room Annibale worked on in Palazzo Farnese, probably in 1595–97, was the Camerino, where he (probably with assistants) painted the ceiling with frescoes of the *Myths of Ulysses and Hercules* (*in situ*), surrounding an allegorical canvas of the *Choice of Hercules* (Naples, Capodimonte), one of his most soberly Classical designs; the subject of the hero choosing between ambitious Virtue and pleasurable Vice was particularly appropriate for a young prince embarking on a career in the Roman church.

The decoration of the neighbouring Gallery, 66 feet long and about a third as wide, presented a more formidable task, and here Annibale certainly had assistance: from his brother Agostino, who came from Bologna in 1597 at the beginning of the work, and later, after their quarrel in 1600, from pupils of the Academy like Albani, Domenichino, Lanfranco, and Badalocchio, all of whom were in Rome by 1602. After that year (in which Agostino died in Parma) Annibale may have taken a less direct part in the decoration; certainly he ceased to function after the onset of his melancholia in 1605. The Gallery was probably finally completed, with the wall decorations, only in 1608. This length of time may not seem very impressive when compared with the astonishingly brief span of four years in which Michelangelo painted, virtually without help, the ceiling of the Sistine Chapel, twice the Gallery's size. But Annibale's creation, while hardly approaching Michelangelo's in grandeur of conception, is more decoratively complex and more richly varied in detail; his great achievement is to combine these qualities not just with an overall harmony of scale and mood, but also with a completely unified illusionistic system which controls the composition of the entire ceiling.

The basic form of Carracci's design derives from Tibaldi's Sala d'Ulisse in Palazzo Poggi (now the University), Bologna, where a cruciform arrangement of framed scenes is open at the corners to fictive sky, against which Michelangelesque *ignudi* perch on illusionistic colonnades. Annibale's composition is far subtler and more densely layered. Its linking component is the architectural illusion, or *quadratura,* of an elaborate entablature rising above the walls of the room (and also opening to the sky at the corners), richly decorated with "stone" herms and garlands flanking "bronze" roundels and naturally coloured pictures, while in front perch apparently real *ignudi.* Against the centre of each side of the entablature is propped a large framed painting; those on the short sides are surmounted by smaller paintings, flanked by fauns posturing against the sky now seen above the cornice. Across the central section between the long sides is a framework supporting three further framed pictures, the largest in the middle forming the centrepiece of the whole scheme. An important contribution to the unified effect is that all the fictive elements, unlike Tibaldi's (whose frames were stucco), are frescoed like the narrative scenes they surround; a precedent for this had been set in Palazzo Farnese with Salviati's Sala dei Fasti Farnesi. But the crucial difference between Salviati's and Carracci's designs is that in the latter's all the illusionistic elements share the same space and scale, thus forming a legible and convincing imaginary framework for the mythologies they contain and point up.

The mythological narratives which are the chief iconographical content of the decoration are generally far from abstruse. It has been proposed (in the absence of any evidence) that the Cardinal's secretary Fulvio Orsini provided a detailed programme, and even that Carracci's intellectual friend Monsignor Giambattista Agucchi contributed ideas; in fact, the subject is evidently the generalised theme of *omnia vincit amor,* epitomised by the battling Cupids in the corners and illustrated by well-known stories drawn chiefly from Ovid. They show love dominating gods and heroes (Diana and Endymion, Hercules and Omphale), deceiving the pure (Diana and Pan) and forcing the unwilling (Cephalus and Aurora), inspiring fatal passions (Polyphemus, Galatea, and Acis), unleashing tragic consequences (Mercury summons Paris to judgement), and immortalising a favoured few (Ganymede). Some of the roundels depict fables connected with the accompaniment of love, music (Pan and Syrinx, the Flaying of Marsyas). The subjects of a few of the scenes are unclear or disputed. What is clear is that they are all arranged visually rather than thematically, paired and related by composition rather than subject. It is even thought that the central picture, the *Triumph of Bacchus,* was originally conceived without Bacchus's own beloved, Ariadne, simply as an allegory of love's other classic accompaniment, wine.

The *Triumph of Bacchus* occupies most of the curved apex of the ceiling's barrel vault and is the climax of the composition. In it, as in the other framed scenes, Carracci abandons the specific references to Michelangelo which enrich the *quadratura* and enters a world full of the happy idealisation of Raphael, the warm sensuousness of Titian and Veronese, and the uncomplicated beauty of the antique; it also encompasses some of the density, humour, and mannered grace of Giulio Romano, Salviati, and Tibaldi. But all is dominated by the joyous vigour of the movement which impels the procession across its stage, sweeping from the left towards the dancing figures and prancing goats in the centre, and fanning out towards the luscious fleshly forms on the right. The exuberant physicality of the figures is also new, and was achieved referring their poses, from whatever source derived—whether Classical, Renaissance, Mannerist, or invented—to a study of the live model. Over 600 drawings for the Gallery survive, most certainly by Annibale, ranging from the smallest details to fully realised cartoons, and bear witness not only to the Carraccis' insistence on Academic methods but also to that devotion to the appearance of the physical world which was to become the hallmark of the Baroque.

—Nigel Gauk-Roger

Mathis Grünewald (c. 1475–80—1528 or 1531–32)
Isenheim Altarpiece, 1508–15
Panel; 8 ft. 9 in. × 10 ft. ⁷/₈ in. (269 × 306.8 cm.) (closed
 dimensions)
Colmar, Musée d'Unterlinden

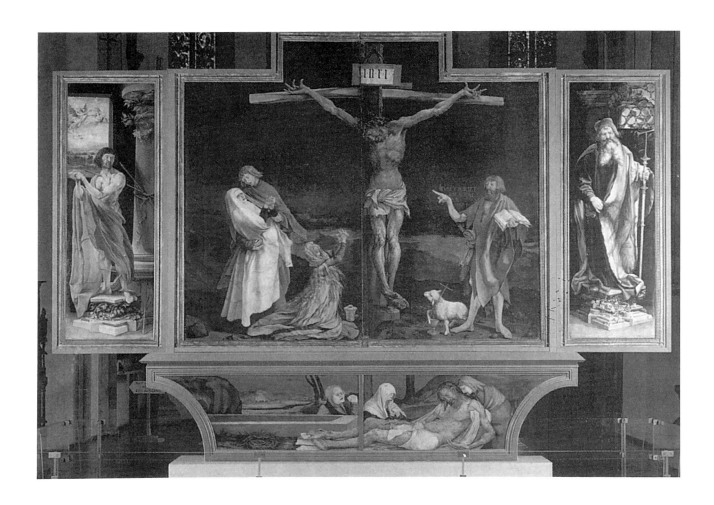

Bibliography—

Kuhn, W., "Grünewalds Isenheimer Altar als Darstellung mittelalterlicher Heilkrauter," in *Annuaire de la Société Historique et Litteraire de Colmar*, 2, 1951–52.

Scheja, Georg, *The Isenheim Altar*, New York, 1969.

Eckert, Georg, *Der Isenheimer Altar: Seine geistigen Wurzeln und sein spirituell-künstlerische Gehalt*, Freiburg, 1973.

Hayum, Andrée, "The Meaning and Function of the Isenheim Altarpiece: The Hospital Context Revisited," in *Art Bulletin* (New York), December 1977.

Richter, Gottfried, *Der Isenheimer Altar des Grünewald*, Stuttgart, 1981.

Richter, M., "Zur Entstehung und Bestimmung des Isenheimer Altars," in *Konsthistorisk Tidskrift* (Stockholm), 50, 1981.

Sarwey, Franziska, *Grünewald-Studien: Zur Realsymbolik des Isenheim Altars*, Stuttgart, 1983.

Cuttler, Charles, "Further Grünewald Sources," in *Zeitschrift für Kunstgeschichte* (Munich), 4, 1987.

The *Isenheim Altarpiece*, commissioned by two successive preceptors of the Antonite monastery at Isenheim, Johan de Orliaco and Guido Guersi, is a composite work. The sculptures of the innermost shrine, depicting Saints Anthony, Augustine, and Jerome, were completed by Nicolas Hagenau by 1505 (a sculpted predella of Christ and the Apostles was by Desiderius Beichel). The painted panels which overlay the sculpted shrine were commissioned by Guersi from Grünewald and completed in 1515, the date on Mary Magdalene's ointment jar. The panels, now displayed separately in the Musée d'Unterlinden, were originally disposed in three stages, united by the interrelated ideas of spiritual salvation, physical healing, and the monastic vocation of the Antonites.

The Antonites were hospitalers primarily concerned with "St. Anthony's Fire" or ergotism, contracted by eating grains poisoned with the ergot fungus, which caused painful burning and putrefaction of the limbs. The altarpiece figured in the treatment of patients and was also a focus of pilgrimage.

The exterior, normally displayed during weekdays, is a gruesome Crucifixion, atop an equally pathetic Lamentation on its predella, and flanked by the healing Saints Anthony, on the right, and Sebastian, on the left (some scholars would reverse these panels). The Crucifixion, down to the anachronistic inclusion of John the Baptist, was influenced by St. Bridget's meditation on Christ's suffering in her *Revelations*: Christ's body is covered with gangrenous lacerations, his head slumps on his chest, and his stomach sinks toward his spine. His shoulders are dislocated. Despite Grünewald's realism, he also employed expressionistic exaggeration: the landscape is a bleak plain with a greenish-black sky, setting off the iridescent colors of the figures. Christ's feet and hands, with their splayed fingers, are enlarged, and his whole body is significantly bigger than the figures beneath the cross. Magdalene, her body lost in a spasm of grief and swirling drapery, is an inspired creation. John the Baptist's words—"He must increase, but I must decrease" (John 3:30)—explain Christ's large scale. Thus, the savior's divinity is recognized even in death. Both flanking saints are shown as living sculptures.

Anthony is threatened by demons charging at a window behind him while Sebastian (possibly a self-portrait of the artist), wringing his hands in imitation of Magdalene, is covered with festering arrow-wounds.

The middle stage, dominated by fiery yellows and reds and by the joy of the Incarnation and Resurrection, contrasts stridently with the exterior. It was normally displayed on Sundays and certain feast days. Mary plays a crucial part in this stage. At the left is the Annunciation, with Gabriel gesturing like John the Baptist; in the center are an angelic concert and a Madonna and Child in a radiant, symbolic landscape. Christ holds a rosary and is wrapped in tattered swaddling clothes foreshadowing his loincloth in the Crucifixion. At the far right is an unusual Resurrection, modified to suggest aspects of Christ's Ascension and the Last Judgment. The rainbow-colored angels serenading a tiny, crowned Mary beneath a baldacchino constitutes the most difficult scene to interpret. Is the small figure the idea of Mary in the mind of God before time, the recently impregnated Virgin who venerates the infant Christ to the right, or is she Mary at her Coronation, crowned with her future glory? In any case, her radiance corresponds to Christ's mandorla in the Resurrection, which allowed the suffering patients to witness the savior's once tormented body levitating and dissolving into light. His upraised arms form the "Omega" which completes the "Alpha" suggested by the Gothic vaults in the Annunciation. Christ was indeed the Alpha and Omega for the Isenheim patients. In his suffering and triumph they found meaning in their own pain.

St. Anthony, founder of the anchorite order in Egypt, was the archetypal monk. The monastic theme dominates the third stage, but the motifs of disease and healing are still present. On the left, in the desert, Anthony meets with St. Paul (the hermit, not the apostle), whose gesture repeats John the Baptist's, and they are miraculously fed by a raven carrying loaves of bread. The landscape contains medicinal herbs used in the treatment of ergotism. On the right is St. Anthony's torment by demons, influenced by Martin Schongauer's famous engraving (c. 1470). The demons are inventive, hybrid animals, except for one pustule-ridden figure in the left corner, humanoid except for webbed feet. He served as a vivid reminder of the illnesses treated by the Antonites. Across from his is a sheet of paper with St. Anthony's lament, "Where were you, good Jesus?" This inscription reminds us that the loss of faith through suffering was to be feared as much as physical pain or death.

As a monumental example of the folding northern European polyptych, only Jan van Eyck's *Ghent Altarpiece* and Rogier van der Weyden's *Last Judgment Altarpiece* in Beaune, also dedicated to St. Anthony and set within a hospital-context, can compare to Grünewald's masterpiece. Like these works, the *Isenheim Altarpiece* is notable for its psychological and theological subtlety. Grünewald consistently suggested the interdependence of suffering and triumph within the Christian perspective. While embodying essential Christian truths, he related his panels to each other, both formally and thematically, and to the specific context and audience of a monastic hospital.

—Linda C. Hults

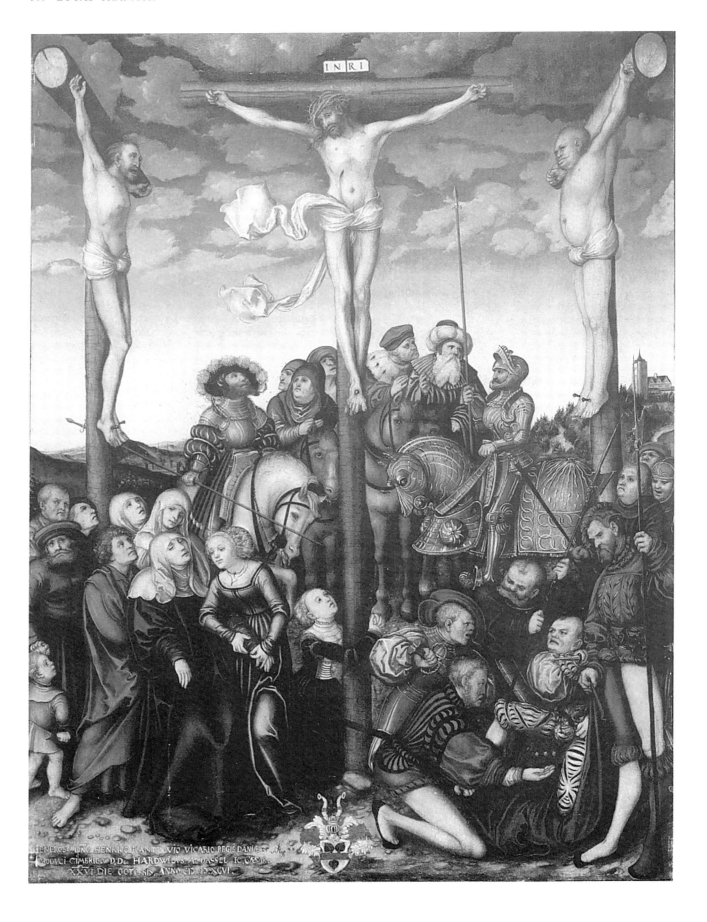

Lucas Cranach (the Elder) (1472–1553)
Crucifixion, 1532
Panel; 30 × 21¹/₂ in. (76 × 54.5 cm.)
Indianapolis, Museum of Art

Bibliography—

Dixon, Laurinda S., "The Crucifixion of Cranach: A Study in Lutheran Reform Iconography," in *Perceptions,* 1 1981.

The humanist scholar Melancthon included Lucas Cranach the Elder in his "Trinity" of great German painters, along with Dürer and Grünewald. Indeed, Cranach came from four generations of painters, and his sons Hans and Lucas the Younger established yet another. He was court painter to the German Electors and a personal friend of Martin Luther. At the same time, Cranach moved in Humanist intellectual circles and painted for Roman Catholic patrons. A tireless worker, he was also a businessman and a diplomat, even serving a term as mayor of Wittenberg. A man of exceptional intelligence and personal popularity, Lucas Cranach was recognized during his own time as a painter of great merit and exceptional industry. He lived eighty-one years, long enough to become a dominant figure in northern Renaissance art.

Cranach was a man of his time, deeply influenced by the tumultuous events of the early 16th century, when the fundamentals of human knowledge and experience were being challenged by such men as Copernicus, Columbus, and Luther. It is therefore impossible to represent his painterly output by a single work. Style and subject matter were dependent upon the intended audience and, in Cranach's case, that audience was extremely diverse. Early in his career, while working in Vienna, he painted in the agitated, hyper-emotional style of the Danube School. A *Crucifixion* from this time (Alte Pinakothek, Munich) is full of the suffering and drama one would expect from Grünewald or Altdorfer. Later, as Court Painter in Wittenberg, Cranach's style assumed a mannered sophistication characterized by rich surface pattern and titillating subject matter (see, for example, the *Fountain of Youth,* Gemäldegalerie, West Berlin). Yet a third way of painting was reserved for the followers of Martin Luther, most of whom were dubious about the place of religious art in their reform movement. It is to this last group of devotional paintings that the Indianapolis *Crucifixion* belongs. Though not as enticing as one of Cranach's hedonistic mythological subjects, it demonstrates the painter's awareness of the religious and political intrigues of his day and identifies him as a painterly spokesman for the Reformation in Germany.

At first glance, the *Crucifixion* would seem to be a conservative depiction of a conventional religious subject. Several similar versions exist (for example, at the Chicago Art Institute and the Yale University Art Gallery, New Haven), indicating that Cranach mass-produced them with the aid of his apprentices to satisfy public demand. The painting shows Christ's cross placed frontally in the center of the composition with those of the two thieves symmetrically oriented at either side. Beneath the crosses are those who have come to view the event—the nonbelievers who gamble for Jesus' robe on his left and the swooning Virgin and her attendants at his right. This arrangement was traditional in medieval iconography, which

placed good and evil at the right and left hands of God. On closer inspection, however, it becomes obvious that this is not a traditional *Crucifixion* at all, but a statement of the rebellious religious views of Martin Luther. Gone are the gilded halos that traditionally surround the heads of saints and holy people. Missing also is St. Veronica with her veil, which bore the miraculously imprinted image of Christ's face. The absence is explicable, however, in the context of Lutheran ideology, which banned saintly intercession and viewed relics such as Veronica's veil as distractions from the pure message of the Church.

Cranach was noted during his lifetime for the realism of his portraits. Accordingly, he included the faces of well-known public figures who were active in Reformation politics within the crowd of onlookers witnessing the Crucifixion. To the right of the cross is a distinctive group of men consisting of a cardinal of the Church, a turbaned Oriental, and an armored warrior. Together they represent the Pope, the Turks, and the emperor, and they bear the features of Pope Julius II, Muley Hassan, Bey of Tunis, and the Hapsburgh Emperor Charles V. Their presence reflects the world political situation in the 1530's, which saw a series of panicked alliances by the popes, the emperor, and the Italian city-states against the infidel Turks. The chaotic dominion of a state insensitive to Luther's teachings is represented by the grimacing, argumentative mob who gamble for Christ's cloak at the lower right, overseen by the bloated crucified body of the bad thief.

The left sector of the panel is populated by those who gaze directly at Christ and who, in fulfillment of Luther's teaching, experience their own personal revelations. The good thief inhabits this sector and, with open mouth, speaks the words: "We receive due reward for our deeds: but this man hath done nothing amiss" (Matthew 27:54). In recognizing Christ, the good thief emphasizes the basic Protestant precepts of revelation and conversion. The centurion, dressed in German armor, also gazes raptly at the cross. Cranach has given him the features of his patron John the Steadfast, whose very name refers to his "steadfast" support of Martin Luther. The monk next to him has features very similar to those of Luther himself, judging from the many portraits by Cranach in which the painter recorded his friend's tendency to corpulence (see the *Portrait of Martin Luther,* Uffizi Gallery, Florence). In the *Crucifixion,* the monk looks to his protector for support of the German Protestant State as Luther did in real life.

Luther declared that the only function of religious art was to instruct. In its simplicity, then, the *Crucifixion* both serves its didactic function and compliments the move toward religious austerity begun by Luther. The division of the scene into sections reserved for the pious on one hand and the infidels on the other reflects the basic Protestant theme of *Sündenfall und Erlösung* (fall and redemption) which formed the basis for the many popular Lutheran propaganda woodcuts produced by the Cranach printing press. Beholders of the *Crucifixion* would have felt the awesome contrast between salvation through good works and damnation by materialism and greed. They would also have recognized the faces of the famous participants in the religious and political intrigues of the day. The *Crucifixion* reflects not only Cranach's mature style, but also points the way to a distinctively "Protestant" way of painting.

—Laurinda S. Dixon

Hans Burgkmair (1473–1531)
St. John Altar, 1518
Panel; 60¹/₄ × 49¹/₂ in. (153 × 125 cm.) (central panel)
Munich, Alte Pinakothek, and Augsburg, Staatsgalerie

Bibliography—

Falk, Tilman, "Das Johannesbild Burgkmairs von 1518," in *Munuscula Discipulorum: Kunsthistorische Studien Hans Kauffmann zum 70. Geburtstag 1966*, Berlin, 1968.

Hans Burgkmair's *Saint John Altar* of 1518 (interior panels in Munich; exterior in Augsburg) was created after a period of relative inactivity in painting, when the artist was involved in designing woodcuts for Maximilian I's various projects. The *Saint John Altar* and the stylistically related *Crucifixion Altar* of 1521 (panel dispersement as for the *St. John Altar*) bear witness to Burgkmair's absorption of Italian Renaissance art from his 1507 trip. Here, this is evident in his adoption of the rich, saturated color of Venetian painting. Though he was an artist of many talents, the *St. John Altar* establishes Burgkmair's reputation today as an important painter of altarpieces. The altar has the traditional northern form of a winged altarpiece. When closed, the exterior panels presented Saints John the Baptist and John the Evangelist on an open loggia. When opened on feast days, the interior panels displayed John the Evangelist on Patmos flanked by Saints Erasmus (left) and Martin of Tours (right).

The intended location and patron of the *Saint John Altar* are unknown, though inferences have been drawn. It has been suggested that because of the appearance of the two Johns on the exterior, the altar was intended for the St. John's Church in Augsburg which had such a dedication. The reason for the inclusion of Saints Erasmus and Martin remain unknown. Fortunately, Burgkmair signed and dated the work. An inscription on a thin filament hanging from John's make-shift desk reads: "IOHANN.BVRGKMAIR/PINGEBAT MDXVIII," and the date is repeated on the exterior: "1518." By the early 17th century, the altar found its way into the Elector Maximilian I of Bavaria's collection where some alterations were made, most notably a reworking of the apparition of the Virgin in the central panel. Perhaps the exterior panels were separated at that time as well.

The strength of the altar lies in its ability to render by pictorial means the significance and power of John's experience. Burgkmair does this ever so gently through a variety of visual dialogues. By presenting visual theses and antitheses, Burgkmair creates a certain visual tension for the viewer causing him to explore, feel, and ultimately to come to a further understanding of the nature of spiritual experience.

The triptych format inherently imparts a sense of balance, and this is played upon here and given added visual harmony by the similarity in ecclesiastical garb of the flanking saints, the harmony of colors, and the landscape that continues across the three panels. Attention is focused on the action of the central panel through the glances of the flanking saints, the central placement of John, and the intense red of his garment. John is framed in the center by the trees grouped around him and the plethora of creatures that animate the landscape. These devices create visual arcs that enframe him on different planes in the fictive three-dimensional space. A forceful diagonal exists between the Virgin and the rays that emanate from her, John's turned head, and the eagle in the lower right. (As John's symbol, the eagle mimics John's pose—an appropriate alter-ego association.) The power of the center is reinforced by the counteracting diagonals of the bent palm tree (adapted from Martin Schongauer's engraving *The Flight into Egypt*) and the cloud bank, thus creating an X.

The wings impart a sense of calmness and stasis. This stability is counteracted by the suggested movement and change in the darkening sky and the subtle momentary effect of the coins dropping from Martin's hand into the beggar's bowl. The lush flora and fauna of the central panel include that found locally and the exotic (the African vegetation and creatures Burgkmair could have observed in the Fugger's collections in Augsburg). The stillness and stability implied in the central panel through the compositional devices are jarred by the seeming movement of the vegetation behind John and the alertness of the creatures; for they have, for the most part, stopped their actions and watch intently. John's active pose—his dramatic head-turning—wild hair, and open mouth give a dramatic sense of the momentary here.

The visual dialogues here between movement and stasis, between harmony and discord, create a certain amount of psychic tension. The source for this disturbance apparent in the atmosphere, the figure of John, and the flora and fauna, is clearly the sudden interjection of the apparition in the sky. It is precisely this apparition of the Virgin that has provoked some discussion. The more common visualization of John on Patmos illustrates Revelation 12: 1–2, that is, the vision of the woman clothed with the sun, and the moon at her feet. Burgkmair's Virgin has none of the apocalyptic attributes, and they do not appear in the preparatory drawing in Stockholm. The drawing shows the Virgin and Child in half-length. According to Tilman Falk, the scene here is not the vision of Revelation 12: 1–2, but is more closely related to Revelation 1: 10–12. Falk sees the figure of John as similar to the earlier medieval portrait-type of the inspired author.

Because the Virgin was repainted in the early 17th century, Burgkmair's original intent remains uncertain. However, though there are conjectures about original intent and meaning, we must deal with the painting as it exists today. The altered image of the Virgin does not detract from the work, but gives a valuable effect. The Virgin appears both near and far at the same time. This hallucinatory, perception-jarring effect allows the viewer to experience the extraordinary event along with John. It alters the viewer's senses in order that he recognize the power and immediacy of the divine message being imparted.

—David Heffner

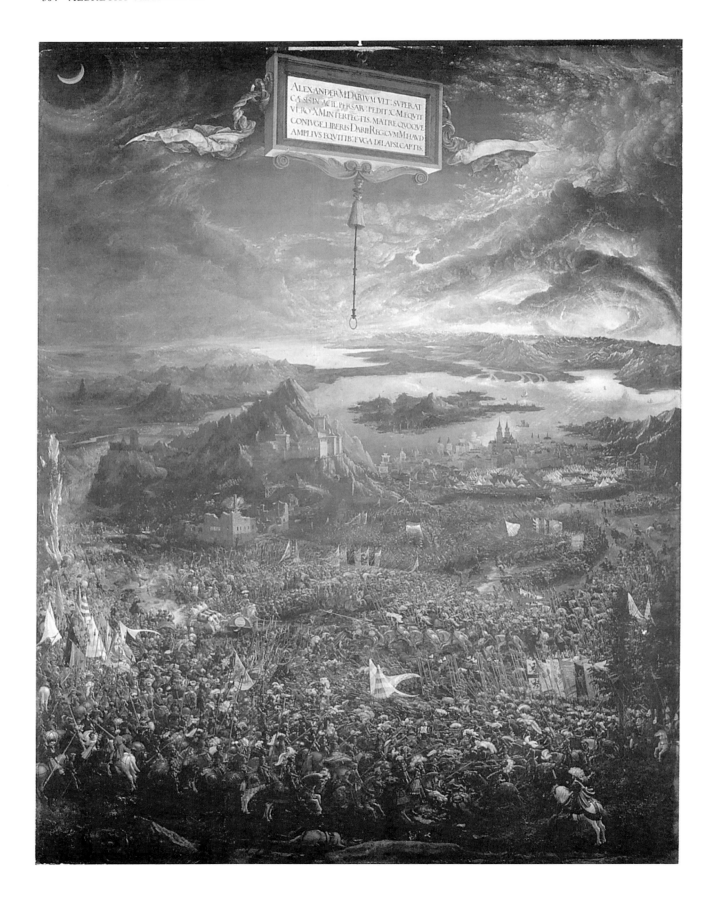

Albrecht Altdorfer (c. 1480–1538)
The Battle of Alexander, 1528–29
Panel; 62 × 47 in. (157.5 × 119.4 cm.)
Munich, Alte Pinakothek

Bibliography—

Buchner, Ernst, *Altdorfer: Die Alexanderschlacht*, Stuttgart, 1956.

Martin, Kurt, *Die Alexanderschlacht von Altdorfer*, Munich, 1968.

Krichbaum, Jörg, *Altdorfer, Meister der Alexanderschlacht*, Cologne, 1978.

The best known of Albrecht Altdorfer's panel painting is the large *Battle of Alexander* in the Alte Pinakothek in Munich. Altdorfer executed the work in 1528–29, having refused the post of Burgomeister of Regensberg in order to concentrate on the commission. It was ordered by Duke Wilhelm of Bavaria for the city. The subject of the painting is the victory of Alexander the Great over the Persian emperor Darius at the battle fought at Arbela on the Issus River in 333 B.C. This is announced by the inscription on an enormous plaque, painted as if hung from the center of the upper frame, bedecked with swirling mantle and pendant tassel.

The viewer's vantage for the battle is from high above it on a precariously narrow ledge of rock that is just visible along the lower margin of the picture. His gaze runs uninterrupted to the middle distance. There the surging armies clash in zig-zag waves down a vast slope. Enormous numbers of soldiers in bright costume, helmets with waving plumes, and colorful, shiny armor charge on horseback from left and right. Battle flags and guidons cluster and flare at various points in the great swirl of armies, all the way to the far reaches of the battle. Some are inscribed with the name of one or another of the generals, but they do little to aid us in understanding the strategies of this enormous fray. The astonishing feat accomplished by Albrecht Altdorfer in this painting lies in his combined power to represent so much meticulous detail with so much energy and to produce a powerful and arresting composition in the process.

A great ruined fortress, a high mountain, and a besieged city are in the distance. They appear at the end of a huge, nearly landlocked bay fringed by a whole cordillera of bluish mountain ranges. The earth's own curvature is traced by the horizon. Clouds boil above, ringing the low sun setting at the right and dimming the crescent moon at the distant upper left. The setting sun reminds us that the battle raged throughout one day. The sun and moon are also symbolic of the fact that this is a clash of two hemispheres of the earth.

In the midst of the melee, racing across the scene from right to left along a slight rift partway down the near slope, the flight of Darius in a troika drawn by three white horses can be seen. In pursuit close behind is Alexander the Great on his steed, Bucephalos. The painting is intended as an inspiration to victory over the Turkish armies that had recently invaded Austria and were poised now to threaten all of Europe. Altdorfer, the city engineer, had already aided Regensberg in a practical sense by redesigning and building its fortifications. Here he acts on duke Wilhelm's behest as the stirring propagandist to inspire his countrymen by example of history. Fortunately, in 1529, the very year that Albrecht Altdorfer completed the *Battle of Alexander*, the Turkish invaders were defeated in their attempt to capture Vienna. This was as far west as their invasion was to reach.

—Charles I. Minott

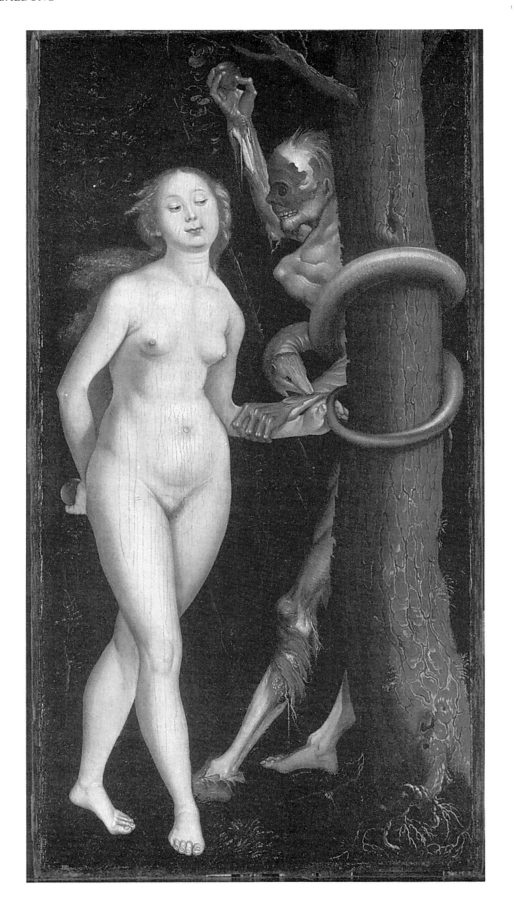

Hans Baldung (1484 or 1485–1545)
Eve, the Serpent, and Death, c. 1529–30
Panel; 25¹/₄ × 13 in. (64 × 32.5 cm.)
Ottawa, National Gallery

Bibliography—

Nahn, F., "Baldungs Bilderätsel: Eine häretisch-gnostische Verfremdung," in *Die Weltkunst*, 40, 1970.
Whitfield, Clovis, "Révélations sur une tentation d'Eve," in *Connaissance des Arts*, June 1971.
Koch, Robert A., *Baldung: Eve, the Serpent, and Death*, Ottawa, 1974.
Hartmann, Wolfgang, "Baldungs *Eva, Schlange, und Tod* in Ottawa," in *Jahrbuch der Staatlichen Kunstsammlungen in Baden-Wurtemberg*, 15, 1978.
Wirth, Jean, *La Jeune Fille et la mort: Recherches sur les thèmes macabres dans l'art germanique de la renaissance*, Geneva, 1979.
Hieatt, A. Kent, "Baldung's Ottawa *Eve* and Its Context," in *Art Bulletin* (New York), June 1983.

Eve, the Serpent, and Death came to light in 1969 when it was put up for auction at Sotheby's in London by an Edinburgh teacher who had inherited it from her grandfather, an estate agent for the Duke of Devonshire. Since 1875, it had been in the collection of William Angerstein. All this time, the painting was mistakenly attributed to Lucas Cranach the Elder. Physically, the panel is notable for its excellent condition and its visible underdrawing, especially under Eve's body, which lets us view Baldung's working procedure. He made adjustments in the position of Eve's mouth and eyelids and in the size of her right breast. The modelling lines on her body indicate an initial light-direction from the upper left which Baldung changed to the upper right in the course of painting. He originally contemplated covering Eve's genitals with an extended branch, but decided, significantly to leave them bare.

Much of the scholarly discussion surrounding this work has focused on its date. Robert Koch and others have related it to *Death and the Three Ages of Woman* in the Kunsthistorisches Museum in Vienna (c. 1510), but it has been decisively dated to the late 1520's or early 1530's. The Eve of the Ottawa panel represents a culmination of Baldung's female nudes of the 1520's, refining the qualities of the 1523 *Weather Witches* in Frankfurt, the *Venus* of the Kröller-Müller Museum in Otterlo (1525), and other figures. The Ottawa Eve is more plastic and vigorous than contemporary, paper-thin nudes by Lucas Cranach the Elder, while she displays a flatter, smoother body and more simplified, elegant contours than Dürer's female nudes.

Beyond the issue of date, scholars have been most concerned with the content of this odd picture. There have been attempts to explain it in heretical terms, with Eve and the serpent allied in an attempt to destroy Death. More improbably, the painting has been viewed as a humanistic allegory of art and fame (qualities likening human beings to the gods), pursued by Eve and the serpent. This interpretation by Jean Wirth is part of his effort to see Baldung as a libertine, a position not easily supported by Baldung's works or what we know of his biography.

A. Kent Hieatt has convincingly proposed that the Ottawa panel is Baldung's innovative visual essay on Heinrich Cornelius Agrippa's *De originali peccato*, published in 1529. According to Agrippa, sexual intercourse first occurred at the Fall, when Eve convinced Adam to make use of his penis. For Agrippa, the serpent personified the male member (here there is a pun on *serpens* with its connotation of swelling). Eve was not subject to mortality as was Adam, because God's commandment not to eat the fruit of the Tree of Knowledge was given to Adam before her creation.

Agrippa's exegesis of the myth of the Fall helps to explain Baldung's puzzling painting. The corpse is manifestly not the same skeletal being who attacks the voluptuous maidens in the two panels in Basel (Offentliches Kunstsammlung). Instead, his flesh is remarkably variegated, with touches of blood-red that indicate the sudden onset of mortality. He is Adam transformed into a corpse at the moment he grabs Eve's wrist and the apple. In other words, death is brought upon him with the tumescence of sexual desire, embodied in the serpent, who is suggestively fondled by Eve as it bites Adam's arm.

The Ottawa painting is crucial for an understanding of Baldung. In a sense, it synthesizes two of his favorite themes, investing Death from his Death and the Maiden images with a specific identity (Adam), while making the consequences of sin gruesomely visible within the context of the Fall. Baldung did more, however, than provide a visualization of Agrippa's ideas. He gave these ideas a visual panache. Baldung's Eve has an irrepressible vitality that mitigates, to some extent, the work's basic misogyny; it might also be noted that Baldung painted a tiny ox-eye daisy at Eve's feet to symbolize Mary, the second Eve who would help redeem humanity from the sin of the first. The vivid contrast between Eve's pale body and the shredded, multi-colored flesh of the corpse, as well as the placement of these two figures against the dark forest, is highly effective. But nowhere is Baldung's imagination better represented than in the knot of forms in the painting's center, where the conflicting forces of sexuality and death meet.

—Linda C. Hults

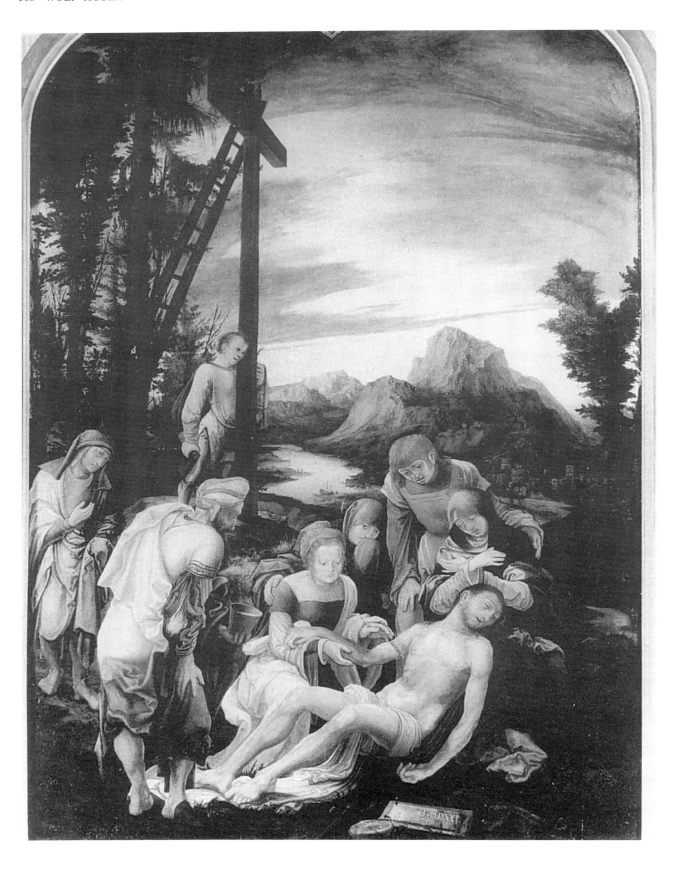

Hans Holbein (the Younger) (c. 1497–98—1543)
The Ambassadors, 1533
Oil and tempera on oak panel; 81¹/₈ × 82¹/₄ in. (206 × 209
 cm.)
London, National Gallery

Bibliography—

Hervey, Mary, *Holbein's Ambassadors: The Picture and the Men,* London, 1900.

Holbein painted the life-sized, full-length double portrait known as *The Ambassadors,* the most splendid of his surviving works, as well as the most fascinating, in 1533. In the spring of 1533 Georges de Selve, newly appointed Bishop of Lavaur, came to London to spend six weeks with his good friend, Jean de Dinteville, Seigneur of Polisy, Bailly of Troyes, and Francis I's ambassador to the English court. There is reason to believe that the 25-year-old bishop's visit was more than a social call, but the details of his mission remain unclear. It seems possible that it had to do either with plans for the approaching "summit meeting" between Henry VIII and Francis I, which took place in Calais and Boulogne in late October, or, more probably, with Henry VIII's need to cultivate French churchmen now that he had gotten rid of Cardinal Wolsey, since he no longer had representation in the Vatican and had been unable to have other English cardinals named who were sympathetic to his cause. Georges de Selve, who was fluent in German, was well known as one of the few French clergymen of the day who were sympathetic to ideas of reform and who hoped for accord within the church.

It seems to have been Dinteville who commissioned the painting, which remained in the possession of his family until the 18th century, but it may have been Georges de Selve who suggested employing Holbein, for he was a friend of Niklas Kratzer, Henry VIII's German astronomer, whom Holbein had painted in 1528 on his previous trip to England. The scientific instruments in Kratzer's portrait offer an important precedent for the prominent still-life in the *Ambassadors.* However, Dinteville's arrival in England had been coincident with the secret marriage of Henry VIII to Anne Boleyn; Holbein by this time had already been employed by Henry to design a number of pieces of jewelry for Anne, and as he went on to make a portrait drawing of her and to portray other members of the royal household in 1533 there are a number of sources from which the two friends could have learned of the painter's skill.

The two "ambassadors," secular and sacred, stand on the familiar cosmati-work floor of Westminster Abbey, which almost certainly alludes to issues of the English reformation which were of current concern to the two friends. De Selve, who was not yet consecrated as bishop, is dressed in a simple violet soutane, and rests his arm on a Bible. A silver crucifix hangs in the upper left corner of the painting. Lying on the lower shelf of the high table between them is a lute with a broken string, which has been interpreted variously as a symbol of Lutheranism, political disharmony, or simply as a *vanitas* motif. The open book below it is Johann Walter's hymnal, published in Wittenberg in 1524, which is open to Martin Luther's chorale "Komm heiliger Geist."

Other objects on the shelves are representative of the arts and sciences: a copy of Petrus Apianus's *Merchant's Arithmetic* (Ingolstadt, 1527); a terrestrial globe, marked with Polisy and other points of personal interest for the two friends; a celestial globe, with the constellations marked, and various scientific instruments used for surveying, navigation, and astronomy, including a compass, square, two sundials, and a quadrant and torquetum, used for determining altitude and position.

Most curious of all, however, is the elongated shape on the floor between them—an anamorphically foreshortened skull. Anamorphosis, or distorted perspective, was a popular device during the 16th century, which doted on puzzles of all sorts, and at least one artist, Erhard Schoen, specialized in making such images. Painted skulls were not uncommon as devices either in, or in the backs of fashionable portraits, for the medieval preoccupation with death had not disappeared overnight with the Renaissance, but simply become more poignant, as Holbein's own woodcuts of the Dance of Death attest. The unexpected confrontation of youth and death was still a favorite conceit in art and letters as late as Shakespeare's day. The very size and prominence of this *memento mori,* however, is startling. The idea for its inclusion probably from Dinteville, who wears a badge ornamented with a skull pinned to his cap.

Jean de Dinteville is both robust and elegant, in the swaggering style affected at the court of Henry VIII. Upholstered importantly in ermine and black velvet and wearing the Order of St. Michel, he stands at ease, his hand on his ornamental dagger and his feet planted firmly apart in the stance that Holbein was later to choose for the full-length portrait of Henry himself (now known only in copies). It is distressing to relate, however, that upon his return to France Dinteville, who had previously been portrayed by Jean Clouet as well as by Holbein, had himself painted in 1537 by Felix Chretien as Moses (in the Allegory of the Dinteville Family, New York), and in 1544 by Primaticcio (formerly at Wildenstein's), as a sinuous hero decked out in a revealing Fontainebleau-style cuirass and greaves, with a lance and a dead dragon to identify him as St. George. As for Holbein, he went on to paint Dinteville's successor as French Ambassador, the grizzled veteran of Marignano, Charles de Solier, Sire de Morette (1534–35; Dresden).

The Holbein double portrait was taken to the Dinteville family chateau at Polisy, where it remained until the 17th century, and then to Paris in 1653 by the sitter's great-great-nephew, where it was purchased at auction in 1787 by Charles Le Brun, who exported it to England. By Le Brun's day Georges de Selve's identity had been forgotten. The work went for a time in English collections as a portrait of the poet Sir Thomas Wyatt and an unknown friend, and later as the two Counts Palatine, Ottheinrich and Philipp von Neuburg, before Mary F. S. Hervey's detective work unearthed their proper names.

—Jane Campbell Hutchison

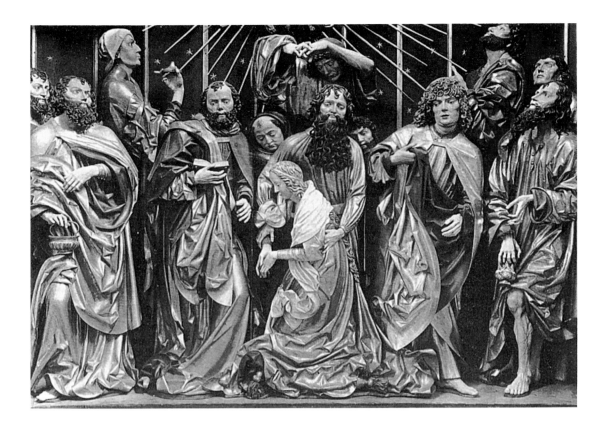

Veit Stoss (c. 1440–50—1533)
St. Mary Altarpiece, 1477–89
Wood
Cracow, St. Mary

Bibliography—

Dobrowolski, Tadeusz, and Jozef Edward Dutkiewicz, *Stwosz: The Cracow Altar*, Warsaw, 1966.

The sculptor Veit Stoss was in his late twenties when he was commissioned to execute the high altar for the church of St. Mary in Cracow. St. Mary was the church of the German community in the Polish city on the Vistula. The first record of Stoss's life is the document by which he renounced his citizenship of Nuremberg in 1477 to travel to Cracow for this work. The altarpiece, dedicated to the Virgin Mary, is the best-known sculpture that Stoss produced. It took 12 years to complete and is still in the church.

The enormous altarpiece is of carved and polychromed wood. Overall it is 40 feet high and over 35 feet wide. The main body (corpus) of the work is 23' 9″ × 17' 6″. It shows the *Death of the Virgin* and her *Assumption*, emphasizing Mary's death in a frieze of over life-size figures who act out the major scene. Stoss appears to have invented an entirely new version of the subject. The apostles here surround the swooning Virgin as she sinks to her knees, her consciousness and strength ebbing. A central group attend and grieve at her death. The others are turning simultaneously to witness a smaller scale depiction of Mary's Assumption above them.

This huge combination of scenes is enclosed by a frame that arches over them, enclosing architectural shrinework across the upper third of the corpus. In the frame are carved prophets. The spandrels over the arches contain carved figures of the doctors of the church. The pinnacle over the corpus displays the *Coronation of the Virgin* with two angels and Saints Adalbert and Stanislaus on either side and more pinnacles of shrinework above. All the figures in the corpus, its frame, the spandrels, and the pinnacle above are carved in the round. The corpus figures are gift and appear against a blue background.

Flanking the corpus are two moveable wings. When open they include six scenes carved in high relief: the Annunciation, Nativity, Adoration of the Magi, on the left and the Resurrection, Ascension, and Pentecost on the right. These figures are polychromed more naturalistically than those of the corpus using flesh tones and a variety of colors.

Except on holidays and feast days the two moveable wings were kept closed over the central scenes of the altarpiece. When closed they reveal two fixed wings on either side of the corpus. Each has three carved relief scenes on it. These, together with three scenes on each outer side of the wings, closed over the corpus, provide 12 panels of low-relief sculpture. The scenes include six each from Mary's life and the Passion. Even greater naturalism is found in the polychromy of these figures. The grandeur and fame of the St. Mary Altarpiece were intended as an assertive statement of power and community by the German colony in Cracow. They established the fame of the sculptor who remained in Cracow for seven years after completing the *St. Mary Altarpiece*, receiving commissions from the Polish court as well as the German community.

—Charles I. Minott

Tilman Riemanschneider (c. 1460–1531)
Altarpiece of the Holy Blood, 1502–05
Painted lindenwood 35 ft. 5 in. (1080 cm.) (height)
Rothenburg ob der Tauber, Jakobskirche

The work was commissioned by the parishioners of St. James Church (Jakobskirche) in Rothenburg ob der Tauber in 1501 to provide an exalted environment for a gilded cross containing a drop of the blood of Christ, and was to be placed within an existing framework fashioned by a local carpenter shop.

The central piece of the lindenwood complex, *The Last Supper*, was finished in 1502, and the last, an *Ecce Homo*, was in place by 1505. In the course of time the altarpiece has been moved from its initial placing in the west choir to the east choir, then to the east end of the south side aisle, and finally, after the completion of its restoration in 1965, back to its original site in the west choir. In the restoration procedure later polychrome additions were removed uncovering a lightly pigmented glaze over slight touches of color in the facial features of the figures, ornamental detail presumed to date from Riemanschneider's own workshop.

The altarpiece, height 10.8 meters, width, 4.16 meters, is constructed in the form of a triptych elaborately crowned by a filigreed tower rising in sets of elegant ogive arches toward a central tower flanked by sinewy finials. Below the spire is an *Ecce Homo* figure placed above a canopy surmounting the reliquary cross containing the drop of blood. Supported by two angels who simultaneously witness the Annunciation with Mary to the viewer's left and Gabriel to the right, the cross and its angels have their counterparts in the predella, where one angel, holding the pillar of the Flagellation, and another, the cross, are present at the Crucifixion.

The left wing of the triptych shows *The Entry into Jerusalem*, that on the right *The Agony in the Garden*, the former considered a work by Riemanschneider's assistants, the latter by the artist's own hands, very likely based on a Schöngauer engraving. Riemanschneider's ability to depict genuine human gestures and emotions comes across very subtly is the contrast between the sleeping disciples in the lower part of the right wing and the eagerly alert Judas and advancing soldiers in the upper. The relatively shallow space of the wing panels shows Riemanschneider's roots in Gothicism, as does his tendency to express emotional states through bodily gestures and distortions. Even in the central section, *The Last Supper*, carved much more deeply, these features are present. However, in the grouping of the disciples, the off-center placing Christ, the true-to-life characters and their agonized facial expressions revealing both an inner searching of the spirit and an external quest for understanding, a more mature and independent creative imagination is at work, that of an artist seeking to combine the loftily transcendental with a physical and emotional earthly reality.

—Reidar Dittmann

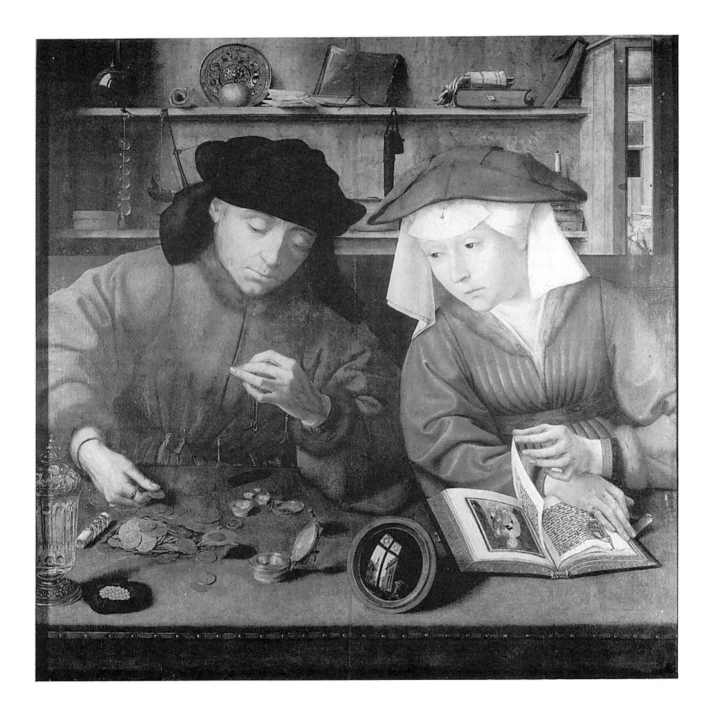

Quentin Massys (1465–66—1530)
The Money Changer and His Wife, 1515–20
28 × 26³/₄ in. (71 × 68 cm.)
Paris, Louvre

More than any of his other works, the *Money Changer and His Wife* shows Massys's interest in the sort of genre painting made popular by Jan van Eyck in the 15th century. This painting may have been based on a "Picture with half-length figures representing a patron making up his accounts with an agent," described by Marcantonio Michiel when he saw it in a Milanese collection later in the 16th century (Panofsky, *Early Netherlandish Painting,* New York, 1971, vol. I, p. 354). That picture has since disappeared, so Massys's work is now generally compared to the *St. Eloy in His Study* (1449, New York, Metropolitan Museum of Art), painted by Van Eyck's follower Petrus Christus. The compositions have similarities, but whereas Christus had chosen a saint as the hero of his painting and gave the work a clear moralizing tone, the intention of Massys's painting is less clear.

The work focuses on a couple in a corner of their home. The man, wearing a fur-trimmed dark green coat and black hat, is busy weighing the coins of his profession, while his wife, dressed in a fur-trimmed red velvet dress, looks up from her perusal of a holy book to watch. An array of household objects—books, a flask, a candle, and a piece of fruit, among other things—line the shelves behind them. A small mirror set at an angle on the table between the couple reveals a man in a red headdress who is seated by a window through which one glimpses some buildings of the town.

At first the work looks as if it might be a purely secular image, perhaps even a double portrait. Its original frame, however, was inscribed with a quotation from the book of Leviticus (19:35): "You shall have just balances and just weights." This biblical citation suggests that the painting had an instructive and perhaps religious theme. But what exactly is it? Is it an admonition to the moneychanger to practice his trade with honest weights? Or is the inscription scolding the couple for concentrating on the purely worldly concerns of material wealth rather than religious interests, symbolized by the ignored book and the distant church spire glimpsed in the mirror? As much as the focus on money tempts one to regard the painting as a criticism of the new banking profession in Flanders and the materialism it encouraged in society, there is a quaintness about the work that makes one hesitate to see it as such a clear attack on 16th-century social values. The figures, first of all, do not even belong to that era, as the woman is wearing a costume from the previous century very much like that seen in Van Eyck's portrait of his wife in Bruges. The regularity of the composition, marked by strong horizontal and vertical lines and the symmetrically placed figures, further suggests a theme of balance rather than disorder. Might Massys be looking back to the previous century with nostalgia as a time when life seemed to him to be better balanced?

Whatever its theme, the painting is a significant example of the enduring popularity and importance of 15th-century art in 16th-century Flanders. Massys was instrumental in introducing new styles from Italy and from elsewhere in the Netherlands to his adoptive city of Antwerp, yet he also was important for reminding his contemporaries, many of whom were turning almost solely to Italy for their inspirations, of the importance of their own earlier Netherlandish heritage. Could he perhaps have meant his call for just weights and balances to have aesthetic as well as moralizing implications?

—Jane Nash Maller

Jan Gossaert (Mabuse) (c. 1478–c. 1533–36)
Danaë, 1527
Panel, 44^1/$_2$ × 37^3/$_8$ in. (113 × 95.2 cm.)
Munich, Alte Pinakothek

Bibliography—

Kahr, Madlyn Millner, "*Danaë*: Virtuous, Voluptuous, Venal Woman," in *Art Bulletin* (New York), 60, 1968.

Mabuse's choice of the pagan subject Danaë for his work of 1527 is not surprising given his Romanist interest. Indeed, this figure from classical mythology was a favorite among Italian humanists and appears in works by the 16th-century artists Correggio and Titian. Mabuse's treatment of the subject is quite different from that of the Italian painters, however; whereas they emphasize the sensuality and pagan spirit of their subject, Mabuse gives his figure an innocent, almost holy character. In doing so, he reveals both his Netherlandish heritage and his knowledgeable approach to humanistic themes.

Danaë, the mother of the Greek hero Perseus, appears in the *Metamorphoses* of Ovid, who describes her impregnation by Zeus. Danaë's father, frightened by an oracle which predicted that he would be killed by his own son, imprisoned Danaë in a tower to ensure her virginity. Though no man could reach her there, Danaë's prison could not deter Zeus, who impregnated the maiden through a shower of golden rain. This event, though described briefly by Ovid, became the source for considerable discussion among later writers, who sought to interpret the myth. Some, such as Fulgentius, accused Danaë of being a prostitute, ready to sell herself for gold. Others, such as Boccaccio, explained the tale as a warning to young girls not to let themselves be deceived by would-be seductors. Still others, and in particular the author of the 14th-century French *Ovide Moralisé*, compared Danaë to the Virgin Mary, who similarly experienced a divine conception. This text spawned many other moralized versions of the *Metamorphoses*, especially in northern Europe. One of these must have served as inspiration for Mabuse's *Danaë*.

Mabuse painted the *Danaë* almost twenty years after making his important visit to Italy. The impact of the classical style that he had studied in the south is immediately evident in the classical structure that surrounds Danaë and in some of the buildings glimpsed in the background. James Snyder (*Northern Renaissance Art*, 1985) suggests that Mabuse has substituted a structure derived from the Temple of the Vestal Virgins in Rome for the tower of the myth, but Danaë's semicircular niche resembles an apse of a church built in the style of Bramante as much as any ancient building. The religious overtone which this setting suggests is echoed in the Gothic buildings seen in the background and, even more, in the treatment of Danaë herself, which remains largely within the tradition of earlier Flemish painting. Unlike the sensual nude Danaës painted by the Italians, Mabuse's heroine is dressed in a rich blue gown and thin white veil, garments traditionally associated with the Virgin. Her pose is relatively modest and her face innocent in wonder. Only her one bared breast suggests the sensuality found in Italian works of the time, although, as Madlyn Millner Kahr points out, this detail could also relate Danaë to a *Maria lactans*.

Unfortunately we do not know the terms of the commission for the *Danaë*. It would be interesting to know who ordered this unusual work and where it was originally hung. Even without this extra knowledge, however, the Danaë remains a fascinating example of the shift in Flanders from the traditional Christian art of the 15th century to the new interest in classical themes and styles that developed in the 16th century, and of Mabuse's instrumental role in effecting that transition.

—Jane Nash Maller

Joachim Patinir (1480–90—1524)
Charon Crossing the Styx
Panel; 25¼ × 40½ in. (64.1 × 102.9 cm.)
Madrid, Prado

The panel, in the Prado, Madrid, is considered one of Patinir's later works and is the primary source of the opinion held by some that he may have been a student of Bosch. Indeed, the subject reiterates Bosch's persistent depiction of the threat of Hell, and the two artists certainly share a fondness for the landscape. Yet their differences in the treatment of these subjects are far greater than their similarities, with Bosch's menacing shapes and diabolic caprices yielding in Patinir's panel to an eerie, silent, otherwordly vacuity.

Divided into three concise vertical sections with a glassy river separating a serenely exotic paradise on the left from a grimly shadowed hell on the right, the panel is composed as an aerial perspective along the established receding color scheme of brown, green, and blue, here dominated by the blue in its gradations from the dismal darkness on the right to the welcoming shimmer of the river surface near the opposite shore to the bright promise of the distant sky.

A grotesque, crouching figure guarding the cavernous entrance to hell on the right side is only slightly larger than the miniature angels beckoning on the opposite shore, while the title figure, midstream, guiding the boat with the spectral soul of the dead, makes a more imposing impression. Viewed head on and with no concession to a foreshortening suggested by the aerial perspective of the landscape, Charon and his boat are seen ambiguously afloat not only in the Styx but in the very space of which the river, winding its way to infinity, is the central part.

—Reidar Dittmann

Maerten van Heemskerck (1498–1574)
Family Portrait, c. 1540
Panel; 46¹/₂ × 55¹/₈ in. (118.1 × 140 cm.)
Kassel, Staatliche Kunstsammlung

Bibliography—

Bruyn, J., and Dolleman, M. T. de B., "Heemskercks Fami-
liegroup te Kassel: Pieter Jan Foppesz en zijn gezin," in *Oud
Holland* (The Hague), 1983.

The panel, a sizeable 46¹/₂ × 55¹/₈ inches, painted c. 1540,
is now in the Staatliche Kunstsammlung in Kassel.

Husband and wife, seated at the dining table at the conclu-
sion of a meal, are the principal participants, providing both
the balancing element and the framework of the composition
as they protectively enclose the two children in the center,
whose smiling faces and playful gestures contrast with the so-
ber yet warmly secure miens of the parents. Darker fore-
ground colors of red, brown, and olive receive an unexpected
infusion of brightness and vitality from the noonday sky with
its fluffy good-weather clouds that highlight and recapitulate
the shapes of the sitters.

A color relationship exists between the seasonal fruits on the
table, the healthy flesh tones of the parents, and the rosy-
cheeked exuberance of the children, whose spontaneous joy,
gently checked by the father's cautioning hand, gives the panel
an air of happy security and consummate well-being; so also
the table with its remnants of a good meal. However, a closer
scrutiny lends the representation of a subtle spiritual quality as
well, evoked by the unmistakable Madonna and Child image
projected by the mother and her infant son and by the father
ritually lifting a chalice-like goblet of wine.

This tranquil domestic idyll, uncluttered and orderly, warm
but far from sentimental, is Heemskerck's single most endur-
ing contribution to early 16th-century Dutch art.

—Reidar Dittmann

Lucas van Leyden (1489 or 1494–1533)
Last Judgment, 1526–27
Panel; 8 ft. 10³/4 × 6 ft. ⁷/8 in. (271 × 185 cm.)
Leiden, Town Hall

Images of the last judgment were to be found everywhere in 16th-century Europe—in hospitals, civic buildings, private chapels, over the tombs of the dead, and of course in monasteries, churches, and cathedrals. Visions of the second coming served as the ultimate and most awesome admonition that Christ would return to make final judgment of mankind and to consign all souls to their proper place in the eternal scheme. Lucas van Leyden's monumental and undeniably spectacular version of the subject in Leiden is part of a well-established northern European tradition and in its own way a remarkable departure from the norm.

The reasonably verifiable circumstances of its origin are these. Documents show that the triptych was commissioned on 6 August 1526, for 35 Flemish pounds in memory of one Claes Dircz. van Swieten, and that it was probably finished and placed in the Church of St. Peter in Leiden during the following year. Claes Dircz. was a timber merchant and a prominent citizen of the town, a member of the council, twice an alderman, and once one of the town's four burgermasters. He died in 1524–25, and in all likelihood the *Last Judgment* was ordered and paid for by his children, or more specifically by those whom he designated in his will as "well-behaved"

and thus worthy of his inheritance. A generation later the painting wandered from its original location, temporarily orphaned by a series of dramatic disruptions. Then in 1602 the Emperor Rudolph II made an unsuccessful attempt to purchase it for his collection, but this entreaty was refused. By the 17th century it had come to be esteemed among the town's most prized possessions.

The *Last Judgment* is a triptych with moveable wings painted on both exterior and interior surfaces. When the wings are closed over the main scene, as they would have been on particular religious observances, their versos display Sts. Peter and Paul—the two principal apostles of the faith, and also the patron saints of the church for which the triptych was originally destined. St. Peter is to the left, identifiable by the keys which he brandishes in his hand. On the right is St. Paul shown with the sword at his feet, the instrument of his martyrdom. Behind them a landscape stretches out over the sea and unites the panels in its panoramic sweep. By the gestures of their hands the two saints appear to be in colloquy. Some scholars have taken note of the fact that at this time Peter and Paul represented respectively the chief apostles of the Catholic and Reformation faiths, and thus it has been supposed that Lucas might have meant to stage a very contemporary kind of theological debate. Off in the distant bay behind Paul a ship can be seen foundering on turbulent seas, a motif which has been taken as a further sign of theological discord. In fact, this detail is probably meant to recall an episode in the missionary life of St. Paul when he was supposed to have been shipwrecked off the coast of Malta. Furthermore, pairs of saints were customarily shown in conversation as a means of enlivening what would otherwise be a static and less interesting subject. The books scattered on the rocks no doubt imply a discussion of doctrine, but it seems very unlikely that Lucas would have introduced a seriously contentious note in a memorial intended to appeal for the salvation of a departed soul.

When the wings of the triptych are unfolded, we are treated to the extravagant and gracefully choreographed convocation of all mankind at the end of time. At the center upon a rainbow (a sign of the covenant) Christ sits in regal judgement—his right hand raised in blessing and his left hand lowered in a gesture of condemnation. The lily and the sword issuing to either side of his face give us a further sign of his will. In line with the tradition for this subject, men and women are shown rising up out of the ground and parting according to the condition of their souls—the blessed to right of Christ, and the damned to the left (the inverse of our perspective). The souls are shown naked as the truth, each consigned to the arms of an angel or a tormenting demon according to its destiny. Thereafter they are led off to ascend into celestial bliss or be flung into the fiery maw of the beast.

The *Last Judgment* triptych offered Lucas his first opportunity to display his talent for portraying the nude figure on a monumental scale. In the medium of prints he had done such nudes many times, but here in color and in a composition with dozens of figures the project proved more difficult to manage. He took the challenge head-on, arraying his figures in complicated postures and groupings, and pressing them into exaggerated actions. Lucas's figures often seem to bow rather than to articulate at the joints, and the poses seem oddly contrived, rather like the performance of a modern dance. Lucas never really mastered anatomy. He preferred a willowy suppleness in his body language that is more convincing on a smaller scale than in these epic proportions. But Lucas's wit is intact, however somber the subject of this piece. To the lower left in the center panel a naked couple is being urged on by an angel acting rather like a nervous chaperon worried that its charges might go astray. Then Lucas strikes a note of undeniable coyness on the wing further to the left. There an angel looks out at us with a fetching glance and gently rests a hand on the buttock of one of the departing blessed.

High in the arched crown of the center panel above Christ appears the dove of the Holy Spirit, and still further up the figure of God the Father, the three together constituting the Holy Trinity. This upper portion of the painting has a history of its own. In the summer of 1566 the Netherlands was swept by a wave of iconoclasm. Works of religious art were being removed and very often destroyed by partisans of the Calvinist cause. By cleansing the churches the Protestants claimed to be enforcing the Old Testament commandments against graven images in the face of what they perceived to be Catholic abuse. As a consequence, in many parts of the Netherlands important altarpieces were being removed from their location in churches and monasteries and stored away for protection. This seems to have been the case with Lucas's masterpiece. It appears that the *Last Judgment* soon found its way into the burgermasters' chamber in the Leiden town hall where it would have acquired a judicial significance and thus been better insulated from the charges of idolatry being leveled at devotional images still in ecclesiastical settings. Probably also at this time the curiously rabbinical figure of God the Father dressed in contemporary Jew's garb, one of the triptych's most original iconographic features, was painted out and replaced by the three Hebrew letters for God. This measure, along with the relocation of the painting, was certainly taken to guard against further offending the reformers. Only in 1935 was the over-painting finally removed to reveal once more the third person of the Trinity as Lucas conceived it. The painting was again restored between 1973–77, this time with great thoroughness. It now stands in a condition that must be remarkably close to its original appearance.

—Peter W. Parshall

Pieter Aertsen (1509–75)
Christ in the House of Martha and Mary, 1553
Panel; 4 ft 1¹/₂ in. × 6 ft. 6 in. (125.7 × 200 cm.)
Rotterdam, Boymans-van Beuningen

Bibliography—

Moxey, Keith, "Erasmus and the Iconography of Aertsen's *Christ in the House of Martha and Mary* in the Boymans-van Beuningen Museum," in *Journal of the Warburg and Courtauld Institutes* (London), 34, 1971.

Aertsen's secular-religious works of the 1550's—where the material immediacy of mundane objects and genre-like figures seemingly displace a Biblical narrative to small scale and rear-ground—is his personal exploration of an established northern thematic evolution. Most immediately, the Flemish painter Jan Sanders Van Hemessen, had juxtaposed large and clearly secular-appearing foreground figures adjacent to much less conspicuous rear-ground religious scenes as in his *Lute Player with Christ and the Apostles* (Berlin). Earlier, in prints of the Germans Hans Sebald Beham and Jorge Breu (*The Feast of Herod, The Prodigal Son*) aristocratic feasting and dancing were seen up close at the edge of the pictorial stage while spiritual narrative was relegated to the rear.

In *Christ in the House of Martha and Mary* (Luke 10: 38–42), the title episode is shown at the center but at a distance behind an elaborate display of food, flowers, and utensils which stretches across the entire frontal plane. Just behind this still life is found two figural groups, clearly visible since they are half the height of the painting. Since there is a sharp distinction in costume, it has been asserted that the left-hand group in contemporary 16th-century garb, with somewhat coarse faces, is meant as a servant group. Here two cooks, male and female, serve a function like that of such figures in Aertsen's "Kitchen" scenes, or of the stall-holders in the outdoor market scenes where the foreground as here is filled with a riot of foodstuff. Recent critical scholarship has pointed to the strong Humanist currents in the 16th-century Netherlands; and with the powerful influence of Erasmus, classical authors came to be read as moralists. Especially well-known was the *De Officiis* of Cicero and its moral exempla and stoical teaching: there, in the great disparagement of cooks and food-sellers as dispensers of sensual pleasure, may be found a source of this motif around which Aertsen fashioned a body of powerful and absorbing paintings. The vivacity of the image itself—its invitation to seduction by the eyes—might also have served as moral example.

Meanwhile the "historic" clothing, like that worn by Christ and the other figures in the rear-ground Biblical scene, is also found on the three men and two women before the fire-place at the right. Such costume would make them the Apostles who are told the parable of the good Samaritan just before the visit of Christ to the House of Martha and Mary. The Apostles present an image of drunkeness and womanizing. Peter, holding a vessel and tilting backwards, touches the shoulder of the young woman in a low-cut dress—these gestures of sexual desire further affirmed by her pointing to burning coals which are firmly entrenched in the emblem literature as a sign of sensual pleasure and the harlot. Thus the feast of bodily appetites implied by the figures and the vividly depicted objects, some at the verge of *trompe l'oeil*, is shown as the converse of the spiritual feast in the word of God depicted in the background scene with Martha and Mary.

In Aertsen's version of the same subject in the previous year, 1552 (Vienna), the entire foreground, as if in the kitchen itself, is given over to still life culminating in a quasi-surreal hovering slab of a beef-quarter. As well, a *trompe l'oeil* door with key inserted is opened to reveal silver and documents within a chest, while moneybags rest upon the door-edge. With the presence of these emblems of luxury, the food is all the more readily identified, even without human protagonists, as bodily appetite and materialism. In this work, with the most overt moralism of Aertsen's surviving paintings, the fireplace carries the inscription "Maria heeft wtvercoren dat beste deel" (Mary has chosen the best part). The reference is to the Biblical text where Martha is admonished by Christ for her complaint against Mary who had not aided her in the meal preparation, but instead has listened to Christ.

As in this earlier work, our image presents Christ and the other women before and within an elaborate classicizing architecture whose model has been easily identified in Sebastiano Serlio's *Fourth Book of Architecture*, 1539. Renaissance architecture was little known and still exotic, and thus the Doric fireplace, the Corinthian doorway, and Ionic facade were all attempts, no doubt, to elevate the scene further for a Humanist audience and to present the Biblical subject all the more "historically." In this same vein, Aertsen has very carefully shown the foreground vase as decorated with an Italian grotesque frieze, a motif only recently introduced into the Netherlands.

The two relief panels over the entablature of the rear wall continue the seeming Netherlandish passion for disguised symbolism as they present Moses with the Tablets of the Law, and Aaron in priestly robes swinging a censer. Both subjects have traditionally been regarded as appropriate for the decoration of a scene, as here, taking place under the Old Dispensation. Yet strangely, the Hebrew characters over the fireplace are only decorative with no clear text.

While the food of the foreground has been asserted an erotic emblem, the lilies so prominent in the foreground vase may be a reference to Luke 12: 22–27 where Christ utters the well-known "Consider the lilies how they grow . . ." and urges his listeners to a spiritual life. As an emblem of chastity, the flowers in this context might allude to Christ's virginity. This exegetical turn may be supported by the other flower, the compass, which has a traditional status in the Netherlands as a bridal attribute, and thus as spiritual love is related to the Mary Magdalene. The bundled marsh grass below refers to vanitas and inconstancy—here then an emblem of Martha. Thus the floral group would contrast between pure and impure love, personified in Mary and Martha. A recent reconsideration of the significance of Martha recalls that she is the patron Saint of husbands and wives—their feast day was traditionally July 29 and this painting is signed "27 July." This painting might then be seen as a plea for temperance: as Christ points to Mary, he recommends to Martha a purer form of marital love, which would make this large painting a wedding gift.

The dynamic of this thematic display is mirrored, indeed to some large extent created, by the forceful technique. The plasticity of the modelling of both foodstuff and figures, as well as the rich coloration and freer brushwork, was only a recent development in Netherlandish art. Aertsen had adopted this "Romanist" approach as images by his compatriots such as van Scorel and van Hemessen have come to be labelled—northern artists absorbing the pictorial ideas of the south—the influences of the Italian Renaissance.

—Joshua Kind

Antonis Mor (c. 1520—76-77)
Portrait of Queen Mary Tudor, 1554
Panel; 42⅞ × 33⅛ in. (109 × 84 cm.)
Madrid, Prado

Antonis Mor's *Portrait of Queen Mary Tudor* was signed and dated by a justly proud, thirty-four year old painter from Utrecht: *"Antonius Mor pingebat 1554."* His sour-faced and rather unattractive sitter, born in Greenwich on 18 February 1516, was four years Mor's senior. In rank and station, however, she was placed far above him; the daughter of Henry VIII and Catherine of Aragon, she had been named Queen Mary I of England in 1553. As it appears, this portrait was painted just before her marriage to Philip II, King of Spain and son of the Hapsburg Emperor Charles V, on 25 July 1554. Inadvertently, it later became a *"memento mori"*: Mary died, aged 42, on 17 November 1558, being succeeded as Queen of England by Elizabeth I. The portrait, and perhaps even its sitter, must have, however, appealed to her father-in-law, since the Emperor Charles (to whom Mary was betrothed briefly and unsuccessfully some 30 years before) took the painting with him in his retirement to Yuste, where he too died in 1558.

In Mor's portrait, Mary Tudor is shown in almost full figure, rigidly and somewhat uncomfortably perched upon the edge of a gold-embroidered, dull-red velvet upholstered chair. She is obliquely placed in a neutral brownish background. On one level, as some would have it, perhaps this portrait conveys a certain sense of psychological insight; the royal sitter seems to bear upon her visage the marks of suffering she endured when Henry VIII rejected her mother, Catherine of Aragon. On another, her haughty stiffness might by a sign of the notorious inflexibility of her bearing, shown in many other ways by the historical record of the fanaticism of her beliefs. Nevertheless, since such poignance seems foreign to the cooly depersonalized office of a decorous court-painter, which Mor certainly was, these speculations are most likely merely modern, hence anachronistic, projections into the stiff and saintly, pseudo-Byzantine and austerely stylish, manner of all such rhetorical and elaborately etiquette-bound state-portraiture. Mary's outer robe is made of thick, dull-brown fur; her dress underneath is heavily embroidered in patterned silver on a purple velvet ground. Her superior being is ornamentalized and literally bejeweled; gold and gems encrust her coiffure, neck, hands, and belt, and a heavy gold pendant hangs from her high-collared neck. In her right hand she holds a rose, an emblem of the all-powerful Tudor dynasty.

This frigid and haughty image is, besides being a dynastic portrait in the most literal sense, an exemplary visual document of the reigning conventions of international Mannerist art, such as this was so often put into the service of the absolutist ruler. Perhaps more than any other, Antonis Mor was the definitive creator of this hieratic mode of dynastic representation. His "style," an illustrative convention, was widely diffused throughout the courts of Europe, and is later seen obediently replicated in the works of Alonzo Sánchez Coello and Pantoja de la Cruz in Madrid and The Escorial, by Bartolomeus Spranger in Bohemia, by Francis Pourbus in Mantua, François Clouet in Paris, Isaac Oliver in London, Hans van Aachen in Bavaria, Scipione Pulzone in Rome, to name but a few of his many followers. In this portrait of *Queen Mary Tudor*, and in numerous similar cases, the individual sitter is of small consequence; what matters in the end is only his/her office. Thus, any state-portrait like this one is really only an illustration of a public, but highly elevated office: kingship. The personality of the artist gives way before the exigencies of the fixed iconographic dynastic paradigm, distant and semi-divinized. The painter therefore tends to minimalize, if not indeed annul, his own personality and sympathies.

All transient human qualities are sacrificed in such contrived portraiture to the abstract needs of the State, in what the Spaniards of the court of Philip II were to call *"el retrato de aparato,"* stressing the material signs and the tangible values of the allegorized and ceremonialized, majestic high office. These superhuman, emblematic ideas were also commonly verbally expressed; for instance, according to Padre José Sigüenza (1605), "The magnanimous Prince [Philip II] would make no movement nor any sign of sentiment, a grand privilege of the House of Austria [Hapsburgs]; among other reasons, so as not to lose for any happenchance the serenity of his face nor the gravity due to the Empire." Similarly, Luis Cabrera de Córdoba spoke of the painted image of King Philip II as an object *"digno de toda verneración,"* and, accordingly, "it was saluted with reverence," as would a holy icon. On a more commonplace level, the international courtly art of *maniera* is scarcely based upon "reality" as we know it today; rather, its sources and limitations are artistic *pratica*, comprising stylistic convention, social function, erudite artifice, technical virtuosity, and emblematic obliqueness. Similarly, the sitter's individual humanity is generally subordinated to the hieratic, cumulative, and microcosmically studied design-effects of his official vestments and costly ornaments—all indispensable emblematic signs of the regal sitter's superhuman social condition and responsibilities. As a nearly inevitable result, supposedly incidental accessories are treated with as much (if not more) painstaking attention than are the truly incidental specifics of flesh and blood: the robes of office count for far more than does the momentary wearer of these. In effect, international Mannerism, the reigning art of the munificent European courts, established the enduring iconographic standards of the representation of rulers by divine sanction—and long after that style had become obsolete in other, more earthbound, sectors. And that, in the end, is the great art historical significance of Antonis Mor's otherwise unpalatable *Portrait of Queen Mary Tudor of England.*

—John F. Moffitt

Pieter Bruegel (c. 1525–30—1569)
Hunters in the Snow, 1565
46 × 63 in. (116.8 × 162 cm.)
Vienna, Kunsthistorisches Museum

The *Hunters in the Snow* is the most famous surviving work from what is believed to have been a series of twelve, or more likely six canvases depicting the months of the year that Bruegel painted in 1565, probably for the Antwerp banker and art collector, Nicolas Jongeling. The other remaining paintings are *The Harvesters, The Return of the Herd, The Dark Day*, and *Haymaking*: the painting depicting April and May apparently disappeared some time after the late 17th century when the six panels were mentioned together in an inventory. The group of remaining paintings reveals Bruegel's mastery of a subject which was still somewhat unusual in his day, the landscape, and shows his ability to use that genre as a medium for social comment.

The theme of the months descended from medieval precedents and was common in Flemish miniature painting of the 15th and 16th centuries. Examples of it can be found in the work of Pucelle, the Limbourgs, and Bruegel's most likely source, the early 16th-century illustrator Simon Bening. Bruegel departs from these antecedents, however, by emphasizing the atmosphere of the season more than the activities associated with it, and by giving his landscape a new sense of grandeur and physical power.

The *Hunters in the Snow* probably represents the months of December and January. If so, it is interesting that Bruegel has chosen to show not the feasting scenes frequently connected with those months' holidays, but a bone-chilling look into the hardships of the winter season. A sense of cold desolation permeates the scene's chilly whites and grays. Interwoven as they are with austere blacks and browns, they leave little room for gaiety in the landscape. The heavy atmospheric perspective blurs the distant details in a frigid veil, and the green-gray sky threatens additional snowfall. Barren trees dwarf the tiny houses that seem half-buried under their snow-clad roofs.

Bruegel has captured the extraordinary still beauty of fresh snowfall in the lined tree branches and snow-capped hills. He has given not only nature but also weather a new grandeur. In so doing, however, he has also allowed both to overpower the humans in the scene. Though some tiny specks in the distance play on the ice, the dominant figures in the foreground struggle to survive the hardships of winter. People near the tavern on the left prepare a fire, probably to singe a pig. A figure in the lower right carries a load of wood to help warm a home. The returning hunters, who dominate the foreground and give the painting its name, bend over as they trudge home through the snow. They seem worn down by their pursuit, which, moreover, has proven almost fruitless as they have managed to bring home only one small animal. We are confronted by a landscape that overwhelms humanity and subjects it to the will of nature.

Bruegel's painting was thus revolutionary not only in the new importance he gave the landscape, but also the minor role he allowed his figures. In creating works like the *Hunters in the Snow*, he overturned the basic theme of Renaissance humanism. At the same time, he showed how landscape, like the religious and allegorical scenes he had painted before, could serve his own interest in social commentary.

—Jane Nash Maller

Pieter Bruegel (c. 1525–30–1569)
Peasant Wedding, c. 1568
Panel; 44^{7}/$_{8}$ × 64^{1}/$_{8}$ in. (112.6 × 162.7 cm.)
Vienna, Kunsthistorisches Museum

Bruegel's *Peasant Wedding*, one of his best-known paintings, is the sort of scene that helped give Bruegel his reputation for being a painter of peasants or perhaps even a peasant himself. Since it was shown some time ago that the painter was a cultured burgher, the tendency has been to regard the painting as an example of his interest in satire and complex detail, and as evidence of his sarcastic disdain of the peasants.

The picture has frequently been regarded as a pendant to Bruegel's *Peasants Dancing*, also in Vienna, as the two works have similar dimensions and have shared a similar provenance for at least the last two centuries. Their tone is also similar as they celebrate the baudiness of country celebrations.

The *Peasant Wedding* takes place in a barn. A wall of straw delimits the seating area and indicates the season as being after the fall harvest. The bride is instantly recognizable, seated before a green drapery with a smug look on her plump face and her hand piously folded. She sits before a royal cloth of green symbolic of love and fertility and a paper crown hangs over her head, proclaiming her queen of the day. But where is her groom? Some have suggested that the man seated three seats to her right and gluttonously spooning rice pudding into his mouth is her prize. Other more sympathetic critics have suggested that the man in a red hat passing the bowls of food to his friends seated at the table is her new husband. But neither choice is obvious, and neither man is particularly attentive to the bride, so her self-satisfaction seems somewhat foolish.

The group of diners as a whole is a mixed and rather unattractive crowd. Most have hidden or rather undistinguished faces so we fail to identify with them. Many eat and drink voraciously with little respect for the supposed dignity of the occasion. The stack of mugs being filled by the man in the left foreground forewarns of a drunken orgy, while the child next

to him licking a bowl with her finger suggests ill manners and gluttony. There is also a certain callousness in the merrymakers as they ignore the hollow-eyed, hungry look of the bagpipe-player, one of the few thin faces in the crowd. Other figures seem out of place, particularly the monk and the well-dressed bearded man who carry on a private conversation to the far right. Though identified as the artist by Van Mander, the latter is generally assumed to be a judge or the Lord of the manor on which all this takes place.

Certain details in the picture act as symbols for the vices portrayed. The peacock feather in the hat of the girl in the left foreground is a traditional symbol of vanity. The bagpipes which provide the entertainment for the crown can refer to lust. The dice on the bench by the well-dressed man at the right might symbolize the transitory quality of earthly things. All of these elements might be seen as satirical comments on the gluttonous feasting.

Other aspects of the painting are more difficult to interpret within the context of the scene, however. The green hanging behind the bridge, though probably a bridal reference, is also reminiscent of the baldachins found frequently behind images of the Madonna Enthroned. Moreover, it has been suggested that the subject may be related to the Marriage at Cana, and the composition as a whole has been compared to those of some Italian Renaissance Last Supper scenes. Should we assume that Bruegel had any such religious allusions in mind or did he simply adopt motifs from art as he did from life? In either case, this dilemma gives further evidence that Bruegel's works, however simple they may at first appear, are in fact the product of a complex mind and a wealth of resources.

—Jane Nash Maller

Jan Bruegel (1568–1625)
Hearing, from the *Five Senses*
25⅝ × 42⅛ in. (65 × 107 cm.)
Madrid, Prado

Jan Bruegel, given several nicknames which suggest his mastery of several elements of painting ("Flower," "Velvet," and "Paradise"), had an assured reputation during his lifetime (and since), and though his flower paintings might be thought to be his most famous, his allegorical *Hearing,* part of a larger sequence of the *Five Senses,* is in many ways a typical work.

Bruegel did other allegorical series (e.g., *Four Elements,* in Rome, Galleria Doria), and one of his most famous paintings, *Paradise* (also called *Adam and Eve in the Garden,* The Hague), a collaboration with Rubens, has an implicit moral view. In fact, behind the history of northern landscape is an implicit moral or symbolic tradition: stunted trees, idle figures, markets, etc., all come to have an underlying moral interpretation. This came to be applied to flower and still-life paintings as well, leading to the *Vanitas* tradition whereby the objects of ordinary life—especially food, candles, etc.—remind us of our limited existence. On a *Vase of Flowers* (private collection) attributed to Bruegel is the following inscription: "How you stare at this flower, which seems to you so fair,/Yet is already fading in the Sun's mighty glare./Take heed, the one eternal bloom is the word of God;/What does the rest of the world amount to?—nothing" (quoted in Bob Haak, *The Golden Age: Dutch Painters of the Seventeenth Century,* 1984).

The *Five Senses* tradition, strong in the medieval period, had a lively revivification during the baroque period. The fashion hardly outlived the 17th century, but while it lasted a number of painters pictured the five senses in series of paintings. Bruegel's series, now in the Prado, is cunningly related to the five senses. The setting of the large *Sight and Smell* is a picture gallery, but the portable elements consist of a large selection of flowers, as well as a civet. A smaller work, *Sight,* extends the gallery to include sculptured works, but the focus is on a woman contemplating a picture of *The Healing of the Blind;* alongside is a large floral-wreath painting. *Taste* is essentially a game piece, with a huge mound of dead game presented to the viewer, but vegetables and fish are present in large numbers, along with a banquet table already set for a meal; this painting also includes a floral-wreath painting. *Touch* is a floral jungle, but also with a wonderful variety of animals and skins (including the civet again).

All of these paintings have a well-ordered composition, and are much more than merely a catalogue of the various elements. The same applies to *Hearing,* and the control over the mass of details is a tribute to his experience in several genres. Though he provides what is considered to be a relatively complete "inventory" of early 17th-century musical instruments (this itself was to lead to such musical still-lifes as those by the Bergamo painter Baschenis), as well as a table arranged for part-singing, and a host of other references to music and song, one does not feel that Bruegel's interest is mainly in the *Vanitas* or moral overview of the sense of hearing, but rather in the challenge of expressing in his exquisite colors and coherence the variety of still-life elements that excite him visually. The fact that the picture can also be considered a painting in "miniature" further adds to our admiration.

—George Walsh

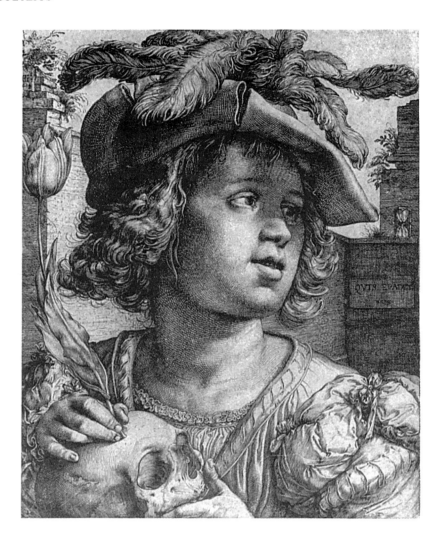

Hendrick Goltzius (1558–1616 or 1617)
Portrait of a Young Man with Skull and Tulip, 1614
Drawing; 18¹/₈ × 14 in. (46 × 35.5 cm.)
New York, Pierpont Morgan Library

The life-size, bust-length *Portrait of a Young Man with Skull and Tulip* is a splendid example of Hendrik Goltzius's innovative style in pen-and-ink drawing, a style that was said to have made him famous all over Europe. The swelling lines, which approximate engraved lines, follow the contours of the forms, creating an extraordinary tactile quality. The brown ink used lends a special warmth.

A rich variety of textures enlivens the surface. The young man wears a silken jacket, with elaborately puffed sleeves, over a frilled shirt. His slashed beret is topped with a bunch of quills. In his left hand he holds a skull, on which he rests his right hand, holding a long-stemmed tulip. His thick, curly hair hangs well below his earlobes. In the background, on the left and the right are ruined walls overgrown with weeds. On the wall at the right is an hourglass, and below it a tablet with an inscription, as if incised: "Quis Evadet/Nemo." Goltzius's monogram and the date 1614 appear near the top of the left wall.

This allegory of the transience of life was drawn two years before Goltzius's death. He had not worked as an engraver for some time. Perhaps this hand-drawn simulacrum of an engraving filled a felt need on the artist's part, a drive not to give up the creative activity that had brought him fame and satisfaction. Certainly it provides proof that he had lost none of his dexterity. The control required for this technique is formidable.

Ruins, hourglass, skull, and flower were all well-recognized symbols in Goltzius's day of the brevity of life and the unreliability of earthly pleasures. Emblem books made clear the implication that one had better give thought to the Life Eternal. The fact that the man portrayed in the midst of these alarming symbols and the Latin warning ("Who escapes? No one.") appears to be young, healthy, and cheerful makes this moralizing message all the more poignant. Perhaps the drawing was a memorial to a man who died in the flower of youth. It is certainly a worthy memento of the brilliant artist who made it.

—Madlyn Millner Kahr

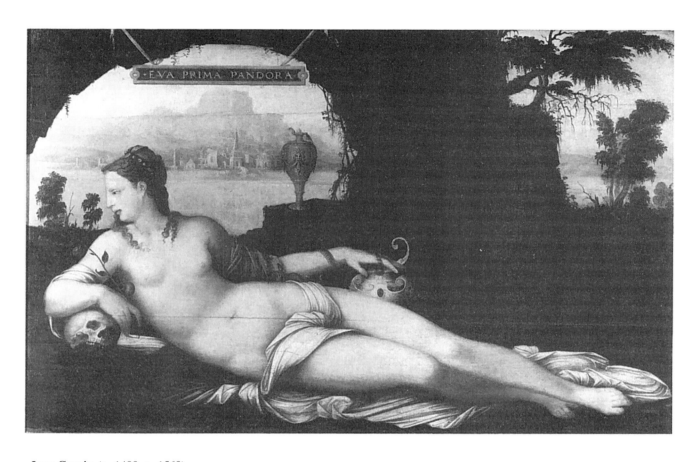

·EVA·PRIMA·PANDORA·

Jean Cousin (c. 1490–c. 1560)
Eva Prima Pandora
Panel; 38 × 59 in. (97.4 × 149.9 cm.)
Paris, Louvre

The *Eva Prima Pandora* is the most intriguing of Cousin's works and probably the most significant for defining his artistic propensities. The influence of Rosso Fiorentino is paramount in the style of the painting, but this influence is haunted by reminiscences of Leonardo, Andrea del Sarto, and perhaps even of Albrecht Dürer in the landscape setting. Most extraordinary, however, is the iconographical conceit of the picture. Heralded sometimes as the first monumental nude in the history of French painting (actually the Fountainebleau School abounded in nudes, e.g., those by Rosso including the so-called *Nymph of Fountainebleau* in the Gallery of François I), Cousin's image conflates an aggregate of feminine symbolic meanings, rather in the way in which images were combined in the mythographic writings of the 16th century, in Vincenzo Cartari's *Geneologia degli dei,* for example, or later Cesare Ripa's *Iconologia.* In Cousin's work the framed inscription explains the pictorial fusion of the classical and Hebreo-Christian embodiments of womanhood, Eve and Pandora. The snake wound around the figure's left arm, along with the ser-

pents twisting through the grotesque underbrush, and the apple cradled in her right arm, identify her as Eve. At the same time, she is accompanied by two fantastically shaped vases, presumably the containers of good and evil appropriate to Pandora. And the skull on which the woman reclines could be understood as a symbol of both Eve and Pandora. Finally, still more symbolic meanings can be discerned in Cousin's image beyond those referred to in the inscription. Such a sensuous reclining nude, even with her distorted mannerist proportions, could hardly fail to evoke the reclining Venuses painted by Bellini, Giorgione, and Titian; and the bizarre setting of the scene in an underground grotto, as well as the serpents, could be associated with earth dieties such as Cybele, Gaea, or Proserpine as well as with Eve and Pandora. Whatever the iconographical references contained in and evoked by the picture, the *Eva Prima Pandora* is a fascinating artistic invention which must have had a special appeal in the courtly milieu of Valois France.

—William R. Crelly

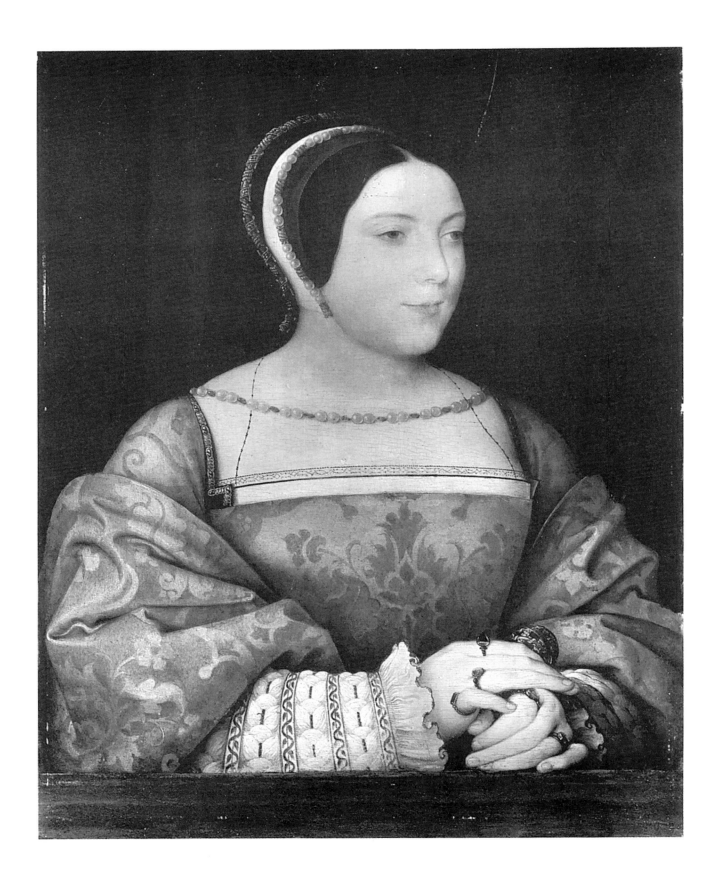

Germain Pilon (c. 1528-90)
Tomb of Valentine Balbiani
Marble
Paris, Louvre

Bibliography—

Grodecki, Catherine, "Les Marchés de Pilon pour la chapelle funéraire et les tombeaux des Birague en l'église Sainte-Catherine du Val des Ecoliers," in *Revue de l'Art* (Paris), 1981.

The funerary effigies of Valentine Balbiani were part of a magnificent wall tomb, the memory of which is preserved in two 17th-century drawings. The whole was set against and framed by a black and white marble drapery upheld by angels. The half reclining figure, and two putti bearing overturned torches, rested on a black marble slab carved according to the receding planes of the base and sarcophagus, which carried the relief of the cadaver. The top half of the monument was divided into compartments bearing the epitaph, niches with bronze angels, a cross, escutcheons, and much decorative low relief and ornamental sculpture, the geometry of the whole skilfully balanced.

By April 1574, when the definitive project for this tomb was signed, Pilon was a mature artist with wide experience, having filled commissions as varied as models for goldsmiths and for garden and church sculpture. His work in the field of funerary monuments included that of *Catherine of Medicis and Henry II* at the abbey of St. Denis. In the years following the commission of the Balbiani tomb, Pilo continued to sculpt funerary monuments of many different kinds, a most remarkable achievement being the kneeling bronze statue of the *Cardinal de Birague* in 1584–85.

Even though we know from contracts that René de Birague's wishes were precise, Pilon not only had the interpretation of them, but some decorative freedom. The remaining pieces of the monument offer us evidence of the multiple facets of his talent—from the idealized portrait in the round and the naturalistic details of cloth, lap-dog, and children, to the dry relief of death, a good illustration of the ease with which Pilon handled different attitudes and surface treatments. These are of amazing quality. The monument also reflects various influences of the time, combining Italian elements of detail and style with more traditional French aspects, mannerism and a naturalistic, straightforward approach side by side.

The drapery that once framed the monument, the rich combination of black and white marbles with bronze, undoubtedly one of the tomb's most striking features, are now lost, though some idea of the latter can be had from the tomb of *Catherine of Medicis and Henry II* at St. Denis. Italian influences are also present in the chosen position of the live effigy, and in the contrapposto attitude of the putti. This predisposition for Italian themes is not surprising since things Italian had been studied, imported, and interpreted in France since the beginning of the century, and Primaticcio held artistic power until his death in 1570. Above all, both Valentine Balbiani and her husband were of Italian origin.

The superposition of the live and dead effigies of the deceased, however, had become habitual during the 16th century for French royal tombs, and the cadaveric "transi" is a French tradition going back to the Middle Ages. In this relief beauty, luxurious trappings, life, have departed. The naturalistic details of empty skin over sinews and bones, of the last trace of a once-rounded belly, of some incomprehensible tension in the clenched jaws, underline the ineluctability of death. Plastically this expressionism is translated by the subtlety and precision of the shallow relief, the thin sharply creased shroud, the protruding dessication of the bones, the manneristic lengthening of fingers and neck.

In startling contrast, the muscular, twisting putti, Michelangelesque in their manner, are a picture of healthy vitality. Their dimpled skin, their open-mouthed good humor, their movement, all deny any burden of grief though they hold overturned torches, the symbols of escaped life.

With the half-reclining figure of Valentine Balbiani, Pilon gives us an idealized image of the aging woman. Her face appears smooth, unwrinkled, and framed between the deep shadows of her ruff and tight curls, yet the sculptor does not give her youth: if the lines under her eyes are hardly perceptible, the flesh under the cheek-bones and around the mouth is that of a mature woman. We can appreciate the sculptor's skill in portraiture, his adroit compromise between the truth and an ideal. The long slender hands, the tapering fingers, are a characteristic of Pilon's.

The rich brocade, the braid and buttons, the tassels, the domed head and curls of the much-loved precious dog, the forgotten book, all surround and enhance the lovely woman. Yet Pilon has managed to taint all this once enjoyed splendour with a subtle melancholy. Valentine Balbiani seems to dwell not on the image of what she will become, but on something more remote, less fathomable. Although her expression is untormented, contemplative, it does not reflect serenity, but rather a gentle wistfulness. There is not here the peace of a Christian surrendering to God, but uncertainty.

It is important, though, not to let the impressions of secular weath and of human emotions which disclose the Renaissance preoccupation with man cast the religious signification into the shade. More than the Christian decorative imagery, the effigies reminded the onlooker of both the transitional aspect of existence on earth, and the hope of rebirth and eternal life.

—Deborah Palmer

Jean Goujon (c. 1510—c. 1568–69)
The Fountain of Innocents, 1549
Stone; dispersed
Paris, Square of the Innocents

Bibliography—

Miller, Naomi, "The Form and Meaning of the Fontaine des Innocents," in *Art Bulletin* (New York), 50, 1968.

Together with the reliefs on the Louvre facade, Goujon's *Fountain of the Innocents* is considered the paradigm of Renaissance classicism. Completed in 1549 for the occasion of the triumphal entry into Paris of Henry II, it was situated at the corner of the Rue St. Denis and the Rue aux Fers, alongside the Church of the Innocents. Constructed on the site of a late 12th-century fountain, it was built into the wall enclosing the Cemetery of the Innocents. The veneration which the Parisian populace accorded this fountain was due partly to its prominent location on the fixed processional route of official entries.

As seen today, in the midst of the newly designed Square of the Innocents, the fountain is a hymn to the revival of the Plateau Beaubourg. Its present state (in the form of a pavilion-baldochino crowned by a dome) is the result of numerous alterations and displacements which began with the demolition of the adjoining cemetery and church from which the fountain derived its name.

Despite the widely acclaimed beauty of the fountain, documents are scarce, but the attribution to Goujon, based largely on stylistic affinities with his early work in Rouen and Paris, as well as literary accounts, has not been questioned. Lescot's possible role in the creation of the structure remains unresolved. Du Cerceau's engraving of the fountain in the 1570's is the earliest known dated depiction of the original design, though 17th-century representations by Marot and Sylvestre provide a better idea of its severely restricted site. Part of a tribunal on a raised stone base, its general aspect is enhanced by three open "triumphal" arches. Paired fluted Corinthian pilasters flank the bays with their bronze balustrades and surround the nymphs and the shields bearing the emblems of the city. Maritime divinities adorn the three reliefs at the base of the arcade as well as those above. The latter are framed by escutcheons with the arms of Henry II and Catherine de' Medici. Beneath the cornice of the loggia is a frieze that appears to be of intertwining dolphins alternating with acanthus.

Probably due to its location, the *Innocents* was constructed in the form of a gallery, as a grandstand from which dignitaries could see and be seen. The unique shape of the fountain compels us to seek the reasons which determine it, for its structure includes components of tribune and temple, altar and tomb, open loggia and triumphal arch. Only water is minimal in this monument to its glory. Jets springing from taps beneath lion mascarons constituted the fountain's sole waterworks.

Lacking the essential element for a fountain, Goujon chose to create a monumental allegory of water through his carved reliefs, which appear to be saturated by its fluidity. His success resides largely in this metamorphosis of the properties of one medium into another—of the *idea* of water into the material of stone. Nowhere is this transformation made more manifest than in the quintet adorning the fountain, who breathe the air of the maidens on the Acropolis while at the same time betraying their descent from the sculptured saints of the cathedral portals. Gently twisting beneath their diaphonous wet drapery, these Naiads seem to have just emerged from the sea, elegantly bearing its contents in their amphorae. As a horizontal counterpoint, motifs derived from antique sarcophagi appear on the attic reliefs. Infants propelled by billowing sails and other symbols of immortality are allied to Dionysiac references, while the dolphins were particularly appropriate in a monument honoring Henry II, the dauphin. The flying fames, undisguised in their Roman ancestry, are also relevant motifs for the themes of triumph and immortality.

Viewed in the context of the Entry, the fountain built in the new style *à l'antique* was a triumphal climax to the procession, and also a source of civic pride, symbolizing as it did the amelioration of hydraulic works under the new monarch, and the inauguration of a public work as an ornament of Paris. Specific prototypes include fountains in Rouen, Autun, and Fontenay-le-Comte, but do not account for its extraordinary classicism. Goujon's knowledge of antiquity surely comes into play, above all, in his illustrations for the 1547 edition of Vitruvius, but also it is gleaned from sources available in France, such as the classical casts at Fountainebleau, antique monuments in Nimes and Reims, triumphal arches in Serlio's *Book IV,* and in tapestries. Even closer to the spirit of the *Innocents* is Sansovino's *Loggetta,* built in Venice from 1537–40, whose reliefs extoll the riches and virtues of the Venetian Republic. It is through Venice and the resurgence of Pan-hellenism there that Greek as well as Roman ideas were disseminated in France.

Considered as a fountain-temple, the closest antecedents of the *Innocents* may be found in the description of monuments that the Greeks raised near the springs to honor the water divinities who dwelt therein. Like other fountains, the *Innocents* evoked the medieval connotations of the life-giving fountain as a meeting place for the faithful. With its many allusions to the kingdom of the sea, the fountain was the metaphorical ship of state, a symbol of the triumph of Henry II. Concurrent with the festivities marking the King's entry was the publication of Du Bellay's *Deffence et illustration de la langue françoyse,* which declaims what the fountain displays: "that the greatest part of artifice lies in the imitation of the antique," thereby affirming by means of literature the glory of France.

In the mid-16th century, the fountain was above all a poetic metaphor. With its multiplicity of allegorical allusions, the *Innocents* might be deemed the tangible expression of the political and amatory forces at the time of the royal entry—the love of Henry II and Diane de Poitiers. Recalling Roman triumphal entries, the idea of the *Fountain of Innocents* as an imperial *fons vitae aeternae* becomes inevitable.

As a prelude to the classicism of the golden age, the *Fountain of Innocents* continued to be much esteemed and admired. Recognized as the source of a new style, the beauty of the *Innocents* overwhelmed even such a visitor as Bernini, who, upon seeing the fountain in 1665, exclaimed to Colbert that it was "la plus belle chose de Paris."

—Naomi Miller

Alonso Berruguete (c. 1487–1561)
The Transfiguration of Christ, 1543–48
Alabaster; figures are life-size
Toledo, Cathedral

Alonso Berruguete's *Transfiguration* in Toledo Cathedral is the triumphant work of Spain's most important Renaissance sculptor. The dramatic figure group, carved in white Spanish alabaster, crowns the Archbishop's throne within the choir at the center of the cathedral nave. The choir is a magnificent complex of architecture, sculpture and monumental metalwork, erected by Archbishop Juan Tavera between 1535 and 1542 as a fitting setting for the public ceremonies of the prelate and canons of Spain's primal see. Berruguete came to Toledo in 1538 to carve half of the choir stalls, and in some 70 individual figures of walnut and alabaster he explored the expressive potential of the human figure and the medium of relief.

Berruguete's work on the choir stalls inspired the Archbishop to commission from Berruguete in 1543 a life-sized figure group to complete the newly installed choir and adorn his own central throne. Liberated from architectural designs conceived by others and from the need to conform with the more conservative styles of his collaborators, Berruguete created an unprecedented design in which the sculpture was freed from an architectural setting to stand unrestricted in the open space above the choir enclosure. The ardent energies of the boldly carved figures are only controlled within the hierarchy of the pyramidal composition.

The scene shows Christ at the summit of Mount Tabor revealing for the first time to his chosen disciples the full radiance of His divinity: "And after six days Jesus taketh Peter, James, and John his brother, and bringeth them up into an high mountain apart, and was transfigured before them: and his face did shine as the sun, and his raiment was white as the light. And, behold, there appeared unto them Moses and Elijah talking with him" (Matthew 17:1–3). The three disciples cower in wonderment and shield their eyes from the blinding radiance of their transformed leader. The kneeling prophets flanking Christ both present Him and implore Him, and their gesticulating hands and speaking mouths recall their prophecies of His miraculous resurrection. In representing this visionary subject in stone, Berruguete created a sculptural metaphor of man's struggle for faith and transcendence over the material world.

The mass of stone that represents the mountain is carved in the swirling shapes of clouds or flowing lava, and the life-size figures appear to rise out of molten earth which teems with cherubs and marine creatures. The apostles are immersed in the stone at the base of the mountain; their draperies are carved in relief while only their heads and arms extend fully from the stone in violent gestures. The Apostles' struggle towards three-dimensional form reflects their links to the Old Law and their inability to comprehend the vision above them. Christ, on the other hand, rises free from the stone ground, accompanied by His prophets who through their faith and vision recognized Christ's divinity. In this moment, Christ momentarily abandons His human existence to display His immaterial, supernatural form.

The full meaning of the composition grows out of the program of the choir stalls below. The alabaster reliefs in the attic story of the choir depict the genealogy of Christ from the aged and fallen Adam to the Virgin Mother: Berruguete's Old Testament figures writhing in their niches map the tortuous route from man's fall from grace to the promise of his salvation. The series of walnut reliefs on the stalls includes saints, prophets, and the 12 apostles at the center. The realization of both programs comes only in the scene above: the transfigured Christ revealing His divine nature to His disciples represents both the Savior of the traditional "Apostolado" and the fulfillment of God's promise.

Berruguete completed the metaphor by incorporating the light symbolism essential to the biblical narrative. As the figures in the stalls and the *Transfiguration* rise from the stone in varying degrees of relief, they also emerge from the penumbra of the choir enclosure into the light of the nave. The sculptor framed the figures of Christ and the two prophets with an open gilt structure in the form of a Serliana and silhouetted them against the circular rose window of the west facade. Issuing forth from the alabaster and shining white in the full illumination of the open nave, Berruguete's Christ is transfigured in the full radiance of His divinity.

—Samuel K. Heath

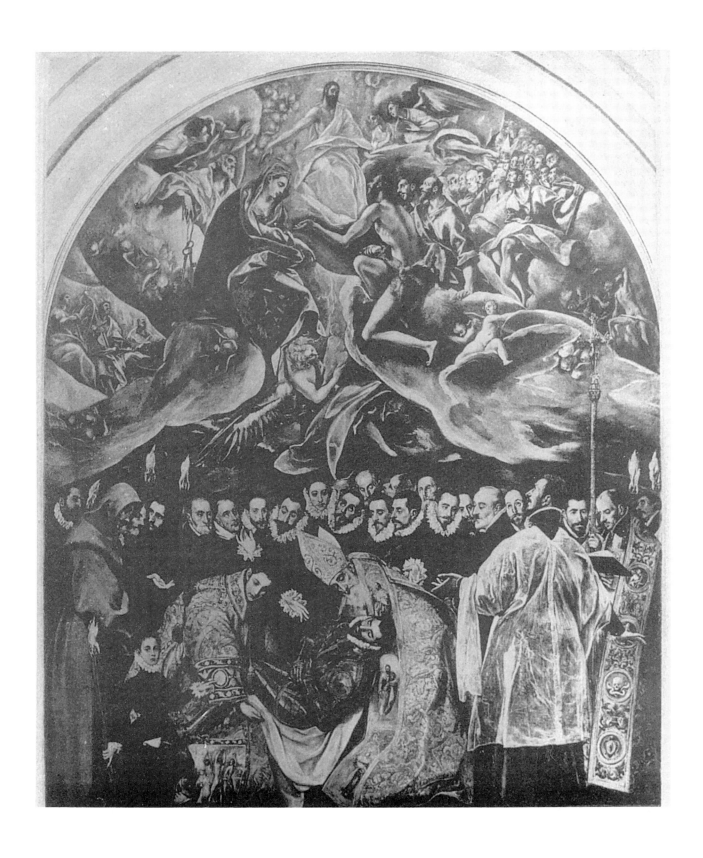

El Greco (1541–1614)
Burial of the Count of Orgaz, 1586–88
15 ft. 9 in. × 11 ft. 9³/4 in. (480.1 × 365.2 cm.)
Toledo, Santo Tomé

Bibliography—

Gomez Moreno, Manuel, *El entierro del Conde de Orgaz: Estudio critico*, Barcelona, 1943.

Domenikos Theotokopoulos, known as El Greco, arrived in Spain in 1577, settling in Toledo. He was born in Candia, Crete, in 1541, and after early training as a Byzantine icon painter, he spent time in Venice modernizing his art. He travelled to Rome in 1570; there he learned further new lessons until his departure for Spain, where he was perhaps lured by the prospect of working at the court of Philip II. El Greco received generous payment for the two works he created for Philip, the *Allegory of the Holy League* of 1577–79 and the *Martyrdom of Saint Maurice* of 1580–82 (both in El Escorial), but did not receive further commissions at court. He thus established himself instead in nearby Toledo, where he had connections through friends made in Rome. After a long and successful career in his adopted city, El Greco died in Toledo in 1614.

The subject of *The Burial of the Count of Orgaz* (Toledo, Santo Tomé), the best known painting of El Greco's Toledan years, is simply described in a 1586 contract:

On the canvas he [El Greco] is to paint the scene in which the parish priest and other clerics were saying the prayers, about to bury Don Gonzalo de Ruiz, Lord of Orgaz, when Saint Augustine and Saint Stephen descended to bury the body of this gentlemen, one holding the head, the other the feet, and placing him in the sepulcher. Around the scene should be many people who are looking at it and, above all this there is to be an open sky showing the glory [of the heavens].

The size and shape of the painting were determined by the architecture of the chapel for which it was intended. Below it was planned an epitaph in Latin and, below that, "a fresco in which the sepulcher is painted"; the fresco was never painted.

El Greco's painting, as stipulated in the contract, actually depicts a moment of Toledan history. Gonzalo de Ruiz, the Count of Orgaz, had been rewarded for a lifetime of generous donations to religious institutions in Toledo by a miracle. When Ruiz died in 1323, Saint Stephen and Saint Augustine appeared to lower his body into the tomb. Over 200 years later, the depiction of the miracle in an enormous painting by the pre-eminent painter of the day was prompted by a series of contemporary events. Gonzalo de Ruiz had bequeathed an annual donation to the church of Santo Tomé, to be directly paid by the citizens of the town of Orgaz, of which he was lord. Around 1562 the townspeople simply decided to stop making the donation, perhaps thinking that Ruiz's will might be forgotten after more than two centuries. The parish priest, how-ever, instituted suit against the town two years later. He eventually won the case and decided to use the monies due to improve the burial chapel of the Count of Orgaz. El Greco's painting is the eventual result of that decision.

In *Burial of the Count of Orgaz* we see the results of El Greco's years in Italy. He adapted to a personal manner the loose and expressive brushwork of Titian and Tintoretto, whose works he knew in Venice. He also absorbed the tendencies toward somewhat abstract forms and compressed space practised by the painters of the late Renaissance in Rome whose works we call Mannerist. The composition of the painting is related to the famous example of Titian's *Assumption of the Virgin* (Venice, Church of the Frari); in both, the large format is divided into an earthly and a heavenly zone. There the resemblance ends, for El Greco's composition is firmly Mannerist in the shallowness of the space and anti-classical in the elongated proportions of the figures.

The composition of the lower half of the painting reflects quite faithfully the requirements of the parish priest, Andrés Núñez de Madrid. Saints Stephen and Augustine, in their brilliantly embroidered dalmatics, gently lower the Count of Orgaz into his tomb. The miracle takes place within the more ordinary context of a funeral service, presided over by a parish priest (perhaps Núñez himself) in his gauzy white alb to the right. The event is attended as well by a number of clerics, important citizens of Toledo in austere black accented with white ruffs, and a Franciscan. A young boy, believed to represent El Greco's son, Jorge Manuel, draws our attention to the armor-clad corpse of the Count of Orgaz.

The contract gave El Greco much more artistic freedom to compose the upper half of the painting, for Núñez only required "an open sky showing the *gloria*." An angel bearing aloft the ghostly image of Ruiz's soul lightly connects the sober, naturalistically painted figures who attend the funeral with the sky above, dramatically opened to reveal the heavenly host. The brilliantly lit figure of Christ's at the top of the painting receives the recommendation of Ruiz's soul from the Virgin and Saint John the Baptist. The ecstatic moment is attended by agitated figures of all the saints.

The didactic message carried by this masterpiece of Counter-Reformation art is multiple, but clear. The efficacy of good works as a means to reach heaven had been challenged by Protestant leaders. After the Council of Trent, the Catholic church forcefully reaffirmed its beliefs, especially through the medium of works of art. In *The Burial of the Count of Orgaz*, the Catholic church of Toledo demonstrated that the good works—the charity—of Gonzalo de Ruiz was rewarded by a miraculous interrment and his glorious acceptance into heaven. His life and death are thus a reminder to the reluctant citizens of Orgaz and a lesson to us all.

—Suzanne L. Stratton

El Greco (1541–1614)
View of Toledo, c. 1600
47³/₄ × 42³/₄ in. (121.3 × 108.6 cm.)
New York, Metropolitan

Bibliography—

Moffitt, John F., "Anastasis-Templum," in *Paragone* (Florence), 33, 1982.
Kagan, Richard L., and Jonathan Brown, "View of Toledo," in *Studies in the History of Art* (Washington), 11, 1982.

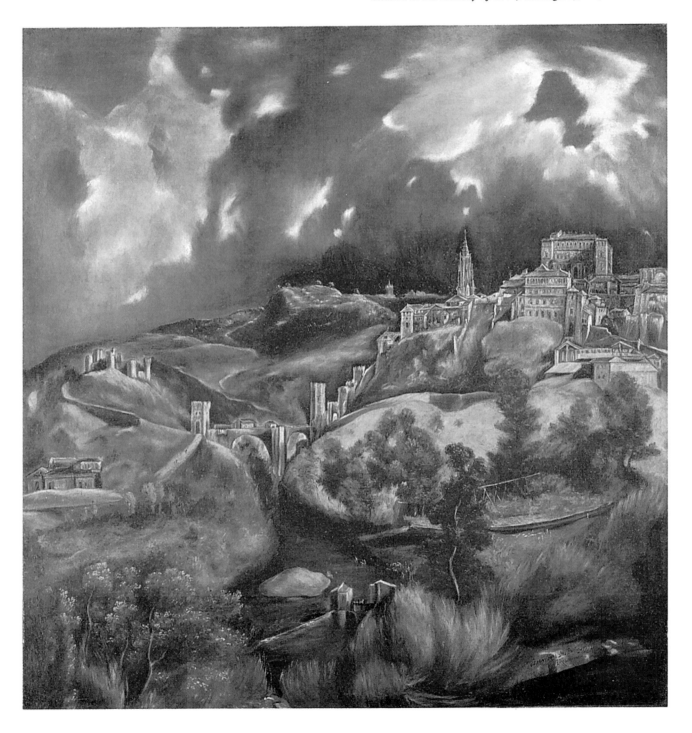

This now-famous work was virtually unknown until its publication by M. B. Cossío in *El Greco*, 1908. It is now taken to represent one of the most expressive of "pure landscape" pictures, an interpretation that quite misses its original meaning. After Cossío, innumerable writers have concentrated their attention on the painting's "modern" sensibility (another pathetic fallacy), by which they particularly stress the "emotional" effects of a tempestuous and oddly moonlit sky, the bizarre color tonalities (spinach-green ground and cobalt-grey heavens), and the writhing and loose brushwork knitting together the whole and suggesting an ecstatic "dream-vision."

These modern evaluations are basically wrong since they are anachronistic: in no way is El Greco a "modern" artist. The much remarked upon *"expressionismus"* is, however, a trait common to all of El Greco's late works, and it has its own very traditional antecedents. Born in 1541 in Candia, Crete, Domenikos Theotokopoulos was raised in a Greek-speaking possession of Venice (since 1204) where the dominant style in painting was still late Byzantine (Paleologue) and, as such, consistently characterized by diagrammatic distortions of space and elongated human figures. In addition to these somewhat routinized medieval schematizations, El Greco was (c. 1568) exposed to the conventions of Venetian late Renaissance painting, characterized by rich, sometimes clashing, color-schemes and lush, sweeping brushwork. To these factors, there was added a large measure of current, International Mannerist, proclivities expressed visually by grossly exaggerated poses, forced and unclear proportional and spatial relationships, un-natural colors, and all the rest.

One should also address the question of the traditional content of a painting like the *View of Toledo*. This, too, is a product of its time, and a historical analysis of its content reveals how very un-modern in concept is this quintessential "landscape." Before 1600, the number of independent (figureless) landscapes is proportionally minuscule. El Greco's *View* belongs to the mood of the Catholic Counter-Reformation, a period in which lesser categories of (literally) mundane imagery could be allowed, even praised, as signs of "many most wonderful qualities" of God's creations: "Greatness, multitude, variety, efficiency, and beauty," all such virtues could metaphorically be found in a painted landscape, according to Federico Borromeo, Archbishop of Milan.

More specifically, although taking some topographical liberties, El Greco has depicted a recognizable city-scape, that of Toledo. Thus we have two other traditions to explore, the rise of urban *vedute*, and the metaphorical meanings of Toledo itself at the end of the 16th century. The first wholly accurate portrait of a given famous city, one rife with symbolic connotations, is the woodcut of Jerusalem by Bernard von Breydenbach. In 1500 Jacopo de' Barbari executed an engraving of a bird's-eye view of Venice, and a bit later similarly fictive aerial surveys appeared of Rome. In the Renaissance emblematic city-view, topographical fidelity is melded to symbolic needs, with major, characterizing architectural monuments shown displaced and disproportionately large, just as is the case with the *View of Toledo*. El Greco knew perspective theory, including various published city-views, for these are mentioned by name in the 1621 inventory of his books.

El Greco's View is hybrid in projection and selective in detail, presenting the "external" spiritual and historical face of Toledo rather than its exact and mundane physiognomy in 1600. Eliminating from his interests two-thirds of Toledo, the emigré artist shows us only the easternmost part of the cosmopolitan city, dominated by its exaggerated heights, topped with a palace, the *Alcázar*, of which we see its more characteristic northern face. To the left is the visible sign of the "Church," or ecclesiastical authority, that is the bell-tower of the Cathedral (so placed on the "right" side of the corresponding symbol of "State"), which, in reality, should be situated so far to the right as to be outside the picture. In the left margin, El Greco shows a mysterious group of buildings resting on a simulated cloud, indicating a dream-like apparition; recent scholarship identifies this complex as the long-vanished Agaliense Monastery, where St. Ildefonso, the Visigoth patron saint of Toledo, spent those meditative-spiritual retreats discussed by the proud chronicler of Toledo's glorious historical past, Pedro de Salazar de Mendoza, the man who actually owned El Greco's *View*.

Such topographical liberties reveal the true meaning of this highly emblematical—historicized, moralized, and spiritualized—city-portrait. The "crown" of Toledo contains the current architectural symbols of the union of Church and State; the famous bridge (rebuilt by the Arabs) and the vanished monastery placed at its very foundations, openly testify to this City's glorious and continuous past, from its Roman (classical) foundations to the Visigothic period, when Toledo was first made the temporal capital of a united Hispania in the 6th century and, additionally, the seat of all its present ecclesiastical authority. After its reconquest from Moslem domination, in 1065, once again Toledo was dubbed *Ciudad Imperial* (a title still in use). In the late 16th century, Toledo still had plausible aspirations to retaining its role as Imperial Capital (its spiritual primacy was never in doubt). As late as 1595, letters were being sent to Philip II encouraging him again (as he did in 1560) to take up fixed residence in the great city, potentially still enjoying great economic advantages due to the wealth of the archdiocese, not to mention its established textile, stock-raising, and metal-working industries (even though the population had diminished by a third in 1600, having attained its peak in 1571).

At this time, many panegyrics were being written to praise the Imperial Capital, and the use of such topical encomia as *"nueva Roma"* and *"nueva Jerusalén"* were commonplace, thus relating the meaning of any emblematic city-view of Toledo to all those similarly symbolically charged *vedute* of Rome and Jerusalem presumably known to El Greco. Thus, besides its blatant retrospective historical eulogizing, El Greco's *View* must be now regarded as a timely rhetorical piece of topical political propaganda, one quite in line with the panegyric composed by a celebrated poet, Lope de Vega, in 1605 to honor the birth of a future king, Philip IV, and to stress the city's on-going imperial pretensions: "Toledo the imperial noble city, / The capital of Spain, that onetime famous court of the Gothic kings, / As the heart in the body is the core and fount of life, / So is Toledo, heart of Spain."

—John F. Moffitt

Francisco Ribalta (c. 1565–1628)
St. Francis Embracing the Crucified Christ
62¼ × 44½ in. (158.1 × 113 cm.)
Madrid, Prado

Francisco Ribalta's *St. Francis Embracing the Crucified Christ* is a mesmerizing image in which a visionary event occurs in the most believable and understandable of terms. Clearly in conformity with the Counter-Reformation religious temperament of the day, and much like the concrete mental images conjured up in the minds of late 16th and 17th-century spiritual mystics, this mature work by an early Spanish baroque master fuses the everyday and the otherworldly, creating a close and inseparable bond between mundane, earthly existence and the supernatural aspects of Catholic religion.

The painting is one of several works executed by Ribalta for the Capuchin monastery of the Sangre de Christo (Blood of Christ) near Valencia. The reformed order of Franciscans had been installed in the city and their monastery built under the auspices of Valencia's doctrinaire archbishop and patriarch, Juan de Ribera. Significantly, the archbishop had also served as Ribalta's primary patron; soon after moving to Valencia in 1599, the artist was employed by Ribera to paint major altarpieces for the newly constructed Colegio de Corpus Christi, a seminary founded by the archbishop and dedicated to promoting the strict, religious reforms of the Council of Trent. That Ribalta was able to satisfy the archbishop's strict requirements for religious orthodoxy and represent such themes in a comprehensible way is clearly evidenced by Ribera's continual support and by the fact that after the patriarch's death in 1611, Ribalta continued to paint for like-minded patrons, among them the Capuchins of Valencia.

Around 1620 Ribalta is known to have painted an image of the *Last Supper* for the refectory of the Capuchin convent (the painting does not survive). Presumably around this date he also executed the undocumented canvases of *St. Francis Embracing the Crucified Christ* and *St. Francis's Vision of the Musical Angel* (Madrid, Prado), both of which stood, according to early sources, upon lateral altars of the monastery church. The maturity of style displayed in both surviving canvases is perfectly consistent with the artist's expression in the last decade of his life. His previous style, often mannered and closely based on borrowing from others, gave place in the 1620's to works devoid of stylistic embellishment and overly complicated iconographical conceits; the degree of descriptive naturalism, combined with a dramatic lighting, increases, prompting an empathetic response from the viewer and allowing an intimate and personal contact with the divine. Ribalta's *St. Francis Embracing the Crucified Christ,* a fully mature production, is among the finest examples of a spiritually realistic style of painting in early baroque Spain.

The painting is carefully calculated to forge a link between viewer and image. Within a geometrically structured composition, the fluidly painted, monumentally sized figures possess an overwhelming, tangible presence that projects outward to within arms' reach of the spectator. The slightly enobled figure of Christ is seen in the center foreground, miraculously suspended upon a plain, wooden cross set against a darkened background. To the musical accompaniment of angels at the right, the Saviour disengages one arm from the cross and removes his crown of thorns, which is promptly replaced with a

garland of flowers supplied by another wingless angel at the left. The Lord, in turn, is about to fix the spiky symbol of His Passion upon the tonsured scalp of St. Francis, patron of the Capuchins. Francis, whose gruff, physical features are based on observation of a real model (perhaps a Capuchin father from the Valencian monastery), balances on the head of a panther sprawled at the foot of the cross and pushes his body upward toward Christ, whom he lovingly embraces and into whose oozing, bloody wound he relishingly thrusts his face. The appearance of Christ before him—a Christ as concrete and real as he is—totally transfixes the humble ascetic. The saint from Assisi has achieved a mystical union of body and soul with his God, evidenced also by the presence of the stigmata upon his hands and feet. Francis, who has dedicated his life to imitating that of Christ, has been rewarded with a "real" vision of his Lord; his experience is an example of the potential reward to others who follow the same devout path.

The mystical temper of this enraptured embrace is dependent in great part upon the artificial spotlighting which proceeds from an unseen source beyond the border of the canvas. Carving the main participants into relief, while obscuring the minor characters in shadow, the light sets the warm earthen tones of Christ's body and St. Francis's head and torso aglow. Similar to the tenebristic innovations of Caravaggio (although arrived at independently by Ribalta), light has been adeptly utilized to give both physical reality and elevated spiritual meaning to the painting. Not only does it direct attention to the dramatic heart of the work and enhance the naturalistic clarity of its parts, it also denotes the radiant attendance of the Creator Himself upon the scene, thus raising the particular moment—notwithstanding all its earthiness—above that of the everyday.

The exact source of this painting's subject matter—the embrace of Christ and Francis—is perplexing since no recorded account of St. Francis's life relates such an episode. Nonetheless, the theme had been treated previous to Ribalta's example and did circulate in prints; it is conceivable in this case that Ribalta based his general format upon engravings by Hieronymous Wierix. Still, Ribalta's work contains additional symbolic connotations not found in the possible models, yet so specific as to indicate that the artist followed the strict, theological counsel of his Capuchin patrons. The picture's iconography conforms closely to the ideals of the Capuchin order and the preoccupations of the Valencian monastery in particular. The "vanitas" imagery below—including the panther symbolizing pride, and seven additional feline monsters representing the capital sins—is a reminder that this ascetic wing of Franciscans abhorred all worldly glory. And as grisly as it may seem, the placing of St. Francis in direct, physical contact with Christ's body and in relishing proximity to the Lord's bloody wound—a eucharistic accent upon the body and blood of Christ—was perfectly appropriate for an order stressing the mortification of the flesh and a monastery specifically dedicated to the blood of Christ. In Ribalta's painting, Francis—and presumably his Capuchin brethern—seek not earthly acclaim but mystical union with Christ, a theme looming large

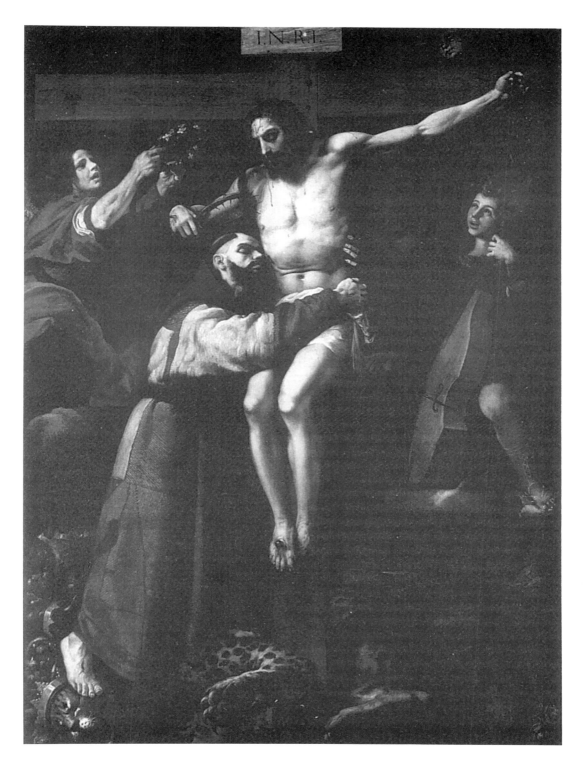

in the literature of the period and specifically in the writings of the Capuchin order. Expositions by Capuchin authors on the mystical life and their treatises designed to guide the way to it stress, not intellectual reasoning as a means to reach God, but above all a stimulation of the heart: the means to alliance with God is found only when the body is under the influence of pure spirit and divine love, as is that of St. Francis in Ribalta's depiction.

There can be no doubt that Francisco Ribalta—himself ardently religious, a friend of literary figures, and patronized by one of the strictest Tridentine religious orders of the time—was profoundly affected by these currents of thought and gave them artistic form in a canvas that eloquently and elevatingly captures this mood by so forcefully relying upon and appealing to human emotions.

—David Martin Kowal

Nicholas Hilliard (c. 1547–1619)
Young Man among Roses, 1580's
Watercolor on vellum; 5³/₈ × 2³/₄ in. (13.7 × 6.9 cm.)
London, Victoria and Albert

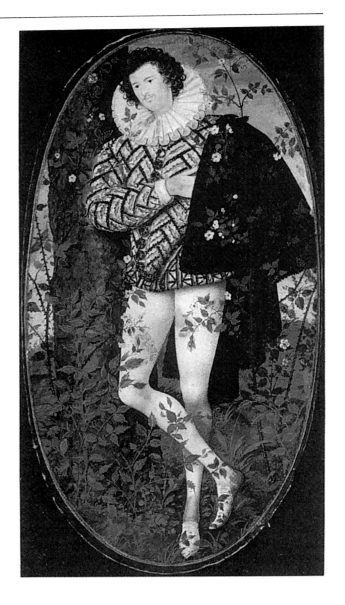

England has excelled in the art of portrait-miniature painting or "limning" ever since its development in the 16th century, and Hilliard's *Young Man among Roses,* dating from the 1580's, is one of the most famous examples. It did not, however, become generally known until it entered the national collection at the Victoria and Albert Museum in London in 1910. Since then this enigmatic work has prompted continuing speculation about the identity of the sitter, the significance of his pose, dress, and setting, and the meaning of the Latin inscription. Miniatures of the day were generally not much more than about two inches high, small enough to be held in the palm of the hand, but the *Young Man* is twice as high, and its unusual elongated oval indicates that it was commissioned for a specific placing. In style the miniature is unparalleled either in Hilliard's surviving work or by anything else produced in England at the time: the artist seems to have been strongly influenced by mannerist works commissioned for the French Court, which he would have studied during his two-year visit to France in the 1570's.

Emblems or "devices"—*imprese*—were beloved of the Elizabethans, and the *Young Man among Roses* follows the rules set out by the scholarly William Camden: that there should be "a correspondency of the picture . . . and the motto," the latter to be "in some different language." Hilliard's subject is depicted as though seen from below, with his head and features—executed in the artist's characteristic unshadowed style—disproportionately small: the intention was probably to indicate that he was exceptionally tall. He has often been supposed to be Elizabeth I's favourite Robert Devereux, Earl of Essex—who was indeed a tall man—and he is wearing black-and-white, the Queen's colours. As for the white roses, they have been identified with the eglantine, the rose with sweet-smelling leaves much used by Elizabethans for fashioning bowers in gardens, often intertwined with honeysuckle. The eglantine was sometimes regarded as the Queen's flower. However, *Rosa eglanteria* has deep pink, not white, flowers, and Hilliard's plant is perhaps more likely to be the trailing white rose of the English hedgerow, *Rosa arvensis,* the "sweet musk rose" above the bank where Titania sleeps in Shakespeare's *A Midsummer Night's Dream.* It is generally agreed that the tree-trunk in the miniature signifies constancy: but the trunk, and the young man's hand-on-heart pose, could indicate not devotion to the Queen, but faithful friendship. Such an interpretation would fit the inscription—executed in Hilliard's exquisite calligraphy—*Dat poenas laudata fides,* "fidelity, though praised, brings penalties." The words are from Lucan's *De bello civili,* and the passage from which they were taken—well-known in England into translation at the time—declares that fidelity brings penalties "when it supports those whom Fortune crushes." The words "whom Fortune crushes" are obviously inapplicable to the Queen, and the motto would seem to mean that the young man—whatever his identity—is no fair-weather friend, but faithful in good times and bad, symbolised by roses and thorns.

—Mary Edmond

Isaac Oliver (before 1568–1617)
Unknown Melancholy Man, early 1590's
Watercolor on vellum, 4⅝ × 3¼ in. (11.7 × 8.3 cm.)
Royal Collection

Unknown Melancholy Man is one of the larger "cabinet" miniatures which Oliver painted at intervals throughout his career. Unlike Nicholas Hilliard, from whom he learned the techniques of limning, he rarely dated his works, but on grounds of style and costume, this one can be assigned to the early 1590's, when he had not long completed his tuition. The naturalistic portrayal of flowers and plants in the foreground is in the Hilliard manner, but Oliver has already abandoned the clear, unshadowed portrayal of the face and begun to develop his own characteristic style, which owed much to Flemish influence. The sitter is portrayed with three-dimensional realism, the source of light coming from the left and the features built up in *chiaroscuro.*

Oliver rapidly emerged as a complete artist, as Hilliard had done a generation before: to quote the art historian George Vertue, whose notebooks are now in the British Library, and who saw and sketched this miniature in the early 18th century, it constitutes "a plain proof that Oliver had already gaind all the Skill he was ever master off." The identity of the sitter is unknown, but his rich dress and sword proclaim him, in Vertue's word, "Genteel." The historian twice states firmly that he is Sir Philip Sidney, basing this on information from an unknown "Mr. Correy," in whose possession and that of his forebears the miniature had been "time out of mind." But the sitter in no way resembles known portrayals of the poet and soldier, and the suggested identification has now been abandoned. Similarly, the formalized background is no longer supposed to represent either of the two great English houses with which Sir Philip was closely associated, Wilton in Wiltshire (as Vertue believed) and Penshurst in Kent. The background is imaginary, and based on a contemporary engraving by Hans Vredeman de Vries.

The miniature is a notable representation of the fashionable Elizabethan cult of melancholy, recently imported from Renaissance Italy and much commented upon by contemporary writers and painters. The sufferer was usually portrayed with hat over eyes and crossed arms, as noted by Shakespeare in his sophisticated early comedy *Love's Labour's Lost,* where Armado, that "man in all the world's new fashion planted," wears his hat "penthouse-like" over his eyes and has his arms crossed on his doublet "like a rabbit on a spit." Oliver's young man is in a sylvan scene, on a bank raised above the mansion and formal gardens behind, emphasizing the melancholic's desire for solitude. The work can be compared with the artist's later *Edward Herbert, 1st Baron Herbert of Cherbury* (the Earl of Powis, Powis Castle), brother of the poet George Herbert, who reclines head on hand beside a brook, and also with Hilliard's reclining *Henry Percy, 9th Earl of Northumberland* (Rijksmusem, Amsterdam); and both with Shakespeare's melancholy Jaques in *As You Like It,* discovered by two lords reclining under an oak beside a brook in the forest of Arden.

—Mary Edmond

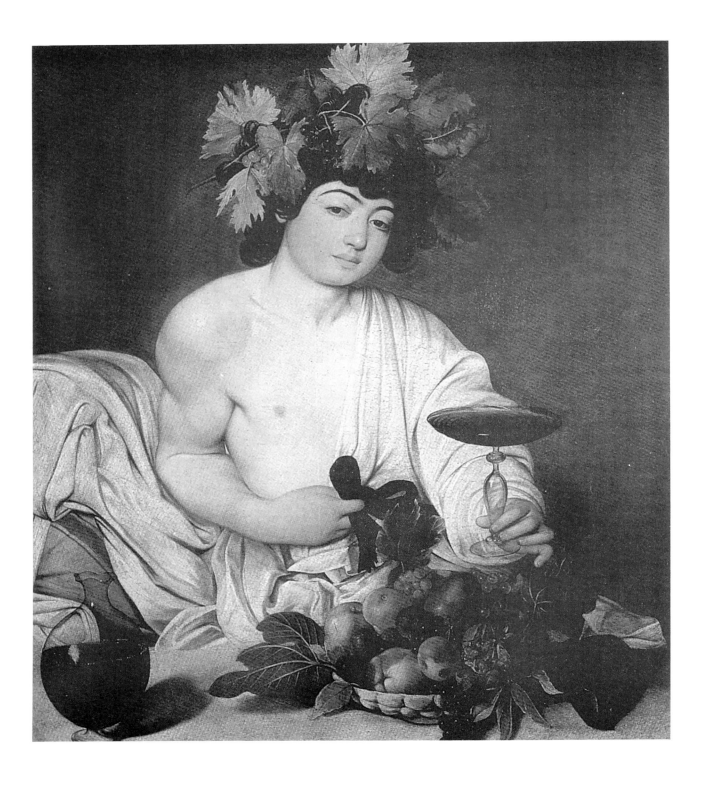

Caravaggio (1571–1610)
Bacchus, 1590's
37³/₈ × 33¹/₂ in. (95 × 85 cm.)
Florence, Uffizi

Caravaggio's earliest surviving work, done in the years after his arrival in Rome, c. late 1592, is dominated by a clutch of enigmatic half-lengths of scantily clad boys with still-life accessories of fruits and flowers. Most of the pictures in this small group (e.g., *The Boy Bitten by a Lizard,* National Gallery, or *The Concert of Youths,* New York) were probably intended to be symbolic in ways which are no longer precisely clear. The Uffizi *Bacchus* (and another in the Borghese Gallery, Rome), with their direct yet not inappropriate evocation of the ancient Roman god of wine, are the only exceptions to this iconographical obscurity.

The pictures constitute a group because they are visually and psychologically of a kind. One cannot, for example, ignore the strong, unifying aura of sensuality and of camp homosexual innuendo which they all exude—nor the pseudo-classical, fancy-dress form which this assumes, for several of the youths wear provocatively disposed antique-style robes or chemises. Caravaggio was certainly homosexual or bisexual, as one contemporary and another early account indicate, but the strongly cultivated aspect of these works begs a fuller, sociological explanation. Donald Posner has perceptively connected them with the young male prostitutes, or "bardassi," who, ironically, abounded in Counter-Reformation Rome (as they had in ancient times), while it is also possible that such images were guided into being by a sophisticated, homosexually inclined patron like Cardinal Francesco del Monte, who certainly owned two of them and may also have commissioned the *Bacchus.*

The *Bacchus,* which hails from the Medici collection, was possibly given as a present by del Monte to Ferdinando de' Medici, Grand Duke of Tuscany, since the cardinal was Ferdinando's chief representative at the papal court. Yet whether commissioned by the cardinal or perhaps even by the Grand Duke himself, it might well have been conceived as a particularly appropriate status symbol. For it is possible that the patron had in mind a story retailed by Vasari (and derived from Pliny the Elder) about a masterly and highly esteemed picture of Bacchus by the ancient Greek Painter, Aristides. It was not uncommon for Renaissance artists and patrons to try and enhance their reputations through such recreations of lost antique masterpieces described in the literature.

The fact that the Medici picture seems, however, to have been kept from the public gaze until its rediscovery in 1916, suggests that its owners were as aware as we are of its salaciousness. Although the many stories which make up the Bacchus legend stress his effeminacy (and even, on occasion, implicate him in homosexuality and transvestitism), few people could have been prepared for such an outrageously decadent rendering.

Caravaggio's rouged, lipsticked, and eyebrow-pencilled "dainty Bacchus" (Shakespeare, *Love's Labour's Lost*), crooking the little finger of his left hand, is a creature of the del Montean demi-monde (we know that the cardinal who, among his many interests, was a keen alchemist, owned recipes for a wide range of cosmetics). The "giver of joy," as Virgil described Bacchus, is handing us a glass of wine but it is clear that he is also offering himself. The god reclining on his studio-prop *triclinium* is already half undressed and not a little embroiled in the language of bed: is there meant to be a distinction between his robe and the sheet that covers the bolster, or are they one and the same? The black bow of his loosened sash, tied suggestively round his index finger, is a love-knot which does not mince meaning, while the ripening, orificial fruits in the white, Faenza bowl compound the message. The sexual suggestiveness of fruits and vegetables, employed by Caravaggio in a number of his early works, is almost universal in popular culture and it had also entered high culture in the Renaissance—in, for example, the decorative borders to Raphael's frescoes in the Farnesina and in Francesco Berni's ribald poems of the 1520's (the *Capitoli*), the latter still relished in certain circles in Caravaggio's day.

The singlemindedness with which Caravaggio cuts through the traditional literary and conventional accretions of his subject is fully matched by his determination to opt for an unflaggingly realistic style. His naturalism is rooted in his north Italian, Lombard heritage: we are reminded here of the delicate Brescian light effects and cast shadows of a Savoldo and the brilliantly textured mastery of still-life detail of a Moretto or a Moroni. 16th-century north Italian painting also provided precedents for reflections in glass decanters and for the location of a figure behind a foreground table. Another possible and appropriate source of inspiration for Caravaggio may have been the at times decidedly realistic art of ancient Rome—but whether in the form of carved marble busts and reliefs of the type showing the Emperor Hadrian's favorite, Antinous (which display formal correspondences with our picture), or perhaps even mosaics or painted portraits is difficult to tell.

Yet Caravaggio's love of realism was more doctrinaire and polemical than that of his predecessors. He is constantly at pains to underline his mastery and commitment through virtuoso effects—the cast shadow; the dirty finger nails; the blemishes on the fruit and their wilting leaves; the unflat, beaded surface of the wine in the decanter, suggesting that it has just been put down; and the reflection of a man in this same decanter—thereby cleverly implying a recipient for Bacchus's overture.

What is even more fascinating is that these naturalistic procedures substantially determine the way in which the subject is presented. We have here a plausible Bacchus but one who is nonetheless circumscribed both by studio conventions and by Caravaggio's dominant desire to reconstruct the reality of a corner of a room. That it still works so well as a characterization is a tribute to the artist's unerring dramatic sense.

—John Gash

Caravaggio (1571–1610)
The Calling of St. Matthew, 1600
10 ft. 6³/₄ in. × 11 ft. 1⁷/₈ in. (322 × 340 cm.)
Rome, S. Luigi dei Francesi

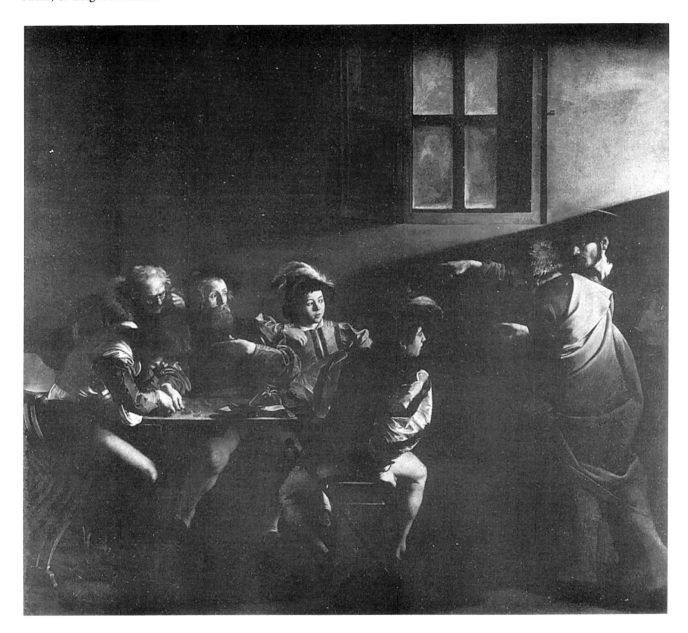

Orazio Gentileschi (1563–1639)
Allegory of Peace and the Arts with Apollo and the Nine Muses
London, Marlborough House

Bibliography—

Hess, Jacob, "Die Gemalde des Gentileschi für das Haus der Königin in Greenwich," in *Kunstgeschichtliche Studien zu Renaissance und Bartock,* Rome, 2 vols., 1967.

Orazio's nine ceiling paintings were transferred to their present site from the Queen's House, Greenwich, sometime after 1711. In Greenwich they had decorated the ceiling of the main entrance hall in Inigo Jones's Palladian-style mansion, begun for Queen Anne, wife of James I, in 1617 and finished for Queen Henrietta Maria, wife of Charles I, in 1635. Gentileschi's pictures, commissioned by Henrietta Maria, probably date from 1635–39.

Orazio had been a friend and disciple of Caravaggio, and his direct, Caravaggio-inspired realism, though somewhat softened by his own nature, and, after his move to England c. 1626, by contact with the refinements of the Stuart court, found its most natural expression in easel paintings. That Orazio was also, however, an accomplished practitioner of decorative ceiling painting is shown by the fresco of a *Musical Concert Sponsored by Apollo and the Muses* which he had executed, together with the architectural quadratura painter, Agostino Tassi, for the Casino of the Nine Muses, Palazzo Pallavicini-Rospigliosi, Rome, in 1611–12. Neither was the ceiling in the Queen's House Gentileschi's first decorative venture in England: he is known to have done "a large ceiling" in Cobham Hall, Kent, for James Stuart, fourth Duke of Lennox, and a ceiling (oil on canvas) of "Apollo lying upon a Cloud, and the Nine Muses underneath it" for the Duke of Buckingham at York House, London (both now lost).

But if the Queen's House ceiling is related to these earlier decorations in its subject matter, its visual organisation was substantially determined by Inigo Jones's classicizing, Palladian architecture. The Great Hall of the Queen's House is a perfect cube, and the compartmentalisation of the ceiling is precisely echoed in the patterning of the tiled floor. The nine sections of the ceiling are made up of a square of c. six metres in the centre, four of two metres at the corners, and four equal rectangles of six by two metres round the side between the corner squares. In order to adapt the canvases to the slightly smaller and oblong shape of the Marlborough House Ceiling, it proved necessary to trim the size of the central roundel by about half a metre, to lessen the height of the two side rectangles and to reduce the length of the top and bottom rectangles by removing pieces of canvas from their centres and trimming them at the ends.

Given such a setting, Orazio resorted to a traditional, 16th-century formula conceived for the compartmentalised ceilings of those very Palladian villas of the Veneto upon which Inigo Jones had modelled the Queen's House. His main source was Veronese's frescoed ceiling of *Divine Wisdom with the Gods and Goddesses of Olympus* (c. 1560), which Jones had sketched, in the Villa Barbaro at Maser. There we find not just the same number of compartments in the same overall disposition (although five of them are of different shape) but, in the

central section, an almost identical arrangement of a circle of cloud-borne figures surrounding a personification floating above them in the Heavens. The only significant difference is that the Villa Barbaro ceiling was curved and Veronese ingeniously linked up the allegory of the upper ceiling with the world of the room beneath by painting simulated balconies with contemporary figures on them on the cove of the ceiling. In the Queen's House Inigo Jones sought to transpose this conceit by incorporating an actual balcony, which runs round all four walls of the entrance hall not far below the flat ceiling. This has been repeated (in the form of a balcony-passage) along one wall only of the Marlborough House salon. Although Orazio's ensemble as we now see it at Marlborough House presents an impressive colouristic and formal effect, it is not possible to see the detail well from ground level. It must originally have been intended at the Queen's House that, having grasped the ceiling's overall design on entering the room, one should ascend and inspect its deft realism at close quarters by walking round the balcony.

The allegorical subject matter of the ceiling is elaborate and political. The central white-clad figure of the central roundel holding an olive wreath and a staff represents the Peace brought by the Stuart monarchy, while the three surrounding figures probably indicate the means by which Peace is assured: a crowned Victory, exactly beneath Peace in a striking scarlet robe, holds a palm and laurel wreath and has a horn of plenty at her feet; an armoured Strength, to Victory's right, has her foot on a column; and Concord, directly above Peace, holds a sheaf of wheat. Two other, more spiritual personifications, the winged Religion lifting up her hand and gaze to the heavens, and Meditation in characteristic pose, flank Concord. It is, however, the fruits of peace in terms of the flourishing of the arts which constitute the more specific theme of the ceiling. The seven other female figures in the central roundel represent the Seven Liberal Arts (clockwise, from 2 or 3 o'clock, Geometry, Arithmetic, Music, Astronomy, Grammar, Rhetoric, and Logic). In the four flanking roundels Orazio has depicted (bottom left) Apollo, presiding deity of the arts and leader of the Muses, and the three arts of design (clockwise, from top left, Sculpture, Architecture, and Painting). The latter were not traditionally accepted as Liberal Arts (although there was by the 17th century a strong movement for them to be so) and this accounts for their exclusion from the upper Heaven. In the rectangular canvases between the four corner roundels are Apollo's handmaidens, the Nine Muses, who give inspiration.

Gentileschi's largest ever creation must be seen within a broader context of the glorifications of the Stuart monarchy through art and literature. Ruben's near-contemporary ceiling of the Banqueting House in Whitehall and the numerous court masques masterminded by Inigo Jones dealt in the same eulogistic currency (ironically at a time of imminent political catastrophe). The Queen's House ceiling alone, however, focused on the flourishing of the arts.

—John Gash

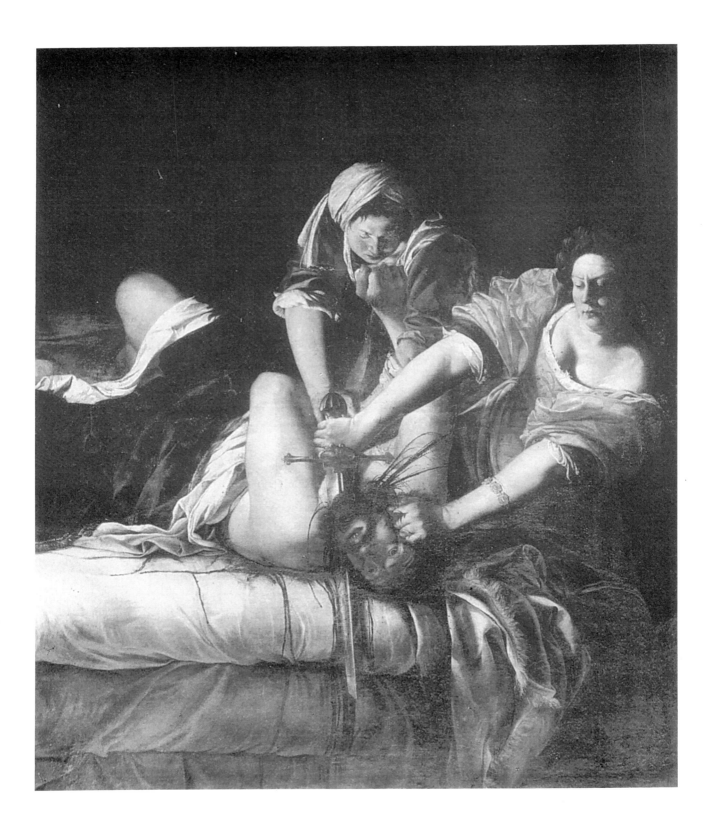

Artemisia Gentileschi (1593–c. 1652)
Judith Slaying Holofernes, c. 1612–21
6 ft. 6³/₈ in. × 5 ft. 4 in. (199 × 162.5 cm.)
Florence, Uffizi

This forceful portrayal of a favorite Caravaggesque theme by the outstanding female painter of the 17th century is known in two versions (the other being in the Gallery of Capodimonte, Naples). The Florentine picture (which is also the larger of the two) is the prime version and was probably painted for Cosimo II de' Medici, Grand Duke of Tuscany, during Artemisia's protracted residence in Florence between 1612 and 1621. It is first recorded in a Medici inventory of 1637, when it was housed in the Palazzo Pitti.

Like most Caravaggesque depictions of the subject, Artemisia's depends closely on Caravaggio's rendering in the National Gallery, Rome (Palazzo Barberini), although there are also striking differences. Caravaggio's picture was, up until 1639, in the Roman collection of the banker Ottavio Costa and must have been well known to Artemisia. She had spent her life prior to 1612 in Rome, and her father, Orazio, with whom she remained in close touch, and who had been a friend of Caravaggio, continued to be based there up until c. 1621. The most obvious derivation from Caravaggio, apart from the dramatic nocturnal lighting (which, as in Caravaggio's picture, comes from a source outside the painting), is the pose of Judith herself: Artemisia has reiterated the parallel-armed sawing action of Caravaggio's heroine with some relish.

The story is taken from the Old Testament Apocryphal book of *Judith* which tells of the beautiful Israelite widow who saved her besieged city of Bethulia and the entire Israelite nation by killing the Assyrian commander Holofernes. She set about her task with consummate cunning aided by divine guidance, dressing "to beguile the eyes of all men that should see her" (10,4). Having tricked Holofernes into believing that she would help him take the city, she also inspired his lust. Holofernes held a small private banquet in his tent with a view to bedding Judith, "For, lo, it is a shame for our person, if we shall let such a woman go, not having had her company; for if we draw her not to us, she shall laugh us to scorn" (12,12). Judith was careful not to indulge in the heady oriental wines and foods, while Holofernes, delighting in her company, "drank exceeding much wine, more than he had drunk at any time in one day since he was born" (12,20). When night fell and the guards and servants left the couple alone, Holofernes's plan succumbed to Judith's. As he lay in a drunken stupor, she removed his scimitar from its scabbard and "drew near unto his bed, and took hold of the hair of his head, and said, Strengthen me, O Lord God of Israel, this day. And she smote twice upon his neck with all her might, and took away his head from him, and tumbled his body down from the bed and took down the canopy from the pillars; and after a little while she went forth, and gave Holofernes's head to her maid. . . ." (13,7–9). The two then returned stealthily through the night to Bethulia, carrying their trophy.

Artemisia's departures both from the text and from Caravag-

gio's prototype are interesting—even if most painters of this subject, including Caravaggio himself, indulged in a fair degree of artistic licence. Caravaggio, however, had followed the text in depicting the instrument of death as a scimitar, whereas Artemisia opted for a more conventional sword—an oversight characteristic of her fairly unlettered approach to iconography. Another, more calculated innovation, however, her inclusion of the maidservant in the act of slaughter, can be considered a masterstroke. It is an ingenious homage to the new cult of realism pioneered by Caravaggio in that it plays down the role of divine involvement and cruelly conveys the extreme physical effort of the kill. Yet this effort is also transformed into a beautifully expressive cartwheel which surges up from Holofernes's splayed legs to culminate in the maid's head, before plunging down again through the radiating spokes of Judith's arms.

The decision to show the servant as a young woman is at variance with the tradition followed by Titian and Caravaggio, who had made her an old crone to contrast with Judith's beauty. The text gives no clear ruling on the matter, although it implies at one point that she was young (16,23). Artemisia had, early in her career, opted for a young woman in her *Judith and her Maidservant* of c. 1612 (Pitti), but that picture had probably been either designed, or inspired, by her father. Orazio seems, indeed, to have been the progenitor of a number of variants by both himself and Artemisia on the theme of Judith and her young Maid holding Holofernes's severed head (e.g., Orazio, Hartford, Connecticut, 1610's–20's, and Artemisia, Detroit, c. 1625). In the present case, however, Artemisia would have been especially aware of the visual and psychological appropriateness of the choice of a young maidservant for the very different episode depicted. Indeed, so fundamentally instinctual was Artemisia's approach to her art that it may not be altogether misguided to discern in this picture an echo of her own personal circumstances. She had been raped at the age of 19 by her father's friend, the painter Agostino Tassi, and subsequently led a distinctly independent life for a woman of the time. Artemisia here seems to be conceptualizing a triumph of "sisterhood," if not a rape revenged.

Artemisia's style in this picture is greatly indebted to that of her father, as is particularly evident in her rendering of rich costumes and jewellery. But Orazio's precision of drawing and crisp modulation of tone become somewhat blurred in her hands. The effect is more atmospheric than in many of Orazio's pictures, as if the scene is being lit by the flickering light of torches. Such broad tonalism also helps Artemisia impart to her heroines a distinctive softness and lack of self-conscious sexuality which is at variance with how the majority of male artists conceived them.

—John Gash

Guido Reni (1575–1642)
Aurora, 1614
Fresco
Rome, Casino Rospigliosi

The triumphant clarity and grace of this fresco painting have made it emblematic of both Baroque classicism and Reni's cool and ideational style. The image actually presents the passage of Apollo as Sun God in his chariot over a half-darkened earth, and, at the far right, Aurora, Goddess of Dawn. The curtain of night perhaps flutters around her shoulders as she scatters roses from the bouquets in both hands. Just to the right of the pictorial center, a torch-bearing amoretto, his body placed at an angle parallel to that of Aurora, represents the morning star, Phosphor. Around Apollo is a group of female figures usually labelled "Horae," that is, dancing Hours. This identification apparently stems from *Le vite di pittori* by G. B. Passeri, c. 1678. Yet the understanding of the "Horae" commonly available in the 17th century was that they represented not the Hours of the day but the Seasons. Here, as wardens of the sky, they are properly placed as they roll back the clouds from the gate of Olympus, as Apollo goes forth in his chariot. Seven women are seen, and the rhythmic spacing of their heads suggest two more might be hidden from view, i.e., nine in all, possibly the Muses. Tradition has associated the Muses with Apollo because, as God of music and prophesy, he was their leader.

Under the widespread move in the 1610's by his fellow Bolognese artists in Rome to establish a profound classicism, Reni painted the *Aurora* as a *quadro riportato*—that is, to appear without any illusionism as a framed picture. Although it is filled with Baroque feeling for movement and coloristic variety, Reni wanted his image to be as frieze-like and thus as flattened as possible in its idealizing homage to antiquity. Beyond any loyalty to a Bolognese ideal, Reni may have felt that a proper mode for this mythological subject should be restrained and tightly composed. And so among his artistic problems was how to establish Aurora in space in front of the horses without disturbing the planar envelope by insistent overlapping. Through color alone, Reni placed the Goddess at a distance, since her figure is as large as those of the foreground dancers; and yet to bring her as quietly close to the foreground as possible, no part of Aurora's body is overlapped: the toes of her right foot are shown contiguous with the forelegs of the horse, while her mantle's billow likewise just touches a muzzle of a horse, and her extended left arm is kept within the frame.

Other such delicate manipulation for the sake of planarity can be found in the center foreground of the work. The leg of Phosphorus, whose body and torch are aligned to appear related to Aurora, is shown in front of the extended horses' reins held by Apollo, just as the head of the "Hour" below appears in front of the third rein, while her hair is just touching the foremost rein. Similarly, one may almost feel Reni straining in yet two other sections of the image to retain the sense of relief. Ambiguity hovers around the two female heads in the second row behind the horses. There appears to be no space for them—as almost no bodily drapery accompanies their appearance on the shoulders of the two foreground figures. Likewise the four horses are so compacted that no real depth is indicated, almost as if derived from a medallic tradition. Ironically enough, although the *Aurora* is a model for countless future classicizing compositions, Reni himself never again produced so "Hellenic" a work. The *Aurora* is not typical of his work—it is typical of Reni's thoughtful consideration of the nuance of his subject, and his always careful culling through his repertory of style, learned during an arduous apprenticeship in the last years of the 16th century, for an appropriate response.

These student years in his native Bologna, with Denis Calvaert and the Academy of the Carracci, gave Reni access to the full richness of the 16th century, from the sensual colorism of Correggio and the Venetians to the stricter formalism of the Roman High Renaissance. Since he obviously considered working in an "antique mode," like a sarcophagus relief perhaps, for this fresco, Reni went to the world of Raphael for both specific motif and the larger prospect of the image. His format appears close to a work of Baldassare Peruzzi, in a fresco of the *Chariot of Apollo* in the Villa Farnesina in Rome; while another source, the same subject, also from the circle of Raphael, appears in the Vatican apartments of the Borgia. Individual ideas appear to be absorbed more directly from Raphael himself—for instance, the central amoretto with torch is very close to the lower central putto over the water in the fresco *Galatea,* c. 1513, also in the Villa Farnesina; the figure of Aurora appears related to the angels at the upper left corner of the *Disputa,* 1509, (in The Vatican). The dancing figures have been traced to a relief on the altar table front of the Chigi Chapel, S. Maria del Popolo, Rome, and are also found in a painting attributed to Guilio Romano (Florence, Palazzo Pitti).

The one real break with classical theory in this work comes with the haunting aerial view of the darkened, dawn-lit landscape at the lower right. Perhaps the commission for Aurora, in a garden loggia on a palatial estate, inspired that terrain view. However, such darkened, horizon-lit landscapes occur throughout Reni's career: from the early *Martyrdom of St. Catherine* (1606–07, S. Alessandro Conscente) to the famous *Samson* (1618–19, Bologna) and *The Crucifixion* (1637–38, Milan, Biblioteca Ambrosiana). Like the poignance of the materiality of life that fills several important works of this "classicist," such landscapes must point to Reni's sense of idealism's inadequacies in the face of life's mystery.

Reni seems to have lived his own life that same way. In 1608, he became a member of the household of the wealthiest and grandest patron of the arts in Rome, Cardinal Scipione Borghese. Through his sponsorship, Reni obtained important Papal commissions in the Vatican and the Quirinal Palace. Recent archival research has shown that Reni abruptly left the Borghese service in May 1612. The preparation of the Casino vault for the *Aurora* went on nonetheless and was completed in December 1612. A proud artist, utterly devoted to his craft, Reni hated the environment in Rome for its condescending treatment of the artist, as well as the prevailing climate which seemingly disregarded the quality of artwork and only urged haste in its completion. And so Reni had to be forced back to the city, Borgheso having convinced the Pope to issue a sentence of arrest should Reni not return in late 1613. As Reni received his last payment for the Aurora in August, 1614, he

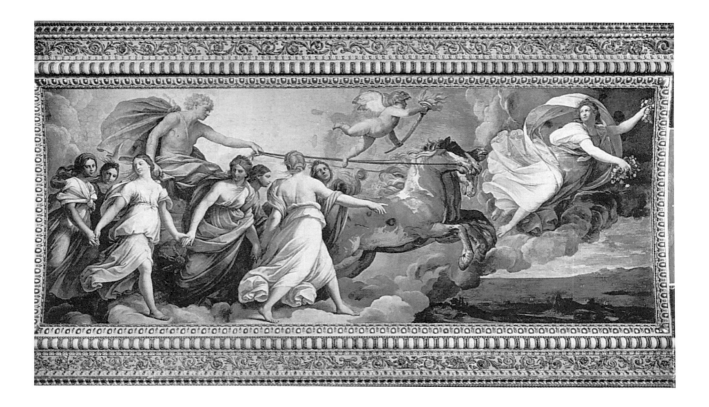

accepted a commission from the Cardinal Petro Aldobrandini, Archbishop of Ravenna, for work in that city. Aldobrandini was Scipione Borghese's chief rival, and Reni was leaving Rome, intending never to return. Given the extremity of Reni's feeling for Borghese as representative of Roman patronage, one wonders whether there is not some *scherzo* embedded within the *Aurora?* In some discrepancy between accepted numbers for the "horae" and those shown, perhaps Reni's anger lies—a subtle gift to him from his circle of poet-admirers, for his use in just such a situation where the stature of the artist was at risk.

—Joshua Kind

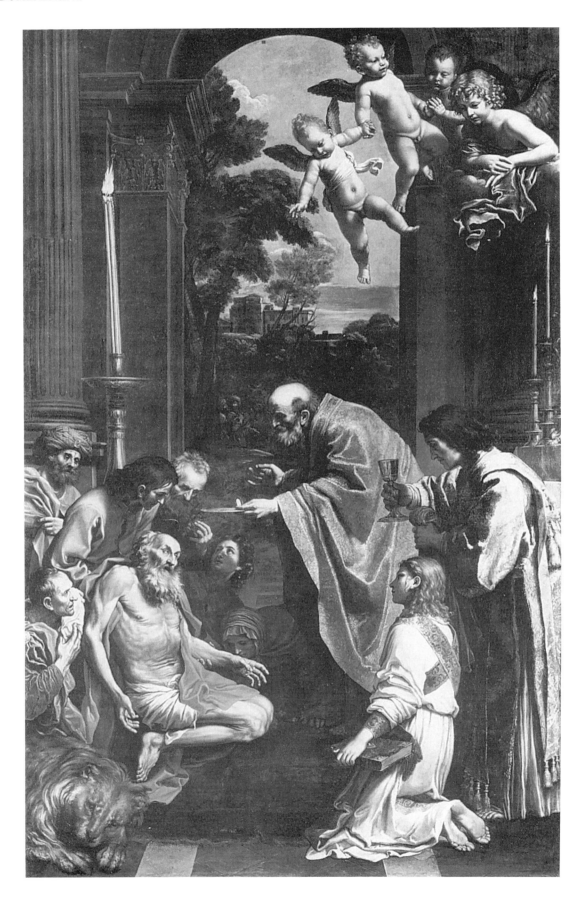

Domenichino (1581–1641)
The Last Communion of St. Jerome, 1614
13 ft. 9 in. × 8 ft. 4¹/₂ in. (419.1 × 255.3 cm.)
Vatican, Pinacoteca

Bibliography—

Spear, Richard E., "Looking at Art: Domenichino's *Last Communion of St. Jerome*," in *Art News* (New York), November 1983.

Cropper, Elizabeth, "New Documents Concerning Domenichino's *Last Communion of St. Jerome*," in *Burlington Magazine* (London), March 1984.

This painting was Domenichino's first major altarpiece in Rome and, as if to signal its importance to his career, it was the first work he signed: Dom. Zampierus Bonon. / F. A. MDCXIV (Domenico Zampieri of Bologna made this in the year 1614). It is clear that he accepted the commission, for an altar in S. Girolamo della Carità, to make himself better known; he was only paid 50 scudi and was required to provide his own canvas. This occurred in about 1611, by which time, after some eight or nine years in the city, his only important independent work there had been his uncompromising, and not entirely well received, fresco of the *Scourging of St. Andrew* (1609; S. Gregorio Magno, Oratorio di S. Andrea). Domenichino responded to his new opportunity with an even more committed display to the Romans of the modern Bolognese manner, for his composition was closely based on the version painted by his teacher Agostino Carracci in the 1590's for the Certosa in Bologna (now Bologna, Pinacoteca Nazionale).

Carracci's altarpiece was one of his finest, presenting a sweeping group of solidly realised monumental figures in front of an ornate arch, with a romantic evening landscape behind and robust angel *putti* above, all bathed in a warm Venetian tonality. For pupils of the Carracci Academy like Domenichino and his friends it must have been one of the "classics" of their youth; Domenichino's decision to produce a considered critique of it in his own treatment of the subject was a deliberate attempt to measure himself against one of his early masters. He certainly did not, as his arch-rival Lanfranco later claimed, merely plagiarise a work unknown to the Roman art world. Domenichino's self-imposed contest stimulated him to produce the first great achievement of his maturity.

Carracci's picture was probably not unknown in Rome, in fact, since it had been engraved. It may indeed have been a print which suggested to Domenichino the idea of reversing Carracci's composition. Domenichino had no reason to forget the original, since he owned 16 of the preparatory drawings, acquired from Carracci's son Antonio (although possibly at a later date); he could also have seen it again on his visit to Bologna in 1612. His reversal of the composition is only the most obvious of various alterations, all consistent with his newly formulated Classical theories. He reduced the number of figures and presented them in two clearly defined groups. The communicant priest is given the dominant position in the centre, towering over the rest, backed by his two carefully characterised acolytes and surmounted by attendant angels; the figure of the saint, shrunk with age and impending dissolution, is supported by a lively but amorphous group of followers. The colour scheme, dominated by the dull gold of the priest's cope, is distinctly cooler, the lighting more concentrated, the gestures and expressions more measured, the architecture simpler and more open, the landscape calmer and more monumental, all the forms more firmly modelled. Domenichino has replaced Venetian warmth with Roman *gravitas*.

The subject that Domenichino invested with such grave dignity was of considerable importance to the Counter-Reformation. St. Jerome was one of the four Western Doctors of the Church, celebrated for his translation of the Bible into Latin (the Vulgate); his legend included an episode in which he earned the gratitude of a lion by removing a thorn from its foot, and he ended his life in the Holy Land, in a monastery founded by his Roman patrician convert St. Paula. Domenichino's altarpiece shows both the lion, at the saint's feet, and Paula, kissing his hand. But its real subject, emphasised by all the changes he made to Carracci's treatment, is the holy sacrament of the Eucharist, the communion in both bread and wine to which Jerome, as a priest, was entitled and which the Protestants dared to laicise.

Domenichino's work was admired more by later generations than by contemporaries: Poussin considered it the equal of Raphael's *Transfiguration* (Vatican). Napoleon removed it from S. Girolamo della Carità and sent it, with the Raphael and the Carracci, to Paris; but on its return to Italy after 1815 Domenichino's painting was lodged with Raphael's in the Vatican, while Carracci's stayed in Bologna.

—Nigel Gauk-Roger

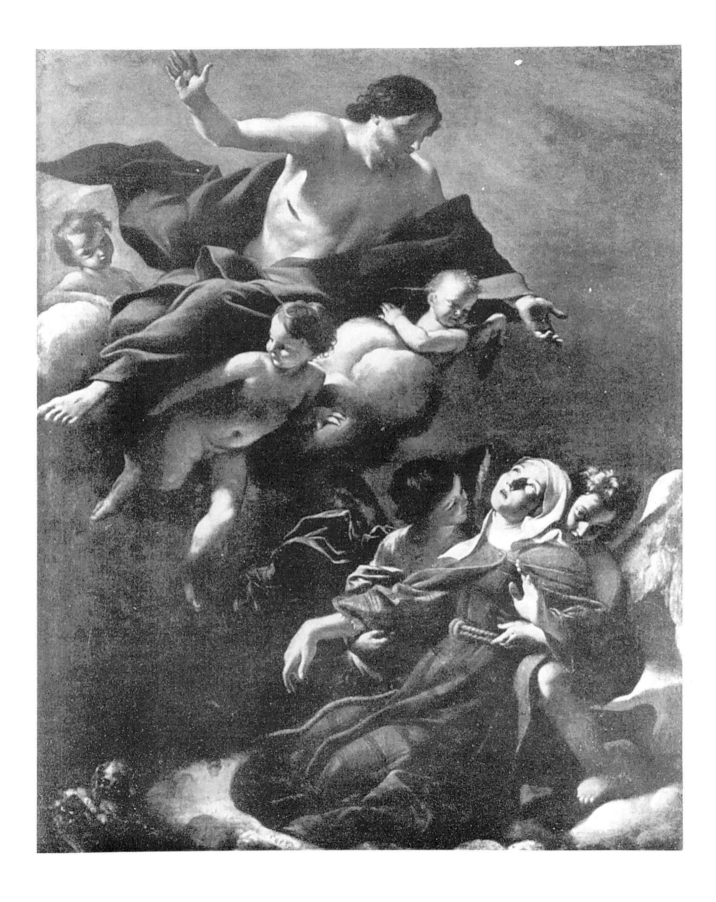

Salvator Rosa (1615–73)
Democritus in Meditation, 1650–51
11 ft. 3¹/₂ in. × 7 ft. ¹/₄ in. (344 × 214 cm.)
Copenhagen, State Museum of Art

Bibliography—

Wallace, Richard W., "Rosa's *Democritus in Meditation* and *L'umana fragilità*," in *Art Bulletin* (New York), 50, 1968.

Democritus in Meditation is one of Salvator Rosa's earliest and most successful large figure compositions, and it initiated the mature phase of his career in Rome. Rosa, an author of satiric poetry as well as an artist, considered himself a painter-philosopher. In his writings he professed the attitude and ideas of the ancient Stoics, striving to live a virtuous life in accordance with nature. The Cynic Diogenes was his particular hero, but several ancient Greek and Roman philosophers became important subjects in his paintings by the mid–1640's. *Democritus in Meditation* is one of the most complex and striking of these.

The large canvas painted in somber shades of brown and grey shows the philosopher seated beside a tomb. The entire upper half of the painting is taken up with elements typical of Rosa's landscapes—gnarled, broken trees and dark, moody sky. Democritus rests his head on his hand with a downward gaze, a post synonymous with meditation, contemplation, and melancholy, as seen, for example, in Dürer's well-known engraving *Melencolia I* and an earlier painting by Rosa, *Allegory of Moral Philosophy* (Caldaro). On the ground an array of human and animal remains, skulls and bones, surround Democritus, while other evidence of death and decay can be seen in the withered leaves, crumpled books, altar, sarcophagus, coffin, and funerary urn. The philosopher directs his eyes towards the human skull, which appears to return his gaze with mocking grin. On the right a cracked, overgrown obelisk belies its intended purpose, and a second obelisk, tipped over, bears obscure symbols which Wallace identified as represented the human condition. The artist's signature appears on a scroll next to a rat, and the cypress-wreathed term and gloomy owl complete the imagery of death.

The general composition is a departure from Rosa's earlier paintings of philosophers in which he portrayed them as smaller figures in narrative situations set into more expansive landscapes. (*Alexander and Diogenes*, Althorp; *The Philosophers Grove*, Florence). The monumentality of *Democritus* has more in common stylistically and thematically with the later *L'umana fragilità* (1657, Cambridge).

Scholars have cited several ancient sources (Lucian, Hippocrates, Diogenes Laertius) Rosa could have used to create his representation of Democritus. In antiquity Democritus was considered a learned, inquisitive scientist who scoffed at superstition. He was described as a seeker of solitude, even shutting himself up to work in a tomb. Rosa depicted this aspect of the philospher as a contemplative, solitary scholar, but he combined it with another role Democritus played, that of the "laughing philosopher." Several ancient sources told of Democritus laughing at the folly he saw in the world, and he was usually contrasted with his opposite, the weeping Heraclitus. By the 16th century there was a well-established tradition, particularly in northern Europe, of portraying the two philosophers together, one who laughs at mankind's folly and the other who weeps in grim despair. In fact, Rosa painted a *Democritus and Heraclitus* (Vienna) and made a drawing of the same subject (1646, Haarlem).

In *Democritus in Meditation* Rosa created a unique, ironic version by showing this philosopher in the traditional attitude of melancholy associated with Heraclitus. An interpretation of Rosa's picture may be approached by a reading of the inscription Rosa added to a later etched version he made of the same composition (1661). The Latin phrase "Democritus omnium derisor, in omnium fine defigitur" (Democritus, the mocker of all things, is transfixed at the end of all things) tells us that the laughing philosopher is finally silenced as he confronts the vanity of human achievements and inevitable physical and moral corruption. His meditation on the end of all things, the impossibility of understanding life and death, has brought him to a state of inactive melancholia. The clever interpolation of Democritus fittingly expressed Rosa's self-made characterization as a scornful Cynic and melancholic satirist.

The work is documented in several of Rosa's letters and by his biographer Filippo Baldinucci. When Rosa made this painting he had recently returned from Florence to Rome and wanted to create a sensation in the artistic capital. He wrote to his friends in Florence of how well he had brought the painting to a marvelous state of perfection, keeping it hidden until he revealed it to the public. Although the painting was a critical success when exhibited at the Pantheon, it did not sell. In another letter Rosa mused that perhaps the philosopher preferred to remain with a Stoic like himself rather than to be shut up in a rich man's palace. As a practical measure to attract potential buyers, Rosa painted a pendant (also etched in 1661) of *Diogenes Casting Away His Bowl*. This scene represented the Cynic philosopher throwing away his last worldly possession when he recognized that the simple boy drinking water from his hand provided a lesson in virtue. When Rosa exhibited the second painting the following year, they were sold together as pendants. As a pair, the paintings can be understood as representations of the contemplative and active aspects of moral philosophy.

By combining complex allegorical imagery which incorporated his personal philosophy with the best features of his landscapes, Rosa could appeal to learned patrons while exhibiting his technical skill. In *Democritus in Meditation*, the derisive yet melancholic philosopher, he created a provocative image which exemplifies the best of his distinctive painting style.

—Wendy Wassyng Roworth

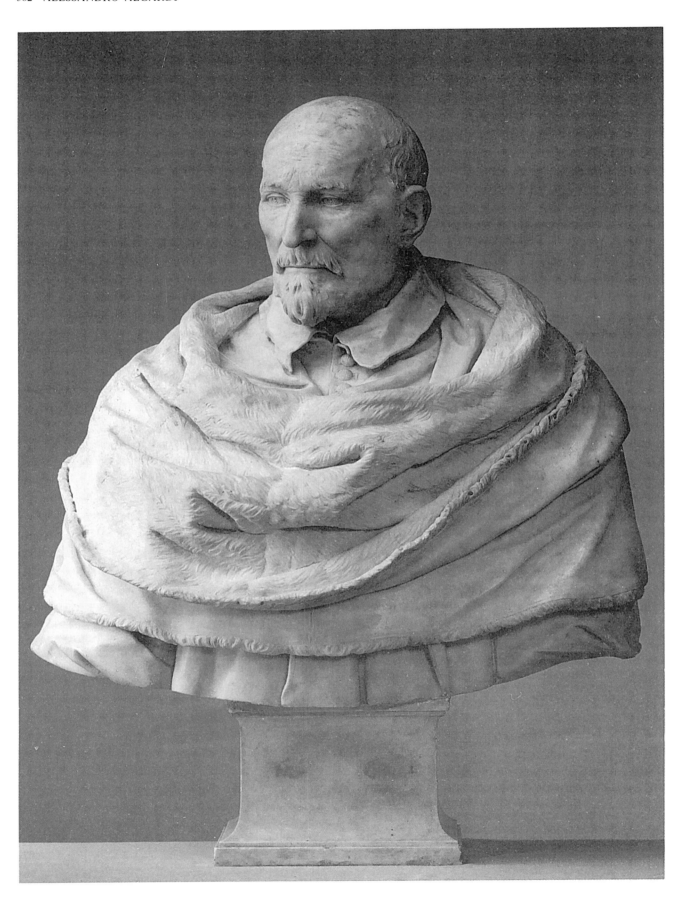

Alessandro Algardi (1598–1654)
Bust of Cardinal Laudivio Zacchia, c. late 1630's
Marble; 28 in. (71.1 cm.)
Berlin, Staatliche Museen

Algardi was often at his best as a modeller and carver of portrait busts. For while some of his religious commissions seem hesitant by comparison with the dramatic flair of his arch rival, Bernini, the portraits served to focus his virtues: immaculate skill in the rendering of detail and an instinctive appreciation of the quieter, more enduring aspects of personality.

The Genoese Laudivio Zacchia (1565–1637), whose elder brother, Cardinal Paolo Emilio Zacchia, was also sculpted (posthumously) by Algardi (terracotta, c. 1652–54, London, Victoria and Albert), read jurisprudence at the University of Pisa, reputedly with great application, and entered Holy orders only on the death of his wife, Laura de' Nobili, who had borne him a son and a daughter. His ecclesiastical career was launched during the early years of the 17th century under the patronage of his brother, who held an important post under Clement VIII but died in 1605 having failed to secure himself election to the papal throne only because of his rapidly failing health. Laudivio took over his mantle and gradually established a reputation as an astute ourial politician. He was made Papal Nuncio to Venice by Gregory XV in 1621 and was described by the Pope's nephew, Cardinal Ludovico Ludovisi, as the best of all the papal officials. His qualities were equally recognised by the next pope, Urban VIII, who appointed him Prefect of the Apostolic Palace and, on 29 January 1626, a Cardinal. His reputation for administrative expertise and political shrewdness was matched by one for "the highest integrity." Indeed, he was one of only three cardinals at Galileo's trial in June 1633 who declined to sign the guilty verdict.

The original base of the statue (now replaced) bore an inscription: "Laudivius Card. Zacchia Anno MDCXXVI," but recent opinion has tended to discount the possibility that 1626 indicates the date of execution as well as that of Laudivio's elevation to the cardinalate. The delicacy of touch, brilliance of surface, and facial morphology all point to a more mature phase of the artist's career. There agreement ends. Although many have noted the facial and textural similarity with Algardi's tomb bust of Cardinal Giovanni Garzia Millini in S. Maria del Popolo, Rome, now known to have been commissioned in 1637, there is debate over whether the Laudivio was taken from life or done posthumously with the aid of a death-mask. For while many old men display the sunken features represented here, the particular form which they assume is, as Montagu has argued, very characteristic of a death-mask—from the emphatic bone-structure, through the tight skin drawn back from the nose and cheekbones, to the long mouth and wide, flattened naso-labial fold. Such posthumous renderings (relying on masks and painted portraits) were by no means uncommon, and Algardi is known to have been something of a specialist in the field.

If the work was executed during the Cardinal's lifetime it is likely to have been towards its end and if after his death in 1637 then only shortly thereafter, since the command of surface detail is of a kind with that of other busts convincingly dated to the late 1630's: Cardinal G. G. Millini, Monsignor Antonio Cerri, Gaspare Mola, and Urbano Mellini.

The fact that Zacchia did not have a nomument erected to him in his titular church of S. Pietro in Vincoli, as well as the fact that Algardi's tomb sculptures were normally placed above eye level, with their heads tilted forward accordingly so that the viewer could see the features from below, might imply that this forward-facing head was produced for the family palace or villa—where it may later have been joined by the bust of Laudivio's brother (Bargello), carved after Algardi's death from the Victoria and Albert terracotta which the sculptor himself had prepared. Indeed, it was increasingly common practice in the 17th century to establish collections of commemorative ancestral heads in emulation of the ancient Roman custom described by Pliny the Elder—although in ancient times they were usually of wax.

The Zacchia has a distinctly Roman realism and "gravitas," qualities which Algardi obviously felt appropriate to the cardinal's practical yet dignified personality. Swathed in his silken, fur-lined cloak, which he sports like a toga, he stares into infinity with a fixed, stoic-seeming gaze—a wintry Counter-Reformation Cicero or Marous Aurelius. Algardi was deeply familiar with antique sculpture, which he had often restored in Mantua and Rome, but the influence of the Roman portrait bust on Italian sculpture goes back to the 15th century, when men like Antonio Rossellino and Benedetto da Maiano were inspired by it in ways which seem prophetic of Algardi's Zacchia (note Benedetto da Maiano's *Pietro Mellini,* 1474, Florence, Bargello). The most striking feature of both busts is the meticulous attention paid to the surfaces of the face (from wrinkles to warts and veins) and the textures of the clothes, the most notable difference that Algardi has considerably refined the techniques of representation. This is especially evident in the carving of Zacchia's cloak and the collar and buttons of his mozzetta. The area of the clothes is, typically for Algardi, much larger than in a 15th-century bust, and this, together with the deep cutting of the cloak to create shadows and the finely chiselled description of fur, conjures up a presence which expands while also setting off the more concentrated realism of the head. The slight tilt of the head to one side is a formula developed by Algardi and adds a hint of movement to an otherwise very restrained and sobre rendering.

Algardi's restraint and sobriety clearly appealed to patrons, for he received many portrait commissions—although his reasonable prices and rapid completion times (usually only six weeks) must also have helped. Even at its best, as here, however, Algardi's additive realism and static poses could not quite match the dynamic flair of Bernini's few mature portrait busts, for Bernini was able to convey the essence of character through concentrating on a transitory or symbolic attitude and by directing all of his efforts of design to that single, unifying end.

—John Gash

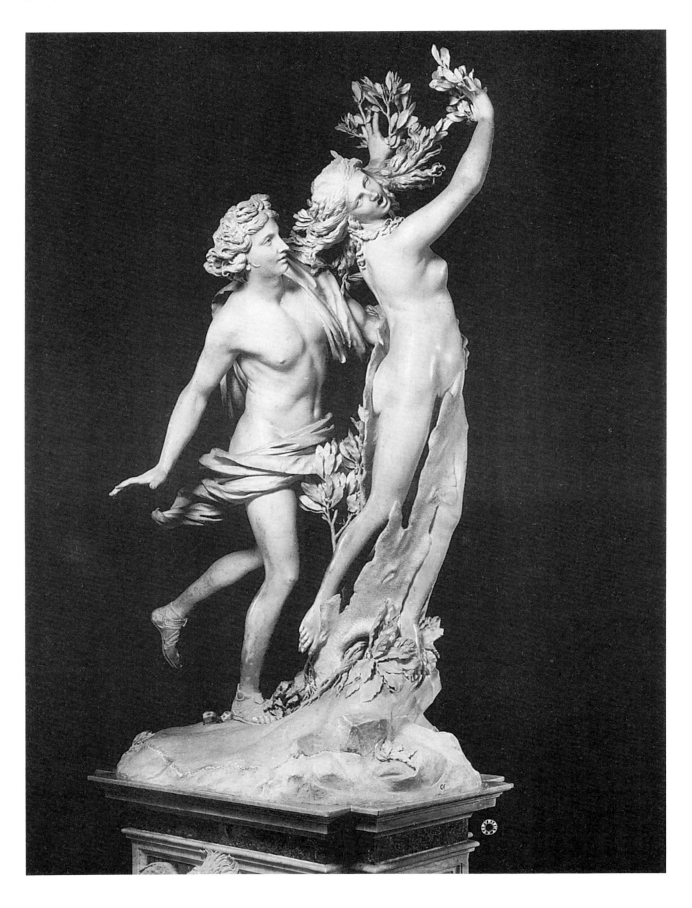

Gian Lorenzo Bernini (1598–1680)
Apollo and Daphne, 1622–25
Marble; 7 ft. 11³/₄ in. (243 cm.)
Rome, Borghese

Bibliography—

Reidl, P. A., *Bernini: Apollo und Daphne,* Stuttgart, 1960.

Daphne was the daughter of Peneus, the river god of Thessaly. Her beauty attracted the unwanted attentions of Apollo, who pursued her, forcing her to flee. Apollo was on the verge of capturing his prize when the nymph prayed to her father for aid. To save his daughter from the god, Peneus transformed her into a laurel tree. Thereafter, the laurel was sacred to Apollo.

The excitement, passion, disappointment, terror, and metamorphosis that Ovid relates in the story of Apollo and Daphne were miraculously translated by Bernini into a marble sculpture. Although Apollo's noble form is modelled on the ancient *Apollo Belvedere,* the *Apollo and Daphne* represents Bernini's anti-classical artistic manifesto. God and nymph exist in a universe where flux, not equilibrium, is the norm. The *Apollo and Daphne,* as in a Baroque poem by G. B. Marino, presents paradoxical juxtapositions of fantasy and keen observation, intellectualism and eroticism, beauty and horror. To escape her pursuer, the unfortunate nymph must sacrifice her supple flesh and redolent locks for twigs and bark and leaves. Even as she leaps upward in flight, her feet sprout roots that bind her to the earth. Apollo is denied even the slightest brush with her palpitating skin: his fingers grasp at gnarled bark.

The *Apollo and Daphne* was the culmination of Bernini's activity for Cardinal Scipione Borghese, his chief patron and the leading collector in Rome. Begun in 1622, his work on the group was interrupted in favor of the *David* for the same patron, and not delivered to the Villa Borghese until 1625. Baldinucci (1682) records that the *Apollo and Daphne* established Bernini's fame once and for all time; after it was unveiled, "all Rome competed to see it as if it were a miracle."

Years later, Bernini in Paris mentioned to his friend, the Sieur de Chantelous, that Cardinal Maffeo Barberini (the future Pope Urban VIII) had paid him the honor of coming to view the work-in-progress. During Barberini's visit to the sculptor's studio, the Cardinal de Sourdis pointedly remarked that the nude beauty of the young girl might prove to be disturbing to persons who saw it in a house belonging to a cardinal. Cardinal Barberini resolved this conflict by providing Bernini with a Latin epigram, which was engraved upon the pedestal. The epigram describes Apollo's disappointment with the clear implication that "The joy which we pursue will never be caught, or, when caught, will prove bitter to the taste."

—John T. Spike

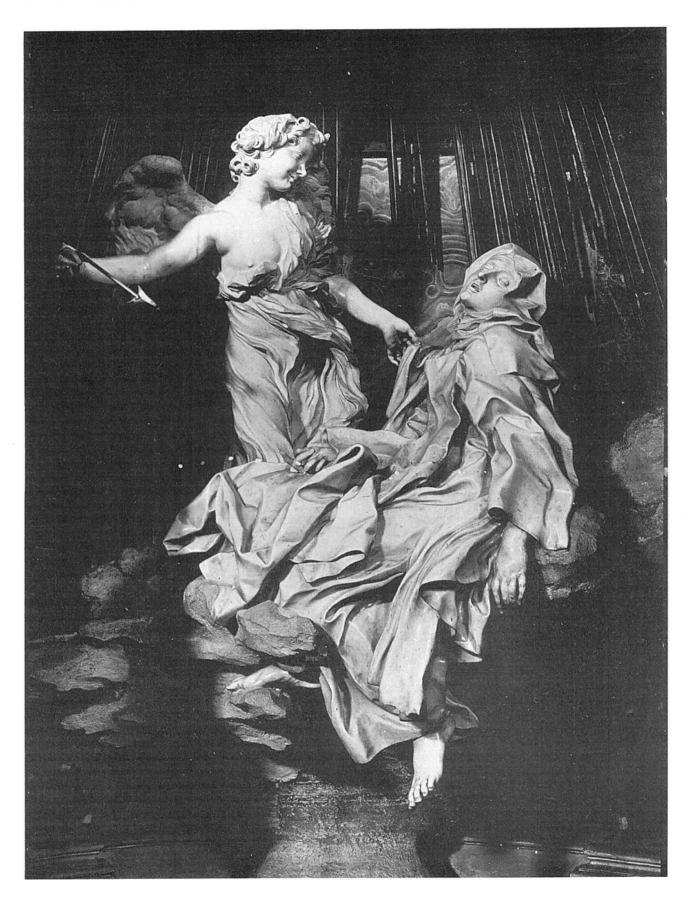

Gian Lorenzo Bernini (1598–1680)
The Ecstasy of St. Teresa, 1647–52
Marble, other stone, and bronze
Rome, S. Maria della Vittoria

Bibliography—

Kuhn, R., "Der Union mystica der Hl. Therese von Avila von Bernini in der Cornarokapelle in Rom," in *Alte und Moderne Kunst,* 12, 1967.

Petersson, R. T., *The Art of Ecstasy: Teresa, Bernini, and Crashaw,* New York, 1970.

Ranke, W., "Berninis Heilige Teresa," in *Das Kunstwerk zwischen Wissenschafte und Weltanschauung,* Cologne, 1970.

Preimesberger, Rudolf, "Berninis Cappelle Cornaro," in *Zeitschrift für Kunstgeschichte* (Munich), 40, 1986.

"It is widely held that Bernini was the first who ever tried to unify architecture with sculpture and painting in such a manner that they make a beautiful whole." It is clear from this remark by Filippo Baldinucci (1682) that Bernini's contemporaries appreciated the innovative scope and boldness of his art in terms that are very much like our own. The Cornaro Chapel with its altarpiece sculpture of *The Ecstasy of St. Teresa* was Bernini's earliest and it remains his most perfect realization of his efforts to use a fusion of the traditional art forms in order to attain higher realms of spiritual expression.

The Cornaro Chapel occupies the left transept of the early 17th-century church of S. Maria della Vittoria, which belonged to the order of Discalced Carmelites that was founded by St. Teresa of Avila. Cardinal Federico Cornaro acquired the rights to the chapel in January 1647, which is presumably the date of the commission to Bernini. The chapel space was unusually shallow and narrow in proportion to its height: Bernini extended the depth of chapel somewhat by building a kind of housing on the outside wall of the church. It was by necessity, therefore, that Bernini set out to create an illusion of a mystical event which remains compelling even though it is possible for spectators to approach closely. The chapel was completed only in 1652, but had been in use since the previous year.

Over the altar Bernini sculpted two figures: a smiling seraph who holds an arrow, and St. Teresa, enveloped in the turbulent folds of her habit and recumbent in an ecstatic swoon. Behind the sculptural group, light from a hidden window streams down, guided by rays of gilded bronze, onto the brilliantly polished marble. The sculptures represent the moment of her mystical *transverberation,* "the piercing of her heart by a fiery dart," by an angel, an event described in Teresa's *Autobiography* (1588). Bernini's interpretation of Teresa's account is true to the saint's careful descriptions of the physical sensations that accompanied this spiritual union with the divine. As Robert T. Petersson noted, "many have taken her character to be completely erotic and her spiritual passion to be sexual sublimation. Indeed she is erotic. The error is to limit that quality to the physical instead of realizing that God is the object of her love and her love is total and indivisible, including the body."

The white sculptures of the saint and seraph are enframed by a richly colored pediment, inspired by Borromini, and panelled walls with splendid marble inlays; in all, some 20 different stones were used in the chapel. The vault overhead was painted with a celestrial glory on Bernini's design. At either side of the chapel, Bernini added a motif of extraordinary novelty: in privileged boxes, exactly as in a theatre, various Cornaro dignitaries are portrayed as if in attendance to the miracle. Only the portrait bust of Cardinal Cornaro is reputed to have been carved by Bernini himself. Many commentators have commented that it seems odd that the Cornaro personages do not face the saint directly. Perhaps Bernini wished in this way to indicate the separation between their mortal world and the mystical inspiration of Teresa.

—John T. Spike

Gian Lorenzo Bernini (1598–1680)
Fountain of the Four Rivers, 1648–51
Mixed media
Rome, Piazza Navona

Bibliography—

Huse, Norbert, "La Fontaine des Fleuves du Bernini," in *Revue de l'Art* (Paris), 7, 1970.

The *Fountain of the Four Rivers* is situated in the center of the Piazza Navona, which is the largest square in Rome and preserves the oval shape of the ancient Circus of Domitian. The fountain was commissioned of Bernini by Pope Innocent X Pamphili as part of his campaign to make the piazza into a sort of monument to the papal family. Following his election in 1644, Innocent X initiated plans to enlarge the Pamphili palace on the south end of the square, rebuild the church of S. Agnese, and add a college to balance the palace to the north of the church. The fountains at the north and south ends of the piazza, which brought water from the Acqua Vergine to this thickly populated part of Rome, were likewise refurbished. In front of the church of S. Agnese, which had not as yet been reconstructed, the fountain of the Four Rivers was planned as the central feature of the square. Innocent X decided that the fountain would be used as a base for an ancient obelisk that had been found near the via Appia.

Francesco Borromini was the Pope's original choice as architect. His rival Bernini had been out of favor since the death of the previous Pope, Urban VIII Barberini. The fountain project provided Bernini with an occasion to prove his mettle, however, and he resorted to subterfuge to capture the assignment from Borromini, as Baldinucci (1682) relates.

Prince Niccolò Ludovisi, who was married to a niece of the Pope, prevailed on Bernini to make a model of the fountain. Bernini made the model, and the Prince arranged for it to be transported to Palazzo Pamphili in Piazza Navona. There it was secretly placed in a room through which the Pope had to pass after he had finished his repast. Upon seeing such a noble creation and a design for such a vast monument he was nearly ecstatic. After admiring the model for fully half an hour, he burst out, saying, "This is a trick of Prince Ludovisi, but it will be necessary to make use of Bernini despite those who do not wish it, since he who does not wish to use the designs of Bernini, must not see them."

Bernini's design was officially approved on 10 July 1648, and work on the foundations was begun immediately. The obelisk was erected in August 1649. Payments to the sculptors of the four rivers were made beginning in February 1650. The fountain was finally unveiled on 14 June 1651 to universal acclaim. Baldinucci tells a revealing anecdote, namely, when the fountain was almost completed, but still covered from public view, the Pope arrived, "with about fifty of his closest confidants," to spend an enjoyable hour admiring the work. The water had not yet been turned on, Bernini informed the pontiff that some time would be necessary to put everything in order. As the Pope turned to leave, Bernini gave a secret signal for the ducts to be opened, and, the water suddenly gushed forward on all sides in great abundance. Innocent reportedly exclaimed, "In giving us this unexpected joy, Bernini, you have added ten years to our life."

The iconographic program of the work may have been dictated to the architect, although the novelty and excitement of the design is uniquely Bernini's. The obelisk, symbolizing both divine power and the rays of the sun, stands on a travertine grotto surrounded by statues of the four rivers, which symbolize the four continents of the world. The supportive grotto is hollowed out directly under the massive obelisk to achieve astonishing, if slightly disconcerting, effects of openness and light. The river gods were designed by Bernini but executed by studio assistants—the *Danube* (Europe) by Antonio Raggi, the *Nile* (Africa) by Giacomo Fancelli, the *Ganges* (Asia) by Claude Poussin, and the *Rio de la Plata* (America) by Francesco Baratta. The four Rivers respond in terror or submission to the obelisk above them. The principal theme of the Fountain (many more subtle interpretations have been mooted) is that the power of the papacy, symbolized by the papal keys and tiara at the base and by the Pamphili dove on the top of the obelisk, has transformed a pagan monument into a symbol of triumphant Christianity, which dominates the four corners of the world. On the other hand, Bernini's animated, gesticulating sculptures, not to mention the splashing, festive waters, of the fountain of the Four Rivers have always offered a cordial welcome to convivial Romans and footweary tourists alike.

—John T. Spike

Domenico Fetti (c. 1589–1623)
The Parable of the Wheat and the Tares
Panel; 23⁷/₈ × 17³/₈ in. (60.5 × 44 cm.)
London, Courtauld

The 14 moderately sized panel paintings which Fetti did of the parables and sayings of Christ are his most charming and distinctive contribution to the history of art. Their popularity is attested by the large number of copies and variants (many by the artist himself). There are other versions of the *Wheat and Tares* in the Castle Museum, Prague, and the Art Museum, Worcester, Massachusetts. While nothing is known of the origins of this "series," it has been widely surmised that most of the prime versions were executed for Ferdinando Gonzaga, Duke of Mantua. Fetti had worked for Ferdinando while the latter was still a cardinal in Rome in the years prior to his accession to the duchy in 1613 and he subsequently spent the rest of his short career working mainly in the ducal service at the Mantuan Court. It is noteworthy that a group of Fetti's parable paintings is documented in 1631 as hanging high up in some of the small apartments of the ducal palace. The stylistic and technical maturity of the parable paintings, with their strong Venetian bias, has led the majority of critics to place all of them late in the artist's career (c. 1618–22), but this is not certain.

Ferdinando Gonzaga was a singular man of wide cultural interests (ranging from alchemy and painting to poetry and religion) and it is easy to see how he would have been fascinated by the richly imagistic and enigmatic doctrinal pronouncements contained in Christ's parables. Fetti himself seems to have been sufficiently inspired by the subject matter for his innate poetic instinct to have become fully aroused.

The parable of the *Wheat and Tares (Weeds)* is told in *Matthew*, 13, 24–30: "The kingdom of Heaven is like this. A man sowed his field with good seed; but while everyone was asleep his enemy came, sowed tares among the wheat, and made off. When the corn sprouted and began to fill out, the tares could be seen among it. The farmer's men went to their master and said . . . 'shall we go and gather the tares?' 'No,' he answered; 'in gathering them you might pull up the wheat at the same time. Let them grow together till harvest; and at harvest-time I will tell the reapers, "Gather the tares first, and tie them in bundles for burning: then collect the wheat into my barn." ' " Which Christ, uncharacteristically, explains a few verses later (37–39) as follows: "The sower of the good seed is the Son of Man. The field is the world; the good seed stands for the children of the Kingdom, the tares for the children of the evil one. The enemy who sowed the tares is the devil. The harvest is the end of time."

There was a substantial tradition of parable depiction for Fetti to draw on: this included the illustrations of late medieval Gospel books, a number of 16th-century Italian paintings, and, especially, 16th and early 17th century North European art. Fetti was, at the beginning of his career, greatly inspired in Rome by the work of Rubens and Elsheimer. And the latter, along with other northerners in Rome such as Lastman,

Pynas, and Uyttenbroeck, did produce parable pictures. Yet of all the northern examples, the most readily accessible were probably prints. In the case of the *Wheat and Tares,* for example, it is possible to note broad similarities both with the incisive, monumental naturalism of Dürer's woodcut of the subject and with an engraving of 1605 by J. Matham after Abraham Bloemart.

As often with Fetti, we are struck above all by the beautifully transfigured naturalism of his vision. The heavy featured, coarse limbed peasants have reddened faces and extremities which conjure up an impression of heat and work—even of drunkenness. One of them has a black handkerchief tied around his head, while the spread-eagled figure in the right foreground, semi-clad, is illuminated on his bare arm and torso by some lingering rays of sunlight. The thwarted presence of the sun is also suggested by some other warm highlights, notably along the top of one of the clouds. But the pervasive atmosphere, established by the beautiful blue-grey sky, is appropriately overcast, as the enemy/devil introduces evil into the sleeping world. The characteristic Fetti trees (pollarded, vine-covered, thick-set) and undulating, foamy undergrowth are being swayed by a strong breeze—which also blows against the devil. Indeed, it has been noted that everything about this figure is contrary: he strides against the wind, across the furrows and sows with his left hand. To such a finely tuned conceptual grasp Fetti adds a more intuitive feel for characterization which, like other aspects of his art, is extremely subtle. Note, for instance, the way in which the devil's attributes (horns and cloven feet) are so delicately rendered as to be far from obvious at first glance, while his duplicity is also cleverly conveyed by the way in which he guiltily glances up to Heaven as he surreptitiously drops the tare seeds from his left hand. Above all, perhaps, Fetti emphasizes his malevolent sensuality—for this slightly swaggering, semi-clad interloper seems to be taking a physical delight in his transgression, as his prehensile feet edge fondly over the springy field.

The broadly painted, muted tones of the landscape (of which the greens of the foliage, however, have faded) are spangled with the more glowing, Venetian-style, glazed colours of some of the clothes (royal blue, wine red, chocolate brown). The parsley-like foliage recalls Elsheimer, while the very fluid, skein-like handling of some of the clothes is perhaps most reminiscent of Rubens.

It might be noted that the interpretation of Christ's parables has often been given a new inflexion by the turn of historical events, as must have been the case here. For the sowing of tares was, understandably, equated during the Counter Reformation with Protestant "heresy."

—John Gash

Bernardo Strozzi (1581-1644)
The Calling of St. Matthew, c. 1625–30
4 ft. 6⁵/₈ in. × 6 ft. 1³/₈ in. (139 × 188.8 cm.)
Worcester, Massachusetts, Worcester Art Museum

The artistic millieu in which Strozzi began to paint was characterized by the strong tradition of the northern Renaissance artists and Tuscan Mannerists. Added to this, the Genoan visit by Rubens, van Dyck, and the northern followers of the emerging Roman Baroque style, in the early 17th century, created a very complex artistic environment. The *Calling of St Matthew* is a splendid and impressive work belonging to the last years of Strozzi's stay in Genoa before his departure for Venice in 1630. The compositional source is related to Caravaggio's famous altarpiece of the same title in the Roman church of San Luigi dei Francesi, painted in 1597–98. Since we do not have any evidence of Strozzi visiting Rome, we can assume that he was influenced by the northern followers of

Caravaggio, in particular Terbrugghen. The painting also exhibits strong stylistic elements of the Mannerist tradition, especially that of Federico Barocci, seen in the painting in the strange and original colors and the exaggerated figures, particularly that of Christ. The dramatic impact of the moment when Christ points to Matthew, the tax collector, is clearly expressed in the gesture of the latter's surprise and reinforced by the way the light enters the room from the left side. Many beautiful passages in the painting, particularly the depiction of the money and other still-life objects on the table, remind us of the strong northern tradition in Genoa.

—Michael Milkovich

Andrea Pozzo (1642–1709)
Allegory of the Jesuit Missions (The Triumph of St. Ignatius)
Fresco
Rome, S. Ignazio

Bibliography—

Pozzo, Andrea, *Significati delle pitture fatte nella volta della chiesa di S. Ignazio,* Rome, 1828.

Fabrini, Natale, *La chiesa di. S. Ignazio in Roma,* Rome, 1952.

Calvo, Francesco, *Kirche des hl. Ignatius in Rom,* Bologna, 1968.

Andrea Pozzo's association with the Jesuits in Rome began when he was transferred there from Milan in 1681. Called by Gian Paolo Oliva, the Father-General of the Society of Jesus, Pozzo, who had already established himself as a painter of architectural perspectives, was awarded a series of commissions for the decoration of the interior of S. Ignazio. The first of these projects, the creation of an illusionary dome painted on canvas and attached over the crossing area in lieu of a real architectural dome, dates to 1685. On the success of this, Pozzo was asked to decorate the pendentives, the apse and finally in 1691 the ceiling of the nave of S. Ignazio. The work was complete by the year 1694 when Pozzo not only received final payment but also wrote a letter to the Prince of Liechtenstein explaining the complex iconography of his program for the vault.

The vault decoration was an enormous undertaking, and Pozzo's design solution for the 750 square meters of the nave ceiling is daring. The composition is controlled by his creation of an elaborate painted architectural stage, a device called *quadratura* or painted architecture that creates the illusion of extending the real space below. This deep, pictorial space furnishes the stage for the figural action representing *The Triumph of the Society of Jesus at the Hands of S. Ignatius.* The *quadratura* defines a great rectangular corral of space, closed on four sides by grand architectural elements and open to the infinite space of heaven beyond. The relationship of the painted architecture to the real building elements below is significant in the establishment of a fictive space that is both continuous and divorced from the space of the viewer. The painted elements respond to the division of the nave into three bays: the paired order of columns above that define the bay divisions in the painted program echo the paired pilasters that line the nave below. Similarly, the bays that open between the orders match the nave bays and the real fenestration of the clerestory. But the painted architecture is more muscular; its apparent scale is grander and its character is far more fantastic than is the real architecture of the nave of S. Ignazio. Each end of the vault is described by painted triumphal arch motifs that are also more complex and weighty than the arched openings defining the nave.

The greater drama of the painted space above is further reinforced by the dynamic figural composition. For just as the architecture is more dramatic than is the real space below, so too is the action of the crowds of figures in their painted environment greater than any that occurs below. Here, great swarms of figures are nestled around the bases of the orders at the sides of the painted space. And, the groups, if smaller in scale, are no less active as the space recedes into the open sky beyond. In all, the painted architecture in concert with the figural composition creates the illusion of a space that, if continuous with the real space of the church, is also clearly beyond the bounds of the real world. The viewer is offered a glimpse of heaven, but the severe telescoping of the painted space and the isolation of the key figure of St. Ignatius deep within this space makes for an image beyond the reach of the viewer. This, coupled with the restriction of the viewer to a particular spot in the nave from which the architectural illusion is operative, produces the visionary quality prominent in all *quadratura* imagery.

The iconography of the ceiling is fully documented in a letter written in 1694 to the Prince of Liechtenstein, then Austrian Ambassador to the Holy See. Pozzo identifies one of his sources as Christ's words "I have come to bring fire to the earth; and would that it were already kindled" as recorded by Luke (12:49) and echoed in St. Ignatius's words to his followers, "Go and light the flame over the world." The verse from Luke, inscribed in Latin on cartouches at each end of the painted vault, establishes the major themes of the ceiling. Primary among these is the theme of the missionary work of the Society of Jesus as ignited by Ignatius of Loyola in the 16th century. This Pozzo describes by showing the saint at the center of the composition, a small figure shown on a throne of clouds as if ascending into Heaven with arms opened to his vision of the Trinity above. Ignatius receives in his heart a ray of light from the Trinity, and functioning as an agent of God's light, he deflects it to the four corners of the earth represented by allegorical figures of the four continents enthroned below the paired orders at the sides of the composition. The beams of light directed at the continents pass through intermediate spatial zones populated by the great missionary saints of the Society of Jesus; for example, St. Francis Xavier, active in the missions in India, appears between Ignatius and the allegory of Asia. Likewise, Francesco Borgia, Stanislao Kostka, and Luigi Gonzaga form the triumverate of figures between their leader and the figure of Europe.

A second, related theme is that of fire and light. Cauldrons burn at each end of the fresco and angels distribute torches in a metaphor, Pozzo tells us, for the spread of faith and charity. Directly over the entrance to the area of the crossing an angel rises towards Heaven carrying a great shield inscribed with the monogram of Christ and of the Society of Jesus. The illusion is of the figure in the midst in rotating the shield and in so doing deflecting the light of God by way of Ignatius directly into the nave below and thereby into the heart of the viewer.

Th S. Ignazio ceiling is often paired with the nave vault decoration of Il Gesù by Giovanni Battista Gaulli, called il Baciccio, which was completed in 1679. Both decorations rely heavily on illusion; both celebrate the Society of Jesus and are propagandistic in nature. But, the Gaulli ceiling, a *quadro riportato* solution depicting *The Triumph of the Name of Jesus and The Fall of the Damned,* is more aggressive toward the viewer, more sensuous and ultimately more generic in its mes-

sage. Pozzo's ceiling, by comparison, appears more didactic; it is painted in a dryer, almost literal fashion. The selection of a *quadratura* structure for the S. Ignazio ceiling alone makes for a sobriety quite apart from the ecstatic and spiritual nature of the Gesù program.

In the context of Roman baroque painting Pozzo's work is often cited as an example of the reintroduction of a type of ceiling painting that had appeared in Rome during the 1620's. Notable examples of *quadratura* ceilings from this period include the Aurora ceiling in the Casino Ludovisi (1621–23) by Guercino, and Domenico Domenichino's Palazzo Costaguti large hall ceiling (c. 1622). However, both of these earlier examples are smaller and considerably less ambitious in the extent to which the architecture defines the painted stage of space. More likely sources for Pozzo's solution are examples of perspectival painting from Milan and of set-like architectural backdrops for history painting from the Veneto. Earlier in his career Pozzo had worked in Milan where he first joined the Jesuits as a lay brother. At this time he was called in to modify real architecture with his painted inventions as in the case of his work for the church of S. Francesco Saverio in Mondovì (1675). This type of perspectival work recalls the inventions of Donato Bramante at S. Maria presso S. Satiro in Milan and seems the impetus for Pozzo's continuous study of perspective and perspectival projection as set down in his treatise *Tractus perspectivae pictorum et architectorum,* a two-volume publication to which Pozzo referred in his letter explaining the S. Ignazio ceiling. The way in which the *quadratura* furnishes the stage for the figures who actually populate these painted architectural spaces seems more closely aligned with the function of painted architecture in the backdrops of grand history paintings by Paolo Veronese, such as *The Feast in the House of Levi* (1573), than with the Roman frescoes of Guercino and Domenichino in which the painted architecture merely frames the open sky where the action occurs.

The northern flavor of Pozzo's solution may also explain the fact that his grand ceiling at S. Ignazio had its greatest impact on later ceiling decorations in the north. Within a short period of time *quadratura* decorations based on Pozzo's at S. Ignazio began to appear elsewhere, as for example in Giuseppe Barbieri's ceiling for S. Bartolomeo in Modena (1694–98) and in Pietro Gilardi's ceiling in the Oratory of S. Angelo in Milan (1715). Moreover, Pozzo himself continued to paint ceilings of this sort, most notably for the Liechtenstein Palace in Vienna, that furnished important sources for the great painted ceilings of Giovanni Battista Tiepolo and for the emergence of rococo decorative programs in Austrian and Germany.

—Dorothy Metzger Habel

Evaristo Baschenis (c. 1617–77)
Still Life with Musical Instruments and a Statuette
45¼ × 34¼ in. (115 × 87 cm.)
Bergamo, Accademia Carrara

The 17th-century genius for tropes and conceits, exemplified in the poetry of John Donne and other metaphysical poets, had its counterpart in the ability of some still-life painters to transcend the decorative and illustrative in search of philosophical or spiritual meaning. Food, flowers, or mundane objects that had played a supporting role in art since antiquity, as attributes of gods or saints, as domestic accessories or allegorical allusions, now took center stage as vehicles of complex artistic expression. In France, Chardin invented a poetics of crockery and kitchenware. In Italy, his artistic peer, Evaristo Baschenis, translated the "beautiful objects" of Dutch tradition into a meditation on temporality and transcendence.

Baschenis, a painter-priest, made a few pictures of fruit or poultry, but the objects of his most intense and reflective scrutiny were musical instruments. He painted them with precision yet made them resonate with thematic profundity. A typical Baschenis composition consists of assorted instruments piled on a table in studied disarray, suggesting that the players have departed: perhaps, in view of the faint veil of dust sometimes powdering the surfaces, forever. The lutes and harps are rendered with exacting naturalism, and Baschenis shows a fine sensitivity to their elegant geometries and satiny veneers. It is their "speaking silence" on the canvas, however, that reverberates with haunting overtones, evoking the harmonious but ephemeral effects of music, and eliciting associations of delight, effort, repose, melancholy, and joy. Baschenis's compositions offer a poignant descant to the *Vanitas* theme. Acknowledging, in an original and idiosyncratic iconography, the triumph of all-conquering Time, the fragility of human endeavor, and the brevity of life *(Memento Mori),* these paintings movingly portray the frail barriers erected by art against the depredations of impermanence.

In the *Still Life with Musical Instruments and a Statuette* a table covered with a rich cloth supports a casual arrangement of lute, mandoloncello, and harp, while a violin nearly obscures the books stacked beneath it. From an ink box a projecting quill intersects the violin's bow and the neck of the lute. Across the upper edge of the picture and down its right side the ornately worked folds of a tassled gilt brocade are suspended. On the left stands the small statue of a nude male, twisting away from the center. Hitherto unidentified in the scholarship on this picture, it is a Saint Sebastian, a well-known bronze by Alessandro Vittoria. Above all these objects—which perhaps represent the arts of music, sculpture, and poetry—a dark and empty area at the heart of the picture confronts us. The shadowed air, the dead space once briefly filled with music, the negligent curl of the abandoned sheet of music below: these hint at a moment of time lost and the inexorable passage of time. In the contrast between the warm light caressing the curves of the splendidly crafter objects and the darkness hovering above, Baschenis, evoking emotional tonality through chromatic tonality, honors the nobility of human artistic expression.

—John T. Spike

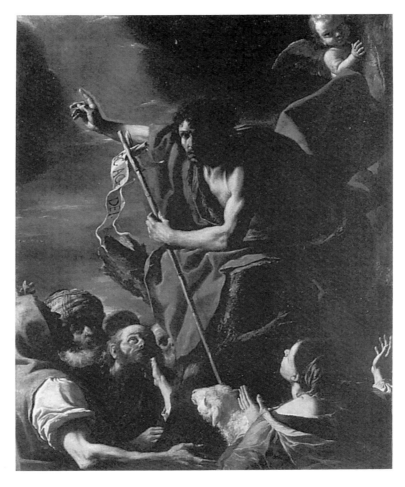

Mattia Preti (1613–99)
St. John the Baptist Preaching, mid-1660's
7 ft. 1½ in. × 5 ft. 7 in. (219 × 170 cm.)
San Francisco, Fine Arts Museums

St. John the Baptist Preaching to the Multitudes was one of the standard themes in the repertory of Italian Baroque painting. Its theme of charismatic evangelism was attuned to the missionary and Counter-Reformational impulses of the 17th century. Preti's canvas in San Francisco is based on the story as told in Matthew (3:1–4):

In those days came John the Baptist, preaching in the wilderness of Judaea, And saying, Repent ye: for the kingdom of heaven is at hand. For this is he that was spoken of by the prophet Isaiah, saying, The voice of one crying in the wilderness, Prepare ye the way of the Lord, make his paths straight. And the same John had his raiment of camel's hair, and a leathern girdle about his loins; and his meat was locusts and wild honey.

Many Italian painters, notably Francesco Albani and Pier Francesco Mola, favored this subject as an opportunity to set a sacred story in the midst of a pastoral landscape. Mattia Preti, however, was first and last a painter of sacred histories: his figures fill every part of the San Francisco picture and the landscape is completely suppressed. As a Knight of Malta,

Preti was frequently called upon to paint John the Baptist, the patron saint of the Order of St. John of Jerusalem, Rhodes, and Malta; yet, his response to this subject seems never to have been perfunctory or by rote. There are no other known or related versions of this composition. Preti clearly felt challenged by and sympathetic to the Baptist's singular brand of visionary, rugged, and impassioned spirituosity.

Although detailing the chronology of Preti's paintings is rather more an art than a science, this *St. John the Baptist Preaching* can be dated with some confidence to the mid-1660's. Among several fixed points of reference during Preti's first decade of residence on Malta is his closely comparable canvas, *Pilate Washing His Hands* (New York) which is securely dated to 1663. One of the characteristic developments in Preti's style during the 1660's was his return to the relative stability of vertical compositions inspired by the Venetian Renaissance. In two altarpieces of this period painted for the chapel of the Grand Master's Palace in Boschetto and for the countryside Tal-Mirakli Church in Lija, the artist's reference back to Titian's *Pesaro Madonna* is explicit. The same tendency to organize his compositions along a diagonal axis extending from the lower left to the upper right corner is present in this *St. John the Baptist Preaching* and in Preti's *Judith Showing the Head of Holofernes to the Crowd* (Cologne), which depicts a similar company of half-length spectators in the foreground.

—John T. Spike

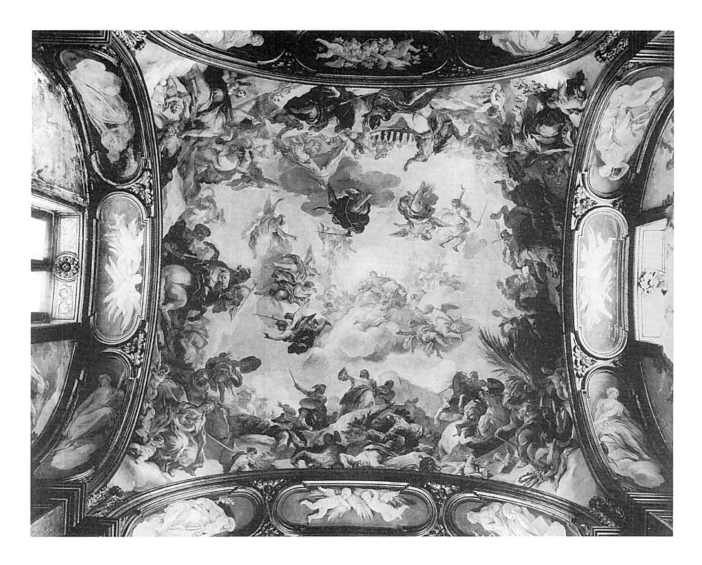

Luca Giordano (1632-1705)
Triumph of Judith, 1704
Fresco
Naples, Certosa di S. Marino

Inaugurated in April 1704 the fresco decoration of the cupola of the Chapel of the Treasury should be considered as an important source of the new trends in Italian painting where dramatic and heavy compositions were replaced by a style that was airy and animated. The entire work is masterfully adjusted to its architectural setting, including the decorations of the lunettes. Among several surviving preparatory studies, the most important are two oil sketches in the St. Louis City Art Museum. Others include a sketch for the *Triumphant Judith* in the Bowes Museum in Barnard Castle and rather unimportant copies of the St. Louis paintings recorded in the Treccani Collection in Milan.

Giordano finished the *Triumph of Judith* a year before his death, and it is considered a masterpiece. The subject is based on two episodes from the book of Judith in the Old Testament Apocrypha. One scene refers to the moment when the Jewish heroine emerges triumphantly, showing high above her the severed head of the invading Assyrian general Holofernes. The second episode shows Judith revealing Holofernes's decapitated body to his shocked army. The panic created by these scenes moves the army into retreat and abandonment of the siege against the Jewish city of Bethulia.

Compositionally and stylistically the cupola influenced a younger generation of artists, in particular de Matteis, Bardellino Mondo, and Mura.

—Michael Milkovich

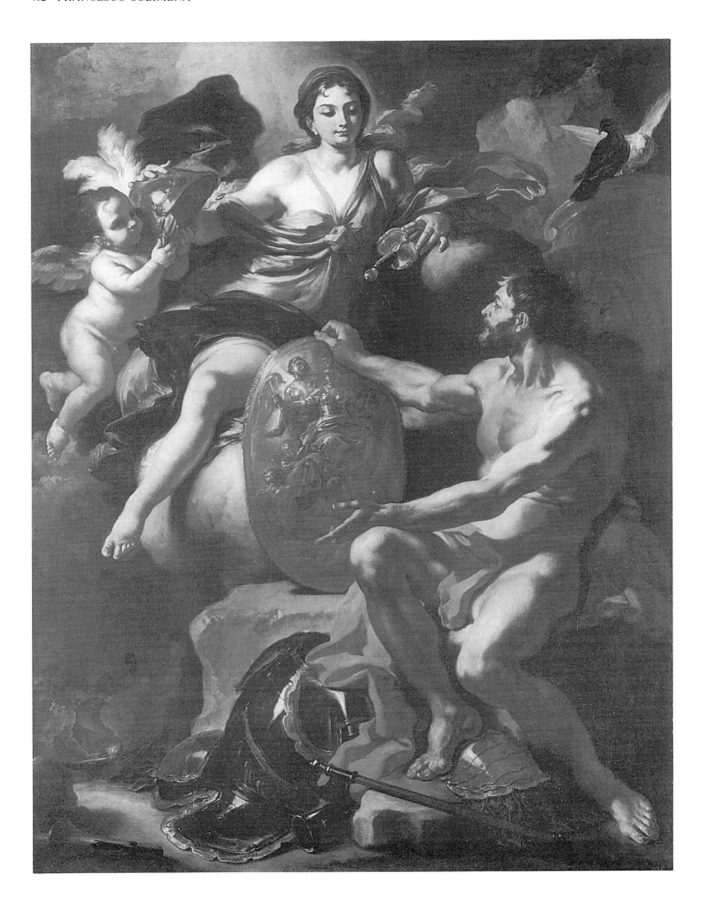

Francesco Solimena (1657–1747)
Venus at the Forge of Vulcan, c. 1704
6 ft. 8⁷/₈ in. × 5 ft. ¹/₄ in. (205.5 × 153 cm.)
Malibu, Getty Museum

De Dominici gives the full title of this picture as *Venus Approving the Armor Vulcan Has Made for Aeneas*. The goddess, elevated above her earth-bound husband, barely glances at Vulcan's offerings: her veiled gaze and complacent half-smile suggest self-satisfaction rather than gratitude. One hand caresses the gleaming plumed helmet, the other toys with the sword; above her shoulders her drapery floats back like wings. A black dove joins the more usual white dove perched on a convenient fragment of architecture nearby. Although Venus's shoulder, breasts, and left leg are nearly bare, the sheer fabric over her torso is drawn into deep folds by the 90° torsion of her upper body. Vulcan's rotation is less extreme, but allows his left thigh to lie in the same diagonal plane as the lower limbs of both Venus and her attendant cherub (possibly Eros). Solimena has emphasized Vulcan's heroic stature by suppressing any hint of his lameness, eliminating all signs of the toil, dirt, and dangers of metal-forging that might have marked his body, and distancing him quite literally from the workers, cyclopes who labor in the far background at lower left.

It is probable that this *Venus* was one of a group of five pictures painted c. 1704 for the Procurator Canale in Venice. These pictures are linked thematically by their evocation of conflicted male-female relations. To this group was added c. 1708 a sixth painting, *Tithonus Dazzled by Aurora*. By 1773 the *Aurora* was in the Pezzana family collection, San Polo, Venice, perhaps with the *Venus*. After this time these two pictures remained paired, as they are still. Aurora and Venus are traditionally promiscuous, both wed unsuitably to partners whose inferiority is signaled literally by their placement in the composition: and both request arms from Vulcan for a son not of his begetting. In both pictures the goddesses' dazzling, lu-

minously white skin, the tenebrous background, and the nude males' solid, rippling flesh are all evidence of Solimena's respect for the legacy of Mattia Preti, *il cavalier Calabrese*. Solimena inherited Preti's sobriquet, with the adjective *nobilitato;* and the artist has indeed invested these figures with respect and dignity, despite their less-than-edifying behavior in myths.

The meeting of Venus and Vulcan, like the parting of Aurora and Tithonus, strikingly paralleled by Solimena's use of similar but reversed compositions, derive from episodes in the epics of Homer and Virgil. Solimena's classicism is far from slavish, however. This particular encounter between Venus and Vulcan is not mentioned in the *Aeneid*, and Virgil's account of the arms Vulcan makes for Aeneas differs substantially from the artist's depiction (the poet, for instance, specifies a spear and greaves among the arms, and describes the corselet as "blood-red" brass). Although the shield figures centrally in this section of the poem, as it does on Solimena's canvas, no painter could have followed literally Virgil's 150-line description of a design which reprises every salient event in Italian history. Solimena instead places three figures on the shield: a winged woman, probably a Victory, an armed goddess (perhaps an embodiment of Rome), and a recumbent male nude (perhaps a personification of the Tiber).

Venus hints at Solimena's level of culture, but cannot alone reveal his wide-ranging abilities and interest in architecture, sculpture and music, or the flexibility of his painterly talent. But his achievement in this picture indicates his ascendence into the firmament not only of Neapolitan but of European painting.

—Elizabeth Barrett

Giuseppe Maria Crespi (Lo Spagnuolo) (1665–1747)
Confirmation
49³/₈ × 36⁵/₈ in. (125.5 × 93 cm.)
Dresden, Staatliche Kunstsammlungen

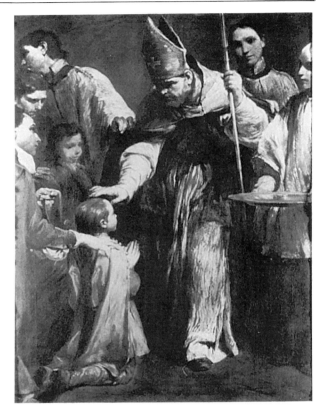

The Sacraments, or holy rites of the Roman Catholic Church (baptism, eucharist, confirmation, matrimony, ordination, penance, and unction) have rarely been the subjects of art. The notable exceptions prior to Crespi's seven paintings of the Sacraments were the two monumental series that Nicholas Poussin had painted in Rome in the 17th century—archeologizing works that were acclaimed for their piety, high-mindedness, and scrupulous reconstruction of Roman antiquity.

It is more than the novelty of the subjects, however, that makes Crespi's series of paintings remarkable. What struck his contemporaries with special force was the unprecedented naturalism and informality of the artist's treatment of these rites. Nothing about the paintings is idealized or made glamorous; Crespi the populist does not look to high society or to historical authority to ennoble his conception. In *Confirmation* the lay participants wear contemporary clothing (notably the young confirmand's Sunday best). The backgrounds in the series are so shallow and dark as to eliminate even common church ornament, and the compositions have a candid and unposed quality: figures in profile, or turned away, or cut off by the edge of the picture.

Writing in 1739, the academic critic G. P. Zanotti thought this approach so idiosyncratic that he treated the series as a kind of sport in Crespi's oeuvre: a commission from Cardinal Ottoboni, unsought, uncongenial, and executed with tongue in cheek. For Zanotti, and even for Luigi Crespi, the artist's son and biographer, there was more social comment than religious feeling in these paintings. Both commentators ascribed the "extravagance" of Crespi's compositional tactics to the constraints of the small canvasses on which he was forced to continue the series (by the happenstance of his having painted what became the first, on a relatively small scale). Both cite, too, the inspiration of that initial study *(Confession)* by the "accidental" observation of an effect of light as the painter chanced upon a real-life scene. These critics were evidently attempting to excuse or to account for Crespi's abrupt departure from academic norms.

Some 250 years later, we are less struck by any supposed violation of decorum. In each picture the action depicted is the central moment in the administration of the Sacrament: the celebrant is shown pouring baptismal water, communicating, absolving, blessing, and anointing. (Curiously, however, *Ordination* does not focus on the "laying on of hands," but on a moment of lesser drama.) The faces of the participants are absorbed, serious, reflective, though with the peripheral figures in *Matrimony* there is a hint of impertinent levity.

In *Confirmation* the essential dignity of Crespi's conception is unmistakable. The mitred, crozier-bearing bishop occupies the very center of the composition. Squeezed into the left and right edges are supporting figures, while the confirmand, a boy of no more than 10, kneels in quarter-profile, his head neatly framed between the horizontal of the bishop's anointing hand above and his sponsor's steadying hand below.

If Crespi's anti-academic leanings caused him to represent Confirmation (and the other Sacraments) as natural and earthly events, the introduction of ordinary human emotion into the ritual in no way lessens its religious impact. The anxiety of the candidates, the solicitude of the sponsors, the gravity of the officiant, and the calm of the acolytes all underscore the solemnity of the event and attest to the faith of the participants. Crespi's bishop bends forward, not to accommodate the dimensions of the canvas but to add depth and movement to the scene—and perhaps to suggest that heaven inclines toward earth in these sacramental moments. Crespi's Sacraments were executed in a revival of late Baroque fervor and dramatic compression, fully worthy of the young Guercino.

—John T. Spike

Nicolas Poussin (1594–1665)
Et in Arcadia Ego, c. 1638–40
33¹/₂ × 47⁵/₈ in. (85 × 121 cm.)
Paris, Louvre

Bibliography—

Panofsky, Erwin, "*Et in Arcadia Ego:* Poussin and the Elegiac Tradition," in *Meaning in the Visual Arts,* New York, 1955.

Verdi, Richard, "On the Critical Fortunes—and Misfortunes—of Poussin's Arcadia," in *Burlington Magazine* (London), February 1979

Bernstock, Judith E., "Death in Poussin's Second *Et in Arcadia Ego,*" in *Konsthistorisk Tidskrift* (Stockholm), 55, 1986.

While Arcadia is mentioned in Virgil, and, more relevantly, in Sannazaro's 1502 Renaissance pastoral poem *Arcadia,* offerings are made by shepherds at a tomb near the river Alphaeus, there is no precise source for Poussin's depiction of the theme. The phrase "et in arcadia ego" can actually be interpreted either as "I [the one who is dead, was] too in Arcadia" or "I [Death, am] too in Arcadia," and does not seem to predate the 17th century.

The subject of the celebrated painting at the Louvre, the presence of mortality even in Arcadian bliss, had been essayed by Poussin in an earlier picture, now in Chatsworth, *The Arcadian Shepherds* of about 1628. In that early work, so wonderfully, broadly painted and coloristically rich, youthful, robust, and fleshily rendered young shepherds and a lovely, sensually evocative young woman lean forward, completing a firm diagonal into space established in the foreground by the seated figure of a river god. Their diagonal movement is directed towards a large tomb bearing the inscription ET IN ARCADIA EGO. A skull set on top of the monument underlines the moral message of the vanity of human desires (the *memento mori* a motif borrowed from a slightly earlier version of the theme by Guercino), while the river god, his head sunken and turned away from us, continues to pour water from his jar, embodying the immutability of nature. The young artist's delight in the physical and sensual world is reflected in the monumental, partly naked figures so dominating the canvas and the robust trunks of the trees extending upwards with such vigor from behind the tomb. How different the second, Louvre version of this stoic theme, probably dating from about 1638–40 is! (The painting has been dated as late as the early 1650's by Anthony Blunt, but the earlier dating argued by Denis Mahon, Walter Friedlaender, Jaques Thuillier, and Christopher Wright, among others, is more convincing.)

While a visual source for the artist's earlier version of the theme is undoubtedly Guercino's 1620 *Et in Arcadia Ego* at the Palazzo Corsini, Rome, in Poussin's transformation of the subject from one of dramatic surprise to the stoic acceptance of fate and the inevitablity of death in the Paris version, he considerably reworked the composition. The much simplified tomb and its inscription are now set at the center foreground of the composition rather than diagonally and only partially revealed on the extreme right, as in the Chatsworth painting. As Blunt has observed, Poussin has substituted for the breadth, coloristic brilliance, and dramatic intensity of the former version a more classicistic and severe rationality of order, and, abjuring almost all sense of motion, a focus upon the intellectual, contemplative implications of the subject. These differences extend to the landscape itself, which distinctively from the organic vitality and diagonal thrust of the trees against the warmly lit blue sky and sweeping clouds of the Chatsworth picture, presents a more serene, ordered setting, comparable to such works, executed just before Poussin's departure from Rome for France in late 1640, as *The Nurture of Jupiter* in Berlin, which also features, painted in a notably close color scheme, a composition with a tightly set and centrally placed figure group in the foreground, the Louvre *Moses Saved from the Water* of 1638, the Rouen *Venus Presenting Arms to Aeneas* of 1639, and the Chicago *Landscape with St. John on Patmos,* documented to 1640. Yet the landscape of the Louvre painting is not executed in the highly stylized, geometrically abstract style of the artist's late landscapes beginning in the late 1640's. Indeed, it has been related to an actual site, the tomb very similar to one near Rennes-le-Chateau near Carcassonne and the local landscape, as Christopher Wright has observed, similar. That Poussin referred to a specific site is not a unique occurrence among his landscapes, although the implications in this case remain disputed. Nonetheless, Poussin has clearly modified and idealized the setting to depict an elegiacal Arcadia and to complement the meditative mode of the theme.

The figures in the Louvre picture, far from the sensually apprehensible beings of the earlier, Chatsworth painting, seem as timeless as the subject itself, demure and classically attired, idealized both physically and as embodiments of modes of contemplation and response to the message inscribed on the tomb. They are set in the restricted foreground space before the simple, rectangular block of the tomb, as though relief figures in classical sculpture. Their positioning and gestures all serve to direct the viewer to the single focus of the painting: the inscription on the centrally set tomb. One of the shepherds, kneeling on the ground, extends his finger to read the incised letters, while another kneeling figure points to the inscription and turns to study the response of the muse-like shepherdess who rests her hand on his shoulder. In a very real sense these figures constitute counterparts to the role of appreciative viewers studying the figures, "who know how to read them," as Poussin described the process regarding another, contemporary work in a letter of 1639 to Jacques Stella. The expressions, poses, and gestures of the figures, symmetrically placed about the central tomb with its inscription, all serve to further our own meditation and interpretation of the theme, described by Giovanni Pietro Bellori, Poussin's friend and biographer, as "happiness subjected to death." The painting thus embodies the fundamental characteristics of Poussin's mature style: a stoic theme; clear, geometric ordering and symmetry of composition; classical idealization of figures depicted in clear profiles with localized colors, whose gestures and setting complement the tenor, or mode, of the subject, which is also conveyed by the color tonalities of the painting; and an epigramatic clarity in the presentation of the subject designed to encourage the contemplation and interpretation of the viewer. The subsequent popularity of the image has been the subject of an article by Richard Verdi.

—Hilliard T. Goldfarb

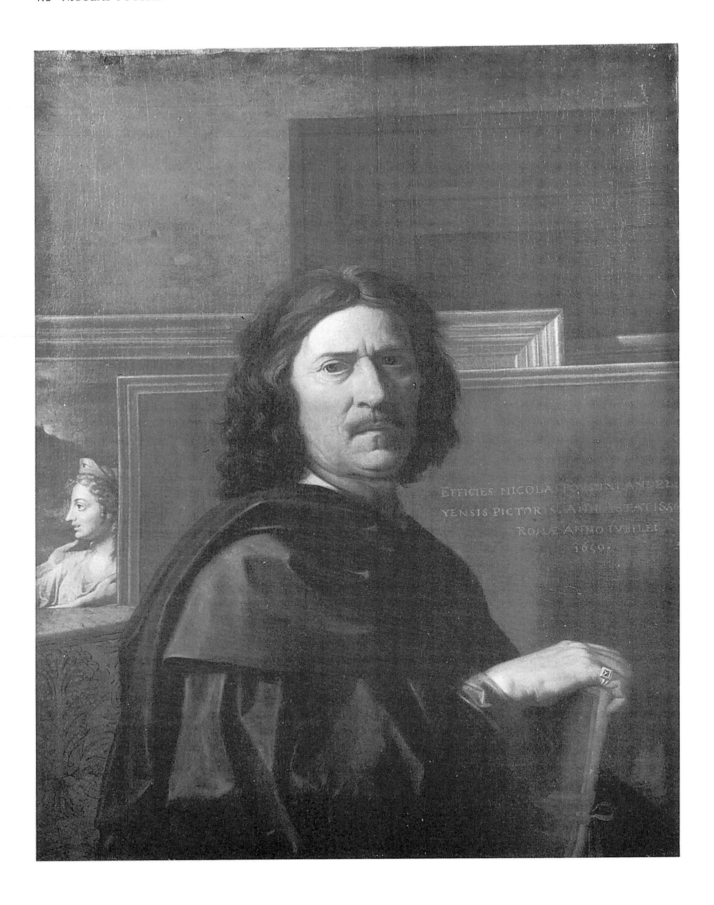

Nicolas Poussin (1594–1665)
Self-Portrait, 1650
38¹/₂ × 29 in. (97.8 × 73.7 cm.)
Paris, Louvre

Arguably among the most esteemed, if not beloved, self-portraits in the history of European painting, the Louvre *Self-Portrait* by Poussin (1650), is remarkable as much as an intellectual and psychological study as for a physical rendering of its subject. Executed by Poussin for his Parisian friend and patron Paul Freart de Chantelou over two years after the mature artist had written to Chantelou regarding his theory of modes and shortly after completing such paintings as the second series of *Seven Sacraments* for the same patron (1644–48), the *Madonna of the Steps* and *Judgement of Solomon* (1649), the Louvre portrait is a remarkable statement of Poussin as philosopher-painter. In the previous year the artist had painted another self-portrait (East Berlin)—his only other portrait painting, at once more intimate and less imposing. Poussin, who had begun the process of executing a self-portrait reluctantly and at the insistence of Chantelou, confirming his willingness in December 1647, first executed the Berlin portrait, completed in 1649. Not completely satisfied with the result, in that same year he began painting the Louvre portrait, sending the former to another Parisian collector, Pointel, and advising Chantelou that he had received the better work.

The first painted depiction, in which the artist portrays himself informally posed in half-length in front of a marble plaque decorated with putti and garland, holding a pen and book inscribed "DE LUMINE ET COLORE," is in its own right a masterful work, but the Louvre painting is a significant refinement towards severe, monumental geometric ordering of composition over the somewhat more suave and relaxed, more diagonally posed, earlier version. In clearly defined profile, the artist rests, seen in bust, his torso turned to the right, holding a portfolio tied with a red ribbon, his head turned to the left and the light, enframed by his thick, dark hair. In lettering modelled after antique inscriptions, the Louvre picture bears the notation EFFIGIES NICOLAI POUSSINI ANDELYENSIS PICTORIS ANNO AETATIS 56 ROMAE

ANNO IUBILEI 1650 on an enframed, otherwise blank canvas to the artist's left. His countenance is turned calmly to confront the viewer, and the image presents a complicated and personal iconographic program, already discussed by Giovanni Pietro Bellori, Poussin's Roman friend and biographer, in his *Vite,* published in 1672, and more recently and completely interpreted by such scholars as Anthony Blunt, Georg Kauffmann, and Donald Posner.

In the carefully balanced composition the artist is set before the horizontal and vertical planes of framed canvases (the portrait is also invaluable testimony to the simple gilt frames that Poussin preferred), holding a portfolio. Indeed, the centrally posed figure is locked within a grid of horizontal and vertical axes and planes established by the severe lines of the gilt frames of the canvases set so carefully against the studio wall behind him. To his right, as though on a painting in his studio, and turned to face the extreme left of the picture, again towards the light, is a partially revealed female figure in a landscape, wearing a diadem with an eye on it, being embraced. She represents Painting, the eye probably referring emblematically to reason, perspective, and intellectual creation. Bellori explains that the hands embracing the figure of Painting refer to the love of that art and the friendship between Poussin and Chantelou. Furthermore, the artist wears a diamond ring cut in pyramidic design, the Stoic symbol of constancy, to underline Poussin's feelings towards Chantelou. Both conceptually and compositionally this picture, with its limited platte, dominated by black and browns, constitutes an unforgettable image of gravity and psychological subtlety. Poussin was proud of the picture, which was also admired by Bernini during his visit to Paris, and it has served as a model for portraits by such diverse artists as Philippe de Champaigne, Sebastien Bourdon, and Reynolds, while being cited in works by Girodet and Seurat.

—Hilliard T. Goldfarb

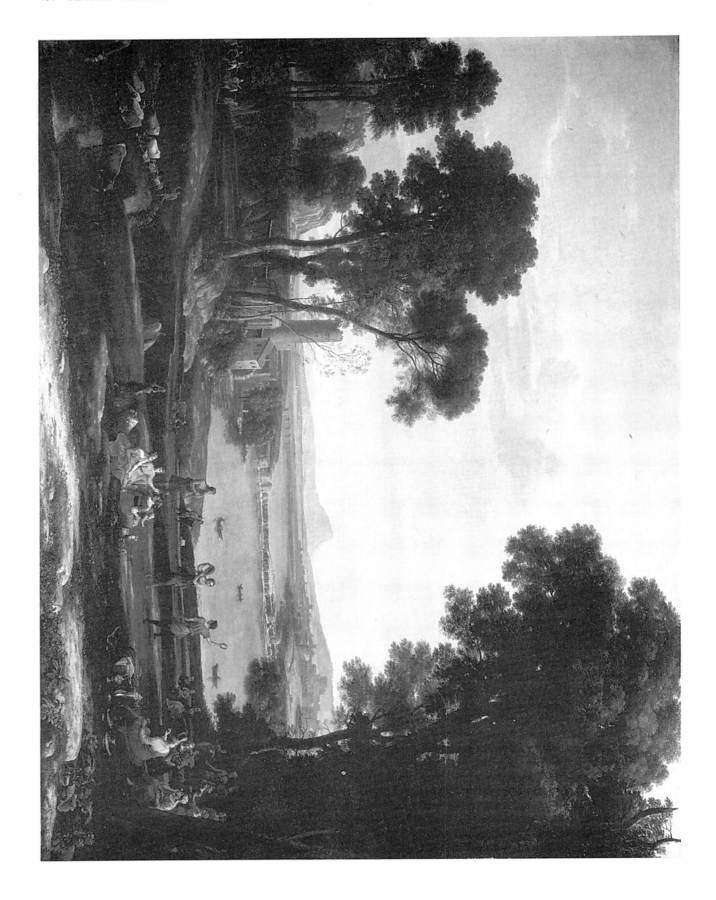

Claude Lorrain (1600–82)
The Marriage of Isaac and Rebecca, 1648
4 ft. 10 in. × 6 ft. 5¹/₂ in. (149.1 × 196.9 cm.)
London, National Gallery

The Marriage of Isaac and Rebecca, together with its pendant *The Embarkation of the Queen of Sheba* (1648), both of which are in the National Gallery, London, are two fine examples of Claude's mature style. The arrangement in which they are hung is an immediate indication of some of the fascinating intricacies that surround the interpretation of the subject matter of his paintings. The value of his work for Romantic art and criticism is attested to by the two Turners between them, there under the terms of the latter's will; but one should note that Turner knew *Isaac and Rebecca* under its later title of *The Mill* and that the Biblical subject is implicitly ignored in its coupling with the scene of mundane working life of Turner's *Sun Rising through Vapour: Fishermen Cleaning and Selling Fish*.

This introduces the question of whether Claude's painting depicts the Old Testament episode of the older title, or simply a rustic dance in the tradition of earlier works like *Village Dance* (1634–36; St. Louis) or *Country Dance* (1663; Windsor). Firstly, it should be noted that the wedding itself is not mentioned directly in Genesis (as the Queen of Sheba's departure for the court of Solomon, never depicted elsewhere, is not in I Kings X). Here Claude follows his typical practice, also seen in his scenes from *The Aeneid* and *The Metamorphoses*, of using unusual material oblique to an implied narrative. Doubt over the subject occurs because the inscription referring to it on the tree stump in the middle foreground is in French and appears to have been added for the painter's buyer, the Duc de Bouillon, when it was almost finished. Circumstances suggest, however, that the subject had already been set by the original patron, Prince Camillo Pamphili. The prince, nephew of Pope Innocent X, had to leave Rome in disgrace in 1647, having renounced his cardinalate in order to marry. Claude's commission was suspended, to be renewed in 1649, by which time the first painting had gone to Bouillon; and Pamphili received the other version still in the Villa Doria-Pamphili in Rome.

If this is so, then the theme of marriage as shown in *Isaac and Rebecca*, and as contrasted to the story of Solomon and Sheba, takes on an extra resonance. Such a direct link between a work and the private life of the patron (although it is doubtful whether a 17th-century aristocrat could be said to have had a "private" life in exactly the modern sense of the word) is upheld by the commission of *The Father of Psyche Sacrificing to Apollo* (1662; Anglesey Abbey) by Prince Altieri while he was planning the marriage of his son.

Both the work and its pendant appear, moreover, to treat of the theme of the prosperous or wise marriage (another link to Pamphili). While Rebecca and Isaac's marriage would be happy and prosperous (symbolised, perhaps, in the silver plate in the right foreground, and in the evening homecoming of the cows and goats on which this wealth would depend), the Queen of Sheba, despite her wealth, would not be able to persuade the proverbially wise Solomon to marry her. Interpretation therefore depends on principles of comparison and contrast governing the relationships of meanings contained in the works. Russell points out that there is also a Christological interpretation of the pair, the two subjects being taken by the Church Fathers to signify the union of the soul with Christ or of Christ with the Church. Here is another potential link to the current preoccupations of the patron.

Principles of comparison and contrast also govern the painting's composition, which was designed to be seen alongside and to the left of its pendant (another sense in which Turner's hanging, although interesting for its own sake, is historically inaccurate). The closed group of trees sheltering the figures on the right of *Isaac and Rebecca* are balanced by the open portico and arch on the left of *The Embarkation*; the trees in the left middle distance of *Isaac and Rebecca*, open to show a mill ("Turner's subject," no more apparent at first glance than Claude's), are balanced by the closed backdrop of the palace on the right of the second painting; in both this movement ends in the vertical accent of a cylindrical tower.

All this said and done, then why is this such a satisfying work of art? The answer to this must depend partly on the allusions to half-buried narratives and "other worlds" (the reason for Claude's appeal to the Romantics, and also to the post-Freudian modern world) which are contained in the whole complex of the painting, its pendant, the variants, their subjects, and relation to other works by Claude. Then, of course, there is the sheer visual beauty of the thing itself—not only its grandeur, but also the minutiae of observation (all with their own contribution to the meaning of the whole: see the cows being safely herded home). There is, too, in this, an element of "charm" which extends to, and is perhaps reliant on, slight, deliberate imperfections (the difference in scale between seated and standing figures) and a certain "superabundance" of nature as displayed in a work where picturesque observation is in equilibrium with the moral implications of "heroic" landscape.

—David Crellin

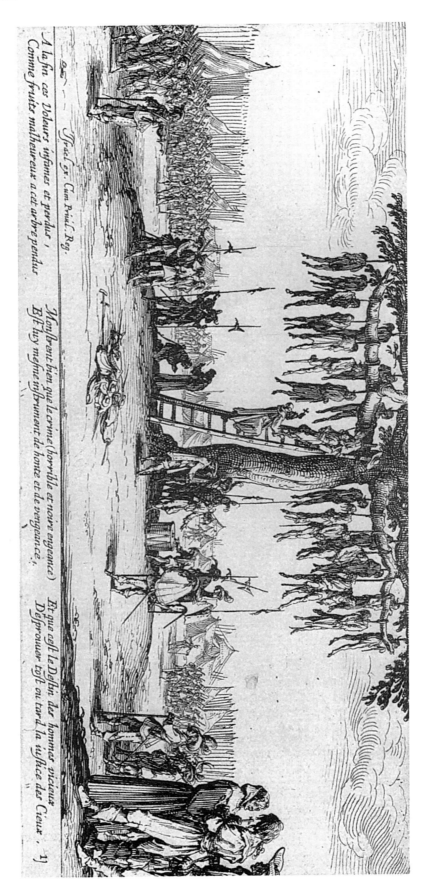

Antoine Coysevox (1640–1720)
Triumph of Louis XIV
Stucco; 12 ft. 10 in. (392 cm.) (diameter)
Versailles, Salon de la Guerre

Bibliography—

Kuraszewski, "La Cheminée du Salon de la Guerre au Châ-
teau de Versailles: Sa création et ses transformations succes-
sives," in *Bulletin de la Société d'Histoire de l'Art Français*
(Paris), 1974.

This work, which is of major importance in terms of its
size, its subject matter, and its position—the Salon de la
Guerre is situated at one end of the Galerie des Glaces, bal-
ancing the Salon de la Paix at the opposite end—poses a histor-
ical problem since it is not mentioned in the registers of the
royal accounts. The only reference is to a payment for the bas-
relief under the medallion, *History Writing on a Shield*. The
attribution of the piece to Coysevox is, nevertheless, certain,
since it was noted in the obituary of the sculptor written by
Fermel'huis and published the day after his death.

It would certainly not have been the sculptor's intention to
keep the bas-relief in stucco, but to translate it into marble in
the manner of Puget's *Alexander and Diogenes*, created for the
lower vestibule of the chapel and for which work began in
marble in Toulon in 1672. Rome provided the inspiration for
these huge marble bas-reliefs which rivalled painting with
their illusionist effects (Bernini, Algardi, etc.).

May we not seek the principal source for Coysevox's work
in the masterpiece by Bernini at Saint Peter's in Rome, the
equestrian *Constantin* (1670), which stands at the foot of the
monumental staircase, the Scala Regia, clearly visible at the
extreme end of the basilica's portico? The *Constantin*, origi-
nally conceived in the form of a round boss, gains depth from
the background drapery and stands out as a high relief. Ber-
nini was working on it during his stay in France—as Chantelou
notes—and the idea it embodied formed the basis for his proj-
ect for an equestrian statue of Louis XIV. The royal commis-
sion given to Bernini would undoubtedly have been seen by
contemporary French sculptors as a challenge. It is perhaps no
accident, therefore, that the horse on Coysevox's relief is seen
to rear up like Bernini's, bearing a rider dressed in the fashion
of classical antiquity. Let us not forget that the sovereign
drawn by Le Brun in his *History of the King* sequence (Gobe-
lins tapestries; for example, the episode depicting the *Arrival
of Louis XIV at Dunkirk*, where the monarch is seated on a
rearing horse, an image very similar to Coysevox's relief) is
shown in contemporary costume; we know, on the other hand,
that he appeared in heroic classical guise on the ceiling vaults
of the Galerie des Glaces. Coysevox is therefore at the center
of a great network of references: the Roman tradition of the
embellished monumental bas-relief, taken up by Puget for Ver-
sailles, the lessons provided by Bernini and Le Brun relating to
the classical hero seated on a rearing horse, and the challenge
taken up by his rival Girardon.

Coysevox succeeded in this "challenge" by incorporating

Louis XIV on horseback in a composition which has elements
of both a scene typical of Le Brun—the conquering hero
crushing his enemies—and the public monument: indeed, the
medallion is surrounded by stucco bas-reliefs depicting, at the
top, spirits blowing trumpets (allegory of *Renown*) and, below,
slaves in chains (very similar to the *ignudi* of Annibale Car-
racci at the Galleria Farnese). Beneath this piece, decorating
the false chimney, is a rectangular bas-relief (over six feet in
length) representing *History Writing on a Shield* and offering
an exact complement to the iconography of the principal piece.
According to the royal accounts, this scene was executed in
bronze but never put into place (it disappeared at the end of the
18th century).

The notion of a *Louis XIV* as a conquering hero accompa-
nied by slaves in chains was of course not new; it was even
something of a cliché. At more or less the same date, Desjar-
dins was outlining his monument for the Place Notre-Dame
des Victoires, its pedestal decorated with four monumental
prisoners. The choice of History glorifying the hero in writ-
ing, as a juxtaposed theme, is more frequently found as a
motif accompanying a funerary monument—such as that of
Président de Thou by François Anguier—but its significance is
the same: it rounds off the glorification of the illustrious per-
sonage. Coysevox's relief has the word "History" inscribed on
the left, below the figure of a young woman with wings who is
writing on a shield held for her by a small cherub; a second
putto on the right is attempting to place a helmet on top of a
breastplate. The composition, if we are to believe a drawing in
Stockholm which is attributed to him, is by Le Brun, whose
potential role as the designer of the entire decor has recently
been discussed by Kuraszewski.

The iconography of the overall work is resolutely military,
that much is clear; during the Revolution, Louis XIV was even
depicted in the guise of the god Mars by Claude Dejoux. Does
this explain the sculpture's lack of success? The medallion that
was never translated into marble, the bronze relief relegated to
the warehouses and never set in place—everything suggests
that the installation of the piece was merely temporary. In
1715, the year of the king's death, the sculptor's nephew Ni-
cholas Coustou received a commission to create a new monu-
mental bas-relief for the Salon de la Guerre. The subject was
politically more appropriate: even if the *Crossing of the Rhine*
dealt with a military success, Coustou's slant was that of pa-
cific allegory, depicting a standing Louis XIV, crowned by
Victory. The work was executed in marble (completed after
Nicolas's death by his brother Guillaume, in 1738) and, in-
stead of replacing Coysevox's stucco work, it took the place, in
1824, of *Alexander and Diogenes* in the lower vestibule of the
chapel. More of an Apollo than a Mars, the new Louis XIV
embodied the mentality of the Age of Enlightenment.

—Guilhem Scherf

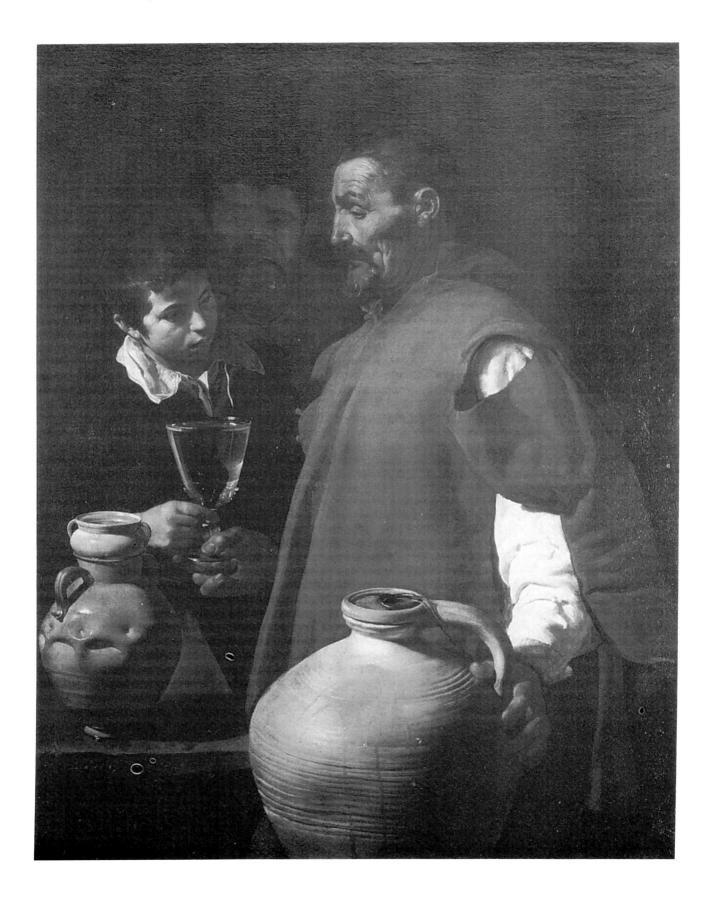

Diego Velázquez (1599–1660)
The Waterseller of Seville, c. 1619
41³/₈ × 31¹/₂ in. (105 × 80 cm.)
London, Wellington Museum

Bibliography—

Moffitt, John F., "Image and Meaning in Velázquez's *Water-Carrier of Seville,*" in *Traza y Baza* (Barcelona), 7, 1978.

The great Spanish painter Diego Velázquez was born in the city of Seville, in Andalusia, and was trained there as an artist. From 14 March 1617, when, still under the age of eighteen, he qualified with the Guild of Saint Luke as an independent painter, until he visited Madrid in 1622 and settled there in the following year, he painted in Seville. One of the outstanding paintings made during this youthful period of his career, *The Waterseller of Seville* of about 1619 (London, Apsley House, Wellington Museum), splendidly exemplifies his artistic interests and his early style, already highly developed.

Though he painted a few religious subjects and some portraits during his Seville years, his surviving works indicate that he specialized in paintings of the type known in Spanish as *bodegones. Bodegón,* literally meaning tavern, came to be used to designate pictures of ordinary people engaged in everyday activities, often having to do with food and drink. Later the use of this word was extended to include what we now call still life. Velázquez's *bodegones* were related to both subject matter and style to the modern trend in painting that had been initiated shortly before the turn of the 17th century by the Italian painter Caravaggio: small groups of lowly individuals—in Velázquez's paintings most often only two—shown close to the picture plane in unembellished settings. The figures were modelled in strong relief and unified by sharply focused light. How Velázquez became acquainted with this style by this early date is not known. It seems likely that paintings by the Spanish Caravaggist artist Jusepe Ribera, who worked in this style in Naples, as well as works by Italian artists who followed the Caravaggist trend, were brought or sent to Seville by Spanish residents of Naples, which was under Spanish rule.

While sharing some subject matter and stylistic features with paintings by such artists, Velázquez's *bodegones* were distinguished by a notably personal color scheme of modulated earth tones and by an air of dignity that was essential to his artistic personality. The *Waterseller* impressively exemplifies these distinctive features of the naturalism of Velázquez's paintings of his Seville years. Though wearing a ragged cloak, the waterseller impresses us as stately, even commanding; his gesture in handing the boy the glass of water has a sacramental quality, an emotional tone that is reinforced by the gravity of the boy's expression. Indeed, the provision of potable water in hot, dusty Seville was not to be taken lightly. (It has been noted that the glass contains a fig, to freshen the water.)

The pottery and glass, like the two chief figures, are firmly three-dimensional in effect; the jug, indeed, appears to share the space from which we observe the painting. Even the drops of water on the jug are fully rounded.

Between the waterseller and the boy is seen the vaguely depicted head of a man drinking from a glass. The presence of this third figure suggests the implication that The Three Ages of Man, a traditional subject for art, is represented by the group of young boy, old waterseller, and adult man of middle years. It would be difficult to find a better example in art of the power of paint to distinguish skin marked by age from that with the smooth gleam of youth, to set off the glistening water drops against the mat-finished pottery, to convey the individual qualities of metal, glass, cloth, hair.

This is the earliest painting by Velázquez whose history of ownership is known almost completely, thus providing a standard for the attribution and dating of other early works by him.

—Madlyn Millner Kahr

Diego Velázquez (1599–1660)
Las Meninas, 1656
10 ft. 5¹/₂ in. × 9 ft. ⁵/₈ in. (318 × 276 cm.)
Madrid, Prado

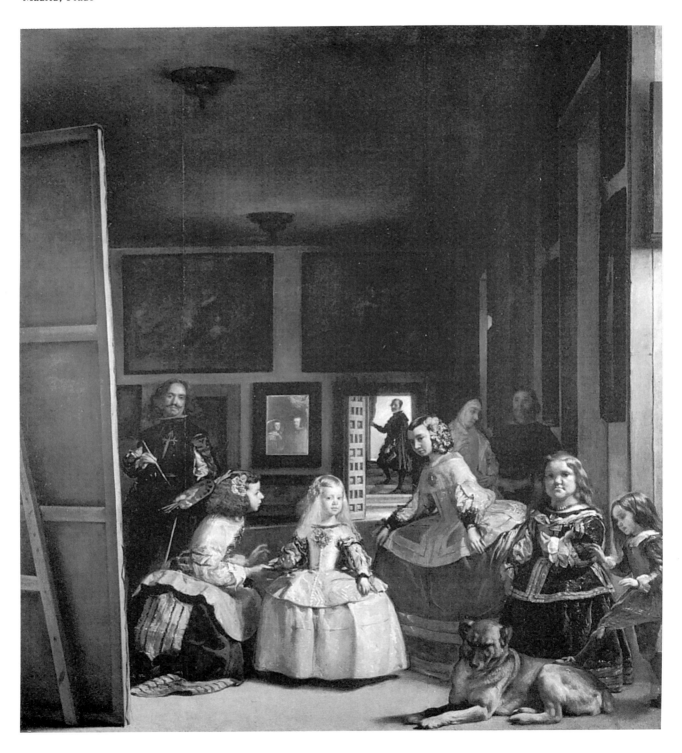

Bibliography—

Kahr, Madlyn Millner, "Velázquez and *Las Meninas,* in *Art Bulletin* (New York), 57, 1975.

Brown, Jonathan, "The Meaning of *Las Meninas,*" in *Images and Ideas in Seventeenth-Century Spanish Painting,* Princeton, 1978.

Stoichita, Victor I., "Imago regis: Kunsttheorie und königliches Porträt in den Meninas von Velázquez," in *Zeitschrift für Kunstgeschichte* (Munich), 49, 1986.

Velázquez's large painting of nine assorted people and a submissive dog—in a room that has obscure paintings and a mirror on its walls but is devoid of furniture—has stimulated the publication of an endless stream of comments and questions. Why was this odd group depicted in a single composition that included the artist himself at work at his easel? How was its extraordinary effect of realism achieved? These and other questions have not been answered to universal satisfaction since the great Spanish artist painted *Las Meninas.*

Dating from 1656, late in the artist's life, unique in Velázquez's career and in the history of art, this intriguing painting at the same time incorporates a wealth of associations both to art traditions and to the circumstances of Velázquez's life. Given the title *Las Meninas* (The Maids of Honor) only in the middle of the 19th century, it was described as "the Empress with her ladies and a dwarf" in a 1666 inventory of the royal palace in Madrid, the first-known mention of this painting.

It is one of the anomalies of this composition that we see the artist, right hand holding the brush poised above the palette he holds in his left, as if considering his next brushstroke, but we do not see what he is painting. The enormously tall stretcher of the canvas on which he is presumably working is a prominent factor in the foreground. This is clearly a representation of the artist at work. It differs from most other pictures of artists painting in their studios in that we see neither the subject from which he is working nor the image on his canvas. The setting and the presence of visitors of high rank associate Velázquez's painting with the Flemish tradition of gallery pictures.

The eyes of the painter appear to meet ours as we look at *Las Meninas.* Does this imply that he shows himself in the act of painting a subject that, while he painted it, was in the place that we spectators now occupy? If so, was this subject the scene we see before us in the painting now in the Prado? Some writers have answered this question affirmatively, making the unlikely assumption that in fact Velázquez was, from his place before the huge canvas, looking into a mirror that reflected the standing individuals and the setting that we see in *Las Meninas,* including himself. (One of several arguments against this assumption is the fact that it is questionable that a suitably large mirror was available to him.) Others have concluded that the clue to the subject being painted by Velázquez lies in the image in the mirror on the far wall, which dimly shows half-length figures of King Philip IV and Queen Mariana beneath a drapery typical of aristocratic 17th-century portraiture. Extensive efforts have been made to prove that the image in the mirror is a reflection of a double portrait of the royal couple as it appears on the canvas on which the artist is working, though there is no evidence that such a double portrait ever existed. The enormous height of the canvas, which would make it inappropriate in size for such a portrait, is also inconsistent with

the assumption that Velázquez was providing, by means of the mirror image, a naturalistic revelation of what it is that his large canvas conceals from us.

To some writers *Las Meninas* is a painted equivalent of a snapshot of a scene that Velázquez came upon by chance and instantly made permanent, at a time when he was engaged in painting a double portrait of the King and Queen. The presence of the royal couple, posting in the very place in which we stand as we look at *Las Meninas,* would, according to this theory account for the fact that the central figure, five-year-old Infanta Margarita, as well as several of her companions, appear to be looking in our direction. Thus the Infanta's parents, visible to us only by way of the fuzzy reflection in the mirror, are presumed to be the focus of attention of major participants in the scene that occurred in real life.

The fact that several of the poses could have been held only momentarily, contributing to the illusion of instantaneity that impresses observers of the painting, argues against the theory that the painting was made in the presence of a chance grouping. Besides, everything we know about Velázquez's studio methods and the painting practices that prevailed in his time would also contradict the notion that the group depicted in this painting was assembled and painted from life.

What seems likely is that the artist made drawings or oil sketches of the individuals to be depicted and then invented a composition that incorporated these figures. As artful an arrangement as that of *Las Meninas,* with its convincing rendition of perspective, is surely based on the genius of Velázquez rather than on a chance gathering. The parabolic curve that perceptually organizes the heads of the painter, the young woman who kneels beside the Infanta and offers her a drink of water, the Infanta Margarita, the second *menina,* and the female figure deeper in space at the right, provides a remarkable visual unity of a considerable depth in space. At the same time, this curve forms a garland that brackets the mirror on the far wall and the dramatic open door, with its view of a light-flooded wall and a stairway on which stands a man, like an exclamation point. The elaborately varied silhouettes of the figures and their poses, most of which represent momentary stopped action, are held in check by the strongly emphasized pattern of rectangles: on the right, the strong verticals of window embrasures and picture frames, on the left the firm horizontals of the cradling of the canvas, on the rear wall the frames of pictures (whose subjects are barely visible), mirror, and doorway, whose coffered door provides rectangular grace notes for this handsome abstract pattern.

The dispersal of the light is equally ingenious, from the radiant little Princess, the center of attention, to the relatively well-illuminated figures near her, the less distinct figures at a greater distance, and the poorly illuminated far wall, punctuated by the loosely painted mirror and the dramatic contrast of the burst of light visible through the open door, which sets up a tension between foreground and background.

Through subtle variations of color, light, and brushstrike, Velázquez endowed the figures and the space in which they exist with a magical reality that provides its own justification for the admiration that *Las Meninas* has evoked from the earliest known comments on the picture to the present. It has never ceased to inspire later artists. Picasso, for one, in 1957 based a series of more than 40 compositions on *Las Meninas.*

—Madlyn Millner Kahr

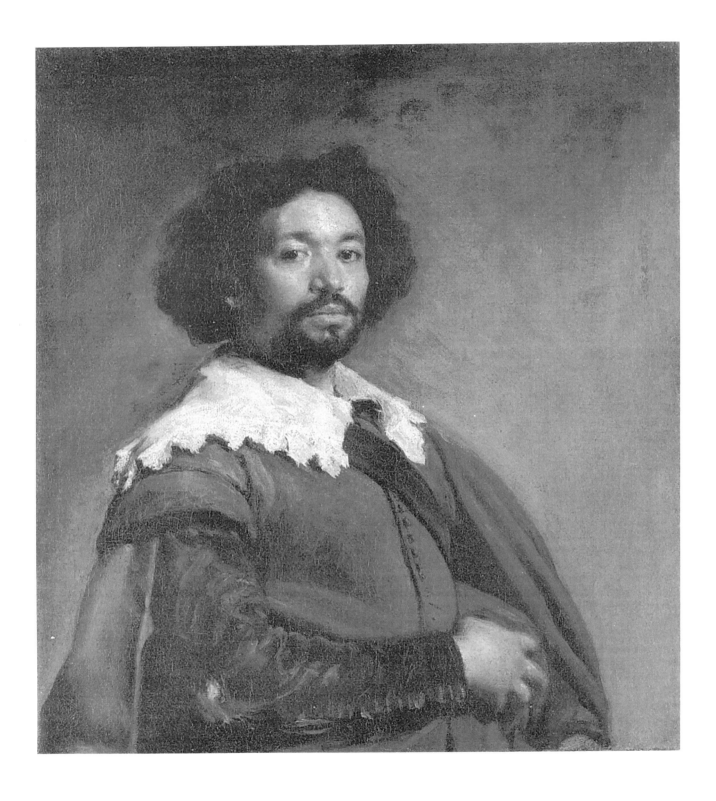

Diego Velázquez (1599–1660)
Juan de Pareja, 1650
30 × 24³/₄ in. (76 × 63 cm.)
New York, Metropolitan

When it was sold at auction in 1970 for the unprecedented price of $5,544,000, Diego Velázquez's portrait of Juan de Pareja (New York, Metropolitan Museum) attracted the attention even of those who knew—and cared—more about money than about art. Was it worth the price? This question was widely discussed, from varied points of view. For some observers, it led to further questions. How are we to set a value on a superb painting by a great artist? Is it worth whatever the market will bring? Regardless of how the money might otherwise be used? Is its value simply beyond price? And, if we accept the generally uncontested opinion that Velázquez is indeed one of the great masters of all time, is this an outstanding example of his work?

That it is unquestionably a masterpiece in the mature style of a painter of highest rank is the considered opinion of those who have studied the paintings of Velázquez most intensively. Art lovers in general appear to agree.

Besides the visible appeal of its painterly perfection, *Juan de Pareja* has an additional claim to attention in that it is a portrait of a person who was closely associated with the artist, and it was made by Velázquez for his own purposes, not to please a patron. Most of Velázquez's career was spent aas Court painter to King Philip IV of Spain, so that his primary obligation was the painting of portraits of the royal family and others connected with the Court. It was, thus, to his outstanding skill at producing likenesses that pleased the sitters that Velázquez owed his employment and his status. Like any artist, he faced certain constraints in painting commissioned portraits. It is, then, a matter of special interest to learn from Antonio Palomino's book that during Velázquez's second trip to Italy, while in Rome from July 1649 to November 1650, in preparation for the important task of portraying Pope Innocent X, he painted from life this portrait of "his slave and clever painter," Pareja, a resident of Seville, who had accompanied Velázquez to Italy as his assistant. (That he was in fact a slave had been questioned by a number of writers on Velázquez.

Like many details published by Palomino more than fifty years after Velázquez's death, however, it has been confirmed by contemporary documentation. On 23 November 1650 Velázquez signed a notirial act giving Pareja his freedom. Pareja, according to this document, was required to work for Velázquez for four more years.)

Palomino goes on to relate that this portrait, exhibited with celebrated ancient and modern paintings, met with acclaim from artists from many nations then resident in Rome, who found the other pictures merely *paintings,* this one *truth.* Friends who saw Pareja along with his portrait wondered, as Palomino tells the story, whether they should speak to the man himself or to this marvelous facsimile. Such praise of art as rivalling life already had a long history in Palomino's day; it would nonetheless have been understood as the highest possible commendation of Velázquez as a portraitist and of this particular picture as among his most admirable.

Velázquez achieved his richly human effect with minimal means: a limited palette, complete absence of space-creating devices, the sole subject the half-length figure of a dark-eyed black-haired, bearded man wearing quiet, unassuming clothing. The magic of the artist's brush creates the space that convincingly harbors the figure. Against the subtly modulated greyish-brown background, the coppery skin tones of face and hand, the gamut of muted brownish greys of his costume, and the sparkling, lace-edged white collar that focuses attention on the face that looks out at us candidly—these cooperate to create a vivid impression of an encounter with a vigorous individual who boldly meets our gaze.

The painting is in exceptionally good condition. Never relined, it retains its original unevenness of surface, which lends itself to the play of light called into being by the artist's brushstrokes. This is particularly evident in the freely placed dabs of white that make the lace border of the collar take form before our eyes.

—Madlyn Millner Kahr

Jusepe de Ribera (1591–1652)
Martyrdom of St. Philip, c. 1639
92$^{1}/_{8}$ × 92$^{1}/_{8}$ in. (234 × 234 cm.)
Madrid, Prado

Of all 17th-century artists, the Spanish-born Jusepe Ribera was perhaps the quintessential painter of suffering Christian heroes. His various depictions of martyrdom were first celebrated by 19th-century Romantic writers like Lord Byron, who commented that Ribera "tainted his brushes with the blood of all the saints." Yet such descriptions, which singularly accent the horrific tortures to which the saints were subjected, give insufficient account of the Catholic Counter-Reformation view that these individuals had forfeited their lives for the true faith and were to be acclaimed as models of Christian orthodoxy for all to follow. Such is the case in the many martyrdoms painted by Ribera, including the Prado canvas; no matter how harsh the punishment and pain inflicted, the Christian hero ultimately triumphs over his tormentors and provides the uplifting message that sincere spiritual conviction can conquer physical persecution and mortal death.

The martyr of Ribera's canvas has been traditionally identified as St. Bartholomew, who, according to the Golden Legend, was flayed alive in Armenia for refusing to worship pagan idols. The martyrdom of Bartholomew was a popular subject with Ribera in both paintings and etching. In his many depictions, Ribera most usually represents Bartholomew as middle-aged, long-bearded, and either in the process of being flayed or at the least with his attribute, the knife, with which his skin was removed. Typically, Ribera includes the severed head of a classical statue lying upon the ground, a reference to Bartholomew's denial of the pagan gods. In the Prado painting, however, the martyr is neither elderly nor with long beard and there is no decapitated statue present, although the columns of a pagan temple in the background might serve an identical purpose. More equivocal is the question of whether it is a flaying that will here take place, since the only potential indicator of it is the butt of a knife projecting from the pocket of the red-vested tormentor.

Alternatively, it has been suggested that the character of the saint and the circumstances of the story depicted by Ribera might more closely correspond to the legend of the Apostle Philip, who, it must be admitted, is rarely represented in western art and has no parallel among Ribera's many renditions of martyrdom. Philip is said to have proselytized in the city of Hierapolis (Asia Minor) where, with the aid of a cross—which thereafter served as his attribute—he succeeded in expelling a serpent which was worshipped in the local temple of Mars. For his act of defiance the local priests had Philip crucified (eastern tradition held that Philip was crucified upside down although western examples, such as Filippino Lippi's Strozzi Chapel fresco, do not maintain this pattern), and he is conceivably being hoisted into position in Ribera's canvas. The columns at the right could properly allude to the Temple of Mars referred to in the legend. Moreover, in accordance with the traditional manner of representing Philip, Ribera paints him as a man of middle years with short beard.

In the fashion of a truly baroque master, Ribera devised the painted event in stylistic and temperamental terms which elicit the direct participation of the viewer. It is not the gruesome martyrdom itself which he painted, but the preceding moments that lead up to it, thus leaving the spectator actively to imagine the foreboding future. At center stage Philip is awkwardly set at a cross diagonal to the picture plane, his body and arms strained and contorted by the beam and ropes which will hoist him up toward mortal death. Virtually oblivious of his tormentors and unable, if not unwilling, to offer physical resistance, the stripped and totally unidealized figure looks longingly upward, beyond the physical borders of the canvas, towards the heavens where his spiritual salvation awaits. The message is clear and unequivocal; while Philip's unbecoming earthly flesh may perish, the strength of his inner spiritual conviction will persevere and ultimately make him victorious. The poignancy of the martyr's faith is made all the stronger in contrast to the powerful, anonymous executioners at the left who vigorously pull their victim upward like a sail, going about their malign task in an unthinking manner. Of the torturers, perhaps it is only the figure in red, turning toward Philip in an effort to lift the saint's leg, who recognizes the severity of this ungodly act.

The painter's desire that his viewer contemplate the repercussions of this act is pointed up by the presence within the canvas of spectators who border the central scene at either side. Because some of them are cut by the frame, implying an extension of the picture space into the real world, these painted spectators become counterparts to the true-to-life viewer. Those to the right silhouetted against the cropped temple columns look on with curious attention, while those squeezed into the lower left are more inwardly reflective. In the foreground of this latter group is a mother holding a child to her breast (an allusion to the Madonna and Child?) and looking directly out of the canvas as if to engage the viewer's thoughts and reactions to the spectacle. Is the viewer to share in the guilt of this martyr's death? Does Bartholomew's temper provide a model of Christian action that those tested in their faith should be willing to emulate?

While universally accepted as a primary work from Ribera's hand, questions regarding the specific date of the canvas remain. Upon the rock at the lower right, Ribera has signed and dated the painting. Yet, due to both the equivocal nature of the draughtsmanship and a deterioration of the canvas, the numerals have been read as either 1630, placing the work in Ribera's first "realistic" phase, or 1639, within the artist's second, more dynamic stylistic stage. Indeed, in many ways the painting adheres to the markedly tactile, sensory-inspiring nature of Ribera's initial style. Typical are the monumental, rustic figure types painted with earthen-colored tones, the paint laid on with a loaded brush, building textured surfaces which simulate the look and feel of raw flesh. A crepuscular light—ultimately inspired by Caravaggio and his followers—enhances this modeling technique and establishes solid, yet fluidly positioned forms. Notwithstanding, the probable date of the canvas is 1639; for the painting is also replete with the characteristic elements of the energetic baroque style in which Ribera worked from approximately 1635 to 1640. The participants are silhouetted against a more thinly painted, cloud-filled sky of luminous blue (through which the brown underpainting pro-

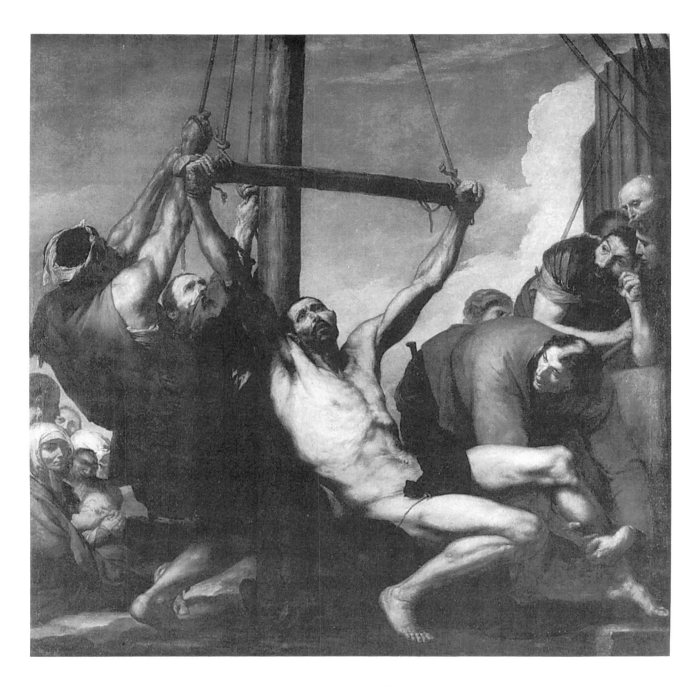

trudes) which, together with the sharp red accent of the tor-
mentor's tunic and the glowing purple of the baby's swaddling
cloth, add an element of coloristic richness to the canvas. This
combines effectively with the vigorous movement of the brush
and the activated pinwheel composition of the figures, inspir-
ing in the viewer an engaging and empathetic sensory reaction
to the event.

The faithful Catholic has, in essence, been granted a front
row seat to a powerful passion play, having the privilege of
being an eyewitness to both the torment and the hope of a
christian martyr. This immediate engagement makes the *Mar-
tyrdom of St. Philip* one of the most powerful and persuasive
works from Jusepe Ribera's hand.

—David Martin Kowal

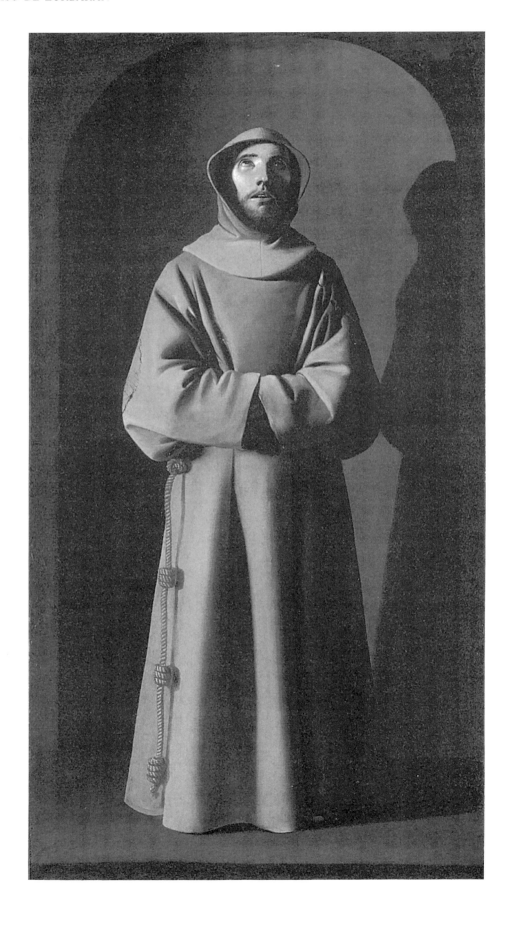

Franciso de Zurbarán (1598–1664)
St. Francis in His Tomb, c. 1640
6 ft. 9¹/₂ in. × 3 ft. 6 in. (207 × 106 cm.)
Boston, Museum of Fine Arts

Zurbarán painted numerous variants upon the theme of "St. Francis of Assisi in Meditation" (for instance, the National Gallery in London has two excellent examples where the saint in a landscape setting clutches a human skull, a reminder of man's mortality). The Boston example may stand in the purely visual sense as a characteristic work of the painter's mature oeurve. As in the majority of Zurbarán's works, large, stable forms are defined by sharp outlines and enlivened only by a harsh, clear light that falls suddenly into deep shadow. The saint stands immobile in a shallow niche. His worn and patched simple brown habit covers his body except for the face, looking upward into the heavens with an enraptured expression of intense devotion. A steady stream of harsh light descends at an oblique angle from the upper left hand, sharply silhouetting the body of the saint lost in revery. His heavy woolen robe, with a sharply defined knotted rope nearly reaching to the ground, hangs in long parallel folds to emphasize the rigidly vertical attitude of the estatic visionary. An early biographer, Antonio Palomino, stated (1724) that the painter "used mannequins when he painted drapery and a live model for the flesh tones, following the school of Caravaggio." As he added, the drapery is "painted so that the material is immediately identifiable." Speaking of a *Crucifixion* by Zurbarán, which he had seen in a monastery in Seville, Palomino made an observation that surely holds for this painting as well: "all who see it and do not know it is a painting believe it to be a work of sculpture" There is, in fact, a polychromed wooden sculpture, executed by Pedro de Mena in 1663 (Toledo, Cathedral), which looks so much like Zurbarán's painting of the upright St. Francis as to make one believe that the former was a literally corporeal simulacrum of the latter, illusionistically represented in paint. In both examples, the common ground is plain, and itself represents a consistent pattern in Spanish art: tangible, surreal *presence.*

In this example, as in nearly all others, Zurbarán's dramatic chiaroscuro may be taken to have clear metaphorical significance: the light of spiritual revelation vanquishes the engulfing darkness of ignorance. In a larger sense, all the compositional effects are engineered to express animated states of the soul and the mind. The stark and frontalized placement of the enraptured saint and the absence of fluent compositional rhythms abstracts the event of mystical enlightenment from the realm of the ordinary. Zurbarán's St. Francis is released from the constraints of time and place by a rigorous suppression of irrelevant detail and the severely limited pictorial space forces our intense concentration upon the object of contemplation. Truly Zurbarán's forte, as exemplified so well here, was the depiction of man in contact with divinity, an exalted moment of fusion with the supernatural. Zurbarán conceived of his religious scenes as if they were contemporary events enacted by common people but these intensely felt psychological transactions are nearly inevitably *illuminated,* in both the physical and the supernatural sense, by arbitrary and unnatural effects of light, which (as one must apparently take pains to emphasize repeatedly) were in themselves commonplace metaphors of spiritual "illumination."

Specifically this painting, among Zurbarán's many depictions of St. Francis, takes a special place in his repertoire due to the painter's choice of a truly bizarre theme (a half-length repetition of the subject is exhibited in Barcelona at the Museo de Arte de Cataluña). This (as we now see) literally "statuesque" figure was inspired by pious legend. In order to promote a belief in the incorruptibility of the body of St. Francis (c. 1182–1226) after his death, in 1449 Pope Nicholas V visited the monastery of Assisi and explored its dark subterranean crypt. At five in the morning, he descended with a working party to conduct a torchlight search in the stygian gloom, whereupon they came across the rigidly erect body of the saint, standing upright on a slab of marble. According to the eyewitness accounts, Francis's hands were clasped and covered by the wide sleeves of his habit. The Pope and his fellow explorers then fell to their knees before the miraculously preserved body with open eyes raised to heaven and blood still streaming from the stigmata hidden by his habit. This mummified effigy was the goal of numerous pilgrims, especially after the canonization of Francis in 1628. As may however be further remarked, apparently Zurbarán's source for this stark image of the miraculously preserved body was textual rather than graphic, specifically as this motif was described in Francisco Pacheco's *Arts de la Pintura* (1638). According to the text of this Sevillian painter, St. Francis is to be depicted as he was found in Assisi, "standing, as if he were alive—*en pie, como si estuviera vivo.*" As he adds, he is to be represented "just as today the body of Francis is seen in his sepulchre, standing up, feet apart, the soles well implanted." As we understand from this, Spanish "surrealism" is a scrupulously circumstantial rendering of the supernatural reality of life after, or "above," death.

—John F. Moffitt

Bartolomé Esteban Murillo (1617–82)
The Holy Family with a Bird, c. 1650
56³/₄ × 74 in. (144 × 188 cm.)
Madrid, Prado

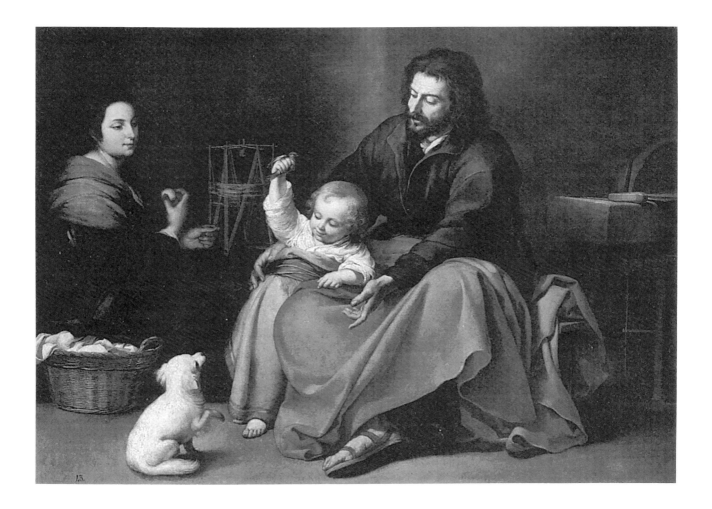

Juan de Valdés Leal (1622–91)
Immaculate Conception with Two Donors, 1661
6 ft. 2³/4 × 6 ft. 8¹/2 in. (189.7 × 204.5 cm.)
London, National Gallery

The *Immaculate Conception with Two Donors* was painted by Juan de Valdés Leal in Seville in 1661. It is signed: JUAN BALDES FAC A.1661. Very little is known about the commission, and the two donors for whom it was presumably painted have never been identified. Their dress alone gives clues to their occupations. The older woman on the left of the picture is presumed to be either a nun or in mourning, and it has been suggested that the young man on the right is her son and possibly a canon of the Church or a city official.

The Immaculate Conception was a popular theme, particularly in Seville, and Valdés Leal was to paint it throughout his career. It represents the conception of Mary without original sin. Although this was not recognised as official doctrine by the Church during the 17th century, there were concessions granting it a more important status which were celebrated in Seville, frequently by the commissioning of paintings. For instance, in 1617 Pope Paul V declared that no views contradicting the doctrine were allowed, which Juan de Roelas celebrated in his *Allegory Commemorating the Procession in Honour of the Immaculate Conception.* The year 1661 was also important for the history of the doctrine, since Alexander VII defined the terms of the Immaculate Conception and forbade further discussion on the subject. Valdés Leal may thus have been commissioned by supporters of the doctrine in 1661 to celebrate this recognition from Rome.

Early images of the Immaculate Virgin have an elaborate iconography which made her easy to identify and differed greatly from later pictures by artists such as Murillo. The acceptable way to depict the Immaculate Conception was laid down by the Seville painter and Inquisitor Francisco Pacheco in his book *Arte de la Pintura* of 1649. He said that the Virgin should be a young girl aged 12–13 with perfect features, framed by the sun, with a halo of 12 stars, dressed in blue and white and standing on a downturned crescent moon. Her attributes, described in the *Song of Songs* were to be found in the sky around her—the cypress tree, the walled garden, the Tower of David, Jacob's ladder, the temple of the Holy Spirit, the lily, olive, and palm. Both Pacheco in his *Immaculate Conception* for the Church of San Lorenzo, Seville in 1624 and his son-in-law, Velázquez in his picture of c. 1617 (now in the National Gallery, London) show a close observance of Pacheco's views. Valdés Leal would have known how Pacheco thought the Immaculate Virgin should be depicted. He would also have been required as one of the officials of the newly founded Academy in Seville, to declare his belief in the orthodox doctrine of the Immaculate Conception. In his picture of 1661 he follows Pacheco loosely but gives a freer interpretation. Mary is depicted in traditional terms standing on a downturned moon with a halo of stars and surrounded by her attributes in the sky—the spotless mirror, the olive, palm, rose, iris, lily, the gate of heaven, and the staircase at the top of which stand the Archangels Gabrial and Michael and the

throne of Solomon. However, instead of wearing blue and white, she is dressed in a rose-coloured tunic and white mantle, and, probably influenced by Murillo, Valdés Leal paints many angels at her feet and above her head. It is one of Valdés Leal's outstanding works, painted at the height of his career. It demonstrates his skill at portraiture and foreshadows works such as his portrait of Miguel Manara (c. 1681) in the Hospital of Santa Caridad, Seville. The painting is characteristically light and refined and the palette is colourful. Typically, the brushstrokes are broad and impressionistic with background figures such as God and the Holy Spirit loosely sketched in. Similarly the composition shows the overcrowding and confusion which appears in other canvasses by Valdés Leal.

The majority of Valdés Leal's commissions for images of the Immaculate Conception came in the 1650's and 1660's. These include the elaborate *Virgin of the Silversmiths* (now in Córdoba) of c. 1654. St. Eloy, patron saint of silversmiths, and St. Anthony of Padua kneel beside the Immaculate Virgin, who stands on the crescent moon above an intricate gilt and silver throne. Similarly, the *Immaculate Virgin with St. Andrew and St. John the Evangelist* of c. 1655, now in the Louvre, is based on the same compositional devices but is a more integrated composition. The Virgin is encircled by angels bearing her attributes and the dove of the Holy Spirit places a crown above her head. The most successful of Valdés Leal's Immaculate Virgins, however, was part of a nine-canvas commission for the Church of San Benito de Calatrava, Seville, of c. 1659. (and is now in the Church of la Magdalena). The composition is well-balanced and there is a sense of space which is unusual for Valdés Leal. The Virgin stands on a crescent moon in which angels' heads appear in the manner of Zurbarán or Murillo. Mary's attributes are sketched semi-naturalistically in the sky and they also appear on the ground in a realistic landscape setting. The sweetness and isolation of the Virgin are reminiscent of Murillo.

The later images of the Immaculate Conception emphasise the diversity of Valdés Leal's approach to the subject. For instance, the painting of c. 1665 (now in Seville) with the jumbled profusion of angels is unlike any he has previously painted. Different again is the Immaculate Virgin of c. 1682, formerly in the Convent of San Clemente el Real, in which the Virgin stands unusually close to the picture plane with rays shooting from the spotless mirror diagonally across the canvas onto a monstrance.

Valdés Leal shows an awareness of the work of Zurbarán and Murillo and some stylistic influence in his treatment of the Immaculate Conception. However the similarities are superficial. Valdés Leal never simplifies the iconography to the same extent as Murillo and is more inventive and less homogeneous in his approach to the composition.

—Susan Jenkins

Claudio Coello (1642–93)
Charles II Adoring the Blessed Sacrament, 1685–90
16 ft. 4⁷/₈ in. × 9 ft. 10¹/₈ in. (5 × 3 meters)
Escorial

Bibliography—

Sullivan, Edward J., "Politics and Propaganda in the Sagrada Forma," in *Art Bulletin* (New York), June 1985.

Claudio Coello painted his masterpiece of *Charles II Adoring the Blessed Sacrament* (also known as the *Sagrada Forma*) between 1685 and 1690. It was his largest canvas (5 metres high by 3 metres wide) and designed to be set in a sculpted retable in the south end of the sacristy at the royal monastery of El Escorial, where it can still be found. It is signed and dated: CLAUDIUS COELL REGIAE MAIESTAS CAROLI II CAMERARIUS PIC.FACIEBAT ANNO DNO 1690.

No documentation exists concerning the commission, but it appears that it originally went to Coello's teacher, Francisco Rizi, who was also required to design a marble altar. When Rizi died in 1685, the task was given to Coello, whose pupil, Palomino, said that he rejected Rizi's plans and began anew. Coello seems to have made careful preparations for such an important commission. For instance, a sketch was found in Coello's inventory on his death, and Palomino, again, says that Coello made separate portrait studies of individuals, some of which are in the Louvre.

It has been suggested that the prior of the monastery, Fray Francisco de los Santos, worked with Coello to design the picture. He takes a prominent position in the canvas, in front of the altar, facing Charles II. He is dressed in a chasuble and holds a monstrance containing the host. On either side of him kneel the deacon and subdeacon of the monastery, and opposite him kneel the king and members of nobility. Among the royal retinue Antonio de Toledo, the Duke of Medina Sidonia, the Duke of Pastrana, and the Duke of Medinaceli have been identified. In the middle ground is an organ which belonged to Charles V, behind which Fray Diego de Torrijos, the choir master, directs the monks and choirboys. On either side, two rows of seminarians carry 40 silver candlesticks. In the foreground in the bottom left corner stands a group of three figures who have never been identified, although it has been suggested that one represents the artist in profile, next to the mayor of Escorial.

The picture gives an accurate and detailed view of the interior of the sacristy. Three of the pictures visible on the walls have been identified as Tintoretto's *Christ Washing the Feet of the Apostles;* Titian/Giorgione's (the attribution is still disputed) *Virgin and Child Between St. Anthony and St. Roch,* and Van Dyck's attributed *Woman Taken in Adultery.* The high ceiling, frescoed by Granello and Castello, helps lend monumentality to the picture, suggesting the heavenly rather than the terrestrial sphere. The three angels of Religion, Divine Love, and Royal Majesty preside over the activity below, and four putti at the top of the canvas grapple with a red curtain and hold a banded inscription: "regalis mensa praebebit delicias regibus" ("the table of the king shall provide delights for kings"), a reference both to the altar of the Lord and the Eucharist.

The picture had various unusual features. Having replaced on the sacristy altar what was then believed to be the *Madonna della Perla* by Raphael (now attributed to Guilio Romano), it was set up on pulleys. This meant that although it provided a screen to hide the host when it was not on public view, it could be lowered twice annually for ceremonies. In addition, on the back of the picture, which faced into the camarín where the king worshipped, was painted a view of the Church with the figures of Faith, Hope, Charity, Moses, and Isaiah.

The picture is significant in a number of ways. It testifies to the strong tradition of Habsburg religious devotion and demonstrates a special interest in the Eucharist. This had been indicated, for instance, in 1628, when the *Triumph of the Eucharist* tapestry cycle had been commissioned from Rubens for the royal monastery of the Descalzas Reales. The *Sagrada Forma,* however, was particularly worthy to be venerated by the monarchy because it was in the form of a relic. It was said to have been responsible for miraculous conversions of the heretical Dutch when, trampled underfoot, it had begun to bleed. Philip II had received it at the Escorial in 1597, where it had been kept in a reliquary in the Annunciation altar of the church. Charles II was particularly devoted to the *Sagrada Forma* and saw himself, like his Habsburg predecessors, as the defender of the Catholic Faith.

The commission however, was inspired by a scandal in which a group of nobles burst into the Escorial to attack a royal favourite who was claiming sanctuary there. They were excommunicated by the monks, and to secure their pardon, Charles was bound to build a new altar at the Escorial. This was effected in 1684 when the host was transferred from the Church to the sacristy in an elaborate ceremony.

In addition, Coello's canvas is significant because it is one of the last in a line of images celebrating the secular and religious might of the Habsburgs. It is in the tradition of pictures such as Titian's *Gloria* of c. 1551–54 for Charles V or El Greco's *Allegory of the Holy League* for Philip II in 1577–79. More contemporaneous influences such as Velázquez's *Las Meninas* of 1656 or Francisco Rizi's *Auto de Fé in the Plaza Mayor* of 1683 have been suggested. But just as Coello was the last great Madrid painter of the 17th century, so his picture of *Charles II Adoring the Blessed Sacrament* seems to mark the end of Habsburg religious and secular might.

—Susan Jenkins

Adam Elsheimer (1578–1610)
The Flight into Egypt, 1609
Copper; 12¼ × 15⅛ in. (31 × 41 cm.)
Munich, Alte Pinakothek

This is probably the picture of the same title recorded in Elsheimer's Roman studio at the time of his death in December 1610. It must have been executed only shortly beforehand. Although the only example in his *oeuvre* of a moonlit landscape and also perhaps the most transcendent of his works, it brings together the various strands of his achievement since his arrival in Rome some ten years previously. It is, like all of his paintings, small and on copper, a fact which reminds one of his German origins, since painting on copper had begun in the Renaissance very much as a Northern speciality. It is both a landscape and a night scene, thereby combining the two branches of art for which he was most renowned in his lifetime, yet it also, like all of his landscapes except the celebrated *Aurora* of c. 1607 in Brunswick, makes much show of his equally landed mastery of the figure.

Landscape painting during the 16th century was mainly practised by Netherlandish and German artists, even in Italy, and they usually worked on small wooden or copper panels. Very few indeed of their pictures were entirely without human staffage and most of them illustrated religious or mythological episodes in panoramic settings which had become popular through the work of Joachim Patinir and Pieter Bruegel the Elder. But the spatial composition, with its high viewpoint, the features of the landscape (epitomised by fairytale mountains) and the colour and lighting tended to become increasingly formulaic (e.g., in the work of Paul Bril). It was Elsheimer's historical achievement to have transformed this manner into a style which was far more naturalistic—from the low viewpoint which he used to depict a small, readily assimilable trace of countryside ("prospetto di paese") to his subtle mastery of natural light effects and keen observation of natural growth.

Perhaps Elsheimer's greatest achievement in *The Flight into Egypt,* however, is the way in which he marries landscape and subject in a most poetic fashion. Elsheimer follows the brief biblical account (Matthew 2, 13–15) by showing the flight taking place at night: Joseph, having heard of Herod's intention of killing the infant Jesus, takes Mary and the Christchild off to safety in Egypt. The seating of Mary and Jesus on an ass led by Joseph had become standard (if not universal) in depictions of the story and was inspired by one of the many apocryphal accounts through which the individual details of the narrative had become greatly amplified. The shepherds lighting up a fire at the left, on the other hand, seem to have been Elsheimer's own invention—their function to add an aura of homely security with a promise of temporary refuge for the fleeing family, and also to act as one of the three sources of light in the picture. The other two are the moon and Joseph's torch. Together these three lights spread their softening, cushioning, and comforting illumination over the whole scene and assert the beneficence of nature.

The most poetic touch of all is the star-spangled deep blue vault of the sky, which includes the Milky Way and the Great Bear—although not in astronomically precise configurations. Furthermore, with a bright full moon as shown it would not be possible to see the Milky Way. Galileo's observations of the Milky Way through a telescope were published in 1610 and the event if not the book may have been known to Elsheimer. Neither should one underestimate the extent to which the increasing popularity of astronomy from Copernicus through to Kepler must have guided people's gaze with renewed fascination to the heavens.

The colour-scheme appears, as one would expect in a night scene, to be fairly monochromatic but, on close inspection, the boldly brushed trees and water can been seen to contain subtly modulated shades of green, brown, and grey which contrast expressively with the intense, magical blue of the sky and the brilliant colour chord of Joseph's red jacket and yellow sash.

The picture, which was probably taken back to Utrecht after Elsheimer's death by his friend Count Hendrik Goudt, and engraved there by him in 1613, was highly influential—mainly, one suspects, through the agency of the print, although a number of artists, including Rubens, knew the painting itself. Its evocative lunar lighting led those of the stature of Rubens, Jordaens, and Rembrandt to try and emulate its charms, while the Dutch painter Aert van der Neer found in it the inspiration for a whole new sub-genre of paintings of moonlit landscapes.

The composition, too, may be seen as prophetic, for if the tunnel of trees behind the campfire at the left is indebted to Coninxloo and the late 16th-century Frankenthal school of landscape painting, the right hand side of the picture looks forward to the tonal phase of Dutch landscape painting. The wedge of trees and their reflections symmetrically separating sky from water, as well as the muted diagonal of the water itself, bleeding out of the edge of the picture, were to become almost axiomatic in the work of Jan van Goyen and Salomon van Ruysdael.

—John Gash

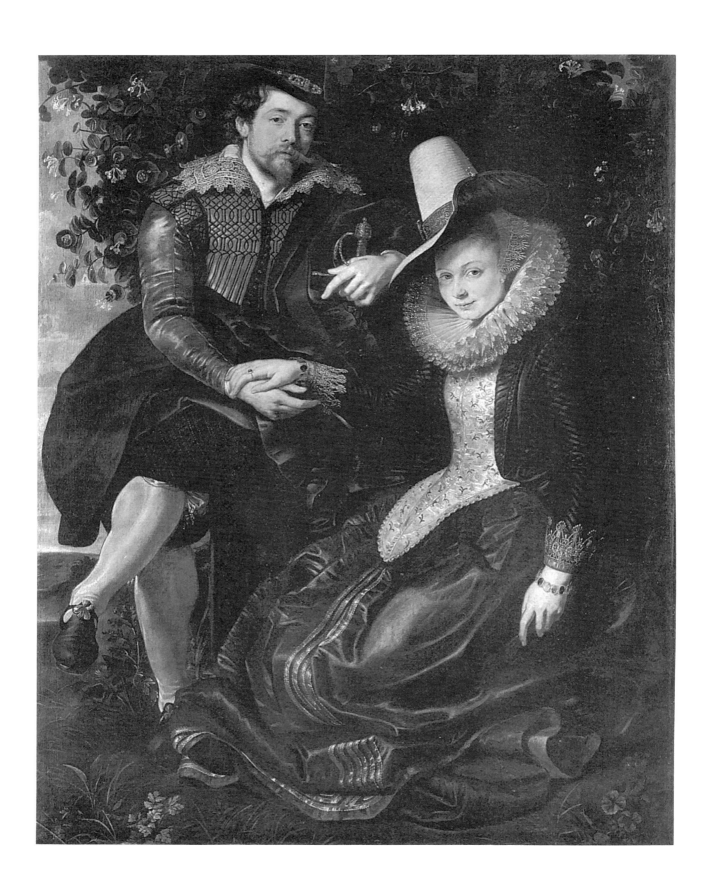

Peter Paul Rubens (157--1640)
Rubens and His Wife Isabella Brant under a Honeysuckle Bower, 1609–10
69 × 52¼ in. (174 × 132 cm.)
Munich, Alte Pinakothek

Upon the marriage of his brother Philip to Maria de Moy in the spring of 1609, Rubens wrote that "my brother has been favored by the Cupids, Juno, and all the gods: there has fallen to his lot a mistress who is beautiful, learned, gracious, wealthy, and well-born," adding pointedly that he himself would "dare not follow him, for he has made such a good choice that it seems inimitable." But within a matter of months, he likewise "dedicated himself to the service of Cupid." Peter Paul Rubens and Isabella Brant, daughter of a lawyer and city alderman Jan Brant, were married in the Abbey Church of St. Michael on 3 October 1609. His famous double portrait, painted soon after his marriage, visually dispelled any reservations he may previously have entertained.

The handsome couple are symbolically seated before a honeysuckle bower, an emblem of romantic love, as in Shakespeare's *A Midsummer Night's Dream:* "Sleep thou, and I will wind thee in my arms. . . . So doth the woodbine, the sweet honeysuckle gently entwist. . . . Oh, how I love thee!" Against this botanical backdrop Rubens adds another traditional emblem: the couple's joined right hands, the *iunctio dextrarum,* symbolic of marital harmony and concord. Rubens's conjugal masterpiece—like Rembrandt's *Jewish Bride*—inevitably calls to mind its most famous Netherlandish predecessor, Jan van Eyck's *Arnolfini Wedding Portrait* (National Gallery, London). In his baroque revision of Van Eyck's symbolic imagery, Rubens replaces a sacramental covenant with a poetic union of complements. Yet he retains a sense of medieval hierarchy. Omitting any sign of his profession, Rubens presents himself dressed to the hilt as a prosperous Antwerp gentleman, his left hand resting on a bejeweled sword. Seated on a wooden bench, he places himself a couple of feet higher than his wife who sits (presumably on a low stool or perhaps a cushion) in a pose of feminine humility, like a Renaissance *Madonna dell'umiltà.* Her gold-trimmed silks and satins elaborate upon the golden hues of the honeysuckle and the evening sun glowing through the bower. The meticulous brushwork in her delicate lace neck ruff and cuffs recalled Rubens's portrait of Marchesa Brigida Spinola-Doria (National Gallery, Washington), here translated into a more colloquial Flemish idiom of well-to-do, middle-class assurance. Legs crossed and head slightly inclined—his hat concealing his already receding hairline—Rubens leans protectively toward Isabella, whose tilted straw hat gently reciprocates. The two figures are bound in a parenthetical oval.

Throughout his happy seventeen-year marriage to Isabella, Rubens never again painted their double portrait, but a few years after completing this picture he adapted the formula in the "double portrait" of the mythological painter Pausias and his spouse Glycera (Ringling Museum, Sarasota), an allegory of the marriage of art and nature. A decade later he elevated it to Olympian heights in the Medici cycle (Louvre, Paris), where Jupiter and Juno, in a rare moment of divine conjugality, look down approvingly on the prospective bridegroom, Henry IV, their hands joined in an emblem of concord. Recollections of the early masterpiece may also be found in Rubens's poetic revival of connubial imagery following his marriage in 1630 to Helena Fourment—the *Garden of Love* (Prado, Madrid), the *Walk in the Garden* (Alte Pinakothek, Munich) and its late recapitulation in his *Self-Portrait with Helena and Peter Paul* (Metropolitan Museum, New York). In reworking the latter self-portrait—his last—he artificially added several inches to his height so that, with his hand supporting his wife's, he towered over Helena in a protective, chivalric fashion that recalls his first marriage portrait. By that time, 1639, the *Honeysuckle Bower* was listed in the inventory of his late father-in-law's estate. Was it painted for Jan Brant, with whom Rubens and Isabella lived during their first years of marriage? Or did Rubens perhaps give it to Brant after Isabella's death and his remarriage to Helena Fourment? Whatever its provenance, the fact that Rubens never copied the painting or its precise and personal formulation is a testament to its unique place within his oeuvre.

—Charles Scribner III

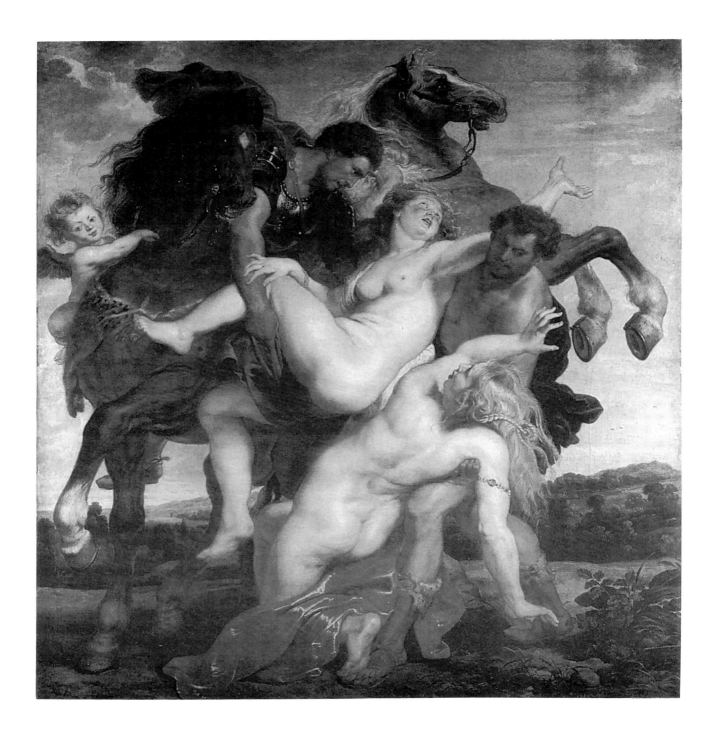

Peter Paul Rubens (1577–1640)
The Rape of the Daughters of Leucippus, c. 1618
87³/₈ × 82¹/₄ in. (222 × 209 cm.)
Munich, Alte Pinakothek

Rubens's mythologies from the decade 1610–1620 may be bracketed, or embraced, by two "rapes," those of *Ganymede* (Palais Schwarzenberg, Vienna) and of the *Daughters of Leucippus*. While the underlying meaning remained constant—divine rape as a metaphor of the soul's heavenly ascent—its formal expression underwent dramatic metamorphosis from a frontal, iconic image to a dynamic *contrapposto,* a projection onto canvas of freestanding statues with multiple views. The myth of the rape of the daughters of King Leucippus of Messene by the demigods Castor and Pollux is recorded in ancient literature (Theocritus, Hyginus, and Ovid), but appears to be unprecedented in painting. The twins, Castor and Pollux, were better known as calmers of the sea and as horse-tamers; their equestrian statues on Quirinal Hill in Rome are here recalled by Rubens's inclusion of their spirited steeds.

The unusual scene of the daughters' abduction was found on ancient sarcophagi as an allegory of the soul's salvation. Rubens's visual source of inspiration was Giambologna's famous *Rape of the Sabines* in the Piazza della Signoria in Florence. This mannerist sculpture was conceived as a tour de force, an exploitation of multiple viewpoints. Rubens in turn created with his brush a geometric coordination of opposites, like the revolving spokes of a wheel, the painter's version of a *perpetuum mobile.* The contrasting hues and textures of male and female flesh are mirrored in the juxtaposition of red and gold drapery and dark and light horses. Gravity is seemingly suspended as Hilaeira is raised heavenward, her eyes upturned like a Baroque saint in ecstasy. Her pose derives from Rubens's early *Leda* (Gemäldegalerie, Dresden), itself based on Michelangelo's *Leda,* an apt quotation since Leda—seduced by Jupiter disguised as a swan—was the mortal mother of the demigods Castor and Pollux. Phoebe's twisted pose and expansive gestures originate in the *Laocoön* (Vatican Museum), the antique touchstone for so many of Rubens's figures, both secular and sacred. The poses appear more rhetorical than reactive, for the "rape" was benign. Castor and Pollux married the princesses and were model husbands, a happy outcome Rubens conveys by the two winged cupids holding the reins. Brute passion is bridled. Lust has been reigned in by Love.

The upward sweep of gestures and rearing horse is heightened by the unusually low vantage point, with over two thirds of the backdrop given to sky. The landscape, a sensuous carpet of undulating hills and plains, is punctuated by deep foliage and shadows, nature's reflection of the central subject and a harmonization of opposites that recalls Rubens's *Landscape with Carters* (Hermitage, Leningrad). Even the horizon line gently rises from the left. No painting of this period invites closer analysis. From the perfectly choreographed feet of Pollux and Phoebe—his toes precisely intervening between hers and the ground—to the multiple parallel gestures, the implied sensation is closer to an ecstatic dance than a violent abduction. Even its immediate predecessor, *Boreas Abducting Orithyia* (Academy, Vienna) appears comparatively chilling, as befits a bracing abduction by the god of the North Wind. In the *Daughters of Leucippus* warm colors and golden hues illuminate Rubens's classic, Mediterranean vision.

The origins of the painting are unknown; its primary meaning remains speculative. Is it, like the *Ganymede,* an allegory of salvation, of the soul's transport, in keeping with its iconographic derivation from sarcophagi? Or, based on Rubens's knowledge of its literary sources, is it an allegory of marriage and conjugal harmony? Or perhaps even a political allegory, as has more recently been proposed? The solution, if indeed there is but one, must encompass the internal evidence: the pervasive themes of conflict and consummation, discord and harmony, abduction and elevation. The key, perhaps, is offered by the cupid holding the rein who alone looks out of the picture towards the viewer and insures the reconciliation of heavenly and earthly love.

—Charles Scribner III

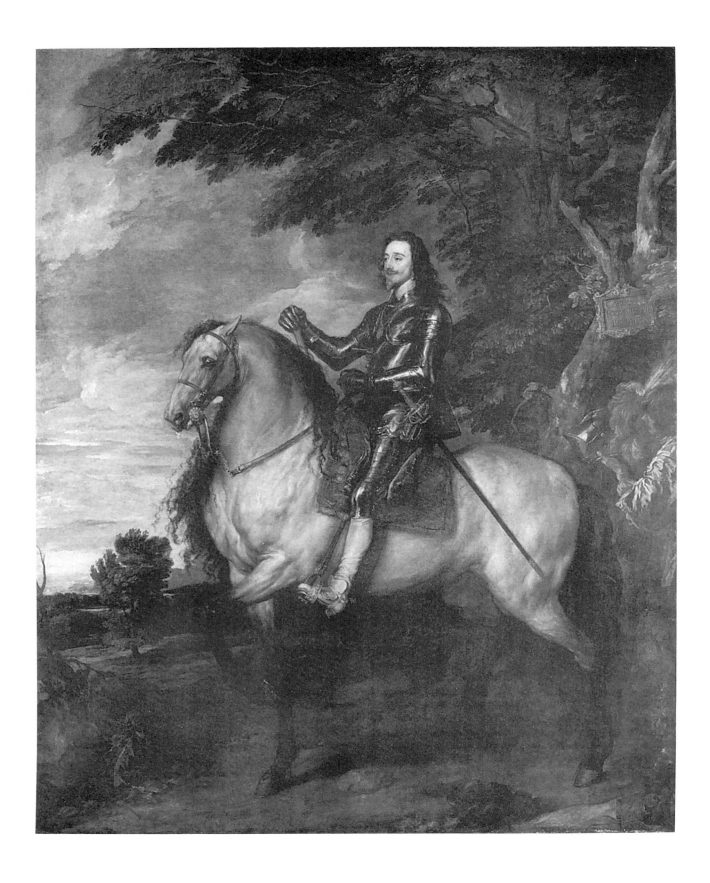

Anthony van Dyck (1599–1641)
Charles I on Horseback, c. 1636
12 ft. 2 in. × 9 ft. 8 in. (367 × 292 cm.)
London, National Gallery

Bibliography—

Strong, Roy, *Van Dyck: Charles I on Horseback,* London, 1973.

Moffitt, John F., *"Le Roi à la ciasse?*: Kings, Christian Knights, and Van Dyck's Singular *Dismounted Equestrian-Portrait* of Charles I," in *Artibus et Historiae* (Florence), 4, 1983.

The National Gallery's equestrian-portrait of King Charles I is recognized to be one of the finest of all absolutist-royal icons. The bareheaded King, wearing light armor (designed for ceremonial tilting rather than warfare) and carrying a sheathed sword at his waist, is mounted upon a large and alert light-bay horse with raised foreleg. Behind the regal rider, an equerry in red livery respectfully leans forward, tendering to his royal master his scarlet plumed helmet. The physical setting is a lush grove of royal oaks, from which the king appears to have emerged with majestic nonchalence onto a downward sloping greensward. The ambient light is of an opalescent amber tonality, suggestive of a golden dawning, towards which Charles directs his pensive glance. The rider's compass-orientation is indicated by the cast-shadows, in which case we are looking to the south. Tied to the branch of the tree behind the King is a tablet, inscribed in Latin: "CAROLVS I REX MAGNAE BRITANIAE." As is recognized, the equestrian-portrait retrospectively celebrates the moment (20 October 1604) on which Charles's father, James VI of Scotland, proclaimed himself King of a united, Greater Britain; thus, as may be further assumed on the basis of the son's majestic southerly movement from the dark wood, Charles I regally rides on his metaphorical mission of unification, from Scotland into England.

This painting superbly documents one of the most intimate of all court-painter-king relationships in the history of art, between King Charles I and Anthony Van Dyck, the artist who was to create a new canon of aristocratic portraiture, lasting in England until the times of John Singer Sargent. With suave and naturalistic works like this, Van Dyck decisively broke with the reigning canons of abstract and icon-like portraiture made traditional by Tudor and Jacobean artists. In Van Dyck's greatest portraits, the painter began with a quasi-religious assumption (now foreign to us) that the sitter was made in God's image and thus represents a microcosm of divinity. Allied to this conviction was a typically baroque integration of social position and individual character, a worldly and spiritual function that psychologically distinguishes Van Dyck's portraits and makes them an epitome of the ideals of his age.

Although the princely sitter was to die on the executioner's block scarcely ten years later, this magnificent canvas was painted during the most secure years of king's long reign. Thus, notwithstanding that often noted general air of elegant and pensive melancholy about the sitter, a trait in fact common to all the other royal portraits, this psychological factor should better be considered a hallmark of Van Dyck's conventionalized image of regal care and travail in the service of the com-

monweal. In the equestrian-portrait of Charles I we are confronted with a quasi-liturgical icon of the absolutist ruler, whose authority has divine precedent. Charles, wearing a gold medallion, is depicted as Knight of the Garter, much as he was verbally depicted by John Denham: "In whose Heroic face I see [George] the Saint, / Better expressed than in the liveliest paint, / That fortitude which made him famous here, / That heavenly piety, which Saints him there"

Denham's verse, as much as Van Dyck's portrait, indicates that this royal rider saw himself as both a *miles christianus,* or "Christian Knight," and as *defensor fides,* and the "defender of the faith" motto has since appeared on all royal coinage. This observation in turn points to Van Dyck's iconographical model, Dürer's celebrated engraving of 1513 popularly known as *Knight, Death, and the Devil.* Nevertheless, this print (doubtlessly known to Van Dyck) was actually called by Dürer just "The Rider" (*Der Reuter*), and is now recognized to represent the archetypical Christian Knight. Both Van Dyck's royal equestrian and its prototype share common scriptural motifs, namely "the armour of God," the "breastplate of rightousness," the "sword of the Spirit," and the "helmet of Salvation." Additionally, both Van Dyck and Dürer concur in the following compositional details: the movement of the horse from right to left, its distinctive gait, the direction faced by the rider (like Christ, into the rising sun), the symbolic dark wood, from which the *miles christianus* spiritually emerges with triumphant, measured pace, and so forth.

For all that has been written on these Caroline equestrian representations (including a famous cognate in the Louvre, Van Dyck's *Le Roi à la ciasse*), there has been a significant lacuna in the scholarly literature: the meaning of ANY equestrian-portrait of a baroque prince. In this case, it is the horse (rather than the rider) which explains the larger political significance, the metaphorical common ground of most 17th-century equestrian-portraiture of absolutists rulers by divine right. When we turn to a typical encyclopedia of contemporary symbolism, such as Valeriano's *Hieroglyphica* (1556), it is found that a bridled horse, like the mount of Charles I, stands for "a hieroglyph of an invincible courage, but one tamed by superior reason," that is of the regal rider. "Likewise," states this authority, "it is necessary to lead unbridled men (to use a figure of speech) towards reason and to correct doctrine. Similarly, the horse is a courageous and sly animal; he is one who will, nevertheless, be eventually brought to obeissance." The idea of the stern, princely rider firmly grasping the metaphorical reigns of government, the horse symbolizing the recalcitrant body politic, was a commonplace in baroque thinking. And that is the ultimate meaning of Van Dyck's magnificent portrait of *Charles I on Horseback,* an imperial icon of absolutist rule, just as are all the other baroque images of mounted rulers magisterially taming their impetuous mounts and directing them by superior reason towards new spiritual horizons and ever-increasing physical conquests.

—John F. Moffitt

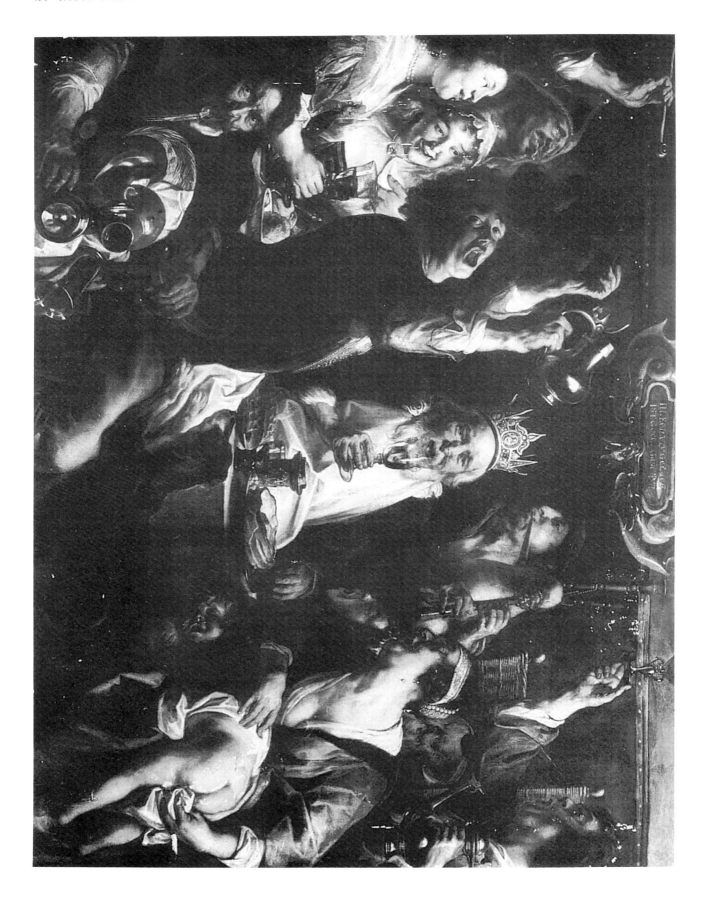

Jacob Jordaens (1593–1678)
The King Drinks
5 ft. 1³/₈ in. × 6 ft. 10⁵/₈ in. (156 × 210 cm.)
Brussels, Musées Royaux des Beaux-Arts

The feast of Epiphany, or Twelfth Night, marked the arrival of the Magi in Bethlehem and was an old Catholic Feast that had existed for a long time in Flanders. It was celebrated in the company of family and friends on the sixth of January. Each family chose a "king" either by drawing lots, or by means of a bean or silver coin baked in a cake. The person whose portion held the bean was declared king. Other roles, such as queen, counselor, jester, cupbearer, musician, singer, carver, physician, or page, were assigned by lot or by "decree." The person who was selected king donned a paper crown, presided at the table, and gave orders. When the king picked up his cup, the court was obliged to follow, crying: "the king drinks!"

A large and impressive painting in the Louvre from c. 1638–40 is one of many versions of the Twelfth Night celebration that Jordaens executed during the 1630's through the 1650's in paintings, drawings, and prints. It follows his earliest known picture which is in Kassel (the major section dates from the 1630's; a strip was added at the left c. 1650–60). Subsequent pictures are today in Brussels, Vienna, Munich, and Leningrad. No specific patron for any of the paintings are known. The Flemish bourgeoisie, however, must have appreciated the subject given the frequency with which Jordaens executed the theme.

In the Brussels representation family members are grouped around the table eating, drinking, and singing, a compositional arrangement that Jordaens favored for each depiction of the subject. The king is the oldest person, and the moment illustrated is that when the king raises his glass and the whole company shouts gleefully, "the king drinks."

Jordaens's appreciation of the family character of the celebration is clearly evident since he relied on likenesses of members of his immediate family and relations to heighten the immediacy and ultimately the realism of the event. In the Louvre representation the hale and hearty grandfather on the left is a portrait of Adam van Noort, his father-in-law, whose features were always used for the old king in the Twelfth Night pictures. His portrait appears a second time as the old man seated to the king's left. Facing the viewer is Jordaens's wife Catharina. Next to her is Jordaens's daughter Anna Catharina, aged about ten. On the rear side of the table is Elizabeth Jordaens, aged about 21, while the boy pouring wine is probably modeled on Jacob Jordaens, Jr., about 14 at this time.

The spirit of the celebration is vividly captured through Jordaens's animated grouping of the figures around the well-laid table and the exuberant facial expressions. The old woman and young man at the far right bellow from the depths of their lungs, while Jordaens's children maintain alertness so as not to miss a moment of the action. Faces, hands, and draperies are softly illuminated while patterns of light and shade move gently across the surface and unify the design. Warm colors balance the composition and reinforce the familial nature of the celebration.

The King Drinks in Brussels is more crowded and noisier than the Louvre painting. Merrymaking has turned into a brawl. Some members of the family behave in an indecorous fashion, especially the physician in the lower right corner who releases the contents of his bloated stomach. Adam van Noort, bathed in full light, sits regally as the king in the seat of honor at the head of the table, with the rest of the family grouped around him. Here Jordaens has approached the event as a burlesque, characterized by raucousness and lively states of inebriation. Versions in Munich and Leningrad are likewise scenes of turbulence and unbridled gaiety.

Large family portraits in Leningrad, Kassel, and Madrid painted by Jordaens early in his career provided the foundation for his exploration of the nature of family groups within a genre context. Paintings like *The King Drinks, Satyr and Peasant,* or *As the Old Sing, So Pipe the Young,* represent a continuation of his interest in portraying family gatherings.

Jordaens does not necessarily condone such excess, particularly since the motto "Nothing is more like a madman than a drunkard" is inscribed on another Vienna picture, which was transferred there in 1656 with the collection of Archduke Leopold William. The same inscription also appears on a print bearing a second inscription: "Do not challenge good men in their cups, for wine has put an end to many a man." Such proverbial phrases reflect the contemporary penchant for moralizing in the Netherlands, and reveal Jordaens's own didactic inclination for representing proverbs and inscribing verses on paintings, drawings, and tapestries. His genre scenes are frequently layered with various references to moralizing ideas, but in the Twelfth Night paintings it was of equal if not more concern to create, using the family as the leitmotif, an atmosphere of good-hearted merriment and joyous festivity on a happy occasion.

In this series of paintings Jordaens portrays the Flemish passion for eating, drinking, and feasting with a frank liveliness, all presented in the spirit of good fun. This particular theme afforded him the opportunity to paint the Flemish bourgeoisie, their reunions, and their spirited mealtimes. These were the citizens of the comfortable class, the people Jordaens knew best and those he had observed intimately in their many facets of life. Taking everyday life as his subject matter, he does not flatter his models, but appreciates in them their robustness, their laughter, and their freedom from restraint. In sum he creates an epic scene of Flemish conviviality and festivity.

—Kristi Nelson

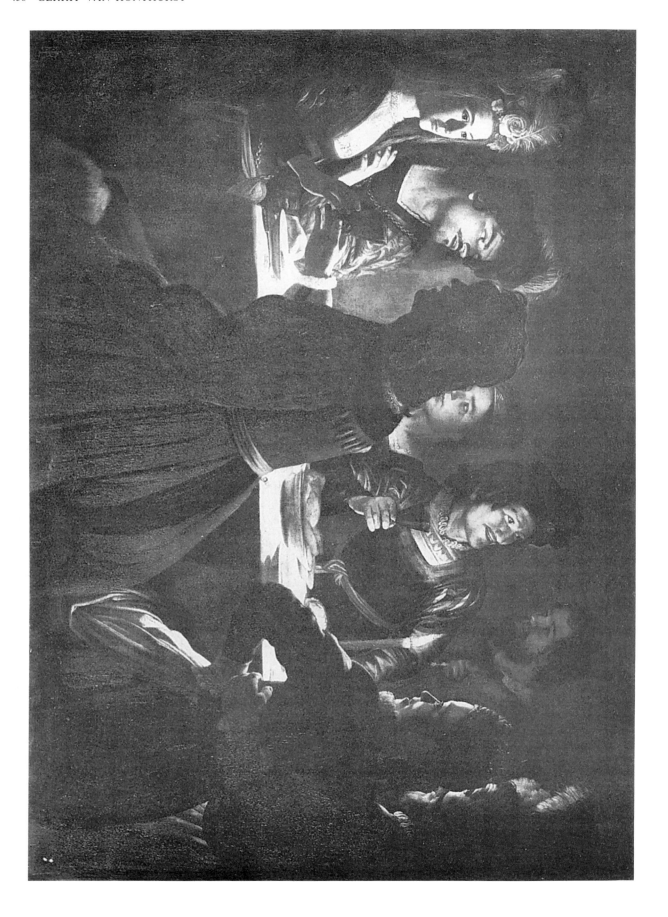

Gerrit van Honthorst (1590–1656)
The Supper Party, late 1610's
54⁷/₈ × 83¹/₂ in. (142 × 212 cm.)
Florence, Uffizi

Honthorst may have arrived in Italy as early as 1610–12, and by the time of his return home to Utrecht in 1620 he had become one of the leading exponents of Caravaggism in Rome. *The Supper Party* was painted towards the end of his Roman sojourn and is probably a picture referred to by Giulio Mancini in a manuscript of c. 1619–25: "recently for the Grande Duke of Tuscany (Cosimo II) a Supper of buffooneries lit from two artificial lights which, with certain reflections and shimmerings, with the complication of the light, shows much art. . . ." It may well have been one of six pictures by Honthorst which Cosimo was in the process of buying through his ambassador in Rome in the Autumn of 1620. It was given (together with two other pictures by Honthorst, a *Fortuneteller* and a *Wedding Supper,* and two by Bartolemeo Manfredi, a *Concert Party* and a *Cardsharps*—all today in the Uffizi) by Ferdinando II of Tuscany as a New Year's present to his mother, Maria Maddalena of Austria, in 1625–26, and the group of pictures was subsequently kept in the Medici villa of Poggio Imperiale. We do not know whether they were originally intended as a set, but they make a fine miscellany of festivity and recreation.

"Merry Company" scenes had existed in Netherlandish art of the 16th century (from Lucas van Leyden to Cornelis van Haarlem) but Honthorst utterly transformed the genre in response to recent developments in Italy. Caravaggio had produced a small number of picturesque yet highly realistic genre scenes with three-quarter-length figures (e.g., *Cardsharps* and two versions of a *Fortuneteller*) which precipitated a new fashion for "low life" subjects and fired the imaginations of many young artists, including Honthorst. These Caravaggios, however, contained few figures, and *The Supper Party* is more closely indebted to some of the multi-figure secular compositions by one of Caravaggio's most original Italian disciples, Manfredi (e.g., his Uffizi *Concert Party* and *Cardsharps* and the *Gathering of Drinkers* currently on loan to the Los Angeles County Museum of Art). Although Manfredi also painted religious pictures, the "Manfredi manner" for which he became famous towards the end of the second decade of the 17th century is best typified by these picturesque secular subjects, which were especially influential on north European artists in Rome (Valentin, Tournier, Régnier, Honthorst himself).

Yet if *The Supper Party*'s assorted entourage of seated and standing figures grouped around a central table is decidedly Manfredian, Honthorst has also been directly inspired by Caravaggio. For his picture has equally marked compositional affinities with one of Caravaggio's religiuos pictures, *The Supper at Emmaus* (Milan). If one excludes the two women at the left of the Honthorst, the grouping of figures is essentially the same as in the Milan picture.

The colour scheme of rich reds and mellow browns, so typical of the Italian-period Honthorst, also harks back to Caravaggio's mature religious art (as distinct from his early, lighter coloured genre pieces). And yet it is, paradoxically, in the lighting that Honthorst at the same time departs most decisively from the example of both Caravaggio and Manfredi since, as Mancini noted, he used internal light sources. Artifical illumination was far more characteristic of northern European than Italian art (although the Bassani practised it in Venice) and Honthorst would have become familiar with such systems during his training under Abraham Bloemart in Utrecht. But night scenes were very much the speciality of the German miniaturist Adam Elsheimer, who worked in Rome in the first decade of the 17th century, and Honthorst's gravitation in this direction might well owe a good deal to his example. By 1620 Honthorst had so far assumed Elsheimer's mantle in this field that he was known as "Gerard of the Nights." The majority of his pictures in these Italian years were nocturnal religious scenes.

The light sources in *The Supper Party* consist of a concealed and a visible candle. The former is hidden behind the male drinker nearest the viewer, casting him into a bold silhouette and revealing the faces behind with varying degrees of intensity. It also casts beautiful reflections on the metal candleholder. The other candle has been removed from the holder by the standing young woman, who thereby opens up a second centre of interest and action to our gaze. As she holds the candle in her left hand she loads a pancake (?) into the gaping jaws of the compliant toper, watched by an indulgently smiling old maidservant. Once again, the light falls with differing intensity on the surrounding faces and objects, producing a marked effect not only of realism but of atmosphere and excitement.

The Uffizi picture is Honthorst's first recorded example of the kind, and marks the start of a lifelong exploration of hedonistic subjects. The precise significance of the subject matter in the present case, however, is difficult to determine. For while the dress, innuendo, and old procuress-type of figure would suggest a scene of high-class prostitution, we could be dealing with a less venal kind of aristocratic party—possible intended to commemorate a specific occasion. As with some earlier Italian depictions of aristocratic leisure by Nicolò dell'Abate on the walls of the Palazzo Poggi, Bologna (pre-1550), it is impossible to make a categorical distinction between ladies of the court and courtesans.

—John Gash

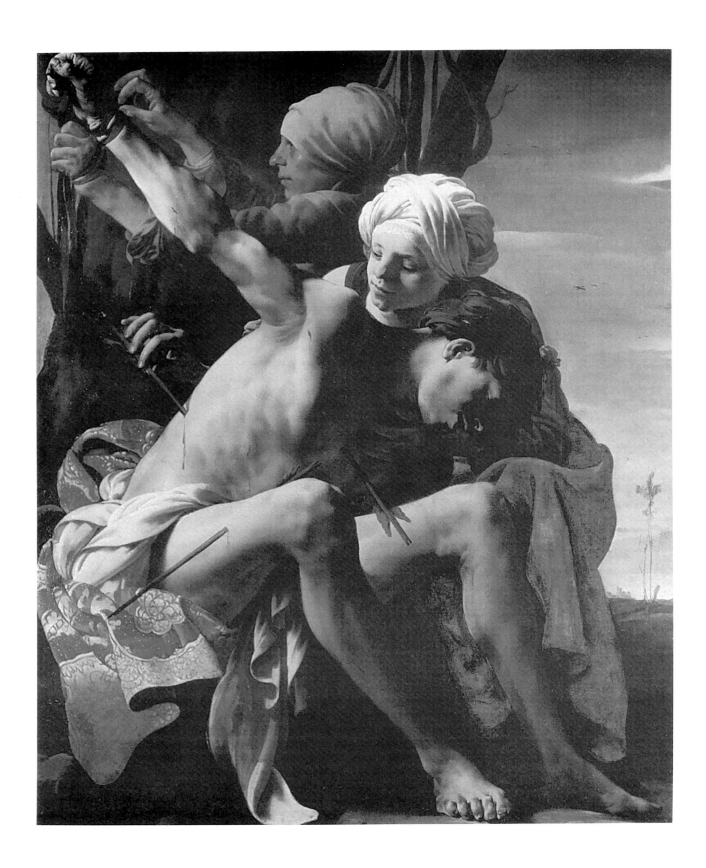

Hendrick Terbrugghen (1588–1629)
St. Sebastian Tended by St. Irene, 1625
59 × 47 in. (150.2 × 120 cm.); original dimensions 63 × 50
 in. (162 × 127 cm.)
Oberlin, Ohio, Oberlin College

Bibliography—

Stechow, Wolfgang, "Terbrugghen's *St. Sebastian*," in *Burlington Magazine* (London), 96, 1954.

Terbrugghen's *St. Sebastian* is one of his most beautifully contrived and evocative pictures. It bears witness both to his empathy for the art of Caravaggio and to a highly distinctive pictorial vision rooted in North European experience.

Sebastian was, by tradition, an officer of the Praetorian Guard in the reign of the legendary persecutor of Christians Diocletian (Emperor, 284–305). When Sebastian's Christian allegiance was discovered he was ordered to be shot with arrows, but these failed to pierce any of his vital organs and he was nursed back to health, according to the 13th-century *Golden Legend,* by a widow called Irene. As often in the literature of martyrdom, this divinely thwarted first attempt provided the victim with an opportunity to demonstrate his persistence in the Christian faith, and, after reasserting that faith before Diocletian, Sebastian was beaten to death with clubs and thrown into the Cloaca Maxima, Rome's main sewer.

The subject of a standing St. Sebastian tied to a tree or column, his body punctuated with arrows, was popular during the Renaissance and Baroque periods, perhaps because it provided the opportunity for depicting an elegantly posed male nude. But the episode of the saint being taken down or subsequently tended by Irene and her female helper(s) only became common in the 17th century—most especially in Northern Europe from the 1620's onwards. A full explanation for this vogue has still to be found, but it was probably triggered off by a relatively recent publication, Cesare Baronio's *Annales Ecclesiastici* (1586), which contains a far more detailed account of the life of St. Irene than the brief reference to her in the life of St. Sebastian in the *Golden Legend.* The episode may also have become popular because of the growing emphasis placed upon female sanctity by the actively proselytizing Counter-Reformation church. Furthermore, although we know nothing of the circumstances surrounding the commission of Terbrugghen's picture, this subject may owe its appeal in the 17th-century Netherlands to two other factors: Sebastian was often invoked as protection against the plague (a continuing threat), while he was also the patron saint of the Companies of Archers which flourished in the Dutch cities.

The subject of St. Sebastian (not always with the holy women) was popular in Utrecht in the early 1620's (Honthorst, London, without the women but in a comparable pose to Terbrugghen's figure; Bijlert, Rohrau, Graf Harrach Collection; and an undated picture by Terbrugghen's friend, Baburen, in Hamburg). All three of these works seem to have provided Terbrugghen with ideas for poses and details, so much so that one wonders whether they may not all have been submissions for the same commission. Terbrugghen may also have been inspired by Dürer's *Job* from the Jabach altarpiece, and his picture is certainly the most accomplished and poignant of the Dutch versions, only rivalled by the Lorraine artist

Georges de La Tour's masterly but more detached rendering of the late 1640's (Louvre).

Terbrugghen's northern-looking, ectomorphic St. Sebastian is, despite his good looks, rendered with due, almost polemic, regard for realistic detail: the gnarled toes, the distinctive, irregular contours of legs and knees, the bulging muscles and veins of the right arm. The precise actions of the two women absorbed in the tricky practicalities of their task also underpin the realistic aesthetic. But it is a realism which heightens eloquently expressive details (such as hands, faces, and feet) through careful formal arrangement. As with Caravaggio himself and, among his disciples only perhaps to the same extent La Tour, Terbrugghen imposes an expressive geometry on the raw material of the human body.

The geometry, which functions on different levels, begins as a compositional armature around which the figures are woven. The picture field is divided diagonally from top left to bottom right into two triangles whose common base is formed by a line running, roughly, through Sebastian's right arm and lower left leg, his slumped posture nicely evoked by the clever transition of this axis from the right to the left side of his body. The axis is reinforced, and ingeniously wedded to the drama, by the descending triad of heads which runs along its upper side, the two contrasting profiles flanking the three-quarter view of Irene's face. Indeed, a triadic principle informs the whole composition: note the three arrows, all of them geared to establishing lines of directionality, and the way in which Sebastian's right arm is eloquently framed by those of the maidservant.

Such formal manipulations, together with the expressive disposition of light and shade (chiaroscuro), derived ultimately from Caravaggio but here made more lyrical, effectively establish both mood and drama. All calculations are geared towards conveying the underlying contrast between the tension of the upper half of the picture and the way in which this is transformed, through the calm effort of the women, into relief for the rescued Sebastian in the lower half—a relief, redolent of gratitude, that is registered on his face and enshrined in the limp inertia of his left leg.

The colour scheme is muted but with characteristically strong accents. The grey sky turns to golden as it descends to the twilit horizon, and is comparable to, though deeper than, the illumined flesh tones of the principal figures. Sebastian himself, however, is emphasized by the bold colours which surround him: the ornate red and gold brocade upon which he sits, the olive green of Irene's bodice, and by what must at one time have been the red of her cloak—although now only a few traces remain. Two other technical features typical of Terbrugghen are evident: Irene's turban is tinged with pink, a device which the artist frequently used to indicate strong light falling on white material; and long, thin highlights applied to fingers, noses, and toes give them a peculiar sheen reminiscent of glazed pottery.

—John Gash

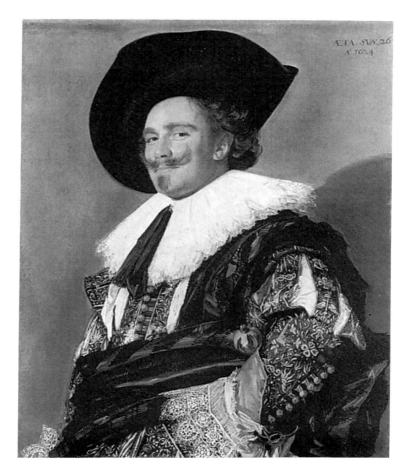

Frans Hals (c. 1580–1666)
The Laughing Cavalier, 1624
33 × 26¼ in. (83.8 × 66.6 cm.)
London, Wallace Collection

The unnamed, 26-year-old sitter in Frans Hals's *The Laughing Cavalier* is a kind of dandy who was apparently not uncommon in early 17th-century Holland. Among other places we can find his like among the young ensigns in the artist's militia-company portraits. They, too, adopt elegant poses, wear slashed sleeves, elaborate lace, and flashy colors, and some of them have upturned mustaches. As cavaliers, real or aspiring, they pattern themselves after the fashions and the courtly mode of behavior of an imported, aristocratic *beau monde*. As such, they stand for a romantic ideal that had its roots in medieval chivalry and was associated with both valour—note the Cavalier's sword—and with love. Hals's sitter literally wears this last association on his sleeve in the form of embroidered emblematic motifs. In addition to Mercury's cap and wand, which are symbols of fortune, there are bees, winged arrows, lovers' knots, and flaming cornucopias, all tokens of love.

For the Renaissance and the 17th century, love was a highly refined passion, closely tied to courtly values and as much a matter of art as of feeling. The artfulness of love is implicit in the stylishness and the wit of contemporary love poetry. Against this background it becomes clear that the aesthetic sophistication of *The Laughing Cavalier* is closely tied to its meanings and values. Thus, the same red and gold embroidery that bears these complex iconographic messages is also formally quite striking. These bright colors mix with the blacks and grays of the man's sash and jacket and with the silvery tonalities of the picture's light effects to create an exquisite sense of artifice.

More than most of Hals's subjects, this young man makes us acutely aware that he is playing a role: that his image is, in effect, an invention. The idea that the self is—or should be—a work of art is, in fact, a basic feature of Renaissance thought, especially in the courtly circles with which the Cavalier associates himself. It grows out of a sense of life as a social theatre, in which one acts out one's character before an audience. At the same time, this notion lends itself to a protean conception of the self, readily recognizable in Shakespeare's Hamlet. Hals's sitter also seems to have this quality to some degree and, with it, a sense of irony. It is commonplace to remark that the Cavalier is not laughing, but his humor is nonetheless evident in a subtle, suppressed smile that can only be called ironic. And the source of his irony is manifest in the structure of his pose, whereby he thrusts out his glittering elbow, with all its artful and emblematic courtly associations, even as he himself remains aloof, slipping away, as it were, along the retreating arc of his hat. In the very act of disguising his inner self behind his artful veneer, he reveals his inner resources of wit and self-mastery.

—David R. Smith

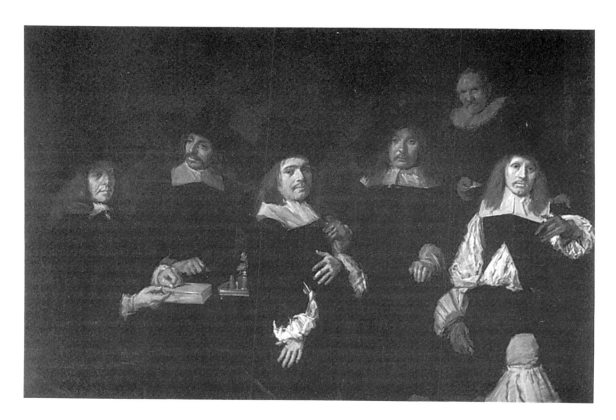

Frans Hals (c. 1580–1666)
The Regents of the Old Men's Home, 1664
5 ft. 8 in. × 8 ft. 4³/₄ in. (172.7 × 255.8 cm.)
Haarlem, Hals Museum

Bibliography—

Jongh, E. de, and P. J. Vinken, "De boosaardigheid van Hals'
regenten en regentessen," in *Oud Holland* (The Hague), 78,
1963.

The Regents of the Old Men's Home is one of the master-pieces of Frans Hals's late style. But in recent years discussions of its vivid characterizations and remarkably free brushwork have been eclipsed by other questions. Attention has turned instead to debunking the legend, which is apparently no older than the later 19th century, that the painting and its pendant of the regents' female counterparts are scathing satires on the subjects' unsavory characters. Close inspection reveals, for example, that the dazed expression of the second regent from the right was actually caused by a neurological disorder. And the angle at which he wears his hat is the fashion of the day, not a sign of inebriation. Despite claims to the contrary, moreover, Hals was never an inmate at the Old Men's Home, and thus he could not have had the bitter experiences that supposedly inspired his attack.

There are legends of this sort about many great paintings, and given the way such stories distort perceptions and trivialize meanings, it is always important to correct the record. But in the case of Hals's group portrait, clarification has tended to have a reductive effect on our understanding. For many scholars and critics, the alternative has been to see the painting as a simple reprise of a conventional portrait formula, under-standable entirely in terms of the conventions themselves.

It seems wiser to suggest that the picture's legend, no matter how mistaken, grew out of genuinely problematic aspects of the work itself. Its darkness, for example, seems to create a brooding, expressionistic mood, especially when coupled with Hals's loose brushwork. This is partly just the result of natural aging, for the paint has darkened in 300 years. But the figures also make an ambivalent impression, and precisely at the point where they touch on conventional forms. Hals has, in fact, used a surprisingly old-fashioned portrait type, whereby the sitters rhetorically present themselves to their audience. In his previous regent piece, of 1641, he had used a livelier, more narrational approach, which was becoming common practice in the genre. Having chosen such a conservative form here, however, the artist then cancels the clarity of presentation that rhetoric demands. As one scholar has noted, the sitters in this kind of portrait ordinarily engage in active, explicit gestures, which allude to their charitable duties. Here, the hands are pointedly inexpressive. Only the regent with the cocked hat makes a rhetorical gesture, and its effect is almost entirely lost because the man in the center blocks our view. At the same time, the one man whose gestures could be called expansive wears gloves, which were a symbol of aloofness and withdrawal in the 17th century. This is the dandy with the slashed sleeves and the red stocking on the far right, who looks away with a distracted expression, evidently isolating himself from this inherently public occasion.

These ambiguities and disjunctures do not necessarily imply a criticism of the regents themselves. But they do suggest that Hals recognized a social and psychological complexity in this group that is virtually unprecedented in Dutch group portraiture.

—David R. Smith

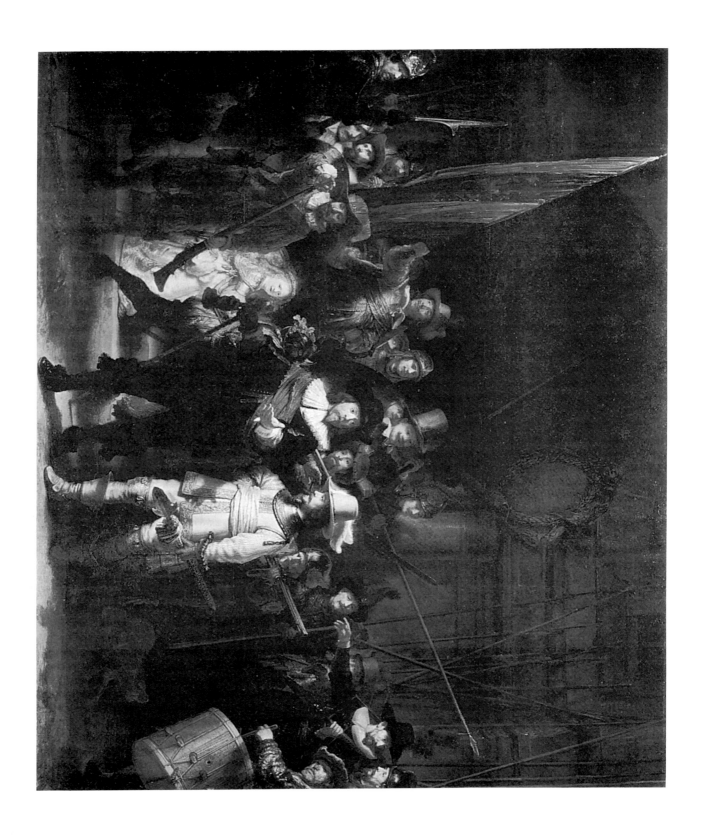

Rembrandt (1606–69)
The Night Watch, 1640–42
11 ft. 9³/₈ in. × 14 ft. 4¹/₂ in. (359.1 × 428 cm.)
Amsterdam, Rijksmuseum

Bibliography—

Kuiper, L., and W. Herterman, "Report on the Restoration of
 Rembrandt's *Night Watch,*" in *Bulletin van het Rijksmuseum*
 (Amsterdam), 24, 1976.
Hijmans, Willem, et al., *Rembrandt's Nightwatch: The His-*
 tory of a Painting, Alphen aan den Rijn, 1978.
Haverkamp-Begemann, E., *Rembrandt's "The Nightwatch,"*
 Princeton, 1982.

In *The Night Watch,* the great Dutch 17th-century painter,
Rembrandt Harmensz. van Rijn, created a unique depiction of
active motion in progress in a commissioned group portrait.
Inscribed with Rembrandt's signature and the date 1642, the
picture was painted between December 1640 and the middle of
1642 (the year in which his wife, Saskia, died).

The often-repeated legend that this painting was a failure
and led to the artist's financial ruin and professional isolation
has no basis in fact. There is no evidence of discontent on the
part of the men who paid for their portraits on a sliding scale
depending on the prominence of their placement. The picture
was praised in published writings not long after it was painted
and many times thereafter, occasionally with mild criticism on
specific points. Samuel van Hoogstraten (1678), for instance,
wrote that he would have liked it to be lighter, but: "It will
outlive all its rivals, being so original, artistic, and forceful
that others look like playing cards."

This is not a night scene. The title, *The Night Watch,* was
first used toward the end of the 18th century, perhaps because
at that time the sole function of the Civic Guards was night
patrol. The most informative title for it would be *The Officers
and Men of the Militia Company of Captain Frans Banning
Cocq and Lieutenant Wilhelm van Ruytenburgh.* Eighteen
names are inscribed on the cartouche (a later addition) on the
right side of the archway. Eighteen of the twenty-nine figures
in the painting were portraits; two of them were removed when
the painting was cut down on all four sides in about 1715 to fit

a space in the Town Hall to which it was moved at that time
from the headquarters of the Civic Guard company, the Klove-
niersdoelen, for whose new building, completed in 1636, it
had been commissioned.

Three of the men are shown handling their weapons in poses
derived from the illustrations by Jacques de Gheyn II in a
Manual of Arms published in 1608. They show the three suc-
cessive stages in shooting a musket. In addition to the central
figures of the Captain and his Lieutenant, whose dominant
positions and active roles are emphasized, and the members of
the Company who are ranged behind them, there are a number
of undefined and unidentifiable figures who contribute to the
sense of mass movement; the Company actually had two hun-
dred members. There are also some figures heading in another
direction from that in which the members of the Guard are
moving, and these have given rise to considerable speculation.
They are most probably allegorical figures. The most visible
of them, a girl dressed in a gleaming, golden costume, whose
facial features resemble those of Saskia, and another girl
mostly hidden behind her, have been identified as allegorical
Emblem Bearers, in keeping with an old tradition. They wear
the colors of the Company, blue and gold, and the claw of the
fowl hanging from the belt of the golden girl refers to the
emblem of the Kloveniers.

The composition makes clear the distinction between the
aristocratic and politically ambitious officers and the members
of the Company, who belonged to the upper middle class. At
the same time, it is a statement of the pride they all shared in
the traditional role of the citizens' militia in defending Amster-
dam in its determination to maintain independence from the
House of Orange, as well as their readiness to fight for the
Dutch Republic in case of any attack by foreign foes. At the
time of this painting, however, the activities of the Civic Guard
were largely social and ceremonial.

—Madlyn Millner Kahr

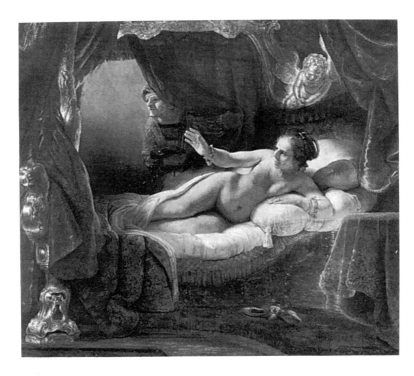

Rembrandt (1606–69)
Danaë, 1636
6 ft. ⁷/₈ in. × 6 ft 7⁷/₈ in. (185 × 202.8 cm.)
Leningrad, Hermitage

Bibliography—

Kahr, Madlyn Millner, "Danaë," in *Art Bulletin* (New York), 60, 1978.

Rembrandt's painting of *Danaë,* which is signed and dated 1636, is a rare subject for him. He painted few nudes; indeed, female nudes were not common in Dutch 17th-century painting in general. And there are only eleven extant mythological paintings by Rembrandt, all of which were produced between 1630 and 1636. In the case of the *Danaë,* however, it is clear on both stylistic and technical grounds that the artist repainted the figures of Danaë and the old woman who pushes back the bedcurtains behind her, probably toward the end of the 1640's. Though the brushwork in this central area of the picture is in his later, freer style, the composition retains the Baroque qualities that typified his art of the 1630's, and the details are dealt with in his explicit style of that period.

A number of different interpretations have been proposed for this painting, but in fact it fits neatly into a well-established tradition of depictions of Danaë in paintings and prints by 16th- and 17th-century masters, including Correggio, Primaticcio, and Titian. Rembrandt's painting reflects elements from a number of these earlier representations, but, as in many other cases, he shows here his marvelous ability to transform what he inherited. He presents Danaë as a woman capable of both giving and accepting love, a freely consenting sexual partner.

Apollodorus wrote the earliest version of Danaë's story known to us, probably around the middle of the 1st century B.C. Her father, Acrisius, King of Argos, Apollodorus re-

lates, was warned by the oracle that his daughter would give birth to a son who would kill him. To prevent this, Acrisius had this daughter imprisoned in a brazen chamber. But Zeus had intercourse with her in the form of a stream of gold which poured through the roof into Danaë's lap, and Danaë gave birth to Perseus. Numerous later writers, both pagan and Christian, wrote versions of this myth, usually with moralizing intentions, and Danaë became a symbol of modesty and chastity.

By the 16th century, the prevailing attitude toward Danaë had changed. Her voluptuousness was emphasized, along with her venality. The emblem books that were so popular in the 17th century used Danaë to illustrate the moral that "gold corrupts everything." Paintings of the nude Danaë could then be acceptable even to churchmen and pious kings as warnings against the sins of avarice and lust.

Rembrandt took a more compassionate view of Danaë. Not the beautiful Danaë, but her old nurse is shown as responsible for any financial arrangements; in her right hand she clutches a moneybag, and at her wrist hangs a bunch of large keys. The presence of Zeus, however, is not announced by the usual rain of gold coins, but by a golden glow. Cupid, who appeared as a live, independent creature in many of the previous pictures of Danaë, here is depicted as a carved ornament on Danaë's bed. His wrists are bound, and he weeps in sympathy with Danaë's enforced isolation. In keeping with the Netherlandish tradition, Rembrandt incorporated all of these details into a naturalistic scene.

Danaë looks happy, as if she foresees her fulfillment. Her affectionate expression and welcoming gesture speak for themselves. Rembrandt's sympathetic understanding of human relationships and his unparalleled gift for communicating emotional states through images enabled him to present Danaë as untainted by avarice, offering love.

—Madlyn Millner Kahr

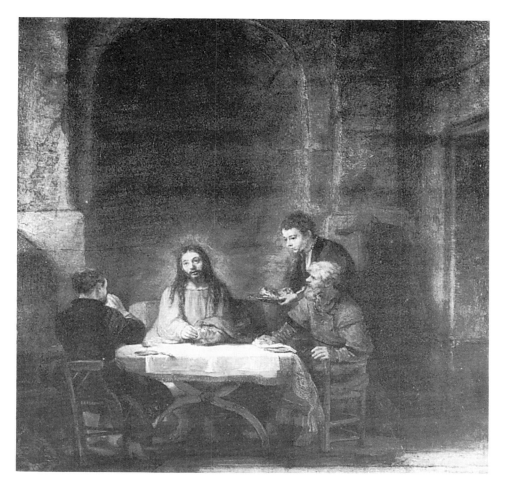

Rembrandt (1606–69)
Christ at Emmaus, 1648
Panel, 26³/₄ × 25⁵/₈ in. (67.8 × 65 cm.)
Paris, Louvre

Inscribed with Rembrandt's signature and the date 1648, the painting *Christ at Emmaus* splendidly exemplifies the balance and stability in composition and the warm blending of color and shading that characterize his mature style. Even among his other beautiful paintings of the 1640's that depict the Holy Family and various subjects from Scripture, this one is outstanding for its sublime spirituality.

The table parallel to the picture plane and the poses of the three figures seated at the table reflect a painting by Rubens of this subject that was owned by a Delft collector. Rembrandt might have seen the painting or known its composition from an engraving after it that was made in 1611 by Willem van Swanenberg, a nephew of Rembrandt's first teacher, Jacob Isaacsz. van Swanenberg. As is well known, prints—especially prints after paintings by great masters—were used as teaching tools in Dutch studios in the 17th century, and Rembrandt may well have copied this engraving at some time during his three years as an apprentice in Leiden. It was usual for drawings after prints, or after paintings or casts, to be kept for later use in planning paintings.

In this case, Rembrandt adopted Rubens's motif to a totally different setting. He not only separated the figures more widely, but he added a lofty, arched architectural setting that does much to set the tone of exalted veneration. As in the Rubens composition, the pilgrim at the left is seen from the rear, with his head in "lost profile" position, the pilgrim on the right in profile, and Christ between them in full frontal view. Rembrandt set the table farther back from the picture plane, provided more space on both sides, and—the most effective alteration in the design—reserved a tall, stately, niche-like place of honor for Christ, whose resplendence is set off against the shadowy archway. Recognizing a miracle, all eyes are fixed on the risen Christ.

Rembrandt had depicted this subject early in his career, probably around 1628, in a painting on paper, (Paris, Musée Jacquemart-André) inscribed with the monogram that he used in his Leiden years, "RHL" (standing for "Rembrandt, son of Harmen of Leiden"). This early version is replete with baroque drama, with depth in space emphasized by means of strong diagonals, striking contrasts of light and dark, and other implications of a moment of high excitement. The Louvre painting, in contrast, is in the style to which Rembrandt came in his mature works, a style that has often been referred to as "classicizing," with its firm architectural structure limiting the spatial depth, the colors and values modulated, and the marvelously unified effect imparting profound inner experience, true to the text on which it was based, from the Gospel according to Saint Luke, Chapter 24.

—Madlyn Millner Kahr

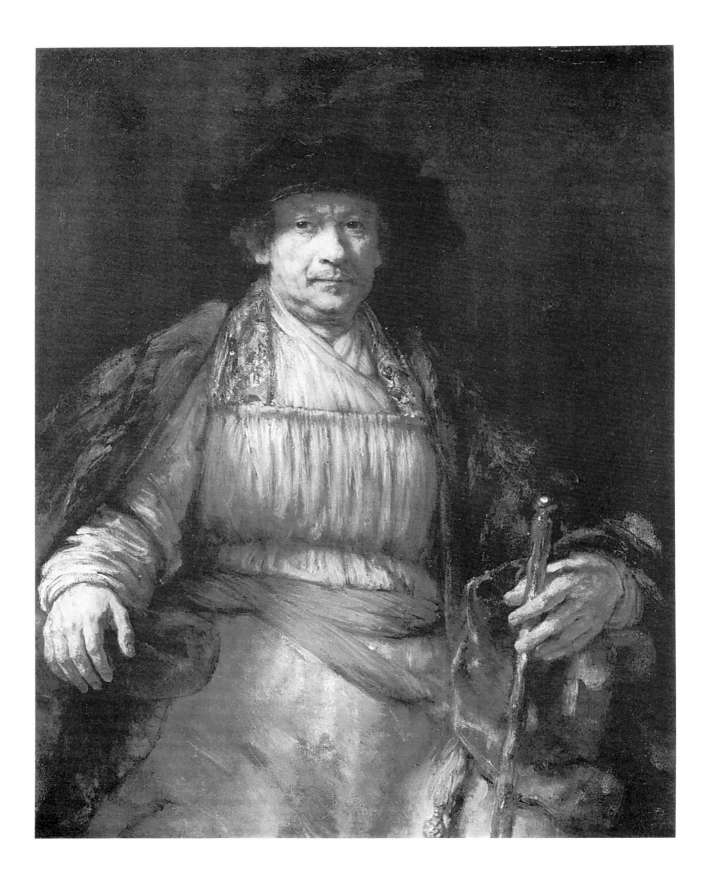

Rembrandt (1606–69)
Self-Portrait at the Age of 52, 1658
51⅝ × 40⅛ in. (131 × 102 cm.)
New York, Frick

From 1629 to 1669, Rembrandt painted, drew, and etched more than eighty self-portraits, in addition to self-portraits that he inserted in narrative subjects, a number quite possibly unmatched by any other major artist. Why did he become so involved with his own image? About this, we can only conjecture. Granted that he was his own most readily available model—and one who did not demand payment—but this would be true of any artist and would not account for Rembrandt's exceptional number of self-portraits.

Was he, like Narcissus, enamored of his own image? It seems unlikely that his self-portraits were motivated primarily by narcissism, if we take into account that many of them were far from flattering. In an etching dated 1630, for instance, he shows himself dressed in rags and torn shoes that expose his bare toes, sitting huddled on a curb; this has been called *Self-Portrait as a Seated Beggar.*

In some of his early drawings and etchings, made between 1628 and 1630, mainly in 1630, he appears to have posed to demonstrate various physiognomic expressions, many of which do not show him at his best. In his time, such studies were considered an important aspect of an art student's training, to be used in paintings later, particularly in narrative subjects in which the expressions of particular emotions by specific figures would be an asset in communicating the story. (Compare, for example, the dramatically expressive faces in his 1635 painting, *Belshazzar's Feast,* London, National Gallery.) This might, of course, be a type of self-portraiture to which other young artists would be expected to devote themselves as much as he did, but the evidence that this actually occurred is lacking.

The occasion for some of Rembrandt's self-portraits is clear, as is the case with his etching of 1636, which shows him drawing (with his left hand, a reversal brought about by printing) in the presence of his young wife, Saskia, a record of his life situation in 1636. *The Self Portrait with Saskia in a Tavern Scene,* painted in 1635–36, on the other hand, shows the young couple in an undignified pose, with Saskia on his lap, and in a setting that was surely not their usual environment; given the customs of the time, a moralizing intention must have been implied. *The Self-Portrait Leaning on a Stone Sill,* an etching of 1639, is one of his exercises in the transmutation of works by other masters, in this case, Titian and Raphael.

Some self-portraits of the years that followed show Rembrandt in simple clothing, some in the elegant attire of an aristocrat of his own time or of an officer, some in clothing of a different—or even an imaginary—era, some with brushes and palette in hand. Rembrandt clearly did not cast himself in a single role in his depictions of himself.

In the Frick *Self-Portrait,* however, the largest of all his self-portraits, he appears to be playing the part of *Rembrandt Enthroned.* On the chair-arm at the right is inscribed "Rembrandt f.1658." In February, 1658, the large house in which he had resided and worked since 1639 was sold, as part of his attempt to solve his ever more pressing financial problems. From the 1658 self-portrait we would never guess that this was a man in trouble. Rembrandt appears dauntless.

He faces squarely forward, and his firm gaze meets ours, though his eyes are shaded by his hat. His arms rest on the arms of his chair, his large hands prominent and boldly painted, the left hand holding a carved stick with a silver knob. Flat on his head is a velvety black beret. His gold-hued robe has a square-cut neckline and a waistline that provides an added horizontal emphasis, which is underscored by the terra cotta-colored sash below it. Gold-embroidered suspenders border the creamy white shirt that is revealed beneath his robe at the neckline and at the sleeves. A rich fur cloak covers his shoulders and left arm. The brushstroke is free and vibrant, the colors gleam against the dark ground, and the composition is utterly foursquare and stable—altogether true to Rembrandt's brilliant late style. Is this a self-portrait of the artist defying fate?

—Madlyn Millner Kahr

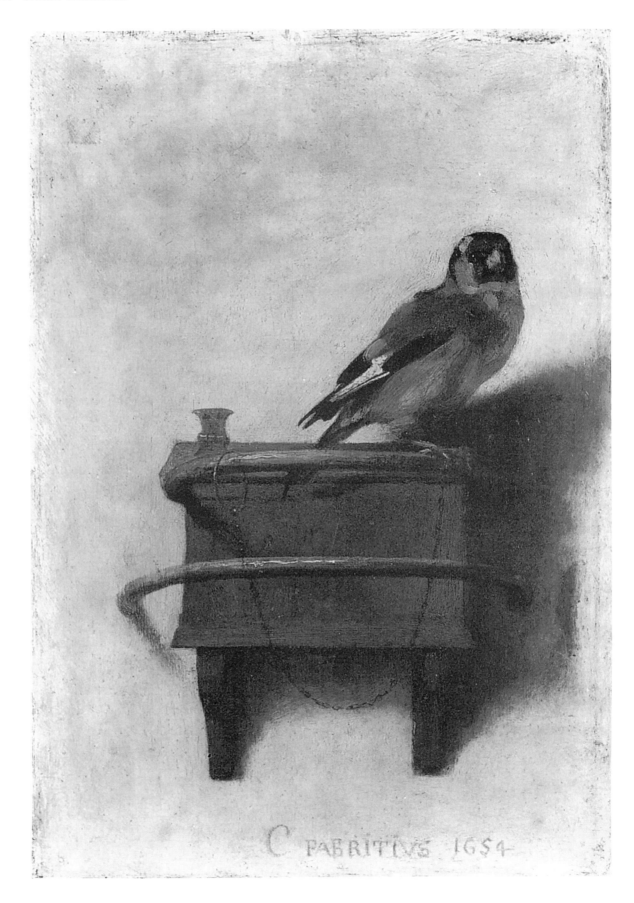

Carel Fabritius (1622–54)
The Goldfinch, 1654
Panel, 13 × 8 in. (33 × 21.8 cm.)
The Hague, Mauritshuis

Bibliography—

de Vries, A. B., "*Het Putterje* van Fabritius," in *Openbaar Kunstbezit,* 8, 1964.
Wurfbain, M. L., "Hoe was het *Putterje* gebeckt?," in *Opstellen voor H. van de Waal,* Amsterdam, 1970.

The Goldfinch demonstrates an important area of Fabritius's experimentalism. Tiny and simple in subject, it functions as a deceit of the eye (*bedriegertje* or *trompe l'oeil*), rendering depth, shadow, and perspective through the medium of sunlight.

Fabritius had a significant reputation as a painter of perspectives, some of which were viewed inside specially constructed boxes. Samual van Hoogstraeten favourably compared his skill as a muralist with both Peruzzi and Giulio Romano. Dirck van Bleyswijck, in his *Beschrijving der Stadt Delft* (1667), sums up Fabritius's posthumous reputation thus: "Carel Fabritius, an outstanding and excellent painter, who was so quick and sure in the use of perspective as well as natural colours and in putting them on canvas that (in the judgement of many connoisseurs) he never had his equal." That judgement is admirably borne out by *The Goldfinch.*

The goldfinch sits on the top perch of his box, to which he is secured by a chain attached to his foot. Bird and box are set against a light, creamy background typical of the daylit subjects of Fabritius and other Delft painters in the 1650's. The device of placing a dark object against a light background gives depth to the image and lends the illusion of three dimensions—a device well known to Leonardo and discussed in his *Treatise on Painting.* The illusion is enhanced by the shadow cast by the goldfinch against the wall, a formula repeated by Fabritius in *The Sentry,* painted in the same year and employing a closely similar pallette.

The goldfinch itself forms a brilliant colour link between the sunny background, the brass perches, and the dark grey box. The highlights of the plumage pick up the light colour of the back wall, but in a lower tone that has more intensity and impact. The chest plumage carries in its darkest passages the grey of the box. The general outline is made altogether sharper by the black areas which, in the wing tips, crown of the head, and areas behind the eyes, add definition. Thus, in a small, unpretentious image Fabritius achieves a frisson of illusionistic virtuousity within a harmonious whole.

Caged birds were emblematic symbols of chaste love in Dutch art, "the sweet slavery of love" (Jacob Cats, *Silenus Alcibiadis, sive Proteus,* Amsterdam, 1622). This is a rather unusual version, the bird being isolated rather than part of a genre scene, and chained rather than contained. With Fabritius, however, unconventionality is par for the course.

The possible purpose of the picture has been much discussed. The panel on which it is painted is unusually thick, and nail holes close to the edge suggest that it was once fixed to a solid surface. Its title has also given rise to speculation. The Dutch *Het Puttertje* could be a pun on the name of its commissioner, e.g., De Putter—also a common misspelling of De Potter, the name of one of Fabritius's patrons—or on the literal Dutch meaning of the word which is "water-drawer." It could, for example, have been an appropriate sign or symbol for the premises of a wine merchant.

The real subject of this picture is, however, *bedriegertje,* or *trompe l'oeil.* The most reasonable explanation of its purpose is that it was designed to be inserted as a panel into a piece of furniture, such as a cupboard, or simply into a wood panelled wall. Such a position would have allowed its eye-deceiving intentions their full impact.

—Lindsey Bridget Shaw

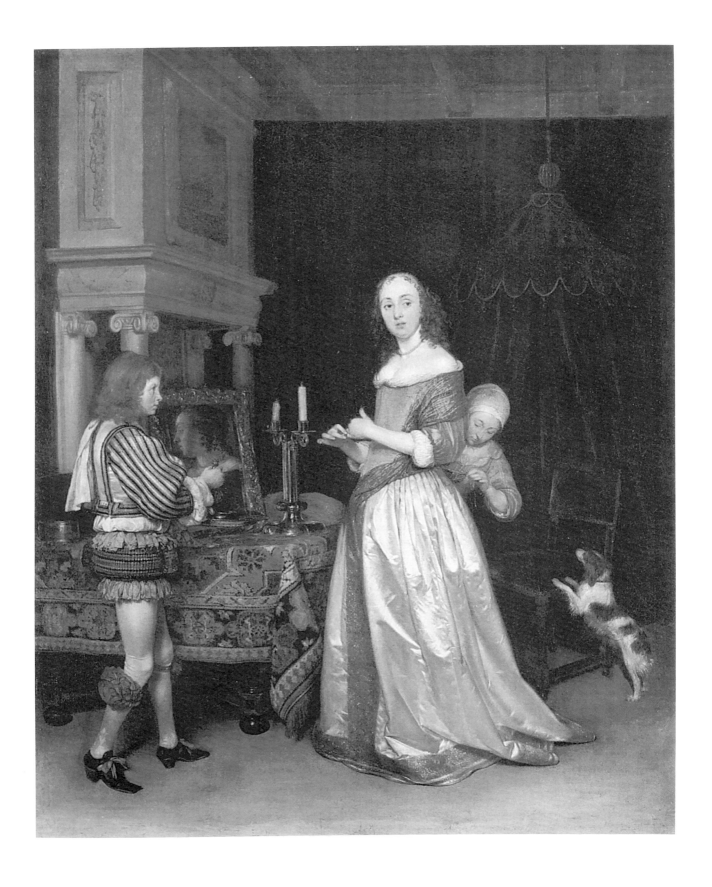

Gerard ter Borch (1617–81)
A Woman at Her Toilet, c. 1660
30 × 23¹/₂ in. (76.2 × 59.7 cm.)
Detroit, Institute of Arts

This picture was painted in the midst of ter Borch's most innovative period. It shows three figures in an elegant interior, the central feature of which is an imposing, marble, neoclassical fireplace. In the background is a curtained bed, in the foreground a table covered with a turkey carpet, and a velvet upholstered chair. It is morning, and a heavy, two-armed silver candlestick, lately in use, stands on the table. A woman, richly attired in brocaded satin, fingers a ring abstractedly while her maid secures her clothing. An elaborately dressed pageboy, holding a scent bottle, stands expectantly beside her mirror, but the woman looks away from her image, lost in thought. The pageboy fixes his attention on her apprehensively, awaiting the outcome of her diverted thoughts.

The subject of a woman at her toilet was one which ter Borch painted throughout the 1650's. There are at least six other versions, only one of which is a full-length. The earliest (Gudlaugsson 77, c. 1648–49, Paris, Georges Renand) is in the unusual form of a half-length tondo, with his sister Gesina as his model. Another (Gudlaugsson 83, c. 1650, Muri bei Bern, J. de Bruyn) is unusual in showing the woman in seated lost profile, her face stunningly revealed in the mirror, which is again held by a page. Ter Borch constantly experimented with a subject, striving to combine current fashion with compositional novelty.

The mirror as a symbol of worldly vanity was well known in 17th-century art and literature. Here, the subject is closely related to the theme of *Vrouw Wereld* (Lady World), and specifically to a more didactic painting of 1633 by the Haarlem artist Jan Miense Molenaer, whose work ter Borch must have known during his Haarlem years. In Molenaer's painting the woman sits resting her foot on a skull. Her room is lined with musical instruments to indicate the sensual life in which she is engaged. In contrast to her youth and beauty, her maid is shown as an old woman, which combines with the skull to emphasize the transience of the young woman's qualities. While the maid dresses her hair she holds a mirror on her lap. Like ter Borch's subject, however, she looks away from it and out towards the viewer, holding up a ring in her right hand. The small boy, elaborately dressed as in ter Borch, does not attend her, but reinforces the *vanitas* message by ostentatiously blowing soap bubbles, an emblematic reference to fragility.

In spite of similar compositional material, ter Borch has achieved a quite different mood. Apart from the mirror, the only object with *vanitas* resonance in his picture is the two-armed candlestick with its lately snuffed candles. In his more luxurious interior, the proceedings are altogether less contrived: they are simply the morning ritual of a rich young woman. Characteristically, however, he has caught the one moment when this ritual has been arrested by a question in the woman's mind. It is this question which engages the earnest attention of the pageboy—and, by coercion, of the viewer. Where Molenaer's picture makes a general didactic point, ter Borch presents that same point in an interrogative way. The question of *vanitas* enters his picture as an aberration, an incipient question hanging over an otherwise normal bourgeois morning.

Gudlaugsson has implicated the theme of fidelity, revolving around the inclusion of a favourite motif of ter Borch, the little dog. He refers us to Jacob Cats's emblem, "As the dog, so the woman." In Dutch genre, dogs in the presence of women frequently imply an absent male. Like women, though, dogs were seen as having two sides to their nature: faithful, obedient companions on the one hand, lascivious and greedy on the other. Here the dog is in the process of making a decision: whether or not to jump onto the empty chair. Ter Borch loved to capture just such a moment of choice. It involves choosing: whether or not to succumb to temptation. The raised front paws of the dog echo the woman's slightly raised forearms as she fingers her ring. It is this latter action which reinforces the notion of fidelity in the meaning of the picture.

The format is typical of the one ter Borch had developed by 1650: a vertical composition with few figures, unified by a simple lighting structure of invisible source. Light is centred on the protagonists. The use of colour is also typical: strong, unmixed primaries in the blue of the woman's bodice, the red of the pageboy's frills, and in the Turkey carpet. These primaries are set off by background neutrals. Both neutrals and primaries act as foils to the pale reflective textures that constitute the centres of opulence and fashion: the satin and brocade of the woman's skirt, the pageboy's striped veston, and the solid, cool marble of the fireplace. A combination of primaries and neutrals was used to effect by a number of mid-century genre painters, especially Gabriel Metsu and Pieter de Hooch. Ter Borch was unique, however, in his exploitation of lustrous silks and satins cadenced by marble.

Ter Borch's versions of this subject were highly influential, especially on Frans van Mieris and ter Borch's own pupil, Caspar Netscher. The subtlety of ter Borch's command of psychology is only underlined by comparison with other versions. Netscher's woman, full-length but seated, makes direct contact with the viewer. She turns from her mirror not in inner contemplation, but to smile enticingly at the viewer—as in a version by another Haarlem-trained painter Pieter van Roestraeten (c. 1672–75; Collection of Captain T. H. Clifford). Winsome though these pictures are, they entirely lack the poignant dialogue between outward assurance and inward dilemma that ter Borch's picture so successfully presents.

—Lindsey Bridget Shaw

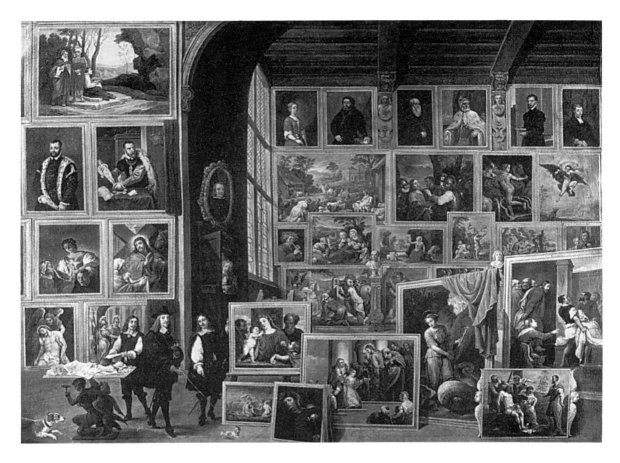

David Teniers (the Younger) (1610–90)
*Picture Gallery of the Archduke Leopold Wilhelm in Brussels,
 Fourth View,* 1651–53
37⁷/₈ × 50³/₈ in. (96 × 128 cm.)
Munich, Alte Pinakothek

David Teniers the Younger became Court Painter to Arch-
duke Leopold Wilhelm, cousin of the King of Spain and ruler
of the southern Netherlands, in 1650. It was at this point that
he began documenting the Archduke's collection of paintings
by Italian masters. Some of these works the Archduke had
purchased from the collection of Charles I. Teniers made at
least six renditions of this work. They can be dated between
1651 and 1653, as these are the only dates appearing on any of
the examples. Besides those in Munich, of which this is one,
other examples of the *Picture Gallery of Leopold Wilhelm* are
found in the Prado and the Kunsthistorisches Museum, Vi-
enna. As this documentation process was underway, Teniers
also executed small *pastiches* of each of the Archduke's Italian
paintings. These were turned over to a staff of engravers who
created a catalog entitled the *Theatrum Pictorum.* This was
published in 1658 by Abraham Teniers, brother of David II. It
went through two additional amended editions which appeared
in 1660 and 1673. This last was issued by the widow of Abra-
ham Teniers.

The paintings of the assembled picture gallery are generally
large in scale, and obviously meant to serve as a sort of cata-
logue of the collection. In none of them do we see the entire
collection, but merely representative examples of works by the
better-known artists, such as Titian and Raphael. Teniers was
merely following a tradition of "gallery" paintings, or
Kunstkamers, popular in Flanders in the 17th century.

The purpose of the artist executing a gallery painting is to
document the works on hand. To this end, Teniers sublimated
his own personal style and made what are rather exact little
copies of the paintings in the collection. This does not take away
from the general quality of the work, however, in that he seems
to have taken pains to produce these *Picture Gallery* paintings
with as much skill of draughtsmanship and delicacy of detail as
he was capable. Teniers was quite gifted in the rendering of
items of still life and other details in very thin and carefully
applied glazes. This technique is well demonstrated in the Mu-
nich *Picture Gallery* of Leopold Wilhelm. One sees it in the
copies of the paintings, displayed as it were in the palace gallery.
One takes visual delight in the dogs which usually appear in the
scenes. And, one also sees Teniers's considerable technical skill
in small items of still life and sculpture which are customarily
displayed in these works. The artist himself appears in the paint-
ings along with the Archduke, so that these works served to
celebrate Teniers's status as Court Painter as well as to com-
memorate the taste of Leopold Wilhelm.

Others who created works such as these included Tenier's
father-in-law, Jan Brueghel I, and Frans Francken II. Teniers
seems to have taken most of his stylistic inspiration from
Francken II. In fact, it is known that Teniers purchased some
unfinished *Kunstkamer* paintings from Francken's estate and
finished them himself.

—Jane Davidson

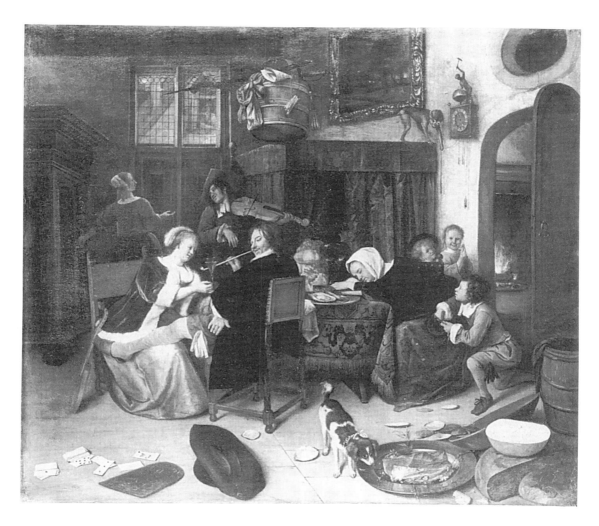

Jan Steen (1629-79)
The Dissolute Household
31³/₄ × 35 in. (80.5 × 88.9 cm.)
London, Wellington

Jan Steen's domestic paintings reflect his variety of style and moral implications. He often used the robust Haarlem style as well as the more "fine painting" associated with Leiden, in both of which cities he lived and worked during his active life. Of his 7-800 paintings, a large number fall into series, of Love-Sick Wives, Children at Play, Tavern Gardens, etc. One of the most well-known is the series on Dissolute Households (or Crazy Company, Life of Man, World Upside Down).

The painting called *The Dissolute Household* in London is representative of the group. Painters like Bosch and Pieter Bruegel had used the theme earlier, usually with a strong religious or moral angle, and though Steen tends to take a less priggish view, suggesting the liveliness and the playfulness of the scene as much as the denunciatory, there is an underlying moral. Like others in the series, the group of figures includes several generations as well as pets, and, as several commentators have pointed out, the *vanitas* implication is emphasized by the variety of incident and detail and the suggestions of all the senses being displayed. The central couple in this version is a young man smoking a long clay pipe, and about to accept a

glass of wine from a well-dressed woman; his leg is resting on her lap, and they are both at ease. (The man is actually a self-portrait; in fact, Steen includes a number of portraits of himself in groups of figures.) Behind them a man plays a stringed instrument, while a woman listens with her arm extended; to one side, an older woman sleeps at a table while a young boy picks her pocket (two other children look on, amused by the theft); above the children, a monkey is playing with the dangling weights of a large clock, and in the foreground a dog eats from a large platter on the floor. Playing cards and oyster shells litter the floor, and in an adjoining room a fire blazes (images of lust).

In companion pictures, a few additional details are added: in the Vienna *The World Upside Down*, a pig has decided it's safe to enter the room, and in *The Life of Man* (The Hague) a small child, half-hidden in the rafters, is blowing soap-bubbles with a skull beside him, both images of transience and vanity. Some others emphasize the moral implications relating to the children (*The Effects of Temperance*, London, National Gallery, and *The School*, Edinburgh).

Steen's fame as painter of the pleasures of life, often with little regard for the moral niceties, has meant that a "Jan Steen" household is still a byword for catch-as-catch-can sort of establishment.

—George Walsh

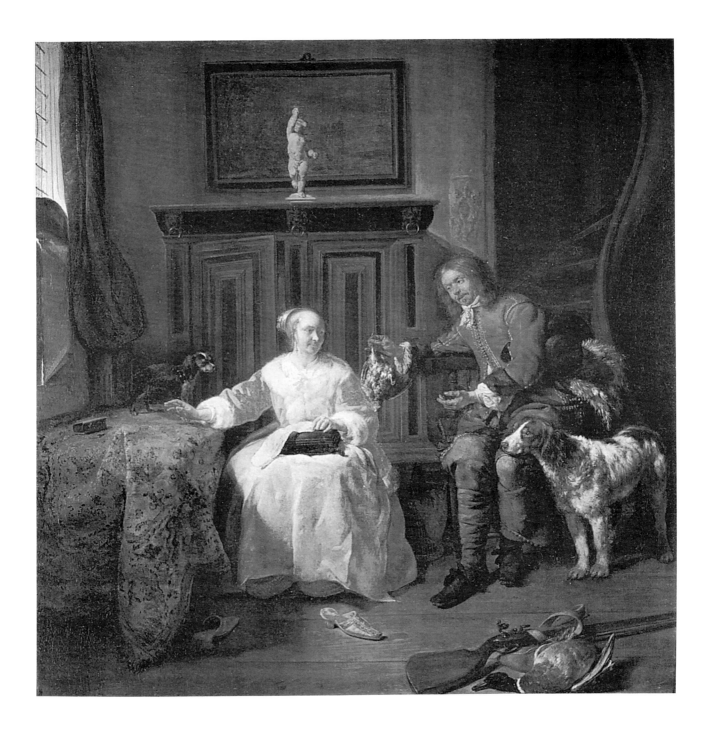

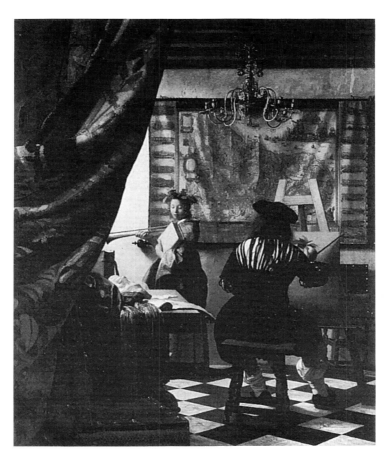

Jan Vermeer (1632–75)
The Art of Painting, c. 1665
47¹/₄ × 39¹/₈ in. (120 × 100 cm.)
Vienna, Kunsthistorisches Museum

Vermeer's *Art of Painting* (Vienna, Kunsthistorisches Museum) is generally assumed to be the picture referred to by that title that was inherited from him by his wife. It has been called *The Painter's Studio,* though it differs strikingly from the naturalistic renderings of artists at work in their studios that were usual in its period. Overt in its symbolism to a degree matched in only one other of Vermeer's works, *Allegory of the Faith,* also a large, late work, the painting of the artist and his model could justly be identified as *The Painter in History.*

Beyond a drawn-back tapestry hanging in the immediate foreground, and the chair that props it, we look into a room in which an artist is seated at his easel. He is seen from the rear, wearing a costume from a time long past—in itself a clue to the fact that it is not the everyday world but the sphere of allegory into which we have been admitted. On the canvas before him, he is painting a representation of the laurel wreath worn by the young woman who stands at some distance from him, near the light-swept far wall. She holds the trumpet of fame and a large book, attributes of Clio, Muse of History. Though her body is seen in profile, her head is turned toward us, but her eyelids are lowered so that she makes no acknowledgement of either the artist or the presence of onlookers.

The head and shoulders of the model, and her book and trumpet, overlap a map that covers a major part of the wall.

The strong horizontals of the map rollers underline the rigid horizontals of the ceiling beams. The two figures are fixed in a box-like space in a way that suggests immutability.

That the map is old is made evident by its cracks and wrinkles, besides the fact that it shows the seventeen provinces of the Netherlands as they were under Habsburg rule, before the independence of the seven Northern provinces had been won by long and arduous struggle. Bordering the sides of the map are twenty panoramic views of "the most important towns and courts of the Netherlands." The mask on the table, with its associations to Antiquity, further brings the artist into the context of time-honored status. His very costume makes him a part of history.

This intricately organized composition in itself constitutes a tribute to the art of painting. A system of overlappings that organizes the design not only horizontally and vertically, but also in the third dimension, provides an astonishing visual unity. The contrived but naturalistic-appearing demonstration of perspective, the suavity of the modeling of forms and the contrasting evidence of faithful observation (as seen, for instance, in the artist's foreshortened hand), and the strong yet ingratiating color scheme—all work together with superb effectiveness.

Third in size of all Vermeer's known paintings, *The Art of Painting,* which probably dates from about 1665, serves as a summation of the art of Johannes Vermeer, while it makes a claim for his unending fame.

—Madlyn Millner Kahr

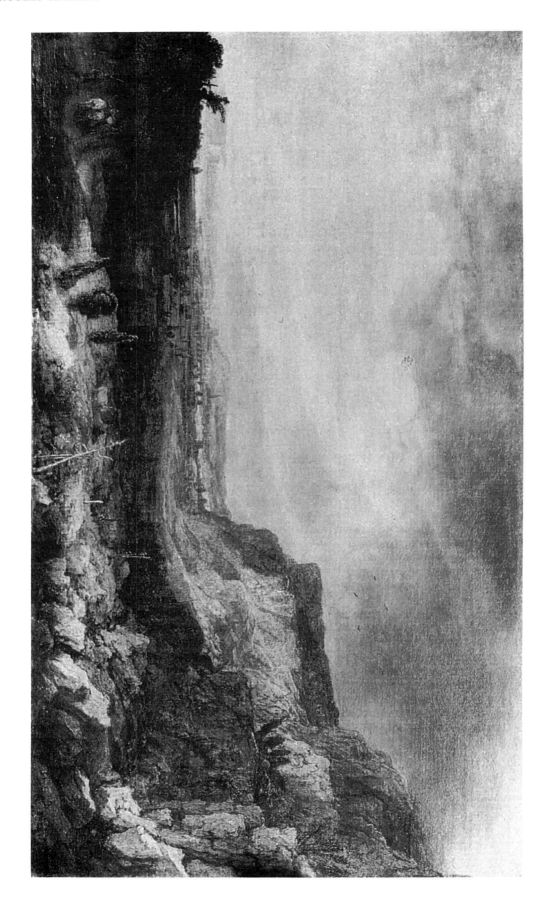

Hercules Seghers (c. 1589-90—1638)
The Mountain Landscape, 1620–30
Panel; 21⁵/₈ x 39³/₈ in. (55 × 100 cm.)
Florence, Uffizi

The Uffizi *Mountain Landscape* was attributed to Rembrandt until 1871, when the early scholar of Seghers's works, Wilhelm von Bode, recognized it as being by the older artist. Structurally, this painting of a valley, overhung with moisture-laden clouds and flanked on one side by layers of rocky cliffs, owes much to the mannerist landscape tradition. As viewers, we are placed high in space, at eye-level with a luminous, grey-green horizon, so as to augment our sense of nature's vastness and grandeur. The foreground is particularly barren and forbidding, with a few gaunt, leafless trees near the center reinforcing this impression, and Seghers employed no formal devices to lead us comfortably into his space. *The Mountain Landscape* reflects not the hospitable, mundane Dutch landscape (which Seghers also painted—for example, in his topographical *View of Rhenen* in Berlin), but rather a tradition of imaginary landscape that seeks to overwhelm us with nature's power.

Almost certainly one of the eight paintings by Seghers recorded in the 1656 inventory of Rembrandt's collection and described there as a "great landscape," the Uffizi canvas was apparently repainted by the younger artist, who was surely the most important heir to Seghers's conception of nature. At the left, Rembrandt seems to have covered Seghers's granular brushstrokes with glazes of reddish and greyish brown. He added a wagon with horses and a driver to create his own kind of staffage, similar to the figures in his famous etching, *The Three Trees* (1643). The figures, horses and wagon also serve to humanize Seghers's original evocation of an eerie, lonely mood.

At the right, Rembrandt evidently repainted Seghers's rocks, heightening the shadows in the middle distance, and intensifying the contrast between these and the pearly horizon, which is more typical of Seghers himself. The alterations in the rocks especially reveal the younger artist's interest in broad and in-

tense contrasts of light and dark, which is distinct from Seghers's more uniform, less baroque approach to chiaroscuro. Rembrandt's concern for broad contrasts also affected the sky, which he seems to have repainted to achieve a more active and threatening quality, again reminiscent of the storm in *The Three Trees*.

Despite Rembrandt's changes, no work reveals what was unique about Seghers—and hence what appealed to the younger artist—better than the Uffizi canvas. In its panoramic breadth and forbidding mood, *The Mountain Landscape* might have contributed heavily to Rembrandt's landscapes of the 1630's, such as *Stormy Landscape with an Arched Bridge* (c. 1638, Staatliche Museen, Berlin-Dahlem), and the better known *Landscape with an Obelisk* (c. 1638, Isabella Stewart Gardner Museum, Boston). The latter work has a distant bluff in the center which is similar to that of the Uffizi work, and a huge gnarled tree in the right foreground that yields a similar sense of aged power as Seghers's craggy rocks, but is, characteristically, almost anthropomorphic. All in all, Rembrandt's landscapes of this period, although awesome, seem more humanized than Seghers's. The foregrounds are closer to us, and figures and architectural details are more prominently scattered throughout. Roads or paths—absent or less immediately accessible in Seghers's works—give us more direct entrance into the space. While retaining, and in some ways (as with chiaroscuro) heightening Seghers's grandiloquence, Rembrandt domesticated the older artist's vision of nature, and found his most profound mystery (as always) in the familiar. What is most striking about Seghers's imaginary landscapes, on the other hand, is their stubbornly alien, other-worldly quality: this is still perceptible beneath Rembrandt's brush in the Uffizi picture.

—Linda C. Hults

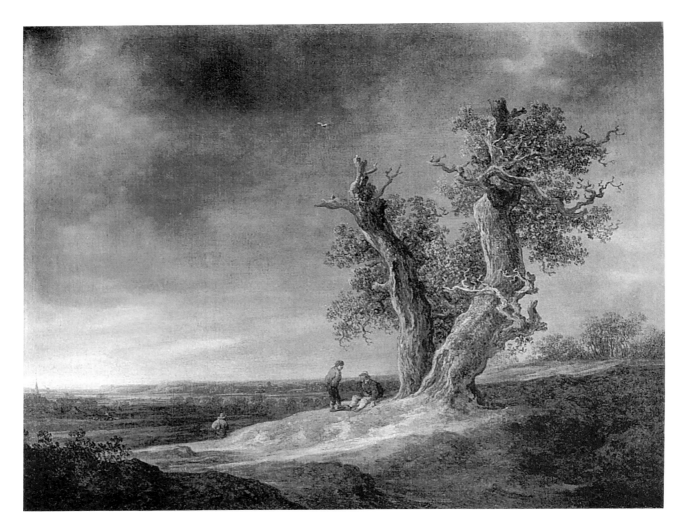

Jan van Goyen (1596–1656)
Landscape with Two Oaks, 1641
34⁷/₈ × 43¹/₂ in. (88.5 × 110.5 cm.)
Amsterdam, Rijksmuseum

Of all the Dutch 17th century painters who were prolific, Jan van Goyen was the most consistent. His artistic development followed a precise course with gradual changes being introduced, such as a change of horizon line or the diminution or increase in the use of colour. Most of van Goyen's pictures are small in scale and almost all of them tend towards the monochrome. However, at occasional points in his career, van Goyen attempted a larger scale or more highly coloured work which sometimes brings together all the elements of his art. The *Landscape with Two Oaks* is just such a picture, as it uses almost all the devices the artist employed in his many hundreds of other pictures.

He was highly skilled at painting damp grey weather, and in this picture the sky is moisture-laden and overcast. A shaft of light on the horizon throws some shadows in the foreground, allowing the picturesque silhouettes of the two old oak trees to dominate the composition. The small figures are perfectly in-

tegrated into the scene—which was often a difficulty for landscape painters when they employed other artists to add figures. The result is often a tension between the two artists' achievements. Van Goyen avoided this, even though with some loss of character in the individual figures. Even though this picture might be dismissed as damp and picturesque when compared to the monumental achievements of Jacob van Ruisdael, it has other qualities. The artist has caught the effect of atmospheric distance almost effortlessly in a way which was not to be rediscovered until the 19th century.

Van Goyen's pictures were too freely painted to appeal to 18th-century collectors, and it was only toward the end of the following century that his art was rediscovered. He is now admired for that very freedom from convention for which he was so long despised.

—Christopher Wright

Frans Snyders (1579–1657)
Pantry Scene with a Serving Figure, 1615–20
4 ft. 6 in. × 6 ft. 6 in. (137.2 × 198.1 cm.)
Munich, Alte Pinakothek

The pantry still life in the Alte Pinakothek, Munich, is a typical example of Frans Snyders's grandiose baroque style. The work was painted between 1615 and 1620 and a preparatory drawing of it is preserved in the British Museum. In composition, the completed picture shows the influence of Peter Paul Rubens's oil sketch, *The Recognition of Philipoemen* in the Louvre, Paris. Two pyramidal masses of game are arranged so as to overlap on the broad horizontal table. Sweeping diagonal lines create movement and unify the composition. The tighter geometric approach of Snyders's earlier works has now given way to a more open and freely conceived arrangement. The still life is balanced by an equal disposition of masses on both right and left, while a number of lighter, more curvilinear elements are introduced in accessories such as the grape vines and spawling legs of the deer. This, as well as the drama supplied by the dog, cat, and serving figure, helps to enliven the composition. In addition, the sharpness of the artist's earlier chiaroscuro has been tempered by warmer and deeper colors. The earthen shades of the game are set against a deep red tablecloth while a gathered white drapery provides a focal point. The green colors of the vegetables and grape leaves provide some variety, while the bright red lobster and berries in blue and white Chinese porcelain dishes form the coloristic highlights.

A number of the accessories in Snyders's still life are used again in later works. The dead deer, boar's head on a plank over a square tub, and the lobster on the blue and white porcelain dish are motifs that the artist probably had preserved as sketches to be referred to again and again. In fact, hundreds of drawings by Snyders have survived ranging from small studies of fruit or animals to larger more finished compositional drawings. The artist doubtlessly made use of these sheets in every phase of his work. It was certainly not possible to assemble all the items that appear in still lifes such as the Munich picture. Not only would they have spoiled or deteriorated before the painting could be completed, but the items were costly. The display on this table was not one enjoyed by the common Flemish citizen. Indeed, the abundance and costliness of the accessories suggest that only a person of aristocratic means could possess a larder of such richness. For example, the artichokes, asparagus, and quinces depicted here were considered delicacies in Flanders. The variety and species of game also associate the picture with the nobility.

Hunting was the traditional sport of the upper class, and such prized animals as the deer and boar could be sought only by the privileged. Even the greyhound sniffing the deer in the foreground was a dog usually owned only by the nobility. Finally, the very size of this painting, some 4¹/₂ by 6¹/₂ feet, suggests a setting in a grand chateau rather than the modest home of a Flemish burgher.

Overall, the picture combines an impression of aristocratic elegance with the rhythmic movement and coloristic richness of the baroque age. Snyders's works such as these were subsequently influential in the development of game paintings in 17th-century Holland and Germany and through his followers in France in the 18th century.

—Scott A. Sullivan

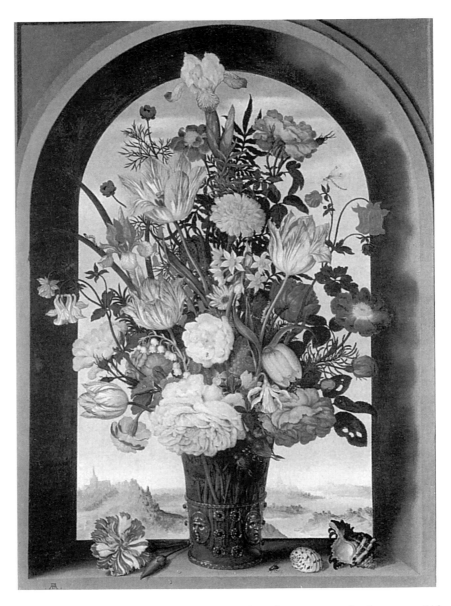

Ambrosius Bosschaert (1573–1621)
Vase of Flowers, 1620
25¼ × 18⅛ in. (64 × 46 cm.)
The Hague, Mauritshuis

This painting is the largest and most elaborate example of Bosschaert's painstaking art. The influences which formed it are remarkably few and can be traced back to the flower pieces of Jan Bruegel which Bosschaert would have known in his youth in Antwerp. Bosschaert developed a personal way of drawing each individual flower and then arranging a group of them together. (Some of the flowers can be recognized from picture to picture; i.e., he did not draw each one afresh for each new painting.) He tended to ignore the precise time at which each flower bloomed and combined them for decorative effect, sometimes giving the impression that such a mass of flowers might not have fitted into the container because their stems would have been too big. Such an approach was purely practical, as each painting would have taken too long to be

done from nature as the flowers would have faded. Bosschaert observed with a clarity and precision which have rarely been equalled. He was more concerned with the form and colour of each flower than with its texture and atmosphere—that was to be a development later in the century.

In this picture he has used a format which he occasionally favoured—that of placing the flowers against a landscape background, which in this case is strongly influenced by Jan Bruegel. The light tone and bluish colours allow the reds and yellows of the flowers to be displayed even more forcefully, and the intensity of the whole is even more striking because of the dark frame of the niche in which the flowers appear.

Bosschaert was briefly but effectively influential on his three sons who imitated him (though with less skill) and on the still-life and flower painter Balthasar van der Ast. After about 1640 this meticulous and brilliant style of flower painting went abruptly out of fashion in favour of a more realistic and less decorative approach.

—Christopher Wright

Adriaen Brouwer (c. 1606–38)
Peasants Quarreling over Cards
12^{5}/$_{8}$ × 19^{1}/$_{4}$ in. (32 × 49 cm.)
Munich, Alte Pinakothek

Despite their characteristic small dimensions, the paintings of Brouwer are excellent examples of baroque style. Brouwer frequently depicted such low-life types as soldiers and brawling peasants. They were not idealized, but rather dispassionately shown going about their daily activities. In this respect, his work is yet another component of Flemish 17th-century genre. It is not Brouwer's subject matter which is so astonishing, but rather his technical genius with paint which marks him as a master of considerable stature. His paintings contain all the emotional drama and implied physical activity of works executed on a much larger scale. Further, they are marvelous technical pieces, being executed in considerable detail with extremely thin glazes and usually a limited palette. In these respects, they recall, if not actually resemble, the paintings of his teacher, Frans Hals. Brouwer's great skill is readily evident in his treatment of delicate still-life details which are often painted with only one layer of paint. He also displays a fine ability as a draughtsman and a keen appreciation for color.

In this work we find the artist depicting a dusty tavern with drunken, brawling peasants whose emotions virtually spill out of the painting. They seem almost to overwhelm the rather constricted space in which they are set. Brouwer's ability to handle paint was of much interest and impact upon contemporary genrists. In his Antwerp period, from which this work dates, Brouwer was quite influential on his contemporary David Teniers II. Teniers imitated the grey glazes of Brouwer which are found in works such as the *Peasants Quarreling over Cards,* and he even occasionally made freehand copies of Brouwer's works. These glazes are achieved by overpainting with a blend of two parts blue pigment (probably Azurite blue), one part raw umber, and one part white. This was applied over a ground of raw umber. Brouwer's works were also esteemed and collected by many fellow artists, including Rubens.

—Jane Davidson

Willem Claesz. Heda (c. 1594–c. 1680)
Still Life: The Dessert, 1637
Panel; 17³/₈ × 22 in. (44 × 56 cm.)
Paris, Louvre

Heda belongs to the tradition of austere still-life painting in Haarlem which was a direct contrast to the rich banquet pieces favoured in most of the other Dutch cities. His skill was in understatement, as each minute detail and reflection on precious metal and glass is subordinated to the whole.

Most of his pictures are scenes of mealtime—the breakfast pieces or the dessert, with the obvious necessity to balance the casual items on the table with the formal need to present a well-balanced composition.

In this picture, there is a mixture of elaborate artifice—the placing of the glass and the silver—and the realism of the fruit pie. Only a portion remains on the plate with the serving spoon, and in the other the absent diner has broken his portion of pie into pieces on the plate. Many such still-life painters represent an elaborate symbolism with heavy moral weight brought to bear on such seemingly casual items. In this instance, there is the clear statement that the luxurious objects have been abandoned after the diner is full.

Heda's meticulous style meant that his production was slow and his pictures are rare.

—Christopher Wright

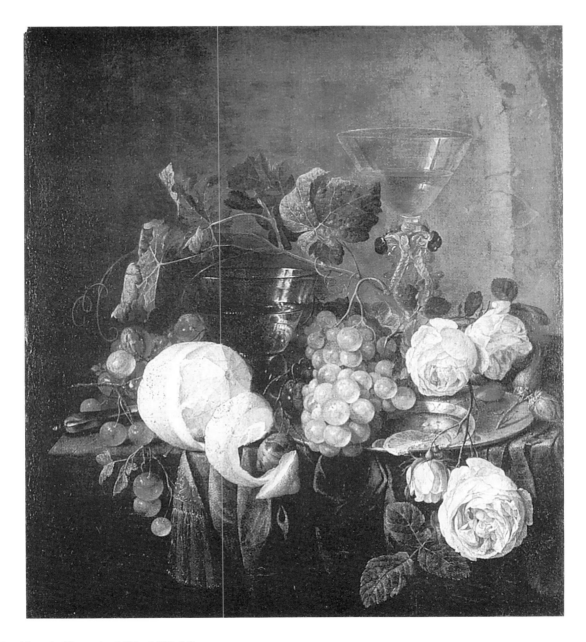

Jan Davidsz. de Heem (c. 1606—1683-84)
Still Life
18 × 16 in. (45.7 × 40.6 cm.)
Cheltenham, Art Gallery

De Heem was an innovator in the field of still-life and flower painting because he combined a number of familiar elements into a recognisable style which became the standard for a whole generation of artists, including other members of his family, Abraham Mignon, and Rachel Ruysch. Although most of his pictures are elaborate and carefully composed still lifes, like the one here, he also painted a number of subject pieces. These range from a *Vanitas* of a young man surrounded by the world's vanities to an elaborate garland of flowers surrounding a depiction of the Host. Such pictures are untypical in the general context of his work, as most of the rest of it repeated the recognisable themes.

In the Cheltenham picture, an unambitious work, there is a combination of all the artist's favourite motifs. He was equally adept at painting both fruit and flowers, which was unusual, as most artists specialised in one or the other area. Each motif is treated with minutely observed restraint—the pink rose, the peeled lemon, the wine glass, and the grapes. Yet when seen together, the effect is one of opulence quite different from the austere effects of William Claesz. Heda. It is unlikely that where there is any elaborate interpretation of subject matter in this picture as there are no *Vanitas* overtones.

—Christopher Wright

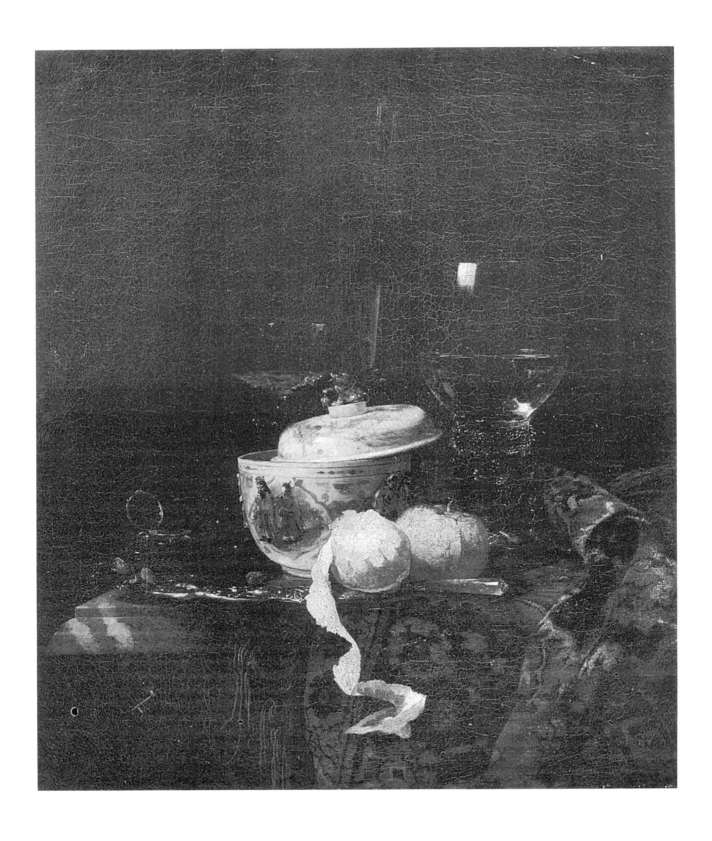

Willem Kalf (1619–93)
Still Life with Chinese Bowl, 1661
25¹/₄ × 20⁵/₈ in. (64 × 53 cm.)
Berlin-Dahlem, Staatliche Museen

This picture was made at the height of Kalf's achievement, during the years 1658–63 in Amsterdam. A paragon of technical and compositional virtuousity, it also illustrates the subtle, tranquil, mystical mood these gifts enabled him to achieve.

The picture is vertical in format and its composition is dominated by a strong vertical axis. This stretches from the top of the tall flute glass to the base of the lemon peel spiral, thus also connecting foreground and background. Depth is intimated by diagonals: the large fold in the Turkey carpet, curving around the base of the roemer; the handle of the fruit knife, which takes our eye to the left background; the watch-key to which this diagonal leads, ingeniously painted dangling from its ribbon and visible only below the table ledge. Within the limits of this axis, objects are ranged at three levels. The highest is set by the two glasses: roemer and *façon de Venise;* the middle range is that of the sugar bowl; the lowest that of the fruit, carpet fold, and open watch-lid.

Out of the dark, neutral background, emerges a dialogue of warm and cool tones. The orange forms the colourful centre of the image. This connects with the warm red and red-brown of the carpet and the glow of red wine in the flute glass. These warm colours are underlined by the dark greens of the roemer and the carpet, and generally dominate the right-hand side of the picture. Yet they are everywhere countered by cool accents. The orange is nudged by the bright, pale yellow of the lemon. Behind this, the gleaming blue and white of the porcelain bowl combines with the lemon to create a centre of light. Yet these cool-warm juxtapositions are a true dialogue, not a contrast of resistance. Kalf uses a warm effect (the wine in the flute glass) to relieve the objects from their background. Yet the adjacent, pale, greenish-yellow white wine in the roemer echoes the lemon. Even the lightest, chilliest piece—the china bowl—is tempered: the little relief figures, so brilliantly

painted as if in three dimensions, are clad in the brown-reds of Kalf's warm pallette.

What is also impressive is the range of texture Kalf achieves. He can successfully differentiate two translucent media, wine and glass; he can juxtapose these with the reflective surface of china, itself placed upon reflective metal. The silver platter, with its curves and chasing, is typical of his virtuousity. Only partially visible, it allows him to paint small points of sharp reflection alongside more ambiguous areas that barely shimmer. Upon the rim of this he places the lemon, its moist flesh in sympathy with the gleaming silver plate and knife handle, its skin a complete contrast—porous, yet opaque. This object is the most broadly painted area. It demonstrates Kalf's command of an exacting pointilliste technique that enhances, rather than detracts from, his otherwise high finish.

As with the lemon, so the carpet is rendered in all its density of pile and pattern. It is a relieving presence in every way, the deeper blue and red successfully combining references to both pallettes, the black passages connecting with the background.

Through craftmanship and precision, Kalf arrives at a distilled symbolism that draws the viewer to the picture and invites meditation. This meditative quality is far above that demanded by a *vanitas* still life. Yet in these quiet presences, the *vanitas* iconography—the transience of life and the emptiness of earthly riches—is potently at work. Kalf's compositions have the ability to ravish the eyes. His painterly evocations of symbols of earthly wealth could arouse a lust for possession that the Calvinist viewer would recognize in themselves and condemn. Thus, icons like these, superbly executed, both celebrated the fruits of wealth and satisfied their owners that the picture, with its *vanitas* sub-text, advertised their moral awareness of the implications.

—Lindsey Bridget Shaw

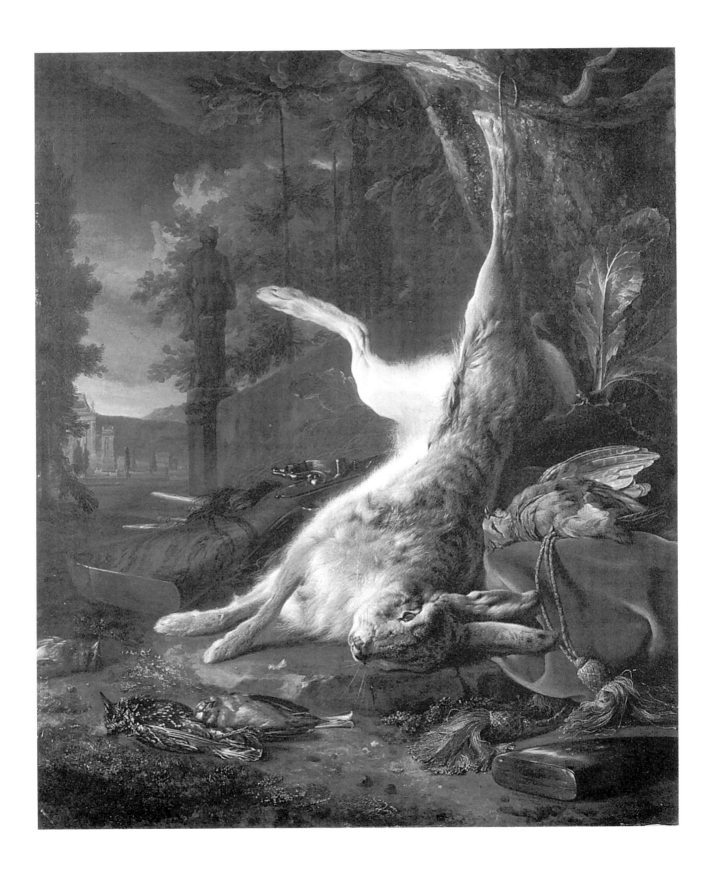

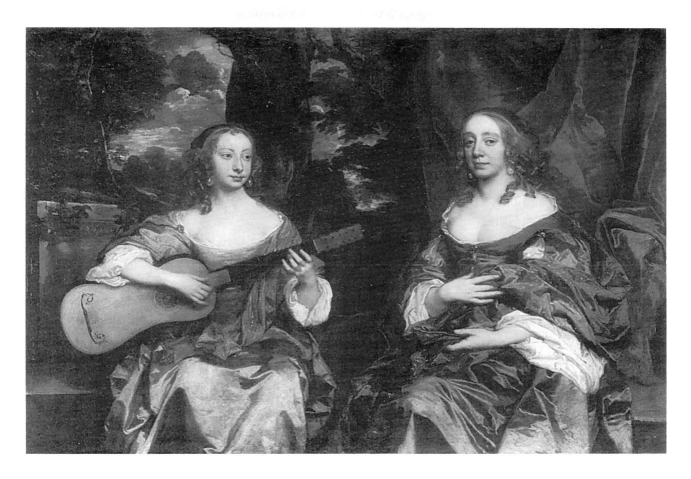

Peter Lely (1618–80)
Two Ladies of the Lake Family, c. 1660
4 ft. 2³/₈ in. × 6 ft. ¹/₂ in. (128 × 184 cm.)
London, Tate

Two Ladies of the Lake Family (c. 1660) is characteristic of portraits painted by Peter Lely during the English Restoration. The three-quarter length treatment of the two seated figures (in other portraits, subjects may be either sitting or standing) is typical of his Restoration work. The lady on the left plays a stringed instrument; the figure on the right raises one hand to display long elegant fingers which toy with her bodice, while the other is restlessly displayed on her lap. Such hand movements, stock gestures which Lely developed in his highly organized factory studio, are the major expressive means the painter has used to portray the character of the sitters. The genius of Lely is his ability to take stock poses and invest them with some limited individuality. It is chiefly through his skill with suggested movement that he accomplished this end.

This portrait exemplifies a recurrent weakness in Lely's portraiture style, a lack of insight into the sitters' character. In order to flatter his female sitters, he often treats their faces in a more complimentary, generalized manner. The lady on the left, in this vein, corresponds to a popular type, while the lady on the right is more individualized. Another weakness is apparent here by Lely's lack of insight into the sitters' characters.

The textures in the portrait are rich and painterly, the high-

lights and shadows enlivening the fabrics as well as the personalities in a loose Baroque style adapted from Anthony Van Dyck. Lely's figures, however, never acquire the individuality of character or reveal the depth of insight into personality of Van Dyck's paintings. Particularly in his Restoration-period portraits, Lely emphasized luxuriousness. The fabrics, low-cut necklines, and rich flesh tones convey this quality, along with the verdant landscape setting. Lely's best-known works from this period, in which he adopted a quite different approach, are the series of paintings known as the Windsor Beauties, painted for the Duchess of York. The celebrated Beauties of the English court are characterized by a langorous, drowsy voluptuousness, their eyes sometimes appearing half-closed, and their dresses looking distinctly disheveled. This treatment is in marked contrast to that of the aristocratic Lake family ladies, who shine with respectability.

Two Ladies of the Lake Family is unusual for Lely insofar as the subjects of his group portraits are more commonly mixed, a man and woman, mother and child, etc. Yet even this departure from his usual practice is part of his legacy to future generations of portrait painters. Everything about this painting details the portrait-type that Lely bequeathed: an aristocratic setting composed of drape, column, and gentle landscape; the subjects in poses suggesting movement; rich contrasts of shading and highlight.

—Ann Stewart Balakier

Godfrey Kneller (1646–1723)
William Congreve, 1709
36 × 28 in. (91.4 × 71.1 cm.)
London, National Portrait Gallery

William Congreve, (1709) an example of Godfrey Kneller's bestknown series of portraits, the Kit Kat Club (1702–17), typifies many aspects of the series. These 42 portraits exemplify Kneller's technical highs and lows and his probing of character. The subjects of the paintings are the members of a Whig Party social group of the period of Queen Anne who opposed the Tory politics of the Queen's party. Jacob Tonson, the secretary of the group, commissioned the works. Congreve, the subject of this example (1670–1729), was one of the most eminent playwrights of the day.

Kneller's "head and one hand" style of composition, as in this example, is closely related to a stock type Kneller learned from Peter Lely's portraits. The strongest examples from the group are expressive variations of this type, aimed at revealing the sitter's personality. The less successful examples merely demonstrate meaningless gestures in compositions of low technical quality.

William Congreve exemplifies a mix of the best and less than the best of Kneller's output. Congreve's half-length pose shows him standing in the standardized type of setting developed by Lely and inherited by Kneller: an undescribed dark interior opening to a gentle wooded landscape. The indistinct tree-forms to the right of the figure seem ill defined and are undoubtedly an example of the poor work some studio assistant cranked out. Kneller has left out the drape and column

often included in the type. The figure points with what critics refer to as the familiar meaningless gesture common to so much of Kneller's work, his face and stance providing no clues as to what sort of man he is. The roundness of face describes a fashionable type of Kneller's time. The painting is much more rewarding technically and compositionally than as an exploration of personality. Kneller's thin fluid method shows off here to great advantage. The highlights on the coat, skin and hair display sensitive brushwork of broken strokes which capture light falling across varied textures. The lights and shadows contain elements of the silvery quality for which Kneller was so justly famous. The direction of falling light, however, seems calculated more for the lovely effect it produces than to add credibility. The silvery lights shining off clouds, trees, and water help to create the benign landscape so familiar in British portraits.

C. H. Collins Baker has raised an intriguing point about the periwigged portrait type, such as Kneller's *William Congreve*. It is his view that this type, no matter who did the painting, has been slighted. The inferior quality of so many portraits from this period, he argues, has resulted in a uniform dislike of all periwigged portraits. Whenever these same painters produce portraits without wigs, the paintings are invariably considered to be of higher quality and are more fairly appraised. His remarks seem to be born out by at least some of the qualities of the Congreve portrait. It is not the best work of the period, yet it is not the worst either. In all fairness, what Kneller does accomplish in this proficient though uninspired portrait should not be overlooked.

—Ann Stewart Balakier

Rosalba Carriera (1675–1757)
Louis XV As a Boy, 1720
Pastel on paper; 18¹/₂ × 14 in. (47 × 35.6 cm.)
Boston, Museum of Fine Arts

The 18th-century Venetian painter Rosalba Carriera was highly esteemed throughout Europe as a painter of miniatures on ivory and, more importantly, portraits in pastel. Although the medium of pastel had been in use since the 15th century for studies and copies of works in oil, it was not until the 18th century that colored chalks were used with great frequency for finished paintings. The French painter Joseph Vivien was already producing completed works in pastel by 1701, but it was Rosalba Carriera's fresh, spontaneous, almost impressionistic style that popularized pastels throughout Europe and rendered her one of the innovators of the Rococo period.

Carriera's portraits were particularly sought after by French visitors to Venice. One of these was the wealthy banker Pierre Crozat, who became good friends with the artist. Crozat convinced Rosalba to visit him in Paris, which she did from April 1720 to March 1721. It was during this very successful stay in France that Carriera painted her portrait of Louis XV.

According to the journal that Rosalba kept during her stay in Paris, the ten-year-old French King was one of her first patrons. She first saw him attending mass in the Church of Filles Saint-Thomas. Shortly after that she was asked to make a sketch of him for a miniature painting and later for a portrait in pastel. It appears that Louis XV was a good subject for the illustrious Italian portraitist, because his Governor the Duke de Villeroi commented on his patience during the sitting.

In her portrait of the King, Carriera managed to unite the hautiness and confidence of the monarch, with the sweet charm of a boy. The regal bearing and handsome face of this youth anticipate his later being called the most handsome man in France. Technically, the face is very detailed, but his hair and attire are rendered in a sketchier, more spontaneous manner. Rosalba was particularly known for her treatment of lace, as in Louis XV's cravat, achieved by sliding the flat end of the chalk over a darker color. It is interesting to note that Rosalba's mother was a lace-maker, for whom Rosalba executed pattern designs. Her facility for softly blended colors was also much admired, along with her adeptness at flattering the sitter while still capturing the character and likeness of the individual.

Carriera's portrait of the King was a great success and the artist was rewarded for it quite handsomely. The payment was not made immediately, however, due to French financial difficulties experienced by the collapse of John Law's "Mississippi Scheme" (Law also posed for Rosalba). The King's treasurer, M. Grain, finally delivered 3,000 francs in silver to the artist several months after the painting was completed.

It was based on the merit of the Louis XV portrait that Carriera was admitted to the Royal Academy in October 1720, although her actual reception piece was *Nymph from the Suite of Apollo* (1721, Louvre) painted after her return to Venice. It is a testament to Rosalba's talent that she was named an academician, since the quota of women allowed entrance to the academy at this time had already been met.

Rosalba Carriera's *Louis XV* portrait was so highly acclaimed that various courtiers requested copies of the work, which is why other versions exist, including one in the Hermitage, Leningrad.

—Kathleen Russo

Giovanni Battista Piazzetta (1683–1754)
The Parasol, 1745
77³/₈ × 57¹/₂ in. (196.5 × 146 cm.)
Cologne, Wallraf-Richartz

Bibliography—

Bombe, W., "Die Sammlung Dr. Richard von Schnitzler in Köln," in *Cicerone,* 10, 1918.
White, D. Maxwell, and A. C. Sewter, "Piazzetta's So-Called *Group on the Sea Shore,*" in *Connoisseur* (New York), 143, 1959.
Binion, Alice, "From Schulenburg's Gallery and Records," in *Burlington Magazine* (London), 112, 1970.

The *Parasol* was commissioned by Field Marshal Johann Matthias von der Schulenburg, an expatriot Saxon military commander in the service of the Venetian Republic. He was an enthusiastic patron of contemporary Venetian painting and ordered from Piazzetta two paintings, the *Pastoral Scene,* today in Chicago, and the *Parasol,* now in Cologne. The precise date of completion of the Cologne *Parasol* had been established by Alice Binion as 30 April 1745, when final payment was made to Piazzetta.

The *Parasol* is an important work in Piazzetta's career because it establishes the complete transition from his middle period to his late style. During the 1740's, Piazzetta explored the ideas of light and color in his paintings, as can be seen in the *Saint Vincent, Hyacinth, and Lorenzo Bertrando* for the Gesuati, Venice. Yet, this period also marked his trend towards the familiar dark palette of his early style. By 1744, the return was complete. The *Parasol* illustrates this in its use of varied color and dark shadows and the hazy quality in its treatment of light.

The difficulty with the *Parasol* lies not in its stylistic implications, but in its interpretation. In deciphering the meaning of two young ladies, of whom one holds a parasol, two peasant youths, and the head of a cow, Rodolfo Pallucchini had argued that the painting is typical of Piazzetta's large genre pictures and is meant to be only a pastoral fantasy.

D. Maxwell White and A. C. Sewter have challenged this view, for they see in the painting a commentary on 18th-century Venetian society. The girl with the parasol, a symbol of rank and refinement in the 18th century, represents the Venetian aristocracy on holiday. The second woman is a domestic servant or lady-in-waiting in attendance on her young mistress. The head of a cow establishes a pastoral note as do the peasant boys. The seated youth in the foreground, however, adds a note of discord with a smirk of contempt for the wealthy girl who turns her back to him. White and Sewter, therefore, argue that through this youth we are invited to see and judge an Arcadian pastoral through a peasant's eyes and that Piazzetta has given us a satire of a complex social issue.

Leslie Jones contends that there is no evidence that Piazzetta approached this subject with such cynicism or sociological sensitivity, or that such an attitude was embraced by Marshall Schulenburg who commissioned the painting. She believes that the painting's unusual iconography is rooted in a type of erotic genre imagery inspired by 18th-century Dutch examples and explained by 18th-century word usage. The key to the meaning of the *Parasol* is the cow's head, which was a symbol for a prostitute.

Because the *Parasol* is not named, but only described in the inventory of Schulenburg's collection, the title of the painting was first given as *Idyll on the Shore* by Bombe and picked up by later writers. Ugo Ruggeri believes this title is not appropriate because the scene does not take place on the lido of Venice, or any other seashore, but is set in the country on the Brenta River. The title he accords the painting is *Country Promenade.*

In addition to the present-day Cologne picture which was acquired by Dr. Richard von Schnitaler from an English private collection in 1896, a second version exists in the National Gallery of Ireland, Dublin. Scholars acknowledge the superiority of the Cologne version, and suggest Domenico Maggiotto as the artist of the second version.

—Susan Harrison Kaufman

Giovanni Battista Tiepolo (1696–1770)
Banquet of Cleopatra, 1740's
Melbourne, National Gallery of Victoria

Bibliography—

Levey, Michael, *Tiepolo: Banquet of Cleopatra,* Newcastle upon Tyne, 1965.

For a period of several years in the 1740's Tiepolo was pre-occupied with the story of Antony and Cleopatra, producing large paintings both in oil and fresco, as well as drawings of the subject. An episode which seemed to hold particular fascination for the artist and his patrons was the *Banquet of Cleopatra.*

In January 1744 Algarotti reported that he had arranged for Augustus of Saxony to acquire a painting from Tiepolo of the *Banquet of Cleopatra and Antony.* The painting, now in the National Gallery of Victoria, Melbourne, was begun sometime before "pour d'autres," and was presumably lying unfinished in the artist's studio. The mysterious "others" who had commissioned but not claimed the painting have never been identified. Two months later the completed picture was delivered to Dresden and Tiepolo received payment. This would appear to be Tiepolo's first large scale treatment of this theme although there is a drawing from the previous year.

The painting is an outright homage to Veronese. Pale, classical architecture forms a symmetrical backdrop; pairs of columns serve to isolate groups of exotic onlookers including two young blacks, a dwarf, and the shadowy, somewhat disreputable looking figure at the left. This is a cast of characters out of Veronese, in a Veronese setting. The costumes, particularly Cleopatra's prickly collared dress, have been updated not to Tiepolo's 18th century but to Veronese's 16th!

The story comes from Book IX of Pliny's *Natural History,* in a discussion of the properties of pearls. There has been a wager between Antony and Cleopatra about the amount of money she can spend on a banquet. She produces a rare pearl, drops it into a glass of wine where it dissolves, and drinks it.

The third person at the table is Lucius Plancus, a Roman whom Tiepolo, out of ignorance or licence, depicts as an eastern potentate. Nearly all eyes in the painting, including the dog's, are rivetted, as ours must eventually be, on Cleopatra's hand holding the pearl suspended above the glass. We are tempted to hold our collective breaths as we await, in the next instant, this truly extravagant gesture.

The orthogonals formed by the green tiles in the foreground not only lead the eye to the pearl but have a disarming tendency to follow the viewer across the face of the painting. Many a weary visitor to Melbourne spends a long time walking back and forth in front of this painting, held in thrall by the master's sleight of hand.

The various other versions of this subject, most notably the fresco in the Palazzo Labia, Venice, have their strengths but none is as compelling as the Melbourne painting. The Palazzo Labia work, commissioned by a family famous for lavish entertainments, shows the queen holding the pearl with one hand while reaching for the glass of wine on a servant's tray with the other. The low viewpoint, illusionistic steps, musician's gallery, bare-breasted heroine, and dwarf's derrière are all showy touches but the focus is diffuse. Antony and Cleopatra are callow, uncompelling figures. The eye drifts off into the sky toward the shimmering but irrelevant obelisk. The dramatic tension is lost.

In the Melbourne *Banquet of Cleopatra* Tiepolo used this purely secular story of royal excess for some extravagant gestures of his own. The dazzling yet controlled play of light, color, and space is as impressive as any of his work in oil, and his instinctively correct choice of the dramatic moment, shows that if Veronese was his artistic mentor, Shakespeare was his theatrical one.

—Frank Cossa

Pietro Longhi (1702–85)
The Geography Lesson, c. 1752.
24³/₈ × 16³/₈ in. (62 × 41.5 cm.)
Venice, Querini Stampalia

Pietro Longhi's *The Geography Lesson* (*La lezione di geografia*) is considered by Terisio Pignatti, among other scholars, to be a family portrait, partly because of its resemblance to the *Sagredo Family* in the same collection. If this judgment is correct, then this painting is one of the best examples of the migration of the English Conversation Piece, which originated in the circle of Hogarth in the 1720's and 1730's. While it may be a straightforward presentation of a family group at their leisure, it would appear to contain suggestions of Hogarthian satire as well.

The young woman who is the object of the lesson sits at a small table pointing to a globe and using a compass to measure distances. Two well-dressed gentleman assist in her study. A book of maps lies open on the floor, propped up on another volume. To the left a drape has been drawn aside to reveal shelves with weighty tomes carelessly arranged.

This certainly has all the characteristics of a typical Longhi genre piece, showing aristocratic Venetians at home. All that is missing is the ubiquitous masked visitor who lends a disquieting note to so many of these, or such anomalies as card-playing monks. Perhaps it is the very ordinariness of this scene that lends it credibility as a portrait rather than a piece of whimsy. Indeed, Longhi here has chronicled, as was often the case in his work, an actual contemporary phenomenon. Algarotti, who seems to have figured prominently in the affairs of 18th-century Venetian artists, had published a "Newtonianismo per le dame": science made simple enough even for ladies to understand.

Whether this lady understands any science, however, is highly questionable. She looks directly out at us, elegant and immensely pleased with herself. The portly gentleman seated at the left is supposedly reading aloud to her but is in fact looking up at her. The man standing next to her is peering through a monocle not, as we might expect, at the globe but at the presumably more compelling orbs that rise above the lady's flimsy bodice.

Clearly the only topography being studied here is that of the lady herself. She, not the globe, is at the center of the composition; she, not the globe, catches all the light. Her silvery blue dress and creamy skin glow against the dull tonalities around them. The lesson of this geography it that *she* is the center of the world; this world anyway.

No doubt exhausted by her labors *La Signora* has rung for some refreshment. Two servants arrive: one young, attractive, holding a tray with cups, and an old crone with the coffee or chocolate pot. This juxtaposition of beauty and ugliness, a traditional *Vanitas* image, allows Longhi another level of wry commentary in this already busy scenario.

There are a number of studies for this painting in the Museo Correr. One for the seated man shows him with a monocle, wigless, stooped, and with altogether more character than in the painting. Three studies of the young servant, from different angles, show her with a smaller head and longer proportions, more like the figures of Watteau or Chardin. Engravings of Watteau may have come to Venice with the French artist Joseph Flipart who later made engravings after Longhi. At any rate the connection with the style of the French Rococo is very strong in these drawings, if less so in the paintings.

The Geography Lesson shows Longhi to be much more than a mundane chronicler, as he is often described. He was clearly possessed of a satirical wit, not perhaps worthy of Hogarth but certainly rare among his contemporary artists in Italy. A close reading of these seemingly slight "conversation" pictures makes it easier to understand the high regard in which his contemporaries held him. A patrician diarist Pietro Gradenigo referred to the artist's "speaking charicatures," and Guarienti, in his *Abecedario pittorico* (1753) described his "whimsical and capricious skill."

—Frank Cossa

Jacopo Amigoni (1675?–1752)
The Story of Jupiter and Io, c. 1732
Moor Park, Hertfordshire

A series of four paintings, the story of *Jupiter and Io* was painted c. 1732 on the first-floor level of the two-story entrance hall at Moor Park, Hertfordshire. This series is Amigoni's best-known work and is an accomplished example of his Venetian Rococo style paired with mythological subject matter. The scenes derive from the tale of "Juno and the Peacock" in the first book of Ovid's *Metamorphosis.* The first painting is Jupiter's seduction of Io. The second is Io's transformation by Jupiter's jealous wife Juno into a white heifer, in order to keep Io away from him. Argus, in whose care Juno has placed the heifer, is lulled to sleep with music by Mercury, who has been commanded by Jupiter to kill Argus and set Io free. The third canvas shows Argus asleep, his head resting on a rock. Mercury is unsheathing his sword while Jupiter watches from a cloud. In the fourth painting, Juno, seated on a throne of clouds, receives Argus's head from Mercury. Behind her, the peacock, her favorite bird, displays its tail feathers, which have been richly patterned with Argus's eyes in commemoration of his deed.

The paintings are in Amigoni's mature style. The colors, bright rose and yellow and soft blue-gray, emphasize the same intensities as porcelain, an impression heightened by the presence of a chalky white. The figures, painted flatly with little shading, are softly blurred at the edges. They are placed close-up to the picture plane and arranged as if disposed across a stage. The impression of a shallow stage is furthered by a lack of depth in the setting. Strangely characteristic of Amigoni's figures is their relaxed attitudes, which contradict the emotions which supposedly rage within them.

Amigoni's style is believed to have been influenced, along with a knowledge of French Baroque art (e.g., the works of Nicholas Poussin, who pioneered the same theatrical manner of presentation in the seventeenth century), by his many theatrical connections. He spent about 12 years before coming to England, in fact, working at the strongly French court of the Elector of Bavaria where he would certainly have been exposed to such influences.

The paintings making up the story of *Jupiter and Io* were instrumental in the spead of Venetian Rococo influence in England. They not only introduced a lighter palette and gayer more relaxed mood, but also helped to popularize the Venetian practice of substituting canvas-covered walls for plaster surfaces in decorative wall painting, an innovation much better suited to humid climates than the fresco method.

Benjamin Styles, the owner of Moor Park, had originally commissioned James Thornhill to enlarge and reface the exterior and to decorate the interior. But a bitter quarrel occurred over payment after Thornhill had finished the decorative paintings in the entrance hall. In his anger over losing the subsequent lawsuit (1727), Styles removed Thornhill's interior decorative work and hired Amigoni and others to redecorate. In the process, the interiors of Moor Park mark the change from a Baroque decorative treatment to a Rococo one.

—Ann Stewart Balakier

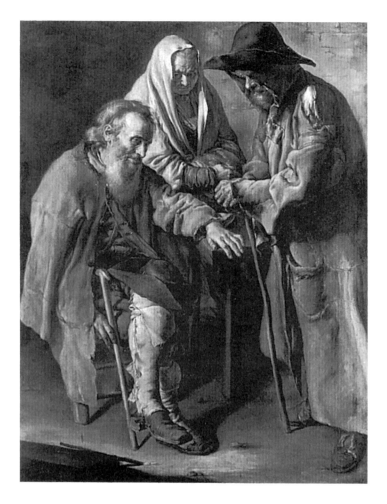

Giacomo Ceruti (1698–1767)
A Group of Beggars
48⅝ × 37 in. (123.5 × 94 cm.)
Lugano, Thyssen-Bornemisza Collection

Italian Baroque painters explored "low life" subject matter for both its source of picturesque interest and its potential to evoke more serious human themes. The depiction of beggars, gypsies, and other humble or indigent people was not always free from condescension. Giacomo Ceruti's first genre style, influenced by the trivializing approach of the Brescian Antonio Cifrondi and by G. F. Cipper (called Todeschini), retains vestiges of caricature. Ceruti's portrayal of *A Group of Beggars,* however, unites an extraordinary degree of realism with an insistence on the dignity of his poor and aged sitters.

Three elderly people are grouped around a simple table in poses of calm containment: their bowed heads suggest reflection rather than abasement. The dramatic monumentality of the painting derives in part from its compositional strategies. The crowded disposition of the figures seems to be concentrated about a tight central juxtaposition of three gnarled hands. The repose of the hands and the artist's compassionate attention honor their resigned acceptance of hardship, elevating them above apathy or despair. Although the three do not make contact, their bodies incline toward one another. The concerned glance of the woman standing at the center and a suggestion of solicitude in the posture of the man to the right (his face obscured) indicate an emotional relation corresponding to the formal one. These three are bound together chiefly, perhaps, by the common miseries of age and impoverishment: yet Ceruti's precise rendering of each wrinkle and tatter in no way overshadows the bonds of sympathy and human worth with which the artist has compellingly endowed them.

Mina Gregori has identified this canvas with a painting of *Three Old Peasants* sold from the Schulenberg Collection in 1775, and acquired, in all probability, as *Three Beggars* (for the meagre sum of eight zecchini) in February 1736. This provenance provides a much-needed point of reference for Ceruti's chronology, and dates the picture to 1735–36, at the beginning of the artist's activity in Venice and Padua. This is the moment of Ceruti's transition into his mature style, evidenced in *A Group of Beggars* by the combination of naturalistic detail and and emotional depth.

In March 1736, Schulenberg paid another eight zecchini for a painting of *A Beggar with a Little Girl.* In subsequent Schulenberg inventories, and finally in the London sale catalogue of 1775, Ceruti's two paintings are always considered as a pair. Gregori has published the photograph of a painting that may be the untraced pendant to the present *Group of Beggars.* These two images of poverty are as moving as any that have ever been represented in art.

—John T. Spike.

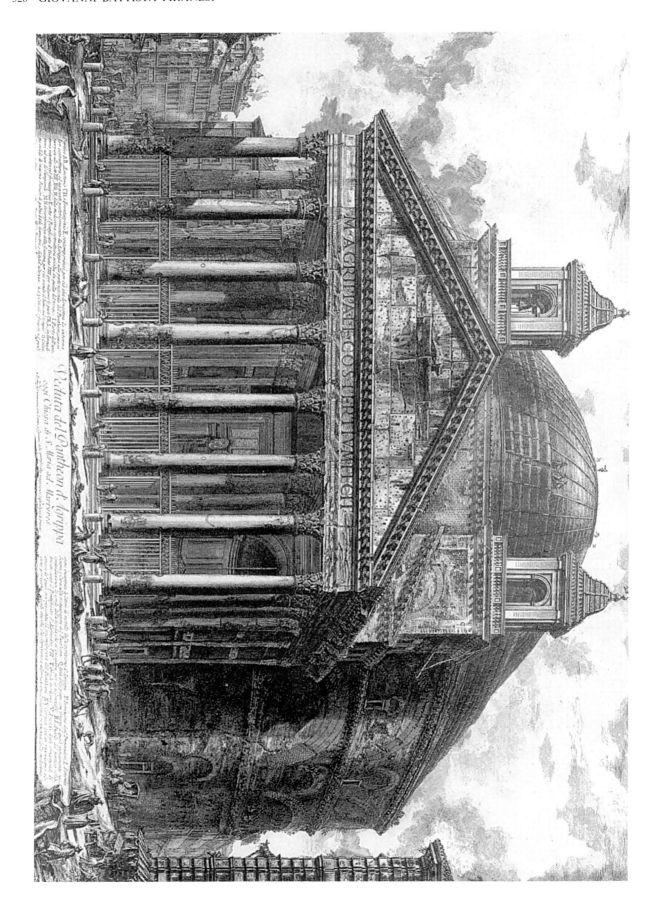

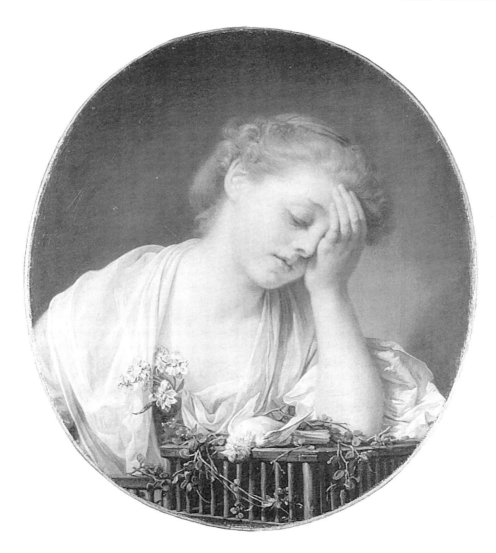

Jean-Baptiste Greuze (1725–1805)
Young Girl Crying over Her Dead Bird, 1765
Oval; 20 × 17 in. (50.8 × 45.7 cm.)
Edinburgh, National Gallery

When *Young Girl Crying over Her Dead Bird* was exhibited at the Salon in 1765, it was greeted with overwhelming praise and admiration by the influential critic Diderot. He proclaimed it "The most agreeable and perhaps the most interesting" of the works presented, and continued, at length, to mention the profundity, melancholy, beauty and overall "deliciousness" of Greuze's painting. Diderot's enthusiasm for Greuze was not limited to this work, for he was a major supporter of the artist during the initial development of his career.

This painting is one of many by Greuze that explores the theme of lost virginity. It was inspired by a poem by Catullus entitled *De Passere mortuo Lesbiae,* in which the author implores the Graces to cry over the death of his *"petite mignonne's"* bird. A literal reading of the work shows a young woman's sadness in her first encounter with death and loss. The theme of a bird out of its cage as a symbol of lost virginity, however, had already been popularized in France, most notably in the many works depicting this theme by Boucher.

Other similar symbols for virginal deflowering, also treated by Greuze, included broken mirrors, broken eggs, and broken pitchers. The *Broken Pitcher* (Louvre) of 1773 is a well-known example.

Greuze had a penchant for displaying the feelings of melancholy and sadness that follow this rite of passage. He was influenced towards moral narratives by the works of William Hogarth. His women, however, display more of a bittersweet reverie than the clinging desperation and overt dishevelment of Hogarth's women in the works he entitled *Before* and *After* (1798, Cambridge) that dealt with this same theme.

The decade in which this work was painted was the most successful for Greuze, beginning with his highly acclaimed *The Village Bride* of 1761 (Louvre). His paintings of this period were executed in a lush, painterly style that was inspired by an admiration for Rubens and Van Dyck. By the end of the century, his style becomes dryer and his compositions more contrived. After 1769, his popularity began a slow decline. By the time of his death in 1805, his moral narratives and senuous young women reflecting on their lost innocense, of which *Young Girl Mourning over Her Dead Bird* is one of the most charming examples, were no longer fashionable.

—Kathleen Russo

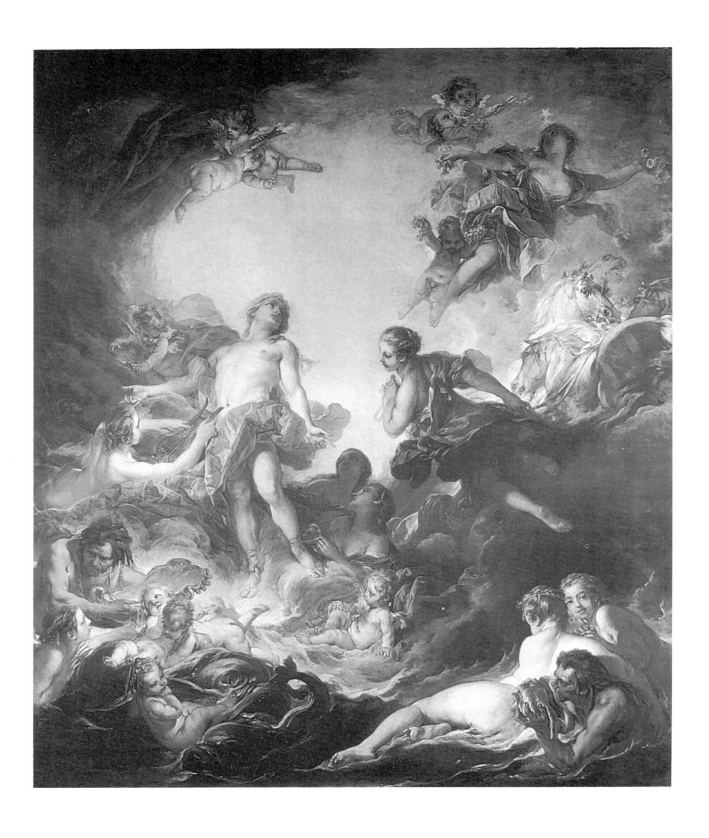

François Boucher (1703–70)
The Rising of the Sun
10 ft. 4 in. × 8 ft. 8 in. (315.9 × 264.1 cm.)
London, Wallace Collection

This radiantly innocent yet mysterious work comes from a half-decade when the artist painted some of the masterworks which were to place him in the ranks of the great decorative painters of the European tradition. This, and its pendant painting, *The Setting of the Sun* (also in the Wallace Collection), where, at close of day, Apollo is received by his court as he descends from his chariot, are considered among the most beautiful of French 18th-century images. Boucher himself placed them among his lifetime favorites, and they were to be among his last large works.

The commission of these works points to the two most creative and lucrative opportunities which Boucher received. In 1734 J. B. Oudry hired the still-young Boucher as co-director and designer of the tapestry manufactory at Beauvais. Working later for the Royal manufactory at Gobelins, Boucher composed *The Rising of the Sun* and its pendant as tapestry cartoons. During a cleaning in 1949, it was found the *The Rising of the Sun,* as was usual practice for cartoon paintings, had been initially painted entirely in grisaille and only later overpainted; the pendant painting is without such underpainting, and was from the outset conceived in full color.

The distinction might be explained in that the original commission was from Louis XV himself; when the picture was already at the manufactory, it was perhaps discovered by Madame de Pompadour—Boucher's patron and (even) friend, she was mistress to the king—and somehow she was able to obtain the pictures for her chateau at Bellevue. The paintings, after their service as tapestry designs, became a part of Mme. de Pompadour's collection, but the tapestries, for reasons unknown, were sold in 1768 and lost from history. While some of Boucher's tapestry designs are paralleled by other paintings, these two works are among those subjects he did not treat in any other form.

The image itself presents the darkened and watery edge of the world, where Apollo—in a posture taken perhaps from a martyrdom or assumption—is about to accept the reins of his celestial chariot. In the upper right corner, Aurora, the goddess of dawn, with the morning star gleaming faintly over her forehead, rises in the brightening sky while scattering flowers; at the upper edge of the picture, the curtain of night is held up by a pair of cupids. A hovering nymph extends the horses' reins to Apollo. Perhaps befitting his representation here as a gentle shepherd type—Boucher is said to have had trouble inventing male protagonists—and as if to display the effortless-

ness of the task, Apollo's hands are shown awaiting the reins in an exquisite position with inner digits curled and outer digits extended. Other nymphs prepare him for his voyage across the heavens by tying his sandal lace and handing him his lyre. The supernatural allegory is eased into a gentle and human disorder with cheerful good humor through the presence of the playful cupids; Boucher's ease with children gave him access to a world of essential childish innocence which saves his cupids from sterile abstraction.

It has been remarked that Boucher's mythologies are free of drama since nature is for him associated with relaxation. The overall mood of the spectacle here is to dissipate the grandeur in favor of the pleasantly mundane, and so the high invention here is truly pictorial. It has been difficult to find sources for Boucher's manifestation in the work of the shimmering passage of night to day, since previous artists had been loathe to undertake such descriptive virtuosity. Even Boucher in a smiliarly watery kingdom (e.g., *Triumph of Venus,* 1740, Stockholm) presents only a diffused lighting scheme.

The vigorous assemblage of figures within a spiraling compositional framework seems indebted to the inventions and aura of Rubens, readily accessible in the work for Marie de' Medici (1621–25). Closest in format to *The Rising of the Sun* is the *Landing at Marseilles,* where the water is filled with tritons and naiads. Boucher retains Rubens's virile male triton type for his watery denizens who try to divert the attentions of the naiads. In his generally female-populated mythic images, Boucher tends to use a more corpulent (and Rubens-like) female body type to designate a higher rank (Aurora and the reins-bearing nymph). Boucher owned several drawings, including 12 studies of horses, by Rubens.

Both *The Rising of the Sun* and its pendant present the youthful god as the subject of worshipful adoration by female attendants. In such a setting, clearly a metaphor of the royal career of Mme. de Pompadour, it has been suggested that her portrait might be alluded to in the face of the naiad at the lower left. In 1751 Mme. de Pompadour was in a new suite of rooms, not shared with the king, yet her influence at court only increased after the close of her love affair. Works of art which she commissioned or which were associated with her, became compelling emblems of her personal stature. Perhaps *The Rising of the Sun* appealed to her as a memorial to her intimate relationship with the king.

—Joshua Kind

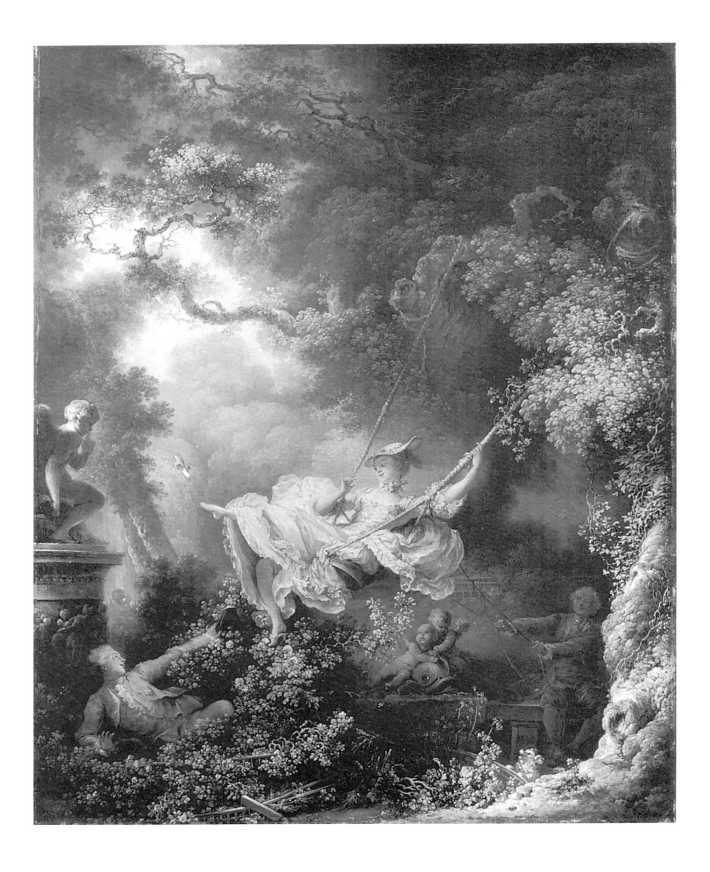

Edmé Bouchardon (1698-1762)
Fountain of the Four Seasons, 1739–45
Marble, Tonnerre stone, and bronze
Paris, Rue de Grenelle

Constructing a fountain in the Rue de Grenelle, in the prestigious Saint-Germain quarter, was mooted during the Regency. The project remained at a standstill, however, until in about 1735 the nuns of the Recollettes convent granted the City of Paris the necessary land.

Since his return from Rome in 1732, Edmé Bouchardon had been celebrated as a sculptor of considerable note, and an initial agreement regarding the fountain was reached between the merchants' representative, Michel Turgot, and the sculptor in 1739.

The main drawback was the cramped position of the fountain, which backed on to a wall flanking a narrow street. Having worked in Rome on the reconstruction project for the Trevi fountain and seen the fountains designed by Bernini, Bouchardon could not fail to regret the lack of open space which would have allowed the fountain to be viewed in proper perspective. Since he was responsible for both the architecture and the decorative sculpture, he resolved to give his preference for monumentality full reign, even if this meant risking the criticism that he had built a stone wall rather than a fountain: a few taps, through which thin streams of water flowed, were the sole indication of the construction's utilitarian function. But what did it matter? After all, Bouchardon himself had not selected the site, which was too small to accommodate a large pool with waterworks. And what the artist demonstrated here went well beyond the argument over function: the work was a neoclassical manifesto masterfully reconciling antiquity with the study of the living model, and achieving this in the middle of the rococo era.

The work comprises three distinct sections set against a slightly concave wall. A projecting section in the centre immediately strikes the eye, having a portico and three monumental sculptures in marble: the *City of Paris* in the guise of a seated woman, framed by personifications of the *Seine* and the *Marne*, lying horizontally. The two wings are decorated in Tonnerre stone on the theme of the seasons: the statues of four winged *Génies* are installed in niches overtopped by four bas-reliefs depicting *Children's Games*, their attributes reflecting the seasons of the year.

The work was finished in 1745: Bouchardon had required only six years to conceive his *chef-d'oeuvre* and bring it to completion. He is known to have made numerous drawings relating to this commission. He also made careful studies from life—doing detailed drawings of the anatomy, gestures, and expressions of children and adolescents. Thanks to his long stay in Italy, he had a thorough knowledge of key classical works—the young *Mercury* in the Pitti Palace and the Borghese *Faun*. The winged *Génies* in particular—inspired by classical medals, as the sculptor himself indicates in his specification of materials—are not idealized in the manner of classical models but present the physical irregularities of

adolescents seen in the street; they also exhibit that solidity, that physical heaviness, which is exclusive to Bouchardon's art, opposed as it is to the use of any superfluous lines. However, in rejecting a decorative bias, he risks a certain stiffness in his bas-reliefs: the children are silhouetted in isolation and take part in their games without the playfulness and good humour of those sculpted by Duquesnoy or (later) Clodion. Bouchardon's children are haughty individuals drawn, in stone as on paper, with a concern for contour and correct proportions, and fitting with difficulty into an overall composition.

This balance between "antiquity" and "nature," to use the terms of the 18th-century critics, is less visible perhaps in the three marble statues of the projecting section, whose solemnity is strongly reminiscent of the great Roman model. The *City of Paris* (terracotta version in Dijon; plaster version in the Musée Carnavalet, Paris) is a sumptuously dressed matron reminiscent of the classical *Polymnia* and *Agrippina*. The *Seine* (terracotta in Dijon) is allegorized as a bearded masculine figure lying stretched out, and is fairly banal in conception. The young woman personifying the *Marne* (two terracotta versions in Dijon and the Louvre) is more surprising: the motif of the female figure leaning on an urn from which water is flowing was to be taken up and used exhaustively in engraving, and became a commonplace. Bouchardon's figure, however, with her opulent bosom and sturdy hips aggressively advertising her femininity, is virtually stripped of all idealism.

A possible point of reference for the two rivers in the fountain was the cascade in the gardens of the Château of Saint-Cloud realized by Bouchadon's rival, Lambert-Sigisbert Adam. Though Bouchardon despised Adam, whose style was deliberately influenced by Bernin's and clashed with his own tendencies, he could not have remained indifferent to the principal motif of the cascade, the models of whose central grouping were exhibited at the 1737 Salon; indeed, Adam's *Seine* and *Marne* are direct forerunners of Bouchardon's horizontal masculine and feminine figures. But if Bouchardon roughly reproduced the Saint-Cloud figures and their arrangement for his fountain in the Rue de Grenelle, he nevertheless inserted them in a monumental setting which quite transformed them, and, above all, he sculpted them using a formal analysis which went far beyond Adam's treatment of the same motif.

Bouchardon far outranked his rivals as the master of "this pure preference for antiquity, this solid and wise preference which the study of nature in all its beauty can alone convey," according to the beautiful text which Bouchardon's loyal friend Mariette published in 1746, therein hailing the Four Seasons Fountain as one of the monumental masterpieces of Paris.

—Guilhem Scherf

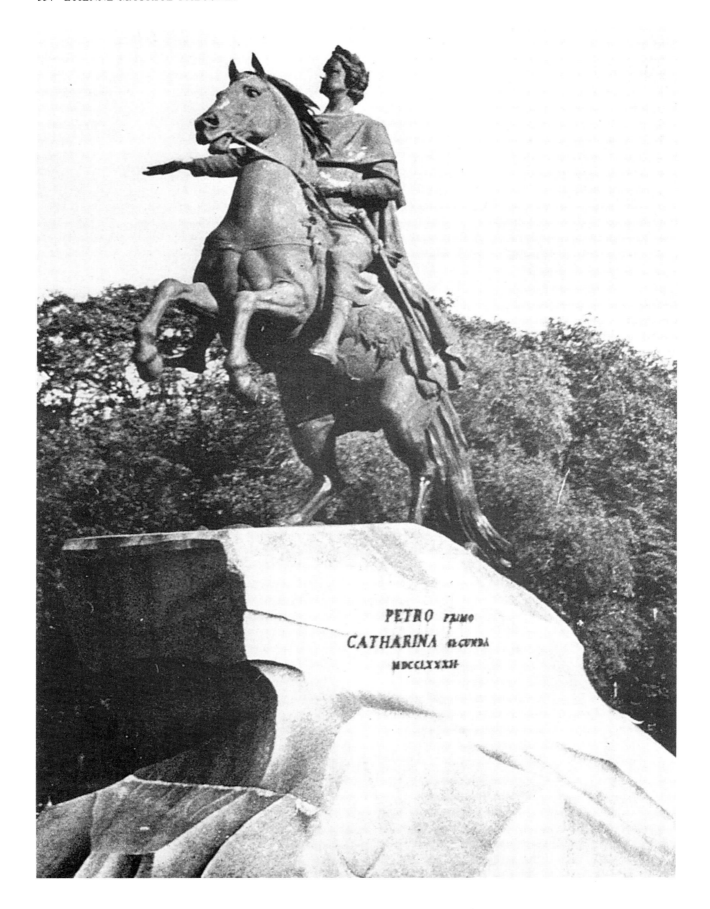

Etienne Maurice Falconet (1716–91)
Peter the Great, 1767–78
Bronze; 17½ ft. (533.4 cm.)
Leningrad, Peter Square

Bibliography—

Kaganovich, A., *The Bronze Horseman* (in Russian), Leningrad, 1975.

The equestrian statue of Peter the Great facing the river Neva which stands in Peter Square, Leningrad, is not only an imposing work of art in its own right but also encapsulates many historical and literary references which are barely comprehensible to non-Russians. A monument to Peter I by Count Carlo Bartolomeo Rastrelli (whose architect son was to design the Winter Palace and other notable buildings in St. Petersburg) was erected in 1744. Conventional in design, stodgy in effect, it depicts Peter glaring ahead of him, crowned with a laurel wreath and clothed in antique attire, seated on a rather docile steed. On her advent to the throne, immediately after the murder of her husband in 1762, Catherine II (the Great) set out to establish her supremacy as imperial sovereign of Russia. Since by origin she was a minor German princess, penniless and protestant, a variety of strategies was called for to promote herself as a worthy successor of Peter, among them the creation of an image of herself as a cultured, enlightened, and benevolent ruler of a modern state. A memorial to her great predecessor was an integral part of this project. To this end she conceived the idea of a monument which would in some way, however indirectly, link her own genius with his. Her agents and correspondents in Europe, among them Diderot, suggested one name to her: that of Etienne-Maurice Falconet. Negotiations for him to come to Russia went on through 1766, an initial contract was issued in December that year, and he arrived in St. Petersburg in 1767.

Falconet had achieved fame with his *Milo of Croton* (1754), which like so much of his work looked back to the *rocaille* elements in French sculpture and forward to the growing spirit of neo-classicism which mixture he occasionally infused with something of the sentimentality of Greuze. Catherine's commission set him a task far beyond his previous experience. He had no practice in modelling an equestrian group, of casting and setting up an immense statue still less. Nor had he any models close at hand apart from Rastrelli's monument. Peter had died in 1725, but there remained a mask taken in life as well as numerous portraits so that a life-like portrait was feasible as far as the face was concerned. This task was given to Falconet's pupil, the able M. A. Collot (later to become his daughter-in-law) who had accompanied him to Russia. The finished model exhibited in the artist's studio in 1770 seems to have attracted little attention, although the originality and slpendour of the monument as it was planned would not have been easily apparent on the model's smaller scale. Falconet's inexperience in casting, the lack of trained workmen, squabbles with Count Betskoy, Director of the Imperial Academy of Arts, over his salary, and the material difficulties involved in carrying out his conception so wearied him that he left Russia for good in 1778.

The casting of the statue and its erection on a huge black of granite were carried out entirely by Russians. The huge boulder on which it rests was found at Lakhta near St. Petersburg and pulled over an iron tramway, rolled over canon balls and floated on a kind of pontoon drawn by two ships to the capital. Five hundred men and vast numbers of horses were employed for five weeks. Eventually the granite block weighing 1500 tons, 14 ft. in height, 20 ft. wide and 43 ft. long was hauled into place. The bronze statue, weighing over 16 tons and 17½ ft. in height, was then hoisted on top. Catherine placed an inscription in Russian and Latin on either side of the pedestal-rock: "Petro Primo, Catherina Secunda MDCCLXXXII." After Catherine's death, in a spirit of jealous rivalry, her son Paul had Rastrelli's statue placed near his St. Michael Palace with the inscription: "To the Great-Grandfather from the Great-Grandson." Neither Rastrelli's statue nor Paul's action could look anything other than puny against Falconet's group and the vision of its imperial begetter.

Falconet depicted Peter reining in his horse on the brink of the massive rock on the front of which as well as at the two sides steep precipices threaten his immediate destruction. His stern but eager face looks over the Neva, his outstretched arm indicates his will to conquer all obstacles, while a serpent, emblematical of the enemies and dangers he had overcome, is trampled underfoot by his charger. The rider and horse are balanced on its hind legs and tail which are joined to the body of the serpent which acts as an anchor. The irrepressible energy with which Falconet invested the group hides the technical achievement of the Russian foundrymen who varied the thickness of the metal from 1 inch to ¼ inch so that the centre of gravity lies immediately above the horse's rear hooves and thus allows its startled rearing. The modelling throughout is of superb quality.

Apart from the work's intrinsic artistic qualities and its political and historical significance, Falconet's equestrial group has its place in the literary and artistic life of St. Petersburg. The power that it holds over the city's imaginative life finds expression in Pushkin's "The Bronze Horseman" and the novel *Petersburg* by the symbolist writer Andrei Biely. It was a subject beloved of the *Mir Iskusstva* artist's such as Benois and Lanceray, few of whom failed to depict its terrifying power. Even now, on a moonlit night, when the waters of the nearby Neva gleam coldly, its silhouette commands awe. It partakes of both the rococo, baroque, and neo-classical aspects of Leningrad, and represents a triumph not only for Falconet whose masterpiece it was but also for the Russian genius for overcoming enormous material difficulties and for acquiring new techniques with incredible speed and efficiency when the occasion so demanded.

—Alan Bird

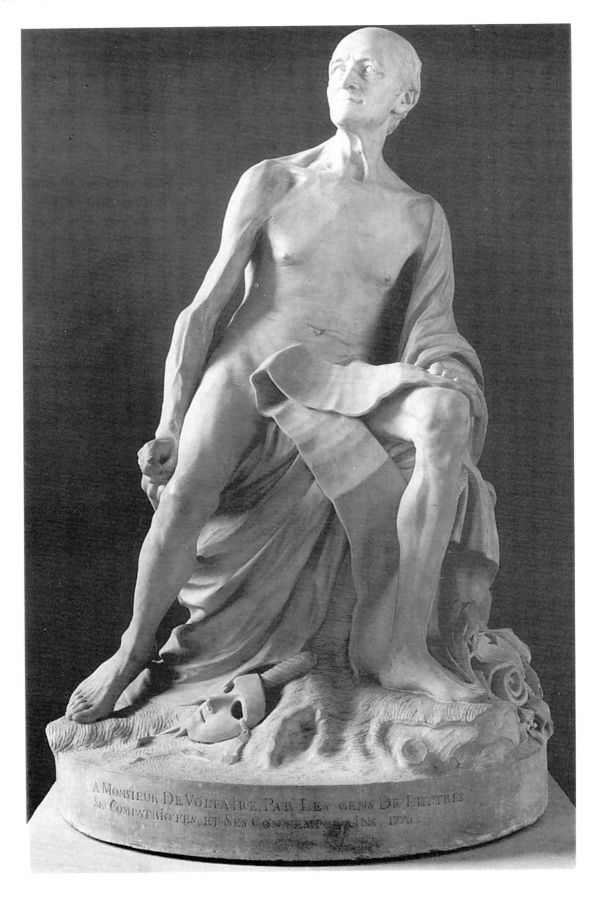

Jean-Baptiste Pigalle (1714–85)
The Nude Voltaire, 1776
Marble; 59 in. (150 cm.)
Paris, Louvre

On 17 April 1770 Mme. Neckar entertained a group of men of letters to dinner, including Diderot, Grimm, Helvetius, the abbé Raynal, Marmontel and the sculptor Pigalle. The sculptor showed the guests a terracotta sketch (Orléans) for a statue immortalizing Voltaire, and financed by public subscription. The decision to erect a statue of a writer during his lifetime was exceptional, and put him on the level of a monarch. Because the group had accepted his sketch of a naked Voltaire, with only his shoulders covered by a drapery, Pigalle made the journey to Ferney and recorded the philosopher's face in a terracotta study with a truthfulness which was enthusiastically received. Henceforth, the artist was given a free hand to treat the statue as he intended. In his memoirs, the abbé Morellet, who had been at the dinner, attributed to Diderot the idea of the naked pose and of making "an antique statue like the Seneca cutting his veins." The celebrated *Dying Seneca* from the Borghese collection (now in the Louvre), in reality a dying fisherman according to Winkelmann, had inspired Rubens. Jérôme de Lalande, who was closely involved with Diderot and the group around the *Encyclopédie,* in his *Voyage en Italie* (1769) considered that the *Seneca* was a masterpiece and remarked how edifying it was to witness the death of a virtuous man. Diderot, who wrote an essay on Seneca, defended the nude in his *Essays on Painting:* "Nude figures . . . do not offend us. Flesh is more beautiful than the most beautiful drapery . . . in showing nakedness the scene is distanced, a more innocent and simple age is recalled . . . it is because we are discontent with the present, and because this return to antiquity does not displease us . . . it was the custom of the Greeks, our masters in all the Fine Arts."

In his depiction of Voltaire, by referring to the model of the so-called Seneca and to antique heroic-nudes, Pigalle created a work inspired by neo-classicism. But the reaction of Quatremère de Quincy, who saw the work in Pigalle's studio and condemned it as too naturalistic, was that Pigalle "had come to exaggerate the reality of individual imitation to the point of banishing the general idea of beauty. . . . [The statue of Voltaire] has become a sort of mythological study which, despite the lack of a convenient location, would be more suited to the decoration of a school of anatomy" (*Notice . . . sur la vie et les ouvrages de M. Houdon,* 1834). Its fault is that Voltaire is presented nude in the classical style but his body, instead of being idealized, is that of an emaciated old man. Whereas Seneca's was beautiful, rugged, and powerful, Voltaire's is skeletal and flaccid, precisely described by Pigalle, always aware of physiological accuracy through his contact with surgeons and anatomists, notably the famous Ferrein.

The sculpture was badly received. Mocking, Rosseau insisted he become part of the subscription, launched after the dinner at Mme. Neckar's. Gustaf III of Sweden, passing through Paris, wished to subscribe, but towards a coat. Voltaire attempted to make Pigalle give way:

> Que ferez-vous d'un pauvre auteur
> Dont la taille et le cou de grue
> Et la mine très peu joufflue
> Feront rire le connaisseur?
> (What would you do about a poor author
> whose waist and crane's neck
> and so gaunt appearance
> will make a connoisseur laugh?)

but faced with the sculptor's obstinacy he yielded, writing to his friend Tronchin on 1 December 1771: "I can only admire the antique in the work of M. Pigalle; naked or clothed does not matter. . . . M. Pigalle, the absolute master of the statue, must be left alone; it is a crime of the fine arts to try to shackle genius." This magnificent pronouncement on the independence of the artist echoes Diderot (letter to Pigalle, 1756) in relation to the tomb of the Maurice of Saxony: "A great artist such as you should rely on himself more than anyone."

Completed in 1776, the marble statue was put at the disposal of the subscribers, offered to Voltaire, then relegated to a provincial castle and finally to the corridors of the Institut de France. This resulted in it hardly being seen before its permanent installation in 1962 at the Louvre. The "official" representation of Voltaire, following the tradition of "Great Men" commissioned by d'Angiviller from 1776, is the one that Houdon produced (1781, marble, Comédie Francaise; preparatory terracotta, 1778). This shows Voltaire draped in a gown, his head bound by a philosopher's fillet (in the classical tradition), and "corrected" the image of Voltaire as interpreted by Pigalle. His Voltaire has a spiritual and refined smile which accords with his reputation; the classical refences do not impose in such an intellectual manner as with Pigalle. Without violent contrasts, antiquity is suggested by the great folds of the gown, evoking a toga. The neo-classical adaptation is more accessible than Pigalle's provocative formula.

One of the artist's commentators, Joubert, in his *Eloge de Pigalle* (c. 1786) contrasted Pigalle's approach with that of classical sculptures. Pigalle avoided all trace of the "ideal" in his works, since he was a supreme sculptor and the ancients were "poets."

—Guilhem Scherf

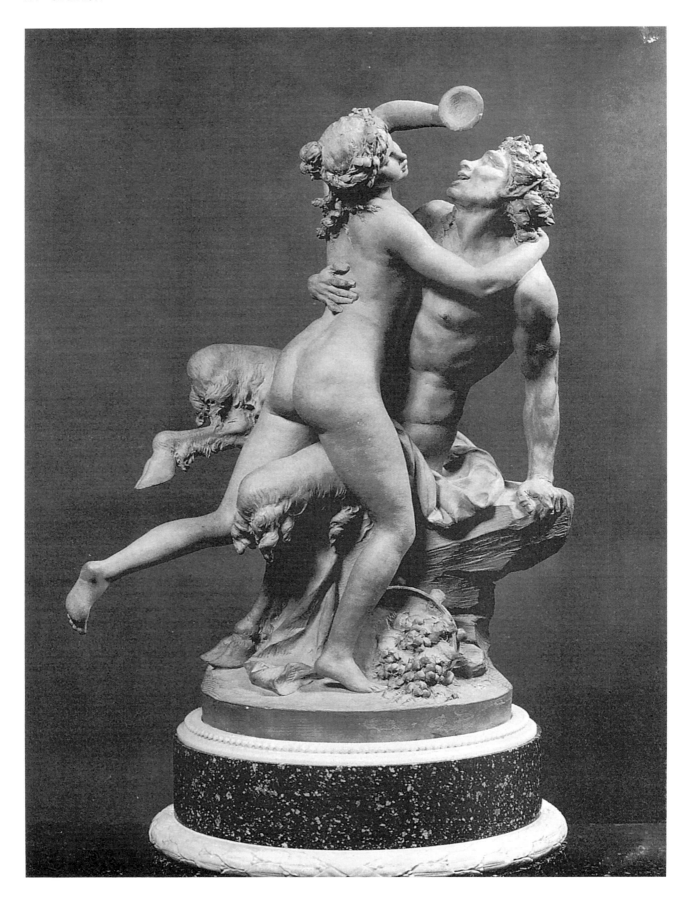

Clodion (1738–1814)
Nymph and Satyr (The Intoxication of Wine), c. 1770–80
Terracotta; 23¹/₄ in. (59.1 cm.)
New York, Metropolitan

This ravishing work, both in aesthetic power and invention, would universalize intoxication to all the senses. The sculpture is here at Clodion's usual small scale for terracotta—the fired clay seemingly a material he was born to concentrate his career upon, the first sculptor to do so. The tactile immediacy and warmth of the clay—which would often appear, especially earlier in his career, as rough and spontaneous—further intensifies the salacious yet, usual for Clodion, disarmingly innocent and warmly pleasurable intimacies depicted. Despite his great gift for conveying the joyous animality of man, Clodion at times realized a broader narration by including a child in such Bacchic groups, mischievous and involved, and urging the adults on to fiercer revel. By that same genius by which he avoided an erotic vulgarity, so did he avoid sentimentality to produce a haunting poignance which allowed such works to sell well from the moment of their first appearance. It may be that by simply being sculpture, Clodion's terracotta was able to achieve a lilting sensuality distinct from the inherently more abstract Rococo in paint; but it was also his knack in translating, in these works of Bacchic urge, Baroque urgency, impersonal and perhaps unself-conscious, into Rococo individualizing desire. This *Nymph and Satyr,* for instance, is said to have its distant yet essential prototype in Bernini's *Apollo and Daphne.* In this regard, Clodion was led to understand the transition of style by the works of his uncle Lambert Sigisbert Adam; he was able to study and work in his studio for a few years during his late teens. It used to be felt that he gained little there, aside from the important working knowledge of a studio operation which allowed Clodion to continue the family sculptor dynasty when he himself set up shop in Paris. Even though there was an identification of the Adam studio with large-scale and outdoor work, there was also a lithe decorativeness in such work which the young Clodion clearly absorbed. Since few of the Adams terracottas have been preserved, it was felt that their primary use was as models for larger work in metal or stone. Recently a fuller picture has been constructed which permits Clodion's art to be seen as a continuation of the delicate Rococo strain in L. S. Adam's 1725 *Bust of Amphitrite* (Chicago). Small Bacchic works of his uncle, all in terracotta are also now known; and Clodion's grandfather, Jacob Sigisbert Adam, was a court sculptor in Clodion's native Nancy, and was famed for his small-scale terracotta sculpture.

For some reason, Clodion himself dated his work only from 1766 to 1770 and from 1795 to 1805, so the chronology of his large output remains problematic. It would appear that a work such as the two *Vestals,* c. 1765–70 (Sackler Collection), shows a looser surface modelling than a work such as *Running Satyr,* c. 1770–80 (Waddesdon Manor), which appears to parallel the *Nymph and Satyr* in its handling as well as the musicality of its motion. In our work, the garlanded hair of both celebrants, his shaggy lower legs, and the fallen tambourine with its grapes all appear as opportunities for freer manipulation in contrast to the more smoothly modelled expanse of skin. Clodion apparently wished to be held as a sculptor of wide range and at his infrequent appearances in the Salon he would present work in marble as well as in terracotta. But he is to be remembered in the great tradition of French artists such as Poussin, Watteau, Boucher, and Fragonard, because his grasp of the pagan, the classical, and the Rococo somehow allowed him to produce work of deep humanity. Although presented chastely, this work is surely one of the great sexual works in the Western tradition. Its complete acceptance of the erotic moment may well also hang upon a concept not frequently met before the 20th century—as if the satyr has sat down exhausted from the orgiastic chase which the nymph would continue.

—Joshua Kind

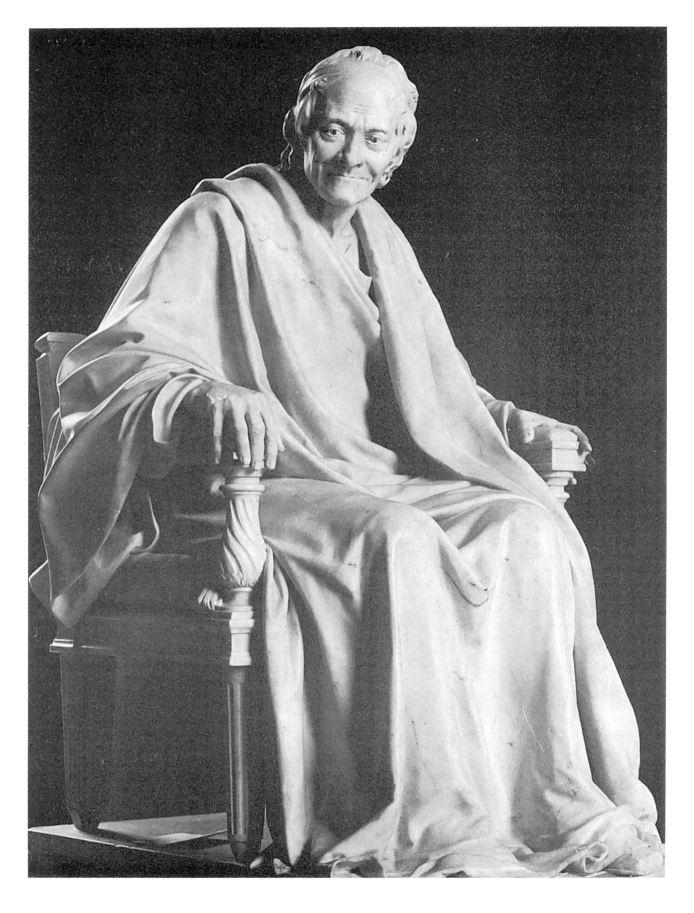

William Hogarth (1697–1764)
Marriage-à-la-Mode, c. 1743; engravings, 1745
27 × 35 in (68.5 × 89 cm.)
London, National Gallery

Bibliography—

Wensinger, Arthur S., and William B. Coley, *Hogarth on High Life: The "Marriage à la Mode" Series from Georg Christoph Lichtenberg's Commentaries*, Middletown, Connecticut, 1970.

Cowley, Robert L. S., *Marriage à-la-Mode: A Re-View of Hogarth's Narrative Art*, Manchester, 1983.

The first plate of *Marriage-à-la-Mode*, Hogarth's most ambitious and complex progress, may well be the most significant of its six tableaux. Here Hogarth introduces the key personae in this domestic drama and its dominant themes: the decay of the aristocracy, the foolishness of middle-class ambitions, and the plight of women. The remaining five scenes play out the narrative set in motion by the commercial transaction sealed in this initial picture.

Set in a chamber in Lord Squanderfield's house, the primary characters are not the bride and groom but the agents of this merger, the fathers. The corpulent Lord Squanderfield has come upon hard financial times. Through the window, we can see that the construction of his Palladian house has been suspended for want of money. The mortgage conspicuously displayed on his table is further evidence that the Earl is heavily in debt. Regardless of his fallen fiscal state, he hold dominion in his quarters with a grand air of self-importance. He sits upon a throne-like chair and points with assumed dignity to his lineage which descends from William the conqueror, while his other hand gestures officiously to his own elegantly bedecked self.

There is shamelessly little pretense in his acknowledgement of what he is selling, his social position. Across the table sits the other primary player, an Alderman who trades his middle-class daughter for elevated social status. More simply garbed, he scrutinizes the arrangement with mercantile precision, making certain he gets what he has bargained for. His emptied money sacks have been discarded upon the floor next to his chair.

The two principals in the drama are secondary actors in this tableau; they sit off to the side, just as the human dimension of this transaction is merely an aside. The young daughter's sullen posture expresses her downcast spirit at the contemplation of a loveless marriage to the silly fop sitting with his back to her upon the settee. Although her pout indicates her resistance to this union, she is resigned to it.

The final character, the bridegroom himself, is juxtaposed to his father; his awkwardness contrasts with the older man's self-assured arrogance. The son is perched on the edge of the seat, lost in his own self-contained world of pleasure, gazing at himself in the mirror and enjoying snuff. He is effete to the point of effeminacy. He is so self-absorbed that he fails to see the image of disaster looming in Silvertongue's reflection in the mirror, where the lawyer coos into the bride's ear.

In the second plate, the young couple's household has already fallen into dissolution. Though yoked in matrimony, the couple continue to pursue separate pleasures. At first, the bride is exhilarated by a new awareness of her own sensuality.

She enjoys middle-class pleasures—long evenings of card parties and music at her new home. She also discovers a new sense of independence from the domination of males like her father, albeit this power is due to her spouse's husbandly neglect.

The third plate shows the husband occupying himself with increasingly decadent gratifications that yield decreasing satisfaction. His degradation becomes steadily more abhorrent as he takes a young girl as his mistress, and he frequents the demimonde of whores and quacks. Syphilis also seems to have taken hold; the mark on his neck may be a venereal sore.

Unchecked, the bride pursues her own downward course in Plate 4. While her entertainments were first confined to the more public rooms of the house, by the time the old Earl has died and she and the new Earl have an offspring, she now entertains her friends and Lawyer Silvertongue in her bedroom; he lolls languidly upon a sofa as milady's hairdresser primps her for the evening's masquerade ball.

In Plate 5, her ladyship's dalliance comes to its inevitable end, discovery. The countess and Silvertongue leave the masquerade that night and scurry off to a bagnio or brothel. The husband, who has learned of their affair, finds them there. Unfortunately, Squanderfield proves no more successful as a swordsman than he did as a husband and lover. Silvertongue mortally wounds him, and as he expires in a moment of suspended pictorial animation, his wife falls to her knees and begs forgiveness. Silvertongue exits unceremoniously via the window, dressed only in his shirt.

In the final scene of this drama, her husband dead and her lover hanged, Lady Squanderfield chooses suicide by a self-administered dose of laudanum. Slumped in a chair, she awaits her death. A wizened old nursemaid brings her young daughter for a final embrace. Together these three women form a tableau of genuine affection. The mother is openly grieving, and her frightened child reaches out to her in a desperate attempt to hold on to her dying parent. The old woman who has watched this sad drama play out grimaces in anguish. She can foresee still another sorrow. The little girl, soon to be orphaned and left to the charge of her mercenary grandfather, the Alderman, will probably fare no better than her mother. The child's inability to surmount the hindrances of her gender and her class is symbolized by the braces on her crippled legs. In addition, she also shows signs she has inherited her father's venereal disease. She is even less marketable than her mother.

By the drama's conclusion, four of the principal players have died: the elder Lord Squanderfield, his son, Lawyer Silvertongue, and the Alderman's daughter. Only the Alderman remains, like his solitary, starving dog in the last scene, gnawing at scraps of a pig's head upon his master's table. Hogarth's moral is clear: if the middle-class, in their eagerness to climb up the class ladder, abandon their values, they will be infected with the corruption that has caused the decline of the aristocracy: avarice, moral bankruptcy, and the lack of genuine human sensibility. Hogarth depicts this tragedy with chillingly, witty realism.

—Jeanne S. Weiland

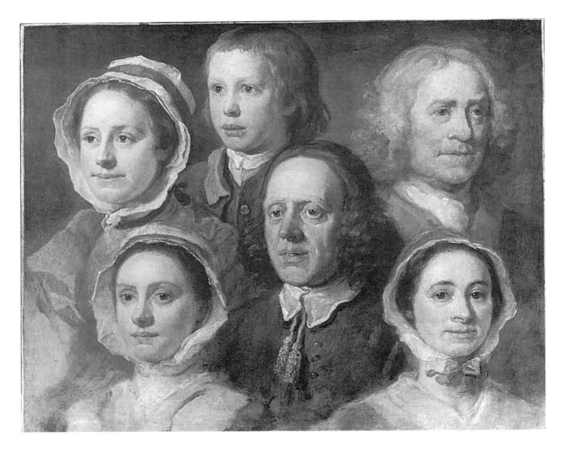

William Hogarth (1697–1764)
Hogarth's Servants, mid-1750's
24¹/₂ × 29¹/₂ in. (62.2 × 75 cm.)
London, National Gallery

Hogarth's Servants was painted by the artist for his own pleasure in the mid-1750's, toward the end of his career. Though the heads of Hogarth's three maids and three menservants seems to be arranged in a spontaneous and arbitrary fashion, they are ordered with considerable art. At the center of the picture is the Hogarth's chief steward, the most fully realized of the six people. He is surrounded by a constellation of faces that contrast with his: two to the left, two to the right, and one youthful visage directly above him. The faces of the six servants show different sexes, ages, and temperaments, from the somber stewart to the bright, innocent boy to the cheerful, mature woman next to him.

All six visages are executed with sympathetic realism. Hogarth makes no attempt to hide his subjects' flaws; his steward has heavy eyelids, a ruddy nose, and buck teeth. On the other hand, the artist does not obscure his servants' plain good looks. The young boy's blooming cheeks, full, sensual lips, and shining eyes makes him the centerpiece of the picture on account of his cherubic appearance. In all the studies, Hogarth's eloquent, simple technique reveals the artless charms of his servants, their warmth, and their deep humanity.

Who are these people and what tasks did they perform in Hogarth's household? Only the name of the old man with the white wig in the right hand corner of the painting has survived. He is Ben Ives, the artist's most devoted and admiring

servant. The different functions of the six people are also lost, though it is possible to guess what they did. In the center of the picture, the man with the curled, brown wig is Hogarth's butler; he may also have served as Hogarth's valet, for his decorative tassels show he is well-dressed. To his left, Ben Ives is probably the coachman, while the youth across from him who wears his own hair is a scullion and messenger boy, in all likelihood.

The woman with the green ribbon on her bonnet, to the left of the *major domo*, is the housekeeper. Her two subordinates are the cook (directly below) and Mrs. Hogarth's personal maid, who wears a little bow under her chin. In the 18th century, the households of middle-class professional people would have consisted of at least five servants, so Hogarth's retinue of six is not unusually large.

Nor was it unusual for artists to paint portraits of their housekeepers. *Hogarth's Servants* belongs to an important branch of English portraiture depicting maids, nurses, menials, and other "necessary" people. The artist's celebrated *Shrimp Girl* (c. 1740) also belongs to this class of performance. The portrait painter John Riley (1646–91) was the best-known practitioner of this form of limning in the generation of British artists preceding Hogarth. Riley's *Scullion* (Christ Church College, Oxford) shows a handsome young man performing his daily kitchen chores within the precincts of the college cloisters, while his *Bridget Holmes* (1686, Windsor Castle) depicts James II's melancholy housemaid of 96 years of age brandishing her mop at a mischievous page boy.

—Sean Shesgreen

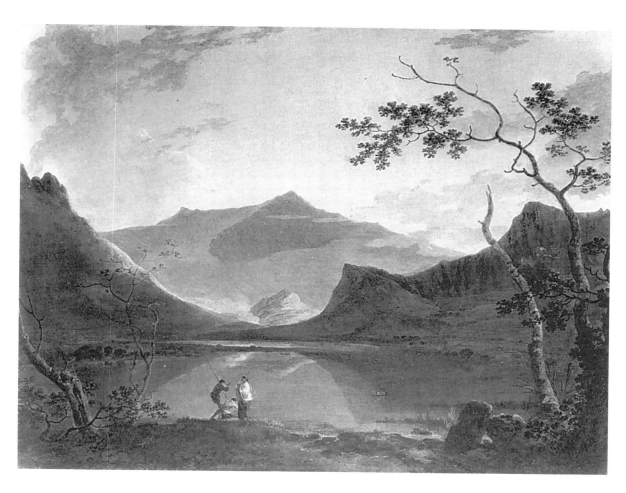

Richard Wilson (1714–82)
Snowdon from Llyn Nantlle, c. 1765–66
39³/₄ × 50 in. (101 × 127 cm.)
Liverpool, Walker

Wilson painted this view for William Vaughan, a distant relative and one of the richest landowners in north Wales. Wilson painted Welsh landscape throughout his career, selling it mainly to the Welsh landed gentry—often newly rich from industrial enterprises like mining—who in the mid-18th century were taking an immense and patriotic pride in their own country. Vaughan was the first President of the Honourable Society of the Cymmrodorion, founded to promote Welsh culture. This Celtic Revival also attracted interest in England, where poems such as Thomas Gray's "The Bard" (1757) were popular.

Snowdon postdates Wilson's sojourn in Italy and is strongly influenced by the paintings of Claude. The composition is arranged in carefully controlled planes of alternating light and dark so that the eye is led into the landscape down a central axis. The tree in the right foreground is a typical Claudean device, although instead of making it heavy-leafed and shadowy, as happens with Claude, Wilson has attenuated it to a few curving branches, silhouetted decoratively against the light. This rococo delight in decoration is also apparent in the elegant curves of the mountain ridges: Wilson made several changes to the left hand mountainside and its reflection in his

search for a crisp elegance of outline. Although he exaggerated the steepness of some of the peaks, Snowdonia does not appear as a threatening place; the highest peak is kept decently far off, the lake is glassily calm, and the small scale of the foreground vegetation is comforting.

The sense of an ordered, harmonious world is reinforced by a luminous blue sky and three figures placed centrally in the foreground. They are fishing and chatting—rural figures at ease in the landscape, burdened by neither idleness nor back-breaking labour. Wilson was painting for a landowner who would have been reassured by his vision of happy peasantry, and proud to own part of a country which Wilson has depicted as a modern-day Arcadia.

As was his practice, Wilson made a second version of this view (Nottingham) which differs only in minor details. One of the versions was shown at the Society of Artists (a forerunner of the Royal Academy) in 1766. The six previous shows held by the Society had contained only two Welsh landscapes by any painter; that of 1767 had seven. Wilson's views, produced for Welsh patrons, seem to have given an impetus to the discovery of Welsh landscape by English travellers. Wales was increasingly explored and depicted by artists; Turner made his first visit in 1792. By the time Wordsworth wrote of climbing Snowdon in *The Prelude* (1805), the mountain was acquiring a central position in Romantic consciousness.

—Susan Morris

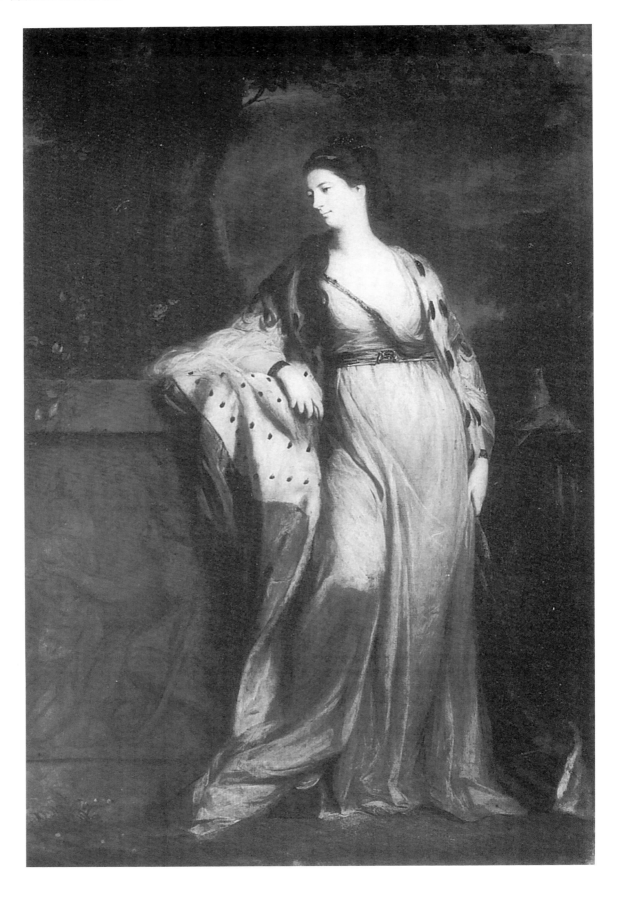

George Stubbs (1724–1806)
A Horse Frightened by a Lion, 1770
37 × 49³/₈ in. (94 × 125.5 cm.)
Liverpool, Walker

Stubbs first painted the Lion and Horse theme in 1762. By the mid-1790's he had produced at least seventeen variations on the subject in oil, enamel, print, and Wedgwood plaque. His treatments of the motif fall into two principal groups: first, the lion stalking and frightening the horse, and second, the lion on top of and clawing the horse's back. The Walter picture is a variant on the first episode.

Stubbs's obvious fascination with the subject has been variously accounted for. The most fanciful originates in an article in *The Sporting Magazine* of May 1808 which relates that when Stubbs was returning to England from Italy in 1755, he visited North Africa and that, from the fortified wall of Ceuta in Morocco, he witnessed a lion stalk and kill a horse. The most straightforward and likely explanation lies in the antique marble statue of a lion devouring a horse, on show at the Palazzo dei Conservatori in Rome. The statue was well known and copied with variations by several sculptors, on both a large and small scale.

Stubbs stayed briefly in Rome in 1754. Normally, artists went to copy Renaissance pictures and antique statues, paying homage to the masters of the past, as both Reynolds and Wilson did in their sojourns there in the 1750's. Osiaz Humphry, Stubbs's biographer, suggests that this intention was far from his mind and that he preferred rather "to look into Nature for himself and consult and study her only." Despite this stated naturalistic bias, it is testimony to the pervasive strength of the classical idiom that it should have provided the basis for the most repeated them in Stubbs's entire work. It is not unreasonable to speculate that of all the statues that Stubbs might have seen at Rome, this, with its direct affinity with natural history, unsullied by deistic or historical overtones, would have appealed to him most strongly. There seems to have been a steady market for Stubbs's repeated images on the Lion and Horse theme. They conformed to the tenets of what was, in the 1770's, a newly developing aesthetic of the "sublime." Sublime in current usage is a superlative synonymous with the notion of peerlessness, but in the latter half of the 18th century it was more closely connected with the awesome, and was given theoretical validity in the writings of Edmund Burke. In common currency it was seen in the emotional indulgence by the spectator induced by mildly fearsome or violent narrative episodes or the more severe and wild type of landscape. Stubbs's picture combines threatening landscape, a windswept and mountainous desolation, and the impending violence of the horse's attack. It is a sublime, indeed almost a Romantic image.

According to Humphry, Stubbs studies one of the horses at the Royal Mews, where the startled fear in the beast was achieved by pushing a brush directly at its front hooves. Stubbs had access to private zoos and menageries in and around London, and had opportunity to study lions at close quarters. However, for all the evident panic in the horse, expressed in its frightened gaze, taut muscles, and protruding veins, the diminutive scale of the lion in this picture suggests that the horse rather than the lion is the stronger contestant. The wild landscape background is close in spirit to, if not actually based upon, that of Cresswell Crags in Derbyshire, included in a picture painted three years earlier, and is of a type used by Stubbs in several of his paintings of wild animals. Kept deliberately dark in tones it throws into relief the white horse, adding to the drama of the painting.

The picture was painted as a pendant to the *White Horse Attacked by a Lion* (Yale University Art Gallery), which shows the lion devouring the horse's back in a pose closer to the Palazzo dei Conservatori statue

The Lion and Horse pictures may be collectively seen as Stubbs's attempt to break out of the stereotypical role of horse painter. It is perhaps ironic that what was for Stubbs an exercise in giving an elevatory tasteful and classically associated lift to his subject matter should have produced a series of paintings, of which this is the best example, that have been claimed by several historians as among the most potent of late 18th-century images heralding later Romantic horse painting by artists like Gericault and Delacroix.

—Frank Milner

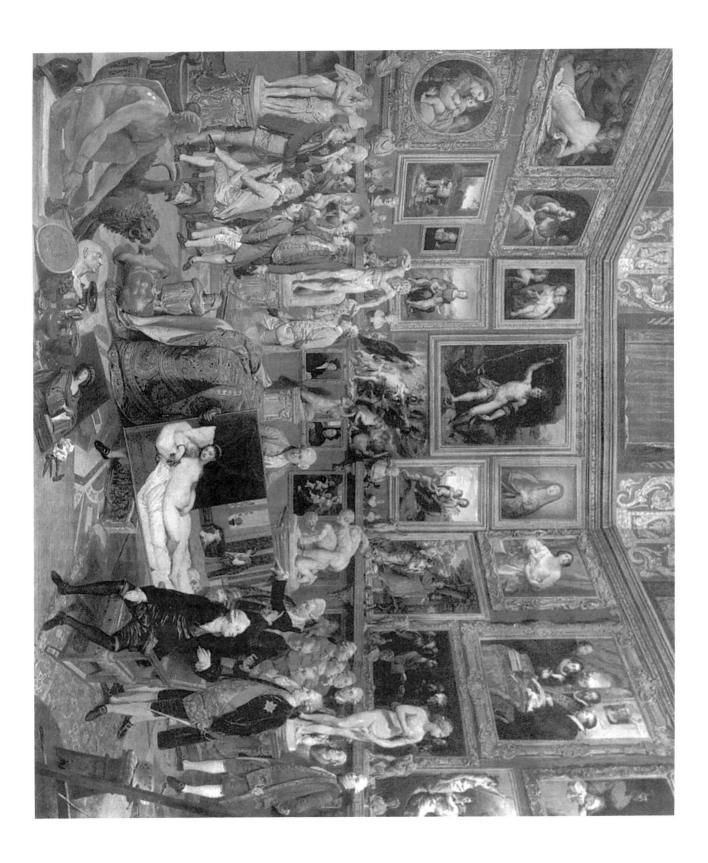

Johann Zoffany (1733–1810)
The Tribuna of the Uffizi, 1774–80
47⁵/₈ × 59¹/₂ in. (120.9 × 151.1 cm.)
Royal Collection

Bibliography—

Millar, Oliver, *Zoffany and His Tribuna*, London, 1967.

Zoffany's abortive plan to accompany Captain Cook's expedition to the South Seas in 1772 left him in an unfortunate position: he had sold his property and possessions in anticipation of the journey, and he had eagerly anticipated the excitement of travelling. As a compromise, Zoffany accepted a commission and a stipend from Queen Charlotte to go to Florence to paint the celebrated picture gallery in the Uffizi, the *Tribuna*. As neither George III nor Queen Charlotte had seen the gallery for themselves, the work was to provide them with a vicarious view by an artist known for his ability to depict detail faithfully and convincingly. The Queen's letter of introduction gave Zoffany special dispensation to make copies of work in the Grand Duke of Tuscany's collection, and Zoffany thus had no real obstacles to overcome in order to fulfill his commission to the best advantage. However, the painting was not completed until six years later. In the interim between the commissioning of the work and its exhibition at the Royal Academy in 1780, the original conception of a documentary view of the Uffizi Tribuna gradually evolved into a conversation piece with many figures, and a less than accurate indication of the actual paintings and sculptures on display in the Tribuna itself. The painting was both a reflection of Zoffany's virtuosity and an indication of his artistic idiosyncrasies.

Zoffany's work follows a Flemish tradition of depicting picture galleries which was popular in the 16th and 17th centuries among such artists as David Teniers, Willem van Haecht, and Jan Bruegel. The view of a room crowded with paintings allowed the artist to show his ability to reproduce accurately the styles of different masters. Zoffany had established this quality in his own work already. In his portraits of the royal children Zoffany included actual paintings which hung in Buckingham House and invented others. Zoffany also introduced pictures on the back wall of some of his theatrical conversation pieces, such as the *Scene from "Love in a Village"* (c. 1765; version London, National Portrait Gallery), where they seem to serve a decorative function rather than indicate the actual stage setting. This scrupulous rendering of the style of diverse masters can likewise be seen in the *Tribuna*, where Zoffany revealed his skill in representing works by such varied artists as Titian, Rubens, Guido Reni, Holbein, and Pietro da Cortona. He also showed his facility in reproducing picture frames, statues and other miscellaneous art objects, such as an Etruscan helmet and jug.

A second characteristic of Zoffany's style reflected by the *Tribuna* is his manipulation and falsification of reality. Of the works of art depicted, at least one sculpture and six paintings were not actually in the gallery at all while Zoffany was painting there (Millar, 1966). Although these other works were in the Pitti Palace, Zoffany included them in the *Tribuna* to produce a more satisfying composition as well as to enhance the quality of the collection itself. Furthermore, it would have been impossible for all of these works to fit in the modest Tribuna, so Zoffany also had to alter the relative scale of the paintings to accommodate this problem. In the centre of the composition is Titian's *Venus of Urbino*, removed from its frame and being admired by a group of connoisseurs. This painting was the prize of the Grand Duke's art collection and his protectiveness of it did not usually permit such intimate examination. By manipulating reality in this way, Zoffany provided a wider range of excellent art objects and created a more varied composition in which to display his artistic virtuosity.

The greatest divergence between the original intention and the final result in Zoffany's *Tribuna* is the presence of the many connoisseurs in the painting. These are all portraits of Englishmen who visited Florence during Zoffany's stay there. Some, like the British Envoy, Horace Mann, and the Consul, Sir John Dick, were notable public figures whose presence in such a work could not have been questioned. Others, such as the artist Thomas Patch or the obscure "Mr. Gordon," were merely making the Grand Tour circuit, and their inclusion in the painting was lacking in the propriety expected of a royal commission. When Zoffany finally finished the painting and returned to London with it, several observers spotted the lack of decorum in the presence of these figures, and the King and Queen were shocked at the impropriety. However, the work was a critical success, and it confirmed Zoffany's ability to produce a complex, multi-figure subject that was nevertheless compositionally pleasing and adept in its handling of a wide range of faces, pictures, and sculpture.

—Shearer West

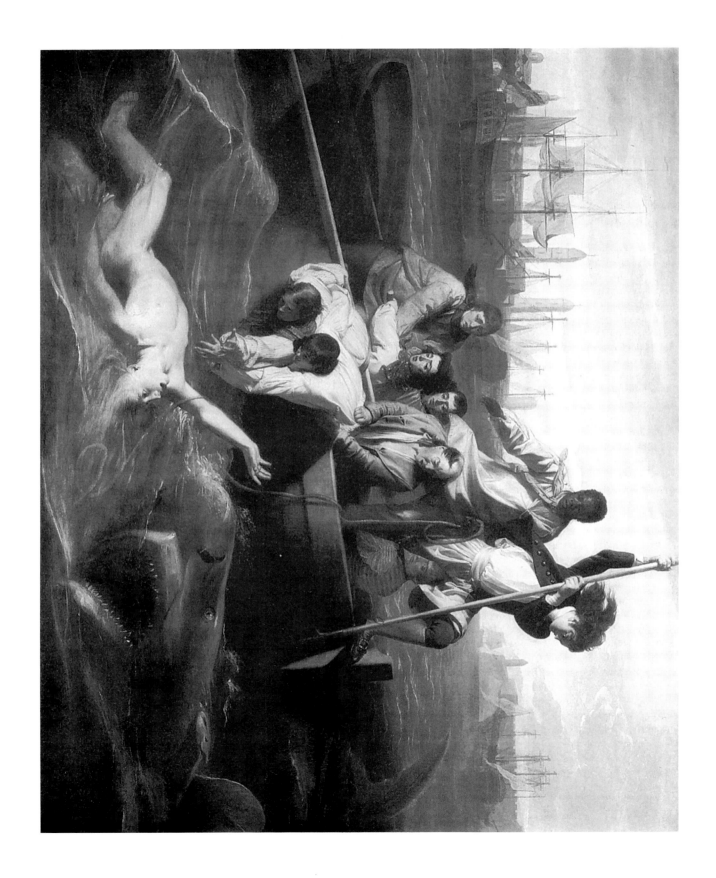

John Singleton Copley (1738–1815)
Watson and the Shark, 1778
5 ft. 11⅝ in. × 7 ft. 6⅜ in. (182.1 × 229.7 cm.)
Washington, National Gallery

Bibliography—

Jaffe, Irma B., "Copley's Watson and the Shark," in *American Art Journal* (New York), May 1977.

Watson and the Shark is an uncommon example of a painting which almost singlehandedly lifted an artist up from obscurity. It established Copley's reputation in England as a well-known history painter and shifted the focus of his career away from portraiture.

The painting, from 1778, depicts an actual event from the life of the prominent London merchant Brooke Watson (1735–1807). Watson, who would later become Lord Mayor of London, had been attacked by a shark in 1749, while swimming in Havana Harbor. Even though circumstantial evidence suggests that Watson may not have commissioned the original painting, and that Copley may have selected the subject himself, it is clear that Watson at least owned an artist's copy of the work, if not the original itself.

In creating the scene, Copley chose to depict the most dramatic moment in Watson's struggle, when the shark was making a third pass, already having stripped the flesh from the lower portion of Watson's right left and having severed his foot and ankle. The outcome of the confrontation is not predictable from the evidence in the painting. Swift and powerful, the shark approaches, a figure of death surrounded by darkness, about to destroy the young Watson. Watson appears to be in a state of shock, staring into the leviathan's massive jaws, unable even to grasp the rope or the sailors' hands. At the Royal Academy exhibition of 1778, a description next to the painting made it clear that Watson escaped death. It read: "A boy attacked by a shark, and rescued by some seamen in a boat: founded on a fact which happened in the harbor of the Havannah." This description also served the purpose of informing the viewers that Copley's work was a history painting, recording a contemporary event.

Copley had been very astute in selecting or agreeing to paint this subject: it provided the kind of challenging and dramatic theme he required for a successful competition piece. He used the opportunity well, displaying his technical skills in passages such as the two strongly foreshortened sailors who reach toward Watson and in the depiction of Watson's nude figure under water. Moreover, Copley employed an impressive array of brushwork, from rather tight detailed sections reminiscent of his earlier colonial period (for example in the men's faces) to fluent bravura brushwork (in passages such as water and clothing). The majority of contemporary critics received the painting warmly. They praised Copley for his rendering of a variety of expressions, for his draughtsmanship and use of color, and for his display of artistic erudition. The London *Morning Chronicle* stated, "We heartily congratulate our countrymen on a Genius, who bids fair to rival the Great Masters of the Ancient Italian Schools."

By emulating the old masters, and following the art theory of figures such as Joshua Reynolds and Charles du Fresnoy, Copley was consciously participating in the tradition of the Grand Manner. Although *Watson and the Shark* is founded on historical fact, and its background based on vedute prints of Havana, the scene has clearly been "improved" by selective ordering and distillation. In portraying the incident, Copley adopted old master conventions, including a Claudian sky, a pyramidal composition set off by strong diagonals, reminiscent of Rubens's lion hunts, and a traditional zigzag movement back into space. He also borrowed figural positions from established masterpieces. Among the sources suggested for the figure of Watson is the *Borghese Gladiator* (Paris), the *Laocoon* (Vatican), and the demoniac boy in Raphael's *Transfiguration* (Vatican). Through this painting Copley not only reaffirmed past artistic traditions, but also participated in the late 18th-century practice of contemporary history painting.

In an effort to create a "modern" image Copley emulated Benjamin West's *Death of General Wolfe* (1770; Ottawa), a pioneering contemporary history scene in which the figures are depicted in modern dress. *Watson and the Shark* differs from West's painting in its representation of an event which is historically unimportant, its lack of didactic content, and its depiction of a subject more attuned to late 18th-century interest in the macabre and the sublime. Like George Stubbs's contemporary images depicting savage animal struggles, and Philip de Loutherbourg's landscapes, Copley's scene embodies Edmund Burke's ideas of the sublime. By placing Watson and the attacking shark in the extreme foreground, against the picture plane, Copley effectively amplifies the painting's sense of immediacy, emotional pathos, and horror.

Through the Havana location, as well as the prominently placed black sailor, Copley may have intended to remind viewers of his North American heritage, an exoticism which he had previously assisted Benjamin West's reputation. Scholars have also proposed that the painting includes such complex allegorical themes as salvation through redemption in the church, and the conflict between the old and the new world.

Watson and the Shark became very popular, and a mezzotint engraving after the painting sold well in 1779. Copley held great affection for the work and kept a copy of the painting, which is now in the Museum of the Fine Arts, Boston, in his studio. He made another, smaller, copy, now in the Detroit Institute of Arts.

A watershed in his career, *Watson and the Shark* played an important role in establishing Copley's reputation in England. Strongly rooted in its time, this late 18th-century painting also strikingly anticipates early 19th-century romantic history paintings such as Gericault's *Raft of the Medusa* (Paris).

—Randall C. Griffin

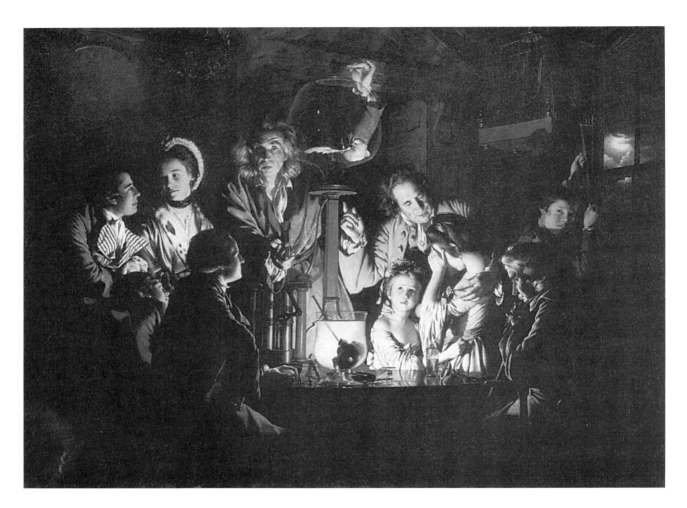

Joseph Wright (of Derby) (1734–97)
An Experiment with an Air Pump, 1766
6 ft. ¹/₂ in. × 8 ft. (184.2 × 243.8 cm.)
London, Tate

Bibliography—

Busch, Werner, *Wright of Derby: Das Experiment mit der Luft-pumpe: Eine heilige Allianz zwischen Wissenschaft und Religion,* Frankfurt, 1986.

In a letter of 1772, James Northcote, a protégé of Sir Joshua Reynolds, named Joseph Wright of Derby "the most famous painter now living for candlelights." The term "candlelights" refers to a class of painting that is characterized, irrespective of subject, by a single source of illumination—a candle, fireplace, or forge. This stylistic mannerism, sharply lit figures that reside in deep, hollow spaces and bright, forward surfaces, was not Wright's invention. Ultimately, one must go back to the Italian baroque artist Caravaggio to find its source. It is most likely that 17th-century Dutch *caravaggisti,* such as Honthorst, Valmarijn, and Hendricksz, most influenced Wright. The dramatic intensity of his pictures, however, and their complex psychological portrayal, are wholly characteristic of Wright.

Wright exhibited his first "candlelight" painting in 1765 at the Society of Artists. The following year he sent a larger and more fully realized oil, *An Experiment with an Air Pump.* The subject of the picture is a gathering of a group—diverse in age and in interest—to witness a scientific demonstration. By means of a pump the air in a glass bowl is evacuated to the point that the bird within is near death. The demonstrator is about to release a valve to reintroduce air into the chamber to save the bird. The group's reaction, sharply caught by the dim light of a hidden candle, is varied. A young couple on the left is concerned only with one another, ignoring, in sharp contrast, the lecture of the intense and impassioned scientist. Adjacent, a young boy and a man are in rapt attention. On the right of the table, a "philosopher"—a figure that appears occasionally in Wright's paintings—ponders the demonstration, while nearby a father comforts his two daughters, who are frightened by the convulsions of the imprisoned bird. In the back of the room, near a window that frames a mysterious moonlit landscape, a lad lowers a bird cage to place the revived animal.

Unusual as the subject is, there are other paintings by Wright of scientific experiments and demonstrations which indicate the level of popularization that was occurring in science and technology in 18th-century England. As such, in addition to being examples of consummate artistry, Wright's oils are unique documents of the burgeoning Industrial Revolution.

—Lynn R. Matteson

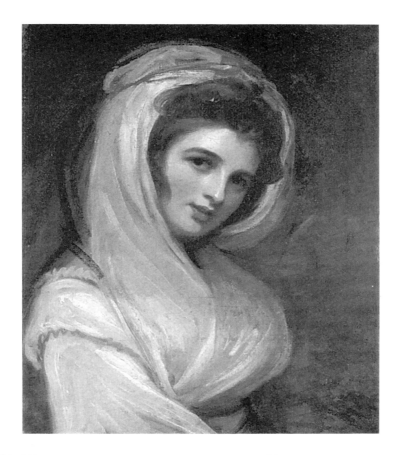

George Romney (1734-1802)
Lady Hamilton, 1780's
24 × 21 in. (62.2 × 54.6 cm.)
London, Victoria and Albert

This is one of the best of a series of portraits of Emma Hamilton which Romney made in the 1780's. They range from free and informal sketches as here, to more formal portraits, fancy portraits, and finally figures in full-scale historical compositions, such as the large *Thetis pleading with Achilles before Troy.* Though traditionally referred to as Romney's Lady Hamilton portraits, they were all executed when the sitter was plain Emma Hart, before her marriage to Sir William Hamilton in 1791 and when she was under the protection of his nephew, Charles Greville, second son of the Earl of Warwick. The latter's family had been regular patrons of Romney since the early 1770's and Charles Greville himself had sat to Romney in 1781. The following year when Emma became his mistress, Greville brought her to Romney's studio and between 1782 and 1786 she sat for Romney on many occasions.

There can be no doubt that Romney adored Emma and that the emotional ties between them went beyond the professional relationship of artist and model. Romney has consequently acquired an honoured, though tangential, place in the Lady Hamilton legend, and his portraits of her have attained a gratuitous archetypal status, quite at variance with their art-historical importance but perfectly reflecting attitudes during the late 19th-century craze for Georgian portraiture, from which this myth derives. Today, it is customary to see Emma as a particularly congenial and patient model whom Romney was able to use to establish many of his more fanciful and imaginative figure subjects. Going beyond this, it certainly seems that Emma acted as some sort of release for Romney's pent up frustrations with the business of routine portraiture, liberating him to paint freely and spontaneously; and that Romney himself was acutely conscious of this. If her role in Romney's art can be described as archetypal, it is in this diminished sense that she alone stood at the interface of his public and private styles. But even this view depends on a simple, if entrenched, historiography of Romney which perhaps does not bear too close scrutiny.

This particular work can be seen as typical of Romney's portraiture as a whole in its high, fresh colours, many of which contain a large admixture of white; and in the way that the viewer is engaged at once by the sitter's direct and confrontational gaze, a strategy which invests many of Romney's portraits with a slightly larger-than-life quality and might be said to place them in the vanguard of a new era of public morality. It might be argued too that the sketchiness of the present work—in this context, of course, entirely justified and natural—is symptomatic of the difficulty Romney always experienced in finishing portraits and more generally of his nervous and restless nature. Nevertheless, it makes better sense to regard this painting less as typical than embodying, in one direction, the limits which Romney was capable of achieving. In its spontaneity of modelling and its scintillating technical virtuosity it marks a tremendous advance on most of his public portraiture.

—Alex Kidson

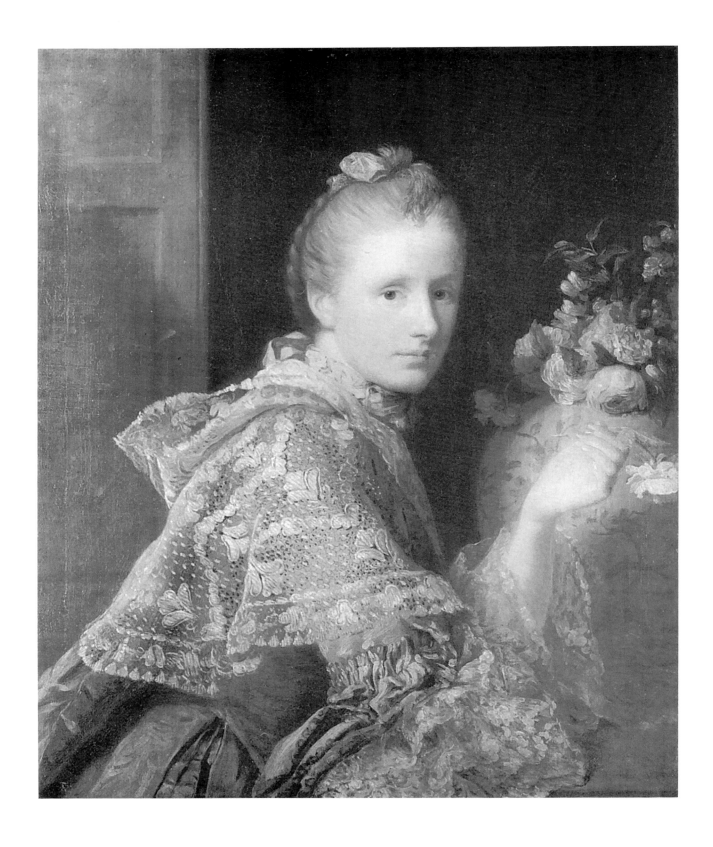

Allan Ramsay (1713–84)
Margaret Lindsay, The Painter's Second Wife, c. 1760
$29^{1}/_{4} \times 23^{3}/_{8}$ in. (74.4 × 59.5 cm.)
Edinburgh, National Gallery

Bibliography—

Smart, Alastair, "A Newly Discovered Portrait of Ramsay's Second Wife," in *Apollo* (London), May 1981.

In 1752, having been a widower some eight years, Ramsay married for a second time and took as his wife the lady whose portrait concerns us here. Margaret Lindsay was the elder daughter of Sir Alexander Lindsay of Evelick and she counted among her kinsmen some of the most powerful in Scotland. The lovers married without Sir Alexander's consent, causing serious family difficulties. This, together with the threat to Ramsay's eminent position from the young Reynolds, probably played a part in leading Ramsay to refresh his artistic vision by travelling to Italy once more. However, Ramsay took great delight in that country and he possibly felt a longing to share these pleasures with his young wife. A major factor in the departure for Italy which has been stressed is surely the energy and zest for life he must have regained through marriage to this young lady. Ramsay delighted in travel and the pregnancy of Mrs. Ramsay at the time of their departure in 1754 does not seem to have deterred them. A daughter, Amelia, was born in Rome in March of the following year.

In Italy during this time of happiness and recreation, Ramsay's style was to undergo profound changes, and we find him moving in a quite unexpected direction: towards the elegance of contemporary French painting. It cannot be merely coincidental that this period in his life also sees Ramsay publishing the first of his many literary works. The young lady in this portrait clearly had a profound impact on Allan Ramsay and it seems fitting that it was in an earlier portrait of her that we find one of the first statements of his late style. That portrait of his wife, *Margaret Ramsay Holding a Parasol*, in a private collection and only in recent years identified as the portrait executed during the early part of their Italian trip, indicates Ramsay's growing fascination with the work of artists such as Nattier. Under this French influence, a startling change in language occurs. Ironically, the change occurs in Italy. In place of the pugnacity and forthrightness of the early work, we now find delicacy and courtly grace. Where before the portraits could be somewhat hectoring and sonorous in tone, they are now mellifluous and tender. The earliest manifestations of this new style seem to appear at about 1754 when he spent a lengthy time in Edinburgh prior to departing for Italy.

The portrait of *Margaret Ramsay, The Painter's Second Wife* which Smart now dates to c. 1760, is one of the best examples of his late style but is, at first glance, an inconsequential work. It is a small painting and designed for private viewers in a domestic setting. In its reticence it easily succumbs to the bustle of a large room. Everything about it has a delicacy and impermanence that, like a light fragrance, is lost by the slightest disturbance. The transitory pose and passing moment in time that are captured in the work are the achievement of a great European master, now working at his best. A pyramid of lace and fine cloth cascades from Mrs. Ramsay's shoulder, and such tangible elements as these combine with intangible features like shadow and spatial interval to create a harmonious compositional design. The whole painting is a carefully composed series of opposites; the tightly coiffured hair which lends such sharpness to Mrs. Ramsay's glance contrasts with the freedom and splendour of the drapery and the limp rose held in her hand. Her face, pale in colouring, sets off her fine dark eyes. This is a lady who clearly missed nothing, and it is not difficult to believe that she aided her husband in both his writing and his lucrative business. Her head is thrown into relief by the dark background which establishes a rhythm of lights and darks across the canvas, elaborated by the diagonals formed from the back of her dress, her right arm, the beam of light streaming through the window, and the slanting compositional caesura which falls between her face and the other focal point of the painting, her hand. The whole arrangement is so contrived that it is amazing that it does not collapse into artificiality. It is no surprise that the artist was to make use of this intricate composition more than once, as well as producing a replica of this portrait. All force has gone from Ramsay's style. There is no suggestion of the strident qualities of the earlier paintings or the feeling that an audience is being addressed. All is calm and private, with an air of informality which is often mentioned by commentators who forget that this is an informality of a very courtly kind.

In this late style Ramsay is imitating in oil the technique of the French pastelists, and this manner of painting possesses its own poignancy due the delicacy of the means he employed. It required rare mastery of the oil medium to paint like this. Diaphanous touches of paint are floated onto the canvas with great subtlety of colouring. The delicacy with which the work was created heightens the sense of the fleeting moment the work captures. Mrs. Ramsay has just been disturbed by our entry while arranging the flowers; in an instant her attention will once more return to her task. Painting like this could not be left to studio assistants. It demanded inexhaustible patience and a very high level of technical skills which Ramsay could not long support with his advancing age, declining health, and, some believe, his failing eyesight.

The roll call of the dead in Ramsay's life was long, and even at this distance in time it makes pitiable reading. The lady in this portrait died in 1782 causing him, some six months later, to leave with his young son for his fourth and final trip to Italy. It seems characteristic that in old age he should once more seek solace in that country which he loved and where he had spent some of his happiest times. His painting career was now long over and his achievements in that field forgotten. At his death he was remembered as a writer.

—David Mackie

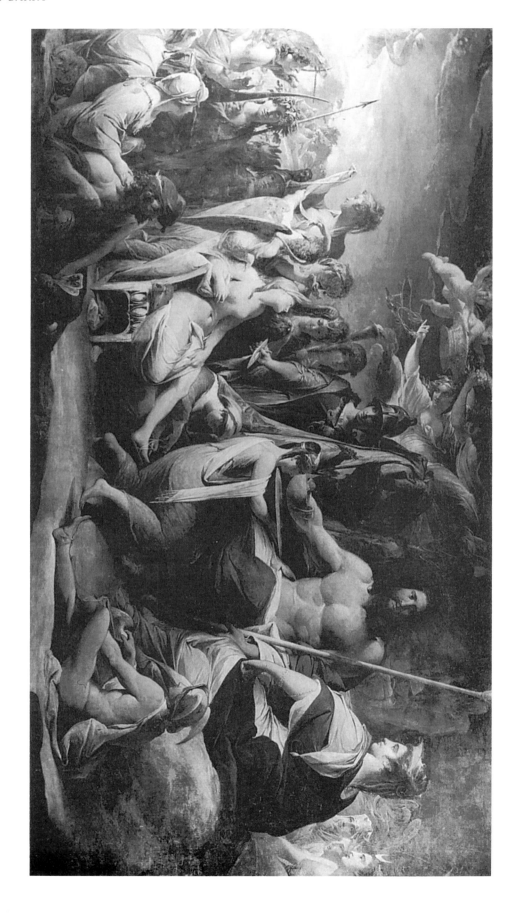

James Barry (1741–1806)
The Birth of Pandora, 1804
10 × 17 ft. (304.8 × 431.8 cm.)
Manchester, City Art Gallery

In 1804, just two years before his death, Barry finally completed his painting *The Birth of Pandora*, a subject on which he had been working since his Roman sojourn in the late 1760's. The subject matter was novel in that it had rarely been treated in modern art and never on a monumental scale. Yet, like so many of Barry's works, there was a classical prototype, in this instance Phidias's relief sculpture of Pandora on the base of his statue of Minerva in the Parthenon. As briefly described by Pausanias, Phidias's relief showed 20 gods present at Pandora's birth, each of whom bestowed a gift upon her. Barry perceived each god as representing a particular perfection, and in his "recreation" of Phidias's subject he hoped to recapture these ideal forms embodying abstract virtues.

The monumental figure of the reigning deities Jupiter and Juno sit at the right, Jupiter about to hand the kylix of nectar offered by Hebe to his consort. Beneath them sits Mercury preparing to carry Pandora to earth to her husband Epimetheus. A languid Pandora, her soul only beginning to awaken, looks toward Minerva, the goddess of wisdom, who, holding the peplus of the Panathenaic festival, instructs her in the art of weaving. Weaving represented for Barry the art of painting, and its association with wisdom confirmed for his the superiority of painting over the other arts, including epic poetry. To the far left sits Apollo singing a hymeneal, and reclining in the foreground is Vulcan, the creator of Pandora's form. One of the Fates in the background between Jupiter and Juno comes forward with the fatal vase, the opening of which will release numerous evils into the world, with only hope remaining behind to help mankind endure his misery.

Barry, as Milton and others before him, saw Pandora as a heathen Eve. He seized on the classical myth as a paradigm of mankind's promising beginnings which all too soon end in a fall from grace. For him the classical myth validated the Christian account by showing the seamless unity of the basic truth found in both worlds. Aurora in the background indicates that this is literally the dawn of humanity. It is the beginning of mankind's arduous journey that will ultimately lead back to the eternal bliss enjoyed in Olympus or heaven.

When first embarking on this work in Rome, Barry stated that he wished to rival Raphael's frescoes of Cupid and Psyche in the Villa Farnesina. None of his early drawings of *The Birth of Pandora* survive, but a print by Louis Schiavonetti of 1810 reproduces one of these works, and the dispositions of the figures is not unlike Raphael's *Council of the Gods*. The print is composed in a style of elegant outlines with little internal modeling, and the figures are arranged with frieze-like clarity across the elongated composition. The painting offers a denser, more dynamic arrangement. In its compression, its crisscrossing diagonals, and animated, raking light and deep pockets of shadow, it exhibits a Rubensian energy that had been lacking in the purer, abstracted imagery reflected in the Schiavonetti engraving. In 1775 when Barry exhibited a study for this subject at the Royal Academy, Horace Walpole wrote disparagingly in his catalogue, "Great want of proportion." The collisions in scale are still very much in evidence in the painting, disorienting the viewer as it thrusts him into a brave new world of the imagination. By 1846, the painting seemed only an anachronistic curiosity, bringing only 11 $^{1}/_{2}$ guineas when it was sold at Christie's. It was viewed as an eccentric last gasp of heroic academic painting, whereas now it is seen as an original and provocative reexamination of classical subject matter and the conventions of the Grand Style.

—William L. Pressly

Henry Raeburn (1756–1823)
The Rev. Robert Walker Skating on Duddingstone Loch, mid-
1790's
29¹⁄₈ × 24 in. (74 × 61 cm.)
Edinburgh, National Gallery

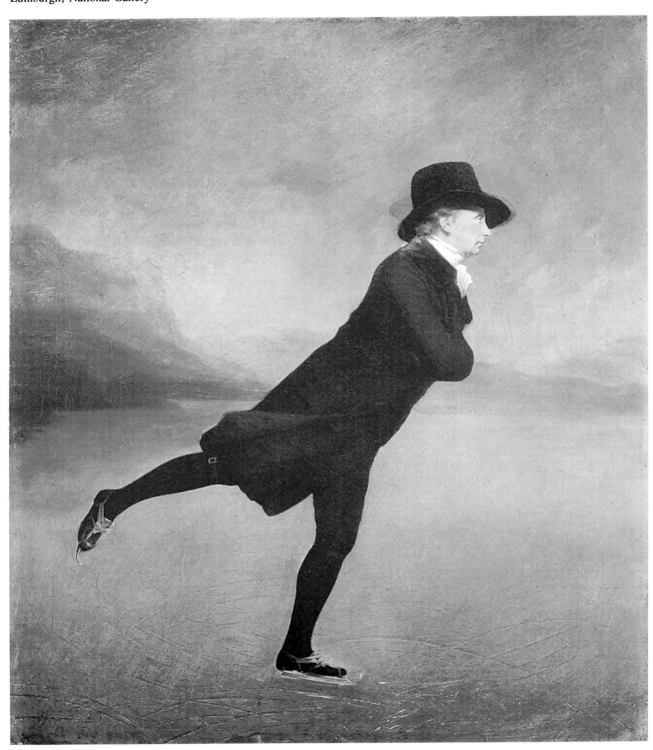

According to family tradition, this portrait is of the Rev. Robert Walker and was painted by Raeburn in 1784 when Walker joined the Edinburgh Skating Club. The portrait came to light early this century, still in the hands of Walker's family, having been given to them by the artist, it is said, at the sitter's death in 1808, Raeburn having painted it for his own pleasure. But, from the time the painting first appeared this oral tradition has been questioned and doubt cast on the attribution to Raeburn, the proposed date of the portrait, and the identification of the sitter. There are, however, some points of coincidence with the family remembrance that make it difficult to dismiss the tradition out of hand. For instance, Raeburn did paint portraits from time to time simply for his own satisfaction and on completion they remained with the artist, Walker did become a member of the Edinburgh Skating Club in 1784 but most important of all, there are stylistic aspects of this very singular portrait which support the tradition that Raeburn was the author.

In cannot be denied that the painting shows some unusual features. For instance, there is only one other small-scale full-length work, a little sketch for an equestrian portrait of the artist's son, Henry. But in support of the attribution there is, among other factors, the interest in profile which was first pointed out by Dr. Duncan Thomson of the Scottish National Portrait Gallery in 1981 at a public lecture and this observation on Raeburn's style after the Italian trip has important implications for the dating of the work. The profile view is a feature of some of the paintings done after the artist's return from Rome and is used on a number of instances until the middle of the 1790's. Proposing a date in this region for the *Rev. Walker* contradicts the family tradition but overcomes at a stroke the problem of the sitter's apparent age. In this painting he is clearly a mature man and this has thrown no doubt onto identity of the sitter. (Walker was only 29 in 1784.) Walker, if he is indeed the subject, grew up in the Netherlands, his father the minister of the Scots Church in Rotterdam. Later in life he wrote on golf, which he seems to have become familiar with in Holland, and he wrote also on the Dutch and the House of Orange. That he learned to skate in the Netherlands as a child is entirely feasible.

The profile portraits are quite numerous, and include among many others *John Johnstone of Alva with His Sister and Niece* at Washington and *Robert and Rolnald Ferguson of Raith*, called *The Archers*, in a Scottish private collection. All share a distinct air as a consequence of the artist adopting a profile view; we do not meet the sitter's eye, he is unaware of our presence and we are at liberty to study him without the psychological charge of a response to our scrutiny, observing the sitter detached from the world, occupied with his thought, oblivious of ours.

Another typical Raeburn feature is that the painting is at the same time both portrait and genre, an approach to portraiture that is encountered in a number of Raeburn's works after the Roman trip. Raeburn often shows the sitter engaged in a favourite pursuit such as singing or conversing, or a sport. Many works that have always been discussed by commentators as though the sitter was merely posing for the artist show, on further examination, that he is engaged in conversation, either addressing or attending to someone not shown in the painting. Depicting Walker skating is entirely consistent with the artist's early conception of portraiture, which might be summarized as social involvement. Raeburn's attitude in these paintings seem to be that by showing the sitter at play, completely absorbed in his recreation and no longer aware of those around him, a piercing insight into the private man is achieved. This approach makes for a very humane style of portraiture not without humor and far removed from the rhetoric of the grand manner.

In the Walker portrait the main compositional element is the bold diagonal of the sitter's body, clothed in clerical black, hovering with meditative calm in the frozen atmosphere, his body sharply contrasting with the distant winter landscape. This compositional arrangement of a figure set against vast distance is yet another typical feature of Raeburn's portraits after the Roman visit also found in *Sir John and Lady Clerk of Pennicuik* (Beit Collection).

The handling of paint in the figure has also caused some doubt about Raeburn's authorship, it being believed that he always painted in a broad free manner. The skates especially show an exactitude in their depiction that is thought to be otherwise unknown in Raeburn's painting. However, at all stages in his career Raeburn was capable of manipulating paint with surprising carefulness, usually restricted to small areas, for instance the shadow cast by spectacles on a sitter's nose, while in the remainder of the canvas the treatment is more summary. The background in this work does show the free handling that is commonly expected of Raeburn.

The suggestion that a specific place is represented, as implied by the title, must be dismissed. This is not a view of Duddingstone Loch. Raeburn tends to make specific reference to place only rarely. Most often the landscape plays its part in the structure of the composition with trees and foliage reiterating the lines of the figure. In this example the mountains to the left act as a counterbalance to Walker's dipping frame. A similar consideration of establishing balance has caused the artist to alter the angle at which the sitter wears his hat. The lines of the composition, both in the landscape and the figure, converge on the area of Walker's hip which is the centre of gravity of the composition around which the sense of movement is created. This is not the outcome of chance but the product of a carefully planned and essentially very simple compositional arrangement, one diagonal running from bottom left to top right of the painting.

Raeburn, if he was as I suggest the author of *The Rev. Walker*, was never to attempt a sequel to this picture, and later works show great changes in style and interest. In the vivacious and animated portraits of the 1790's one of the aims of the artist is to produce a painting which crystallizes a moment of life. Here the fleeting second is captured when Walker glides on one skate. In an instant he will swing the other leg forward and, with the nonchalance of the practiced skater, propel himself out of our view. The atmosphere is calm, it is private. Raeburn gently pokes fun at the deeply preoccupied minister. The landscape is vacant, the air still. The expansive sheet of ice slips imperceptibly into the far distant land which then elides with the sombre sky. The marks in the ice suggest the recent attendance of crowds of skaters. They have departed and Raeburn's Rev. Walker is left alone with his thoughts.

—David Mackie

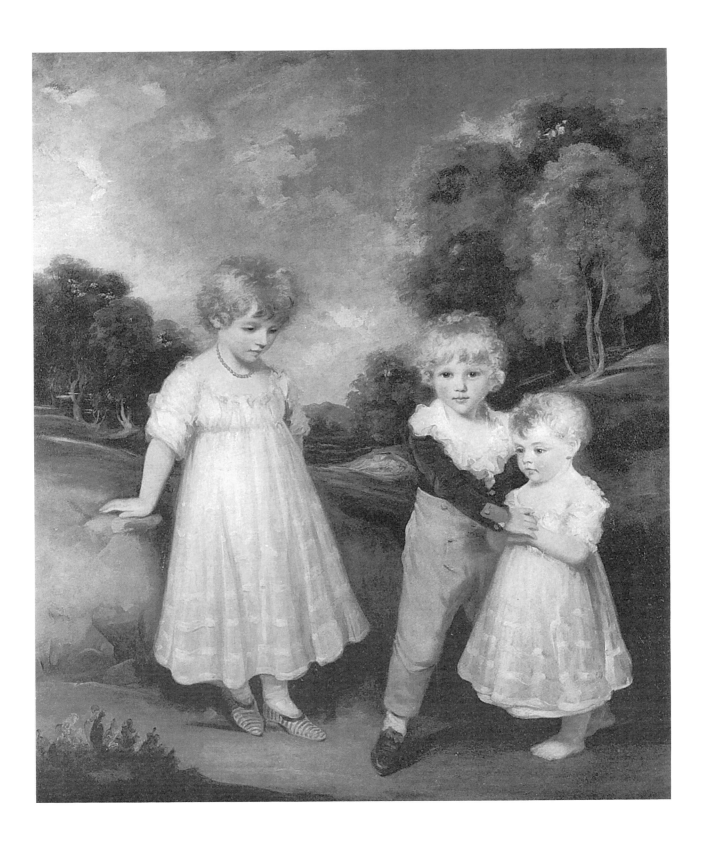

John Hoppner (1758–1810)
The Sackville Children
60 × 49 in. (152.4 × 124.5 cm.)
New York, Metropolitan

Hoppner exhibited *The Sackville Children* at the Royal Academy in 1797. He was 29 years of age and his style had already set in the mould of Reynolds. He had entered the Royal Academy Schools in 1775 when Sir Joshua Reynolds was at the height of his powers and when, partly through the medium of his annual Discourse, he was at the height of his influence with the students. It so happened that in that year Reynolds delivered no Discourse, but that of the previous year, 1774, with which any intelligent new student would have made himself familiar—and Hoppner was both intelligent and lively—was partly devoted to the theme of "borrowing." The synopsis contains the phrase "borrowing, how far allowable" and again "the true method of imitating." Hoppner has been played down by the critics for allowing himself to become too easy, even too careless, an imitator of Reynolds, and the review of the 1797 exhibition in the *Monthly Mirror* said of *The Sackville Children* that it was "well composed, the control free and bold; the children much after Sir Joshua's manner, but rather flat, from the light being too generally diffused over the figures." By this time, Reynolds had been dead five years. It is pertinent to note that the writer also used the word "bold." Hoppner was often a weak draughtsman and this is evident in the right arm of the boy as he joins hands with his small sister. The boldness lies in the assurance with which the figures are placed and the quality of the painting of the landscape behind them. As a landscapist Hoppner was variable, but here he is in his best form.

How great is the debt to Reynolds in this group and how far does it merit consideration in its own right? The composition is Hoppner's own. It is not a direct borrowing. The mood, however, is less lively than that generally achieved by Reynolds. In comparison it is *piano*. The expressions are less coy than those often evoked by Reynolds but they are rather more natural. In this naturalness, in the creation of a composition which is less clearly "thought out," Hoppner is himself. His gift was for a natural, unsophisticated charm. The brushwork, in sympathy, tends to be loose. It is not unfair to say that his style is Reynolds deintellectualised, often Reynolds below par. His colour, however, is pleasurably strong. In this instance the boy's blue-black coat with its red cuffs contrasts with the white dresses of the girls and the coral necklace of the elder. *The Sackville Children* shows Hoppner successfully expressing the gentler side of his nature. In this and similar groups, particularly that of his own children (now in Washington), the aggressive and difficult side which we know to have existed is not evident.

The Sackville children, George (1793–1815), Mary (1792–1844) and Elizabeth (1795–1870) were the family of the 3rd Duke of Dorset. George succeeded his father as 4th Duke in 1799, but died, unmarried, as a result of a hunting accident near Dublin. The family seat, Knole, in Kent, now a property of the National Trust, is one of the most romantic houses in England. Hoppner's full-length portrait of the children's mother, Arabella, Duchess of Dorset, may still be seen there. *The Sackville Children* takes its place in the long line of informal family groups stemming from Van Dyck and designed for the walls of the country houses of the nobility, which are a branch of English portraiture in themselves. There was understandable regret when it left Knole. It was presented to the Metropolitan Museum in New York by Thomas Lamont in 1948.

—Kenneth Garlick

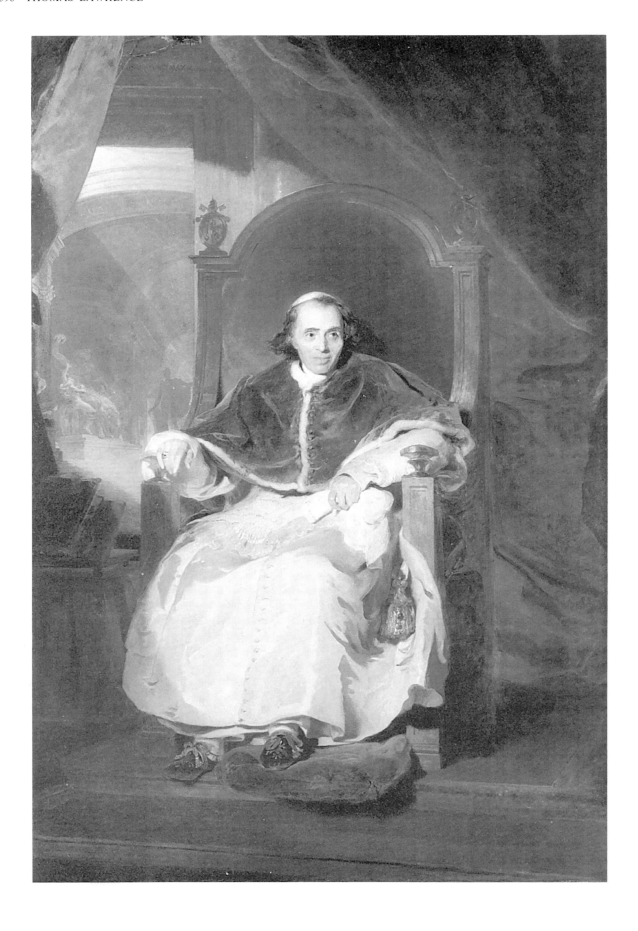

Thomas Lawrence (1769–1830)
Pope Pius VII, 1819
8 ft. 10 in. × 5 ft. 10 in. (269.2 × 177.8 cm.)
Royal Collection

In 1815 Thomas Lawrence was commissioned by the Prince Regent to attend the peace conferences following the defeat of Napoleon and to paint portraits of the victorious Heads of State and military commanders. In the event Napoleon escaped from Elba and Lawrence did not set out until September 1818. He worked at Aix-la-Chapelle and Vienna and in May 1819 arrived in Rome where he stayed until December. His commission there was to paint the portraits of the Pope and his secretary, Cardinal Consalvi. Pope Pius VII, Luigi Barnaba Chiaramonti, was then in his late seventies. He had led a troubled life since he was elected Pope in 1800. He had agreed to crown Napoleon as Emperor in Paris in 1804 but had excommunicated him after the annexation of the Papal States in 1809 and from that time until 1814 had been a hostage of the French in Fontainebleau. Cardinal Consalvi who had been his Secretary of State since 1800 was a shrewd man of the world and his reliable advisor. In the portrait of the Pope Lawrence conveys a sense of resignation after years of unease and intellectual and emotional distress. There is too an expression of natural piety. The Pope's faith, one feels, has not been undermined.

This painting is perhaps Lawrence's masterpiece. The Pope gave him long sittings and treated him with all the courtesy due to a representative of the future King of England. The two men respected each other. For Lawrence, whose beginnings held no promise of this kind of eminence, the experience must have been a deep, if unshared, satisfaction. For Lawrence had no wife or family. The Pope, though not alone in his grandeur, was aged and worn. There was a mutual sympathy.

The Pope is seated on the *sedia gestatoria*, the portable throne on which the holder of his office is carried on certain ceremonial occasions. In his hand he holds a document which bears the name of the sculptor Canova and probably bears reference to the fact that Canova had negotiated the return from France of certain treasures of the Vatican looted by Napoleon. Three of them may be identified in the vista behind the Pope of the newly designed Vatican sculpture gallery, the *Apollo Belvedere*, the *Torso Belvedere* and the *Laocoon*. Lawrence had casts of them in his London house. He had drawn from casts of them when he was a student in the Royal Academy Schools. To paint this portrait of the Pope himself sitting nearby the originals must have given him a rich sense of achievement. He put everything into it. He had always had a liking and a capacity for manipulating large areas of paint in one colour and here his management of red is magnificent. He was a great master of the brush and his enjoyment is manifest. This mastery increased as the years went by. He owed much to a study of Rubens and his visit to Vienna had further, probably for the first time, introduced him to the liquid richness of Velázquez. In Rome he would have seen too the Velázquez portrait of Pope Innocent X in the Palazzo Doria. In Naples he had seen the Titian portraits of the Farnese Pope, Paul III. He must have been spurred to emulate these masterpieces in his own papal portrait. For he was never without professional ambition in the best sense of that word. From Rome he wrote to a friend in London, "I cannot close my letter to you, one of the most valuable friends that my life has known, without acquainting you that I have entirely succeeded in my mission here. No picture that I have painted has been more popular with the friends of its subject and the public, than my portrait of His Holiness; and according to my scale of ability, I have executed my intention; having given him that expression of unaffected benevolence and worth, which lights up his countenance with a freshness and spirit entirely free. . . from that appearance of illness and decay which he generally has when enduring the fatigue of his public functions." This was not a boast. It was a statement of fact. The portrait, with that of the Cardinal, is in the collection of H. M. The Queen in the Waterloo Chamber at Windsor Castle.

—Kenneth Garlick

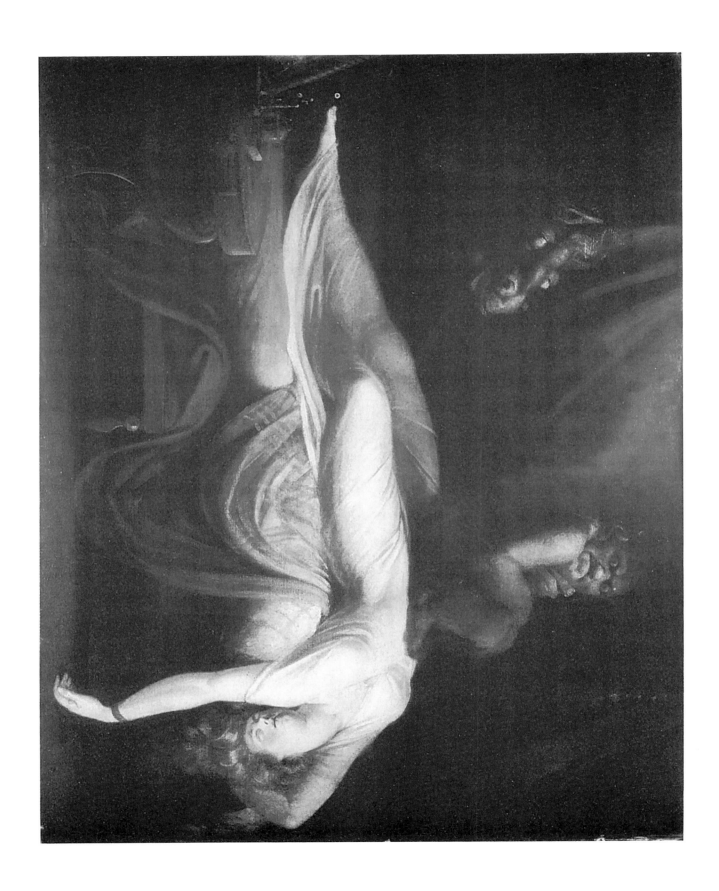

Henry Fuseli (1741–1825)
The Nightmare, 1781
40 × 50 in. (101.6 × 127 cm.)
Detroit, Institute of Arts

Bibliography—

Richardson, E. P., "Fuseli's *Nightmare*," in *Detroit Institute of Art Bulletin*, 34, 1954–55

Kalman, Harold D., "Füssli, Pope, and the *Nightmare*," in *Pantheon* (Munich), May-June 1971.

Allentuck, Marcia, "Fuseli's *Nightmare*: Eroticism or Pornography?," in *Woman as Sex Objects: Studies in Erotic Art 1730-1970*, edited by Thomas B. Hess and Linda Nochlin, New York, 1972.

Powell, Nicholas, *Fuseli: The Nightmare*, London and New York, 1973.

Jansen, H. W., "Fuseli's *Nightmare*, in *Sixteen Studies*, New York, 1974.

Henry Fuseli's bizarre, dramatic, and enigmatic painting entitled *The Nightmare* was such a popular success when it was first exhibited at the Royal Academy of London in 1782 that the artist subsequently painted a number of other versions of this theme and engravings of the work were widely circulated. The choice of a subject involving sleep and dreams was common with Fuseli. His first known painting was *Joseph Interpreting the Dreams of the Butler and Baker of Pharaoh* (1768, aquatint by Franz Hegi, 1807, after Fuseli in Basel), and numerous later works depicted dreams or supernatural visions. Examples of these include *The Shepherd's Dream* (1798: London, Tate) from Milton's *Paradise Lost* and *Richard III Visited by Ghosts* (1798, Tate) inspired by Shakespeare. What is atypical of *The Nightmare* is that the theme is an imaginary one, based on folklore and popular tales and not on the Bible or any of the other literary sources known by this erudite artist, who was also an ordained minister.

The Nightmare centers on a sleeping woman who is dramatically draped over the end of a bed. She is surmounted by a gruesome looking incubus, while a horsehead projects from a curtained background. The contemporary interior includes a small table to the left, and a stool partially hidden by disheveled blankets. The whole scene is highlighted with chiaroscuro lighting and expressive brush work which give it an eerie and mystical quality.

It is believed that the work was inspired by stories of witches and demons that invaded the dreams of people that slept alone. Men would be visited by old hags or horses, giving rise to the terms "hag-riding" or "mare-riding," while women were believed commonly to have sex with the devil. Fuseli has juxtaposed these tales by showing both a masculine demon crouched on top of the woman and a horse's head in the background. The horse head may have been an afterthought, since an original sketch owned and described by Fuseli's early biographer John Knowles did not include it. The engravings circulated shortly after the work was exhibited were underscored by a poem by Erasmus Darwin (grandfather of Charles). The poem began "on his Night-Mare, thro the evening fog, flits the squab fiend, o'er fen and lake, and bog." This had led Jansen to believe that Darwin may have influenced Fuseli to include the horse. Even if the idea was totally Fuseli's, the poem highlights the significance for contemporary viewers of the relationship of the horse (Night Mare) to nightmares. The word nightmare was not, however, first related in any way to a horse. As stressed by Powell, it was derived from the mythological term *mara*, which referred to a spirit that was sent to torment sleepers. Whatever the source of the figures, the horrific and quite erotic interpretation of this theme, is certainly a product of Fuseli's imagination.

The overt sexual aspects of this work are probably linked very directly to Fuseli's personal life. A few years prior to executing this painting, Fuseli fell passionately in love with a woman named Anna Landholdt. Fuseli met Anna, the niece of his long-time friend Lavater, while visiting his home-town of Zurich on his return from Rome to London in 1779. His "Nanna," as he called her, does not seem to have been as overwhelmed by the artist as he was with her. She married a family friend not long after meeting Fuseli, much to his chagrin. In one of the numerous letters and poems in which he discussed this unrequited love, Fuseli wrote to Lavater "Last night I had her in bed with me—tossed my bedclothes huggermugger—wound my hot and tight clasped hands about her—fused her body and her soul together with my own—poured into her my spirit, breath, and strength. Anyone who touches her now commits adultry and incest! She is mine, and I am hers." Jansen suggests that it might be Anna Landholdt represented in *The Nightmare* and that Fuseli, himself, is the crouching demon. Jansen further supports this view by the fact that an unfinished painting of a girl is on the back of *The Nightmare* canvas, a portrait, perhaps, of "Nanna."

The sexual aspects of *The Nightmare* have been particularly stressed in Marcia Allentuck's brief study of the subject. Allentuck argues that the main concern of Fuseli's painting is to show female orgasm, a state that she analyses in depth. The many overt, even pornographic, drawings executed by Fuseli, including *Symplegma of Man with Two Women* (1770–78; Florence, Horne) certainly make such an explicit and direct connotation feasible. The sexual and psychological significance of *The Nightmare* was acknowledged by contemporary critics, many of whom thought the work scandalous. It is interesting to note that Sigmund Freud had a copy of the work hanging in his Viennese apartment.

Of the other versions of this theme painted by Fuseli, the best known is in Frankfurt (1782–91, Goethe Museum). In this work, the woman swoons to the viewer's left, instead of right, the table is to the rear of the bed, and the incubus is a pointed-eared variant of the Detroit version.

As overwhelmingly romantic as *The Nightmare* is, it is typical of Fuseli that he borrowed compositions and ideas from classical sources. Powell has indicated that the pose of the female derives from the Vatican Ariadne and the incubus was inspired by Classical Selinus figures.

Fuseli was a very prolific artist who lived until he was 84 years old. He painted mostly works derived from literature, including eight scenes for Boydell's Shakespeare Gallery and 47 works for his own Milton Gallery. To many, however, he is best known for *The Nightmare*.

—Kathleen Russo

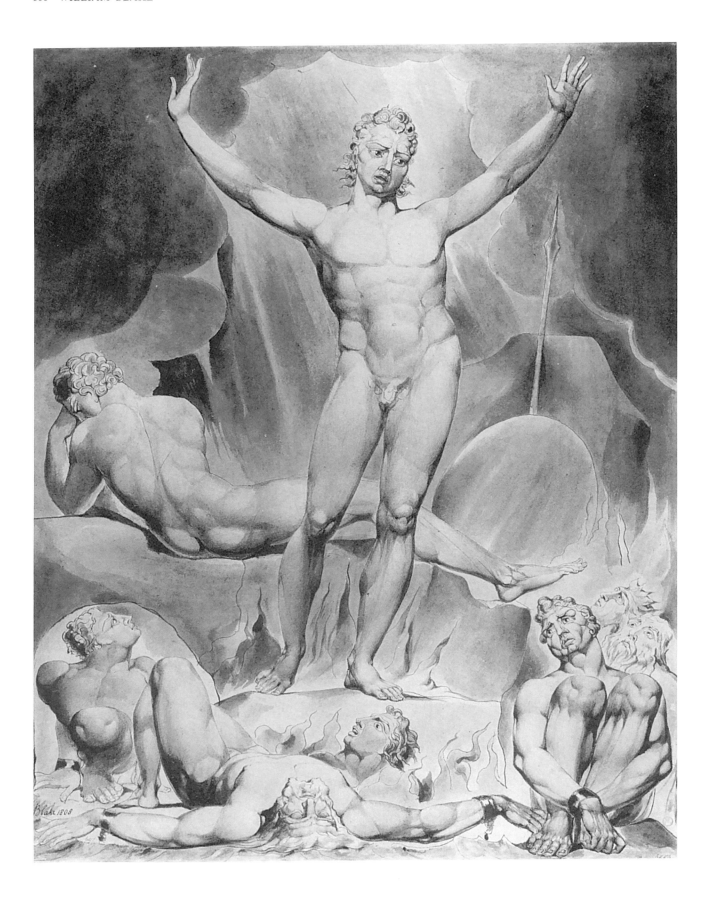

Benjamin West (1738–1820)
The Death of General Wolfe, 1770
4 ft. 11¹/₂ in. × 7 ft. 2 in (151 × 213.4 cm)
Ottawa, National Gallery

Bibliography—

Mitchell, C., "West's Death of General Wolfe," in *Journal of the Warburg and Courtauld Institutes* (London), 7, 1944.
Wind, Edgar, "Penny, West, and the Death of General Wolfe," in *Journal of the Warburg and Courtauld Institutes* (London), 10, 1947.

In terms of Benjamin West's career, *The Death of General Wolfe* was undoubtedly his most important painting. Moreover, its moral purpose and the style in which it was executed encouraged other painters to emulate what Sir Joshua Reynolds believed to be a picture that would "occasion a revolution in art."

West had travelled in Italy between 1760 and 1763 when he had studied the old masters and also come under the influence of the Neo-Classical painters Pompeo Batoni, Nathaniel Dance, and Anton Raphael Mengs, who were prominent in Rome at the time. Under Mengs's advice West turned to "historical" painting. Initially his subjects were drawn from literature and mythology; *The Death of General Wolfe* marked a turning point.

West had decided to paint the event that had taken place only ten years previously—in itself a change from the classical subjects he was known for—with its figures in contemporary dress. Reynolds tried to dissuade the artist from his intentions, sharing George III's concern that the subject's dignity would suffer. On its completion, both the king and Reynolds retracted their opinions and the painting was duly exhibited at the Royal Academy in 1771.

The painting shows a scene from the battle between British and French forces that took place on the Plains of Abraham outside Quebec on 13 September 1759. In the foreground Major-General James Wolfe lies mortally wounded. He was to die in the last stages of the battle but not before he had heard news of victory: on the left a soldier carrying a captured French standard runs towards the group of officers surrounding the general. Behind the running soldier the figure falling from his horse is said to be Marquis de Montcalm, Wolfe's adversary who also died in the battle. In the background a narrative of the battle unfolds with British ships on the right being unloaded by troops who then progress up the cliff into battle after which, victory is symbolised by the running soldier on the left.

Several of the figures have been identified as serving officers, though many others have not been accurately named. It has been pointed out that most of those portrayed would not have been with Wolfe at his death. The reason for the inclusion of the American Indian is unclear as no Indians served at Quebec. It has been suggested that this figure was included in order to aid the identification of the officer standing next to him as Sir William Johnson. Johnson was not at Quebec but had served as Superintendant of Indian Affairs during the Seven Years War when he would have been in command of American Indians. The two figures may have been included in order to honour Johnson for previous services, again at the cost of historical exactitude.

The Death of General Wolfe was designed, however, not as an accurate record of events but as a classical idealisation modelled on 17th-century paintings of the Deposition. Its purpose was to portray a heroic, patriotic general whose self-sacrifice is being honoured by officers who would have been largely recognisable to the public. It is history recorded in harmony with the wishes of those who sought to influence morally its spectators. An immensely popular painting which demanded an uncritical gaze and near-worship of its subject, it was readily copied by a large number of artists. West himself executed several replicas, the first of which was commissioned by George III.

—Simon Hancock

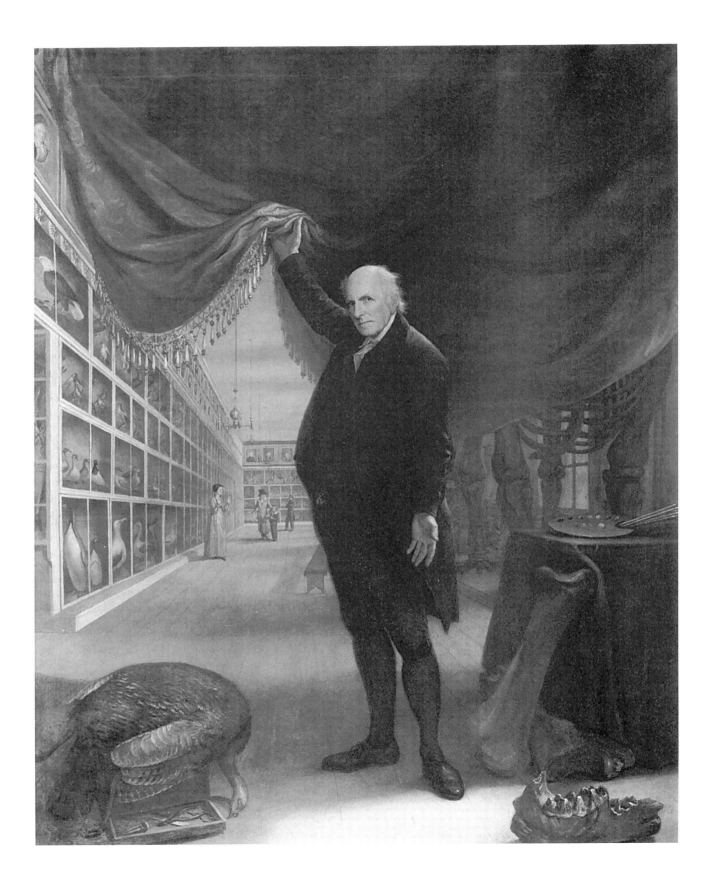

Charles Willson Peale (1741–1827)
The Artist in His Museum, 1822
8 ft. 7¹/₂ in. × 6 ft. 8 in. (262.9 × 203.2 cm.)
Philadelphia, Pennsylvania Academy of the Fine Arts

Bibliography—

Stein, Roger, "Peale's Expressive Design: The Artist in His Museum," in *Prospects*, 6, 1981.

In 1822, towards the end of a long life, Charles Willson Peale was asked by the trustees of his Philadelphia Museum (founded 1791) to paint a whole length portrait of himself to hang in the museum. The commission stimulated the aging artist to "not only make it a lasting monument of my art as a Painter, but also that the design should be expressive, that I bring forth into public view, the beauties of Nature and Art, the rise & progress of the Museum." That he had "given to his country a sight of natural history in his labours to form a museum" was, for Peale, his most significant public service; therefore, the museum and its collections had to be made central to his composition. Moreover, since for Peale the whole world was "a museum in which all men are destined to be employed and amused," the objects selected to be shown in his painting would have to serve also as emblems of the construction of that world, its organization and its history. As a result, Peale's painting stands as a visual statement of 18th-century cosmology, a view of the world that by 1822 was already undergoing radical change.

Peale's composition is a double portrait—of himself and of the museum. The artist occupies the foreground, while the museum the middle and far ground; the two are integrated by the crimson curtain which Peale draws aside to reveal his creation. Light and space also integrate the division: Peale and the objects flanking him in the foreground remain in relative darkness, while light illuminates the middle ground and deep space of the museum, casting its glow, however, on Peale sufficiently to provide "a faithful likeness" and draw him into the museum's orbit. Describing his efforts to his son Rembrandt, Peale wrote

> I make a bold attempt by *the light behind me,* and all my features lit up by a reflected light beautifully given by the mirror, the top of my head on the bald part a bright light, also the hair on each side. That you may understand me, place yourself between a looking glass & the window, your features will be well defined by that reflected light, a dark part of a curtain will give an astonishing view to the catching Lights. . . .

Perceiving his self-portrait as a public commission, Peale resorted to the tradition of heroic portraiture which he had absorbed while studying art in London from 1767 to 1769. During the years of the Revolution and early Republic, the heroic portrait had provided a model for his *William Pitt* (1769; Westmoreland County Museum, Virginia), *John Beale Bordley* (1770; private collection), *Conrad Gérard* (1779; Philadelphia, Independence National Historical Park Collection), and *George Washington* (1779; Philadelphia, Pennsylvania Academy of the Fine Arts)—full length portraits replete

with objects that told a story or pointed a moral and were designed to honor the subject as an exemplar of heroism and virtue. Roger Stein has pointed out that for this self-portrait Peale also made use of a painting then hanging in the Annapolis Statehouse—that of *Charles Calvert, 5th Lord of Baltimore* by the Dutch artist Herman Van der Myn, with a foreground covered with emblematical objects, a middle ground that immediately defined the subject, and a deep background containing elements that provided the overarching significance of the portrait.

Thus, in the foreground of his painting, Peale placed those natural objects from which the museum collections were fashioned. On the left, he positioned a dead turkey, waiting to be shaped for exhibition within the museum by the taxidermist's tools lying nearby. Similarly, the bones lying at Peale's feet provided the raw material for the reconstructed mastodon that looms behind the curtain within the museum's space. The artist's palette and brushes complete the autobiographical assemblage that defines Peale's life while representing the means whereby the objects in the interior space are crafted.

The museum forms the middle ground of the painting; here in a rational, geometric design, Peale organized the various species of the animal kingdom to show their relationship in what the 18th century conceived as "a great chain of creation." Rows of birds and specimens are arranged according to the Linnaean system of classification of species, while superimposed above these are the portraits of revolutionary heroes and notable Americans, representative not only of the human species at the apex of the great chain but also of virtue and character worthy of emulation.

Within the museum, the past and future are merged with the present: the portraits bring the lessons of the past into the present while continuing to influence the future; the mastodon, which Peale had unearthed and reconstructed in 1800, symbolizes the continuity and permanence of original creation as interpreted by 18th-century cosmology. Once transformed by art, the turkey, brought back from frontier Missouri by the artist's son Titian Ramsay, like the birds in their habitat boxes in the middle ground, will assume significance and reveal its meaning in natural history and as a national symbol. In the center of the museum, the child accompanied by his parent represents posterity learning and benefiting from the lessons of nature and history.

Peale painted at least 17 self-portraits which present him in the different roles he had assumed through life as artist, naturalist, writer, educator. In this last one, painted towards the end of his long life, he brings all these roles into a single focus by selecting those objects that he considered best represented his achievement as educator and public servant. The painting marks and summarizes his achievement as an artist: in its design, aesthetic use of light, mastery of spatial relationships, meticulous attention to detail, and successful rendering of meaning, Peale's *Artist in His Museum* continues to intrigue, delight, and command attention.

—Lillian B. Miller

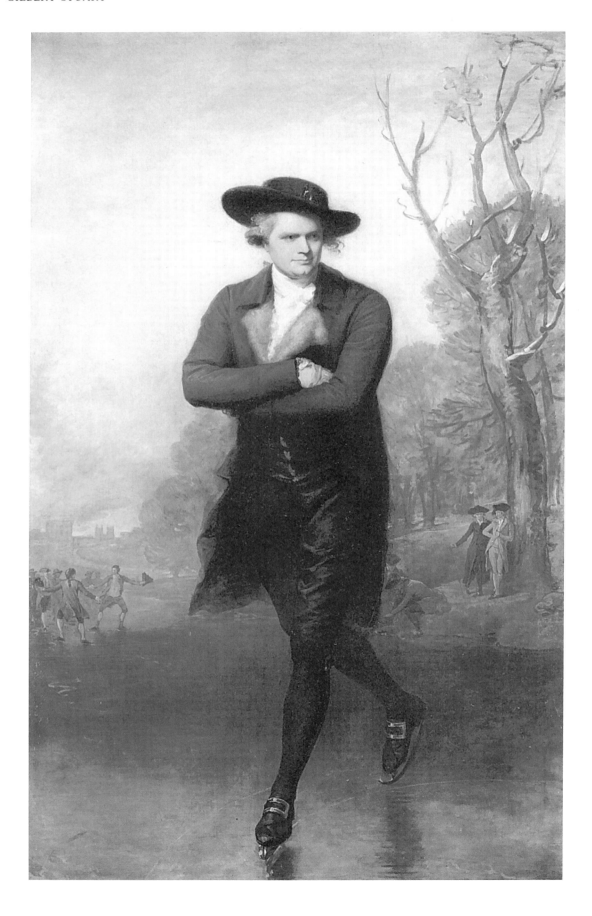

Gilbert Stuart (1755–1828)
The Skater (Portrait of William Grant), 1782
8 ft. ⁵/₈ in. × 4 ft. 10¹/₄ in. (245.5 × 147.6 cm.)
Washington, National Gallery

After having seen the London Royal Academy exhibition of 1782, Sir John Cullum wrote to his friend Frederick Hervey, Bishop of Derry, about one of the pictures that had caught his attention: "One would have thought that almost every attitude of a single Figure had long been exhausted in this land of portrait painting but one is now exhibited which I recollect not before—it is that of Scating. There is a noble portrait large as life thus exhibited and which produces the most powerful effect." Sir John was referring to Gilbert Stuart's *Portrait of William Grant*, now more commonly referred to as *The Skater*. Up to this point in his career, Stuart had shown promise as a painter, but it was *The Skater* which made his reputation, launching him as a portraitist of distinction. Stuart himself saw the painting in these terms, having deliberately set out to create a masterpiece in the word's original sense: it was a test of his skills intended to establish his professional competence. He was 26 years old when *The Skater* was exhibited, and despite earlier important commissions for full-length portraits, this was the first one he had the confidence to complete.

Stuart had been studying in London with Benjamin West and had clearly profited as well by his exposure to the Grand-Manner portraiture of Sir Joshua Reynolds and Thomas Gainsborough. His fluid, expressive brushwork in particular owes a great deal to the latter. Grant is elegantly attired; his suit, shoes, and broad-brimmed hat are black, relieved only by silver buckles, gray fur-lined lapels, white cravat and cuff, and a tan glove. The background is muted as well, cool tones punctuated only with the bright colors of the coats of a few of the skaters. The background recedes from right to left, curving away from the figure, while the arc formed by Grant's forward skate forms a counter curve that will propel him into the viewer's space. The tree trunk on the right echoes the softly undulating contour of Grant's left side, wile the contour of the figure's right side is more dynamic, in keeping with the active poses of the skaters behind. It is a carefully orchestrated image, calculated to please, showing the sitter in serene isolation, commandingly gliding over the ice on a cold winter's day.

Reynolds was a master at elevating a portrait by associating it with some noble, intellectual conceit, and Stuart follows this same principle in *The Skater*. William Grant is represented as the melancholy intellectual, a man whose refined sensibilities mark him as a superior being. The tradition of melancholy genius is an old one, in England dating back to the Elizabethan period, but Stuart's conception is part of a larger revival of interest in this topos in the Romantic period. Just the year before, in 1781, Joseph Wright of Derby had exhibited at the Royal Academy a portrait of Sir Brooke Boothby (Tate Gallery, London) showing the sitter meditatively reclining in a glade, a characterization based on an Elizabethan type. While the crossed-arm pose is a prescribed skating position, it also traditionally signifies the self-absorbed, contemplative individual. The black clothes (as in the case of Hamlet) and the broad-brimmed hat also signify melancholy, as does the errant lock of hair, the sitter being too self-absorbed to worry about such details. Then, too, the shadowed eyes, pensive gaze, and quizzical smile bespeak the brooding intellectual. Winter is a season often associated with melancholy, and finally skating, a perilous sport sometimes employed in illustrations of the Dance of Death, evokes an appropriate sense of life's frailty and transience. Stuart is in fact said to have conceived of the painting after having gone skating with Grant in Hyde Park, their sport having been abruptly terminated when ominous cracks appeared in the ice.

While Stuart wanted this portrait to serve as a masterpiece in the older sense of the word in that it was to announce his coming of age as an artist, he was also striving to create a work that would encompass the modern sense of this term as well in that his picture should embody the indisputable excellence of artistic genius. He was successful on both accounts.

—William L. Pressly

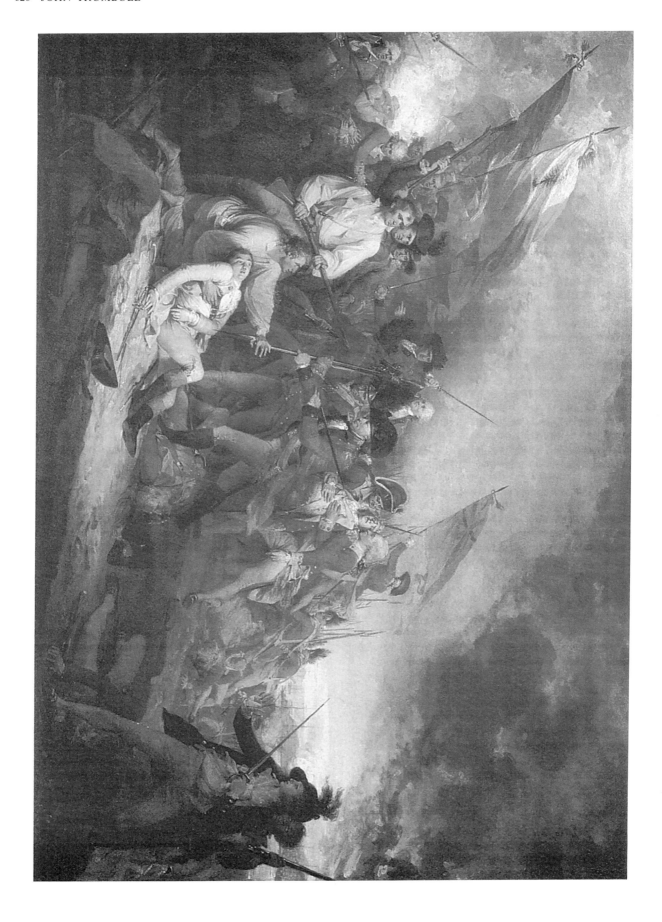

John Trumbull (1756–1843)
*The Death of General Warren at the Battle of Bunker's Hill,
 June 17, 1775*, 1786
24 × 34 in. (61 × 86.4 cm.)
New Haven, Yale University

The late eighteenth century in England was a time when military heroes were memorialized and glorious engagements recorded in art: Wolfe on the Plains of Abraham, Pierson in Jersey, Don Jose de Barboza in Gibraltar. Neoclassical heroizing combined with romantic ardor to produce some of the most emotionally stirring works of art of the time. Trumbull's *Death of General Warren* triumphantly takes its place in that pantheon.

The battle at Bunker's Hill, overlooking Charlestown, Boston and part of the harbor area, represented the first serious collision of arms between British troops and organized American insurgents. The colonists lost, but not without inflicting grievous psychological as well as physical damage on the enemy. Trumbull depicted Dr. Joseph Warren of the Massachusetts Militia, one of the earliest and most notable casualties of the Revolutionary War, in the act of expiring. (In an invented incident, Trumbull shows British Major John Small deflecting a bayonet from one of his own men against Warren, as a way of acknowledging Small's magnanimity to American prisoners.) In accordance with the dictates of the "new" history painting, details of uniform, costume and weaponry were meticulously duplicated and the physical features of the principals were exact likenesses obtained by Trumbull personally, or from other portraits or prints. The Anglo-American artist Benjamin West (q.v.), mentor and friend to Trumbull, is said to have painted in the portrait of Col. Howe, who refused to sit for the American rebel.

One of a series of eight small paintings dedicated to the American Revolution, *The Death of General Warren* was the first begun (1785), the first completed (1786), and the highest in quality. West is credited with suggesting the subject to Trumbull and the painting was worked on in his London studio. Fresh from the field of battle (he observed the debacle at Bunker's Hill through field glasses from the opposite end of the city), Trumbull would have needed little persuasion. Professionally ambitious and fiercely patriotic, he found the perfect subject for his burgeoning career as history painter; his energies were abundant and his training up-to-date. The previous year, he had helped to paint a replica of West's monumental *Battle of La Hogue*, which he considered to be of "inestimable importance" in his artistic formation.

Trumbull's work obviously owes much to the prototypical examples of West's *Death of General Wolfe* (1770; Ottawa, National Gallery of Canada) and John Singleton Copley's *Death of Major Peirson* (1783; London, Tate Gallery), but emerges nonetheless as a distinct achievement. West set history painting in England on a new course with his insistence on modern costume and documentary details in the *Death of Wolfe*, but his poses were wooden and expressions stilted. Trumbull's more fluid figural style, dynamic composition, and rich coloring, drew more from West's recent work and most especially from Copley. *The Death of Major Peirson's* flaming reds, dashing actions, and dramatic diagonals spurred Trumbull to attempt greater feats—more penetrating weft, greater brilliance in color, strong individual expression. Trumbull applied the academic doctrine of Expression based on LeBrun with special skill, giving his narrative considerable psychological impact. As for his coloristic efforts, they occasioned a rare compliment from Goethe, who viewed the painting in Germany where it was being engraved.

Admired by West, lauded by Reynolds, and praised by Goethe, *The Death of General Warren* nevertheless failed to achieve the financial success desired and needed by the artist. Even the engravings by Muller (published by Antonio di Pozzi in London in 1798), although technically excellent, did not sell well. The painting passed to Yale University in 1831, along with the others in the series, as part of the Indenture between Trumbull and that institution.

—Patricia M. Burnham

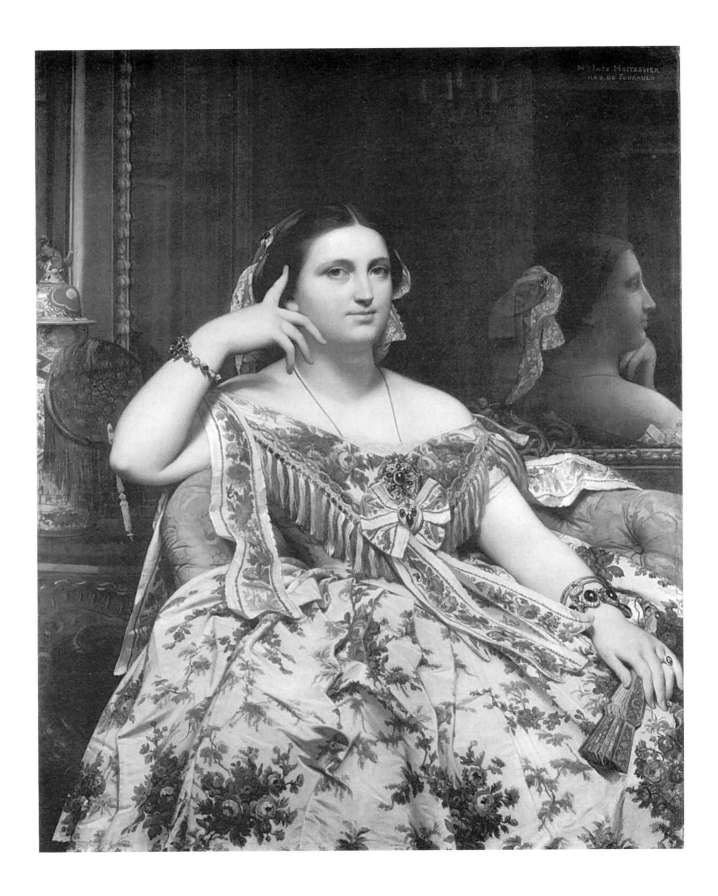

Johan Barthold Jongkind (1819–91)
River with Mill and Sailing Ships, 1868
20 x 32 in. (52.5 x 81.3 cm.)
Paris, d'Orsay

While Jongkind's greater ability undoubtedly lies in his preparatory sketches, executed in watercolor or pencil, he nevertheless considered painting in oil to be the best medium and consequently produced several canvases, particularly during the 1860's when his career was at its peak. Due to Jongkind's stalwart and thorough attempts to create powerful masterpieces in oil, these works bear the burden of affected self-consciousness while the drawings, less studied and laboured, retain a spontaneity and freshness that the Impressionists found most compelling. In terms of execution and subject matter, however, *River with Mill and Sailing Ships* reflects the skill of the drawings rather than most other works produced in this medium.

This painting, not unusually, has been executed with a palette knife: Jongkind was always keen to emphasize the tactile qualities and spontaneous effect of the impasto technique. In contrast to his normally more restricted palette of whites, blues, and browns, Jongkind has chosen very vibrant, resounding black and orange. Rather than restrict himself to a strictly defined color range as his fellow Realists were wont to do, Jongkind relied on his strong powers of observation and depicted the country sunset exactly as it appeared to his senses. He was intrigued by the powerful but fleeting effects of light on any given subject, hence the markedly different depictions of light and varying subject matter. Thus, *Rue Saint-Jacques in Paris*, 1876, is executed in cooler color tones to convey the atmosphere—literally and figuratively—of a city street in daylight; while *River with Mill and Sailing Ships* by contrast, conveys the strange beauty of a blazing sunset, the blackened silhouettes of the foreground windmill and boat picked out against an illuminated sky.

In composing *River with Mill and Sailing Ships* Jongkind refers to the Dutch method of creating a "four-fifths" vista, whereby the sky dominates the greater part of the picture. The looming central images, which provide vertical relief in an otherwise horizontally dominated painting, are further emphasized by their reflections in the water that comprises the lower section of the composition. Jongkind has painted the scene from the level of the opposite river bank: the man-made structures rise abruptly before us while a sense of compositional depth is suggested by their position in the middle ground, the atmospheric haze, and the distant echoing of a further mill and boat. The grand scales of the windmill and the central sailing ship compete with the splendour and vastness of the surroundings, implying a symbolic battle between humankind and nature, where each has met its match. It would not be inappropriate here to make certain comparisons with the art of Jongkind's contemporary Van Gogh, another Dutchman who spent much of his life in France; for Van Gogh's turbulent bucolic landscapes also express the process and effects of this terrible struggle.

—Carolyn Caygill

Gustave Courbet (1819–77)
The Burial at Ornans, 1849–50
10 ft. 4$^{1}/_{2}$ in. × 21 ft. 11$^{3}/_{4}$ in. (316.2 × 669.8 cm.)
Paris, d'Orsay

Bibliography—

Nochlin, Linda, "Innovation and Tradition in Courbet's *Burial at Ornans,*" in *Marsyas,* supplement 2, 1965.
Ferrier, Jean-Louis, *Courbet: Un Enterrement 'a Ornans,* Paris, 1980.
Ornans 'a l'enterrement—Tableau historique de figures humaines, Ornans, 1981.
Mainzer, Claudette R., "Le Manifeste realiste de Courbet," in *Les Amis de Gustave Courbet Bulletin,* 79, 1988.

The Burial at Ornans is the most complex and significant work in a series of "personal history paintings" created by Gustave Courbet between 1848 and 1850. Others of this group include *The After-Dinner at Ornans* (1848–49; Lille), *The Stonebreakers* (1849; Dresden, destroyed 1944), and *The Peasants of Flagey Returning from the Fair, Ornans* (1850–54; Besançon). The subjects depicted in this early series reflect social attitudes and economic conditions among the provincial bourgeoisie of Courbet's native Ornans, and together they present a pictorial record of Franche-Comté life and traditions.

Courbet's first Salon success, *The After-Dinner at Ornans,* which portrayed an intimate scene bathed in the warm glow of a provincial hearth, was praised for its similarities to 17th-century Dutch genre. *The Stonebreakers,* by contrast, evokes the severity of the strenuous manual labor required for roadway repair in the rugged terrain of Courbet's native province. Socio-political readings of this work established Courbet as a controversial artist. *The Burial at Ornans* combines aspects of both. Its monumental scale and frieze-like composition suggests comparison again with Dutch painting, and specifically Rembrandt's *The Night Watch* and van der Helst's *Captain Bicker's Company.* The striking austerity of Courbet's unidealized figures, reminiscent of his stonebreakers, once more suggested social readings. Yet, with *The Burial at Ornans,* Courbet surpassed the novel achievements of his earlier paintings by creating a highly provocative work which was challenged on all grounds.

The critical debate surrounding *The Burial at Ornans* was factionalized by the divergent artistic values manifest in Paris following the Revolution of 1848. Politics and painting were thus brought forth for battle at the Salon. *The Burial at Ornans* stood as an antithesis to class-prejudiced judgments about art and aesthetic values as commonly advocated by the Academy and sanctified by the State. The subject's worthiness and the style's appropriateness were challenged by conservatives who attacked the very premise of the painting as art. Several critics pronounced Courbet the advocate of the "deliberate depiction of ugliness," and Théophile Gautier labeled him a "mannerist of ugliness." Yet others did not fail to recognize Courbet's objective. *The Burial* was the hallmark of a new style, in fact, a new aesthetic, and a new form of painting. Paul Mantz predicted that this picture would represent the pillars of Realism in the development of modern art. Sabatier-Ungher proclaimed it to be "democratic," and Enault deemed Courbet the "Proudhon of painting." Champfleury, the artist's close

friend, provided what is perhaps the most unique and meaningful assessment, by calling *The Burial at Ornans* a "simple record of provincial life." It is his statement that suggests consideration of the socio-historical circumstances which lay behind Courbet's concept for the revolutionary painting.

A complete record identifying those pictured in attendance at this funeral does not survive historically. However, obvious identifications may be established for many, based on comparison of individual portraits Courbet had recorded prior to and after 1848 (Mainzer 1988): 39 persons (out of some 51 still visible on the darkened canvas) may be identified by name and placed within the context of Ornans society. And further investigation of genealogical relationships ultimately suggests who is being buried (Mainzer, 1981, 1982; Mayaud, 1981). The full title of Courbet's painting is *Tableau of Human Figures: A Historical Account of a Burial at Ornans.* Long misconceived as the burial of Gustave's maternal grandfather, Jean-Antoine Oudot, the subject is actually the funeral of the artist's great-uncle, Claude-Etienne Teste, who died on 6 September 1848. Teste was the first Ornans citizen to be interred in the controversial new cemetery of 1848.

In Ornans proper, burial rites and interment had occurred in a single location since Roman times in the 3rd century A.D. The local populace upheld this ancient tradition of burial in the churchyard cemetery of the parish of Ornans for 33 years, refusing to abandon the religious significance of this revered site. Civil documents of Ornans record the debates which long opposed relocation of these burial grounds, as had been originally specified by the Napoleonic Code of 1804.

The complex history underlying the pictorial composition and setting of *The Burial at Ornans* informs us of an important behind-the-scenes impetus which sparked Courbet's new concept for history painting. Ornans's "Cemetery of 1848" thereby functions as a stage upon which the overlapping dramas of ideological conflict, class consciousness, and the passing of generations show broad societal changes affecting all of France following the Revolution of 1789. These transformations had come to fruition on the eve of the Revolution of 1848 and were immortalized by the monumental and radical style of Courbet's *Burial at Ornans.* He subsequently referred to the work as "My beginning and statement of purpose." The opening of the "Cemetery of 1848" at Ornans was the culmination of a long post-Revolutionary drama. The town's final agreement to the relocation of the burial rites at its outskirts is metaphorical of the secularization of Church property, and by analogy, the dislocation of its influence following the Revolution.

The Burial at Ornans mirrored numerous aspects of contemporary society. It has subsequently achieved art historical significance as a work that lies at the intersection of personal history and the history of a nation. And finally *The Burial at Ornans*—as Courbet's "Realist Manifesto" which prodigiously ruptured the Paris Salon of 1850–51—heralds the autonomy of the artist for generations to follow.

—Claudette R. Mainzer

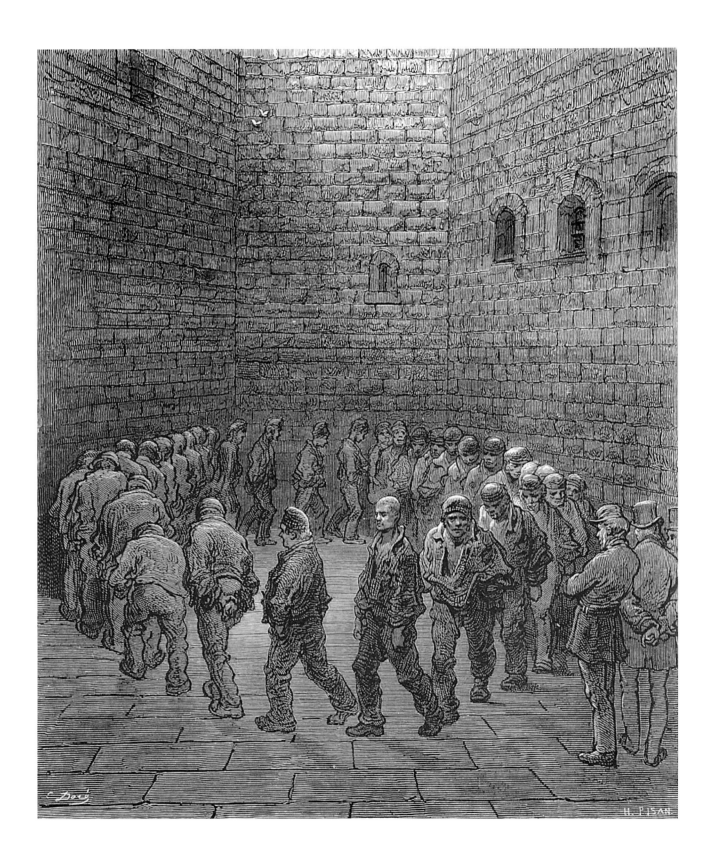

Gustave Doré (1832–83)
Newgate—Exercise Yard, from *London: A Pilgrimage*, 1872
Woodcut

Bibliography—

Maré, Eric de, *The London Doré Saw: A Victorian Evocation*, London, 1973.
Noël, Bernard, *Londres de Doré*, Paris, 1984.

In 1872 there appeared *London: A Pilgrimage* by Gustave Doré and Blanchard Jerrold, both in folio and in parts. Doré had already contributed to the *Illustrated London News*, as had Constantin Guys. Gavarni, working in London, had produced his *Gavarni in London*; and Eugène Lami had earlier published *Souvenirs de Londres* (1826) and *Voyage en Angleterre* (1829–30), so there was ample precedence for Doré to work with Jerrold, even if decidedly unwillingly. For the first time he was dealing with a non-literary subject and at the same time was obliged, against his usual practice, to make first-hand observations. In fact, Doré travelled comparatively little—most of the illustrations to his *Don Quixote* were drawn in Baden-Baden—and he relied almost entirely on his fertile imagination and phenomenally retentive memory. Yet it is true to say that Doré's *London* is now the best-known of all his works; and its illustrations are continually reproduced, especially in books of a sociological or historical nature, as evidence of the condition of London's inhabitants, more usually of the poorer workers or the indigent, in the second half of the 19th century. Yet it is *Newgate—Exercise Yard*, one of the least reproduced, that invites us to consider Doré's distinctive talent.

It is notorious that Doré did not himself engrave or woodcut his numerous illustrations but passed his sketches on to capable workmen either in his own workshop or those of the publishers for whom he was working. These sketches have naturally vanished but there do exist a number in Indian ink and gouache on blue-gray paper from the late 1860's. One of these is of a female pauper and her child lying on the stones by some tumbledown buildings over which gleams St. Paul's Cathedral. In this concern for the unfortunate Doré has already set the note for the illustrations he was to provide for London. *Newgate—Exercise Yard*, which bears little relationship to Jerrold's text, depicts a yard in the old prison which was demolished in 1902—there is now no chance of verifying the accuracy of Doré's depiction of the actual setting. The perspective is distorted, as with Piranesi, so that the walls, contrived of great stone blocks, broken by four tiny arched windows, seem to be closing in like a coffin on the circle of prisoners trudging over the flags in a circle, watched by a prison officer and two onlookers whose elegant bearing and attire contrast poignantly with the shapeless clothing and tight caps of the prisoners. High up between the prison walls where there is the merest glimmer of light flutter two or three birds symbolic, perhaps, of liberty.

It was objected by British critics of *London* that Doré had put French baskets on the arms of his London flower girls, put a measure of French wine in front of a drunkard, and failed to appreciate the distinctive nature of the capital not only of Britain but of the vast Empire. It was also claimed that the sharp contrasts of black and white (the society scenes are light, dock scenes, for instance, dark) derived from those he had evolved to illustrate heaven and hell in *The Divine Comedy*; but it may

well be that he deliberately used these contrasts seeing them as appropriate to an evocation of London and especially to its infernal regions which he had visited, playing Dante to Jerrold's Virgil. But it is instructive to note Doré's procedure with regard to *Newgate—Exercise Yard*. Jerrold complained that Doré could seldom be prevailed upon to make sketches on the spot, preferring to rely on his memory. When they went to Newgate together the artist "remained in a corner of the prison yard, observing the prisoners taking their exercise—a moving circle of wretchedness. He declined to make a sketch . . . he asked the turnkey who accompanied us, to leave him for a few minutes at an opening that commanded a view of the yard. When we returned to him he had not used his pencil. . . ." However, Jerrold continues, "The next day we met he laid before me his circle of prisoners. It was a chain of portraits from the poor frightened little postman who had succumbed to temptation in his poverty, to the tall officer who had cheated a widow out of her last mite." What is revealed in Jerrold's comment is not the exactness of Doré's visual memory nor his own peculiarly Victorian tendency to classify and particularise, but the artist's intent which is to show how degradation and brutality reduce men to the same subhuman level. The point is surely that Doré was going beyond the literal into the area of critical social comment and humanitarian concern: he is not so much concerned with the victim of the system as with systematic authoritarianism. As in the wider world of Victorian England the rich and poor stand far apart, so in the Newgate prison yard prisoners and authorities stand separately in deliberate non-communication. The image of the prisoners monotonously treading the prison flags in meaningless motion is all too reminiscent of the treadmill used as a controlling punishment in both prison and workhouse. Doré had witnessed revolution in Paris: that the London poor had not revolted was incomprehensible to him, still more that the hungry, overworked masses has not risen up against the exploiting minority. Like the convicts in the exercise yard, the masses passively, if sullenly and grudgingly, accepted their lot. Yet in Doré's image there is a note of defiance: one man alone at the centre front does not wear a cap, does not bow his head, but, instead, stares defiantly in front of him, as does one of the bargehaulers of the Volga in Repin's famous icon of repression and misery painted in 1870–73. Still later, in 1890, Van Gogh, who treasured a set of Doré's illustrations to *London* acquired when he lived in that city, painted *Prisoners' Round* in which he has emphasised the defiant prisoner's proud stance.

Unlike the majority of Victorian pictures of the poor, which range from the sentimental to the patronizing but which run away from confrontation, in *Newgate—Exercise Yard* Doré created a representation of repression, of the cowed masses, of economic and social callousness. No other artist of the day devised so effective and moving an image of an unthinking society based not only on his own direct emotional reaction but also on a clear-sighted scrutiny which transcended literal realism and which owed everything to sincere and total artistic integrity.

—Alan Bird

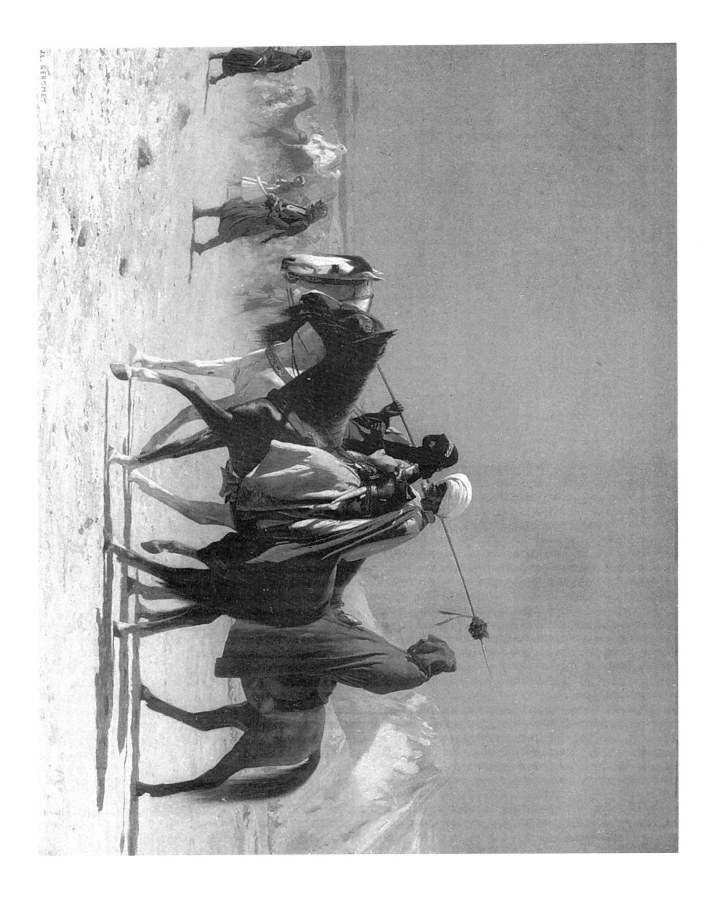

Jean-Léon Gérôme (1824–1904)
Arabs Crossing the Desert, 1870–80
16¼ × 22 in. (41.2 × 56 cm.)
Private collection

Gérôme's *Arabs Crossing the Desert* (41.2 × 56 cm [16.25″ × 22″], 1870–80, private collection) demonstrates his virtues and his proclivities: a strong yet delicate composer, a great draughtsman, a brilliant colorist, a master of oil techniques, and a lover of the masculine atmosphere of the Near East.

Bright sunlight, a deep blue sky that makes a dusty transition to the dry sands below, frame a group of Bedouins on the march across an unidentified desert. Some are on foot, some are mounted on camels, others are on horseback. The place is no place: it is full desert. There are no landmarks, just a dry hill, a ravine, a few scattered rocks: no settlement, not even a palm tree in sight. The crowd moves like an apparition, unidentified Bedouins moving from an unknown destination towards another destination known only to them. They are silent, admirable yet mysterious in their steadfast, uncomplaining sense of purpose.

Three men on horseback are in the right foreground, the colors of their garments, the sinews of their horses all clearly seen in the bright sunshine; the others are a bit further off, obscured already in the dust raised by their movement. Only one face of the three horsemen is seen, that of an old man with a white beard; he looks forward, and the man behind him is completely hooded and cloaked by a long red robe, like a specter of death trailing them all. The composition is extremely subtle: it pulls our eye into the crowd which the horsemen represent, and then back to the horsemen.

Gérôme himself was an avid traveler and hunter who had already, when he painted this picture, made several months-long safaris into the Sahara and the Sinai desert. In the desert he must have often come across unannounced groups of Bedouins marching through the unmarked spaces; as he became older, wandering groups in the desert became an increasingly frequent theme in his paintings.

Gérôme had started his career as a neo-classicist, painting fanciful scenes set in antiquity. The money from a state commission for the Universal Exhibition of 1855 allowed him and three young companions to visit Egypt for a six-month stay. Back in Paris in the spring of 1857 he showed five paintings of oriental scenes at the Salon, three of them located in the desert; from then on half of his paintings were of oriental subjects. And he continued going to the Near East, organizing huge hunting safaris which included other artists and writers, traveling great distances to El Fayoum in the Western Desert and to St. Catherine's on the Sinai peninsula. He sketched constantly on these trips—scenery, interiors, animals, and people—both in pencil and in oil on paper. And he and members of his crew took photographs. Often a full dromedary load of photographic equipment accompanied them, for the glass plates used then had to be developed on the spot. And

along the way he bought costumes and properties (guns, saddles, hookahs) for use in his studio at home, for his pictures, with their fine, impeccable surfaces, were all painted in his own atelier, using Arabian models found in Paris. His memory, sketches, and photographs helped him fill in the backgrounds.

For a while—before the term "orientalist" was accepted—he was called an "ethnographic painter." His depiction of the physical types and settings of the East were considered accurate, even scientific. Recently, the objectivity of every "Orientalist" painter has been questioned, and all "Orientalist" painting has been characterized as infused with a superior, imperialist attitude towards the citizens of the Near East. Gérôme's work, however, does not denigrate the personalities or activities of his ethnic subjects. The Arabs, Egyptians, Arnauts, and other ethnic types in his compositions are heroized, as here; even so, they are still strange, cut off from us by their language, wrapped in their culture like the last horseman in his red cloak. Look at the three Arab horsemen in *Arabs Crossing the Desert*. Despite heat, aridity, wind, sandstorms, a pernicious atmosphere, and the fright of endless, seemingly unarticulated space, they still move stalwartly forward. They think not of what they have left behind, neither of the distance they must cover nor of their goal: their steadfastness makes them symbols of their acceptance of fate. Gérôme sees their unquestioning concentration on their goal as stoic heroism. Nonetheless, Henry James had complained that Gérôme was "of the troupe . . . that rifled the oriental world of its uttermost vestiges of mystery." He should have said, "of romanticism", for in Gérôme's depiction of the desert there is still mystery, that of an incomprehensible but integral reality.

Gérôme manifested his own realism by clarity of vision, by accurate reporting, by always working from models, by the impersonality of a perfect oil technique (which could not cover up a marvelous sense of color) and by his lack of social criticism, despite the fact that he was working in the genre tradition which has always been a scolding, moralizing tradition.

Arabs Crossing the Desert is given a date of "around 1870" in a manuscript catalogue made in Gérôme's studio around 1883. If that were the correct date, it might have been painted in London, where Gérôme sat out the Siege of Paris. However it was consigned to Gérôme's dealer, Boussod Valadon and Company in Paris, in 1880, and immediately sold to an American dealer, so the date of execution is probably closer to 1880 than 1870, but even so, the work was painted in a decade in which Gérôme was still at the height of his technical and imaginative powers. Continuously in private hands, the work has seldom been exhibited.

—Gerald M. Ackerman

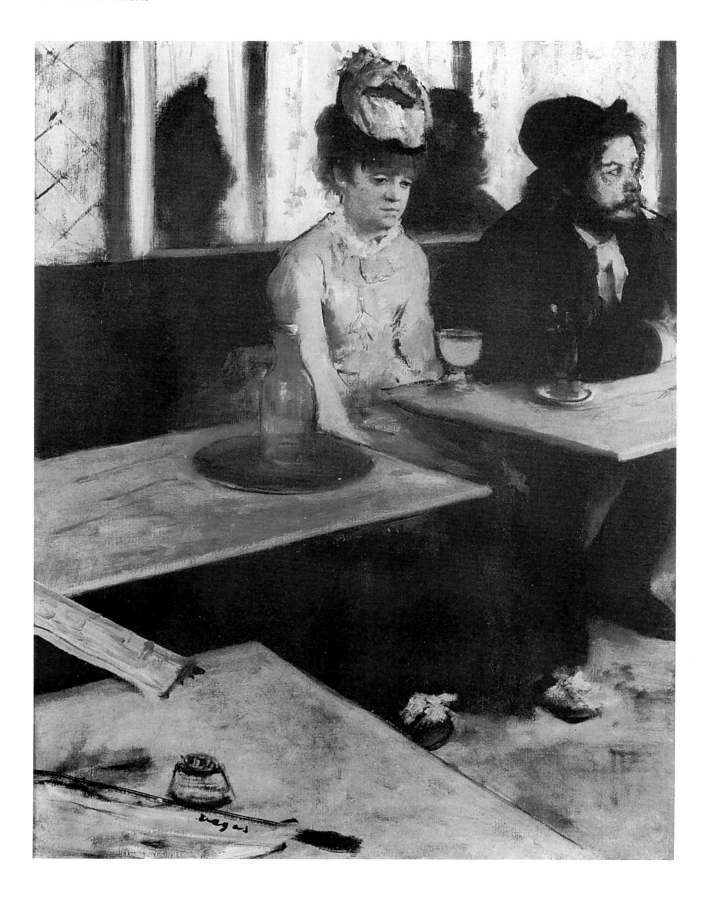

Edgar Degas (1834–1917)
The Absinthe Glass (In a Cafe), 1876
36¹/₄ × 26³/₄ in. (92 × 68 cm.)
Paris, d'Orsay

The Absinthe Glass, or *In a Café*, the title given to the painting by Degas when he listed it for the second Impressionist exhibition of 1876, shows two people seated at a table in a café, the man on the right smoking a pipe, the woman with a glass of absinthe in front of her. At first glance it looks like a random view of typical Bohemians, but Degas's notebook identifies the work by "Hélène and Desboutin in a café 90 cm × 67 cm" with a quick pencil sketch of the setting, color notes, and a sketch of the woman's shoe.

The setting is the Café de la Nouvelle Athènes which became the meeting place of Manet, Degas, and a number of Impressionist painters. Degas posed two friends, the actress Ellen Andrée and the painter-etcher Marcellin Desboutin in specific attitudes for the painting. Ellen Andrée was a pantomime actress and sometime model who changed her name from Hélène. She had performed at the Palais-Royal Theatre since she was 17, and then at the Variété and Folies Bergère. She has been tentatively identified in several other works by Degas: a monotype of c. 1876 (Chicago, Art Institute) which shows a smiling young woman much younger and more attractive than the pensive café denizen; a drypoint of 1879 (Delteil 20), and also possibly in *Project for Portraits in a Frieze* of c. 1879, a pastel in the collection of Dr. Herman J. Abs, Chicago. Her partner, Desboutin, was well-known among the Impressionists as a painter (his portrait of Fauré of 1874 is in the collection of Wheelock Whitney and Company, New York) and etcher. According to Paul-André Lemoisne, in his catalogue of Degas's oeuvre, Desboutin had lived in Florence but had returned to Paris in 1875, financially ruined. Armand Silvestre in *Au Pays du Souvenir* described him as "Tall, thin, a huge black fleece of hair adorning a wide and tormented-looking face, eyes like half-extinguished embers, since they were both black and glowing; an adolescent's beard which he kept twirling between his fingers. . . . A cheap hat adorned his head, seeming often to be riding on the crest of his billowing locks . . . a pipe, small, black, well-seasoned never left his mouth. . . ." Degas also portrayed Desboutin in a monotype (Janis 52), a transfer lithograph (Delteil 55), and an oil painting of c. 1876, *M. Desboutin and L. Lepic*, in the Musée des Beaux-Arts, Nice. Desboutin's picturesque visage also appears in Edouard Manet's *The Artist* of c. 1875 in the Museu de Arte Moderne, São Paolo, and a watercolor (c. 1875, Fogg Museum of Art, Cambridge, Massachusetts).

The two figures, seated behind marble topped tables and in front of a mirror which shows a reflection to the left of each head, are placed off-center to the right in the composition. The viewer's gaze is led into the painting, as in Japanese woodcut organization, by a diagonal of a slanted table top, a newspaper on a rod joining this table and the line of table tops in front of the protagonists. The colors are subdued whites, grays, browns, and black, the only bright hue being the woman's yellow jacket. Edges of the tables and the woman's figure are outlined in black. An empty carafe on the table next to the actress emphasizes the full glass of absinthe in front of her. A slight tinge of green colors the lower area of the woman's face. The placement of the woman on the left of the painting echoes a number of Degas's earlier works which have the female figures on the left. The man, whose figure is cut off on the right side of the canvas, looks to the right, smoking his interminable pipe, while the woman gazes pensively down in front of her, seemingly lost in thought. The carefully composed scene may appear to be a naturalistic rendering or an illustration to a novel by Emile Zola, such as *L'Assomoir* (which came out in installments in 1875) but in fact it testifies to Degas's statement, "No art is less spontaneous than mine."

Although the painting was listed in the 1876 exhibition catalogue, no reviewers mentioned it, and a letter from Degas to Charles W. Deschamp, in charge of Durand-Ruel's London gallery, reveals that it was sent to London before the time the Impressionist exhibition closed. Ronald Pickvance adds that it was sold to Captain Henry Hill of Brighton who lent it to the Third Annual Winter Exhibition at Brighton in September 1876. In 1877 it was returned to France to be in the Third Impressionist Exhibition. It reappeared in the sale of the Hill collections at Christie's in London in 1892 as #209, *Figures at a Café*. When it was exhibited at the Grafton Gallery, London, in February 1893, under the provocative title *L'Absinthe*, it became the occasion for a confrontation between Ruskinian critics denouncing its immorality, and New Critics, under the leadership of D. S. MacColl of *The Spectator*, extolling its artistic and esthetic merits. It was acquired, under the innocuous title of *L'Aperitif*, by Count Isaac de Camondo in May 1893 and entered the Louvre as part of the Camondo Bequest in 1911.

An unsigned review in the *Globe* of 25 February 1893 criticized Degas for showing people "of the most degraded type, both under the influence of the deleterious drug." The 1986 edition of *The Oxford Companion to Medicine* defines absinthe as a drug "prolonged addiction to which notoriously resulted in mental and neurological changes," and one outlawed in France. Degas certainly did not intend a moral statement in this painting, but in calling attention to the glass of absinthe he may have been offering a commentary on his times. In art, Degas said, one is never entitled to disregard what is true.

—Alicia Craig Faxon

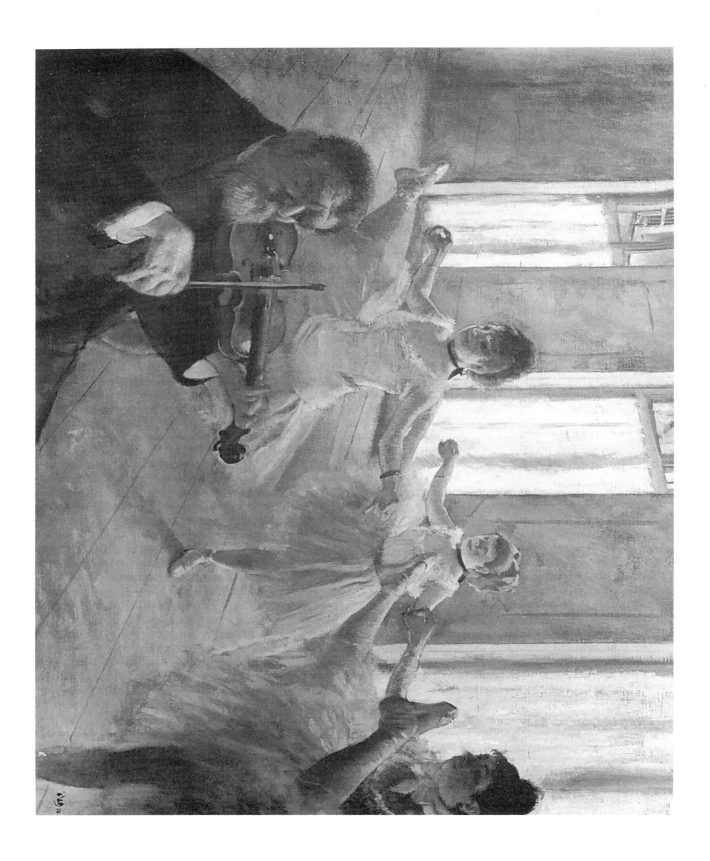

Edgar Degas (1834–1917)
The Rehearsal, c. 1878–79
18³/₄ × 24 in. (47.6 × 60.9 cm.)
New York, Frick

The Rehearsal shows the half-length figure of an elderly violinist in the lower left foreground playing for four dancers, two of whom are fully visible in the center of the composition; the third is partially cut off on the right side, and only the leg of the fourth dancer is visible on the right. The composition is organized with the diagonal of the floor boards leading in from the right. The dancers, with arms held at shoulder height, wrists turned forward, and right legs at 90-degree angle from the floor, are performing a "developpé à la seconde," which begins usually from the fifth plié position. The scene takes place in a rehearsal room either at the old opera house on the rue Le Pelletier or in the new opera building by Charles Garnier, which opened in January 1875. The slant of the floor boards can be ascribed both to Japanese woodcut diagonal design influence and to the fact that ballet dancers both rehearsed and danced on raked floors.

There are a number of preparatory studies for this piece, the most important being drawings for the violinist in the Museum of Fine Arts, Boston, the Clark Art Institute, Williamstown, Massachusetts, the Minneapolis Art Institute, and the Bibliothèque Nationale, Paris. A number of studies for the dancers also exist, the most complete being a charcoal sketch in the Norton Simon Foundation, Pasadena, and an oil sketch, *La Coryphée*, in a private collection.

The dancers in white tutus stand out against shades of gray on the walls and floor. The main color accents are the peacock blue hair ribbon and sash of the central dancer and the brilliant red tights of the dancer farthest left. (A pastel, *Dancer with Red Stockings*, in the Hyde Collection, Glen Falls, New York, shows red tights similar to those of this dancer.)

The Frick Collection *Rehearsal* is specifically related to two other rehearsal paintings with a violinist in the left foreground: *The Rehearsal*, an oil painting of c. 1873–78 in the Fogg Museum of Art, Cambridge, Massachusetts, and *The Rehearsal*, 1876, oil and distemper, in the Shelburne Museum of Art, Vermont. The first in the sequence is undoubtedly the Fogg Museum one with its large number of dancers and its careful execution on squared-off canvas, characteristic of Degas's early treatment of the theme. The Shelburne Museum version, with a more limited cast of dancers, is probably the intermediate one, and the Frick Collection *Rehearsal*, focused on a few figures, larger in scale and closer to the viewer, would appear to be the last in the sequence. Here Degas employs such devices as cropping the figures on the right, a greater concentration on the fall of light and a daring spatial organization, characteristic of his mature work.

Degas's interest in the subject of dancers began as early as 1868–69 with *The Orchestra of the Opera* (Paris, d'Orsay) and *The Ballet from "Robert Le Diable"* (1871; New York, Metro-

politan) in which the dancers appear as a backdrop to the orchestra in the foreground. From the 1870's he portrayed dancers from every conceivable angle and in all the media he worked in: oils, drawings, pastels, monotypes, book illustration, and sculpture, the most notorious of which was his bronze *The Little Fourteen Year Old Dancer* of 1879–80 wearing a real muslin tutu and silk hair ribbon which was exhibited at the Sixth Impressionist Exhibition in April 1881 (versions in the d'Orsay and the Metropolitan, among others). As in the sculpture of Marie von Goetham, Degas strips away the glamor of the dancer and shows her without illusions, in awkward and characteristic poses of tension and weariness. It is not the performance or the star which he usually captures, but the endless classes and rehearsals, exercises at the barre, dancers relaxing or adjusting their costumes before the performance. As in his paintings of laundresses, café singers, or jockeys, he is concerned with the characteristic motions of the métier and the realities of the performer's life. The artist presents his oblique view like a snapshot of the participants taken unaware, but his seemingly unposed paintings were the result of endless study and calculated construction, much in the same way that the floating grace of the dancers on stage was the product of numerous rehearsals and repeated exercises until the artifice of the performance looked effortless and natural.

The scenes Degas showed were not created on the spot. The artist had a season ticket to the Opéra which enabled him to go backstage to watch the dance exercises and rehearsals. Unobtrusively he sketched the various poses and attitudes and later organized the separate figures into his compositions in oil or pastel in his studio. He would often repeat the same pose in a number of paintings, as in the motif of the dancer yawning, adjusting her shoulder straps, or stretching her back in weariness. The figures were shown from unusual angles, obliquely, from above or below, which may be in part a symptom of impairments in Degas's vision, as Richard Kendall pointed out in his March 1988 *Burlington Magazine* article.

About half of Degas's output of paintings and pastels, some 2,000 in all, are of dancers. This can be explained by his interest in motion, and his feeling that ballet, as he told Lousine Havemeyer, was "all that is left us of the movements of the Greeks." There was also a pressing economic motivation, as Degas's father died in 1874 with undischarged bank debts and Degas assumed these for the honor of the family name. From then on he was under pressure to sell paintings, and his ballet subjects provided much-needed income. Above all, Degas had found a subject which united classicism of form with the modernity of contemporary subject matter.

—Alicia Craig Faxon

Edouard Manet (1832–83)
Le Déjeuner sur l'herbe (Luncheon on the Grass), 1863
6 ft. 11¹/₈ in. × 8 ft. 10¹/₄ in. (211.1 × 269.8 cm.)
Paris, d'Orsay

Bibliography—

Isaacson, Joel, *Manet: Le Déjeuner sur l'herbe,* New York, 1972.

In 1861 the young Manet won the distinction of an Honourable Mention at the state-sponsored biennial art exhibition, the Paris Salon. This award was for the *Spanish Guitar Player* (New York, Metropolitan), a painting which was boldly handled but which drew extensively on older artistic styles, particularly in its overt use of Spanish prototypes. Manet was only 29 years old but it looked as if his artistic future was set.

At the following Salon, in 1863, Manet submitted six works to the selection jury: three etchings and three oil paintings. All were refused, along with almost 3000 other works. The sheer enormity of works deemed unsuitable for exhibition that year was unprecedented and there was a general outcry at the injustice. For many artists the inability to display their work and attract custom was particularly strongly felt since there were few other commercial outlets for painters and sculptors in Paris during the Second Empire.

In response to public pressure and as a political gesture which cost him little, the Emperor Napoleon III published a decree allowing for a counter exhibition of refused works which was intended to complement the official Salon. As many artists recognised, however, this was not simply a magnanimous gesture on the Emperor's part, but was intended to justify the original decision of the jury in refusing so many works, by allowing the public to judge. Those artists who refused to submit themselves to public scrutiny after having been judged unworthy of exhibition by the official arbiters of taste withdrew their works. Others, like Manet, Whistler, and Cézanne, decided to display their works in the *Salon des Refusés,* hoping that it would be recognised as belonging within the grand tradition of Salon painting, and be judged accordingly.

However, the public and critics were generally hostile to Manet's work, the paintings *Young Man as a Majo* and *Mademoiselle V. as an Espada,* in which he attempted to rework Spanish scenes, and particularly *Le Bain* (it was only renamed *Le Déjeuner sur l'herbe* four years later) which hung between the two figure paintings. This work was originally conceived as a Salon painting and was therefore quite different in character from works intended for private consumption. It was much larger, over eight feet in length, standard practice with a painting intended for public viewing which had to compete for the spectators' attention. It took the artist some time to paint, borne out by X-rays of the work which confirm that Manet reworked the canvas over a period of time, deliberately altering his initial conception of the subject. Finally, the content of the painting is complex, drawing on artistic conventions yet consciously trying to set it within a contemporary context.

In juxtaposing naked, or near-naked, women with fully dressed men, in a landscape setting, Manet was deliberately setting his painting within a tradition which dated back to Titian's *Concert champêtre* in the Louvre, a copy of which was in Manet's studio. However, in Titian's work the unreality of the scene is underscored by the universalised landscape setting and by the fact that the women could be construed as nymphs in attendance to the two young men who appear lost in their music. At first sight Manet's work has certain superficial similarities: he has represented two young men conversing in the wood attended by two women, in whom they do not seem particularly interested. The whole is set within a generalised landscape.

Manet wanted the people in his work to be regarded as modern figures, yet at the same time he has made overt references to the art of the past, not only in the general mood which was borrowed from Titian, but more specifically in the composition of the three main figures. A perceptive critic in 1863 recognised that the pose of these figures was taken from a group of two river gods and a nymph which appeared in an engraving by Marcantonio Raimondi after Raphael's *Judgement of Paris* (now lost). Even for those who did not immediately recognise the source, the stiffness and rather contrived nature of Manet's figures might have indicated a classical prototype. At the same time, Manet made no attempt to suggest that his models were anything other than contemporary. His main female model, Victorine Meurent, would have been identified as being the same as in the adjacent canvas of *Mademoiselle V. as an Espada.* The two male models were Manet's brother and his future brother-in-law.

However, there are important changes. The men in Manet's picture do not have the cultivation of Titian's figures, who play music. Manet's figures are accompanied by a sizable picnic which demonstrates their very corporeal appetites. Similarly the women in *Déjeuner sur l'herbe* cannot be read as wood nymphs lending a sylvan mood to the men's contemplation. The young woman in the foreground has ostentatiously removed her clothing which lies in a heap beside the picnic. This was one of the additions revealed by X-rays which Manet made to the work in the course of its execution. Clearly in deciding to add the woman's hat and dress he wished to identify her as a contemporary figure who has shed her clothing.

Manet's setting his figures within a universalised landscape gains a certain poignancy when one realises the speed with which Paris was industrialising at that time. While his figures are specifically modern and Parisian—the men are dandies, and the women belong to the *demi-monde*—there is little hint of a conception of nature which was anything other than permanent and unchanging. It is impossible to locate the landscape either in time or place. In a sense the discrepancy between foreground and background, with Manet's apparent unable to reconcile them, leads to a reading of the landscape as highly unrealistic.

Critics of the painting were disturbed by Manet's cavalier attitude to past art, to his bringing the old masters up-to-date by references to less than respectable aspects of modern life. Yet much of their displeasure was voiced in terms of the handling of the work. It was thought to be too sketch-like in its technique, particularly in the apparent lack of internal modelling in the treatment of the flesh. However, in some respects

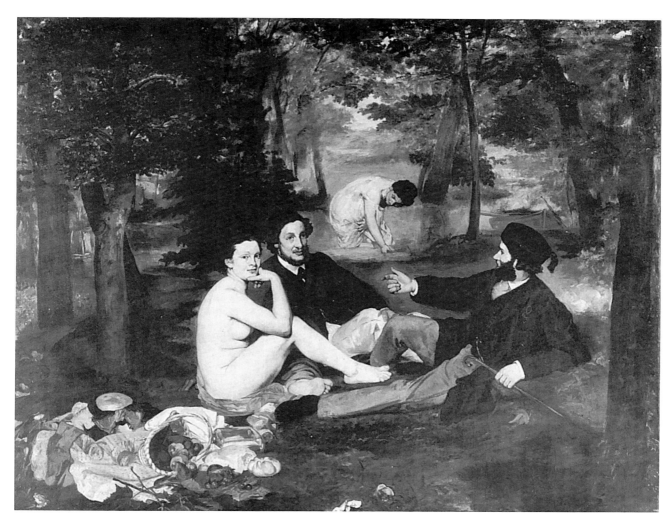

Manet's practice was far from radical. While his painting depicts figures out-of-doors, there is no sense of reflected light on the people, who have clearly been posed in the studio. This and the use of a palette which relied on heavy browns, ochres, and blacks made this work quite different from that of the future Impressionist painters with whom Manet is sometimes aligned.

It is frequently suggested by art historians that Manet is the first modernist artist, and the first example of "modern art" is *Déjeuner sur l'herbe*. It has been suggested that the provocative stare of the female nude "is not so much in invitation as to remind the spectator that it is only a painting he is looking at." This modernist claim—that art becomes self-referential in na-

ture, and that the spectator is encouraged to read paintings as two-dimensional configurations of paint and canvas—fails to appreciate the wealth of meaning in the content of the *Déjeuner sur l'herbe*.

It seems important to rescue this work from the claims of 20th-century art historians who wish to place it at the beginning of modern art. When placed back within its Salon context, which is where Manet originally intended it to be received, it can be recognised that rather than wishing to break with all artistic traditions, the artist was attempting to work within certain conventions and prove that he was worthy of inclusion at the official Salon.

—Lesley Stevenson

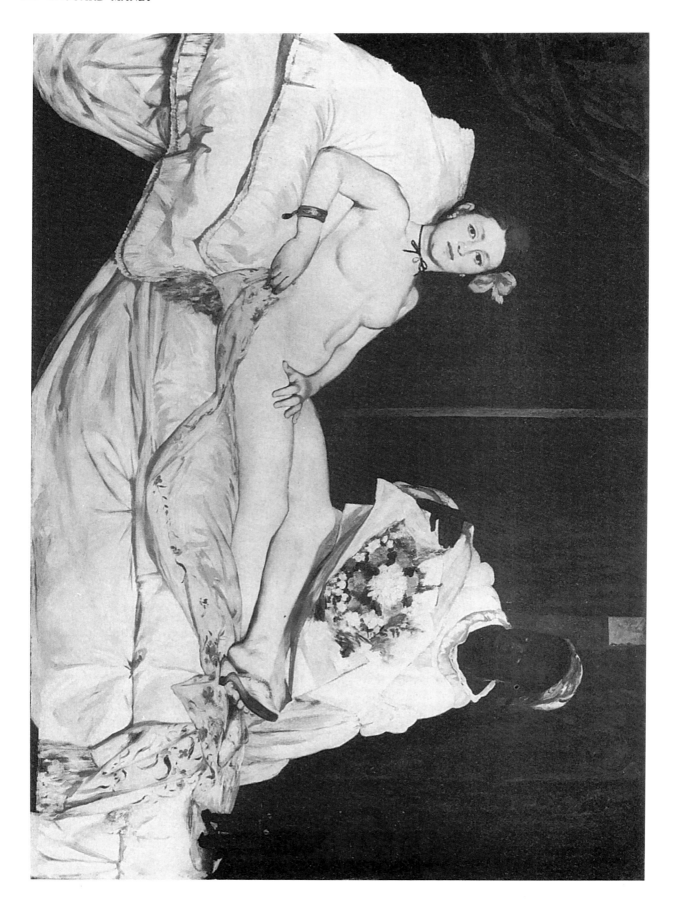

Edouard Manet (1832–83)
Olympia, 1863
4 ft. 3 in. × 6 ft. 2³/4 in. (129.5 × 189.8 cm.)
Paris, d'Orsay

Bibliography—

Reff, Theodore, *Manet: Olympia,* New York, 1977.

Manet exhibited his painting of *Olympia* at the Salon of 1865, but he had in fact painted it in 1863, the same year his *Déjeuner sur l'herbe* had caused an outcry at the *Salon des Refusés.* In a sense *Olympia* can be read as a conceptual pendant to the *Déjeuner.* They both deal with roughly the same areas of concern: traditional artistic stereotypes, in this case the female nude, treated in such a way as to shock the spectator into seeing them as being uncompromisingly contemporary or modern.

In attempting to fuse the traditional and the modern Manet was greatly influenced by the work of his friend, the writer Charles Baudelaire whom he had known since 1858 or 1859 and with whom he shared many beliefs about the purpose of modern art and what forms it should best take. While *Olympia* did not illustrate any particular poem from Baudelaire's *Les Fleurs du mal,* the poems' influence is apparent in the painting, both in the choice of motifs—the cat, the black woman, the orchid in Olympia's hair—and more specifically in the mood which pervades the work.

Baudelaire's essay *The Painter of Modern Life,* 1863, served as another important source for contemporary artists who were concerned with painting the modern. Manet must have been aware of Baudelaire's specific recommendation of certain "types" to which the modern artist should devote his attention, and one social group with which he was specifically concerned was the demi-monde. The prostitute, he stated, was "a woman in revolt against society." It appears that Manet has accepted Baudelaire's implicit challenge in painting *Olympia,* and presented her as a heroic figure. Clearly the society against which Manet wished to revolt was that of the hypocritical Salon visitors, who relished the representation of the female nude, but decried her real-life modern counterpart.

To contemporaries, however, it was *Olympia*'s painted, rather than her literary, precedents which were more apparent. Few people would have failed to recognise an overt reference to Titian's *Venus of Urbino* (1538, Uffizi) in the work, and indeed Manet had copied the original while still an art student. In the preparatory studies which Manet made for the work, his debt to the sensual reclining figure of Titian's female nude is more apparent, and he was more consciously working within that tradition. At the same time, he was aligning himself with generations of painters of the reclining nude who used Titian's prototype for reworkings of their various Venuses. Manet's latter-day Venus has to be regarded against the backdrop of Salon nudes which had gradually become vaguer and less specific both in intention and in detail. *Olympia* is an ironic comment on the state of the Salon nude. In a sense, she has been re-eveluated to the status of a portrait, and Manet has encouraged a reading of the nude as an individual; indeed he had used the same model for the main female figure in his *Déjeuner.*

Critical reaction to the work was not encouraging. The popular press, which reviewed the annual Salons with great energy and was responsible for the formation of many artistic reputations, tended to be openly hostile. Most critics, while recognising that the work dealt with a prostitute, tended to couch their displeasure in fairly euphemistic terms, dwelling on Manet's technique at the expense of the work's subject. And yet the theme of a courtesan was not an uncommon one at the Salon. Manet's teacher Thomas Couture had based much of his reputation on an 1847 work with that subject, *Romans of the Decadence* (Paris, d'Orsay). Then critics had seen that the central figure of the prostitute was used to suggest the decline of a society. The social implications of such a work were not lost on the public and critics in 1847, nor was the courtesan disguised as a Venus-figure. However, while the scene represented might have had political implications for contemporary France, it was sufficiently distanced in both time and place to present little real threat. *Olympia*'s immediacy was to prove her undoing.

In attempting to combine the traditional depictions of the nude with modern subject matter, Manet has relied greatly in the use to which he put accessories in the work. While Olympia's maid, jewellery, cat, and surroundings all draw on reworkings of similar motifs in the Titian, it is clear from the X-rays of the painting that Manet added some of them fairly late in his working of the painting, presumably in an attempt to bring his nude up-to-date. On one level, Olympia's accessories such as her slippers and the orchid in her hair, identify her as being fairly wealthy, and thus successful in her profession. Therefore, there is little sense of the artist offering any kind of moral judgement. At the same time, Manet is referring back in a fairly humorous way to Titian's work, where the sleeping lap dog becomes a cat, a common erotic symbol in Baudelaire's writing, and the discreet maidservants are transposed into a much more active black servant who offers Olympia a still-wrapped bouquet. In doing this, Manet has given the work a certain narrative quality for, when coupled with Olympia's direct gaze, the suggestion that the spectator looking at the painting is to be identified with the bringer of the flowers is too apparent to be ignored.

In presenting the work to the Salon public Manet provided them with certain clues, inviting them to examine the work in a quite specific way. His friend the poet Zacharie Astruc provided five lines of verse for the exhibition catalogue imitative of the erotic tone of Baudelaire's poetry which identified Olympia's profession. At the same time, in calling the work *Olympia* Manet was consciously breaking with certain Salon conventions in which nudes, and indeed naked prostitutes, could be represented so long as they were passed off as Venus figures. By naming his figure Olympia, with its vaguely classical overtones, he was perhaps intending an ironic comment on that kind of title. It is not inconceivable that the name might also refer to the kind of pseudonym adopted by a courtesan. Both of these aspects encourage a fairly literary examination of the painting.

As in *Déjeuner sur l'herbe* Manet has sent an ambitious work to the Salon in which he attempted to reconcile specific artistic conventions with modern subject. His criticism of certain social and artistic institutions which began with *Déjeuner sur l'herbe* was much more specific in *Olympia* and yet in both he has worked within certain constraints, offering his work for approval within the carefully demarcated and conservative confines of the Salon system in the 1860's.

—Lesley Stevenson

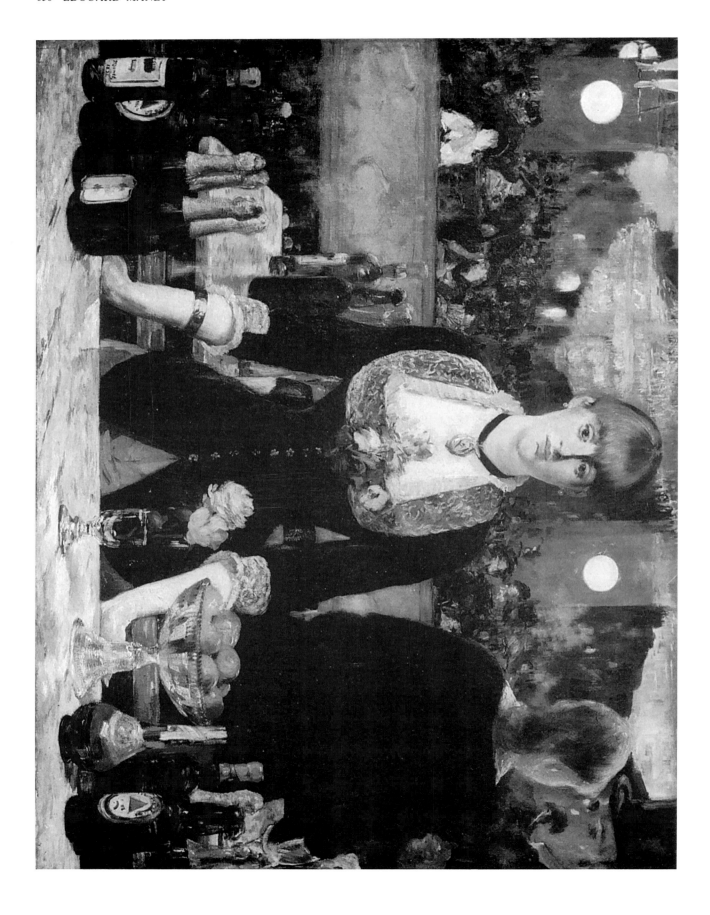

Edouard Manet (1832–83)
A Bar at the Folies-Bergère, 1882
37³/₄ × 51¹/₈ in. (96 × 130 cm.)
London, Courtauld

Bibliography—

Busch, Günther, *Manet: Un Bar aux Folies-Bergère*, Stuttgart, 1956.
Ross, Novelene, *Manet's Bar at the Folies-Bergère and the Myths of Popular Illustration*, Ann Arbor, 1982.

A Bar at the Folies-Bergère (*Un Bar aux Folies-Bergère*) is a delight: a highly complex painting which nevertheless has a direct and simple appeal. I always hold it in my memory as colourful, yet it is largely blue. The blue is complemented by the oranges in the bowl—placed right between the dark masses of the woman and her back view—and together with the sense of activity among the brightly lit crowd, the restricted colours seem full of variety. Yet this is only the first of many deceptive aspects of the work.

The painting draws us into it. We stand where the man would be—but not quite; the crowd in the background must be with us—or watching us. We begin to sense that in order to gain the fullest appreciation of the painting, we have to approach its complex syntax in contradictory ways. Without at all losing sight of its surface meaning and pleasurable appeal, we move into its perceptual world.

A Bar at the Folies-Bergère is first of all a convincing depiction of Parisian nightlife, with an atmosphere we can still recognise today. Its modernity was striking when it was painted in 1882, even though by then the avant garde had been depicting modern life for over ten years. The woman's expression, or lack of it, is not how women were usually portrayed. No concession here to the ego of a patron, no alluring or modest glance. It is the face of alienation, or "ennui." The experience of ordinary working women in bars and their male customers was not even on the list when it came to the hierarchy of subject-matter—and such a hierarchy existed, with heroic subjects and formal portraiture of the powerful very high up. Whoever dares to construct a general truth about our common humanity around the experience of a barwoman is to my mind a radical. As the poet Mallarmé said in "The Impressionists and Edouard Manet," written six years before Manet painted this painting, Manet's work "surprised us all as something long hidden but suddenly revealed. Captivating and repulsive at the same time, eccentric and new, such types as he gave us were needed in our ambient life . . . if [the] public will then consent to see the true beauties of the people . . . then will come a time of peace."

Manet is equally bold in terms of form. The most obvious feature of *Un Bar aux Folies Bergères* is its use of doubles: two chandeliers, two globes, two horizontals (the bar and the balcony), two areas of broken colour (the bottles and the crowd), two views of the woman. These visual doubles are paralleled by its doubled central action—the transaction which takes place between the woman and the man is the analogue of the transaction between the painting and us, its audience. Though the woman stands squarely facing us, she does not meet our gaze, nor does she meet that of the man whose displaced and partial image is squeezed into the top right hand corner.

The work has furthermore an uncanny capacity to make us accept as realistic an impossible geography. This is something Manet often does, sometimes to the extent of making it virtually a structural principle, as he does here. There are reflections, but where exactly are the mirrors? Where exactly is the man? If the bottles behind the woman are a reflection, they are the wrong bottles. If they are not, then what appears to be the reflection of the woman's back view can't be. And where is the balcony—behind us or behind her? And so on. The fullest understanding of this painting depends on how its spatial construction is read. Its repetitions and contradictions may be understood as complex signs, functioning on more than one level at the same time, in that they bear differing relations to the signified. In this way the painting opens the possibility of inscribing a temporal element and its discontinuities appear rather as temporal progression, the inconsistencies and repetitions as registering peripheral vision. Through such internal movements, tensions are set up, but the final term which might complete the meaning is refused so that no place in socially instituted meanings is assigned to the signified. The structure is then that of a primal fantasy that leads back to the body from which it derives the woman and the woman-as-painted, both signs. The physical reality and the painted perceptual reality move between the physical perceptions of the receiver of the message as well as of the sender. They also move between both of these and the sign-body in which they encounter themselves and each other.

The manifest contradictions within the painting accurately re-present an experiential truth about the bar, the woman, and her customer on a level which reaches past the circumstantial to indicate an analytic and emotive perception—both physical and metaphysical—about the society of which they were a little-regarded part. The painting is, in Valéry's words describing Mallarmé's poem "Un Coup de des . . . ," "the figure of a thought." It reveals in its structure a new insight into the interactions between signs, perception, and meaning.

—Penny Florence.

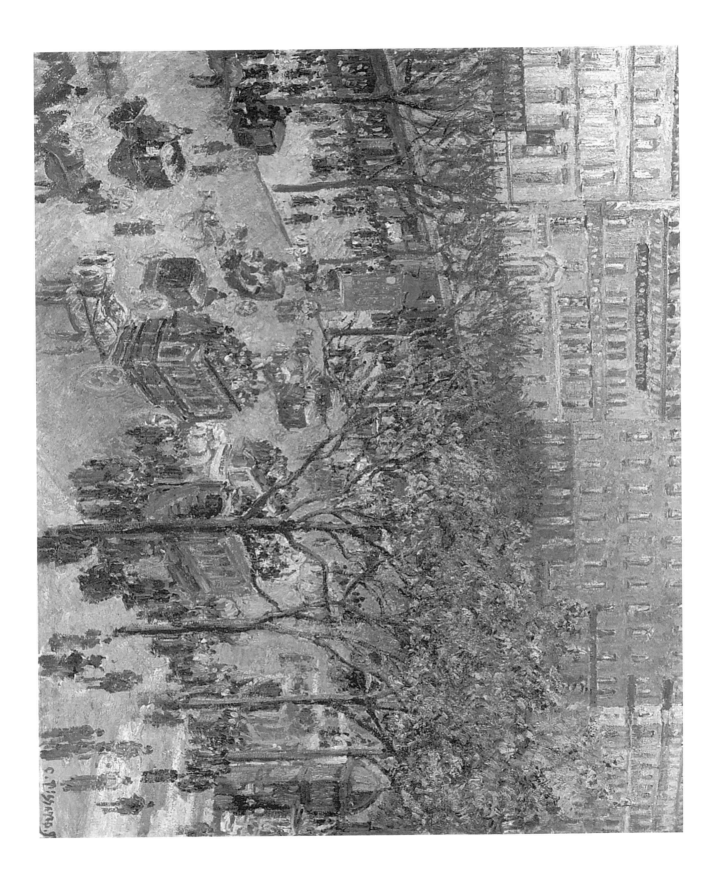

Camille Pissarro (1831–1903)
Boulevard des Italiens, Morning, Sunlight, 1897.
28³/₄ × 36¹/₄ in. (73.2 × 92.1 cm.)
Washington, National Gallery

On 8 February 1897 Pissarro wrote his son Lucien: "I am returning to Paris again on the tenth to do a series of the Boulevard des Italiens. . . . A series of paintings of the boulevards seems to [Durand-Ruel, his dealer] . . . a good idea, and it would be interesting to overcome the difficulties. I have engaged a large room at the Hotel de Russie, 1, rue Drouot, from which I can see the whole sweep of boulevards." His room commanded a view of both the Boulevard des Italiens and the Boulevard Montmartre.

Within a month, he had made three canvases of the crowds celebrating the Mardi Gras on the Boulevard Montmartre and had several others in progress. His plan was to do a series from the same vantage point rather than paint haphazard, miscellaneous street scenes.

"My pictures are progressing," he reported to Lucien on March 28, "but certain effects are holding me back. In two months I have set fourteen paintings on my easel and developed all of them. . . . I only work for two hours in the morning and two hours in the evening, and even less sometimes." An eye infection prevented outdoor work and limited his workday.

By the end of April he brought sixteen canvases to his home in Eragny for final retouching. Of the series, two were close-ups of the Boulevard des Italiens: *Boulevard des Italiens, Morning, Sunlight* and *Boulevard des Italiens, Afternoon.* The former is literally a slice of Parisian life. From the perspective of his hotel room, Pissarro plunges the viewer almost rudely into the bustling activity of a Parisian boulevard. Drastically cutting the scene on all four sides, he hems the viewer in to this short stretch of crowd in motion. There is no sky, no horizon, no broad sweep of boulevard.

It is a transient moment with little human intercourse, in contrast to his scenes of rural life, where Pissarro portrayed peasant men and women as individuals, if sometimes idealized, often working cooperatively. Here, humanity is anonymous—mostly lone, disconnected figures with pedestrians, carriages, omnibuses intermingled, disorderly.

The painting is almost monochromatic, except for scattered touches of color. A pale wintry sun strikes the tops of the sickly trees and penetrates to the right corner, its suffused reflection saving the picture from drabness. But it is painted with vivacity, the rapid, calligraphic brush work equal to the vitality of the scene. The touch is sure, a virtuoso technical triumph.

If the painting lacks the animation and elegance of style of some of his views of the Avenue de l'Opéra and the Place du Théâtre Français, its swift reconstruction performs the more difficult task of capturing *l'esprit* of a crowded Paris boulevard.

John Rewald quotes a letter Pissarro wrote to a young painter, Louis Le Bail, that describes his methodology:

The motif should be observed more for shapes and colors than for drawing. There is no need to tighten the form, which can be obtained without that. Precise drawing is dry and hampers the impression of the whole; it destroys all sensations. Do not insist on the outlines of objects; it is the brush stroke of the right value and color which should produce the drawing. In a mass, the greatest difficulty is not to establish a minute contour but to paint what is within.—Don't work bit by bit, but paint everything at once by placing tones everywhere. . . . The eye should not be fixed on a particular point but should take in everything, while simultaneously observing the reflections that the colors produce on their surroundings. Keep everything going on an equal basis; use small brush strokes and try to put down your perceptions immediately. Do not proceed according to rules and principles, but paint what you observe and feel.

Meyer Schapiro calls Monet's and Pissarro's paintings of Paris "the first truly modern pictures of the city as a world of crowds in random motion." Schapiro considers a Pissarro street scene, with "its strewing of vehicles and figures," as the abstract precedent to Mondrian's *Composition with Lines.*

Pissarro's earlier paintings of Paris scenes were spasmodic and without plan; but with the boulevard paintings, he launched the first of three impressive series. In the closing years of the century, the second series included scenes of the Place du Théâtre Français and the Avenue de l'Opéra. In the final series, he painted the Jardin des Tuileries, the Louvre, and the Seine. Together they comprise the most comprehensive and intensive set of Paris cityscapes. Some are wooden, lacking inspiration, but these cityscapes of Paris include some of the finest work of Pissarro, painter of rural France.

—Ralph E. Shikes

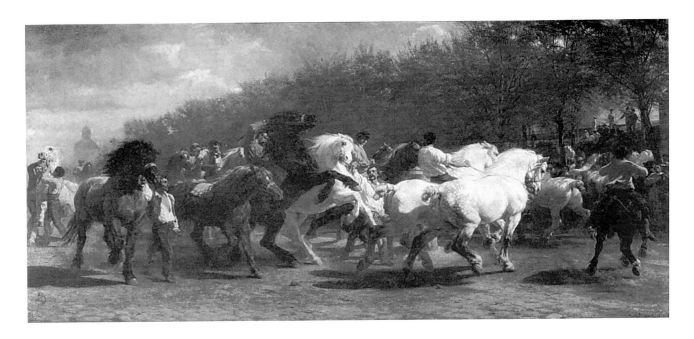

Rosa Bonheur (1822–99)
The Horse Fair, 1853
19 ft. 8¼ in. × 24 ft. 7¼ in. (600 × 750 cm.)
New York, Metropolitan

In 1887 the glamour which surrounded the acquisition of *The Horse Fair* by Cornelius Vanderbilt for the Metropolitan at the then astronomical price of 268,000 francs (about $5,000,000 at today's rate) cancelled the history of the painting's genesis, of its commission for the collections of the Second Empire, and ultimately of its rejection on the ground that a scene with farm animals would be more appropriate to the cultural politics of the new regime. The Duke of Morny, half-brother of Napoleon III and his prime minister, had handled the negotiations. After having been the most noticed painting of the 1853 Salon, *The Horse Fair* was bought a year later by Gambart, the London-based dealer who was to be the first to make Rosa Bonheur's international fortune, for 40,000 francs; during the next 30 years, the huge canvas was displayed all over England and the United States, contributing to Bonheur's growing legend. Until World War I, it was among the most famous paintings in the world, second only to the *Mona Lisa*.

From our contemporary perspective, *The Horse Fair* is a masterpiece of Romantic Realism, that is, an example of 19th-century thoroughness in the interpretation of the real as a reconstitution of a moment of life, but a reconstitution that is intended to implicate the viewer in the glorification of the reality described. It is not just the market of La Villette in the early morning when dealers bring their plough horses to be sold, but rather an epic rendition of the event. The breed of horse known as Percherons appears real because it is based on the endless studies Bonheur conducted at the market early in the morning, dressed as a man to avoid harassment in such a masculine environment (she had obtained special permission from the police to wear male clothing for her own protection).

The men who handle the horses are captured with accuracy and the architectural background can still be identified today: countless sketches and drawings have served to memorize the scene, to master its tempo, its natural flow, but the final work was to be composed in the studio, assembling images isolated as fragments in the studies from nature, recreating by an effort of memory the poignancy of the moment. The final result conveys the power of such a scene, yet sources as diverse as the frieze of the Parthenon and Gericault's *Roman Horse Fair* are being evoked: the overpowering presence of a defined and particularized reality does not prevent the spectator from reminiscing of other realities in which the horse is equally a symbol of power. The technical mastery of colors, forms, compositional elements on such a huge scale, by a young woman barely 30, is an amazing accomplishment, and one that alone would justify the immense popularity the painting achieved during the life of the artist and for at least two decades after her death.

—Annie-Paule Quinsac

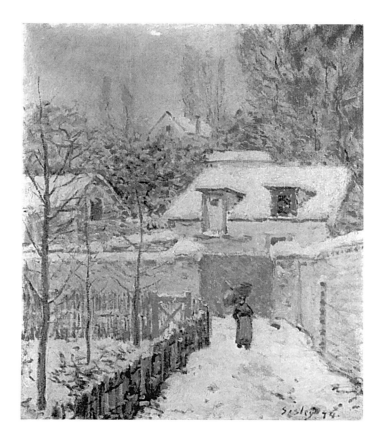

Alfred Sisley (1839–99)
Snow at Louveciennes, 1874
22 × 18 in. (55.9 × 45.7 cm.)
Washington, Phillips

During the Paris Commune of 1871 Sisley went with his family to the village of Voisins-Louveciennes 30 kilometers outside Paris. Like the other members of the Impressionist group Sisley became dissatisfied with Paris as a source of motifs in the 1870's and like them turned increasingly to the suburbs as a compromise. Although the village offered virtually rural subject matter and was a much cheaper place in which to live and raise a family, it was still within easy access of Paris and the centre of the art market. Louveciennes was a popular spot in the 19th century with other painters—Renoir, Pissarro, and Morisot spent some time there, as did the writer Guy de Maupassant. In the following four years which he spent there Sisley's output was large, and even when he moved to nearby Marly-le Roi he often returned to work in Louveciennes.

This canvas was painted in the winter of 1874, using a motif which Sisley had explored the previous autumn in *Louveciennes Autumn* (private collection) which is dated 1873 and is four inches longer than the present work but the same width. The vista is almost identical with a high viewpoint along which one looks towards a vanishing woman whose presence helps us to read the picture in terms of depth and scale. Indeed, so essential is her presence to the composition (particularly in the way in which it echoes the uprights of the fence, wall, and trees), that it looks as if Sisley the arch-Impressionist has conjured her up for purely pictorial purposes. It is clear from the site which is still to be found in

present-day Louveciennes that he has also taken certain liberties with the little alley along which the woman passes, widening it out in such a way that it occupies the whole of the foreground of the picture space and appears very much grander than it in fact is. The motif of a figure passing down a road, in which Pissarro too was interested as a means of ordering space, was a favourite device of the Barbizon painters in whom Sisley continued to be interested long after the other Impressionists had ceased to rely on older traditions.

In both of these works Sisley is concerned with attempting to capture the atmosphere of a specific season and time of day, and in *Snow at Louveciennes* returned to the favourite motif of a snowy landscape. In choosing to represent snow, Sisley demonstrated an impressionist concern for studying colour reflections on a white ground, and in this work we find him introducing blues and soft pinks into the snow. He has left certain areas of canvas untouched by paint and its creaminess appears yellowish or pinky according to the surrounding colours. In the sky the bare canvas shining through the weak blue contributes greatly to the sense of an approaching snowstorm. Of course such a technique served a practical purpose too. Obviously constrained by the effects of the weather, by the cold and rapidly changing climatic conditions, Sisley has worked as quickly as possible, applying thin washes of colour in a summary fashion. Not all of the picture would have been completed in the open air, and a certain amount of definition and finishing would have been added in the studio. The figure of the woman, in all probability an imagined addition, is the best example.

—Lesley Stevenson

Claude Monet (1840–1926)
Gare St. Lazare, 1877
29¹/₂ × 39³/₈ in. (75 × 100 cm.)
Paris, d'Orsay

Bibliography—

Seiberling, Grace, *Monet's Series,* New York, 1981.

On 17 January 1877, Monet was ready to move into a rented one-bedroom apartment at 17 Rue Moncey in order to paint in and around the nearby Gare St. Lazare. Of the six major Paris railroad terminals, the St. Lazare was best known to him since he used it to get to and from Argenteuil. Moreover, the artists' Batignolles quarter, where the fledgling Impressionist painter-to-be had met in the 1860's, was bordered by the track beds. By March, Monet had painted 12 views of the station; seven were among the total of 30 paintings Monet would show at the Third Impressionist Exhibition in April.

His station images can be considered a sequence, that it, free variations on a motif, rather than a "series," such as the *Cathedrals* and *Poplars* of the 1890's, when Monet set up rows of paintings in his studio, all with similar patterns, and worked on them together. There appears to be little afterwork in the St. Lazare set, although the critic LeRoux commented on Monet's difficulties at the station due to train movements, which led to the need to retouch afterwards. In fact, among the 12 pictures were several which Monet himself considered *esquisses*—freely painted yet complete; he sold two of them to Caillebotte in 1878. (Monet's *Carnet* lists these as selling for 300 francs while a carefully "finished" work was priced at 685 francs. In these years, Monet was under great financial pressure, and unlike his usual intention with such loosely finished works, he sold such *esquisses* to others than fellow artists and friends.)

The four images which present a view from within the station, and thereby show the reversed V-shaped iron and glass train-shed enclosure at the upper margin of the canvas, are the most finished of the set. Significantly, the two most carefully painted are also the largest canvases of the group, and were made on the side reserved for suburban lines. The two other shed-interior views are less detailed, and were made on the side given over to long-distance lines. These latter two, and all the other eight, are exactly the same size. None of the others pictures the interior within the shed-roof: while two still show this distinctive shape, the others show the track bed with apartment blocks and the Pont de l'Europe bridge as a major motif. Monet seemed to have been searching for a locale as satisfying as the metal enframement for the billows of the man-made landscape, which is the motif unifying the entire group.

Monet's deft compositional grasp, and his solution of the problem of luminosity, are easily seen in his treatment of smoke throughout the set. Most of the principal clouds are painted directly on the primed canvas—with either drawings or direct work on the canvas itself as preparation. The locomotive, source of this smoke, is shown in all but one of the pictures, but in only two can there be said to be any detail. It is shown in its least picturesque view, that is, foreshortened, with the individual cars of the train not easily seen. As John Rewald says, "He found pretext rather than an end in itself; he discovered and probed the pictorial aspects of machinery but did not comment upon its ugliness or usefulness." Similarly, in previous views of trains, as in the *Railroad Bridge at Argenteuil* (1874), the train is hidden by the high sides of the bridge, and in an 1870 painting *Train in the Countryside,* a few cars are shown as the train disappears behind a stand of trees. A close prelude to the near-head-on view of the train in the St. Lazare set can be seen in an 1876 view at Montgeron Station, and in the more well-known *Train in the Snow* (1875; Paris, Marmottan). The foremost aim of Monet, perhaps increasingly so throughout the decade, was the presentation of a color field seen as instant vision; and such an image was both concretized and emblemized by the paint strokes and layers which here indicated the vaporous billows of smoke and steam and the concommitant diffusion of light from all other objects and forms.

Ironically the more "finished" works offended many of the contemporary critics—through their aggressive scumbling and lack of outline. Others of the set, such as *Arrival of the Normandy Train,* although less carefully brushed, were spoken of with more appreciation since their look more readily coincided with the current concept of an oil sketch.

In this Third Impressionist Exhibition, where style was supposedly quite radical, the great majority of imagery was genteel, even pastoral subject matter. While we may accept these St. Lazare scenes as equally Romantic—even given their self-conscious and truly astonishing aesthetic—their clearly urban and machine-age redolence easily distinguished them from all the other exhibited work. The only painting there to present a comparable "industrial subject" was Gustave Caillebotte's *Pont de l'Europe,* smoothly finished and in the Salon-scale. Though the urban prospect and prominence of metal relate these two works, Monet's forceful Impressionism is all the more clearly defined. That *style* label still had a subversive aura about it in 1877. But Monet's *subject,* full of verve and dynamism, coming only six years after the ruinous war of 1870–71, secretly celebrated French recovery from the psychic depression caused by the German victory and the Commune. Monet then turned away from any association with current time or daily life.

—Joshua Kind

Claude Monet (1840–1926)
Le Portail et la Tour d'Albane, 1894
42¹/₈ × 28³/₄ in. (107 × 73 cm.)
Paris, d'Orsay

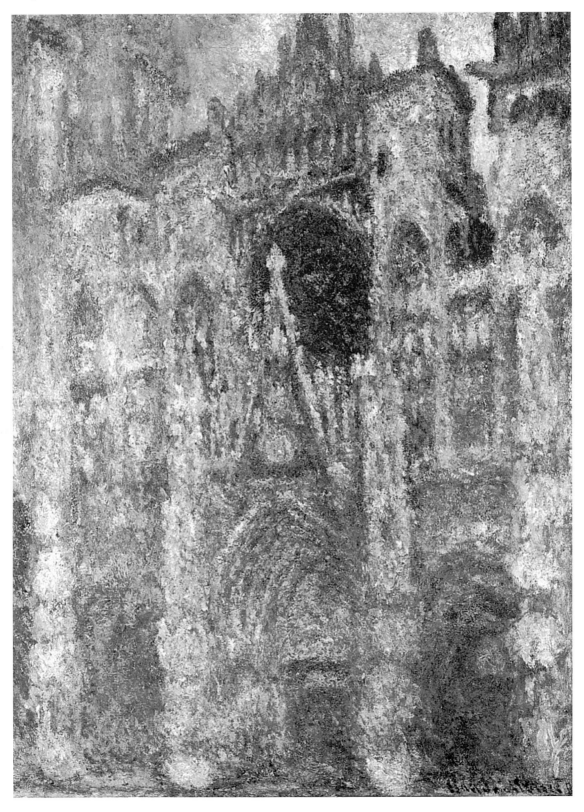

Berthe Morisot (1841–95)
In the Dining Room (The Little Servant), 1886
24¹/₈ × 19⁵/₈ in. (61.3 × 50 cm.)
Washington, National Gallery

In the Dining Room or *The Little Servant*, No. 85 in the catalogue of the eighth Impressionist exhibition of 1886 at 1 rue Lafitte in Paris, is one of Berthe Morisot's most complex and fully achieved paintings. Morisot had eleven paintings in this exhibition and an additional group of watercolors, drawings, and decorated fans which showed the range of her work. This final exhibition of the group now known as the Impressionists had seventeen artists participating, among them Pissarro, Degas, and the newcomers Georges Seurat and Paul Signac who were included at Pissarro's insistence. Morisot had been a founding member of the group in 1874 and had exhibited in all but the fourth exhibition in 1879, due to the birth of her daughter in 1878.

In the Dining Room was painted 1885–86 in the dining room of Morisot's own house at rue de Villejust. The model for it was seventeen-year-old Isabelle Lambert who also posed for two other Morisot paintings in the 1886 exhibition, *The Bath (Girl Arranging Her Hair)* 1885–86 now in the Sterling and Francine Clark Art Institute, Williamstown, Massachusetts, and *Getting Out of Bed*, 1886, in the Durand-Ruel collection in Paris. *In the Dining Room* is an oil on canvas, 24¹/₈ × 19⁵/₈ inches, signed in the lower left, Berthe Morisot. The predominant colors are blue, green, and white, with accents of red, orange, and tan.

It shows a young woman in a dark blue dress and long white apron standing slightly off center to the left in a corner of the dining room who looks out at the viewer. The servant is framed by a glass fronted china closet and cupboards on the left, and a window showing the street beyond, a chair and a partial view of a table on the right. Although seeming to be a quickly caught moment of everyday life, the picture is obviously carefully composed in almost geometric sections. The prevailing feeling is of light pouring into the room, touching the figure and surfaces in the room by freely brushed-in accents of white. The artist conveys a sense of space in the construction of the setting and the placement of the forms within it. The painting displays a sophisticated technique in its solid draftsmanship and complex composition combined with freely brushed reflections defining the retinal response to the play of light in the room.

In the Dining Room contains multiple aspects of subject matter: domestic interior, genre painting, still life, figure, portrait, and landscape (which can be seen through the window on the right). It demonstrates Morisot's mastery of all these types of painting, unified in a seemingly immediate scene of everyday life. Morisot's dazzling use of white is particularly evident in this painting, all subtly modulated in different areas of light and shadow. The blond tonalities hark back to the rococo masters both Morisot and Renoir admired, particularly the work of François Boucher whose painting *Venus at Vulcan's Forge* in the Louvre she had recently copied a detail from. Although *In the Dining Room* shows Morisot's Impressionist style in its maturity, the solidity of the forms and sophistication of the composition anticipate Morisot's late style of 1888–95 in which her brushstroke becomes longer and more form-defining and she uses deeper color harmonies and contrasts. The free handling of the paint also shows the influence of her watercolor technique transferred to oil to catch the passing moment with seeming spontaneity and immediacy.

The subject matter of the painting is typical of the Impressionist domestic scene painting interpreted in an original and personal manner. Taking the vicissitudes of everyday life as their subject, the Impressionists created a democratic style which was accessible to female as well as male artists, and the group welcomed Mary Cassatt and Marie Braquemond as well as Morisot in its exhibitions. *In the Dining Room* typifies the modernity of Impressionist subject matter in the fact that it is secular, not commissioned by either state or private patrons, a non-heroic slice of contemporary life. In it the young woman is shown as the subject of the painting, self-defined, not glamorized or an object of voyeurism. As in normative Impressionist practice, the technique of painting is as important as the ostensible subject, and it is the transcription of the artist's perception of the scene defined by light as a certain time of day that is emphasized.

At the same time, the subject of a woman in a dining room may have particular relevance to the artist herself, as Morisot had no studio in the house in the rue de Villejust and used the dining room to paint in, the large windows letting in light and giving a view of the landscape beyond. When she had finished for the day or had another duty to attend to, she put her brushes and paints out of the way behind a screen in the dining room. Morisot may have even seen herself, perhaps unconsciously, as a servant to the demands and expectations of her role as a bourgeois hostess, attentive wife, and devoted mother, which took a toll on her working time as an artist.

The effortlessness of presentation and the painting's low-key evocation of a sunny day in a dining room does not reveal the arduous journey to achieve such mastery, Morisot's fierce professionalism, and her high standards. *In the Dining Room* exemplifies Morisot's bravura technique and her unique artistic vision at the peak of its realization. 20th-century artists such as Matisse, Bonnard, and Vuillard were to follow her in taking the domestic interior as an appropriate subject in all its color, light, and intimacy.

—Alicia Craig Faxon

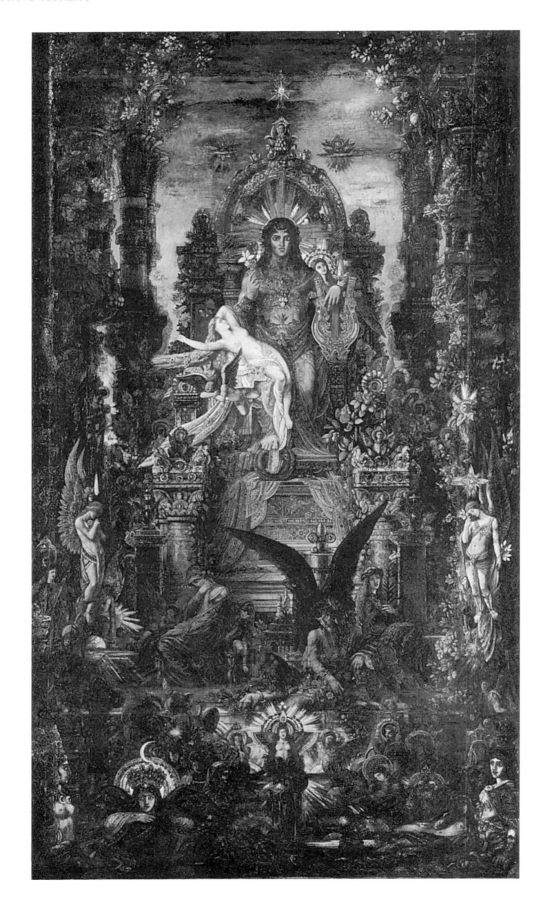

Gustave Moreau (1826–98)
Jupiter and Semele, 1889–95
$83^7/_8 \times 46^1/_2$ in. (213 × 118 cm.)
Paris, Moreau Museum

Bibliography—

Kaplan, Julius D., "Moreau's *Jupiter and Semele*," in *Art Quarterly* (New York), Winter 1970.

Jupiter and Semele, 1889–95, is the culminating painting in Moreau's oeuvre. It is the last major painting he finished and a synthesis of stylistic and contextual ideas with which he had worked all his life. The painting was commissioned by Leopold Goldschmidt, who gave it to the Moreau Museum in 1903.

The painting climaxes Moreau's final artistic phase, begun in 1880. It is full of precisely defined details which are painted thickly to give the work a jewel-encrusted look. All the details require a "reading," similar to northern Renaissance painting, which in fact inspired Moreau in this work. This new pictorial language served a new content—a complete philosophical statement in which every detail served as part of the argument.

Jupiter and Semele went through several revisions, but the major elements (Jupiter on a throne, Semele falling away from him, unable to survive this contact with the divine; Dionysus-Bacchus, born from this confrontation, and Jupiter's attribute, the eagle) were set in an oil sketch of 1889. Next, a full-size drawing worked out specific details and added new figures, such as Pan, supposed son of Jupiter, a major earth divinity with goat's feet and horns, covered with plants and vines. A standing winged figure to the left adores this divine scene. Death holding a sword, reclines to the eagle's left, and to the right a seated woman (Moreau named her Sadness) with a crown of thorns and a lily, symbolizing respectively suffering and purity, reinforces the idea that there is an earthly realm below the divine one.

Moreau copied a small northern Renaissance altarpiece in the manner of Robert Campin and seems to have used it as the source for *Jupiter and Semele*. Rigid symmetry and balance, hierarchic scale, and rich, precise decoration characterize both. The altarpiece, an image of transcendental truth in the form of a divinity or a divine act, often with numerous figures, was a perfect model for Moreau's concern for the relationship between divine and earthly realms.

Like Renaissance art, Moreau's painting is filled with symbols that transform his painting into a synthetic, universal statement. Jupiter as male principle is indicated by the lingam, the phallic Hindu symbol of Shiva, seen between the wings of the eagle. He is also a poet and a thinker, which is represented by the lyre in his hand. The snake biting its tail below his foot symbolizes the infinite under his control, as does the lotus, an Egyptian symbol of eternity, upon his stomach. These symbols define the eternal nature and masculine power of the god/poet/thinker and reveal that this painting is a culturally synthetic vision.

Moreau used wide-ranging sources in creating this painting. Dionysus is directly taken from a Flaxman illustration of Dante's torture of Navarios Ciampolo; Semele is quoted from Moreau's own *Phaeton* of 1878, another figure who dies because of Jupiter's power; the figure of death comes from his *Young Man and Death* of 1865; while the contemporary Pre-Raphaelites, Rossetti and Burne-Jones, influence the figure of sadness.

Moreau's last major change in *Jupiter and Semele* was to expand the composition, making it taller and a bit wider in order to add the lower section filled with eyes, faces, and orb-like forms. He researched these details carefully and wrote that they represent all that is terrible—Hecate, death divinities, and Night. The three-headed monster at the lower right is Asmodeus, the Zoroastrian devil, an image that Moreau found in an illustrated journal. Moreau also made Jupiter a solar divinity (rays of light emerge from his head, a winged scarab, sign of the chief Egyptian solar god, on his stomach). Jupiter is beardless and youthful, suggesting an androgynous figure, and thus the basic sexual duality of mankind. Moreau adds a symbolic image of life (the small figure holding a caduceus, Mercury's magic wand used to raise the dead of life) next to the figure of death, thus adding a hint of promise.

All these symbols, references, and associations partake of the rich cultural currents in French intellectual life at the end of the 19th century. Like the Synthetists, Nabis, and Rose + Crois artists of the 1880's and 1890's, Moreau synthesized all these sources into a personal statement of divine aspiration. But unlike theirs his was an additive rather than a simplifying style.

The mythological source was just a starting point for Moreau's expression of a universal ideal. Semele serves to show that material reality must be destroyed in order to attain union with the divine, a Christian idea that Moreau mentions in his written commentary about this work of 1897 (there was another slightly different one of 1895.) He explains that the painting is about the joyful union with the divine in a perfect achievement of the ideal, an expression of the philosophical neo-platonism to which he subscribed.

Moreau's commentaries stress the relationship of light and darkness. This idea is Gnostic-Manichaean, a dualistic theology claiming that matter is inherently evil and the individual must constantly strive to overcome it by exploiting his own spark of divine light. Moreau's contact with these ideas prompted him to alter the painting and add the lower area of darkness. He may have been influenced by theosophy too, which often presents Christianity as the concluding development of hermetic knowledge, just as Moreau too puts a Christian conclusion to his commentary. Moreau's visual and philosophic synthesis in *Jupiter and Semele* parallels that of his intellectual and artistic contemporaries at the end of the century.

Like Gauguin and the Symbolists, Moreau also believed that paintings could speak for themselves, that the viewer only had to open himself, to dream, to let the imaginative power of the work communicate. Yet he did not identify with the Symbolists, a younger generation of artists. His was an accumulative and precise idiom, full of symbols that had precise meanings. He used clearly defined imagery to suggest universal content whereas they abstracted and simplified to achieve the same purpose.

—Julius D. Kaplan

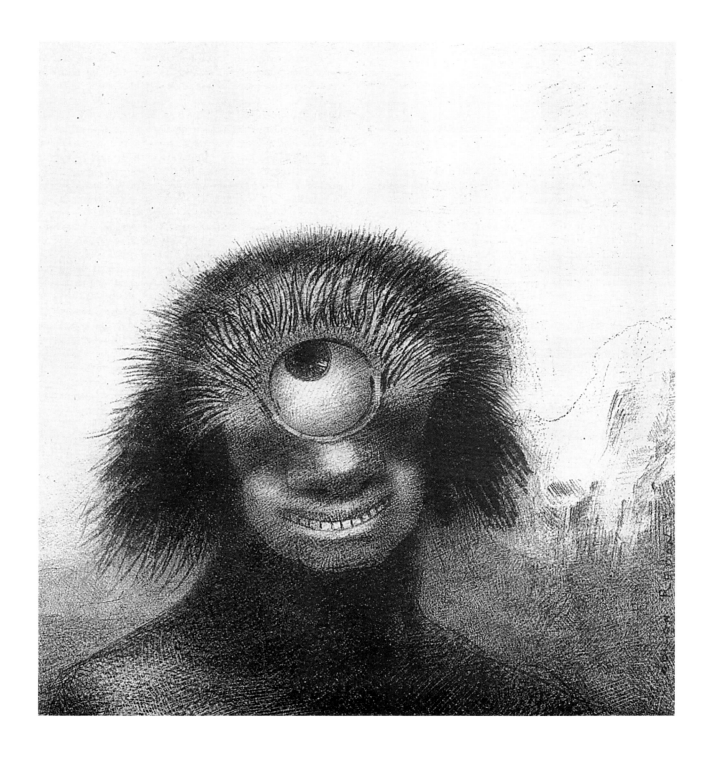

Odilon Redon (1840–1916)
Il y eût peut-être une vision première essayée dans la fleur, in
Les Origines, 1883.
Lithograph

This is the second image of *Les Origines*, a series of eight lithographs (plus cover) published as an album. It was therefore designed to be looked at as part of a sequence. *Il y eût peut-être une vision première essayée dans la fleur* (There was perhaps a vision first tried in the flower) is a dynamic image which directs you both inwards into its complex meanings and outwards along far-reaching chains of meaning. Structurally, the image works as language works in addition to its power as an image. Redon's carefully constructed suggestion is designed to extend the meanings potential in his subject beyond the limits both of the literal image and of the frame. This is also how his captions work, for the words *Il y eût peut-être une vision première essayée dans la fleur* should be read as continuous with the image, forming a complex dynamic between language and vision.

The eye may be seen both as the centre of a flower and as the single eye of a Cyclops. If the image is read as a flower, according to the caption, the vertical lines below it suggest the stem, with a kind of leaf lying horizontally against it. The radiating lines would then become analogous to the petals and the darker area would tend to recede behind the lightest of the concentric circles. The Cyclops reading is equally possible, and this is confirmed in the next image in the series which is clearly of a Cyclops, but with shaded areas below the eye as if suggestive of two-eyed vision. The leaf shape now suggests a mouth and the radiating lines, eyelashes, and hair and the shaded area becomes a head. The figure-ground relation changes according to which reading predominates so that the eye and the dark hair appear on the same plane in relation to the picture surface if the image is a head, but not if it is a flower, because the dark area then becomes the background. This forces the spectator to see in two contradictory ways and to become aware of the effect on perception of sense-making

activity. You have to reinterpret what you are seeing if you wish to settle for one or other representational meaning.

Both meanings are, of course, present, suggesting a relationship between a flower and vision based on similarity. Further still, there is on one level an identity between seer and seen. The eye sees the flower, and the flower, the eye. This reading is reinforced in the ambiguity of the caption, which by saying "there was [a] vision" does not locate the vision as it would if it said "a vision of a flower" or "vision was the first flower." Nor is the vision exclusively active/doing or passive/being, subject or object. The vision is both in and beyond the flower, since "there was [a] vision" and it was "tried in the flower." In T. S. Eliot's words, the flowers "Had the look of flowers that were looked at."

These multiple structures and meanings open on to a speculative exploration of conjunctions as a way of seeing and of generating new meaning. Philosophically they imply continuity between animate and inanimate matter, a more subtle and integrated sense of evolution than the Darwinian ideas which some have attributed to them. In semiotic terms, the image and caption both operate as more than one type. They are duplex in mode and therefore work as both index and symbol. The total text refers to itself as a sign, and thus to its verbal and visual language-codes, as well as having referential meanings.

The "origins" explored in the album and in this lithograph are their own, both in an immediate and in a historical sense. Their primary meaning, to my mind, concerns perception, as did many of the best works of its period. The "vision première" is an evocation of the kind of vision that precedes convention, having the clarity of perception that renders the visible visionary.

—Penny Florence

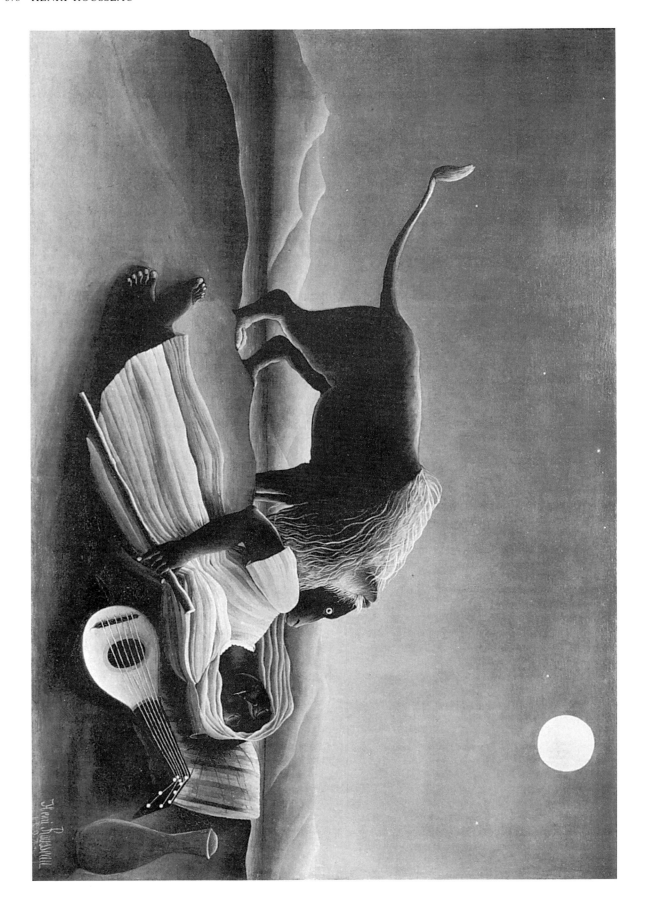

Henri Rousseau (1844–1910)
Sleeping Gypsy, 1897
4 ft. 3 in. × 6 ft. 7 in. (129.5 × 200.7 cm.)
New York, Moma

Bibliography—

Stabenow, Cornelia, "Artificial Paradise: Rousseau's Jungle Landscapes," in *Arts in Virginia* (Richmond), 26, 1986.

In 1898, a year after *Sleeping Gypsy* was executed, Rousseau wrote a letter to the Mayor of Laval describing the painting and offering it to the people of his home town for the princely sum of 2000 or 1800 francs. ("A wandering Negress, playing her mandolin with her jar beside her [a vase containing water], sleeps deeply, worn out by fatigue. A lion wanders by, detects her and doesn't devour her. There's an effect of moonlight, very poetic. The scene takes place in a completely arid desert. The Gypsy is dressed in oriental fashion.") Although Rousseau could never hope to receive such payment—indeed, in this case no sale was made—his price tag reflects an unshakeable confidence in his own work and especially in this particular canvas, now generally acknowledged as one of the artist's greatest masterpieces.

Although the treatment of figures and landscapes in *Sleeping Gypsy* is quite individual Rousseau nevertheless drew on other sources to inspire his subject matter. Looking to the recent French fashion for academic subjects in archaeological locations he was evidently struck by *Boghari Woman Killed by a Lion* by Matout and *The Two Majesties* by Gérôme, stirring depictions of lions in exotic landscapes. It has also been suggested that the atmosphere of quasi-religious awe that pervades the composition is derived from Egyptian funerary frescos that Rousseau was known to possess in the form of photographic reproductions. In spite of the commendable leonine examples of the French painters and the real thing in the Paris zoological gardens, Rousseau's animals, not least the lion in *Sleeping Gypsy,* all take on the appearance of beady-eyed, stuffed toys. This is not surprising when it is remembered that Rousseau was in the habit of working from dolls, and may also account for the lack of modelling and stiff, introspective quality of the sleeping figure, though it is equally likely that she is derived from Egyptian sarcophagi.

The rendezvous takes place in an arid brown desert, any sense of perspectival recession destroyed by a clearly defined horizon line bringing the landscape sharply forward. The lion's mane and gypsy's brilliant robe, the eye's immediate focii, are illuminated by mysterious moonlight. Predator and victim are further linked by the related forms of lion's tail and gypsy's stick. However, it is in fact the still life of mandolin and jar in the lower right hand corner, borrowed from Matout, that balances the composition. This still life echoes Cézanne and anticipates Cubist subject matter and even crude treatment of form; parallel to the picture plane it opens the picture to us, and further enhances the still, monumental quality of the composition.

Sleeping Gypsy belongs to a special category of large-scale, mainly jungle compositions which do not adhere to chronological ordering yet exude a common air of mystery and suspense. The painting shares the theme of entranced sleep and introversion with *The Dream,* 1910, both paintings suggesting that what we see is a hallucination or dream on the part of the human protagonist. The circumstances of the sleeping gypsy are part of her own fantasy and she will awaken, in the traditional manner, before the lion pounces. Rousseau was by no means a pioneer of the visual language of dreams, but intuitively exploited a field that was loaded with possibilities in the era of Freud. Rousseau himself was apparently subject to his own fierce imagination and his firm belief in ghosts, which left him at the mercy of jesters and practical jokers. He was quite confident that his compositions contained no element of fantasy, and endeavoured to paint in a realistic manner; yet the potency of this painting yields more than anything the rich fruits of Rousseau's repression.

—Caroline Caygill

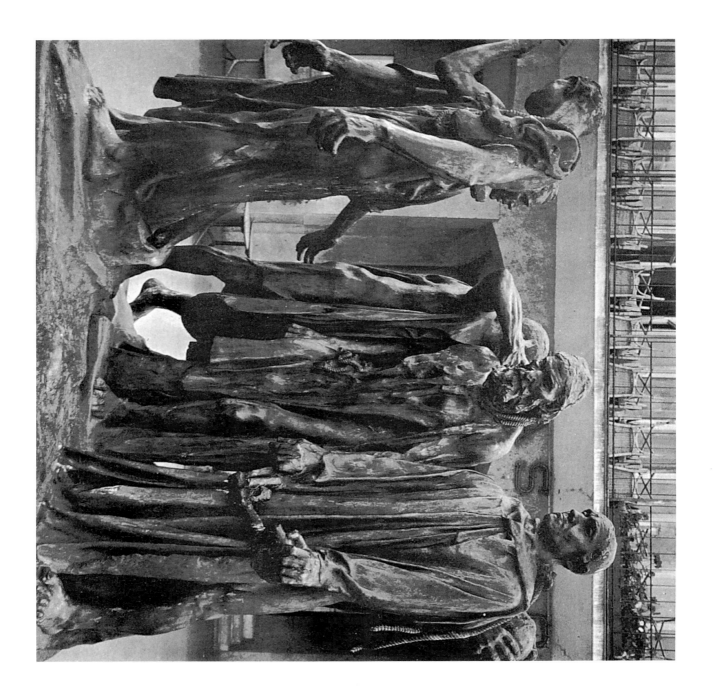

Auguste Rodin (1840–1917)
The Burghers of Calais, 1884–95
Bronze; 9 ft. 10¹/₈ in. (300 cm.)

Bibliography—

Elsen, Albert E., and Mary Jo McNamara, *Rodin's Burghers of Calais,* Cantor, 1977.

The Burghers of Calais is a testament to Rodin's highly personal approach to public sculpture. Though the history of the commission is fraught with difficulties, it is often considered one of Rodin's most successful monuments. Even so, there was plenty of debate between Rodin and the commissioning body, the municipal council of Calais, about the final form and site for the group, and it was nearly 11 years before the work was installed.

The city council had made previous attempts to initiate a monument to Eustache de Saint-Pierre. In 1845 they approached David d'Angers, who died soon after; in 1868, Jean-Baptiste Clesinger was selected, but the Franco-Prussian War intervened. Finally, in the fall of 1884, Omer Dewavrin, the mayor of Calais, contacted Rodin, probably through the urging of Rodin's friend and fellow-artist, Jean-Paul Laurens, a citizen of Calais. Rodin's work on the Gates of Hell for the state's new Museum of Decorative Arts, and his *Call to Arms,* a competition entry for a monument to the Franco-Prussian War had already won him notoriety. Rodin must have been relieved to be given a public commission without having to participate in a competition.

In his first maquette of 1884, Rodin had decided to depict a group rather than the single figure requested by the council. In this, he was faithful to his literary source, Jean Froissart's medieval *Chronicles.* As Froissart described it, in 1347 King Edward III had agreed to end his 11-month siege of the city of Calais if the city fathers would offer themselves as hostages. Led by Eustache de Saint-Pierre, six men dressed in sackcloth and carrying the keys to the city walls, gathered in the town square, prepared to hang. Rodin depicted six figures preparing to depart for Edward's camp. As he described it in a letter to Dewavrin, "This group of six self-sacrificing figures has a communicative expression and emotion. The pedestal is triumphal . . . in order to carry, not a quadriga, but human patriotism, abnegation, and virtue." From the beginning, Rodin had conceived a monument to the psychology of human courage, not a detached historical marker.

Rodin modeled the individual figures of the burghers nude, adding the drapery later. He also traveled to Calais to find local residents to use as models. He struggled with the arrangement of the group, a process of composing similar to his concurrent work on the *Gates of Hell.* In fact, the *Gates of Hell,* though located in a different studio, influenced Rodin's overall approach to the *Burghers.* For both projects, Rodin began with a literary source, then transformed it into a more generalized statement about humanity. This may have been the result of working so closely with the figures, recombining them in different syntheses, that they lost their historic specificity and became instead real people.

The Calais city council objected to the lack of conventional heroism in the maquette, stating, "Their defeated postures offend our religion." They also protested the lack of hierarchy in composition. But Rodin refused to ameliorate them, and made a few changes which pleased them even less: he demanded that the group be placed in the middle of the town square, without a pedestal, so that the group would participate in the daily life of the city. But in 1886 the banks of Calais failed, and the city had to suspend the project until 1893. Rodin continued to work on the expressive attitudes of his figures, attempting to imagine each individual's grief, or what he called, "each of them isolated in front of his conscience." The *Burghers* summarized many of Rodin's concerns as an artist: his interest in Gothic art, his search for essential truths using the grammar of the human form, and finally, what he once described as, "the impulse of our conscience towards the infinite, towards eternity, towards unlimited knowledge and love" Rodin's sympathetic conception of the internal struggles of these six burghers is a monument to both civic spirit and personal anguish. The group was finally unveiled on 3 June 1895. But to Rodin's dismay, it was placed on a conventional base and surrounded by an iron railing; the site, on the side of town was described by one contemporary as being "near a garbage dump." It was not until 1924 that the work was installed as the sculptor had requested.

—Caroline V. Green

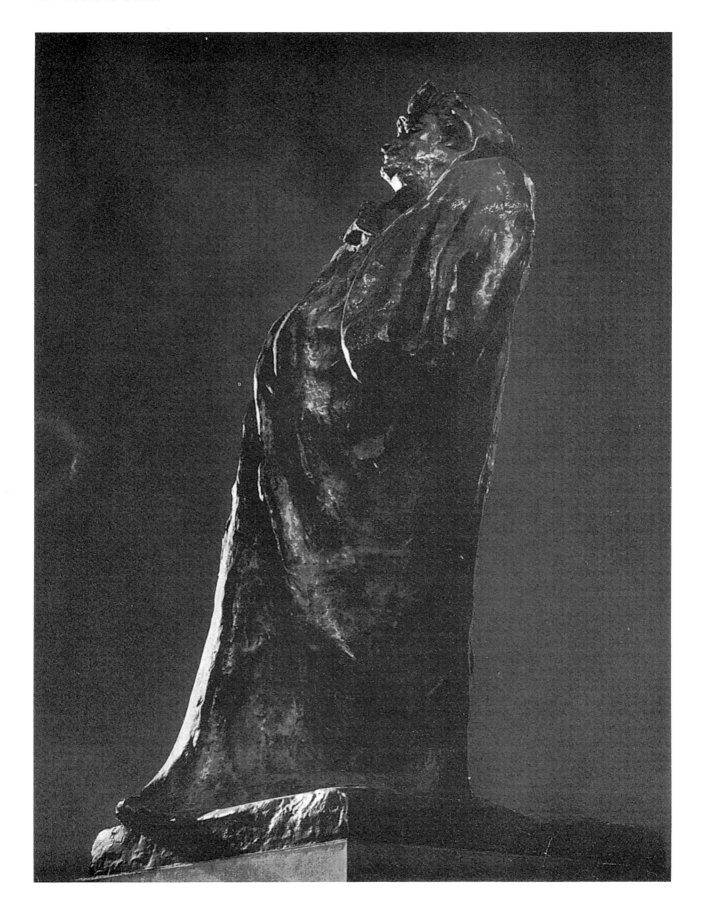

Auguste Rodin (1840–1917)
Balzac, 1898
Plaster version; 9 ft. 10 in. (299.7 cm.)
Paris, Musée Rodin

For all its current appeal the statue of *Balzac* has a difficult history, causing waves of controversy from the moment of its inception. Commissioned in 1891 by the Societé des Gens de Lettres to produce a worthy monument to the dead French literary hero, Rodin wrestled for seven years with the problems of paying proper tribute to the author of *The Human Comedy*. As well as effecting a reasonable likeness of the corpulent, misshapen Balzac, whose decadent lifestyle had brought on his premature death in 1850, Rodin had to contend with creating a statue that would hold its own amid the noise, bustle, and splendid architecture of the Place du Palais Royal. Rodin was unaccustomed to working without a live model before him, but rose to the challenge of this new commission by undertaking to read Balzac's works, study the few existing poor-quality portraits—paintings, sculptures, photographs, and particularly caricatures—of the man himself, and visit Balzac's hunting-ground of Tours. From his books he learned that Balzac, like Rodin himself, was a man of great artistic stature, in whom intellectual and physical potency were one. Balzac was stocky, bloated, and unattractive, hence his popularity with the caricaturists; but he was capable of enchanting all with his noble eyes. He was a dandified dresser about town, though happiest when at home and sporting his Dominican monk's robe.

Rodin decided that he should make a feature of Balzac's ugliness while simultaneously transcending the physical to embody the undeniable creative strength of the writer. He was also tired of the bland, idealised, frock-coated commemmorative statues that stood wearily in every Paris square, and resolved to invest his *Balzac* with vigour. The sculptor's visit to Tours had produced results: Balzac's tailor had been sought and requested to make a suit from the writer's measurements; Rodin had also produced several maquettes of pot-bellied locals striking various poses and in various states of undress. Rodin decided to depict Balzac as elderly rather than youthful, for like Rodin himself, Balzac had not realised his full artistic potential until well into his middle years. Available iconography was also limited to more recent portraits; and furthermore, a boyish portrayal would not have enhanced Balzac's image, for as a young man he had been even uglier.

Two of the preparatory studies, a statue of the novelist dressed in his dramatic flowing gown and a headless figure clutching his erect penis, foreshadow the final monument to Balzac which, almost twice life size and prominent as the proverbial sore thumb, combines these and other vital elements in an awesome whole. Balzac shoots grandly upwards like a tree, obelisk, or cathedral, leaning back so alarmingly as to necessitate an extended base. The right foot exceeds the boundary of the plinth, extruding and dominating space like the statue itself, suggesting the writer's fevered inspirational pacings. However, the entire weight of the figure appears to be borne by the left foot. Rodin had decided against erecting Balzac on a raised plinth; instead, as in the case of *The Burghers of Calais*, 1886–88, the statue was positioned, controversially, at ground level, shifting the emphasis of grandeur onto the statue itself as well as relating it more directly to the onlooker. The heavy gown, shrouding the body and covering a multitude of sins, is shaped only by rough folds and a thick collar.

Significantly, the sleeves of the gown hang empty: Balzac's hands are concealed by the drapery, yet their form is suggested by the bulge about the statue's midriff. The overall posture may relate to a daguerrotype of Balzac by Nadar, definitely known to Rodin, in which one flabby hand stretches across the writer's torso, although the influence of the daguerrotype alone does not explain why the sculptor chose to veil the hands. Rodin, however, was in the habit of removing superfluous elements from his statues, for he found arms, legs, and heads often interfered with the expressive possibilities of the human body; and expression in the case of his monument to Balzac was of paramount importance. A writer, or, indeed, sculptor, mediates between idea and material with his hands: thus concealing or removing these vital members may imply the severing or emasculation of creativity, or conversely, the transcendence of creative inspiration over physical limitations. The hands of Balzac grip his penis in a powerful, creative gesture, though simultaneously the hands and engulfing gown serve to protect a fragile, vulnerable area. The conflicts of physical and spiritual, of elation and suffering, power and vulnerability are expressed at the omphaloi of penis and ugly but proud head.

The plaster version of the *Balzac* monument was finally exhibited alongside *The Kiss*, 1886, at the Paris Salon exhibition of 1898. Public and critics alike were unrestrained in their analysis of the great statue, describing it as a big side of beef and a toad in a sack. The Societé des Gens de Lettres, who had originally commissioned the work, rejected it unequivocally; so Rodin, confused and saddened by the general reaction, placed the statue in his back garden where it remained until cast into bronze and erected in the Boulevard Raspail, Paris, in 1939.

—Caroline Caygill

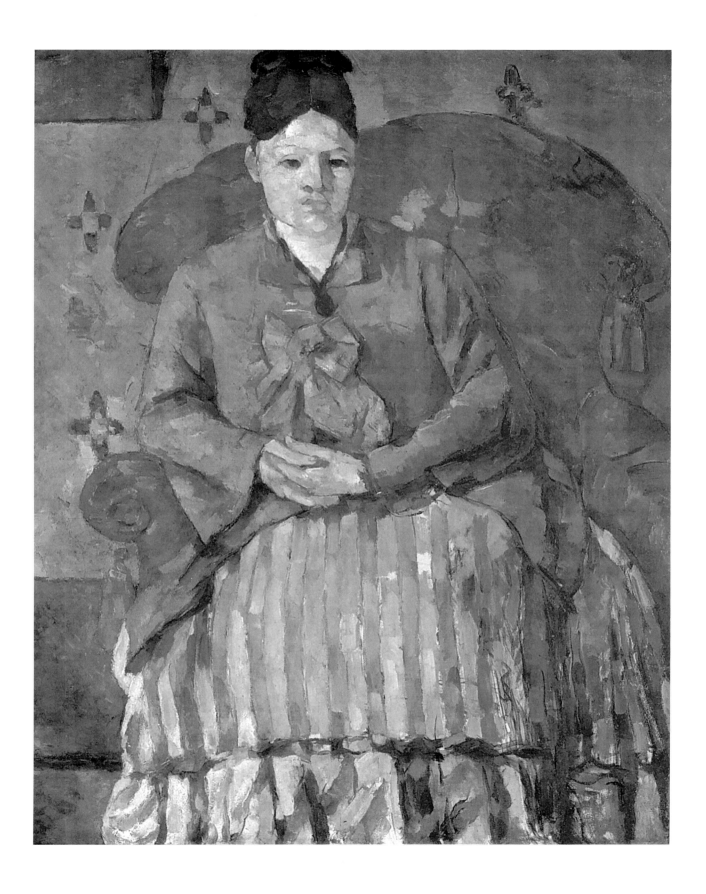

Paul Cézanne (1839–1906)
Madame Cézanne in a Red Armchair, c. 1877
28^1/$_2$ × 22 in. (72.9 × 55.9 cm.)
Boston, Museum of Fine Arts

Paul Cézanne painted 33 portraits of Hortense Fiquet, his wife. The portrait in the Boston Museum of Fine Arts is the sixth. In most of Cézanne's portraits, we learn far more about the painter's painterly concerns than about his sitters. Cézanne is reported to have said to his models, "Be an apple! be an apple!"

The years around 1877 mark a significant stage in Cézanne's development. Four years earlier he had begun painting from nature consistently, under the guidance of Camille Pissarro. By 1877, Cézanne mediated what he saw through an ever sharpening concern for a new kind of pictorial space.

Like his earliest portraits of the mid-1860's, *Madame Cézanne* is frontal and almost iconic. But the painting forecasts the complex shifting of planes, the rich play of surface pattern that will characterize his work for the next nearly 30 years.

Madame Cézanne is painted in a blue frock, with a blue/green striped skirt, seated in a red armchair, against a yellow green wall patterned with four (lozenge shaped) designs. In the upper left corner there is a green rectangle and toward the bottom edge, directly below, a blue band where the wall meets the floor. There is more activity in the skirt than in her impassive face. In each of the skirt's vertical folds, there are subtle gradations, shifts in tone, from blue to green, tinged with ochre and off white.

Although Madame Cézanne and the chair occupy most of the picture and give an impression of centrality, in fact, everything shifts and billows, staking out a highly complex picture space. The chair swells out beyond proportion to the right side of the picture. Her body compensates, shifting to the left, while her skirt manages to occupy center right.

Cézanne records the act of looking as part of the finished image. As if he, or she, shifted positions. We see Madame Cézanne's right sleeve painted twice. Cézanne has left the evidence of a shifting perspective. Then, to emphasize the outer contour of her arm, he painted a shadow that runs from her elbow down the skirt, obscuring its vertical stripe as it descends. The chair, responsively, has been made more ample to accommodate the shifting thoughts on the skirt. But if the degree of thought in motion creates a kind of shadowed displacement on the right, on the left, everything is more incisive: the rectangle, the clear horizontal lines that mark the top and bottom of the blue strip by the floor, the clear curl of the arm of the red chair with its tassel. What leads us through the shifting planes and rich surface texture is the line at the bottom, starting with the demarcation of wall and floor, giving rise to the volume of her skirt, and then sketched out by the time it reaches the more unruly right side. There is another complexity here. The skirt is remarkably flat. There is no indication of an indented lap, of legs beneath the cloth, until the line is made to curve outward as it reaches the skirt. And the skirt is stopped by the bottom edge of the canvas. No need for feet. It is extraordinary how such a still solid figure can imply such a fundamental shift. All the motion is in the placement and brushstroke.

These shifting perspectives became Cézanne's hallmark: seeking out form and capturing the process in the image created. "Painting is not copying the object . . . ," Cézanne wrote. In this period Cézanne created a dynamic balance between things as they appear in depth, their worldly reality, and the equally compelling reality of the canvas itself. The pictorial drama is in the tension between depth and surface.

—Judith Wechsler

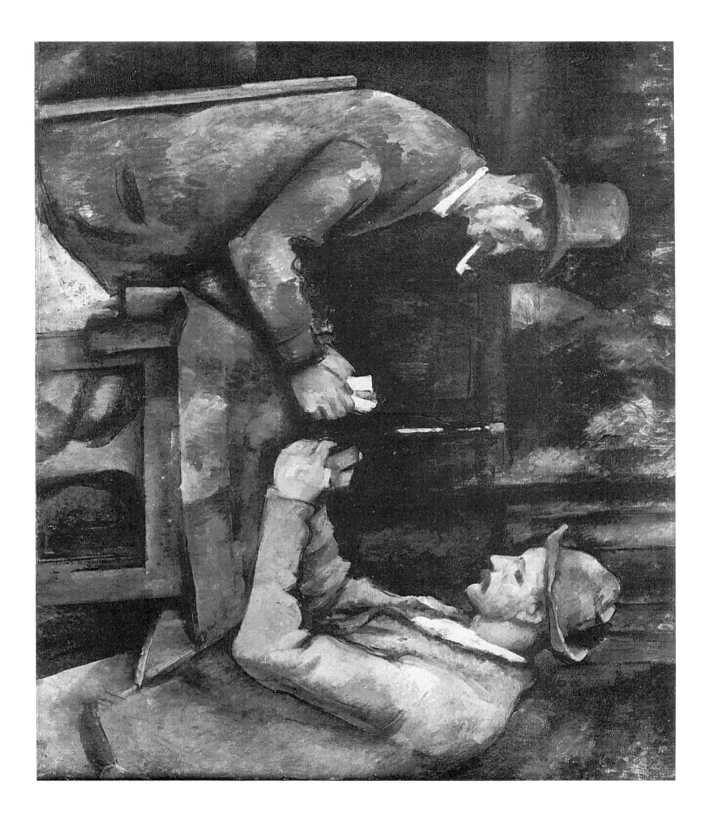

Paul Cézanne (1839–1906)
The Card Players, c. 1890–96
$18^{1}/_2 \times 22^{1}/_2$ in. (47 × 57 cm.)
Paris, d'Orsay

The Card Players in the Musée d'Orsay shows two men three-quarter length playing cards at a table. Both men hold cards in their hands and appear to be meditating on them with a downward gaze. There are no cards on the table, and, although there is a dark wine bottle, no glasses are apparent. Neither man engages the other with a look, they seem to be solely concentrated on their own cards. What is often in earlier Flemish or French versions of a card game an occasion for social interaction has been turned by Cézanne into a monumental study in contrasts.

The axis of the canvas has been shifted to the right. The man on the left is fully shown while the figure on the right has been cut off, creating a dynamic tension between the forms. The player on the left is taller and sits erect; his hat is a high bowler with brim turned down. The man on the right leans forward, his weight on his elbows, his hat crushed down, the brim turned up. Color also distinguishes the figures, with the yellow-tan of the figure on the right contrasting with the dark brown of the other man's suit. The figure on the left smokes a white clay pipe and the cards he holds are white, while the other player's cards are shaded. The two figures are a different distance from us, the man on the right closer to the picture plane. Even the table in the foreground varies on each side, a straight downward leaf on the left, an angle toward the right on that side. The table, represented parallel to the picture plane, is a reddish brown in color, contrasting with the men's coats and the darker background. The rigidity of the forms is counteracted by the animation of the brushstrokes on the surface, and the color modulations within the forms.

Cézanne's *Card Players* in the Musée d'Orsay is one of five paintings he did on this subject. The largest, with five figures in it, is in the Barnes Foundation, Merion, Pennsylvania, the version in the Metropolitan Museum of Art, New York has four figures, and other canvases with two players are in the Courtauld Institute, London, and a private collection in Paris. There is some disagreement as to the sequence of these works, but the consensus is that, as in other themes, Cézanne progressively simplified his material, and that the two-player version follows the others, with the Musée d'Orsay canvas probably last in the series, as the figures become progressively less particularized and more universal. As Lionello Venturi pointed out in his 1936 catalogue raisonné of Cézanne's paintings, this series is especially significant as it shows a turning away from his earlier concentration on landscape during his "constructive" period (1878–87) to move to figures or groups of figures in the beginning of his "synthetic" period (1888–1906).

There are a number of studies for this painting, including a front view of the player on the left (V. 564) at the Courtauld Institute, London; a profile study of the same player in oil (V. 566) and in watercolor (V. 1088) in private collections; and

watercolor and pencil studies of the player on the right in the Museum of Art, Rhode Island School of Design, Providence, Rhode Island (V. 1086), the Art Institute of Chicago, and the Boymans Museum, Rotterdam (V. 1483). The man on the left has been identified as Père Alexandre, a gardener on Cézanne's father's estate, Jas de Bouffan.

The most frequently cited artistic source for the *Card Players* series is *The Card Players* of c. 1635–40 by the Le Nain brothers in the Musée Granet at Aix-en-Provence, a bequest made in 1855. We know Cézanne was familiar with the picture because, according to Joachim Gasquet, he came to a stop before *The Card Players* and said, "This is what I want to paint!" and brought Gasquet back to the painting frequently. Cézanne had copied a number of paintings in the Musée Granet and borrowed ideas from others. Another possible source for the *Card Players* is Nicolas Poussin's *Shepherds in Arcady* (or *Et in Arcadia, Ego*) (Musée due Louvre, Paris) in which the two major standing figures face each other over the horizontal mass of a marble sepulcher. This possibility is reinforced by the fact that Cezanne had a reproduction of this painting on the wall of his studio at Les Lauves.

The solemnity and concentration of the two figures, so different from a casual game, have led viewers to look for a possible significance beyond the activity of playing cards. It may be a simple genre scene, in the tradition of 17th-century depictions of the subject. It may also represent a study in contrasts, as Meyer Schapiro suggested in his 1952 study of Cézanne, or even a parallel to the artist's own activity, selecting different colors and forms as a card player chooses and discards cards. As John Rewald pointed out, it was the critic Jules Castagnary who first compared Manet's *Olympia* to a playing card in 1865 and Cézanne himself, writing to Camille Pissarro July 21, 1876, said "My picture of L'Estaque is like a playing card." Since Manet's flat rendering was synonymous with modern painting, Cézanne may have identified his paintings with playing cards and, according to different interpretations, seen the two players as himself and his father or himself and Emile Zola, in both cases in a contest to have his art winning the approval of the other.

Still another suggestion, made by Mary Louis Krumrine in *Cezanne: The Early Years*, exhibition of 1988, is that the two players may represent two different aspects of the artist himself, his self-control versus his passionate nature, or his classical contrasted to his baroque tendencies. This interpretation would place the painting in a long tradition of oppositions such as Michelangelo's rendering of the active and the contemplative life in his Medici Chapel tombs in San Lorenzo, Florence. It may be a subject from contemporary life, an opposition of types, and a bid for recognition all in one.

—Alicia Craig Faxon

Paul Cézanne (1839–1906)
Mont Sainte-Victoire Seen from Les Lauves, 1902–04
27¹/₂ × 35 in. (69.8 × 89.5 cm.)
Philadelphia, Museum of Art

The Philadelphia Museum painting shows a Provençal landmark, Mont Sainte-Victoire, traditionally associated with the Roman general Gaius Marius's victory over the Teutons in 102 B.C. which had the sainte added when the culture became Christianized. The view is from Les Lauves where Cézanne built his studio halfway up a hill on the north side of Aix in 1902. The mountain, seen at a distance over a plain, dominates the composition, silhouetted against the sky. The mountain and sky area occupies approximately two-fifths of the space and is rendered in predominately blue tones with patches of green and brown. Cézanne creates an expression of space in front of the mountain by alternating horizontal bands of green and ocher, patches of green representing foliage, and ocher the semi-abstract forms of buildings. In the foreground shades of green and black combine to demarcate a horizontal line of trees. As Cézanne said of his method to Karl Osthaus, who visited him in 1906, "I try to render perspective solely by means of color. The main thing in a picture is to achieve distance." The carefully structured layers in the foreground lead the eye to the more freely brushed dominant blue in the background, a blue which appears consistently in Cézanne's late works.

The motif of Mont Sainte-Victoire begins in Cézanne's earliest Romantic period (1865–72) in the background of the *Railway Cutting with Mont Sainte-Victoire* (c. 1870; Neue Staatsgalerie, Munich), but is not concentrated on until the 1880's in his "constructive" period, 1878–87, examples of which are in the Courtauld Institute, London, the Metropolitan Museum of Art, New York, the Phillips Collection, Washington, and the Pushkin Museum, Leningrad. In these paintings the mountain appears framed by trees in a civilized landscape of carefully balanced houses, viaduct, and roads. In Cézanne's "synthetic" period (1888–1906) the earlier representations such as *Mont Sainte Victoire Seen from Bibemus Quarry* (Baltimore, 1897–1900) contrast the warm color of ocher in the foreground with the cool blues and greens in the distance. A later group of these views after 1900 becomes more abstract, with a surface pattern of small brushstrokes. The very last paintings of this theme, such as *Mont Sainte-Victoire Seen from Les Lauves* (Basel, 1904–06) tend toward near abstraction, with a dense brushstroke dominating the surface and predominant colors of blue and green. Forms become increasingly dematerialized and merged, with only geometric shapes for houses.

Cezanne created over 40 oil paintings on the theme of Mont Sainte-Victoire, and a number of watercolors and drawings as well. They have been categorized as serial imagery, such as

Monet's waterlillies, or as "pure painting" by the Symbolists, or a classical motif by critics like George Rivière and artists Maurice Denis or Emile Bernard, who called Cézanne the Poussin of landscape painting. Such critics as Roger Fry and Clive Bell emphasized the formal qualities of the artist's work, Bell maintaining that "Cézanne is the Christopher Columbus of a new continent of form." Clement Greenberg in 1951 claimed Cézanne as "the most copious source of what we know as modern art." Meyer Schapiro was the first to look at the significance of Cézanne's subject matter from a psychological point of view, while Kurt Badt emphasized its spiritual content. Gertrude Berthold and Theodore Reff have analyzed Cézanne's relation to the Old Masters, whereas William Rubin has seen Cézanne's Mont Sainte-Victoire as an impetus to Cubism. Among artists Pablo Picasso testified, "He was my one and only master," and Georges Braque, Henri Matisse, André Derain, and others acknowledged Cézanne's importance for their art in the 20th century.

What did Mont Sainte-Victoire mean to the artist himself and why did it dominate his late work? Cézanne had a great attachment to his native Provence and spent the last decades of his life painting its landscape. He wanted to "paint what is always there," the motif of Mont Sainte-Victoire, both in its physical manifestation and the image in his own consciousness. He ultimately reconciled the two by painting the scene over and over from different sites until it resembled both the outer phenomenon and his inner vision. "I do not want to reproduce nature, I want to recreate it," he said. For interpreters like Meyer Schapiro, Cézanne's quest to recreate Mont Sainte-Victoire was a testimony to his victory over his own passions as well as a conquest of the means of his art. Others, like Michel Hoog, have seen the solitariness of the mountain as a symbol of Cézanne's own aloofness and alienation from society, the condition he needed to achieve his art.

In his views of Mont Sainte-Victoire the artist made of Impressionism "something solid and enduring like the art of museums." The Philadelphia Museum *Mont Sainte-Victoire Seem from Les Lauves* realizes the artist's sensation of nature at a midpoint between the representational and the dissolution of form into the abstraction of the last paintings. Speaking of art to Joachim Gasquet, Cézanne said, "It ought to make us taste it eternally." His late views of Mont Sainte-Victoire embodied Cézanne's quest for the eternal under the appearances of reality. In representing a loved motif of his youth and old age he reached the summit of his art, combining a classic balance from the past with a dynamic prophecy of the future.

—Alicia Craig Faxon

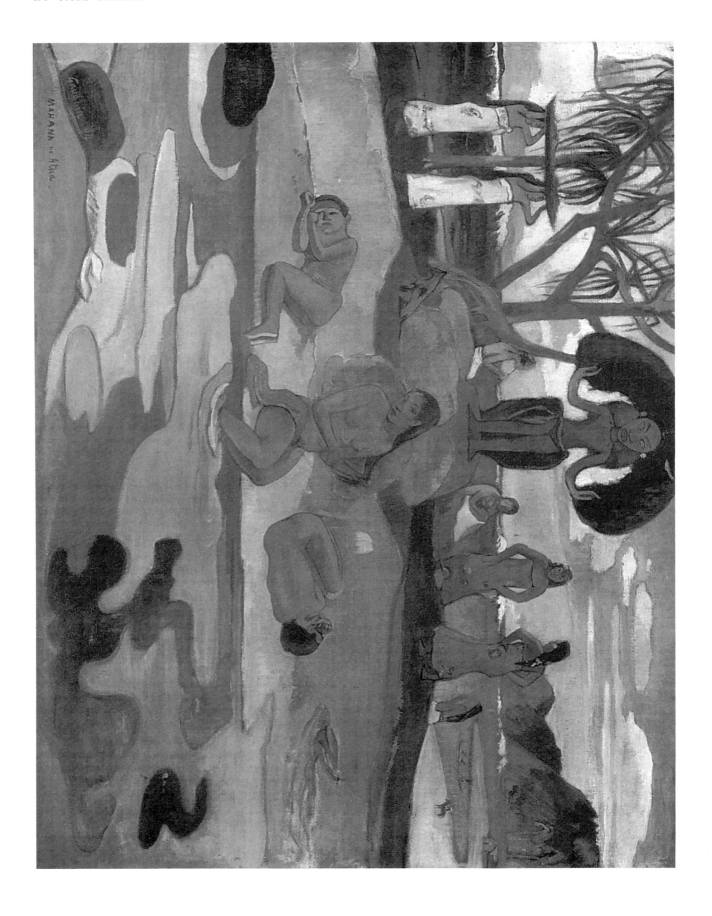

Paul Gauguin (1848–1903)
Day of the God (*Mahana no atua*), 1894
27 × 35 in. (69.6 × 90.5 cm.)
Chicago, Art Institute

After his first trip to Tahiti which had begun in April 1891, Gauguin was repatriated towards the end of June 1893 and arrived back in France two months later. In Paris, he began to assemble work for a one-man exhibition which the Impressionists' dealer Durand-Ruel had agreed to host in his gallery, thanks to the intervention of Degas. The exhibition was not the success that Gauguin had wished for, although he had a number of favourable reviews. The canvases he managed to sell only covered his expenses, and many of his most recent Tahitian works, although admired for their formal qualities and their daring unnaturalistic use of colour, were often met with a degree of incomprehension by a public which already had a preconceived notion of life in the South Seas fostered by a number of popular fictionalised accounts.

One of the reasons cited for the lack of understanding of his work was Gauguin's refusal to translate his Tahitian titles and thereby make the works more accessible to a Parisian audience. After the exhibition at Durand-Ruel's it became apparent that the best way to rectify this situation was to provide an intermediary text, an idea he had been working on for some time. During the last months of 1893 he worked on the text and illustrations for *Noa Noa*. This work, which purports to be a reminiscence of his time in the South Seas and a record of a number of Tahitian legends as recollected by his young Tahitian bride, was in fact largely borrowed from J. A. Moerenhoet's *Voyages aux îles du grand ocean*. The central figure of the god in this canvas derives from the same source.

At about the same time, Gauguin began work on *Day of the God*, a reinterpretation of his time in Tahiti which, like *Noa Noa*, had little basis in reality. During this period in Paris he mixed with various literary figures and devoted himself to writing and reworking a number of motifs, rather than searching for new inspiration for his paintings. However, at this time he greatly expanded his technical repertoire, and in *Noa Noa* in particular he began to experiment with the woodcut. He made a woodcut of *Day of the God*, and much of the painting's technique owes something to Gauguin's interest in graphic art. The thick blue lines enclosing the figures and the decorative abstract area in the foreground point to his rapid assimilation of new ideas.

The work depicts Gauguin's version of an ancient Tahitian ritual centring on the figure of the god, which forms the apex of a pyramidical composition. The other figures face inwards towards this figure and are at the same time arranged as if on a frieze, an effect heightened by their echoing poses. At the same time, the composition has been arranged into three horizontal bands. The background, painted in cool blues to suggest a feeling of distance, is closest to a realistic depiction of Tahiti, with suggestions of everyday life and work. The centre or middle distance, which plays on a harmony of pink and blues, is where the ritual takes place, and the foreground element, which presumably represents an area of water, is composed of interlocking organic forms painted in pure unmodulated areas of colour with little basis in the external world. The effect is strangely static and timeless. The decorative quality of the work is heightened by the use of a rhythmical, flowing line which binds figures and landscape.

While the work is in fact fairly small, the impression it gives is one of calm monumentality, not only because of the ritualistic subject matter but also because of the bas-relief quality of the figures and the glowing, unnaturalistic colour. In the work, Gauguin has fictionalised life in the South Seas, not so much because of a defective memory as from a desire to appeal to his Parisian audience much as he was attempting in writing *Noa Noa*.

—Lesley Stevenson

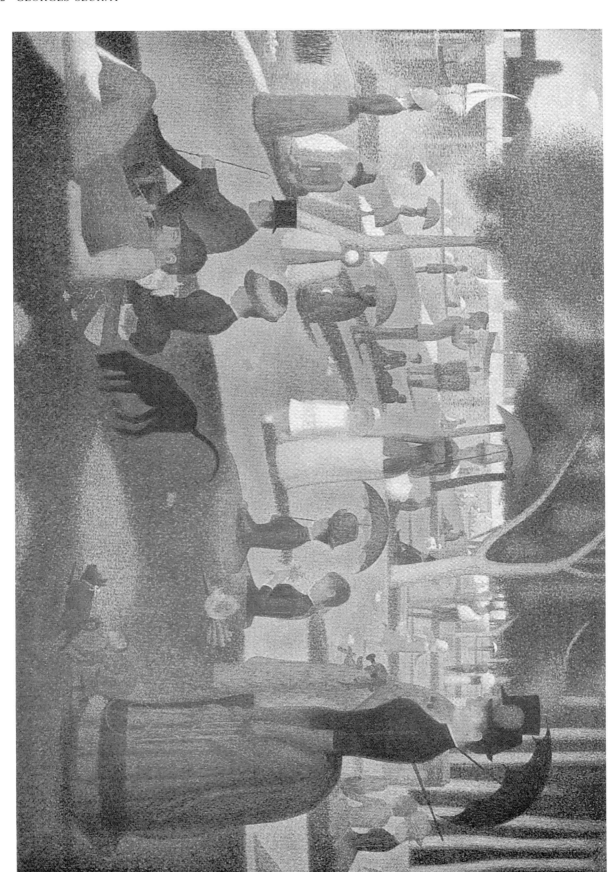

Georges Seurat (1859–1891)
Sunday Afternoon on the Island of La Grande Jatte, 1884–86
6 ft. 9³/4 in. × 10 ft. 1¹/4 in. (207.5 × 308 cm.)
Chicago, Art Institute

Bibliography—

Zervos, Christian, "Un Dimanche à la Grande Jatte," in *Cahiers d'Art* (Paris), no.9, 1928.

Schapiro, Meyer, "Seurat and La Grande Jatte," in *Columbia Review* (New York), 1935.

Rich, Daniel Catton, *Seurat and the Evolution of "La Grande Jatte,"* Chicago, 1935.

Morris, Johnny, *Seurat: A Sunday Afternoon on the Island of La Grande Jatte,* London, 1979.

Brettell, Richard R., "The Bartletts and the *Grand Jatte:* Collecting Modern Painting in the 1920s," in *Museum Studies* (Chicago), 12, 1986.

La Grande Jatte is frequently discussed purely in terms of colour technique and composition, from which considerations it can be said that Seurat was moving ever further from the Impressionists. His interest in scientific writings about line and colour and aesthetic formulae which he applied in his work make his paintings increasingly deliberate without any of the supposed spontaneity of the Impressionists.

The painting's precision and uniformity and the stiffness of the figures are based on more than the mere application of aesthetic formulae, however. There is a mood of banality in the painting that sours the enjoyment of the Sunday afternoon. But this banality and the picture's geometrical construction are not ends in themselves, but the means by which a subtle disquiet is achieved. Despite the uniformity, the painting is not static except in form. Between the figures there exist living, complex relations, and it was on the uncomfortable balance between social classes that Seurat's attention was focussed. Of *La Grande Jatte* T. J. Clark claims that "it attempts to find form for the appearance of class in capitalist society, especially the look of the 'nouvelles couches sociales'; that the forms it discovers are in some sense more truthful than most others produced at the time; and that it suggests ways in which class might still be painted."

The island of La Grande Jatte was popular with Parisians of various sexes, ages, and classes, but their enjoyment, as Seurat presents it, does not entail an uninhibited, harmonious mingling of all but rather highlights their separateness: worker, petit bourgeois, and bourgeois share their leisure space while retaining all the isolating characteristics of their respective class. The painting's oddness is emphasised by some of the figure juxtaposition. While the unmistakeably bourgeois man and woman on the right of the picture belong together, comical and separate from the others, the lefthand foreground is occupied by three figures whose relationship is harder to fathom. They are sitting close enough to appear as one party, yet despite their proximity their different modes of dress and their lack of mutual interest do nothing to disguise their separateness. This is a characteristic that persists throughout the picture. The only tangent between the prim clerk with his hat and cane, the immaculately dressed bourgeois with her monkey, and the pipe-smoking worker in shirtsleeves is their self-conscious attempt at enjoying their day off in a place designated for leisure.

The overall effect *is* one of banality, but a complex banality which requires more than an untroubled acknowledgment. Richard Shone, for example, recognises it but seems to go no further: "The geometrical rigidity of the posture and spacing of the forty or so figures, the elaborate planning of detail and the use of multiple perspective contribute to the painting's grand immobility and its almost disquieting air of 'unreality.' At the same time Seurat is so sensitive to the nuances of values, the modulation of contour and enlivening detail, that a perfect balance is maintained between abstraction and the exigencies of his subject in all its Sunday banality." For Seurat this effect was not the end of his intention but the point from which his intention started, his intention "to seize the diverse attitudes of age, sex, and social class: elegant men and elegant ladies, soldiers, nannies, bourgeois, workers."

—Simon Hancock

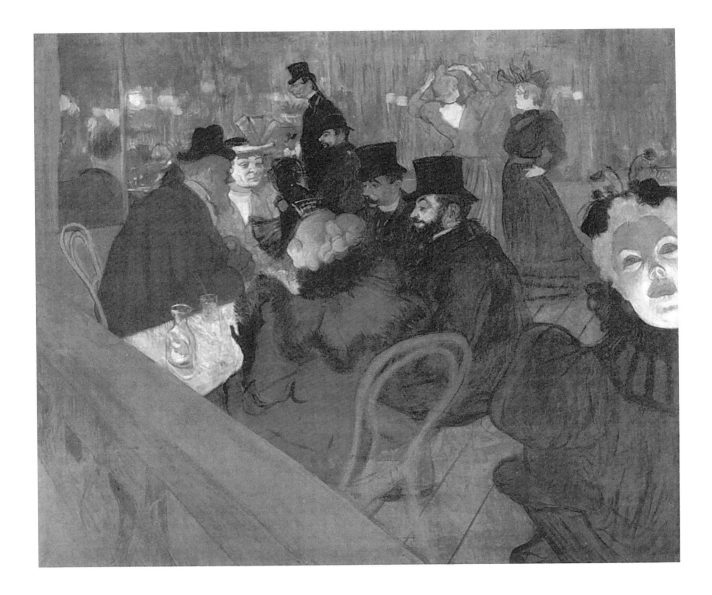

Henri Toulouse-Lautrec (1864–1901)
At the Moulin Rouge, 1894–95
48¹/₂ × 55¹/₂ in. (123 × 141 cm.)
Chicago, Art Institute

Bibliography—

Heller, Reinhold, "Rediscovering Toulouse-Lautrec's *At the Moulin Rouge,*" in *Museum Studies* (Chicago), 12, 1986.

Among the largest and most structurally confident of the artist's paintings, this rich and allusive work remained, unexhibited, in his possession during his lifetime. Some of Toulouse's closest friends are shown, and a newly assigned date—c. 1895 given to the *entire* work—places it at the onset of the cabaret's decline when Toulouse began to haunt more literary and less picturesque places and became a part of the *La Revue Blanche* group. The image is therefore now interpreted as a farewell to the Moulin Rouge. The painting is said to present the *promenoir* when, between acts, dancers would sit at the customers' tables.

For long, the painting was held to be an initial rectangular image later extended by an L-shaped addition, still visible as a line of slight surface and paint alteration—just above the seat of the foreground bent-wood chair and just to the left of the vividly lit head at the extreme right foreground. (This powerful motif was usually identified as a "Nelly C." and only in 1979 was securely offered as the face of the English, or American, dancer May Milton.) The literature of this work, on the basis of other such grotesque heads which the artist produced about 1895, assumed that this head was added at that time to the original compact, circular figural group at the table and its rearground figures—typically then this picture was dated about 1892.

At the left is the poet and critic Edouard Dujardin, editor of *Revue des Indépendants,* and next to him the Spanish dancer La Macarona. Seen from the back is Jane Avril, an expressive and experimental dancer. The other two male heads in the foreground group are the professional photographer Paul Sescau and Maurice Guilbert, proprietor of a vineyard. To the back, and providing the climax for the clearly witty ascending scale of black-hatted heads, is Toulouse Lautrec himself and his far-taller and favorite cousin Dr. Tapié de Céleyran. At the back right stands another celebrated dancer of the moment, La Goulue, with a friend, La Môme Fromage, seen in profile. The vivid descending line of the balustrade—itself perhaps an acknowledgement of the then-current physiognonic assignment of "melancholy" to lines moving downward, left to right—places us as viewers clearly outside the circle of intimates; as well, the clear gaze of May Milton's eyes is meant to fix the position of the viewer, establishing our gaze at just that level and thus accounting for an underside view of the hat brims of those seated at the table side. This analysis is offered as a part of the argument for the original, single and integral image in recent research (Heller).

While appearing with the vivid immediacy of an observed and literal moment, the figures may easily be traced to previous visualization in Toulouse's work. He continually reused favored motifs, both from his own and others' works. For instance, at the back, La Goulue and La Môme Fromage resemble their bodily posture and facial silhouettes in an 1892 color lithograph. Similarly, Avril seen from the back relates to the *Le Divan Japonais* poster of 1892–93, as does, reversed, Dujardin's profile. And the face of La Macarona here appears a re-use of her 1894 portrait. The looming head of May Milton may relate to such Degas works as the *Singer with Glove,* 1878 (Cambridge, Massachusetts) and the *Ballet Scene from an Open Box,* 1885, (Philadelphia).

At the death of Toulouse-Lautrec, his dealer Maurice Joyant was made executor of his estate and was given this work by the artist's father. Sometime before 29 March 1902, when the painting was publicly exhibited for the first time at the Salon des Indépendants, it was cut down to exclude the sharply lit head and the lower-edge strip. Milton and Jane Avril had been close friends at the time the painting was produced—perhaps the color chord of Avril's red hair and the green lighting of Milton's face is meant as reference to such complementarity. On the basis of published statements of Joyant and others, an intense negative feeling about their presumed lesbian relationship had come about in the Toulouse-circle; and this was the direct cause of the elimination of the head of May Milton from the work. Joyant, in fact, is the source of the label "Nelly C."; thus even after the picture was restored sometime before 1914, for a retrospective exhibition of the artist's works, he continued to deny Milton her presence in it. Absolute material confirmation of the picture's original appearance came in 1985 in the course of a conservatorial examination. Not only are the paint surfaces and facture the same, but the weave of the canvas is the same in both segments, with the fat threads of the weave running straight across the line of severance.

Recent literature had affirmed the great importance of lithography for Toulouse, both as a medium in which he felt free to be a draftsman, and as emblem of a process and product in which traditional fine-art strictures might be suppressed. The thin wash of paint here, on a cardboard-color-tinted canvas surface, seems to allude to his graphic art posture. (Since he had used cardboard almost exclusively as a painting surface in the years 1891–94, his use here of canvas is offered as further confirmation of the 1895 dating of the image.) Even more so, the flattened forms, with their undulating contours stressed as pattern, allude to his lithography as source, as well as to the Japanese woodcut, Gauguin, and the Nabis. The raking floor, the use of mirrors as backdrop, and the varied counterpoint of the figure groups, including the near-far juxtapositions—and in fact, the cabaret as arena itself—are all aspects of Toulouse-Lautrec's life-long devotion to the art of Degas.

—Joshua Kind

Medardo Rosso (1858–1928)
The Conversation in the Garden, 1896
Plaster; 13³/₄ in. (35 cm.)
Barzio, Rosso Museum; a slightly smaller bronze version is in
 Rome, Arte Moderna

Linked by Rosso in his memoirs to his stay in London, this small group sculpture should be dated 1896, not 1893 as it is sometimes given. 1896 corresponds to his most important visit to London when he executed numerous pencil and charcoal drawings of people interacting in an outdoor setting. During that winter of 1896, he was moved by the importance the parks assume in London city life, and this group captures in a synthetic form his bewilderment in front of people unaware of being looked at, interactings freely in a public space. It has the freshness of a quickly captured observation and is possibly one of the clearest examples of Rosso's "anti-plastic" concept of sculpture.

The forms, three silhouettes barely suggested in a reductive language in which every element is abstracted to the maximum, evoke motion, tension, complicity of the surroundings, but are never described. It is the gesturing of the sitters that is clearly conveyed to us, but as beholders we are required to add what has been omitted in this extreme economy of formal language, and to reconstruct our own image of this interaction from the ever-changing reality proposed by Rosso. The open space between the figures is more important than their multi-faceted shapes. For this group Rosso, who in most cases indicated the appropriate lighting in which the work should be presented, prescribed lighting from the left side to allow for cast shadows.

There exists a third version of this work, a wax over plaster, in a private collection in Milan, in which all the magic quality of the non-descript is reinforced by the transparency of the medium.

—Annie-Paule Quinsac

Giovanni Segantini (1858–99)
The Evil Mothers, 1894
3 ft. 11¼ in. × 7 ft. 4⅝ in. (120 × 225 cm.)
Vienna, Galerie, Stallburg

One of a group of six works dedicated to a theme inspired by a poem, *Nirvana*, the painting *The Evil Mothers* is among the most powerful images of *fin de siècle* symbolism. Segantini, who was a friend of the poet and librettist Illica, knew that the story according to which he would have been only the discoverer and translator of *Nirvana* from a 14th-century Sanskrit poem by an obscure Hindu writer name Panghiavali, was a tale invented by Illica to add an exotic flavor to his own creation in the hope of insuring its success in a period of oriental mania. The poem fascinated him not because of its oriental origin but because it dealt in an inspired way with one of his most constant obsessions, the relationship of mother and child, and because it gave him the opportunity to express his ambivalent vision of a pantheistic nature both nurturing and destroying. From 1891 to 1896 he produced six works on the theme of Nirvana, all related: two large oil paintings (the Vienna version, the largest, is from 1894; one in the Walker Gallery, Liverpool, called *The Punishment of Lust*, is from 1891), two drawings, and two "sgraffitos" on paper (1896, Zurich), each of them corresponding to either the Vienna or Liverpool paintings. The sgraffitos—using the traditional Swiss technique of scraping off the paint to produce a linear effect over a monochromatic piece—transpose both scenes in tonalities of dark blues that suggest a moonlight effect, while the scraped off lines confer an *art nouveau* quality upon the image. The Vienna version is the most faithful to Illica's redemptive saga. The poem, believed until now to be by Panghiavali, narrates the punishment and redemption of women who, lured by the promises of a life of sensuous pleasures, have given up the children their sexual involvements could have generated. It has been often read as implying that these women had actually committed abortion, but the verses are not explicit on this point. Segantini did not attempt to force the interpretation of the poem, and it is interesting to note that the first painting, *The Punishment of Lust*, is changed to *The Evil Mothers* when the second painting was first exhibited. Illica situated his Nirvana—the place where the redemptive cycle takes place—in an ice-covered setting beaten by the winds. Segantini identified it with the landscape of the Engadine in the winter, a place where he had lived since 1894 (though not in the winters, since he felt the ground became like a shroud, and nature showed the "death of all things").

More clearly than the Liverpool version, the Vienna painting and the drawing and sgraffito derived from it center on the redemption of the mothers. A main protagonist, attached by her hair to a thorny tree, is being reunited to her rejected offspring, while others are waiting for a similar fate. In Illica's poem these mothers are condemned to an ice-covered purgatory where only the shrubs which keep them captive can grow, until, breaking through the ice at the roots of the trees, the heads of tiny infants finally arise; babies and mothers are reunited by the dried limbs which have become umbilical cords. The poem emphasizes that only the child's forgiveness can redeem the mother from her "sin." This strange saga must

have had a personal, haunting quality for Segantini. Left an orphan at seven by a mother who had not been able to rear him because of recurring illness and a destitute social status, Segantini—as noted by Karl Abraham in his psychoanalytical study of the artist—saw in the representation of motherhood, at human and animal level—a catharsis for his own unresolved childhood conflicts. Mother themes are dominant in his iconography, and with the series inspired by Illica's *Nirvana*, his own ambivalence toward the mother figure could find full expression.

Of the six works, the Vienna version is the most powerful, not only because it is the most ambitious in size and the most successful pictorially, but also because it is the one in which the image is the clearest and most disturbing in its content. A pleasure-pain equation is directly stated in the representation of the child savagely biting the mother's breast while her facial expression is that of ecstasy; the baby's neck is meanwhile being strangled by the tree limb. A reunion with the child is not represented fully, except for the nursing process. The tree is rendered so as to appear revolving. It is impossible to know whether Segantini intended to indicate that the three female figures are images of the same mother at different stages of her progressive liberation, or three sisters who have undergone the same fate. In any case, in the middle ground on the left other women are depicted ready to undergo the end of their purgatory, an imminent development indicated (in the Liverpool version) by the head on an enfant emerging above the ice.

The complexity of the painting's iconography escaped most his contemporaries, and the work became the object of vehement controversies. Termed incomprehensible in Berlin, it was acclaimed in Vienna as "the most significant masterpiece of the century," and was to have a decisive influence on Klimt and the Vienna Secessionists.

Without the knowledge of Illica's text, the subtleties of the painting's iconography are not readily understandable. However, the power of the painting is not diminished by ignoring some of that content because the image has an overpowering evocative meaning. Naturalism is expressed in an almost hyper-realist way: the Engadine landscape in winter is faithfully transcribed in a language of long filaments of pure color that give a vibrant quality to the white of the snow; the cadaverous color of the main mother's body contrasts with the decorative undulation of her figure and the pre-Raphaelite richness of her hair. There is enough observation of that awesome fragment of nature that we accept the image, and recognize that, as in a dream, such eerie creatures could indeed inhabit such a setting. Segantini's symbolism, unique among his contemporaries, looks forward to some aspects of Surrealism in the manner he forces his viewers to accept reality. *The Evil Mother*'s poignancy stems from a uniquely personal vision which encompasses all the *fin de siècle* ambivalence toward women and in which nature is the main protagonist.

—Annie Paule Quinsac

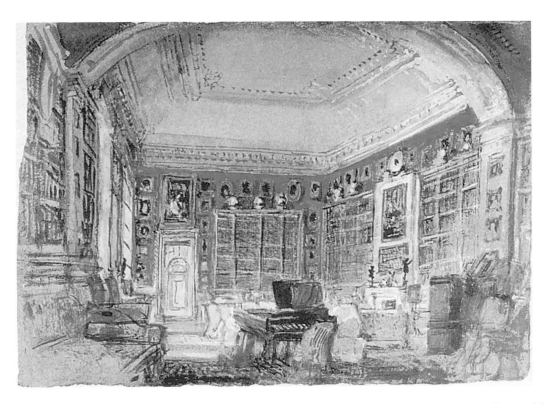

J. M. W. Turner (1775–1851)
The White Library, Petworth, 1827
Watercolor and bodycolor on paper; $5^1/_2 \times 7^1/_2$ in. (14 × 19 cm.)
London, Tate

Bibliography—

Youngblood, Patrick, " 'That House of Art': Turner at Petworth," in *Turner Studies* (Abingdon), 2, 1983.
Butlin, Martin, Mollie Luther, and Ian Warrell, *Turner at Petworth*, London, 1989.

The White Library belongs to a series of over 100 small drawings in watercolor and bodycolor on blue paper made by Turner on his visit to Petworth House, Sussex, in the autumn of 1827. The owner of Petworth, the 3rd Earl of Egremont (1751–1837), was notable both for his bohemian lifestyle and for the hospitality and patronage he extended towards contemporary artists. From Turner he either bought or commissioned 20 oil paintings between 1802 and 1830. Turner paid about ten autumn or Christmas visits to Petworth between 1827 and 1837 and clearly felt completely at home there, painting in a studio provided for him in the Old Library, fishing in the lake, and enjoying the company of the other guests. Until recently it was not possible to associate his series of watercolors with any particular visit he made to Petworth, but new research has now dated them precisely.

In some respects Turner's Petworth watercolors are unique in his work: they were an entirely private record of life in the grandest household with which he was familiar, and they were executed simply for pleasure, not as the basis for more finished drawings for exhibition or engraving. However, they possess all the characteristic features which make up his genius as a watercolorist: technical virtuosity, radiant and harmonious colors, intense interest in everything that was going on around him, and the ability to capture the spirit of a place within the compass of just a few inches.

The White Library needs to be considered within the context of the Petworth group of watercolors as a whole, which falls into three subject-areas. The first group shows the broad expanses of Petworth Park, usually around sunset or at twilight. The second and largest group captures incidents in the daily life of the household: groups of men and women talking, painting, reading, making music, discussing paintings or sculpture; men playing billiards, ladies sitting at their dressing-tables. In some of these drawings daylight floods in through the windows, in others figures are seen by candlelight or firelight. Sometimes—but not always—it is possible to identify the particular room in which the incident is taking place, but usually the setting is of far less importance than the human activity depicted. Finally, there is a small group—including *The White Library*—in which Turner dazzlingly portrays the biggest and most imposing rooms in Petworth House in all their glory and completely uninhabited. It is as if he had risen very early, even before the servants, in order to revel in their splendor entirely on his own. These drawings contain considerably more detail than the others, but it is swiftly flicked in with the feathery touch of the virtuoso, and the play of light on a complex decor is just as much Turner's subject as the decor itself. In *The White and Gold Room*, for instance, Turner's shimmering surface outclasses the modest rococo decoration of the room itself, while in *The White Library* he has presented with nonchalant economy not only the careless clutter of the Petworth he knew and loved but also something more: the epitome of an English aristocrat's library.

—Cecilia Powell

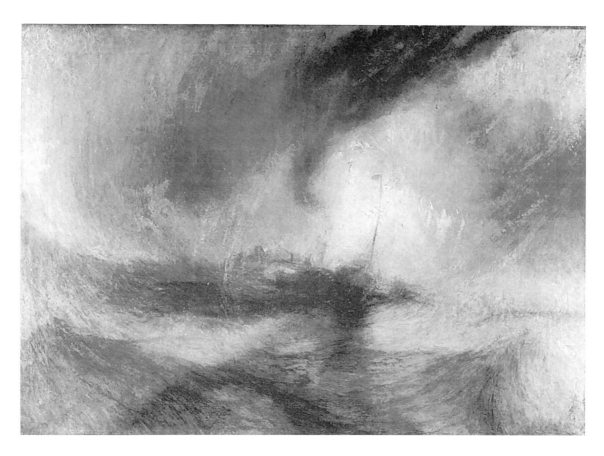

J. M. W. Turner (1775–1851)
Snow Storm—Steam-Boat Off a Harbor's Mouth, 1842
36 × 48 in. (91.5 × 122 cm.)
London, Tate

Snow Storm—Steam-Boat off a Harbor's Mouth is one of Turner's most famous and most powerful late oil paintings which brings to a climax his lifelong concern with the sea, with the sublime grandeur of natural forces, and with the heroism of man's struggle against the elements. Unlike many of Turner's late oil paintings, *Snow Storm* is notable not for its brilliant coloring but for its sombre chiaroscuro, the grey-black and muddy cream of both the raging storm and the heaving sea being only occasionally relieved by patches of blue sky and the bright signals of the vessel in distress. It was probably this lack of color, together with the flurries of impasto which whirl around the entire surface of the canvas, which led to the painting being described by a critic in 1842 as a mass of "soapsuds and whitewash." Ruskin recorded Turner's unhappiness on the day this criticism was published and his comment on it: "I wonder what they think the sea's like? I wish they'd been in it."

The painting's full title when it was exhibited in 1842 was *Snow Storm—Steam-Boat off a Harbour's Mouth making Signals in Shallow Water, and going by the Lead. The Author was in this Storm on the Night the Ariel left Harwich.* Such a detailed caption unequivocally presents the painting to the viewer as a record of a real storm witnessed by Turner; furthermore, Ruskin recorded a conversation between his friend the Rev. William Kingsley and the painter himself in which Turner amplified the words of his subtitle in an extremely specific way: "I got the sailors to lash me to the mast to observe it [i.e., the storm]; I was lashed for four hours, and I did not expect to escape, but I felt bound to record it if I did."

The sublimity of the storm is expressed with such overwhelming intensity in this painting that most writers from Ruskin onwards have taken Turner's account of its genesis at face value. In recent years, however, research into the painting has made several art historians doubt nearly every word of Turner's concerning it. They cannot trace an *Ariel* operating out of Harwich at a suitable date and they suggest that Turner's claim to have been lashed to the mast in order to study the storm was a fiction based on his knowledge of a similar exploit by the 18th-century French marine painter Joseph Vernet. It seems unlikely that further research will establish conclusively whether or not Turner was ever actually lashed to a mast, though it may succeed in discovering an *Ariel* which ran into trouble in a storm which Turner could have observed. What is surely far more important, however, is that the artist has completely succeeded in his avowed aim of showing "what such a scene was like." Despite the comparatively small size of the painting, viewers cannot help feeling they have been sucked into the dizzying heart of the storm, into a nightmare of clouds and snow, spray and waves where there can be little or no hope of survival. Turner has not needed to exaggerate any of his ingredients, as in his earlier exercises in the sublime; by now, as a mature painter with 40 years' personal experience of the sea behind him, he knew precisely how to blend realism and sublimity into a masterpiece.

—Cecilia Powell

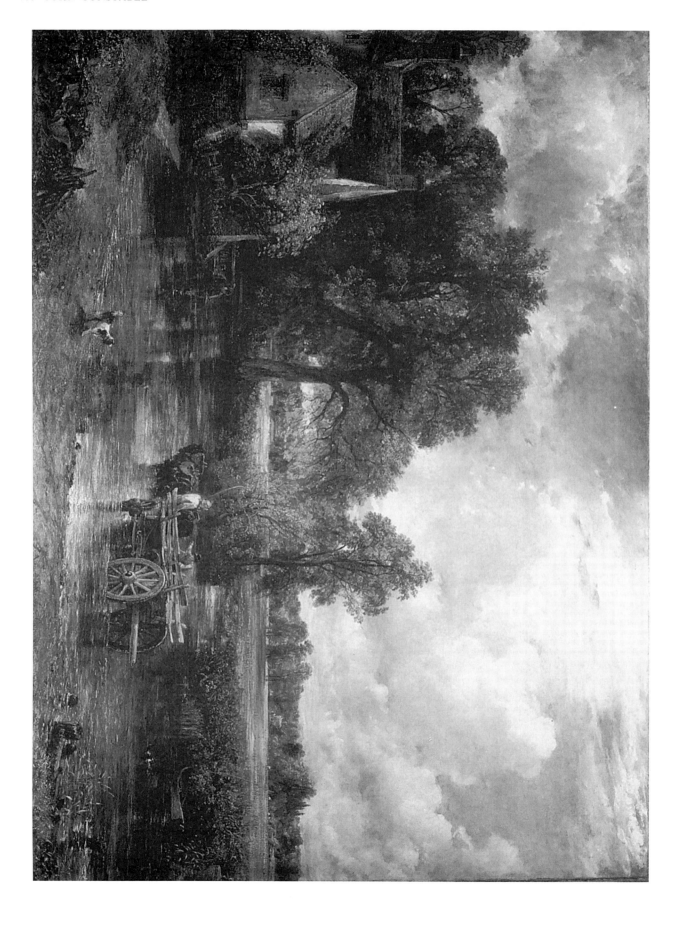

John Constable (1776–1837)
The Haywain, 1821
51¹/₄ × 73 in. (130.1 × 185.4 cm.)
London, National Gallery

Perhaps no other picture in Constable's *oeuvre* better embodies what one critic has termed the "ideal of naturalistic landscape that is immediately accessible" than *The Haywain*. The large oil on canvas painting is the third in the series of "six footers," a term Constable coined to describe his large canal scenes set in the landscape of his native Suffolk. The appeal of Constable's art has been its versimilitude. When the work was first exhibited at the Royal Academy in April 1821, a reviewer for *The Examiner* praised the work as "nearer to the actual look of rural nature than any other modern landscape." Constable felt strongly that only those artists who had an intimate acquaintance with a specific landscape could render it truthfully. He wrote: "Londoners with all their ingenuity as artists know nothing of the *feeling* of country life (the essence of landscape)—any more than a hackney coach horse knows a pasture."

When Constable sent the work to the Paris Salon in 1824, it created a stir: Delacroix was to write in his *Journal* entry for June 19 that the work had" . . . done [him] a power of good," and Thiers found Constable's work appealing because its "*truth* has for me an immediate and irresistible charm." It is this "truth" that Constable sought in his work. Unlike so many of his contemporaries he was not seduced by the sublime landscape of the Lake District, Wales, the Scottish Highlands or the Alps. Constable paid but one short visit to the Lake District and found the scenes not to his liking. In his essay "English Landscape Scenery," Constable refers to his body of work as "chiefly consisting of home scenery." It is this intimacy, this closeness to the places he knew as a boy and man, that gives his landscape paintings their edge. The view across the tail race of Flatford Mill to Willy Lott's cottage in *The Haywain* gains its power from the freshness of the scene.

The painting was originally titled *Landscape: Noon*. It is not unimportant that the name tells us nothing of location but emphasizes an exact time of day. Constable's unique method of laying in pure color to imitate the sparkle and reflection of light off surfaces, and his bold brushwork to suggest the movement of the wind through grass and sky and over the water are powerfully realized. Constable elected to send *The Haywain* to the British Institution exhibition. He appended to the frame the following extract from Thomson's *The Seasons*: "A Fresher gale / Begins to wave the wood, and stir the stream, / Sweeping with shadowy gust the fields of corn." The verse seems a virtual description of the scene. The two boys directing the old cart across the shallow waters of the ford to the sunlit field beyond are at the center. The foreground is empty, except for the hound on the shore, a frequent prop in Constable's canal pictures. Originally, figures had been placed in the center foreground but these were removed by the artist as he opened the scene. The composition is closed off on the left side by the white-washed cottage of Willy Lott. Lott, who was alive in Constable's day, had been associated with the artist's father's water mill operations and had lived out his 80 years in the cottage, seldom straying from the riverbank. The leafy elm

trees complete the closure on the left. These trees with their extraordinary range of color capture the effect of intense sunlight and deep, dank shadows. The right side of the canvas is open and the eye moves quickly into the deep space beyond the river's edge. The power of the painting is clearly derived from the sky. As in so many of Constable's great works the sky is the protagonist. It is the sky, with its billowing clouds, which determines the character of the landscape below it. The painting suggests the constant flux of cool shadows and the heat of the open air and sky. It was in 1821, the year that Constable completed this work, that he began what he referred to as his "skying." These studies, mostly of cloud formations, are remarkably accurate and straightforward. Constable was later to acknowledge the primacy given to the sky in his works; in a letter he stated: "It will be difficult to name a class of landscape, in which the sky is not the 'key note,' *the standard of 'Scale'* and the *chief Organ of sentiment*. The sky is the *source of light* in nature—and governs everything." It is the generous sweep of the sky which animates this rural scene. Parallels were drawn in Constable's day between his work and that of Dutch and Flemish landscape artists of the 17th century. In these earlier works Constable could witness the struggles of painters to catch the character of a terrain not at all dissimilar from his own low-lying native Suffolk, where the bulk of a view is made up of sky. *The Haywain* is a work that shows just how well Constable had absorbed the lessons of his Continental predecessors, especially Rubens whose work he admired for its "Dewy light and Freshness." In February 1804, in Benjamin West's studio, he had seen Rubens' *Chateau de Steen* which Lady Beaumont had purchased for her husband, Sir George Beaumont. The Beaumont collection was an important inspiration to a whole generation of British artists including Constable, Turner, and Cotman.

It took Constable less than five months to complete *The Haywain* from its earliest sketches to the finished version which was preceded by the very large study now in the Victoria and Albert Museum. The study, the largest executed by Constable, is a study in tonal painting; the reddish-brown underpainting can be read with ease, and the work is remarkable for its loose, suggestive brushwork. The earliest notation for the ideas that would lead to *The Haywain* may be a small oil-on-paper study of Willy Lott's cottage of July 29, 1816 (Ipswich Museum and Gallery).

Though the work was praised when first exhibited in London it went unsold. Constable, at the urging of Archdeacon Fisher, sent the work to Paris in 1824, where it was honored with a gold medal in the Salon by Charles X. There is debate, but it seems likely that when the work was seen by Delacroix it may have caused him to repaint the foreground portions of *The Massacre at Scio*, imitating Constable's bold juxtaposition of pure color to suggest the reflection of light.

The Haywain had a special place in Constable's heart. It was a work he often chose to lend to exhibitions and he appreciated its unique success which he termed "rather a more novel look than I expected." Because of its prominent position in the National Gallery, it has become something of an icon symbolizing the beauty of the English landscape and the merits of its native school of painters.

—Anthony Lacy Gully

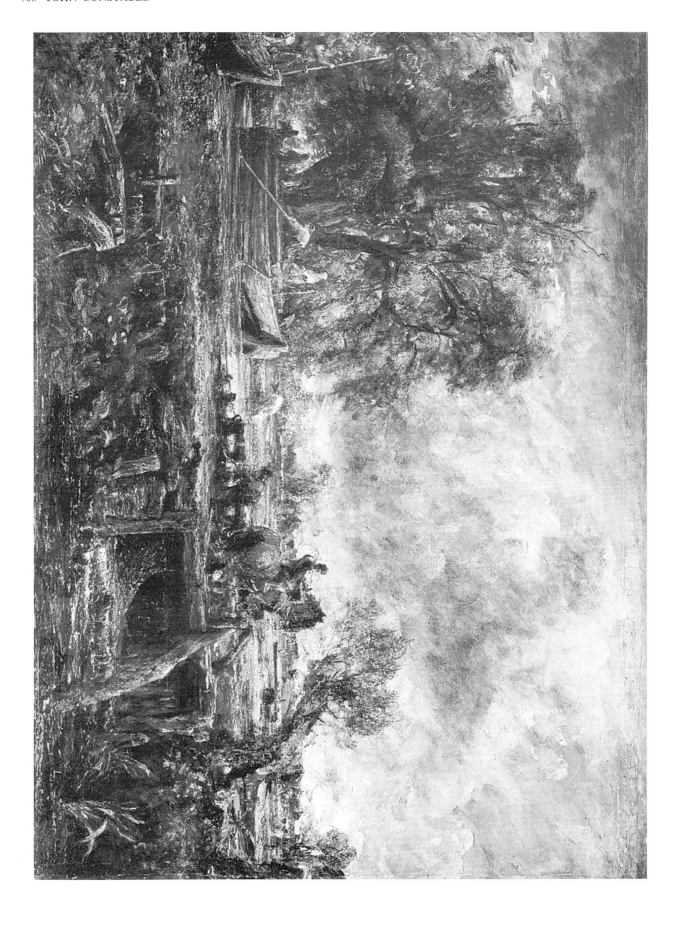

William Powell Frith (1819–1909)
Derby Day, 1858
40 × 88 in. (101.6 × 223.5 cm.)
London, Tate

Frith's *Derby Day* (exhibited R.A. 1858; London, Tate) was his most popular work, and it exemplifies his particular artistic obsessions, as well as those of the art market of his day. With the success of *Ramsgate Sands* (1854; Royal Collection), Firth felt under pressure to find another subject of equal appeal—one which was filled with incident and set in some familiar English location. A visit to Epsom in 1856 gave him the idea to paint the crowd attending the Derby, and 15 months later he completed the painting. Frith felt that this incident would be pleasing and would offer an "infinite variety" of interest to observers of the painting.

Certainly the work reveals Frith's ability to manipulate a multi-figured composition. A series of studies and oil sketches for the painting show how he considered each individual grouping separately before consolidating the whole in the final large (40″ × 88″) painting. Following his usual practice, Frith painted most of the figures from models in his studio, and he chose his models for their appropriateness. Thus, a Drury Lane acrobat was used for the child performer in the foreground, and Frith found a real jockey to pose for the jockey astride a horse in the far right background. Frith's strict adherence to nature led him to pose his model on an uncomfortable wooden horse while he painted him. His concern for fidelity also induced him to use photographs of the racecourse itself in order to aid his reproduction of the scene. He acquired the assistance of John Frederick Herring, Sr. (1795–1865), a famous animal painter, to add the only horse clearly visible in the work.

Aside from the variety of modern life, Frith claimed that he was inspired to paint *Derby Day* when he witnessed the attempted suicide of a man at Epsom who had lost everything betting on the horses. However, little of this theme is apparent in *Derby Day* itself, although Frith later developed his homily on the disastrous consequences of gambling in such works as the *Salon d'Or, Homburg* (1871) and the *Road to Ruin* (1878; Baroda). In *Derby Day*, enjoyment is more obviously the theme, and the only potential threat to the pleasures of the day is the presence of a pick-pocket at the left of the painting, carrying out his crime while his victim is observing a shell game. Frith, however, avoids moral or social comment, and merely offers the incident as one diversion amidst the variety of vignettes available to the observer of the work. Social comment is also absent in the intermingling of different classes of society. The barefoot beggar children are more picturesque than pitiful, and their presence in the work led Ruskin to describe *Derby Day* as Dickensian. Other critics also offered backhanded compliments to Frith, praising his work as skillful, but condemning it as superficial.

Despite its limitations, *Derby Day* was a popular and commercial success. Even before it was completed, Jacob Bell offered £1500 for the painting and Ernest Gambart paid Frith another £1500 for the right to make an engraving from it. When it was exhibited at the Royal Academy, the enthusiastic and numerous observers made it necessary for a rail to be placed in front of the painting in order to avoid damage. This was the first time since the exhibition of Wilkie's *Chelsea Pensioners* (1817–21) that such protection was required. An agreement between Bell and Gambart allowed the latter possession of the painting for the next four years, and once the work was engraved, Gambart sent it on a world tour to increase his subscription list for the print.

—Shearer West

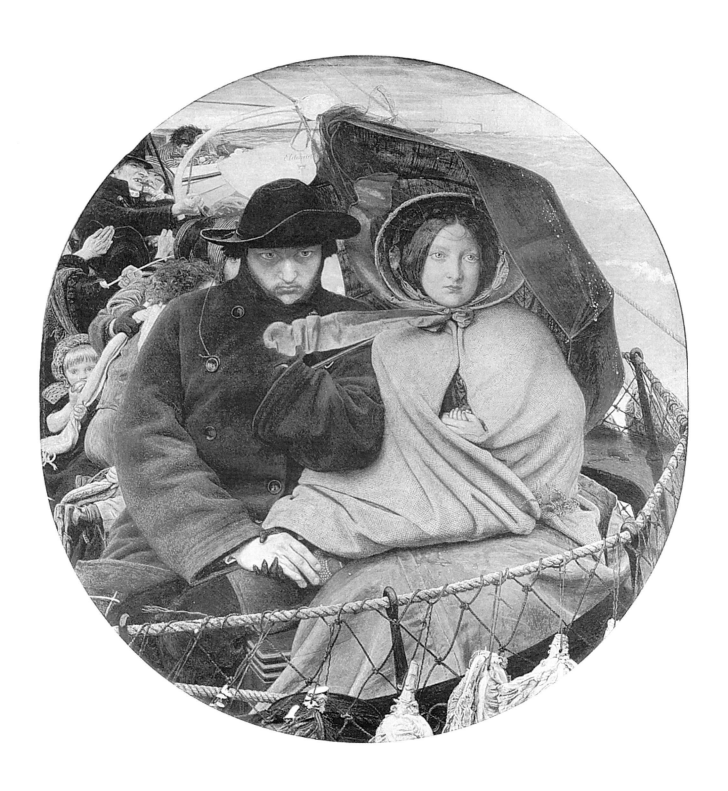

Ford Madox Brown (1821–93)
The Last of England, 1855
Panel, 32½ × 29½ in. (82.5 × 74.9 cm.)
Birmingham, City Art Gallery

In the corpus of Ford Madox Brown's work the painting *The Last of England* is arguably the most expressive in subtleties of interpretation. It was begun in the early 1850's when migration, chiefly to Australia to seek gold, was a desperate and courageous attempt to carve out a better life, when class distinction penetrated every section of society (and to this Brown was particularly vulnerable), and when true Pre-Raphaelite ethics were making their mark in the world of art. These three important aspects of life in mid-19th-century England were roughly the means with which Brown hoped to catch the prevailing sentiments of the time.

He was born in 1821 at Calais, and, living chiefly abroad in his early years, had had no formal education though his art studies had been conducted under distinguished masters at Bruges and Antwerp; in Paris he had started to do some work on his own account. In the mid-1840's, an impoverished widower with a young daughter, he returned to England and started on a career which brought him mingled success and despair, and though in his spelling and in the construction of a phrase there were vestiges of the foreign language he must have known as a child, his thought was now almost entirely governed by subjects concerning England and her history. There is no end to the list: *An English Autumn Afternoon, An English Fireside, An English Boy, Cromwell on His Farm, The Seeds and Fruit of English Poetry, Wycliffe, Chaucer,* and others. In 1848 he met the young D. G. Rossetti, and his influence became evident though Brown was never a member of the Pre-Raphaelite Brotherhood.

His poverty and his indomitable ambition to achieve near-perfection are the two most salient aspects of *The Last of England*, for his diary sets out in agonizing detail his progress on the canvas and to the pawnshop. Scraping out, repainting, redesigning, working on the man's coat, the woman's shawl, shawl pawned, the tarpaulin, the bulwark, the netting, ropes, faces, fingers, the blackguard, the cabbages red and white in the ship's foreground, bought or cadged from neighbours, the hand blue with cold painted with snow on the ground—all add up to a tale remorseless in its driving force.

The poignant subject of a man and his young wife from the middle classes—which Brown is eager to emphasize: "high enough in education and refinement . . . yet depressed enough to have to put up with the discomforts and humiliations incident to a vessel 'all one class' " (for in a flash of despair he had considered emigrating to India)—is seen here in the person of Brown himself as the emigrant seated beside his second wife, Emma, on the deck of a vessel, their eyes fixed on an England they are leaving, his brooding, hers no less thoughtful, an impression, one might justly feel by the intensity of their regard, which will never leave them. Enveloped in the woman's shawl is their young baby whose tiny hand is clasped within its mother's. The man holds up an umbrella to shelter her from the elements of wind and rain but on which drops of water, perhaps of sea spray, have already fallen, while a strong gust of wind blows the woman's carmine bonnet ribbons upwards ("an especial desolation," according to Henry James) and horizontally half-way across the composition.

Brown's own description of the background to the two in the forefront absorbed in their melancholy reflections, encompasses the various figures active in their own diversions: "An honest family of the green-grocer kind, father (mother lost), eldest daughter and younger children, make the best of things with tobacco-pipe and apples. Still further back a reprobate shakes his fist with curses at the land of his birth . . . his old mother reproves him . . . while a boon companion, with flushed countenance . . . signifies drunken approbation. A cabin-boy is selecting vegetables for the dinner out of a boat-ful." A steamboat in the far distance, outlined against the cliffs of Dover white under a threatening sky, hastens for shelter.

Complete as we now see the picture triumphant in its atmospheric creation of the "peculiar look of *all round*" which objects have on a dull day at sea," the effect is so realistic that it is momentarily hard to visualize the hardships which accompanied its execution or to conceive any moment in the story of the chief participants than the one the artist has caught and offered so starkly to us.

—Virginia Surtees

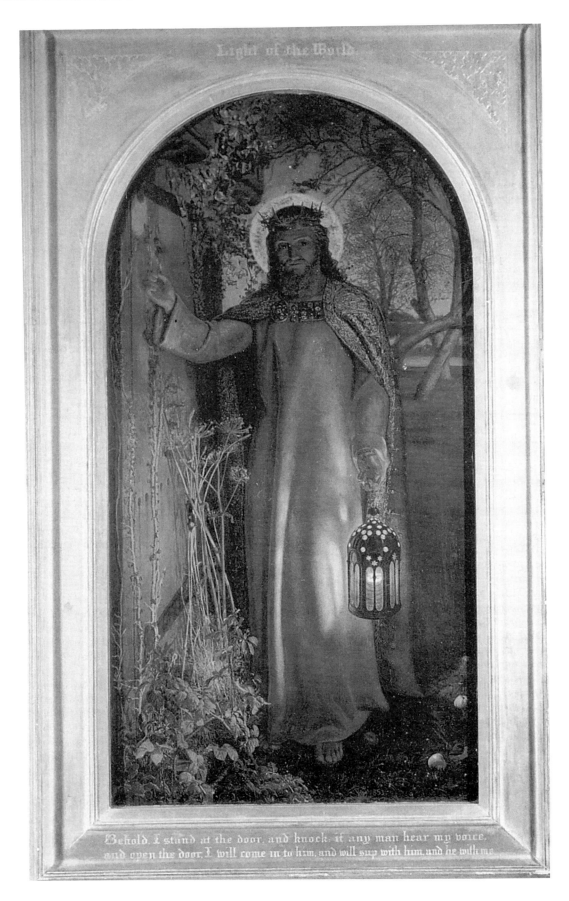

William Holman Hunt (1827–1910)
The Light of the World, 1854
$47^1/_4 \times 23^5/_8$ in. (120 × 60 cm.)
Oxford, Keble College

Bibliography—

Roskill, Mark, "Hunt's Differing Versions of *The Light of the World*," in *Victorian Studies*, March 1963.
Maas, Jeremy, *Hunt and "The Light of the World*," London, 1984.

The Light of the World, a record of William Holman Hunt's personal conversion experience, marks a crucial point in his search for a new artistic language to express religious meaning. In this painting Hunt first demonstrated "that he could combine realistic style, imaginative vision, and a religious iconography in a form accessible to others" (Landow, p. 37). Its huge success and widespread dissemination have caused critics to deplore the extent of its "tenebrous influence" (Hilton, p. 89), but despite its eventual popular triumph, contemporary commentators were not well-disposed to the picture when it was hung at the 1854 Royal Academy exhibition. After-shocks from the vituperative reception of Millais's *Christ in the House of His Parents* were still being felt: there was a heightened sensitivity to "popery" as well (perhaps stimulated by the Gorham Judgment or by the restoration of the Roman Catholic hierarchy, both in 1850), and the rather gorgeous and mystical representation of Christ (with the stigmata visible on His hands) was felt to be too immediate and too real for the spiritual experience it represented. Hunt departed from Pre-Raphaelite dictates, however, in his idealization of the Savior's face, a composite fully in keeping with conventional Christian tradition. (Comparison of the face with contemporary photographs of the artist raises the possibility of an element of self-portraiture.)

As this serious, slightly melancholic and introspective head was a composite of various male models, so the setting was inspired by a variety of Biblical texts. The original impetus was the text inscribed on the frame: "Behold, I stand at the door and knock: if any man hear my voice and open the door, I will come unto him, and will sup with him, and he with me" (Revelations 3:20). Other sources, for example John 8:12 for the title, or Romans 13:12 which suggested the nocturnal setting ("The night is far spent, the day is at hand"), or Psalm 119:105, "Thy word is a lamp unto my feet and a light unto my path," completed the conception.

The conventionally appealing Christ figure and the scripturally grounded setting together probably accounted for much of the painting's eventual success. At, and for some time after, its first appearance, however, commentary centered on other aspects, chiefly on the door and its appurtenances. The adversi-

ties of Hunt's *in situ* midnight labors (and his later efforts in the studio to replicate the effects of moonlight and lantern-light by day) passed into the legend of the work. In contrast to the license from Pre-Raphaelite tenets that Hunt permitted himself in idealizing Christ's features, the artist spared no pains to assure the most exact "truth to nature" of the setting. Hunt's adamant insistence (here and elsewhere in his oeuvre) on the necessity of working in authentic light, *en plein air* if possible, was in fact one of his most enduring and significant contributions to the art of his time.

Although Hunt was unfailingly devoted to accuracy of light and natural form, this Ruskinian theory was combined with an underlying infusion of symbolic significance. Virtually every detail of *The Light of the World*, from the brambles and ivy, to the rusted hinges, the bat, the unkempt orchard, the crown, and the vestments, had a covert spiritual meaning. They spoke to the nature of the religious experience, to the state of the soul represented by the door, and to the character of the divine and human participants. Not only Hunt himself, but Ruskin and others plunged into explication of the iconology. Particular attention was paid to the lantern, made to Hunt's specifications, with seven varying sides said to represent the seven churches mentioned in Revelations (Bronkhurst, p. 119), and to the circular and rectangular clasps or "Israelitish and Gentile breast-plates conjoined," by a jeweled link, on the cloak.

It may seem paradoxical that Hunt made such a dark painting about light, but one can hardly agree that "it comes very near to being a picture about despair" (Hilton, p. 89). The darkness is intended to set off the light, as the neglected state of the door is contrasted to the fact that Christ has not, finally, forgotten the soul behind it. This is a picture about hope. Hunt, a man isolated by his personality, outside the artistic and social establishments, depicted a solitary and questing Savior in search not of the crowd's acclaim but of one responsive and accepting spirit. The averted glance (typical of many of Hunt's figures), gives this Christ a diffident and vulnerable air, at odds with His regal attire. The conjunction of close observation and symbolic depth, as well as such departures from convention as the unexpected combination of kingly crown and crown of thorns, of priceless jewels and bare feet, and even the substitution of the full moon for a conventional halo, argues that the picture's later popularity (and the disappointing copies the artist himself made in 1853–57 [Manchester Art Galleries] and 1899–1904 [St. Paul's Cathedral, London]) should not blind us to Hunt's original achievement in this painting.

—Patricia Dooley Lothrop

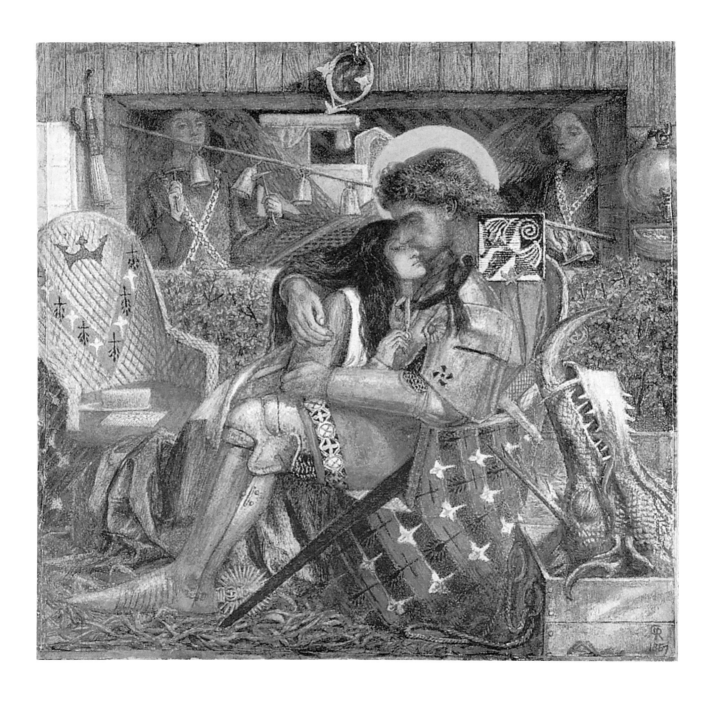

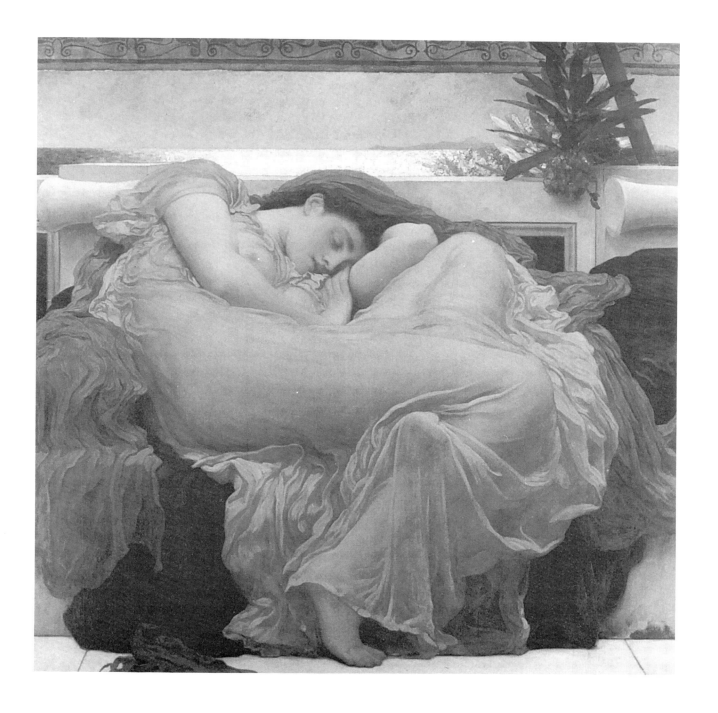

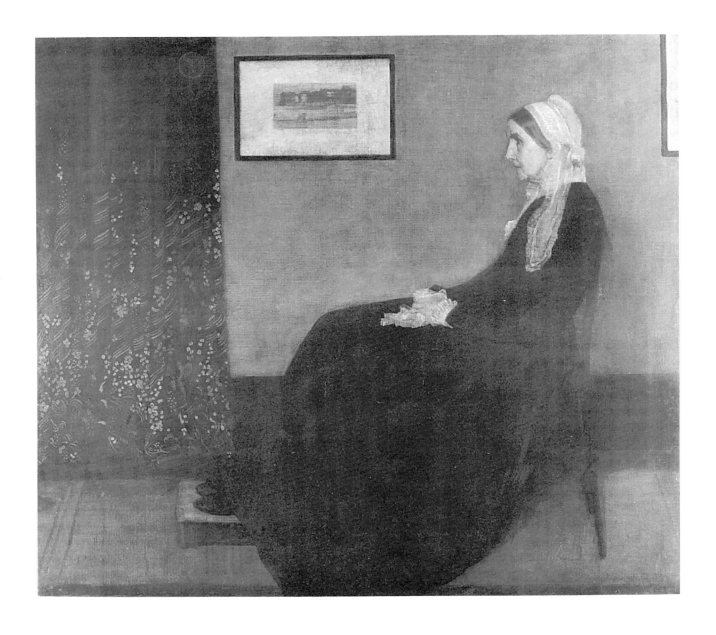

James McNeill Whistler (1834-1903)
Arrangement in Grey and Black No. 1: The Artist's Mother,
1871
4 ft. 9$^{1}/_{8}$ in. x 5 ft. 4$^{1}/_{2}$ in. (145 x 164 cm.)
Paris, Louvre

Arrangement in Grey and Black No. 1: The Artist's Mother is without a doubt the most well-known Whistler painting. Located in the Louvre, the painting has faded considerably since its creation, over one hundred years ago. This is due, in large part, to the sparse application of paint, the "canvas simply being rubbed over . . ." with Whistler's liquid paint mixture, or sauce, as he called it. The title indicates Whistler's interest in music for its suggestive and evocative nature. It also, in itself, asserts the work as a mere arrangement of colours as much as a depiction of a human being. The subject is both artistic creation, painting in particular, and the sitter: Whistler's mother.

While the title reads as a Whistlerian manifesto, the formal techniques are distillations of those of the great masters and Whistler's contemporaries alike. The dark greys, greens, and black form a typical Whistler palette, born in the studio of his teacher, Gleyre. The contrast of the white lace against the black dress mimics the technique of Frans Hals whom Whistler greatly admired, as do the overall starkness and simplicity of the image. The flat planes of color and the overall austerity reflect the influence of Manet and Degas. The strong horizontals and verticals—of the floor boards and picture frames—create a silent cubical space, not unlike those of Vermeer. The side curtain is flecked with a floral pattern resembling the swirls and buds of Japanese screens, objects which Whistler owned and adored. The curtain also calls attention to the entire image as a staged work. Yet, whether this performance is accessible or not is open to debate. While the platform extends into the viewer's space, the gaze of the mother is not to be met. She stares into the side wings, her frail and bony hands folded neatly on her lap. Thin and steely, this puritan character offers no warm human connection. If contact cannot be made with the mother, it can be made with the picture behind her. On the green wall which forms the backdrop, Whistler has painted an image of his etching *Black Lion Wharf,* 1859. The painting of an artwork, in this case an etching, is a common device of the artist, adding yet another layer of interpretation. The artist is simultaneously acknowledging other members of his oeuvre and admitting that the entire piece is artifice, a stage. What is omitted is as important as what is included. The right edge of the canvas crops the frame of another image (an etching?); all that is left is a suggestion of its former self. In emphasizing suggestion over depiction, Whistler is aligning himself closely with the symbolist poets of his time, especially with Mallarmé, who believed that suppression of the obvious would allow for the true essence to show through.

The treatment of paint varies across the canvas. The broad brushstrokes of thick cream and grey on the wall radiate in all directions. The surface of the skin—which is rich in yellows, creams, and pinks—is liquid and smooth. The white of the lace and handkerchief was laid on rather dry while the black of the skirt was painted very thinly and rubbed in many areas. Both round and square-end brushes were used with the paint, which in some cases was mixed with linseed oil. The thin oily texture endows the painting with a dark and varnished quality, making it reminiscent of the Dutch masterpieces. Visual, photographic, and X-Ray examinations have revealed that many alterations were made to the painting. The figure and footstool were originally several inches higher, the knees and arms were tried in several positions, and the curtain and picture frame were originally further to the right. An additional object, such as a wall or curtain, may have been planned for the space between the figure and the edge of the canvas, thus centering the figure more than it presently appears.

Whistler was known for making his subjects pose for hours on end. This presented a problem for many of his patrons who had to remain standing throughout the entire procedure. Most of Whistler's portraits have the full-length vertical format modeled after Velázquez. Fortunately, the artist's elderly mother was allowed to sit. The painting, which took three months to complete, was rendered in Whistler's second-story back studio which had grey walls and a black dado.

Criticism on the work is mixed. The first reviews lauded the powerful grasp of the Protestant character. Some critics singled out the decorative details and fine craftsmanship, while others suggested that a glass of sherry in the subject's hand might soften the image a bit. In 1883, a series of French critics lashed out verbal abuse which rivaled that delivered from Ruskin years before. Swinburne insisted in 1888 that the painting was not an arrangement of colors but a sentimental portrait of the artist's mother; this cost him his friendship with Whistler.

The painting was used as an asset when Whistler filed for bankruptcy in 1879. Finances on the painting remained in a state of flux until 1891 at which point it was purchased for 4000 francs and placed in the Luxembourg. In 1922, the painting was transferred to the Jeu de Paume until 1926, when it reached its present location, the Louvre.

—Sarah E. Bremser

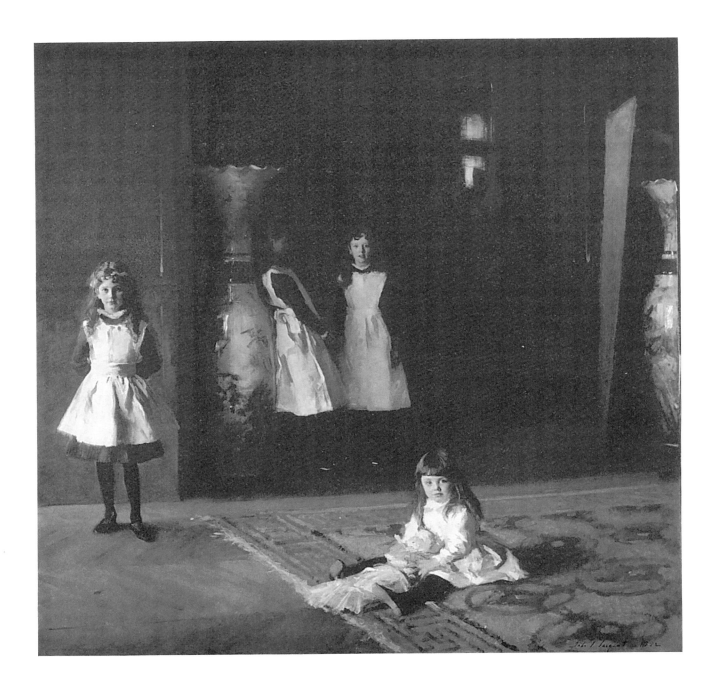

John Singer Sargent (1856–1925)
The Daughters of Edward D. Boit, 1882
7 ft. 3 in. × 7 ft. 3 in. (220 × 221 cm.)
Boston, Museum of Fine Arts

The Daughters of Edward D. Boit is both physically and psychologically striking, an unusual combination in John Singer Sargent's work, which is generally beautiful without being thought-provoking. Painted in 1882 and first exhibited in 1883 at the Paris Salon, it is a portrait of the children of Edward Boit, an American painter and ex-patriot living in Paris. Its strongest influence is Velázquez's *Las meninas* (1656), which Sargent copied on a trip to Spain in 1879. The composition of both paintings is similar, especially in the characters' relationship to the space surrounding them. Both read horizontally and have a strong geometrical balance.

In the painting four sisters stand or sit in a dark room lit indirectly from a window at their right. Two oversized blue and white Japanese vases, a scarlet screen, and a blue-grey rug set up the geometrical lines of the scene. The light picks out a mirror on the back wall, the glaze finish of the vases, and, most spectacularly, the girls' pinafores. Sargent's technique of using broad, luminous strokes of paint is very effective here. The pinafores, almost seeming to have lives of their own, give the girls a hovering, ethereal quality.

That sense of independence is a key characteristic. The girls—even the one whose face is in profile—are, like their pinafores, strikingly self-possessed, direct, and detached, from each other and the viewer. Sargent often painted women with this direct yet detached, evaluating rather than evaluated, look—*Lady Agnew* (1892–93), for instance, or *Ena and Betty, Daughters of Mr. and Mrs. Asher Wertheimer* (1901). But it is a shock to see that self-possession in one so young, until one considers that most children *are* remarkably sure of themselves and only learn to look away as they get older—as the eldest in the portrait demonstrates. In fact the painting could be seen as a study of the stages of growing up: from the youngest, sitting closest to the viewer, center stage, anchored on the floor; to the young girl at the left with a determined look and stolid, if a little self-conscious, stance; to the girl at the back staring straight at us but from a safe distance; and finally, to the girl who prefers to stay in shadow and relieves us of the relentless stares of the other three.

As a family portrait it is unusual, perhaps subversive. While the Velázquez painting, for example, gives the impression of a closs-knit family group with a well-defined internal hierarchy, public image, and social standing, Sargent's treatment of the family is ambiguous. The daughters are so clearly individuals that it is hard to see them as a unit. Each is closed into her own world, and her own presentation to the outer world, and the familial links between them are submerged. The parents are markedly absent, another sign of the girls' disconnectedness. On the other hand, the boundaries within which they are "caught" are quite clear, from the solid lines of the room's objects and even the dimensions of the painting, which, uncommonly, is square. The portrait's strength, besides the beauty of the light it captures, is in the contradiction it presents between the definition of a family (and a family portrait) and clearly unique personalities. This universal conflict—of maintaining individuality within a unit—provides a tension that keeps the painting alive, alluring, and unresolved, and goes some way towards combatting claims that Sargent's work is superficial.

—Tracy Chevalier

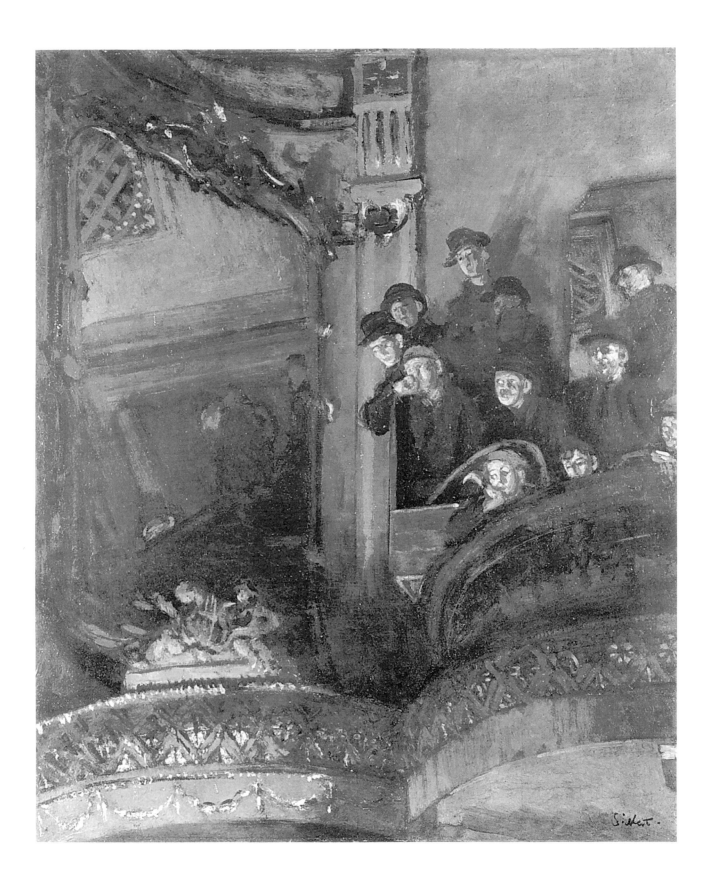

Walter Sickert (1860-1942)
The Gallery of the Old Bedford, c. 1894
30 × 23³/4 in. (76.2 × 60.4 cm.)
Liverpool, Walker Gallery

The music hall motif was adopted by Sickert in the late 1880's, and was the main subject of his work until 1890. It was chosen early in his career, in imitation of Degas's cafe concert theme (Sickert owned a pastel of this type) and constituted his first original contribution to English art as far as subject matter is concerned. The subject legitimised his taste for dark tonalities, and also provided the garish light effects with which Degas distorted the faces of his *chanteuses.* As anthropological studies of social atmosphere they prepare for the iron bedsteads of Sickert's Camden Town period; it may also be that the suggestive clichés of the songs, sometimes attached to paintings, prepare for the differently suggestive but equally clichéd anecdotal titles that Sickert enjoyed attaching to his psycho-dramas.

Sickert had had a teenage attraction to the stage, acting briefly in Henry Irving's company. In selecting specifically the music hall he may also have been influenced by his distaste for the hot-house drawing-room subjects of his teacher Whistler. Certainly the working-class halls were considered a vulgar subject, though the Old Bedford itself was chosen by Sickert out of nostalgia for its dated picturesque quality (the more grandiose and genteel Edwardian hall was adopted later).

Sickert assimilated his borrowed subject by exploring complex spatial relationships in the confined and complex layout of the theatre. His earliest music-hall subjects closely follow Degas, viewing the stage from the auditorium with a foreground of silhouetted heads; but gradually his focus moved from performers to the relationship between audience and performers within the tiered setting. The huge mirrors of the Old Bedford are used to condense the theatre space onto the picture surface. The composition of *The Gallery of the Old Bedford* represents the highpoint of this spatial experimentation, but it is also the first of a new genre featuring audience alone. The Liverpool version is the most resolved painting within the large number of the Old Bedford gallery studies.

The Gallery of the Old Bedford bridges two distinct "music hall" periods in Sickert's work; the first, 1887-89, deals primarily with performers (though they are usually seen obliquely); the second, c. 1905-15 deals almost exclusively with audience and architecture. The transference may have been suggested by the music hall song "The Boy I Love Is Up in the Gallery," apparently the subject of *Little Dot Heatherington* painted in the previous year. The song title was given to the Liverpool painting in its first showing at the New English Art Club in 1895 and an alternative title, *Cupid in the Gallery,* maintains that connection.

The composition is highly constructed to form the appearance of a casual glance. The Bedford Theatre, then known as Gatti's, was the subject of a huge number of drawings by Sickert when he first adopted Degas's method of painting from drawings in the studio. The practice was antithetical to the attempted "spontaneity" he had learnt from Whistler, and to some extent unfashionable in advanced circles in the wake of impressionism. The Gallery composition appears also to have been influenced by a favourite woodblock caricature, known since early childhood, when Sickert's painter father implanted a taste for 19th-century German illustration. If this is so, the composition is a disguised precursor of the late and controversial series of *Echoes,* coloured paintings of Victorian engravings. Certainly the figures are, like many of Sickert's portraits, essentially caricatures: there is no interest in painted psychology, or in infecting the mood of the painting with that of the spectators.

Sickert's "live" sketches from his frequent music-hall visits are tiny scraps, but a large number of detailed studies for *The Gallery of the Old Bedford* are known, including studies of heads and of the architecture and precise, squared-up composition studies which suggest the very conscious construction of the elements. Some oil versions postdate the Walker painting, but these are variations and repetitions; the Walker version appears to be the definitive one. The drawings show that Sickert tried moving the focus to the left to make the mirror reflection more central, and to the right to centralise the spectators; the resolution is one that maximises the reflected image, making the glass, rather than the decorative frame, the object of focus, giving roughly equal space to reflected and directly seen objects. Shadowing the gallery edge, Sickert increases again the height and precarious position of the spectators, redoubling the effect in the reflected ceiling cartouche. By confining the contents of the mirror to features shown directly from another angle, Sickert provides a detached concurrent narrative for the viewer, an example of the "coolness" in relation to subject matter that emerged spectacularly in the late paintings. The dark tonality typical of this early period is enriched by the counterpoint introduced in the reflection; just as the application of paint is sketchier and more "impressionist" in reflection, the tones are flatter and more abstract. Although there is a reminiscence of Whistler's tonal "symphonies" in the range of yellow and olive, brown and grey, Sickert has introduced burnished lowlights of yellow and salmon pink rather than the flashy contrasting highlights he had borrowed from Whistler in earlier paintings.

The Gallery of the Old Bedford may well have been an attempt to summarise and conclude music-hall painting before attempting a new "professionalism" in portrait and landscape painting. Fully conscious of career progression throughout his life, Sickert deliberately attempted to create a museum quality painting, and succeeded.

—Abigail Croydon

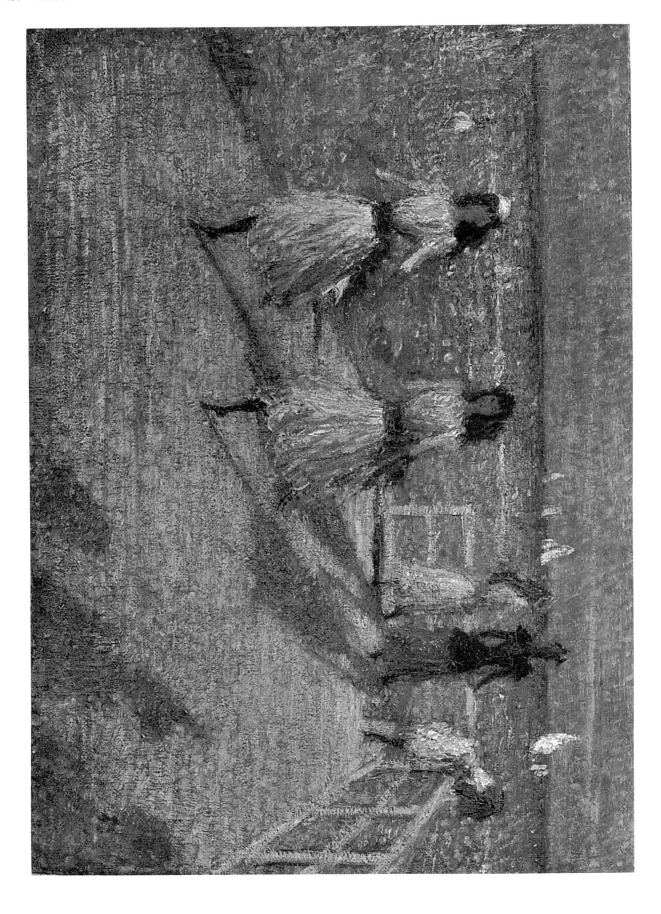

Wilson Steer (1860–1942)
Girls Running, Walberswick Pier, 1894
24³/₈ × 36⁵/₈ in. (62 × 93 cm.)
London, Tate

Girls Running, Walberswick Pier is one of the last and best of a series of coastal scenes painted between 1886 and 1894 when the youthful Steer was at the forefront of the English avant-garde and experimenting with the latest French imports of Impressionism and post-Impressionism. This painting is stylistically derivative but nevertheless reveals the artist at his freshest and most intrepid. The seaside paintings form a small part of Steer's oeuvre but are easily the most memorable, for his subsequent landscapes in oil and watercolour are sombre and trite by comparison. The subject matter for the painting is derived partly from the English tradition of moody landscape as established by Turner, Constable, and Dyce; but a debt is also owed to the French "pleinairists" and the Impressionists, especially Monet, who delighted in the clear light and airiness of the coast. Neo-Impressionism, or Divisionism, as practised by Seurat, Signac, and Henri Edmond Cross, was slowly reaching English shores, and Steer was among the first to experiment with bright, individual dots of colour that achieved an overall effect of limpidity and heightened atmosphere, as successfully expressed in *Girls Running. . . .*

The picture is painted from the viewpoint of a person standing at the pier's edge. Steer has concentrated on a horizontal format, emphasizing the spit on the left of the composition and the yacht-studded horizon line. Pictorial space is shallow, despite the gentle recession of the pier and the long shadows cast by the afternoon sun. The two girls in flight seem to hover on the surface of the painting as if pinned there; a doll-like quality is stressed by their slight forms, lack of modelling, and the awkwardness of Steer's faux-naive style. The eye is immediately drawn to the girls' red sashes and black legs, which in turn correspond immediately with the clothing of the woman in the background, bringing the forms sharply together in space and cheating the eye of a sense of depth. The groups are connected by more than this: the elongated shadows of the fleeing protagonists lap at the ankles of the females at the end of the pier suggesting a tenuous relationship. Similarly, a link

with the isolated clutch of anthropomorphic shadows at the lower right corner of the canvas can be made. Like the three females depicted in Seurat's painting *Les Poseuses*, 1888, who may represent one woman in a sequence of time and action, the groups of people in *Girls Running . . .* may in fact be one group at different points of time: read anti-clockwise, the shadowy figures approach the pier, walk to the end—and then hastily return. This theory does not account for the third figure, that of the adult, but does add, however, to the mystery of the painting.

The Walberswick series shares similarities in subject matter, not least in the depiction of children at play. A sketch produced at this time consists of a frieze of dancing children, from which the two running girls are undoubtedly derived. With their light, graceful poses and floating dresses they resemble ballerinas. Indeed, the combination of the broad, foreshortened pier, strong queer light and long shadows in *Girls Running . . .* almost suggests a theatre stage, the foreground shadows representing the audience. Parallels can be drawn with Steer's contemporary Degas, who also delighted in the depiction of dancing girls.

In his discussion of Steer's painting John Rothenstein spoke of *Girls Running . . .* as possessing "apocalyptic intensity." The composition certainly displays certain disquieting features, attributed partly to the intangible and hazy quality of neo-Impressionist dots. However, other factors contribute to the overall effect. The hot light and shadows exude the same silent, heavy mystery of Giorgio de Chirico's early work. Strong parallels may be drawn with the latter's 1914 painting *Mystery and Melancholy of a Street*, in which a silhouette of a child with a hoop runs toward the light and the menacing shadow of an unseen figure. The Steer protagonists too are heading for the source of light and the three mysterious shadows. The reason for their flight is never clear.

—Caroline Caygill

Bibliography—

Boime, Albert, "Friedrich: *Monk by the Sea*," in *Arts Magazine* (New York), November 1986.

Three events occurred in 1810 which would profoundly affect the development of German art: one was a beginning, one an end, and one a moment of transition. In concert, they represent a rare, natural partition within that complex era. From Vienna a group of art students, who had abandoned the academy, moved to Rome where they hoped to revive German art. Calling themselves the Brotherhood of St. Luke, later known as the Nazarenes, they selected 15th-century Italian art as their artistic model in hopes of recapturing the spiritual purity of that time. This move signaled the outset of a new revival style. In Germany, a similar desire to produce something new, meaningful, and uniquely German had already manifested itself but in an opposite direction. Philipp Otto Runge and Caspar David Friedrich had rejected the possibility of an effective revival style because they believed art was bound to its time and place. Runge had been working since 1803 on a new kind of landscape art as an alternative to the classical tradition. Unfortunately, his efforts were cut short with his death at the age of 33 in 1810. But while one path was closed, another was being publically defined. Friedrich sent from his home in Dresden two large oil paintings for exhibition in Berlin. He had a phenomenal success. Both works were purchased by the Prussian king Friedrich Wilhelm II, at the urging of the 15-year-old crown prince. But more than simply establishing Friedrich's reputation, these works signaled a new era in the history of German landscape painting.

The Monk by the Sea and *The Abbey in the Oak Forest* were the culmination of several years of artistic experimentation, and showed a new direction. Their imagery, composition, and emotional tone came to characterize German Romantic landscape painting. Of the two, *The Monk by the Sea* achieved the greater notoriety. The originality of conception, for which Friedrich is still honored, was immediately recognized. The writer Heinrich von Kleist reacted to its radical elements by writing in the *Berliner Abendblätter*: "The picture with two or three mysterious objects appears like the apocalypse, as if it were dreaming Young's *Night Thoughts,* and because of its monotony and boundlessness, with nothing but the frame as foreground, one feels as if one's eyelids have been cut off." The shocking image evoked by Kleist's analogy suggests the power of Friedrich's compositional and thematic invention. To his contemporaries, schooled in the landscape modes of the heroic, idyllic, and picturesque, Friedrich's stark rejection of such formulas was either a bold step or a dangerous mistake. Audiences, however, should have been prepared for Friedrich's audacity.

This vision of a wanderer at the edge of the ocean (the work originally had no specific, literary title) was probably begun in late 1808 or early 1809. In either case, it followed the controversy occasioned by the showing in his studio, during the Christmas holidays of 1808, of Friedrich's first large oil painting, *The Cross in the Mountains* (Dresden), now known as *The Tetschener Altar.* The debate over the aesthetic worth of that painting, referred to as the *Ramdohrstreit,* centered on the necessity of following prescriptive formulas or rules in landscaped art. Friedrich was accused of having willfully forsaken every guiding principle for a good landscape painting. His friends countered and defended his originality by proclaiming that rules were nothing more than the codification of devices artists had intuitively created to express their passions. Rules should only describe what has happened, not delimit what is possible.

Friedrich did not heed Ramdohr's criticism. He compressed the space in both of the paintings sent to Berlin and avoided completely the expected graceful transitions from foreground, through well-defined planes or passages, to a distant background. Friedrich was most extreme in *Monk by the Sea* and reduced the multiplicity of nature to its elements of earth, air, and water. It was this stark reduction of the image to a figure and three bare zones which aroused such impassioned responses.

The painting passed through several versions before being sent to Berlin. Visitors to Friedrich's studio in 1809 and 1810 reported on the dramatic seascape on which he was working. Their reminiscences reveal that the image was constantly being adjusted: at one time there was a waning moon in a night sky; there were also two sailboats (still visible in infra-red photography). But the final idea was devoid of such embellishments. Nothing was added to aid in interpreting the ambivalent interaction of man and environment.

Ambiguity is a hallmark of Friedrich's work. The figure is very possibly a self-portrait, as Börsch-Supan has suggested; certainly the hair and beard are similar to those seen in portraits of the artist. But dressed in religious garments, the figure obviously represents far more that a self-portrait. Exactly who or what the man is remains open. Contemporaries called him a hermit and a Capuchin friar, but current scholars remain uncertain of the figure's religious meaning. This indeterminacy pervades the entire experience. The work is affective through sensations not words. Friedrich has not only rejected the superficial patterns which were then standard but has also, more fundamentally, rejected the basic tenet of landscape art—that landscape should reflect some human story. Here, in this reduced setting with the absence of any narrative, nature supplies the "text" and its reading is a spiritual, pre-verbal experience.

Scholarship on Romantic art in general and on the life and work of Friedrich in particular is controversial. In his catalogue raisonné of Friedrich's work, Börsch-Supan offers what amounts to a "dictionary" of meanings in which individual themes are defined by pre-existing definitions; for example, the lighter sky behind the dark bank of clouds and haze "means" the Christian promise of eternal life. Other scholars prefer more open-ended, context-determined readings. Commentators agree, however, that Friedrich has created a unique expression of loneliness and isolation.

Monk by the Sea marked a moment of transition. It was the culmination of Friedrich's earlier exercises in emotionally charged, symbol-laden landscapes, and it offered new solutions for expressing contemporary tastes. Friedrich was able to meet the growing demand for an art form which would effectively embody the new historical moment. In this work, with its compelling presentation of a spiritual communion with God through nature, Friedrich achieved a breakthrough. Although its obvious uniqueness was condemned by some, *Monk by the Sea* was widely hailed as a new stage in German art history.

—Timothy F. Mitchell

Philipp Otto Runge (1777–1810)
Rest on the Flight, 1805–06
38⅝ × 51 in. (98 × 132 cm.)
Hamburg, Kunsthalle

Runge painted *Rest on the Flight* as a thematic pendant to *The Source and the Poet* (1805; Hamburg) which expresses "the idea of the first creation" (Runge). The former was conceived by him as "Morning of the Orient" to contrast with the meaning of the latter, "Evening of the Occident." In his later *Morning* (two versions, 1808, 1809) he was to express a similar ideative content to that of *Rest of the Flight,* namely the promise of the beginning of a new universal life cycle. He intended *Rest* as an entrée to his *Morning* allegories. Whether or not he also painted it in response to a potential church commision (not discharged) in Greifswald, Pommerania, is uncertain.

In one of his frequent letters to Goethe on color theory Runge mentioned this painting as a practical application of his theories on color, e.g., the naturalistically rendered light and atmospheric conditions in the painting, and added a description of its contents: "Mary and Joseph have spent a night's rest with the Child alongside the slope of a hill, the first ray of sunlight falls on the group, and the Child reaches into it with His hand. . . . Angels [in the Tuliptree] play music in the direction of the light." Runge also said that he "wants the Child to be the most moving and lively factor in the painting." The panorama of the "Nile valley with flat islands, Pyramids and buildings" completes the scene. In actuality, it is the Baltic littoral, a view that was much more familiar to him. Compositionally the picture reflects his favorite technique—silhouetting—in the repoussoir-like figures, donkey, and tree in the foreground. These contrast dramatically with the deep, infinite landscape and lambent sky at center. The child-to-light aggregate that occupies the central space was meant by Runge to be the ideative focus of the whole assembly. Compositionally, influences stemming from Reni, Domenichino, Altdorfer, and Cranach have been proposed but are conjectural and unconvincing.

Joseph, a lumbering, realistically rendered figure of a laborer, dominates the left foreground. He and an earthy Virgin on the right enframe the asymmetrically placed, ample and joyously wriggling Christ Child lying on the ground. This rustic tableau is contrasted by an utterly fantastic tree with angel-geniis perched on its blossoming crown and a luminous sky with myriad color gradations of a glass-like, luminescent atmosphere. The painting, an allegory on life, weaves, with its naturalistic figures and color effects and remarkable fantasy setting, a dream of religious contemplation.

Runge's "free inconography" here is part of a complex private mystical equation based in part on 17th-century theosophic sources (e.g., Jakob Böhme) and in part on his own flower and figure symbolism: morning equals spring which is the symbol of birth and childhood, which stand for creation, which embodies "becoming" and which, in turn, signifies the coming into the world of the Light of the Lord. Iconographically, the painting expresses a German Romantic longing for a confirmation of the gospels in nature. Thus, nature becomes the embodiment of religious longing fulfilled, of mysterious revelation of divine truth and of a prophesy of the progressive, universal, living Christ.

Placed in the context of Runge's comprehensive theories, his greatest accomplishment, the painting exemplifies Runge's hope for "terminating" art history and beginning afresh with an original, heartfelt, emotional art. Specifically, the painting begins to actualize four phases of Runge's hoped-for Romantic revolution: religious art will become spiritualized landscape painting. Landscape painting will shift from merely describing nature or arranging it picturesquely to objectifying and interpreting its occult forces. The making of art will become a profoundly personal experience based on an intuitive creative psychology. And the understanding of art will require the sincere empathy and instinctive involvement of the viewer. As the product of an inspired and far-reaching though inchoate (and probably unrealizable) body of speculations on various levels—religion, philosophy, history, nature, science, art—*Rest on the Flight* anticipates his "hieroglyphic" and metaphoric fantasy, *Morning* (1809). Together with that painting, *Rest on Flight* hints at but does not consummate the high ideals of his theories and the general cultural rebirth that these predict.

—Rudolf M. Bisanz

Hans von Marées (1837–87)
The Hesperides, 1884–85
Triptych; panel; 5 ft. 9^1/$_8$ in. × 6 ft. 8^3/$_4$ in. (174.5 × 205
cm.) (middle panel); 5 ft. 9^1/$_4$ in. × 2 ft. 10^7/$_8$ in. (175 ×
88.5 cm.) (side panels)
Munich, Neue Pinakothek

Atlas and Hesperis had from three to seven daughters, the Hesperides (e.g., Aegle, Hestia, Arethusa, Erythia, etc.). At her wedding to Jupiter, Juno ordered them to guard the Tree of Golden Apples that Earth had given the couple as a wedding gift. As the Hesperides proved untrustworthy guardians who had helped themselves to the trees' riches, she sent the ferocious dragon Ladon to watch over it. Meanwhile, Eurystheus, King of Mycenae, dispatched either Hercules or Atlas, or both, to purloin three apples for him. But Minerva, who had obtained the apples from Hercules, saw to it that they were returned to their rightful place of origin, the grove.

Marées, who was "more or less indifferent to literary relationships" (E. Ruhmer), had once dubbed the painting a "landscape of longing." The three asymmetrically posed, brightly flesh-toned women in the center panel appear frieze-like on a shallow spatial stage. The darkling background is replete with a "screen" of tree trunks whose vertical planes facilitate the illusion of depth by overlapping with distant horizontal planes in an abstract, spatial architecture. The motif in the left panel, two nude male figures in attitudes of picking fruit, occupied Marées often before, most notably in his fresco *Orange Pickers* in the Zoological Station in Naples (1873). The motif is also suitable to the "story," i.e., the theft of Golden Apples by Hercules and/or Atlas. However, the subject of the right panel—an old man seated and pondering, children gathering fruit—does not relate to the story at all but, instead, to themes of other paintings by Marées, e.g., his *Golden Age I* (1879–85; Munich, Neue Pinakothek). The three panels are "visually" connected by the continuous landscape and border of foliage and round carmine fruit at the top and, at the base, by a frieze border with six Putti and a cartouche-like fountain on a simulated, Pompeian red "wall."

When fresco commissions failed to materialize for him after 1873, Marées turned to the triptych format as a substitute for wall painting. *The Hesperides* belongs to his late idealist and monumental phase and is one of four triptychs that he completed in the years 1880–87. (An earlier version of the *Hesperides* may have been destroyed in Adolf von Hildebrand's studio.) Marées worked on several projects simultaneously and drew ceaselessly series or cycles of drawings after models in what K. M. V. Pidoll, a pupil of his, dubbed "observational rows" (Meier-Graefe). In turn, the paintings grew out and are abstract derivatives of the drawings. The result is a style that is comparable to that of Puvis de Chavannes or Moreau, for example, as well as, in some respects, to his fellow German-Roman Anselm Feuerbach.

Marées suppressed all specific appearances in favor of the typical and general. Significantly, he attempted to combine his impulse for universal values with a personal (if vague) expression of humanity and spirituality. Moreover, doing all of this within the composite landscape-cum-figure syntax stretched to the breaking point his capacity to unify his compositions. And we sense that unresolved tension. On the other hand, Cézanne, another French artist with whom Marées bears comparison, "relinquished [similar] personalist spiritual concerns" with his series of *Bathers* (1890's; R. Zeitler). Thus he was able to complete the formal unification of landscape and figure, the polarities of 19th-century art, that Marées had lastly failed to resolve (idem).

Strategies for compositional and simplification and for a strengthening of form may have merely served Marées as handmaidens for the attainment of a more comprehensive intellectual goal. Yet, at a time when our capacity for empathizing with 19th-century German passions for a classic intellectual "lost paradise" recreated through art wears thin, the same strategies seem to have produced the most lasting results, namely formal affectivenes. Marées's colors, shapes, lines, lights, and shadows exist in their own right and tend toward abstraction. The nascent self-referentiality of the elements of form of his paintings is undeniable. "Inaccessible and remote," his shapes are "clad in their own radiance. In a realm beyond time, they dwell in beauty" (G. Schiff). Accordingly, his paintings become constructs of a new, independent artistic reality. Moreover, a new modernist space-to-form relationship informs his compositions: relative flatness of form wins over illusion, design effects triumph over traditional three-dimensional composition, unity of form ascends over literary content.

Marées's triumph lies in having confirmed the independence and legitimacy of art as a language and means of acquiring knowledge in their own rights. The generation of younger post-Impressionists and early Expressionists and their champions, e.g. C. Fiedler, L. Justi, J. Meier-Graefe, were the first ones to understand the values of his art in that light. Recently, K. Liebmann, a Marxist, has reached for a reinterpretion of Marées as a "social critic." In this reading, Marées "wished to censure the bourgeoisie by withdrawing from society." Moreover, Liebmann classifies his art, e.g., his *Hesperides,* as "social realism" (!). Consequently, his iconography bespeaks "dissatisfaction with the economic *status quo,* therefore, does not betoken an aloof interest in form at all but rather reflects "political reality and social consciousness." Regardless, we prefer to side with those pioneers of modern art who recognized in Marées a forerunner of theirs.

—Rudolf M. Bisanz

Wilhelm Leibl (1844–1900)
Three Women in Church, 1882
Mahogany panel, 44$^{1}/_{2}$ × 30$^{3}/_{8}$ in. (113 × 77 cm.)
Hamburg, Kunsthalle

By 1878, when Leibl settled down in the small Upper-Bavarian village of Berbling near Rosenheim, to paint *Three Women in Church,* his most successful painting, he stood at the zenith of his creative development. The work falls midway between his celebrated early *Portrait of Frau Gedon* (1869; Munich, Neue Pinakothek) and the disastrous, misproportioned *Poachers* (1886, segmented). Stylistically, he had already evolved through his student work in the manner of the realist Dutch masters, honed his formal objectivism with his Manet-inspired manner, and perfected his slow and meticulous Holbein-influenced enameling technique. He used that last technique in *Three Women in Church,* a painting of the accomplished mature phase of his development. (Concurrent and subsequent style directions of Leibl's include a French Impressionism-related naturalism and a Rembrandt-inspired tenebristic style.)

The wet-in-wet *alla prima* technique used in *Three Women in Church* resulted in a facture that has the successive, minutely fan-shaped, and measured appearance of crystals. Leibl utilized this technique to achieve high-keyed color effects in a uniformly well-lighted environment. In his fanatical pursuit of visual minutiae, no detail of the subject matter was too small to catch his attention—or to require his meticulous translation into its artistic equivalent, painted facture. The colors are exquisitely nuanced and meticulously graduated. His single-minded pursuit of a steady and purposeful technique lies at the point of inception of his goal, to "paint honestly with one's own naive eyes" (C. Schuch).

The query "how" to paint (i.e., technical questions) as opposed to "what" to paint (subject matter) dominated all art discussions of the Leibl circle (E. Ruhmer). In Leibl, the "how"—the process—assures the outcome. Thus, verisimilitude equals psychological authenticity which equals "truth," hence, "beauty." The academics postulated "deductively" general goals for art, then relied on various ad hoc stylistic decisions to achieve those ideals in actual art practice. Acting exactly in reverse, Leibl's first condition is the "inductive" method of painting; no deviation from it can be permitted for fear that the results be compromised. Accordingly, a consistent adherence to the proper technique literally guarantees the right outcome, i.e., the "true, therefore, the beautiful" (Leibl).

Leibl's toilsome technique meant that painting soon turned into arduous duty, then to hardship. Leibl letters during the four years he spent painting *Three Women in Church* are a tissue of complaints about the pain and exertion of work and self-encouragements not to waver in his dogged pursuit of the steady course (Leibl; see M. Petzet). Sensing this, Lenbach promptly characterized the painting as *Zuchthausarbeit* (penitentiary labor; E. Diem). On the whole, German critical opinion misunderstood Leibl's intentions equally tragically. By contrast, in its Paris showing, the painting was hailed as a supreme masterpiece and its sale substantially improved Leibl's financial situation.

The women who served Leibl as models for four years were villagers chosen to portray three different generations of church goers. Similar generational juxtapositions interested him in several other paintings (e.g., *The Unequal Couple,* 1877; Frankfurt). The location is the Holy Cross Parish Church in Berbling, one of the loveliest rococo country churches in Bavaria. The painting immortalizes its elaborately carved pews. Leibl stressed the eloquence of hands by enlarging them proportionately. (Or is this and the discrepant sizes of the figures the result of faulty foreshortening and perspective, problems that vexed Leibl with other compositions?). He usually refrained from commenting on his artistic intentions. His short remark about *Three Women in Church* is a rare exception: the picture should raise a feeling "as I experienced in my youth . . ." while listening to "the moving church music of the Old Music Masters . . . which gave me a strange thrill and a feeling of devotion which cannot be described."

The actual impression the painting conveys is far less poetic and, on first glance, infinitely more jejune. Leibl, who was neither pious nor a churchgoer (A. Langer), shows a rural commonplace, a colorable "motif." Its hushed calm "fails to spiritualize silence" (R. Zeitler). Distraction due to endless posing shows in the faces, especially with the girl (about whose "ill health" Leibl commented laconically). Unlike his contemporaries, B. Vautier or A. Tidemand, who staged their subjects—churchgoers—for symbolic or dramatic effect, the "value-neutral" Leibl shunned similar strategems. Because of this, *Three Women in Church* ventilates no religious devotion and the different ages of the women seem "out of context." For the same compositional reasons—reasons that accentuate the commonplace at the expense of "displaying" hidden meanings—Leibl does not editorialize on the social condition of the villagers, either. Thus, the nature of their communal affiliations is not divulged. Nor, in fact, is their personal relationship to each other or their consanguinity, if such was the case. As motifs go, they differ little from the carved pew in which they sit.

In *Three Women in Church,* a welter of cultural, social, and personal relationships is conspicuous by its inhibition. The women are solitary islands in a contextually unarticulated milieu. They seem displaced and lonesome. A direct result of Leibl's objectivism, sharp powers of observation, and mechanical painting technique is that he did not add anything that was not part of the motif, in the first place. Is it possible, therefore, that the women "seem" disjointed because they "are" disjointed? His subjects appear as if seen by a viewing apparatus without conscience that has mercilessly stripped them of their inferred relational support system. Yet, his refractory though factitious image posits unalloyed humanity. His seemingly unscrupulous painting regimen, by focusing uncompromisingly on the individual *appearance* of his figures, propitiously lays bare their essential nature, their true existential selves: "When I paint the human being as she is, the soul is there all the same."

—Rudolf M. Bisanz

Lovis Corinth (1858–1925)
The Three Graces, 1904
63³/₈ × 61 in. (166 × 155 cm.)
Munich, Neue Pinakothek

Corinth's oeuvre is heterogeneous, and different critics have attached alternate values to its diverse parts. Until recently, discussions of Corinth customarily stressed his late gestural and abstracting landscapes, portraits, and still lifes. Modernist criticism favored them because they resemble most closely Impressionism *and* Expressionism. Meanwhile, modernist injunctions in behalf of a formalist or psychology-based art have lost much of their persuasiveness. Accordingly, cogent criticism now once again returns to historical facts. Thus, even though Corinth may have ultimately failed at a unified style with his figure art, it is still necessary to understand it, both quantitatively and qualitatively, as the dominant part of his oeuvre.

Three Graces occupies a salient position among his "history paintings" and embodies the height of his creative powers at age 46, a time when he has consolidated his position as Germany's pre-eminent "Impressionist." Measured by the standards of most of his progressive contemporary critics or his own views on the matter of figural imagery, this work exemplifies a highly successful instance of grand figure painting, his life's avowed ambition. After all, he wanted to succeed Böcklin as Germany's foremost exponent of "idea painting," (a Neo-Idealist form of literary figure art) even though conservative critics contemporary with him judged his efforts in this regard "an unfortunate aberration" (P. Hahn after H. Kuhn).

Stylistically and technically *Three Graces* mediates between Corinth's earlier, dark realism and his later, brighter Impressionism. It combines various remnants of his numerous previous styles: Löfftz's cultivated naturalism, Leibl's robust realism, personal inflections of Parisian Impressionism, references to French Salon art, the lessons of the old masters: Rubens, Titian, Velazquez. Corinth merges these and other styles into a highly illusionistic and technically brilliant personal studio manner. Art as craft and "painting culture" for their own sakes dominated much of 19th-century German art. He followed in that tradition. But, above all, he emulated Böcklin.

As early as 1857, Böcklin had surprised the art world with a highly effective, large-scale Neo-romantic art based on mythological themes with life-like figures arranged in unselfconscious and spontaneous poses. In vying with the older master, Corinth exaggerated certain of his effects and added new ones. He plunged into *medias res*—"all has turned into detail" (H. Beenken)—to heighten the effect of immediacy. He cropped the space and even the extremities of his figures to achieve the feeling of Impressionistic spontaneity. He dazzled the viewer with his technical virtuosity in textural passages: palpitating flesh, moist skin, glistening hair, diaphonous fabric. He "intensified the technique of the accidental" (S. Wichmann) and viewed his models from odd angles, thereby magnifying the impression of proximal actuality. He accentuated the "most importunate physical actuality" of the models (P. Hahn), thereby enhancing the aura of their biological veracity. Totally dependent on his models for his aesthetic orientation, he explores them with near-clinical closeness of observation. By arranging his models on a small, shallow stage and focusing on them as narrowly as he does, "he achieves a kind of *tableau vivant* effect" (Hahn) whose urgency is heightened by the inevitably resulting distortions of foreshortening. Some have mistaken this feature for "Expressionism." In fact, it is further proof of his flamboyant studio manner. All of these characteristics are fully in evidence in *Three Graces.*

With these means Corinth hoped to achieve "general human contents" and "multiple spiritual expressions" (P. Hahn after Corinth). However, he exaggerated Böcklin's "genre effect" too much (i.e., mythology as every-day event, caught at a glance). He thus exceeded the capacity of the picture category of classic figure painting to contain the contrasting meanings he wished to convey, such as literary aspirations *and* material satisfaction, the topical *and* the universal, the intellectual *and* the sensual. The Salon painters, confronting a like challenge, managed the problem of balancing intellectualism with eroticism by adapting an illustrational technique at the expense of an authentic personal style. But Corinth, wishing to appear biologically compelling, psychologically urgent, spiritually uplifting, and technically dashing at all once, created an air of incongruity that borders on the grotesque. Moreover, by locking his models into an awkward "ideal" situation but accentuating their physical imperfections, he seems to presage *art brut.* Critics variably lauded these features as "dynamic" *and* chastized them as "barbaric." Were it not for Corinth's confessed seriousness in these matters, we would be tempted to think that he was mocking his contemporaries' beloved cultural preoccupation, treating mythography as thriller and moral lesson.

At his best, Böcklin was able to assuage his naturalism with the genuine magic of poetry and, thus, achieve pictorial unity. But with Corinth, subject and content disengage: the lacuna that opens up lays bare the ruins of a tradition. Later, Max Beckmann, a student of his, succeeded in reuniting strands of the pictorial tradition with an autobiographical present in powerful mythographic *and* personal expressions. By contrast, Corinth's work, merely echoing an aesthetic *Zeitgeist,* refurbished history painting with style-fashion. Corinth's "aesthetic neighbours," Fritz von Uhde and Max Klinger, or, similarly Gustav Klimt, for example, played successful variations on that theme. In that context, Corinth's *tour de force, Three Graces,* succeeds admirably, too. Still, it is lastly a trenchant if baffling paean to a fitful era in the throes of an epic aesthetic upheaval, the transformation from tradition to modernism.

—Rudolf M. Bisanz

Arnold Böcklin (1827–1901)
Island of the Dead, 1880
3 ft. 7³/₄ in. × 5 ft. 1³/₈ in. (111 × 156.1 cm.)
Basel, Kunstmuseum

Bibliography—

Magyar, Zoltan, *"Die Toteninsel,"* in *Munster,* 29, 1976.
Hirsh, Sharon, "Böcklin: Death Talks to the Painter," in *Arts Magazine* (New York), February 1981.

Böcklin most well-known painting is a sombre portrayal of the delivery of a coffin to an island cemetery. As one figure rows a boat towards the rocks, a second white-draped figure stands over the coffin and faces the island. As an earthly update of the mythological travels of Charon over the River Styx, the painting characterizes Böcklin's best work in that it blends an imaginative, personalized expression with well-established pictorial traditions.

Five versions of the painting were executed. The original painting, commissioned for Frau Marie Berna, dates from 1880, and was acquired by the Kunstmuseum Basel in 1920; it is the largest canvas overall and most squared in shape. Later versions are increasingly rectangular and differ primarily in details of the island and its architecture. The second smaller version, also painted in 1880 for Frau Berna, was left unfinished and is now in the Metropolitan in New York. Like this second painting, the third version of 1883–84 is painted on wood, and is also notably lighter, so that the scene appears in daylight or twilight, rather than at night. This small version, acquired for the so-called "Linz Collection" by Adolf Hitler through his Reichs Chancellery, resurfaced after decades of being noted as "missing" and was purchased in 1980 for the Berlin Nationalgalerie. The fourth version, also of 1884 but painted on metal, has been missing since 1945; a final version from 1886 is now in Leipzig.

Precedents for much of the imagery of the *Island of the Dead* exist in Böcklin's earlier work, including *Charon* (1876, George Schafer Collection). Other elements of the scene, such as the rocks in water, the architecture seen from water, and the islands can be found in *Mountain Lake with Mowen,* c. 1847, *Burgruine,* 1847, versions of *Villa on the Sea* 1859–80.

The vision that Böcklin created from these mythological and nature images—a beautiful island shrouded in blue shadows, tall cypresses, and mystery—summarized the late Romantic movement of which he was a part. In contrast to the Realists in other countries, German and Swiss artists had never rejected the role of the mind and the imagination in art. Böcklin's *Island of the Dead* follows this Germanic tradition, and serves as an important work linking earlier Romanticism with the Symbolist movement of the 1880's–90's. Although often cited as a precursor to Symbolism, the painting remains more Romantically inviting than Symbolistically mystifying. In a typically Romantic approach, Böcklin draws the viewer into a manipulated but still natural, melancholic world. The composition, recalling German Romantic landscapes of Friedrich and Carus, emphasizes a strong foreground, little middleground, and an infinite background. In the *Island of the Dead* compositions, this is heightened by the frontally centered island, from which expanses of sky and sea, often blended together, stretch out. This dramatic arrangement has as its focus the strong white shapes of the standing figure and the coffin shroud. These, like similar figuration in the work of Friedrich, are small in scale and seen from the back, in order to serve as intermediary figures for the viewer. Focusing on the boat, the viewer then glides with it towards the center of the island, also the center of the painting. This dark central passage of the painting is Böcklin's most dramatic compositional feat: an essentially "negative" space that not only dominates the painting's center but also serves as its focal point. The entire

composition, like those of the Romantics, was intended to lead the viewer, through nature, to the contemplation of another world of ideas. As Böcklin first entitled the painting, it was a "picture for dreaming."

It is intriguing that the name given to the paintings by a dealer/critic, and by which the works are known today, is so much more literal. Its acceptance suggests a desire to deal with the painting on a traditional level of allegorical meaning. Böcklin's imagery of death in this and other works was conventional and easily appreciated by his contemporaries, who shared a late 19th-century fascination with death. In response to the positivist philosophies that had dominated the century's struggles with the Industrial Revolution, many late 19th-century artists returned to more philosophical questions of existence: love, spirituality, life, and death. Böcklin was no exception, and addressed these in many of his large paintings such as *Vita Somnium Breve* (1888, Basel) and *The Sacred Grove* (1882, Basel). In many, the traditional imagery of the dance of death (*Totentanz*) is utilized, with skeletons and skulls used to represent death. In 1872, Böcklin created his *Self Portrait with Death the Fiddler* (Berlin, Nationalgalerie). The most commonly suggested source for this work is the *memento mori* portrait, but Böcklin's specific identification of himself as an artist actually has sources in the *Totentanz* depiction which in Basel in particular featured the painter visited by death.

Intriguingly, Böcklin did not utilize truly violent images of death until the last years of his life when he painted *War* (1896, Dresden) and *The Pestilence* (1898, Basel). These gruesome, apocalyptic visions were again, however, in keeping with his times. In light of this consistent concern with death imagery, then, Böcklin's *Island of the Dead* stands at a middle point in his career and a turning point in his approach to the theme. It is generally agreed that it was for mental as much as physical recovery that Böcklin sought refuge on the island of Ischia, near Naples. It was here that Böcklin must have encountered the natural source for the *Island of the Dead:* it must have been one of the famous Cemetery Islands that lie close to Ischia. But although Böcklin could have seen only the Castle Alfonso of Aragon, which rises majestically before the city of Ischia, it is the small island of St. Juraj that is most similar in appearance to Böcklin's own invention.

Although not universally admired, *Island of the Dead* had a great influence on later artists. In the mid-1880's, the dealer Fritz Girlitt commissioned Max Klinger to make three Böcklin works into etchings, one being *Island of the Dead.* In Salvador Dalí's *The True Painting of Arnold Böcklin's Island of the Dead at the Hour of the Angelus* (1932, Wupperthal), Böcklin's island is placed in a Surrealist landscape with a solitary tiny figure, molten coffee cup, and endless expansive space. Most influential was Böcklin's re-introduction of the landscape as mood-evoking vehicle for modern art: his dual approach to the imagination and nature in this "picture to dream about" provided a model for artists from Symbolism through Surrealism, and might now be cited as a precursor to Neo-Expresionionist paintings (e.g. the work of Anselm Keifer) which have returned to mythic, mystic landscapes as expression of universal feelings and beliefs.

—Sharon Hirsh

Ferdinand Hodler (1853–1918)
Night, 1890
45³/₄ × 117³/₄ in. (116 × 299 cm.)
Bern, Kunstmuseum

. . . To date, my most important work, in which I reveal myself in a new light, is *Night.* Its appearance is dramatic. It is not one night, but an ensemble of impressions of the night. The phantom of death is not there is order to mean that many men are surprised by death in the middle of the night, as . . . has [been] said, but it is there as a most intense noctural phenomenon. The coloration is symbolic: these sleeping beings are draped in black; the lighting is similar to an effect of the evening after sunset, which is an effect preliminary to the night. But that which is most striking is the phantom of death. This way of representing the phantom, at once harmonious and sinister, envisions the unknown, the invisible.

With these words Hodler described *Night,* an imposing painting depicting eight figures sleeping in a barren landscape; in their midst one man has awakened to stare into a faceless, black-draped nightmare. Originally, the painting was framed with a verse written by the 18th-century poet Charles François Panard, which underlined the universal meaning of this image of subconscious terror: "More than one who has gone to sleep tranquilly in the evening will not awaken the next morning." But as Hodler would later point out, the painting was intended to be much more than a traditional *memento mori*: in fact, it was in this work that he expressed his own obsessions. By portraying himself as the central man who awakens, horrified, to discover the incubus upon him Hodler visualized in startlingly realistic imagery the fear of death that haunted him in 1890. His morbid preoccupation was not unjustified; since his childhood, death had been a constant companion. As he lost, one after another, both of his parents and five siblings—all the members of his immediate family—to the ravages of tuberculosis, he feared that he, too, must be condemned to an early grave.

This feeling of doom was compounded by his unhappy personal life. Although seemingly content in his relationship with Augustine Dupin, the woman pictured in the left foreground, he had recently married Bertha Stucki who, according to identifications made during Hodler's lifetime, was the model for the female figure on the right. The marriage, which occurred in June 1889, did not last. By August of that year he was again with Augustine, and in October Bertha filed for divorce. The divorce was not finalized, however, until 1891. In 1890, when he painted *Night,* Hodler therefore was caught literally, as he is figuratively in the painting, between the two women.

This exposure of one's own fears and frustrations was entirely in keeping with the self-conscious and self-revealing generation of the *fin-de-siècle.* Like Van Gogh and especially like Munch, Hodler sought to express through very universal images in his art his deepest concerns and feelings. The haunting image of *Night* serves as an excellent example of this self-exposure. For although the image of a nightmare incubus was common to numerous other symbolic paintings, beginning with Fuseli's *Nightmare* (1783, Frankfurt), and continuing through many Symbolist works contemporary with and similar to Hodler's work, the true impact of *Night's* vision is derived

from its autobiographical references. The phantom was for the painter much more than a self-induced nightmare; in other sketches and drawings from the time, the same figure represented "somber genius." Like a Düreresque *Melancholia* personification, this specter was therefore Hodler's creative "Doppelganger," the darker side of his artistic imagination come to life before his eyes. As such, the most appropriate predecessor of *Night* was a self-portrait etched by Goya, the brooding Spanish master whom Hodler held in great esteem. As frontispiece to his *Caprichos* etching series of 1797, Goya created a print depicting himself being visited by the demons of his own imagination. Goya entitled the print *The Sleep of Reason Produces Monsters*; for Hodler, struggling in the early 1890's to overcome the depressions that tormented him in the night, Goya's warning was timely and true.

Nevertheless, the self-portraiture in *Night* is not limited to the terrified victim. The man in the right background, whose pose is that of the Diogenes figure of Raphael's *School of Athens* (Vatican), is also portrayed as Hodler. This second self-portrait figure, lying peacefully apart from the others and out of danger, seems to prophesy the happier, more secure future that Hodler would eventually enjoy. When *Night* was first exhibited in the Geneva municipal exhibition of 1891, the city council had the work removed prior to public opening, citing what they considered to be the painting's "lewd and immoral" implications inherent in Hodler's portrayal of nude men and women lying together in unseemly relationships. Hodler then, however, took the canvas to Paris, where it was accepted for the prestigious Champ-de-Mars exhibition. This was undoubtedly accomplished with the support of many of his friends who were directly involved with the Parisian art world. Among these were Edouard Rod and Mathias Morhardt, who wrote for both Geneva and Paris journals; their reviews of the exhibition lauded the merits of *Night.* Both staunchly defended the painting against the charges of indecency that had been leveled at the painting in Geneva, admitting that while it was "aggressive" and "provocative," it certainly could not be considered offensive. Emphasis instead was placed on the painting's masterful composition, comparable to those of modern masters like Puvis de Chavannes, and to the quality of drawing so evident in the figures.

With *Night,* Hodler began an important series of paintings that dealt with basic questions of existence—life and death, faith and despair—presented in terms of balancing opposites that together would express the underlying harmonious order of the universe. Thus, *Night's* image of impending darkness and death finds it symbolic complement in the life-awakening figures of *Day* (1900, Berne), while the dark force of evil that rules the superstitious world of *Night* is banished by the bright vision of *Truth* (1903, Zurich).

Night also proved to be a turning point for Hodler's own career; its Paris success in 1891 helped to establish a reputation that would grow to international stature in the 20th-century.

—Sharon Hirsh

Max Klinger (1857–1920)
Attunement, from *The Brahms Fantasy,* 1894
Engraving, aquatint, and mezzotint, 10⁷/₈ × 15³/₈ in. (27.7 × 39.1 cm.)

Attunement (*Accorde*) is the first image in Max Klinger's print cycle *Brahms-Phantasie* (*The Brahms Fantasy*) (published in Leipzig in 1894) and one of the earliest to be established during his preparations for this work (1889–94). It introduces the first half of the cycle and is complemented by a formally simpler but more ambiguous treatment of the same theme, *Evocation,* which opens the second half. *Accorde* and *Evocation* are the only signed sheets in the series. Neither scene, nor any of the other 39 images interspersed through a selection of poems and their musical settings by Brahms, is intended as direct illustration of texts or music. Combining the decorative, the narrative, and the symbolic, they are, as Klinger explained and as Brahms himself recognized, intended as attempts to visualize the composer's inspiration. The *Brahms-Phantasie* is Klinger's most complex print cycle from a technical point of view (using aquatint, engraving, etching, mezzotint and lithography); it also marks a turning point in his views on life, art and the role of the artist.

As with most images in the *Brahms-Phantasie,* Klinger combines print-making techniques in *Accorde* not only for a richer visual effect but also to convey more directly the conceptual basis of the work. An obvious advantage of the technical range in this sheet is the achievement of an almost alarming sense of space: between the obtrusive immediacy of foreground objects such as the piano (where Klinger has used the scraper to obtain the deep black of mezzotint) and the dream-like distance of the clouds and mountains (delicately worked with aquatint) no connection seems possible beyond the dizzying series of readjustments required as attention is shifted around the image by way of potentially mediating (engraved) features such as the churning waves. Klinger's purpose is especially well-served by forcing this disconcerting experience on the viewer, for he thus transmits directly a sense of the frustration felt by the artist in his role as intermediary between two worlds. The attunement sought here, in all awareness that success may be short-lived, is that between conventional perceptions of reality and alternatives apparent to inspired imagination.

The *Brahms-Phantasie* is as much an example of Klinger's adherence to the "total work of art" as are any of his painted or sculpted approaches to this concept. Its combination of music and poetry embraces a wide range of mood and form. In the first half, settings for solo voice and piano of a wistful Bohemian folk ballad and several contemporary world-weary love poems are accompanied by evocative images of single figures lost in reverie. In the second half, a choral arrangement for the exalted visions of Hölderlin's *Schicksalslied* (*Song of Destiny*) is preceded by episodes from the legend of Prometheus. Especially in its first, bound edition, the work was also an instance of "applied art" (in Klinger's view an important aspect of "totality") in serving as a vocal and instrumental score, such as the one at which the pianist in *Accorde* (Klinger's self-portrait) stares so intently.

Only two complete print cycles (out of a total of 14) followed the *Brahms-Phantasie,* which comes from a period when large-scale paintings and polychromatic sculpture were beginning to dominate Klinger's output. This bias is reflected in the markedly "sculptural" aspects of *Accorde, Evocation,* and other images in the series. More significantly, the *Brahms-Phantasie* records the major shift in Klinger's views at this time, for it acknowledges the exaltation of triumph as compellingly as the reality of sadness and frustrated effort. Ironic pessimism derived from wide reading of contemporary literature and philosophy—especially the writings of Nietzsche—had informed most of Klinger's earlier work. As Klinger turned increasingly, after 1890, from realistic to symbolic subject matter, his views were conditioned less by the depressing evidence of the world around him and more by his concern with the artist's role as a salutary link to an ideal, timeless realm. The *Brahms-Phantasie,* both in its regret for lost happiness and in its dream of happiness yet to be secured, links Klinger with artists, such as Böcklin or Thoma, associated with the late 19th-century revival of the ideology and iconography of Romanticism. The parting clouds and storm-tossed boat of *Accorde* are unequivocal signals of the realignment.

—Elizabeth Clegg

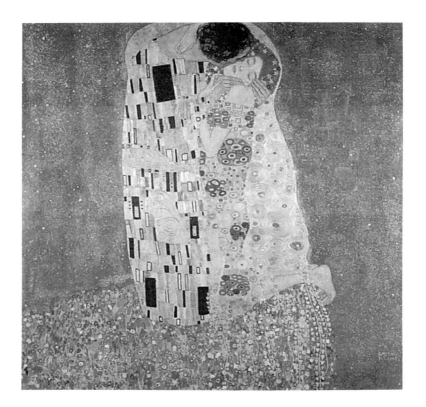

Gustav Klimt (1862–1918)
The Kiss, 1908
5 ft. 10⁷/₈ in. square (180 cm.)
Vienna, Osterreichische Galerie

The painter Gustav Klimt, concerned with evoking images of a perpetual springtime, created works of lasting beauty and sweetness. Klimt evokes states of temporal bliss and ecstasy in colors that cascade in powdered mosaics, as exquisite as a butterfly's wing in nature. Culling this lightness of vision from the Impressionists, Klimt was nevertheless influenced by the strange esoteric worlds of symbolism, characterised by the use of evocative and suggestive imagery. The practioners of Art Nouveau or Jugendstil were also known as the Stylists, and this is an apt way to describe Klimt, whose work is the culmination of a diversity of differing styles and artistic ideas. From Art Nouveau he took the biomorphic forms and sinuous lines of nature, and the symbolists and Nabis provided him with an inspired interest in orientalism. Klimt's attraction to the Byzantine friezes of northern Italy added to these forces, giving him geometrical form, mosaic-like pattern, and the transcendental gold of religious art. This use of an archaic idiom added to the mystery of his work and intensified the forces of Art Nouveau, with its flowing arrangements of line and color. The theme of ecstasy was one which pervaded Klimt's work. At times we see this as union with nature, in the celebration of its beauty. In *Water-Snakes 1.* (1904–07, Vienna), we find the hybrid creatures of Symbolism in an ecstatic union with the deep. In *Fulfillment* (1905–09, Strasbourg) and *The Kiss,* this becomes union of man and woman.

Though Klimt's interest in the religious paintings of the Byzantine world may suggest a spiritual dimension to his work, in his painting of *Danaë* (1907–08, Vienna Sammlung Dichand) we see an overt eroticism reminiscent of Japanese art, and no spiritual content is inferred.

Klimt was a man, who, dressed in monk-like attire, mused for many hours in the solitude of his own garden. He had forged a lasting relationship with one woman whom he refused to marry in case this should affect the free artistic expression he had accustomed himself to. Perhaps nature and natural love were to Klimt expressions of the spiritual side of human life, and these enriching experiences were his paradise on earth. To be, as it were, accepted in loving union with another human being surely is paradise of a kind, and the enrichment of the senses could perhaps hold the key to an understanding of our own inner grace.

Klimt's fields of poppies and flower gardens recall the poppy fields and waterlilies of Claude Monet, though the sustained flattening out of the image and the use of surface pattern gives a decorative strength to the overall design. These flowers, alive in their varying shades and colors, form breathtaking facades which impose their exquisite beauty and grace.

In *The Kiss* the spiralling forms and circles help to suggest union as the gold mantels of the embracing figures merge into one. The couple rest on a hillock of flowers, setting them again in the midst of nature. A dark background, spattered and powdered with gold, suggests a cosmic void, and this sense is impressed upon us further by the use of hard and soft focus. Klimt evokes a sense of the mysterious or esoteric, approaching Odilon Redon in this respect. Klimt's involvement with the painting as a decorative surface had evolved from his earlier training as a decorator, and perhaps it was the early acceptance of this one aspect of his artistic talent that held him safely within certain formal and decorative limits that made him less a Symbolist and more a Stylist.

—L. A. Landers

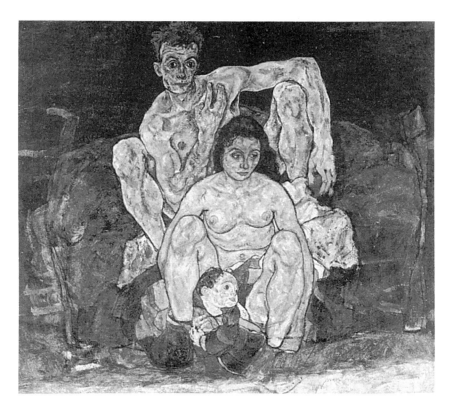

Egon Schiele (1890–1918)
The Family, 1918
59 × 63 in. (150 × 160 cm.)
Vienna, Osterreichische Galerie

Bibliography—

Hofmann, Werner, *Schiele: Die Familie: Einführung,* Stuttgart, 1968.

Coming from a background of continuing family crisis only served to encourage the enquiring mind of the already over-sensitive Egon Schiele, enlarging his sensibility and giving him an awareness of the questions surrounding human existence and their possible resolution in human terms.

Schiele was a painter obsessed by a desire to probe and explore the various facets of human existence. His habit of using child models brought allegations of child abuse and immorality, resulting in his detention and brief imprisonment. It seems the same intense drive which lead him to pursue his artistic course had taken him to the edges of a new personal crisis, yet after his marriage to Edith Harms his personality mellowed, probably due in part to his army service and the new structuring which this gave to their existence, as well as Schiele's improved health. And, to be placed, as it were, in a socially acceptable role must have helped to ease the inner doubts and anxieties placed upon him by his earlier imprisonment.

The Family (1918, Vienna) was painted three years after his marriage to Edith, and is marked by a certain mellowing both in the style in which it is painted and in the psychological rendering of its subjects. The figures, more naturalistic, certainly lack the rigid monumentality as seen in *Mother with Two Children* (1917, Vienna), and the angularity of form has gone. Instead Schiele has placed the couple in the naturalistic setting of a living-room with sofa, which seems a far cry from the bleak void which he had previously used. The first title of this work was *Crouching Couple,* and the original painting contained only the figures of a man (Schiele) and a woman. Though it is not certain if the model used was in fact Edith, Schiele added the child after hearing of his wife's pregnancy. Like Kokoschka's paintings of a few years later, Schiele probes the psychology of the figures in an image which at first sight seems to contain all the features of a harmonious family group. The crouching woman stares vacantly as if in acknowledgement of her own sense of insecurity; the man crouched behind her, lips pursed, eyes wide, one hand placed across his breast in typical Expressionist gesture, seems to assert his strength, which in Expressionist terms can be equated with feeling. The child, added later, is not placed in the secure embrace of its mother's arms but clutches at a cloth which is wrapped around her ankle. This fact alone is perhaps one key to this complex and unfinished painting, for in placing the child so, Schiele reminds us of the basis of Freudian thought and Expressionist ideology, which is this struggle for self-identity and the assertion of individuality.

The painting, while conveying the feeling of a group of people belonging to each other and the world, is nevertheless a reflection on individual identity and destiny. And though Schiele, his wife, and their unborn child were to die that same year in the flu epidemic, the family certainly had existed in its essence in the living relationship which manifested itself in this tender painting.

—L. A. Landers

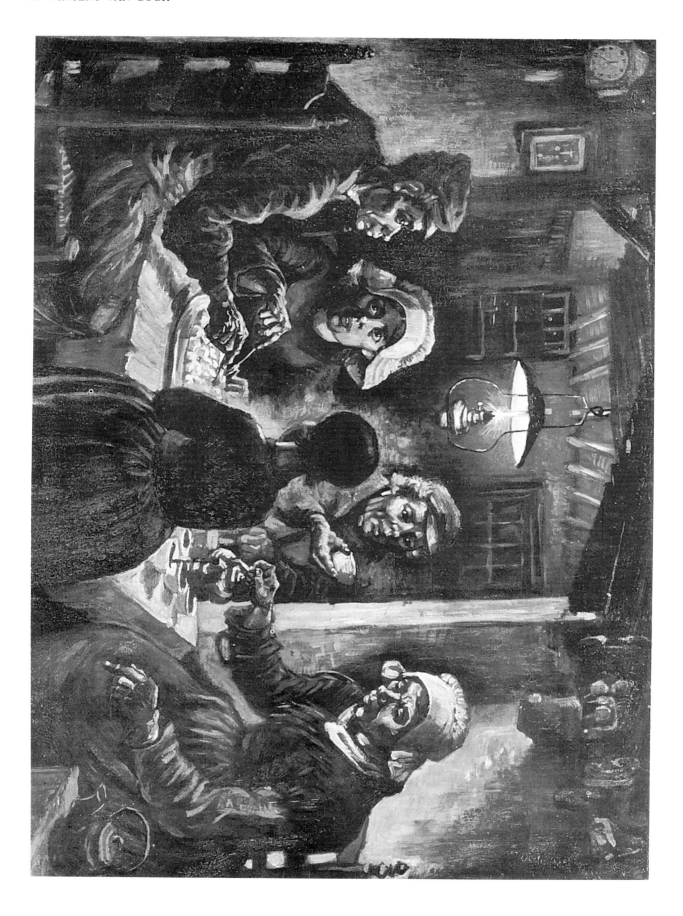

Vincent van Gogh (1853–90)
The Potato-Eaters, 1885
32¼ × 44⅞ in. (82 × 104 cm.)
Amsterdam, Rijksmuseum

The Potato-Eaters is considered to be Vincent van Gogh's main work from his Dutch period. In any case, it is one of his best-known paintings of these years and also one of the most extensively discussed in Van Gogh's own letters. It was done in April 1885 in the village of Nuenen (near Eindhoven in the south of The Netherlands). Van Gogh had been gradually working towards it, shifting his interest as an artist from landscapes and still-lifes to people. For some time now he had been living among the poor farmers and weavers of the region, and he had developed a deep understanding for their hardships.

In October 1884 he had written to his brother Theo (the Paris art-dealer who helped him in his struggle for existence) that he was planning to paint a great number of heads of peasants, and in February 1885 he could report: "I have surely already painted thirty of them and done an equal number of drawings" (letter 394). He also did a number of studies of hands, and around February or March the project of painting a group of peasants, having their simple meal in a lamp-lit hut, must finally have taken shape, as a few pencil-drawings of a group of four peasants, sitting around a table, clearly suggest.

On 26 March, Vincent's father, who was the Protestant minister in Nuenen, suddenly died of a heart attack, but luckily this tragic circumstance did not prevent Vincent from finishing his work. When Theo had come over from Paris for the funeral, Vincent must have told him about his project, but at that time only a few preliminary sketches were in existence. However, writing again to Paris a few days later, Vincent told his brother: "This week I intend to start that composition of those peasants around a dish of potatoes in the evening" (letter 398).

His first attempt, of which he immediately sent Theo a sketch (F1226, JH 736), was still not entirely to his satisfaction. It was the painting which is now in the Kröller-Müller museum in Otterlo (F 78, JH 734). In the last week of April he wrote: "I want to tell you that I am working hard on the potato-eaters. I have resumed them on a new canvas, and I have painted new studies of the heads; the hands especially are greatly changed" (letter 403). He later explained that he had found the flesh tones far too light, and he said: "All the heads were finished, and even finished with great care, but I painted them again, inexorably, and their colour is now *the colour of a very dusty potato, unpeeled of course*" (letter 405). The result was the painting we reproduce here; it can be seen in the Rijksmuseum Vincent van Gogh in Amsterdam.

All this proves how much thought and careful planning had been spent on a painting which at the time must have seemed incredibly ugly to most people, almost an insult. Even Vincent's painter friend Anthon van Rappard wrote him, when he had received a lithograph after the painting: "You will agree with me that such work is not meant seriously" (letter R 51).

Yet nothing was accidental here, and stressing this, Van Gogh explained in his usual passionate, but precise and expressive style: "All winter long I have had the threads of this tissue in my hands, and have searched for the ultimate pattern; and though it has become a tissue of rough, coarse aspect, nevertheless the threads have been chosen carefully and according to certain rules. And it might prove to be a real *peasant picture. I know it is.* But if anyone prefers to see the farmers in a sweet, sentimental way, let him." He was not at all anxious for everyone to like it or to admire it, he said, but what he had done was deliberate: "I have tried to emphasize that these people, eating their potatoes in the lamplight, have dug the earth with those very hands they put in the dish, and so it speaks of *manual labour*, and how they have honestly earned their food" (letter 404).

One of the artists Van Gogh admired most during these years was the French painter Jean-Francois Millet, who had become famous for his rendering of peasant-life. Talking of his own potato-eaters, Vincent could not resist quoting what someone had written about Millet: "His peasant seems to be painted with the earth he is sowing!" And with this example in mind, he could end the defense of his painting with an eloquent series of comparisons: "If a peasant picture smells of bacon, smoke, potato-steam, all right, that is not unhealthy; if a stable smells of dung—all right, that belongs to the stable; if the field has an odour of ripe corn or potatoes or of guano or manure—that's healthy, especially for city people."

The Potato-Eaters was an important achievement, not only in the eyes of posterity. Van Gogh himself had a strong predilection for it. Writing to his sister Wilhelmina two years later, he declared: "What I think of my own work is this, that that picture I did at Nuenen of those people eating potatoes is the best one after all" (letter W 1). When he had finished his extremely personal painting of the *Night Café* in 1888, he wrote: "It is the equivalent, though different, of the *Potato-Eaters*" (letter 533), and even shortly before his death, in April 1890, he still had a vivid memory of the painting, and he wrote to Theo: "I am thinking of doing again the picture of the peasants eating, with the lamplight effect. That canvas must be quite black now, perhaps I could do it all over again, from memory" (letter 629).

—Jan Hulsker

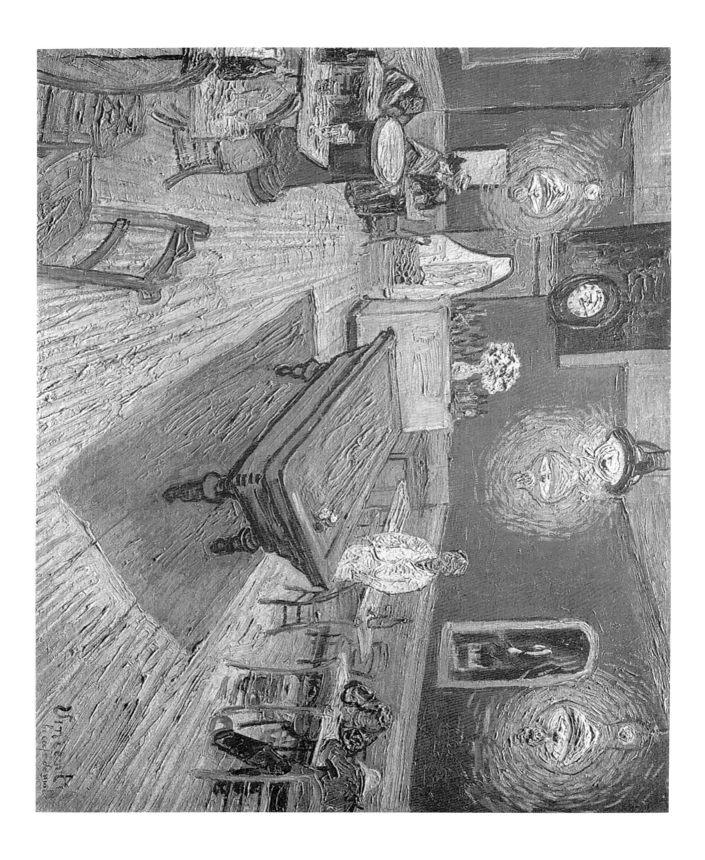

Vincent van Gogh (1853–90)
The Night Café, 1888
27 × 35 in. (70 × 89 cm.)
New Haven, Yale University

Vincent van Gogh's *The Night Café* tells as much about his life in Arles as about the rapid change in his style of painting in 1888. Not that he was one of the "night prowlers" who could take refuge there "when they had no money to pay for a lodging or were too tight to be taken in," as he had put it in a letter to his brother Theo in the beginning of August 1888 (letter 518). He did depict a few of those drunks in his picture, but he himself was one of the few people who stayed there as a boarder. It was not before the middle of September that the well-known "Yellow House" on the same Place Lamartine was sufficiently furnished that he could sleep there. The night café, which was called *Café de la Gare*, was run by a certain Joseph Ginoux, and even after Vincent's move to the Yellow House he remained a friend of Ginoux and his wife and kept visiting their café with his friends Paul Gauguin and the postman Roulin. It was not only Van Gogh who painted an interior of the *Café de la Gare* but also Gauguin, and both did portraits of Madame Ginoux, sitting at one of the café tables.

This did not mean that Vincent was not critical of the place, and it was only half jokingly that he wrote to his brother in September: "Because I am always bowed under the difficulty of paying my landlord, I made up my mind to take it gaily. I swore at the said landlord, who after all isn't a bad fellow, and told him that to revenge myself for paying him so much money for nothing, I would make a picture of his rotten joint so as to repay myself. Then to the great joy of the landlord, of the postman whom I had already painted, of the visiting night prowlers and of myself, for three nights running I sat up to paint and went to bed during the day" (letter 533).

What a place like this really meant, he tried to express through the style of his painting, accompanying the letter in which he explained this to Theo with a water-colour, done after the oil-painting: "I have tried to express the terrible human passions. The room is blood red and dark yellow with a green billiard table in the middle; there are four citron yellow lamps with a glow of orange and green. Everywhere there is a clash and contrast of the most disparate reds and greens in the

figures of the little sleeping hooligans, in the empty, dreary room, in violet and blue." And in a subsequent letter he went even deeper into the symbolic meaning of the colours: "I have tried to express that the café is a place where one can ruin himself, go mad or commit crimes" (letter 534). He wanted the contrasts between his "soft Louis XV green," his "yellow greens and harsh blue greens," to express what he called "the powers of darkness in such a low public house."

In the meantime he realized what the public reaction to such a painting was going to be. "What would Monsieur Tersteeg [his former employer in The Hague] say about this picture when he said before a Sisley—Sisley, the most discreet and gentle of the impressionists—'I can't help thinking that the artist who painted *that* was a little tipsy.' If he saw my picture, he would say that it was delirium tremens in full swing."

The *Night Café* is certainly not one of Van Gogh's greatest paintings. Yet, it is a picture that in its deliberate symbolism, its deviations from reality such as the exaggerated shine of the gaslamps, announces the really "expressionistic" works like some of the mountain landscapes of Saint-Rémy and the famous *Starry Night* of 1889. And from the biographical point of view the picture is perhaps even more interesting. It was in the *Café de la Gare* that for several months Van Gogh spent his evenings and wrote his now famous letters to his brother; it was here that he met Madame Ginoux, the woman who made such a deep impression upon him (he painted two magnificent portraits of her, sitting at one of the café tables, and later copied no less than five times the portrait that Gauguin had made of her); it was here that Paul Gauguin had arrived in the early hours of 23 October 1888 and was greeted by the owner of the café, who had seen a portrait of him, with the words: "So you're his chum! I recognize you." Finally, it probably was the place where the quarrel with Gauguin took place on the 23rd of December, which led to the Vincent's self-inflicted wound with all its tragic consequences for the rest of his life.

—Jan Hulsker

Vincent van Gogh (1853–90)
The Starry Night, 1889
28³/₄ × 36¹/₄ in. (73 × 92 cm.)
New York, Moma

Bibliography—

Boime, Albert, "Van Gogh's *Starry Night*: A History of Matter and a Matter of History," in *Arts Magazine* (New York), December 1984.

This painting should not be confused with a riverscene with the same title which Van Gogh painted in September 1888 in Arles. The *Starry Night* of the Museum of Modern Art was done some eight months later in Saint-Rémy, where he had sought a refuge, enabling him to work quietly after the turbulent months in Arles. We know exactly when it was painted, although—in a curious contrast to the well-documented painting *The Potato-Eaters* of 1885—*The Starry Night* was mentioned in Van Gogh's letters only in passing. "I finally have a landscape with Olive Trees and a new study of a starry night," he wrote in a letter of around 18 June 1889 to his brother in Paris (letter 59). The only other words of some importance referring to the picture were written in September, when he sent it to his brother with some other canvases: "The Olive Trees with a white cloud and a background of mountains as well as the Moonrise and the Night Effect are exaggerations from the point of view of arrangement; their lines are warped as in old wood engravings" (letter 607). Vincent must have been well aware of the tumultuous character of these pictures, especially of that of *The Starry Night*. He was afraid that his brother would not understand them, and Theo's answer, although not unfriendly, was in fact quite critical. He thought that Vincent's "search for style," as he called his deviations from reality, "was detrimental to the true sentiment of things" (letter T 19).

Announcing *The Starry Night* of September 1888, Vincent van Gogh had written to his brother: "It does me good to do difficult things. That does not prevent me from having a terrible need of—shall I say the word?—religion. Then I go out at night to paint the stars, and I am always dreaming of a picture like this with a group of living figures, our comrades" (letter 543). This must not be misunderstood, certainly not when one applies it to *The Starry Night* of Saint-Rémy. Van Gogh had long ago severed all ties with ecclesiastical religion, and he warns us himself that that was not what had inspired him to do the picture. Explaining that what he was aiming at was something he sometimes had been discussing with his friends Paul Gauguin and Emile Bernard (who at that moment were also experimenting with a more symbolic sort of painting in Brit-

tany), he stated: "It is not a return to romanticism or to religious ideas" (letter 595).

Much has been written about the dramatic and exalted way in which Vincent had this time rendered the night sky. It is clear that what had moved him most and what he wanted to express above all was the overwhelming power of the great cosmic forces reigning in the infinity of nature. It has been suggested—and rightly so, it seems to me—that rather than by religion, Vincent's thoughts were now strongly influenced by his reading of the American poet Walt Whitman. It cannot be a coincidence that a year previously, only a month before he painted his first attempt at a *Starry Night*, he wrote to his sister Wilhelmina: "Have you already read the American poems of Walt Whitman? I strongly advise you to read them. . . . He sees in the future, and even in the present, a world of healthy carnal love—of friendship—of work—under the great starlit vault of heaven, something which after all one can only call God, and eternity in its place above this world" (letter W 8). This is a clear indication of what the word religion really meant to him in this phase of his life.

However unrealistic and exaggerated the rendering of the night sky over the village of Saint-Rémy may seem, in some respects Van Gogh appears to have remained true to the reality of nature he loved and admired so much. In an extensive, extremely interesting study of the painting, Albert Boime has shown that these brilliant stars and this radiant moonsickle were not placed at random within the composition, but in complete accordance with the constellation of the sky as it was above Saint-Rémy in the early morning hours of that night in June 1889 when Vincent painted it: the bright white planet of Venus close to the horizon and a particular group of stars (Aries) above it (*Arts Magazine*, December 1984). The author was convinced that Van Gogh had a lively interest in the writings of people like Jules Verne, Camille Flammarion, and other popular astronomists, and their recent discoveries of nebulae may even have been the inspiration for the enormous clouds, interlocked in a spiral movement, in which another author, Heinz Graetz, had even seen the old Chinese symbol of Yin and Yang.

Nevertheless, there can be no doubt that it is the visionary, completely anti-naturalistic character of the painting which is its main characteristic and which has lend it the significance of being one of the greatest, pre-expressionistic paintings of the late 19th century.

—Jan Hulsker

James Ensor (1860–1949)
The Entry of Christ into Brussels, 1888
8 ft. 5³/₈ in. × 14 ft. 1³/₄ in. (257.6 × 431.1 cm.)
Malibu, Getty

Bibliography—

Vanbeselaere, Walter, *L'Entrée du Christ à Bruxelles,* Brussels, 1957.

James Ensor's *The Entry of Christ into Brussels* has been appropriately described as one of the key monuments of 19th-century art. Its impressive size and dense composition of crowded figures combine with a dissonant orchestration of color to present an unforgettable tableau of the Belgian bourgeoisie. The painting is a cinemascopic vision of major proportion and a 19th-century billboard that elevates caricature into the realm of art once reserved for pious, wall-size frescoes.

At the bottom of the composition a parade leader appears; he is a coarse, bloated monstrosity who gives visual expression to Ensor's caustic dictum, "the hot air of windbags always makes them burst like frogs." At the top a banner displays the words "Vive La Sociale." In between, the vast space is filled with curious and compelling details: each face and mask is unique and calls for scrutiny; at the same time the individual images fuse into a multi-colored undulating surface of rippling movement.

The painting's radical vision had a major impact upon a number of artists. Ensor's influence can be seen in the street scenes of Boccioni, Carra, and Grosz; the oversize canvases and smeared paint of the abstract expressionists; and the vigorous, savage images of the Cobra group. In literature the immense mob scene in Nathaniel West's 1939 novel, *The Day of the Locust,* was inspired by the canvas.

Ensor's painting was provoked by the desire to upstage and ridicule Georges Seurat, whose balanced, rational image of Parisian life, *Sunday Afternoon on the Island of La Grande Jatte,* was applauded in 1887 as a modern masterpiece by Ensor's fellow artists in the Belgian art association Les Vingt (The Twenty). In Ensor's picture, a canvas four feet wider than Seurat's large painting, the vulgar Brussels crowd contrasts sharply with Seurat's vision of a serene French utopian society.

The complete title for Ensor's painting is the *The Entry of Christ into Brussels Mardi Gras of 1888.* As with Seurat's title, Ensor's suggests a specific point in the present, the year that the painting was completed and the day—Mardi Gras or Fat Tuesday—before the beginning of Lent. Ensor's picture also recalls the past, from the first medieval processionals and carnivals which were religious in nature, through the "Joyous Entries" of the renaissance, which were politically inspired tributes to foreign rulers. Thus history, religion, and politics are intertwined in a statement that carries local, national, and international significance.

At the center of activity Christ makes His triumphal entry. He rides upon a donkey and His small figure is crowned by a huge golden sombrero that resembles a halo. A gesture of benediction is suggested by the tentative extension of a raised right arm.

Christ first appears on a donkey in the center of Ensor's 1885 drawing *The Alive and Radiant: The Entry of Christ into Jerusalem.* This monumental drawing, over six feet in height, also serves as a prototype for *The Entry of Christ into Brussels* in its depiction of a densely packed crowd that surges forward, oblivious to Christ's presence, and in the use of banners and signs bearing references to religious and contemporary life. In the painting Christ's presence illustrates a pointed irony: Christ is ignored amidst the celebration of an event that His death inspired.

Ensor's debt to Belgian and English art is significant. There are the prototypes from Belgian artists: Brueghel's depictions of Christ lost in a madding crowd; Antoine Wiertz's mob scene in the 1856 painting *The Apotheosis of the Queen;* and Felicien Rops's 1858 prints *Printemps* and *Garde Civique.* In the last, a high vantage point reveals marching musicians and militia as well as lettered banners and flags. A print by the English artists Cruikshank and Mayhew, *London in 1851,* with its masses of tightly packed bodies, a large banner, and signs, is an equally important prototype.

Literature plays a crucial role in the painting as well. The subject is inspired by Balzac's story "Jesus Christ in Flanders" (1832), in which the author chooses Ensor's hometown of Ostend as the site of the Second Coming, and the composition is influenced by Albert Mockel's *Les Fumistes wallons* (1887), with its description of an enormous crowd of idlers and a parade of grotesques with a clown as parade reviewer.

The books of the Belgian writer Charles De Coster, especially *The Glorious Adventures of Tyl Ulenspiegel* (1868), served as a formative influence on Ensor. In fact, *The Entry of Christ into Brussels* can be seen as Ensor's own "ulenspiegel," a mirror in which Belgian society is reflected and mocked. On the left side of the picture the artist appears alone in profile, dressed as a clown with a tall scarlet dunce cap and surrounded by flags that isolate and draw attention to his position. On the other side of the painting, below the parade reviewing stand and near Ensor's signature, his family of masks—symbolizing his mother, sister, and grandmother—appears.

Despite these personal references, the drama of the individual yields to the drama of the crowd and the complex combination of good and evil in all levels of society. Ensor's protagonists have abandoned themselves to revelry, their psyches hidden, their despair masked in the noisy escapism of the Mardi Gras. As the poet Jean Lorrain perceived, "What marvellous insight he has into the invisible and into the atmosphere created by our vices . . . our vices which turn our faces into masks"

—Diane Lesko

Edvard Munch (1863–1944)
The Scream, 1893
Oil, casein, and pastel on cardboard; 35⁷/₈ × 29¹/₈ in. (91 × 74 cm.)
Oslo, National Gallery

Bibliography—

Heller, Reinhold, *Munch: The Scream*, New York, 1973.

In an exhibit pamphlet of 1929 Munch explains the imagery of *The Scream* as having its origin in an evocation of an extreme psychological state brought on by a combination of forces: physical strain and emotional apprehension intensified by an ominous display of nature. "I was walking along a road one evening," he recalls—"on one side lay the city, and below me was the fjord. The sun went down—the clouds were stained red as with blood. I felt as though I could hear a scream. I painted that picture, painting the clouds like red blood. The colours scream."

Although strong and convincing, these words fall far short of the impact made by the painting itself which, with its profoundly disturbing introspective view, has come to be considered the prototype of a particular reaction to the surface orientation of Impressionism. In Munch's case this meant the visual unveiling of the innermost secrets of the human psyche. "Just as Leonardo da Vinci studied human anatomy and dissected corpses, so I try to dissect the souls," Munch says elsewhere, and rarely has an artist succeeded in penetrating as deeply into the realm of emotional torment as Munch did in *The Scream*.

Originally called *Despair* and created in 1893 during his turbulent stay in Berlin, the painting is part of a sequence of works intended to be shown under the collective title *The Frieze of Life*, a concept Munch never clearly defined but suggesting the artist's desire to bring out a continuity of content in his works: "These pictures, when finally brought together, will be more easily understood—they will deal with love and death." Included in the first showing of the series were such epochal paintings as *Madonna, Jealousy,* and *Vampire*, all then featured under titles quite different from those permanently attached to them and all sharing in the artist's desire to visualize the depth of human emotions.

Behavioral scientists have paid a great deal of attention to *The Scream*, using it, often with Van Gogh's *Crows over the Wheatfield* or *Starry Night*, as an illustration of visual creativity gone astray, the artist teetering on the edge of madness. While Edvard Munch, and certainly Vincent Van Gogh, experienced the loss of mental equilibrium, their works reflecting such experiences came about in a state of rigid emotional control as revealed in the supreme visual logic characteristic of such works.

While the protagonist in *The Scream*, neither male nor female but simply the human species, sways in the maelstrom of unspeakable anguish as land, sea, and sky swirl in a tight conspiracy of forces massing against its very existence, the compositional scheme evoking this unmistakable image of terror derives from a most deliberate and logical plotting based on a keen awareness of the creative means available to the artist. A linear pattern of horizontals and diagonals pits the spiraling shore and the undulant sky against the lethal dagger of the pier, forming a set of triangular shapes simultaneously sharp and fluid irresistibly drawing the viewer's eyes past the untroubled world of a calmly promenading pair toward the vertiginously poised protagonist, whose hands frantically pressed against the ears fail to shut out a scream of despair rising from the depth of a tortured soul.

The jarring colors—dissonant streaks of reds and orange interspersed with blues that sometimes float into green—reinforce the ambiguity of the image, its compelling juxtaposition of the real and the imagined.

The landscape, the inner bay of the Oslofjord and its mellower counterpart farther south by Åsgårdstrand, is a persistent leitmotif in Munch's paintings, seen first in *Inger on the Shore* (1889) and subsequently in a number of works, many intended for *The Frieze of Life*, among them *Melancholy, Dance on the Shore, The Dance of Life,* and the many versions of *Girls on the Bridge*. In *The Scream*, through the artist's deliberate manipulation of the elements, this setting with its softly undulant shoreline and gently sloping hills takes on a most ominous function. More often than not, however, it serves to mute the effect of the agony experienced by the character placed in it, and that actually is how Munch himself viewed the Oslofjord landscape: "Through them all [the paintings] there winds the curving shoreline, and beyond it the sea, while under the trees, life with all its complexities of grief and joy carries on."

As Seurat reacted against the casual immediacy of the Impressionists with his ponderously structured, monumental *Sunday Afternoon at la Grande Jatte* and Gauguin in his *Vision after the Sermon* called for a return to a world of myth and legend, so Munch with *The Scream* and other works in *The Frieze of Life* introduced an emotion-charged art deeply in tune with the pessimistic view of the human condition so prominent in Europe's *fin de siècle*.

—Reidar Dittmann

Ilya Repin (1844–1930)
The Cossacks (*Zaporozhie Cossacks Writing a Reply to the Turkish Sultan*), 1880–91
7 ft. 1³/₈ in. × 10 ft. 4³/₈ in. (217 × 316 cm.)
Moscow, Tretyakov

The Cossacks stands as the apotheosis of Repin's art in several respects. It embodies his interest in historical themes with a bearing on contemporary times, his technical brilliance while working in a monumental style, his power as a portraitist, his stature as a realist.

The subject of the painting derives from the artist's personal experience and a chance discovery. Repin knew the Cossack world well because he was born and raised in a Ukrainian Cossack military settlement where his father had served in a Cossack regiment. By accident, in the summer of 1878, Repin chanced upon the text of a mocking reply sent in 1676 by the Zaporozhie Cossacks to Mohammed IV, the Turkish Sultan, in response to his demand for their immediate surrender. Captivated by the subject—hearty and derisive laughter in reply to the arrogant demand for the surrender of freedom—Repin immediately made a pencil drawing, and then turned to other matters. In the summer of 1880 he travelled to the Zaporozhie region to gather materials and to sketch old Cossack types. He then obtained original documentary matter and gathered authentic Ukrainian antiquities in 1887, and in 1889 committed himself to the completion of his idea.

That idea, as expressed by Repin, was as follows: "I admire our Zaporozhie region for its freedom and heroic spirit. There the brave elements of the Russian people renounced everyday comforts and founded a community of equal members to defend the principles they cherish most—Orthodox religion and personal freedom. Today these will seem like obsolete words, but then, in those times, when thousands of Slavs were carried into slavery by the Moslems—when religion, honor, and freedom were being desecrated—then, it was a highly stirring idea."

Moving from the limited scope of his first rough draft, expanding the size of the canvas, removing, replacing, and adding characters, variously attempting to address compositional problems, Repin made the final work of 1891 much unlike the first pencil sketch of 1878 and the version of 1887 (Moscow, Tretyakov Gallery). The final work, oil on canvas, measures 217 cm × 316 cm. On this enormous canvas are more than 20 distinct Cossack figures, each individually clothed, each bearing a unique facial expression and an individual gesture, but all joined in a community of response.

The eye is drawn to the center of the canvas, and the person of the Ataman Serko, by the yellow back of one Cossack and the white blouse and yellow, bald head of another. Cossack lances accentuate the vertical dimension, while two Cossack figures with their backs to the audience stand at each end of the canvas, providing compositional balance and accentuating the spatial breadth. The addition of these two balancing figures was Repin's last addition to the canvas. The dominant structure is a series of circles, growing out from the figure of the scribe who is recording the Ataman's words. The circularity, or roundness, is reinforced by the shaven heads and the laughing mouths of the Cossacks. The overall effect is one of sound and motion.

Each figure is presented substantially and individually in physiognomy, dress, gesture, and expression. The attention to authentic detail is remarkable, for instance, the variety of Ukrainian headgear and the specific Ukrainian ornamentation on knives, swords, and other Cossack accoutrements. The predominant gay and vivid colors (primarily yellow, red, and blue) complement and emphasize the boisterous and rousing chorus of laughter.

The painting is a realistic rather than romantic rendering of Cossack demeanor and spirit. Similar to other Repin works, selected because they convey quintessential qualities of their subjects, *The Cossack* is the work most frequently chosen to illustrate, in any medium, the world of the Cossacks.

—Stephen Jan Parker

Johan Christian Dahl (1788–1857)
Hjelle in Valdres, 1851
36⅝ × 53⅜ in. (93 × 135.5 cm.)
Oslo, National Gallery

The painting bears the artist's signature and the date 1851. Two other versions, smaller—one in the National Gallery, the other in Bergen Picture Gallery—are dated 1850 and may be considered preparatory studies, although the Bergen version, while retaining a remarkably vivid quality of immediacy, appears totally finished.

Shadowy rocks and age-old timbered structures in the foreground yield to a flood of green shaped in an arc of meadowland extending from the cluster of houses near the right frame to the dark pool of the river on the opposite side. From this bright foreground a broad valley flanked by dark slopes recedes toward a rounded, bluish, snow-capped mountain marking the apex of the canvas. In the heart of the valley the meandering river, freed from its shadowy darkness, brightly reflects the blue of the sky.

Despite the virginal green of the foreground, recapitulated in two sloping meadows, one high up to the left, the other farther back and to the right, bending down to the river, it is early autumn as shown by sparse seasonal tones of red in the line of foliate trees extending across the lower part of the canvas and more demonstratively in a ritual circle of golden stakes of grain placed in the center.

Near this circle, to the left and adjacent to a herd of cattle, stands a woman, painted in miniature perfection, gazing at the landscape which, from her vantage point, past the river and over the hills to the distant mountain rising above a wispy streak of mist, encompasses a space of infinite depth.

—Reidar Dittmann

Raoul Dufy (1877–1953)
The Paddock at Deauville, c. 1930
21¹/₄ × 40¹/₂ in. (54 × 102.9 cm.)
Paris, Beaubourg

This scene typifies Dufy's predilection for the portrayal of outdoor scenes: fresh, bright, and unproblematic. His most famous paintings are invariably associated with summer scenes: open windows overlooking azure seas, and brightly coloured figures set against high August skies. These colours express a sparkling joie de vivre, while the handling of line in the painting exemplifies Dufy's technique of avoiding the filling in of all the details, yet creating a unified and evocative scene. Since the details are briefly drawn, added significance is given to the freshness of the colours. What distinguishes him from his early precursors and first influences—the Impressionists—is the unseasonal and unatmospheric effect, yet the creation of a wholeheartedly summer feel. This paradox is strong: for what instantly comes to mind is summer and spring despite the unlaboured process of achieving it.

Dufy always painted the walls of his studio sky-blue, and often used the resulting vignettes: devices such as the outside seen through an open door or a window frame. The figures, trees, and grandstand in *The Paddock at Deauville* seem superimposed on the background of the bright blue sky. He had drawn thoroughbred horses from life when he lived on a farm outside Paris in 1909 and the standard of his draughtsmanship, usually over-looked, is surprisingly high. His paintings evoke a paradise, sometimes exotic, using billowing white sails of tall ships or fruit from far-away countries, sometimes vernacular and craft-based (which extend to the other mediums he worked in, such as ceramics). But a picture like *The Paddock at Deauville* suggests his interest in sporting events which, by their immediacy and universal appeal, become attractively seductive.

—Magdalen Evans

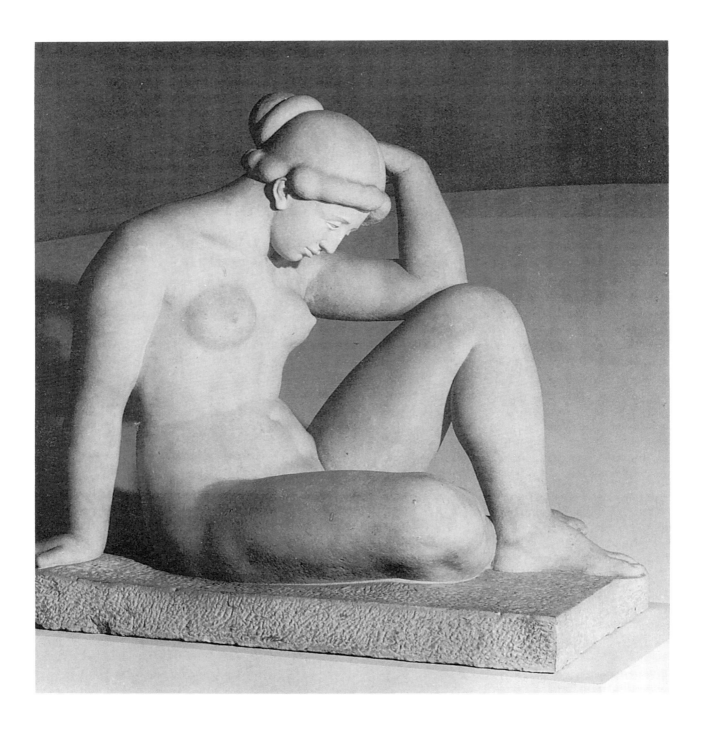

Aristide Maillol (1861–1944)
La Méditerranée, 1902–05
Plaster; 41 in. (104 cm.) (height of bronze cast)
Winterthur, Oscar Reinhart Collection; marble version in
 Paris, d'Orsay, and bronze casts in Perpignan, Town Hall,
 Paris, Maillol Museum, and New York, Moma.

Bibliography—
Hackelsberger, Berthold, *Maillol, La Méditerranée,* Stuttgart,
 1960.
Hoetink, H. R., *Maillol: La Méditerranée,* Rotterdam, 1963.

The original plaster of *La Méditerranée,* which at first was
simply called *Femme Accroupie,* was exhibited in the 1905
Salon d'Automne, Paris, to critical acclaim, ending for Aris-
tide Maillol his years of poverty and obscurity. The work was
purchased by Count Harry Kessler, who became Maillol's pa-
tron, admirer, and friend, after an introduction from Rodin.
(Maillol's hand-made paper workshop, which was funded by
Kessler, used the image of *La Méditerranée* as its watermark.)
A cast of the sculpture was later made for the town hall of
Perpignan in the Catalan-speaking region of which Maillol is a
native, and which inspired his art. In 1923 the French state
commissioned a marble carving of the piece, which is now in
the Musée d'Orsay, while there is a bronze cast in the Tuille-
ries Gardens, among the group which constitutes the outdoor
Musée Maillol.

La Méditerranée is a seated female nude, typical of Mail-
lol's oeuvre in that she is a heavily built, classical figure of
static, calm, assured pose. Although the artist produced sev-
eral seated statues in his career (such as the allegorical *La
Nuit,* 1902–09, and the memorial figure for Claude Debussy,
1930), he generally preferred standing figures. However, the
equation of woman and nature implicit in *La Méditerranée* is
entirely consistent with the spirit of his other work, which is
imbued with an arcadian, pastoral vision of health, vigor and
harmony. The pose of *La Méditerranée* is passive and reflec-
tive, especially with the bent arm and the wrist on her fore-
head. The source of this particular gesture is perhaps
Michelangelo's *La Notte* figure in San Lorenzo, or, more re-
cently, Rodin's *The Thinker,* the Dante figure from his *Gates
of Hell.* However, in Maillol's sculpture, rather than imparting
an aura of introversion or troubled thought, the gesture opens
out the figure inviting the viewer to gaze into her lap, *La
Méditerranée* is truly an example of sculpture "in the round,"
that is to say, it is conceived three-dimensionally. There is no
"best view"; the back and sides offer as interesting perspec-
tives as the full-frontal angle, and there is an absence of narra-
tive, purposive movement of symbolism.

The pose adds a geometric character to the figure: the rigid,

straight left arm behind and the bent right arm in front, meet-
ing the upright bent knee, accentuates the waist line; the taut
back and the thick-set limbs eschew surface expression in fa-
vour of intrinsic form which is picked out by reflected light.
The wrists are disconcertingly stocky, eliminating them as a
distraction; the hair is arranged in a bun, transforming what
might have proved a need for surface decoration into a tangi-
ble, sculptural mass.

La Méditerranée marks a rebellion against the achievements
of Rodin, with classical, meditative simplicity replacing the
latter's romantic, dramatic movements. Its affinities are with
post-Impressionist painting. Gauguin was a vital influence on
Maillol; his Tahitian women clearly providing a prototype for
La Méditerranée, their flattened, naive simplicity anticipating
Maillol's reductive handling of essential masses. Maillol, who
only turned to sculpture when he was 40, started as a painter
associated with the Nabis. His painting *The Sea,* 1898, very
close in style to Emile Bernard and Maurice Denis, clearly
relates in subject matter and style with *La Méditerranée.* Also,
the sculpture recalls Cézanne's bathers, reinforcing the fact
that Maillol's concern was with shape and form.

The novelist André Gide recorded his enthusiasm for *La
Méditerranée* in the *Gazette des Beaux-Arts* in 1905. "She is
beautiful," he wrote; "She has no meaning. This is a work of
silence. I believe one must go far back in the history of art to
find such a perfect disregard of everything which could detract
from the manifestation of beauty. How beautifully the light
falls on the shoulder! And how soft is the shadow of that slop-
ing brow! No thought disturbs her serenity; no passions tor-
ment her powerful breasts. It is simple beauty of plane and
line." Besides being an enduring poetic response, Gide's re-
marks hit upon important critical ideas. He was excited by the
anti-literary, and therefore essentially aesthetic, qualities of the
piece. His evocation of the "simple beauty of plane and line"
anticipates the language used by exponents of abstract art
which is significant, because although Maillol never deserted
the human body, and always sought a lyrical, classical quality
in his art, the formal achievements of *La Méditerranée* are
held to be of great importance in the evolution of Modernist
sculpture.

—David Cohen

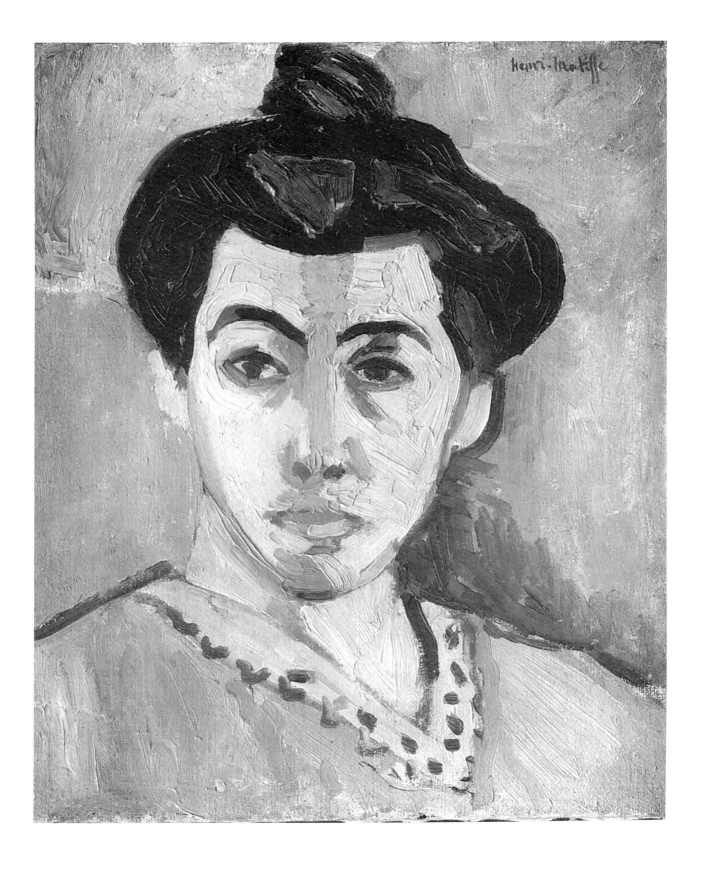

Henri Matisse (1869–1954)
The Green Stripe, 1905
16 × 11³/₄ in. (40.5 × 32.5 cm.)
Copenhagen, Statens Museum for Kunst

This small-scale but extremely powerful portrait of the artist's wife marks a crucial turning-point in Matisse's style. The canvas was painted in the fall of 1905, shortly after Matisse had won notoriety—and the title "Fauve"—at the Autumn Salon with another portrait of Mme. Matisse entitled *Woman with a Hat.* The earlier and larger painting of Amélie Matisse was constructed of loosely brushed, irregular patches of brilliant color which almost dissolved the contour of the seated figure, fashionably attired in an enormous hat, gown, and gloves. That painting, the first Matisse canvas purchased by Gertrude and Leo Stein, established Matisse's role as the leader of a group of "Wild Men of Paris" who painted with a savage directness.

The boldness of *The Green Stripe,* however, is of a different kind. A more personal portrait, it is also more controlled. The painter concentrates attention on the sitter's head and captures her character traits: strength, forthrightness, obstinancy, lack of coquetry, and stability. These traits are conveyed by the new simplicity and firmness of the style. The color is divided between the complementary poles of red-green and (secondarily) yellow-violet. The background is divided between the blue-green area on our right and the two reds (red-violet in the upper zone, crimson in the lower) on our left. The light on the face is also divided, not between light and dark, but between warm and cool flesh tones. On the left, against the red background, the skin is a warm greenish yellow; on the right, against the cool green background, a cooler pink. The division of complementary colors and the simultaneous contrast of warm and cool tones are devices that Matisse learned from Neo-Impressionism. Rather than by color *shading,* Matisse models the face by color *temperature.*

The green line, which starts at the chin and beneath the nose as greenish shadow, suddenly assents the contrary by emphasizing the most projecting features of the face, the nose and brow. No longer green-as-shadowed-recession, the stripe accentuates the light-separation of the face. The visual continuation of this green line to the centering top-knot of the hair provides a central axis that gives the portrait its symmetry, its uprightness. The dark cap of hair balances the shallow v-shape of the neckline. What began as a plastic device becomes the portrait's major expressive means: the centering green line makes the image of the artist's wife into a dynamic icon of strength.

The flat, viscous quality of the paint, the limited but effective use of line as both contour and pattern, and the even distribution of strong color—all of these procedures are new to Matisse in 1905. They will carry over to his major panel, *Bonheur (Joie) de Vivre* (Merion, Pennsylvania), which he began immediately after this portrait. *The Green Stripe* permits the artist to break with the sketchy, illusionistic, mimetic technique that was his heritage from Impressionism. He had begun that break in the previous year when he undertook a careful study of the color principles of Neo-Impressionism or Pointillism. He learned at that time to work with complementary and simultaneous contrasts of colors, but within the framework of a broken, mosaic-like stroke. In *Green Stripe,* Matisse retained the abstract color usage of Neo-Impressionism, but laid out the color in broad, flat, decorative planes.

The model for this flat, highly colored style was Paul Gauguin, whose work Matisse had been able to see in some quantity a few months earlier. The expressive color and impasto brush stroke also owed something to the work of Vincent Van Gogh, another post-Impressionist painter whom Matisse was studying at this time. Matisse combines Gauguin's decorativeness with Van Gogh's expressionism. More surprisingly, the influence of two 19th-century painters who had retrospective exhibitions at the Autumn Salon of 1905, Ingres and Manet, can also be felt in this work. The blunt, painterly application of paint parallels that of Manet, and the sinuous, contour-defining line that flattens forms can be traced to Ingres.

This was not the last important portrait that Matisse was to make of his wife. She was often a model for him in his early, poverty-stricken years when he could afford no other model; she gave him this time although she had small children to raise and partially supported the family as a *modiste.* In this portrait, however, she is not merely a model. She is fully the subject of the painting and her character comprises its content. Although Matisse is not primarily known as a portraitist, he made many psychologically acute studies of individuals during his life. Only a year before he painted *The Green Stripe,* he made a copy of Raphael's *Baldassare Castiglione* (Paris). The nobility and self-possession of the sitter in this portrait is not unlike that of the artist's wife. One finds that Matisse, penetrating the individuating characteristics of his sitter, seems best able to embody them through the innovative and exploratory use of his materials—color, texture, line, and space.

—Catherine C. Bock

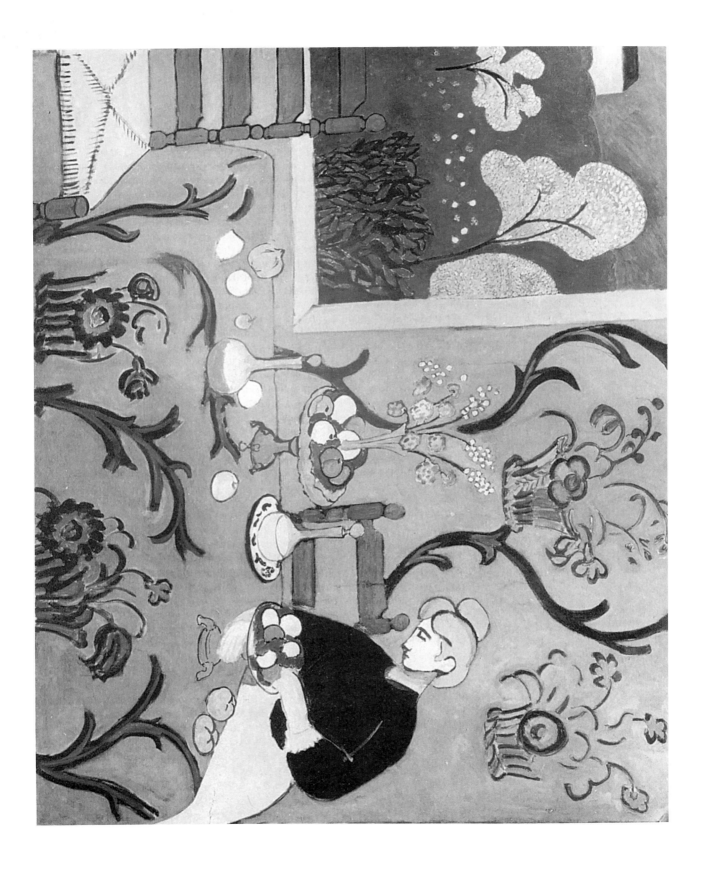

Henri Matisse (1869–1954)
Harmony in Red, 1908
70⁷/₈ × 86⁵/₈ in. (180 × 220 cm.)
Leningrad, Hermitage

Harmony in Red can be considered the first of Matisse's decorative panels in which pattern vies with color as the major expressive means. It may also be viewed as the culmination of a ten-year period of struggle and development in which the artist successfully moved from a style of impressionist realism (exemplified by a painting of 1898, *La Desserte*, with the identical subject) to a more abstract and decorative manner. In *Harmony in Red,* a rich field of brilliant color maintains the tension of the taut picture plane against the variegated, all-over pattern formed by a figure and objects, textile and wallpaper design, and a window opening onto a busy landscape. Field and figure are held in equal balance so that the painting resembles as much a colorful tapestry as an easel painting.

The painting was originally conceived as a decorative panel for the dining room of one of Matisse's major patrons of the period, Sergei Shchukin, a Russian businessman. In its earliest state, the red surface was painted with a thin, saturated green tone, which would have placed the textile-printed branches and flower baskets against a natural green "landscape." This green field was painted over with a rich, medium blue which was the textile's actual color. An early photograph of this *Harmony in Blue* shows an arrangement of the subject nearly identical to that of the final version; the outdoor trees, however, are only delicately stippled in white at the edges, as though just flowering, and the textile pattern of the tablecloth is coarser. Matisse had the painting framed in this state, but ultimately repainted the whole by flooding it with the special, pungent red it now displays. (There is indication that he did this at the last moment—before exhibition or before shipping it to its new owner—as the final red version was painted while framed; an inch strip of unrepainted canvas is still visible inside the frame.) Matisse explained the change merely by saying that he did it "to satisfy my desire for a better balance of color." We see that the new color does better balance the active patterns and multiple small forms scattered on the surface. The warm red color also acts in perfect visual counter-weight to the vigorous blue in the branching pattern, the servant's dress, and the sky seen through the window along with the cool green verdure.

The composition maintains a subtle balance between the two-dimensionality required of a mural panel and the suggestion of three-dimensional space proper to an easel painting. The common patterned red ground shared by the table and wall compresses the composition, but a shallow recession is indicated by the angled position of the chair at the lower left and echoed by the diagonal of the table-edge at the right, formed by its contrast with the woman's white apron. The window frame, with its strong corner angle, also opens the wall onto a deeper vista beyond it. The surface as a whole is further unified by the flow of curvilinear forms which reach from foreground to background, from right to left over the curved shoulder and hair of the serving woman, and from indoor to outdoors in the parallel curves of the swaying trees. The strong curvilinear emphasis recalls the curves of the Art Nouveau style, which was at the height of its popularity as the major "modern style" of the applied arts. Matisse, despite his natural penchant for the decorative, had avoided using the serpentine line before 1906; here, confident that he could now integrate it with color, composition, and theme, he uses it to striking effect.

Matisse's work often circles back on itself, recuperating earlier themes, containing or reinterpreting earlier motifs. In a physical sense, *Harmony in Red* contains a compositional miniature of itself. The image seen through the window, which almost acts like a picture on the wall, recapitulates the composition of the whole panel: the house in the distant upper left takes the place of the window in the large composition, the green hedge mimics the shape of the table, the curving trees echo the servant and large branching patterns, while the spotted flowers duplicate the scattered items on the table. By way of subject matter, *Harmony in Red* recapitulates the 1897 *La Desserte* which also portrays a serving woman solicitously leaning in from the right over a table scattered with decanters, fruits, and flowers; each painting features a background window as well. There is yet another, earlier version of the subject, *Breton Serving Girl* (private collection) of 1896. The subject and composition are identical with the two later canvases, though a door, rather than a window, breaks the plane of the wall in the rear and a blond light suffuses the image with a Vermeer-like calm. The subject of a domestic scene, with its nurturing feminine presence and its profusion of edibles, form the thematic basis for the "harmony" of the canvases in question. The rhythmic regularity of meals indoors and the rhythm of the seasons outdoors, with their plantings and harvestings, domesticates the animal need for sustenance.

Harmony in Red turns, or curves, about these rhythms. The flowering trees indicate nature's abundance; the laden table testifies to that abundance under cultivation in the service of human need. The textile pattern of flowers and branches also "civilizes" natural forms but, given their overwhelming dispersal over the picture surface, they vie with "nature" for importance. The *harmony* in the title, then, is a richly layered balance between nature and culture, physical and spiritual needs, between color and pattern, depth and flatness, present innovation and incorporation of the artist's past. *Harmony in Red* is rightly considered the summarizing masterwork of Matisse's early years and one of the most satisfying images of his entire career.

—Catherine C. Bock

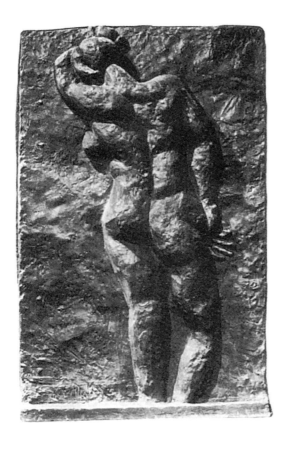
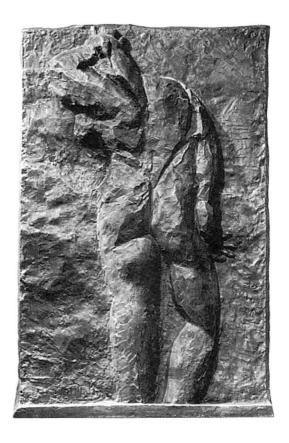

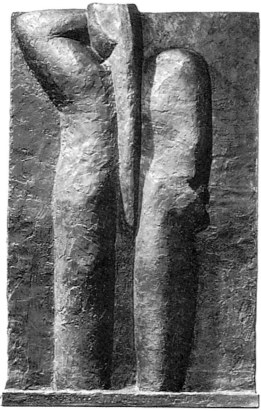
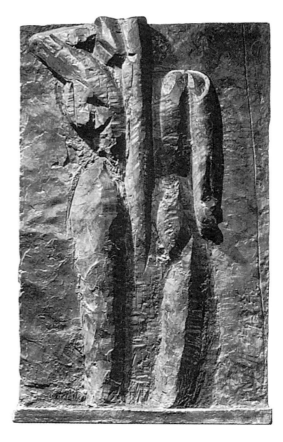

Henri Matisse (1869–1954)
Backs I–IV, 1909–30
74 in. (189.9 cm.); later versions vary slightly

Matisse's *Backs* form a harmonious series that, when displayed together, seem to demonstrate a logical progression of style from more realistic to nearly abstract. The history of their making is, however, curiously erratic; the irregular development of the series is related to contemporaneous painting commissions. The artist himself never saw the four bronze versions together and apparently forgot about *Back II,* which was discovered in 1955 after his death. (It is not mentioned in Barr's monograph of 1951, where the *Backs* are consequently numbered differently.) Finally, a 1909 photograph of a first version of the *Backs* (now called *Back 0*) was discovered only in 1971.

Back 0 was a sensuous, realistic version of a nude female in relief against a wall, her averted head buried in her upraised left arm. The right arm—with its pronated hand—is at her side. This clay version was evidently destroyed when the artist proceded to work out *Back I* directly from this version later in 1909. Matisse investigated the life-sized nude figure in sculpture at the same time that he was working on the commissions for Sergei Shchukin's decorative panels *Dance* and *Music,* which also contained life-sized nudes. As was frequently the artist's custom when his painting was tending toward the flat and decorative, Matisse refreshed himself and worked out related problems in sculpture. When working back and forth between the two media, he once remarked, "It was done for the purposes of organization, to put order into my feelings, and find a style to suit me. When I found it in sculpture, it helped me in my painting." Nevertheless, Matisse stated bluntly, "I sculpted like a painter. I did not sculpt like a sculptor." An analysis of *Backs I–IV* bears this out.

The figure in *Back I* is spread against the wall as though on a picture plane: the feet are avoided by being cut off at a horizontal ridge (a painted figure standing in water from the same time suggests a parallel), the breast and hand are flattened on the plane, and the face is joined to the crook of the elbow in a way that decreases its volume. In *Back I,* the figure is anchored by the solid pillar of the engaged leg, while a rhythm that rises from the movement of the bent leg continues up the spine and is released in the raised arm. This sweeping right-to-left rhythm is balanced by the blunt faceting of the figure in strong planes. Matisse worked on a plaster cast of his first study, *Back 0,* and the cuts of chisel and knife give a crude, expressive strength to the surface. This is true of the entire series.

In *Back II,* the figure is further abstracted and flattened to the plane. (Matisse began to rework the earlier back in 1913 when he resumed a large panel, *Bathers by a Stream,* originally part of the 1910 Shchukin commission.) The s-curve rhythm is subordinated to a "branching" pattern that emerges from the vertical that starts with the inner straight leg, and continues up the back and along the edge of the hair. From this dominant vertical, strong cuts—reminiscent of the sharp facet-ing of cubist painting—break the bent leg, mark the left buttock, spring from the waist to upper torso, and mark the rise of the left arm. The right arm is now aligned with the vertical edge of the plane, as it will be for the rest of the series. Again, chisel marks gouge the surface, setting up surface rhythm like that in cubist paintings of the period.

Back III, begun in 1916 when work on the *Bathers* painting was resumed, further monumentalizes the figure by bringing it into greater unity with the planar support. In place of the indication of the spine, a long braid or lock of hair established a strong vertical that reaches from the top edge of the relief to more than half-way down the plane. The head is now horizontally truncated to coincide with the upper edge of the sculpture. The right arm and leg repeat the vertical. The strong diagonal that reaches from the bent elbow—now in the corner of the plane—to the slanted hand is the only counter-movement to the vertical emphasis. The figure is accentuated with the bulky exaggerations of buttocks, breast, and right shoulder. Matisse has carefully adjusted the figure to the plane, even to the subtle strategy of incising a shallow diagonal line at the right, a move that mediates the diagonal-vertical thrusts and relates them to the framing edge. The female figure has become an amazon in *Back III,* a creature of superhuman presence and power, whose beauty has no longer anything to do with sensual grace.

After a dozen-year hiatus, Matisse took up the *Back* again for the last time in 1930, once again in conjunction with a mural commission (for the Barnes Foundation in Merion, Pennsylvania) and once again in relation to the theme of dancers. At first glance, the awesome stability of the architectonic form in *Back IV* has no relation to the leaping and tumbling figures that Matisse was painting for the three spandrels of the Barnes Foundation wall painting. Both works, however, are the fruit of an architectural awareness. The last *Back* is a distillation of stability and hieratic calm. The two vertical columns of the legs reach to the shoulders and flank the central braid. The upper part of the bent arm softens the angled thrust of the elbow by ending in a horizontal that echoes the upper edge; the other, mitten-like hand that breaks the right contour of the figure balances its mate and varies the insistent vertical rhythm. The architectural aspect of the columnar treatment suggests the tranquil rhythm of caryatids on Greek temples: women's forms, capable of supporting the structure, take the place of columns. This elegant and elegaic treatment of the final *Back* must have sufficiently satisfied Matisse so that he never took up the problem again and kept a plaster cast of *Back IV* displayed in his studio to the end of his life. Made in 1930, *Back IV* initiates Matisse's return to the flattened, abstracted style of the 1930's and 1940's, and also points to the simple contours and subtle figure-ground relationships of the paper cut-outs of his late work.

—Catherine C. Bock

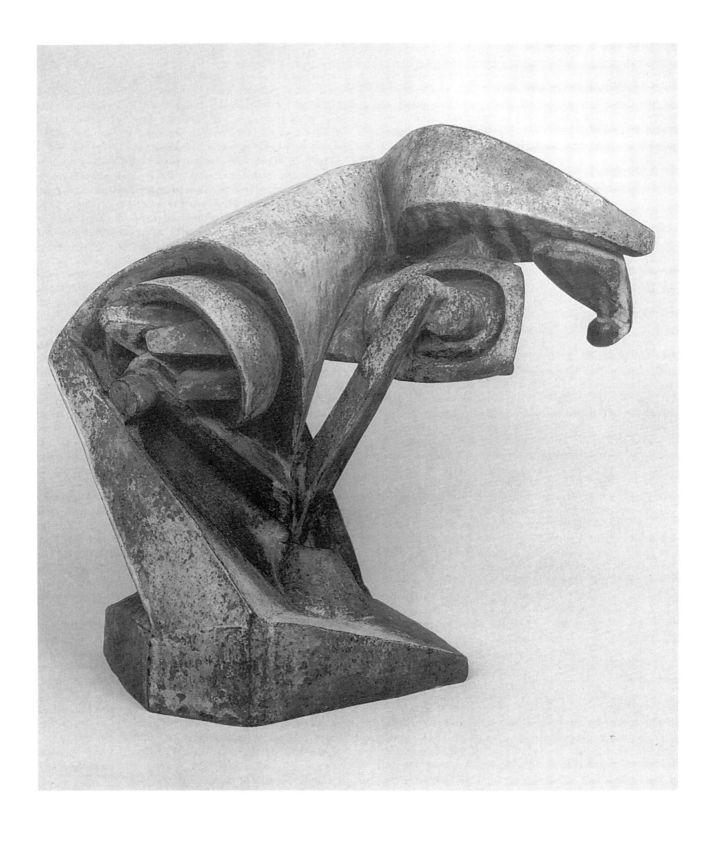

Raymond Duchamp-Villon (1876–1918)
The Horse, 1914
Bronze; 17³/₈ in. (44 cm.)
Venice, Guggenheim; Amsterdam, Stedelijk

Bibliography—

McMullen, Roy, "Duchamp-Villon's *Horse,*" in *Art News* (New York), September 1966.
Habert, Jean, "*Le Cheval majeure* de Duchamp-Villon," in *Revue du Louvre* (Paris), 35, 1985.

In *The Horse* (1914), the French sculptor Raymond Duchamp-Villon transformed the traditional equestrian monument into an emblematic dynamo. Widely recognized as an icon of the machine age, this sculpture embodies the successful translation of Cubist aesthetic theories into the three-dimensional sculptural medium. Not only does the work rank as Duchamp-Villon's finest achievement, but *The Horse* also epitomizes the problems endemic to the experimental and tentative character of much early modern sculpture.

The Horse preoccupied Duchamp-Villon almost continuously during the last four years of his life from 1914 until 1918. The original concept evolved between 1912 and 1913 from clay studies and drawings, notably an undated preliminary sketch from Duchamp-Villon's lost sculpture, *The Cubist House,* (1912). Originally focussed on the motif of horse and rider, Duchamp-Villon's studies of *The Horse* became increasingly abstract as he melded organic and mechanical forms in the *Small Horse,* 1914 (Philadelphia) and the intermediate *Study for "The Horse",* c. 1914 (Philadelphia). Shortly before enlisting as an army medical officer, Duchamp-Villon apparently completed at least one 44-cm. high plaster cast of the final version of *The Horse* (The original cast is lost; versions are in the Musée de Grenoble and on loan to the Philadelphia Museum of Art). By translating the equine anatomy into planar, geometric elements reminiscent of gears, pistons, and fly-wheels, Duchamp-Villon created a dynamic metaphor of horse power.

The central questions raised by *The Horse* revolve around its casting history and Duchamp-Villon's ultimate intentions in creating this forceful image of mechanized animal power. A victim of typhoid fever, Duchamp-Villon died at the front in 1918. He left behind in his Puteaux studio unrealized plans and a partially completed armature for the enlargement of *The Horse.* Neither the original plaster cast (formerly collection of John Quinn, now lost), nor either of the two extant plasters was cast in a permanent material during Duchamp-Villon's lifetime. According to his brothers Jacques Villon and Marcel Duchamp, as well as the testimony of his friend Walter Pach, Duchamp-Villon intended to enlarge *The Horse* to a monumental scale and to have the work cast in steel, a metal more appropriate to machine age technology than the traditional bronze cast.

The complex history of the posthumous casts of *The Horse* requires further documentation and analysis. In 1921, the Manhattan attorney and patron of John Quinn, who had acquired the original plaster maquette from the artist's widow, commissioned the first bronze cast (collection of Edgar Kaufmann, Jr.) from the Roman Bronze Works foundry in New York. Two more bronze casts, also measuring 44-cm. high, were produced in 1930 in France under the supervision of Jacques Villon. A bronze enlargement of 100-cm. high cast at the same time was subsequently acquired by the Museum of Modern Art. In the 1950's, the Galerie Louis Carré issued unnumbered bronze and lead editions of the 44-cm.-high version of *The Horse.* Marcel Duchamp, in 1966, supervised the production of a second edition of *The Horse,* enlarged to the scale of one and a half meters. Critics and historians have questioned the historical accuracy and aesthetic quality of these posthumous enlargements of *The Horse,* particularly the so-called *Cheval Majeur* or *Large Horse* çast in 1966.

Although the later enlargements are problematic, the extant plaster and early bronze casts of *The Horse* provide sufficient evidence of Duchamp-Villon's creative vision. In 1913 he wrote: "The power of the machine imposes itself upon us and we can scarcely conceive living beings without it. . . ." In *The Horse,* Duchamp-Villon tempered the Futurists' literal search for dynamism within a composition of triangular stability. Counterbalanced planes and lines of force create tension and a sense of controlled, potential energy. It was Duchamp-Villon's genius to imbue his sculptural symbol of avant-grade machine aesthetics with an underlying classicism. Marcel Duchamp rightly called his brother's work "a classic piece of Cubist sculpture."

—Judith Zilczer

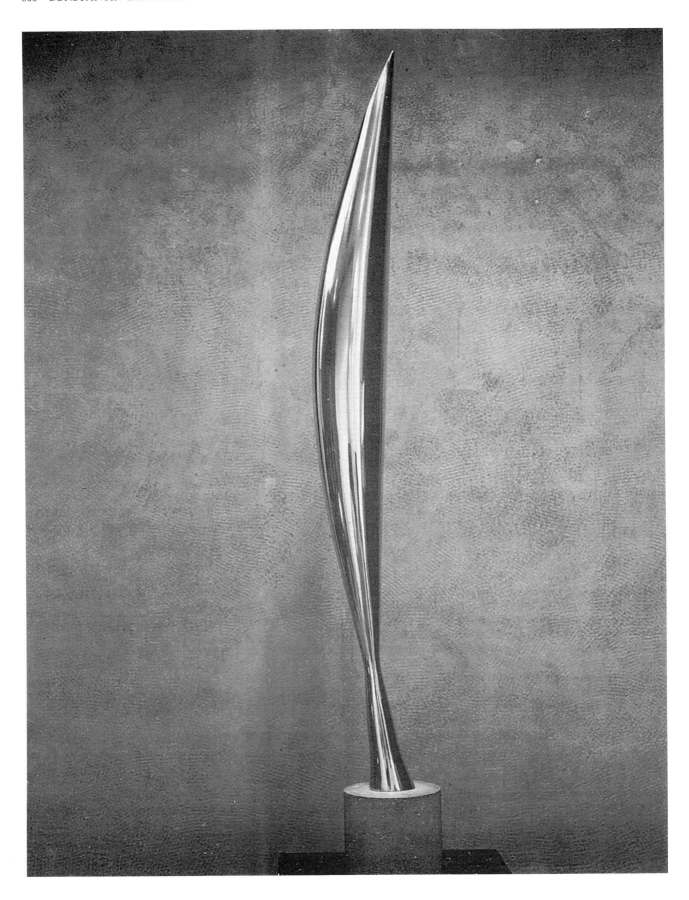

Constantin Brancusi (1876–1957)
Bird in Space, 1928
Bronze; 50³/₈ in. (128 cm.)
New York, Moma

Birds in various guises constitute a large part of Brancusi's oeuvre. *Bird in Space*, arguably the sculptor's definitive ornithological form, exists in several bronze, marble, and plaster versions, identical but for varying dimensions. It evolved from two prototypes: the earliest, *Maiastra*, was based on a mythological solar bird from Romanian folklore and appeared in 1910, along with the first of many egg-shaped sculptures. The proud, full-breasted, open-beaked bird was soon modified, becoming more elongated though still slightly squat and earthbound. *Golden Bird*, the second prototype, sustained this form until 1923 when *Bird in Space* came into its own. Brancusi's interest in birds was fired by contemporary enthusiasm for the forgotten art and myth of ancient and primitive cultures: animal statues and masks were savoured by avant-garde Parisians, Diaghilev staged a production of Stravinsky's *Firebird* in Paris in 1910, and Brancusi probably read *Pasarea Maiastra, poema poporala*, a poem based on Romanian folk tales, published in Bucharest in 1909.

Bird in Space rests upon its own base, reminiscent of pedestalled bird motifs often seen in Romanian cemeteries. The pedestal is the mediator between the earth and the sky and as such assumes a vital role: Brancusi stressed that the pedestal should be either part of the sculpture or done away with completely. It establishes a hierarchy of form and media, starting with rougher, baser wood, graduating onto a more superior, smoothed stone, and culminating with the highly polished bronze or marble sculpture itself. This version of *Bird in Space* rests on a two-tiered pedestal: a sheer, slightly tapered wooden block is surmounted by a stone cylindrical plinth from which the bird rises. The contrast of materials serves to emphasize the inherent beauty and individuality of each component. The bronze bird is supported by an inner backbone of metal, maintaining an otherwise precarious equilibrium. It stands on a conical hoof of bronze, differentiated from the rest of its long body by a slender waist, acquired by lucky chance in the process of casting. The open beak of previous types tapers into a flat plane, but is nevertheless still recognisable. The highly polished bronze surface mirrors light and reflects convex, contorted images.

Unlike its prototypes *Bird in Space* appears to defy gravity, soaring elegantly upwards, body and spirit in flight. The image of the bird, traditionally the symbol of life, peace, the soul, suited Brancusi's purposes: a deeply spiritual man and keen student of oriental mysticism he wished to convey in his work the struggle between body and soul, male and female, and express his humility before nature. This included a profound respect for the materials he used, working with rather than against nature and retaining the essential character of wood or stone. However, as a member of the Parisian avant-garde Brancusi could not help but be affected by the artistic endeavours of his associates in the form of the new languages of Cubism and Expressionism and the dizzy world of advancing science and technology. The slim, aerodynamic form of *Bird in Space* reflects the sculptor's avid interest in aeroplanes: while visiting the Paris Air Show with Duchamp and Léger in 1912 Brancusi expressed considerable admiration for one of the propellors he encountered. He consequently resolved to reproduce its grace and perfection of form.

Brancusi's majestic sculptures proved irresistible to Yeshwant Holkar, Maharajah of Indore, who purchased three versions—black marble, white marble, and bronze—of *Bird in Space* with the intention of building a Temple of Meditation in which to house them. On important days of the solar calendar, it was proposed, light would stream in through a ceiling window and illuminate the polished bronze bird. Brancusi submitted architectural plans for the building and even visited the Maharajah in India, but unfortunately the project came to nought. The Maharajah eventually gave the bronze *Bird in Space* to his ex-wife as a parting gift.

—Caroline Caygill

Georges Rouault (1871–1958)
The Old King, 1916–36
30¹/₄ × 21¹/₄ in. (76.8 × 54 cm.)
Pittsburgh, Carnegie Museum

The Old King is dated in a year filled with completed pictures. In June to October 1937, a large retrospective of 42 works was held at the Petit Palais, the first museum exhibition for the artist. Since the years 1932 to 1936 show but a handful of works, perhaps the exhibition inspired him to work at concluding pictures. Rouault was known to hold back pictures for years and release them as complete a long while after their initial start. Also dated 1937 is the *Christ in Profile* (private collection), to the right, and *The Passion,* to the left, the latter somewhat resembling *The Old King* with his body visible to about the elbow, though with a younger face. The use of the profile view, to either right or left, does not seem to relate in any consistent way to Rouault's feelings about his subject.

Profile views of characteristic types had begun to appear in Rouault's art about 1910. As if inspired by the *Human Comedy* of Balzac or the realist series of novels by Zola, Rouault presents social classes, the professions, the temperaments, grotesques to survey the whole of tragic humanity. (This sort of portrait almost ceased after 1937.) *The Jurist,* 1911, in left profile, presents so much of the body that there is little emphasis on the face, though it does seem to have satirical intent. In the rather nasty *Two Profiles,* 1910, the heads are shown with suits and collars. Christ's head appears full-face in several images of *Veronica's Veil* (*The Holy Face*), 1913. It also appears in at least one profile view, *Christ Mocked* (*Profile*), c. 1913; the way in which the darkened silhouette has been overlaid with brushed-in color produces a mild resemblance to *The Old King*. *The Manager* (*Hector*), 1914, faces right with very little shoulder visible so that full emphasis is on the face. With a sharp, aquiline nose (like that of *The Old King*) and mustached lips; the figure, though not entirely sympathetic, is one of the few Rouault images clearly portraying age: the character, as befitting the stiff and stern nature of a manager, faces the world full-frontally.

Nearer to the humble quietude of *The Old King* is *The Pierrot* (*Profile*), c. 1925 (private collection). The profile has again the aquiline nose, but he is younger, and the neck and head are longer. The strong black lines outlining the areas of color, so distinctive a feature of *The Old King,* became a fixture in Rouault's work from about 1917 (the date of *The Three Clowns,* Pulitzer Collection). It was about this time that Rouault signed a contract with the art dealer and publisher Vollard and began his involvement with intaglio printmaking, possibly an incentive for this use of strong outlines; his early work in stained glass might also have been a factor.

The Old King is unique to the body of Rouault's art. It contrasts with his rather sentimental use of clown and religious imagery in much of his art. The poignance of the mythic aura surrounding the humble, elderly figure is enhanced by the tiny floral bouquet. Though there is no "story" related to the figure, it suggests a legend, and perhaps evokes the memory of legends used in the work of his mentor, Gustave Moreau.

—Joshua Kind

Julio Gonzalez (1876–1942)
Woman Combing Her Hair, c. 1931
Iron; 51¹/₈ in. (130 cm.)
Paris, Beaubourg

Introduced to the abstracted female form as worthy subject matter by his friend Picasso, Julio Gonzalez created a number of welded iron sculptures during the 1930's based on the theme of a woman at her toilet. *Woman Combing Her Hair* appears in several different versions between 1931 and 1937, her changes in appearance signifying the changes in Gonzalez's stylistic development and treatment of the medium. The Pompidou sculpture is an ambitious prototype inspired by Picasso, with whom Gonzalez was then working, and naturally reflects the style and subject matter of Picasso's painting and sculpture. Uncharacteristically and undoubtedly in imitation of his mentor, Gonzalez produced a series of sketches of *Woman Combing Her Hair*, tracing the process of abstraction from reality to idea. However, while comparable to the forms that populate Picasso's canvases, the resulting sculpture bears little resemblance to the former's own work in the plastic medium: Picasso's sculptures refer constantly to the reality on which they are based, but Gonzalez creates objects that are first and foremost abstract in appearance and intention.

Most of Gonzalez's anthropomorphic sculptures aspire to life size, the graceful monumentality of the Pompidou statue setting a precedent for the later works. *Woman Combing Her Hair* stands on a low iron plinth, supported by two spindly rods that approximate to limbs, a curve, vestige of reality, implied in one of the legs. Similar references to the sculpture's organic origin can be discerned within this angular construction, but it remains nevertheless a non-representational object. A thin, crooked arm reaches from the torso to the head in a suggested combing action. The teeth of the comb may be suggested in the pincer forms that protrude from the insectile crown. Within the arc that indicates the head and spine is situated a rounded form, central to the composition, that implies simultaneously a breast, navel, hand-held mirror or even a fruit, reminiscent of early Greek votive statues. Gonzalez had undoubtedly reacted, like his artistic peers and predecessors, to the immense impact of primitive art; indeed, the sculpture's upright position and single, frontal viewpoint echo the statues of ancient Egypt and Greece, while Gonzalez's subject matter—that of ladies at leisure—suggests similarities with certain themes of Greek amphorae and Japanese woodcuts.

Concerned primarily with the exploration and manipulation of space, the Pompidou sculpture is among the first of Gonzalez's experiments on this theme. The spidery connecting bars of iron suggest a skeletal form, the bare bones of the statue, while space is here exploited as the flesh that surrounds them. Thus a new understanding of space as form is required. The later versions of *Woman Combing Her Hair* reveal the sculptor's mature conclusion to the spatial complexities of his medium. Gonzalez abandoned the rods and thin iron panels of *Maternity, Woman with a Basket* and the 1931 version of *Woman Combing Her Hair* for a more three-dimensional rendering of form: *Woman Combing Her Hair*, 1936, is solidly and boldly constructed, as fully, curvilinear forms are now translated unequivocally into sculpted metal and complemented by the frills of the adorned statue. Gone is the cara-

pace of Gonzalez's previous sculptural endeavours; instead, organically derived forms are perforated strategically to great visual and spatial effect and interact harmoniously from any angle.

—Caroline Caygill

Guernica is not Picasso's best painting; it is not innovative stylistically and is thematically too complex. Yet it may be considered his greatest work, surely his most famous and most-discussed "masterpiece," with all that this term implies. In the words of Kenneth Clark, "it is the record of a profound and prophetic experience . . . the work of an artist of genius who has been absorbed by the spirit of the time in a way that made this individual experience universal" (*What Is a Masterpiece,* 1979).

Guernica also is one of the rare commissions that Picasso fulfilled: for the Spanish Republic and its pavilion at the international exposition in Paris, in 1937, during the first year of the Spanish Civil War. Picasso in January had agreed to paint a mural-size canvas for the pavilion's entrance hall. Well aware of the long western tradition of heroic history painting, he knew what was expected of him: a political statement within the context of the civil war. He procrastinated. In late April, he focused on a favorite theme, the artist in his studio, in preliminary sketches for the pavilion, when he experienced that "profound and prophetic" event—the saturation bombing, on 26 April 1937, of the ancient capital of the Basques and cradle of Spanish democracy, Guernica.

The air attack by German pilots flying for General Franco was fully covered by the French press and radio. Picasso furiously began to work: six pencil sketches on May 1st; two pencil drawings and a large oil, the head of a screaming horse, and a detailed compositional study, all on May 2. A week later, he had several drawings of a mother with her dead child, and another compositional study. On 11 May, Dora Maar—an experienced photographer and Picasso's companion for the past year—recorded his outlines on the huge canvas.

Although Picasso continued to draw and paint related studies of the agonized women and the bull and horse, the actual work—major revisions in paint—was done from mid-May to early June on the large canvas. The main protagonists remained constant, true to the very first sketch: a woman with a lamp, illuminating the carnage, and the bull and horse. The animals obviously denote the bullfight, the national *fiesta* of Spain, but their precise meaning has been endlessly debated. In characteristic fashion, Picasso refused to explain and elucidate: "Sure, they're symbols. But it isn't up to the painter to create symbols; otherwise it would be better if he wrote them out in so many words instead of painting them. The public who look at the picture mùst see in the horse and the bull symbols which they interpret as they understand them." Visitors to the Spanish Pavilion in 1937, and to Madrid since 1981 surely identify the bull with the very spirit of Spain. Viewers familiar with Picasso's art also are well aware that the bullman, the Minotaur, became the artist's alter ego during the 1930's. And the horse, Picasso confessed, stood for the woman in his life; it is the quintessential victim. Its agonized scream is as poignant, on a more elemental level, as the mother weeping over her dead child.

This modern *pietà,* like a Crucifixion triptych, has its counterpart on the right, a woman hurtling down from a burning building—a specific reference to the fire bombing. Below, the monstrous foot of a fleeing woman is balanced, on the far left, by the large hand—lines of fate clearly marked—of a dead warrior, decapitated and transformed into a fallen statue. Two symbolic lights compete for the very center: a lamp with rays of sun or shrapnel bursts and shaped like an all-seeing eye with an electric bulb as pupil, and the old-fashioned oil lamp that a woman thrusts out of the window. More allegorical than realistic, she seeks to enlighten the world, to shed light and truth on this horrendous event. The four women thus are both fact and symbol, women victims and witnesses, historic archetypes.

One reason for *Guernica's* emotional impact is the fact that it resonates with allusions to art through the ages. Spanish critics first related *Guernica* and the political/satirical etchings that immediately preceded it, *Dream and Lie of Franco,* to Goya's *The Third of May 1808,* and *Disasters of War.* Others have thought of Poussin's and David's *Sabine Women,* Guido Reni's *Massacre of the Innocents,* Delacroix's *Liberty Leading the People,* François Rude's *Marseillaise,* on the Arc de Triomphe, and Frédéric Bartholdi's Statue of Liberty. Given his phenomenal visual memory, Picasso certainly was aware of these references, but to consider them as specific sources for *Guernica* is to oversimplify the creative process.

Guernica's pictorial style, however, immediately identifies it as a 20th-century statement, despite these allusions to older traditions and symbolism. Picasso's greatest innovations, the analytic and synthetic cubism and collage of the pre-war years and the 1920's, determine its pictorial idiom, its flat geometric shapes and overlapping transparencies. The pure Greek profiles of the figures and their painfully distorted bodies and wildly displaced eyes like teardrops derive from the two opposite tendencies of Picasso's art during the later 1920's and 1930's: neo-classicism and surrealism. On a more profound, private, and perhaps subconscious level, *Guernica* is indebted to Picasso's surrealist images, erotic bullfights, and Minotaurean phantasies, indeed owes its compositional schema to his great autobiographical etching, the *Minotauromachy* of 1935. Like these graphic works, *Guernica* is in stark black and white, with many shades of grey, even though color appeared in the preparatory studies and in bits of colored papers that Picasso pinned onto the canvas while he worked on it. The final painting, however, could only be in this stark monochrome, its subject matter too horrendous for the vitality and aesthetic distraction of color. One thinks, instead, of old newsreels, war documentaries, news photographs and reports—the body of the horse is even textured like newsprint.

Because Picasso was a refugee from Franco Spain, *Guernica* from 1939 to 1981 was "on extended loan" in the Museum of Modern Art in New York, where it inspired generations of American painters, from Jackson Pollock and his friends to the Pop artists. During the Vietnam conflict, it was again politicized as a recognizable peace symbol in posters and anti-war demonstrations. *Guernica* "returned" to Spain during the 100th anniversary of Picasso's birth, joyfully welcomed to Madrid as symbol of reconciliation, proof that the Spanish Civil War and the Franco era had finally ended. Beyond the specific bombing incident that it commemorates but does not depict, moreover, *Guernica* has become our 20th-century icon condemning barbarism and inhumanity throughout the world.

—Ellen C. Oppler

Fernand Léger (1881–1955)
The City, 1919
7 ft. 7 in × 9 ft. 9¹/₂ in. (231.1 × 298.5 cm.)
Philadelphia, Museum of Art

The City stands as a watershed in Fernand Léger's art and thought. The painting is the culmination of his Cubist formalism, the embodiment of his interest in the new urban landscape, and a sign of his increasing social concern. Léger's experiences during the First World War had changed his direction as an artist. From the isolation of the painter's studio, he had suddenly found himself in the trenches, surrounded by the common Frenchman:

During those four war years I was abruptly thrust into a reality which was both blinding and new. When I left Paris my style was thoroughly abstract: period of pictorial liberation. Suddenly, and without any break, I found myself on a level with the whole of the French people; my new companions in the Engineer Corps were miners, navvies, workers in metal and wood. Among them I discovered the French people. At the same time I was dazzled by the breech of a 75-millimetre gun which was standing uncovered in the sunlight: the magic of light on white metal. This was enough to make me forget the abstract art of 1912–13. A complete revelation to me, both as a man and as a painter. The exuberance, the variety, the humour, the perfection of certain types of men with whom I found myself; their exact sense of useful realities and of their timely application in the middle of this life-and-death drama into which we had been plunged. More than that: I found them poets, inventors of everyday poetic images—I am thinking of their colourful and adaptable use of slang. Once I had got my teeth into that sort of reality I never let go of objects again. (Quoted in Cooper, 1949.)

Preoccupied with objects, particularly with those that were precise, clear, and definite—characteristics he attributed to machine forms and mass-produced items—Léger began to present images in his art that had an intrinsic beauty, which had neither sentimental nor descriptive value. In contrast to his contemporaries, he saw artistic significance in the bold designs and bright colors of posters and billboards, in the movements of advertisements on passing vehicles, in the wires of electrical transmission towers, and in the flashing lights on the streets. All of these elements, combined with the common man who lived in this new industrialized environment, emerged as his subject matter. Léger became a painter of modern life as seen rather than as felt, finding beauty in the unpicturesque aspects of the urban landscape.

Shown in the Salon des Indépendants of February 1920, *The City* with its large scale marks Léger's most ambitious attempt to that date of declaring his return to subject matter. The picture gathers disparate elements and images developed in works such as *The Disks*, 1918, and *Follow the Arrow*, 1919. With its themes of modernity, the machine, the street, and the worker, it also establishes a precedent for later works such as *The Constructors*, 1950, and *The Great Parade*, 1954. The painting summarizes his interest in Synthetic Cubism. The overlapping, strongly colored planes are opaque; they collide, but never interpenetrate. Using no chiaroscuro or modulation of hue, Léger staggered the planes to suggest depth by assigning spatial value to these flat areas. The colors, incorporated into the geometric design, enhance the plastic activity without being bound to an object in a descriptive manner. With white animating the spaces between the zones of red, yellow, blue, green, and black, the disconnected quality of the color areas creates an overall dynamic tension and sense of movement that conveys a sense of the city's pace.

Glimpses of urban images, which are neither illustrative nor narrative, are interlaced with the formal elements to suggest the movement of a spectator through the cityscape. The flash of a light, the partial letters of a sign, a staircase, a derrick—all seen as a staccato rhythm—create a pictorial immediacy akin to a cinematic experience. Amidst these vibrant forms and colors are the robistic city men. Gray from head to toe, featureless, these humans are less vital than their environment. Léger's renunciation of traditional humanistic values and his association of the figure with mechanical elements is a recurrent motif in his art. Man is another cog in the great machine of modernity; he is also a partner in the process of its creation.

The City both summarized the past and looked toward the future. It may well be considered the masterpiece of Léger's career.

—Jennifer Gibson

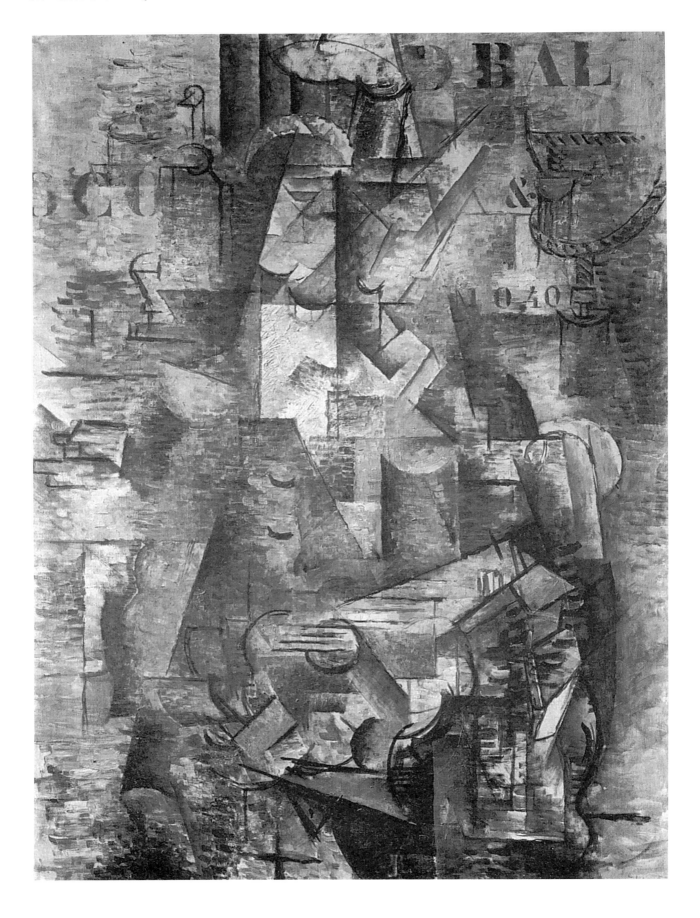

Georges Braque (1882–1963)
Le Portugais (*The Portuguese Man*), 1911
46 × 32 in. (117 × 81.5 cm.)
Basel, Kunstmuseum

Although there is some dispute over who actually painted the first recognisably cubist picture, there can be no doubt that Picasso and Braque were the two artists who "invented" the style. Between 1909 and 1914 they spent virtually every day together, "like two mountaineers roped together," developing cubism from an antagonistic stylistic trait into an ordered and disciplined artistic movement. *Le Portugais* was painted during this period of collaboration.

Braque had been much influenced by the work of Cezanne and his use of geometric shapes to describe the world around him. In the five years before he painted *Le Portugais* Braque had been experimenting with geometric forms as vehicles of description. Still lives, landscapes, and nudes had all been given the "cubist" treatment. Classical notions of representation and proportion had been substituted by a rigid angular style, where form and construction took place over careful rendering of an immediately recognisable image. *Le Portugais* is an example of the "analytical" stage of cubism where use of geometrical shapes was coupled with a desire to give a total and complete image, a desire that went beyond an attempt to show what is seen towards a description of what really exists.

Braque was preoccupied with the desire to show the objective truths of everyday objects. As a cubist he hoped to create an iconography that would be read as a complete and objective view. The image of the Portuguese man is fragmented and distorted so that the viewer will read beyond a simple depiction, perhaps gaining some insight into the various images created, by the same subject, in the real world. Braque hoped that the recreation of an image in a pattern of shape and implied movement would give insight into the true nature and property of his subject, an insight that would not be blurred by time, nor clouded by subjective recognition.

Le Portugais shows the very geometric visual language that the painter used in his work at this time. Description is reduced to straight lines and curves; solid rounded shapes are depicted as flat linear planes. No attempt is made to deceive the viewer into believing that he or she is looking at a real man. This is an image that must be "read" rather than "recognised." To find the subject the viewer must ignore any notion of nature imitated and recognise the rigid descriptive language used in this work. Where a sloping L shape is seen to echo the image of a bent arm, it must be read as a bent arm. Where four parallel lines resemble the strings of a guitar, they must be read as guitar strings. In this way the viewer builds up a total image of the seated man holding a guitar.

Le Portugais is concerned with the analysis of forms and their interaction in space. Colour is reduced to a homogeneous, rather dull tone, so that it will not distract the eye from the central theme of form in movement. Several sources of light are used to highlight forms that require or necessitate particular study, while the actual application of the paint is done in short small dashes so that a form may be built up. As a central feature form, spreading across the canvas, is reduced to the simplest and most descriptive elements of line and curve.

Looking at this picture the viewer gets an immediate impression of a pattern of two-dimensional planes suspended in space. The artist would have argued that this is an articulated object rendered in its purest, and therefore most descriptive form. The portrait of the seated figure, probably taken from Corot, is redefined in terms that do not allow for any form of subjective recognition. All the elements are there to be seen. The fact that these elements have to be read and deciphered only makes the final image all the more absolute and complete. This was Braque's intent.

Le Portugais marks Braque's first use of letters and numbers in his work. Although he had a natural tendency to mystify, the letters "BAL" and number "1040" are introduced as an evocation of the real world, designed to guide the viewer into the picture. In effect, these symbols are immediately recognisable pointers that will encourage the viewer to inspect the canvas, an inspection that will reveal less overt symbols and passages within the painting. These letters and numbers also serve a decorative role in the overall pattern of the painting, while re-emphasising the two-dimensional quality of the image. This is a devise that Braque used in several of his works including *Nature morte avec partitian*, painted in 1912. (Picasso also used this technique with a slightly different emphasis.)

In this period of his long career as a painter, Braque was concentrating on the nature of objects in space, and the least ambiguous ways of depicting objects as they are seen outside the confines of a canvas. *Le Portugais* displays an attempt to create an idea on canvas. Reacting against the uncertainty of Impressionism and the colourful chaos of the Fauves, Braque was forced to use an almost mathematical approach, but an approach that he felt would lead to a clearer understanding of how the eye perceives objects in the real world. Analytical cubism was a style that involved the viewer in an exchange of ideas and images, an exchange that recognised, indeed emphasised, the two-dimensional quality of a canvas, while making an attempt to create an idea or feeling of three dimensional objects.

The style of *Le Portugais* should not be confused with abstract art. Braque was looking to approach his subject as closely as possible, so that he could convey the living experience of that subject. In pursuit of "new space" the artist created an image which although difficult to comprehend must be recognised as an analytical rearrangement rather than an abstraction.

—Rupert Walder

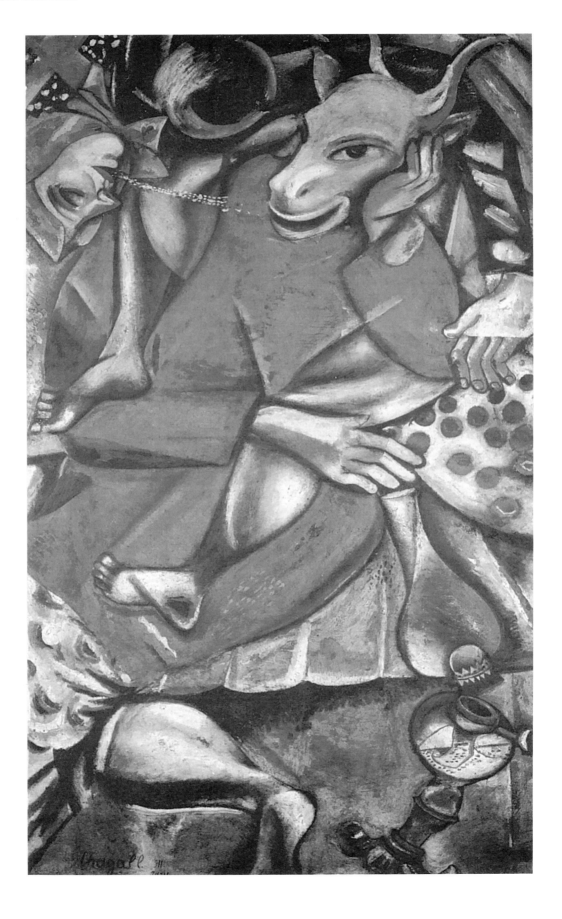

Marc Chagall (1887–1985)
Dedicated to My Fiancée, 1911
10 ft. 2³/₄ in. × 4 ft. 4¹/₈ in. (312 × 132.5 cm.)
Berne, Kunstmuseum

Dedicated to My Fiancée belongs to the period immediately after Chagall's arrival in Paris from Russia and his first encounter with the mainstream of modern European painting and with Cubism. Chagall's own account of his rapid acquaintance with the real centres of energy of modernism in 1910 is characteristic: straight off the train on arrival in Paris, he made his way to the Salon des Indépendants. According to Franz Meyer, Chagall's account (in *My Life*) cannot have been factually correct, but the warning is unnecessary, because what follows is clearly a metaphor. Ignoring a friend's advice that the exhibition was too bewildering and exhausting to visit in a single day, Chagall writes: "Pitying him from the bottom of my heart, and following my own method, I raced through all the first rooms as if a flood were behind me, and made straight for the central rooms. In this way I saved my energy. I made my way to the very heart of French painting of 1910."

What he found in the "central rooms," so to speak, was not any particular "style" of painting, but a new approach to structure: the capacity both to collapse the boundaries that hold objects apart and to dismantle entitles given as monolithic wholes. Cubism, with its fragmenting and unifying geometry, radically broke up and recombined the familiar and the known. It attacked that "immobility of objects" which, as Proust wrote, is "conferred on them by the immobility of our conceptions of them." It had the capacity to "disassemble the thinkable parts" of the world, to use Leo Steinberg's phrase.

Dedicated to My Fiancée demonstrates the enabling power Cubism exerted over the huge thought-provoking themes of Chagall's earlier painting. But, although the painting is concerned with "love," what it expresses cannot be singled out or detached as a separate subject, theme, or debating point, but depends on a mutual relation between different aspects of image and medium. It was characteristic of Chagall's painting even before his arrival in Paris that it depended on relationships of contrast between individualised pairs of images acting as counterparts. The contrasts of a lit indoor space and a nocturnal outdoor space, the human being and the animal, man and woman, up and down as points of orientation for a rational, stable, vertical "right-side-up" sense of balance, as opposed to a irrational, tilting, diagonal "up-side-down" loss of balance, had made their appearance in Chagall's earlier

paintings and constitute some of the main divisions in Chagall's world. *Dedicated to My Fiancée* takes up these mutual relationships and acts as the culmination of their development through a sequence of paintings of 1911.

In an earlier painting of that year, *The Yellow Room,* some of these images have crossed over into their opposites. A cow, and perhaps all that animal nature implies in terms of those things which we would like to see kept outside and elsewhere, has settled itself firmly within a room. And it seems, as a result, the whole painting, in an apparently contradictory way, is stabilized on the tilting, irrational basis of the diagonal. There is a night landscape visible through the open door of the room, and the animal, because of its own dark, nocturnal appearance, seems to be identified with this. The man and woman and the furniture of the room have been knocked sideways. In *Interior 11,* 1911, the sexual theme is more strongly developed: the night animal now has horns, the lamp is falling over, and there is the diagonal rush of the girl mounting the bearded man. But in *Dedicated to My Fiancée* the same pairs of opposites have been radically restructured. The conceptual categories of male/female, figure/ground, inside/outside, human/animal have been broken down under the influence of Cubism, and this also results in a bursting open of the separate compartments in which our thinking about these qualities is held. For example, Chagall has merged images together so that opposites share the same meaning, and the qualities and contrasts of thinking of this sequence of paintings have now become so fused together that their roles alter. In this painting, based on diagonals and a sense of shattered equilibrium, the man has lost his human head and *become* the animal. The woman in black with one moon-like breast has become the night. But the man and woman have also been broken up and re-combined in order to become one image. They are now joined in such a way that the image is not primarily a sexual one—that would have confirmed the relation between the designated roles of man and woman—but one that suggests an ecstatic combination of the qualities and powers belonging to each within a single whole. This wholeness created by the painting is one which our consciousness of the given sexual roles of man and woman tends to keep split apart.

—Martha Kapos

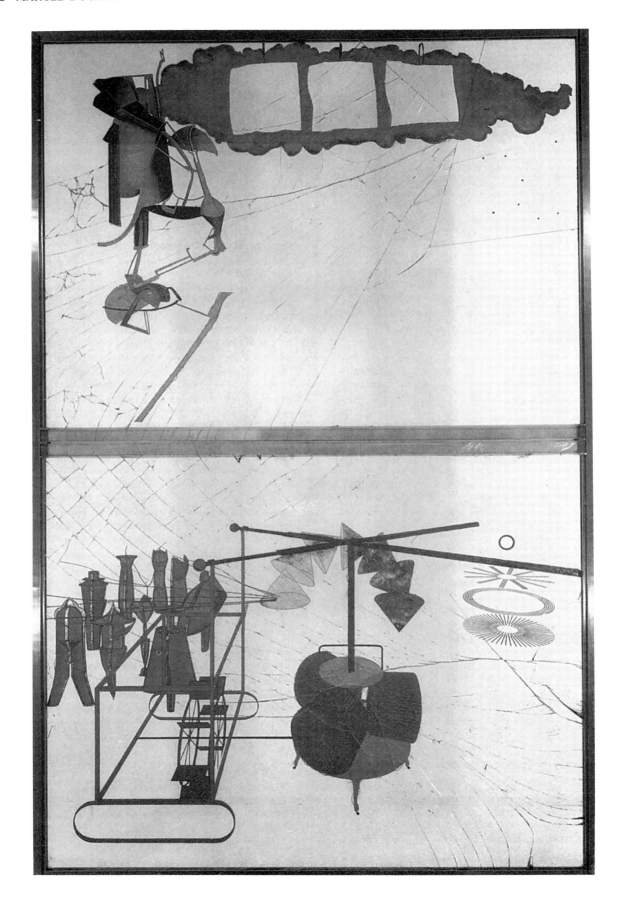

Marcel Duchamp (1887-1968)
The Bride Stripped Bare by Her Bachelors, Even (Large Glass), 1915–23
Oil and lead wire on glass; 9 ft. 1 in. × 5 ft. 9 in. (277.6 × 175.6 cm.)
Philadelphia, Museum of Art

Bibliography—

Hamilton, Richard, *The Bride Stripped Bare by Her Bachelors Even,* London, 1960.

Hamilton, Richard, *The Bride Stripped Bare by Her Bachelors Even Again,* Newcastle-upon-Tyne, 1966.

Golding, John, *Duchamp: The Bride Stripped Bare by Her Bachelors, Even,* London, 1972; New York, 1973.

Steefel, Lawrence D., *The Position of Duchamp's Glass in the Development of His Art,* New York, 1977.

Adcock, Craig E., *Duchamp's Notes from the Large Glass: An N-Dimensional Analysis,* Frankfurt, 1983.

Bonk, Ecke, *Duchamp: La Boite en valise,* London, 1988; as *Duchamp: Box in a Valise,* New York, 1989.

The Bride Stripped Bare by Her Bachelors may not be as famous as Duchamp's urinal or his depiction of the Mona Lisa with a moustache, but this bizarre sculpture occupied the artist's attention for almost nine years between 1915 and 1923. Hundreds of sketches and designs survive of every element of the whole, from tiny doodles to full scale drawings. Two collections of notes were published to accompany the work ("The Box" of 1914 and "Green Box" of 1917), and the artist was never at a loss for words to describe the development of the construction process that preoccupied him for so long.

However, despite this thorough documentation, *The Bride* (or *Large Glass*) is not an easily accessible work. It is not immediately aesthetically pleasing. It is not constructed in familiar artistic mediums of canvas and oil or wood or stone, and the notes are so full of extraordinary sexual and mechanical allegory that they do little to make the work easier to "understand" or "appreciate." Nonetheless, to dismiss the work as the product of a deranged or unartistic mind would be to miss the point of the Dadaists in general and of Marcel Duchamp in particular.

Marcel Duchamp was an enormously influential theorist in his day, and many of his ideas and standards have been taken up by later artists, e.g., Joseph Beuys, Jasper Johns and Richard Hamilton. His was a very deliberate antagonistic and anarchic approach. His readymades were designed to question any traditional view of what should be recognised as art, and his whole life was devoted to expanding the expectations of an audience he largely despised or mocked. In the unfolding story of modern art Marcel Duchamp was one of loudest and most aggressive narrators.

The Bride is a culmination of Duchamp's approach to art. It might be described as a dictionary of his ideas, extraordinary not least because he claimed to have left so much of the final construction process to chance. The smashed face of the glass is the result of an accident in transportation that Duchamp chose to leave unreplaced as a final testament to the importance of chance in the creative process.

The actual piece stands about nine foot high and six foot wide. It is divided into two sections or "domains." The upper domain is the "Bride's Domain" and the lower section is the "Bachelors Apparatus," the two in continual frustration at their distinction and separation from each other. Many of the elements that make up these two domains are reworkings of Duchamp's earlier experiments with strange and ultimately useless "machines" or apparatuses. In effect, *The Bride* is a sandwich, between plates of glass, of wire and metal objects that evoke but do not explain. Preoccupied with the process of invention that could be described as coming from the self or imagination, rather than from that which surrounds us, Duchamp maintains his stature as an artist, not in the appearance of the final object, but by taking part in the creative and physical process that leads to the final object. Late in life the artist claimed to be interested only in ideas and not in visual products. Taking an artisan's approach, so that any notion of aesthetic may be dismissed, Duchamp invents for the sake of invention; he names and identifies elements to encourage the viewer to look beyond that which faces him.

Duchamp would argue that his images of sex and machine are both topical and all-pervasive. Every element serves as a strange piece of a frustrating but everlasting mechanical masturbation. The bride is stripped bare but will never be penetrated by the seething mass of mechanical phallic constructs below her. To name every element that is part of this sexual jigsaw is to delve deeper into the will of the artist to mystify but entice.

Bride Stripped Bare by Her Bachelors, Even might be described as a futurist work because it glorifies mechanical and "moving" images. It can be described as surrealistic in character because the overtone is of strange and imagined sexual practise. It is Dada because it cannot be approached as we would approach classical pieces of art. It asks that we, the viewer recognise and enjoy the confines of the experience.

Marcel Duchamp is an evocative character. The reactionary feel that his work is not art at all and that he only proved his inability to "paint a beautiful landscape" with his continual and bizarre output. The converted feel that Duchamp had an enlightened view of that which should be ridiculed and vilified. Whatever camp the critic of *The Bride* falls into, it will always generate comment and reaction, as a remarkably personal and evocative statement.

—Rupert Walder

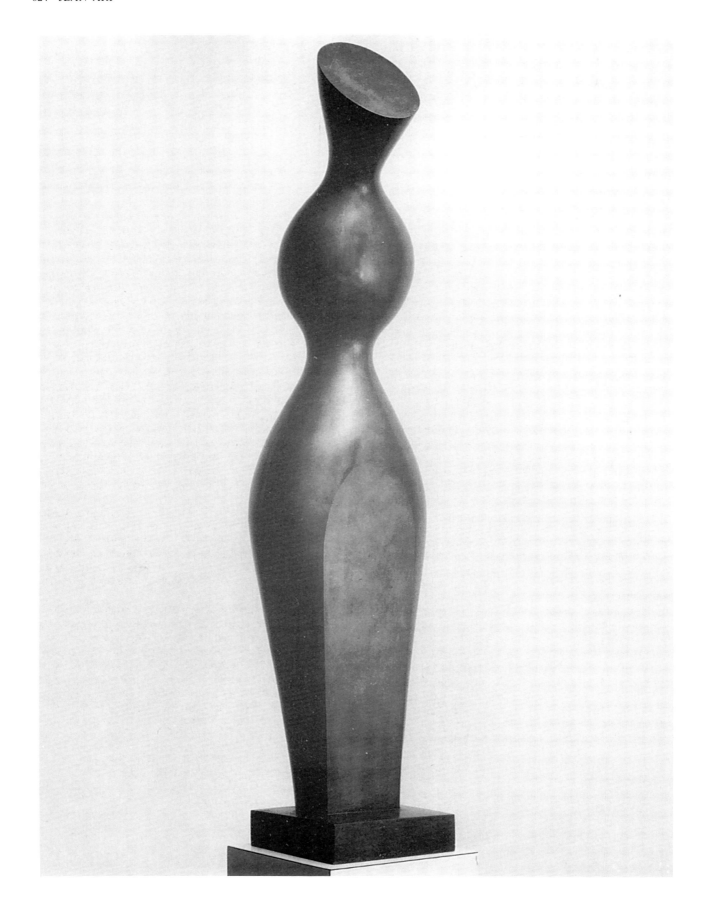

Jean Arp (1887–1966)
Femme Amphore, 1962
Bronze, 41³/₄ in. (105.9 cm.)
New York, Sydney James Gallery

It was very nearly the case that Jean Arp devoted his life to poetry instead of art after a conventional art education—"the everlasting copying of stuffed birds and withered plants"—left the young Arp almost entirely disillusioned with the visual arts. His eventual return to sculpture required a process of unlearning which he has since described as a search for his "natural" ability which began by experimenting with free forms and a return to first principles. Arp's early explorations of the possibility of organic shapes soon developed into a lifetime's study. *Femme Amphore* is one of the fruits of these studies and it possesses many characteristic qualities, at once immediate and mysterious, intimate and other worldly.

In 1930, at the age of 43, Arp committed himself to the production of sculpture in the round after an already successful career working with a variety of media including collage and relief. He soon began working with marble and bronze, finding new avenues of artistic expression using the traditional sculptural methods of carving and modelling. *Femme Amphore* is cast in bronze and shows Arp as a mature sculptor of three-dimensional work and as an artist who still finds interest in the human form.

Arp has been associated with many of the major artistic movements of the 20th century and his mature work can be seen as a synthesis of many of the artistic explorations carried out in the last 100 years. He was a founder member of the Zurich Dadaists and a great supporter of their attempt to teach man to "dream with his eyes open." The Surrealist movement gave Arp's work an organic, poetic quality, and constructive abstraction allowed him to explore fully the formal possibilities in his work. Arp's personal contribution to these various artistic groups is certainly significant but he emerged as an entirely independent artist, transcending the limitations of any individual art movement. In *Femme Amphore* organic and geometric forms are brought into a synthesis and cohesion that Arp has become the master of.

In his writings Arp has often used metaphors relating to nature and natural growth to describe his artistic methods and intentions. One sculpture entitled *Stone Formed by Human Hand* suggests the intimate—and seemingly "natural"—relationship that exists between the sculptor and his medium. Even when using bronze, as in *Femme Amphore,* Arp imbues the subject with a fluidity of form that seems to defy its metal shell. Forms are represented as part of an ongoing process of metamorphoses: "From a sailing cloud a leaf emerges to the surface. The leaf changes into a torso. The torso changes into a vase. An immense naval appears. It grows, it becomes larger and larger." Arp uses sculpture to confound the stability of solid mass and presents all objects as if in a state of flux.

Arp situates man firmly within nature, and his studies of human form such as *Femme Amphore* treat the human body as a natural form. As Arp writes, "my reliefs and sculptures fit naturally into nature." Yet although his sculptures do seem to conjure up a forgotten language of forms that is still present in the natural world, they are forms entirely independent of those to be found literally in the world around us. In his hands they are liberated from detail and particularity and become a sort of universal form.

Arp is often inspired by plain, everyday objects such as moustaches or eggs. When he does depict the human body it is inevitably the torso which recalls the primitive archetype of the human form. Arp's torsos are not fragments of something that should be a whole; they are complete and independent forms. If we look at *Femme Amphore,* for instance, it is clear that there is nothing missing.

Through his sculptures Arp expresses a symbolic language, exploring the relationship in space of planes and volumes. As Max Ernst has said, "Arp's hypnotic language takes us back to a lost paradise, to cosmic secrets, and teaches us to understand the language of the universe." Like primitive forms buried deep into our sub conscious, Arp's scultptures are resurrected into our modern sensibilities. They have a touching symplicity, a calm beauty, and a poetic serenity that speak to us all.

—Lauretta Reynolds

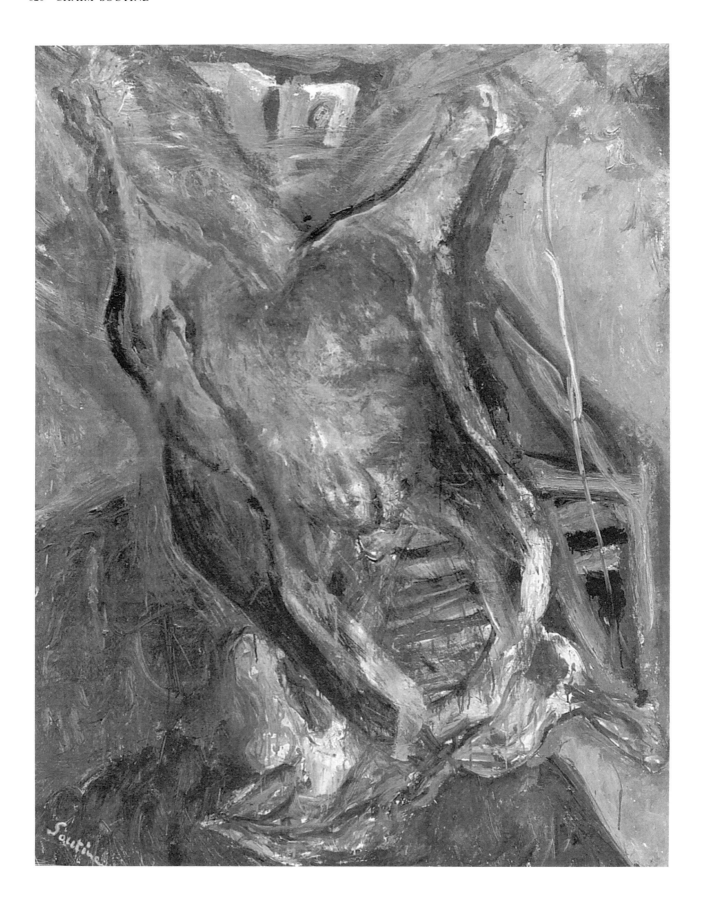

Chaim Soutine (1893–1943)
Carcass of Beef, c. 1925
55¹/₄ × 42³/₈ in. (141 × 107.6 cm.)
Buffalo, Albright-Knox

In the mid-1920's Soutine produced a large number of still-life paintings, a genre, mysteriously enough, to which he would not return. Still life is among his earliest surviving works, already an index of his personal shyness and the repressed autobiography of his art. As fervid as his images appear, so was his lifelong search for subject matter. A telling remark by his boyhood friend Kikoine speaks of Soutine's growing up in the Jewish ghetto and the effect of the almost complete absense of visual tradition there. Soutine always had to have the immediate presence of objects and sitters to move his self-doubt to creative action—and then his focus was so undeviating that compositional pattern mattered little if at all. His fabled attack upon the canvas, most often pinned to a wall and later trimmed to fit its image, was a Hassidic rhapsody.

The *Carcass of Beef* is one of a set of four such paintings which display the dead animals of the butcher shop. He had long been familiar with such subject matter. Although the earliest surviving image of this motif, *The Side of Beef* (Colin Collection), is from c. 1923, it is known that while Soutine lived in La Ruche from 1913 to 1919, slaughterhouse employees brought him pieces of meat as still-life objects. Also, he had painted a *Still Life with Red Meat,* c. 1924 (Levy Collection), in which a slab of bright red meat rests upon a table top, and from the same year there is the *Calf and Red Curtains* (Vandervelde Collection). But the immediate inspiration for the *Carcass of Beef* apparently arises from Soutine's deep feeling for Rembrandt. He had already fallen under the spell of Chardin's *Still Life with Rayfish,* and had painted at least three variants of the work in which the humanoid facial character of the suspended ray—like that of the *Hanging Fowl* of the following years—is the foremost quality. And Soutine must have seen Rembrandt's *Beef Carcass,* 1655, at the Louvre.

At least four works resulted in 1925 which Soutine felt, perhaps because of their size as much as their subject and treatment, were his masterpieces. The smallest of the set (45 x 31 inches, Minneapolis) is also least like the carcass in the Rembrandt: here Soutine shows it frontally, in the canvas center, and like the rayfish series of the previous year and the hanging fowl series in the following year, there is a strong anthropomorphic resonance as the lower legs hang clear of the body cavity. Next larger (55 x 42 inches), the Buffalo painting is also little like Rembrandt's: the body cavity is shown with little detail, and the meat is displayed at a sharp diagonal across the canvas from upper left to lower right. The wash of paint here includes, rare for Soutine, downward paint drips, especially visible in the lower half of the image. As in the other three works, the radiant blue rear ground is also marked by black linear markings vaguely recalling the apparatus upon which the actual beef carcass was placed in Soutine's studio.

The two other paintings of this set are closer to the Rembrandt in their verticality, the beef appearing in them as if slung. One of them is the largest work known by Soutine (84 x 47 inches, Grenoble); the other (65 x 47 inches) is at the Stedelijk Museum in Amsterdam. The impasto in both is extensive and fits in with the clear display of viscera in the upper body cavity.

Despite the extraordinary vigor of these and other such still lifes, some have argued that they are emblems of morbidity and decay. If they are melancholy, in Soutine's innocent yet deeply troubled understanding of their emblematic force, they do not appear morbid. It is not by chance that Chardin, Rembrandt, and Courbet excited Soutine—all were compelled by the vividness of paint which transmuted mortal and organic matter to another plane, in which the organic pulse somehow survived the transfer. In *Soutine et son temps* (1955) by his friend Emil Szittya, the artist is quoted: " 'Once I saw the village butcher slice the neck of a bird and drain the blood out of it. I wanted to cry out but his joyful expression caught the sound in my throat.' Soutine patted his throat and continued. 'This cry, I always feel it there. When as a chid, I drew a crude portrait of my professor, I tried to rid myself of this cry, but in vain. When I painted the beef carcass it was still this cry that I wanted to liberate. I have still not succeeded.' "

—Joshua Kind

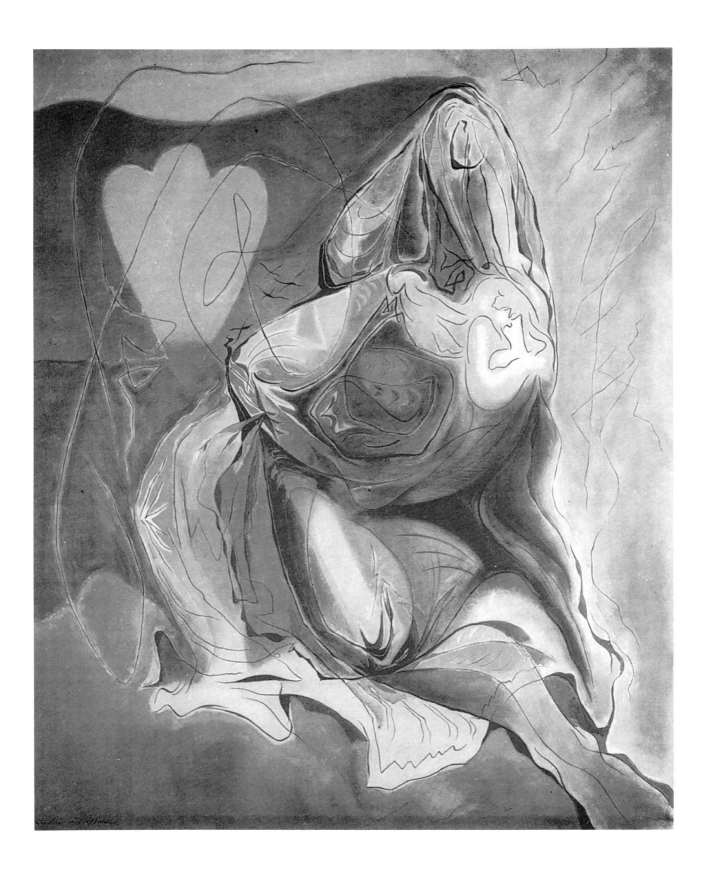

André Masson (1896–1987)
Niobé, 1947
70 × 55 in. (180 × 140.3 cm.)
Lyons, Musée des Beaux-Arts

Niobé is among the last of André Masson's paintings of 1946–47 utilizing Greek mythology as its subject. It is one of several paintings which reflect a direct attempt to express the suffering of the Second World War, a theme Masson took up with his return to France in 1945. Masson began painting *Niobé* at the end of 1946, only finishing it the following year, a moment of crisis for him in which he sought a new direction in painting.

While utilizing classical mythology Masson was keen to avoid the obvious temptation to mimic historical painting. *Niobé* employs Masson's own pictorial vocabulary in an attempt to depict a heroic subject. While it fails in some respects, due to its almost impressionistic qualities, *Niobé* is nevertheless a poignant symbol of the suffering of women and children in the War. It is based on the legend of the queen of Thebes, who cried until she turned to stone because Apollo and Diane had killed her seven sons and daughters.

Masson's choice of Niobé as emblematic of the suffering of France justifies his recourse to myth, with the larger-than-life implications of such subject matter. In 1946 he published the article "Tragic Painting" in the review *Les Temps modernes,* edited by his friend, the philosopher Jean Paul Santre, in which Masson condemned superficial attempts to capture the heroic and tragic. There he wrote, "It is in his own depths, in an awareness, at the moment of his forlorness and of his responsibility toward the other, it is in the certitude of the precariousness of existence and in the continuous cohabitation with emptiness, that today's artist will come to find the authentic expression of his life." *Niobé* captures something of the post-war "existentialist" sentiment in placing human suffering irreconcilably in the face of the tragic forces of destruction.

The large format of this painting accentuates Masson's exploration of heroic emotions. The central figure of Niobé sits madonna-like cradling the corpse of one of her dead children. Masson has given Niobé an almost stony solidity, a feature which contrasts with the schematic and curving linear shapes, seemingly floating in space above her, and evocatively symbolizing the angst of death. Dominating the stylized indications of landscape, Masson has carefully placed this drama in the foreground of the picture, endowing it with the impression of monumentality.

Niobé is a culmination of Masson's preoccupation with myth; afterward he explored a more calligraphic technique of primary mark making, a development which reveals his interest in Impressionism at the time. While *Niobé* preserves the use of a coherent space and figurative draughtmanship, the linear network which forms the central figure points toward Masson's new direction. His choice of a brightly colored palette of green, orange and yellow, combine with the heightened emotion and spatial composition, to give a complex effect at once decorative and baroque. This aspect of *Niobé* is not without importance to the more purely decorative and impressionistic works of 1949.

Following the War Masson gravitated toward Jean Paul Sartre's review *Les Temps modernes* and toward Georges Bataille's *Critique,* although all the while pursuing a direction fundamentally rooted in the Surrealism in which he had previously participated. In 1947 he was included in the exhibition *Le Surréalisme en 1947,* held at the Galerie Maeght, although he did not actively participate. *Niobé* certainly was related to the French experience of the German occupation of Paris, although Masson was abroad during those years. Caroline Lanchner has noted that, in 1945, Masson illustrated Georges Duthuit's poem on the occupation, *Le Serpent dans la galère,* which makes reference to Niobé. Indeed, in 1945 Masson first considered the theme of Niobé in a drawing which contains most of the elements of the central figure composition: the weeping Niobé cradling her dead child in a tragic embrace, brilliantly rendered in a series of quickly applied brush strokes of ink. While Masson followed such post-war trends as Existentialism, he sought a truly liberated painting in his own artistic pursuits, which lead him away from such classical subjects toward a more abstract, almost writing style. Automatism was to reemerge as a viable direction for Masson.

Masson painted *Niobé* in 1946–47 and it first belonged to his representative, the Galerie Louise Leiris (the new name of Kahnweiler's gallery; Louise Leiris was Kahnweiler's sister-in-law and was married to Masson's friend, the writer Michel Leiris). It was exhibited at the Kunsthalle, Basle, in 1950 alongside the sculptures of Alberto Giacometti. In 1962 it was sold by Sotheby's at auction and subsequently it entered the Musée des Beaux Arts, Lyons. In 1977 it was included in Masson's large retrospective exhibition at the Grand Palais, Paris, and the Museum of Modern Art, New York.

—William Jeffett

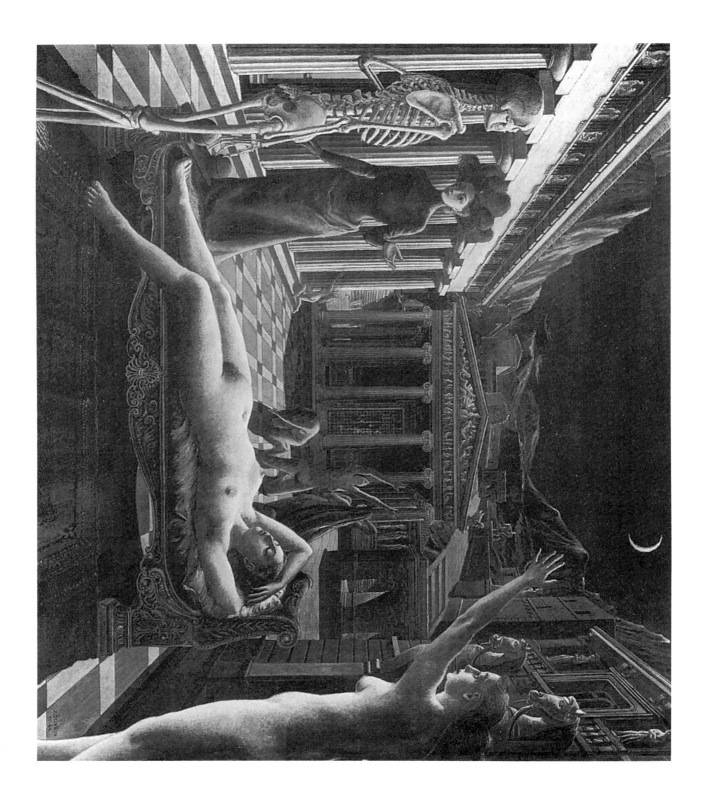

Paul Delvaux (1897–)
Sleeping Venus, 1944
5 ft. 8¹/₈ in. × 6 ft. 6³/₈ in. (173 × 199 cm.)
London, Tate

Sleeping Venus offers a particularly fine demonstration of Delvaux's art in that the tensions and ambiguities of the picture's theme are visually re-enacted in the painting's formal and iconic structure—and in the viewer's complex response to them. All great paintings, of course, work in this way to a greater or lesser extent. Delvaux's achievement here, as in his other works of this period, is to have adapted a relatively conventional, even academic, visual vocabulary (one which his early training had thoroughly imbued him)—to disturbing, *surrealist* effect.

The theme of this picture, as has often been pointed out, is that of Death and the Maiden, but it has been enlarged to include the question—much posed by 19th-century art critics interrogating academic painting—of what sleeping or fantasizing nudes dream of. The answer Delvaux proposes here in pictorial terms is, not surprisingly, ambiguous, even paradoxical: it illuminates both the Freudian concept of the hidden relationship between Eros and Death, and the surrealist notion of *convulsive beauty,* a beauty that is both alluring and repellent. For here the dream is of Death, or of seduction by Death.

In Delvaux's painting, Death's presence is greeted with quiet acquiescence both by the mannequin in Edwardian dress on the left of the picture, whose stiff gestures indicate the availability of the sleeping woman, and by the Venus herself, whose opened legs invite the skeleton's embrace. But this dreamy passivity causes consternation among the awakened maidens depicted in the scene who represent, no doubt, the consciousness of the presently sleeping Venus. As in most of Delvaux's paintings (as André Breton had already observed in 1941), the female roles all tended to be played by the *same* woman, so that the naked doubles lamenting in the middleground, the outraged beauty in the right foreground, the fleeing woman in the distance, and even the dummy itself all embody aspects of the central figure. So, of course, chillingly, does the skeleton itself.

The fundamental identity of the disparate figures of the painting is underlined—despite the apparent difference of their state or mood—by *pictorial* parallels or symmetries. So, for example, the stance of the maiden standing in the right foreground is similar to that of the skeleton on the left, except for the former's raised arm. It is notable also that the pose of the dummy offers a mirror image of that of the skeleton, each having one arm lowered with hand open, the other arm bent at the elbow. But whereas the dummy seems to stare sightlessly out of the picture towards the viewer, the skeleton looks into the picture towards the crescent moon, the main source of light. The latter image is a kind of visual pun. Its sickle-like form reminds us of conventional representations of Death as a skeleton wielding a scythe, and here its eerie light seems to shine with particular brilliance on the skeleton's bony form. The masculine presences depicted (the horseman and the Greek hero in the right background) are both distant and inani-

mate (both are of stone) and are, thus, unable to fend off the imminent approach of Death. The classical temples surrounding the scene of action, likewise, offer scant hope of asylum: the naked blonde in the corner of the square appeals in vain for succour from the phallic Doric pillars which seem to deny the protective gestures adopted by the figures depicted in the temple's frieze. Even the two nudes which hover angelically in the distant sky offer little reassurance.

In this way, Delvaux sets up a complicated visual syntax in which the principles of identity and contradiction—on both thematic and formal levels—combine simultaneously to bewilder and entice the viewer. The eye of the latter is drawn round the picture, seeking, like the protagonists represented in it, an escape from the threatening presence of Death. But the observer is also led to interrogate and explore more objectively and dispassionately the complex iconography of the picture in an attempt to arrive at a coherent "reading" of its theme. But the tensions Delvaux has instituted between the conventional *points de repère* on which we, as "readers" of pictures, generally rely, make it difficult for us to arrive at ultimate conclusions. But this is as Art—and especially Surrealist Art—would have it. For the tension between nude and clothed, classical and modern, dead and alive, stone and flesh, the familiar and the bizarre, the "real" and the oneiric, the erotic and the macabre—are precisely those which create excitement and ambiguity, provoke fantasy and doubt, plunge us into the surreality of the dream world.

Delvaux's own comments of *Sleeping Venus* are illuminating here. The picture was painted in 1944 when Brussels, where the artist was living, was being attacked by German flying bombs: Death was about to possess the sleeping city, whose unprotected squares and arcades seemed almost to invite attack:

It is my belief that, perhaps unconsciously, I have put into the subject of this picture a certain mysterious and intangible disquiet—the classical town, its temples lit by the moon, with, on the right, a strange building with horses' heads which I took from the old Royal Circus at Brussels, some figures in agitation with, as a contrast, this calm sleeping Venus, watched over by a black dressmaker's dummy and a skeleton. I tried in this picture for contrast and mystery. It must be added that the psychology of the moment was very exceptional, full of drama and anguish.

This does not mean that we must read Delvaux's picture as an allegory of the war but merely that a knowledge of the complex mood of the artist at this time enhances our awareness of the tensions that make *Sleeping Venus* such a compelling and infinitely suggestive work.

—David Scott

Yves Tanguy (1900–55)
Indefinite Divisibility, 1942
40 × 35 in. (101.6 × 88.9 cm.)
Buffalo, Albright-Knox

Indefinite Divisibility (1942) was painted not long after Tanguy moved to America. It is a painting which reveals little overt impact of the transition from Europe to the countryside of Connecticut. In 1940 Tanguy had travelled throughout the western states, where he was struck by the similarity of his paintings to rock formations. Tanguy had always had such interests since his youth in Lacronan, Brittany, where he was impressed by prehistoric menhirs and dolmens. In 1930 he had made a similar trip to Africa where he was also attracted to curious rock formations.

Yet *Indefinite Divisibility* is indicative of the consistency of Tanguy's painting. Since 1927, when Tanguy found his "style," he embarked on the refining of a single idea. *Indefinite Divisibility* can be described as a stylization of Tanguy's explorations. What separates this painting from the earlier paintings is the heightened degree of clarity Tanguy achieved with the passing of time. The elements, which inhabit an indeterminate space, become almost sculptural, and the precise shadows they cast take on a tangible sensuality. It is tempting to compare these images with the sculptures of Isamu Noguchi and the early Surrealist-inspired works of David Smith. And certainly, it is on such American artists that Tanguy's art had its impact.

The space in Tanguy's paintings is adroitly compressed and expanded to great psychological effect. *Indefinite Divisibility* opens onto a vast space in which the viewer is instantly disoriented. There is no horizon line and the immediate space of the foreground blends into the vastness of the background. The clarity of the light, entering the space from the right, and the shadows, which proceed from this light source, serve to suggest an element of coherence which is then belied by the vagueness of the space and the blatant irrationality of the figures therein depicted.

The playfulness Tanguy established in paintings like *Indefinite Divisibility* prompted André Breton to note that, "with Tanguy it is a new horizon—the horizon of a landscape distributed in depth, a language that is no longer physical but mental." Breton was referring to a psychological depth. It is pointless to try to find objective correlatives to Tanguy's interior landscape, although, in terms of space alone, it is not improbable that Tanguy found the sheer scale and vastness of America attractive.

In *Indefinite Divisibility* Tanguy avoids the use of a horizon line so typical of his earlier canvases. Breton had written, "There is not even a horizon. There is only, physically speaking, our immense suspicion which surrounds everything." In this painting Tanguy places the pebble-like encrustations in the immediate foreground suggesting a palpable presence to the viewer. They almost become objects or embodiments of ideas which are projected into a real space.

Indefinite Divisibility differs from other Surrealist paintings in its attention to detail. Increasingly, Tanguy became interested in the techniques of painting. Perhaps this was because he had no training and evolved his technique from within his own artistic practice. *Indefinite Divisibility* is characterized by the choice of a metallic palette which combines with the tight application of brush strokes almost to annul the evidence of the painters intervention in this creation. In this way he differed from the more academic Salvador Dalí who employed technique to pretentious effect. *Indefinite Divisibility* is the antithesis of Surrealist automatism. While his painting is superficially similar to that of Dalí, Tanguy often began with a spontaneous point of departure. Rarely did he utilize drawing. For this reason he remained concerned with the inventive aspects of a painting, its potential for "surprise." *Indefinite Divisibility* remains an image of poetic import rather than an academic exercise.

—William Jeffett

Alberto Giacometti (1901–66)
Man Pointing, 1947
Bronze; 5 ft. 10 in. (178 cm.)
London, Tate; New York, Moma

Giacometti's work of the mid-1940's is characterised by elongated, emaciated figures, of which *Man Pointing* is a typical example. The statues differ in certain ways: always slender, they nevertheless vary greatly in height—some are over six feet tall—and, depending on gender, they adopt different poses and gestures, small but telling. The statues indisputably form the most complex and enduring of Giacometti's abstract works, excelling in both form and personal vision his Surrealist constructions of the 1930's and the more naturalistic style to which the sculptor resorted at intermittent periods in his career.

The sculptor's method was first to model his forms in clay on a thin metal frame and then cast them in bronze, their final state. The sculptures stand squarely, *Man Pointing* no exception, on solid bases, rooted by large, heavy feet which sometimes appear indistinguishable from the plinth, their bodies ascending from long, spindly legs. *Man Pointing*, as the title implies, is frozen in mid-gesture, perhaps in a thwarted oratorial action, a sense of space suggested by the outstretched arms and legs. Like a tree, the base of the statue appears fixed, immobile; but the form gradually becomes more upwardly articulate from the torso to the small head that turns in the direction of the extended finger. Giacometti expressed great interest in the phenomenon of movement, as an early example of kinetic sculpture, *Suspended Ball*, 1930, reveals. In this construction, also the earliest "cage" work, a sphere is slid on a string along a crescent-shaped form. Giacometti's explorations assume a more indirect guise in the 1940's as he examined the paradox of movement in a static art via the ostensibly unlikely medium of his slim statues. However, these experimentations become more plausible with the sculptor's description—possibly inspired by cinematography—of his understanding of movement as "nothing more than a series of immobilities. A person speaking was no longer a movement, but immobilities one after the other, completely detached one from another; immobile movements that could last, after all, for eternities."

Giacometti tackled in the medium of sculpture the same problems of volume land space that had been solved in drawing, finding a satisfactory solution to the difficulties of form in the series of stylized figures that includes *Man Pointing*. He explored the relationship of objects to the space they occupy and the elusive contour that differentiates in nature and art but does not, in fact, exist. The sculpture does not invite close inspection: its rough surface repels the eye and the hand, and its form dissolves when inspected at close proximity, becoming whole and regaining its contours at a safe distance. The elongated forms also imply some kind of optical distortion, akin perhaps to popular anamorphic pictures of the 18th century, in which twisted circular paintings were decoded with the aid of a central round mirror. This challenges our optical complacency and suggests the infinite possibilities of the process of seeing. Things are never what they seem.

Giacometti's statues are commonly believed to reflect the mood of the 1950's, the intensely pessimistic era of existentialism. It is true that *Man Pointing* seems to express a profound sense of loneliness in the face of a hostile, empty universe, his gestures ridiculous and futile, his dimensions diminished by the immensity of space, of the void. However, while the message of men may be gloomy, quiet hope lies with Giacometti's female figures, who are posed frontally, rigidly, like the ancient Egyptian statues the sculptor so admired. The men struggle vainly against their fate; it is the still women who, in the biblical tradition, know God.

—Carolyn Caygill

Jean Dubuffet (1901–85)
Archetypes, 1945
Paint, sand, plaster, and tar on canvas; 39³/₈ × 31⁷/₈ in. (100 × 81 cm.)
New York, Guggenheim

Jean Dubuffet's *Archetypes* gives something of the effect of linear graffiti drawings etched into street walls. Undoubtedly, Dubuffet was the heir to Surrealism's championing of Leonardo's observation that such random scratchings could inspire composition. *Archetypes* consists of marks crudely incised into the thick, earthy surface of the mixed media. The sheer simplicity of the figures evokes the untutored vision of prehistoric art, giving a seemingly timeless representation of the male and the female, reminiscent of primitive cave painting, children's art, and the art of the insane.

Archetypes is executed in what Dubuffet called *haute pâte,* a thickly applied impasto incorporating sand, tar, and found materials. For Dubuffet, the series of *hautes pâtes,* of which *Archetypes* is the first, opened up a new direction in which the material gave rise to the image. *Archetypes* grew out of the idea of an automatic graffiti form of drawing, and it owed something to his earlier painting *Wall with inscriptions* (1945; New York, Moma) which depicts an awkwardly rendered figure before a graffiti-covered wall. In *Archetypes* the figure merges with the graffiti; it is born directly out of the drawing process.

In 1945 Dubuffet published a polemical article entitled "Notes for the Well Read" in which he attacked the hegemony of abstract thought. Against the sterility of modern painting, Dubuffet proposed that a direct awareness of materials would open onto inspiration: "A painting is not built the way a house is built, according to the architect's blueprints. . . . Alchemist, hurry to your retorts. Boil some urine, gaze, gaze eagerly at the lead. This is your task. And you, painter, spots of colour, spots and outlines. Look at your palettes and rags. Then you will find the clues you are looking for." In *Archetypes* Dubuffet invokes the transformative power of common material, the substance of spiritual transformation.

Archetypes was among the first paintings in which Dubuffet utilized a controlled form of automatic drawing. While he drew on the Surrealist interest in chance, Dubuffet realized that drawing was partially a matter of habit and unconscious control. Consequently, images, such as the male and female figures in *Archetypes,* were born of an instinctive writing,

"Feed on inscriptions, on instinctive drawings. Respect the impulses, the ancestral spontaneity of the human hand when it draws its signs." As the title of the painting implies, such images lay embedded within the unconscious, primitive memories of the artist.

Archetypes appeared in Dubuffet's second one-man show at the Galerie René Drouin. Entitled *Mirobolus, Macadam et Cie.,* this exhibition provoked a scandal. Perhaps this is not surprising, given the dominant tendency evidenced by the abstract painting of the *Salon de réalités nouvelles.* A resemblance to the burlesque figure of Alfred Jarry's *Ubu Roi* is unmistakable, and Dubuffet held Jarry in high esteem. Taking them an insult, angry spectators attempted to slash the paintings on display, an incident indicative of the provocative irony and black humor so apparent in *Archetypes.*

Michael Tapié, the champion of *art autre,* wrote the preface to the Drouin exhibition, in which he wrote of *Archetypes:* "At this stage, having obtained a unique material possibly a fragment of a rough cast wall, he will draw summarily, with a schoolboy's scraper, like a schoolboy's graffiti, some sort of a man and a woman: the man and the woman, as simple as that . . . a new work by Jean Dubuffet is born (the < <Archetypes > >), but quite also a new way of painting which has no longer much to do with what is understood to date by the word painting." For Tapié it was in the sheer simplicity of the figures that *Archetypes* gained its power. Dubuffet merely incised marks into the surface of the *haute pâte;* the directness of his conception was almost naive. Paintings like *Archetypes* proclaim a region of human experience untouched by logic, in which something indissoluble and human resists interpretation. The task of painting was a process of unlearning, of shaking off the burdens of cultured experience, in which Dubuffet felt that: "A work of art should have a meaning that is so profound, so universal, so myriad and diverse, that one can drink any beverage he likes from it. A totem pole at a crossroads. Never (explaining would mean draining), never totally deciphered." Dubuffet's art brut was an art of archetypes.

—William Jeffett

Victor Vasarely (1908-)
Orion MC, 1964
6 ft. 10 in. × 6 ft. 6 in. (210.1 × 199.9 cm.)
Gordes, Fondation Vasarely

Although Vasarely was in his 50's when *Orion MC* was produced, it is an early work in the output for which he is best known, predating the fluorescent colouring and inflated geometry that marked the height of his fame in the late 1960's.

Orion MC is one of a series of prototypical paintings belonging to Vasarely's *Planetary Folklore.* Although manually created by the artist, the painting is a demonstration of the theory that "plastic beauty" is a matter of system and selection, which can be mechanised and therefore democratised. Prototypes such as this were made as museum pieces, capable of bearing a didactic message, although their main role was that of a programmatic score or manipulable blueprint.

The *Planetary Folklore* title, given by Vasarely to his work of the period 1962–64, is an attempt to rationalise and codify his technical procedures to date, in order to produce a new universal culture. The title puts emphasis on ethnicity and bright colour to reflect Vasarely's belief that the new art should be as integrated and ubiquitous as folk culture. Victory over the self-conscious artist was a central aim. The name is both universal and cosily localised since the system was to operate, in his view, like a human gene bank, i.e., to create an identity by selection from a multitude of predetermined features, which will be simultaneously unique and a recognisable permutation on the predetermined theme. The stellar title of the series within the *Folklore, Orion MC* recalls the "cosmic" promise of Suprematism and a connexion with fundamental molecular and atomic structures.

The units or alphabet of the *Planetary Folklore* was to consist of a grid structure as a background giving geometrical discipline to the infinite permutations of the secondary units. Within this simple framework, Vasarely's own permutation is complex. The secondary units, the circles and ellipses, are arranged in a series of interpenetrating patterns, so that the eye ranges restlessly over the canvas surface, following different structural leads. There is no centre or focus. The monotone scales in the grid, the contrasts and sequences of colours in the circles, the separate sequences of shape and size fulfil Vasarely's notion of optical irritation or aggression. His version of kineticism, *cinetisme,* operates subtly in the painting in the spinning ellipses and chiaroscuro effect of the shaded squares, which set up a kind of motion. The intention of movement and the structural purpose of the grids are clear in preparatory drawings, where the circles are enclosed in the squared graph paper and the axes of the circles are visible. The exploration of the illusion of movement, created by a shifting point of view and by spatial ambiguity is more overtly explored in black and white versions of the same grid and circle pattern, where foreground and background elements are actually separated on superposed planes.

Contrasts of colour are central to the conception of *Planetary Folklore,* which follows immediately the black and white period (1951–63) in which maximum contrast is used (under the influence of Kasimir Malevich's *Black Square*) to maximise spatial ambiguity and optical "aggression." The colour contrasts are partly based on the pointillist idea of using the eye as a mixing palette, and on Robert Delaunay's series of Simultaneous Contrasts; but whereas Delaunay's (and Sophie Tauber Arp's) coloured grids were subjective formal exercises limited in scope to the unique picture, his own were potential multiples, set up as fully resolved systems, manipulable by the non-specialist, whose choices could express character and mood in a scientifically and statistically measurable way. Permutations on *Orion MC* were to be used everywhere in the environment, as an element in the projected social utopia, his Polychrome City.

—Abigail Croydon

Emil Nolde (1867–1956)
Doubting Thomas, 1912
39¹/₂ × 33³/₄ in. (100. × 85.6 cm.)
Seebüll, Nolde Foundation

The *Doubting Thomas* was part of the nine-panel *Life of Christ* series that Nolde executed in 1912. The central panel of the series was the *Crucifixion*, to its left were *Holy Night, The Twelve Year Old Christ, The Three Kings,* and *Christ and Judas*; on the right, *The Resurrection, The Ascension, The Women at the Tomb,* and *Doubting Thomas*. The *Doubting Thomas* is the culmination of a progress in the series towards a more rigorous structure and is the most tightly composed. As Nolde continued with the sequence the forms became simpler and his technique less impressionist which allowed the colors to separate out into flat planes and function as areas with symbolic meaning. There is virtually no suggestion of depth in the piece. The Apostles that stand in the background are reduced to planes of color in front of which the protagonists stand. Their faces with their non-naturalistic colours, and the conflicting sense of scale suggested by their sizes, reinforce the non-naturalistic feel of the painting. This is an art in which traditional pictorial space is absent, rather than just undermined, and where colours are used for their symbolic rather than their descriptive value.

Religious scenes were a frequent subject for Nolde, who had painted a *Last Supper* in 1909 (Copenhagen), *Dance Around the Golden Calf* (Staatsgalerie Moderner Kunst, Munich) in 1910, and went on to paint an *Entombment* in 1915 (Seebüll). The nine-part *Life of Christ* was his most sustained religious project. It is related to the last medieval altar pieces at the church of St. Mary at Flensburg which Nolde knew well since

he had not only copied them but also helped in their restoration.

The Protestant church objected to Nolde's use of obviously Jewish people in his depiction of Christ and his disciples. None of his religious works were ever installed permanently in a church and the church never commissioned any works from Nolde. *The Life of Christ* was rejected by the International Exhibition of Modern Religious Art held in Brussels.

In his book *Artistic Expression of Primitive Peoples*, written at the same time as he was painting *The Life of Christ*, Nolde rejected classical aesthetics in favour of the anonymous and spiritual art of northern Germany, and of the analogous qualities he thought that tribal art exhibited. He recommended direct and spontaneous working methods. Meaning could be expressed by sharp colour oppositions: the idea of unity was a classical one that Nolde rejected. These ideas are exemplified by the *Doubting Thomas*: the simple forms are not only evidence of a speedy and direct technique but conscious signs of it that make this technique clear to the viewer. The subject matter and the references to medieval German painting are part of the attempt to recapture an authentic popular national tradition. Furthermore the subject of the *Doubting Thomas* in which the rationalist disciple questions the reality of the resurrection had a special resonance for the artist living in the modern world with its cities and their supposedly rootless populations, their lives being rapidly transformed in the early years of the century by technical advances. Much of Nolde's work was a denial of these modern rationalist trends and the image of Thomas coming face to face with the physical evidence of spiritual reawakening was precisely the kind of thing that he wanted to see take place on a broader scale in Germany.

—Julian Stallabrass

Paul Klee (1879–1940)
Death and Fire, 1940
Oil and drawing in blackpaste on burlap; 18¹/₈ × 17¹/₄ in. (46
 × 44 cm.)
Bern, Kunstmuseum (Klee Foundation)

Death and Fire is one of numerous paintings which repre-
sents Paul Klee's direct confrontation with death. In 1935 Klee
began to show the first signs of sclerderma. Five years later on
June 29th, he died of the disease. His final years were richly
prolific; in the last four months alone he created 366 paintings
and drawings. It was a period of detachment, meditation, and
resignation. Thematically, the works of the final years often
point to the beyond, and the mood tends, in his own words,
toward a decidedly "tragic vein."

The painting is structured around a bold linear outline. The
image of a central head immediately suggests a skull, an irreg-
ularly shaped and ghostly white visage. Surrounding the face
are smaller shapes; the arm bears a yellow circle and in the
background walks a stick figure. The heavy, black lines read
like hieroglyphics outlining color zones. The image is painted
on a dark and roughly textured burlap and mounted on black
canvas, framing the somber image in a dark rectangle.

The title declares the subject of the painting is death, but
even without that and in spite of the abstract simplicity of the
portrayal, the vacant, glaring mask suggests death. Its static,
powerful centrality evokes a feeling of inevitability. It recalls
the strong medieval tradition in Germany of the dance of death
which extended more immediately to the Romantics in a work
such as Arnold Böcklin's *Self-Portrait with Death As a Fiddler*
(1872; Berlin, Nationalgallerie). In Klee's painting the artist
portrays a face which bears his own initial. The eye of death is
the letter *P*. The *P* might be doubly interpreted as a reference
to Pierrot, the clown of the commedia dell'arte tradition, who
painted his face white and in modern art had come to represent
the melancholy artist of feeling, whose death was a common
subject.

The lines of the haunting figure suggest it holds aloft a yel-
low circle. Like the other color zones, here the burlap shows
through the color and with the extension of the yellow slightly
beyond the outline, the circle seems to shimmer against the red
background. The glowing yellow disk may be seen, as the title
implies, as a ball of fire. It appears not as a destructive ele-
ment but as a symbol of transformation. Fire is first a thresh-
old symbol, especially here as a circle. The circle is a
recurrent symbol in Klee's *oeuvre*. It can suggest a sun, a
moon, or fruit. Klee defined the circle in his Bauhaus lectures
as "the dynamic cosmic form, which comes into being when
earthly bonds are cast off." Here interpreted on its broadest
level, then, the circle is a symbol of wholeness, the wholeness
of life's completion which death carries with it—the unity of
life and the cosmos.

Two related works of the same year offer further understand-
ing of the image. In *Kettledrummer* (Berne) an arm topped by
a circle represents the arm as drum mallet drumming the final
Requiem, which announced the coming of death (Andrew Ka-
gan). Also of 1940 is Klee's *Wandering Artist: A Poster* (pri-
vate collection, Switzerland). Here the walking stick-figure of
the artist holds a circle aloft. This figure relates to the back-
ground figure in *Death and Fire*, to the raised circle, and to
the identification of this image with the artist. In *Death and
Fire* the walking form moves toward the skull, toward the fiery
red zone which surrounds the glowing disk and the dark circu-
lar platformed "head" repeats the foreground shapes. The im-
ages of artist and death seem as if they are about to merge.

Many of Klee's works point to the world beyond. In *Dark
Voyage* of 1940 (Berne) figures similar to that in the back-
ground of this painting suggest the voyage of Charon's boat.
Because this is the artist's last painting it is seem as a summa-
tion of his earthly journey which also expressed verbally by
the artist in his own epitaph:

> I cannot be grasped in the here and now
> for I live just as well with the dead
> as with the unborn
> Somewhat closer to creation than usual
> and still far from close enough.

—Janice McCullagh

Ernst Ludwig Kirchner (1880–1938)
The Street, 1913
47 × 35¹/₂ in. (120.6 × 91.1 cm.)
New York, Moma

Kirchner created a series of works representing the streets of Berlin. He worked in ink, pastel, woodcut, and watercolor, as well as oil. The theme of the street was painted as early as 1908 (*Street, Dresden*, Museum of Modern Art, New York, reworked 1919) and this work may have been inspired by Munch's *Evening on Karl Johan Street* (1892, Oslo Kommunes Kunstsamlinger), though the artist did not wish to acknowledge an influence. In October 1911, Kirchner moved to Berlin and by late 1913 and through 1914 the theme of the street had become central. Prompted by the example of the Italian Futurists, Kirchner painted from his own intensely personal experience of city movement. In strong contrast to his early career, where during summers he had often painted the bather in a rural and harmonious nature, in Berlin Kirchner felt the alienation of the metropolitan environment. Berlin was perceived by many in the early century as the urban image of decadent night life, psychic stress, and moral corruption. Kirchner's Berlin paintings capture this spirit of the modern city more successfully than those of any other visual artist.

The Street relates strongly to Kirchner's first major street painting, *Five Women on the Street* (1913, Museum Ludwig, Cologne). In both paintings the subject is women of the street. These women in their plumed hats and fur-collared coats display themselves like strutting birds. The implication is that these are prostitutes who represent the ultimate commodity in a society motivated by superficial elegance and crass materialism. In *The Street* the two central women are accompanied by one man, whose attention is diverted to the seductive illumination of a shop window, and they are followed by a group of faceless, suited males.

The treatment of the figures is emotionally high-pitched, and the force of the street itself seems harsh and aggressive. The painting style is strongly related to similar drawings where nervous scribbles and sharp angles transcribe the frenetic energy of the street. The overall slashing strokes create a raw and energized surface. The space of the sidewalk is restricted by the compressing shapes of the street and the shop on either side. The uptilted plane of the acid pink sidewalk is flattened to exaggerate the tension of two-and three-dimensional space. The uneven edges of the street are echoed in the pointed features of the people. Their fashionable dress seems slashed or jagged by the compulsive, kinetic forces of the street that compel them. The exaggerated spikiness of the figure's feet make them appear insubstantial as form.

Color and content heighten the feeling of the discord of the city. This is above all an image of a capitalistic society where the focus is on vulgar materialism and egotistic self-absorption. The colors of the painting are artificial, acidic, and jarring. The woman in the foreground wears a purple coat that bites in contrast to her red hair, pink face, and crimson lips. The hand gesture of the foreground woman is unnatural and suggestive. The figures do not interact, nor do they confront the viewer. One might interpret the central woman's look to the profiled woman as an expression of acknowledgement of man as prey. It is they who are on display. The feeling is one of alienation and nervous intensity.

The prostitute in art and literature of this period often signified someone who lived a precarious existence. Like tightrope-walkers or other urban performers, which Kirchner also portrayed, artists identified with their perilous position. Exploited by it and products of it, they lived chancey lives on the fringes of society.

The Street is one of Kirchner's most important works of the Berlin pre-war period. In it he created drama and energy. Even with the intensely personal, exaggerated expressionism of his style, the painting reads as a record of the streets of a modern metropolis, without being a critique. It may be seen as an honest record of the discords of modern life.

—Janice McCullagh

Franz Marc (1880–1916)
Fighting Forms, 1914
35⁷/₈ × 51³/₄ in. (91 × 131.5 cm.)
Munich, Staatsgalerie Moderner Kunst

Fighting Forms is one of a series of paintings that Marc made in 1914 with the word "forms" in the title, a fact that signalled his move away from figurative to more abstracted work. The motifs and in some cases the very form of his earlier painting are transformed in these pieces. *Broken Forms* radically transforms a horse and garden motif; *Abstract Forms* is simply an earlier piece, *Colourful Flowers,* turned on its side and slightly modified. *Fighting Forms* itself is probably an altered version of *Fighting Cows* of 1911.

The painting is highly abstracted. A red object hits a black one which falls back into the blue area. Light on the left is matched against dark on the right. Colors had strong symbolic associations for Marc and in some sense this work can be seen as a representation of the struggle of the spirit against the material. In the red area can be discerned the profile of a bird's head and beak, and, lower down, legs and talons suggesting an eagle; even the outline of an eye can be made out. The eagle was regularly used in Marc's work as a symbol of the force of the spiritual. The identity of the black form is much less clear but its origin is certainly figurative. We might also think of the appearance of the eagle in the book of *Revelation* as evidence for an apocalyptic reading of this picture. Marc and many of his associates were certain that war was inevitable by 1914. They also thought that it would be a major upheaval, the watershed of a new era. While they may have been mistaken about the nature of the post-war period, they correctly predicted the scale of the war and the magnitude of its consequences. In this sense at least, pieces like *Fighting Forms* and even the more figurative *Fate of the Animals* (1913) can be seen to be prophetic.

While the red and the blue are always contrasted in Marc, they do not have to be in conflict. Areas of red and blue are juxtaposed harmoniously in *Painting with Bulls II* of 1914. This idea of opposed colours was expressed in the writing of both Marc and Kandinsky, his closest associate, at this period. The animal for Marc was a symbol of the primitive and the pre-rational, and, as such, a repository of genuine spirituality. His views took some aspects of Schopenhauer's idea of animal existence as being preferable to human life, because it is lived entirely in the present without concern for the future or memory of the past. Nietzsche's view of man as a misinformed animal may also have been influential. The eagle is attacking and bowling over its opponent. So while the picture is an apocalyptic one, it is also optimistic: the animal will win out over the material.

This optimistic view did not long survive the start of the war in which Marc found himself a combatant. The *Sketchbook from the Field* contains 36 drawings from 1916 and exhibits a trend towards a more and more pessimistic vision. In *The Greedy Mouth* a snake's head eats crystalline forms perhaps representing order. *Magical Moment* is a scene of overall destruction containing scattered jagged forms and lines of force which suggest the trajectory of shells. While *Fighting Forms* showed an image of a struggle of immense consequence that would be quickly won by the power of the spiritual, the sketchbooks speak of an image of the disorder of war, of an image that seems impossible to make sense of, and of a material and mechanical might which was shattering nature.

—Julian Stallabrass

Max Beckmann (1884–1950)
The Night, 1918–19
$52^{1}/_{2} \times 60^{1}/_{2}$ in. (133 × 154 cm.)
Dusseldorf, Kunstsammlung Nordrhein-Westfalen

Max Beckmann's enigmatic painting *The Night* is one of the most shocking images of inhumanity created prior to Picasso's *Guernica*, a claustrophobic scene of contemporary hellishness, the more appalling for being brought—literally—home. The victimization of the traditional family unit is central to virtually every cry raised against modernity's stressful progress, so Beckmann's dire scenario consequently carries the force of nightmarish reality.

Begun in August 1918 and completed early in 1919, this painting reflects the turbulent months of Germany's emergence from the war into a Republic threatened by revolutionaries from the left and desperate militarists from the right. Punished by food and fuel shortages, the flu epidemic, and an immediate inflation, the conservative factions of the new Weimar government covertly condoned assassination of leftists, particularly those known to be Spartacists, hiring bands of returning soldiers, the anarchic *Freikorps*, to execute their programs of suppression. Beckmann, whose duties as a frontline medical orderly had undoubtedly contributed to the nervous breakdown he suffered in 1915, had survived the experience, but his pre-war style, a decidedly academic one akin to Lovis Corinth's and Max Slevogt's, had fortunately not. It died with the Belle Epoque; Beckmann's new approach—an amalgam of the shattered planes of Cubism and Futurism supported by an Expressionistic angst—developed so suddenly that *The Night*'s tightly woven style seemed sprung fully grown, like Athena from the head of Zeus, a compelling analogy that defines the speed of his search for a modernized mythos which he had embarked upon in 1912 in order to "fashion from our own time human types with all of their ambiguities and inner strife." Eschewing outdated idealism, he meant to do this with "objective accuracy."

His pursuit was thus briefly aligned to the Critical Realist wing of the developing *Neue Sachlichkeit*. Both Otto Dix and George Grosz similarly utilized the formal fragmentation of Cubo-Futurism in their postwar works, but unlike Beckmann they altered their approaches after the economic stabilization of the mid-1920's, adopting tempera techniques which led, in Dix's case in particular, to a cool Renaissance-inspired portrait style, modern in its acidic content but traditional in its form.

Beckmann's traditionalist impulses embraced the bleached tonality of Piero della Francesca in his new canvases (like 1917's *Deposition* and *Christ and the Woman Taken in Adultery*, *The Night* evokes the ashen air of a medieval charnelhouse), blending it with the equally neurotic figural elongations and abrupt distortions found in Grunewald's and van der Weyden's ecstatic, visionary altarpieces. But he also maintained Cubist spatial compression and planar fragmentation, and the frenetic linearity of Futurism well into the 1920's, after which the influence of Picasso's stolid Surrealist figuration and Rouault's thickened outlining became apparent. As early as 1919 with *The Night*, Beckmann had formulated a uniquely coherent and evocative strategy combining formal modernism with venerable iconographic traditions.

The Night's disturbing sacrificial tableau should not be seen as unique in Beckmann's *oeuvre* during 1918–19, however, for chaos, victimization, and denial permeate the contemporaneous lithographic cycle, *Hell*, which repeats the painting's frozen tragedy in stark black and white. Among its 11 plates, beginning with a self-portrait in clown attire that owes an obvious debt to Egon Schiele's neurasthenic mirror images, is another scene of overt suffering, *Martrydom*, a reference to the assassination of the left's distaff leader, Rosa Luxemburg. Like many of the plates in the cycle, the shattered composition swings in a vortex around the central figure, who is carried into the night in a pose reminiscent of a northern Renaissance saint about to be flayed.

The presence of Luxemburg in this cycle has recently led Marxist revisionists to indulge in overly politicized interpretations of both the cycle and *The Night*. The capped figure carrying the child in that painting, in this light, can be seen to resemble Lenin. But given Beckmann's overt allusions to religious imagery, a more inclusive explication, transcending topical references, will transfer these despairing works to the realm of expressive parable.

Beckmann had a large reproduction of Traini's Camposanto mural, *The Triumph of Death*, which commemorated the Black Death of 1348, in his studio after the war, and while the ominous invader *does* bear resemblance to the Russian revolutionary, the figure is more obviously based on the blind beggar supplicating Death for release on the walls of Pisa's *charnier*, an interpretation consistent with the startling number of inversions of traditional Christian iconography to be found throughout the painting and the prints.

The Night's dark reversals (the hanged man's shroud/surplice, the candles and altar/tablecloth, the woman's martyred sprawl, and the arcane gesture of ritual bloodletting) are indicative of Beckmann's spiritual—and temporal—misery, a station on the way to recovery that sprang from the moment in 1912 when he called for the creation of a "tower from which human beings can scream all their anger and despair, all their poor hopes, joys and fierce longings . . . a new church," a sanctuary linking vital traditions with the modern world, built of art. *The Night* is a necessary step, but not Beckmann's last, for he regained his "metaphysical objectivity" and created a series of redemptive canvases that repudiate his postwar despair.

—Linda McGreevy

August Macke (1887–1914)
Zoological Garden I, 1912
23 × 38⁵/₈ in. (58.5 × 98 cm.)
Munich, Lenbachhaus

In a letter of 30 March 1913, Macke wrote from Bonn to his wife's uncle, the art collector Bernhard Koehler: "It pleases me, that you have sought out for yourself the paintings that are my very favorites. There are two there which are the best that I have painted to this time. The *Zoological Garden* and the *Dancers* . . . also the large triptych, but the small (zoological garden) is certainly better." This painting was perhaps a favorite of the artist's because he captured here what he sought to achieve in many of his works. Macke infused the beauty of the zoological garden in Cologne with the spirit of a garden of paradise to create a modern and timeless paradise. The pervasive feeling is one of profound order, calm, and religiosity.

The subject of this painting appears in numerous related sketches of 1912–14. Many of these sketches were created as the artist worked in the restaurant at the zoo. As a friend of the proprietor, Mrs. Worrenger, mother of the famous Dr. Wilhelm Worrenger, he was welcome to work there and often did. The composition is most closely related to an ink drawing of 1912, (*At the Zoo*, Museum am Ostwall, Dortmund). By painting a zoological garden, Macke followed the tradition of German impressionists Liebermann and Slevogt. He respected both painters, but the concern of this painting was not to record a momentary visual impression, but rather to create from one a vision of perfect harmony. In this painted version of the zoological garden the gulf separating men and animals seems to have been bridged. They share a garden of peace and universal rhythms. The garden is a blend of country and city, where building and fence rhythms are interwoven with the colorful patterns of foliage and trees. A parrot occupies the dominant position. As a bird often painted in association with woman, the parrot stands for the feminine aspect. (In both the painted and the ink versions the female presence, so often central for Macke, as in the Dortmund triptych, was avoided.) The blue parrot and the counterbalancing foreground gentleman suggest the balance of paradise. There are other "birds of paradise" too, swans, and cockatoos. The enclosing deer also represent the male and female dichotomy. The gentle, earthbound deer, symbols of purity and earthliness, are often paired with birds in Macke's works, as they were in Marc's *oeuvre*. The work suggests the promise of world order in contemporary terms.

Many of Macke's works include significant central motifs. Here a tree is a symbol of life. The simple form often used by Macke shows the trunk clearly separating into two curving parts which spread over two sides of the composition. The arched branches suggest growth, as the river behind suggests flow. The tree takes on symbolic power in its archetypal simplicity. It alludes to the Christian paradise. In other traditions also it is a primary symbol of life. At the base of the tree are some flame-like marks which for Macke are an unusual departure from visible inspired reality. In the complementary colors of yellow and purple, the dancing licks of paint blend with, but are unlike any of, the other passages of surface color. This suggests the mystery of fire. Within the Christian tradition, it could signify the flaming sword which was set to guard the tree of life (Genesis 3:24). Like the tree, fire by mythopoeic logic, is a principle of life, a threshold symbol, which connotes the cosmic force and transformation. Eden and reality merge. Man can understand nature because he is a part of it. Fire is a dynamic life principle which implies continual process, like the ever-flowing river and the ever-regenerating tree.

In the modern Paradise, Macke's characteristic image of the human presence is that of generalized humanity. Macke does not paint the individual, but the idea of mankind, the human condition as a universal expression. The faceless figures seem both modern, in their bowler hats, and timeless, in their simplicity. In Macke's painting, the men are rhythmically ordered, so the reading of 1 man, plus 2 men, plus 3 men, lends the work a sense of visual motion. This visual flow again implies Macke's consideration of the theme of eternal recurrence.

The viewer reads the painting's rhythms, while the image is enveloped in stillness. The visually unified gentlemen project a feeling of quietude. Men and animals seem to exist in a state of timeless balance with nature. They appear as integral to the evolution of natural life patterns. Heads bowed or eyes closed, the men are lost in a state of meditation, enveloped in tranquility. This pervasive dream-like quality may have been inspired by Macke's reading of Schopenhauer. His early letters document his enthusiasm for the *World As Will and Representation*. In the fourth book, which Macke specifically cited, Schopenhauer praised Raphael and Correggio, as artists who represented in their works countenances of supreme consolation. Schopenhauer defined it as an ideal state where the sense of yearning has disappeared and the will has vanished.

Macke found in the zoological garden a setting of lively color and ordered equilibrium. He created from it a tapestry of even greater balance. The comforting enclosure of the canopy of nature, the rightness of the sense of order, and the presence of symbols, all imbue the painting with a feeling of religiosity. The painting expresses well what Macke wrote in his essay "Masks," that is, "invisible ideas materialize quietly."

—Janice McCullagh

Kurt Schwitters (1887–1948)
Merz 19, 1920
Mixed media
New Haven, Yale University

Merz 19 [spelled Merzz on the canvas], as its numerical position might suggest, was one of Schwitters's earliest attempts at the medium of collage, following several months' fevered experimentation with assemblages in which the artist articulated the radical effects of Dada and Synthetic Cubism on his style. However, ill at ease with the relatively generous scale that these works necessitated, together with the ensuing problem, therefore, of relating forms coherently, Schwitters began reducing his compositions in both size and variety of media, conveying more fluently his concern with form and content.

The assemblages and first collages also bear evidence of Schwitters's courtship with German Expressionism. It was in fact his reluctance to rebel against the spiritual in art that contributed to the Dadaists' rejection of Schwitters and his work. *Merz 19* lies midway, chronologically and stylistically, between Expressionism and the geometric, Constructivist-inspired style that grew out of Dada. Not concerned with exploring his own feelings via the painted canvas, Schwitters chose to reflect his immediate world with rubbish and ephemera, which he carefully gathered, selected, and pasted, wet, onto paper, this clear rejection of traditional artistic media earning him the reputation of the father of Hanover Dada. Worn and weathered scraps were particularly favoured by the artist for their expressive possibilities; these were torn by chance or design, the materials then blended together to form a pastiche of twentieth century life. *Merz 19* reflects something of a post-war feeling: slightly reminiscent of torn advertising hoardings the assorted papers—cigarette and potato coupons—display themselves as indicators of the state of the world. The partially obscured words "Samstag" (Saturday) and "Sonntag" (Sunday) suggest in turn the joylessness of a rationed, post-war weekend. Schwitters also attempted to create expression through illusionistic depth and juxtaposition: each individual component is carefully ordered to form an unfurling spiral composition. The eye is at once drawn to the number 37, gateway to the collage, then is led down three "steps" formed by the coupons. The eye is compulsorily guided upwards as the foot of the picture is reached, aided by a diagonally placed slip of paper which feeds directly into "Sonn" and the top of the composition. By virtue of the right-hand lettering which encourages a surface reading of the collage, the eye is then led down "into" the spiral, depth suggested by the contrasting plain scraps on the left. Schwitters flirts with word and image to create meaning: as "Sonn" suggests "Sonntag" so it equally implies "Sonne" (sun), thus forming a witty meteorological relationship with the patchy cloud formation at the top right hand of the picture.

Inasmuch as *Merz 19* can be interpreted as an expressive, spiral composition, so it simultaneously bears the brand of Schwitters's new Constructivist rectilinear direction. Read horizontally and vertically, the composition immediately acquires a new identity as forms are positioned within a grid format, emphasizing the flat surface of the collage. Typography, decorative patterning, and the abrupt cropping at the composition's edges of words and papers, remind us that we are viewing a two-dimensional object. Schwitters's fond and frequent use of words and numbers reflects his Synthetic Cubist and Constructivist leanings, as both schools of art exploited these to bold effect. However, in *Merz 19* the artist approaches a more sentimental, quirky angle than his hard-bitten Constructivist and de Stijl contemporaries: though throughout his career he maintained that form was of greater importance than content, Schwitters's collages inevitably display, consciously or unconsciously, a considerable element of ironic visual play, much in the manner of Paul Klee, himself associated with the Blaue Reiter Expressionists in Munich. Schwitters's Expressionist leanings become self-evident.

—Caroline Caygill

Otto Dix (1891–1969)
Portrait of Sylvia von Harden, 1926
Mixed media on wood; 47¹/₄ × 34³/₄ in. (120 × 88 cm.)
Paris, Beaubourg

After Otto Dix's relocation to Berlin from the relatively provincial Dresden, his portraits paradoxically became socially acceptable, attracting a line of eager clients. This was particularly ironic since he was by no means a John Singer Sargent, flattering his elegant sitters; rather, with an old-master technique and a blend of sarcasm and factual observation that characterized his Critical Realism, he stripped and dissected them, exposing their foibles with cruel precision. The art historian Will Grohman's acid comment that these vivid portraits continue to "bear witness, in the near and distant future, for and against us," indicates the success of the artist's strategic choice of individuals who proved to be archetypal. Dix's psychologically astute portraits comprise a rogues' gallery of Weimar denizens—arrogant, neurasthenic, self-satisfied, ineffectual, fatuous, or overwhelmingly anxious—a collective characterization of the modern psyche limned on the tempera panels of an earlier era, an effective formal link between past and present.

These expressively distorted portraits were largely drawn from the metropolis's cultural scene, or from its dark fringes. The raddled exotic Anita Berber, a tubercular alcoholic addicted to heroin, sat for Dix, who envisioned her as a crimson *memento mori,* while the jeweler Karl Kraus strikes a similarly affected pose in his earlier portrait. Canny art dealer Alfred Flechtheim's strong ethnic features and grasping hands were further exaggerated in a personification of the deadly sin, avarice. Flechtheim, who favored the Cubists, suffered doubly for his sins at the hands of this dry critic. Other artists fared best; a sympathetic, even enobling portrait of sturdy Jankel Adler, painted in a thick impasto that will only recur in Dix's work after the Second World War, is surprisingly uncritical. His earlier, folkish *Family of the Painter Adalbert Trillhaase,* with its eerie light illuminating the startled group, is a more affectionate glimpse of a talented friend's bourgeois origins. This humorous approach is present, though more subtle, in his ironically iconic view of the throat specialist Mayer-Hermann, which cleverly centers its swelling composition on the doctor's rotundity.

But perhaps Dix's most stringently observed subject was the journalist Sylvia von Harden, who sits over an aperitif—as she sat daily—at a corner table in the *Romanisches Café,* haunt of Berlin's *literati.* Born Sylvia Lehr, von Harden eked out a living as a correspondent for such papers as *Aktion, Die Rote Erde,* and *Das Junge Deutschland,* supplementing her income with trivial novels and editorial work. Affecting a *Junker* mon-

ocle, she also adopted the aristocratic "von," a designation that suited her haughty demeanor and modish angularity. She was a self-ordained character.

Attracted by an article she'd written in an acerbic style that corresponded to his own, Dix typically relied upon his first impression of this bizarre woman for his choice of an encompassing and psychologically revealing color scheme. For von Harden he selected—or sensed—a purplish red, chillier than the deep crimson he'd used for Berber. Von Harden's disdain is suggested by the faded tempera, applied in transparent layers that emphasize her singular morbidity as they expose the varicose veins beneath her rolled stockings. Poised at her marble-topped table, smoking a carmine-tipped cigarette and gazing out with affected world-weariness, von Harden emerges as an emblem of predatory decadence, a sinister vulgarian eclipsed by style.

The artist's Critical Realism, developed in the immediate post-war years, mutated somewhat after Germany's economic stabilization in the mid-1920's, becoming the most significant aspect of the "leftist" (or socially committed) wing of the *Neue Sachlichkeit,* Germany's complex version of the international trend toward objectified realism. The other wing of this movement, known as "magical realism" and exemplified by Georg Schrimpf's dry figuration, was far more detached than Dix's expressionistically derived faction, all of whom approached reality by more subjective paths. The emotional undercurrent in this wing, which included Christian Schad and Anton Räderscheidt, was decidedly frigid, though Dix's sardonic tone continually threatened to break through the gelid surfaces of his appropriated tempera technique. The tension produced by the methodology's exacting and dry process and Dix's expressive attitude imbues these portraits with a compelling ethical power. His admiration for and imitation of early Renaissance models—in the use of characteristic attributes and hieratic positioning, as well as in technique—make him a forerunner of contemporary historicists. He also occasionally foreshadows Photorealism (and merges with the magical realist wing) in hallucinatory works like the *Playing Children* of 1929. But, because Otto Dix maintained his strong moral commitment throughout the Weimer era, he never fully abandoned the blend of objectivity and subjectivity that characterized Critical Realism. And nowhere in the late 1920's is that criticality sharper than than in his illuminating dissection of Sylvia von Harden.

—Linda F. McGreevy

George Grosz (1893–1959)
The End, from *Ecce Homo,* 1917
Etching

In the crucial transitional years of the late 1910's and early 1920's, one of Germany's leading confrontational artists, George Grosz, laid down his most trenchant battle lines with a veritable barrage of drawings whose linear trails shatter into brittle fragments on urban streets, dissolve sensuously around the curved haunches of whores, and cut deeply into the matter as a well-honed stiletto. These lines, etched into the cheap white stock of inflation era magazines, objectively describe— and subjectively dissect—a waning Wilhelminian Germany's faltering approach to Weimar's Republic.

Grosz, whose mature style, a combination of international avant-garde strategies and topical realism, was forged under the anarchic influence of Berlin Dada between the years 1916 and 1924, maintained a consistent critical approach to reality, never losing sight of his sardonic purpose in pursuit of purely formal concerns. And, like other members of that loose group known under the rubric of Critical Realism, such as Otto Dix and Käthe Kollwitz, his work was most widely disseminated through the radical press.

His colleague in Dada, Wieland Herzfelde, publisher of the communist Malik-Verlag and "Progressdada" to Grosz's "Progagandada," produced the artist's first lithographic portfolio, the *Kleine Grosz Mappe* in 1917 and regularly used individual drawings in his short-lived publications *Die Pleite* (which featured Grosz's anti-governmental "Cheers Noske! The Proletariat has been disarmed" on the cover of its third issue) and the satirical tabloid *Jedermann sein eigner Fussball* (Everyman His Own Football) confiscated after a single issue in 1919.

In these and other publications, Grosz developed his acerbic linearity with favorite targets ranging from militarism to the traditional authoritarian family. For his pains with such vitriolic images as *Fit for Active Service* (1918), *The White General* (1922), and *Free Time after Work* (1919), which skewer Junker arrogance, the militaristic "recycling" to which the artist had been repeatedly subjected during the war, and the unacknowledged atrocities committed—with the government's collusion—by the *Freikorps,* and the notorious *Christ in a Gas Mask,* he was prosecuted and fined, as was Herzfelde.

His omnibus volume *Ecce Homo,* published by the Malik-Verlag in 1923 (at the same time as *Abrechnung folgt!,* a prophetic title), was subjected to trial and partial confiscation, remaining under police prohibition for the duration of the Republic. While in Germany he published only one more portfolio, *Über alles die Liebe* in 1930, which lacked the critical intensity of his earlier cycles. In 1936, after Grosz's remove to America, *Interregnum* appeared; even with its premonitory theme and harsh, thickly inked images, it likewise failed to attract the attention it deserved.

Ecce Homo, which has been reprinted in whole or in part several times, remains his most important graphic cycle, its one hundred drawings and watercolors dating from 1915 to 1922, peak years for his bleak vision of a society overwhelmed by despair, defeat, and inflation, a vision which has made him an avatar of Critical Realism.

Ecce Homo graphically exposes a cross-section of German society easily distinguished on Berlin's cosmopolitan boulevards, specific and yet obviously suggestive of a sociological model. With its stubborn provincials, feral profiteers and prostitutes, its beggars, peddlers, prompt postmen, amputees, political extremists, and self-important businessmen, its addicts, alcoholics, and ubiquitous dachshunds, its ladies off to tea or tennis amidst the granite facades of the capital city, it stands as a peculiarly Romantic anti-epic. Grosz, whose didacticism is seldom concealed by formal approach, tinges his observations in true Critical Realist fashion with intense scorn. But, unlike Otto Dix, he rarely exaggerates his subjects' bestiality; they all seem quite normal, deliberately recognizable.

Some of the plates, in fact, lack the overt, piercing criticality of the majority, ironically—and given the artist's radical "regression" after his exile to America—perhaps prophetically allying Grosz with New York's "urban scene" painters, illustrating all too clearly Hannah Arendt's comment on the pervasive "banality of evil." Yet the best of *Ecce Homo* stamps Grosz—like the writer Alfred Döblin, whose kaleidoscopic *Berlin Alexanderplatz* enmeshes its dim antihero in an overlapping scenario of confusion, and filmmakers Walter Ruttmann, whose documentary *Berlin—Symphony of a City* was objectively realistic, and G. W. Pabst, whose subjective realism permeated *The Joyless Street*—as an heir to the dark side of the Romantic tradition.

Grosz's Romantic cynicism, tempered by the Cubo-Futurist style, targets Weimar's underbelly, delineating the covert paramilitarists that soon gathered under the Nazi banners alongside a variety of sexual and economic strategies for survival, all carried out along Berlin's meandering commercial backbone, stretching from the Kurfürstendamm to the distant Alexanderplatz.

Occasionally, as in one of the final plates, 1917's *The End,* Grosz's objective control collapses into overt Expressionism revealing the artist's bitter misanthropy. An image of paranoia, of an urban jungle inhabited by lurking beasts, *The End* bleeds fear in the form of splattered ink outlines in the face of its double-jawed *vanitas* locked in a final embrace with its resistant victim. With this image George Grosz joins the masters of misanthropy, Bosch and Goya, in a traditional and all-too-human theme.

—Linda McGreevy

Max Ernst (1891–1976)
The Elephant Celebes, 1921
49³/₈ × 42¹/₂ in. (125.4 × 107.9 cm.)
London, Tate

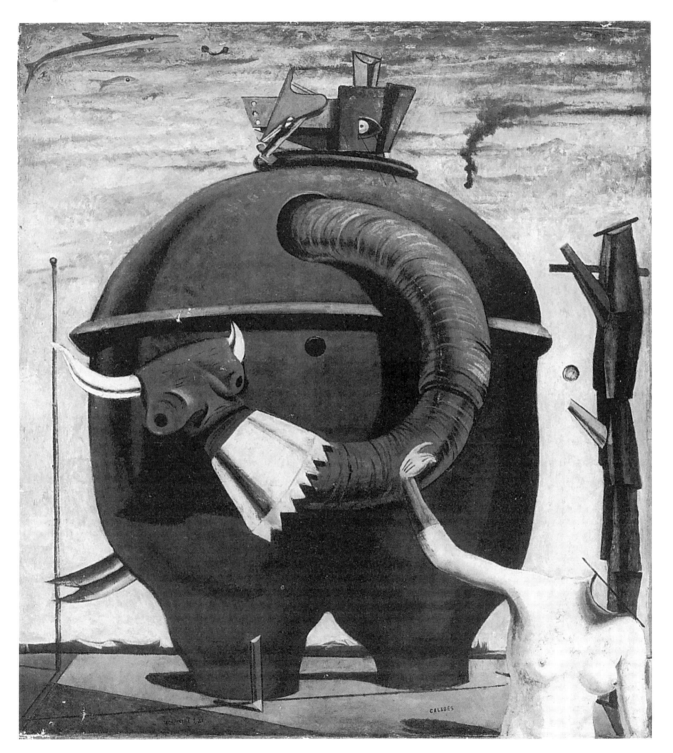

Max Ernst's *The Elephant Celebes* (1921) is a work emblematic of the transition of Dada to Surrealism. Painted in Cologne in 1921 it draws on the collage aspects of Dada and the painting of de Chirico, and it points forward to the hallucinatory images of Surrealism. At the time Ernst was actively contributing to various German Dada publications. The same year Paul Eluard visited Ernst in Cologne, purchased the painting (along with several others), and took it back to Paris. (The painting remained in his collection until 1938, when it was purchased by Roland Penrose). Also in 1921 Ernst exhibited his collages at the Paris Gallery *Au Sans pareil*, for which André Breton wrote a preface attributing the disorientating value of the "marvelous" to these hallucinatory images. The following year Ernst moved to Paris, joining in the activities of the *Littérature* group, where he resumed his Dada-orientated activities.

Ernst's choice of palette and spatial construction in *The Elephant Celebes* owes much to the example of de Chirico, who had been a source of inspiration for the nascent Surrealist group. Ernst also admired de Chirico's fascination with philosophical themes, and, because he had studied philosophy, and read Nietzsche, the haunting cityscapes and metaphysical writings of de Chirico found an avid enthusiast.

Ernst exaggerates the sheer hugeness of the boiler-like form of the Elephant Celebes by composing the picture with a low horizon line. The effect is enhanced all the more by long, late-afternoon shadows which are sharply cast against the ground. Atop the elephant is erected a curious structure of irregular planar shapes reminiscent of the stacked canvas stretchers so typical in the early paintings of de Chirico. Ernst's choice of a dark green and black palette conjoins with the irrational elements of the stacked cones (right), vertical poles (left and center) and the gesture of the hollow, headless female mannequin (lower right).

The gesture of the mannequin (heightened by the red rubber surgical glove) introduces, by way of a *repoussoir*, the monumental Celebes in all its rotund bulk. Ernst has placed him in the diagonally bisected foreground space. A long trunk-like neck protrudes into the foreground on which a horned bull's head is attached just above a metallic collar. Ernst has given the entire creature a metallic finish. The collar and the horns are rendered in metallic white which echoes the twin-horned tail protruding from the shadows from behind the monstrous elephant (left).

The otherwise empty and amorphous sky is filled with visual incongruities. At the upper left two fish fly. Almost like an airplane approaching head on, an enigmatic black shape hovers just to the right of the fish-birds. At the upper right, again suggestive of aerodynamic flight, is a trail of smoke. Balloon-like and suspended in space is a sphere (at right) which echoes the eyes in the head and the spherical hole in the center of the boiler pot of Celebes. All of the airborne allusions imply the mechanical terror of the war experience which prompted Ernst to write of himself: "On the 1st of August 1914 Max Ernst died. He was resurrected on the 11 November 1918 as a young man who aspired to find the myths of his time." *The Elephant Celebes* is one such myth, a myth of destruction.

Max Ernst was one of many young people disillusioned by the pointless massacre of the First World War. All he had been unwittingly led to believe had been shattered by his experiences. With the end of the war the language of art was open to question, and Ernst sought to destroy all the pompous values attributed to this activity. He sought to "go beyond painting."

The Elephant Celebes has little to do with traditional technical practice, although it utilizes elements of perspective to achieve distorted effects. Nor is it abstract in any way, despite Ernst's close friendship with artists, such as Arp, who were closer to abstraction. Ernst's desire "to go beyond painting" in *The Elephant Celebes* reveals a total dissatisfaction with painting as a medium. According to Roland Penrose, "Max Ernst was looking for a third path, neither descriptive nor abstract, a path in which an object, however banal, could derive new power from being placed in unexpected surroundings and in juxtaposition with other objects which have no apparent relationship to it." The idea of juxtaposition formed the basis of the collage principal; while *The Elephant Celebes* is painted, it incorporates conjunctions of the unrelated in the strange hybrid figure of the elephant.

Primitivism was a central aspect of Dada; it was an attempt to return to an authentic origin prior to the decline of modern society. The figure of the elephant Celebes is highly suggestive of ritual and totemic sculpture of African origin, as is evident from its bull horns and the totem pole-like structure at the right of the picture. John Craxton, and later Ernst himself, has acknowledged the prototype of a clay communal corn-bin of the Konkomba tribe of the southern Sudan, which was reproduced in an English anthropological journal. *The Elephant Celebes* must be understood as a happy admixture, or collage, of the found image and the tribal, which in turn provided the inspiration for a new element ("the third way") of imaginative creation.

Ernst has also indicated to Penrose, that the name "Celebes," originates in a found source as well, the scandalous school boy verses, which read as follows:

Der Elefant von Celebes
Hat hinten etwas gelebes
Der Elefant von Sumatra
Der vögelt seine Grossmama
Der Elefant von Indien
Der kann das Loch nicht finden

The elephant from celebes
has sticky, yellow bottom grease
The elephant from Sumatra
always fucks his grandmamma
The elephant from India
can never find the hole ha-ha

The painting is now in the Tate Gallery, London, for which it was purchased by the Elephant Trust in 1975. According to the Tate Gallery's catalogue, on the reverse there are various scribbles and caricatures of figures and animals of little significance to the painting; however, they note that Mrs. Gabrielle Keiller has observed two figures which seem to hold golf clubs accompanying the inscription "GOLF"; the latter are observed by a grotesque head with a balloon emerging from its mouth with the words "HA HA," perhaps referring to the last lines of "The Elephant Celebes" verse.

—William Jeffett

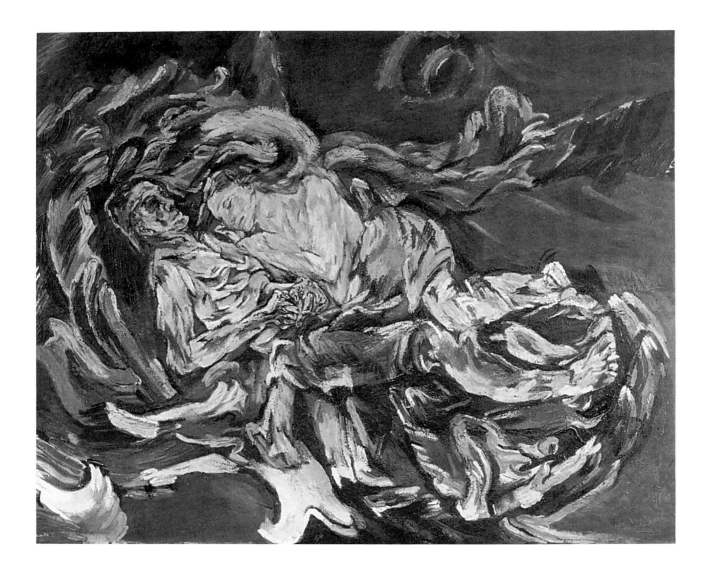

Oskar Kokoschka (1886–1980)
The Tempest, 1914
71¹/₄ × 86⁵/₈ in. (181 × 220 cm.)
Basel, Kunstmuseum

This painting was originally entitled *The Big Boat*. It is a piece that marked the culmination in the deepening and simplifying of colour from Kokoschka's earlier work, a process that began on his visit to Italy in 1913 and was cut short by his military service that began in 1915. In Italy Kokoschka paid particular attention to Tintoretto and began to work towards a greater consistency of colour and a stress on construction. *The Tempest* marks a high point in his work for these concerns since afterwards Kokoschka's colour becomes less unified and there emerges a predominance of whites rendered in swirling brush strokes and the use of unmixed patches of colour. From 1917 Kokoschka turned to the use of a very thick impasto which rendered writhing and incomplete forms.

The piece is also evidence of a thickening of the paint surface from the thin layers that were applied in the early portraits. The skin of the male is rough and is handled in much broader strokes than the careful building up of the paler skin of the female which is closer to that of his earlier portraits.

Some critics see *The Tempest* as representing Kokoschka and Alma Mahler, the composer's widow, with whom Kokoschka was involved. In any case it is to do with both love and the forces that threaten it, whether political or personal. It was exhibited at the annual show of the *Neue Müchner Secession* in May 1914. The boat at sea is a common symbol for the dream, in which the consciousness floats on the sea of the unconscious. Even the form of the boat is marine, seeming to be in the shape of a shell. In this case it is not only love but reason that is in danger of sinking. Some critics have read the warm and cold hues in the picture as signalling the contradictory states of the souls of the lovers. It is significant that while the male figure is awake and aware of the threat, his eyes fixed on the distance the female is relying on him for protection and seems to be asleep. The storm could therefore be a psychological state or imagining of the man, and may be to do either with the impending war or with the end of the love affair. It also suggests the strong differentiation that Kokoschka made between the sexes, which surfaced both in his misogynist play of 1909 *Murder Hope of Women* and in his obsession with a life-size doll that he had made in Mahler's image after she had left him.

Among studies for the piece there is a charcoal drawing of 1914 which shows the couple asleep on a bed with no backdrop. In the painting not only is the bed turned into a boat but the legs of the figures are revealed and the isolation of the male figure is increased: his hands are no longer interlocked with those of the woman but rather clasp each other.

The Tempest has a circular structure which encloses the figures and the boat in a kind of rocking motion. The motion of the sea is posited as a rotation about a centre close to the hands of the male figure.

The piece can be seen as a turning point in Kokoschka's art, not only from a personal point of view (it seemed to mark the end of his relationship with Alma Mahler), but also in his formal development. It is a work that asks the question, can rationality and love survive?—a question that is answered by the postwar works celebrating violent and sensual themes such as the *Slave Girl* of 1923.

—Julian Stallabrass

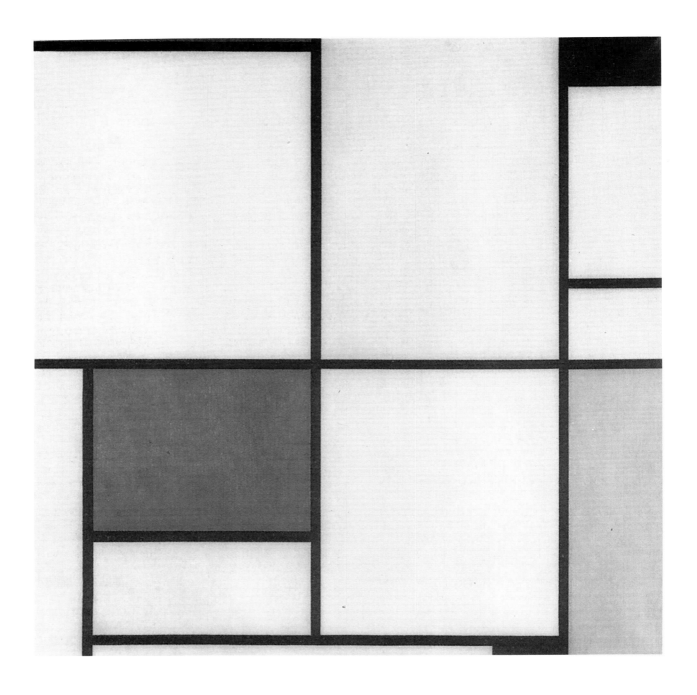

Piet Mondrian (1872–1944)
Composition with Red, Yellow, and Blue, 1921
15 × 14 in. (38.1 × 35.6 cm.)
The Hague, Gemeentemuseum

Composition with Red, Yellow, and Blue is representative of the important change that took place in Mondrian's work in 1921 through which he arrived at the definitive style of the next 20 years. Colors were used more sparingly and were divided by thicker black lines and set off against blueish whites. This is in contrast to his earlier abstract pieces which had a much more consistent color field, often using gray as a neutral ground against which the colors were set, with thinner, more fragmentary lines separating the elements. Mondrian also definitively excluded all but primary colors in the new style. There was no longer any use of the yellowish greens, for instance, that sometimes appeared in the work of 1920. By contrast, in 1922 the changes in Mondrian's work were much less pronounced, the main innovation lying in the way that the color areas were often placed in the margins of the picture, the centre being occupied by a void of neutral white. Mondrian was to pursue variations of this format until the 1940's.

This definitive and confident style was achieved in a climate that was extremely unreceptive to it. Paris was unsympathetic to abstract art and the Parisian artists that did practice it (for instance, Herbin and Léger) tended to do so as a discrete part of their work intended for decorative projects. As a consequence Mondrian's dealer, Léonce Rosenberg, did not vigorously promote the artist's work. When Mondrian published a version of his major theoretical statement, *Neo-Plasticism,* in French in 1920 under the auspices of the Galerie de l'Effort Moderne, it went virtually unnoticed. The 1923 group exhibition of De Stijl at the same gallery was commercially unsuccessful for Mondrian who had to support himself painting flower pieces.

The status of pictures like the *Composition* as saleable bourgeois art objects was of course problematic. Mondrian saw his pictures as signs of the ideal and the spiritual, as both signals to and signs of the coming of a neo-Hegelian dream. In *Neo-Plasticism* he wrote that the turning point being reached in culture is an absolute one and that in reflecting this painting is to express not the materiality of the colors themselves but only their relationships. All particularity is to be done away with, even that of time and space. There are some peculiarities in *Composition with Red, Yellow, and Blue* in relation to Mondrian's theories. We could expect the colors to be pure and the surface smooth as befits a work of pure relationships between elements. However, there are slight surface variations in the color and the texture of the paint. The white in the center is a little more yellow than that above it. The dark color at bottom left is distinct from the black lines which surround it. The black lines stop short of the edge of the picture while the colors continue. Most of these features serve to tie the colors to the surface of the picture. There is a tension between the need to provide a flat picture surface that allows no illusionistic effects of space caused by the advancing or retreating qualities of the colors, and the need to produce a piece that operates by the relationship of pure elements alone.

It is the result of this tension, however, that gives the works of Mondrian such interest as they attempt to reach a compromise between the particular and the universal, between infinity and bounded pictorial space. Mondrian himself thought that in the new era autonomous works of art would no longer be necessary: life and environment would themselves become aesthetic. In the meantime, works of art could only act as signs of this coming state but signs that were inevitably flawed by their contact with the material.

—Julian Stallabrass

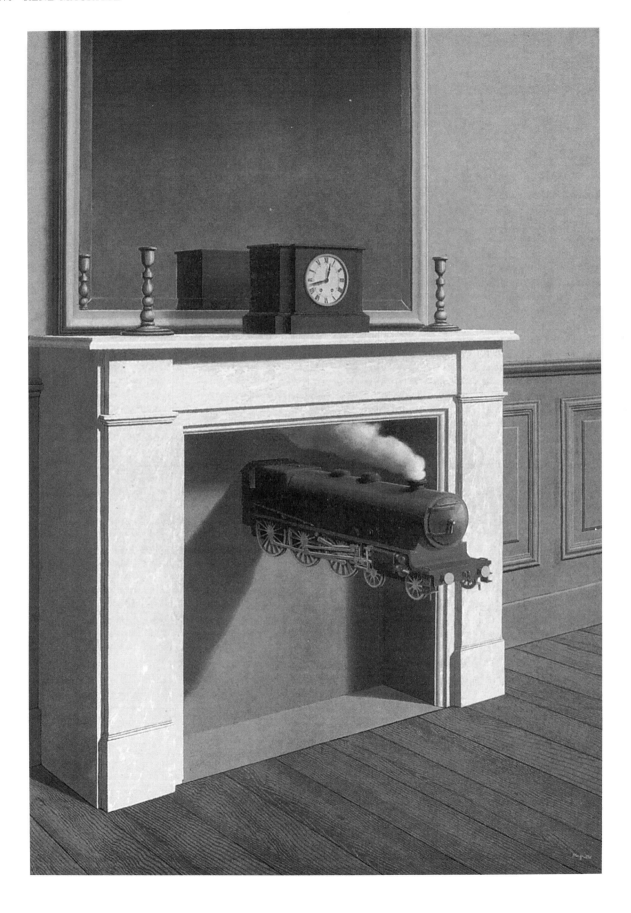

René Magritte (1898–1967)
Time Transfixed, 1938
57⁵/₈ × 38³/₈ in. (146.3 × 97.5 cm.)
Chicago, Art Institute

The locomotive is an image much used in Surrealist art. In the work of Paul Delvaux and Marcel Jean, for example, it often appears in juxtaposition with a naked sleeping woman as a potent symbol of sexual desire. Magritte, in *Time Transfixed*, also exploits this image's phallic dimension, one complement in this case by the candlesticks and the vertical pillars of the fireplace. But Magritte's use of the image has other implications. For, as the title of the painting—for once in synchronisation with its apparent subject—says, this picture is about Time and the nature of Time—both in relation to waiting and in relation to desire.

The theme of waiting is explored surprisingly richly considering the paucity of detail in the painting. But the very austerity of the scene depicted—with its bare boards and empty fireplace—makes it like that of a station waiting-room (except for the domestic features of candlesticks and a mantlepiece-clock as opposed to a wall-clock). Also, there is doubt about the time of day. Although the clock tells us it is coming up to a quarter to one, is this A.M. or P.M.? The shadow cast by the locomotive against the back of the fireplace could be produced by artificial, overhead light or by daylight coming in through a window (neither potential source of light is shown in the picture). The two empty candlesticks are equally non-commital: have the candles burnt right down owing to the lateness of the hour—past midnight—or have they yet to be fitted in the candlesticks as it is only just after midday?

Not only, however, is there doubt about exactly *when* we are waiting but, more importantly, *for what*. Are we really at the station waiting for an express which we imagine to steam promptly out of the fireplace instead of out of the tunnel into the terminus building? Or are we in a more domestic environment awaiting the arrival of some unidentified object of desire, symbolized by the steaming railway engine? Or is the expected object one of dread?—this painting was done in 1938, at a time when the menace of German armed might was shortly to be unleashed against small neighbouring nations such as Magritte's Belgium. Each of these hypotheses is plausible, but Magritte, unlike Delvaux or Jean in a similar context, deliberately refrains from giving any further clues. This is because his main concern is to explore the nature of *time* itself (admittedly a paradoxical ambition for a painter whose medium is essentially that of *space*!) and the way it is experienced by the waiting consciousness, regardless of the particular object expected, dreaded, or desired.

Magritte has therefore been extremely careful not only in his choice of visual images expressing time but also in their relationship. First of all, as we have already noted, all distracting detail—wallpaper, the pattern on the carpet—have been pared away, leaving in clear focus only the essential objects: fire-place, clock, candlesticks, locomotive. The images of chimney, candlestick, and locomotive are linked by the fact that all produce smoke or burn and, in doing so, in various ways measure or indicate time: when candles or fires burn down, it is late; when the locomotive steams, it is making up time, rushing towards its destination. The most interesting links, however, are perhaps those established between candlestick and clock and locomotive: the candlesticks are the chimneys of the steam engine but, more importantly, the clock-face is reproduced in the circular front of the locomotive's boiler, the centrally fitted pressure levers of which imitate the hands of the clock. In Magritte's painting, the locomotive emerges from directly beneath the clock-face: in a sense, the engine may be seen to have rushed through it, carrying its dial forward with it. Magritte has thus created the image of two simultaneous movements of time: that measured by the circular movement of the clock hands round the clock-face and the dynamic horizontal movement of the express. But, in addition, and paradoxically, in Magritte's painting, both these movements of time are *transfixed*: the express has rushed through the clock-face, almost as through a sound barrier, and accelerated time's passage. But, at the same time, it itself has been transfixed as it remains suspended in mid-air—one might almost say in mid-time—in a state of indefinite emergence from the chimney.

Magritte's aim in this picture is thus to stress the subjectivity of our perception of time and our understanding of it, by exploring the commonly reported sensation of "time standing still" in an uncommon way. In doing so, he takes the conventional measures of time's passage—clocks, candles, express trains—and explores the possibility of the irrational connections between them which in fact will tell us more about the nature of time as experienced. In doing this, he is, of course, furthering the more general Surrealist aim of investigating the irrational aspects of human experience—especially our notions of time and space—beyond the measurements and estimates the rational mind or social conventions tend to impose. He is also in this picture—as elsewhere in his work—reinterrogating the conventions of pictorial representation. Painting, he seems to be suggesting, by its very nature also *transfixes time*: it becomes, therefore, especially if used in an innovative, Surrealist way, a privileged medium for the exploration of expectation and desire. But although painting is static, it is also, of course, very much bound up with time. For time—and memory—are a vital element in the viewer's gradual understanding of what painting, and especially Surrealist painting, is about, an understanding which, though focussed on an apparently static object, is often—like the locomotive in Magritte's picture—in a state of permanently suspended dynamism.

—David Scott

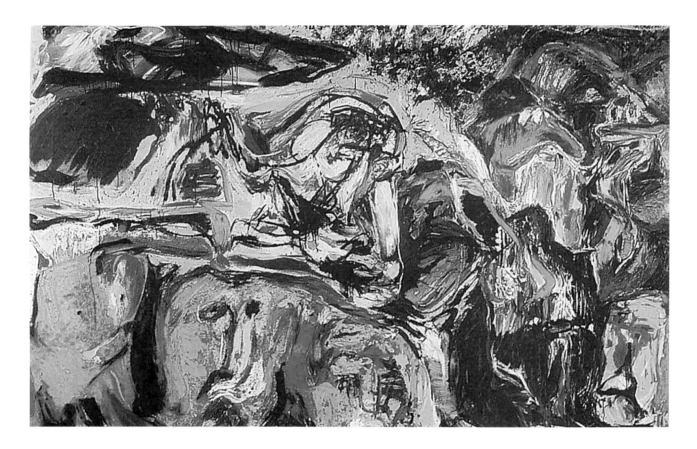

Asger Jorn (1914–73)
In the Beginning Was the Image, 1965
6 ft. 6 ³/₄ in. × 9 ft. 10¹/₈ in. (200 × 300 cm.)
Private Collection

Uniquely representative of the artist's fundamental creative philosophy is this huge canvas—200 × 300 cm—painted in 1965 and now in a private collection in Norway, its evocative title suggesting that art has its origin in a primal anticipatory state, a microcosm rich in floating images, each awaiting the manipulative hand and fertile imagination of the artist to give it meaningful form and function.

A combination of the instinctive and the deliberate gives the picture its visual logic and dramatic tension. A consonant triad of deep red, cerulean blue, and yellow, with tinges of green and dissonant streaks of dark pigments, dominate an intensely emotional colour scheme, while a pyramidal structure rising toward the upper center gives firmness and order to the composition. Crosscurrents of lines and blotches recapitulate these themes of colour and form, simultaneously camouflaging and unveiling a series of ambiguous figural elements.

In the upper left a hint of a horizon above a calm sea beyond a serenely undulant shoreline à la Munch, suggests deep space and contrasts with the tight turbulence of the remainder of the canvas. To the right of the apex of the pyramid a cluster of hatched triangular shapes combines to evoke the disquieting image of an as yet indeterminate biomorphic form emerging, cyprinoid, from the primal chaos, while down below a family of faces, distorted as by the pull of gravity yet identifiably human, impassively await the uncertainty of their destiny.

Other, equally subjective visions may arise from this canvas, for the artist obviously craves the active participation of the viewer in this and his other sometimes playful, more often sober, games of hide and seek. In this painting, its passion dictated by its splendid display of pure, dynamic colours and its emotion kept within bounds of reason by the artist's instinctive sense of structural order, Jorn has created an enduring image of his own private world and through an intriguingly ambiguous title provided at least one clue to the unveiling of its inner secret.

—Reidar Dittmann

Karel Appel (1921-)
Questioning Children, 1949
Gouache on pine wood relief; 34 × 23¹/₂ × 6 in. (87.3 ×
 59.8 × 15.8 cm.)
London, Tate

This painted relief is one of three of the same title all painted
in 1948–49: the other two are in the Musée National d'Art
Moderne in Paris and the Stedelijk in Amsterdam. Appel also
painted a mural in the Amsterdam City Hall canteen of the
same title, which aroused fury: it had to be covered up when
certain city officials were eating there. Their complaint was
that the subject of the mural was incomprehensible: the Press
response to the controversy was generally harsh and condem-
natory towards the work, to such an extent that public opinion
was influenced: and the mural was covered over with wallpa-
per. However, ten years later the climate of public opinion had
changed and the mural was uncovered and restored by the Ap-
pel himself. The circumstance of 1949 proves just how early
and therefore unacceptable to so many this kind of interpreta-
tion was. The mural and the relief were done in, as he says
"the same esprit and motives." In presenting the mural to
journalists and press photographers, Appel recalled that, on a
train journey from Germany to Denmark, he had seen "Ger-
man children begging, the whole length of the train. At the
time I didn't really take note. But the result is this." This is the
considered side to the work, as opposed to the spontaneous,
innocently created, and simple side. Peter Berger describes it
thus: "double character . . ." combining an image of "sim-
plicity, and air of festivity . . . joyous and pure colour" with
"in their eyes . . . a fear which goes beyond mere protest
against the reality of a world created by adults. It is a fear of
existence itself. These are images which belong to a shattered
world."

All three of the reliefs are of similar size and employ the
same "found" materials: bits and pieces of wood that Appel
found. It is thought that the Tate version's back panel is an old,
possibly 17th-century, shutter from Smirna, the house of Oude
Zyds Voorburgwal where he had his studio and where the
work was put together. He then nailed on top robust and crude
smaller pieces of planks which he painted in bright gouache.
The collage of wood pieces are very carefully placed, and the
legs, arms, ears, and decorative borders were added to the
shutter base. Appel wanted a direct effect, and thus positioned
the large, round eyes and symmetrical outstetched arms fron-
tally, rather than at any angle or in profile. The inspiration
from child art is profound, and homages to children's paintings
and drawings that he saw are evident in the reliefs. He later
spoke of their influence upon him: "When I started, I used to
look at children's drawings. They gave me the impetus I
needed to free myself from the things I'd learnt during my
classical education. I could then begin with a blank page like a
child—or let's say, like a 'child adult.' I started again from
scratch thanks to these children's drawings which were like a
gust of fresh air."

The Tate Gallery also owns a painting by Appel, *Amorous*

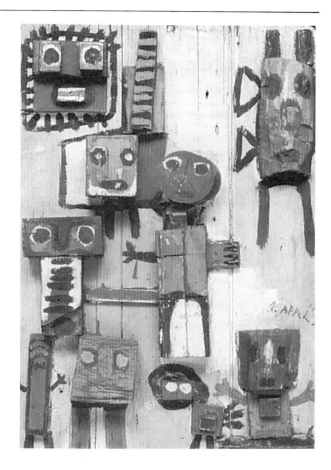

Dance of 1955, which is also inspired by children's painting
but seems to fit much more coherently into the canon of the
Abstract Expressionist post-war movement. What makes the
wooden collages so distinctive is not just their unorthodox ma-
terials, with the connotations of Dada assemblages, and their
peculiar Dutch character, but the unique presentation of what
childlike images can teach the artist and his or her public. The
influence of Dubuffet is strong: his idea that depictions by the
mentally ill and by children were so potent rubbed off on Co-
bra. Appel even went so far as to paint with his left hand in
order to produce a new sensation in his work. He considered
his right hand to be trained and his left spontaneous and irreg-
ular. Appel also had an interest in the art forms of primitive
peoples, and while his female nudes often reveal fetishistic
qualities, these hieratic figures echo a mysterious mythology
alien to the course of standard Western culture.

—Magdalen Evans

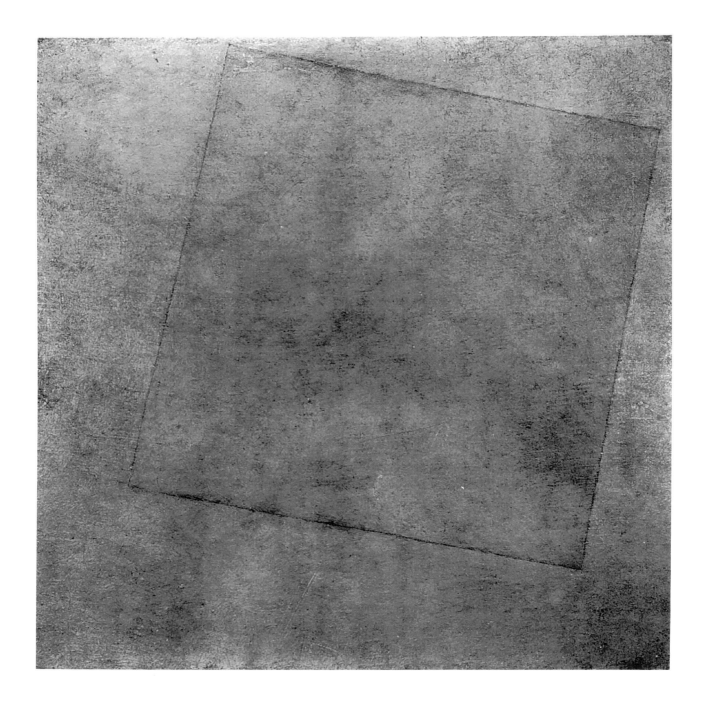

Kasimir Malevich (1878–1935)
White Square on White, 1915
31 × 31 in. (78.7 × 78.7 cm.)
New York, Moma

White Square on White (oil on canvas, 78.7 × 78.7. Museum of Modern Art, New York) represents a summit of the Suprematist style which may be said to have been initiated at the 0–10 exhibition of Futurist painting which opened in Petrograd in December 1915. From 1900 Malevich utilised many painting styles: for instance, in that year, his first picture, a portrait of his mother, was carried out in a dull palette typical of the *peredvizhniki*. Three years later he adopted Impressionism, then post-Impressionism, experimenting at the same time with divisionism. Between 1907 and 1912 he moved into primitivism. His figures became increasingly geometrical in character, the colours intense, almost metallic. Next came synthetic cubism, the peculiarly Russian cubo-futurism, and then a kind of picture created by juxtaposing disparate objects together with displaced words, syllables, and letters. These last works, his a-logical pictures, were essentially literary in that the painted forms and linguistic elements were to be read to create a conceptual portrait—as, for instance, *Englishman in Moscow* or *Woman Beside Advertising Pillar* (both 1914). He had already begun to question the traditional iconography of art such as "Madonnas and Venuses," and this led him to the creation of an autonomous artistic language composed of geometrical shapes whose colouring was determined simply and solely by the artist assisted by rules of chromatism. This style he called Suprematism. There was no apparent relationship with the visible world of man or nature; it was an art activated by what he called "dynamic sensation."

It is necessary to emphasise the nature of this headlong rush which led Malevich to Suprematism because it gave him little time for reasoned argument and explains the contradictions in his writings and what seem to be inconsistencies in his work. For instance, an art which is based on the supremacy of emotion, on the "dynamic sensation" of the individual, would have been difficult if not impossible to teach on a wide scale; and yet Suprematism under his own guidance became in post-revolutionary years a decorative style which was universally adopted for street decorations, book design, the ornamentation of tableware, and mass political demonstrations. With the coming of the revolution in 1917 Malevich, ever in the vanguard, had sensed the parallel between the sweeping away of the old order and its replacement by a new political dialectic and his own rejection of the imagery which had persisted in art through the ages and its replacement by his new order of geometrical shapes and colours free of all naturalistic and traditional connotations. Thus Suprematism became the art style most associated with revolutionary Russia. It must be emphasised, however, that these developments in Malevich's style, influenced as they may have been by writings on cubism, chromatics, and futurism, were undoubtedly logical—more so than, say, the French cubists after 1914.

Under the term Suprematism two distinct styles were explored by Malevich: side by side with the colourful works in which geometric, brightly-coloured shapes float over a white ground were others which investigated visual perception, psychology, and, possibly, mysticism. These works, begun about 1915 and continued for some years after the revolution, were of simple, basic shapes such as a circle, cross, and square, often coloured red, brown, black, or white, and set on a rectangular or square white ground. *White Square on White*, exploiting, as the name suggests, white on white, is one of this series. By a variation in brush strokes—a similar effect can be noticed when the pile of velvet is brushed contrary to its natural flow—Malevich enabled the white square (which is actually placed on an angle) to stand out from the rest of the canvas surface. As a painter his gains were several: the brush strokes themselves produce a rhythm, a sense of movement, form is suggested without outline or shading, dimension is created without cold or warm colours, and space is opened up by the fields of white paint.

As to the significance or meanings of *White Square on White*, as distinct from its painterly achievements, nothing can be stated with any certainty. Although Malevich professed a horror of creating a fourth dimension, there is no doubt that *White Square on White* is concerned with dimensional perceptions: it is a common experience that, depending on the degree of visual concentration, a square set within a square will alternatively advance or recede thus imperilling the flatness of the canvas surface. It is clear also that he was seriously concerned with the conquest of aerial space, an age-old Russian concern. In fact, he was to design buildings which he called planity for use in space. In the catalogue of the 10th State Exhibition of 1919 he claimed that he had ripped through the blue lampshade (by which he sometimes designated the sky) of colour and had come through into the white which was the "true actual colour of infinity." In addition, the Russian Symbolists, a powerful and potent artistic force at the beginning of the century, were obsessed with white, which represented for them, as Malevich was certainly not unaware, the real world of the human spirit. It is not unlikely that he was to some degree influenced by Theosophy which was popular in Russia in the first years of the century and which had as a central feature of its doctrines the search for further dimensions than our earthly ones.

What is certain about *White Square on White* is that Malevich had reduced both form and colour to the irreducible: he could go no further along that particular artistic path. Looking about him in a cool moment he must have seen that Suprematism had become yet another style in the history of art—and a decorative one at that. His return to figurative painting was inevitable. Nevertheless, the audacity and resolution exemplified in *White Square on White* were to inspire a whole generation of artists in Europe and America from the 1960's onwards.

—Alan Bird

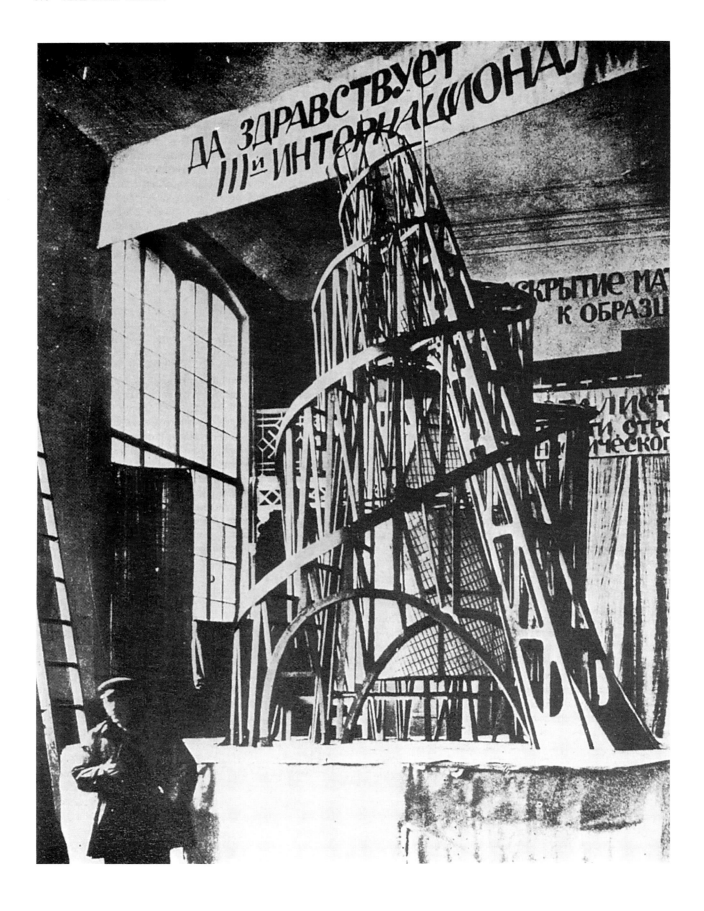

Vladimir Tatlin (1885–1953)
Monument to the Third International, 1919–20
Mixed media model

In 1919 Narkompros, the People's Commissariat for Education and Enlightenment, commissioned Tatlin to design a *Monument to the Third International* which was to function as a government building, a centre of agitation, and a symbolic celebration of the Revolution in Russia. To carry out the project Tatlin set up a collective workshop with I. A. Meyerzon, M. P. Vingradov, and T. M. Shapiro. Together they produced a design for a massive conical structure in glass and iron which was intended both to exceed the height of Eiffel's Tower in Paris and to rival it as an international monument to modernity.

On 8 November 1920 a model of the *Monument* was exhibited in Petrograd. It was made of wood, card, wire, metal, and oil paper, and was adorned with a red ribbon bearing the motto "Engineers, Create New Forms." *Tatlin's Tower*, as it soon became known, was very well received throughout Russia and in 1925 received international attention when it was exhibited at the World Exhibition of Industrial and Decorative Arts. The use of the double spiral and the dramatic diagonal incline of the building captured the popular imagination as a dynamic representation of the striding force of communism. Some critics have illustrated the symbolic significance of the leaning structure by comparing it to that of a striding figure. Tatlin's contemporary El Lissitzky recognised the *Tower* as a metaphor for the Proletariat; "Iron is strong like the will of the proletariat, glass is clear like its conscience."

Although there are precedents for the use of the spiral motif in the history of architecture (Rodin's 1893–94 *Monument to Labour*, for example) Tatlin employs the usual double conical spiral as the skeleton of the building with a dramatic effect. As the coils ascend in height they diminish in size suggesting the possibility of eventual resolution while the asymmetrical lean of the building reinforces the themes of continuity and progress.

If it had been built, *Tatlin's Tower* would have resembled a giant mechanical screw emerging from the earth and stretching itself upwards and forwards towards the heavens. As a metaphor for the Revolution, *Tatlin's Tower* reminds us that change is an ongoing process. The events of October 1917 could not, and did not, transform a nation overnight. Like the Revolution itself, *Tatlin's Tower* has its foundations and its apex. The former is Russia's rich history hidden beneath the earth's soil; the latter is not yet visible but lies somewhere in the future when World Communism has been achieved.

It was Tatlin's intention that the *Monument* itself should incorporate movement. While the iron framework remained static, the interior structures would revolve around their axes at different speeds. The interior space was divided into four massive glass forms within which the various government de-

partments were housed. At the base of the *Tower* a giant glass cube was to provide for the legislative assemblies, rotating at the speed of one complete revolution per year. Above this is a square-based pyramid was given over to executive functions, this would rotate once a month. The Information Centre, housed in the cylindrical structure above, would revolve on a daily basis. At the top of the *Tower* a glass hemisphere is also visible; its function, however, is not recorded.

On 26 October 1917 the Bolshevik Central Committee announced the new government which was to be headed by Lenin. The Commissariat system was presented as a means of realising the ideals of communism within an ordered institutional framework. Russian artists saw themselves at the forefront of the changes taking place after the Revolution; they were the "artist-engineers" helping to construct the world anew. On 1 January 1919 Tatlin was appointed head of the artistic department of Narkompros in Moscow. In his capacity as teacher of the arts, Tatlin made clear his understanding of the role of the artist after the Revolution: "The Revolution is strengthening the impulse towards invention. That is why a golden age of art will follow a revolution, a time when the mutual relation of the individual of initiative and the collective is distinguished. The individual with initiative is the condenser of the energy of the collective."

Tatlin visualises the processes of government decision making and debate as ascending and diminishing spirals. In a wider sense, Tatlin represents the principle of a collective, communal, and universal body whose parts are harmoniously related to one another and to the whole like the planets in the solar system or the organs in the human body. In the early years following the Revolution those in power were immersed in complex debates concerning the role of the individual within communism. But while vying political and artistic factions argued about the minute details and practicalities of communism, there was a collective vision of hope as far as the future was concerned. *Tatlin's Tower* is an expression of that optimism—a monument not only to the present but to the future. After all it was anticipated that one day *Tatlin's Tower* would be the Headquarters of World Communism.

Although it was never built and is technically highly impractical, Tatlin's *Monument to the Third International* is still a pertinent icon for the Revolution in Russia. This is a great tribute to its achievement as a complex interpretation of a social and political ideal. That ideal was International Communism and in the early post-Revolutionary years, for Russia's intellectuals at least, it seemed as though Utopia itself was within their grasp.

—Lauretta Reynolds

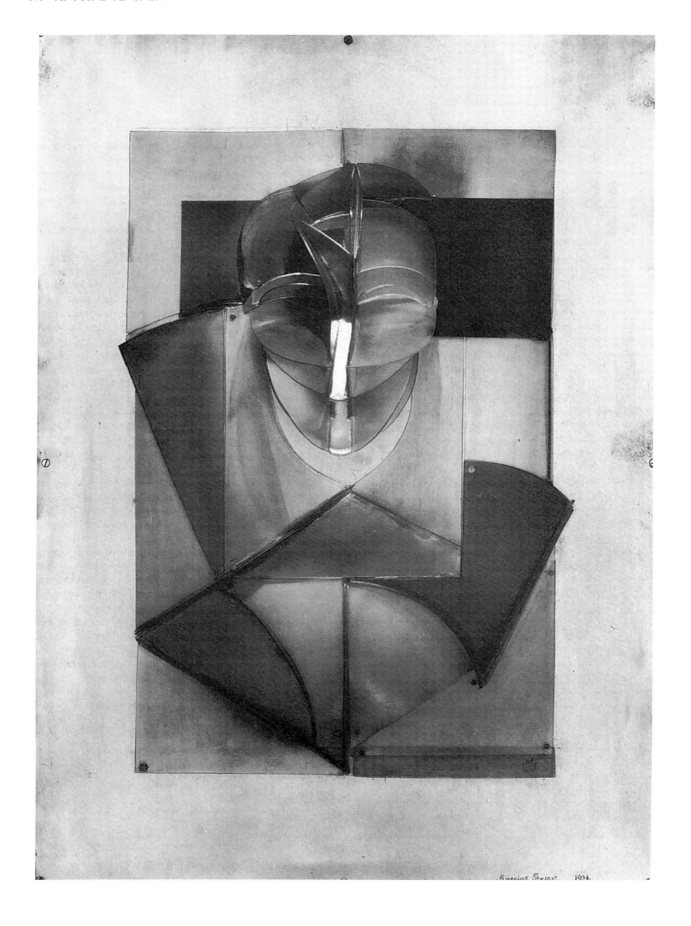

Antoine Pevsner (1886-1962)
Portrait of Marcel Duchamp, 1926
Celluloid and iron on zinc; 37 in. (94 cm.) (height)
New Haven, Yale University

This sculptural portrait was commissioned by Katherine Drier of the *Société Anonyme* in 1926 after she had seen two works that Pevsner exhibited at the *Salon des Indépendants* of that year, including *Torse* (1924; New York, MOMA). Despite the relatively abstract nature of the work, Duchamp actually sat for it in April of 1926 and features of his face such as the long chin can be observed. The tone of Duchamp's 1912 paintings such as *Bride* are curiously reflected in the tones of the celluloid, and specific references are also made to the mecanomorphic shapes of these pieces.

The way in which the forms of the face are delineated by planes leaving the volumes described as spaces obviously owes much to the earlier heads made in sheet metal by Pevsner's brother Naum Gabo from 1917. In general the idea of using a negative space to describe volume is a hallmark of cubist sculpture in the work of both Archipenko and Picasso, whose metal *Guitar* of 1912 is completely made up of these spaces.

However, there are features of this sculpture which mark it off from the general run of cubist sculpture. The most obvious is the curious idea of mounting Duchamp's head on a kind of plaque as though it were a trophy. There are few prototypes for this kind of arrangement although Gabo mounted one of his heads in a base that framed it on two sides, and Archipenko made some sculpto-paintings which are similar. This aspect of the portrait is said to have shocked Dreier when she first saw the completed work. There may be a sense in which this is a joke at the expense of the collector from another continent, perhaps one made with Duchamp's involvement. Dreier could be seen to be bringing back big-game trophies of the great artists from the jungles of the avant garde little known in the United States.

This aspect is fortuitously reinforced by Pevsner's interest in "primitive" works of art which was very fashionable in the Paris of this period. The piece has a mask-like aspect and is formally similar to some West Indian masks. This further adds to its exoticism. It is also a feature that seems to clash directly with the high tech materials that Pevsner was using. Plastics were not much used in sculpture, and one would expect to find that, where they were, the piece would reflect their qualities of smoothness and translucency. Instead the aspect of the plastic is contrasted with the weathered zinc base of the piece as seen in the early photographs of the piece.

The sculpture is also surprising in Pevsner's oeuvre for the way in which it makes the method of its construction clear. The screws that hold it together are clearly showing. Again this is a cubist device analagous to the all too obvious pins that hold some of the *papier collés* together. It is rare in Pevsner's work where generally the working and construction process is carefully concealed and the work is presented to the viewer as a seamless and unitary object.

This work is interesting because it shows us the way in which Pevsner was far more thoroughly involved in the intellectual, and specifically the cubist, concerns of Paris than the look of his later work, which is broadly constructivist, would lead us to expect. It also shows us a Pevsner that in 1926 was fully aware of the devices of cubist sculpture while following the course that Gabo had laid out, and was capable of mixing the two with humour.

—Juilian Stallabrass

Naum Gabo (1890–1977)
Linear Construction: Variation, 1942–43
Plastic; 24 in. (61 cm.)
Washington, Phillips

Linear Construction is typical of the transparent sculpture of Gabo's mature style. This piece exhibits a symmetry around a diagonal axis so that one side of the sculpture is an inverted image of the other. Gabo's study of mathematics is evident in the geometrical and symmetrical shape of *Linear Construction* which appears to be the kind of shape that would be generated from the operation of a particular equation. The style of the work also suggests mathematics, in the transparency of the sculpture that is an expression of immateriality and of the pure world of the ideal, and in the lines that make the subject up since line is an abstraction, a tool of geometry. The lines themselves signal their ideal nature by their thread-like thinness and by the way they draw the light. Further, the criss-cross effects caused by the lines of each plane running in different directions remind us of graphs and diagrams. There is a sense for Gabo in which science, mathematics, and art meet in a higher realm of ideal knowledge. This is a technocratic piece, a celebration of knowledge expressed by geometry on the one hand and of technology expressed by new materials on the other. It is a sign of the qualities of the intellect (transparency, clarity, and abstraction) masquerading as a product of rationality.

In his controversy with the Soviet Constructivists expressed in his *Realist Manifesto* of 1920, Gabo argued that fine art should not be dismissed in favour of research for design and that it still had a separate role to play in society. Pieces like *Linear Construction* express this view clearly. In some ways, with its references to the use of new materials and its mathematical construction, the piece appears to be close to the concerns of Soviet Constructivism. Gabo's argument was never that aesthetic research had no role to play in practical projects. Indeed his 1931 *Project for the Palace of the Soviets* is a highly innovatory design with its two asymmetrical shell-like auditoria cantilevered out from a central core. However, most of his work, certainly after the move to England in 1935, consisted of pieces like the *Linear Variation* which were not directly concerned with the qualities of materials or the effects of combining different substances, subjects which were crucial in the work of Tatlin.

The move to London and later to St. Ives in Cornwall had brought Gabo into contact with Moore, Hepworth, and Nicholson through activity in *Unit One* and *Circle,* a survey of constructivist art that he edited with Nicholson and J. L. Martin. It is clear that the approach of these artists in looking to nature for abstract forms had an great effect on him. This is clear not only in the pieces where he used natural materials, as in *Kinetic Stone Sculpture* of 1936, but also in his work in plastic such as *Spiral Theme* (1941) which derives its shape from shells. This looking for mathematical form in nature was a theme that was to occupy Gabo for much of the rest of his life. In his view, the order that is found in art and mathematics is one that derives ultimately from nature.

Among Gabo's mathematical interests was the idea of the fourth dimension and the possibility of its expression in art. Like the pre-war Cubists, Gabo thought of it as a realm of the ideal and thus by association of the aesthetic. The interference patterns set up by the lines on the different planes of the sculpture was one way in which the usual perception of three dimensions could be disturbed or breached. In this effect Gabo anticipated op art. The two dimensional lines engraved on and following the curved planes of so many of his sculptures brings to mind the standard analogy in dealing with the fourth dimension—to imagine two-dimensional form being distorted by being mapped onto a three-dimensional surface. The criss-cross pattern is formed from the lines running in opposite directions on different planes of the sculpture. When we see them as a kind of grid as it is difficult to avoid doing, we push the planes together in space in another sensation supposed to evoke the fourth dimension. *Linear Variation* is a piece that well exemplifies Gabo's concerns throughout most of his work and the particular form that they took from the 1940's on: while there were some new departures in his sculpture after the date of this piece, particularly his decision to work in bronze, the themes of natural form and mathematics continued to occupy him.

—Julian Stallabrass

Ossip Zadkine (1890-1967)
Destroyed City, 1951–53
Bronze; 21 ft. 4 in. (650.2 cm.)
Rotterdam, Plein

Zadkine's monument to the bombed town of Rotterdam has been considered the greatest memorial of the Second World War. Using a cubistic figurative idiom in a manner evidently descended from traditional heroic sculpture, Zadkine achieved an emotional accessiblity and monumentality appropriate to the 20th century.

In 1941 Zadkine, an assimilated Jew, was forced to leave occupied France for exile in the United States. During this period he produced several nostalgic, even escapist, figures in his edenic primitive style, and a number of works directly occupied with war themes. Of the latter, only one (*Phoenix*) is continued thematically in the Rotterdam monument. There is evidence of a struggle to formulate a public language using simple, traditional allegorical and metaphorical devices, but it was not initially satisfactory: the caged female of *The Prisoner* series is a legible but formulaic representation of occupied France. Only after the normalisation of his personal circumstances was Zadkine able to fuse the public and private elements of his war theme.

The idea for a monument came shortly after Zadkine's return to France, inspired by his first sight of the bombed city of Rotterdam. He described the scene (in retrospect) in gothic terms: "from the station onwards there was nothing . . . the ruins of a church, blackened by fire stood erect, like the teeth of a prehistoric monster." The vision crystallised pre-existing concerns, providing a specific context for the fusion of anti-war sentiments and personal emotions already articulated. The first maquette was made shortly afterwards.

This version, a two feet high terracotta, immediately seized the subject in a human form, as a figure in "fear and revolt." The maquette toured in the first post-war exhibition of French art, but was broken in transit. Zadkine began again, abandoning the picturesque small terracotta for plaster on twice the scale, to be cast in bronze. This version was shown in Amsterdam and Rotterdam in 1949. These retrospective exhibitions began to establish an international reputation for the sculptor. In 1950 he won the sculpture prize at the Venice Biennale for the model, and the commission for the public monument came in 1951 from the city of Rotterdam.

For such a project, Picasso's *Guernica* would provide an almost irresistible model, and Zadkine's bellowing and rushing figure is certainly stylistically comparable to a figure to the right in Picasso's protest to the bombing of Guernica. Zadkine's own *Howling Harlequin* series, expressions of anguish and alienation completed in exile, contributed the central expressionist element to the sculpture. Its deeply gouged mouth transfers directly to the Rotterdam figure. Munch's famous *Scream* may well contribute to both. The spirit of his *Phoenix,* not in this case a bird of rebirth but an image of survival, galvanises the body; adrenalin running through the torn cock survives in the gaping wound which impells the Rotterdam figure. Finally Zadkine's ubiquitous symbol, the primaeval forest, source of all organisms, stands beside the figure, stunted but prepared for regrowth.

The pose of the figure returned to his *Niobe* of 1929 (Philadelphia), a ritual representation of grief with arms "raised in protest to the heavens." In the new figure Zadkine retained the raised palms, but abandoned the frozen body; it was rather the inspiration behind the *Niobe* to which he returned, a memory of a peasant he had seen on a hilltop in his childhood, screaming in pain at the loss of his children in a cholera epidemic. Zadkine's use of the peasant to signify basic humanity and to teach endurance of suffering has numerous precedents, especially in 19th-century Russian literature, strongly echoed in the artist's description of the memory. As a symbol of suffering and endurance, the peasant exemplifies an ideal humanist response to tragedy. From the outset an optimistic didactic purpose was envisaged for the monument. The virility of the figure, its massive masculature (in contrast to the lissom *Niobe*) derive from Rodin as much as from the physical type of the peasant. He had completed a sculptural homage to Rodin during the American sojourn, but in any case the scale of commemoration envisaged placed the work inevitably within the heroic tradition of 19th-century public sculpture. A formal relationship can be traced between Zadkine's figure and Rodin's *Walking Man* (1877) and certain figure studies from the *Gates of Hell* especially the thrown-back torso of the *Prodigal Son* (before 1889) and his *The Falling Man* (1882) whose heavily indented spine might suggest the torn hole in Zadkine's figure.

The final version of *Destroyed City* was erected on a site chosen by the artist, facing the port of Leuvehaven with the laconic inscription of the date of the bombing: May 1941. The fusion of lamentation with defiance and innovation with tradition was finely balanced. After a period of controversy in the Dutch press, the monument became widely appreciated, and continued to play an important part in establishing the artist's claim on an international audience.

—Abigail Croydon

Jacques Lipchitz (1891–1973)
Figure, 1926–30 (cast, 1937)
Bronze; 7 ft. 1 in. (215.9 cm.)
New York, Moma

Lipchitz made the original definitive version of *Figure* in 1926, after a sequence of studies in bronze on the theme. This first version was only 10 inches high: however a client, a Mme. Tabard, was attracted to the little sculpture and commissioned a much larger copy which Lipchitz made in 1930.

The survival of the sketches for the *Figure* allows us to trace its development. The concept that lay behind the piece emerged from the piercing of the sculpture from front to back that Lipchitz had been practising since the *Pierrot* of 1925. Here the centre of the figure is hollowed out allowing the viewer to see right through it. The *Pierrot* marked a radical break in Lipchitz's work away from a planar and angular style associated with Cubism towards a more flexible and additive approach, which was to bring him closer to Surrealism, although this was a characterisation that the artist himself repudiated. It was certainly a style much better suited to modelling in bronze than carving in stone, which Lipchitz abandoned after 1925. This was a significant development because up to this point carved work had predominated in Lipchitz's sculpture.

The first sketch for the *Figure* uses two holes through the torso of the piece that in some sense define the volumes of the body. Even at this stage the overall feel of the sculpture exhibits a return to a generalised African influence—although Lipchitz later denied that this was so. However it is in the next study that the radical change really comes: this is when the decision is made to slot in another element at right angles to the first thus creating a cruciform space. This was a new departure in the work of Lipchitz although he had used solid planes in a similar way in his highly abstracted works of 1916 and 1917. In *Figure* these hollow forms not only define space by the voids that they encompass in themselves, but do so in the space they create between them. In the final study the circular eyes are introduced, the element that more than anything gives the piece its presence as a kind of totem. Also in

the final version the voids are varied to suggest the bodily spaces that they represent: the stomach is almost circular, the void of the torso more elongated.

In its use of space and especially in its frontality *Figure* is related to the *Pierrot with Clarinet* also of 1926. The piece may be also related to *Ploumanach* (1926) which came out of a trip to Brittany that Lipchitz made with Le Corbusier. There he was fascinated by the stones that were balanced on top of others in such a delicate balance that they could be seen to rock in the wind. *Ploumanach,* named after the village in which Lipchitz stayed, is similar to *Figure* in its frontality which gives it the same totemic aspect, and in its transparency since the bottom "rock" is entirely hollowed out. There is a further similarity in the iconography since the details of the upper part of *Ploumanach* are figurative, and this suggests that, like *Figure,* the piece was meant to be seen as an anthropomorphic object of veneration.

Figure, despite its high level of abstraction, is a representation of a female. The motif of the sex of the woman in the finished *Figure* is one that recurs from the almost abstract *Sculpture* of 1916. The sculpture can be connected then with the Surrealist (and more broadly literary) view of "Woman" at the time as an embodiment of natural and mystical forces, not all of which were positive or unthreatening: this may be the reason for its menacing aspect.

The *Figure* can be seen as a combination of various styles that marked Lipchitz's work: the Cubist character of the eyes, the rigorous symmetrical and vertical character of the work of 1916 in the torso, and the interior spaces of the *Pierrot.* However, it was more a transitional work than a synthesis, for the possibilities of this mixture of styles were not really followed up: Lipchitz was to go on to produce a much more fluid and less solid work, more organic than totemic in aspect.

—Julian Stallabrass

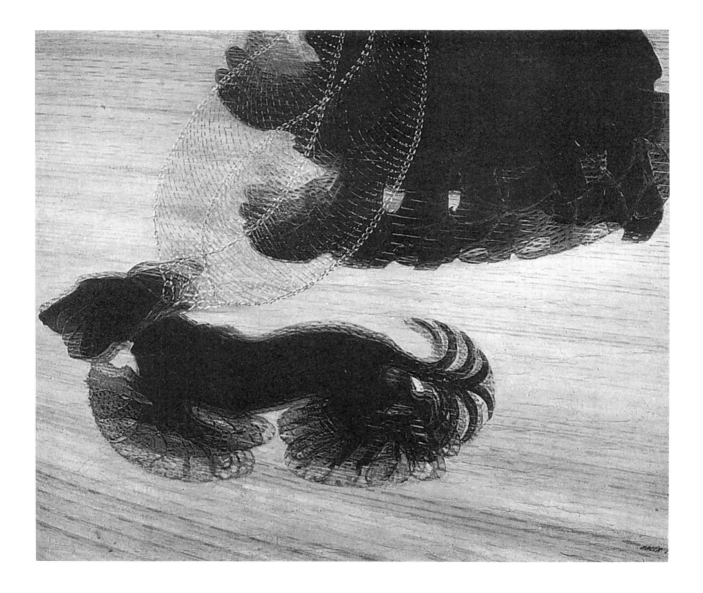

Giacomo Balla (1871–1958)
Dynamism of a Dog on a Leash, 1912
35¹/₄ × 43⁵/₈ in. (89.5 × 110.7 cm.)
Buffalo, Albright-Knox

In 1912, two years after he subscribed to the radical Italian movement Futurism, Giacomo Balla painted his first fully Futurist work: *Dynamism of a Dog on a Leash.* The little dog of the painting, a diminutive flurry of energy, all vibrating legs, ears, and tail, as it propels its mistress across the canvas, has become one of the enduring icons of Futurist art in spite of, or perhaps because of, the contrast of its light-hearted humor to the often heavy-handed rhetoric of the movement.

Balla began the painting on a visit to one of his pupils, the Contessa Nerazzini, at her home in Tuscany. After watching the Contessa walk her small dachshund—surely a daily event—Balla, whose usual practice it was to work from direct observation, discovered a subject for his initial attempt at realizing the Futurist "style of movement." In so doing he created his own variation on one of the most striking images from the *Technical Manifesto of Futurist Painting*—the running horse—a Futurist symbol for the vitality of matter conceived as motion:

A form is never motionless before us, but constantly appears and disappears. On account of the persistency of an image upon the retina, moving objects multiply themselves, become deformed, follow each other in succession, like vibrations in the space through which they travel. Thus, a running horse has not four legs, but twenty, and their movements are triangular.

By 1912 Balla's fellow Futurist painters Umberto Boccioni, Carlo Carrà, and Luigi Russolo had all depicted a galloping multi-legged horse. Russolo incorporated a small twenty-legged horse into the larger montage of *Memories of a Night* (1911; New York, Slifka Collection), as did Boccioni in *Matter,* (Milan, Mattioli Collection), a major canvas of 1912. Carrà gave this theme its most explicit definition in his small watercolor *Speed Disintegrates the Horse* (Milan, Jucker Collection), also in 1912. Only Severini had no place for this Futurist icon, preferring instead another image rendered multi-legged, the nightclub dancer.

When Balla turned to this theme in 1912, he drew on two stylistic resources from his pre-Futurist period, his ever-flexible Divisionist technique and his knowledge of contemporary photography. Rather than using Divisionism to simulate light, he adapts it in *Dynamism of a Dog on a Leash* to the rendering of the equally vibrant insubstantiality of motion, laying large round bricks of color on the body of the woman and dog, small quick strokes as equivalents to the nervous skittering motion of the animal, and dots of paint to make the chain of the dog's leash spin and shimmer. Focusing down and in on his subject like a photographer, Balla concentrates on the sequence and rhythms of movement generated by the dachshund and its owner.

The dark silhouettes of woman and dog, flattened as if in a photograph, stand in contrast to the pale background which seems to be on an independent trajectory, slipping past the figures in long, horizontal streaks, not unlike the coarse graining of early motion picture film. Such a formulation recalls the artist's earlier preference for strong contrasts of light and dark and indicates, as well, a revived interest in low-keyed tonal color inspired partly by photographic models. The silhouetting of forms also results in a more two-dimensional rendering of space, a move away from his previous naturalistic spatial treatment. Balla was still painting what he saw, but what he saw was changing due to the shifting conceptual basis of his art.

Photography also provided Balla with models for the realization of the Futurist's desire to visualize movement as an expression of the dynamism of modern life. Like many European artists of the period, he must have looked carefully at the chronophotographs of the French physiologist Etienne-Jules Marey. Closer to home, the young Roman photographer who was to become Balla's friend, Anton Giulio Bragaglia, had, independently of the Futurist group (although stimulated by their ideas), begun experiments in motion photography in 1911. His *fotodinamiche* were time-exposure photographs recording the trajectory of a figure in movement. Bragaglia's work in photography provided support for Balla's objective and analytical aims in *Dynamism of a Dog on a Leash.* The painter was not only interested in depicting individual phases of movement, but in linking each individual state of the trajectory to the whole in the form of small regular sequences of connecting strokes which fill the interstices, or what Bragaglia called the "intermovemental states."

In so doing, Balla, like Bragaglia, attempts to simulate a sense of the continuity of movement. But in *Dynamism of a Dog on a Leash* there is instead only a limited vibration, as if both figures were running in place on a moving sidewalk, sliding by under them in the opposite direction. Unlike the continuous wave of movement visible in Bragaglia's *fotodinamiche,* Balla's depiction of movement does not suggest the possibility of its extension beyond the confines of the picture plane. As Marcel Duchamp would later comment, Balla depicted only "the successive static positions of the dog's legs and leash."

Dynamism of a Dog on a Leash, was, however, a starting point for Balla. As the artist wrote later, it "was my first analytical study of things in movement, the indispensable point of departure for finding the abstract lines of speed . . . objective first, then synthetic, the fundamental basis for my thoughts on form." In the more ambitious and sophisticated Futurist paintings that followed, Balla achieved his aim, but he never surpassed the innocent delight engendered by his painting of "the little dog."

—Susan Barnes Robinson

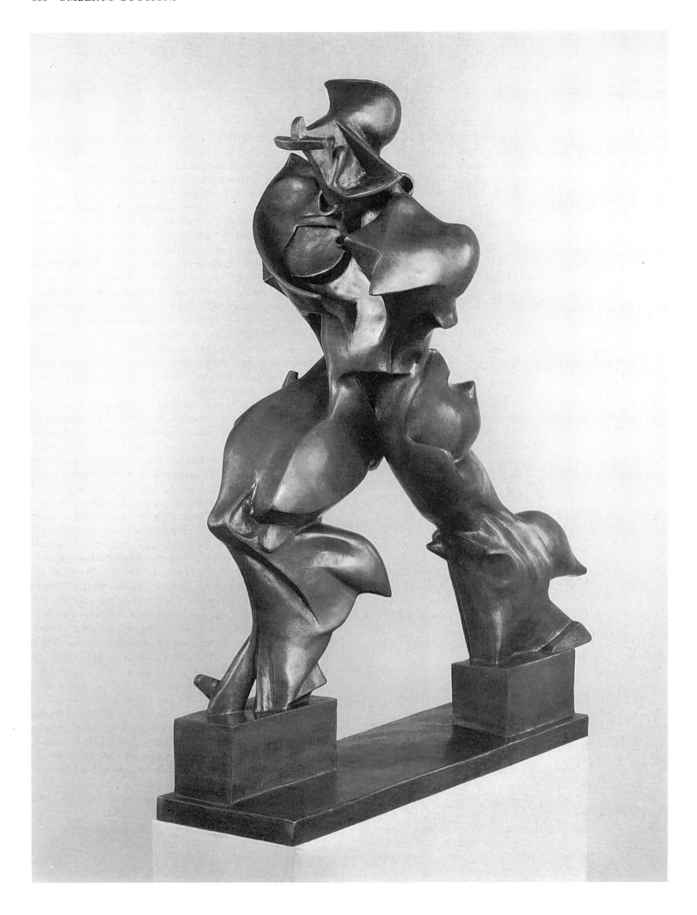

Amadeo Modigliani (1884–1920)
Italian Woman, 1918
40³/₈ × 27 in. (102.5 × 68.6 cm.)
New York, Moma

Italian Woman is one of Modigliani's late and lesser-known portraits, a representation of an unknown seated female whose direct gaze and dominant posture creates an active if not tense relationship between the painting and the viewer. Intelligence and grace are expressed in the woman's head, undoubtedly the main focus of the composition, while the torso and legs are swathed in black or cropped by the edge of the canvas. The artist's major concern throughout his entire artistic career seems to have been the relationship between the cerebral and the physical, which he expressed in the depiction of the human form both nude and clothed, the neck—characteristically long and slender—acting as mediator between the two. In *Italian Woman,* the sitter is photographically posed and fully dressed, detail restricted to the face, the collar and cuffs of a white blouse, and the hands. The last, normally considered as expressive as the face and as frequently exposed, rest in the woman's lap, disappointingly heavy and limp, almost paw-like or arthritic in appearance, their inarticulation serving to steer the eye back to the face.

The beauty and strength of the facial features pay tribute to Modigliani's style, indebted as it first was to Cubism and primitive art. However, with its maturation the artist discarded solid, stylized forms in favor of more sinuous, almost oriental line and structure. The face of the Italian woman, quizzical, defiant, and crowned with a heavy mass of black hair, suggests with a few deft strokes a feline litheness which testifies to Modigliani's skill as a draughtsman; even the black mass of her body is enlivened by the accentuated curve of arm and hip. The luminosity and colour of the face, correspondent with the gold backdrop, adds a certain religious air to the sitter: this, together with her expression and pose, is reminiscent of madonnas in medieval icon paintings. The black cloak may even suggest mourning or grief, though any element of melancholy is quickly lifted by the youthful bloom of the sitter and her vibrant backdrop. *Italian Woman* also bears some striking resemblances to Matisse's portrait of his wife, *The Green Stripe,* 1905, not least in the common inclusion of a green stripe which runs along Madame Matisse's face and the right hand side of Modigliani's painting, in both cases reminding us of the presence of paint on canvas and inhibiting our reading of depth. The women share the same colouring and steady expression; and Matisse, too, has opted for the exclusion of background fuss, simply dividing the area into three patches of Fauvist colour.

Modigliani's paintings reflect his interest and talent for sculpture: forms are invariably solid and unmodelled and paint is often applied in a thick impasto, increasing the three-dimensional quality of the composition. By virtue of these devices and the luminous, plain background the figure in *Italian Woman* looms forward, almost parallel to the picture plane. Modigliani, ever the sculptor, was interested in the relationship of objects, in this case the sitter, to space, and less preoccupied with embellishing that space. Thus his figures occupy most of the canvas; and instead of a token landscape or interior we are offered blank backdrops painted in strong colours with mere hints of shadow or decor. One result of this is that the background is brought sharply forward so that it appears to occupy the same space as the protagonist. The seated figure appears to be supported by the sheer bulk of her gown; however, areas of dark brown and black on the left seem to bolster the voluminous figure. On the right the broad green stripe, strongly outlined at the top of the painting, emphasizes the artist's signature and balances the sinewy line comprising the woman's face and the heavy forms opposite. It also challenges the relationship of canvas to frame and consequently to our reality by acting as a frame in its own right.

—Caroline Caygill

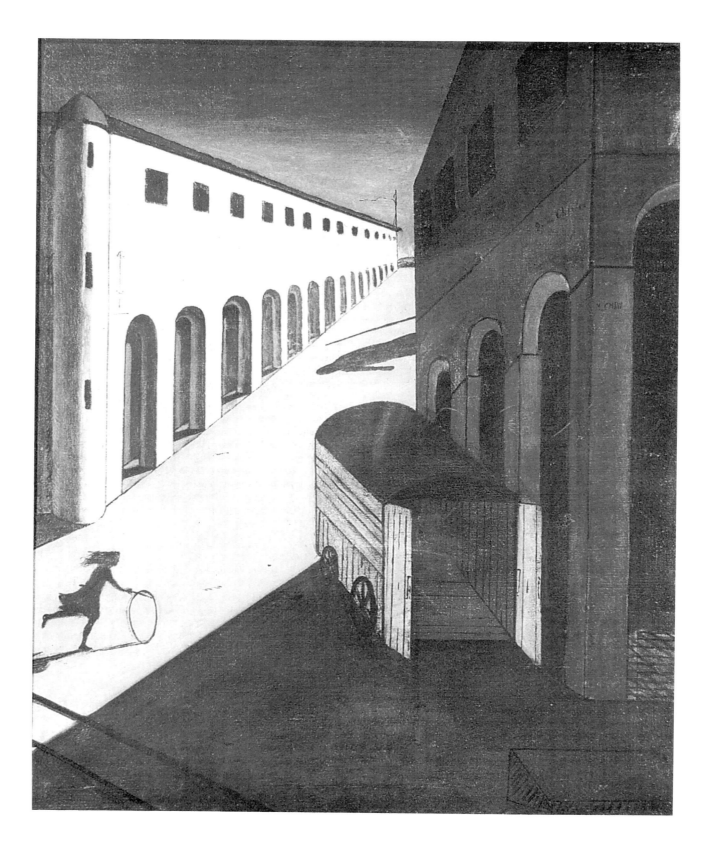

Giorgio de Chirico (1888–1978)
Mystery and Melancholy of a Street, 1914
$33^{1}/_{2} \times 27^{1}/_{4}$ in. (85.1×69.2 cm.)
Private collection

Giorgio de Chirico has said, "To live in the world as in an immense museum of strange things, of curious variegated toys that change their appearance, which we as children sometimes break to see how they are made inside, and, disappointed, we discover they are empty." Childhood and its perceptions were themes that preoccupied de Chirico. In his early work particular emphasis is placed on the peculiar ambiguities of infancy and of playthings; toys are the carelessly arranged still lifes dominating the 1914–15 compositions, princes and small girls feature in the titles or works—and in *Mystery and Melancholy of a Street* of a child makes a rare appearance, a fleeing, fleeting silhouette of a girl with a hoop. De Chirico's figures inhabit a shadowy, mysterious world of barren surfaces, sweeping facades, and fairground objects: towers, carnival wagons with doors open and shut, and "crazy-house" perspective hint at the sinister face of fun. The artist was by no means a pioneer in this field, for Nietzsche had explored, in his late writings, the significance of children's games as a symbol of a return to childhood; and Henri Rousseau, the so-called "naive" painter, had produced *Baby's Party,* 1903, an unnerving image of a robust child toying with a helpless man-puppet, undoubtedly seen by de Chirico.

The enigma of *Mystery and Melancholy of a Street* is increased by the use of light and shadow: the composition which we view from an ostensibly elevated angle, is divided diagonally into two areas of dark and light; yet these boundaries are transgressed, the first by the eerie incandescent glow of the yellow wagon, the latter by the two shadowy figures. The girl with the hoop, a mere silhouette, appears to be directed toward the unknown light source, but her path is impeded by the other shadow which looms menacingly from behind the arcade. The identity of the second figure is uncertain, but is probably that of a frock-coated statue of a man that appears in other paintings by de Chirico, e.g., *The Enigma of a Day,* 1914, his arm outstretched like an ancient votive statue. Alternatively, the gesture may be interpreted as threatening—childhood fears of strangers are evoked as we consider the consequences of their meeting. Shadows, indications of solidity of form and time of day, also assume further significance among the superstitious as containers of the life and soul of a person. If, in earlier times, a shadow was stabbed, severed, or accidentally trapped in the foundations of a new building this would mean certain injury or death to its owner. The child's shadow is cropped by the edge of the canvas, increasing the sense of foreboding—and reminding us, literally, of the limits of the medium of painting.

The distinctive image of the running girl has been borrowed from Seurat's painting *Sunday Afternoon on the Island of the Grand Jatte,* 1884–86. De Chirico was a confirmed admirer of the latter's enigmatic style, and took for himself this particular motif, altering its environment from park to piazza, colour from red to black, position in the middle ground from right to left, and helpfully providing the hoop we do not see in Seurat's painting. Like the second girl standing quietly at the centre of the *Grand Jatte,* de Chirico's child operates as the immediate focus; but it is the hoop, the girl's toy, that acts as the fulcrum upon which the composition depends, echoing the rounded forms of arch and wagon wheel and initiating activity in a still and sultry place.

—Caroline Caygill

José Clemente Orozco (1883–1949)
Hospicio Cabañas Murals, 1936–39
Frescoes
Guadalajara, Hospicio Cabañas

Bibliography—

Merida, Carlos, *Orozco's Frescoes in Guadalajara*, edited by Frances Toor, Mexico City, 1940.

The murals of José Clemente Orozco in the Hospicio Cabañas (1936–39) are thought to be the most outstanding work of this Mexican painter. Their importance is determined by their formal qualities and their subject matter. It was Everardo Topete, Governor of the State of Jalisco, who commissioned Orozco to paint these murals together with two others in the city of Guadalajara: the Paraninfo of the University of Guadalajara (1936) and the staircase of the Palace of Government (1937).

Orozco's Hospicio murals are found in the old chapel of what was once an orphanage founded at the end of the 18th century in Guadalajara by Archbishop Juan Cruz Ruiz de Cabañas. The building is now a cultural center housing a large part of Orozco's work. This building was designed by the Spanish architect Manuel Tolsá. It is in the neoclassical style and is distinguished by its severity and perfect proportions. The chapel is laid out in the shape of a cross and has a large boveda above the nave. Orozco's frescoes cover an area of 1,200 square meters, almost the entire building. Here, more than anywhere else, Orozco left a synthesis of his philosophy, which essentially revolved around the role of the individual in history. Although he had these concerns throughout his life, his ideas crystallized at this time for two reasons: his disenchantment with the Mexican Revolution and the advent of major events on the international scene—the economic crisis of 1929 and World War II.

His historical thinking was greatly influenced by members of the Delphic Studio, a group of pacifists who espoused an existential humanism of esoteric content. Orozco had a close relationship with this group between 1928 and 1936, the period he lived in New York and which had a lasting effect on his work.

Orozco saw the history of man as one of "cycles in which falls into the abyss alternate with periods of consciousness and control of his destiny, in a constant struggle on the part of the individual to conquer barbarism and base instincts." He relates the positive forces of nature with the individual and attributes the positive changes in humanity to individual effort and sacrifice. Orozco repeatedly affirms that it is the masses that generate barbarism and sustain totalitarianism. He attributes the visionary with the ability to direct the course of mankind and maintains that it is he that provides humanity with the means to go forward: scientific and, especially, artistic production.

At the Hospicio Cabañas Orozco uses these ideas to interpret the New World, concentrating on the conquest and colonial period of Mexico. In order to transmit his message clearly, he distributes the different scenes in such a way that each side of the naves has its own meaning with one wall opposing or complementing the other. He used the same system with the vaults that show us positive and negative aspects of history.

The pictorial cycle begins at the entrance of the chapel in the transept, with a representation of fanaticism, a phenomenon he considered a negative facet of the pre-colombian world and which he also refers to in his murals at Dartmouth College (1932). On the opposite wall, where the transept and the nave join, are the contrasting figures of two visionaries: Cervantes and El Greco, who represent Spain's contribution to the New World in the field of art.

Orozco continues to develop his thesis on the vaults and walls of the main nave. The figure of Philip II representing mystical Spain is followed by bloodthirsty Spain, personified by an armoured horseman riding a two-headed horse over the bodies of indian warriors. This is followed by the conversion of the indians by the Franciscans whose work is extolled on part of the vault.

In the other arm of the nave we are only shown the warlike nature of the conquistadores. The figure of Hernan Cortes stands out in these scenes. Like the horsemen appearing in the following two panels, he is presented as a mechanized being. Along the full length of the walls of the naves, Orozco continues to work with opposites: on the left hand wall, the first three panels deal directly with the masses of our present-day society, victims of militarism and dominated by tyrants. The scenes appear to come from Dante: faceless beings, others with grotesque faces, imprisoned by barbed wire fences and surrounded by threatening machines. Across the nave we find suffering mankind seeking out the figure of Archbishop Ruiz de Cabañas. He is standing blessing a group of women and children. The serenity with which he is portrayed contrasts with the agitation of the dictators. To the north, on the other side crossing the transept, Orozco painted different moments and states in the history of mankind.

In the cupola crowning the transept we find the most important figure in this group of frescoes. It is important both for its formal merit and its meaning within Orozco's thought: this is Prometheus, a figure Orozco had already used in his frescoes at Pomona College (1930). For Orozco, Prometheus embodies the revolutionary who has the ability to save humanity, giver of the prophetic fire that burns itself out and nourishes the antagonisms inherent to mankind. The figure of Prometheus is found in the upper part of the main cupola, in a circular composition. The burning man, following the form of representation, is naked, disintegrating in the flames which, at the same time, revitalize him and carry him upwards. Along the sides of the cupola, three human figures, whose grey, extended torsos Orozco placed on the bottom edge of the vault, frame and give consistency to the great flaming mass of vivid reds that illuminate the entire space. In these figures, once again we can see a single one, represented within the dualities: conscious and penetrating, confused and fallen.

The frescoes have a sense of solemnity in harmony with the building. The unity of the painting and the architecture is achieved with colour. Orozco contrasts the grey of the stone walls with a series of dark and brilliant shades where red, black, and green predominate. The colour is applied very freely; strong brushstrokes are combined with smaller, firm brushwork.

In general, Orozco's compositions vary according to the idea he wants to transmit. They are, however, always symmetrical in their equilibrium and proportions. The group of frescocs together achieves a total harmony with the building and constitutes a truly grandiose effect.

—Alicia Azuela

Diego Rivera (1886-1957)
Detroit Industry, 1933
Frescoes
Detroit, Institute of Arts

Bibliography—

Pierrot, George F., and Edgar P. Richardson, *The Rivera Frescoes: A Guide to the Murals of the Garden Court,* Detroit, 1933; as *Rivera and His Frescoes of Detroit,* 1934.

Page, Addison Franklin, *The Detroit Frescoes of Rivera,* Detroit, 1956.

Jacob, Mary Jane, *The Rogue: The Image of Industry in the Art of Charles Sheeler and Rivera,* Detroit, 1978.

The *Detroit Industry* fresco cycle in the Detroit Institute of Arts is the finest example of work by the Mexican muralist in the United States, and Diego Rivera considered it the most successful work of his career. The murals are a tribute to Detroit industry in the 1930's. In one of the few modern works that successfully incorporate representations of functional machines, Rivera transformed their physical power and practical design into dynamic images and sensual forms. The complete cycle combines the artist's love of industrial design and his admiration of North American engineering (first alluded to in his 1932 San Francisco Art Institute mural) with his philosophical views about industry's positive and negative contributions to society.

In the late 1920's amicable governmental relations between the United States and Mexico resulted in increased trade, tourism, and mutual cultural awareness. The renaissance in mural painting then occurring in Mexico, led by Orozco, Siqueiros, and Rivera, came to the attention of American art patrons, and many commissions for murals followed. In 1930 Dr. William Valentiner, director of the Detroit Institute of Arts, who had seen Rivera's work in Mexico, met the artist in California, where he was working on murals for the Luncheon Club of the San Francisco Stock Exchange. Valentiner decided that Rivera should be brought to Detroit to create two large murals for the museum in what was then known as the Garden Court. Edsel Ford, president of the Institute's Arts Commission as well as of the Ford Motor Company, generously offered to fund the project for a sum of $20,889. The only stipulation of the commission was that the theme of the murals should relate to the history and development of Detroit and Michigan.

Rivera arrived in Detroit in late April 1932, after a very successful one-man exhibition at the Museum of Modern Art in New York. As part of that exhibition he painted four portable frescoes, three of which were based on subjects from his Mexican murals and one, an interpretation of New York titled, *Frozen Assets,* 1931 (Collection of Dolores Olmedo). This mural prefigures the Detroit fresco cycle in the registration (a cross-section of the city with the skyscrapers on top, a prison in the middle, and a bank vault below), social class distinctions, and hierarchy of images from the general to the particular.

In Detroit Rivera spent over a month studying the Ford Motor Company's huge industrial complex. He was aided by a Ford staff photographer, W. J. Stettler, who took reference photographs and subsequently documented the mural project with hundreds of photographs and thousands of feet of film. As

Rivera toured the Ford complex and other industries around the city, his enthusiasm for Detroit increased. Although he had originally been asked to paint just two of the largest panels in the Court, Rivera soon suggested that he paint murals on all four walls. Ford was the first large industrial complex Rivera had seen and it must have seemed to him like a microcosm of the industrial age. In this single complex one could see raw materials, aged thousands of years in the earth, transformed from their primordial state into modern self-propelled machines.

Rivera had long been fascinated by machines and believed that engineers were America's greatest artists. As a child he loved to draw locomotives and imaginary mechanical inventions. His love of machines combined with his idealist Marxism, according to which the hope for society rested on the use of technology to free the working classes from menial labor and provide for the materials needs of all. In the *Detroit Industry* cycle the factory workers are not freed from menial and strenuous tasks. Yet, while dominated by the machines, the workers are shown in harmony with them, their dance-like poses are part of mechanized ritual.

This machine imagery became pivotal for later work; it appears in five other major mural projects and culminates in the gigantic central image of *Pan-American Unity,* 1940 (City College of San Francisco). Here the stamping press, which first appeared in the south wall automotive panel in Detroit, is half transformed into the monumental sculpture of the Aztec earth and death goddess Coatlicue, making the analogy obvious between the two creative traditions of the industrialized north and the agrarian south.

The *Detroit Industry* mural project is, like the Chapingo mural project, a well-integrated work thematically. The cycle presents the development of technology from its first form in agriculture through aeronautics, pharmaceutics, chemical operations, medicine, chemical warfare, and the automobile industry. The productive and destructive aspects of technology are contrasted, while the themes of human dependence on the earth's raw materials, the importance of the multi-racial work force and the interdependence of the agrarian and industrialized countries are also explored. Analogies are made between the volcano and the blast furnace and between the form and function of stamping presses and monumental sculptures depicting Aztec deities. Rivera was also aware of the orientation of the Garden Court to the cardinal points of the compass and related his images to the universal meanings of those directions.

While the cycle at Chapingo is a catechism for the new revolutionary Mexico, the *Detroit Industry* cycle is a celebration of technology. Painted during the height of the Depression in a city hard hit by economic disaster, there is no reference to the reduced workforce, bread lines, bank closings, and hunger marches, although Rivera was no doubt aware of these. His idealistic view of technology overshadowed the surrounding realities. The negative aspects of life in the United States do not appear until Rivera became personally disillusioned by the country after the controversy at Rockefeller Center (the unfin-

Rufino Tamayo (1899–)
The Singer, 1950
6 ft. 4³/₄ in. × 4 ft. 2¹/₈ in. (195 × 130 cm.)
Paris, Beaubourg

The Mexican artist Rufino Tamayo always stood apart from his fellow countrymen of the so-called Mexican School of painting between the 1920's and the early 1950's in that his work is not political. From the early years of his artistic career, he consistently opposed the muralists' concern for a politicised art. First in Mexico, where he was linked with a group of writers and artists known as Los Contemporaneos, and then, as a voluntary exile in New York, he defined painting as an art whose value is derived only from its plastic qualities, qualities obtained by a process eliminating all superficiality in order to arrive at the essence, plastic substance ordered with poetic sensibility.

While concerned with essence, Tamayo is not an abstract painter. He has always sought to rid forms of superficial elements so as to represent the structure and substance of things and people. On the basis of these premises, he has proposed a Mexican Art that is part of universal art but which conserves those fundamental elements that define it as Mexican.

His defense of these principles has passed through the different phases that mark his stylistic evolution. The first of these covered the years between 1926 and 1940. Tamayo began by structuring the surface of the canvas with clearly defined lines and stark masses. In spite of its transparency, color was subordinated to drawing and the composition was constructed in two planes. His wonderful paintings *Niña del vestido rojo* and *La niña bonita* (1937) correspond to this period. In 1941 Tamayo began to fragment the figure and to apply color as a function on his composition, no longer of his theme. Space continued to be two dimensional and aesthetic: *Mujer con jaula de pájaros* (1941; Chicago).

In 1946 he abandoned two-dimensional compositions and began to portray movement in his paintings. His new work used the multi-dimensional space that the artist employs to give a cosmic meaning to the content of his work. By exaggerating the proportion of his figures, he gave them mobility. In *El grito* (1947); Mexico City, Galleria Nazionale de Arte Moderno) all these characteristics can be seen.

The Singer (El hombre que canta) belongs to the following phase of Tamayo's work, and we find many of the elements that have characterized his evolution. It is the man-instrument, a whimsical figure who, with his guitar and his music, occupies the whole picture. There he is, alone with his guitar and we have no way of knowing if he's playing for himself or for us. The two figures are fragmented by abruptly broken lines. This is a typical feature of Tamayo's work during the early 1940's when he ceased structuring his work with strong lines and masses that stand out from one another with simple clarity. His influence at that time on the Cuban painter Wilfredo Lam is very important. The singer's body is made up of a series of angles that imitate the curvilinear shape of the guitar. It seems that the resonance of the voice of the singer has made his neck lengthen until it resembles that of the guitar: a peg sticks out of the neck as if it were a thorn. At this point, the neck is stretched vertically with the effort of singing. The head is small, the ears and also one of the eyes are also shaped like guitar pegs. Smiling, he shows us his white teeth, like piano keys.

The figure is utterly whimsical, just like all the figures painted by Tamayo since the mid-1950's. The forms, proportions, and colors of the body are not the same. The right arm, bending, follows the curves of the guitar and culminates in an enormous hand whose fingers scratch at the strings of the guitar. It is an iridescent red because it reflects the reddish tones of the singer's shirt. The left hand, in position, is so black that the fingers are difficult to distinguish from the neck of the guitar that sustains the strings they are plucking. Not even the shirt is uniform—the collar lengthens to the right to the point where the peg buries itself in the throat. The singer's torso is broken like the points of a star, showing the separation between chest, waist, and arms, placidly resting the body of the guitar on the belly.

In this painting, as in all his work, Tamayo uses a few colors only, preferring, a limited number so he can exploit all their possibilities. To this end he plays with different graduations of hue and light. Here we have red, in the shirt and reflected in the arm and walls, in an enormous variety of shades going from orange to lilac and pink, all with great luminosity. Black and dark green are the only other colors; they are both in the guitar. Some of the figures are outlined in black.

Color is a constituent element of Tamayo's compositions. With it he constructs and gives body to the different forms, and uses its transparency to illuminate his work. He does not choose what to paint as a function of the theme but because the subject will make an interesting composition. Sometimes it is an emotive choice.

In 1946, Tamayo abandons two-dimensional composition and starts to deal with space in a new way: he makes it multi-dimensional in order to give a cosmic meaning to his world. Also, at the same time, he tries to project the forms out of the canvas in an attempt to use the space between the picture and the spectator.

In *El hombre tocando la guitarra,* as in many of his paintings, he creates a three-dimensional space, giving it four walls that, moreover, contribute to the creation of atmosphere and states of mind, but instead of directing the spectator's gaze across the surface of the picture, he invades the spectator's own space by placing a dominant figure in the foreground that automatically seems to push out of the picture.

The artistic activity of Rufino Tamayo is still intense and he continues to produce work of great merit. Although his style has continued to evolve, *El hombre que canta,* with its invading presence, remains one of his most representative works.

—Alicia Azuela

Augustus John (1878–1961)
Madame Suggia, 1923
6 ft. 1¹/₂ in. × 5 ft. 5 in. (186 × 165 cm.)
London, Tate

This painting is reputedly Augustus John's most famous. It certainly epitomizes a great period in his working life and is one of the best-known images in the Tate Gallery. It has hung there (intermittently) since 1925, two years after its completion, following its presentation by Lord Duveen through the National Art Collections Fund. There was a considerable outcry when it was initially sold to an American, and Duveen felt that it was essential that it be bought back from the collection of William P. Clyde, Jr., for he considered that it represented an immensely important example of grand 20th-century portraiture. It had indeed made a deep impression on the British public when it had first been exhibited at the Alpine Club Gallery in 1923, and on the American, too, during its subsequent travels to the United States where it toured from the Carnegie Institute in Pittsburgh to Philadelphia, Cleveland, Washington, and Detroit. It gained first prize at the Carnegie Institute, and the fact that it was no longer for sale must have caused considerable irritation.

Augustus John was noted for his portraits above all else, though he was a prolific landscape painter as well. Some portraits he *had* to undertake in order to ensure his livelihood, but others, notably those of Ida, Dorelia, and their extensive families, were done for himself. Madame Suggia provided a good sitter for John: he could be sure of selling the finished picture, and yet it was not a boring undertaking for his adventurous creative nature.

Guilhermina Suggia was born in 1888 in Portugal. She studied in Leipzig, and made her debut there; she then went to study under another great Iberian cellist, Pablo Cassals, whom she was rumoured to have married in 1906. She was a frequent visitor to England, and from 1914 made it her home. She made her last public appearance at the Edinburgh Festival of 1949, the year before she died. The fact that she was an artistic, if idiosyncratic, member of the London cultural scene meant that he could depict her an a large scale, as unusually dramatic, even slightly outrageous for the time, and yet the finished portrait would still fit into a conventional canon. Apparently John was more than usually enthusiastic about the whole venture: he allowed her not only to have a look at the painting as it progressed but also actually invited criticism.

The picture was begun in John's studio in Chelsea in 1920, upon the suggestion of a friend, Edward Hudson. Initially progress was very good: Madame Suggia said "On my first view of the picture I was surprised to see how swiftly it had already progressed." However, it then took 70 further sittings to complete. This was partly because John would only paint her on bright days, and he did an immense amount of repainting: he repositioned the right arm over and over again and could not decide on the eventual pose (if you look at one of the preparatory drawings which the Tate also owns, Madame Suggia is looking over her left shoulder instead). He also changed the colour of her dress more than once: from old gold to white and finally to wine red. Madam Suggia played Bach throughout, "chiefly because, it being classical music, it suited with the attitude required by the artist."

The energy of the vigorous brushwork provides an intuitive insight into the sitter's extrovert and arrogant personality; among other British artists, John fell under the influence of the great artists of Spain. John's portraiture is based firmly upon a tradition, acquired at art school and consolidated by his appreciation of artists like Velázquez. John's own hallmark on this "grand manner" of portraiture was a particularly dense use of colour and composition, quite opposed to the impressionist techniques adopted by some of his contemporaries. The brushwork is loose and handled to make the colours sharp and high in tone.

The result is particularly interesting because of three considerations: firstly, it is illustrative of his exuberant and forceful treatment of all his sitters in general; secondly, it is a formal portrait of a professional woman, indicative of the wide variety of commissions and work that John undertook; and thirdly, it combines the unorthodox element which appealed so strongly to John: her specifically un-English appearance, her eyes closed in rapture at her music, and the dramatic abandonment of her cello playing. Albert Ruthersone points out that, although her crushed red dress belies it, the gypsy spirit is contained within this portrait. The bohemianism is not confined to those well-known paintings of rural idyllic landscape with figures, such as the huge *Lyric Fantasy* of 1911–15, also in the Tate, but pervades all his work to such an extent, that "even in his portraits of society women, he is not 'of the world' " (Rutherstone).

The product of this combination is a painting which must be cited as one of the most immensely dramatic portraits of the inter-war years; one which looked back to the grand tradition of portraiture and yet was also incisively new and, in its own turn, influential. It can be said to be Augustus John's best-known work, in that it encapsulates so many facets of his character as an artist.

—Magdalen Evans

Jacob Epstein (1880–1959)
Rock Drill, 1913–16
Plaster and readymade drill; reconstruction is 9 ft. ¹/₂ in.
 (250.1 cm.); cast of plaster torso is 29¹/₂ in. (70.5 cm.)
Birmingham, Museum and Art Gallery; casts in London, Tate,
 Auckland, Art Gallery, and New York, Moma

The radical difference between the original version of Epstein's *Rock Drill* exhibited with the London Group in 1915, and the extant bronze torso from this sculpture, made the following year, highlights the disenchantment with the "machine age" brought about by the Great War. The earlier version, which has a plaster man astride an actual rock drill, one of the first instances of a "readymade" in modern sculpture, is an audacious statement of masculine stamina and brute force. The later work dispenses not only with the drill, but with the muscular legs which link man and machine, the working right arm and the balancing, protecting left hand: in other words, it transforms the subject from one of boundless confidence and energy to one of pathos and vulnerability. His subsequent works would eschew the dehumanized, mechanistic charter of *Rock Drill* in favour of a tender, compassionate view of humanity.

Rock Drill was conceived at a crucial moment in Epstein's career, and represents a highpoint in his efforts of capture the primal forces of life, birth, reproduction. It follows the lead of such earlier sculptures as his British Medical Association carvings, 1908, *Maternity,* 1910, and the *Tomb of Oscar Wilde,* 1912. However, its radical points of departure are its substitution of archaic sources with "primitive" African tribal material, and its embracing of the machine-age metaphor. From 1912, when he was in Paris to install the *Tomb of Oscar Wilde,* Epstein developed a fascination with African carvings, and began what would become a major collection of "primitive" art. Drawings which subsequently inspired *Rock Drill* are clearly taken from "primitive" sources. For instance, *Totem,* c. 1913, in the Tate Gallery, has at its base a man standing on his head, coitally penetrating a woman sitting astride him, she holding a child on her shoulders. Scholars have located African relief carvings as the source of this structure, whose dynamic thrust is clearly echoed in *Rock Drill. Study of Man-Woman,* also in 1913, in the British Museum, has a male figure in a jumping position, clenched fists above his head, knees bent and an enormous penis absurdly positioned ready to pound into the earth. The testicles are tiny bolts fastening this cannon-like object to the legs. The downward-thrust oversized phallus can be related to a Tabwa carving formerly in Epstein's collection. In African art, Epstein evidently encountered frank expressions which corresponded with his own sexual obsessions.

At the same time that he discovered African art, Epstein also developed an "ardour for machinery," to quote the artists's autobiography, which coinincided with his affiliation with the Vorticists, the English counterpart of Italian Futurism. Epstein associated with Ezra Pound, Wyndham Lewis, C. R. W. Nevison, Edward Wadsworth, and others at the forefront of the London avant grade, but he was especially close to the philosopher and art critic T. E. Hulme. He identified with

Hulme's view that "the new 'tendency towards abstraction' will culminate, not so much in the simple geometrical forms found in archaic art, but in the more complicated ones associated in our minds with the idea of machinery." In *Rock Drill,* Epstein was clearly looking for a machine image which would embody the sexual and primitive urges already motivating his art.

The idea of a rock drill probably occurred to Epstein when he visited a stone quarry in 1913: the choice of machine was a sound one from a Vorticist-Futurist point of view, as this powerful, noisy, destructive invention had recently revolutionised the mining industry. It also approaches the status of "automaton," a machine which simulates human actions and human anatomy. Epstein's decision to incorporate an actual, secondhand rock drill was revolutionary: he was just "pipped to the post" by Marcel Duchamp, who in 1913 exhibited a bicycle wheel as a "readymade" sculpture, although in Epstein's case the found object is of course juxtaposed with a modelled image. His aim was not just to challenge the conventional reading of sculpture by asserting that it is a real object rather than an interpretation of one, but to force a recognition of the aesthetic qualities of the machinery, its geometric energy, its uncompromising roughness, its kinetic potential. He actually considered attaching a motor to *Rock Drill,* but desisted partly because he shared the Vorticists' disapproval of the wobbly, ambiguous, illusionistic lines in Italian Futurist painting.

Predictably, *Rock Drill* was greeted with derision in the press. A representative critic described it as "unutterably loathsome . . . even leaving aside the nasty suggestiveness of the whole thing, there remains the irreconcilable contradiction between the crude realism of real machinery (of American make) combined with an abstractly treated figure." However, the avant garde were deeply impressed: Wyndham Lewis, who had fallen out with Epstein, put aside personal differences to proclaim it "a vivid illustration of the greatest function of life." This robot figure, with a foetus lodged within the iron grid of its rib cage, its visored head recalling African animal masks, its taut limbs, stretched neck, and its stridently coital pose was rightly perceived as a shamelessly optimistic image of generative power.

When first exhibited in March 1915, no one associated *Rock Drill* with the war, then in its eighth month. With hindsight, writing his autobiography many years later, Epstein was able to see it as "the terrible Frankenstein monster we have made ourselves into." Against the backdrop of the growing popular disenchantment with technology that followed the deployment of machine guns, gases, tanks, and barbed wire, and which claimed the lives of Epstein's closest friends, Gaudier-Brzeska and T. E. Hulme, he dismantled his original construction. The new version, as already mentioned, took on an entirely different meaning. The foetal shape, once huddled against the drill, is now exposed; the driller is now disarmed and vulnerable. The fissures in his back, originally of course denoting muscularity and movement within a modernist sculptural vocabulary, could now be read more literally as wounds. *Rock Drill* was one of those rare works of art so imbued with a life of its own that it contained an element of prophecy.

—David Cohen

Stanley Spencer (1891–1959)
The Resurrection: Cookham, 1924
9 × 18 ft. (274.3 × 548.6 cm.)
London, Tate

Bibliography—

Wilenski, R. H., *Spencer: Resurrection Pictures,* London, 1951.

Appropriate to his benign and life-long child-like innocence, Spencer had a photographic memory. Perhaps from this, as well as from his technical facility, he had the confidence to undertake monumental, mural-sized paintings—based upon study of Italian fresco tradition—where mythic narrative, miraculous events, are presented in ordinary time and mundane surroundings. His images' dream-like, hushed, yet electric atmosphere is furthered by their sharply lit space and by the decisive actions of the people within them. The subject of the resurrection recurs throughout his career and gives a thematic unity, a leitmotif, to his work. Surely this subject was his favorite, not only because of the several astonishing variants that he wove from it, but also because it brought together his sense of the ultimate goodness of man with the transcendent power of human love, and, with good-natured faith, set out a possible interpretation of the existential mystery.

An early treatment occurs in 1915, *The Resurrection of the Good and the Bad* (private collection), with motifs that will occur again in the 1924 work: the figures appear from vulva-like openings in the sod, one of them flower-edged (since Spencer did not believe in Hell, the bad are only marginally distinguished from others). The famous 1932 *Resurrection of the Soldiers,* on the center altar wall of the Chapel at Burghclere, presents the artist's experiences in World War I distilled through his optimism and his sense of the power of intimate materiality. After World War II Spencer returned to the theme in many works, such as the small triptych *The Resurrection: Reunion,* 1945 (Aberdeen), and the enormous *The Resurrection: Port Glasgow,* 1947–50 (London, Tate).

The Resurrection: Cookham was the largest of the artist's work to that time, and is centered on the church and its adjacent yard in his beloved native village, the "holy suburb of heaven," in John Donne's phrase. Like all his resurrection scenes, the work is really a Last Judgment, not a Resurrection of Christ. Since there appears no sin, suffering, or damnation, Spencer himself liked the title "Last Day," which suggests his optimism about mankind's natural goodness. Under the central, rose-covered porch, Christ is shown seated against an abstract, curved, and white-walled enclosure; God the Father stands idly behind it, his arms and hands dangling forward. Christ holds several tiny children in his right arm, and another larger child looks on. In the group of thinkers and prophets along the church wall, Moses is clearly set apart by the tablets of the Law before him.

Spencer himself appears nude, gazing off to the left; he appears again, at the lower right corner, fully clothed and reclining in a book-shaped wedge. The nude figure kneeling, with a seemingly symbolic gesture, just before Spencer represents Richard Carline, who became his brother-in-law during work on this picture. Their nudity may be an emblem of the universal love which is intended to permeate the central portion of the picture.

Just to their right, in a sun-baked portion of the churchyard, emerge a group of black Africans. From his earlier travels, Spencer had begun to experience a strong pull towards Universalism and Islam, and the break-down of the barriers of race and nationality. In his art, this culminated in the extraordinary *Love among the Nations,* 1935 (Cambridge, Fitzwilliam), where Caucasian-Negroid love play is used to foster the sense of a higher spirituality. Spencer's own sexual life is referred to in the 1924 *Resurrection* by the appearance of Hilda Carline, whom he married in 1925 after a stormy engagement. She reclines, eyes closed and not yet awakened, on the ivy-covered central tomb; she also appears smelling a yellow flower and climbing over a stile leading to the packed pleasure boats on the River of Life (the Thames) in the top left corner. A woman like Spencer's mother also appears in the painting, as does his friend and patron Sir Henry Slesser. This mixture of the rhapsodic and mundane marks the entire work.

The panoramic view, fan-shaped with a rapidly retreating perspective on the left, may be due to sophisticated understanding of western visual tradition, such as that epitomized by Pieter Bruegel the Elder, but it also reflects Spencer's early sheltered life in this very village. Spencer was also fortunate that his training and maturity coincided with modernist interest in abstracted modes of tradition, from Post-Impressionism to the revival of interest in the Italian primitives. By fusing them with English pragmaticism and Pre-Raphaelite pictorial precision, Spencer had just the right vehicle to convey his sense of the world.

—Joshua Kind

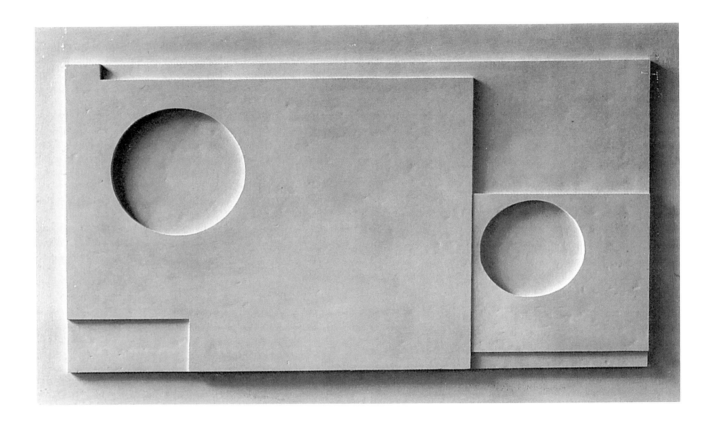

Ben Nicholson (1894–1982)
White Relief, 1935
Carved mahogany; 40 × 65¹/₂ in. (101.6 × 165.1 cm.)
London, Tate

The series of white reliefs made between 1934 and 1939 of which this is an important example marks a highpoint in the creative output of Ben Nicholson. They capitalize on earlier experiments, and at the same time branch out boldly in a new direction, anticipating formal achievements elsewhere. It should be pointed out, however, that this work is not typical of his oeuvre: many characteristics which bind together his early, naive paintings and the varied output of landscapes, architectural scenes, still lifes, and abstract compositions of the mature period of his career are entirely absent here: exploratory, free-flowing lines, textured surfaces, a cool but distinct feel for colour.

In the 1930's Nicholson was closely alligned with the Constructivist movement; he visited Mondrian, Arp, Calder, and Brancusi in Paris, and together with sculptress Barbara Hepworth, his wife, joined Abstraction-Création, an international organization of abstract artists. The influence of Mondrian and Der Stijl is clearly evident in this *White Relief,* with its steadfast absence of diagonal lines, its clear, clean precise interplay of perfectly alligned elements. In his Constructivist work, Nicholson dispenses with the elements of still-life and references that were retained in his Cubist-inspired paintings; his use of relief, a sculptural process which emphasises the physicality of the art object, represents a further breaking away from the conventional idea of the picture as an illusion, a window to another reality. Undoubtedly, his relationship with Hepworth encouraged him in this direction; from 1932 he shared her studio in Hampstead, saw her working "in the round" and had access to her carving tools.

Of the precedents of carved wooden reliefs in modern art the most relevant in the case of Nicholson are probably those or Arp, which are cleanly worked, applied in layers, and evenly painted, although Picasso and certain Russian constructivists might also be cited as examples. Nicholson himself claims to have come upon the medium by chance. While engraving lines into a board he had coated with plaster—one of his techniques for gaining a more tactile relationship with the picture surface—a large chip fell out; in exploring this accident he effectively found himself carving in relief. In his first reliefs, Nicholson worked in the muted browns and greys of his earlier Cubist period, which shows how the relief technique was not at first necessarily a conscious step towards pure abstraction; his lines and circles were free drawn at this stage.

White Relief, 1935, was one of the first Nicholson made with rulers and compasses; at roughly 20 square feet, it is also one of the largest. Most of these are worked in board, although a few are in better quality woods such as walnut and, in this case, mahogany. Here he used a thick piece of wood, a loose leaf from a dining table he picked up in a market, and directly carved into it; elsewhere, however, he clearly constructed reliefs out of individually worked sheets. In a certain respect, the reliefs mark a continuation of his earlier experimentation with different planes, such as the painting *Au Chatte Botté,* 1932, where he was excited by the interaction of a shop window, its reflection of the street, and its contents. It is interesting how effectively using them as quasi lines interpenetrating the different planes.

Nicholson's exclusive use of white in these reliefs gives them a singly Modernist feel, relating them to international style architecture, Purism, and modernist design principles. However, some critics prefer to interpret his use of white here with his experiments in atmosphere and light in earlier landscape painting. They can point to the impact of snow and sunlight in Ticino, where Nicholson spent his winters, and the whitewashed studios of Arp and Brancusi as sources of inspiration. It is significant, in this respect, that while working on these uncompromisingly abstract reliefs, Nicholson was all the time producing representational landscapes and still lifes.

While, formally speaking, the white reliefs come out of Nicholson's earlier experimentation, they also need to be seen in an art historical perspective, as a almost declamatory statements in support of pure, hard-line abstraction against the competing claims of social realism and Surrealism in the fiercely divided art world of the 1930's. In 1935, the year he made this piece, he staged an exhibition solely of white reliefs, and in *Circle,* the anthology of contemporary constructivist art and architecture he co-edited with J. L. Martin and Naum Gabo in 1937, the four examples of his own art Nicholson reproduced were also limited to this group. The negative response of the critics indicates how advanced, if not esoteric, his abstraction was in Britain at the time: "the abyss of the absolute" and "the death rites of painting" were talked about. Their originality within an international context should not by underestimated. One can agree with Charles Harrison that the white reliefs were "a major contribution by an English artist to the European modern movement in the first half of the Twentieth Century."

—David Cohen

Henry Moore (1898–1986)
Madonna and Child, 1943–44
Brown Hornton stone; 59 in. (149.9 cm.)
Northampton, St. Matthew's

In 1942 Henry Moore was commissioned to carve a Madonna and Child in celebration of the 50th anniversary of the parish church of St. Matthew's in Northampton. The commission came from the Rev. Walter Hussey, who had also asked Benjamin Britten to compose a cantata, and later was to commission Graham Sutherland to paint a Crucifixion. This was the first religious work executed by Moore, and despite his obsession with the mother and child theme, it represented a challenge both in its iconography and in being his first full-length carving of this theme. Recognizing the significance of its religious context, Moore stated that it should possess "an austerity and nobility and some touch of grandeur (even hieratic aloffness) which is missing from the everyday mother and child idea."

In preparation for the group, Moore executed a series of drawings and clay models. The changes seen in the preparatory stages reveals how Moore altered his original arrangement of the child facing and clinging to his mother to the frontal pose with the child seated in her lap, firmly, yet tenderly, supported.

The group is carved in Hornton stone, chosen by Moore for its warm brown colour and attractive grain and also because it was an English stone. As a young sculptor, he had endeavoured to use native materials "because being English I should understand our stones . . . I discovered many English stones including Hornton stone. . . ." Originally intended to be placed on a throne which shields the group from the wall, the final group is seated on a simple bench. The folds of drapery over the massive bulk of the Madonna's legs form a sling in which the infant sits, one leg drawn up. The Madonna's right hand rests on his left shoulder, while her left hand cradles his hand; as Richard Cork describes it, "in the most poignant part of the sculpture the Madonna's fingers close around the child's small hand as if to affirm an instinctive maternal determination to protect him from harm." Each gazes in the opposite direction and past the spectator, yet their compassionate grandeur compels the viewer to draw close. The hieratic stance of the group is relieved by the Madonna's tender, enveloping form, and the child's solemn and compact form.

Moore had admired the works of Masaccio since his first trip to Italy in 1925, and the profound impression of Masaccio's *Madonna and Child* (London) and the central panel from the Pisa polyptych is evident in this reinterpretation of the archetypal devotional image. It has also been suggested that Moore's awareness of child psychology, newly explored during the 1930's, contributed to his representation of the mother and child theme, not only her but also in his abstract groups. How-

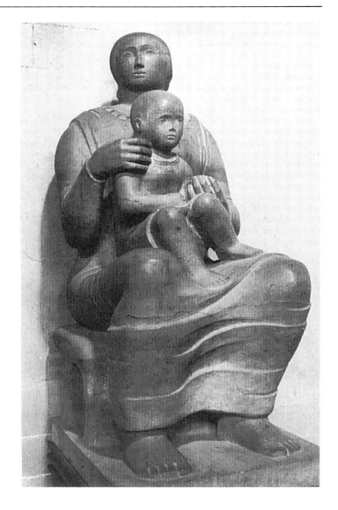

ever, here Moore conciously aligned himself with the masters he most admired, his intention being to "make sculpture that would stand beside the great sculpture of past ages and masters . . . He saw no point in anything less" (Lynton, 1987).

Despite earlier scepticism towards Moore's work from a public uncomfortable with his abstract sculpture, the *Madonna and Child* was met "with enthusiasm from all sorts of people who saw it." This enthusiasm has not abated, and the group's significance as a devotional and earthly image of the mother and child ensures its place in the ranks of such archetypes.

—Antonia Boström

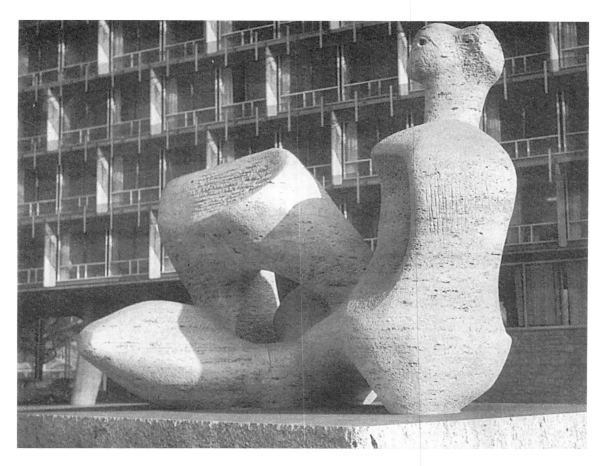

Henry Moore (1898–1986)
Reclining Figure, 1956
Travertine marble; 16 ft. (386.1 cm.) in length
Paris, UNESCO Headquarters

In May 1955 Moore accepted the public commission for a sculpture for the UNESCO headquarters in Paris. This resulted in one of the largest carvings he had so far undertaken. The sculpture, originally intended to be in bronze, was carved in travertine marble and measures some 16 feet in length. Its size was largely dictated by the new UNESCO headquarters, designed by Marcel Breuer, Pier Luigi Nervi, and Bernard Zehrfuss. Moore produced a vast quantity of preparatory sketches, models, and maquettes, and finally settled on the theme of the recumbent figure. To gain an idea of its appearance and size he placed a full-scale cut-out of the maquette on the site.

The travertine marble used in the sculpture came from a quarry near Rome, but Moore carved the piece at the Henraux quarry at Querceta near Forte dei Marmi in Italy. This was his first collaboration with the quarry near which Moore was later to buy a house. Financial constraints prevented the shipping of the stone to Britain to be carved at Much Hadham, but for Moore the significance of working at the quarry where Michelangelo had selected stone was pre-eminent. Although work on the piece stretched over a year, Moore was reluctant to be separated from his wife and child for long periods and would return to England every other month, leaving the roughing out of the stone to Henraux stonemasons.

The UNESCO sculpture represents the culmination of a period, beginning in the 1930's, of experimentation with the theme of the reclining figure and hole motif. The *Recumbent Figure* (London, Tate, 1938), originally commissioned by Serge Chermayeff for his terrace at Halland, was one of Moore's first used of the gouged hole in an outdoor reclining figure. Moore felt that "the hole itself can be the intended and considered form." However, here the head and features were not yet as abstracted as other bronze reclining figures executed around the same time. The landscape backdrop was important in reinforcing the undulating curves of the sculpture, supplying the sculptor with his ideal setting of sky and nature. In the carving of the UNESCO figure, Moore was inspired by the location of the quarry in the Apuan mountains, in particular by Monte Altissimo. The association of sculptural force and mountains is one that much preoccupied Moore and his earlier contemporaries: "Sculptural energy is the mountain," Gaudier-Brzeska had stated, and Moore had written in 1930 that sculpture "is static and it is strong and vital, giving out something of the energy and power of mountains."

In this sculpture, the massive forms of the raised knees contrast with the slender outline of the arm and neck, and the small head. The figure was not intended to refer overtly to the function and aims of UNESCO since he wished to "avoid any kind of allegorical interpretation that is now trite." In so doing, he produced a sculpture of understated grandeur and calm outlines which becomes a tangible symbol of the organization's humanitarian values and spirit.

—Antonia Boström

Barbara Hepworth (1903-75)
Forms in Echelon, 1938
Tulip wood; 41³/₄ in. (105 cm.)
London, Tate

Forms in Echelon was made during the period of Barbara Hepworth's close involvement with the international Constructivist movement, when she was a member of Abstraction-Création, and one of the foremost pioneers of avant garde art in Britain. A year after it was made the sculpture was exhibited in an international exhibition, *Abstract and Concrete Art,* at Guggenheim Jeune, London. As an example of "pure abstraction," *Forms in Echelon* compares on equal terms with the work of other artists in this show, Arp, Brancusi, Calder, Gabo, and Mondrian, men with whom Hepworth was in frequent contact at this time.

The sculpture, consisting of two upright motives arranged on a wooden base, has a highly polished, sensuous finish; it veers away from the more sharply edged geometrical abstraction Hepworth had been pursuing in the last three years, and contains hints of the organic allusions more typical of her output, which would return to her work when she left London in 1939 for Cornwall. The rounded edges and the pleasing veneer remind one of Arp's description of his own sculpture as "fruits," while at the same time they accord with Hepworth's conception of "truth to materials." She believed in direct carving, in releasing the image from the block, and in allowing the intrinsic nature of the stone or wood to suggest the form. In this case, the material used is a rich, warm tulipwood. Hepworth was introduced to wood carving by her first husband, John Skeaping, when she was studying in Rome in the mid-1920's. The deep, resonant grain of the wood leads the eye across its surface, and has been beautifully worked up.

The title, *Forms in Echelon,* indicates the sculptor's aesthetic priorities. "Forms" inforces the formal, "pure," anti-literary, abstract element, resisting interpretation and demanding to be taken on its own terms, while "echelon" focuses attention on the spatial relationship between the two motives. Hepworth is striving here for a perfect balance between two objects which avoids symmetry; at the same time the arrangement exploits to the full the three-dimensional character of sculpture. There is no "best view"; the viewer is invited into the group from every conceivable angle, to explore the different configurations, which emphasises the reality of the art object. At a given position one form might appear as a flat expanse while in contrast the other will be a rounded pole. One of the figures is pierced right through, a formal device Hepworth used from 1931, a year before Henry Moore introduced his first "hole." The "spatial displacement," as Hepworth called these cavities, has equal formal value to the actual carved material; again, it forces the viewer to engage the sculpture as a real object in space, as well as providing yet another view of the element in relation to its partner.

As she was making *Forms in Echelon* sympathetic critics were comparing her sculptures with prehistoric carvings, and the figures in this work do indeed have an affinity with monoliths. This is significant for two reasons. Firstly, as the scientist J. D. Bernal pointed out, neolithic art, like modernist art, involves a process of ruthless reduction, a striving for the minimal expression of basic forms. Like modernism, it was a sophisticated reaction to a preceding era of naturalism. Secondly, Hepworth strove for a meaningful, public role for her art, akin to the ritual importance monoliths must have once exercised. The pure, universal form which Hepworth and other artists sought in abstraction was tinged with a social utopianism similar to the spirit of international style architecture. In fact, Hepworth was active in avant garde groups which aimed to harmonise fine and applied art and architectural design.

Forms in Echelon anticipates later pieces like the slate *Two Figures (Menhirs),* 1964, whose title makes the prehistoric association explicit, and her *Family of Man* group of totemic bronze figures, 1970, which she installed outdoors like a stone circle.

—David Cohen

Graham Sutherland (1903–80)
Crucifixion, 1946
Hardboard; 96 × 90 in. (243.8 × 228.6 cm.)
Northampton, St. Matthew's

This crucifixion was commissioned in 1944 by the Anglican parish priest of St. Matthew's Northampton, Canon Walter Hussey, later Dean of Chichester. Hussey was an ecclesiatical patron of usually bold and modern taste, who commissioned cantatas from Benjamin Britten and Michael Tippett, leading avant garde composers of the time, as well as works by equally controversial artists. Henry Moore's carving *Madonna and Child* (1934–44) was made to celebrate the 50th anniversary of the church, a large Victorian structure of no special architectural merit. It was on Moore's advice that Hussey approached Graham Sutherland, inviting him to paint an "Agony in the Garden." Sutherland was already recognized for his particular vision of nature, his landscapes imbued with a romantic, melancholy, brooding spirit certainly appropriate to the theme of Gethsemane. However, a convert to Catholicism, he preferred to tackle the subject of the Crucifixion which had been occupying his mind during the turbulent war years.

Sutherland's *Crucifixion* occupies a remarkably similiar position in his oeuvre to Moore's *Madonna*. Both artists found they needed to modify their style in a major way in order to produce something accessible and dignified for the church setting, but at the same time their efforts marked a welcome departure from the prevalent church decorations, which Moore characterised as "affected and sentimental prettinesses." The temptation for each of them was to repeat their avant garde, secular artistic formulas in their religious commissions. But for Moore, "a" mother and child—his favourite sculptural theme—was not the same as "the" madonna and child, while Sutherland rejected his first idea of exploring thorns as a metaphor for Christ's passion, of making a nature study not dissimilar from his current work. Both artists looked back to the great periods of church patronage; Sutherland was particularly in awe of the late 15th-century German master Grünewald, whose Crucifixion was the source of his image.

Sutherland's Christ, however, which Canon Hussey described as "profoundly disturbing and purging," was also drawn from a contemporary source, namely a United States Office of War booklet containing photographs of the recently liberated concentration camps of Belsen, Auschwitz, and Buchenwald. Many of the massacred corpses or starving survivors, it struck Sutherland, assumed crucified positions, shoulders hunched and stomachs distended. His composition discards the usual attendant figures, the Madonna, the Magdalene, St. John, as if to focus all attention on the suffering body of Christ. Studies show that he originally intended to include these, and after he finished this painting he produced a striking, Picasso-influence *Deposition* which used up these designs. In *Crucifixion* he employs an unusual device, an ornamental railing around the feet of the saviour. Perhaps this symbolises that, while his suffering has a universal significance in these hellish times, this is "the" crucifixion, divinely ordained for the redemption of sin, and it therefore cordoned off.

The body has a sharply divided, almost totemic nature, and unusually is viewed full-frontally. The arms are twisted around in a way that thrusts the rib cage forward so that the breasts read almost like inverted shoulder blades. The stomach is revealed as a brooding cavity; the white loin cloth hardly stands out from the luminous, deathly white of the flesh, and the legs are rendered in a particularly unconventional manner, set widely apart allowing the feet to cross without undoing the symmetry of the figure. Also this position give a greater weight to the lower part of the body. The blood issuing from the wounds is strident and dramatic, achieved with sharp, emphatic lines, as is the crown of thorns, strikingly white against the bearded face and the shadow that envelopes the body, creating chiaroscuro effects. The cross is a rudimentary structure whose box-like appearance is echoed in the square formations set into the background. This cubistic element is said to have derived from the model cross the artist constructed out of old packing cartons. Altogether, the cross is ambiguous, the transept seeming to tuck inside the central plank like quilt work, while the inscription, INRI, is almost lost at the top of the picture. The space it occupies is more symbolic than real; at the base drops of blood seem to be reflecting in a dark receding pool. The cross is set against a deep blue-purple expanse which the artist finished in situ in order that it should "work" within the gloomily lit, Bath-stone church interior.

In the 1950's Sutherland was occupied with another church commission, this time a tapestry design for Sir Basil Spense's Coventry Cathedral, which is adorned with a major sculpture by Epstein, and which was the commissioning venue of Britten's *War Requiem*. Retrospectively, therefore, St. Matthew's was the testing ground for Church patronage of modern art in Britain.

—David Cohen

Victor Pasmore (1908–)
Abstract in White, Black, and Crimson, 1964
Glass and plastic; 32 in. (81 cm.) (height)
Perth, National Gallery of Western Australia

Abstract in White, Black, and Crimson is the third version in a series of relief constructions executed between 1962 and 1964. It was not uncommon for Pasmore to do a series of works on a particular theme, varying compositional or color elements. This series demonstrates a gradual movement towards increased dynamism which changes the identity of the picture plane. This, in turn, shows how the materials themselves and their relationship to each other in the composition subvert conventions held about a work of art being an object which contains, and is composed of, its parts.

Abstract in White, Black, and Crimson is the most successful of the three in this endeavor. The picture plane is transparent; fading into surrounding space it loses its traditional function as the referent for the elements within it. These elements, the plastic projectiles, become the points of reference themselves. They become the art work. This relationship between the plane and the object is further emphasized by their physical placement in reference to the plane. Rather than containing the elements, the projectiles pass through it, even along the edges of the glass. The plane ceases to be an active surface holding together the elements of the work, and becomes a passive surface which supports but cannot contain them. This passage also suggests movement through space. This concern is not unique to Pasmore, and he must have been informed by the Futurists, who in certain paintings and sculptures throw fragments of their subjects outside of themselves. He was also informed by the Cubists in his use of color. Playing on the optical effects of recessive darks and projecting lights, he reverses their properties in relation to the relief elements, creating a push and pull effect. The ends of the projectiles painted black are in the highest relief, whereas the white and crimson ones remain on or behind the transparent plane, creating a sense of movement and tension. This use of color is reminiscent of the relief sculptures of Duchamp-Villon around 1912.

The companion pieces in the series do not use these elements as comprehensively or successfully. The first version, *Abstract in White, Black Grey, and Ochre* of 1962 (painted wood and plastic, collection of Dr. Rudolph Blum, Zurich), is static in comparison. Its dark projectiles residing near or on the picture plane emphasize its flatness. Its centralized composition also locates it as a more traditional "painting," in which the work as a whole contains its constituent parts. *Abstact in White, Black, Vermilion, and Turquoise* of the following year (painted wood and plastic, collection of the artist) breaks from the centralized plan, its projectiles cutting through the edge of the plane, yet it too is static in terms of color.

It is difficult to classify works like *Abstract in White, Black, and Crimson*. They are currently being referred to by art historians with the descriptive term "relief constructions," which links them with sculpture. Herbert Read also included them in his *A Concise History of Modern Sculpture*. Yet Pasmore has spoken of his relief constructions as projecting the surface of painting as far as it will go, suggesting that he did not consider them as sculpture. Charles Biederman, with whom he was in contact from the later 1940's until 1955, did not consider his own "relief constructions" to be either painting or sculpture, but New Art, both a synthesis of the two and a new departure. Although Pasmore never takes this line, his reluctance to refer to his works as sculptures indicates to us that their status as highly theoretical paintings should not be discounted.

—Nancy C. Jachec

Francis Bacon (1909–)
Three Studies of a Crucifixion, 1962
Triptych, each panel 78 × 57 in. (198.1 × 144.8 cm.)
New York, Guggenheim

The theme of crucifixion recurs frequently in the work of Francis Bacon. As early as 1933 Herbert Read reproduced his *Crucifixion* (now destroyed) in *Art Now,* alongside a Picasso *Baigneuse* of 1929 from which it clearly derives, and in 1945, Bacon's career was relaunched in earnest with the controversial display of *Three Studies for Figures at the Base of a Crucifixion,* 1944, a triptych of grotesque biomorphic distortions again recalling Picasso. Besides the painting considered here, and *Crucifixion* 1965 in Munich, crucified figures or references to crucifixion abound in canvases throughout his work. His attraction to the theme is hardly surprising, as this most brutal mode of execution offers ample opportunity for the artist to explore his fascination with physical pain, sadism, contortion, and isolation.

Much has been made by critics of the distinction between "a" crucifixion and "the" crucifixion, the passion of Christ. The figures in the 1944 triptych have been identified by the artist as the eumenides, the furies of Aeschylus's *Orestia,* and his approach to martyrdom has been perceived by critics within a contemporary, "existentialist" framework. However, "a" crucifixion can surely be read in a different way, as "a" painting of "the" crucifixion. (Only a crucifixion in a church, after all, would have a Base.) Because of Bacon's historicity, his exploitation of old master formats such as the triptych, and his loyalty to such a conventional medium as oil on canvas, the crucifixion is imbued with deeper resonance. What confronts the viewer here must be something more than a merely formal exploitation of stylistic effects coincidentally associated with religious painting of the past.

In the first of his revealing interviews with David Sylvester, Bacon identified the source of the figure in the right hand panel of the Guggenheim triptych as Cimabue's *Crucifixion* in Santa Croce, Florence. He says he has always seen this "as a worm crawling down the cross." From this mundane, empirical vision has emerged a distended and, significantly, inverted figure, chest exposed like a rack of meat and mouth aghast in a silent scream (two obsessional motifs in Bacon's oeuvre). This reading of Cimabue has been cited as evidence of Bacon's formal, anti-interpretative attitude both to the art of the past and his own images. However, the provocative, tongue-in-cheek quality of Bacon's comment should not by underestimated: the inversion of the cross has specifically anti-Christ connotations which cannot so readily be overlooked.

Three Studies for a Crucifixion is the first of Bacon's many large-scale triptychs; that it hangs in the Guggenheim perhaps associates this adjustment in scale with his growing international reputation. The Guggenheim purchased the painting in the year it was made, and the following year, 1963, staged Bacon's first overseas retrospective. Bacon has made the triptych format very much his own. While he is able to evoke the feel of the old masters through this format, he defies the narrative or iconic functions of the madonnas or crucifixions flanked by donors. There is a "crucified" figure in each panel: on the left, the arched zoomorphs (almost bird-like, recalling the 1944 picture) relate to his *Figure with Meat,* 1954, where the sides of beef flank a screaming pope; in the middle panel is a crouched, defenseless, blood-spattered nude displayed on a bed; and on the right, the Cimabue image, pinioned to a sort of L-shaped structure defined tentatively in Bacon's characteristic grid lines which are said to derive from his tubular furniture designs of the 1930's. (In the 1965 Munich *Crucifixion* this image is further developed, with the arms of the victim cruelly fastened to an overturned chair.) Bacon does not allow us to "read" any sequential narrative from left to right, or from the centre outwards. It is as if the picture is cut into three in order to emphasize the tortured isolation of the individual figures.

Similarly the figures, worked intensely in oils, with loose, exploratory strokes, seem alienated from the smooth, evenly applied ground, done in acrylics and house paints, here typically laid out in neat, bland segments of illusionistic interior space, simple black structured door and window frames, or roller blinds, bright orange floors, and blood red walls. The figures exemplify Bacon's procedure: they sometimes start with a specific variation in mind, such as the Cimabue, and often end by recalling former solutions, such as the rack of meat, but for their successful realisation they depend on accidental discoveries in the fastly worked, heavily overworked, evolving images. Along the way he exploits chance effects, such as the dripping and smudging on the body of the nude, the sperm-like smear of white across his legs and the wild splattering of red drops over the black roller blind. By contrast, the husk-like formation that wraps around the back of the Cimabue figure is slowly, meditatively worked out, the dry brushstrokes rubbed deep into the raw fabric. (Here, as in all his mature paintings, Bacon works on the reverse side of pre-primed canvas.) Bacon never does preparatory sketches, but "draws with the brush." The various elements of his technique and the brutal frankness of his imagery come together, for, as Michel Leiris puts it, "his work carries the signs of his actions rather as a person's flesh bears the scars of an accident or attack."

—David Cohen

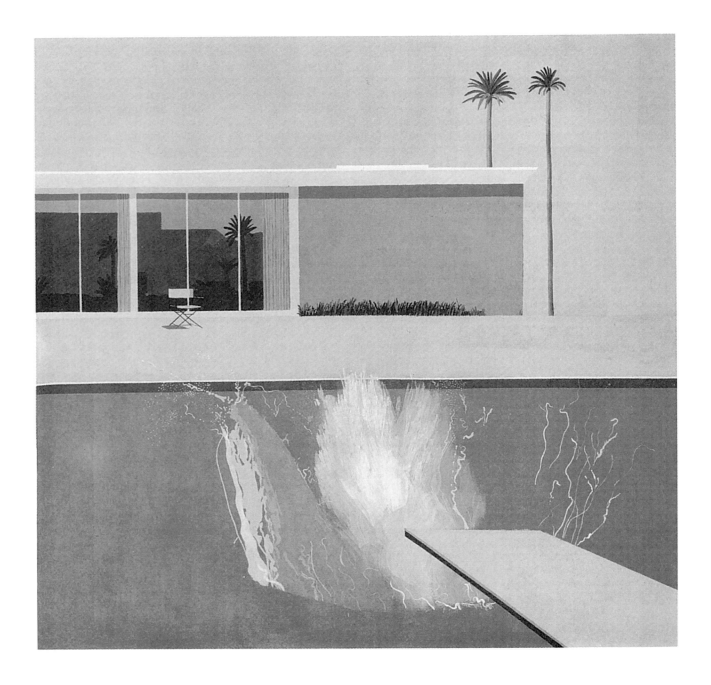

David Hockney (1937—)
A Bigger Splash, 1967
Acrylic; 8 × 8 ft. (224 × 244 cm.)
London, Tate

A Bigger Splash is the last of three paintings painted from a photograph taken from a book about how to build swimming pools. The first was a small picture, *The Little Splash,* whose subject Hockney thought interesting enough to paint again. *The Splash* was rather bigger and more care was taken in its execution. Deciding that it was "slightly fussy" and "too complicated" Hockney undertook a third version "using a very simple building and strong light." The result is *A Bigger Splash.*

Its development from the smaller Splashes, its enlarged but honed down appearance provides the key to understanding the painting's success as well as its shortcomings. While the earlier versions, being smaller, yet fuller, are unimposing studies, *A Bigger Splash* is something of a monument. The bold acrylic colours were rolled on in broad stripes and the simplified southern California building contributes to the painting's abstract character. The chair and trees do nothing to contradict the stillness so that it is the splash alone that does not appear clinical. Henry Geldzahler notes, appreciatively, the painting's detachment and Hockney's intention "to paint the world of today dead-on." Its "intellectual preoccupation," he continues, is "how to apply an academic training in perspective, foreshortening, rendering and composition to a new subject matter in such a way as to capture it on a surface that continues to look absolutely flat." The fascination, in other words, is a purely formalist one; the painting's success is one of mastery of method.

Its monumental character exists outside such considerations, however, and its dedication appears to be to an empty, detached, opulent Californian lifestyle. However unintentional this may be, the painting's concentration on form denies the space for irony: *A Bigger Splash* is not a gibe. Its intention does not even leave room for ambiguity. From the artist's point of view the painting, like the building, the swimming pool, the chair, simply *exists.* Constructed with skill and ingenuity, they are all objects to delight, enhanced by the brilliance of the Californian light.

In such a way the painting's "intellectual preoccupation" acts as a blinker. To those not entranced by the success, if it be so, of this preoccupation the painting remains problematic.

In other similar paintings featuring the architecture, swimming pools, and bright sunlight of California, the formal preoccupation is tempered by further content: figures, that allow the spectator to see the painting as *involved* with life. Instead of indulging in clinical detachment the paintings even permit a certain communication with the spectator. True, this does not erase the fact of the paintings' uncritical portrayal of a particular lifestyle. Art collectors portrayed before their homes which may be the setting for (detached) private collections appear exclusive; the communication is terse where not self-involved. But where more public concerns are involved the paintings become more inclusive of the spectator. The obvious example stems from Hockney's sexuality. Where gay men are featured—whether they are nude or not, whether they are erotic pictures or not—their portrayal is inherently political. An issue of public interest is aired. The fact of the Californian setting, the wealth that cushions the lives of middle-class California, does not evaporate but the painted experience, or simply the figures themselves, allow for public involvement which is inhibited by the aseptic, and still unavoidably political, portrayal of a California in which all the spectator can hold on to is the painter's fascination with taking two weeks to paint a splash that exists for less than a second, or in Hockney's words, with "painting like Leonardo."

—Simon Hancock

John Sloan (1877–1951)
The Coffee Line, 1905
21¹/₂ × 31⁵/₈ in. (54.6 × 80.3 cm.)
Pittsburgh, Carnegie Museum of Art

The Coffee Line, executed in the winter of 1905, belongs to the key period in Sloan's development after his move from Philadelphia, and was the first major painting that he completed in New York. He himself always considered it one of his most important achievements and included it in the selection of his finest paintings that he made for his book *The Gist of Art.* From 1905 to 1908 it was the canvas that Sloan exhibited most frequently: he sent it to exhibitions in New York, Chicago, Seattle, Dallas, Spartanburg, South Carolina, Worcester, Massachusetts, and Pittsburgh. At Pittsburgh, thanks to the presence of Robert Henri and Thomas Eakins on the jury, it received an Honorable Mention, the first significant honor of Sloan's career. *The Coffee Line* has also been included in numerous later showings of Sloan's painting, including the retrospective exhibition held at the National Gallery of Art in Washington, D.C., in 1971.

The subject matter of the painting marks a surprising break from the genteel and innocuous images which were popular at the time. It depicts a wind-blown winter night in Madison Square at Fifth Avenue in New York, where a long line of cold and hungry men waited their turn for one of the free cups of coffee being dispensed from a wagon as a promotional ploy for one of the Hearst newspapers.

Even today, the composition of the painting seems remarkably bleak, black, and minimal. Most of the canvas is taken up by dark elements—a somber night sky, fitfully illuminated by the lights of distant buildings, the black silhouettes of the coffee wagon, and the outline of the men standing in line. Only the snow in the foreground, which is painted with great technical bravura, moves away from a sober palette of blacks and grays. The highest group of lights in the center of the painting evidently belong to the Flatiron building, then the tallest structure in New York, which appears also in Sloan's painting *Spring, Madison Avenue,* executed a few months after *The Coffee Line.*

Robert Henri's New York views served as direct precedents for *The Coffee Line,* which is painted in very similar manner, with the white snow in the foreground brushed into the soupy black background with a sensuous impasto. Sloan was undoubtedly also familiar with the nocturnes of Whistler, which in their turn had inspired Henri. Despite these obvious influences, however, Sloan's painting conveys a feeling of direct, unsentimental observation that is superior to the work of Henri. Indeed, the stark presentation of buildings and billboards in *The Coffee Line* foreshadows the work of the later American realist Edward Hopper. Curiously, while it was based on an actual incident, *The Coffee Line,* like nearly all of Sloan's canvases, was painted from memory in his studio.

In its unsettling depiction of poverty, suffering, and social inequality, *The Coffee Line* directly relates to Sloan's radical political beliefs. Not long after he completed it he joined the Socialist party, and in 1912 he became art editor of *The Masses,* for which he produced a forceful group of drawings influenced by Forain and Daumier. In February 1909 the critic Charles Wisner Barrell noted of *The Coffee Line* (in *The Craftsman*) that: "It is as great a depiction and as biting a commentary upon the social system of our big cities as Stephen Crane's unforgettable prose sketch, entitled 'The Men in the Storm,' or one of Gorky's poignant little masterpieces." The painting brings to mind Theodore Dreiser's description, in his novel *The Genius,* of the effect of Sloan's canvases, which he had examined during a visit to the artist's studio. According to Dreiser, Sloan's paintings seem to shout: "I'm dirty, I'm commonplace, I'm grim, I am shabby, but I am life!"

—Henry Adams

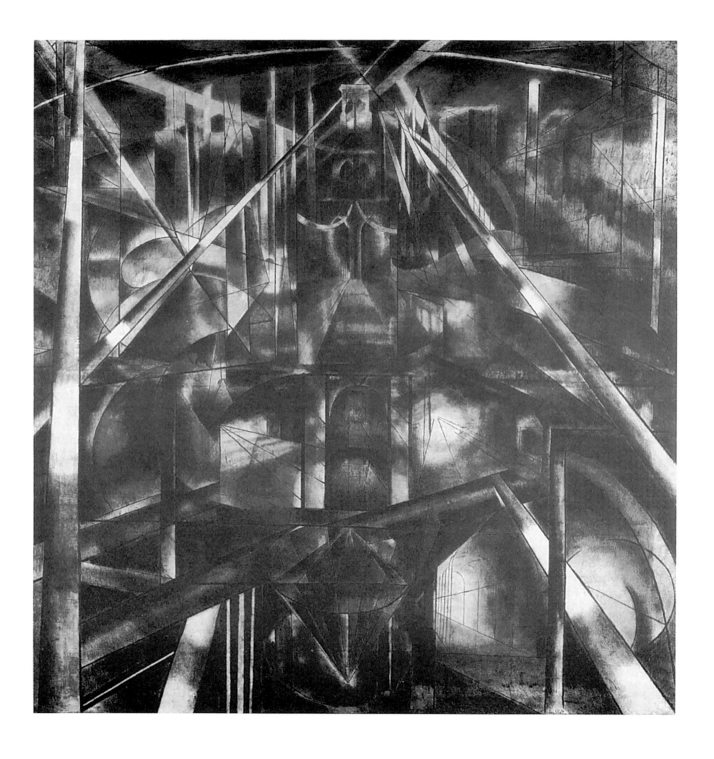

Joseph Stella (1877–1946)
Brooklyn Bridge, 1918–20
7 ft. ¹/₂ in. × 6 ft. 4 in. (214.5 × 194 cm.)
New Haven, Yale University

Bibliography—

Stella, Joseph, "*The Brooklyn Bridge* (A Page of My Life)," in *Transition* (Paris), June 1929.
Saunders, Robert, and Ernest Goldstein, *Stella: The Brooklyn Bridge,* New York, 1984.

Joseph Stella's reputation as a major American modernist derives in large measure from the arresting power of a single canvas: *Brooklyn Bridge.* Created over a two-year period, Stella's painting represents a masterful transformation of the familiar bridge structure into a symbol of urban America in the new Industrial Age. Stella's *Brooklyn Bridge* also encapsulates the stylistic sources, thematic preoccupations, and cultural contradictions inherent in early American modernism.

Although Stella was not the first artist to depict the Brooklyn Bridge, his composition ranks as the most memorable visual homage to Roebling's engineering feat. From its opening in 1883, Brooklyn Bridge had been the subject of paintings, topographical studies, and poetry. The American printmaker Joseph Pennell, Photo-Secession photographers, and the French Cubist Albert Gleizes all had attempted earlier to capture the spirit of the bridge.

Stella's fascination with the Brooklyn Bridge dates to his arrival in New York City in 1896, thirteen years after the engineering marvel was erected. He did not translate his response to the bridge into painting until after he had absorbed the lessons of European modernism, particularly Italian Futurism. Returning to New York from a period of study in Paris, Stella recalled that in 1912 that he "was thrilled to find America so rich with so many new motives to be translated into a new art." Four years later he moved to a Brooklyn neighborhood situated near the bridge. Working in such close proximity, Stella completed the large painting by 1920. No preliminary studies for the composition are known.

Stella chose to portray the bridge at night from the Brooklyn side of the East River. He used the steel cables of the bridge to organize the composition within a grid-like framework of faceted planes and force lines, devices he derived from Futurist and Cubist painting. The muted, almost monochromatic color scheme, inflected with patches of blues, reds, and greens, evokes the flickering, filtered light of stained glass windows. The central focus of the canvas is the pedestrian walkway leading under Gothic arches of the structure's massive, supporting piers. Stella's repetitive use of the arch motif creates a rhythmic procession into the background of the canvas with its suggestion of the Manhattan skyline on the opposite shore. In rendering the recurring Gothic arches and the network of steel cables, Stella fused traditional, linear perspective with the experimental techniques of the modernists—fragmentation and simultaneity. The resulting spatial ambiguity enabled Stella to capture the mystical aura of the bridge.

In Stella's vision, the bridge became a cathedral of modern technology. With *Brooklyn Bridge* Stella had created a fitting icon of the new industrial order. It is ironic that Stella chose a monument of 19th-century engineering as the symbolic embodiment of 20th-century machine aesthetics. He was both fascinated and awed by modern technology. He once described Brooklyn Bridge as a "weird metallic Apparition." With its Gothic arches, the architecture of the bridge itself suggested the mystical marriage of tradition and modernism that fascinated Stella.

After 1920, Stella returned frequently to Brooklyn Bridge as a motif for paintings, but the first painting remains the most significant of the group. In both style and subject *Brooklyn Bridge* anticipated the geometric order and industrial landscapes of the American Precisionists.

Fully comparable to Robert Delaunay's studies of the Eiffel Tower, Joseph Stella's *Brooklyn Bridge* ranks as the most powerful interpretation of the bridge motif produced in the 20th-century.

—Judith Zilczer

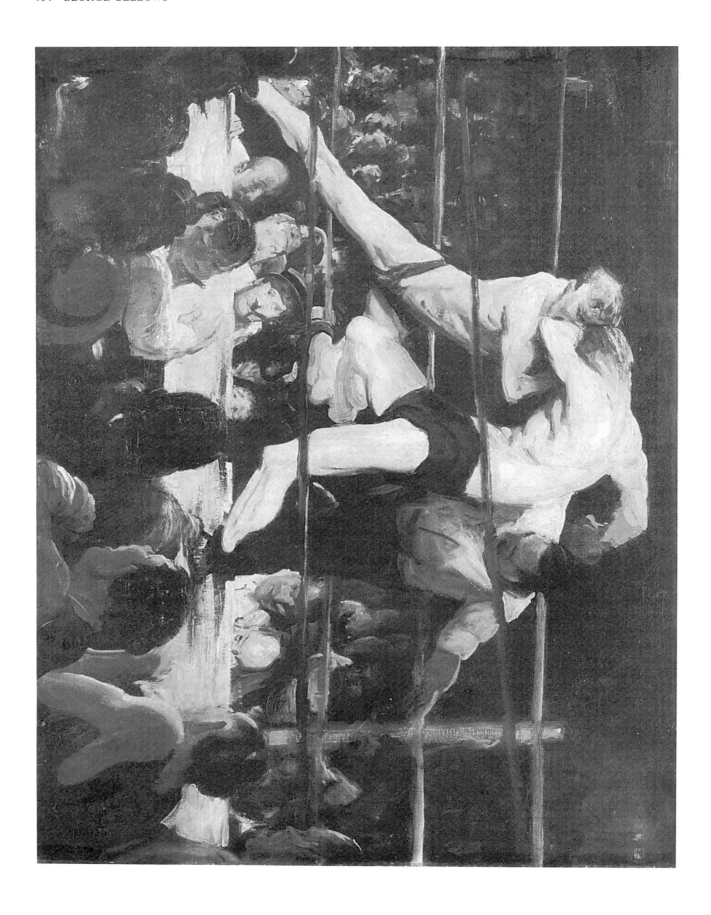

George Bellows (1882–1925)
Stag at Sharkey's, 1909
36¹/₄ × 48¹/₄ in. (81.4 × 122 cm.)
Cleveland, Museum of Art

George Bellows's boxing paintings are virtually synonymous with his name, even though he made the prizefight the subject of only six oil paintings out of an *oeuvre* of some 600 canvases. *Stag as Sharkey's* was Bellows's second painting on the theme. Together with *Both Members of This Club* (1909; Washington), it established his reputation as an artist before he was 30. The setting for *Stag as Sharkey's* was a New York City bar run by Tom Sharkey, a retired boxer who staged bouts in his back room. Sharkey's Athletic Club, as it was called, was located not far from Bellows's first studio, and the artist had attended fights there in 1907. While public boxing was illegal in New York in the first decade of the century, prize fights could be held at private clubs. Sharkey called his bar a "club," made tickets to such fights "dues" and the boxers "members" for the evening, thereby easily circumventing the law. The audience in Sharkey's back room was entirely male: women were not permitted to such "stag" events.

When a critic objected that Bellows had not accurately depicted boxer's stances and hand positions, the artist replied: "I don't know anything about boxing; I am just painting two men trying to kill each other." Everything in the painting speaks to this violence: the raw brutality of the anonymous fighters in head to head combat, the packed crowd, eager for blood, the opposition of bright light and murky darkness, the bold brushstrokes, the sheer physicality of paint.

To this inherently unstable subject of two men punching away at each other, Bellows brings a firm sense of composition without sacrificing the intense immediacy of the moment. Locked together in a flurry of action, the combatants are also locked in place pictorially by Bellows's alignment of the horizontals of ropes and floor, and the contrasting verticals and diagonals of post, legs, and arms. A strong pyramidal stucture unites the three main figures—the two boxers and the referee—with the extended right leg of the boxer in green trunks and the referee's gesturing left arm setting the side diagonals of the triangle.

In contrast to the structured, intensely lit drama inside the ropes, the audience at Sharkey's seems vaguely sinister in its cloak of darkness, and, in fact, Bellows once wrote about boxing, "the atmosphere around the fighters is a lot more immoral than the fighters themselves." Recalling Goya's frenzied crowds, the onlookers are caricatured, simplified, and distorted as they fuse together in their common emotional response to the bout: some move forward with excitement, others pull away, most blur into the background. Only one face at ringside escapes contortion: it is Bellows, ducking his bald head and peering up from his seat on the far side of the ring.

Extroverted and athletic, Bellows played basketball at Ohio State University and had been good enough at baseball to consider turning professional. Instead, determined to be an artist, he found a way of bringing his interest in sport to his painting and printmaking, depicting the more genteel activities of polo, tennis, and golf, as well as boxing, at a time when such subjects were rare in art.

In the years following the completion of *Stag as Sharkey's* Bellows provided further insights into his choice of subject: "Prizefighters and swimmers," he wrote, "are the only types whose muscular action can be painted in the nude legitimately. . . . A fight, particularly under the night light, is of all sports the most classically picturesque. It is the only instance in everyday life where the nude figure is displayed." These remarks reflect Bellows's deep interest in anatomy that led him to seek subjects that allowed him to combine studies of the human body in movement with realist subject matter. Thomas Eakins, a heroic figure to Bellows and to his generation of American realists, had also sought such subjects, and Eakins, too, had painted boxers. Bellows aligns himself with this tradition in American art.

After he finished *Both Members of This Club* in 1909 Bellows did not paint boxing subjects again until 1923. By then, his interpretation of the sport, his style, and boxing itself had changed. Now legal, matches held in the squalid back rooms of dives such as Sharkey's had given way to public contests where former title-holders were treated as celebrities (*Introducing John L. Sullivan,* 1923; John Hay Whitney Collection), crowds were fashionably dressed and even included women (*Ringside Seats,* 1924; Washington, Hirshhorn), and when the fight itself is shown, as in Bellows's curiously stilted last boxing painting, *Dempsey and Firpo* (1924; New York, Whitney), the fans, now well-lit and well-behaved (though still excited), have lost their rabid, Goyaesque force of contrast.

In *Stag as Sharkey's* Bellows's realist commitment to depicting contemporary urban life in its seamier aspects came together with his consuming interest in men in sporting combat to create a powerful canvas that with its fused excitement of theme and brushwork reveals Bellows at his best.

—Susan Barnes Robinson

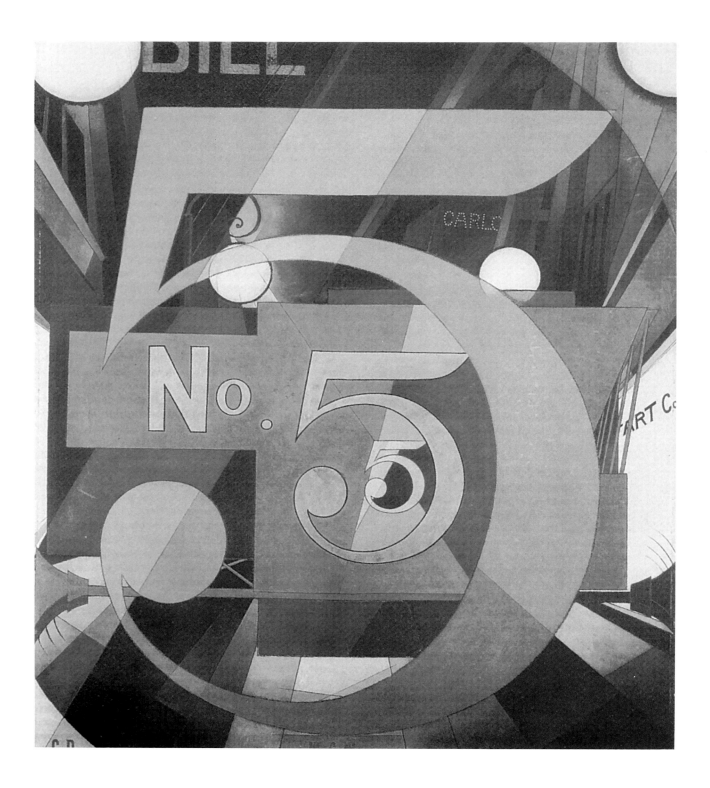

Charles Demuth (1883–1935)
I Saw the Figure 5 in Gold, 1929
Composition board; 36 × 29 in. (91.4 × 75.6 cm.)
New York, Metropolitan

Bibliography—

Breslin, James E., "William Carlos Williams and Demuth: Cross Fertilization in the Arts," in *Journal of Modern Literature* (Philadelphia), 6, 1977.

Davidson, Abraham A., "Demuth Poster Portraits," in *Artforum* (New York), 27, 1978.

Aiken, Edward A., "*I Saw the Figure 5 in Gold:* Demuth's Emblematic Portrait of William Carlos Williams," in *Art Journal* (New York), Fall 1987.

In 1924 Charles Demuth inaugurated a series of emblematic poster portraits of important American artists and writers with a non-figurative tribute to his friend Georgia O'Keeffe around the time of her marriage to Alfred Stieglitz. Non-figurative portraits had figured in the development of artists associated with the Stieglitz group since 1913, presumably inspired by the literary portraits of the eminent modern artists Henri Matisse and Pablo Picasso by Gertrude Stein which had been published in Stieglitz's journal *Camera Work* in 1912.

The nine poster portraits by Demuth, of which *I Saw the Figure 5 in Gold* is the best known and most fully realized example, are tributes to the greatness of artists whom Demuth believed represented the zenith of a specifically modern American aesthetic. These emblematic portraits differ significantly from commissioned portraits in which artists attempt to record an isolated physical moment. The poster portraits were intended to capture a more meaningful and lasting impression of the individual's significant accomplishments as a key to personality rather than leaving a record of evanescent physiognomy.

Inspired by William Carlos Williams's poem "The Great Figure," *I Saw the Figure 5 in Gold* was dedicated to Williams as a major American Poet. Demuth had known Williams since their student days in Philadelphia when they lived in the same rooming house. They had retained a special friendship based on their mutual interests in art, which lasted until Demuth's death in 1935. Although Williams practiced as a physician in Paterson, New Jersey, he was also a well-known figure in the New York Literary world. Like Demuth, Williams was concerned to develop a particularly American aesthetic experience and Williams attempted to capture the specifics of American life in his spare poetry.

Williams related that the event that inspired the poem took place one night when he was walking through New York to visit the painter Marsden Hartley, who was friendly with Demuth as well as Williams. In it Williams tried to capture the sensation of seeing a brilliant red fire truck blazing through the city.

Among the rain
and lights
I saw the figure 5
in gold
on a red
firetruck

moving
tense
unheeded
to gong clangs
siren howls
and wheels rumbling
through the dark city.

The painting is also intended to capture the sensation of seeing and hearing the fire truck as a distillation of the poet's sensory experience. *I Saw the Figure 5 in Gold* is the poster portrait most clearly related to Demuth's Precisionist paintings of architecture. It is defined by similar futurist line of force that emphasize the frantic noise and activity simulated in the poem.

As in the paintings by the French Cubists and Italian Futurists, Demuth utilizes lettering and numerals to demarcate planar areas of the composition, but they are also used to designate specific attributes of the poet. Demuth signs the painting with his initials in the lower left corner of the painting. Using the same script as the monogram, he places Williams's initials, w. c. w., at the center base line of the composition. Thus the tribute is established from c. d. to w. c. w. Williams's nickname, Bill, is emblazoned, albeit in a truncated version, across the upper left of the painting. Although Williams was known to his friends as Bill, the painting is also a signboard or bill designated by the artist. Demuth actually referred to Williams by his middle name Carlos, which he painted with a series of dots that simulate lights towards the center of the portrait. At the far right side of the composition the letters Art C, suggest Art Company, certainly a tribute to the company of artists in which the poet and painter found themselves when they were together.

The most pervasive image in the poster, however, is the figure 5 imposed in four variations that appear to resonate out from the center of the painting in reverberating waves. The fourth one is barely visible as a sweeping curve around the edges of the painting. The superimposition of the numerals produces a visual echo that simulates sound. The cinematic quality of *I Saw the Figure 5 in Gold* has been suggested by Edward A. Aiken in his article on the painting and he interprets the red shape in the center of the composition not only as a fire truck but also as a simulation of a movie camera. The 20th-century innovation of the movie camera is best able to capture the lasting experience of the sight and noise of a fire engine. It is left to the artist and poet, therefore, to distill the essence of the experience. Round globes of city lights also help to punctuate the light and movement in the modern city.

By using William's poem "The Great Figure" as a source for the painting, Demuth intimates that the great figure is none other than the poet himself and that the specific poem captures the best of the poet's expressive abilities. The dramatic character of the painting also hints at the nature of the poet's personality. *I Saw the Figure 5 in Gold* is not only a tribute to Williams's importance as a poet, but also documents the friendship between the painter and poet. The poster portraits are among Demuth's most significant achievements in his attempt to present an innovative vision of artistic expertise using methods of modern American popular culture.

—Percy North

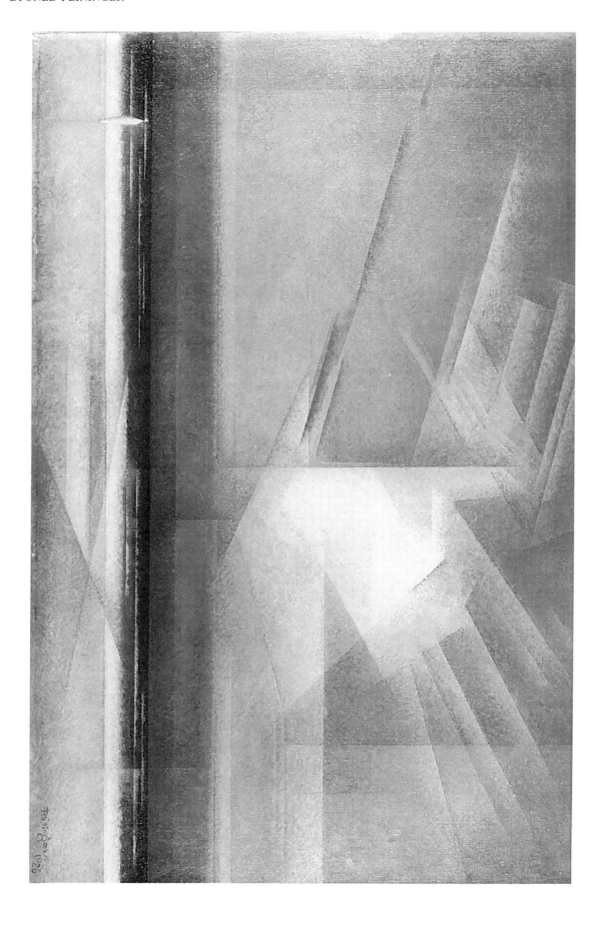

Lyonel Feininger(1871–1956)
Bird Cloud, 1926
17¹/₄ × 28 in. (43.8 × 71.1 cm.)
Cambridge, Massachusetts, Busch-Reisinger Museum

This painting is the result of Lyonel Feininger's search for an image to represent the essence of a recalled experience. *Bird Cloud* was preceded by preparatory drawings and at least two watercolors (also in the Busch-Reisinger Collection). The painting was created the year Feininger moved to the Bauhaus in Dessau.

The painting represents a theme central to the artist throughout his career, the sea, the clouds, and a figure on the shore. While the motif is a typically Romantic one, the mood is more austere. Feininger's painting does not reflect the specific turbulence of a great cloud, but through a distilled clarity of form it represents the meeting of atmosphere, light, and color. Preparatory works recall an experience. A pencil sketch of "Cloud after the Storm," dated 6/8/1924, records an energetic notation of the great white cloud formation. A watercolor, also of 1924, is a careful graphic outline of basic elements. In the final painting the composition is dramatically simplified—all details (boat, figures, shoreline land forms) have been omitted. Crisp straight lines, right angles, and transparent overlapping planes suggest the hidden geometry which underlies the majestic beauty of nature. Planes of color suggest light, creating a sense that air, space, water, and sand are equally palpable. The strong vertical of the cloud is echoed in the small white figure standing on the shore. The figure does not suggest romantic yearnings. It is rather a small point of balance in an expansive moment of revelation. The composition is a distillation of carefully ordered counterpoints. The large, white cloud balances the low, narrow band of the dark horizon. Feininger exposes the clear, yet mysterious, relationships between small/large, vertical/horizontal, static/dynamic, experience and form. The intersection of light and shadow on the sand gives the viewer a profound awareness of space: the expanse of golden beach reaches out to the horizon and the infinity of the sea and sky. The painting is about the sublime magic of the edge of land and sea, heaven and earth.

Obvious stylistic associations exist between this painting and Cubism. Feininger's geometric interpretation of form with transparent planes of color is parallel to the discipline of a Cubist approach, yet Feininger's conception is a personal one which evolved from an expressionist source. Unlike the Cubists', whose images are emotionally cool in their archetectonic precision, Feininger's abstraction resulted from a direct and intense experience in nature. For Feininger form was found in reality and transformed and crystalized. In this case the process evolved over two years. His purpose was to reveal a felt reality with greater depth. Feininger acknowledged a debt to Turner, in leading him to his understanding of light and color, magical space, reflections on the water and in the atmosphere.

This painting is one of Feininger's most successful representations capturing a sense of peace and spirituality. In many of his paintings the form of a building is stratified; layers of planes, for instance, make a church appear ethereal and luminous. In *Bird Cloud* the immaterial form of a cloud becomes a form of grandeur and monumentality.

—Janice McCullagh

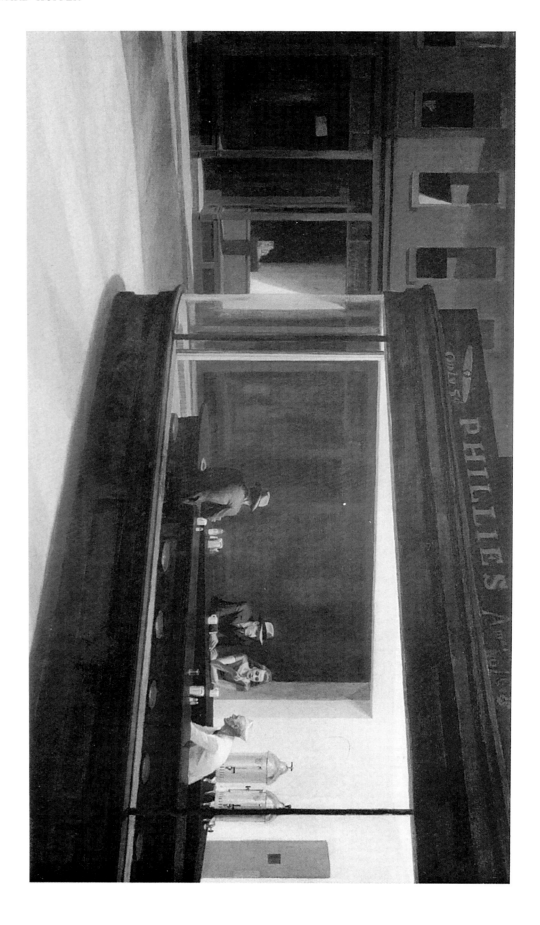

Edward Hopper (1882–1967)
Nighthawks, 1942
33 × 60 in. (83.8 × 152.4 cm.)
Chicago, Art Institute

Bibliography—

Burrey, Suzanne, "Hopper: The Emptying Spaces," in *Arts Digest* (New York), April 1955.

Levin, Gail, "Hopper's *Nighthawks,*" in *Arts Magazine* (New York), May 1981.

Edward Hooper's *Nighthawks* is generally considered to be the artist's masterpiece. Even the self-critical artist admitted that it was one of his paintings that he especially liked. Hooper claimed that this painting was "suggested by a restaurant on Greenwich Avenue where two streets [Seventh Avenue and Eleventh Street] meet." He completed *Nighthawks* on 21 January 1942 in his New York studio, situated not far from the locale that he said inspired him. For many of their meals Hooper and his wife frequented just such cheap neighborhood restaurants.

Hooper's choice of title offers a clue to both the content of this picture and its sources of inspiration. Employing the word "nighthawks" to refer to people who are just habitually up or moving about late a night seems excessive when the more innocuous "nightowls" might have served that purpose. Nighthawks suggests predatory activity. Hooper's sources might have included Van Gogh's *Night Cafe* (Yale University Art Gallery), Ernest Hemingway's short story, "The Killers," and even the poetry of the French symbolist Paul Verlaine.

Like that in Van Gogh's *Night Cafe,* Hooper's palette for *Nighthawks* emphasizes red and green with yellow nocturnal light. There is ample evidence that Hooper knew Van Gogh's 1888 painting both from reproduction and exhibition in New York. Furthermore, this painting was exhibited at the Paul Rosenberg Gallery in New York during the weeks when Hooper was painting *Nighthawks.* Critics have frequently compared these two works, citing the sinister quality of both images.

In 1927, just after Hooper had finally been able to abandon his career as an illustrator and devote himself to painting, he discovered Hemingway through his short story "The Killers," published in *Scribner's* that March. Uncharacteristically, Hooper wrote a fan letter to *Scribner's* praising the story as honest. What Hooper must have appreciated most in this story—the suspense of impending violence that never takes place—he also suggested in his painting *Nighthawks.*

There are also aspects of *Nighthawks* that suggest Hooper's own commercial illustrations for magazines like *System* during the 1910's. The basic furniture and the still-life details (like the cash register) recur in the painting, although the artist's expression of a disquieting mood is not yet present in his earlier commissioned illustrations.

A number of Hooper's studies for this canvas are extant. These conte crayon sketches on paper include a detailed sketch of his wife, Jo, posing for the woman seated at the counter (Whitney Museum of American Art). The pose of the man who accompanies her is strikingly similar to that of the figure of Marcellin Desboutin in *Absinthe* (The Louvre) by Edgar Degas, one of the artists Hooper most admired.

Much-loved, *Nighthawks* has become an American icon, appearing transformed on greeting cards, in cartoons, films (such as in Herbert Ross's *Pennies from Heaven*), recreated as the set for modern dancers, and frequently appearing in the work of contemporary artists (such as Red Grooms's *Nighthawks Revisited*) who pay homage to Hooper.

—Gail Levin

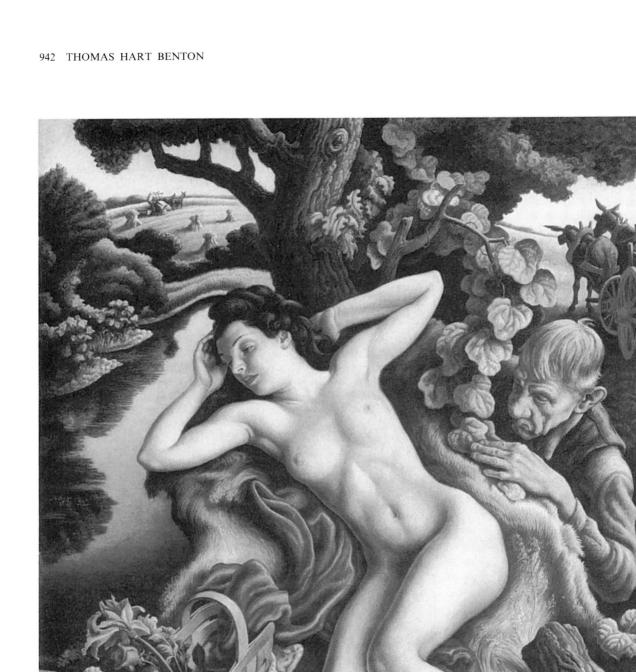

Thomas Hart Benton (1889–1975)
Persephone, 1939
6 ft. × 4 ft. 8 in. (182.9 × 142.2 cm.)
Kansas City, Nelson-Atkins Museum

Benton's famous mural cycles of the 1930's sparked violent controversy because of their frank depiction of unsavory American characters, such as gangsters, bootleggers, chorus girls, and Ku Klux Klanners. His most famous easel painting, *Persephone,* also created a stir—this time because of its lusty depiction of the female nude. The story of the painting, of course, was a classical one, and the female nude one of the most time-worn themes of visual art. Benton, however, gave the subject a vulgar piquancy by showing *Persephone* as an up-to-date American girl, with a modern hair-style and high-heeled shoes, and presenting Pluto, the god of the underworld, as a red-nosed hillbilly who has just hopped out of his mule-drawn cart.

In characteristic fashion, Benton conflated the principles of high and low art. The figure of Persephone recalls a George Petty pin-up from the pages of *Esquire,* yet her pose is lifted directly from Correggio's *Venus and Antiope* in the Louvre. Thus, Benton slipped a pin-up girl into the stuffy world of the museum, at the same time that he hinted at the lusty-mindedness of the old masters.

The general effect combines observed reality with pictorial rhetoric and artifice. Every element of the painting was based on sketches made from life (the mule-drawn cart, for example, was based on a 1926 travel sketch). But the sinuous composition was also carefully planned out in the studio—Benton even made a clay model of the ensemble before beginning to paint.

The plants in *Persephone* all carry symbolic import, for *Persephone* lies beside a basket of day-lilies, a symbol both of purity and daylight, while Pluto stands on barren red dirt and is set off from the foreground by a decaying log. Between him and Persephone stand a bunch of grape leaves, a symbol of intoxication.

A major theme of the painting is the equivalence between woman and nature. The sinuous curves of the sunbathing girl echo those of the rolling American earth—a device found also in other notable nudes of the 1930's, such as Alexander Hogue's dust-bowl landscape *Mother Earth Laid Bare.* Perhaps *Persephone* celebrates, in part, Benton's return to the landscape of rural Missouri after nearly 20 years of residence in New York.

Indeed, despite the brashness of its execution, the billboard-like boldness of its handling, *Persephone* seems to have been imbued with personal and private messages. It seems to allude with surprising directness, for example, to Benton's early sexual traumas. Physically the goddess resembles the prostitute who took Benton's virginity when he was in his teens—a girl with pale skin and black hair in curls, like the model in the painting. In real life this seductress wore a flaming red kimono, which is evoked in the painting by the crimson cloth that Persephone lies on.

The theme of rape, taking a woman against her will, was one which Benton had witnessed at an early age, for as a young toddler he was often wakened by his mother's screams when his father forced his way into her bedroom. Significantly, the head of Pluto in the painting closely resembles Benton himself, although represented as older and with his features humorously exaggerated. Thus, in *Persephone* Benton re-enacted a major trauma of his childhood, placing himself in his father's role.

—Henry Adams

Hans Hofmann (1880–1966)
Effervesence, 1944
Oil, india ink, casein, and enamel on plywood; 54³/₈ × 35⁷/₈
 in. (138.4 × 91.1 cm.)
Berkeley, University of California

Hans Hofmann's *Effervesence* is an important, although eccentric, work in the artist's career. In 1944 Hofmann was struggling with the issues of spontaneity versus structure and the possibility of total abstraction in his art. From 1936 through 1941 Hofmann had painted rather conservative still-life compositions which utilized the simplified planar structure of Synthetic Cubism and the bright colors of Fauvism. Surprisingly, between 1942 and 1944 Hofmann adopted ideas from Surrealism which he had previously considered an anathema. During this time he used rapid brush drawing which resulted in imagery that often had mythic connotations. This type of work derived from the Surrealist notion of psychic automatism, or creation without conscious planning, which was intended to reveal hidden states of mind. Such experiments by Hofmann followed in the wake of automatist explorations by Pollock, Motherwell, Baziotes, Rothko, and other Abstract Expressionist artists. Yet these Surrealist works did not sufficiently loosen Hofmann's style. Vestiges of a Cubist armature remained, as did representative forms.

In 1944 Hofmann undertook a series of the most spontaneous painting of his career, of which *Effervesence* is one. (They were preceded by a single equally experimental work, *Spring* of 1940.) In *Effervesence* Hofmann painted a moderately sized plywood panel with a loosely brushed layer of casein in blue and grey tonalities. He then placed the panel on the floor, as may be determined from the flow patterns of the pigment. Hofmann poured and dripped onto its surface oil paint, enamel, and india ink in a variety of colors including white, black green, and yellow. Using this poured technique, Hofmann relinquished to chance much of the artistic control he had preserved in his art up to this point. His reason for employing so many materials was clearly to experiment with varying viscosities and their interaction. Although the elements of chance play a large role in *Effervesence,* one can detect a degree of artistic control, most notably in the manner Hofmann balanced areas of white enamel and black india ink through several pourings at the center of the composition, and the accents in india ink in the lower portions of the painting. There is no evidence that Hofmann modified *Effervesence* with further brushwork after the pouring took place.

Effervesence pioneers many painting ideas which were essential to Abstact Expressionism. These include the relationship between artistic control and chance occurrences and "overall" composition in which there is no hieratic relation between parts. Also explored are projecting rather than illusionistically receding surfaces and the potential for expression through total abstraction. For Hofmann and the other Abstract Expressionists, such compositional ideas expressed a world view in which change, flux, and transience ruled. The processes of painting, through the artist's direct contact with his materials, became a heroic, though always problematic, activity in a world where man seemed to have less and less efficacy.

Hofmann's *Effervesence* preceded by three years Jackson Pollock's first great dripped paintings, but it does not establish Hofmann as the innovator of that style. Hofmann's experiment remains somewhat isolated in his oeuvre. After 1944 Hofmann returned to predominantly brushed canvases, and during the 1950's a structural armature of brightly colored rectangular planes reasserted itself in his work. Nevertheless, it was *Effervesence,* and works like it that prompted Hofmann to pursue a less constrained and abstract mode of expression for the remainder of his career.

—Robert Saltonstall Mattison

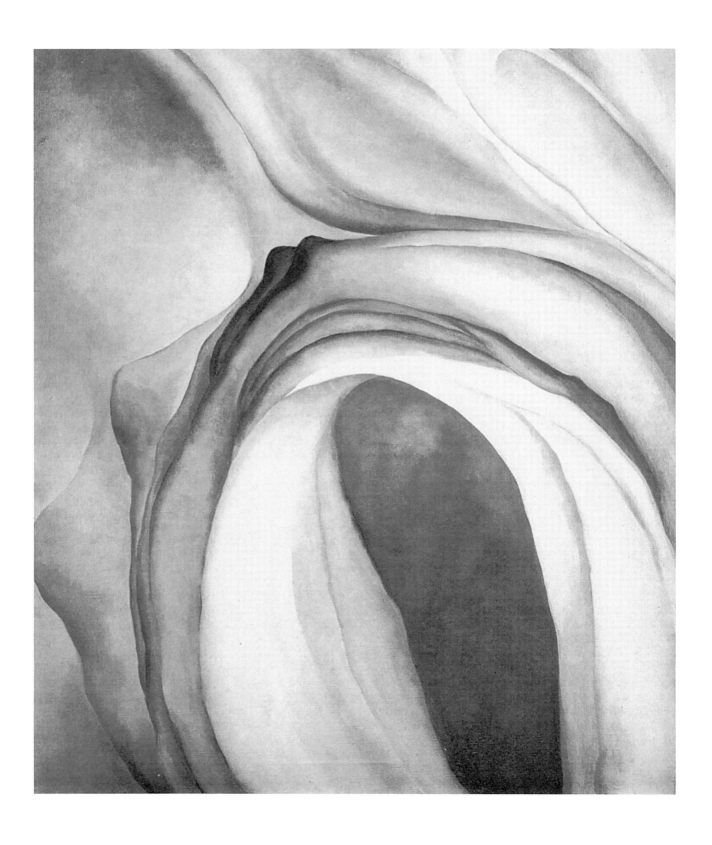

Georgia O'Keeffe (1887–1986)
Music—Pink and Blue II, 1919
Emily Fisher — Landau Collection

The enduring interest in Georgia O'Keeffe's powerful personality and pivotal position in the midst of America's artistic innovators, combined with the popularity of her accessible and easily sentimentalized paintings of flowers, has led to the trivialization of an important body of work created by the most significant female artist in the early decades of this century. Quintessentially experimental, O'Keeffe was one of the first artists to explore the possibilities of non-objectivity, and thus was a seminal contributor to visionary modernism. An instinctual painter, suspicious of intellectual approaches to art, she was an introspective and independent visionary who thrived on isolation. She nonetheless maintained a long, if stormy, relationship with the gregarious, extroverted photographer Alfred Stieglitz, whose international contacts and prescient exhibitions filled three major avant-garde galleries and fueled her stylistic evolution.

But O'Keeffe's contact with certain fundamental emotive theories in art had occurred long before she entered the privileged circle around Stieglitz, as early, in fact, as 1912 when she attended Alon Bermant's classes at Columbia Teacher's College in New York. Introduced in the same year to Kandinsky's recently published *Concerning the Spiritual in Art* and Arthur Dow's *Composition,* O'Keeffe was indirectly influenced by late romantic concepts that challenged objective reality, the intellect's dominion, and the necessity for descriptive form or color. Kandinsky's poetic treatise conflated theosophical beliefs in the spiritual potential of color with symbolist desires for the merger of all the arts—visual, theatrical, and tonal—into a harmonic unity, which he called "visual music." O'Keeffe responded to the synesthetic implications of the Russian's theory, merging them with Dow's appropriations of Gauguin's Synthetist credo, which valued the synchronous results created by "dreaming before nature."

As indicated by its title, *Music—Pink and Blue II* of 1919 reflects these concepts through rhythmic formal reduction and by its analogy of color to music. Painted with a dry brush and a rococo palette of vibrantly merging pastels—a paradox that typifies O'Keeffe's work—this image emerged in the wake of two series devoted to non-objective explorations.

The earlier of these, a group of charcoal drawings collectively entitled *Special* and completed between 1915 and 1918, was (with one exception) monochromatic in tone and organic in form, alternating silhouetted figures composed of undulating lines drooping heavily from vertical positions or descending across the composition in sweeping diagonals. One of these, with obvious landscape references, became the sole *Special* to be translated into color: a golden hillock which swells to release a cascade of feathery crimson spheres, symbolic of natural fecundity.

Thereafter, O'Keeffe relied upon color's associational powers almost exclusively. The other non-objective series, begun in 1918 and identified by a numerical system later favored by color-field painters and minimalists, pursues the emotional implications of color to abstract extremes. These paintings, in addition, explore her characteristic compositional strategies, the "rift" and the "void," later fully developed in her representational imagery. O'Keeffe first noticed the presence of the rifts in her work in 1916, referring to them as "slits in nothingness" in a letter to Anita Pollitzer, her friend and confidant with whom she often discussed her motivations and content. Even more profoundly than Barnett Newman's consciously applied "zips" in his huge color-field canvases of the 1960's, O'Keeffe's rifts and voids indicate an emergent universal creative force.

The deep void at the center of her compositions remained her most recurrent motif; in allusive non-objective images like *Music,* she surrounded it with a coiled vortex suggestive of swelling rhythms emerging from primordial silence. In more representational work, this central depth was found at the heart of a flower or hidden within the shell's revolutions, and even in the uncharacteristically geometric paintings of Georgia O'Keeffe's final refuge in New Mexico, her beloved Ghost Ranch, it appeared—as the door opening onto the vast desert, the arena of nature's creative flux, revealed to the disciplined eye of its most receptive artistic visionary.

—Linda F. McGreevy

Alexander Archipenko
Walking Woman, 1912
Bronze; 26¹/₂ in (66 cm.)
Donald Karshan Collection

This piece is pivotal in Archipenko's career, marking both important Cubo-Futurist applications to his sculpture and pointing the way to the direction of much of his subsequent work. *Walking Woman* is stylistically an abrupt departure from what came before it: although Archipenko had shown some Cubist influence in his works of the preceding year, marked by a planar treatment of forms, it is in *Walking Woman* that the fully addresses problems central to Cubist sculpture: the treatment of a work of art as an object in its own right, the interaction of object and space, the use of intersecting planes to describe volume, and the use of construction over modelling. Archipenko also takes on the Futurist concept of motion as well. *Walking Woman* also has a complex relationship to its surrounding space: both the head and the torso of the figure are open, and defined by the sculpture itself, which is reduced to an informative frame. The spectator is forced to read, to construct mentally that space as a solid object. Here a dynamism is implied—the change from non-being into being, and this element of change is situated within time. In this way, the sculpture is linked to Futurism as well. Boccioni's famous *Construction of a Bottle in Space* works in a similar manner. The fragments of the object, arranged around a spiralling vertical axis, demands that the spectator reconstruct it.

The entire work, which is constructed of planes rather than modelled, functions as a frame around the space, the planes suggesting the volume of the figure rather than constituting it.

Although Archipenko was soon to discard this Cubo-Futurist approach (in 1912 he formally announced that he was through with Cubism), certain ideas developed in the *Walking Woman* were to stay with him for the rest of his career. The use of void space, particularly for the heads of figures, reappears in many of his works. Also, the way the viewer has to reconstruct the space of the piece and the use of sculptural surface to imply it become habitual features. Although Archipenko's later work was generally less innovative and decorative, pieces like *Walking Woman* had much influence on other Cubist sculptors, particularly Lipchitz and, some would argue, the early construction of Picasso.

—Nancy C. Jachec

Stuart Davis (1894–1964)
Lucky Strike, 1921
33¹/₄ × 18 in. (84.4 × 71.1 cm.)
New York, Moma

In 1921 Stuart Davis initiated a series of paintings based on cigarette packaging that signalled his arrival as a mature artist. These works, including *Lucky Strike,* indicate a new direction, not only in Davis's art, but in the direction of American art as well. The 1920's marked a break in the chain of development of American modernism, and many American painters were abdicating from European modernist influences and appropriating what they perceived as particularly American subject matter in scenes of daily American life.

Although Davis aligned himself with the nationalist belief in the need for an indigenous American artistic expression, he adhered to the desire to propogate a modernist aesthetic in tune with the currents of the 20th-century. *Lucky Strike,* therefore, serves as both a specifically American while at the same time a modern image. It reveals Davis's interest in the forms of French synthetic Cubism introduced by Picasso and Braque in 1913 and 1914 in its flattened forms and graphic use of lettering. The subject of tobacco, however, is decidedly New World. Tobacco was America's primary cash crop in its early colonial years, having been introduced to Europe by Sir Walter Raleigh, and the innovative packaging and marketing of the product of cigarettes represents the technological progress of the country from its colonial 17th-century origins to its sophistication as a world power in the 20th-century.

Davis chose a familiar American product with consumer identification and elevated it to the level of fine art. Thus Davis breaks down the distinction between fine and commercial art and suggests that America's greatness may rest with its merchandising and technological prowess. In *Lucky Strike* Davis represents a familiar product of contemporary American life that distinguished the most basic characteristics of American society—commercialism, merchandising, and product identification with a brand name.

The painting appears to be simply a flattened cigarette packet enlarged to over-sized proportions. In its attention to detail *Lucky Strike* is similar to the trompe l'oeil still-life paintings of cards and letters on racks that were popularized in America by William Michael Harnett during the 1890's. Although the painting hints at elements of collage, *Lucky Strike* is completely painted in oil on canvas, thereby instilling a sense of confusion about the multiple layers of interpretation possible in modern art.

Seven different sizes and configurations of lettering appear on the painting from the dimunitive signature of the artist in the lower right to the enlarged (and repeated) title of the painting as the brand name of the cigarettes. The titles appear at right angles to one another with the larger letters appearing perpendicular to the smaller inscription at the lower left of the canvas reinforcing the grid pattern of the composition. Here the viewer might expect to find an artist's signature rather than the name of a product. The name of the cigarette manufacturer, The American Tobacco Co., is presented in elegant script—as it would appear on the cigarette packet—parallel to the enlarged brand name to reiterate the American theme of the painting. On a band next to it, a modernistic monogram for the product appears as a decorative device. Package seals, a striated box top, and a circular shape indicating the smoke-ring emblem for the brand of cigarettes invigorate the horizontal and vertical grid configuration of the composition. Repetition of words and images is used to reinforce memory of the product and to associate it with a variety of signs and symbols. The red, white, and green planes of color designating the package are as flattened as the letters and numerals on it emphasizing the fool-the-eye character of the painting. The empty, flattened packet demonstrates that the wrapping itself and its design are more important than its contents.

The date 1910 indicated in the lower center of the composition is not the date of the completion of the painting, but is the date of the registration of the trade mark. This adds an amusing twist to the artist's usual personal historical recording of a painting. Here Davis elevates the historical significance of the brand mark.

Although Davis chose the subject for its familiarity, he was also well aware of the multi-leveled word play of the title. The marketing ploy of the advertiser reminds the user that the cigarettes are activated by a lucky strike of the match, and that the product produces a fortuitous pleasure. The painting proved to be an exceptionally lucky strike for the artist, who initiated his mature style, reactivated American painting, prefigured the adoption of banal subject matter in the art of the 1960's, and attracted continuing national attention with this work.

—Percy North

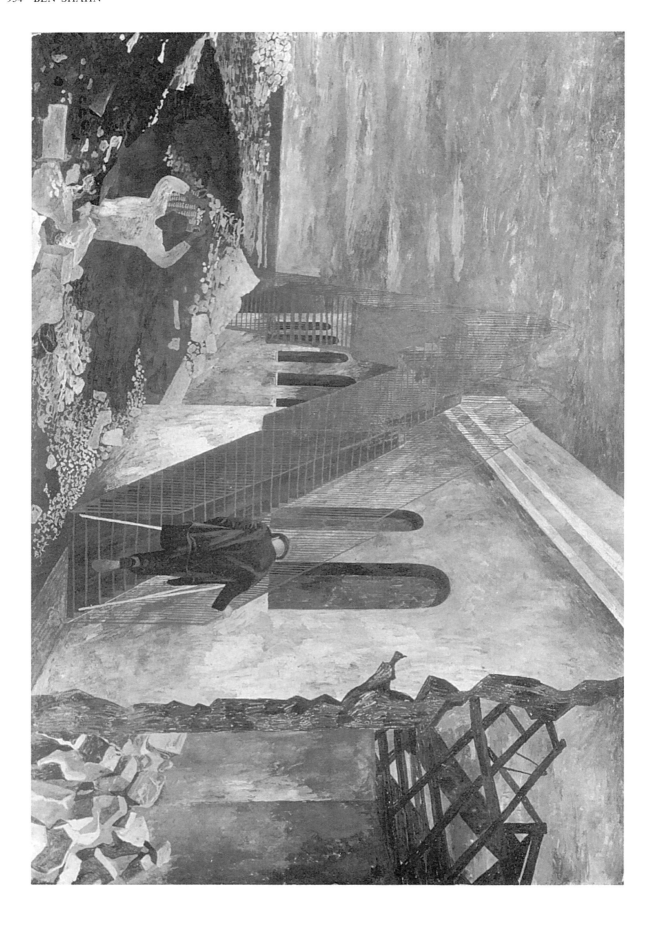

Ben Shahn (1898–1969)
The Red Stairway, 1944
Tempera on masonite; 16 × 23 in. (40.6 × 59.9 cm.)
St. Louis, City Art Museum

Unlike his polemical works of the 1930's, Ben Shahn's *The Red Stairway* is not intended to induce an immediate social action and it lacks his earlier satiric bite. The painting evokes instead the general melancholy and malaise precipitated by the then rampaging Second World War. It is one of the few American paintings of the 1940's to address the issue of the war, for the popularity of narrative socially conscious painting has waned after the end of the 1930's. All that appears in the composition is a wasteland of desolated landscape, bombed building, and a pair of physically as well as psychically wounded people: an elegiac tribute to a loss of civilization. The painting has a spectral, brooding quality from the grim blue expanse of open landscape littered with the stones of decimated buildings, the sole residue of a formerly inhabited space. The painting serves not only as a metaphor for the havoc wreaked on the land by the conflict, but also for the devastation to the collective human psyche.

The stairway of the title defines the space of the composition, forms its major motif, and is the only bright area of color to break the moody blue that permeates the entire canvas. An elegant linear design that rises up to the sky in jagged mountainous peaks and then descends to the ground at a 45° angle, the red stairway asserts a diagonal line into the depths of a decimated landscape producing a seemingly endless path to the horizon. Braced against the side of a stark wall with an arcade of empty windows, behind which its former building lies in rubble, the red stairway creates a compelling visual pull into a vast nothingness. Although the wall and staircase are still standing, the composition infers that their position is precarious. The stairway symbolizes the stability and progress of civilization—tenuous and faltering; it may appear to be rising, but it really has nowhere to go but back down to its baseline. Although the brilliant red of the stairs is visually compelling, it is also a grim reminder of the blood shed in the conflict in which the world was then involved.

Two male figures, both mutely depicted from behind, appear in the foreground of the composition as symbols of all humanity rather than as specifically designated individuals. The figures are small and insignificant within the scale of the landscape and they have been reduced to simplified silhouettes. The men are engaged in unrewarding, difficult, and tedious tasks. A dark coated man with one leg attempts to climb the red stairway with the aid of crutches. His difficult task of reaching the apex of the stairs is futile, for there is nothing at the top for him to attain except a clearer vision of the oppressive sky. The act of ascent is doubly dangerous for the wall may crumble at any moment. Thus, ascending the staircase is an act of courage induced by force of will. The man on the ground is carrying a basket of rocks in what appears to be an attempt to clear the rubble and begin building again. Both the figures attest to human resilience and the inevitable will to survive and prosper in the face of all hardships. The men, therefore, appear as inspirational images against the bleak historical backdrop of the war, but the painting also has a haunting quality of imminent danger and ultimate despair at the unnecessary and senseless destruction.

As in *The Red Stairway,* Shahn's paintings of the 1940's present a surreal aura from the utilization of imaginary and haunting locales. Here no country or specific site is indicated. The landscape could be anywhere in a devastated war zone and thus presents a universal plea against all armed conflict. The consistent use of blue establishes a melancholic mood broken only by the brash blood red of the stairway. The blue sky, churned up with active strokes of white paint simulating menacing clouds, hangs heavy on the barren blue landscape of nightmares into which the viewer is plummeted by the rushing diagonal of the red stairs. Shahn knew that there was no turning back from the horror of the war and its inevitable wounds, but *The Red Stairway* is a reminder to keep climbing and keep building as a means to heal. It is the perfect painting to document his transformation from raging social activist to meditative, poetic painter, a demonstration of his intellectual maturity and late subtle consciousness.

—Percy North

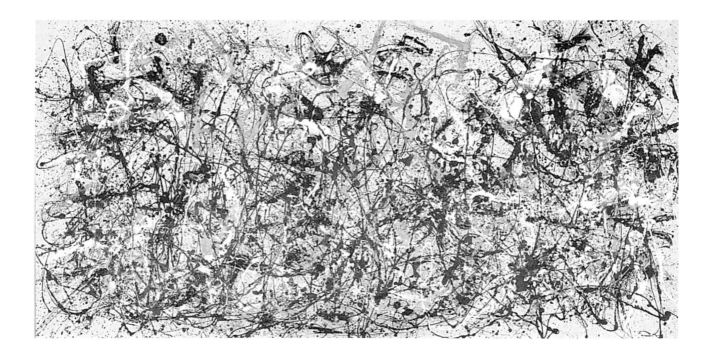

Jackson Pollock (1912–56)
Autumn Rhythm: No. 30, 1950, 1950
9 ft. × 17 ft. (274.3 × 518.2 cm.)
New York, Metropolitan

Over 17 feet long and almost 9 feet high, Jackson Pollock's *Autumn Rhythm: No. 30, 1950* dominates any large museum space in which it hangs. Nevertheless, viewing the painting can be an extremely intimate experience, as one is pulled into the painting to trace the webs and skeins of lines and shapes that hover on the surface of the unprimed canvas. Graceful, repeated arcs of thin black paint are balanced against heavier, more cumbersome passages of thick black paint, while white and tan lines and shapes interweave with the black ones. Very sparely applied drips of blue paint soften the generally somber tonality of the painting.

In August 1950 the *New Yorker* magazine carried an interview with Pollock and his wife Lee Krasner. In reference to the issue of titles, Krasner remarked that Pollock's use of number as titles emphasized the painting as pure painting, and her husband added, "Abstract painting is abstract. There was a reviewer a while back who wrote that my pictures didn't have any beginning or any end. He didn't mean it as a compliment, but it was." While the first part of the title of *Autumn Rhythm: No. 30, 1950* has an evocative counterpart in nature, the remainder of the title is appropriately neutral. Like its pendant, *One (No. 31, 1950)* (New York, Moma), *Autumn Rhythm: No. 30, 1950* has no obvious counterpart in perceptual reality. Rather, both paintings are about the spontaneous act of painting and, further, about paintings as a means of tapping into the realm of the unconscious.

When *Autumn Rhythm: No. 30, 1950* was first exhibited in late November and December at the Betty Parsons Gallery in New York, critical reactions were mixed, although the show was voted second among the three outstanding one-man exhibitions of 1950 by the editorial staff of *Art News.* Howard Devree, writing in the *New York Times,* noted Pollock's sources in Surrealism by drawing a parallel between the paintings and automatic writing, adding, "Its content (not definite subject-matter but *content*) is almost negligible—that what one gets out of it one must first put there." Belle Krasne wrote less sympathetically in *Art Digest* that "Those who go for the intellectual no-strings-attached sort of decoration will go for this year's Jackson Pollock show, his richest and most exciting to date." The accusation of "decoration" was frequently made against Pollock's large abstractions, diminishing the intensity and depth of emotional experience that the artist sought to record on his canvases.

Despite the initial lack of understanding of Pollock's painting, *Autumn Rhythm: No. 30, 1950* was acquired by the Metropolitan Museum of Art in 1956, after already having once turned it down. Legend has it that the trustees of the museum were finally convinced to purchase the painting after observing the interest shown in it by a group of school children. Together with *One (No. 31, 1950)* it now represents the high point of Pollock's art, as one of the most lyrical and evocative statements of the Abstract Expressionist epoch.

—Kristen H. Powell

Franz Kline (1910–62)
Chief, 1950
58³/₄ × 73¹/₂ in. (149.1 × 186.7 cm.)
New York, Moma

Franz Kline's *Chief* is one of the large black and white abstractions, created during the 1950's, which mark Kline's greatest achievement as a painter. Trained in an illustrative tradition, Kline's earliest works had been representative and anecdotal. By the mid-1940's, under the influence of the nascent Abstract Expressionist painters, Kline's art had grown more abstract and his style broader and more painterly. Kline was particularly cognizant of the black and white abstractions created by Willem de Kooning between 1946 and 1949.

Because of an article by Elaine de Kooning, it has long been assumed that *Chief,* and Kline's other early black and white abstractions resulted from an accidental discovery. In 1948 or 1949, Kline saw one of his small ink drawings enlarged in a Bell-Opticon projector, According to Elaine de Kooning, the drawing "loomed in gigantic black strokes which eradicated any image," and "From that day Franz Kline's style of painting changed completely." Yet a thorough study of Kline's drawings and paintings from the mid-1940's until 1950 shows a gradual progression towards abstraction and a strengthening of the gestural strokes which define those composition. The Bell-Opticon experience could only have acted as a confirmation for a direction in which Kline was already headed.

Another misconception about Kline's art, disproved by *Chief,* involves degrees of spontaneity. While *Chief* seems to have been painted in a creative explosion of energy, the work was achieved through a subtle balance of planning and immediate creativity. *Chief,* like many of Kline's mature abstractions, was preceded by small compositional sketches (in this case, probably *Untitled,* 1950, collection Mr. and Mrs. David Orr). The relationship between sketch and final painting shows that the basic shapes of *Chief* were derived from the drawing, but important modifications were also made during the painting process. These modifications occurred particularly in the increased areas of dense black pigment toward the center of the painting. They serve to transform the delicate sketch into a much more powerful and assertive painting. One might also note that the three crescent patches of white at the center of the black shapes, which allow that mass to breathe, have been carefully over-painted to increase their prominence. In Kline's work, as well as that of the other Abstract Expressionists, a high degree of artistic sophistication is combined with intuition.

In his abstractions Kline meant to paint feelings and experiences, not objects. Yet his works do contain vestigial references to the exterior world which aid us in grasping their meaning. Many of the black and white abstractions may be divided into groups, vertical compositions which contain figurative images, and horizontal paintings often suggesting locomotives and architecture in landscape. *Chief* is interesting because it combines these two groups. In it, we find the horizontal and diagonal swaths of black paint which lend the industrial landscape paintings their brute force. At the same time, more organic, curvilinear shapes are held aloft on fragile stick-like legs. The painting's tentative balance between raw energy and frailty may also be mirrored in its title. Kline usually chose his titles after the paintings were completed, and they reflect his responses to the works. In the case of *Chief,* Elaine de Kooning recalls that Kline was reminded of the name of the famous express train *The Chief.* That train, a former symbol of power in the coal belt where Kline was raised, was a rusting and forgotten hulk by the time *Chief* was executed. Kline may have been thinking simultaneously of an Indian chief, a figure of uncertain stature in the modern world. If so the title of *Chief* confirms what the forms already tell us, that Kline viewed the world as a precarious equilibrium between conflicting emotions and values.

—Robert Saltonstall Mattison

David Smith (1906–65)
Cubi XIX, 1964
9 ft. 4³/₄ in. (286.5 cm.)
London, Tate

Cubi XIX is one of twenty-eight stainless steel sculptures forming David Smith's last series, the Cubis. Probably his best known works, the Cubis are also considered by many critics to be one of the most inventive and forceful sculptural groups created in America as well as Smith's most important body of work.

Fundamental to Smith's way of working was to take a single idea or theme and develop it in a sequence of closely related sculptures. Smith executed more than fifteen such series in his career, from the Agricolas of the early 1950s to the Cubis, still in process when he died in 1965. What unites a series could vary considerably, according to theme, materials, forms, or even the place it was made (as with the Voltris). All the Cubis are welded together of prefabricated stainless steel volumes—cubic, rectangular, cylindrical, and disc shapes—and all share an architectural scale.

Cubi XIX is most closely related to three other sculptures in the series, *Cubi XVII* (Dallas), *Cubi XVIII* (Boston, with which the Tate sculpture is frequently confused in the literature on Smith); and *Cubi XX* (Los Angeles, University of California): in these four Cubis the hollow stainless steel units are grouped on a platform, recalling the table-top tableaux of the 1940's where such horizontal supports organized the forms of Smith's secretive autobiographical dramas. By 1961 when he began the Cubi series, Smith had purged such personal symbolism from most of his work; nonetheless the Cubis remain complex presences, full of formal paradoxes.

Cubi XIX is at once tough and fragile, stable and unstable, solid and insubstantial. It seems a precarious structure: on the horizontal bar—a secure visual anchor itself but nonetheless perched askew its vertical support—a pair of cubes teeter on edge, two rectangles tilt at perilous angles, one supported only by an insecure cube, and a disc seems poised to catapult off. Smith creates a visual balance so fragile that the slightest movement would seem to risk toppling this steel house of cards. Such fragility is illusory, of course; with confidence gained from his long experience with welding, Smith could give free play to the creative possibilities of his process, securing each part in place through the unique strength of the welded joints which make the tensions of *Cubi XIX* possible as well as permanent.

Smith introduces other internal contradictions into the sculptural vocabulary of *Cubi XIX* by treating the surfaces of his stainless steel modules in a painterly fashion, thereby mitigating both their three-dimensional solidity and their cold industrial perfection. Throughout Smith's career pictorial and sculptural ideas interacted closely in his work and the artist once described himself as "a sculptor who painted his images." Before the Cubi series, Smith had experimented with color in sculpture and from time to time with a gestural treatment of surface. Now Smith saw the stainless steel itself as full of painterly potential; where to earlier works he had applied color, in the Cubis he scumbled the surface using his sander like a paint brush to make the steel glint, flex, shimmer, and shift as if it were no more substantial than the surface of a pond. Smith, in fact, took a Monet-like pleasure in the responsiveness of the Cubis' burnished surfaces to changes in light and color:

I polish them in such a way that on a dull day, they take on a dull blue, or the color of the sky in the late afternoon sun, the glow, golden like the rays, the colors of nature. And in a particular sense, I have used atmosphere in a reflective way on the surfaces. They are colored by the sky and the surroundings, the green or blue of water. . . . They reflect the colors. They are designed for outdoors.

If *Cubi XIX* seems somewhat uncomfortable in its museum setting, it is perhaps worth remembering this preference on Smith's part for his sculptures to be seen outdoors. For years he displayed his work in the fields around his studio/home at Bolton Landing, New York. There, his earlier mild steel sculptures, unlike stainless steel, not invincible to rust inevitably deteriorated. Finally, in 1957 when he could at last afford it, Smith began using the more durable stainless steel.

Despite Smith's innovations in the choice and use of industrial materials, the Cubis are still additive sculptures in the traditions of Cubism and Constructivism. Furthermore, the difficulty of working with stainless steel basically restricted Smith to geometric modules that could be pre-cut at the factory and then assembled to make a lexicon of cubes, boxes, and discs of various sizes. Working with these prefabricated parts put constraints on Smith's artistic process, which he characterized as emotional and intuitive, and this distance from the sources of his art may explain the formal inertia which afflicts some of the Cubis. But in the strongest works in the series, and *Cubi XIX* is certainly among them, Smith successfully brings the aggressiveness of his stainless steel material and welding process together with the complex formal interactions of his sculptural vocabulary, to create original and compelling images that make the Cubis unique in modern art.

—Susan Barnes Robinson

Mark Rothko (1903–70)
Green and Maroon, 1953
7 ft. 7^{1}/$_4$ in x 4 ft. 6^{3}/$_4$ in. (321.8 x 139.1 cm.)
Washington, Phillips

In many ways *Green and Maroon,* painted in 1953, breaks with the conventions of Rothko's earlier works. Throughout his career, Rothko, who claimed his pictures were "violent," feared that his paintings would be seen merely as decorative exercises. This fear of being misunderstood led Rothko, in the 1950's, to change his palette to darker and more somber tones. In most of his earlier works shades of bright yellow, orange, and red dominate. His use of the two complementary colors red and green rather than the colour harmonies of closely related hues is unusual. However, the tension of the two colour fields directly adjoining is diminished by a diffuse white stripe, emanating from behind like an inner light. The two rectangles float in a dark blue field without an exactly determinable position or clear figure-ground relationship. This typical spatial ambiguity is intensified by the frayed edges and the highly textured surfaces of the red and green rectangles with the underlying blue shining through.

The room in the Phillips Collection in which *Green and Maroon* hangs was the first exhibition space entirely devoted to paintings by Rothko in a permanent collection. Though it is not known whether Rothko participated actively in the installation, it certainly follows his ideas about the hanging of his work. It is a small rectangular room with a relatively low ceiling, grey walls, and low lighting levels. The four large paintings in this room, which were not created for the space, hang quite low, thus enveloping and directly addressing the viewer, as was Rothko's intention. It is the confrontation of the viewer with the canvas, his experience of interacting shapes, as well as his physical relationship to them, that constitutes the transcendental experience Rothko called for.

Rothko painted large canvases because he wanted the spectator to be enveloped by them: "To paint a small picture is to place yourself outside your experience" . . ."I want to be very intimate and human." The human scale and format of his paintings prevent a total identification with the painting as in Barnett Newman's work. Rothko intended his works to act in a dialectic interrelationship with the environment as a whole and the single painting.

Rothko was always obsessed with "controlling the situation" his paintings were viewed in. In his early work the tension and ambiguity were created within a single self-contained painting. Later it took place in the consciousness of the viewer in a unifying communicative process between the observer, the painting, and the environment. With the emergence of his mature style in the late 1940's Rothko developed a normative system for the presentation of his paintings which was adjusted to each individual situation.

Rothko was always very concerned that a wrong setting or interpretation would distort the meaning of his work. He insisted that his non-mimetic, non-metaphorical, and non-symbolic images could not be interpreted; they had to be experienced: "I believe that a painting can only communicate directly to a rare individual who happens to be in tune with it and the artist."

—Christoph Grunenberg

Morris Louis (1912–62)
Theta 1960, 1960
Acrylic; 8 ft. 6 in. × 14 ft. (259.1 × 426.7 cm.)
Boston, Museum of Fine Arts

Theta is one of a series of paintings which are known as the *Unfurleds,* executed in 1960 and 1961. Louis tended to work in series, and the *Unfurleds* can be seen as a phase in his exploration of the function of color which led to increasingly reductive abstract compositions. A stark and enigmatic piece, it is best considered as a momentary summation of Louis's artistic concerns, rather than in isolation. For it is only in comparison with his earlier works that we can fully understand what Louis was trying to achieve through his continually changing use of color and compositional elements.

Louis's first notable series, the *Veils* of 1954, were also his first innovative exploration of the relationship between color and form in abstract composition. These two elements become one and operate without the use of defining line. Stained into the canvas and pressing out towards its edges, the colors, as in color-field paintings, become one with the picture surface. Louis's following series, the *Veils* of 1958 and 1959, are both a continuation of and an elaboration upon certain characteristics of their predecessors. They still juxtaposed contrasting colors to emphasise their integrity as forms, but the fan-shaped image which the colors create draws away from the edges of the canvas, and this is a new development. The *Veil* has become a composite image of color suspended in the picture space. In this series, then, we see the development of an interest in the relationship between color, its form, and the relationship of these elements to the composition as a whole. Within the two series there is an increasing interest in the identity of distinct colors as entities in their own right, being used to define the structure of the overall image.

A comparison of *Atomic Crest* (1954) with *Golden Age* (1958) illustrates this clearly, although it must be pointed out that these changes were gradual, and even though the second series is distinguished by its stronger composition, Louis's use of color vacillates between the subtle blending of his 1954 work and much starker contrast. The *Where* and *While* pictures of 1959–60 are the stylistic ancestors of *Theta,* in which bands of pure color, although arranged in the fan shape and stained into the canvas, read as distinct formal units, and are sometimes separated by canvas.

This movement towards the simplification of color and form relations within the overall composition of Louis's work in the 1960's is virtually a realization of Greenberg's thoughts on the reductive development of abstract painting. As Greenberg had acted from 1953 until the end of Louis's career as a personal critic and advocate of his work, it is probable that his views influenced the artist. The *Unfurled* paintings build upon this use of color, using it to completely different compositional ends. Abandoning the upward moving fan-shaped composition, Louis uses a void, moving the painted stripes to the lower corners of the canvas, where they appear to run off the bottom of the picture and into real space. In *Theta* the function of color is ambiguous. The hot colors are grouped on the left, the cool on the right, yet the occasional mingling of one with the other repels any optical effect. Compositionally the bands appear to function as a frame for the void. The meaning of this empty space, which dominates *Theta,* all of the *Unfurleds,* and all of his subsequent work, is difficult to identify. Barnett Newman, Louis's contemporary, was also exploring the void in his early 1960's work, and although they were also non-referential, his iconography enables a possible reading. Louis's silence about his paintings disallows a confident explanation of their significance, and it must be through a much-needed contextualization of his work that an interpretation can be hazarded.

—Nancy Jachec

Robert Motherwell (1915—)
Elegy to the Spanish Republic, 1961
5 ft. 9 in. × 9 ft. 6 in. (175.3 × 281 cm.)
New York, Metropolitan

In 1947 Robert Motherwell created a small black and white drawing to accompany the poem "The Bird for Every Bird" by the art critic Harold Rosenberg. The poem and drawing were to be published in the second issue of *Possibilities,* a magazine of contemporary culture which Motherwell and Rosenberg jointly edited. That issue was never realized, and Motherwell put the drawing in a drawer. When he rediscovered it one year later in a studio move, he was so compelled by the image that he made a large version, entitled *At Five in the Afternoon.* These works mark the beginning of Motherwell's *Elegies to the Spanish Republic,* a series of paintings spanning 40 years and numbering over 150 examples. Collectively they form such an important part of the artist's career that they have been called his "signature."

The Elegies are generally large-scale paintings, and they are linked by the common image of black organic ovals squeezed by stiff black vertical bars, on a white ground. (Other colors appear in the Elegies, but they play a secondary role.) The shapes in the Elegies, ovoids and bars, are signs in which the artist recognizes basic aspects of his personality. The pressure of the unyielding bars against the biomorphic ovals abstractly signify such contrasting ideas as forcefulness and vulnerability, power and sensitivity, even the life and death impulses (Eros and Thanatos). Similarly the black and white stand in strong opposition and are among the most symbolically loaded colors in our culture. Motherwell is quick to point out, however, that black and white have varied associations. While we commonly link black to death and white to purity and life, Motherwell has written that his black pigment is made from animal bones, living matter, and being soot is light and fluffy. By contrast his lead white pigment is extremely poisonous. In Melville's *Moby Dick,* one of Motherwell's favorite books, white is the symbol of evil. Even more to the point, white is emptiness and black is the mark of the artist on the canvas. Such creative ambivalence in both the forms and colors is actively sought by Motherwell and contributes to the poetic power of the Elegies.

Within the Elegy format, Motherwell has created an impressive variety of works which embody his thoughts and moods at the time of each painting. At one end of the emotional spectrum might be the austere and architectonic *Granada* (1949), created during an 18-hour painting session at the time that Motherwell's first wife left him and he needed to exercise symbolic control over his emotions. On the other extreme, might be his violently executed *Figure Four on an Elegy* (1960), in which the splashed paint and red accents remind Motherwell of splattered blood. Between these poles are numerous examples, each with its own character. Motherwell has commented. "I learned that I can't say it all in one work," and elaborated, "To me the question is still a mystery of how they

can change—the slightest touch will produce a whole new felt tone—and yet they remain Elegies."

Much critical discussion of the Elegies has centered around how specifically their forms might be interpreted. One group views the oval and bar configuration as representing such specific objects as genitalia, architecture, and an enlargement of the artist's signature. Another views the works as essentially non-representational structures. Motherwell falls between these two poles, and, in fact, considers neither exclusive. He insists that the paintings do not describe any particular objects, and that while creating them he is thinking of only such relationships as rhythms and proportions. Yet Motherwell acknowledges that the paintings do call forth a number of associations like primitive megaliths, figures, or phalluses and wombs, in the manner of a "Jungean archetype," and he encourages the viewer to find any symbols which will help bring out his own feelings. The broad communicative power of the paintings lies in their ability to suggest multiple meanings without limiting the viewer to any single interpretation.

Although the Elegies seem to have come to Motherwell spontaneously from the rediscovery of his little ink drawing, they are in fact connected to many sources both within and outside of the artist's own body of work. As early as 1943, Motherwell had presupposed the Elegy format in a figurative collage *Pancho Villa, Dead and Alive,* which was also a meditation of the life and death impulses. Picasso's great black and white *Guernica* (1937) was also extremely important for the genesis of the Elegies. In that painting Picasso saw the bombing of the Basque town of Guernica as a theme of suffering and humanistic outrage. As a young man Motherwell was also moved by the fall of Republican Spain, thus the title of his Elegy series. But more physically and temporally removed than Picasso, he conceived the theme in even broader terms as a tragic feeling about the future of humanity. The Elegies were also influenced by literature, particularly the poems of Frederick Garciá Lorca, after whose poem one of the first Elegies, *At Five in the Afternoon,* was named. The rolling rhythms and powerful repetitions of Lorca's poem, as well as its theme of death resemble the Elegies. These sources and many, many more were in Motherwell's mind during the creation of the Elegies.

Today Robert Motherwell continues to create *Elegies to the Spanish Republic* as probably the most profound aspect of his varied artistic output. We know that when we encounter moving and tragic experiences we are burdened with how to say precisely what we feel. In this regard the Elegies, with their articulate statements about powerful feelings, stand as remarkable achievements.

—Robert Saltonstall Mattison

Larry Rivers (1923—)
Washington Crossing the Delaware, 1953
6 ft. 11 in. × 9 ft. 3 in. (212.3 × 283.4 cm.)
New York, Moma

In *Washington Crossing the Delaware* Larry Rivers uses the visual rhetoric of the Salon Grand Manner and transforms a patriotic stereotype into a refreshing, expressive experience in paint. Rivers draws from the familiar and the traditional in American folklore and in doing so he challenges the idea of the artwork as a singular and unrepeatable experience. Rivers says he painted "George"—as his painting is affectionately called—when he was feeling "energetic and egomaniacal"; he wanted to do something that others would think of as "disgusting, dead and absurd, so what could be dopier than a painting dedicated to a national cliché—*Washington Crossing the Delaware.*"

"George" is a reworking of Emmanuel Leutze's 19th-century classic which was acquired by the Museum of Modern Art in New York in 1955. Leutze's painting is a heroic celebration of a famous landmark in American History—it represented everything that was scorned by the artists of the 1950's. In painting *Washington Crossing the Delaware* Rivers deliberately disengaged himself from the "avant garde" in the belief that extreme positions in art are bound to be ephemeral or induce boredom. Instead Rivers immersed himself in art-school academicism so that from his vantage point at the centre of artistic debate he would be in an ideal position to re-examine its parameters. A trip to Europe in 1950 introduced Rivers to the works of Bonnard and Soutine. A study of their work convinced him that, despite the supremacy of Abstract Expressionism in the post-war American art world, there was still creative potential for an artist to work in a realistic figurative mode.

In taking a 19th-century subject from the history of art and reconstituting it as a 20th-century work of art, Rivers breathed fresh life into a national cliché. *Washington Crossing the Delaware* takes as its subject a national hero, part of a nation's collective historical identity. That it is painted with the technical sophistication of 19th-century academic art means that the work is as much about art (a subject drawn from the history of art) as it is about life (the national hero it portrays). "George" is painted in thin washes of colour—the figures are sketchy and the execution is painterly. The effect of this was not to emulate Leutze's heightened heroization of the event. Instead, Rivers has given the scene a human touch; "I saw the moment as nerve racking and uncomfortable." Rivers gives the canvas a tense 20th-century anxiety in contrast to his predecessors' theatrical heroism.

Rivers felt that "George" represented the theory of "painting as an idea." It was not anti-art but art which tried to diminish the role of pictorial form to the level of an idea. By using as his subject that which is already known—in this case a 19th-century painting—Rivers was free to investigate the language and content of painting itself. By painting a painting Rivers effectively "gets inside" the history of art and calls to our attention to the whole process of naming objects "art." Whereas Leutze's *Washington* subjugates the method of its production to the historical moment, Rivers's celebrates it, dissolving history into art.

At first the deliberate contrariness of Rivers's art caused a great deal of controversy. When "George" was first exhibited at the Tibor de Nagy Gallery in December 1953 Rivers tells us that it received, "about the same reaction as when the Dadaists introduced a toilet seat as a piece of sculpture in a Dada show in Zurich. . . in the bar where I can usually be found a lot of painters laughed." But their laughter was brief, and soon the kitsch trappings of Americana were to provide the staple diet of the second wave of American artists in Pop Art.

—Lauretta Reynolds

Robert Rauschenberg (1925—)
Bed
Mixed media ("combine"); 75¹/₄ in. (191 cm.) (height)
New York, Moma

Rauschenberg scandalized the art world in the mid–1950's with provocative "combines" such as *Bed*. At a time when high-minded, painterly abstraction dominated the New York art scene, *Bed* appeared outrageous because of its perverse literalism and its ironic references to Abstract Expressionist brushwork. The artist called this and similar works "combines" because they started out as paintings to which he collaged various pieces of fabric and paper as well as three-dimensional "found objects." According to Rauschenberg, *Bed* was not prompted by any preconceived idea, but, instead, resulted from not having "any money to buy canvas." Looking around his studio for something to paint on, he picked up a quilt that he wasn't using, stretched it like a piece of canvas, and then counterbalanced the coverlet's bold geometric pattern by adding his pillow, daubing both items with painterly brush work to unify them.

In another famous "combine," *Monogram* (1955–59), he took a stuffed Angora goat, encircled its torso with an automobile tire, and stood it on a collaged platform. For *Canyon* (1959) he painted and collaged a canvas and then appended a stuffed raptor with outspread wings that perches on a small sill; a pillow dangles by a rope from the lower edge of the work.

Rauschenberg's "combines" greatly amplified the scale and materials of traditional collage. Though he was obviously indebted to past masters in the medium such as Picasso and Schwitters, Rauschenberg often selected "found" images and objects that reflected the fast-paced, consumer culture in which he found himself. He played a major role in the development of a "junk art" aesthetic, inspiring many artists to concoct assemblages and constructions from urban debris, which they were now able to perceive as free art materials. Anything and everything, Rauchenberg implied, could serve as art materials.

At a time when many vanguard artists considered it retrograde to depict commonplace objects in illusionistic, three-dimensional space, *Bed* suggested more literal and inventive ways to reintroduce representational subject matter to painting. *Bed* played an influential role in shaping—and domesticating—the ideas of a succeeding generation of Pop artists. Within a few years, Jim Dine was attaching actual toasters and tools to canvases, Tom Wesselmann was positioning his "Great American Nudes" against painted walls with actual radiators and curtains, and Claes Oldenburg was constructing his roomlike environment of bedroom furniture.

—David Bourdon

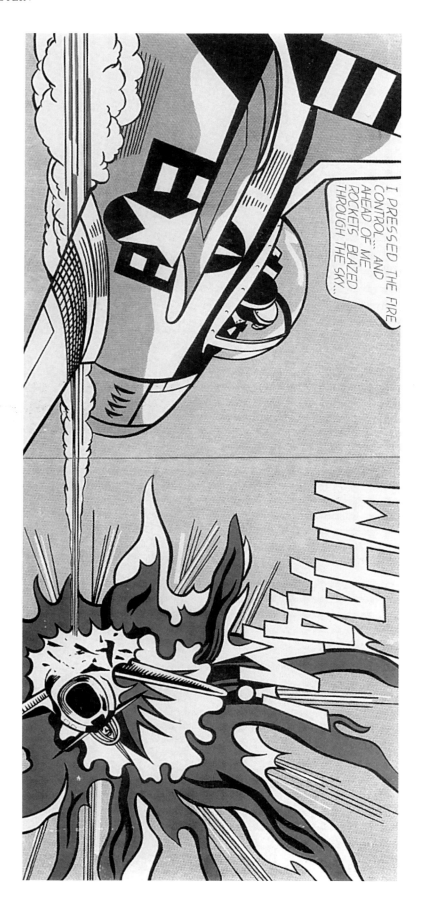

Roy Lichtenstein (1923–)
Whaaam!, 1963
5 ft. 8 in. × 13 ft. 4 in. (172.7 × 406.4 cm.)
London, Tate

Although he had previously made drawings and paintings that included Disney characters in *Look Mickey,* 1961 (collection of the artist), Roy Lichtenstein launched the comic-strip format and ubiquitous benday dots that made his work instantly controversial. Despite the cartoon images heralded by *Look Mickey,* black and white single object paintings retained a prominent place in his work until 1963, however his impending switch to overall design was signaled by the earliest war cartoons.

Between 1961 and 1965 Lichtenstein's cartoon subject matter, as John Coplans observed, fell into three main categories: "(1) war and violence, (2) science fiction, and (3) love and romance." The war and violence images, rendered in Lichtenstein's arbitrarily limited pallette (red, yellow, and blue, plus black and white and, occasionally, green), date from the classic Pop Art period, 1961-64, and remain among the most densely packed pictures of his career: *Takka Takka* (Ludwig Museum, Cologne), *Blam* (Richard Brown Baker Collection, Yale University Art Gallery), and *Brattata* (Teheran Museum of Contemporary Art)—all 1962. In *Live Ammo,* 1962 (a five panel painting now separated), the artist introduced a new kind of tension and balance—three tightly composed canvases paired with two open compositions. In the first two panels (Mr. and Mrs. Morton Neuman, Chicago), cartoon-style lettering and text squeeze the images off the picture plane; in the third (Edwin Janss, Thousand Oaks, California), action predominates; and in the last two (formerly Karl Stroher, Darmstadt, and Chrysler Museum, Norfolk, Virginia), the subjects—a soldier and a plane—though not centered, are handled with the simplicity of the single image paintings. As a result *Live Ammo* is a visual diary of Lichtenstein's emerging style.

Returning to two monumental panels (68 × 160 inches total), in *Whaam!,* 1963 (Tate Gallery, London), Lichtenstein began refining tension and balance between action sequences and passive spaces. The tension he required came not only from the push/pull of the variously weighted elements, but also from the almost bizarre joining of vernacular, non-art images with a mechanical, abstract style. In a continuous kind of black-line drawing, filled in with primary colors—a stylization of the already stylized form he chose to adapt—he created a relatively literal transposition on the left and a highly decorative interpretation of an explosion on the right. The plane recedes and the explosion presses forward. The event is described in one panel and the action takes place in the other. In between, but pushed to the left of center by the force of the explosion, is a vast expanse of blue benday sky. The only bridges between the two separate images are the cartoon narrative and rocket trails, and the contrast between the panels is emphasized by the subdued text balloon floating off above the streaking plane and the violent Whaam! lettering bursting from the explosion. All of the compositional uncertainties of *Live Ammo* are resolved in *Whaam!.*

The study for *Whaam!,* 1963 (Tate Gallery, London), is the only extant drawing for a multi-panel war cartoon, and the opportunity to compare it with the painting offers vivid evidence of the importance of Lichtenstein's subtle modifications. The drawing is at once carefully transposed to the canvas, but significantly changed. Crop marks indicate how the left-hand image has been enlarged to occupy a greater portion of the panel. On the right, the vertical thrust of the wing is aligned with the exclamation point rather than halted under the lettering, as in the drawing, and the entire image is increased in size, brought forward so that it forces the boundaries of the picture plane. The painting, its emotional charge enhanced by scale and color, realizes the potential of the drawing, and the juxtaposition of agitated imagery with dot-filled voids is loaded with drama.

The increasingly sophisticated composition that characterizes *Whaam!* is further evident in *As I Opened Fire,* 1964 (Stedelijk Museum, Amsterdam), one of the final works in this informal series. A three-panel painting united by a single yellow band of text that no longer intrudes in balloon form, *As I Opened Fire* reveals more complicated figure/ground relationships and the largest areas of solid color to date; the cartoon images are further enlarged, drastically cropped, and simplified to the point where they become abstractions of the same elements in earlier, more literally rendered works. While the narrative events depicted in the two panels of *Whaam!* seem oddly disparate, in *As I Opened Fire*—which is, in a sense, the summation of the series—they are clearly sequential, even cinematic. The canvases are interdependent, linked pictorially, verbally, and by the implied passage of time.

At first the formal content of these works lay submerged in the fact that Lichtenstein enraged critics by choosing to deal with themes of war and violence through quoting common, vulgar comic strips in a mechanical style that he initially thought would provide a certain anonymity. Far from anonymous, by 1964 Lichtenstein's inimitable style was firmly established in the all-over patterning of the war pictures plus the arabesques and sinuous Art Nouveau-like lines that dominated his concurrent love and romance of "girl" paintings such as *Drowning Girl,* 1960 (Museum of Modern Art, New York). Reserving the explosion design for later paintings and sculpture, for the time being he abandoned the angularity, diagonal thrusts, and deep spatial illusions that had animated this small but important body of work and the war/violence cartoons gave way to a new series of more serene, invented rather than adapted, landscapes.

—Constance W. Glenn

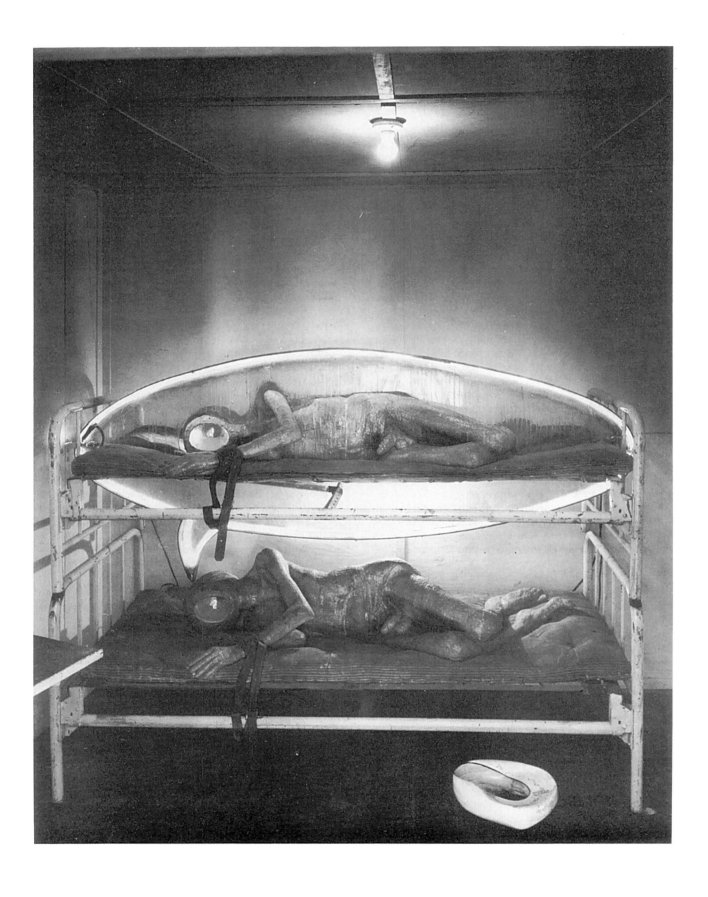

Edward Kienholz (1927–)
The State Hospital, 1966
Mixed media; 8 ft. (244 cm.) (height)
Stockholm, Moderna Museet

Like *The Art Show* (1963–76; collection of the artist) and *The Back Seat Dodge '38* (1966; Washington, Institute of Contemporary Art), *The State Hospital* was one of a powerful series of "Concept Tableaux" which were conceived by Kienholz in the early 1960's. The idea behind these works was that their "concept" could be sold by the artist without them necessarily being created by him in practice. Luckily, in most cases, the works were in fact realized later in that decade though some, such as *The Art Show*, were not completed until well into the 1970's. It was these "tableaux" which established Kienholz's reputation as an artist of international standing. A retrospective exhibition of eleven of them (including *The State Hospital*) toured the capitals of western Europe in 1970–71 and gave Europeans a chance to experience at first hand Kienholz's sensational new artistic formula which combined social realism and surrealist fantasy in life-size three-dimensional form. *The State Hospital* was also like other "Concept Tableaux" of the 1960's in that it was partly inspired by Kienholz's variegated career in the late 1940's and early 1950's when he took jobs as varied as vacuum-cleaner salesman, window-display designer, manager of a dance-band, and orderly in a mental institution. This wide range of experiences seems to have given him important insights into the subjects and materials that he would use in his later works. But a decade of artistic experiment and development (from the early 1950's to the 1960's) was to precede the emergence of his first great series of works, of which *The State Hospital* is one of the most striking.

As with the other "Concept Tableaux," Kienholz had before its realization worked out his conception of *The State Hospital* to the smallest detail, as we can see from the following extract from his blueprint of the work which dates back to 1964:

This is a tableaux about an old man who is a patient in a state mental hospital. He is in an arm restraint on a bed in a bare room. (This piece will have to include an actual room consisting of walls, ceiling, barred door, etc.) There will be only a bedpan and a hospital table (just out of reach). The man is naked. He hurts. He has been beaten on the stomach with a bar of soap wrapped in a towel (to hide tell-tale bruises). His head is a lighted fish bowl with water that contains two live black fish. He lies very still on his side. There is no sound in the room.

Above the old man in the bed is his exact duplicate, including the bed (beds will be stacked like bunks). The upper figure will also have the fish bowl head, two black fish, etc. But, additionally, it will be encased in some kind of lucite or plastic bubble (perhaps similar to a cartoon balloon), representing the man's thoughts.

His mind can't think for him past the present moment. He is committed there for the rest of his life.

But Kienholz's account of this work at "concept" level—though accurate enough—only hints at the impact it exerts when viewed in reality, especially when seen for the first time. For the observer is obliged to peep through the grille in a locked door into the compartment where the patient is kept. This voyeuristic stance is one into which Kienholz is highly adept at manoeuvring the viewers of his work. It is implied in other tableaux from the 1960's—such as *Back Seat Dodge '38* in which we see a man made of chicken-wire raping a female dummy in the back of a car—right up to the 1980's—as in the *Rhinestone Beaver Peep-Show* of 1980 (collection of the artist) which rewards the viewer with a combination of images (fishnet stockings, rats) which contrive both to allure and to repel. The function of Kienholz's technique here is not only to make the viewer/voyeur conscious of his or her own prurient curiosity but also to reward it with unexpected—and usually disconcerting—observations. Thus as well as the leather straps and prominent genitalia, the morbid interest of the viewer of *The State Hospital* is stimulated by those unanticipated, surrealistic details that it is the genius of Kienholz to invent. In *The State Hospital* it is the life-size duplication of the suffering inmate that is the nightmarish and moving feature, even though the "double" is enclosed in a garish comic-strip-like bubble. It is also the fish-bowl heads in which swim two black fish (these are purchased fresh by Kienholz for every installation of the work!). It is details such as these which succeed in transforming this tableaux from a grim but powerful piece of social comment into a surrealist masterpiece. For the fishes' endless circling expresses not only, as Kienholz had intended, the claustrophobia of the patient's mental condition, but also the unfathomable fascination which is the viewer's response.

—David Scott

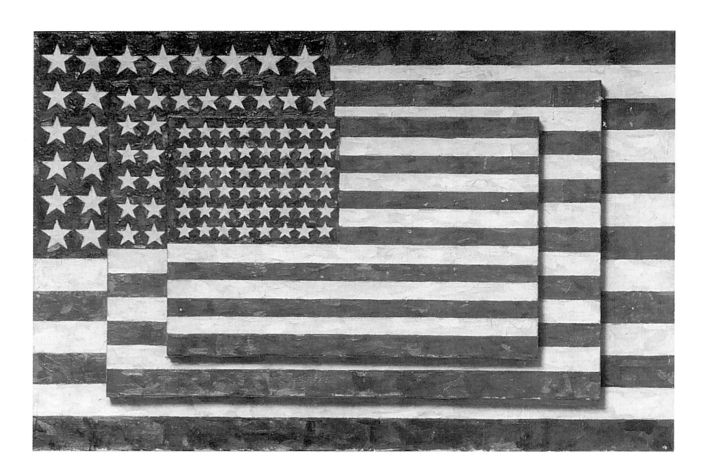

Jasper Johns (1930—)
Three Flags, 1958
Encaustic on raised canvas; $30^7/_8 \times 45^1/_2$ in. (78.4×116 cm.)
Collection of Mr. and Mrs. Burton Tremaine

In 1954, so the story goes, Jasper Johns had a dream in which he saw himself painting a large American flag. Soon after this, Johns painted the first in a series of "flag" paintings in which he explored and re-evaluated many of the contemporary issues of representation. Throughout his career, Johns's subject matter—whether flags, targets, alphabets, or numbers—was drawn from the familiar and the banal. It amounted to a blatant and deliberate attempt to shift the artistic debate away from the subjectivism of Abstract Expressionism towards a more fundamental concern with the materiality of art.

To use the American flag, or any other flag, as a subject for painting allowed Johns to examine the artistic possibilities of representing a pre-given sign. Surprisingly, perhaps, the result of this was not to reinforce or multiply the original symbolism of the object but to question it. In other words, when Johns painted the Stars and Stripes he was not, primarily, glorifying the emblem of a great nation or indicating his personal patriotism—although both of these are possible interpretations. Nor was he holding up an image of the American flag as a great work of art. Instead Johns, in the painted version of the flag, forces the viewer to reconsider the familiar by presenting it in an unfamiliar way. As Johns puts it, the flag is "something the mind already knows" and as such it is "seen and not looked at, not examined."

Three Flags is a shallow relief composed of three paintings of the American flag on canvases of different sizes placed one on top of the other. By using multiple flags within a single field Johns was able to continue and diversity the debates around representation which he had begun in his first flag painting of 1954. Firstly we are made aware that realism is not affected by scale; each of the three flags is perceived as equally correct and true. Because the flag is of fixed proportions, if these are accurately repeated, no matter what the scale, the image will always be true. Further, Johns has used reverse perspective: the largest canvas is placed furthest away from the viewer and the smallest is placed nearest. Although *Three Flags* has its own depth—it is three canvases deep—the viewer experiences a feeling of confusion as to where the actual surface of the painting is. Conventionally, it would be found at the point nearest the viewer—which in the case of

Three Flags would be the smallest of the canvases. Yet it is clear that the surface of the entire work extends beyond the perimeters of the smallest flag as far as the largest of the three. It is not surprising, therefore, that Johns has been described as the leader of the movement of Absolute Uncertainty. He forces us as viewers continually to reassess our preconceptions as to the nature of painting.

Perhaps the most striking feature about the use of a flag as an icon in art is its irresolute flatness. A flag, pictorially, employs no illusionistic devices—no perspective, no modelling, no foreshortening. Because of its flatness, the flag requires no simulation: it is already a man-made object. The flag is also clearly a non-personal object: it belongs to everybody and can not therefore be understood purely in relation to the artist's subjective concerns. To paint the American flag as in *Three Flags* is problematic for the viewer because we are confused: what we see can not be easily and neatly categorized. *Three Flags* neither fits into our predetermined idea of what a flag is, nor into our understanding of what a painting ought to be.

Johns, as it has often been said, is an artist concerned with the surface in art. To this day he uses familiar objects such as flags to investigate the possibilities of the surface of a painting. He brings the debate about illusion and reality to the fore by stressing the independent nature of the painting as object.

By using a ready-made design—as opposed to creating an image afresh—and making it into art Johns forces us to re-examine the signs which make up our lives. In doing so he echoes the words of Marcel Duchamp, "It is the spectators who make the pictures." While this is always the case in art—the artist can never fully determine the work's perception or reception which ultimately constitutes its meaning—Johns forces the viewer to confront this truism head on. We are forced to make a primary decision as to the work's eligibility as art.

That *Three Flags* has subsequently achieved notoriety as the world's first million-dollar painting by a living artist is a measure not only of Johns's standing as an artist but also an indication that we can accept almost anything as the subject of art.

—Lauretta Reynolds

Andy Warhol (1928–87)
Gold Marilyn Monroe, 1962
Synthetic polymer, silkscreen, and oil on canvas; 6 ft. 11$^1/_2$
 in. × 4 ft. 9 in. (212.1 × 114.8 cm.)
New York, Moma

Andy Warhol exhibited his first series of "Marilyns" in 1962 at the Stable Gallery and they caused an uproar in the art world. The Marilyns called into question the abstract subject matter, individual paint handling, and high culture references which were at the core of Abstract Expressionism. They established the ironic attitude of Warhol's early work and his uncanny ability to challenge the presumptions of modern art. Of all the Marilyns shown that year, *Gold Marilyn Monroe* was the largest and most challenging.

Warhol's selection of Monroe as a theme is telling. On the surface his choice seemed only to be an assault upon the high-minded seriousness of the art world. But Marilyn was more that that for Warhol; she was an alter-ego. Monroe was a tragi-comic figure, who both manipulated the media and was used by it. She was regarded as a talented artist by some and a joke by others. Beneath her confident and showy exterior was a character marked by complexity and insecurity. These same words could be used to describe Warhol. It is significant that Warhol chose to depict Marilyn after her death. He did so, I believe, not only due to sensationalism, but because the ironies and contradictions of her life were most apparent then.

Warhol's depiction of Marilyn in *Gold Marilyn Monroe* reinforces his conflicting vision of her and of himself. Her images, taken from a studio publicity photograph, has been garishly colored, yellow hair, hot pink flesh, and blood red lips. The very features that were signs of Monroe's sexual attractiveness through exaggeration became nearly repulsive. In the painting, Warhol's deliberate mis-alignment of color and line makes the image seem to disintigrate before our eyes. In this spirit, the critic Micheal Fried was "moved by Warhol's beautiful, vulgar and heartbreaking icons of Marilyn Monroe."

Setting the image of Marilyn on a gold ground in this particular painting underlines Warhol's emotional ambiguity toward her. On one hand she is enshrined, gold being a traditional color for devotional images since the Byzantine Empire. Yet Marilyn's image is so small that it floats nearly lost amid the expanse of glowing color.

Gold Marilyn Monroe did not assault the modern art world solely because of its image of a low culture movie star. After all, breakthroughs in avant-garde art have been made through the assimilation of low culture sources, as a way of escaping the strictures of a given style, since Gustave Courbet painted peasants and Eduard Manet depicted gypsies in the 19th century. An even more serious attack on modern art was made by Warhol's use of photographic silkscreen, which first occurred in his Marilyns. This technique, which was developed for low-cost commercial printing, involves the chemical transfer of a photographic image onto a screen. Areas of the screen corresponding to the photograph are thus made non-porous. The screen is placed over a canvas and a rubber blade is used to force paint through the uncovered portions of the image.

The silkscreen technique was so "assembly line" that it raised serious questions about Warhol's part in producing the art works he signed. Indeed Warhol frequently used assistants to brush on his background colors and to perform the labor required in the silkscreen process. In addition the silkscreen paintings may be produced in multiples, as Warhol did with the Marilyns and other early works, thus undermining the uniqueness long treasured in painted canvases. Yet those who questioned the originality of the Marilyns were prejudiced by the hand-made quality of Abstract Expressionism, and ignored the assertion made by Marcel Duchamp's "Readymades," five decades earlier, that art was primarily idea not craftmanship. Also, in Warhol's silkscreens many important decisions remained for the artist. These included image selection, the scale of image and ground, colors, and the "accidental" effects achieved through improper register of the colors. Warhol was known to supervise the production of his works carefully and to be imperious in rejecting results that did not completely satisfy him. There is an irony that in subverting the traditional ideals of originality, Warhol produces images that are immediately recognizable as his. A silkscreen Marilyn by Warhol is as personal in its own way as a painting by Willem de Kooning.

Although Andy Warhol's *Gold Marilyn Monroe* was motivated by the low culture experiences which, like it or not, we all share, it does not advocate simple acceptance of those experiences. Like all important art, *Gold Marilyn Monroe* challenges us to see the world around us in new and provocative ways.

—Robert Saltonstall Mattison

INDEX

INDEX OF LOCATIONS

François Clouet: Pierre Quthe
Jean Clouet: Marie d'Assigny, Madame de Canaples
Corot: Chartres Cathedral
Cousin: Eva Prima Pandora
David: Oath of the Horatii
Delacroix: Liberty Guiding the People
Géricault: The Raft of the Medusa
Goujon: Fountain of Innocents
Heda: Still Life: The Dessert
Le Nain: The Forge
Leonardo: Mona Lisa
Leonardo: The Virgin and Child with St. Anne
Massys: The Money Changer and His Wife
Millet: The Gleaners
Pigalle: The Nude Voltaire
Poussin: Et in Arcadia Ego
Poussin: Self-Portrait
Prud'hon: Justice and Vengeance Pursuing Crime
Puget: Milo of Crotone
Rembrandt: Christ at Emmaus
Sassetta: St. Francis Altar
van Eyck: The Madonna with Chancellor Nicolas Rolin
Vouet: The Presentation of Jesus in the Temple
Watteau: Island of Cythera
Whistler: Arrangement in Grey and Black No 1: The Artist's
 Mother
Paris: Moreau Museum
 Moreau: Jupiter and Semele
Paris: d'Orsay
 Boudin: On the Beach of Deauville
 Cézanne: The Card Players
 Courbet: The Burial at Ornans
 Degas: The Absinthe Glass
 Jongkind: River with Mill and Sailing Ships
 Maillol: La Méditerranée
 Manet: Olympia
 Manet: Le Déjeuner sur l'herbe
 Monet: Gare St. Lazare
 Monet: Le Portail et la Tour d'Albane
 Vlaminck: La Restaurant de la Machine à Bougival
Paris: Rodin Museum
 Rodin: Balzac
Paris: Rue de Grenelle
 Bouchardon: Four Seasons Fountain
Paris: S. Catherine du Val-des-Ecoliers
 Pilon: Tomb of Valentine Balbiani
Paris: Unesco Headquarters
 Moore: Reclining Figure (© Henry Moore Foundation)
Parma: Cathedral
 Correggio: Assunta Cupola
Perth: National Gallery of Western Australia
 Pasmore: Abstract in White, Black and Crimson
Philadelphia: Jefferson Medical College
 Eakins: The Gross Clinic
Philadelphia: Museum of Art
 Cezanne: Mont Sainte-Victoire Seen from Les Lauves
 (George W. Elkins Collection)
 Duchamp: The Bride Stripped Bare by Her Bachelors, Even
 (Bequest of Katherine S. Dreier)
 Léger: The City (A. E. Gallatin Collection)
 Renoir: The Bathers (Mr. and Mrs. Carroll S. Tyson Col-
 lection)
Philadelphia: Pennsylvania Academy of Fine Arts
 Peale: The Artist in His Museum
Pisa: Baptistery
 Nicola Pisano: Pulpit
Pisa: Campo Santo

Traini: The Triumph of Death
Pistoia: S. Andrea
 Giovanni Pisano: Pulpit (© Mondadori and Associati Editor
 spa)
Pittsburgh: Carnegie Museum
 Rouault: The Old King
 Sloan: The Coffee Line
Ponce, Puerto Rico: Museo de Arte
 Leighton: Flaming June
Port Sunlight: Lady Lever Art Gallery
 Reynolds: Elizabeth Gunning, Duchess of Hamilton and
 Argyll
Raleigh: North Carolina Museum of Art
 Magnasco: Bay with Shipwreck
Rennes: Musée des Beaux-Art
 La Tour: The Newborn Child
Rome: Borghese
 Bernini: Apollo and Daphne (© Archivi Alinari spa)
 Canova: Pauline Borghese as Venus
 Dossi: Circe (© Archivi Alinari spa)
 Titian: Sacred and Profane Love
Rome: Casino Ludovisi
 Guercino: Aurora
Rome: Casino Rospiglioso
 Reni: Aurora (© Archivi Alinari spa)
Rome: Il Gesù
 Gaulli: Triumph of the Name of Jesus
Rome: Palazzo Barberini
 Pietro da Cortona: Salone
 Sacchi: An Allegory of Divine Wisdom
Rome: Palazzo Doria
 Perino del Vaga: Fall of the Giants
Rome: Palazzo Farnese
 Carracci: The Farnese Gallery
Rome: Piazzo Navona
 Bernini: Fountain of the Four Rivers (© Archivi Alinari spa)
Rome: S. Agostino
 Andrea Sansovino: The Virgin and Child with St. Anne (©
 Archivi Alinari spa)
Rome: S. Cecilia in Trastevere
 Cavallini: The Last Judgment
Rome: S. Ignazio
 Pozzo: Allegory of the Jesuit Missions
Rome: S. Luigi dei Francesci
 Caravaggio: The Calling of St. Matthew
Rome: S. Maria del Popolo
 Caravaggio: The Conversion of St. Paul
Rome: S. Maria della Vittoria
 Bernini: The Ecstasy of St. Teresa (© Archivi Alinari spa)
Rome: S. Pietro in Vincolo
 Michelangelo: Moses
Rome: Villa Albani
 Mengs: Parnassus (© Archivi Alinari spa)
Rome: Villa Farnesina
 Raphael: Triumph of Galatea (© Archivi Alinari spa)
Rothenburg ob der Tauber: Jakobskirche
 Riemanschneider: Altarpiece
Rotterdam: Boymans-van Beuningen Museum
 Aertsen: Christ in the House of Martha and Mary
 Witte: A Protestant Gothic Church
Rotterdam: Plein
 Zadkine: Destroyed City
St. Louis: City Art Museum
 Shahn: The Red Stairway
St. Wolfgang am Abersee: Parish Church
 Pacher: St. Wolfgang Altarpiece
San Diego: Museum of Art

INDEX OF ARTISTS

NOTES ON CONTRIBUTORS

ACKERMAN, Gerald M. Professor of Art, Pomona College, Claremont, California. Author of *The Life and Works of Jean-Léon Gérôme*, 1986. **Essays:** Canova (and *Pauline Borghese as Venus*), Eakins (and *The Gross Clinic*), Gérôme (and *Arabs Crossing the Desert*), and Leighton (and *Flaming June*).

ACRES, Alfred J. Ph.D. candidate, University of Pennsylvania, Philadelphia. **Essays:** Multscher (and *Virgin and Child*).

ADAMS, Henry. Samuel Sosland Curator of American Art, Nelson-Atkins Museum of Art, Kansas City, Missouri. Author of *Thomas Hart Benton: An American Original*, 1989, and articles on Homer, Bingham, and La Farge; co-author of *John La Farge* and of *American Drawings and Watercolors in the Museum of Art, Carnegie Institute*. **Essays:** Benton (and *Persephone*), Bingham (and *Fur Traders Descending the Missouri*), Homer (and *The Gulf Stream*), Prendergast (and *On the Beach No. 3*), Sloan (and *The Coffee Line*), and West.

AHL, Diane Cole. Associate Professor of Art, Lafayette College, Easton, Pennsylvania. Author of the articles on Fra Angelico and Benozzo Gozzoli, and a forthcoming book on Gozzoli. **Essays:** Fra Angelico (and *Annunciation*), and Gozzoli (and *Adoration of the Magi*).

AZUELA, Alicia. Staff member of the Instituto de Investigaciones Estéticas, Mexico City. Author of *Diego Rivera en Detroit*, 1985, and articles on Rivera and Orozco, and on Mexican art. **Essays:** Orozco (and *Hospicio Cabañas Murals*), Siqueiros (and *Portrait of the Bourgeoisie*), and Tamayo (and *The Singer*).

BALAKIER, Ann Stewart. Member of the Department of Art History, University of South Dakota, Vermillion. Author of articles on Thornhill and the poet James Thomson. **Essays:** Amigoni (and *Story of Jupiter and Io*), Kneller (and *William Congreve*), Lely (and *Two Ladies of the Lake Family*), and Thornhill (and *Painted Hall, Greenwich*).

BARRETT, Elizabeth. Free-lance writer. **Essay:** Solimena's *Venus at the Forge of Vulcan*.

BAZAROV, Konstantin. Free-lance writer and researcher. Author of *Landscape Painting*, 1981. **Essay:** Johns.

BENGE, Glenn F. Professor of Art History, Tyler School of Art, Temple University, Philadelphia. **Essays:** Barye (and *Tiger Devouring a Gavial Crocodile*), Giambologna (and *Rape of the Sabine Women*), and Vittoria (and *St. Jerome*).

BERGSTEIN, Mary. Lecturer in Art History, Princeton University, New Jersey. Author of articles on Titian and Nanni di Banco. **Essays:** Nanni di Banco (and *Four Saints*).

BIRD, Alan. Lecturer for the Open University. Author of *Russian Art*, 1987. **Essays:** Doré (and *Newgate–Exercise Yard*), Falconet (and *Peter the Great*), Malevich (and *White Square on White*), Menzel (and *The Iron Rolling Mill*), and Thorvaldsen (and *Cupid and the Graces*).

BISANZ, Rudolf M. Professor of Art History, Northern Illinois University, DeKalb. Author of *The Art Theory of Philipp Otto Runge*, 1968, *German Romanticism and Philipp Otto Runge*, 1970, and *The René von Schleinitz Collection of the Milwaukee Art Center: Major Schools of German Nineteenth Century Popular Art*, 1980, and of articles on Goethe, Oehme, Grützner, and others. **Essays:** Corinth (and *The Three Graces*), Leibl (and *Three Women in Church*), Marées (and *The Hesperides*), Overbeck (and *Italia and Germania*), Runge (and *Rest on the Flight*), and Waldmuller (and *Christmas Morning*).

BOCK, Catherine C. Member of the Department of Art History, School of the Art Institute of Chicago. **Essays:** Matisse (and *Harmony in Red, The Green Stripe*, and *Backs*).

BOSTRÖM, Antonia. Free-lance art historian and writer, London. Contributor of the *Macmillan Dictionary of Art* and the *Guinness Encyclopedia*. **Essays:** Francesco di Giorgio (and *The Deposition*), Gentile da Fabriano (and *Adoration of the Magi*), and Moore (and *Madonna and Child* and *Reclining Figure*).

BOURDON, David. Free-lance writer and art critic. Author of *Christo*, 1972, *Calder: Mobilist, Ringmaster, Innovator*, 1980, and *Warhol*, 1989. **Essays:** Calder (and *Lobster Trap and Fish Tail*), and Rauschenberg (and *Bed*).

BRADLEY, Simon. Student at the Courtauld Institute of Art, London. **Essays:** Corot (and *Chartres Cathedral*).

BREMSER, Sarah H. Assistant Curator, La Jolla Museum of Contemporary Art, California. **Essays:** Whistler (and *Arrangement in Grey and Black No. 1: The Artist's Mother*).

BROWN, M.R. Associate Professor of Art History, Newcomb, Tulane University, New Orleans. Author of *Gypsies and Other Bohemians: The Myth of the Artist in Nineteeth-Century France*, 1985, and of articles on Manet, Ingres, and Degas. **Essays:** Cézanne, Degas, Manet, and Monet.

BURNHAM, Patricia M. Lecturer at the University of Texas, Austin. Author of articles on Trumbull and Theresa Bernstein. **Essays:** Trumbull (and *The Death of General Warren at the Battle of Bunker's Hill*).

CAMPBELL, Malcolm. Professor of Art History, University of Pennsylvania. Author of *Mostra di disegni di Pietro Berrettini da Cortona per gli affreschi di Palazzo Pitti*, 1965, *Pietro da Cortona at the Pitti Palace*, 1977, *Piranesi: The Dark Prisons* (cat), 1988, and *Piranesi: Rome Recorded* (cat), 1989. **Essays:** Pietro da Cortona (and *Salone of the Barberini Palace*).

CAPLOW, Harriet McNeal. Professor of Art History, Indiana State University, Terre Haute. Author of *Michelozzo*, 2 vols., 1977, and the articles "Michelozzo at Ragusa" and "Sculptors' Partnerships in Michelozzi's Florence." **Essays:** Donatello (and *David* and *St. George*), Luca della Robbia (and *Madonna and Child*), Michelozzo (and *Aragazzi Monument*), and Antonio Rossellino (and *Cardinal of Portugal Tomb*).

CAVALIERE, Barbara. Contributing Editor, *Arts Magazine*, New York. Author of *William Baziotes*, 1978. **Essay:** Gorky.

CAYGILL, Caroline. Free-lance writer and research assistant. **Essays:** Boudin (and *On the Beach at Deauville*), Brancusi (and *Bird in Space*), Cassatt (and *The Bath*), de Chirico (and *Mystery and Melancholy of a Street*), Giacometti (and *Man Pointing*), Gonzalez (and *Women Combing Her Hair*), Jongking (and *River with Mill and Sailing Ships*), Modigliani (and *Italian Women*), Ray (and *The Gift*), Rodin's *Balzac*, Henri Rousseau (and *Sleeping Gypsy*), Schwitters (and *Merz 19*), Steer (and *Girls Running, Walberswick Pier*), and Vuillard (and *Woman Sweeping*).

CHAPPELL, Miles L. Chancellor Professor of Art History, College of William and Mary, Williamsburg, Virginia. Author of *Cristofano Allori (1577–1621)*, 1984, and of articles of Allori, Smibert, and Fuseli. **Essays:** Smibert (and *The Bermuda Group*).

CHENEY, Liana. Member of the Art Department, University of Lowell, Massachusetts. **Essays:** Bronzino (and *Venus, Cupid, Folly and Time*), Cellini (and *Perseus with the Head of Medusa*), and Dossi (and *Circe*).

CHEVALIER, Tracy. Publisher's Editor and free-lance writer. **Essays:** Sargent (and *The Daughters of Edward D. Boit*).

CLEGG, Elizabeth. Free-lance writer. Author of articles on Menzel and Malczewski. **Essays:** Klinger (and *Attunement*).

COHEN, David. Free-lance art critic. Author of articles on S.W. Hayter, Thérèse Oulton, R.B. Kitaj, and others. **Essays:** Bacon (and *Three Studies for a Crucifixion*), Epstein (and *Rock Drill*), Hepworth (and *Forms in Echelon*), Maillol (and *La Méditerranée*), Nicholson (and *White Relief*), and Sutherland (and *Crucifixion*).

COLLINS, Howard. Professor of Art History, University of Nebraska, Lincoln. Author of articles on Gentile and Jacopo Bellini, Donatello, and on Chinese bronzes. **Essays:** Jacopo Bellini (and *The Procession to Calvary*).

COSSA, Frank. Assistant Professor of Fine Arts, College of Charleston, South Carolina. Author or co-author of articles on Masaccio, Josiah Wedgwood, and the "Flower Portrait" of Shakespeare. **Essays:** Chardin (and *Grace* and *The Attributes of the Arts*), Flaxman (and the *Agnes Cromwell Monument*), Longhi (and *The Geography Lesson*), Tiepolo (and *Banquet of Cleopatra* and the *Wurzburg Residenz Ceiling*), and Watteau (and *Island of Cytherea*).

CRELLIN, David. Free-lance writer, London. **Essays:** Claude Lorrain (and *Marriage of Isaac and Rebekah*).

CRELLY, William R. Professor of Art History, Emory University, Atlanta. **Essays:** Cousin (and *Eva Prima Pandora*), Le Nain (and *The Forge*), and Vouet (and *The Presentation of Jesus in the Temple*).

CROYDON, Abigail. Free-lance writer, London. **Essays:** Sickert (and *The Gallery of the Old Bedford*), Vasarely (and *Orion MC*), and Zadkine (and *Destroyed City*).

DAVIDSON, Abraham A. Member of the Art History depart-ment, Tyler School of Art, Temple University, Philadelphia. **Essays:** Ryder (and *The Dead Bird*).

DAVIDSON, Jane P. Professor of Art History, University of Nevada, Reno. Author of *David Teniers the Younger*, 1979, and *The Witch in Northern European Art 1470–1750*, 1987, and an article on the alchemical paintings of Teniers. **Essays:** Brouwer (and *Peasants Quarreling over Cards*), and Teniers (and *Picture Gallery of the Archduke Leopold Wilhelm in Brussels*).

DITTMANN, Reidar. Professor of Art History, St. Olaf College, Northfield, Minnesota. Author of *Henrik Ibsen and Edvard Munch*, 1978, and *Eros and Psyche: Strindberg and Munch in the 1890s*, 1982; editor and translator of *Edvard Munch: Close-Up of a Genius* by Rolf Stenersen, 1969. **Essays:** Dahl (and *Hjelle in Valdres*), Heemskerck (and *Family Portrait*), Joos van Ghent (and *Institution of the Eucharist*), Jorn (and *In the Beginning Was the Image*), Lochner (and *Madonna in the Rose Bower*), Maitani (and *Creation of Adam and Eve*), Munch (and *The Scream*), Patinir (and *Charon Crossing the Styx*), Pintoricchio (and *Enea Silvio's Mission to King James of Scotland*), Pordenone (and *Treviso Dome Frescoes*), Riemanschneider (and *Jakobskirche Altarpiece*), and Schongauer (and *Madonna of the Rosehedge*).

DIXON, Annette. Visiting Professor, Union College, Schenectady, New York. Author of catalogue entries in *Medieval and Renaissance Stained Glass from New England Collections*, 1978. **Essays:** Giovanni da Milano (and *Pietà*).

DIXON, Laurinda S. Associate Professor of Fine Arts, Syracuse University, New York. Author of *Alchemical Imagery in Bosch's "Garden of Delights,"* 1981, and *Skating in the Arts of 17th-Century Holland*, 1987, and of articles on Bosch, Cranach, Giovanni di Paolo, and Rogier van der Weyden. Co-Editor of *The Documented Image: Vision in Art History*, 1985. **Essays:** Bosch (and *Garden of Earthly Delights* and *Ship of Fools*), Petrus Christus (and *Portrait of a Carthusian*), Cranach (and *Crucifixion*), Giovanni di Paolo (and *Expulsion from Paradise*), Memling (and *Altarpiece of the Two St. Johns*), van der Goes (and *Portinari Alterpiece*), van der Weyden (and *Descent from the Cross*), and van Eyck (and *Ghent Altarpiece* and *Madonna with Chancellor Nicolas Rolin*).

DODGE, Barbara. Associate Professor of Fine Arts, York University, Toronto. Author of an article on the sinopie in the Traini cycle in the Camposanto, 1983, and other reviews and lectures. **Essays:** Martini (and *Annunciation*), Masolino (and *S. Maria Maggiore Altarpiece*), and Sassetta (and *St. Francis Altarpiece*).

DOWNS, Linda. Curator of Education, Detroit Institute of Arts. Author (with Mary Jane Jacob) of *The Image of Industry in the Art of Charles Sheeler and Diego Rivera*, 1978. Co-Editor of *Diego Rivera: A Retrospective*, 1986. **Essays:** Rivera (and *Detroit Industry*).

EDMOND, Mary. Free-lance writer and researcher. Author of *Hilliard and Oliver*, 1983, and *Rare Sir William Davenant*, 1987, and of articles on Pembroke's Men, John Webster, and Jacobean painters. **Essays:** Dobson (and *Endymion Porter*),

Hilliard (and *Young Man among Roses*), and Oliver (and *Unknown Melancholy Man*).

EUSTACE, Katharine. Curator, Mead Gallery, University of Warwick. Author of exhibition catalogues *Michael Rysbrack, Sculptor*, 1982, *Thomas Howard, Earl of Arundel*, 1985, *Artists of Promise and Renown: The Rugby Collection*, 1986, and *To Build a Cathedral: Coventry Cathedral*, 1987. **Essays:** Rysbrack (and *Isaac Newton*).

EVANS, Magdalen. Researcher at Thomas Agnew & Sons, London. Author of catalogues for Agnew & Sons, and an article on Marianne Stokes. **Essays:** Appel (and *Questioning Children*), Dufy (and *The Paddock at Deauville*), John (and *Madame Suggia*), and Vlaminck (and *Le Restaurant de la Machine à Bougival*).

EVELYN, Peta. Curator in the Sculpture Department, Victoria and Albert Museum, London. Assistant author of *Northern Gothic Sculpture 1200–1450*, 1988. **Essays:** Giovanni Pisano (and *S. Andrea Pistoia Pulpit*).

FAXON, Alicia. Associate Professor of Art, Simmons College, Boston. Author of *A Catalogue Raisonné of the Prints of Jean-Louis Forain*, 1982, and *Jean-Louis Forain: Artist, Humanist, Realist*, 1982. Editor of *Pilgrims and Pioneers: New England Women in the Arts*, 1987. Author of articles on Degas, Rodin, and Cézanne. **Essays:** Cézanne's *The Card Players* and *Mont Sainte-Victoire Seen from Les Lauves*, Degas's *The Absinthe Glass* and *The Rehearsal*, and Morisot (and *In the Dining Room*).

FLORENCE, Penny. Writer and filmmaker. Author of *Mallarmé, Manet, and Redon: Visual and Aural Signs and the Generation of Meaning*, 1986. **Essays:** Manet's *A Bar at the Folies-Bergère*, and Redon (and *Il y eût peut-être une vision première essayée dans la fleur*).

FOSKETT, Daphne. Free-lance writer. Author of several books, including *British Portrait Miniatures*, 1963, 1968, *Dictionary of British Miniature Painters*, 2 vols., 1972, *Samuel Cooper*, 1974, *Samuel Cooper and His Contemporaries*, 1974, and *Collecting Miniatures*, 1979. **Essays:** Cooper (and *Elizabeth Cecil, Countess of Devonshire*), and Hoskins (and *Charles I*).

GALE, Matthew. Free-lance art historian. Author of "The Uncertainty of the Painter" in *Burlington Magazine*, 1988. **Essays:** Carrà, Picabia (and *I See Again in Memory My Dear Udnie*), and Picasso.

GALIS, Diana. Trust Officer, Provident National Bank, Philadelphia Author of "Concealed Wisdom: Renaissance Hieroglyphic and Lorenzo Lotto's Bergamo *Intarsie*," in *Art Bulletin*, 1980. **Essays:** Lotto (and *Sacra Conversazione*).

GARLICK, Kenneth. Free-lance writer. Author of several books, including *A Catalogue of the Paintings, Drawings, and Pastels of Sir Thomas Lawrence*, 1964. **Essays:** Hoppner (and *The Sackville Children*), and Lawrence (and *Pope Pius VII*).

GASH, John. Lecturer in the History of Art, University of Aberdeen. Author of *Caravaggio*, 1980, and articles on Algardi, American baroque, and classicism. **Essays:** Algardi (and *Bust of Cardinal Laudivio Zacchia*), Caravaggio (and *Bacchus* and *Calling of St. Matthew*), Elsheimer (and *Flight into Egypt*), Fetti (and *Parable of the Wheat and the Tares*), Artemisia Gentileschi (and *Judith Slaying Holofernes*), Orazio Gentileschi (and *Allegory of Peace and the Arts*), Guercino (and *Aurora*), Honthorst (and *The Supper Party*), Lanfranco (and *Ecstasy of St. Margaret of Cortona*), Sacchi (and *Allegory of Divine Wisdom*), and Terbrugghen (and *St. Sebastian Tended by St. Irene*).

GAUK-ROGER, Nigel. Free-lance writer. Author of articles on Chinoiserie, Georgian portrait sculpture, and Victorian painted furniture, and on other subjects. **Essays:** Abbate (and *Landscape with the Death of Eurydice*), Ammanati (and *Fountain of Neptune*), Carracci (and *Farnese Gallery*), Domenichino (and *Last Communion of St. Jerome*), Palma Vecchio (and *St. Barbara Altarpiece*), Salviati (and *The Deposition*), and Sebastiano del Piombo (and *The Raising of Lazarus*).

GIBSON, Jennifer. Member of the Arts Division, Maryland-National Capital Park and Planning Commission. Author of *Alice Lees* (cat), 1988, and an article on Surrealism. **Essays:** Derain (and *The Pool of London*), and Léger (and *The City*).

GLENN, Constance W. Member of the Staff, University Art Museum, California State University, Long Beach. **Essays:** Lichtenstein (and *Whaaam!*).

GLOWEN, Ron. Contributing Editor, *Artweek*, Oakland. **Essay:** Tobey.

GOLDFARB, Hilliard T. Curator for European Art, Hood Museum of Art, Dartmouth College, Hanover, New Hampshire. Author of *A Humanist Vision: The Adolph Weil Collection of Rembrandt Prints* (cat), 1988, and *From Fontainebleau to the Louvre: French Drawings from the Seventeenth Century*, 1989, and of articles on Poussin, Titian, Boucher, and Andreani. **Essays:** Poussin (and *Et in Arcadia Ego* and *Self-Portrait*).

GOULD, Cecil. Keeper and Deputy Director of the National Gallery, London, 1973–78. Author of books and catalogues on such artists as Leonardo, Michelangelo, Raphael, and Bernini. **Essays:** Correggio (and the *Assunta Cupola*), Leonardo's *Virgin of the Rocks, Last Supper*, and *Virgin and Child with St. Anne*), Michelangelo (and *Pietà, David, Sistine Chapel Ceiling, Moses,* and *Medici Chapel*), Raphael (and *School of Athens*), Tintoretto (and *St. Mark Freeing a Slave, Crucifixion*, and *Susanna*), and Veronese (and *Mars and Venus* and *Feast in the House of Levi*).

GREEN, Caroline V. Member of the Art Department, Boston University. **Essays:** Rodin (and *The Burghers of Calais*).

GREENE, David B. Director of Arts Studies, North Carolina State University, Raleigh. Author of *Temporal Processes in Beethoven's Music*, 1982, *Mahler, Consciousness, and Temporality*, 1984, and *Nativity Art and the Incarnation*, 1986, and articles on "The Artist as Philosopher" and pictorial space. **Essays:** Caravaggio's *Conversion of St. Paul*, and Giorgione (and *Tempestà*).

GRIFFIN, Randall C. Luce Fellow, University of Delaware Art History Department. **Essays:** Copley (and *Watson and the Shark*).

GRUNENBERG, Christoph. Free-lance writer. **Essays:** Newman (and *Vir Heroicus Sublimis*) and Rothko (and *Green and Maroon*).

GULLY, Anthony Lacy. Associate Professor of Art History, Arizona State University, Tempe. Author of an article on Blake. **Essays:** Bonington (and *La Siesta*), Constable (and *The Haywain* and *The Leaping Horse*), and Rowlandson (and *A Statuary Yard*).

HABEL, Dorothy Metzner. Associate Professor of Art, University of Tennessee, Knoxville. Author of *European and American Drawings: Selections from the Collection of the Joslyn Art Museum* (cat), Omaha, 1978, and of articles on Raguzzini and Rainaldi, and on architecture generally. **Essays:** Gaulli (and the Gesù vault frescoes) and Pozzo (and the St. Ignazio vault decoration).

HANCOCK, Simon. Free-lance writer, London. **Essays:** Hockney's *A Bigger Splash*, Seurat's *Sunday Afternoon on the Island of La Grande Jatte*, and West's *The Death of General Wolfe*.

HARPER, Paula. Associate Professor of Art History, University of Miami. Author of *Pissarro: His Life and Work* (with Ralph E. Shikes), 1980, and *Daumier's Clowns*, 1981. **Essays:** Essays: Daumier and Pissarro.

HEATH, Samuel K. Staff Member, World Monuments Fund, New York. **Essays:** Alonso Berruguete (and the *Transfiguration*).

HEFFNER, David. Ph.D. Candidate, University of Pennsylvania, Philadelphia. Author of an article on Dürer's *The Virgin and the Dragonfly*. **Essays:** Burgkmair (and *St. John Altar*) and Huber (and *Lamentation*).

HIRSH, Sharon. Professor of Art History, Dickinson College, Carlisle, Pennsylvania. Author of *Ferdinand Hodler*, 1982, *Hodler's Symbolist Themes*, 1983, and *The Fine Art of the Gesture: Drawings by Ferdinand Hodler* (cat), 1987, and articles on Hodler, Böcklin, and Carrà. **Essays:** Böcklin (and *Island of the Dead*) and Hodler (and *Night*).

HOLLOWAY, John H. Senior Lecturer in Chemistry, University of Leicester. **Essay:** Albers (with John A. Weil).

HOWARD, Seymour. Professor of Art History, University of California, Davis. Author of several books, including *Classical Narratives in Master Drawings*, 1972, *A Classical Frieze by Jacques Louis David*, 1975, *New Testament Narratives in Master Drawings*, 1976, and *Saints and Sinners in Master Drawings*, 1983. **Essays:** Jacques-Louis David (and *Oath of the Horatii*).

HULSKER, Jan. Director-General of Cultural Affairs, Ministry of Culture, The Netherlands (now retired). Author of several books on Van Gogh, including (in English) *Van Gogh's*

Diary, 1971, and *The Complete Van Gogh: Paintings, Drawings, Sketches*, 1980. **Essays:** Van Gogh (and *The Potato-Eaters, The Night Cafe*, and *The Starry Night*).

HULTS, Linda C. Assistant Professor of Art History, College of Wooster, Ohio. Editor of *The Prints of Thomas Moran in the Thomas Gilcrease Institute of American History and Art*, 1987, and author of articles on Dürer, Moran, and Baldung. **Essays:** Balding (and *Eve, The Serpent, and Death*), Callot (and *Miseries and Misfortunes of War*), Dürer's *Knight, Death, and the Devil*, Goya's *Disasters of War*, Grünewald (and *Isenheim Altarpiece*), and Seghers (and *Mountain Landscape*).

HUTCHISON, Jane Campbell. Professor of Art History, University of Wisconsin, Madison. Author of *The Master of the Housebook*, 1972, *Graphic Art in the Age of Martin Luther* (cat), 1983, and forthcoming biography of Albrecht Dürer, and of articles on the Housebook Master and Dürer. Editor (or co-editor) of *Early German Artists* (the Illustrated Bartsch, vols. 8 and 9), 1980–81. **Essays:** Bertram of Minden's *Grabow Altar*, Dürer (and *Self-Portrait*), Master Francke's *St. Thomas à Becket Altar*, Holbein (and *George Gisze* and *The Ambassadors*), Master of the Housebook (and *Aristotle and Phyllis*), Moser (and *Tiefenbronner Altar*), Witz's *The Miraculous Draft of Fishes*, and Wolgemut (and *God in Majesty*).

JACHEC, Nancy. Ph.D. Student, University College, London. **Essays:** Archipenko (and *Walking Woman*), Barlach (and *The Ascetic*), Louis (and *Theta 1960*), and Pasmore (and *Abstract in White, Black and Crimson*).

JACOBS, Fredrika H. Assistant Professor of Art History, Virginia Commonwealth University, Richmond. Author of articles on Carpaccio, Vasari, and Cellini. **Essays:** Carpaccio (and *St. Ursula Cycle*) and Vasari (and *Allegory of the Immaculate Conception*).

JEFFETT, William. Free-lance writer, London. **Essays:** Dalí (and *The Persistence of Memory*), Dubuffet (and *Archetypes*), Ernst (and *The Elephant Celebes*), Masson (and *Niobé*), and Tanguy (and *Indefinite Divisibility*).

JENKINS, Susan. Staff member, Witt Library, Courtauld Institute, London. **Essays:** Coello (and *Charles II Adoring the Blessed Sacrament*) and Valdés Leal (and *Immaculate Conception*).

KAHR, Madlyn Millner. Professor Emeritus of Art History and Criticism, University of California, San Diego. Author of *Velázquez: The Art of Painting*, 1976, and *Dutch Painting in the Seventeenth Century*, 1978, and of articles on Velázquez, Veronese, Titian, and Rembrandt. Co-translator of *Principles of Psychoanalysis*, by Herman Neuberg; 1955. **Essays:** Goltzius (and *Portrait of a Young Man*), Rembrandt (and *Danaë, Night Watch, Christ at Emmaus,* and *Self-Portrait at 52*), Velázquez (and *Waterseller of Seville, Las Meninas,* and *Juan de Pareja*), and Vermeer (and *View of Delft* and *The Art of Painting*).

KAPLAN, Julius D. Professor of Art, California State University, San Bernardino. Author of *Gustave Moreau* (cat), 1974, and

Gustave Moreau, 1982, and of an article on Moreau's *Jupiter and Semele*, 1970. **Essays:** Moreau (and *Jupiter and Semele*).

KAPOS, Martha. Free-lance writer and lecturer. Author of articles on Ken Kiff, Chagall, and other art subjects. **Essays:** Changall, Delacroix (and *Liberty Guiding the People*), and Picasso's *Demoiselles d'Avignon*.

KAUFMAN, Susan Harrison. Assistant Professor of Art, Fordham University, New York. Author of an article on Crosato, 1983. **Essays:** Piazetta (and *The Parasol*).

KENWORTHY-BROWNE, John. Free-lance writer and art historian. Author of an article on Matthew Brettingham, 1983. **Essays:** Nollekens (and *Sir George Savile, Bart.*).

KIDSON, Alex. Assistant Keeper of British Art, Walker Art Gallery, Liverpool. **Essays:** Reynolds (and *Elizabeth Gunning, Duchess of Hamilton and Argyll*) and Romney (and *Lady Hamilton*).

KIND, Joshua. Faculty Member of the School of Art, Northern Illinois University, DeKalb. **Essays:** Aertsen (and *Christ in the House of Martha and Mary*), Andrea del Castagno (and *Last Supper*), Antonella da Messina (and *St. Jerome in His Study*), Bonnard's *Dining Room in the Country*, Boucher (and *The Rising of the Sun*), Clodion (and *Nymph and Satyr*), Crivelli (and *Annunciation*), Miro (and *Head of a Woman*), Monet's *Gare St. Lazare*, Reni (and *Aurora*), Rosso Fiorentino (and *Deposition of Christ*), Rouault (and *The Old King*), Ruisdael (and *Jewish Cemetery*), Sánchez Cotán (and *Quince, Cabbage, Melon, and Cucumber*), Soutine (and *Carcass of Beef*), Spencer (and *The Resurrection: Cookham*), and Toulouse-Lautrec (and *At the Moulin Rouge*).

KOWAL, David Martin. Associate Professor of Fine Arts, College of Charleston, South Carolina. Author of *Ribalta y los ribaltescos*, 1985, and *Francesco Ribalta and His Followers: A Catalogue Raisonné*, 1985, and of articles on Ribera and Ribalta. **Essays:** Cano (and *S. Diego de Alcalá*), Maino (and *Adoration of the Magi*), Ribalta (and *St. Francis Embracing the Crucified Christ*), and Ribera (and *Martyrdom of St. Philip*).

LAGO, Mary. Professor of English, University of Missouri, Columbia. Editor of several books, including *Imperfect Encounter: Letters of William Rothenstein and Rabindranath Tagore*, 1972, *Max and Will: Max Beerbohm and William Rothenstein*, 1975, *Men and Memories: Recollections of William Rothenstein*, 1978, and *Burne-Jones Talking: His Conversations Recorded by His Assistant Thomas Rooke*, 1982. **Essays:** Burne-Jones (and *King Cophetua and the Beggar Maid*).

LANDERS, L.A. Free-lance writer. **Essays:** Klimt (and *The Kiss*) and Schiele (and *The Family*).

LARSSON, Lars Olof. Author of *Adriaen de Vries*, 1967. **Essays:** Vries (and *Hercules Fountain*).

LAWRENCE, Cynthia. Associate Professor of Art History, Tyler School of Art, Temple University, Philadelphia. Author

of *Flemish Baroque Commemorative Monuments 1566–1725*, 1981, and *Gerrit Adriaensz. Berckheyde: Haarlem Cityscape Painter*, 1988, and of articles on Berckheyde, Rembrandt, Rubens, and others. **Essays:** Berckheyde (and *View of the Grote Markt, Haarlem*).

LESKO, Diane. Curator of Collections, Museum of Fine Art, St. Petersburg, Florida. **Essays:** Ensor (and *Entry of Christ into Brussels*).

LEVIN, Gail. Associate Professor, Baruch College, City University of New York. Author of several books on Edward Hopper, and *Synchromism and American Color Abstraction 1918–1925*, and *Twentieth Century American Painting: The Thyssen-Bornemisza Collection*, 1987. **Essays:** Hopper (and *Nighthawks*).

LEVY, Mark. Member of the Art Department, California State University, Hayward. **Essay:** Arp.

LIEDTKE, Walter A. Curator of European Paintings, Metropolitan Museum of Art, New York. Author of several books on Dutch painters and painting. **Essays:** Saenredam (and *Interior of the Grote Kerk at Haarlem*) and Witte (and *A Protestant Gothic Church*).

LISTER, Raymond. Emeritus Fellow of Wolfson College, Cambridge. Author of several books, including *Edward Calvert*, 1962, *British Romantic Art*, 1973, *George Richmond*, 1981; *Samuel Palmer: His Life and Art*, 1987, and *Catalogue Raisonné of the Works of Samuel Palmer*, 1988. **Essays:** Blake (and *Satan Arousing the Rebel Angels*) and Palmer (and *A Hilly Scene*).

LOTHROP, Patricia Dooley. Extension Lecturer, University of Washington, Seattle. **Essays:** Hunt (and *The Light of the World*) and Millais (and *Christ in the House of His Parents*).

MACK, Charles R. Professor of Art History, University of South Carolina, Columbia. Author of *Classical Art from Carolina Collections*, 1974, and *Pienza: The Creation of a Renaissance City*, 1987, and of articles on art and architecture. **Essays:** Desiderio da Settignano (and the *Tabernacle of the Sacrament*), Floris (and *Fall of the Rebel Angels*), and Bernardo Rossellino (and the *Bruni Monument*).

MACKIE, David. Mellon Fellow, Yale University, New Haven, Connecticut. **Essays:** Bassano (and *Rest on the Flight into Egypt*), Raeburn (and *Rev. Robert Walker Skating*), and Ramsay (and *Margaret Lindsay*).

MAINZER, Claudette R. Member of the Department of Fine Art, University of Toronto. Author of several articles on Courbet. **Essays:** Courbet (and *The Burial at Ornans*).

MALLER, Jane Nash. Associate Professor of Art, San Francisco State University. Author of *Veiled Images*, 1985, and an article on Titian. **Essays:** Pieter Bruegel (and *Hunters in the Snow* and *Peasant Wedding*), Gossaert (and *Danaë*), Massys (and *The Money Changer and His Wife*), and Titian (and *Sacred and Profane Love*, *Pesaro Madonna*, and *Venus of Urbino*).

MANCA, Joseph. Member of the Art and Art History Department, Rice University, Houston. Author of articles on Masolino and Roberti. **Essays:** Cossa (and *Hall of the Months*), Roberti (and *Pala Portuense*), and Tura (and *Roverella Altarpiece*).

MASSI, Norberto. Free-lance writer. **Essays:** Gentile Bellini (and *Procession of the Cross in St. Mark's Square*), Giovanni Bellini (and *S. Giobbe Altarpiece* and *Doge Leonardo Loredan*), Cavallini (and *Last Judgment*), and Ghirlandaio (and *Birth of the Virgin*).

MATTESON, Lynn R. Dean of the School of Fine Arts, University of Southern California, Los Angeles. **Essays:** Cozens (and *Valley with Winding Stream*), Géricault (and *The Raft of the Medusa*), Girtin, Wilkie (and *The Blind Fiddler*), and Wright (and *An Experiment with an Air Pump*).

MATTISON, Robert Saltonstall. Member of the Department of Art, Lafayette College, Easton, Pennsylvania. **Essays:** Hofmann (and *Effervescence*), Kline (and *Chief*), Motherwell (and *Elegy to the Spanish Republic*), and Warhol (and *Gold Marilyn Monroe*).

McCULLAGH, Janice. Free-lance writer. **Essays:** Feininger (and *Bird Cloud*), Kandinsky (and *Improvisation 30*), Kirchner (and *The Street*), Klee (and *Death and Fire*), and Macke (and *Zoological Garden I*).

McGREEVY, Linda F. Associate Professor of Art History and Criticism, Old Dominion University, Norfolk, Virginia. Author of *The Life and Works of Otto Dix: German Critical Realist*, 1981, and of articles on Sue Coe and Newton and Helen Mayer Harrison. **Essays:** Beckmann (and *The Night*), Dix (and *Sylvia von Harden*), Grosz (and *The End*), Kollwitz (and *Outbreak*), and O'Keeffe (and *Music: Pink and Blue II*).

McKENZIE, A. Dean. Professor of Medieval Art History, University of Oregon, Eugene. Author of several books and catalogues, including *Greek and Russian Icons*, 1965, *Russian Art, Old and New*, 1968, *Windows to Heaven: The Icons of Russia*, 1982, and *Sacred Images and the Millennium: Christianity and Russia*, 1988, and of articles on Moldavian fresco painting, Byzantine painting in Attica, and French castles in Gothic manuscript painting. **Essays:** Broederlam (and *Champmol Altarpiece*), Fouquet (and *St. Stephen and Etienne Chevalier*), Limbourg Brothers (and *October*), and Rublev (and *Old Testament Trinity*).

MILKOVICH, Michael. Director, Museum of Fine Arts, St. Petersburg, Florida. Author of catalogues on Luca Giordano, 1964, Sebastiano and Marco Ricci, 1966, Bernardo Strozzi, 1967, the age of Vasari, 1970, Impressionists in 1877, 1977, Degas, 1986, and French marine paintings, 1987. **Essays:** Giordano's *Triumph of Judith*, Magnasco's *Bay with Shipwreck*, Ricci's *Adoration of the Magi*, and Strozzi's *The Calling of St. Matthew*.

MILLER, Lillian B. Historian of American Culture, and Editor of the Peale Family Papers, National Portrait Gallery, Washington. Co-author of *Charles Willson Peale and His World*, 1982, and editor of *The Selected Papers of Charles Willson Peale and His Family*, 7 vols, from 1983. **Essays:** Peale (and *The Artist in His Museum*).

MILLER, Naomi. Professor of Art History, Boston University. Author of *French Renaissance Fountains*, 1977, *Heavenly Caves: Reflections on the Garden Grotto*, 1982, and *Renaissance Bologna: A Study in Architectural Form and Content*, 1989, and of articles on French and Italian Renaissance architecture. **Essays:** Goujon (and *Fountain of Innocents*).

MILLS, Roger. Free-lance writer. **Essays:** de Stael and Hockney.

MILNER, Frank. Member of the staff, Walker Art Gallery, Liverpool. **Essays:** Stubbs (and *Horse Frightened by a Lion*).

MINOR, Vernon Hyde. Associate Professor of Art History and Humanities, University of Colorado, Boulder. Author of articles on Chracas's *Diario Ordinario*, Filippo della Valle, and Tommaso Righi. **Essays:** Fragonard (and *The Swing*) and Houdon (and *Seated Voltaire*).

MINOTT, Charles I. Associate Professor of the History of Art, University of Pennsylvania, Philadelphia. **Essays:** Altdorfer (and *The Battle of Alexander*), Campin (and *Mérode Triptych*), Gerard David (and *Baptism of Christ Altarpiece*), Pacher (and *St. Wolfgang Altarpiece*), Sluter (and *Well of Moses*), and Stoss (and *St. Mary Altarpiece*).

MITCHELL, Timothy F. Associate Professor of Art History, University of Kansas, Lawrence. Author of several articles on Friedrich and on modernism. **Essays:** Friedrich (and *Monk by the Sea*).

MOFFITT, John F. Professor of History of Art, New Mexico State University, Las Cruces. Author of *Spanish Painting*, 1973, and *Occultism in Avant-Garde Art*, 1988, and of articles on Velázquez, van der Goes, El Greco, Rembrandt, Van Dyck, Tischbein, and Ribera. **Essays:** El Greco's *View of Toledo*, Goya's *Third of May, 1808*, Mor (and *Mary Tudor*), Murillo (and *The Holy Family with a Bird*), Van Dyck (and *Charles I on Horseback*), and Zurbarán (and *St. Francis in His Tomb*).

MORRIS, Susan. Writer for *The Antique Collector*, London. Author of *Thomas Girtin*, 1986. **Essays:** Gainsborough (and *Cornard Wood* and *Mr. and Mrs. Andrews*), Girtin's *The White House at Chelsea*, and Wilson's *Snowdon from Llyn Nantlle*.

MOSKOWITZ, Anita F. Associate Professor of Art, State University of New York, Stony Brook. Author of *The Sculpture of Andrea and Nino Pisano*, 1986, and of articles on Andrea Pisano, Donatello, and Titian. **Essays:** Andrea Pisano (and *Florence Baptistery Doors*) and Nicola Pisano (and *Pisa Baptistery Pulpit*).

MURDOCH, Tessa. Senior Assistant Keeper, Museum of London. **Essays:** Roubiliac (and *George Frederick Handel*).

NELSON, Kristi. Associate Dean for Academic Affairs, College of Design, Architecture, Art, and Planning, University of Cincinnati. **Essays:** Jordaens (and *The King Drinks*).

NORTH, Percy. Visiting Assistant Professor of Fine Arts, Vanderbilt University, Nashville. **Essays:** Davis (and *Lucky Strike*), Demuth (and *I Saw the Figure 5 in Gold*), and Shahn (and *The Red Stairway*).

NUTTALL, Paula. Free-lance writer. Author of articles on Cosimo Rosselli and Giuliano da Maiano, 1985. **Essays:** Filippino Lippi (and *Vision of St. Bernard*) and Andrea Sansovino (and *The Virgin and Child with St. Anne*).

OLSON, Roberta J.M. Professor of Art History, Wheaton College, Norton, Massachusetts. Author of *Italian Drawings 1780–1890*, 1980 and *Fire and Ice: A History of Comets in Art*, 1985, and of articles on Botticelli, Bartolini, Brunelleschi, Rossi, Giotto, and Palladio. **Essays:** Botticelli (and *Mystical Nativity* and *Primavera*) and Piero di Cosimo (and *The Death of Procris*).

OPPLER, Ellen C. Professor of Fine Arts, Syracuse University, New York. Author of *Fauvism Reexamined* and several articles on Modersohn-Becker, and editor of *Picasso's Guernica*, 1988. **Essays:** Modersohn-Becker (and *Self-Portrait*) and Picasso's *Guernica*.

OVERY, Paul. Free-lance critic and lecturer. Author of *Edouard Manet*, 1967, *De Stijl*, 1969, and *Kandinsky: The Language of the Eye*, 1969, and of articles on Vorticism and "the new art history." **Essays:** Delaunay (and *Windows Open Simultaneously*).

PALMER, Deborah. Free-lance writer, Paris. **Essays:** Pilon (and *Tomb of Valentine Balbiani*).

PARKER, Stephen Jan. Professor of Slavic Languages and Literatures, University of Kansas, Lawrence. Co-author of *Russia on Canvas: Ilya Repin*, 1981, and author of *Understanding Vladimir Nabokov*, 1987; co-editor of *The Achievements of Vladimir Nabokov*, 1984. **Essays:** Repin (and *The Cossacks*).

PARRY, Ellwood C. III. Professor of Art History, University of Arizona, Tucson. Author of *The Image of the Indian and the Black Man in American Art 1590–1900*, 1974, and *The Art of Thomas Cole: Ambition and Imagination*, 1988, and of articles on Eakins. **Essays:** Bierstadt (and *The Rocky Mountains, Lander's Peak*) and Cole (and *Scene from "The Last of the Mohicans"*).

PARSHALL, Peter W. Professor of Art History, Reed College, Portland, Oregon. **Essays:** Lucas van Leyden (and *Last Judgment*).

PARTRIDGE, Loren. Professor of History of Art, University of California, Berkeley. Author of *John Galen Howard and the Berkeley Campus*, 1978, and (with Randolph Starn) *A Renaissance Likeness: Art and Culture in Raphael's "Julius II,"* 1980, and of articles on the Villa Farnese at Caprarola and Ucello. **Essays:** Cima da Conegliano (and *Virgin and Child*), Domenico Veneziano (and *Virgin and Child*), Perugino (and *Christ Consigning the Keys to St. Peter*), Pollaiuolo (and *Martyrdom of St. Sebastian*), Raphael's *Triumph of Galatea* and *Pope Leo X*, Jacopo Sansovino (and the *Loggetta*), Uccello (and *Battle of San Romano*), Verrocchio (and *Colleoni Monument*), and Zuccaro (and *Cardinal Farnese Entering Paris*).

PELZEL, Thomas. Associate Professor of Art History, University of California, Riverside. Author of *Anton Raphael Mengs and Neoclassicism*, 1979, of articles on Mengs, and the catalogue *The Arts and Crafts Movement in America*, 1972. **Essays:** Batoni (and *Thomas Dundas*), Mengs (and *Parnassus*), and Pannini (and *Visit of Carlos III to the Basilica of St. Peter*).

PETERS, Carol T. Free-lance writer. **Essays:** Daddi (and *Bigallo Triptych*), Agnolo Gaddi (and *Legend of the True Cross*), Taddeo Gaddi (and *Baroncelli Chapel*), Giotto's *Ognissanti Madonna*, Ambrogio Lorenzetti (and *Good and Bad Government*), Lorenzo Monaco (and *Adoration of the Magi*), and Orcagna (and *Strozzi Altarpiece*).

PIPERGER, Justin. Free-lance writer. **Essays:** Braque and Oldenburg.

POMEROY, Ralph. Contributing Editor, Arts Magazine, New York. Author of several books, the most recent being *Stamos*, 1974, *The Ice Cream Connection*, 1975, and *First Things First*, 1977. **Essays:** Morandi and Schlemmer.

POWELL, Cecilia. Turner Scholar, Tate Gallery, London. Author of *Turner in the South: Rome, Naples, Florence*, 1987, and articles on Turner. **Essays:** Turner (and *The White Library, Petworth* and *Snow Storm – Steam-Boat Off a Harbor's Mouth*).

POWELL, Kirsten H. Member of the Art Department, Middlebury College, Vermont. **Essays:** de Kooning (and *Woman I*), Millet (and *The Gleaners*), and Pollock (and *Autumn Rhythm*).

PRESSLY, William L. Associate Professor of Art, University of Maryland, College Park. Author of *The Life and Art of James Barry*, 1981, and the catalogue *James Barry: The Artist as Hero*, 1983, and of articles on Surrealism and Zoffany. **Essays:** Barry (and *The Birth of Pandora*) and Stuart (and *The Skater*).

QUINSAC, Annie-Paule. Member of the Art Department, University of South Carolina, Columbia. **Essays:** Bonheur (and *The Horse Fair*), Fattori (and *The Palmieri Rotunda*), Rosso (and *The Conversation in the Garden*), and Segantini (and *The Evil Mothers*).

RADKE, Gary M. Associate Professor of Fine Arts, Syracuse University, New York. **Essays:** Benedetto da Maiano (and *S. Croce Pulpit*).

RAJNAI, Miklos. Free-lance consultant and writer. Author of several books and catalogues on Cotman. **Essays:** Cotman (and *Greta Bridge*) and Crome (and *Poringland Oak*).

RAND, Olan A., Jr. Member of the Department of Art History, Northwestern University, Evanston, Illinois. **Essays:** Champaigne (and *The Ex-Voto of 1662*) and Ghiberti (and *The Gates of Paradise*).

REYNOLDS, Lauretta. Free-lance writer. **Essays:** Arp's *Femme Amphore*, Johns's *Three Flags*, Rivers (and *Washington Crossing the Delaware*), and Tatlin (and *Monument to the Third International*).

RIEDE, David G. Professor of English, Ohio State University, Columbus. Author of *Swinburne: A Study of Romantic Mythmaking*, 1978, *Dante Gabriel Rossetti and the Limits of Victorian Vision*, 1983, and *Matthew Arnold and the Betrayal of Language*, 1988. **Essays:** Rossetti (and *The Wedding of St. George and the Princess Sabra*).

ROBINSON, Susan Barnes. Professor of Art History, Loyola Marymount University, Los Angeles. Author of *Françoise Gilot: A Retrospective* (cat), 1978, *Giacomo Balla: Divisionism and Futurism*, 1981, *The French Impressionists in Southern California*, 1984, and *The Spirit of the City* (cat), 1986. **Essays:** Balla (and *Dynamism of a Dog on a Leash*), Bellows (and *Stag at Sharkey's*), Boccioni (and *Unique Forms of Continuity in Space*), Severini (and *Dynamic Hieroglyphic of the Bal Tabarin*), and Smith (and *Cubi XIX*).

ROWORTH, Wendy Wassyng. Professor of Art History, University of Rhode Island, Kingston. Author of articles on Rosa and Kauffmann. **Essays:** Kauffmann (and *Painting, Design, Genius, and Composition*) and Rosa (and *Democritus in Meditation*).

RUDA, Jeffrey. Associate Professor of Art History, University of California, Davis. Author of *Lippi Studies*, 1982, and of articles on Lippi. **Essays:** Filippo Lippi (and *San Lorenzo Annunciation*).

RUSSO, Kathleen. Associate Professor of Art History, Florida Atlantic University, Boca Raton. Author of articles on Greuze and Fuseli. **Essays:** Carriera (and *Louis XV as a Boy*), Fuseli (and *The Nightmare*), Greuze (and *Young Girl Crying over Her Dead Bird*), Piranesi (and *The Pantheon*), and Vigée-Lebrun (and *Self-Portrait with Cerise Ribbon*).

SCHERF, Guilhem. Curator in the Sculpture department, Louvre Museum, Paris. **Essays:** Bouchardon (and *Four Seasons Fountain*), Coysevox (and *Triumph of Louis XIV*), Girardon (and *Apollo Served by the Nymphs*), Pigalle (and *The Nude Voltaire*), and Puget (and *Milo of Crotone*).

SCHNEIDER, Laurie. Professor of Art History, John Jay College, City University of New York. Author of articles on Piero della Francesco, Donatello, Leonardo, and Raphael, and editor of *Giotto in Perspective*, 1974. **Essays:** Giotto (and *Arena Chapel Frescoes*), Leonardo (and *Mona Lisa*), Mantegna (and *Camera degli Sposi* and *Dead Christ*), Masaccio (and *Tribute Money* and *Trinity*), Melozzo da Forli (and *Sixtus IV and His Nephews*), and Piero della Francesca (and *Arezzo Frescoes* and *Resurrection*).

SCOTT, David. Lecturer in French, Trinity College, Dublin. Author of *Edward Kienholz: Tableaux 1961–1979*, 1981, *Pictorialist Poetics*, 1988, and the forthcoming *Paul Delvaux*. **Essays:** Delvaux (and *Sleeping Venus*), Kienholz (and *The State Hospital*), and Magritte (and *Time Transfixed*).

SCRIBNER, Charles III. Vice-President, Macmillan Publishing Company, New York. Author of *The Triumph of the Eucharist: Tapestries Designed by Rubens*, 1982, and *P.P.*

Rubens, 1989. **Essays:** Rubens (and *Rubens and His Wife Isabella Brant* and *The Rape of the Daughters of Leucippus*).

SHAW, Lindsey Bridget. Free-lance writer. **Essays:** Fabritius (and *Goldfinch*), Hooch (and *A Women Lacing Her Bodice Beside a Cradle*), Kalf (and *Still Life with Chinese Bowl*), Metsu (and *The Huntsman's Present*), and ter Borch (and *A Woman at Her Toilet*).

SHESGREEN, Sean. Professor of English, Northern Illinois University, DeKalb. Author of *Engravings by Hogarth*, 1973, *Hogarth and the Times-of-the-Day Tradition*, 1983, and *The Criers, Hucksters, and Peddlers of London*, 1988. **Essays:** Hogarth (and *Hogarth's Servants*).

SHIKES, Ralph E. Free-lance writer. **Essay:** Pissarro's *Boulevard des Italiens, Morning, Sunlight*.

SLAYMAN, James H. Associate Professor of Art History, Tyler School of Art, Temple University, Philadelphia. **Essays:** Prud'hon (and *Justice and Vengeance*).

SMITH, David R. Associate Professor of Art History, University of New Hampshire, Durham. Author of *Masks of Wedlock: 17th-Century Dutch Marriage Portraiture*, 1982, and articles on Hals, Rembrandt, and Raphael. **Essays:** Hals (and *The Laughing Cavalier* and *The Regents of the Old Men's House*).

SOBRÉ, Judith Berg. Associate Professor of Art History, University of Texas, San Antonio. Author of *Behind the Altar Table: The Spanish Painted Retable 1350–1500*, 1989, and articles on Spanish art and artists. **Essays:** Bermejo (and *The Pietà of Canon Lluis Desplà*, Pedro Berruguete (and *Auto da Fé*), and Huguet (and *Consecration of St. Augustine*).

SPIKE, John T. Critic and writer. **Essays:** Baschenis (and *Still Life with Musical Instruments and a Statuette*), Bernini (and *Apollo and Daphne, Ecstasy of St. Teresa*, and *Fountain of the Four Rivers*), Ceruti (and *A Group of Beggars*), Crespi (and *Confirmation*), Preti (and *St. John the Baptist Preaching*), and Solimena.

STALLABRASS, Julian. Ph.D. student, Courtauld Institute of Art. **Essays:** Gabo (and *Linear Construction: Variation*), Kokoschka (and *The Tempest*), Lipchitz (and *Figure*), Marc (and *Fighting Forms*), Mondrian (and *Composition with Red, Yellow, and Blue*), Nolde (and *Doubting Thomas*), and Pevsner (and *Portrait of Marcel Duchamp*).

STANDRING, Timothy J. Member of the Art Department, Pomona College, Claremont, California. **Essays:** Castiglione (and *Allegory of Vanity*).

STEVENSON, Lesley. Free-lance writer. **Essays:** Gauguin's *Day of the God*), Manet's *Déjeuner sur l'herbe* and *Olympia*, Renoir (and *Monet Painting in His Garden* and *Bathers*), and Sisley (and *Snow at Louveciennes*).

STRATTON, Suzanne L. Curator of Exhibitions, Spanish Institute, New York. Author of *La inmaculada en el arte espanol*,

1988, and of articles of García Lorca, Goya, and Rembrandt. **Essays:** El Greco (and *Burial of the Count of Orgaz*).

SULLIVAN, Ruth Wilkins. Research Curator, Kimbell Art Museum, Fort Worth, Texas. Author of several articles on Duccio. **Essays:** Cimabue (and *S. Trinità Madonna*), Duccio (and *Maestà*), Pietro Lorenzetti (and *Birth of the Virgin*), Maso di Banco (and *St. Sylvester Cycle*), and Traini (and *Triumph of Death*).

SULLIVAN, Scott A. Professor of Art History, University of North Texas, Denton. Author of *The Dutch Gamepiece*, 1984, and of articles on van Beyeren, Snyders, Rembrandt, and Weenix. **Essays:** Snyders (and *Pantry Scene with a Serving Figure*) and Weenix (and *Still Life with a Dead Hare*).

SURTEES, Virginia. Free-lance writer. Editor of Ford Madox Brown's *Diary*, 1981. **Essay:** Brown's *The Last of England*.

TEVIOTDALE, E.C. Kress Fellow, Warburg Institute London. Author of articles on manuscript music illustrations and on Monet. **Essays:** Monet's *Le Portail et la Tour d'Albane* and *Le Bassin aux nymphéas*.

THOMPSON, Elspeth. Free-lance writer. **Essays:** Marini (and *Pomona*).

TOMLINSON, Janis A. Assistant Professor of Art History, Columbia University, New York. Author of *Francisco Goya: The Tapestry Cartoons and Early Career at the Court of Madrid*, 1989, and *Graphic Evolutions: On the Print Series of Francisco Goya*, 1989, and of articles on Goya. **Essays:** Goya (and *Family of Charles IV*).

TUFTS, Eleanor. Professor of Art History, Southern Methodist University, Dallas. Author of *Our Hidden Heritage: Five Centuries of Women Artists*, 1974, *American Women Artists: A Selected Bibliographic Guide*, 1984, *Luis Meléndez, Eighteenth-Century Master of the Spanish Still Life, with a Catalogue Raisonné*, 1985, and *American Women Artists 1830–1930*, 1987, and of articles on Albertinelli and Goya and Bellows. **Essays:** Meléndez (and *Still Life with Small Green Pears, Bread, Amphora, Flask, and Bowl*).

VERDON, Timothy. Professor of Art History, Florida State Study Center, Florence, Italy. Author of *The Art of Guido Mazzoni*, 1978, and of articles on Donatello and other subjects. Editor of *Monasticism and the Arts*, 1984, and *Christianity and the Renaissance*, 1989. **Essays:** Mazzoni (and *Lamentation*) and Niccolò dell'Arca (and *Lamentation*).

WALDER, Rupert. Free-lance writer. **Essays:** Bonnard, Braque's *Le Portugais*, Duchamp's *The Bride Stripped Bare by Her Bachelors Even*, and Seurat.

WALSH, George. Publisher and free-lance writer, Chicago. **Essays:** Bouts (and *Last Supper*), Brown, Jan Bruegel (and *Hearing*), Canaletto (and *The Stonemason's Yard*), Gauguin, Geertgen, Gris, Guardi (and *S. Maria della Salute*), La Tour (and *The Newborn Child*), Le Brun, Parmigianino (and *Madonna of the Long Neck*), Primaticcio, Puvis de Chavannes,

Quercia (and *St. Petronio Doorway*), Theodore Rousseau, Signorelli, Steen (and *The Dissolute Household*), and van de Velde (and *The Cannon Shot*).

WANKLYN, George A. Lecturer in Art History, American University of Paris. Author of articles on Delaune and Jean Cousin. **Essays:** François Clouet (and *Pierre Quthe*), and Jean Clouet (and *Marie d'Assigny, Madame de Canaples*).

WECHSLER, Judith. Professor of the History of Art, Rhode Island School of Design, Providence. Author of *The Interpretation of Cézanne*, 1981, and *A Human Comedy: Physiognomy and Caricature in Nineteenth Century Paris*, 1982, and editor of *Cézanne in Perspective*, 1975, and *On Aesthetics in Science*, 1978. **Essays:** Cézanne's *Madame Cézanne in a Red Armchair* and Daumier's *A Third Class Carriage*.

WEIL, John A. Professor of Chemistry, University of Saskatchewan, Saskatoon. **Essay:** Albers (with John H. Holloway).

WEILAND, Jeanne E. Instructor in English, Northern Illinois University, DeKalb. **Essay:** Hogarth's *Marriage-à-la-Mode*.

WELLS, William. Member of the staff of the Burrell Collection, Glasgow (now retired). Author of articles on early Renaissance art. **Essays:** Perréal (and the *Moulins Triptych*).

WEST, Shearer. Lecturer in the History of Art, Leicester University. **Essays:** Frith (and *Derby Day*) and Zoffany (and *The Tribuna of the Uffizi*).

WHITTET, G.S. Free-lance writer and consultant, London. Author of several books, including *Lovers in Art*, 1972. **Essay:** Duchamp.

WOLK-SIMON, Linda. Member of the Public Programs office, Metropolitan Museum of Art, New York. **Essays:** Andrea del Sarto (and *Madonna of the Harpies*), Fra Bartolommeo (and *Mystical Marriage of St. Catherine of Siena*), Beccafumi (and *Birth of the Virgin*), Giulio Romano (and *Fall of the Giants*), Perino del Vaga (and *Fall of the Giants*), Pontormo (and *Deposition*), and Sodoma (and *St. Sebastian*).

WOODS-MARSDEN, Joanna. Assistant Professor of Art History, University of California, Los Angeles. Author of *The Gonzaga of Mantua and Pisanello's Arthurian Frescoes*, 1988, and of articles on Pisanello and other subjects. **Essays:** Pisanello (and *Triumphator et Pacificus*).

WRIGHT, Christopher. Free-lance writer and consultant. Author of many books, including *The Duch Painters*, 1978, *French Painting*, 1979, *Painting in Dutch Museums*, 1980, *Italian, French, and Spanish Paintings of the 17th Century*, 1981, *The Art of the Forger*, 1984, and *The French Painters of the Seventeenth Century*, 1985, and books on La Tour, Rembrandt, Vermeer, and Hals. **Essays:** Berchem (and *Landscape with a Man and a Youth Plowing*), Bosschaert (and *Vase of Flowers*), Cuyp (and *View of Dordrecht*), Goyen (and *Landscape with Two Oaks*), Heda (and *Still Life: The Dessert*), Heem (and *Still Life*), Hob-

bema (and *The Avenue at Middelharnis*), and Ruysch (and *Still Life of Flowers*).

ZILCZER, Judith. Associate Curator of Painting, Hirshhorn Museum and Sculpture Garden, Washington. Author of *"The Noble Buyer": John Quinn, Patron of the Avant-Garde*, 1978, and *Joseph Stella: The Hirshhorn Museum and Sculpture Garden Collection*, 1983, and of articles on synaesthesia, Quinn, and Duchamp-Villon. **Essays:** Duchamp-Villon (and *The Horse*) and Stella (and *Brooklyn Bridge*).